DRAWN BY NEW YORK

SIX CENTURIES OF WATERCOLORS AND DRAWINGS AT THE NEW-YORK HISTORICAL SOCIETY

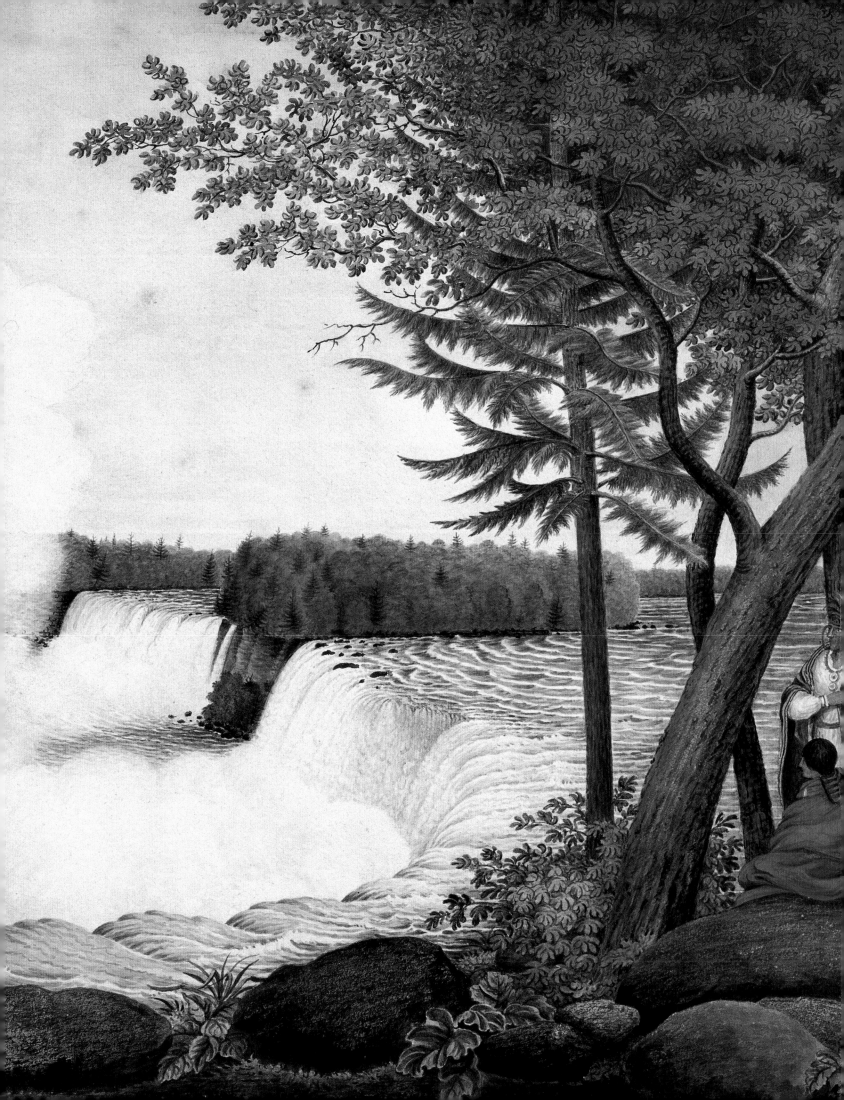

DRAWN BY NEW YORK

SIX CENTURIES OF WATERCOLORS AND DRAWINGS AT THE NEW-YORK HISTORICAL SOCIETY

ROBERTA J.M. OLSON

WITH THE ASSISTANCE OF ALEXANDRA MAZZITELLI

NEW-YORK HISTORICAL SOCIETY, NEW YORK IN ASSOCIATION WITH D GILES LIMITED, LONDON

The exhibition and publication of this catalogue and its research were generously funded by The Getty Foundation, Leonard L. and Ellen Milberg, Barbara and Richard Debs, The Samuel H. Kress Foundation, Eli Wilner & Company, Inc., Pam and Scott Schafler, Furthermore: a program of the J. M. Kaplan Fund, Alexander Acevedo, and Graham Arader.

© 2008 New-York Historical Society
Published by the New-York Historical Society in association with GILES, an imprint of D Giles Limited, on the occasion of the exhibition *Drawn by New York: Six Centuries of Watercolors and Drawings at the New-York Historical Society* at the New-York Historical Society (on view September 19, 2008-January 7, 2009), followed by venues at the Frances Lehman Loeb Art Center, Vassar College, Poughkeepsie, New York (August 14-November 1, 2009), and the Taft Museum of Art, Cincinnati, Ohio (November 20, 2009-February 7, 2010).

First published in 2008 by GILES
An imprint of D Giles Limited
2nd Floor
162–164 Upper Richmond Road
London, SW15 2SL
UK
www.gilesltd.com

Softcover edition:
ISBN 13: 978-0-916141-02-8
ISBN 10: 0-916141-02-0
Hardcover edition:
ISBN: 978-1-904832-34-8

For the New-York Historical Society:
Project Manager: Roberta J. M. Olson
Project Editor: Fronia Simpson
Photography of all objects in the N-YHS collections by Glenn Castellano.

For D Giles Limited:
Proof-read by David Rose
Designed by Anikst Design Limited, London
Produced by GILES, an imprint of
D Giles Limited, London
Printed and bound in Hong Kong

All measurements are in inches and centimeters

Front cover illustration:
George Harvey
Afternoon: Hastings Landing, Palisades Rocks in Shadow, New York, 1836–37 (detail)
Watercolor, gouache, graphite, scratching-out, and touches of black ink and glazing on paper, laid on brown card
Gift of Mrs. Screven Lorillard, 1952.410

Back cover illustration:
Nicolino Calyo
The Great Fire of 1835: View of New York City Taken from Brooklyn Heights on the Same Evening of the Fire, c. 1835 (detail)
Gouache on heavy paper, laid on Japanese paper, wrapped over board
Purchased by the Society, 1935.167

Frontispiece:
Thomas Davies
Niagara Falls from Above, c. 1766 (detail)
Watercolor, brown and black ink, gouache, and graphite with selective glazing on paper
Traveller's Fund, James S. Cushman, and Foster-Jarvis Funds, 1954.2

CONTENTS

PRESIDENT'S PREFACE

Drawn by New York: Six Centuries of Watercolors and Drawings at the New-York Historical Society is a landmark publication for the New-York Historical Society. This important volume takes its place immediately as an invaluable reference, not only to the Society's remarkable collection but also for the entire field of scholarly investigation and connoisseurship pertaining to original works on paper. Scholars of history, students, art historians, curators, and collectors will welcome the new information, scholarly depth, and magnificent illustrations presented in what is sure to be hailed as a model collection catalogue. I must extend special thanks to Vice President and Museum Director, Dr. Linda S. Ferber, who initiated the production of this ambitious publication soon after her arrival in 2005. She, in turn, was able to enlist the adept organizational support of Museum Director for Administration, Roy R. Eddey.

Of course, without the unwavering commitment of Dr. Roberta J. M. Olson, Curator of Drawings, whose five-year project to catalogue the Society's entire collection of over eight thousand sheets has redefined the collection itself, this publication of some two hundred masterworks, as well as the dazzling exhibition that accompanies it, would not have been possible. Dr. Olson deserves our enduring gratitude for her vision, for her impeccable scholarship, and for restoring the public profile of a great and hitherto virtually unknown collection.

We deeply appreciate the magnificent generosity of the Getty Foundation in providing long term baseline support for bringing this cataloguing and publication project to fruition. The Samuel H. Kress Foundation provided additional funding for the research phase. We wish to acknowledge with profound gratitude the splendid support of Leonard L. and Ellen Milberg that allowed us to realize our highest ambitions for the production of this handsome publication, an endeavor, together with the exhibition of the same title, also supported by Barbara and Richard Debs, Eli Wilner & Company, Inc., Pam and Scott Schafler, Furthermore: a program of the J. M. Kaplan Fund, Alexander Acevedo, and Graham Arader.

For the ongoing support of the Museum's Trustees, we extend special gratitude to our Chairman, Roger Hertog, and to every member of our Board. Without the confidence and engagement of our Trustees, it would not be possible to initiate and maintain such a high level of publication and exhibition programming as is exemplified by *Drawn by New York: Six Centuries of Watercolors and Drawings at the New-York Historical Society*.

Dr. Louise Mirrer
President and C.E.O.

DIRECTOR'S FOREWORD

The New-York Historical Society harbors an unknown treasury of original works on paper comprised of some eighty-five hundred sheets. This volume provides a revealing introduction to that treasury, offering an insightful (and delightful) journey through these massive holdings via some two hundred and fifty works selected by Dr. Roberta J. M. Olson.

The Society's collection of original works on paper is one of the earliest to be assembled and reflects the history of the oldest museum in New York City, founded in 1804. The original stewards of these sheets offer a revealing record of acquisition and disposition that tracks New York patronage, taste, and interests as well as the Society's own collection formation.

From the first acquisition of original works on paper in 1816, the collection has grown over two centuries by generous gift, thoughtful bequest, wise purchase, and serendipity. It has evolved in tandem with, and often in direct relation to, other great print, photography, and architectural collections now housed in the Society's Library. While the Museum's holdings of original works on paper has greatest depth in the chronological span from the late eighteenth to the late nineteenth centuries, there are also surprises and strengths in the periods both predating and following this concentration.

Highly portable original works on paper provided first hand reports and visual records that were often breaking news of their moment and precious historical evidence later on. Remarkable images were created primarily in service to topographical, architectural, ethnographic, scientific, engineering, military, and documenting purposes. Landscape painters working in the field used graphite, watercolor, and oil on paper to produce the studies essential for their inspiration in the studio. European visitors used sketchbooks to record the sights and scenery as they toured the newly founded United States. Practitioners (often anonymous) of calligraphy, silhouettes, and folk traditions have left brilliant visual records as well. Many original works on paper were preparatory for translation into other media: prints; magazine, newspaper, and book illustrations; oil paintings; murals; even stained glass.

Many rewarding trails can be followed through this remarkable treasury. One might chronicle images of New York City itself as a narrative of the turns and twists of history from the 1650 view of New Amsterdam to Edward Burckhardt's urban panorama of the mid 1840s detailing the city's rapid expansion. In the last century, Chesley Bonestell's chilling 1950 fantasy of Manhattan under atomic attack and Richard Welling's 1970 panorama of the World Trade Center under construction assume new forms of meaning in the wake of recent events in a city that seems always to be at the center of world events. Like New York City itself, these collections are perpetually in formation. This distinguished publication demonstrates the Society's importance as a force in recording and interpreting the history and art history of New York and the nation.

Dr. Linda S. Ferber
Vice President and Museum Director

ACKNOWLEDGMENTS

Like most collection catalogues, *Drawn by New York: Six Centuries of Watercolors and Drawings at the New-York Historical Society* has enjoyed a lengthy gestation. Envisioned as an exhibition catalogue, it showcases highlights of the roughly eight thousand drawings and watercolors in the collection. As is the case with many similar publications, *Drawn by New York* is the product of a collaborative venture involving colleagues within the institution as well as outside agencies and a host of individuals, whose intelligence, skill, generosity, knowledge, and encouragement have been indispensable to its realization. Foremost among the many valued colleagues at the New-York Historical Society, I would like to thank President Louise Mirrer, under whose leadership of the Society this project has come to fruition. Dr. Mirrer enthusiastically supported it from the moment she took over the helm of the N-YHS from her predecessor, Dr. Kenneth T. Jackson, under whose presidency it was conceived. With the inspired stewardship of Linda S. Ferber, Vice President and Director of the Museum, the catalogue and exhibition have taken their current shape. Her link to the project predated her tenure at the Society. Already in 2002, Dr. Ferber, then at the Brooklyn Museum, generously discussed the fledgling project with me in a stimulating telephone conversation and has subsequently offered unstinting support and scholarly insights. At the urging of Dr. Jan Seidler Ramirez, her predecessor as director, the project and its funding assumed both its initial direction and original mapping. During the final, crucial stages of the catalogue, Roy Eddey, Director of Museum Administration, has been instrumental in shepherding *Drawn by New York* through the shoals of publication and exhibition planning with his sagacious and judicious expertise. To these valued colleagues I remain most grateful for their belief in the ambitious undertaking that, against many odds, has germinated and matured into this handsome volume.

At the outset of this project, the New-York Historical Society received indispensable support from the Getty Foundation in the form of a Preparation for Publications Grant. This munificent award, which coincided with the institution's bicentennial, allowed the first comprehensive and systematic study of the Society's drawing collection in the organization's two-hundred-year history. During the first year, we examined each of the over eight thousand sheets and entered the pertinent technical information into the Society's Access database to create the general catalogue of the collection that now is available in e-museum on the Web. Early in the second year, we selected a group of 201 drawings for the catalogue and the accompanying exhibition that were intended to showcase highlights of the larger collection. They were researched, and in-depth, scholarly catalogue entries were written for each. In the process we accumulated reams of information to enrich and swell the individual object files and constantly updated the technical files as new material was discovered. I would like to express my personal appreciation to the Getty Foundation for this critical initial funding. An indispensable Curatorial Fellowship from the Samuel H. Kress Foundation followed the Getty funding; it helped support the work of a curatorial assistant Alexandra Mazzitelli, who has been pivotal in ensuring the success of every aspect of this project and its realization–ranging from writing catalogue entries to pursuing the most minute historical facts. Major support for the landmark publication that celebrates a great collection has been provided by Leonard L. and Ellen Milberg. We are also grateful to Barbara and Richard Debs, the Getty Foundation, Eli Wilner & Company, Inc., Pam and Scott Schafler, Furthermore: a program of the J. M. Kaplan Foundation, Alexander Acevedo, and Graham Arader for their support of the catalogue and exhibition.

Any attempt to express gratitude to all those individuals who aided the realization of this project in a constellation of thanks is apt to fall prey to sins of omission. It is an impossible task to acknowledge the contributions of everyone who has been instrumental in facilitating an endeavor of this scope. Colleagues, past and present at the New-York Historical Society, generously shared their expertise, including Alan Balicki and Heidi Nakashima, as well as Leslie Augenbraun, who offered advice on matters concerning media and conservation and in some cases performed treatments on works; Debra Schmidt Bach, Stephen R. Edidin, Margaret K. Hofer, Kathleen Hulser, Kimberly Orcutt, Lee Vedder, and Amy Weinstein, fellow curators, who generously shared their respective expertises and knowledge; Jenny Gotwals, Marilyn Kushner, Kelly McAnnaney, Matthew Murphy, Sandra Markham, and Kristine Paulus, who graciously fielded many requests about the frequently connected collections in the Department of Prints, Photographs, and Architectural Collections (DPPAC); and Jean Breskend, an indispensable volunteer, who invaluably contributed to various aspects of this project. A succession of talented and insightful interns have added much value to this endeavor: Alison Castaneda, Elizabeth Gaudino, Thea Gunhouse, Katherine Jenkins, Michelle Jodon, Hyejin Jennifer Kim, Laura Melnyczenko, Justine Pokoik, Gretchen Riewe, Lauren Sinclair Rogers, Shane Rosen-Gould, and Clara Ines Rojas-Sebesta. Among the legion of other colleagues, thanks are due to Sarah Armstrong-Crum, Karen Buck, David Burnhauser, Glenn Castellano, Miguel Colon, Marybeth De Filippis, Marcel Downer, Emily Foss, Paul Gunther, Jeff Hall, Marybeth Kavanaugh, Davis Lopez, David Mandel, Maureen McGillan, Daniel McGloin, Jill Reichenbach, Danny Santiago, Gerhard Schlanzky, Drew Sterling, Denny Stone, and Julia Zaccone. Members of the Society's library staff expeditiously aided the research for this project at every turn, among them, Jean Ashton, Maurita Baldock, Lorraine Baratti, Joseph Ditta, Emilia Epelbaum, Jan Hilley, Kimberly Latham, Edward O'Reilly, Eric Robinson, and Mariam Touba.

Access to great library collections and staffs outside the Society has been one of the privileges enjoyed by everyone who has worked on the research aspects of this catalogue. New York City libraries provide collectively one of the finest clusters of research facilities in the world. I know of no other location where the works contained in the N-YHS drawing collection—which combines western European and American material—could have been successfully studied so expeditiously. In addition to the stellar collection of American holdings in the Society's library, the greatest debt is to Kenneth Soehner, Arthur K. Watson Chief Librarian, and the staff of the Thomas J. Watson Library of the Metropolitan Museum of Art, without whose rich resources this catalogue, especially its European component, could never have been researched. Among the numerous individuals who have been more than helpful in negotiating the hurdles of scholarship and facilitating the quest for information there, I would like to single out

personnel past and present: Lisa Beidel, Ronnie Fein, Linda Seckelson, Nancy Mandel, Betsy Bing, Victoria Bohm, Robert Cederberg, Robyn Fleming, Robert Kaufmann, Oleg Kreymer, John Lindaman, Daniel Lipcan, Ren Murrell, Holly Phillips, Fredy Rivera, Mike Rodriguez, Evalyn Stone, and Deborah Vincelli. The unique resources of the many divisions of the New York Public Library also added richness and texture to many of the arguments contained in various entries, and I am most grateful to the NYPL for access to its collections and for the privilege of using the Wirtheimer Study Room. Wayne J. Furman, John Rathé (Rare Books), Robert Rainwater, and Nicole Simpson of the Miriam & Ira D. Wallach Division of Art, Prints and Photographs and the Spencer Collection should be singled out in a general thanks to the entire staff of this venerable institution with its invaluable resources. Another essential research facility was the Frick Art Reference Library, whose incomparable collection of books, auction catalogues, and photographs greatly enhanced the catalogue's completion. Thanks also are extended to J. Fernando Peña of the Grolier Club, the Columbia University Libraries, and, by extension of the various interns, the libraries of Rutgers University and Yale University.

Countless colleagues in other museums and related institutions liberally shared information on objects in their collections and answered queries about various issues during the course of the catalogue preparation. Among them are colleagues at the Amsterdam Historical Museum (Mrs. Nel Klaversma); the National Archive, Amsterdam (N. B. J. Meiboom); the Universiteitsbibliotheek, Amsterdam (Jan Werner); the U.S. Naval Academy Museum, Annapolis, Maryland (James Cheevers); the Museum of Fine Arts, Boston (Patrick Murphy and Kate Silverman); the Fogg Art Museum, Harvard University Museums, Cambridge, Massachusetts (William Robinson, Alvin J. Clarke Jr., and Miriam Stewart); the Alfred Jacob Miller Limited Company, Charlottesville, Virginia (Deborah A. White); the Devonshire Collection, Chatsworth (Peter Noble); the Arnot Art Museum, Elmira, New York (John D. O'Hern); the Newington-Cropsey Foundation, Hastings-on-Hudson, New York (Kenneth W. Maddox); the University of Iowa Art Museum, Iowa City (Elisa Ewing); the Senate House Museum, Kingston, New York (Dina Preston); the Minneapolis Institute of Art, Minnesota (Patrick Noon); the Yale University Art Gallery, New Haven, Connecticut (Graham C. Boettcher, Suzanne Greenawalt, and Robin Jaffee Frank); the American Museum of Natural History, New York (Mary LeCroy); the John Street Methodist Church (Jason P. Radmacher); the Metropolitan Museum of Art, New York (Kevin Avery, Carmen Bambach, Megan Holloway Fort, Alice C. Frelinghuysen, Morrison Heckscher, Nadine Orenstein, Marjorie Shelley, Perrin Stein, Barbara Veith, Beth Wees, H. Barbara Weinberg, Liz Zanis, and Mary Zuber); the Museum of the City of New York (Melanie Bower and Andrea Fahnestock); the National Academy of Design, New York (Annette Blaugrund, Mark Mitchell, and Marshall Price); the New York Academy of Medicine Library (Miriam Mandelbaum); the Oliver Tilden Camp #26, SUVCW, New York (Captain George J. Weinmann); the Pierpont Morgan Library, New York (Anne Varick Lauder); the New Jersey Historical Society, Newark (Tim Dekker); the Joslyn Art Museum, Omaha, Nebraska (Penelope B. Smith); the Musée du Louvre, Paris (Christian Michel); the Tiffany Archives, Parsippany, New Jersey (Louisa Bann); the Huntington Library, San Marino, California (Peter J. Blodgett); Historic Hudson Valley, Tarrytown, New York (Patty Pinsonnault and Genevieve Swenson); the Musée d'Art et d'Histoire, Troyes (Chantal Rouquet); the University Library of Utrecht (Marco van Ergmond); École nationale supérieure des Sciences d'Information et de Bibliothèques, Villeurbanne, France (Vanessa Selbach); Moody Library, Baylor University Library, Waco, Texas (Melvin Schuetz); the Musée et Château de Versailles (Xavier Salmon); and the National Portrait Gallery, Washington, D.C. (Ellen G. Miles).

I would also like to express my appreciation to many other scholars and learned individuals who shared their knowledge on individual artists or historical issues, including Nicolas Barker, formerly of the British Library; Nina Gray; Emma P. Hoops; Alexander B. V. Johnson; Harry Katz, formerly of the Library of Congress; Elaine Kilmurray; Joep de Koenig; Richard Ormond; Henrietta Ryan, formerly of the Royal Library, Windsor; and Jane Turner, editor of *Master Drawings*.

Colleagues at galleries and auction houses also aided in tracing pertinent material and information. Among those individuals are Flavia Ormond of Flavia Ormond Fine Arts and Lynda McCloud and Marijke Booth of Christie's, both in London; Lillian Brenwasser of Kennedy Galleries, Inc., Joseph Goddu of Hirschl & Adler Galleries, Inc., Robert Kashey of Shepherd and De Rom, Kristen E. Dayton of Christie's, Hugo Martinez of the Martinez Gallery, Heather Parks of the Forum Gallery, and Constance and David Yates, all in New York City. Numerous gallery catalogues that preserve the legacies of various exhibitions allowed us to trace provenances and movements of objects.

We have been fortunate to have the efficient staff of D Giles Limited, London, as the co-publisher/distributor for the catalogue. Dan Giles's excitement about the collection and vision of the volume are much appreciated. The adept publication team, foremost among them the independent editor Fronia W. Simpson, the production director Sarah McLaughlin, and the gifted designers Alfonso Iacurci and Misha Anikst (of Anikst Design Limited, London), and proofreader David Rose, molded this sampler of material into a visually coherent and exciting ensemble.

I also wish to acknowledge the sustained commitment of visionary donors and friends over the years, all of whom have advanced the N-YHS's holdings by donating works and/or crucial funds for acquisitions.

The list of those to whom this publication owes its existence is much longer than this space can accommodate. To all those individuals who are listed above and those not mentioned, I extend my sincerest gratitude.

Dr. Roberta J. M. Olson
Curator of Drawings

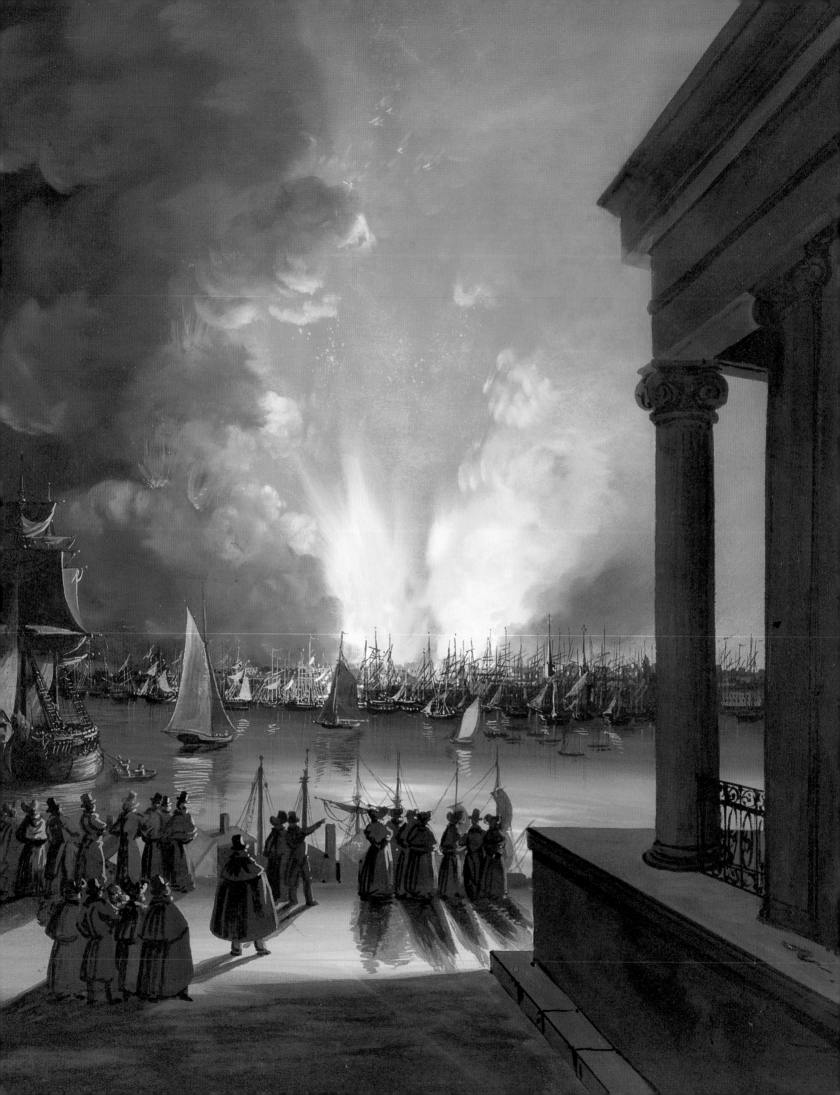

ESSAY

SHARING ONE OF THE BEST-KEPT SECRETS:
THE DRAWING COLLECTION OF THE NEW-YORK HISTORICAL SOCIETY*

Roberta J. M. Olson

As the New-York Historical Society (N-YHS) enters its third century, this catalogue showcases highlights of its distinguished drawing collection, whose evolution is as complex as the history of the Society itself. New York City's oldest museum was founded on 20 November 1804 to "collect and preserve whatever may relate to the natural, civil or ecclesiastical history of the United States in general and of this State in particular."[1] Today the Society consists of two divisions: the renowned research library—which also encompasses the Department of Prints, Photographs, and Architectural Collections (DPPAC) and the Department of Manuscripts—and the museum, whose rich holdings comprise some eight thousand original works on paper that, like their artists, were drawn by the magnetic pull of New York City. Just as the Society's founders were devoted to preserving their country's historical documents, so too are today's New Yorkers fascinated by the history of their city and state against the backdrop of America.

Since the Society has the earliest assembled public drawing collection in the United States,[2] it is surprising that it is not more widely known. In part, this oversight may be tied to problems of identity and funding that the Society has confronted since the 1940s,[3] coincidentally the era when the belated study of American drawings was born.[4] An exception to this lack of general knowledge of the collection is the signature group of 435 watercolors by John James Audubon preparatory for *The Birds of America* (fig. 3), whose fascinating story is related later in this essay and in catalogue 42.

In 1816 the N-YHS acquired through donation its first two drawings. Portraits in pastel, a medium popular at the time, they depicted eminent American men and were thus deemed documentary records of historic significance.[5] In the decades following independence, portraiture was the genre of art most eagerly sought by American patrons. Having one's portrait taken was an index of personal prosperity and also signaled a more established country. With this near tyranny of the face, it was not until 1855 that the Society acquired its first landscape drawing. A view of the Hudson Valley town of Kingston, it augured one of the collection's emerging strengths.[6] Through the generosity of donors, coupled with the vision of trustees and staff (men of erudition such as collectors, merchants, civic leaders, and antiquarians), drawings continued to be acquired organically along with paintings and prints as an integral part of a two-dimensional world collected for the historical evidence it contained. Even in the twentieth century, when archival practice had already largely abandoned subject classifications, the overriding organizing principle at the Society remained iconographic, an approach that assisted researchers who liked to browse by subject. Thus it is possible to make many connections between objects of different media in the Society's various collections. For example, drawn studies and finished works based on them abound, such as Jasper Francis Cropsey's study for one of the oil versions of *Youle's Shot Tower, New York City* (cat. 98).

Without a drawings specialist on staff, prints, drawings, and photographs were kept together until 1939, when the Map and Print Room was established within the library and the museum division was created. These different repositories sometimes resulted in works by the same artist being found in both divisions of the Society. A case in point is the eight-hundred-odd sheets by Alexander Jackson Davis, mostly architectural plans and elevations, which continue to be housed with the architectural collections in the DPPAC (successor to the Map and Print Room), whereas twenty-four drawings and watercolors by the architect remain under the museum umbrella, for example figure 1 and catalogue 67.

The drawing collection thus evolved in an impromptu manner, growing up rather like Topsy. Exacerbating this situation was a periodic fluctuation of departmental nomenclatures and territories, combined with internal shiftings of collections. While during the twentieth century, there was a curator of the museum—the distinguished Richard J. Koke, who held the position from 1947 to 1983—as well as a curator of paintings and sculpture and a curator of maps and prints (later solely a curator of prints), it was not until 1989 that the word *drawings* appeared in any position title or departmental name. In that year Annette Blaugrund was appointed curator of paintings, drawings, and sculpture; she

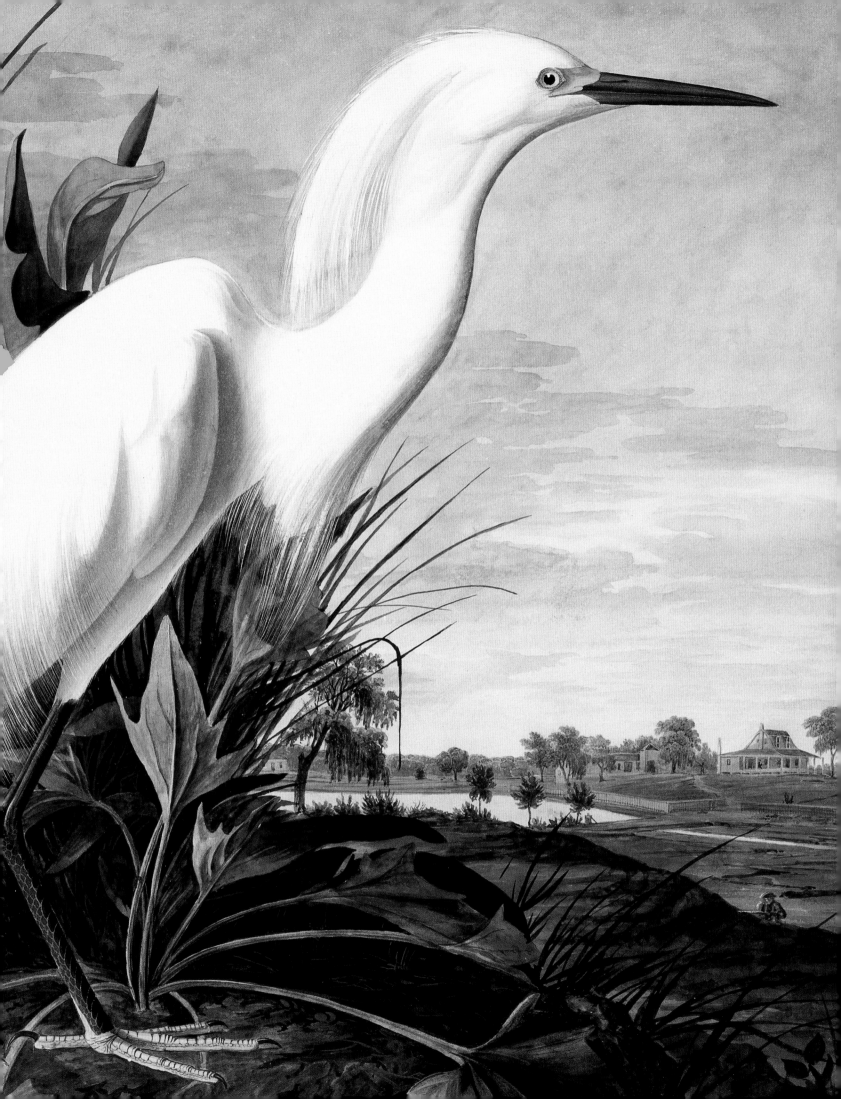

was soon elevated to the position of Andrew W. Mellon Senior Curator of Paintings, Drawings, and Sculpture, which she held until 1995. During a very difficult period in the Society's history, she worked to bring the collections to the attention of a wider audience and to ensure the objects' physical survival. Only since the year 2000 has there been a curator charged specifically with the care of drawings.

The undeniable strength of the drawing collection resides in the early half of its holdings, centered on the late eighteenth and first half of the nineteenth centuries and focused primarily on historical content. For historians living in the early years of the country, drawings, like documents, were considered evidence that revealed truths. Although from 1804 to 1870, the Historical Society was, de facto, New York City's only true "art" museum, it did not approach its collection primarily for its aesthetic qualities, since its mission emphasized the documentary importance of its holdings.

Drawings and watercolors at the Society are generally considered under the rubric "original works on paper" (to distinguish them from works in printed media that are multiples), a category they share with other unique sheets—such as the silhouettes in the collection, which number more than 350. Twenty-four silhouettes, including figure 2 and catalogue 46 (a group of cut "shadows" populated by an astounding seventeen figures), are by the celebrated French artist Augustin-Amant-Constant-Fidèle Édouart, made during his ten-year sojourn in the United States in the 1830s and 1840s. These silhouettes and all the Society's original works on paper are housed in the renovated study-storage

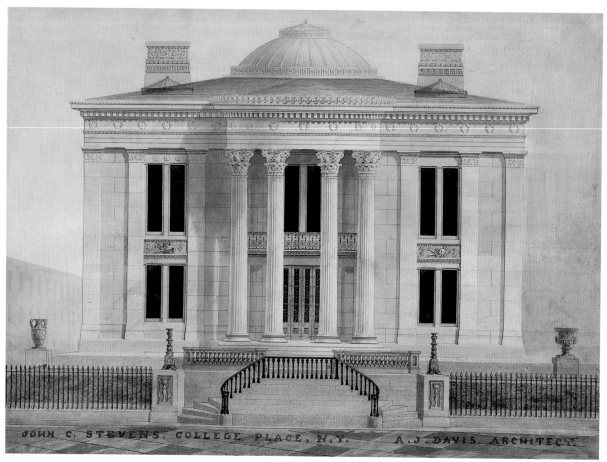

Fig. 1. Alexander Jackson Davis, *Residence of John Cox Stevens, New York City*, 1835. Watercolor, black ink, and graphite on two sheets of heavy paper, laid on cloth, 15 7/8 × 20 7/8 in. (403 × 530 mm). Gift of Daniel Parish Jr., 1908.27

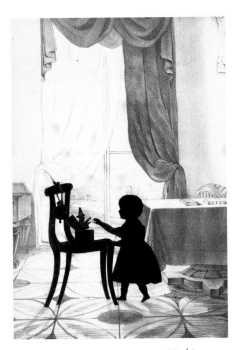

Fig. 2. Augustin-Amant-Constant-Fidèle Édouart, *Philip Milledoler Beekman (1845–1846): Silhouette*, 1846. Black prepared paper cutout, white chalk, and white gouache, laid on yellow prepared paper with lithographic background and gray wash, 10 7/8 × 7 3/8 in. (277 × 187 mm). Gift of the Beekman Family Association, 1948.515

facilities of the Henry Luce III Center for the Study of American Culture. The Center occupies the fourth floor of the Society's eighth location, the landmark beaux-arts building on Central Park West designed by York and Sawyer (1901–8).

Draftsmanship played an important role in American art, beginning with the work of the first artist-explorers. The earliest drawings in the Society's collection are by European artists who immigrated to America to record its legendary landscapes for an audience back home, including a group of inspired Anglo-American artists involved with print-making, such as John Hill (cat. 24) and William Guy Wall (cat. 48). Intermingled in the collection are drawings by professionals and amateurs alike, by such luminaries as Audubon (cats. 42 and 43) and John Frederick Kensett (cat. 88) as well as by "folk" artists—such as Joseph H. Davis (cat. 75), an unknown calligraphic artist (cat. 118), and fraktur artists (for example, cat. 49), some purchased from Elie Nadelman and his Museum of Folk Arts, Riverdale-on-Hudson, Bronx, New York. Works by topographical draftsmen, naturalists and explorers, and illustrators, who were increasingly drawn to New York City as it became a vital publishing hub in the nineteenth century, join them. These panoramic offerings reflect America as it saw itself: first as a dependent colony in a primeval wilderness; then as a young country with a seemingly limitless frontier; and finally as a world power with great urban centers. With these assets the collection affords matchless insights into historical places, people, and events and presents a broad survey of American art, from early times, when European influences and artists (and even art supplies) dominated the scene, to later periods, when there arose indigenous styles and artistic movements, such as the Hudson River School.

Throughout its history, however, the Society did not aim to amass representative examples of the development of American art but rather to form a collection consonant with its mission. At first, the stated goal had been to assemble original documents, artifacts, and artworks illustrative of the development of the United States and New York State. More recently, the mission had narrowed to focus on materials capable of narrating the story of New York City and the metropolitan region. Beginning with the institution's bicentennial in 2004, the mission has come full circle and once more includes the whole state and country. Needless to say, the individuals who formed the collection cast their nets widely, using "American" loosely to include both foreign-born artists (many of whom returned to their country of origin) and expatriate Americans whose art played an influential role in the cultural aspirations of the United States. Hence, the collection uniquely mirrors the reality of the country's formation and maturation.

Although its identity, like that of many nascent museums in the nineteenth century, was not immediately defined, the N-YHS gradually metamorphosed into an important art repository, its history intertwined with the development of art, taste, historiography, and patronage in America. In 1825 the first general meeting of artists ever held in the city for the advancement of their profession took place in the rooms occupied by the Society in the New York Institution at City Hall Park. Chaired by Asher B. Durand (cats. 51–54) and recorded by Samuel F. B. Morse (before he became preoccupied by the telegraph), both prominent painters, the attendees founded the New York Drawing Association, which in 1826 was reorganized as the prestigious National Academy of Design (NAD).[7] (Continuing this linkage with the visual arts and organizations that championed draw-

ings, the N-YHS would later publish the academy's exhibition records, along with those of other American art schools.) When the Society opened its new self-contained building, its seventh incarnation, on what was then fashionable Second Avenue at Eleventh Street in 1857, the character of the Society changed from a quiet repository of books, manuscripts, and Knickerbocker-oriented memorabilia into what was, for that time, a first-class, quasi-professional museum. By the end of the 1850s the Society had adopted an extremely flexible collecting policy with an international flavor that reflected the sprawling collecting habits of ever-wealthier Americans who had begun traveling in Europe and collecting on the world stage. The collections even extended to the thirteen Assyrian reliefs, Egyptian antiquities, and mummified bulls that eventually were transferred to the Brooklyn Museum.[8] During the later decades of the nineteenth century, the Society came of age. Building on its growing patrimony of family portraits and heirlooms, it soon possessed landscape and genre art of the highest caliber by keystone figures of nineteenth-century American art, many of whom worked in or around New York City and were important draftsmen.

Although the winds of patronage have deposited numerous gifts into the Society's collections, the majority of the drawings were purchased. Perhaps the most celebrated acquisition is the large group of watercolors by John James Audubon, including his *Snowy Egret* (fig. 3), which was

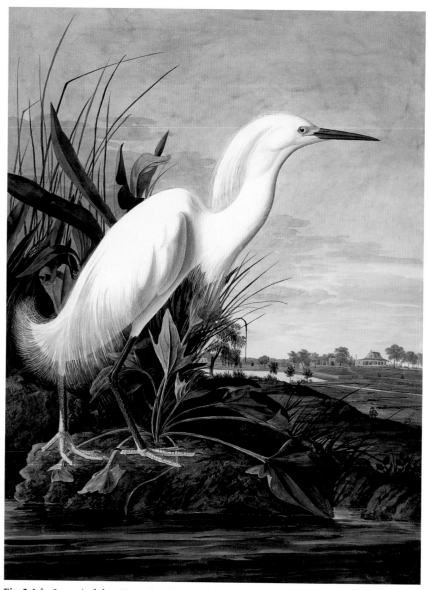

Fig. 3. John James Audubon, *Snowy Egret* (Egretta thula): *Study for Havell Plate No. 242*, 25 March 1832. Watercolor, gouache, and graphite with scratching-out and touches of glazing on paper, laid on thin board, 29 1/4 × 21 5/16 in. (743 × 542 mm). Purchased for the Society by public subscription from Mrs. John J. Audubon, 1863.17.242

offered for sale in 1861 by the artist's destitute widow, Lucy.[9] This cache included 434 original watercolors preparatory for the 435 hand-colored aquatints featured in Audubon's double-elephant folio edition of *The Birds of America* (1827–38), engraved by Robert Havell Jr. Arguably the most sumptuous color folio edition ever produced, the work is one of the world's preeminent natural history documents.[10] The watercolors were purchased by subscription, ironically the same technique originally used by Audubon to market *The Birds of America*. The asking price of four thousand dollars was raised in 1863, a remarkable feat during the Civil War, and was urged by later-President Frederic De Peyster.[11] Today, thanks to a donation in 1966, the Society owns all of Audubon's 435 known extant original watercolors preparatory for *The Birds of America*, making it the largest single repository for Audubon watercolors, prints, and Auduboniana.[12]

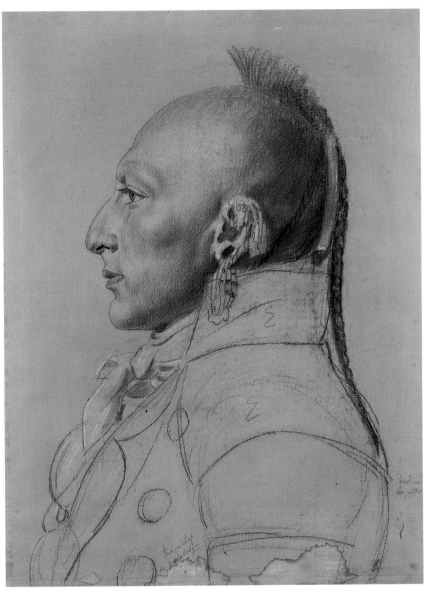

Fig. 4. Charles-Balthazar-Julien Févret de Saint-Mémin, *Unidentified Osage (Chief of the Little Osage)*, 1804. Charcoal with stumping, black pastel, black and white chalk, and Conté crayon over graphite on pink prepared paper, nailed over canvas to a wooden strainer, 22 5/8 × 17 in. (575 × 432 mm), irregular. Elizabeth Demilt Fund, 1860.93

This coup represented the first acquisition by the Society of a very large group of drawings; the cache remains a centerpiece of the collection today. The achievement occurred during a pivotal period, when the institution was evolving from a museum documenting natural and social history to an institution concerned with the fine arts; the symmetrical beauty of the Audubon sheets resides in their pertinence to both of these definitions of a museum. The watercolors added to a core of fine arts holdings, which had begun in earnest with the donation of Luman Reed's collection by the New York Gallery of Fine Arts in 1858.[13] The Audubon purchase and the subsequent bequest of the collection of Thomas Jefferson Bryan (1867) catapulted the Society into the lead as New York City's greatest art museum until the Metropolitan Museum of Art was founded in 1870.

Aware of this important national patrimony, the Society today houses Audubon's watercolors in state-of-the-art storage in the Luce Center on its fourth floor. The public can view quarterly migrations of sheets to the Luce Center Audubon Niche, next to the Luce Center Drawings Niche, where several Audubon watercolors at a time are installed behind ultraviolet-filtering Plexiglas, after which they are returned to storage for at least ten years to ensure their preservation for future generations. Like many of his contemporaries, Audubon was an American not by birth but by adoption; he came to the United States in search of his fortune, as well as to escape a troubling political situation and conscription into Napoleon's army. With his spectacular avian watercolors, he created a certain kind of immortality for himself.

Three years before the watershed Audubon acquisition, the N-YHS had purchased eight rare portraits of Native Americans by another American by adoption, Charles-Balthazar-Julien Févret de Saint-Mémin (cats. 25–27). They had probably been acquired in 1859 by Elias Dexter of New York through his agent James B. Robertson from the artist's descendants in Dijon and deposited at the Society in 1860; they were purchased in 1861.[14] A French aristocrat, Saint-Mémin turned to art to support himself and his family in New York after fleeing the storms of the French Revolution in 1793. With his famed mechanical drawing device, the physiognotrace, Saint-Mémin outlined the contours of his sitters' pro-

files, subsequently embellishing them in mixed media (fig. 4 and cat. 26).[15] His three indigenous American sitters reproduced in this catalogue, including the chief Payouska, were members of the delegations of Osage people (Plains Indians) who visited Washington, D.C., between 1804 and 1807 following the Louisiana Purchase and during the presidency of Thomas Jefferson. Savvy in marketing, the artist offered package deals that consisted of one life-size portrait and the same portrait reduced to miniature with the aid of a pantograph device on an engraved plate, together with twelve impressions. The cost was $25 for men and $35 for ladies, the difference a consequence of the greater difficulty of rendering the intricacies of women's costumes and coiffures. Saint-Mémin's profiles are some of the most memorable images in the history of American portraiture.

The Society's initial group of Saint-Mémin's portraits became the nucleus of a holding swelled by purchases and

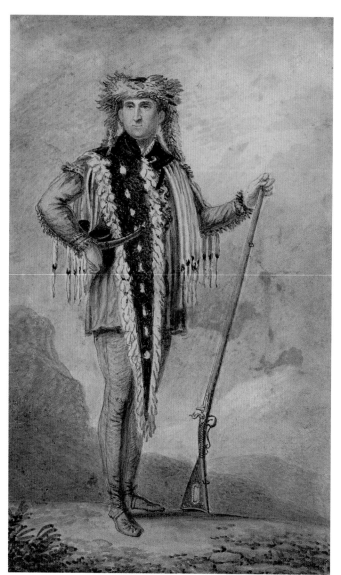

Fig. 5. Charles-Balthazar-Julien Févret de Saint-Mémin, *Meriwether Lewis (1774–1809) in Frontiersman's Regalia*, 1807. Watercolor, black ink, and graphite with touches of red gouache on heavy paper, mounted on card, 6 5/16 × 3 3/4 in. (160 × 95 mm). Gift of the heirs of Hall Park McCullough, 1971.125

donations. Among the former is the large drawing, squared for transfer, preparatory for the artist's first engraving, *View of the City and Harbor of New York, Taken from Mount Pitt* (1794), acquired in 1909 (cat. 25), and among the latter is a watercolor of Meriwether Lewis in frontiersman's dress (1807) made shortly after the explorer's return from his expedition to the Pacific Ocean with William Clark (fig. 5). Recent examination has reduced the fifteen works once given to Saint-Mémin in the collection to thirteen. One of these sheets, a portrait of Richard Morris, is now reattributed to Louis Lemet, Saint-Mémin's second partner in the lucrative business of portraiture; Lemet also painted a portrait of the same sitter, which likewise resides in the Society's collections.[16]

The oldest works in the collection, dating mostly from the mid–sixteenth century, are the 214 newly discovered avian watercolors depicting 219 birds (plus one representing a mammal) by the renowned French illustrator Pierre Vase, or Cruche, also called Pierre Eskrich, and his collaborators once mounted in four albums (cat. 1). A missing chapter in the history of ornithological illustration, they provide a context for Audubon's watercolors for *The Birds of America* and a tantalizing window onto the Protestant Reformation in Europe and early collecting in the United States.

The N-YHS collection preserves few works from the colonial and revolutionary periods, although there is a fascinating anonymous watercolor of an alternative coat of arms for New Amsterdam with rampant beavers (cat. 2). Before the Revolution, America proved generally unfertile territory for artists, not only because of the Puritan mistrust of the arts and the lack of church and state patronage but also because of the amount of energy that needed to

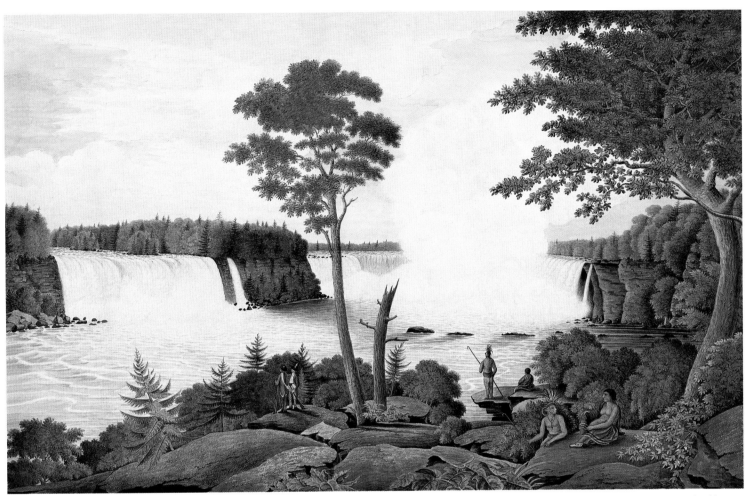

Fig. 6. Thomas Davies, *Niagara Falls from Below*, c. 1766. Watercolor and gouache over graphite with scratching-out on paper, laid on card, 13 9/16 × 20 5/8 in. (344 × 524 mm). Abbott and Foster-Jarvis Funds, 1954.3

be expended on more practical pursuits. However, the Society does own several early depictions of New Amsterdam, such as the watercolor and ink view from the mid–seventeenth century (cat. 3), among the earliest known, and a brown wash drawing with a distant cityscape that was preparatory for an allegorical engraving published by Pieter Mortier about 1700 (cat. 4). They are joined by a small group of eighteenth-century works, among them a dramatic pair of watercolors by Thomas Davies depicting Niagara Falls from both above and below (fig. 6 and cat. 8). The British naturalist and agriculturist Sir William Strickland (cat. 13) made a tour of the eastern United States in 1794, when he befriended George Washington. During his trip he made some of the earliest views of the Hudson River in the collection as well as a view of Mount Vernon seen from the Potomac River (fig. 7).[17] The nucleus of eighteenth-century works also includes a number of sheets with marine subjects, a genre that is well represented in the Society's holdings (for example, cats. 12 and 39), and portraits. Notable among the latter are eleven pastels by James Sharples Sr. (cat. 11), three by other members of his family, and one pastel after a Sharples original. Among these are the first two drawings given to the Society, as noted above.

From the eighteenth through the end of the nineteenth century the status of original works on paper escalated. The trend went hand in hand with developments in paper production and the variety of materials and their uses that were disseminated via published instructional manuals and trade catalogues. Some media began to be used less frequently;

Fig. 7. Sir William Strickland, *View of Mount Vernon, Virginia, from the Northeast*, 1795. Graphite on paper, 8 1/8 × 13 1/8 in. (206 × 333 mm). Gift of the Reverend J. E. Strickland, 1958.55

pen and ink, for example, was largely supplanted by graphite. Others, like watercolor and pastel, were used very differently at the beginning and end of this period for aesthetic and technical reasons. Various mechanical devices for copying and transferring and a range of lightweight apparatus for outdoor sketching greatly enhanced the ability of artists to portray their subjects. New materials—Conté crayons, steel-nib pens, and wove papers (as opposed to laid papers) and other supports—as well as technologically improved media—such as non-blackening Chinese white pigment and moist watercolor introduced in 1832—eventually transformed the art of drawing.[18] For an early-nineteenth-century school for teaching watercolor and drawing methods and the equipment employed, see the comparative figure in the entry on Samuel Folwell (cat. 19).

Most of the Society's early works are American in subject matter only. America was seen from across the Atlantic as an alluring territory for adventurers, military officers, and natural scientists, who frequently recorded their journeys in the pre-photography world in drawings and watercolors. Foreign visitors who were drawn to the New World and New York were often the most perceptive recorders of the American scene, describing its physical appearance as well as offering social commentary, many times for an audience back home. At first these European sojourners who represented the country's natural wonders, such as its justifiably famous waterfalls and burgeoning settlements, were amateur draftsmen intent on exploration or military exploits,[19] but by the beginning of the nineteenth century more professional artists were active. A transitional figure is George Heriot (cat. 14), a British artist who had been trained by Paul Sandby, the highly influential drawing master in topographical watercolor techniques at the Royal Military Academy at Woolwich near London. Heriot, who later served as deputy postmaster general of British North America, is represented by a pair of sketchbooks recording his impressions captured during a journey from Canada to Washington, D.C., in 1815. Similarly, the wonderfully fresh, freely rendered images in the sketchbook of Captain Joshua Rowley Watson (cat. 28) of the British Royal Navy, who journeyed through the northeastern United States in 1816, include views of East Coast cities as well as wilderness areas. His depictions of the Hudson River and the New Jersey Palisades (fig. 8) anticipate by nearly a decade the itinerary of the American grand tour as articulated in *The Hudson River Portfolio*, after watercolors by William Guy Wall (cat. 48). Among the earlier views executed by travelers outside the professional mainstream of the academies are those by the Baroness Hyde de Neuville (cats. 15 and 16). Having begged exile from Napoleon for herself and her royalist husband in lieu of a death sentence, she immigrated to America, traveling through the Northeast between 1807 and 1814 and again from 1816 to 1822. During her trip in 1816, after Louis XVIII had appointed the baron minister plenipotentiary to the United States, Baroness Hyde de Neuville preserved aspects of her twenty-nine-day voyage on the *Eurydice*, exemplified by a watercolor of her husband reclining in his cabin bed reading, attended by a young servant of African origin and accompanied by two nearby women (cat. 16). The baroness possessed an uncanny observational ability that is demonstrated in the 124 sheets by her hand in the col-

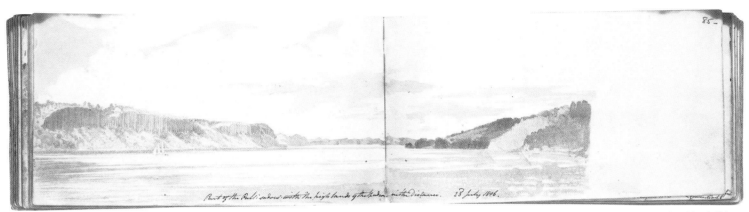

Fig. 8. Joshua Rowley Watson, *View of the Palisades with the Highlands of the Hudson in the Distance*, 1816. Watercolor over graphite on two sheets of paper, bound into a sketchbook (fols. 80v and 81r), each sheet 4 7/8 × 8 7/8 in. (123 × 225 mm), irregular. Beekman Family Association Fund, 1958.85

lection.[20] With great candor, they preserve for posterity the face of a bygone America, its bucolic landscape, people, and customs, including a view of the cottage the couple lived in near New Brunswick, New Jersey (fig. 9).[21]

During the first quarter of the nineteenth century, landscape and geography embodied the country's preoccupations with its destiny. A wave of reproductive printmakers and engravers (and the artists associated with them) who migrated to America in the early 1800s helped prepare the groundwork for America's first native landscape school and firmly established the itinerary of the American grand tour. Two American publications of landscape prints by the English-born artist John Hill (cat. 24), represented by five drawings in the collection, were instrumental in laying the foundation for the American landscape tradition and an audience who appreciated it. He bequeathed his interest in landscape to his son John William Hill (fig. 10 and cats. 76 and 77).[22] The Society has nineteen watercolors and drawings by him, including a huge bird's-eye view of the port of New York.[23] The family proclivity for landscape passed to John Hill's grandson John Henry Hill (represented by a sketchbook, three watercolors, and two graphite drawings). John Hill produced the seminal aquatint images after watercolors by his collaborator, the Irish landscapist William Guy Wall, for *The Hudson River Portfolio* (cat. 48), published between 1820 and 1825, and then again by popular demand in 1828. Its title foreshadowed the moniker later assigned to the Hudson River School, America's first indigenous group of landscape painters.

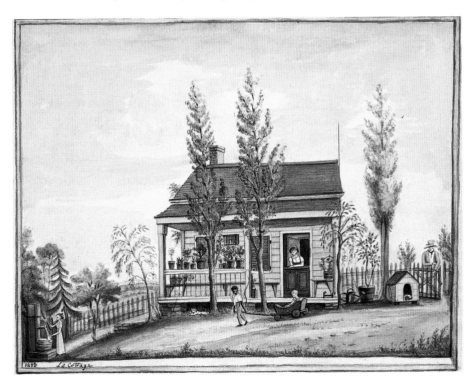

Fig. 9. Anne-Marguérite-Henriette Rouillé de Marigny, Baroness Hyde de Neuville, *The Cottage*, 1813. Watercolor, graphite, and black and brown ink on paper, 6 3/4 × 8 1/4 in. (171 × 209 mm), irregular. Purchased by the Society, 1953.203

The Society has fourteen watercolors (nineteen works in total) by Wall, including all eight known extant watercolors preparatory for the *Portfolio*'s aquatints and several alternative views that were not reproduced as plates.[24] Long considered a cornerstone in the development of American printmaking and landscape painting, its twenty topographical views cover roughly 212 miles of the majestic 315-mile course of the Hudson River from Luzerne (today Lake Luzerne) south to Governors Island near Manhattan for the armchair traveler. The first series of prints to make Americans aware of the beauty and sublimity of their own scenery, the *Portfolio* paved the way for a wider public appreciation of landscape in the United States and helped stimulate national pride, patriotic feelings, and cultural identity.[25]

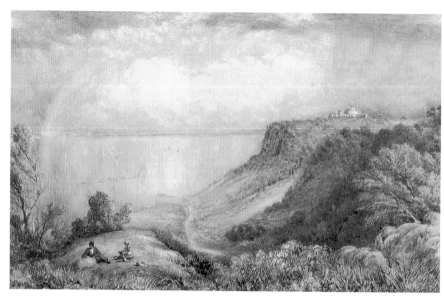

Fig. 10. John William Hill, *View of the Hudson River from the Palisades, Englewood Cliffs, New Jersey, with Rainbow*, 1873. Watercolor, graphite, and touches of gouache on paper, laid on card, 8 3/8 × 13 1/8 in. (213 × 333 mm). Abbott-Lenox Fund, 1969.41

By the 1820s American artists were aware that watercolor had been recognized as an independent medium in England and were inspired by it. The new status accorded watercolor was first evidenced in England at the 1795 exhibition of the Royal Academy of Arts and later at the first exhibition of the Society of Painters in Water-Colours in 1805.[26] However, most professional watercolorists in America still worked in the topographic tradition, since the country lacked a prestigious group of amateurs to support its use, unlike the situation in England, where the cosmopolitan apparatus of societies, annual exhibitions, competitive patronage, and sophisticated connoisseurs promoted the growth of the medium. Whereas a multitude of treatises exclusively on watercolor were published in England in the first half of the nineteenth century, only one—Fielding Lucas's *The Art of Colouring and Painting Landscapes in Watercolours* (Baltimore, 1815)—was published during this period in America.[27] By contrast, many American drawing manuals were aimed at schoolchildren and women, resulting in a democratization of art; like writing instruction, they were intended as educational tools for seeing and thinking more clearly.[28] As Peter Marzio has argued, drawing instruction also became the centerpiece of a national campaign in the nineteenth century to improve the taste of American citizens.[29] Although the status of the medium was in the ascendancy and many English-born American watercolorists began working in the early decades of the nineteenth century, a group of watercolorists felt that the public considered them inferior to history painters working in oil. Accordingly, they formed a club, the New York Watercolor Society, that gathered for monthly meetings in the early 1850s and mounted a single exhibition at the Crystal Palace exposition in 1853. The society ceased meeting two years later, but many of its former members witnessed the special *American Exhibition of British Art* that traveled to New York, Boston, and Philadelphia in 1857–58 and featured important watercolors by many of the Pre-Raphaelite painters. It was not until 1866 that the American Society of Painters in Water Colors (later renamed the American Watercolor Society) was founded with Samuel Colman (cat. 104) serving as its first president.[30] This new regard for the medium is reflected in the N-YHS collection.

The importance of the Society's drawn city views, townscapes, and regional locales, many representing vistas, landmarks, and buildings long vanished, cannot be overemphasized. Most depict locations in New York and the Northeast, and many are dated, adding to their historic importance. The Scottish brothers Alexander (cat. 29) and Archibald Robertson (cat. 21) produced early topographic views of a more developed New York. Archibald—who had studied with Henry Raeburn, Sir Joshua Reynolds, and Benjamin West (represented in the Society's collections by three paintings)—was dubbed "the Reynolds of Scotland" and wrote the first drawing manual printed in the United States (*Elements of the Graphic Arts*, 1802).[31] Although Archibald Robertson came to the United States to paint a portrait of George Washington, he settled in New York City, where, in 1798, he executed his watercolor of the now demolished Federal Hall (cat. 21), which had been reconstructed on the plans of Pierre-Charles L'Enfant shortly before being used for the 1789 inauguration of George Washington. With its view of Wall Street toward Trinity Church, Robertson's watercolor (really a tinted drawing) preserves the structure, which became the first home of the fledgling N-YHS from 1804 to 1809. The seven large gouaches by the Neapolitan-born and trained artist Nicolino Calyo illustrating the Great Fire of 16–17 December 1835 (cat. 56) and the destruction it wreaked on the metropolis (cat. 57) document one extreme cause of change to the urban landscape.[32] The acquisition of such cityscapes accelerated in the final decades of the nineteenth century, as more became available. Others were given by benefactors, and some were bequeathed from private collections by connoisseurs and bibliophiles, such as Daniel Parish Jr. in 1908. Falling into the latter category are the twenty-three diminutive, charming brown ink drawings of New York City by the English-born artist Charles Burton from the 1830s, eighteen of which were the bequest of Stephen Whitney Phoenix in 1881 (cats. 65 and 66). Among this cluster that preserve the city's architecture and rhythm of life is the vignette of the Greek Revival Bowery Theatre (fig. 11).[33]

Some of the Society's drawings belong to larger collections that cut across different areas of its holdings, such as the impressive gathering of Fultoniana—objects and documents associated with the artist and inventor Robert Fulton who was best known for his construction of the first commercially viable steamboat. The lion's share of this impressive collection was donated through the bequests of Randall Le Boeuf Jr., a member of the Society, in 1976 and Harriet Ross Le Boeuf in 1998 (49 and 14 objects, respectively, in various media).[34] An important object in the Le Boeuf donation is John Vanderlyn's portrait of Fulton (cat. 31). After studying at the Columbian Academy in New York City, Vanderlyn went to Paris, where he befriended Fulton and developed into one of America's major neoclassical painters and one of the first artists to begin the search for a truly American art. His refined portrait of Fulton was executed in Paris in 1798. Also in the La Boeuf donation were two watercolors of engineering subjects involving the inclined plane boat and canal transportation drawn by Fulton himself (cat. 20).

One of the fascinating products of post-Enlightenment technology—the hot-air balloon—fueled a passion for the genre of panoramas. Among the panoramic views in the collection are Archibald Robertson's over six-foot-long portrayal of New York City from Pavonia, New Jersey, on five sheets of paper (c. 1823),[35] and Edwin Whitefield's panorama of Brooklyn (c. 1846) in three

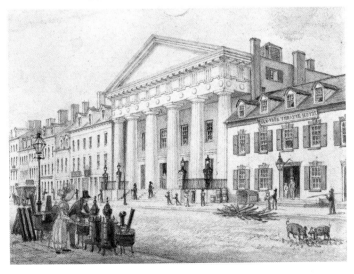

Fig. 11. Charles Burton, *Bowery Theatre, New York City: Study for Plate 7A of "Bourne's Views of New York,"* c. 1831. Brown ink and wash and graphite on paper, 2 3/4 × 3 1/2 in. (70 × 88 mm), irregular. Bequest of Stephen Whitney Phoenix, 1881.14

sections that measure forty inches in length.[36] By far the most extraordinary example in the collection is Edward Burck-hardt's twenty-foot-long drawing in eight sections, which, when joined together, create a circular panorama of New York City in 1842–45 as seen from the steeple of the North Dutch Church (demolished) at the northwest corner of Fulton and William streets in downtown Manhattan (cat. 82).

Landscapes of the countryside, whether in the region of the Hudson River or elsewhere in America or Europe, are plentiful in the Society's collection. Many were executed by artists who worked in close fraternal association—either in formal organizations or with more casual connections—traveling and sketching together. Three of the earliest New York organizations promoting this practice were the New York Drawing Association (est. 1825), which became the NAD (est. 1826), and the Sketch Club (est. 1827).[37] The artist John Ludlow Morton, who belonged to all three and was the first secretary of the NAD, compiled a rare *album amicorum* (an early-nineteenth-century custom on both sides of the Atlantic that consisted of collecting works drawn by friends and colleagues to symbolize their friendship, shared goals, and fellowship). It was given to the Society in 1944 via the bequest of Emily Ellison Post, his granddaughter, who, like many artists' descendants, donated treasures to the Society. Dominated by landscapes, the album contains twenty-seven drawings by twenty-three of her grandfather's comrades, including Thomas Cole (cats. 61 and 62), Morse, Thomas Sully (cat. 40), and Durand (fig. 12 and cats. 51–54).

With the largest collection of Durand material in the world, the Society is blessed with an embarrassment of riches. By means of many dated sketches, the artist's peregrinations throughout much of his professional life can be traced, including his European trip of 1840–41 and his early successful career as an engraver (fig. 13).[38] A friend of Cole, his mentor in landscape painting, and a second-generation Hudson River School artist, Durand shared with Cole and the poet William Cullen Bryant (cat. 64) a pantheistic belief in nature and an appreciation of the spiritual aspects of the American countryside. However, his more pragmatic, direct approach to landscape, which included painting outdoors (*en plein air*), allied him with contemporary European painters.[39] Durand's empiricism and dedication are evident in the stockpile of ten sketchbooks (two of them fragmentary), around 296 independent drawings, and around 110 oil paintings held by the Society's museum, supplemented by prints and a large number of Durand-related ephemera and objects of material culture (such as the artist's paint box, easels, and desk). This impressive hoard of material is largely due to the succession of gifts from the artist's descendants, including his son John Durand (in 1903); his daughter Lucy Maria Durand Woodman (in 1907 and 1918), an artist in her own right who is also represented in the collection; and his granddaughter Nora Durand Woodman (in 1918, 1930, 1932, and 1935). The vast majority of Durand's drawings are acutely observed studies of trees on various colored papers rendered with solid realism and poetic depth (cat. 54).

Noteworthy among the mid-nineteenth-century landscapes are several other large clusters by artists, who, like Durand, adopted plein air painting and were spurred by an appreciation of nature in the wake of the burgeoning urbanization and industrialization of America. The importance of John Ruskin's *Elements of Drawing* (London, 1857), which had a profound impact on Durand and other artists in its emphasis on drawing as a useful skill and its

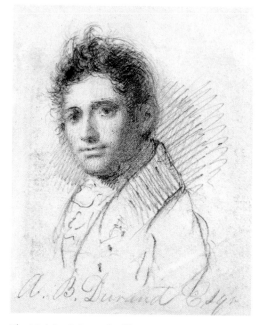

Fig. 12. Asher B. Durand, *Self-Portrait (1796–1886)*; verso: sketch of a palette with brushes, c. 1819. Graphite on paper with binding holes at left, 3 7/16 × 2 13/16 in. (87 × 71 mm), irregular. Gift of Miss Nora Durand Woodman, 1942.550

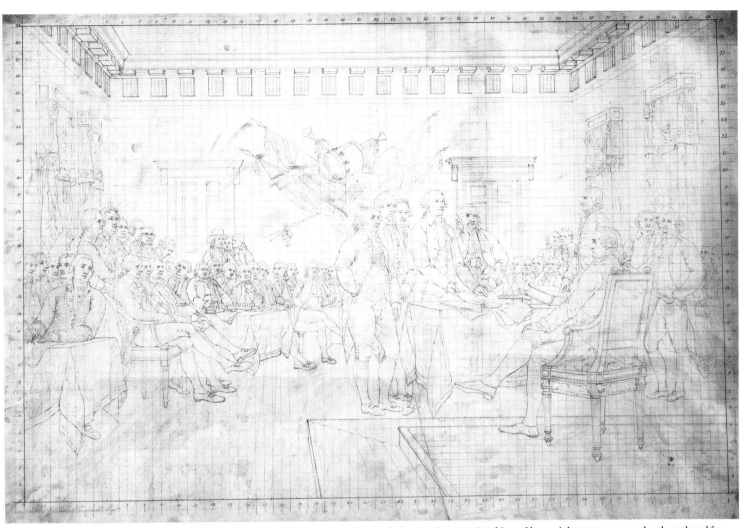

Fig. 13. Asher B. Durand, *The Declaration of Independence after John Trumbull: Preparatory Drawing for the Engraving*, 1820. Graphite and brown ink on paper, squared and numbered for transfer, laid on canvas, 22 7/8 × 32 in. (581 × 813 mm). Gift of the Durand family, X.500

urging a close observation of nature, can never be overestimated.[40] One of these clusters consists of works by William Rickarby Miller (cats. 92 and 93), a superlative watercolorist of the New York region who is represented in the collection by 188 original works on paper, one of which is a watercolor self-portrait (cat. 92), and eleven oil paintings. A goodly number of these were given by George A. Zabriskie, as well as by the artist's granddaughter Grace Miller Carlock, while others were purchased. Many of Miller's landscape drawings were preparatory for prints, as is the case with the breathtakingly atmospheric landscapes of the English-born George Harvey (cat. 63), who commuted between England and America sporadically during his career. In 1947 Charles E. Dunlap gave to the Society eighteen watercolors and three oils by Harvey, establishing it as the largest repository of the artist's works. Today the N-YHS counts twenty-seven watercolors (nineteen of the twenty-two known "Atmospheric Landscapes"), six oils, and four miniatures by Harvey in its collections. In 1836 Harvey had engaged William James Bennett (cat. 41) to engrave his watercolor series of "Atmospheric Landscapes" of North American scenery. The delicacy of Harvey's stipple technique, which foreshadows that of the American Pre-Raphaelites, is apparent in his sunrise view of Flatbush from Green-Wood Cemetery (fig. 14), where only the breath of a cow punctuates the pastoral calm of then-rural Brooklyn, and in his canal scene set against the backdrop

of the Allegheny Mountains (fig. 15). His view of the Hudson River and the Palisades at Hastings-on-Hudson of about 1836 (cat. 63) similarly demonstrates that he could hold a candle to the best English watercolorists of his time and underlines his connection with the tradition represented by Wall's *The Hudson River Portfolio* (cat. 48) and Watson's even earlier watercolor of a similar view (fig. 8).

Interspersed in the collection of predominantly northeastern American material are landscapes executed in more distant American locales, together with studies of Native Americans from the western half of the nation; these testify to the expansion and maturation of the country. Among them are the 221 original "Outline Drawings" by the American artist George Catlin (cat. 50), which he re-created in 1866–68 in the Hôtel Duc de Brabant in Brussels from originals he had made years earlier (1830–36) during his travels through the American Plains (the earlier sheets had been confiscated by a creditor) and from later studies made west of the Rocky Mountains. The series remains an important pictorial source of ethnic Native American culture and customs during the mid–nineteenth century (fig. 16).[41] The fame of Albert Bierstadt—who was born in Germany, came to America as a child, and returned to Düsseldorf to study at the famed academy there—rests on landscapes of the Ameri-

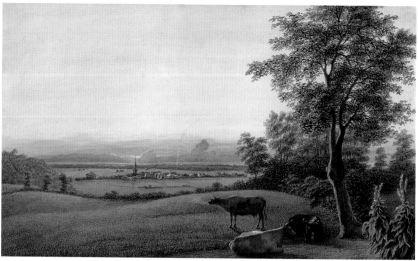

Fig. 14. George Harvey, *Sunrise: Flatbush and the Ocean from the Green-Wood Cemetery, Long Island [Brooklyn], New York*, 1830s–40s. Watercolor, graphite, gouache, selective glazing, and scratching-out on paper, laid on card, 8 1/2 × 13 3/4 in. (216 × 349 mm). Gift of Charles E. Dunlap, 1947.553

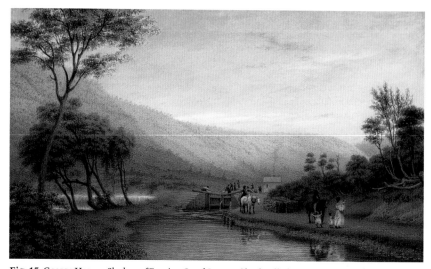

Fig. 15. George Harvey, *Shadows of Evening: Canal Scene amidst the Allegheny Mountains*, c. 1836. Watercolor, graphite, gouache, selective glazing, and scratching-out on paper, laid on brown card, 8 3/8 × 13 3/4 in. (213 × 349 mm). Gift of Charles E. Dunlap, 1947.554

can West that enshrine Manifest Destiny. On his western treks between 1859 and 1873 he also recorded Native American camps and portraits (cat. 102).

There are more landscapes of European locations in the Society's collection from the second half of the nineteenth century, when American collectors increasingly traveled to distant lands. Around midcentury, when Paris replaced Rome as the art mecca for Americans, Thomas H. Hotchkiss became part of an international coterie of expatriates in Rome, which included Elihu Vedder and Charles Caryl Coleman, clinging to the earlier haunt of young American and international art students. Much admired by Durand, in whose circle his artistic education began, Hotchkiss's realistic investigations are apparent in an early plein air cloud study painted in the Catskill Mountains (fig. 17).[42] The technically precocious Hotchkiss continued his carefully observed nature studies outdoors in the Roman Campagna in the tradi-

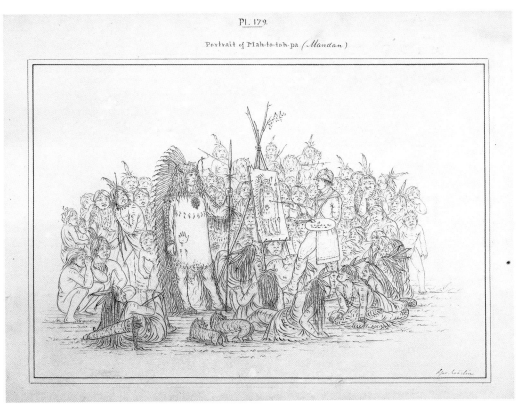

Pl. 179.

Portrait of Mah-to-toh-pa (*Mandan*)

Fig. 16. George Catlin, *Catlin Painting the Portrait of Mah-to-toh-pa (Mandan) in 1832*, 1866–68. Graphite and black ink on prepared card, 18 1/4 × 24 1/8 in. (464 × 613 mm). Purchased by the Society, 1872.23.179

tion of the earlier Etruscan School, composed of English and Italian artists, and led by the Italian Nino Costa.[43] Hotchkiss's work coincided roughly with that of the Macchiaioli in Tuscany and the Barbizon painters in France. The Society is enriched with seventeen paintings on canvas and sixty-seven original works on paper by Hotchkiss, most of which are due to the largesse of Nora Durand Woodman (in 1932) and her heirs (fig. 18). Characteristic of the group are Hotchkiss's bravura watercolors from about 1861 of the Claudian Aqueduct (including cat. 111)—its ten miles of ruins were deemed one of the de rigueur icons to record during any Roman sojourn, attracting many Americans, among them Cole, Cropsey, Sanford R. Gifford (cat. 100), and George Inness—and his bold oil study of the sun-bleached Greek theater at Taormina (cat. 112), when he was painting against time and the hovering shadow of death.

A survey of the Society's collection reveals many idiosyncratic holdings, including some that carry on an important dialogue with Europe and its artists, especially those of England and France. One example is the handsome watercolor portrait of the young diplomat Aaron Vail by the accomplished British artist George Richmond (cat. 72), painted when the sitter served the American government in London. Another is Kensett's romantic, Claudian *Moonlit Scene of Windsor Castle* (cat. 88), probably executed while the artist traveled in Europe with John Casilear, Thomas Pritchard Rossiter (cat. 94), and Durand. John Ward Dunsmore was one of the many American artists during the second half of the nineteenth century who studied with a European master. His teacher was the esteemed French academic painter popular with Americans, Thomas Couture, whose stunning deathbed portrait he drew (cat. 123). Ironically, Dunsmore had in his own collection Couture's sketch of the personification of Death (cat. 83), which has joined in perpetuity his portrayal of his deceased master. Then, there is the tour de force watercolor *The Cavalier, Self-Portrait in Period Costume* by Ernest Meissonier, purchased by

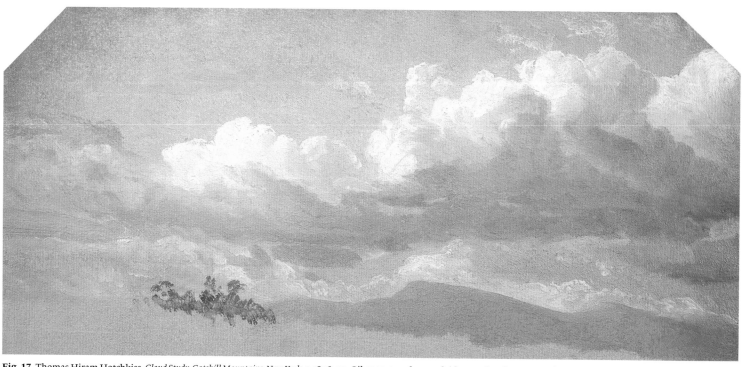

Fig. 17. Thomas Hiram Hotchkiss, *Cloud Study, Catskill Mountains, New York*, c. 1856–59. Oil on textured paper, laid on card and overmatted, 6 1/2 × 13 1/4 in. (165 × 336 mm), irregular, image. Gift of Miss Nora Durand Woodman, 1932.189

Robert L. Stuart for his burgeoning collection (cat. 84). The work came to America when Meissonier donated it to the sale of foreign works contributed by artists to aid the victims of Chicago's Great Fire of 1871. The Society's collection is filled with works containing similarly provocative connections.

The collection's figure drawings, which are not as numerous as its portraits (including many portraits and self-portraits of artists) or landscapes, reveal a preponderance of preparatory studies for paintings, illustrations, or prints. A case in point is a seemingly casual, bold drawing of a man wearing a hat and smoking by William Sidney Mount (cat. 70), which the artist used in his painting *After Dinner* (1834; Yale University Art Gallery, New Haven, fig. 70.2). Mount is well represented in the collections by ten oil paintings and nine drawings. A gift of an anonymous donor, the drawing of the man smoking expresses a new interest in everyday life and ordinary activities that characterized the age of Jacksonian democracy. Depictions of people in times of war can be found alongside pictures of peacetime. During the brief Spanish-American War in 1898, William James Glackens was sent to Cuba to capture the action for *McClure's Magazine*. His illustrations, published at a time when photographers had made documentary sketch artists virtually obsolete, represent the apotheosis of American graphic journalism. Although the dashing drawing executed at the invasion headquarters in Tampa, Florida (cat. 133), was not used for an illustration in an article, the bold panache of this field sketch closely resembles those that were published.

Other diverse clusters in the Society's holdings merit mention in passing. First among them are the 107 largely unpublished Civil War sketches by the "special artists" of *Frank Leslie's Illustrated Newspaper* assigned to the Union armies and naval forces in the Southern war zone. Together with a related sketchbook by George Kerth, they lend an on-the-spot immediacy to scenes of battle and camp life provided by embedded journalistic sketch artists before the advent of a camera capable of operation in the field (cat. 106). Second is the series of eighty-five large watercolor portraits of prominent Americans by Enit

Kaufman (cat. 141), who emigrated from her native Czechoslovakia to the United States in the first half of the twentieth century. These include likenesses of Eleanor Roosevelt and Dwight D. Eisenhower, the artists John Marin and Thomas Hart Benton, the architect Frank Lloyd Wright, the actress Helen Hayes, and the singer Marian Anderson. Collectively, they amplify the substantial holdings in portraiture in various media (paintings, miniatures, sculpture, and prints), including the veritable gallery of 238 notables of the Dutch Treat Club (an organization for people in the creative arts founded in 1905), among them Noël Coward and Gertrude Stein, by William H. Walker. Third is the specialized collection of original watercolors of military uniforms and equipment of the American Revolution by Charles M. Lefferts, which is regarded as one of the major compilations of Revolutionary War militaria (148 sheets). Fourth are the hundreds of drawings and sketchbooks of Henry Alexander Ogden and John Ward Dunsmore, whose focus during the Colonial Revival, like that of Howard Pyle (cat. 121), was on the Revolutionary War. Fifth are the 453 watercolors of engraved powder horns (c. 1886–95) by Rufus Alexander Grider (cat. 90), the gift in 1907 of the artist-historian Isaac J. Greenwood. Finally but not the last cluster by any means is the important, extensive group of marine depictions, rich in views of American naval engagements and portraits of legendary ships, many containing informative inscrip-

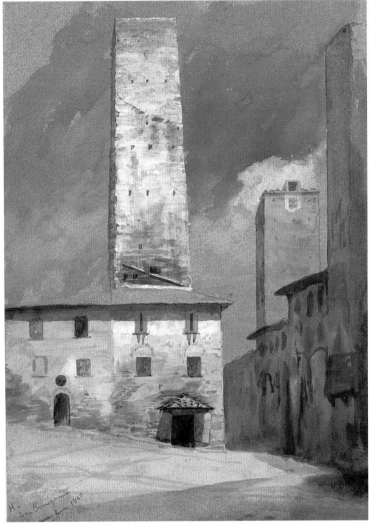

Fig. 18. Thomas Hiram Hotchkiss, *View of the Main Piazza with the Torre del Commune, San Gimignano, Italy*, 1860. Watercolor and gouache over graphite on blue paper, 11 5/8 × 8 3/16 in. (295 × 208 mm). Gift of Miss Nora Durand Woodman, 1932.192

tions and some preparatory for prints. Among the few eighteenth-century sheets is a watercolor by an unidentified artist depicting the landing of New England forces in the expedition against Cape Breton Island in 1745.[44] Others by Dominic Serres, the British naval artist, and Pierre Ozanne, who accompanied the Comte d'Estaing's French squadron to America in 1778, rank as rare originals from the American Revolution. The majority of these marine works date from the nineteenth century, beginning with the War of 1812. A portion traces their provenances to the former collections of Irving S. Olds and Dr. Eugene H. Pool, both of whom donated objects in diverse media. Some of these sheets were executed by individuals who were contemporary specialists in naval battles, as was the case with Thomas Birch (cat. 36). Several of these artists, like Ambroise-Louis Garneray (cat. 39), were French; others, like William Pocock and Thomas Buttersworth, were British, but the engagements they depicted are an integral part of U.S. naval history.

Rounding out these brief descriptions of selected categories are the nearly four thousand works by numerous illustrators, some of whom have already been mentioned, that fed the demand for visual material produced by the voracious

publishing firms of New York City. On one of these sheets Felix Octavius Carr Darley illustrated the Return of Rip Van Winkle in preparation for the fifth of his six lithographs commissioned by the American Art-Union in 1848 to illustrate Washington Irving's classic New York story (cat. 97). The category also includes drawings by important contributors to the American Golden Age of Illustration—Charles Dana Gibson (cat. 131), Edward Penfield (cat. 129), Thomas Nast (cat. 115), and Frederic Remington. Moreover, illustration is the strongest single area of concentration for both the twentieth and twenty-first centuries, and the collection includes works by illustrators of quintessential New York publications such as the *New Yorker* and *Harper's*. It encompasses clusters of city views, some by Vernon Howe Bailey (212 sheets) and Lester Hornby (39 sheets) and others commissioned by the likes of Charles Magnus & Company (44 in number; cat. 122).

Original works on paper by artists who worked in the twentieth century outside the category of illustration are far fewer in number due in part to increased competition with other museums and, internally, to the absence of a drawings curator. A sizable percentage depicts structures, such as the celebrated New York City architectural icon the Flatiron Building (cat. 134). Some document historic events, among them Lydia Field Emmet's multimedia *View across the Great Basin of the World's Columbian Exposition, Chicago, Illinois* (cat. 128). Again, many complement or are connected to other areas of the collection. For example, when in 1984 the Society received a large gift from Dr. Egon Neustadt, including 133 spectacular stained-glass lamps from Tiffany Studios (the lion's share of a diverse Tiffany collection), four watercolors were part of the gift. These jewel-like works, including one by Louis Comfort Tiffany himself (cat. 137), are presentation designs for stained-glass windows. Another is signed by Tiffany on its Tiffany Studio's presentation mount, indicating that it had been approved for production. They joined a large, stunning watercolor of badge designs for the centennial celebrations of George Washington's inauguration designed by Tiffany & Co. (cat. 136). Works by the progressive Ashcan School artists, whose powerful vision is often best articulated in the more direct statements made in drawing media, in addition to the Glackens mentioned above, include two bold sheets by Robert Henri (cat. 127). Regrettably, John Sloan's ability as a draftsman is not represented in the collection, although the Society's DPPAC does hold six of his prints. Closely associated with Sloan, the Eight, and their social interests was Jerome Myers (cat. 132), who spent much of his career recording the New York scene,

especially that of the immigrant community on the Lower East Side. Other twentieth-century urban realists are represented in the collection, such as Raphael Soyer (cat. 142), painter of urban genre scenes. As one might expect, abstract works by artists of the New York School are not well represented owing to many factors, including the institution's mission and the periodic hiatuses in collecting that occurred during the decades following the emergence of Abstract Expressionism. Two exceptions are the group of five drawings by Oscar Bluemner (fig. 19 and cat. 130), the pioneering German immigrant modernist who participated in the 1913 watershed Armory Show, which included many

Fig. 19. Oscar Bluemner, *View of the Harlem River*, 1913. Black crayon on ivory paper, mounted on card, 5 × 7 5/8 in. (127 × 193 mm). Gift of Mr. and Mrs. Stuart Feld, 1982.100

Fig. 20. Philip Guston, *Bernard J. Schiff (1921–2005)*, c. 1956. Black ink wash on brown paper towel, folded, 14 × 10 5/8 in. (356 × 270 mm). Gift of Mrs. Ruth Schiff, 2006.19

drawings,[45] and the recently donated bold portrait sketch by Philip Guston (fig. 20).[46]

Through a generous grant from the Henry Luce III Foundation, the Society embarked on a twentieth- and twenty-first-century collecting initiative, which has precipitated new acquisitions, both purchases and donations. They range from a large realist watercolor of Audubon Terrace by Frederick Brosen (1998; cat. 146) to a view by Richard Haas of the facade of St. Patrick's Cathedral from inside Rockefeller Center through the *Atlas* sculpture (2002; cat. 145) to three focused studies of the shifting surface of the Hudson River by Eve Aschheim from her "Water Series" (1996–2000; cat. 150). Aschheim's drawings, rendered from her studio on West Street, feature a decidedly traditional New York iconography with a novel twist and twentieth-century concerns. Her sheets round out the Society's distinguished collection of representations of the Hudson River, taking the study of the river to its latest refinement in a cutting-edge manner. Collecting works like these marks a return to the spirit of the nineteenth century, when the Society was always alert to contemporary art, Janus-like looking to the past and pointing the way to the future.

Drawings are unrivaled in demonstrating the touch of the artist and revealing insights into the creative process. They are also visually seductive, possessing an immediacy and special beauty. Recently, beginning in the 1990s and continuing today, artists have again been making original works on paper as their final artistic statements, not just as preparatory works. They consider drawing and its ever-expanding array of media a crucible of creativity. This trend has been accompanied by an accelerating interest in drawings on the part of collectors, both private and institutional, and by an increasingly internationalization of art.[47]

This abbreviated examination of the New-York Historical Society's patterns of collecting drawings reveals a venerable institution that has continuously reinvented itself. At the time of writing, the Society is once again embarking on new projects and trajectories, signaling an exciting, novel chapter in the history of collecting drawings and watercolors—drawn magnetically to New York City and 170 Central Park West—and of interpreting the history of this pivotal American metropolis and the United States.

* An earlier version of this essay was published as "One of the Best-Kept Secrets: The Drawings Collection of the New-York Historical Society," *Master Drawings* 42:1 (2004): 19–36.

1. Minutes of the meeting in Mayor DeWitt Clinton's office, City Hall, from the Minute Book in the Department of Manuscripts, quoted in Richard W. G. Vail, *Knickerbocker Birthday: A Sesqui-Centennial History of the New-York Historical Society, 1804–1954* (New York: New-York Historical Society, 1954), 23. The founding of the N-YHS was part of a larger effort to make New York City the cultural as well as economic capital of the nation. Although other cultural organizations had been founded earlier, the N-YHS is one of the few that still exist.

2. For the first known American collection of European old master drawings, given in 1811 through a bequest to Bowdoin College, see David P. Becker, "James Bowdoin's Drawing Collection," *Master Drawings* 38:3 (2000): 223–32.

3. See Vail 1954; and Kevin M. Guthrie, *The New-York Historical Society: Lessons from One Nonprofit's Long Struggle for Survival* (San Francisco: Jossey-Bass, 1996).

4. See Theodore E. Stebbins Jr., *American Master Drawings and Watercolors: A History of Works on Paper from Colonial Times to the Present* (New York: Harper & Row Publishers, 1976), xii–xiii. One of the earliest considerations of American drawings was Charles E. Slatkin and Regina Shoolman, *Treasury of American Drawings* (New York: Oxford University Press, 1947), which reproduces ten sheets from the Society's collection (one mistakenly labeled as belonging to the Museum of Modern Art). Stebbins 1976, xiii–xiv, points out the paucity of early scholarly writing on American drawings. He notes that watercolors were the first to achieve any kind of consideration. Subsequently, art historians have sought to redress this looming gap, among them, Kevin J. Avery et al., *American Drawings and Watercolors in the Metropolitan Museum of Art: Volume I, A Catalogue of Works by Artists Born before 1835* (New York: Metropolitan Museum of Art; New Haven: Yale University Press, 2002), and a second volume, which is in preparation; John Wilmerding et al., *American Art in the Princeton University Art Museum: Volume I, Drawings and Watercolors*, exh. cat. (Princeton: Princeton University Art Museum, 2004), esp. Kathleen A. Foster, "Writing the History of American Watercolors and Drawings," 52–60; Barbara J. MacAdam, *Marks of Distinction: Two Hundred Years of American Drawings and Watercolors from the Hood Museum of Art*, exh. cat. (Hanover, N.H.: Hood Museum of Art, Dartmouth College; New York and Manchester, Vt.: Hudson Hills Press, 2005); and Theodore E. Stebbins Jr., "Introduction: The Discovery of American Drawings," in *Lines of Discovery: 225 Years of American Drawings; The Columbus Museum*, exh. cat., ed. Charles T. Butler (Columbus, Ga.: Columbus Museum; London: D Giles Limited, 2006), 12–21. See also Elizabeth Mankin Kornhauser,

American Paintings before 1945 in the Wadsworth Atheneum, 2 vols. (Hartford, Conn.: Wadsworth Atheneum; New Haven: Yale University Press, 1996), who also discusses many of the artists in the present volume.

5. Felix T. Sharples, *Alexander Hamilton (1757–1804)*, c. 1806–10, inv. no. 1816.1, and James Sharples, *Samuel Latham Mitchill, M.D. (1764–1831)*, c. 1810, inv. no. 1816.2, both donated by Dr. Samuel Akerly. Mitchill was one of the founding members of the N-YHS. See New-York Historical Society, *Catalogue of American Portraits in The New-York Historical Society* (New York: New-York Historical Society; New Haven: Yale University Press, 1974), 1:325, no. 838; 2:544–45, no. 1426, ill., respectively.

6. Inv. no. 1855.2, it was a panoramic view of colonial Kingston in Ulster County in graphite, by the eighteenth-century artist J. Wilkie; see Richard J. Koke, *American Landscape and Genre Paintings in The New-York Historical Society* (New York: New-York Historical Society; Boston: G. K. Hall & Co., 1982), 1:xii; 3:282–85, no. 2904, ill.

7. See Thomas S. Cummings, *Historic Annals of the National Academy of Design, New York Drawing Association, etc., with Occasional Dottings by the Way-side, from 1825 to the Present Time* (Philadelphia: George W. Childs, Publishers, 1865), 21–22, who records the meeting on 8 November 1825 and the subsequent formation of the NAD on 19 January 1826. Cummings (p. 110) notes the almost coeval formation of the Sketch Club or the Old Sketch Club, which was a successor to the artistic and literary salon known as the Bread and Cheese Club, revealing the importance of drawing to the development and sustenance of art at the time.

8. See Roberta J. M. Olson, "A Selection of European Paintings and Objects," *The Magazine Antiques* 167:1 (2005): 182–87, for a discussion and bibliography on the growing sophistication of American taste and collecting during the nineteenth century.

9. When Lucy Bakewell Audubon first offered the drawings in 1861, she urged the Society's librarian, George Henry Moore, to purchase them so they would not end up in the British Museum. She wrote: "It was always the wish of Mr. Audubon that his forty years of labour should remain in his country." Annette Blaugrund and Theodore E. Stebbins Jr., eds., *John James Audubon: The Watercolors for "The Birds of America,"* exh. cat. (New York: Villard Books, Random House, and the New-York Historical Society, 1993), vii.

10. The Society's library holds the "Duke of Newcastle" copy of the double-elephant folio edition bound in four volumes that was originally issued in eighty-seven fascicles of five sheets each.

11. In 1863 the N-YHS also purchased from Mrs. Audubon thirty-six watercolors of birds by her husband that were not directly preparatory for *The Birds of America* but rather were alternative studies. See also cat. 42.

12. The watercolor study for the final plate in *The Birds of America* was given by Mrs. Gratia Rinehart Waters in 1966; the 435 watercolors are preparatory for 433 of

the 435 plates; no watercolors for plates 84 and 155 are known to exist. See also John James Audubon, *The Original Water-color Paintings by John James Audubon for the "Birds of America," Reproduced in Color from the Collection of the New-York Historical Society* (New York: American Heritage/Bonanza Books, 1985); and Susanne M. Low, *A Guide to Audubon's Birds of America* (New Haven and New York: William Reese Company & Donald A. Heald, 2002).

13. See Ella M. Foshay, *Mr. Luman Reed's Picture Gallery: A Pioneer Collection of American Art*, exh. cat. (New York: Harry N. Abrams, in association with the New-York Historical Society, 1990).

14. The Society holds the receipt for the $80, dated March 1861, paid to Dexter for the drawings. Dexter was a frame manufacturer as well as a dealer in engravings, located at 562 Broadway and reputedly the "Publisher of the St. Memin Collection of Portraits." N-YHS 1974, 1:124–25.

15. See Ellen G. Miles, *Saint-Mémin and the Neoclassical Profile Portrait in America*, ed. Dru Dowdy (Washington, D.C.: National Portrait Gallery and the Smithsonian Institution Press, 1994), 269, no. 161, fig. 7:22.

16. The drawing is inv. no. 1966.66 (N-YHS 1974, 2:557, no. 1456, ill.); the painting is inv. no. 1979.87.

17. See Koke 1982, 3:162–63, no. 2525, ill.

18. See Marjorie Shelley, "The Craft of American Drawing: Early Eighteenth to Late Nineteenth Century," in Avery et al. 2002, 29–78; and Marjorie B. Cohn and Rachel Rosenfield, *Wash and Gouache: A Study of the Development of the Materials of Watercolor*, exh. cat. (Cambridge, Mass.: Center for Conservation and Technical Studies, Fogg Art Museum, and Foundation for the American Institute for Conservation, 1977).

19. See Bruce Robertson, "Venit, Vidit, Depinxit: The Military Artist in America" and "The Picturesque Traveler in America," in Edward J. Nygren and Linda Crocker Simmons, *American Master Works on Paper from the Corcoran Gallery of Art*, exh. cat. (Northampton, Mass.: Hillyer Art Gallery, Smith College, 1986), 83–103 and 187–211.

20. Koke 1982, 2:189, attempted to reconstruct the provenance of these sheets through Paris and various dealers in New York City.

21. Ibid., 2:206, no. 1434, ill.

22. Ibid., 2:140–41, no. 1224, ill. The hotel depicted is the Palisades Mountain House that burned to the ground in 1884.

23. Inv. no. 1908.9; see ibid., 2:138–39, no. 1218, ill.

24. The Society's DPPAC also houses a bound copy of the *Portfolio*.

25. For a recent consideration of the development of American art, see David Rosand, *The Invention of Painting in America* (New York: Columbia University Press, 2004).

26. For the development of the medium in England, see Martin Hardie, *Water-colour Painting in Britain*, ed. Dudley Snelgrove, with Jonathan Mayne and Basil

Taylor, 3 vols. (London: Batsford, 1966–68).

27. Later, in 1827, Lucas published his *Progressive Drawing Book*, which featured a set of nine aquatints by John Hill (cat. 24) after John H. B. Latrobe, instructing the student how to copy in progressive stages a series of works in the overlaid washes of the English technique.

28. Shelley 2002, 34, points out that John Gatsby Chapman's *American Drawing Book* (New York, 1847) was an exception in that it was aimed at both professionals and laymen and contained information on watercolor. Foster 2004, 49–60, observes that the earliest books taught technique and not the history of the medium. She also notes that the country's early modernists following in the footsteps of Winslow Homer and John Singer Sargent (cats. 124 and 125) who found watercolor a distinctly national medium—notably the most progressive painters in the Alfred Stieglitz circle or the Armory Show—were outstanding and committed watercolor painters.

29. Peter C. Marzio, *The Art Crusade: An Analysis of American Drawing Manuals, 1820–1860* (Washington, D.C.: Smithsonian Institution Press, 1976).

30. For a background of watercolors in America, see Metropolitan Museum of Art, *Two Hundred Years of Watercolor Painting in America*, exh. cat. (New York: Metropolitan Museum of Art, 1966); and Shelley 2002, 33–36, 64–76.

31. For the importation of drawing manuals in the United States and their printing here as early as 1787 but more prevalently after 1820, see Carl W. Drepperd, *American Drawing Books* (New York: New York Public Library, 1946); and Marzio 1976.

32. Fire as subject matter dovetailed neatly with Calyo's background training in Naples, where countless artists represented Vesuvius erupting. In addition to the works recording the Great Fire of 1835, the collection includes twenty-one "Cries," or occupational vignettes (cat. 58), and three other landscapes by Calyo.

33. Burton's vignette of this significant structure and city life that revolved around it was engraved by Stephen H. Fosette and published in 1831 by George Melksham Bourne as one of two views on plate 7 of "Bourne's Views of New York," where it was titled *Bowery Theater, New York*. As was usually the case, Burton's drawing was faithfully followed, except the rooting pigs at the right were eliminated. Gloria Gilda Deák, *Picturing America, 1497–1899: Prints, Maps, and Drawings Bearing on the New World Discoveries and on the Development of the Territory That Is Now the United States* (Princeton: Princeton University Press, 1988), 1:262–64, no. 392; 2: fig. 392.7. The building Burton drew is the second occupied by the New York Theatre, also known as the Bowery Theatre, which was rivaled in prestige only by the Park Theatre on Park Row. Four theaters named the Bowery, built on the same site on the west side of the Bowery between Bayard and Canal streets, fell victim to fire. The first was erected in 1826 (burned

26 May 1828). The Greek Revival structure Burton represented was reopened on 20 August 1828. Eight years later, on 22 September 1836, it also burned. For a brief period in 1831–32, it was known as the American Theatre.

34. See Roberta J. M. Olson, "Fulton at the Fulcrum: A Search for Identity," *New-York Journal for American History* 65:4 (2004): 133–39, for additional discussion and bibliography on Fulton and the Le Boeuf bequests.

35. Inv. no. 1885.4; see Koke 1982, 3:104, no. 2409, ill.

36. Inv. no. 1955.38; see ibid., 268, no. 2823, ill.

37. Predating the NAD was the American Academy of the Fine Arts (1802), founded three years before the Pennsylvania Academy of the Fine Arts in Philadelphia; of its seventy-nine founders only three were artists. Both institutions, based on European academic traditions, stressed drawing from casts of ancient sculpture. The American Academy gradually faded away with the establishment of the NAD, and the connoisseurs who had belonged to it transferred their allegiance to the American Art-Union (1816–52), one of whose goals was to make works of art affordable for all Americans. See Mary Bartlett Cowdrey, *American Academy of the Fine Arts and American Art-Union, 1816–1852*, 2 vols. (New York: New-York Historical Society, 1953), for a discussion of these organizations. For the Sketch Club (also known as the Twenty-One), see Mary Alice Mackay, "Sketch Club Drawings for Byron's 'Darkness' and Scott's 'Lay of the Minstrel,'" *Master Drawings* 35:2 (1997): 142–54.

38. See Koke 1982, 1:295–96, no. 571, ill.

39. See Ella M. Foshay and Barbara Novak, *Intimate Friends: Thomas Cole, Asher B. Durand, and William Cullen Bryant*, exh. cat. (New York: New-York Historical Society, 2000); and Linda Ferber, ed., *Kindred Spirits: Asher B. Durand and the American Landscape* (Brooklyn: Brooklyn Museum, in association with D Giles Limited, London, 2006).

40. Ruskin's *Modern Painters*, 5 vols. (London, 1843–60), also exerted a profound influence.

41. See Koke 1982, 1:158, no. 179, ill. (140–59, for the group). For other versions of this scene, see William H. Truettner, *The Natural Man Observed: A Study of Catlin's Indian Gallery* (Washington, D.C.: Smithsonian Institution Press, 1979), title page; Brian W. Dippie, *Catlin and His Contemporaries: The Politics of Patronage* (Lincoln: University of Nebraska Press, 1990), fig. 1; and George Gurney and Therese Thau Heyman, eds., *George Catlin and His Indian Gallery*, exh. cat. (Washington, D.C.: Smithsonian American Art Museum; New York: W. W. Norton & Company, 2002), 80, fig. 18, the frontispiece to Catlin's *Letters and Notes on the Manners, Customs, and Condition of the North American Indian* (1841).

42. See Koke 1982, 2:166, 168, no. 1312; and Barbara Novak and Tracie Felker, *Dreams and Shadows: Thomas H. Hotchkiss in Nineteenth-Century Italy*, exh. cat. (New York: New-York Historical Society, in

association with Universe Books, 1993), 34, fig. 2. It demonstrates an impulse similarly seen in the earlier cloud studies by John Constable, beginning in the 1820s, and other European, especially English and German, artists through the middle decades of the nineteenth century. See, for example, Edward Morris, *Constable's Clouds: Paintings and Cloud Studies by John Constable*, exh. cat. (Edinburgh: National Galleries of Scotland, 2000); and Werner Hofmann, "Turner und die Landschaft seiner Zeit, I, der Anfang aller Dinge," in Hamburger Kunsthalle, *William Turner und die Landschaft seiner Zeit*, exh. cat. (Munich: Prestel-Verlag; Hamburg: Kunsthalle, 1976), 186–206, for additional bibliography on this subject related to the development of the oil sketch.

43. For Costa, see Christopher Newall, *The Etruscans: Painters of the Italian Landscape, 1850–1900*, exh. cat. (Stoke-on-Trent: City Museum and Art Gallery, 1989); and Roberta J. M. Olson, *Ottocento: Romanticism and Revolution in Nineteenth-Century Italian Painting*, exh. cat. (Florence: Centro Di; New York: American Federation of Arts, 1992), 135, no. 24, 178, no. 53.

44. Inv. no. 1971.130; see Koke 1982, 3:323, no. 3063, ill.

45. See Association of American Painters and Sculptors, *Catalogue of the International Exhibition of Modern Art: Association of American Painters and Sculptors: At the Armory*, exh. cat. (New York: Vreeland Advertising Press, 1913).

46. The paper towel on which it is drawn is reputedly from the Cedar Tavern, the watering hole frequented by the Abstract Expressionists.

47. A novel tack and new look at drawing was taken by Laura Hoptman, *Drawing Now: Eight Propositions*, exh. cat. (New York: Museum of Modern Art, 2002).

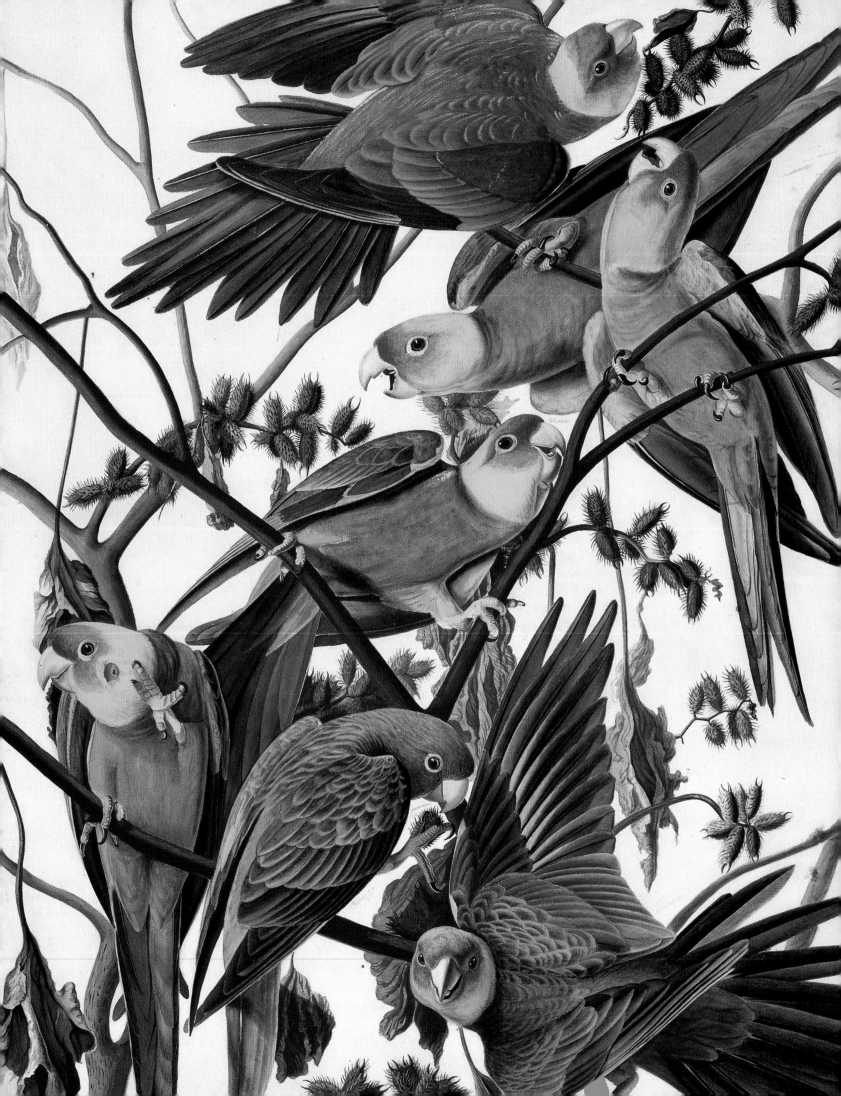

CATALOGUE

NOTE TO THE READER

I feel sometimes an American artist must feel, like a baseball player or something—
a member of a team writing American history. **Willem de Kooning**

Although endowed with an embarrassment of riches in its holdings, the drawing collection of the New-York Historical Society ironically lacks a full documentation of provenance as well as exhibition and publication histories for each object. This situation results from the Society's over two hundred years of growth in eight different locations. During this time, various institutional umbrellas covered and administered the collection. While it blossomed (notably under the expert eye of Richard J. Koke), this distinguished cache lacked a dedicated curator until the year 2000. As a result, often meagerly stocked or non-existent object files and collection records have influenced the format of the entries and contributed to the regrettably incomplete ownership histories for many of these original works on paper. Fortunately, there are some instances where sheets are carefully documented, and others for which we have managed to reconstruct a provenance during several years of sleuthing and archival archaeology. This catalogue and its accompanying exhibition demonstrate the Society's commitment to enriching the invaluable collection and its history. The N-YHS computer database now tracks all the gathered knowledge about each object's history and will serve as the central repository for future knowledge about each work.

The biographies and entries of the catalogue are arranged in chronological order according to the birth date of the artist and then alphabetically when more than one individual was born in a year. Works by unidentified artists are positioned as much as possible chronologically within the sequence, taking into account each one's date, style, and subject matter.

The collection history has shaped the format adopted for the technical sections of the catalogue entries, which include several other features that merit explanation. When the donor of a drawing is related to an artist, that relationship is acknowledged in the credit line. Instead of attempting fragmentary listings of exhibition records for each drawing, significant exhibitions with publications are cited in the bibliography and/or notes to the appropriate entries. Similarly, no sustained attempt was made to describe the various types of papers used by artists, as the two-year time frame of the generous Getty Grant for the research and writing of the catalogue did not allow this luxury for all eight thousand sheets. Since the lion's share of the collection dates from the time when wove paper was used and many sheets are laid on secondary supports, there would have been little benefit to this endeavor. However, when cases arose in which the paper was important, such as crucial questions of dating, that support was examined and watermarks when present are noted in the catalogue. If the paper is white, its color is not mentioned. Otherwise a verbal description approximates the colors of the various supports.

Bibliography

The complete bibliography for this catalogue is far too extensive and diverse to be contained in a single section at the end of the volume. To render bibliographical references more accessible, citations have been compartmentalized into four types. Each artist's biography is followed by a selected bibliography on the individual and his/her oeuvre arranged in chronological order. Another selected bibliography in the technical section of each entry details where that work has been published and/or reproduced, again in chronological order. Further bibliography on the work and its context is cited in the notes to each entry (there are no notes for the biographical sections). Because of the massive number of publications consulted, the selected short citations at the end of the volume is in alphabetical order and contains only frequently cited works (mentioned in three or more entries). These citations also include monographs on artists that appear in the bibliographies following the artists' biographies in a shortened form. Additionally, the introductory essay is self-contained with its own full citations for all references.

Inventory (Accession) Numbers

The standard inventory number begins with the year the object was accessioned, followed by a period and a number indicating the order of its accession in that given year. An inventory number prefaced by an X., Z., or INV. indicates that no record of the object's accession could be found in either the Society's collections records or archives. These classifications were adopted unsystematically at various periods in the institution's past. "S" as prefix to a number (e.g., S-32), indicates a work from the Robert L. Stuart Collection.

Author's Initials

The majority of the biographies and the entries were written by Roberta J. M. Olson. Sections written by other individuals are credited with their initials: notably A. M. for Alexandra Mazzitelli and also J. B. for Jean Breskend.

Titles of Works

Sheets that are preliminary studies for other works of art are identified in the second half of their title as being preparatory for that project. For portraits, the sitter's proper name is used as the title, followed by the subject's birth and death dates, when known.

Media and Measurements

Media are listed after the title of each work in order of importance; if the verso is executed in a different medium or media, it is indicated after a semi-colon. Measurements follow the description of the media and supports. They are first given in inches (rounded to the sixteenth of an inch), followed by conversion into millimeters (in parentheses). Height precedes width. If the support is oval, circular, or irregular, that fact is noted.

Abbreviations

AAA	Archives of American Art, Smithsonian Institution, Washington, D.C.
diss.	dissertation
DPPAC	Department of Prints, Photographs, and Architectural Collections, The New-York Historical Society, New York
exh. cat.	exhibition catalogue
MCNY	Museum of the City of New York, New York
MS	Manuscript
NAD	National Academy of Design, New York
NYPL	New York Public Library, New York
N-YHS	New-York Historical Society, New York

PIERRE VASE OR CRUCHE OR ESKRICH

Paris, France c. 1518–20–Lyon, France? after 1590

Woodcutter and engraver, painter, embroiderer, and designer, Pierre Vase or Pierre Cruche, as he was commonly called, was known by many names in an age before the codification of surnames. He signed only five of his prints, two with the French *Cruche* and three more formally with Latin variants—Petrus Escricheus, Eskrichius, or Eskricheus. After Natalis Rondot's late-nineteenth-century studies, the artist has been most frequently identified in the literature as Eskrich, a name that derives from his Latin signatures. In 1573, when he lodged in a house on the rue de la Vieille-Monnaie in Lyon, he gave his name as "Pierre du Vase dit Cruche."

He was the son of Jacob (originally from Freiburg im Breisgau), a German engraver who worked in Paris during the first quarter of the sixteenth century, and whose surname was Krug (German for jug or pitcher), which by corruption or translation was given variously as Kriche, Eccriche, Cruche, or Vase. Pierre was also referred to in documents as Escript, Eskrich, and d'Estrique, among other variations. Vase was not only literate but also among the inner circle of artisans in the court of Francis I of France. He contributed to a collection of poems offered in 1541 to the king by his embroiderer and valet de chambre Robert de Luz (Bibliothèque nationale de France). In this collection he was named Pierre Cruche and identified as a talented young apprentice in the workshop of the count of Nevers's embroiderer Pierre Valet. In addition, de Luz's poem rejects the vulgar name "Cruche" in favor of the noble and antique name "Vase," which, he says, corresponds better to the learned talent of the young artist. He also praises the poems that Cruche and a fellow apprentice had written on the recent death of the painter Rosso Il Fiorentino. After the death of Pierre's father in 1543, he was imprisoned for debt in 1544 but rescued by the painter and engraver Jean Cousin.

Pierre Vase went south in the late 1540s and by 1548 was in Lyon, where he worked with the publisher Guillaume Rouillé as a book illustrator and was celebrated for his intricate Mannerist borders (*Emblemata Andreae Alciati*, 1548, and *Decameron*, 1551). For more than a century, Lyon had enjoyed the presence of foreigners and a remarkable atmosphere of religious toleration. Vase and his wife, Jeanne Berthet, who held reformist views, benefited from this open-mindedness. After John Calvin's return to

Geneva in 1541, however, the strong stance taken by the government of that city alarmed French authorities, and they responded with the Edict of Châteaubriant (27 June 1551). It resulted in a less tolerant environment, among other things prohibiting the sale, importation, or printing of any unapproved book under pain of punishment and confiscation of goods and property. It also forbade subjects from corresponding with, sending money to, or otherwise favoring persons who had left to reside in Geneva. Soon thereafter Vase immigrated to that nearby city. In 1554 he requested permission to reside in the Protestant haven permanently and in 1555 applied to become a citizen, a request granted in 1560. Pierre and Jeanne eventually had ten children, nine born in Geneva between 1552 and 1564, and the tenth in Lyon in 1568.

At the time of his arrival in Geneva, the printing trade was expanding rapidly. Within a decade Geneva had supplanted Antwerp, Basel, and Strasbourg as the center for Reformation printing and propaganda. The increase in production, however, was not accompanied by a demand for the type of ornamentation and illustrations for which Vase was famous. Instead, there was resistance to illustrations of any kind in religious works, lest they should lead to idolatry. By 1560 illustrations in scriptural books were completely prohibited, which may have forced Vase to ask for public assistance in 1562. When he was refused, he protested and was imprisoned. (Archives in Geneva and Lyon preserve documentation about his life.)

During the Reformation in Geneva, Vase was involved with the largest satirical image published in the sixteenth century, the *Mappe-Monde Nouvelle Papistique*. Printed from sixteen woodblocks, its imagery was surrounded by twelve blocks of text. Not really a map, the composite print mocks the egregious practices of the Catholic Church from a Protestant viewpoint in self-contained vignettes depicting corruption, devilish practices, and deceit, all framed by the Devil's mouth. The work's companion volume with additional text was published independently (*Histoire de la Mappe-Monde Papistique*). The biting satire of the propagandistic *Mappe-Monde* (two editions, 1566 and 1577) extended to the pseudonyms of its authors and publishers, which were invented to preserve their anonymity.

The artist's projects included other works of religious propaganda like the thirty-six illustrations he created for the *Antithesis de praeclaris Christi et indignis Papae facinoribus* by Simon du Rosier (1557). Vase also prepared a view of Geneva, now unlocated, for Admiral Gaspard de Coligny (1564), the Protestant leader who was assassinated during the Huguenot massacre that began on 24 August 1572, St. Bartholomew's Day, at the instigation of Queen Catherine de Medici, mother of Charles IX (to whom he was an advisor). Occasionally Vase also illustrated more standard books, among them Herodotus's *History* and several Bibles with cartographic representations of the land of Canaan. Later in his career he contributed portraits of reformers for *Icones, id est, Verae Imagines* (1580), a book by Calvin's friend Théodore de Bèze.

After the *Mappe-Monde* was finished, Vase returned permanently to Lyon in 1568. He consequently returned to Catholicism, not an uncommon practice for artists in Lyon at the time, and established contacts with some of the most important political personages in the town, eventually entering the service of Monsignor de Mandelot, the governor of the king, as painter and embroiderer. Vase continued to work as an illustrator for his old publisher Rouillé and participated in designing entry decorations and ornamentations for triumphal royal celebrations, like the ones for Charles IX in 1563 and Henry III on his return from Poland in 1574. He seems to have remained active in Protestant circles and must have stayed in contact with individuals in Geneva.

The artist was recorded as living in Lyon as late as 1590. He is best known for his wood-engraved illustrations because they are preserved in books; the rest of his oeuvre remains unstudied as it is unlocated or lost. From the fragmentary evidence of his production, Vase's illustrative style seems to have progressed from the refined, Mannerist intensity of his early decorative works to the bold, crude forms of his Calvinist propaganda, and finally to the realism and economy that characterized his later work and reflected the demands placed on him by his patrons, the course of the Reformation, and the general stylistic developments of his times. Since the N-YHS watercolors are the first drawings or paintings securely attributed to the artist, they constitute a watershed for future studies about his works.

Φαλακοκόραξ. Coruus caluus.
Corbeau galeran. Corbeau voiran.

Cristatus, rostro non paruo, tum subadunco
Est rostro rubro crure Phalacrocorax.
De eodem.
Est iucunda caro, rubrum tibi grandéque rostrum
Est postica tibi crista Phalacrocorax.
De eodem.
Non natat, est fidipes, sectatur prata, paludes,
Est natus vermes esse Phalacrocorax.
L'autheur.,
B. Textor.

De eodem.
Nonne Phalacrocorax Græcis est dicta volucris
Qui Coruus caluus vertitur a Latiis?
De eodem.
Pro quo est hydrocorax nonnullis sumpta volucris,
Præditus es suaui carne Phalacrocorax.

L'autheur.
B. Textor.

Le peintre.
Pierre Vase, alias Cruche.
L'escriuain.
Thomas Huilier.

1a

Bibliography: Natalis Rondot, *Les Peintres de Lyon du quatorzième au dix-huitième siècle* (Paris: Typographie de E. Plon, Nourrit et Cie, 1888), 120–22; idem, *Graveurs sur bois à Lyon au seizième siècle* (Paris: George Rapilly, 1898), 24–111; idem, "Pierre Eskrich, peintre et tailleur d'histoires à Lyon au XVI^c siècle," *Revue du lyonnais* 31 (1901): 257–59, 334–35; Robert Brun, *Le Livre illustré en France au XVI^c siècle* (Paris: Librairie Félix Alcan, 1930), 108–15, 148, 156, 191, 223, 240, 254, 266, 305; Ruth Mortimer, *Harvard Catalogue of Books and Manuscripts: Part I, French 16^th Century Books* (Cambridge, Mass.: Belknap Press of Harvard University Press, 1964), 2:706; Anne Anninger, "Demands of the Text and Demands of the Trade in the Work of Pierre Eskrich," typescript, Fine Arts Department, Harvard University, 1988; Dror Wahrman, "From Imaginary Drama to Dramatized Imagery: The 'Mappe-Monde Nouvelle Papistique,'" *Journal of the Warburg and Courtauld Institutes* 54 (1991): 186–205; *Allgemeines Künstlerlexikon* (Munich and Leipzig: K. G. Saur, 2002), 35:61–62; Frank Lestringant and Alessandra Preda, eds., *Jean-Baptiste Trento and Pierre Eskrich, Mappemonde nouvelle papistique. Histoire de la Mappemonde papistique, en laquelle est déclaré tout ce qui est contenu et pourtraict en la grande table, ou carte de la mappe-monde (Genève, 1566)* (Geneva: Droz, 2007); Vanessa Selbach, "Pierre Eskrich, graveur lyonnais," in *Art et imprimerie à Lyon vers 1550, au temps de Sebastiano Serlio*, ed. Sylvie Deswarte-Rosa (forthcoming).

1a. *Northern Bald Ibis* (Geronticus eremita), c. 1554–65

Watercolor, black and brown ink, gouache, and white lead pigment over black chalk on ivory paper, laid on paper, formerly mounted on an album page; 9 3/16 × 8 3/8 in. (233 × 213 mm), irregular
Copious inscriptions in brown ink on black chalk lines. Inscribed by Thomas Huilier at left of center in brown ink: *L'autheur. / B. Textor.*; at lower center: *Le peintre. / Pierre Vase, aliâs Cruche. / L'escrivain. / Thomas Huilier.*
Provenance: Sir Thomas Lowther, England; The Duke of Devonshire, Chatsworth, England; John Cassin, Philadelphia, by 1869; M. Thomas & Sons, Philadelphia, 1872; Nathaniel H. Bishop, Toms River, N.J.
Bibliography: M. Thomas & Sons, Philadelphia, sale cat., 23 April 1872, lot 62; Roberta J. M. Olson and Alexandra Mazzitelli, "The Discovery of over 200 Sixteenth-Century Avian Watercolors: A Missing Chapter in the History of Ornithological Illustration," *Master Drawings* 45:4 (2007): 457, 478, fig. 33.
Gift of Nathaniel H. Bishop, 1889.10.1.1

1b. *Male Ring-necked Pheasant* (Phasianus colchicus), c. 1554–65

Watercolor, gouache, black ink, and white lead pigment on ivory paper, formerly mounted on an album page; 11 5/16 × 15 7/16 in. (288 × 396 mm), irregular
Inscribed along upper edge in brown ink: *Phasianus mas. 41*; at lower right: *Phaisan Royal*
Watermark: Bunch of grapes with initials DR
Provenance: Sir Thomas Lowther, England; The Duke of Devonshire, Chatsworth, England; John Cassin, Philadelphia, by 1869; M. Thomas & Sons, Philadelphia, 1872; Nathaniel H. Bishop, Toms River, N.J.
Bibliography: M. Thomas & Sons, Philadelphia, sale cat., 23 April 1872, lot 62; Olson and Mazzitelli 2007, 436, 513, fig. 1.
Gift of Nathaniel H. Bishop, 1889.10.4.42

1c. *Male and Female Brambling* (Fringilla montifringilla), c. 1554–65

Watercolor, gouache, black ink, and white lead pigment over traces of black chalk on three sheets of ivory paper, pieced and formerly mounted on an album page; 11 × 12 5/16 in. (280 × 313 mm), irregular
Copious inscriptions in brown ink on black chalk lines. Inscribed by Thomas Huilier at center above right bird in brown ink: *L'autheur. / B. Textor.*; at center below: *Le peintre. / Pierre Vase, alias Cruche. / L'escrivain / Thomas Huilier.*; numbered in brown watercolor clockwise from the upper left: */19/; /20/; 14.f.s.; 19*
Provenance: Sir Thomas Lowther, England; The Duke of Devonshire, Chatsworth, England; John Cassin, Philadelphia, by 1869; M. Thomas & Sons, Philadelphia, 1872; Nathaniel H. Bishop, Toms River, N.J.
Bibliography: M. Thomas & Sons, Philadelphia, sale cat., 23 April 1872, lot 62; Olson and Mazzitelli 2007, 457, 508, fig. 35.
Gift of Nathaniel H. Bishop, 1889.10.4.13

The three avian watercolors examined in this entry belong to a trove of 215 mostly sixteenth-century natural history watercolors, all birds save one mammal, formerly mounted in four oblong, leatherbound, and tooled albums in the N-YHS.[1] The drawings were relatively evenly divided among the four volumes.[2] When accessioned by the Society on 19 March 1889, they were identified summarily in the accession records simply as "European birds." Subsequently they were considered to date from the eighteenth century but were neither studied nor published. Nothing was known about their provenance beyond their donation. Sleuthing has uncovered a partial, fascinating history for these significant works.

The first piece of evidence about their provenance, a clipping from a nineteenth-century auction catalogue, is mounted inside the front cover of the first album. It reads:

DRAWINGS OF EUROPEAN BIRDS, a Collection of upwards of 200 Drawings, most beautifully executed in colours, of European Birds, taken from Nature, and most faithfully copied, with a view to be published; but from the death of the Artists, M. la Grese, and M. Petit, they never were engraved. Most of them are accompanied with their names, in 4 large vols. oblong folio, *formerly in the Duke of Devonshire's Collection.*

The distinguished collection of the dukes of Devonshire—once divided between Chatsworth, Devonshire House in London, and Hardwick but now concentrated at Chatsworth—has a legendary history.[3] Although the first duke collected a few paintings, the real creator of the collection was the second duke, William Cavendish (1673–1729), a connoisseur and member of the Royal Society, whose passion was for drawings. He also acquired books and kept both these and the drawings at Devonshire House in London's Piccadilly. At first glance the second duke appears to be the most likely candidate for acquiring the avian albums. The others are: the sixth duke, William George Spencer Cavendish (1790–1858), who was the creator of the library during the first two decades of the nineteenth century,[4] or the seventh duke, William Cavendish

(1808-1891), a scholar who added to the scientific and mathematical treatises. The seventh duke may have obtained the albums from another family member (Sir Thomas Lowther married the second duke's daughter and their son died without issue). Certainly the dukes had a taste for natural history, as demonstrated by a group of 131 watercolors and drawings of animals, birds, and plants that were first hung by the sixth duke in the Sketch Gallery at Chatsworth but probably were acquired by the second; these sheets have been attributed to Italian masters from the fifteenth and sixteenth centuries.[5]

It is not known when the Society's albums left the Devonshire collection.[6] However, they crossed the Atlantic sometime before 1869, as their owner before his death in that year was the renowned Philadelphia ornithologist John Cassin. When Cassin's library was auctioned on 23 April 1872 at M. Thomas & Sons in Philadelphia, the sale's catalogue described the lot in almost the same words as the earlier auction catalogue quoted above.[7] The Society's donor, Nathaniel Holmes Bishop (1837–1902), was the purchaser.[8]

The N-YHS's 215 watercolors were executed on papers of various sizes, many of which have been trimmed. Before being mounted into their respective albums, they were folded or rolled when stored for a period of time. Evidence of this treatment can be seen in holes, like the ones in the sheet with the male pheasant (cat. 1b), where a worm has consumed an area in the shape of a D. Its mirror image to the left proves that the sheet had once been kept as described above.

Except for the four sheets mentioned in note one, these stunning watercolors are part of a collaborative endeavor. They were primarily executed by three identified artists, mentioned repeatedly in text neatly lettered on light black chalk lines that accompany sixty-five of the illustrations, and several unidentified individuals. The author of the text was Benoît (or Benedictus) Textor or Textorem, Tissier, Tessier, or Tixier (active c. 1530–56), except for one page inscribed as having a passage by "Joannes Tagautius,"[9] three pages inscribed with passages by "De Vannelles," about whom no information has been found, and two pages with sections credited to Alexander of Myndus (or Myndos, first century A.D.). A French writer on medical subjects like cancer and the bubonic plague who was also knowledgeable about birds, Textor

phasianus mas.

Phasan Royal.

1b

served as royal physician to Francis I, was a friend of Calvin, and hence a reformist like Vase. Originally from Pont-de-Vaux near Bourg-en-Bresse, Textor studied in Paris and then lived in Mâcon and Neuchâtel before moving to Geneva in 1543.[10] The scribe was Thomas Huilier, about whom nothing has been found. Since the last page of the second album has a watercolor of a bat, which looks forward to the bat watercolors by John James Audubon (fig. 43.1) and his son,[11] the avian watercolors parallel the first two illustrated ornithological treatises published in 1555 (see below). The fact that some of these watercolors were clearly planned to be accompanied by a text carefully lettered by a calligrapher while others contain more casual inscriptions by Claude Textor (1538–c. 1576), son of Benoît and an expert on birds (see, for example cat. 1b),[12] or

have no inscriptions at all suggests the group may represent a compilation of at least two separate projects or campaigns.

Of the three identified watercolorists, the finest hand is that of Pierre Vase, who worked in several different styles and is identified in the text as "Pierre Vase, alias Cruche." During his later career Vase seems to have been involved with prints that had a scientific orientation, such as his map of Paris (1575).[13] The famous eighteenth-century French connoisseur and collector Pierre-Jean Mariette attributed an unsigned print representing Noah's Ark with a parade of pairs of animals and beautifully executed birds to him as well.[14] Since one of Vase's hallmarks in the *Antithesis* (1557) is the depiction of flights of birds,[15] he must have been greatly interested in avian species. In fact, correspondence between the

noted physician and naturalist Jacques Dalechamps, who moved to Lyon in 1550, and the Greek scholar and physician Robert Constantin contains three references to Vase. Constantin explored the Jura Mountains in eastern France with Vase to study birds and plants and to collect specimens for Dalechamps.[16] Among Dalechamps's other correspondents, not surprisingly, was Konrad Gesner (see below).

A noted and prolific author, Dalechamps published almost exclusively with the Lyonnais publisher who employed Vase, Guillaume Rouillé. He wrote on botany and medicine and produced translations and editions of ancient authors, although his major work is *Historia generalis plantarum* (1586–87), the most important work on the subject during his lifetime. Among the other feathers in his cap, Dalechamps was an

ornithologist who may have planned books on birds and fish on the model of Aristotle's *Historia animalium* to parallel his work on plants. Two albums of avian watercolors in the Bibliothèque nationale de France—MSS lat. 11858 and 11859, both measuring roughly 440 by 290 mm—that once belonged to him shed further light on his activities and may also reveal additional evidence about his collaboration with Vase.[17] The correspondence between Dalechamps and Constantin contains allusions to a project involving avian illustrations. Some letters mention drawings of birds being sent to Dalechamps from various artists. In his study of these two albums, Van den Abeele has assigned them dates, from 1559 to 1581, based on inscriptions, a period that roughly corresponds to the dates of Dalechamps's residence in Lyon after 1550.[18]

At least a quarter of the watercolors in the N-YHS's albums can be either assigned to Vase because of Huilier's inscriptions or attributed to him on the basis of stylistic comparison despite the fact that he executed them in several different styles. His first style is tighter and more descriptive, such as is found in the watercolor of the male and female Bramblings (cat. 1c). Vase modeled their feathers with a combination of media that conveys texture and looks back to Albrecht Dürer and forward to Audubon. His second style is bolder and a little schizophrenic (cat. 1a). At times it is more linear, stylized, and influenced by his work with prints, as in the ibis's feet, or at other times more painterly, as in the bird's body and the landscape, rendered in wash. A cluster of watercolors with experimental stylistic variations may also be by Vase, while others (cat. 1b) may be the work of a collaborator who also rendered nearly identical works in the two albums once in Dalechamps's possession. More than his collaborators, Vase endowed each bird with three-dimensionality, together with its characteristic *jizz* (G.I.S.S. [General Impression of Size and Shape]: proper posture, characteristic appearance, and proportions).

Although no watercolors by the two other artists who rendered birds in the Society's albums are discussed in this entry, they deserve mention in the present context. The second artist identified in Huilier's inscriptions is Michel Petit, who may have been the artist born in Rouen and recorded on 15 October 1554 as living in Geneva.[19] He is the least accomplished of the trio, and his

pigments are frequently muddied. The third illustrator is Isaac La Grese, about whom no information has been located, perhaps because "La Grese" was his sobriquet and his surname is unknown. La Grese executed the largest number of watercolors in the Society's albums. They are characterized by extensive underdrawings in black chalk with many pentimenti and birds with elongated proportions.

Almost certainly these rare watercolors were created during the mid–sixteenth century at least partially in Geneva, where in 1554 two of the artists, Vase and Petit, and two of the text's authors, Textor and Tagautius, resided. At the time Geneva was an international, independent center. When the Reformation triumphed in 1535, the city became a republic and Calvin soon made it his home, earning it the name "Protestant Rome." Beginning in 1550, persecuted Protestants, including Vase and his wife, streamed into Geneva in search of sanctuary. Under the guidance of Calvin and Théodore de Bèze, they added to the greater religious and intellectual status of their new home, which was a center for printing that included a nascent market for scientific illustration. It is in this context that Vase and his collaborators, certainly in need of commissions without the standard patronage of church and state, more than likely produced their bird illustrations.

Two of the handful of sheets that have been removed from the albums, the pheasant (cat. 1b) and the Montagu's harrier,[20] have the same watermark, consisting of a bunch of grapes with the letters DR in the interior. According to Briquet, paper with this mark was produced in Lyon in 1533. Similar watermarks appeared on paper made in many European cities, including later in Lyon (1545–74) and Geneva, where it appears in a work by Calvin in 1566.[21] Although the mark belongs to a larger local type produced in central France,[22] its use in the two cities where Vase was active suggests a link between Geneva and Lyon, the latter the more established printing center and the supplier of paper for Geneva.

Although it is impossible to date the watercolors precisely, they were produced over a number of years or even decades, given their stylistic progressions, especially in the examples by Vase and La Grese. Internal and external evidence suggest that the earliest works date

from the 1550s. That would place them on the cusp of the virtual explosion of avian illustrations that occurred at the very moment when ornithology developed into a serious science. At least a portion of the earlier watercolors were indubitably intended for an illustrated ornithology that was never completed, as a large number, like the Bramblings and the Northern Bald Ibis, have carefully lettered calligraphic texts. The sale catalogues noted above claim that the project was interrupted by the deaths of La Grese and Petit, most likely from the recurrences of the plague that claimed many lives during the 1560s (the time of Benoît Textor's death). Vase may have continued a related project with Dalechamps and Claude Textor involving the two albums in the Bibliothèque nationale de France after some of his collaborators died.[23]

Not coincidentally, the first two illustrated printed ornithologies were created at about the same time as the Society's watercolors, demonstrating that the artistic trio of the four albums were in the vanguard of developments in natural history. The first treatise, by Pierre Belon (*L'histoire de la nature des oyseaux, avec leurs descriptions, & naifs portraicts retirez du naturel*), was published in Paris in 1555. It contains 144 woodcuts after watercolors by Pierre Gourdelle (Gourdet). As in Textor's longer inscriptions, Belon gave the Greek, Latin, and French names of the birds. Belon's groundbreaking book was little noticed because he was murdered shortly after its publication. His work was eclipsed by an even more impressive ornithological work published the same year: the third book (*Qui est de avium natura*) of a highly popular study in four volumes by Konrad Gesner, *Historia animalium*, published in Zurich between 1551 and 1558.[24] Gesner—city physician of Zurich, erudite scholar, and collector of natural history specimens—was the first individual to emphasize the value of illustrations as an aid to the study of zoology.[25] Although several artists were involved in Gesner's project, the only one mentioned for the 218 prints is Lukas Schan, a painter from Strasbourg. While it is clear from Gesner's illustrations that his artists had extensive firsthand experience with birds,[26] his woodcuts, like the Society's watercolors, usually feature a profile view of a species deriving from a long tradition of illustrations in medieval pattern books, albeit enlivened.

Vase and his colleagues, who consulted Belon

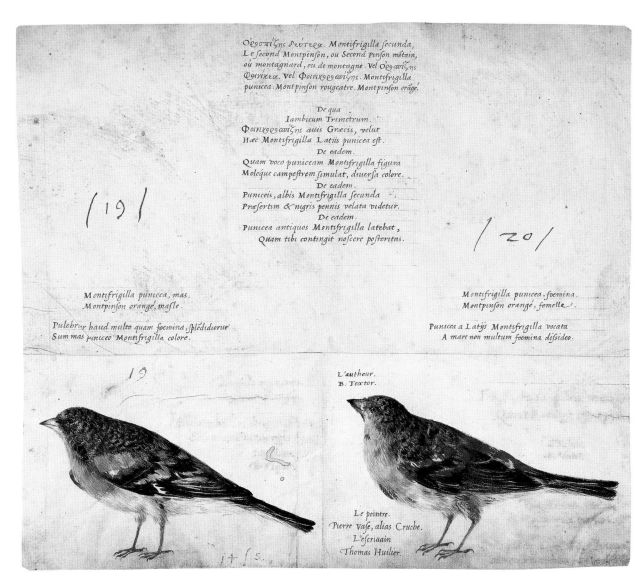

1c

and Gesner, went several steps beyond their illustrations. In fact, the care with which their birds are modeled in colored pigments, coupled with Huilier's beautifully hand-lettered text in brown ink—on black chalk lines made with a straightedge that resemble those in illuminated manuscripts—suggests that at least the first projected compendium was planned as an expensive manuscript. The fact that the scribe's name is mentioned implies that he was held in high regard and that his hand-lettered work was an end in itself and not simply preparatory for publication. Many of the pages contain extensive inscriptions in Latin and Greek, arguing that Textor originally intended the work for an educated patron. Their references to the authors, scribe, and artists are in French, suggesting he was either French or Swiss, while the identifications contain an earnest, early attempt at systematic taxonomy. Many of the birds, such as the pheasant, were studied from specimens, in which the bird was clearly mounted and placed on a stylized platform, a mound of earth that was a topos of the genre. However, Vase seems to have rendered the Bramblings from life and instead of a single bird has inno vatively shown both sexes. Further, not all of the birds are represented in profile, especially the owls, which occasionally gaze out at the viewer in a novel manner, as was the case with Belon's woodcuts. Moreover, some species have their mouths open, and in several cases their tongues are extended or they are eating. Others turn their heads in extreme postures. One of the most important departures from standardized representations is in the assorted sizes of the birds, which never occurs in Belon's work. The artists of the N-YHS's watercolors drew their small birds life-size and the larger birds as close to their natural scale as possible, five to six times larger than the smaller species, as large as the paper permitted, foreshadowing Audubon's innovations.

The three birds reproduced in this entry can be identified with relative certainty. In catalogue 1c, Vase represented the male and female Brambling

(*Fringilla montifringilla*), a European finch that summers in Scandinavia, in their winter plumage. The matte gray patches of lead-based pigment in their feathers were once white.[27] The male pheasant (cat. 1b), whose image is not accompanied by Huilier's calligraphy, is a specimen of the standard Ring-necked Pheasant (*Phasianus colchicus*), whose plumage is variable and sometimes appears without the ring.[28] Textor identified catalogue 1a by Vase as the *Corvus caluus*, literally the bald crow. Today it is known as the Northern Bald Ibis (*Geronticus eremita*), an endangered species whose range is now confined to Morocco, Algeria, and the western Sahara, breeding only in Morocco. It formerly had a much broader distribution, as far north as Switzerland and east to Asia Minor, but had disappeared from Europe by the end of the seventeenth century.[29]

The rediscovery of this highly significant cache of avian watercolors represents a missing chapter in the history of ornithological illustration and offers a fascinating window into science, art, and illustration during the tumultuous decades of the Reformation. Within the Society's collection it provides a contextual background for the 435 watercolors by Audubon preparatory for his celebrated *The Birds of America* (1827–38) and sheds light on an unexplored corner of the history of collecting in America.

R. J. M. O. and A. M.

1. The albums also contained: (1) five previously unknown watercolor models for woodcuts in Konrad Gesner's ornithological treatise (see below), together with a contemporary copy of one of them; and (2) four watercolor models by Eleazar Albin for etched plates in his *A Natural History of Birds* (1731–38), which also includes two plates he copied and others influenced by the techniques and poses from the N-YHS's avian watercolors that he studied while they were in the possession of Sir Thomas Lowther. See Olson and Mazzitelli 2007, 440–43.

2. Although a handful of watercolors have been removed, the albums contained the following numbers of sheets when catalogued in 2006: 57, 55, 51 (including one bat), and 53. The 214 avian watercolors depict 219 individual birds. The gilt, tooled spines of the albums are nineteenth-century replacements, while the leather-bound boards probably date from the late seventeenth or, more likely, the early eighteenth century, as may the folios, whose borders are somewhat crudely tipped in forest green pigment. A generous Save America's Treasures grant from the National Endowment for the Humanities has allowed for the removal and conservation of the sheets.

3. See Nicolas Barker, *The Devonshire Inheritance: Five Centuries of Collecting at Chatsworth*, exh. cat. (Alexandria, Va.: Art Services International, 2003); and Anthony Blunt, *Treasures from Chatsworth: The Devonshire Collection*, exh. cat. (Washington, D.C.: International Exhibitions Foundation, 1979), 13–21.

4. The sixth duke also began the *Handbook of Chatsworth and Hardwick*, which remains the best guide to the great house and its collections. See William Spencer Cavendish, Duke of Devonshire, *Handbook of Chatsworth and Hardwick* (London: privately printed by Frederick Shoberl, 1845); and Francis Thompson, *A History of Chatsworth, Being a Supplement to the Sixth Duke of Devonshire's Handbook* (London: Country Life; New York: Charles Scribner's Sons, 1949). See also Deborah Vivien Freeman-Mitford Cavendish, Duchess of Devonshire, *Chatsworth the House* (London: Frances Lincoln, 2002), 14; and Barker 2003, 229, no. 159.

5. See A. E. Popham, *Old Master Drawings from Chatsworth*, exh. cat. (London: Arts Council of Great Britain, 1949), 29–31, nos. 63, 65, 68, 70, 72; James Byam Shaw, *Old Master Drawings from Chatsworth: A Loan Exhibition from the Devonshire Collection*, exh. cat. (Washington, D.C.: International Exhibitions Foundation, 1969), 15–16, nos. 1, 2, 4, 5, ills.; Blunt 1979, 40, nos. 47, 51, ills.; and Barker 2003, 160–63, nos. 73.1–5, ills.

6. Charles Noble and Nicolas Barker, e-mail messages, 26 September 2005, noted that about 1812–14 duplicate books were deaccessioned from the library, but they could not determine when the albums would have been deaccessioned. They seconded the curatorial opinion that the clipping in the first album is English and its typography dates from the mid–nineteenth century. Barker noted that a similar typography was used by the London auction house of Puttick & Simpson. Although the precise sale has not yet been determined, the descriptive prose and typography associate the label with that firm.

7. Bishop's letter of donation of the four albums in the Department of Manuscripts (8 March 1889) refers to the date and city but not the auction house. See M. Thomas & Sons, Auctioneers, Philadelphia, sale cat., 23 April 1872, lot 62.

8. An intrepid Victorian nature enthusiast, Bishop published, among other works, *The Pampas and Andes: A Thousand Mile Walk across South America* (1869) and *Voyage of the Paper Canoe* (1878) and also gave the N-YHS a complete run of the magazine *Forest and Stream* to which he contributed.

9. Jean Tagaut (1525/30–1560), a French humanist, moved to Geneva for religious freedom between 1552 and 1554 and eventually obtained citizenship; see *Dictionnaire historique et biographique de la Suisse* (Neuchâtel: V. Attinger, 1930), 5: 453.

10. See Christian Gottlieb Jöcher, *Allgemeines Gelehrten Lexicon* (Leipzig: Johann Friedrich Gleditschens Buchhandlung, 1751), 4:1080; *Dictionnaire historique et biographique de la Suisse*, 6:534; and *The National Union Catalogue of Pre-1956 Imprints* (London: Mansell Information/Publishing; Chicago: American Library Association, 1978), 588:358.

11. See Roberta J. M. Olson and Alexandra Mazzitelli, "Audubons' Bats: Like Father, Like Son?" *New-York Journal of American History* 66:2 (2003): 68–89.

12. Claude Textor's distinctive script is preserved in two letters to Jacques Dalechamps of 14 April 1560 and 1 February 1561 (Bibliothèque nationale de France, Paris, MS lat. 13063, fols. 184–87). Educated at the University of Wittenberg in philosophy, medicine, and mathematics, he was heavily involved with birds, having a *falconerie* and sending specimens to Dalechamps and Robert Constantin. He may have taken over the project when his father left Geneva for Mâcon or died (sometimes given as between 1556 and 1560, but probably about 1565 and before 1567), a "grandisime" loss mourned by Constantin in a letter to Dalechamps (MS lat. 13063, fol. 282r). Claude supposedly returned to France and lived until at least 1576. See Baudouin Van den Abeele, "Les Albums ornithologiques de Jacques Dalechamps, médecin et naturaliste à Lyon (1513–1588)," *Archives internationales d'histoire des sciences* 52 (2002): 28, 44.

13. Paris: Chez Michel Sonnius; see Rondot 1898, 46.

14. Ibid., 48.

15. Anninger 1988, 34 n. 75.

16. The three letters from Constantin date to the 1560s and are in the Bibliothèque nationale de France, MS lat. 13063, fols. 271r, 292r, and 295r.

17. The general nature of the two albums has been discussed in Van den Abeele 2002, 3–45, without any knowledge of the Society's albums. Also see Olson and Mazzitelli 2007, 435–521, which briefly examines the Society's albums in conjunction with the two in Paris; it will be followed by a book examining all six albums.

18. Van den Abeele 2002, 42.

19. Carl Brun, *Schweizerisches Künstler-Lexikon* (Frauenfeld: Verlag Von Huber & Co., 1908), 2:529; Henri Bordier, *Peinture de la Saint-Barthélemy par un artiste contemporain (François Dubois dit Sylvius) comparée avec les documents historiques Genève* (Paris: J. Jillien, 1878), 10 n. 1 (in a reference to Geneva in 1573, he observes, "Un autre peintre du même nom s'était réfugié à Genève vingt ans auparavant, savoir: 'Michel Petit, peintre, natifs de Rouan,' inscrit au register des habitants le 15 octobre 1534" [meaning 1554]); and Bénézit 2006, 10:1256.

20. The latter is inv. no. 1889.10.3.28, in watercolor, gouache, and black ink with touches of white lead pigment over black chalk on ivory paper, formerly mounted on an album page, 14 1/4 × 11 5/16 in., irregular; see Wendy Moonan, "Long before Audubon, 'The Missing Link' in Bird Illustrations," *New York Times*, 17 March 2006, sec. E, 39, ill.

21. C. M. Briquet, *Les Filigranes: Dictionnaire historique des marques du papier dès leur apparition vers 1282 jusqu'en 1600* (Paris: Alphonse Picard & Fils; Geneva: A. Jullien, 1907), 4:653, no. 13.154, ill.

22. Ibid., 646.

23. This project involving the two albums in the Bibliothèque nationale de France, MSS lat. 11858 and 11859, and some of the watercolors in the Society's four albums is discussed in Olson and Mazzitelli 2007, 435–521.

24. Roger F. Pasquier and John Farrand Jr., *Masterpieces of Bird Art: 700 Years of Ornithological Illustration* (New York: Abbeville Press, 1991), 32–34. For a history of ornithological illustration, consult this volume; and Joseph Kastner et al., *The Bird Illustrated, 1550–1900: From the Collections of the New York Public Library*, exh. cat. (New York: Harry N. Abrams, 1988). See also René Ronsil, *L'Art français dans le livre d'oiseaux* (Paris: Société Ornithologique de France et de l'Union Française, 1957).

25. Kastner et al. 1988, 19. Gesner (quoted in Pasquier and Farrand 1991, 34) dedicated his magnum opus to "all art lovers, doctors, painters, goldsmiths, sculptors, silk embroiderers, hunters, and cooks, not merely for diversion but for practical and serviceable use."

26. Ibid.

27. For the species, see Roger Tory Peterson, Guy Mountfort, and P. A. D. Hollom, *Birds of Britain and Europe* (Boston: Houghton Mifflin, 1993), 223, pl. 89.

28. Ibid., 90, pl. 32.

29. See Josep del Hoyo, Andrew Elliott, Jordi Sargatal et al., eds., *Handbook of the Birds of the World* (Barcelona: Lynx Editions, 1992), 1:488–90, pl. 35, no. 8. Mary LeCroy, of the American Museum of Natural History, supplied this identification.

UNIDENTIFIED ARTIST*
Active c. 1630

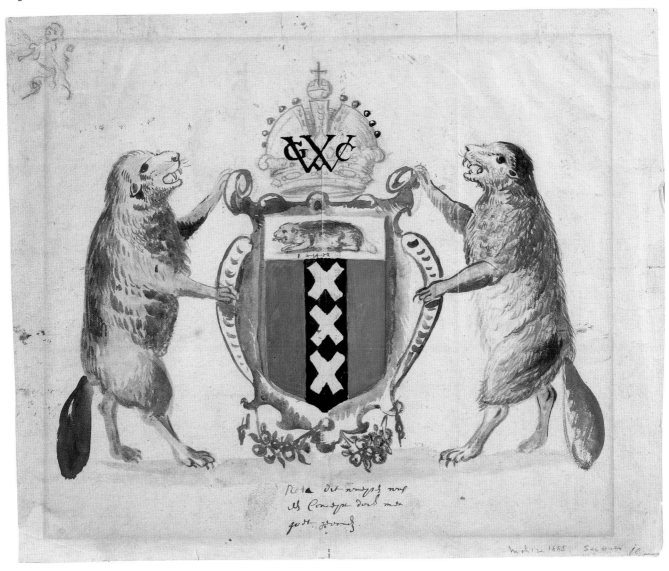

2. *Proposed Coat of Arms for New Amsterdam, New Netherlands: Preparatory Drawing for a Presentation to the Dutch West India Company*, c. 1630

Black ink and wash, watercolor, red and black chalk, and red gouache on paper, mounted on card; 12 × 14 3/16 in. (305 × 361 mm), irregular
Inscribed at lower center in brown ink: *Nota dit waepe[n] was / ee[n] concept doch niet / goet gevonden*; inside escutcheon under beaver: *I Otter*; old typed label on verso of card: *Drawing of a proposed coat of arms for the West-India Company, 1621–23, but not adopted. From the papers of J. Bontemantel, a shareholder and on the special committee of the New Netherlands.*
Watermark: Fool's cap [partially legible]
Provenance: Johannes (Hans) Bontemantel, New Amsterdam (New York); Frederik Muller, Amsterdam, 1869.
Bibliography: Koke 1982, 3:354–55, no. 3179, ill.
Gift of J. Carson Brevoort, 1885.5

An unknown Dutch artist executed this proposed coat of arms for New Amsterdam about 1630, making it one of the earliest drawings in the Society's collection. It was probably preparatory for a presentation sheet with the same provenance in the collection of the NYPL. The latter drawing consists of three small designs for crests for New Amsterdam sent to the Dutch West India Company for approval; the one at the upper left incorporates most of the features of the Society's drawing.[1] Inscriptions on both versions indicate that the design from the Society's collection was rejected, while the other two on the NYPL sheet were approved. The Society's sheet was reportedly found among the papers of Johannes (Hans) Bontemantel (1613–1688), a member of the chamber of the West India Company, who probably acquired it when he served as *schepen*, or magistrate, of New Amsterdam (1655–72).[2]

The proposed crest for New Amsterdam depicted in this design is a modification of the traditional coat of arms of the city of Amsterdam. Amsterdam's original emblem consisted of a central shield with two vertical red bands on either side of a central black band decorated with three silver Andreas crosses, flanked by rampant lions. In 1489, after supporting Prince Maximilian of Austria during an intense territorial conflict, Amsterdam was granted the honor of displaying the intricate crown of the Holy Roman Emperor above its crest.[3] The Society's version of the proposed New Amsterdam coat of arms maintains the general layout of the Amsterdam design but with distinctly North American modifications.

On the proposed coat of arms the shield retains the colors and design of the original, including the imperial crown placed above. A large letter *W* flanked by a smaller *G* and *C*, calligraphy echoing the cross motif on the shield, have been superimposed on the crown. The initials *GWC* stand for Geoctrooiëerde Westindische Compagnie[4] or Chartered West India Company, more commonly known as the Dutch West India Company.[5] An escutcheon was added to the upper section of the shield with a single beaver crouching above an illegible legend.[6] Swags of fruits and foliage, symbolizing the promise of abundance and agricultural fertility in the New World colony, hang below the shield. The rampant lions of the Amsterdam coat of arms have been replaced by rampant beavers that represent industriousness and the literal construction of the New World. In addition, they point to the importance of the fur trade.

During the seventeenth century beaver furs, as well as pelts from other animals such as otter, bobcat, and mink, were more than simply the valuable products of colonial exploration; they served as both commodities and substitute forms of legal tender.[7] As the demand for furs in Amsterdam increased, the value of Dutch currency became significantly dependent on the supply of beaver pelts, making fur a negotiable instrument like paper currency. In fact, beaver fur established the standard by which all other monetary substitutes were measured.[8] Debts were recorded in pelts and wages paid using the "beaver rate" or "beaver price."[9] Only the value of silver coinage, which was scarce in the colonies until the late seventeenth century, superseded beaver pelts in evaluation and exchange.[10]

Despite the importance of the fur trade to the Netherlands and its colonies, the substitution of smaller beavers for lions creates a disproportionate composition with a smaller shield conveying less power than coats of arms with the larger, fiercer regal animals, which may have been one of the reasons this design was rejected. The artist may have recognized the shortcomings of his composition because he offered a more conservative alternative to the New World beavers by inserting a sketch of the traditional rampant lion in red chalk at the upper left of the Society's sheet, similar to the lions used in the coat of arms that was subsequently adopted for New Amsterdam. The central coat of arms in the crest that was approved by the GWC on the NYPL sheet retained the rampant lions of the Old World crest with the recumbent beaver escutcheon from the rejected proposal added to the shield.
A. M.

* Unidentified Artist 2
1. The inscription, in mid-seventeenth century Dutch script, on the Society's sheet can be roughly translated as: "Note this coat of arms was a draft and was not approved." The N-YHS version was sold at auction by the antiquarian dealer Frederik Muller, Amsterdam, sale cat., May 1869, lot 1368, described as a design for a coat of arms of New Amsterdam; the NYPL sheet, lot 1367 from the same sale, is reproduced in Stokes 1915–28, 4: frontispiece I, 77–78. The design of its small coat of arms at the upper left is nearly identical to the Society's sheet, although the legend beneath the animal on the shield is missing and a small *v* is superimposed at the center of the *W*; see n. 5 below.
2. For background, see Hans Bontemantel, *De Regeeringe van Amsterdam*, trans. Arnold J. F. van Laer as *Form of Government in New Netherland A[nn]o 1653*, reprinted in Stokes 1915–28, 4:132–34 (see also 34, 77–78).
3. Sierksma 1962, 18–19; see also L. Ph. C. van den Bergh, *Beschrijving der Vroegere Nederlandsche Gemeentezegels in het Rijks-archeif* ('s-Gravenhage, Netherlands: Nijhoff, 1878).
4. Also known as the West India Company or WIC.
5. In the proposed design, a small *v* was superimposed at the center of the *W* in *GWC* to form a stylized *A*, inserted by the Amsterdam chamber of the GWC to represent that city in the company emblem; see Klaes Sierksma, "Vaandels van de Westindische Compagnie," *Spiegel historiael* 10:4 (1975): 238–41, which discusses the symbols, standards, and colors of the GWC. See also Klaes Sierksma, *Nederlands vlaggenboek: Vlaggen van Nederland, provincies en gemeenten* (Utrecht: Spectrum, 1962), 18–19, 46, 52, 140–41.
6. Koke 1982, 3:354, transcribes the legend beneath the animal on the shield as "I Otter." This could stand for "one otter," as Koke suggested, since otter fur, along with beaver fur, was a valuable commodity. The artist may not have recognized the difference between an otter and a beaver.
7. Oliver A. Rink, *Holland on the Hudson: An Economic and Social History of Dutch New York* (Ithaca, N.Y.: Cornell University Press; Cooperstown: New York State Historical Association, 1986), 42–44, 68, 90; and Brodhead 1853–87, 2:218; 3:75. The desirability and value of a pelt increased if it was thick winter fur rather than summer fur and decreased if the pelt was poor quality or incomplete, but generally during the mid–seventeenth century the value

of a beaver pelt fluctuated between six and eight guilders in Dutch currency.

8. See Rink 1986, 152 n. 12, 209–11, 219–22; and Brodhead 1853–87, 2:218; 3:175, 232–39.

9. See Adriaen van der Donck, *Beschryvinge van Nieuw-Nederlant* (1656), trans. Jeremiah Johnson (1841) as *A Description of the New Netherlands*, ed. Thomas F.

O'Donnell (Syracuse, N.Y.: Syracuse University Press, 1968), 93; and O'Callaghan 1868, 117, 289–91, 357–60. See also Berthold Fernow, *Documents Relating to the History of the Early Colonial Settlements Principally on Long Island* (Albany, N.Y.: Weed, Parsons, and Company, 1883), 105, 108, 169, 372, 450.

10. Charles T. Gehring, ed. and trans., *Fort Orange*

Court Minutes, 1652–1660 (Syracuse, N.Y.: Syracuse University Press, 1990), 250, 301. By the late 1600s a surplus of pelts created a decline in the value of fur that ultimately contributed to the commercial failure of the colony under the Dutch West India Company and a broad economic decline in the Netherlands; see Rink 1986, 67–68.

ATTRIBUTED TO LAURENS BLOCK

Active seventeenth century

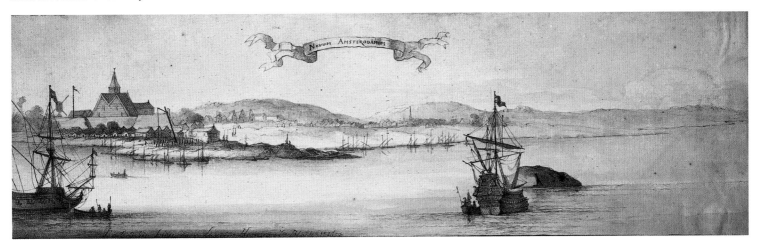

3

Nothing is known about the individual who executed this watercolor. The attribution to Laurens Block derives from the sheet's problematic, faded, and partially relettered inscription in an area that has been rubbed.

3. *"Novum Amsterodamum" (New Amsterdam, New Netherlands)*, 1650

Watercolor and brown and black ink over black chalk on ivory paper, laid on four other layered sheets; 5 13/16 × 19 1/16 in. (149 × 485 mm)
Inscribed inside image within banner in black ink: *NOVUM AMSTERODAMUM* [partially relettered]; along lower left border inside image: *Faer t [Paer t; Vaer t; In't?] Schip Lydia [Leyden?] door LaurEns Hermans Zn. Block. Ao. 1650* [damaged and relettered]; old paper label now attached to reverse of frame inscribed in a similar hand in brown ink: *In t Schip Lydia bc LaurEns Hermans Zn* [superscript with two lines below] *Block / An 1650*[1]
Provenance: Unidentified dealer, The Hague, 1879; Frederik Muller, Amsterdam, 1880.
Bibliography: Thomas Addis Emmet, "Rare Early Picture

of New York," *Magazine of American History* 23:1 (1890): 14–15, ill. (with frame undamaged); Stokes 1915–28, 1:138–39, pl. 4-a; Koke 1982, 1:64–65, no. 169, ill.; Deák 1988, 1:23, no. 33. Gift of C. E. Detmold, 1881.[2]

The authenticity of this sheet, which claims pride of place in the collection as the earliest original view of New York City (then New Amsterdam), has been questioned in the past.[2] The drawing is closely related to two other works: a drawing in a brown ink and wash (now faded to golden brown) in the I. N. Phelps Stokes Collection at the NYPL (fig. 3.1)[3] and the engraving *Novum Amsterodamum*, known as the Montanus View (fig. 3.2).[4] To assess the Society's drawing, a number of complex issues, clustered around the relationship of these three works and other early views of the Dutch colonial city, will be explored below. Several factors link the three works, among them their Latin name for the city, "Novum Amsterodamum."

A comparison of the two drawings with the Montanus View reveals differences among the

three. For example, the City Tavern, a prominent feature of the Society's drawing, does not appear in the NYPL sheet; Stokes discusses the possible reasons for this situation, including artistic license.[5] In addition, the number of windmills in the left background differs: three north and west of the fort in the NYPL drawing and only one in the N-YHS watercolor, a discrepancy that can be explained by the truncated left section of the Society's sheet, a fact never acknowledged in previous scholarship. However, the Manatus Map of 1639, known in two manuscript copies of c. 1670, shows that before that year there were two, not three, windmills to the left (north and west) of the fort.[6] Deák uses this evidence to argue that the NYPL drawing, not the Society's watercolor, is the authentic view,[7] but she never grapples with the fact that it seems there were never three mills in the location shown in the NYPL drawing. Furthermore, after 1639 and by 1660, as recorded in the Castello Plan of New Amsterdam, only one mill remained adjacent to

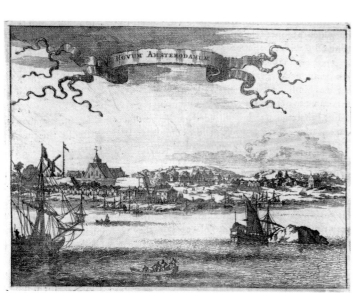

the fort,[8] the number in the Society's view. The N-YHS watercolor also features a flagstaff at the fort that is lacking in the NYPL work but present in the Montanus View. The position of the signal pole with night fire-basket beacon is different in the two drawings, although the Society's watercolor shows it on the ground with a long rope connected to the pole and surrounded by a large crowd of people (perhaps filling the basket) as it appears in the Montanus View. Both drawings lack the adjacent "gallows" or "beam" found in the Montanus View and other roughly contemporary works.[9]

By and large the topography of the Society's watercolor (three of whose borders are outlined in black ink and whose right portion is very sketchy) follows the layout of one of the most important contemporary representations of New Amsterdam: a watercolor by Johannes Vingboons in the Netherlands General State Archives, The Hague. The work by Vingboons is

inscribed *NIEUW AMSTERDAM OFTE NUE NIEUW IORX OPT' TEYLANT MAN*, and its depicted date is roughly contemporary to that of the Society's watercolor.[10]

All three works reproduced in this entry—together with the Vingboons watercolor—depict views before 1654, when bulkheads were erected along the riverbank of New Amsterdam and the half-moon fortification built on rumors of an impending British invasion.[11] All three also do not clearly depict the little wooden wharf or pier—next to the beacon pole—seen in the Vingboons work, which Peter Stuyvesant constructed at Schreyers Hook in 1648–49 shortly after his arrival.[12] Instead, the Montanus View features a truncated pier, and the Society's sheet contains a vestigial pier partially hidden by a boat, while the NYPL sheet omits a pier altogether. All four works feature the fort, the most conspicuous building of New Amsterdam. Visible within it is the tallest structure of the city, the stone church (erected in

1642 with a double-peaked roof), which is flanked by the governor's house on the right and the barracks and the jail on the left.[13]

While the views shown in the three works have elements in common, the Society's drawing is closer to the Montanus View than to the NYPL drawing. It is as though the N-YHS work served as the model for the engraving with one major difference: the print is less panoramic. If, as is suggested here, the Society's drawing or its prototype served as the model for the Montanus View, the printmaker moved the right-hand ship and the nearby rock farther to the left, placing them parallel to the shoreline at a more aesthetically pleasing point where they are embedded below the horizon. To fill the empty foreground and link the two lateral ships, he also moved one skiff facing left to the center foreground. Although the printmaker made many other minor adjustments—for example, adding the requisite palm tree to signal the New World—he seems to have followed the suggested prototype. He also enlarged the banderole announcing the identity of the cityscape—a traditional feature in European prints for city views since the sixteenth century—to harmonize with the proportions of the print.[14] The NYPL drawing diverges from both the Society's watercolor and the Montanus View in its greater expanse of landscape to the left of the fort, the addition of a third ship, and the omission of the flagstaff, among other things.

The three works discussed above and the Vingboons watercolor belong to a larger group of drawings and prints featuring early views of New Amsterdam produced as a result of Dutch commercial expansion and political influence overseas and the ensuing demand for geographical information. During the late sixteenth and early seventeenth centuries, Dutch artists achieved international fame for their ability to portray current and recent events with topographical accuracy. Public authorities, company directors of the Dutch East India Company (Verenigde Oostindische Compagnie, or VOC) and the Dutch West India Company (Westindische Compagnie, or WIC),[15] and commercial publishers sought accurate representations of events and locations, preferably via a cartographic record made on the spot with an eyewitness quality. Between 1602 and 1795 (the years of the chartered companies), hundreds of mapmakers

and draftsmen produced topographical maps, views, and navigational charts that were simultaneously images of power and artifacts commemorating contemporary events. Qualified draftsmen—engineers, surveyors, architects, artists, and talented amateurs, such as ships' pilots and merchants—were, therefore, in great demand on expeditions. Plans and views sent to the Netherlands were sometimes used as models for prints that disseminated the latest information. The Dutch West India Company, like other companies, publishers, and artists—such as Johannes Vingboons, who was closely tied to the WIC and a partner of Joan (Johannes) Blaeu—all maintained picture archives of models and made hundreds of works that were collected in atlases and also sold as individual sheets.[16]

The Society's watercolor belongs to this formulaic type of cityscape produced in assorted media.[17] They were frequently based on profile views of coastlines made aboard ships as aids to navigation, as is the case with the Society's watercolor.[18] Artists who wanted to produce works of art based on overseas subjects, such as Willem van de Velde the Younger and Ludolf Backhuysen, consulted archives compiled by individuals like Blaeu and Vingboons. It is thought that Vingboons's picture archive did not contain originals made on the spot but maps, views, and plans that were compilations or copies.[19] It is only within this context that the Society's drawing of New Amsterdam can be understood, noting that the antiquarian dealer Frederik Muller, who marketed the sheet in 1880, was the source of numerous VOC and WIC maps, charts, and views sold to libraries and private collectors throughout the world.[20]

The inscription on the Society's watercolor underlines its connection to the profile views drawn aboard ship. However, this inscription may have been added to lend it authenticity and immediacy, for no record of Laurens Block or a ship *Lydia* (or *Leyden*) has yet surfaced.[21] A primary contender for the on-the-spot prototype for many of these early views of New Amsterdam about 1650 (including Vingboons's watercolor) is an anonymous sheet dated about 1650 that was discovered in 1991 in the Graphische Sammlung Albertina, Vienna.[22] It features one windmill near the fort, like the Society's watercolor, a flagstaff, beacon pole, and Stuyvesant's pier but no basket, beam, or banderole (its inscription in the sky

identifies it as *DE Stadt NiEuw / AmstErdam*). Another early profile view dating from the mid–seventeenth century is in a private collection. Executed in brown ink, it is smaller in dimensions and less panoramic but has most of the topographic features found in the Albertina drawing, with the exception of Stuyvesant's pier; its banderole is lettered *NIEU AMSTERDAM*.[23] Among the other early pertinent views are several prints with the pier and beam functioning as a gallows (one corpse is seen hanging), including multiple versions (some as a vignette on a map) of what is known as the Visscher View by Claes Jansz. Visscher (c. 1651–52).[24]

Certainly the draftsmanship of the Society's sheet, albeit with redrawn areas like the banderole and inscription,[25] harmonizes with Dutch seventeenth-century works, as does its long, horizontal format, favored by Dutch draftsmen. It can be compared with Hendrik Avercamp's *A View of Kampen from Outside the Walls* in the Royal Library, Windsor Castle,[26] as well as with pen and ink works by Visscher,[27] Rembrandt van Rijn, and a number of their contemporaries.[28] Moreover, the reflections in the water of the boats near the fort lend a lyrical quality to the sheet.

The popularity of New Amsterdam views postdates 1648, the year the Dutch Republic received international recognition as a sovereign state at the Treaty of Münster, which concluded the Eighty Years' War with Spain. The treaty and the extension of the West India Company's patent the same year may have emboldened a group of New Netherland remonstrants to seek definition of their province's borders, as well as political reform and policy changes from the governing body of the fatherland, the States General. At the time, the director general was Peter Stuyvesant, who was responsible to the directors of the West India Company that operated the New Netherland province in America. From 1648 to July 1649 the New Amsterdam remonstrants, led by Adriaen van der Donck,[29] one of the Board of Nine Men appointed by Stuyvesant, prepared their protest, which was presented in The Hague in October of that year. A manuscript map, among other documents, was prepared to induce the States General to begin negotiations with England to determine the exact borders that both nations would respect. The 1649 remonstrance became

the catalyst for renewed interest in the New Netherland province and was followed by a deluge of printed and graphic material.[30] Certainly the Society's watercolor and the related works discussed in this entry belong to this flood of geographical information.

1. See Stokes 1915–28, 1:138, for a discussion of this problematic inscription.
2. Emmet 1890, 15, relates seeing the Society's work, which he reproduces on p. 14 and mistakenly terms a panel: "During the summer of 1888 I visited Amsterdam, and found … the old view of New York which you have decided to reproduce in the *Magazine of American History*. I was told that an old teak-wood vessel which had formerly been in the Dutch navy, and was one of the squadron which took New York from the English, had been broken up a few weeks before. From this vessel, Mr. Müller secured the picture, painted on a wooden panel which was about thirty inches in length. The panel was situated opposite the stairs of the companionway to the main cabin, and I understood that it could have been painted by the artist standing a few steps below, and within easy reach of it, while with his head above the slide the town of New York could have been in full view … . I think there can be little question that this view was painted while the vessel lay at anchor … . The arms and scroll-work [the frame] were of a different wood from the panel [part of the ship], and, as an ornament, was evidently put on afterward." He adds that since Muller had sold it to an American he saw only a photograph of the view (which from his description may have been a different work).
3. Stokes 1915–28, 1:139–40, pl. 4-b, questioned whether this view, then in his collection, was a copy of the Society's drawing: "A careful comparison of the two drawings strongly suggests the same authorship, and there is so much independence and freedom in the treatment of each, and so many slight, but not impossible variations in the topography that it is difficult to believe that one could have been copied from the other. On the whole, however, I am reluctantly disposed to consider this drawing a clever modern forgery based on the Historical Society's view and the Montanus print." Stokes also recounts some of the earlier, perhaps apocryphal, sightings of these two or related works. See also Deák 1988, 1:23–24, no. 33; 2: ill.
4. Stokes 1915–28, 1:142–43, pl. 6 (an impression of which is in the DPPAC). Depicting the city c. 1650, it was published in 1671 on p. 124 of *De Nieuwe en Onbekende Weereld: of Beschrijving van America, … Door Arnoldus Montanus, t' Amsterdam* and soon in other sources.
5. Stokes 1915–28, 1:139–40.
6. See ibid., 1:137, pls. 3–a and b; 2:183–208; and Deák 1988, 1:22–23, no. 31; 2: ill.

7. Ibid., 23.

8. See ibid., 2: fig. 44.

9. These objects were features of the Amsterdam harbor and wharf. For beacon poles, see a drawing by Esaias van de Velde reproduced in Marian Bisanz-Prakken, *Die Landschaft im Jahrhundert Rembrandts: Niederländische Zeichnungen des 17. Jahrhunderts aus der Graphischen Sammlung Albertina*, exh. cat. (Vienna: In Selbstverlag der Graphischen Sammlung, 1993), 52–53, no. 21, ill. For gallows and beacon poles, see a detail of an etching by Adolf van der Laan in Joep M. J. de Koning, "Dating the Visscher, or Prototype, View of New Amsterdam," *de Halve Maen: Magazine of the Dutch Colonial Period in America* 75:3 (1999): 48, ill.

10. See Stokes 1915–28, 1:119–30, frontispiece, and for the identification of all the buildings and sites. Stokes does not think this work can be the drawing referred to by Peter Stuyvesant as drawn by Augustine Herrman and sent to Holland in 1660 (ibid., 139, 142). Like the Society's sheet, it came from Frederik Muller; see Kees Zandvliet, *Mapping for Money: Maps, Plans and Topographic Paintings and Their Role in Dutch Overseas Expansion during the 16th and 17th Centuries* (Amsterdam: Batavian Lion International, 1998), fig. 11.33; and Roderic H. Blackburn and Ruth Piwonka, *Remembrance of Patria: Dutch Arts and Culture in Colonial America, 1609–1776*, exh. cat. (New York: Produced by the Publishing Center for Cultural Resources for the Albany Institute of History and Art, 1988), 95, no. 51, ill. The Vingboons watercolor is nearly identical to the Visscher Map vignette of 1651–52 (see ibid., 41–42, no. 3, ill., where it is given a date of c. 1651–52). Both works may derive from a common source.

11. Stokes 1918–15, 1:121–22.

12. Ibid., 121.

13. For an earlier anonymous engraving, c. 1642–43, of New Amsterdam with some of the same features, see Stokes and Haskell 1932, 9, no. B-10; and Deák 1988, 1:23, no. 32; 2: ill. In it, the church has no steeple, which was probably added in 1643, no fire basket hangs on the beacon pole, and there is no Stuyvesant pier, although it does show the beam next to the beacon pole.

14. For a Dutch view of c. 1635 with a similar banderole, see Zandvliet 1998, fig. 4.5.

15. Also known as the Geoctrooiëerde Westindische Compagnie, or GWC.

16. Zandvliet 1998, 215–16.

17. See ibid., 216–29.

18. Ibid., 230.

19. Ibid., 236, notes: "The complex organization of the production of wall maps and topographic paintings, as well as atlas maps and news maps, turned these art works into 'distant mirrors.' Today, we must be careful not to read 17th-century maps and topographic paintings as objective representations of American, African and Asian realities."

20. Zandvliet 1998, 9, notes that Muller, together with the archivist P. A. Leupe, laid the foundation for bibliographical research into company maps and material.

21. Stokes 1915–28, 1:138–39.

22. Inv. no. 12720/21, in brown ink and wash and watercolor over black chalk on two sheets of paper, 12 7/16 × 16 1/8 in. and 12 7/16 × 9 3/16 in. See Franz Wawrik, "Das Amerika-Bild in Österreich," in Wawrik et al., *Die Neue Welt: Österreich und die Erforschung Amerikas*, exh. cat. (Vienna: Österreichischer Nationalbibliothek, Edition Christian Brandstätter, 1992), 33, fig. 12.1, which dates it 1650–54 and notes the watermark indicates that the paper was produced in Amsterdam in 1646. Zandvliet 1998, 237, suggests it is by Augustjn Heerman (Augustine Herrman), who Stuyvesant notes drew a sketch of New Amsterdam in the 1650s (see n. 10 above). The ten key locations on this sketchy work are labeled *a–k*.

23. In a private collection; see De Koning 1999, 47–56, cover ill.

24. See Stokes 1915–28, 1:143–52, pls. 7-a, b (impressions of which are in the DPPAC), 7-A; Deák 1988, 1:5–27, nos. 38, 42; 2: ills.; and Blackburn and Piwonka 1988, 45, ill. on 42. For the independent print of only the map, see Stokes 1915–28, 1:152, pl. 8-a; and De Koning 1999, 49, 53, 54–55, ill. De Koning believes the map is by Blaeu, and he discusses his theory regarding the genesis of several of the works as they relate to the remonstrants' case and Van der Donck. See his chronology on pp. 51–56, which he elaborates in idem, "From Van der Donck to Visscher: A 1648 View of New Amsterdam," *Mercator* 5:4 (2000): 28–33.

25. Koke 1982, 1:65, records the observations of Dr. R. van Luttervelt, curator of history at the Rijksmuseum, Amsterdam, who believed the ship's rigging and other details were retouched in black ink where the original had faded. He suggested that the word *Lydia* should be read as *Leyden* and that its wood frame with two carved and painted coats of arms (on the left that of the city of Amsterdam, and on the right, the lion of Holland) was also from a later era, a conclusion with which I agree.

26. See Christopher White, *Dutch and Flemish Drawings from the Royal Library Windsor Castle*, exh. cat. (Raleigh: North Carolina Museum of Art, 1994), 62, no. 32, ill.

27. See Marijn Schapelhouman and Peter Schatborn, *Dutch Drawings of the Seventeenth Century in the Rijksmuseum: Artists Born between 1580 and 1600*, ed. Schapelhouman, trans. Michael Hoyle (Amsterdam: Rijksmuseum, in association with Merrell Holbertson Publishers, London, 1998), vol. 6, pt. 1: 183–86, nos. 398, 400, 403; vol. 6, pt. 2: figs. 398, 400, 403.

28. See one of Rembrandt's views near Amsterdam, outlined like the Society's sheet, in Bisanz-Prakken 1993, 88–89, no. 49, ill. For similar conventions for depicting ships, see drawings by William van de Velde the Elder, Reinier Nooms, and Ludolf Backhuysen in ibid., 148–49, no. 80, ill., 152–55, nos. 82 and 83, ills.

29. In his 1656 *Description of the New Netherlands*, Adriaen van der Donck reproduced Visscher's inset view of New Amsterdam (Blackburn and Piwonka 1988, 95). See Stokes 1915–28, 1:154–55, pl. 9, for Van der Donck's map (an impression is in the DPPAC).

30. The specific claim for the Dutch discovery and occupation of the territory was that the explorer and trader Adrien Block, together with Cornelius Hendricksz., had between 1611 and 1616 recharted Henry Hudson's 1609 discovery of the North River. The Dutch ceded New Amsterdam to the English by the Treaty of Westminster in 1674.

UNIDENTIFIED ARTIST WORKING FOR PIETER MORTIER

Leiden, Netherlands 1661–Amsterdam, Netherlands 1711

While the identities of the artist who drew the sheet considered in this entry and the print-maker of its related engraving have thus far eluded scholars, Pieter Mortier's imprint is readily identifiable. Mortier was a well-known map and print publisher in Amsterdam who frequently based the images in his works on previously published material. As European countries vied with each other for hegemony, publishers like Mortier, who rarely executed artistic work themselves, were eager to provide collectors with maps and images of the New World as proof of new settlements.

Mortier, who was born in Leiden, was of French extraction. His grandparents had been French émigrés who settled in London about 1625. His parents moved first to Leiden and then just after Mortier's birth to Amsterdam. Growing up during the Golden Age of Dutch art and printmaking in the rich cultural environment of the capital, Mortier became one of the city's most successful and wealthiest publishers of maps and books. From 1681 to 1685 he trained in the bookselling business in Paris and returned to Amsterdam with well-established relationships with Parisian publishers. During the initial years of his career he concentrated on the sale and publication of French-language books, establishing his shop on the Vijgendam in the Town of Paris section of the city. One of his first publications was the *Voyage de Siam*, a travel report of the French delegation to the East Indies (1687), which included thirty prints. Mortier began to publish maps in 1690 and sales catalogues of his books in 1694.

Mortier cannily realized that it would be more lucrative to republish recent innovative French maps than to recycle old Dutch maps. French cartographers produced superior maps because they applied current scientific methods to the most up-to-date geographical information. Nevertheless, Mortier did not want simply to sell maps printed in Paris because he did not wish to be limited by uncertain transportation. Instead, he chose to reengrave the maps and print them himself in Amsterdam. To that end, Mortier received a charter from the States of Holland and West Friesland on 15 September 1690 granting him the exclusive right to publish the maps of the French geographer Nicholas Sanson and the mapmaker-publisher Alexis-Hubert Jaillot.

Mortier also published atlases. Four of the principal ones (three in elephant-folio format)

were *Atlas Nouveau* (1692 and reissued), in conjunction with Jaillot; *Neptune François* (1693), a pirated edition of the French admiralty's work of the same title; *Suite du Neptune François, ou Atlas Nouveau des Cartes Marines* (1700), charts of other countries of the world; and *Atlas Maritime* (1694 and reissued), with nine charts etched by Romein de Hooghe and dedicated to William of Orange (William III of England). The *Neptune François*, including its second section, *Cartes Marines a l'usage du Roy de la Grande Bretagne* (*Atlas Maritime*), was the most expensive sea-atlas published in Amsterdam in the seventeenth century. Its charts are larger and more lavishly decorated than those of any earlier book of the genre. Mortier's other works include the *Carte nouvelle de l'Amerique angloise* (1700) and *Atlas Antiquus* (1705). These maps and atlases infused new life into Dutch cartography by Mortier's exchanges with mapmakers of different nationalities. His house also published books, treatises, tracts, and Bibles. After Mortier's death, his widow and his brother David, who had returned from living in England, continued the business until his son Cornelius was able to take over. In 1721 Cornelius entered into partnership with his brother-in-law Johannes Covens to form the famous firm Covens & Mortier, which was the largest producer of and dealer in maps and atlases in Amsterdam during the eighteenth century. It continued in existence, with only a slight change of name, until 1866.

Bibliography: Covens & Mortier, *Stock Catalogue of Maps and Atlases by Covens & Mortier* (Utrecht: H&S, 1763 [1992]), 5–15; Cornelius Koeman, ed., *Atlantes neerlandici: Bibliography of Terrestrial, Maritime, and Celestial Atlases and Pilot Books, Published in the Netherlands up to 1880* (Amsterdam: Theatrum Orbis Terrarum, 1967–85), 3:4–20; Marco van Egmond, "The Secrets of a Long Life: The Dutch Firm of Covens & Mortier (1685–1866) and Their Copper Plates," *Imago Mundi: The International Journal for the History of Cartography* 54 (July 2002): 67–86; idem, *Covens & Mortier: Productie, organisatie en ontwikkeling van een commercieel-kartografisch uitgevershuis in Amsterdam (1685–1866)*, Ph.D. diss., University of Utrecht ('t Goy-Houten: HES & De Graaf Publishers, 2005).

4. *Allegory of New Amsterdam or New York in America: Study for the Engraving "N: Amsterdam, ou N: Iork. in Ameriq–:,"* c. 1700

Brown and black ink and wash with red chalk, white lead pigment, black chalk, and tracing impressions from a

stylus on ivory paper, inlaid into a larger sheet; 7 1/4 × 9 3/8 in. (184 × 238 mm)
Formerly inscribed outside image along lower left border: *Pieter*[?] *Mortier*; inscribed at lower center within etiquette in brown ink: *N. AMSTERDAM ou N. IORK / in Ameriq–*.

Provenance: Ogden Goelet, New York; Lucius Wilmerding, New York, 1949.
Bibliography: William Loring Andrews, *New Amsterdam New Orange New York* (New York: Dodd, Mead and Company, 1897), 53–54; Stokes 1915–28, 1:218–19; R. W. G. Vail, "Unknown Views of Old New York," *New-York Historical Society Quarterly* 33:2 (1949): 97–101, 98 ill.; Koke 1982, 2:390–91, no. 2047, ill.
Gift of Lucius Wilmerding, 1949.45

This sheet is a study in reverse for an etching and engraving issued by Pieter Mortier[1] about 1700; an impression with later hand-coloring is in the DPPAC (fig. 4.1).[2] Its unidentified draftsman designed the composition with engraving in mind, as it reads better in the print, where the heavy tree clasped by the Native American figure is at the left. The drawing lacks the decorative borders of laurel leaves and beads of the print (inscribed at lower center inside the image: *P. Mortier cum Privil:*), although the blank space around the simple lower ink border, similar to those found in the plates in another work of Mortier published about 1702 (see n. 7 below), suggests that the print's more ornate frame was drawn by the engraver directly on the copperplate. The central etiquette features an inscription—*N: AMSTERDAM ou N: IORK. | in Ameriq–: | 1*—that is nearly identical to the inscription on the drawing.

In the background of both works—more sketchily in red chalk in the drawing—are views of New Amsterdam (see also cat. 3). They are based on a previously published view known as the Restitutio View that was executed to mark the colonial settlement's recapture by the Dutch from the British on 24 August 1673. Since that famous view first appeared as an inset in a map of New Netherland and was the last engraved view of New Amsterdam made during the Dutch regime, it was frequently copied in contemporary and later Dutch maps.[3] It reflects seventeenth-century cartographic practice in which large printed maps frequently were surrounded by inset images illustrating detailed views of key sites. Likewise, Mortier's artist inserted this famous view of the Netherlands' American colony in the drawing's background for reengraving in its corresponding print (fig. 4.1).

4

The engraving for which this drawing is a study is the first in a series of nineteen city views, twelve of which are located in the Western Hemisphere. They are numbered inside the etiquette and have nearly identical decorative borders.[4] The twelve have been related to seven other views of cities in Europe and Asia, which, though similar in size, appear to belong to a separate series, as they are numbered at the lower right and lack etiquettes.[5] Since none of the nineteen has been linked to a specific publication or atlas, both sets may have been part of an incomplete series that was never integrated into one of Mortier's existing publications.[6] Further, the formats and measurements of the N-YHS drawing and print

resemble the title page to the third book of Mortier's survey of fortifications, *Les forces de l'Europe, Asie, Afrique et Amerique* from about 1702.[7]

Although eighteenth-century viewers might not have been able to identify the city depicted in the print or its preparatory drawing without its inscription, they would have instantly recognized the figures in the foreground as personifications of the Americas. Since the age of exploration, the American continents were usually symbolized by dark-skinned Native American women—other female ethnic types stood for Asia, Africa, and Europe—or Indian groups adorned with feathers or tobacco leaves and surrounded by exotic vegetation, most frequently palm trees.[8] Other personifications of America appeared elsewhere

in contemporary Dutch art that provide a contextual background for the Society's drawing and its corresponding print.[9]

In the right foreground of the drawing a Native American woman embraces a palm tree, a symbol of exotic fertility and prosperity; she stands in close proximity to a Native American man, seen from the back, who holds a bow and wears a quiver of arrows. A third Indian, a bare-breasted woman holding a bowl or basket (most likely symbolizing the abundance of the New World) approaches them in the middle ground. Similar personifications of the continent were reproduced earlier in related contexts. An example by Jan de Visscher after a composition by Nicolaes Berchem is found in the cartouche from

Fig. 4.1. Pieter Mortier, publisher, N: *Amsterdam, ou N: Iork. in Ameriq–:,* c. 1700. Hand-colored engraving, 7 1/4 × 9 5/8 in. (184 × 244 mm). The New-York Historical Society, Department of Prints, Photographs, and Architectural Collections

the map of America in Nicolaes Visscher the Elder's *Atlas*, published between 1657 and 1677.[10] Berchem's preparatory drawing for this composition is in Windsor.[11] With a recto and verso study in reverse, it reveals one way that an artist or printmaker could transfer a composition to a plate. After completing the drawing on the recto, Berchem traced its main outlines through on the verso, thus reversing the image to make the verso appear nearly identical, albeit simpler, and ready for transfer to a plate for engraving.[12]

In the left background of the Society's drawing, reversed in the engraving, are versions of the 1673 Restitutio View of New Amsterdam harbor featuring boats, piers, and the city with a windmill on the horizon. The manner in which this view was executed provides clues to its relation to its prototype and to the method used for its transfer onto a copperplate.[13] The sheet's unidentified artist first drew lightly and quite freely with red chalk (traditionally used by printmakers for the transfer process) the rough outlines of the Restitutio View in reverse, including all three rounded piers. He redrew only two in ink, and it is those that appear in the engraving. Most of these red chalk lines have been incised with a stylus, not always following the exact contours, for transfer onto the soft ground for etching. The unknown draftsman, who might have used a mechanical device to transfer the outlines of the Restitutio View, also employed a red chalk underdrawing in other areas of the composition, together with a few light lines in black chalk (to indicate the palm

fronds and to mark the placement of the etiquette). He redrew certain areas of the city in brown ink and wash, especially in the embankment, attempting to rub out the central pier indicated in the red chalk underdrawing, and added the shipping in the river, figures on the shore, the two piers at the right, the stockade, and trees in the foreground. Into this composition he inserted the large figures on the Brooklyn shore, the sky, birds, rocks, shoreline, and large palm tree in the foreground. The draftsman employed white lead pigment as a corrective medium and also applied it in diluted form to indicate highlights. Subsequently, the engraver shaded many of the areas of the more detailed cityscape based on the Restitutio View and reversed the title in the etiquette on the copperplate.

This rare drawing, which once bore Pieter Mortier's name on its lower left border as an indication of his imprint,[14] is among the earliest drawings depicting New Amsterdam and, together with its corresponding print, offers a window into how Dutch engravers produced the images with which they flooded the market during the seventeenth and eighteenth centuries. While the ambitious sheet's draftsman remains a mystery, Mortier reputedly used the most qualified artists for his maps and books. Romein de Hooghe, for example, created the decorations on the charts of *Atlas Maritime*.[15]

1. For a portrait of Pieter Mortier by Hendrik Pothoven after J. H. Brandon, see Y. Marijke Donkersloot-De Vrij, *The World on Paper: Cartography in Amsterdam in the 17th Century*, exh. cat. (Amsterdam: Amsterdams

Historisch Museum, 1967), 88, no. 147, ill.

2. For the print, see Stokes 1915–28, 1:218–19, pl. 14-a, which notes additional impressions in the N. H. Huntington Collection of the Metropolitan Museum of Art, New York (which he could not trace), and the Library of the University of Amsterdam; Vail 1949, 98, ill., which on 99 reproduces the drawing in reverse in comparison with the print to demonstrate its nearly exact correspondence; and Marilyn Symmes, *Impressions of New York: Prints from the New-York Historical Society*, exh. cat. (New York: Princeton Architectural Press and New-York Historical Society, 2004), 22, no. 1, ill.

3. See Stokes 1915–28, 1:152–53, pl. 8-b; and Vail 1949, 97, ill., for a reproduction of the Restitutio View from the Restitutio Map. For maps that established the conventions and context for Mortier's generation, see Kees Zandvliet, *Mapping for Money: Maps, Plans and Topographic Paintings and Their Role in Dutch Overseas Expansion during the 16th and 17th Centuries* (Amsterdam: Batavian Lion International, 1998).

4. I examined four of the series, all without coloring and with titles ending "in Ameriq—." now in the Department of Drawings and Prints of the Metropolitan Museum of Art, New York: nos. 8 (*Mexico*); 9 (*Havana*); 10 (*St. Augus de Floride*); and 11 (*Quebec*). No. 1 is *N: Amsterdam, ou N: Iork.*

5. Impressions of all nineteen, in a modern binding without a title page, are in the Library of the University of Amsterdam. Stokes 1915–28, 1:218–19, pl. 14-a, lists the twelve views of American cities, which were formerly part of the N. H. Huntington Collection donation of 1883, as housed in the library of the Metropolitan Museum of Art. No longer in the Thomas J. Watson Library, they have been transferred to the Department of Drawings and Prints, which holds only five (see n. 4 above).

6. While there is no exact correspondence, the series resembles in content and composition another group of prints illustrating the promise of prosperity found in the New World. The first of New Amsterdam has been dated c. 1642–43; see Stokes 1915–28, 1:140–42, no. 5, ill.; and Deák 1988, 1:23, no. 32; 2: ill. The city views are also similar to two views published in Amsterdam by a competitor of Mortier, Carolus Allard, in *Orbis Habitabilis*, c. 1700.

7. Pierre Mortier, *Les forces de l'Europe, Asie, Afrique et Amerique, ou Description des principales villes, avec leurs fortifications* (Amsterdam: Chez P. Mortier, 1702?). See also Philip Lee Phillips, *A List of Geographical Atlases in the Library of Congress* (Washington, D.C.: Government Printing Office, 1909), 1:274, no. 537.

8. For the iconography of the New World, see Fredi Chiappelli et al., eds., *First Images of America: The Impact of the New World on the Old*, 2 vols. (Berkeley and Los Angeles: University of California Press, 1976); Hugh Honour, *The European Vision of America*, exh. cat. (Cleveland: Cleveland Museum of Art, 1976); Susan Danforth, *Encountering the New World,*

1493 to 1800, exh. cat. (Providence, R. I.: John Carter Brown Library, 1991); and Rachel Doggett et al., eds., *New World of Wonders: European Images of the Americas, 1492–1700*, exh. cat. (Washington, D.C.: Folger Shakespeare Library, 1992), esp. 168–72.

9. For a drawing depicting America, one of a set of designs for tapestries of the four parts of the world dated 1710 by Godfried Maes, in the Metropolitan Museum of Art, New York, see Honour 1976, 151–52, no. 125, ill.

10. *Atlas contractus orbis terrarum praecipuas ac novissimus complectens tabulas (Concise World Atlas Containing Excellent and Most Recent Maps)*, Map Room, British Library, London.

11. Inv. no. 6441, in brown ink and wash over black chalk. See Christopher White, *Dutch and Flemish Drawings from the Royal Library, Windsor Castle*, exh. cat. (Raleigh: North Carolina Museum of Art, 1994), 76–77, ill., which also reproduces Jan de Visscher's image in the *Atlas contractus orbis terrarum* published by Nicolaes Visscher the Elder. Illustrating how these images were recycled in various publications by Mortier, the identical print in reverse and in the same direction of the recto of Berchem's drawing was later engraved and appears on p. 175 of Frederik de Wit, *Atlas Maior. Le gran atlas, contenant les cartes géographique de toutes les parties du monde*, published by Mortier sometime in the first decade of the eighteenth century.

12. For another related drawing (*America*) by the artist in the Metropolitan Museum of Art, probably for a book illustration, see Honour 1976, 122, no. 95, ill.

13. Vail 1949, 100, theorized that the artist probably used a camera obscura to reverse the image of the city that he took from the Restitutio View for engraving onto the plate. He reached his conclusion without knowing about the Society's drawing, which illuminates the reversal process.

14. Koke 1982, 2:390, as well as Vail 1949, 98, report this inscription that must have disappeared during a conservation treatment.

15. Koeman 1967–85, 4:424.

JOHN WATSON
Scotland 1685–Perth Amboy, New Jersey 1768

Little is known about the early life of John Watson. According to his earliest biographer, William Dunlap (1834), Watson came to America from his native Scotland about 1714 and settled in Perth Amboy, New Jersey. He was a wealthy merchant, financier, and landowner in northern New Jersey and New York City as well as one of New Jersey's earliest portraitists. He painted in oils and executed miniature portraits in grisaille using graphite and ink wash. He also rendered mythological subjects, such as a drawing of Hercules, which were taken from prints. Watson's wealth gave him entrée to potential sitters. He returned to Scotland briefly in 1730, sailing back to America with a niece and nephew named Alexander, as well as with "pictures." These studies and copies of paintings that Watson had made enabled him to establish an art gallery in two rooms of his home in Perth Amboy. He is buried in the cemetery of St. Peter's Church in that town. Two important small, fragile, leather-covered record books of John Watson and his nephew Alexander preserve primary documentation of his activity as a limner and artist. One of these is in the Society's Department of Manuscripts.

Bibliography: William A. Whitehead, *Contributions to the Early History of Perth Amboy and Adjoining Country* (New York: D. Appleton & Co., 1856), 125–28; John Hill Morgan, "John Watson, Painter, Merchant, and Capitalist of New Jersey," *Proceedings of the American Antiquarian Society* 50:2 (1940): 225–317; idem, "Further Notes on John Watson,"

5

American Antiquarian Society Proceedings 52:1 (1942): 126–35; Theodore Bolton, "John Watson of Perth Amboy: Artist," *Proceedings of the New Jersey Historical Society* 72:4 (1954): 233–47; Mary Black, "Tracking Down John Watson: The Henderson Portraits at Boscobel," *American Art and Antiques* 2:5 (1979): 78–85.

5. *Governor William Burnet (1688–1729),* c. 1725

Black ink and wash and graphite with glazing on vellum; 3 7/8 × 2 13/16 in. (98 × 71 mm), irregular oval
Verso inscribed at upper center in faded brown ink: *Governor Burnet*; at center in graphite: *Gov Burnet*[1]
Provenance: Descent through the artist's family: Sophia Watson Waterhouse (a niece of the artist); Sophia Waterhouse Brown; Maria Forbes; Elizabeth Forbes Benton; Susannah F. F. Benton; Roberta Stockton Benton (Mrs. Lucien B. Horton).
Bibliography: Morgan 1940, 300–301, pl. 7, no. 2; N-YHS 1974, 1:113–14, no. 269, ill.
The Belknap Fund, 1953.46

The sitter, William Burnet, was the son of the fervent Protestant Gilbert Burnet, who had gone into exile on the Continent during the reign of King James II and settled in The Hague, where William was born. Gilbert entered the service of Prince William of Orange, and the future King William III and Queen Mary of England served as William's godparents and later appointed his father bishop of Salisbury. Burnet attended Trinity College, Cambridge, at the age of thirteen but was expelled for lack of application. Thereafter, he was privately tutored by, among others it is claimed, Isaac Newton. Burnet eventually became a member of the bar and in 1720 was appointed royal governor of the provinces of New Jersey and New York. Arriving in New York City on 16 September of that year, he lived in his mansion in Fort George at the Battery. Burnet served effectively in New York until 1728, demonstrating a clear understanding of issues surrounding the indigenous American population and wisely attempting to limit trade with the French. However, he antagonized certain powerful mercantile families and was transferred in 1728, when he was named governor of Massachusetts and New Hampshire, a position he occupied for only a year and half until his death.[2] Burnet, who was a member of the Royal Astronomical Society in London and published in its *Transactions*, made astronomical observations with telescopes and other scientific instruments, but his great passion was the study of theology and the Bible.

The Society's early portrait of Burnet is a miniature in grisaille. Based on the evidence of the vellum support's uneven edges, it appears to have been trimmed. In style, format, and date the work is related to thirteen small portrait drawings by Watson that were given to the New Jersey Historical Society in Newark by Mrs. Lucien B. Horton, from whom the Society purchased this example.[3] According to an entry in Watson's account books, in 1726 he also painted a likeness of the governor in New York City, but this was presumably the oval oil portrait in the State House, Boston.[4] The sitter's armor in the Society's portrait of Burnet refers to his ability as a soldier, while his powdered, full-bottomed wig, popular during the early decades of the century, and jabot underline his status as a gentleman. Among the works by Watson given to the New Jersey Historical Society is another small oval portrait of Burnet, rendered in the same media as the Society's likeness, in which the sitter wears a waistcoat and has a tricorn hat tucked under his arm.[5]

1. Morgan 1940, 301, states that the faded ink inscription on its verso is in the artist's hand.
2. See Whitehead 1856, 156–68; William Nelson, *William Burnet, Governor of New York and New Jersey, 1720–1728: A Sketch of His Administration in New-York* (New York, 1892); and idem, ed., *Original Documents Relating to the Life and Administration of William Burnet, Governor of New York and New Jersey, 1720–1728, and of Massachusetts and New Hampshire, 1728–1729* (Paterson, N.J.: Press Printing and Publishing Co., 1897).
3. See "In the Museums: Watson Portraits in Newark," *The Magazine Antiques* 67:3 (1955): 246. The measurements of these portraits are all about 3 1/4 × 5 1/2 in. The thirteen portraits in the donation include likenesses of Queen Anne, Louis XIV, and the Duchess of Somerset as well as Homer; Bolton 1954, 247.
4. For the oil portrait in Boston, measuring 29 3/4 × 24 1/2 in., see Morgan 1940, 285, pl. 5.
5. It measures 4 × 2 3/4 in. Morgan 1940, pl. VII, no. 1; Bolton 1954, ill. opp. 229; and "Watson Portraits in Newark" 1955, 246, ill. For another portrait by Watson in the same medium and format in the Society's collection that has some problematic aspects (inv. no. 1948.122), see N-YHS 1974, 1:346, no. 903, ill.

FRANCIS COTES

London, England 1726–1770

Known primarily as a portrait painter and pastelist, Francis Cotes was the elder brother of the miniaturist Samuel Cotes. About 1741 he was apprenticed to George Knapton, who taught him to paint in oil and to draw in pastel, frequently referred to in contemporary sources as "crayon." Beginning his career about 1748, when pastel was all the rage, Cotes worked in that medium almost exclusively until the early 1760s. During that period he was influenced not only by his master but also by the fashionable pastel portraits that Rosalba Carriera had executed for the tourists on the Grand Tour in Venice during the early eighteenth century. Between 1753 and 1756 the Swiss pastelist Jean-Étienne Liotard was in England, and his realistic approach to portraiture persuaded Cotes to abandon Rococo portrait conventions in favor of naturalistic poses and colors. Although Cotes never gave up working in pastel, especially for his more intimate subjects and portraits, he had pushed the medium to its limits by the early 1760s, when he turned increasingly to oil painting.

Cotes maintained a fashionable studio in London's Cavendish Square, where he attracted many of the major portrait commissions of the day. His oil portraits reveal a familiarity with the new painting modes of Sir Joshua Reynolds and Allan Ramsay, and his work reached a wide public through engravings. Eventually Cotes was overshadowed by both Reynolds and Thomas Gainsborough, the giants of eighteenth-century English portraiture. Retaining much of the charm of his earlier work, Cotes did not achieve the kind of psychological insight that characterizes Reynolds's work. Instead, a number of Cotes's portraits have an intimate warmth lacking in contemporary examples by Reynolds. Cotes tended to focus more on costume than character, which made his portraits of children particularly successful.

About 1764 Cotes began employing the drapery painter Peter Toms, a move that greatly increased his production. In 1765 he became a director of the Society of Artists, with which he had exhibited since 1760, and took on the pastelist John Russell as a pupil. By this time Cotes had become an important figure in the London art world; most notably, he was instrumental in setting up the Royal Academy of Arts in 1768. He presented the case for a fine arts academy to King George II, having

undertaken two exceptional double portraits in oil for the royal family in 1767, one of which is *Princess Louisa and Queen Carolina Matilda of Denmark* (Royal Collection, Buckingham Palace, London). Cotes became especially innovative in the double portrait format, as in *The Honourable Lady Stanhope and the Countess of Effingham as Diana and Her Companion* (1765; City Art Gallery, York), which maintains a complex balance between informality and tradition and a reciprocity between the two sitters.

Bibliography: Edward Mead Johnson, *Francis Cotes: Complete Edition with a Critical Essay and a Catalogue* (Oxford: Phaidon Press, 1971); Alastair Smart, ed., *Introducing Francis Cotes, R.A. (1726–1770)*, exh. cat. (Nottingham: Nottingham University Art Gallery, 1971).

6. *James Rivington Sr. (c. 1724–1802)*, 1756

Pastel on gray paper, laid on canvas, nailed to a strainer; 24 × 17 7/8 in. (610 × 454 mm), irregular
Signed and dated at the lower right in pastel: *FCotes Pxt./ 1756*
Provenance: Descent through the sitter's family: Susan Rivington, the sitter's daughter, 1825; Eliza Van Horne Ellis, her niece; John Stoneacre, her son; Augustus Van Horne Ellis; Mrs. Augustus Van Horne Ellis, New York.
Bibliography: *New-York Historical Society Quarterly* 24:1 (1940): cover ill.; N-YHS 1941, 254, no. 623; Johnson 1971, 59–60, no. 68; N-YHS 1974, 2:666, no. 1710; Jeffares 2006, 130.
Gift of Mrs. Augustus Van Horne Ellis, 1940.16

The publisher and bookseller James Rivington was the son of Charles Rivington, the founder of a London publishing house specializing in theological books. He succeeded his father in the firm until 1756. Four years later he immigrated via New York to Philadelphia, where he opened a bookstore and soon added others in New York (1762) and Boston (1765). His residence in New York was above his bookstore at the corner of Wall and Queen streets.[1] Reflecting his support of the Tory cause, his newspaper *Rivington's New-York Gazetteer* attacked the Revolutionary movement during its early existence from 1773 to 1775. This publication was followed by *Rivington's New-York Loyal Gazette* and later, during the British occupation of New York City, *The Royal Gazette* (1777–83). Rivington's sympathies finally shifted to the side of independence in 1781. He married Mrs. Elizabeth (Van Horne) Van Horne, and eventually his sons Francis and Charles ran

the Rivington publishing business in England. Cotes gave up the printing business but continued as a bookseller in New York.[2]

Cotes's handsome pastel portrait of the young Rivington was executed in England about four years before the sitter's departure for America. Since it was shown in 1824 and 1825 at the American Academy of the Fine Arts in New York by the sitter's daughter, Susan Rivington, her father may have brought it over when he immigrated in 1760. Characteristic of the artist's later works, when he followed the realistic vein of Liotard, Cotes's assured, bravura handling of the pastel in the Rivington likeness places it among his finest works in the medium. Technically it resembles his *Portrait of Sir Richard Hoare* (1757; National Trust, Stourhead House, Stourton, Wiltshire)[3] and displays his hallmark appreciation for the luscious surface textures and colors of the sitter's costume.

1. For the sitter, see Leroy Hewlett, "James Rivington, Loyalist Printer, Publisher, and Bookseller of the American Revolution, 1724–1802: A Biographical-bibliographical Study" (Ph.D. diss., University of Michigan, Ann Arbor, 1958).
2. Gilbert Stuart painted the sitter's portrait as an older man, between 1792 and 1795 (location unknown). It is preserved in a copy by Ezra Ames in the Society's collection (inv. no. 1858.83), a gift of Dr. Samuel C. Ellis, the grandson of the sitter's wife and her first husband, Cornelius Van Horne; N-YHS 1974, 2:665, no. 1709, ill.
3. Johnson 1971, 61, no. 76, pl. 21.

6

PIERRE EUGÈNE DU SIMITIÈRE

Geneva, Switzerland c. 1736–Philadelphia, Pennsylvania 1784

At age twenty-one, as a young man of the Enlightenment and future member of the American Philosophical Society (elected 1768), Pierre Eugène Du Simitière sailed from Amsterdam to St. Eustatius in the West Indies. For fifteen years the aspiring artist, a devoted antiquarian, collected natural history specimens, documents, and objects of culture, intending to use these primary source materials for a civil and natural history of European settlements in the Caribbean. Beginning in 1763, Du Simitière spent the next ten years visiting northeastern cities, becoming a naturalized citizen of New York City in 1769. By 1774 he had settled permanently in Philadelphia, where he spent the last ten years of his life. He resisted conscription in 1777 and was compelled to pay a heavy fine. Nevertheless, the American Revolution brought his aims into sharper focus, and he determined to gather the basic documents to prepare an accurate history of that struggle for liberty. Du Simitière deserves much credit as a courageous crusader for the use of primary historical documentation, but his plan was too ambitious for a single scholar to achieve without either governmental or private financial support. An admirer of Sir Hans Sloane, whose collections formed the nucleus of the British Museum, he served as curator of the American Philosophical Society and was an avid, albeit indiscriminate, collector of American material culture, natural curiosities, and documents. His holdings were so celebrated that in 1782 he opened them to the public, christening the display the "American Museum," intending that it become the first museum in the United States (in the same city Charles Willson Peale founded his Art Museum [1781–84] and Museum of Natural History [1786]) .

Du Simitière painted portraits to underwrite his continuing purchase of objects. In the process, he executed numerous likenesses of famous Americans from the time of the American Revolution, including George Washington, Gouverneur Morris, Baron von Steuben, and perhaps the only lifetime image of the infamous traitor Benedict Arnold, when he was military governor of Philadelphia. Among his most well-known works are a series of fourteen portrait drawings that on 16 September 1780 Du Simitière delivered to the French minister Conrad Alexandre Gérard ("in black lead, being portraits in profile in the form of a medallion of eminent Persons engaged in the American war") to be taken to Paris for engraving by Benoît Louis Prévost. A week later, Major John André was captured with papers exposing Arnold's treason hidden in his boot. When the engravings were completed, prints were sent to Du Simitière to sell, but they were so topical that it was not long before English publishers pirated the original French prints. In 1783 two different sets engraved in London appeared within the space of five days. Both were copies in reverse of the authorized French originals. Shortly thereafter another set by a different engraver was published in the *European Magazine*. The British images, especially that of Washington, were widely influential and were disseminated in copies adapted to various media, such as earthenware, fabric, and enamels.

Du Simitière also painted miniatures in watercolor, cut silhouettes, and designed illustrations for publication. Soon after the Declaration of Independence was signed, he was employed by a committee of the Continental Congress to design a seal for the new republic in collaboration with Benjamin Franklin, Thomas Jefferson, and John Adams, who were less knowledgeable about heraldry and design than he. Although his seal was not accepted, its motto (E PLURIBUS UNUM) endured, and he designed state seals for Delaware and Virginia. In 1781 Princeton University conferred on him an honorary master's degree. Although Du Simitière never realized his museum, the Library Company of Philadelphia and the Library of Congress preserve a large portion of his former collections, including pamphlets and documents, and the latter also holds his "Memoranda Book 1774–1783, Paintings and Drawings Done."

Bibliography: Edna Donnell, "Portraits of Eminent Americans after Drawings by Du Simitière," *The Magazine Antiques* 2:1 (1933): 17–21; Arline Custer, "Archives of American Art: Pierre Eugène du Simitière, ca. 1736–1784," *Art Quarterly* 18 (1955): 194–97; Paul G. Sifton, "Pierre Eugène du Simitière, 1737–1783, Collector in Revolutionary America" (Ph.D. diss., University of Pennsylvania, 1960); Edward P. Alexander, "Early American Museums: From Collection of Curiosities to Popular Education," *International Journal of Museum Management and Curatorship* 6:4 (December 1987): 344–46.

7. *Portrait of a Man*, c. 1775–84

Pastel and graphite on beige paper; 19 3/16 × 14 7/16 in. (488 × 367 mm), irregular
Bibliography: *New-York Historical Society Quarterly* 8:2 (1924): 42; N-YHS 1941, 352, no. 856, ill.; N-YHS 1974, 2:922–23, no. 2346, ill.; Jeffares 2006, 176.
Gift of Samuel Verplanck Hoffmann, 1924.23

The folds of the paper along all four borders suggest that the portrait was once mounted over a strainer, as was frequently the practice at the time for profile portraits. Examples in the collection include a number of works by Charles-Balthazar-Julien Févret de Saint-Mémin (cat. 26 and essay fig. 4).

Judging from the costume in this portrait of an unknown man, with its elaborate jabot and cravat, it must have been drawn after 1775 and, therefore, when Du Simitière was in Philadelphia.[1] No doubt the artist executed the face from life and later added a formulaic bust-length costume. The man's intense gaze is underlined by the graphite elaboration around his eye. More important, the pentimenti below the pastel pigments form a shadow image to the left of the sitter's profile, perhaps in graphite, and suggest that Du Simitière, like Saint-Mémin and other contemporaries, employed the physiognotrace to establish the contours of the profile. Examination of the sheet in a raking light, coupled with the life-size proportion of the face, support this conclusion. Further, the subject's pose and type harmonize with the artist's series of fourteen eminent Americans, known in engravings.[2] From the quality of the light on the sitter's face and the work's dark background, Du Simitière most likely drew this likeness by candlelight. Nocturnal portrayals were in keeping with Enlightenment practices and experiments, as seen, for example, in the paintings of Joseph Wright of Derby, whose interest in light effects and science finds reflection in his paintings.[3]

1. N-YHS 1974, 2:923.
2. See Donnell 1933, 17–21, which notes a complete set of fourteen was issued in two parts of six and eight with the title *Collection des Portraits des Généreaux, Ministres & Magistrats qui se sont rendus célèbres dans la Révolution des Treize Etats-Unis. De l'Amérique-Septentrionale.*
3. See Judy Edgerton, *Wright of Derby*, exh. cat. (London: Tate Gallery, 1990).

7

THOMAS DAVIES

Shooters Hill, England c. 1737–Blackheath, England 1812

Professional soldier, artist, naturalist, Thomas Davies studied watercolor technique and drawing at the Royal Military Academy at Woolwich in England. Draftsmanship was an integral part of an officer's education, whose curriculum included topographical drawing and mapmaking. Later, Davies may have studied under the influential British watercolorist Paul Sandby— who had been trained in surveying, was appointed chief drawing master at Woolwich, and was a founding member of the British Royal Academy of Arts in 1768. Davies exhibited regularly at the Royal Academy of Arts in London from 1771 to 1806.

Commissioned as an officer in the Royal Artillery in 1756, Davies eventually rose to the rank of lieutenant general and received several postings to North America during the Seven Years' War. From 1757 to 1759 he served at Halifax in Canada (Nova Scotia), taking part in the successful attack on Fort Louisbourg and in Robert Monckton's expedition to the St. John River Valley. From 1759 to 1760 he served under Sir Jeffery Amherst at Lake Champlain and Montreal, at which time his talents as a draftsman came to Amherst's attention, possibly gaining Davies his appointment to assist with the survey of the new British territory around Lake Ontario for the next three years. Posted out of New York, he returned to the region from 1764 to 1768. From these tours of duty Davies produced the first accurate renderings of the cities and landscapes of Canada, including Halifax, Fort Frederick, Montreal, and Niagara Falls.

Back in England, Davies's six engravings of North American waterfalls based on drawings made about 1762–68 were published in *Scenographia Americana* (1768). These works mark the beginning of the artist's mature, personal style, characterized by vigorous, sometimes nearly abstract compositions and bold colors resulting from his use of gouache. When Davies returned to Britain, he began to pursue his enduring interest in natural history. He entered the circle of learned men around Sir Joseph Banks, president of the Royal Society, who were creating new fields of study and experimenting widely. In this intellectually stimulating environment he exhibited his watercolors of North American and European flora and fauna and developed an expertise that led to his election as a member of the Royal Society (1781)

and the Linnean Society of London (c. 1797). Gradually Davies achieved recognition for his nature studies, particularly those of birds.

From 1776 to 1779 Davies again served in New York, where he was in charge of Fort Washington on Manhattan Island during the American Revolution, and made several battle sketches. His final posting in North America lasted from 1786 to 1790 at Quebec City, where he commanded the Royal Artillery. Continuing his studies of Canada's natural history during peacetime, Davies executed some of the finest watercolors of Quebec City and its surrounding landmarks in his singular, brilliantly colored, precise style. During the course of his military career Davies went on missions as far afield as Gibraltar and the West Indies. Today, along with George Heriot (cat. 14), who was also trained at Woolwich and studied with Paul Sandby, Davies is considered one of the most talented and original early artists to have worked in the United States and Canada. His watercolors transcend the topographic tradition and communicate the light, texture, and adventure of the unspoiled natural world of the North American paradise.

Bibliography: R. H. Hubbard, ed., *Thomas Davies, c. 1737–1812*, exh. cat. (Ottawa: National Gallery of Canada, 1972); idem, ed., *Thomas Davies in Early Canada* (Ottawa: Oberon Press, 1972).

8. *Niagara Falls from Above*; verso: sketch of Niagara Falls Area, c. 1766

Watercolor, brown and black ink, gouache, and graphite with selective glazing on paper; graphite; 13 1/2 × 20 3/4 in. (343 × 527 mm)
Verso inscribed at upper center in graphite: *Falls of Niagara*
Provenance: Earl of Derby (from an album of more than fifty drawings in the Earl of Derby's library), Knowsley, Lancashire, England; Christie's, London, 1953; Frank T. Sabin Gallery, London; Old Print Shop, New York, 1953.
Bibliography: Christie's, London, sale cat., 19 October 1953, lot 137; Albright-Knox Art Gallery, *Three Centuries of Niagara Falls*, exh. cat. (Buffalo, N.Y.: Albright-Knox Gallery, 1964), no. 71, ill.; W. J. Holt, ed., *Niagara Falls, Canada* (Niagara Falls, Ontario: Kiwanis Club, 1967), 241, ill.; Ralph Greenhill and T. D. Mahoney, *Niagara* (Toronto: University of Toronto Press, 1969), 3, ill. after 10; Hubbard (exh. cat.) 1972, 98, no. 26, ill.; Hubbard 1972, 33, ill.; Koke 1982, 1:248–49, no. 438, ill.; Adamson et al. 1985, 20, fig. 7, 137, no. 69; McKinsey 1985, 29–30, 61–62, fig. 7; Nygren et al. 1986, 89–90, fig. 16; Olson 2003, 191, 356, ill.

Traveller's Fund, James S. Cushman, and Foster-Jarvis Fund, 1954.2

Europeans of the eighteenth century were fascinated by the untamed wilderness of North America, among whose most dramatic wonders were its waterfalls.[1] Since that time Niagara Falls—the huge cataract between Lake Ontario and Lake Erie on the international line between the United States and Canada (Niagara Falls, New York, and Niagara Falls, Ontario)—has rightly been considered one of the major natural icons of the continent (see also cats. 41 and 96). Suffused with prized sublime and picturesque sentiments, its dramatic grandeur has attracted thousands of visitors and countless artists each year since the beginning of mass tourism in the early nineteenth century.[2]

The name "Niagara" is a simplification of the Iroquois name for the river, "Onguiaahra," meaning "the Strait." Goat Island, seen in Davies's watercolor, splits the cataract into the American Falls (167 ft. high, 1,060 ft. wide) and the Horseshoe or Canadian Falls (158 ft. high, 2,600 ft. wide). The earliest written description of the falls is that of Father Louis Hennepin (in *Nouvelle Decouverte*, 1697), who was with the expedition of René-Robert Cavelier, Sieur de La Salle, the French explorer, in 1678.

Davies depicted many American and Canadian waterfalls throughout his career. These include a number of views of Niagara Falls, beginning with one he dated 1762 that features a rainbow rising from the mist of the cascade.[3] That watercolor, engraved nearly verbatim by Ignace Fougeron,[4] appeared as the first in Davies's series of six waterfalls that were engraved by various individuals in *Scenographia Americana* (1768).[5] This collection of prints was published by a group of London printsellers and reengraved various times, including in Andrew Burnaby's *Travels* (3rd ed., London, 1798).[6] The present sheet, together with its pendant, a view of the American and Canadian falls from below (see essay fig. 6), may have been alternative studies for the print since all four works have approximately the same dimensions.[7] Hubbard believes that the Society's pair was executed about 1766 during Davies's exploration of Lake Ontario.[8]

Davies's unconventional, thrilling view perches the spectator dizzyingly close to the precipice of Horseshoe Falls on the Canadian

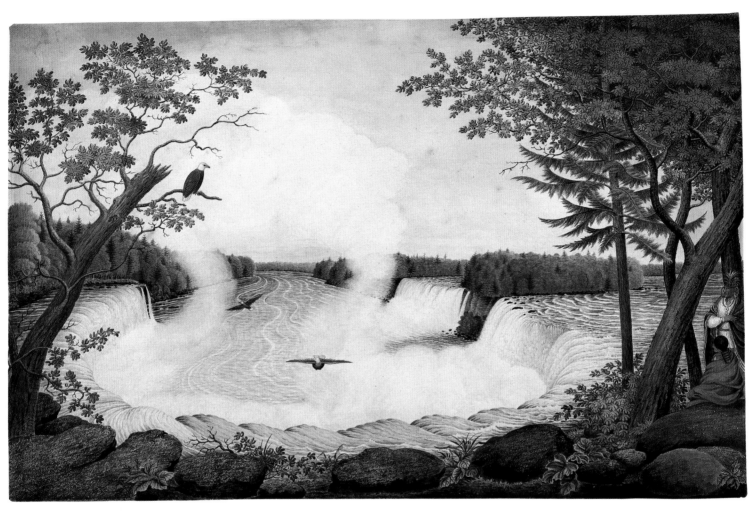

8

shore, with the swirling current beneath and the Niagara River flowing off in the distance. This dramatic vista, by giving the spectator a feeling of being swept over the top of the falls, induces a sense of vertigo, one of the characteristic devices employed by painters of the sublime. To capture the full panorama of the falls, the artist rendered them in an exaggerated curve, as though viewed through a fish-eye lens, placing a few arbitrary boulders on its periphery. Davies's watercolor is among the earliest views of what would become one of the major tourist attractions of the East Coast. The three eagles he depicted represent the birds of prey that hovered over the falls to feed on the animal casualties carried over by the current and deposited below.[9]

1. See Hugh Honour, *The European Vision of America*, exh. cat. (Cleveland: Cleveland Museum of Art, 1976).

2. See Albright-Knox Art Gallery 1964; Adamson et al. 1985; McKinsey 1985; Lane 1993; and Linda L. Revie, *The Niagara Companion: Explorers, Artists, and Writers at the Falls, from Discovery through the Twentieth Century* (Waterloo, Ontario: Wilfred Laurier University Press, 2003).

3. See Hubbard (exh. cat.) 1972, 88, no. 17, ill., in a private collection, whose style looks much earlier. Below the image, the inscription reads: *An East View of the Great Cataract of Niagara / The Perpendicular height of the Fall 162 feet Done on the spot by Thomas Davies Capt Royal Artillery The Variety of Colours in the Woods shew the true Nature of the Country.*

4. Ibid., 138, 140, no. 67-I, ill. Below the image, the inscription reads: *To his Excellency Lieut: Genl: Sir Jeffrey Amherst, Knight of the Most Honourable Order of the Bath, &c. &c. / These Six Views are most humbly Inscribed, by his Excellency's most devoted Servt: Thos: Davies / An East View of the Great Cataract of Niagara. / Perpendr: Height of the Fall 162 Feet, Breadth about a Mile & Quarter. Drawn on the Spot by Thos. Davies Capt: Lieut: in the Royal Regt. Of Artillery.*

5. See Stokes 1915–28, 1:281–94, esp. 293–94, for the six waterfall engravings after Davies.

6. Hubbard (exh. cat.) 1972, 138–44, nos. 67-I–VI, ill. Impressions of this series are in the Society's DPPAC.

7. Inv. no. 1954.3; see Sotheby's, London, sale cat., 15 October 1953, 25 and ill. opp. (the present watercolor belonged to the same lot of c. 120 watercolors mounted in an album); and Koke 1982, 1:248, no. 439, ill.

8. Hubbard (exh. cat.) 1972, 98.

9. See Olson 2003, 191; and, for the larger contextual panorama, Gabriella Belli, Paola Giacomini, and Anna Ottani Cavina, eds., *Montagna. Arte, scienza, mito da Dürer a Warhol*, exh. cat. (Trento and Rovereto: Museo di Arte Moderna e Contemporanea di Trento e Rovereto; Milan: Skira, 2003).

DAVID GRIM

Zweibrücken, Germany 1737–New York, New York 1826

David Grim was a tavern keeper and merchant in New York City. Born in Germany, he sailed with his family to New York in 1739. Grim attended a Lutheran school and in 1757 served aboard the ship *King of Prussia* in the West Indies. He was first noted in the city directories as the innkeeper at the Sign of the Three Tuns, and later as the proprietor of the Hessian Coffee House tavern (1767–89), first on Chapel and then on William streets. A patriot during the Revolution, Grim served as treasurer for the Lutheran Church and succeeded Baron von Steuben as president of the German Society.

From 1789 to 1793 the New York City directories listed Grim as a merchant; from 1794 to the early 1820s he was listed both as an individual merchant and in a partnership with Philip Grim, at several addresses on Water, Cedar, and Vesey streets, and at the Old Slip. David and Philip, probably his son, conducted business at as many as three locations concurrently in the city. Their establishments dealt in imports, general supplies, and manufactures, at different times offering pig iron, cut crystal, flour, butter, gin, and spices.

David Grim lived eighty-nine years, during which time he experienced the new nation's birth and its struggle for independence from the central vantage point of New York City. He was noted by his contemporaries and by I. N. Phelps Stokes for his sharp memory and active intellect, even as he approached his eighth decade of life, when he produced a series of historical views of eighteenth-century New York. The Map Division of the Society's library holds several plans drawn by Grim from memory, with descriptive text for the images, including *A Plan of the City and Environs of New-York as they were in the years 1742-1743-1744* (1813) and *Plan and Elevation of the Old City Hall* (1818), as well as diagrams of the courses of the fires of 1776 and 1778. Grim noted on the reverse of his *Plan of the City* that he drew it for his own "amusement, with the intention that it be, on a future day, presented to the N.Y. Hist. Society."

A comparison of Grim's plans with those made in the early eighteenth century, such as the Lyne Survey Bradford Map (c. 1731; N-YHS Library), demonstrates the remarkable accuracy of his drawings and places in relief the details not provided in other views. He also wrote descriptions of important New York City events to accompany his historical sketches, such as the racial unrest of 1741 and the visit from a Mohawk and Oneida tribal delegation in 1746. Grim's works continue to provide important insights into the history of early New York long after his death.

Bibliography: Hodge, Allen, and Campbell, et al., *New York City Directory and Register*, 1789–1825; obituary, *New York Evening Post*, 27 March 1826; Stokes 1915–28, 1:251–60, 270–72; 6:427; Rita Susswein Gottesman, *The Arts and Crafts of New York, 1777–1799: Advertisements and News Items from New York City Newspapers* (New York: New-York Historical Society, 1954), 96–97; idem, *The Arts and Crafts of New York, 1800–1804: Advertisements and News Items from New York City Newspapers* (New York: New-York Historical Society, 1965), 237; Koke 1982, 2:78.

9

9. *Federal Banquet Pavilion in 1788, New York City*, after 1788

Watercolor, graphite, and black ink on paper folded several times; 10 × 15 3/4 in. (254 × 400 mm), irregular
Inscribed in flag inside image in yellow and black watercolor: *NEW / CONSTITUTION / SEP. 17. 1787*; verso inscribed at center in brown ink: *The New York Federal Table. / as seen from Bunker hill: —*
Watermark: Seated Britannia facing left holding a branch in her proper right hand and a scepter and a shield with a cross in her proper left hand, circumscribed by three circles, crowned; GR, crowned
Bibliography: *Valentine's Manual* 1856, 570–71 and foldout between 570 and 571; Stokes 1915–28, 5:1229–30; Koke 1982, 2:78–79, no. 1117, ill.
Gift of Sophia Minton, granddaughter of the artist, 1864.17

In this historical drawing, David Grim reproduced the layout of the Federal Banquet Pavilion and ten banquet tables in New York City as they appeared on 23 July 1788, designed by Pierre-Charles L'Enfant for the celebration of the ratification of the new United States Constitu-tion.[1] Constructed near the present site of Broadway and Broome Street, the banquet pavilion seated the more than five thousand people who marched that day in the Federal Procession in support of the new Constitution. At the time of the banquet the New York State Legislature had not yet cast its final vote, but the ten states necessary for the Constitution to pass had already ratified it. Just three days after the event featured in Grim's drawing, the legislature followed suit and voted for ratification, thus confirming and enacting the pro-constitutional fervor expressed by the citizens attending this banquet.[2]

Grim selected the vantage point of New York City's Bunker Hill to capture a bird's-eye view of the banquet and emphasize the sunraylike pattern of tables. L'Enfant's design featured a half-moon-shaped pavilion, with flags flanking a central covered dais. Ten banquet tables, representing the ten states that had already ratified the Constitution, radiated in a semicircle from the pavilion, presaging the innovative and dynamic hub-and-spoke street plan that L'Enfant later devised for the new national capital city, Washington, D.C.[3]

This drawing was the model for a hand-colored print that appeared in the *Manual of the Common Council of the City of New-York*, also known as *Valentine's Manual*, in the editions published between 1854 and 1856. The reproduction of Grim's scene, the only known depiction of the Federal Banquet site, was hand-colored with red, blue, green, and yellow washes.[4] This rare view was just one of the historical drawings Grim left for posterity, which, like his *Plan of New-York* mentioned above, provide both visual records and firsthand descriptions of significant events or places.
A. M.

1. Koke 1982, 2:79.
2. *Valentine's Manual* 1856, 570.
3. For L'Enfant and the planning of Washington, D.C., see Hans Paul Caemmerer, *The Life of Pierre Charles L'Enfant* (New York: Da Capo Press, 1970).
4. *Valentine's Manual* 1856, oversize foldout between 570 and 571.

GEORGE BECK

Ellford, Staffordshire, England 1749–Lexington, Kentucky 1812

Among the earliest professional landscape painters in America, George Beck was one of four English-trained landscapists who came to America about 1790–95 (along with William Winstanley, William Groombridge, and Francis Guy). Beck was also one of the first individuals to push beyond the representational limits of topographical draftsmanship and one of the earliest to cross the Appalachian Mountains as an itinerant artist and then as a settler. Unfortunately, neither his life nor his oeuvre has been the object of a serious study.

The youngest son of an English farmer, Beck was precocious but sickly and left school by the age of ten. After educating himself, he secured a teaching position in Tamworth and began to study for holy orders, acquiring a great facility with classical languages. When he contracted tuberculosis he was compelled to postpone this career indefinitely. In 1776 he was appointed to the corps of engineers at the Royal Military Academy at Woolwich and began drawing maps and plans at the Drawing Room of the Tower of London. Two years later Beck's health forced him to resign, and he became drawing instruc-tor to the daughters of Anne Montgomery, Marchioness Townshend, and started exhibit-ing in London at the Royal Academy of Arts and the Society of Artists of Great Britain. In 1790, like other artists of the time, he made a sketching and painting tour through the western counties of England and Wales. Five years later he sailed for America to paint its already legendary landscapes. The new land promised so many possibilities that he sent for his wife of nine years, Mary Menessier Beck, also an artist who had exhibited at the Royal Academy, and never returned to England. He lived in Baltimore for two years and achieved immediate success. George Washington commissioned two canvases from him in 1797 that still hang at Mount Vernon: *The Great Falls: A View of the Passage of the Potomac at the Federal City* and *The Passage of the Potomac through the Blue [Ridge] Mountains*. Several months later William Hamilton, the well-known patron of English and American artists, commissioned Beck to paint a view of the Woodlands, Hamilton's elaborately landscaped estate in Philadelphia. At Hamilton's suggestion, in 1798 Beck settled in that city, then the capital of the country and its largest, most cultivated urban center; he opened drawing schools for men and women to subsidize his income, and his wife established a ladies' seminary.

In the spring of 1804 Beck made an extended expedition along the western frontier, visiting such sites as Niagara Falls, Pittsburgh, and Lexington, Kentucky, where in 1806 he is listed in the directories as a portrait painter. By 1807 the Becks had relocated there. The newly settled wilderness held a great appeal for him, providing the opportunity of exploring

relatively unspoiled nature while living in a social milieu where he and his wife hoped to attract patrons and students. In Kentucky he developed a freer style, and his works increasingly celebrated the unspoiled richness of the frontier. They reveal his fascination with the subjective power and mystery of nature, prefiguring the work of Thomas Cole (cats. 61 and 62). Lacking substantial patronage, Beck took over his wife's school for girls during her illness in 1810 and opened a short-lived academy for young gentlemen that offered reading, writing, arithmetic, geography, surveying, music, drawing, painting, and "belles letters." Not finding reliable patronage in Kentucky at a time when John James Audubon (cats. 42 and 43) was also there, Beck exhibited six views at the Pennsylvania Academy of the Fine Arts in Philadelphia (1813 and 1814).

In England Beck had worked in two landscape styles: a topographical one and a more Romantic, moody style, which he blended in his American works. Like many British landscapists of his generation, he was strongly influenced by Paul Sandby, the most prominent English topographic landscapist of the period and an early practitioner of the aquatint. Another influence on his art was the English landscapist Richard Wilson, whom he probably knew from the Royal Academy in London. Like Claude Lorrain in the preceding century, Wilson used light and atmosphere to unify his works and began to paint and sketch out of doors. Beck, who was highly conscious of the history of Western landscape, owned old master prints and two paintings by the sixteenth-century landscapist Paul Bril.

Beck's known works consist primarily of American city and river views. Between 1800 and 1809 he provided the designs for topographic prints of scenic American views and natural wonders. Atkins & Nightingale of London and Philadelphia published six as aquatints engraved by Thomas Cartwright. Impressions of all six are in the Stokes Collection of the NYPL: *George Town and Federal City or City of Washington* (1801), *East View of Baltimore, Maryland* and *Great Falls of the Potomac* (1802), *Philadelphia from the Great Tree at Kensington, under which Penn made his Great Treaty with the Indians* (1801), *The Falls of Niagara* (1805), and *Wright's Ferry on the Susquehanna, Pennsylvania* (1809); the DPPAC holds an

impression of the Baltimore view. Although the artist assuredly considered his Romantic landscapes significant, Beck's current reputation rests largely on the popularity of these aquatints. Three of them were reproduced on the blue-and-white earthenware of the artist's native Staffordshire.

Beck's early philosophy is partially accessible in the captions he wrote for two of his views published in the *European Magazine, and London Review* in 1785. In them he expressed his lifelong interest in science and mathematics. "Portraitures of men, things, and places," according to Beck, serve the same purpose in the mimetic arts as experiments do in science. He added that the usefulness of drawing is linked to its ability to provide insight into nature's secrets. A transitional figure, Beck was caught between eighteenth-century rational thought and nineteenth-century Romanticism. With his pioneering depictions of the American wilderness, he formed a stylistic bridge to Cole's Romantic landscapes. He leaned toward the aesthetic of the picturesque as articulated by the Reverend William Gilpin, sacrificing accuracy for pleasing effects and celebrating ruggedness over smoothness. A good classical scholar and a poet, Beck published some poetry in the *Kentucky Gazette* and *Western Review*, together with observations on the spectacular comet of 1811. After his death, Beck's widow attempted to have his poetry and some of his translations of ancient writers published by subscription but was unsuccessful in her efforts on his behalf.

Bibliography: J. Hall Pleasants, "George Beck, an Early Baltimore Landscape Painter," *Maryland Historical Magazine* 35 (1940): 241–43; idem, "George and Mary Beck," in *Four Late Eighteenth-Century Anglo-American Landscape Painters* (Worcester, Mass.: American Antiquarian Society, 1943), 11–30 (reprinted from *Proceedings of the American Antiquarian Society* 52:2 [1942]: 195–214); Edna Talbott Whitley, "George Beck: An Eighteenth Century Painter," *Register of the Kentucky Historical Society* 67:1 (1969): 20–36; Nygren et al. 1986, 235–37; Deborah Thomas, "The Landscapes of George Beck," *The Magazine Antiques* 142:5 (1992): 746–53.

10a. *The Falls at Montmorency, Quebec, Canada*, c. 1800–1804

Pastel, gouache, watercolor, and charcoal on paper, laid on canvas, nailed to a strainer; 15 5/8 × 21 1/8 in. (397 × 537 mm), irregular

Canvas inscribed at lower center in charcoal: *Falls Montmorenci.*; original gold and black painted glass (*églomisé*) mount lettered: *FALLS MONTMORENCI*
Provenance: Charles Hitchcock Tyler, New York; Erskine Hewitt, New York, 1938; Kennedy Galleries, New York?; Hall Park McCullough, New York, 1971.
Bibliography: Parke-Bernet Galleries, New York, sale cat. 19 October 1938, lot 503; Koke 1982, 3:323, no. 3065 (as by an unidentified artist).
Gift of Mrs. Ethel McCullough Scott, Mr. John G. McCullough, and Mrs. Edith McCullough Heaphy, 1971.122

10b. *View of Philadelphia and the Delaware River from Kensington, Pennsylvania*, c. 1800–1804

Pastel, gouache, watercolor, and charcoal on paper, laid on canvas, nailed to a strainer; 16 1/8 × 21 3/8 in. (410 × 543 mm), irregular
Canvas inscribed at lower center in charcoal: *Kensington*; original gold and black painted glass (*églomisé*) mount lettered: *KENSINGTON*
Provenance: Charles Hitchcock Tyler, New York; Erskine Hewitt, New York, 1938; Kennedy Galleries, New York; Hall Park McCullough, New York, 1971.
Bibliography: Parke-Bernet Galleries, New York, sale cat. 19 October 1938, lot 500, ill.; Koke 1982, 3:322–23, no. 3060, ill. (as by an unidentified artist).
Gift of Mrs. Ethel McCullough Scott, Mr. John G. McCullough, and Mrs. Edith McCullough Heaphy, 1971.123

Beck is known to have painted *watercolors*, a term that encompasses the media of this pair.[1] From their identical original *églomisé* mounts and frames, these pendants have shared a common, albeit unknown, provenance.

In the first of the pair Beck depicted the famous Canadian falls at Montmorency. Although there is no documentation of his ever traveling to Quebec, more than likely his visit took place during his 1804 trip along the western frontier. The subject and style of the sheet resemble those in the aquatints of waterfalls in the Atkins & Nightingale series (*The Falls of the Potomac* and *The Falls of Niagara*).[2] Artists rendered the spectacular waterfalls that were icons of the sublime to feed the European and American demand for views of these dramatic destination spots on the tour of America.[3] The scenic falls of Montmorency, a small town that today is a suburb of Quebec City, is located at the confluence of the St. Lawrence and Montmorency rivers. Extremely vertical, the falls cascade down 272 feet (99 ft. more than Niagara Falls).

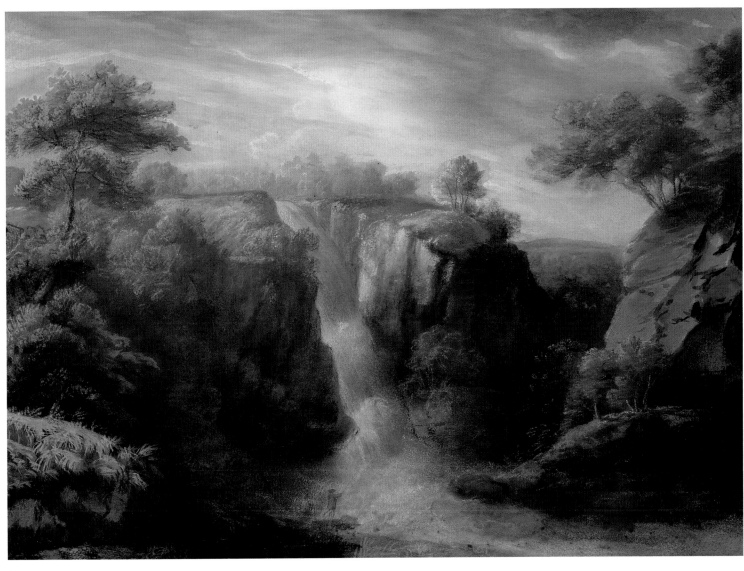

10a

Beck is recorded as executing a number of scenes of Philadelphia and the Schuylkill River similar to the second watercolor of the pair, including *Scene on the Schuylkill River*, an oil of the same size as the two watercolors examined in this entry.[4] Its composition is closer to the aquatint by Cartwright after Beck (see above) of the same location than to the watercolor. Since Cartwright's aquatints and this watercolor have nearly identical measurements (16 1/2 × 22–24 in.), it is tempting to conclude that Beck made this work as preparatory for the print. Although Pleasants believes that none of Beck's original "paintings" for the prints can be traced,[5] a similar watercolor with a related *églomisé* mount (but with foliage at

the corners, inscribed *Georgetown and City of Washington / drawn by G. BECK 1800*), location unknown, bears the same relation to Cartwright's aquatint of its subject (*George Town and Federal City or City of Washington*) as the Society's scene of the Schuylkill River to its corresponding print in the series.[6] Perhaps, therefore, Beck rendered his view of Philadelphia as a candidate for the print series (which may have been the case for the cat. 10a as well) or, alternatively, executed it for a special commission engendered by the popularity of the prints. The appeal of the Philadelphia scene is apparent from its appearance on Staffordshire transferware plates.[7]

Beck took his view of Philadelphia from a

distance, looking down the Delaware River from the north, near the great elm of Shackamaxon, the legendary site of William Penn's treaty with the Indians. Benjamin West also included it in his painting *William Penn's Treaty* (1771; Pennsylvania Academy of the Fine Arts, Philadelphia). Winds blew the tree down in 1810, and it is now commemorated by the Penn Society's monument in Penn Treaty Park. Beck's view also resembles the watercolor by John James Barralet in a private collection (1796; *View of Philadelphia from the Great Elm in Kensington*),[8] as well as *The City & Port of Philadelphia on the River Delaware from Kensington*, published by William Russell Birch in 1800 as one of the famous views of Philadel-

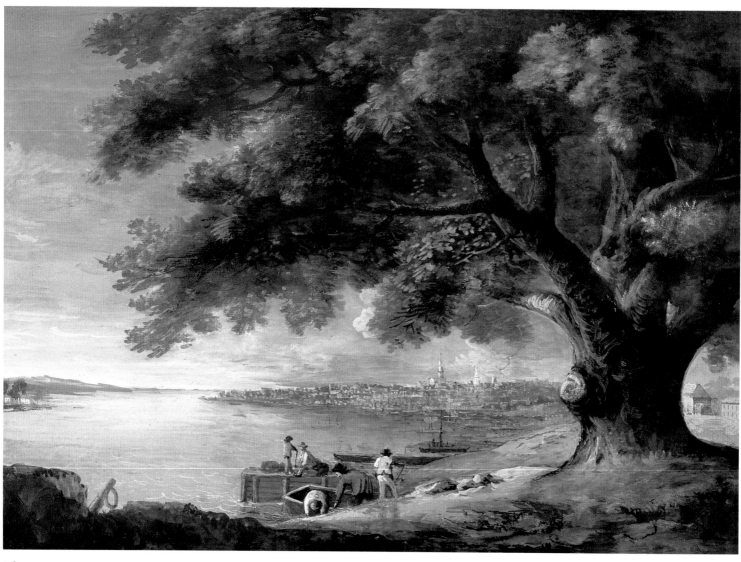

10b

phia that he designed and engraved with his son Thomas (cat. 36).[9] The aquatint after Beck is closer to the Society's watercolor than to Birch's print.[10] In both Beck's watercolor and the related aquatint, Philadelphia and its church steeples are more topographically delineated than in the generalized view by Birch.

Two other watercolors by Beck (*McCalls Ferry on the Susquehannah* and *Schuylkill below the Falls*) were once mounted in a manner similar to the view of Georgetown mentioned above. They demonstrate that, like the Society's view of the falls at Montmorency, the artist executed many more views than the six that were reproduced as aquatints.[11]

1. Whitley 1969, 30, 32, 35. The attribution to Beck was made by Rudolph Wunderlich.
2. Thomas 1992, 746–47, pl. I, and 749, pl. V. For the Atkins & Nightingale series of American cities, see also Stokes and Haskell 1932, 80, 82, 83, 87–88.
3. See McKinsey 1985.
4. See Pleasants 1943, 200, 210–11. The canvas measures 16 1/2 × 22 1/2 in. Formerly (1934) in the estate of Dr. Robert Peter of Winton, in Lexington, Kentucky; see also Thomas 1992, pl. IX, where the photograph is listed as "courtesy of Kennedy Galleries."
5. Pleasants 1943, 214.
6. A photocopy in the object file records the publication of this watercolor, then in a private collection, although no source was recorded on the sheet. See n. 11 below, which suggests that the reproduction might have appeared in a publication of Kennedy Galleries, New York.
7. See Ellouise Baker Larsen, *American Historical Views on Staffordshire China* (New York: Dover Publications, 1975), 209, no. 527, ill.
8. Nygren et al. 1986, 113, fig. 106.
9. See Deák 1988, 1:150–52, no. 228; 2: ill.; see also Koke 1982, 3:323.
10. Cartwright may have taken the Birch view into account when engraving the print; see Deák 1988, 1:152–53, no. 229; 2: ill.
11. All three were once with Kennedy Galleries, New York; their photographs are in the Frick Art Reference Library, New York.

JAMES SHARPLES SR.

Lancashire, England 1751–New York, New York 1811

James Sharples reputedly spent his childhood in France, studying for the priesthood, and his early adulthood in his native England (Bath, Bristol, Liverpool, and London). It is not clear under whom he studied, but he first exhibited at the Royal Academy of Arts in 1787 while living in Cambridge. With this sophisticated background, he came to the United States in 1794 to create a collection of profile portraits of famous Americans for both American and European audiences, whose curiosity about Americans had burgeoned during America's Federal period. Since the excavations at Pompeii and the ensuing rage for the classical style, profile likenesses were in great demand. The format was thought to derive from classical medals or coins honoring famous men of the republics of Greece and Rome and thus was especially appealing to statesmen of the American republic. Other émigré artists—like Charles-Balthazar-Julien Févret de Saint-Mémin (cats. 18 and 25–27), Thomas Bluget de Valdenuit (cat. 18), and Pierre Eugène Du Simitière (cat. 7) who mastered the art of taking profiles in Europe with the aid of the mechanical physiognotrace—turned out profile portraits swiftly, expertly, and inexpensively. Via clever marketing, these artists had established a demand for profile portraits in America at the turn of the nineteenth century.

Sharples responded to this vogue in a singular manner, working almost exclusively in colored pastels often applied with the brush, a technique that reveals his background as a painter in oil. With great savvy Sharples established his brisk entrepreneurial career in America by asking eminent local and national politicians to sit for him and then enticing them into commissioning one or more copies of their portraits. In most cases he kept the original portrait of the celebrity for his personal collection that functioned like a reference library to be consulted for future commissions. William Dunlap, the artist's first biographer, relates that Sharples took about two hours to take each portrait. He also enlisted his third wife, Ellen Wallace (1769–1849), who was a more meticulous painter and also a miniaturist, and their children—Felix Thomas (c. 1786–after 1824), James Jr. (c. 1788–1839), and Rolinda (1793/94–1838)—in what became a profitable business that included producing copies of his original profile visages. None of these is signed, making it

exceedingly difficult to identify the original version or to attribute single sheets to one of the four members in the family workshop, especially since James Senior and Ellen often worked in tandem on one portrait. The family moved through New England and the South in search of sitters in a traveling studio, a one-horse wagon of James Sharples's own invention that held art supplies and his physiognotrace.

From 1796 to 1801 Sharples worked mainly in Philadelphia and New York, making profile and relatively rare three-quarter bust-length pastel portraits, which measured about nine by seven inches. This formulaic approach accords with the use of the mechanical drawing aid that Sharples employed for the profiles, while the three-quarter visages were drawn freehand. His vivid, painterly pastel images were executed with a delicate, precise touch, using predominantly black, white, gray, and flesh tones with dark backgrounds.

In 1801 the Sharples family left for Bath, England, to attend to business and sell their house in Lansdown, eventually returning to the United States (Felix and James Jr. in 1806 and their parents and sister Rolinda in 1809). During their residency in America, the family developed a prolific industry in the profile genre, producing hundreds including at least 130 of George Washington alone. After James Sharples's death, the family with the exception of Felix Thomas returned to England. (Felix's later portraits are

more easily identifiable as they tend to feature full-face or three-quarter views and a broader technique than that of his father.) Before her return, Ellen Sharples auctioned off part of her husband's collection of their oeuvre for a considerable sum and gave much of the remaining material to the Royal West England Academy, Bristol (on permanent loan to the Bristol Museum and Art Gallery).

The Anglo-American career of the Sharples family exemplifies the transatlantic nature of American art and the artistic exchange between Britain and America in the late eighteenth and early nineteenth centuries. The Society holds fourteen pastels attributed to various members of the family (and one after a Sharples original), including eleven pastels attributed to James Senior. Reputedly not a single pastel by Sharples is signed, although the wood backing behind some are inscribed, as in the case of figure 11.1 (see n. 2 below).

Bibliography: Katharine McCook Knox, *The Sharples: Their Portraits of George Washington and His Contemporaries* (New Haven: Yale University Press, 1930); Rossiter 1962, 2:42–43; Arnold Wilson, "The Sharples Family of Painters," *The Magazine Antiques* 100:5 (1971): 740–43; William Barrow Floyd, "The Portraits and Paintings at Mount Vernon from 1754 to 1799, Part II," *The Magazine Antiques* 100:5 (1971): 894–95, 897–98; David Meschuett, "Portraits of Anthony Wayne: Re-identifications and Redistributions," *American Art Journal* 15:2 (1983): 32–43; idem, "A Long-lost Portrait of John Adam and an Unknown Portrait of Portrait of Abigail Adams," *The American Art Journal* 32:1–2 (2001): 76–93; Diane Waggoner, *The Sharples Collection: Family and Legal Papers (1794–1854): A Brief Introduction to the Microfilm Edition of the Sharples Family Collection* (East Ardsley, Wakefield, England: Microform Academic Publishers, 2001).

Fig. 11.1. James Sharples Sr., *Peter Augustus Jay (1776–1843)*, 1797. Pastel on blue paper, 9 1/4 × 7 5/16 in. (235 × 186 mm). The New-York Historical Society, Abbott Fund, 1952.353

11a

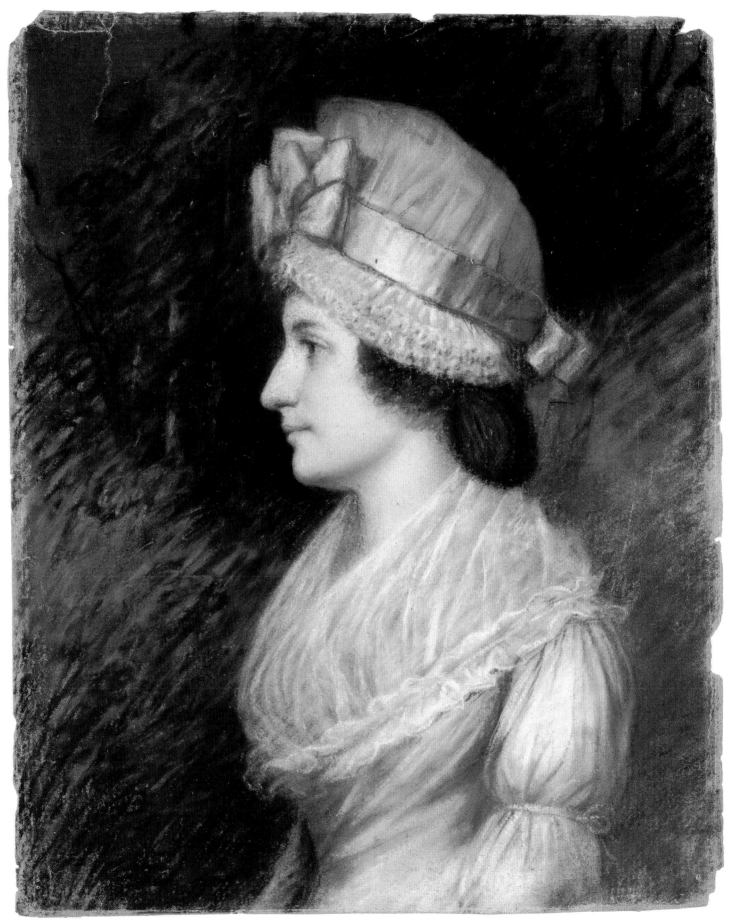

11b

11a. *Leonard Bleecker (1755–1844)*, c. 1796–1801

Pastel on grayish brown paper; 9 3/16 × 7 3/8 in. (233 × 187 mm)
Provenance: Descent through the sitter's family.
Bibliography: Knox 1930, 44, 120; N-YHS 1941, 28–29, no. 66, ill.; N-YHS 1974, 1:80, no. 184, ill.; Jeffares 2006, 496.
Bequest of Mrs. Elizabeth B. Knight, the great-granddaughter of the sitter, 1940.350

11b. *Johanna Abeel Bleecker (1764–1810)*, c. 1796–1801

Pastel on grayish brown paper; 9 5/16 × 7 3/8 in. (236 × 187 mm), irregular
Provenance: Descent through the sitter's family.
Bibliography: N-YHS 1941, 28–29, no. 67, ill.; N-YHS 1974, 1:80, no. 185, ill.; Jeffares 2006, 496.
Bequest of Mrs. Elizabeth B. Knight, the great-granddaughter of the sitter, 1940.351

These two pendants of Leonard Bleecker and Johanna Abeel, husband and wife, face each other on paper as in life. Major Bleecker was born at New Rochelle, New York, the scion of an old Dutch family (son of James Bleecker and Abigail Lispenard Bleecker). After being appointed a second lieutenant in 1775, he joined General Richard Montgomery's forces in the battle at St. Johns, Quebec. He also participated in the battles of Princeton, Long Island, and Trenton and in 1777 was promoted to the rank of captain. In 1780–81 he served under Lafayette and witnessed the surrender of Cornwallis at Yorktown, by which time he had risen to the rank of brevet major and was a friend of George Washington. Bleecker was one of the founding members of the Society of the Cincinnati in 1783. In the same year he married Johanna Abeel (daughter of Colonel James Abeel and Gertrude Neilsen Abeel) and after her death wed Grace Moore Berrian.[1] Not long thereafter, his interests turned to religion, to which he devoted most of the remainder of his life, serving as an officer in numerous religious, benevolent, and philanthropic organizations. For fifty years he was a member of the Chamber of Commerce of New York City.

This pair of profile portraits by Sharples is unusual in that the sitters are placed before loosely suggested landscapes rather than the artist's more characteristic velvety Prussian blue or solid black backgrounds (fig. 11.1).[2] The landscape behind Leonard Bleecker even includes at the lower right the afterglow of a sunset. Like most of James Sharples's pastels, the pair is executed on colored, grainy paper that he rubbed to obscure any surface irregularities or, if needed, roughened to create a nap or tooth that would hold the friable pastel.[3] Like many other artists of his era, Sharples used the hues of his support (visible on the verso) not as a chromatic component in his composition but to facilitate his working process. The colored sheets served as the middle tone from which he developed shadows and highlights. His portraits, like most in the eighteenth century, resemble easel paintings in their highly finished execution and presentation. As described in contemporary manuals,[4] the carefully graduated tones are modeled so that few lines are perceptible, as if the pastel had been applied carefully with a brush. Most pastelists, however, relied solely on purchased sticks of color that were applied directly to the paper or rubbed with a chamois or paper stump or "sweetened" by the artist's fingers.[5] Instead, Sharples reputedly crumbled his pastel crayons and applied the powder to his paper with a camel's-hair brush to further refine his application. In these two portraits, Sharples also used crayon sticks of pastel for the finer, more linear details and for the backgrounds. Usually in emulation of the effect of oil, a pastel's paper support was completely covered with color and was mounted on or backed by a wood panel, which was the artist's practice, or adhered to a wood strainer, as in the case of Saint-Mémin. According to Dunlap, James Sharples charged $15 for a profile likeness (made with a physiognotrace and replicable) and $20 for a freehand full-face image, which he considered "never so good."[6]

A man with the surname of Bleecker is documented three times in Ellen Sharples's diaries. The first time he is mentioned in the company of one or two other gentlemen having supper with the family in January and February 1810 "when sitting for their portraits."[7] The third time, a "Mr. Bleecker," certainly by now a friend, is recorded as visiting during the artist's final illness in the bitter cold of February 1811.[8] It has been argued that both sitters of this pair are portrayed at too young an age to agree with the 1810 date mentioned by Ellen Sharples, implying that either she was referring to a different Bleecker or to a later portrait of Major Bleecker.[9] The date assigned to the pendant pastels rests on evidence presented in the sitters' costumes and their ages.

1. See N-YHS 1974, 1:80–81, nos. 184 and 185. See also Alexander Lewis MacDonald, *The Bleecker Family Book* (New York, 1955), 29; and Walter Barrett, *The Old Merchants of New York City* (New York: Carlton, 1863), 128, which lists Leonard Bleecker as one of the twenty-eight brokers of the New York Exchange Board in 1817.
2. See Avery et al. 2002, 94. The wood backing of the period frame of fig. 11.1 is inscribed in black pastel: *J. Sharples / Cap Boids Sloop / May Holland*[?]; in brown ink: *Drawn by J Sharpless. 1797*. For other similar inscriptions, see Knox 1930, 7, figs. 9 and 10, who on p. 96 records a pastel portrait of Peter Augustus Jay that was owned by Mrs. Arthur Iselin in 1930.
3. For a technical discussion of pastel and its supports and fixing agents, see Shelley 2002, 60–64.
4. Ibid., 62 n. 94, cites John Russell, *Elements of Painting with Crayons* (1772; Dublin, 1773), and Robert Sayer, *The Compleat Drawing-Book* (London: Robert Sayer, 1786), among others.
5. Shelley 2002, 61.
6. William Dunlap, *A History of the Rise and Progress of the Arts of Design in the United States* (New York: George P. Scott and Co., 1834), 2:71.
7. Knox 1930, 120.
8. Ibid., 44.
9. N-YHS 1974, 1:80.

MICHELE FELICE CORNÈ

Elba, Italy 1752–Newport, Rhode Island 1845

1 Nautilius
2 Constitution
3 africa
4 prise
5 Schanon
6 Eulus
7 la Guerriere
8 belvedere

Escape of Constitution

12

Michele Felice Cornè served in the Neapolitan army during the conflict between King Ferdinand IV of Naples and the forces of the French republic before abruptly emigrating in November 1799 aboard the United States ship *Mount Vernon*. He may have been one of three unidentified gentlemen listed in the ship's log or possibly allowed to stow away as a political refugee. On arriving in Salem, Massachusetts, Cornè immediately began a career in decorative painting, presumably having received training in Naples as an ornamental painter. He soon gained recognition, from Boston to Washington, D.C., for his scenic murals, architectural ornamentation, large panoramas consisting mostly of marine and landscape views, many taken from established eighteenth-century prints, and his competent portraits.

Cornè specialized in portraits of sailing vessels, as well as views of naval battles made from personal experience, eyewitness descriptions, and

prints. He is also noted for the four-painting series *The Battle of Tripoli* (c. 1805; U.S. Naval Academy Museum, Annapolis, Md.), commissioned by Commodore Edward Preble in 1805 for presentation to the Navy Department, as well as two sets of four views of the engagement between the USS *Constitution* and HMS *Guerriere* (1812–13; U.S. Naval Academy Museum), commissioned by Commodore Isaac Hull who had commanded the *Constitution* during the landmark battle. In 1807 Cornè collaborated with William King of Salem on the panoramic *Attack on Tripoli* (1807), measuring ten by sixty feet, which was mounted on rollers so that it could be unfurled for viewers.

Cornè also painted ornamental decoration in many of the fine houses in Salem, Massachusetts, and Newport and Providence, Rhode Island. Pastoral and mountain landscape murals from the hallway of Lindall-Barnard House in Salem are now preserved by the Essex Institute (Salem, Mass.), the Salem Athenaeum, and the Winter-

thur Museum in Delaware, while the *Bay of Naples* (1810) and other murals remain in situ in the Sullivan Dorr House in Providence. The Museum of Fine Arts, Boston holds two Cornè overmantels, while several decorated fireboards, a mural painted on copper, and a frescoed plaster dome are in the Peabody Essex Museum in Salem. As evidence of his popular success, Cornè's view of the engagement between the *Chesapeake* and the *Shannon* was transfer-printed in blue onto ceramics by John Rogers & Son of Longport, Staffordshire, England, and several original marine works were printed in black on a series of cream-colored jugs by Bentley, Wear & Bourne of Shelton, Shropshire, England. Cornè also prepared more than twenty small views of naval battles for engravings in such historical volumes as Abel Bowen's *The Naval Monument* (1816) and Horace Kimball's *The Naval Temple* (1816).

A fashionable guest and witty conversationalist, Cornè was noted for his humor and good

temper. Although his work is far from academic, Cornè had a competent and versatile professional style and a picturesque, colorful technique. He was a talented ornamental painter, and the innovative dimension of his marine and landscape views elevated him above much of the American naïve art of the early nineteenth century. Cornè has been credited with disseminating the dynamic marine art traditions and techniques of southern Europe in the United States through his long and productive career and through his American students such as George Ropes, also represented in the Society's collection.

Bibliography: Abel Bowen, *The Naval Monument* (Boston: Abel Bowen, 1816), 2, 11, 77; Horace Kimball, *The Naval Temple* (Boston: Barber Badger, 1816); Nina Fletcher Little and Philip Chadwick Foster Smith, *Michele Felice Cornè, 1752–1845, Versatile Neapolitan Painter of Salem, Boston, and Newport*, exh. cat. (Salem, Mass.: Peabody Essex Museum, 1972), vii–xiv, 18–21; "Marine Paintings of Michele Felice Cornè," in *American Neptune Pictorial Supplement for Volume 32* 14 (1972); Dorothy Brewington, *Dictionary of Marine Artists* (Salem, Mass.: Peabody Museum; Mystic, Conn.: Mystic Seaport Museum, 1982), 94; Koke 1982, 1:213–18; Bénézit 2006, 3:1398.

12. "'Constitutions' Escape from the British Squadron after a Chase of Sixty Hours": Preparatory Study for the Engraving, c. 1816

Gray ink and wash over graphite on paper, inlaid into a larger sheet; 7 1/16 × 11 3/8 in. (179 × 289 mm)
Inscribed at lower center outside image in brown ink: *Escape of Constitution*; at upper left mostly outside image in gray ink: *1 Nautilius | 2 Constitution | 3 Africa | 4 prise | 5 Schanon | 6 Eulus | 7 la Guerriere | 8 belvedere*; ships numbered left to right: *1; 2; 3; 4; 5; 6; 7; 8*
Bibliography: Bowen 1816, 2, ill., 11, 77; Koke 1982, 1:216–17, no. 371, ill.
Gift of the Naval History Society Collection, 1925.128

The N-YHS holds four small ink wash drawings by Michele Felice Cornè of naval engagements fought during the War of 1812. The incident Cornè depicted in this drawing began on the afternoon of 17 July 1812, barely a month after war was declared with Great Britain. The USS *Constitution*, under the command of Commodore Isaac Hull, was sailing north from Annapolis headed for New York when the crew spotted distant sails of enemy warships led by the British frigates *Shannon* and *Guerriere*. Becalmed off New Jersey, the *Constitution* began a series of maneuvers in an attempt to outrun the similarly stranded enemy.

In this scene, Cornè numbered each ship, providing an identification key at upper left.[1] The *Constitution* is depicted at left, its crew deployed in three small boats to tow and warp the ship forward.[2] The British squadron's small boats are aligned at center near the *Shannon* and *Aeolus*, preparing to copy the maneuvers of the *Constitution*. The frigates *Guerriere* and *Belvedera* can be seen firing on the fleeing *Constitution*, which returns fire. In the distance Cornè included the USS *Nautilus* and *Enterprise*, near the British ship *Africa*, although these two ships were not involved in the incident. This slow-motion chase off the coast of New Jersey lasted for nearly three days, during which shots were exchanged several times. Commodore Hull reported that the British volleys always fell short of the *Constitution* but that the American rounds appeared to strike the British squadron several times over two days. On the morning of 19 July an American merchant ship came into view, prompting the British to raise U.S. colors in an attempt to lure and capture the ship loaded with trade goods. The besieged *Constitution* immediately responded by hoisting British colors, thereby exposing the deception, warning the merchant ship, and protecting U.S. trade.

The wind gradually increased, and on the morning of 20 July the swift *Constitution* wet its sails to improve wind resistance and sailed off, leaving the British squadron behind. The British ships returned to the blockade of New York while Commodore Hull sailed the *Constitution* safely into Boston Harbor, ending one of the most dramatic chases in naval history.[3] Just a few weeks later, the *Constitution* and the *Guerierre* would meet for the final time in one of the most spectacular battles in naval history, which ended with the victorious *Constitution* capturing the dismasted hulk of the *Guerriere* (see Garneray, cat. 39).

Cornè's illustration of this daring episode in naval history was engraved by William Hoogland as "*Constitutions*" *Escape from the British Squadron after a Chase of Sixty Hours*,[4] the first incident depicted in Abel Bowen's *The Naval Monument* (1816), a comprehensive illustrated history of U.S. naval engagements during the Tripolitan conflicts and the War of 1812. Bowen also included engraved versions of Cornè's

drawings in the Society's collection *The "Enterprize" and "Boxer"*[5] and *The "Constitution" and the "Guerriere."*[6]

A. M.

1. Although misspelled in the inscriptions, the ships listed were the American *Nautilus*, *Constitution*, and *Enterprise*, and the British *Africa*, *Shannon*, *Aeolus*, *Guerriere*, and *Belvedera*.

2. Warping was accomplished by rowing the anchors ahead in a small boat, dropping them, then pulling the ship forward to the anchor.

3. The description of the incident comes from the original report of Commodore Isaac Hull to Paul Hamilton, Secretary of the Navy, National Archives, Record Group 45, Captain's Letters, 1812, vol. 2, no. 127 (21 July 1812); for additional information on the battle history of the *Constitution*, see Theodore Thomte, *Battles of the Frigate Constitution* (Chicago: Burdette & Company, 1966).

4. Bowen 1816, 2, ill.

5. Inv. no. 1925.137; ibid., 77, ill.; Koke 1982, 1:218, no. 374.

6. Inv. no. 1925.138; Bowen 1816, 11, ill.; Koke 1982, 1:217, no. 372, ill. This sheet depicts the second of the four scenes of the battle. It was apparently modeled on Cornè's earlier painting *In Action* (1812–13; U.S. Naval Academy Museum, inv. no. 1869.01.003; displayed in the White House Oval Office under President John F. Kennedy) and was preparatory for the engraving entitled *The "Constitution" in Close Action with the "Guerriere"*; see cat. 39 nn. 1, 3 and fig. 39.1.

SIR WILLIAM STRICKLAND

Boynton, Yorkshire, England 1753–1834

13

William Strickland was the first son of Sir George Strickland, fifth baronet of Boynton and a lifelong student of agriculture. He inherited his interests from his mother, who ran a model farm that she opened to visitors. Until the age of twenty-five, Strickland followed in his parents' footsteps and managed a farm he had purchased at Wilbur in Yorkshire. A naturalist as well as an agriculturalist, he eventually collaborated with his daughter on *The Illustrated Zoology of Yorkshire*, of which not a single copy is extant. In the company of Miles Smith, a neighbor, Strickland undertook a year's tour of the eastern United States in 1794, journeying from the Hudson River valley south to Virginia and spending a considerable amount of time in Philadelphia. Since his library was well stocked with books on North America, he was prepared for his journey. While on tour, he associated with America's elite and, not surprisingly, became

a friend of George Washington, who shared his interest in farming. Throughout their travels, Strickland sketched and compiled journals.

When he returned to England in 1796, he submitted his impressions of American agriculture to the London Board of Agriculture, and his *Observations on the Agriculture of the United States of America* finally appeared in completed form in 1801. He added to his journals well after his return home, integrating them with the latest information up to 1805. Three years later, he inherited the baronetcy, becoming the sixth baronet of Boynton. The Society's library and museum are rich in Strickland material.

Bibliography: Sir William Strickland, *Observations on the Agriculture of the United States* (London: W. Bulmer and Co., 1801); William Strickland, *Journal of a Tour in the United States of America, 1794–1795*, ed. J. E. Strickland (New York: New-York Historical Society, 1971).

13. *View of Ballston Springs, New York, through the Trees*, c. 1794

Watercolor, black ink, and graphite on paper; 11 1/2 × 17 3/8 in. (292 × 442 mm), irregular
Watermark: J WHATMAN
Reputedly inscribed, probably on a former mount: *View of the Mineral Springs at Ballston near Kayaderossera in the State of New York*
Provenance: Descent through the artist's family; the Reverend J. E. Strickland, Gouray Lodge, Jersey, Channel Islands.
Bibliography: Koke 1982, 3:159, no. 2515, ill.; Nygren et al. 1986, 293–94, pl. 153.
Gift of the Reverend J. E. Strickland, 1956.145

Like William Guy Wall (cat. 48) and Jacques-Gérard Milbert (cat. 35), the English-born William Strickland recorded views of icons along the American grand tour itinerary, such as Passaic Falls (fig. 13.1), and also described them

in his journal. Among the thirty-one works by Strickland in the Society's collection is a view of Mount Vernon, which Strickland, a friend of George Washington, visited in 1795 (essay fig. 7).[1]

The Society holds two other drawings, including a small preparatory graphite study for the watercolor discussed here,[2] that depict views of the mineral springs at Ballston Spa, north of Albany in Saratoga County, New York. Formerly called Ballston Springs, the town lies about 150 miles north of New York City, fives miles from Saratoga. Originally a health resort, it attracted people from around the world who gathered there to drink from its many mineral springs that were believed to have healing powers. In the first decade of the nineteenth century the then-largest hotel in the world, the San Souci, was built on Front Street. European royalty and the wealthy from many continents visited the hotel and springs on a regular basis. Flowing through the village of Ballston Springs and dividing it into a north and south end was Kayaderosseras Creek.[3] Developers soon started utilizing the creek's waterpower and built mills and factories near the village. Among them were several early paper mills. With the advent of the railroad, the village gradually evolved from a tourist mecca into a manufacturing town.[4]

Stickland visited Ballston Springs, which he called "Ballstown" Springs, on 16–17 October 1794, just as it was developing into a fashionable resort spa and notorious watering hole.[5] At that time he drew and annotated the graphite study mentioned above, which is arguably the earliest known view of Ballston Springs.[6] While many of Strickland's works, especially his sketches executed on the spot, are rendered in the highly portable medium of graphite, he also worked in watercolor, as seen in his view of the Great Falls of the Potomac River.[7] Another pair of drawings in the collection with parallel media—one in graphite and the other in watercolor—depict the Potomac River at Harpers Ferry, Virginia, and demonstrate that the artist habitually rendered his watercolors from graphite sketches.[8]

Strickland's view of Ballston Spa is compositionally quite daring and experimental. Instead of focusing on local landmarks of interest, he drew a foreground screen of tall pine trees through which the viewer glimpses several structures in a woodland setting being cleared by the girdling technique. At the center is one of

Fig. 13.1. William Strickland, *View of Passaic Falls, Paterson, New Jersey,* 1794. Graphite on half of folded sheet of paper, 8 1/4 × 13 in. (210 × 330 mm). The New-York Historical Society, Gift of the Reverend J. E. Strickland, 1958.54

the famous springs covered by a roof. The artist was clearly interested in recording the girdling technique, in which trees are stripped of their bark to weaken them so that later they can be chopped down near their roots. After several seasons, during which time the wood would have rotted, their roots would be removed. This was a common method in North America for clearing land and one that eventually led to deforestation. Strickland's fascination with it reveals his interest in agriculture and the natural sciences. The comments in his journal, whose manuscript copy in twenty neatly penned booklets is held in the Society's Department of Manuscripts, on the topic relate to this watercolor and reveal him to be a visionary environmentalist:

The new settlement of Ballstown is cut out of the woods, and like many other similar settlements, without taste, judgment, or foresight. Nothing is preserved, and everything wasted; which is the less excusable here, as several well built, handsome houses indicate the residences of those who might have the means, and ought to have the inclination, of exerting more skill and judgment. But all here, are in this respect alike; the unenlightened, half-savage backwoodsmen agree in this; that trees are a nuisance and ought to be destroyed … and therefore they apply the efficacious instruments of girdling and the fire … . Surely such … waste ought to be checked by the Government of the country, if the individuals have not the knowledge or the virtue to do it! … The Houses are placed near the springs in a situation which with the exertion of a very little taste and judgment would have been

very beautiful; in a hollow which till within two years was shaded with a forest old as the discovery of America, with pine trees upwards of 200 feet in height and fifteen feet in circumference … . Immediately at the back of the Houses, a steep hill every way incapable of cultivation was till very lately covered with this fine timber, which if left standing would have been highly ornamental to the place, and afforded in the summer time, a pleasant retreat and shelter from the scorching Sun, but which when cut down exposes only a barren hill side convertible to no manner of use. Within this twelvemonth the whole scene was wood, within another probably not a tree will remain visible from the place … . The springs are said to be several in number, but two only are now made use of; One of these is fenced round and covered with a roof supported on posts, and is used for drinking, another at a little distance, has an house built around it, and is converted into a bath.[9]

1. Strickland 1971, 224–25, fig. 14; and Koke 1982, 3:162–63, no. 2525, ill.

2. Inv. no. 1958.63 on irregular paper once folded in quarters measuring 15 7/8 × 12 1/2 in.; see Strickland 1971, 104–5, fig. 4; and Koke 1982, 3:159, no. 2514, for this more topographically exacting work. Another closely related sheet (inv. no. 1958.64) shows a view of a road through a forest being cleared. Although Koke (ibid., 165, no. 2535) does not identify it as such, the location is probably Ballston Spa, based on its similarity to the other two drawings of the subject, one of which precedes it in the foliolike sketchbook compiled by this meticulous individual.

3. A view of the bustling village of 2,100 people at the time of the visit of the Baroness Hyde de Neuville (cats. 15 and 16) in 1807 is preserved in one of her

drawings, perhaps executed from the San Souci Hotel, in the Society's collection (inv. no. 1947.449), in ibid., 2:190, no. 1382, ill.

4. See George Waller, *Saratoga: Saga of an Impious Era* (Englewood Cliffs, N.J.: Prentice Hall, 1966); and Grace Maguire Swanner, *Saratoga, Queen of Spas: A History of the Saratoga Spa and the Mineral Springs of the Saratoga and Ballston Areas* (Utica, N.Y.: North County Books, 1988).

5. See Strickland 1971, xii, 131 n. 1, 138–43, 145.

6. Koke 1982, 3:159, no. 2514, claims it is the earliest. Koke (ibid., 159, no. 2515) cites a watercolor "replica,"

measuring 18 1/8 × 24 7/8 in., that in 1978 was with Hirschl & Adler Galleries, New York. Its mount is inscribed: *A View of the Mineral Springs of Ballston in Kayaderossera in the State of New York | Sketched Novbr 1794 by William Strickland Esqr.… . Finished by Joseph Halfpenny 1796.* The mount on this enlarged view suggests a date for the Society's watercolor, although Koke believes that the similarity of technique between the two watercolors could suggest that Halfpenny may have played a part in the execution of the Society's watercolor.

7. Inv. no. 1958.71; see Strickland 1971, 224–25, fig. 13;

and Koke 1982, 3:162, no. 2524, ill.

8. Inv. nos. 1958.59 and 1956.146; see Strickland 1971, 220; and Koke 1982, 3:164, nos. 2530 and 2531, ill.

9. Strickland 1971, 138–39, 142–43. In 1807 Strickland's prophetic description became a reality as preserved in the watercolor by the Baroness Hyde de Neuville mentioned in n. 3 above. The Society's library holds Strickland's papers, including three notebooks, two printed almanacs (one printed in London and the other in Philadelphia), a bankbook for his account at the Bank of New York, an American correspondence letter book for 1797–1801, and assorted letters.

GEORGE HERIOT

Haddington, Lothian, Scotland 1759–London, England 1839

A Scot best known as a skilled landscape watercolorist and the contentious deputy postmaster general of British North America (1800–1816), George Heriot was primarily active in Canada. His artistic training, begun in Edinburgh, continued under Paul Sandby at the Royal Military Academy at Woolwich near London, where he studied topographical drafting and watercolor, like Thomas Davies (cat. 8) at a slightly earlier time. He was one of the few military artists trained by Sandby whose works reveal his master's influence. Choosing not to pursue a military career, Heriot was posted to the garrison at Quebec in 1792 as an ordnance clerk and worked in various government agencies in Canada, where he imaginatively used his topographic training to document Canadian life and landscape. He exhibited some of these views at the Royal Academy of Arts in London in 1797. A career in the colonial service afforded him the opportunity to travel on inspection tours and paint widely in Upper and Lower Canada before confederation, especially while serving as deputy postmaster general of British North America.

Several of Heriot's sketchbooks survive, including examples at the N-YHS and the McCord Museum at McGill University, Montreal, which record his American tour. They reveal a keen topographic interest, together with a poetic sense of landscape. His large finished watercolors, such as *Lake St. Charles near Quebec* (c. 1801; National Gallery of Canada, Ottawa), are frequently masterpieces of this genre that are even closer to

English tinted watercolors. On the other hand, many of Heriot's less formal, freely rendered sketches reflect the specificities of the American and Canadian landscapes and monuments and are valued both for their aesthetic and historic content. As an amateur watercolorist of considerable skill, Heriot applied the picturesque landscape theory and techniques he had learned in England to the scenery of the New World.

The artist visited the United States briefly during the summer of 1815, six months after the end of the War of 1812, before returning to England in 1816. His trip was ostensibly to investigate the possibility of reestablishing a regular passage for the British mail. It seems that he was also drafted to undertake intelligence work, and one of his primary objects during his visit was to obtain information about American harbors and shipping. In New York he discussed mail routes with the city's postmaster, Thomas Moore, and in Washington with the American postmaster general. After returning to England in 1816, he toured the European continent in 1817, 1818, and 1820, continuing to execute watercolors until the end of his life.

Heriot was also a poet. He wrote several important books, whose first editions were published in London: *The History of Canada from its First Discovery* (1804); *Travels through the Canadas* (1807); and *A Picturesque Tour Made in 1817 and 1820 through the Pyrenean Mountains, Auvergne, the Departments of the High and Low Alps, and Parts of Spain* (1824), the last two illustrated with

aquatints after his watercolors. From evidence in recently discovered prints of Guernsey and Jersey, the Channel Islands, Heriot also experimented with etched outlines to which he added watercolor (in the Société Jeriaise, Jersey).

Bibliography: Gerald E. Finley, *George Heriot*, ed. Dennis Reid (Ottawa: National Gallery of Canada, 1979); idem, *George Heriot: Postmaster-painter of the Canadas* (Toronto: University of Toronto Press, 1983); Nygren et al. 1986, 95–96, fig. 18.

14a. *View of the White House ("The President's Palace") in Washington, D.C., with Another View of the City Above, Folio 26r in a Sketchbook*, 1815

Watercolor and graphite with scratching-out on paper, bound into a sketchbook; 4 1/8 × 8 in. (104 × 203 mm) Folio 25v inscribed at lower right in brown ink: *Palace of the President 1ˢᵗ July 1815 | 150 feet long | 80 ft wide* Provenance: Stiles Stevens, Esq., London, 1944. Bibliography: Koke 1982, 2:128–29, no. 1200, ill.; Finley 1983, 151–52, 281–83, no. 335, fig. 65 (as fol. 23r). James B. Wilbur Fund, 1944.430.1

14b. *View of the Falls Near Ticonderoga, Folio 42v in a Sketchbook*, 1815

Watercolor and graphite with scratching-out on paper, bound into a sketchbook; 4 1/4 × 8 in. (107 × 203 mm) Inscribed at lower center in brown ink: *Falls half a mile from Ticonderoga 28 July*, over an inscription in graphite: *Falls near Ticonderoga 28 July* Provenance: Stiles Stevens, Esq., London, 1944.

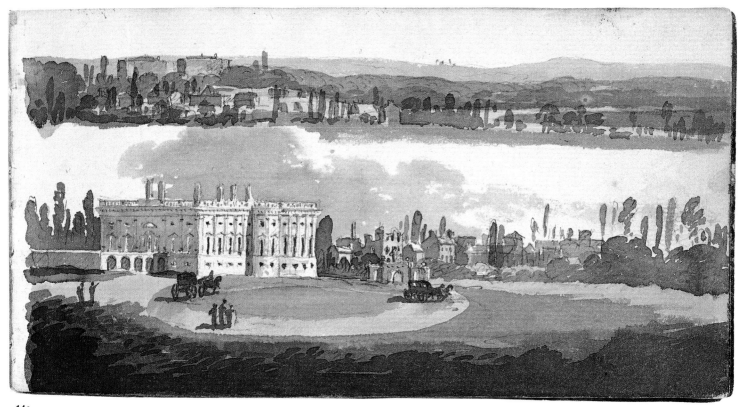

14a

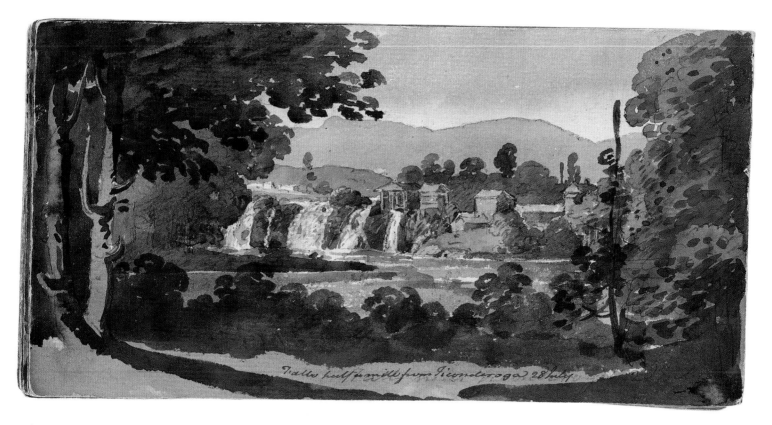

14b

Bibliography: Koke 1982, 2:128–29, no. 1200; Finley 1983, 280–83, no. 336.
James B. Wilbur Fund, 1944.430.2

This pair of watercolors from Heriot's two American sketchbooks in the Society's collection only begins to suggest the range of the artist's observations and talent that are demonstrated on every page.[1] In aggregate the two sketchbooks contain more than one hundred drawings executed between 5 June and 29 July 1815, during Heriot's journey from Canada to Washington, D.C., following the regular postal route with a few detours, and back.[2] They also feature freshly rendered panoramic double-page spreads that capture his excitement at exploring this new territory. Heriot executed many of his views in grisaille, the earliest English watercolor palette, such as the one from his first sketchbook representing the White House in Washington, D.C.[3] It features James Hoban's reconstruction (1815–17) of the original building after the British had burned the structure in 1814. Heriot's sketchbooks reveal a profound fascination with rivers, waterways, and, as with other artists of his time, picturesque waterfalls.[4] A case in point is his view of the cascades known as the Falls of Carillon on the LaChute River in Ticonderoga, New York, between the outlets of Lakes George and Champlain, from his second sketchbook.[5] This historic location known to indigenous Americans was an early portage point and was important during the French and Indian War. In 1755 the original fort was called Fort Carillon but was renamed Ticonderoga after its capture by the British. The name is from the Iroquois "cheonderoga," meaning "between two waters" or "where the waters meet."

Like Joshua Rowley Watson in his sketchbook (cat. 28), Heriot used the translucent tonal mode of the late-eighteenth-century watercolorists, but his generalizing with broad masses of pigment and compositions in the manner of the seventeenth-century artist Claude Lorrain link him to an earlier tradition. His bold application of wash to suggest atmosphere resembles the work of the English watercolorist and theorist of the picturesque, the Reverend William Gilpin, and testifies to his painting on the spot.

Heriot's two sketchbooks trace his journey along the Richelieu River in Canada to Lake Champlain, through Vermont to New York (with views of New York City[6]), Philadelphia, and Washington, D.C., and back via Philadelphia across New Jersey to New York City and up the Hudson River to Lakes George and Champlain. Like the recordings of other traveling artists and amateurs of the time, his sketchbooks contain evidence about the early establishment of the American grand tour route. They also include information about the development of urban spaces, such as Heriot's sketches of the United States Capitol under construction.[7]

1. For a full listing of their contents, see Finley 1983, 281–85, nos. 335–36. Six of Heriot's sketchbooks have been identified (see ibid., 274–85, nos. 331–36).
2. Inv. no. 1944.430.1 contains the earlier drawings dating from 5 June through 18 July; 1944.430.2 begins on 18 July, and the last sketch was made on 29 July.
3. Inv. no. 1944.430.1 consists of 50 folios, 6 blank, 3 at both the beginning and end. Heriot inscribed the inside front cover along the upper edge in brown ink: *46 Sketches in America, by George Heriot Esqr 1st Postmaster General, Brit. America / Taken in 1815.*; stenciled silhouette of Heriot in black ink wash; multiple brown ink inscriptions on the various folios.
4. See also views of William Constable (cat. 38) and William Guy Wall (cat. 48), for example.
5. Inv. no. 1944.430.2 consists of 44 folios. Heriot inscribed the inside front cover along the upper edge in brown ink: *55 Sketches (by George Heriot Esqr· 1st Postmaster General. Brit. America / in the United States 1815.*; stenciled silhouette of Heriot in black ink wash; below in graphite: *These are mostly very rough*; multiple brown ink inscriptions on the various folios.
6. Inv. no. 1944.430.1, fol. 44r, among others.
7. Inv. no. 1944.430.1, fols. 22r, 23r.

ANNE-MARGUÉRITE-HENRIETTE ROUILLÉ DE MARIGNY, BARONESS HYDE DE NEUVILLE

Sancerre, France c. 1761?–Lestang, France 1849

Sources reporting the date of birth of Anne-Marguérite-Henriette Rouillé de Marigny, Baroness Hyde de Neuville, vary considerably, although she is believed to have been older than her husband. Her birth date was long thought to be about 1749, a conjecture based on mistaken evidence from her husband's memoirs. One can be certain, however, that she was born into a wealthy aristocratic family, and, in keeping with her genteel French upbringing, she would have received a formal education, most likely including drawing lessons.

In 1794 she married Jean-Guillaume, Baron Hyde de Neuville, shortly after Maximilien-François-Marie de Robespierre lost his head to the guillotine during the French Revolution. Political reverberations of these events profoundly influenced the lives of the Hyde de Neuvilles. By 1806 the handsome and hotheaded baron, an ardent royalist, had been involved in numerous conspiracies to reinstate the ill-fated Bourbon monarchy. In 1800 the couple was imprisoned because of the baron's involvement with the English Conspiracy. More than once they were forced to live under assumed names, and the baroness sometimes let him pose as her son. Subsequently, Hyde de Neuville was condemned as an outlaw for his alleged part in an attempt to assassinate Napoleon and faced conscription and confiscation of all their property. The elegant and independent baroness (fig. 15.1), fearing for her husband's safety, courageously attempted for two years to have these charges disproved. She was unsuccessful until 1805, when she took her cause to Napoleon in an odyssey across Germany and Austria in pursuit of the French army. She eventually obtained an audience with Napoleon in Vienna, where she pled for leniency. Impressed with her heroics, the emperor allowed the couple to retain their property on condition they leave France immediately and go into exile. After spending a year in Spain, the couple sailed for the United States on the *Golden Age*, arriving in New York on 20 June 1807 with no idea that they would remain for seven years.

The Hyde de Neuvilles resided for more than three years in New York City, which in 1807 boasted a population approaching ninety thousand. Three weeks after their arrival, on the advice of European friends, the Hyde de Neuvilles journeyed up the Hudson River and then west to Niagara Falls with a protracted stop in Ballston Springs (cat. 13), which was becoming a fashionable resort. They were enchanted by the natural sights, the settlements, and the people they encountered. When they returned to New York, the couple participated in the activities of its bustling French colony, making friends with other émigrés, like the esteemed republican General Victor Moreau, in an era when the popularity of French culture in America was at its height and had eclipsed the influence of England. The baron was one of the founders and patrons of the Economical School (École Économique, incorporated in 1810 as the Society of the Economical School of the City of New York), an institution for educating the children of émigrés, many of whom had fled the uprisings in the French West Indies. The couple summered upstate in the hamlet of Angelica near the Genesee River with other French émigrés, such as Victor du Pont de Nemours. Consequently, the baroness recorded many rustic scenes while the baron engaged in voluminous insightful correspondence and a study of agriculture and medicine. Later, they purchased a farm near New Brunswick, New Jersey, and the Raritan River, only "twenty leagues" from the city (essay fig. 9).

Their first stay in America ended in the summer of 1814. With the restoration of Louis XVIII, they returned to France on the Portuguese ship *Amigo Protector*. Soon thereafter the king appointed the baron the French minister plenipotentiary to the United States, and the Hyde de Neuvilles took up diplomatic residence in Washington, D.C., while continuing to summer at their pastoral retreat in New Jersey. He served as minister from June 1816 to May 1820—at which point the Hyde de Neuvilles returned to France, where he was awarded the title of baron—and again from February 1821 to July 1822. The baron's tenure coincided with the Era of Good Feelings of James Monroe's presidency, and he and his wife were renowned for lavish, sophisticated dinner parties and entertaining.

After a brief stay in France, the French king appointed Hyde de Neuville ambassador to Portugal and they lived in Lisbon (1823–25). Thereafter, the couple divided their time between Paris and their country estate in Berry, Lestang.

The Hyde de Neuvilles' extensive American travels, especially in the northeastern states, and their residences are well documented. The baroness, who seems to have carried her

Fig. 15.1. Baroness Hyde de Neuville, *Self-Portrait (c. 1761?–1849)*, c. 1805–10. Black ink and wash, charcoal, Conté crayon, and graphite, 6 3/4 × 5 7/8 in. (171 × 149 mm), irregular oval. The New-York Historical Society, Purchased by the Society, 1953.238

drawing materials with her much as people today carry cameras, left extensive pictorial records of their journeys, while a parallel written account of their American experiences is documented in Baron Hyde de Neuville's *Mémoires et souvenirs*. Her delightfully astute and spontaneous corpus of more than two hundred sheets (123 in the Society) renders a sympathetic portrait of the American republic struggling to define itself while its people built a new nation and settled a frontier. Their naïve style, combining a certain French elegance and American picturesqueness, communicates the baroness's warm regard for humanity, keen powers of observation, powerful intellect, and sense of adventure. A fascinating woman, Baroness Hyde de Neuville pursued her own interests to make invaluable documents of early-nineteenth-century American society with vivid and affectionate characterizations, which preserve a rare glimpse of history that would otherwise be lost.

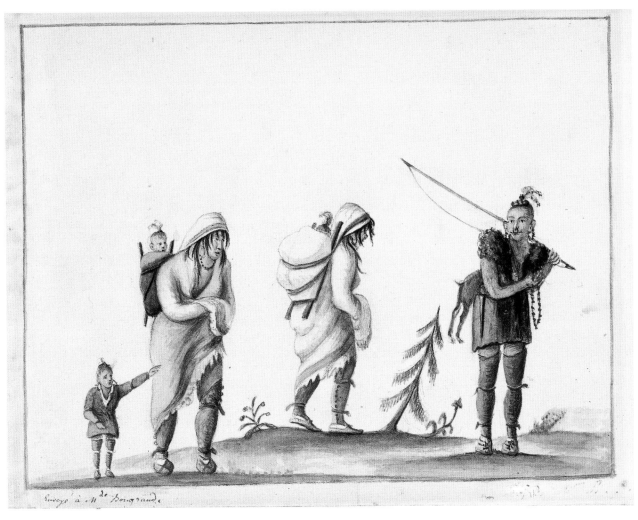

15

Bibliography: Wayne Andrews, "The Baroness Was Never Bored," *New-York Historical Society Quarterly* 38:2 (1954): 104–17; William Fenton, "The Hyde de Neuville Portraits of New York Savages in 1807–1808," *New-York Historical Society Quarterly* 38:2 (1954): 118–37; Koke 1982, 2:188–217; Jadviga M. da Costa Nunes and Ferris Olin, *Baroness Hyde de Neuville: Sketches of America, 1807–1822*, exh. cat. (New Brunswick: Jane Voorhees Zimmerli Art Museum, Rutgers, State University of New Jersey; New York: New-York Historical Society, 1984); Gloria Gilda Deák, "Banished by Napoleon: The American Exile of Baron and Baroness Hyde de Neuville," *The Magazine Antiques* 136:5 (1989): 1148–57.

15. *Oneida Family*, 1807

Watercolor, graphite, Conté crayon, brown ink, and brown gouache on paper; 5 5/16 × 7 9/16 in. (135 × 192 mm), irregular

Inscribed at lower left outside image in brown ink: *Envoyé à Mde Boisgrand.*

Watermark: AMIES

Provenance: Hyde de Neuville family, France; E. De Vries, Paris, 1928; Columbia University Press Book Store, New York, 1929; Old Print Shop, New York, 1953.

Bibliography: Columbia Bibliographic Bureau, New York, *Collection of Rare Old French Books, Americana—Manuscripts, Voyages, and Other Scarce Items* (New York: French Printing & Publishing, 1929), 1–2; Fenton 1954, 130, ill.; Koke 1982, 2:194–95, no. 1392, ill.; Da Costa Nunes and Olin 1984, 9, fig. 7, 34, no. 9; Deák 1989, 1150, pl. IV.

Purchased by the Society, 1953.215

One of twelve drawings by Hyde de Neuville in the Society's collections depicting indigenous

Americans, this image portrays three adults and three children, two of whom are in papoose sacks, on an autumn hunt. They are members of the Oneida Indian tribe, part of the formidable Iroquois Confederacy from Utica, New York (cat. 44).[1] The male at the right, wearing a nose ring and an exotic headdress, looks back over his shoulder and carries the spoils of the hunt, perhaps a deer, a bow, and wampum. Two women, both with infants in papooses on their backs, and an older child accompanying them complete the procession.[2] All the Oneida wear moccasins, about which the baron comments in his memoirs.

Hyde de Neuville's sketches are among the earliest nineteenth-century representations of indigenous Americans in their natural habitat, predating those of George Catlin (cat. 50), Peter Rindisbacher, and Karl Bodmer by at least twenty years.[3] Her works have been praised for

an ethnological integrity that is lacking in the more stereotypical, abstract written views of her husband.[4] Tellingly, the baroness has meticulously recorded the figures' facial features, dress, and customs in a delicate, charmingly notational style without modeling.

The Hyde de Neuvilles' interest in the various tribes of indigenous Americans populating the Hudson River region was stimulated as much by their own curiosity as by conversations they had in Cádiz before their departure for the New World with François René Chateaubriand, who earlier had visited America. The baron commented in his *Mémoires* patronizingly on his impressions of the "noble savages" that Chateaubriand's Romantic book *Atala* (1801) had established in the imaginations of many Europeans.[5] He found many indigenous Americans to be inebriated and indolent and their lodgings unkempt, an opinion he later modified.[6] In discussing the division of labor in a family, he noted that the females, not the males, worked. The baroness's drawing does not complement her husband's observations because she represents the women encumbered by babies, and the male, who moves more quickly ahead, as having hunted. In contrast to the views of her spouse, her interpretations are ultimately sympathetic, inquisitive, and free of his sense of superiority.

1. For Samuel Kirkland's experiences with the Oneida after dealing with them for nearly forty years, see Fenton 1954, 122.
2. Fenton (ibid., 131) and Koke, in his entry on this drawing, have interpreted this watercolor as representing two views of the same female (mother of the family). Fenton relates how the papooses are transported on the women's backs: "most unusual is the arrangement of burden strap and pack-frame, which suggests that the cradle-board came much later."
3. Charles Willson Peale, Charles Bird King, and Charles-Balthazar-Julien Févret de Saint-Mémin (cats. 26 and 27) portrayed them in the first decade of the century but not in their natural environment.
4. Fenton 1954, 130.
5. Jean-Guillaume Hyde de Neuville, *Mémoires et souvenirs du Baron Hyde de Neuville*, ed. Vicomtesse de Bardonnet (Paris: Librairie Plon, 1888), 1:458–59. Chateaubriand, like the baron, was a royalist.
6. Deák 1989, 1152.

Anne-Marguérite-Henriette Rouillé De Marigny, Baroness Hyde De Neuville

16. *The Hyde de Neuville Cabin on the "Eurydice,"* 1816

Watercolor, graphite, and black and brown ink on paper; 7 1/2 × 9 3/4 in. (190 × 248 mm), irregular
Inscribed at lower edge outside image in brown ink: *cabane de L'Eurydice Pt 16 Mai 1816 arriver le 15 Juin au Soir*
Provenance: Hyde de Neuville family, France; E. De Vries, Paris, 1928; Kennedy and Company Galleries, New York, 1931; Old Print Shop, New York, 1953.
Bibliography: Koke 1982, 2:209, no. 1448, ill.; Da Costa Nunes and Olin 1984, 24, fig. 23, 36, no. 31; Olson 2004, fig. 5.
Purchased by the Society, 1953.224

After the baron's appointment as French minister to Washington, the couple set sail on 16 May 1816 for the United States on the French ship *Eurydice*. The baroness documented aspects of the twenty-nine-day voyage in her watercolors, showing intimate views of their quarters and their activities on board. This sheet preserves a view of the Hyde de Neuville cabin. Their spacious accommodations included an elaborate berth, in which she depicts the baron reclining and reading. Behind the bed are two square windows or cabinets with the Bourbon fleur-de-lis on their panes or panels. Symbolic of the Bourbon monarchy, the fleur-de-lis underlines Hyde de Neuville's political allegiance and the sponsorship for his new post as minister of France. He is accompanied by a young black servant,[1] who may be arranging or polishing the baron's shoes (this part of the watercolor is less finished and is damaged) and two unidentified female figures wearing caps. One perches on a chair reading a book, while the other, in the background, sits in a canopied berth, seemingly partly suspended like a hammock, and holds a doll with a feathered hat. The elegant appointments—curtained beds, swags, books, and classicizing columns—reveal that the Hyde de Neuvilles traveled in comfort and relatively high style. In this ambitious watercolor, the baroness demonstrates that, in addition to recording the architecture, settlements, and people of the New World—her more customary subject matter—she was an astute observer of interior spaces.

In a letter, which her husband included in his memoirs, she described their passage:

Though our passage was a short 29 days, it was as stormy as if it had been winter. We passed two "icebergs," one after another which added reality to the illusion … . We saw these floating mountains of ice in the distance, lit up with countless fires under the rays of the sun.

After a final storm, as we were nearing the land, we entered New York Harbor on the 15th of June. The frigate had been signaled the evening before, and was almost immediately surrounded by little boats bringing our friends to greet us … . We should have liked to disembark at once, but it was due to the Representative of France to be received with greater ceremony.[2]

The baroness also drew her own private berth aboard the *Eurydice* in another watercolor, in which she portrayed herself reclining and wearing a turban while an unidentified young girl reads from a book to pass the long hours on the high seas.[3] In his diary for 20 June 1820, John Quincy Adams wrote his impressions of the wife of the French minister. She was, he decided, "a woman of excellent temper, amiable disposition, unexceptionable propriety of demeanor, profuse charity, yet of judicious economy and sound discretion."[4]

1. The young man's identity is uncertain, although he may be the same individual portrayed by the baroness in another drawing dated 1807 in the collection (inv. no. 1953.204). On that sheet she provided a narrative of his life and identified him as *adolph age de 13 ans né a la côte de guineé*. See Koke 1982, 2:192, no. 1386.
2. Quoted in Da Costa Nunes and Olin 1984, 36.
3. Inv. no. 1953.222; Koke 1982, 2:209–10, no. 1449, ill.
4. Quoted in N-YHS 1974, 2:574.

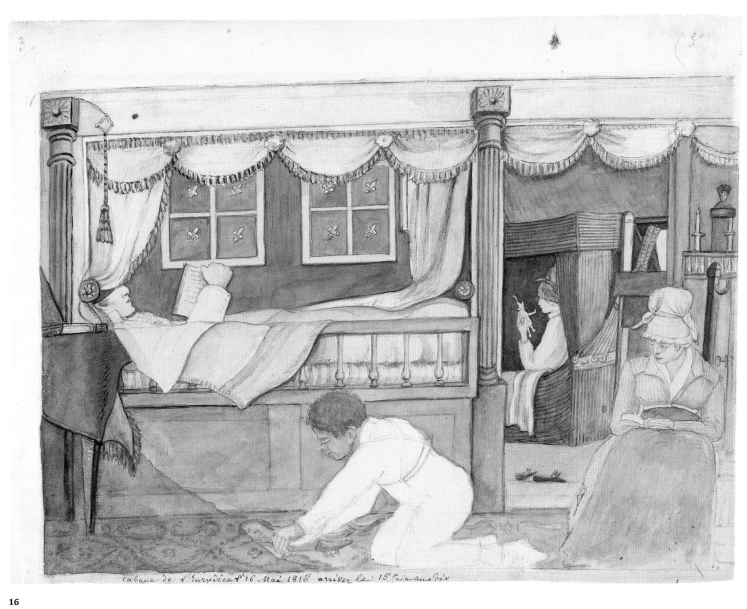

Cabane de l'Eurydice 16 Mai 1816 arriver le 15 Juin au Soir

16

WILLIAM ROLLINSON

Dudley, Worcester, England 1762–New York, New York 1842

17

Born in England, William Rollinson learned the skill of button chasing before coming to New York City in 1789, where he also practiced the craft. General Henry Knox, first secretary of war in the federal government, employed Rollinson to chase the arms of the United States on a set of silver-gilt buttons for the coat worn by General George Washington on the day of his inauguration as first president of the United States that same year. For the next two years Rollinson augmented his income with silversmithing, subsequently ornamenting armbands and medals given to Indian chiefs by the federal government. Rollinson began his career as an engraver with several copperplates for the American edition of *Brown's Family Bible* and George Henry

Maynard's edition of *Josephus* (both 1792), along with his more proficient portrait of Washington (1791). He soon specialized in portraits and plates for books using the stipple technique, and later he expanded his repertoire with additional illustrations for books and magazines, such as the *Analectic*, and maps. After becoming an American citizen in 1798, Rollinson engraved Archibald Robertson's (cat. 21) portrait of Alexander Hamilton (1800), which they jointly published in 1804; for its background Rollinson invented a means of mounting a roulette on a machine. At the time he listed his address as 27 Pine Street, the location of the second establishment and residence of Thomas Bluget de Valdenuit and Charles-Balthazar-Julien Févret

de Saint-Mémin (cat. 18). In 1801 Rollinson engraved a view of New York City from Long Island after John Wood (cat. 32); an impression jointly published by the two is in the Society's DPPAC. Apparently Rollinson also continued to work with silver, engraving a presentation punch bowl by Hugh Wishart (1800; Fine Arts Museums of San Francisco).

From 1801 to 1803 Rollinson served as an artillery lieutenant in General Ebenezer Stevens's regiment and prepared designs for *A System for the Discipline of the Artillery of the United States* by William Stevens. About 1811 he invented a machine for ruling lines on banknotes to assure against counterfeiting. This great improvement in banknote engraving was

enthusiastically accepted by engravers. Having set himself up in the business of engraving banknotes, Rollinson expanded and took on William S. Leney as an associate and designer of vignettes. Rollinson was also a Mason, producing certificates for various lodges, a volunteer fireman, a member of the General Society of Mechanics and Tradesmen, and an academician of the American Academy of the Fine Arts (1817–25). He also produced certificates for Columbia College and illustrations for books, among them a 1796 edition of Captain Cook's voyages and an 1830 edition of the *New Edinburgh Encyclopedia*. His son Charles was also an engraver.

Bibliography: William Dunlap, *A History of the Rise and Progress of the Arts of Design in the United States* (New York: George P. Scott and Co., 1834), 3:187–89; obituary, *Saturday Evening Post*, 22 September 1842; David McNeely Stauffer, *American Engravers upon Copper and Steel* (New York: Grolier Club, 1907), 1:225–27, 447–51; Stokes 1915–28, 1:441–42; Robert W. Reid and Charles Rollinson, *William Rollinson, Engraver* (New York: privately printed, 1931).

17. *View of the Custom House, New York City: Study for an Aquatint*, c. 1796–99

Black ink and wash with touches of graphite on paper; 8 3/4 × 12 5/16 in. (222 × 313 mm)
Watermark: Crowned escutcheon with fleur-de-lis, below intertwined W (J Whatman)
Provenance: Edwin Babcock Holden, New York; American Art Galleries, New York.
Bibliography: American Art Galleries, New York, sale cat., 21 April 1910, lot 2061; Stokes 1915–28, 1:441–42; Richard Hoe Lawrence et al., eds., *History of the Society of Iconophiles* (New York: Society of Iconophiles, 1930), 129, 136; Koke 1982, 3:107–8, no. 2418, ill.
Gift of Samuel Verplanck Hoffman, 1910.39

When New York City was the nation's capital, the Custom House was erected in 1790 as the permanent residence of the president of the United States. It was located at the foot of Broadway below Bowling Green, whose fence is visible at the left in Rollinson's wash drawing.[1] Two stories high, the red brick Custom House featured a portico of four white Ionic columns. Because the seat of government was moved to Philadelphia before its completion, the building was never occupied by President George Washington but it functioned briefly (1791–97) as the official residence of the governors of the state of New York (DeWitt Clinton and John Jay).[2] In

1799 the federal government began using the structure as the Custom House, and, later, from 1809 until it was demolished in 1815, it served as the second home of the N-YHS. Its site was thereafter occupied for many years by private residences, which were later converted into steamship offices, giving rise to the designation Steamship Row. These structures were removed in 1900 to make way for the new Custom House, the landmarked Beaux-Arts edifice that stands on the site today.

Rollinson's wash drawing was preparatory for his aquatint of nearly identical measurements entitled *Custom House New York*, which he engraved and published after 1 May 1799.[3] Although it was quite unusual for the same person both to design and to engrave a print, Rollinson's training as an engraver is evident in the linear style of the drawing. The exact date of the work's execution is unknown, although Stokes believes that it may date from about 1796, when the building was called Government House.[4] He posits that the artist executed it before the 1797 dated watercolor of the building by Cotton Milbourne that is also in the Society's collection,[5] because the latter shows another dormer window and other slight variances that Stokes believes were later additions. The Milbourne view also contains a flagged pavement and angled fence at the right, not found in Rollinson's view. Complicating the matter, Rollinson was not detail-oriented in his articulation of the architectural features, as neither the columns nor pilasters are fluted as they are in the Milbourne watercolor.

In both the watercolor (a term that encompasses wash drawings) and the engraving Rollinson depicted vignettes of quotidian activities near Bowling Green, among them a workman whipping a horse drawing a cart, the contents of which have just been dumped. Nearby are a black workman and to his left a man pushing a wheelbarrow full of stones, like those strewn in the road, or manure.[6] This urban scene also includes another man carrying a basket, elegant spectators strolling arm-in-arm, children petting a dog, and mongrels roaming the street.

1. The iron railing surrounding Bowling Green was installed in 1771 to protect the equestrian statue of King George III, which had been erected the previous year. During the Revolution, patriotic

Americans broke off the small iron balls that adorned the fence and used them as cannon balls. The partially broken fence was repaired in 1786. Stokes and Haskell 1932, 75; and Deák 1988, 1:145.
2. For a year before May 1799 the building was leased as a tavern to John Avery.
3. An impression is in the Society's DPPAC. Koke 1982, 3:108, notes that in the sale at the American Art Galleries in 1910, lot 2061 included the watercolor and the aquatint as a pair. For the print, see Stokes 1915–28, 1:441, pl. 63; Lawrence et al. 1930, 136; Stokes and Haskell 1932, 75, pl. 33-a; Isaac Newton Phelps Stokes, and Daniel C. Haskell, *American Historical Prints: Early Views of American Cities, etc. from the Phelps Stokes and Other Collections* (New York: New York Public Library, 1933), 43, pl. 33-a; and Deák 1988, 1:144–45, no. 219; 2: ill.
4. Stokes 1915–28, 1:441–42.
5. Inv. no. X.285; see Koke 1982, 2:339, no. 1834, ill.
6. Stokes speculates that the activity in the foregrounds of the nearly identical watercolor and aquatint represents street paving, which, however, is not documented until 1809; Stokes 1915–28, 1:442.

THOMAS BLUGET DE VALDENUIT

Les Ricey (Aube), France 1763–France 1846

Thomas Bluget de Valdenuit's family had gained local prominence when his grandfather Thomas Bluget, owner of a salt storehouse, became a member of the nobility in 1745. His father, Gaspard Bluget, added the "de Valdenuit" to the family name after an estate that he owned in the neighboring region of Burgundy. Valdenuit was educated nearby at the Collège des Oratoriens of Troyes in the Champagne region of eastern France and at the military school at Brienne-le-Château. He may also have attended the Royal Military Academy in Paris (École Militaire), where he might have met his future partner Charles-Balthazar-Julien Févret de Saint-Mémin (cats. 25–27), and probably served as an officer in the French infantry. While living in Paris during the 1780s, he learned about the novel type of portrait made by Gilles-Louis Chrétien and the draftsman Edme Quenedey with Chrétien's newly invented physiognotrace and became one of their first patrons in 1788. After the beginning of the French Revolution and the establishment of the new system of representative government, Valdenuit left Paris in 1789 to return to his inherited estate and to participate in the regional assembly at Bar-sur-Seine. In 1792 he went to Nantes and left France legally for the French colony on the Caribbean island of Guadeloupe, arriving on 3 January 1793 and registering his plans with local French government officials to ensure that his name would not be placed on the *Liste des Émigrés*. (Having one's name on the list left one open to penalites.) Soon the events of the French Revolution precipitated uprisings on the island, forcing him to flee to the United States toward the end of 1793.

Virtually nothing is known about Valdenuit's first two years in America, although he probably resided in New York City and, as Hennequin proposed, soon after his arrival encountered Saint-Mémin again. By 1795 he had settled in Baltimore with other French émigrés. He opened a drawing school, which he advertised in the *Maryland Journal & Baltimore Advertiser*, with a French artist identified only as Bouché, who specialized in small profile portraits in a round format, often with landscape backgrounds. It is not known whether this enterprise, which did not employ a tracing device, was successful, but it provided Valdenuit with the model for a business of his own. He also may have been influenced by a second French émigré artist in Baltimore, J. J. Boudier, the first artist in America to advertise portraits made using

a physiognotrace and to offer a package deal for a single price (a portrait drawing, a copperplate, and ten engravings), terms nearly identical to those of Chrétien and Quenedey.

By the time Valdenuit moved to New York around 1796, the idea of making portraits with a physiognotrace and marketing them with reductions had been firmly planted in his mind. All he needed was a partner to make the engravings. He found that individual in another French émigré and fellow military officer, Saint-Mémin, who had lost his possessions when the French Revolutionary government abolished the hereditary nobility and was just beginning his career as an artist. Before the two officially began their partnership, Valdenuit traveled to Niagara Falls, one of the requisite stops on the grand tour of North America, with another Frenchman, Simon Desjardins, who recorded some of the details of this trip and provided the earliest record of Valdenuit's contacts with Saint-Mémin.

When Valdenuit returned to New York, he and Saint-Mémin first worked and lived at 11 Fair Street, moving to 27 Pine Street the following year. Using the physiognotrace, Valdenuit made numerous life-size profile drawings of notable New Yorkers in a rectangular format. In their division of labor, Saint-Mémin reduced them with the aid of a pantograph and copied them onto copperplates for engraving and printing. Longworth's *American Almanack* for 1797 lists the partners as "Valdenuit & St. Memin, physiognotracists." Saint-Mémin must have also worked independently, for his name appears separately in the same publication as "Memin, Charles, St., engraver." During their partnership, Valdenuit made about 60 large profile portraits, most of which were engraved. Together the partners made a total of 145 portraits in New York, averaging 70 per year, a rate Saint-Mémin would maintain throughout his career. The partners also made and engraved at least five small silhouettes. Valdenuit must have learned engraving techniques from Saint-Mémin because he engraved two profile portraits after drawings by an artist named Grimaldi, presumably William Grimaldi, an English miniaturist of Genoese descent. Both are inscribed *Drawn by Grimaldi & Engraved by Valdenuit N.York* and dated 1797.

Within the partnership Valdenuit continued to execute the drawings, most of which he signed. They feature delicate parallel modeling lines.

Although his early style featured tight lines, like those encountered in Chrétien's work, it eventually broadened. Reportedly, only one engraving produced in the partnership was based on a drawing by Saint-Mémin. Inscriptions on the later engravings no longer distinguish between the two artists, giving equal credit to each.

After a little over a year, the partnership dissolved in September 1797, when Valdenuit returned to France to claim a family inheritance on the death of an uncle. Despite his careful planning, his name had been placed on the *Liste des Émigrés* because he had neglected to register his plans with the Département de la Côte d'Or, where he and his uncle had jointly owned the family estate. Fortunately, he succeeded in having his name removed by proving that the slave uprisings caused his departure from Guadeloupe in 1793. When Valdenuit returned to France Napoleon was in control, so the former military man abandoned the arts for a career in government administration. With Valdenuit's departure, Saint-Mémin became the sole operator of their physiognotrace operation, first finishing several orders begun under the partnership and then achieving widespread recognition as a solo portraitist.

Bibliography: René Hennequin, "Le Physiognotrace aux États-Unis (1793–1814). MM. de Saint-Mémin et de Valdenuit, Compatriotes de Quenedey," in *Un "Photographe" de l'époque de la révolution et l'empire. Edme Quenedey des Riceys (Aube), portraitiste au physiognotrace* (Troyes: Imprimerie de J.-L. Paton, 1926–27), 1:141–50; Alice Van Leer Carrick, *Shades of Our Ancestors: American Profiles and Profilists* (Boston: Little, Brown, and Company, 1928), 168–69; Emily (Mrs. F. Nevill) Jackson, *Silhouette: Notes and Dictionary* (New York: Charles Scribner's Sons, 1938), 150; Ellen G. Miles, "Saint-Mémin, Valdenuit, Lemet: Federal Profiles," in *American Portrait Prints: Proceedings of the Tenth Annual American Print Conference*, ed. Wendy Wick Reeves (Charlottesville: Published for the National Portrait Gallery, Smithsonian Institution, by the University Press of Virginia, 1984), 1–29; idem 1994, esp. 60–77.

Thomas Bluget de Valdenuit and Charles-Balthazar-Julien Févret de Saint-Mémin (cats. 25–27)

18. *Silhouette of an Unidentified Woman*, 1795

Black ink, gouache, and graphite on paper, commercially laid on thin card; 4 3/4 × 3 13/16 in. (121 × 96 mm)
Signed, inscribed, and dated below bust in brown ink: *V. nt & St. Memin, N.Y. 1795*.
Provenance: Edgar Sittig, Shawnee on Delaware, Pa., 1945.

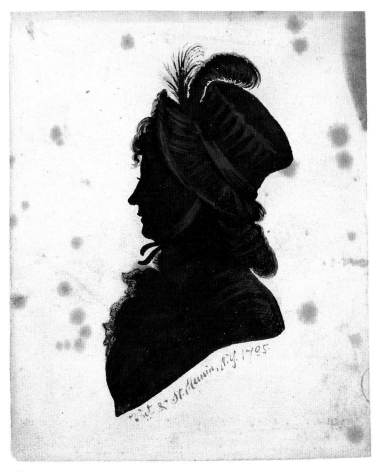

18

Bibliography: N-YHS 1974, 2:930–31, no. 2377, ill.
Louis Durr Fund, 1945.344

The evidence presented in this silhouette argues for a reconsideration of the partnership of Valdenuit and Saint-Mémin. The work is dated 1795, a year before Valdenuit is documented as a resident in New York City, although Hennequin believes he lived there immediately after his arrival in the United States from Guadeloupe.[1] Because its media are unique in the known oeuvres of the two artists, it may be an early collaboration. The silhouette is inscribed with an abbreviation of both artists' surnames, with Valdenuit's first to stress his seniority and his primary role as its draftsman. This order also agrees with what is known about their early working collaboration. Initially, the older Valdenuit seems to have been the driving force, especially as a draftsman. Documentary sources, such as an eyewitness account of John R. Livingston, and

the dates on Saint-Mémin's two earliest etchings (1796) suggest that in 1795 Saint-Mémin was not yet practiced in the technique of engraving, so it was natural for the two French expatriates to turn to the popular genre of silhouettes (in this case drawn and not cut) to earn money.

The five earliest known prints of the partnership are signed and inscribed *Drawn by Valdenuit & Engraved by St. Memin No. 11 Fair St. N. York*, while one of the two surviving drawings relating to this early group is signed by Valdenuit as the draftsman and dated 1796. The second form of their joint signatures and inscriptions, found on sixteen prints, reads *St. Memin & Valdenuit, No. 11 Fair Street, N. York*. Five original drawings related to these engravings exist, and three bear Valdenuit's signature. All ten of these works are in the Corcoran Gallery of Art, Washington, D.C.[2] This same collection includes five engraved silhouettes of unidentified sitters, four signed with the abbreviated surnames of

the partners, followed by the Pine Street address.[3] In a single example Valdenuit's name appears first (*V.nt. & St .M.*), and in three Saint-Mémin's does (*St. M. & Vt.*), which indicates that the latter formula eventually was adopted to recognize Saint-Mémin as the engraver and Valdenuit as the draftsman. All save the uninscribed silhouette of this group are dated by implication to 1797 because their inscriptions include the Pine Street address.[4] Each of these abbreviated signatures is a variation of the one on the Society's silhouette, whose form is tellingly closest to the example in which Valdenuit's name appears first. More important, the four signed works of the group in the Corcoran and the Society's silhouette are signed and inscribed in the same hand. Instead of a specific address the Society's silhouette has *N.Y.*, indicating that it probably was executed during the fledgling stage of the partnership and underlining its experimental, singular nature.

Like the Society's silhouette, the four women of the early engraved group in the Corcoran face left, whereas the single man faces right. The only unsigned example of this early group, the most decorative and delicately rendered, represents a female sitter wearing an elaborate, feathered bonnet similar to the one worn by the sitter of the Society's work. The proportions of this sitter's visage are closest to those of the Society's silhouette, whose nuanced modeling in lighter gouache, as well as the pen and ink and graphite drawing of the ruffles on her jacket, the bonnet's feathers, and her hair suggest the lighter, more refined draftsmanship of Valdenuit.[5] While this type of detailed "painted" work embellishing the simple profile is labor-intensive, it is not uncommon in painted, as opposed to cut, silhouettes.

Taking into account the group in the Corcoran, the Society's unusual drawn silhouette by Valdenuit and Saint-Mémin documents an early collaboration between the pair in New York City before they had firmly established their partnership and first residence at 11 Fair Street in 1796. Its inscribed date also pushes forward Valdenuit's recorded presence in the city, populated with French émigrés, and helps fill the two-year gap between his arrival in America (1793) and his established residency in Baltimore (1795).

1. Hennequin 1926–27, 1:145.
2. Miles 1984, 10. The Corcoran Gallery of Art holds 833 Saint-Mémin engravings that can be traced back to the artist's heirs.
3. See Miles 1994, 411, no. 851, ill., 416, nos. 884–87, ills. See also Carrick 1928, 169.
4. Miles 1994, 72, 74.
5. For Valdenuit as an artist, see Hennequin 1926–27, 1:141–50.

SAMUEL FOLWELL

Burlington, New Jersey 1764–Philadelphia, Pennsylvania 1813

In the early eighteenth century Samuel Folwell's ancestors settled in Burlington, New Jersey, a Quaker community. He began his career advertising himself as an itinerant painter, silhouettist, hair worker, limner, drawing master, and engraver. He was patronized by New Yorkers (William Dunlap in his *A History of the Rise of the Arts of Design* wrote that Folwell "was in New York in 1790"), Philadelphians, and residents of other eastern cities. Folwell had joined the Philadelphia militia as an ensign in 1789 and married Ann Elizabeth Gebler, although he did not settle permanently in Philadelphia until he opened an art school with his wife in 1793, for which he advertised extensively. In a shift away from the Society of Friends—which would not have approved of his neoclassically oriented mourning art and the luxury objects for which he is known—he, at age thirty-eight, and his children were baptized in the First Reformed Church of Philadelphia. In 1796 he exhibited two of his portraits at the Columbianum or American Academy of Paintings, Sculpture, Architecture, etc., the institution created by Charles Willson Peale for annual exhibitions. His mourning works were influenced by the customs of German immigrants to Philadelphia and the cult of mourning precipitated by George Washington's death in 1799. Many of these works repeat stock iconographies derived from European prints and objects. Folwell also executed silhouettes of Washington, including

Fig. 19.1. Attributed to Samuel Folwell, *The Drawing Class*, 1810–13. Watercolor and black ink on paper, 14 5/8 × 23 5/8 in. (371 × 600 mm). The Art Institute of Chicago, Gift of Mrs. Emily Crane Chadbourne, 1951.202 (Photography © The Art Institute of Chicago)

at least one from life (examples are in the Historical Society of Pennsylvania and the N-YHS).

Recent scholarship has resurrected Folwell's important contribution to the education of American women. He was both a drawing master and a designer of embroidery patterns. The often-published watercolor of a drawing class (fig. 19.1) probably depicts Folwell with some of his students. His needlework pictures, in graphite and paint, were worked by students in his wife's school. Many of these were poetic memorials set in Arcadian scenery or representations with a moral theme in line with the millennial sentiments of the time. Although mourning subjects predominate, Folwell also designed allegorical compositions, literary vignettes, bucolic tableaux, and family portraits. In addition, compositions on ivory can be attributed to Folwell, based on their resemblance to his work on schoolgirl embroideries and an ivory backed with his trade card, as well as an etching.

Folwell traveled to sell his needlework patterns. An advertisement in the Charleston *Times* on 24 April 1805 informed Charlestonians that Folwell had on hand "[d]rawings on silk and satin for young Ladies, done agreeably to the newest fashions in the first schools of Philadelphia, and all other capital towns in America, upon the utmost reasonable terms." This suggests that Folwell, who stayed only briefly in cities other than Philadelphia, sold his needlework patterns with their backgrounds already painted, instead of completing them after the needleworker had done her part, as was his practice in Philadelphia.

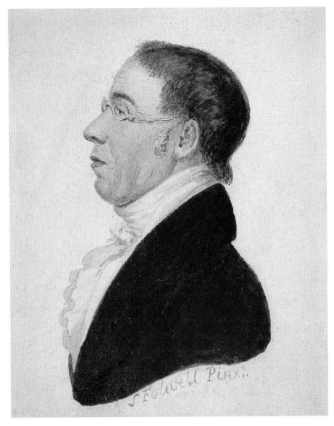

19

A fair body of work has now been attributed to him. In addition to being the only American artist whose patterns for schoolgirl compositions have been identified, Folwell is also the only American miniaturist whose body of memorials, fancy pieces on ivory, and now drawings has been identified as a group. An example of his work as a miniaturist, a portrait of John Jones, M.D. (1729–1791), is also in the Society's collection, signed, dated (25 May 1790), and inscribed as painted in New York City (see below).

Bibliography: Anita Schorsch, "A Key to the Kingdom: The Iconography of a Mourning Picture," *Winterthur Portfolio* 14:1 (1979): 41–71; Davida Tenenbaum Deutsch, "Samuel Folwell of Philadelphia: An Artist for the Needleworker," *The Magazine Antiques* 119:2 (1981): 420–23; Eleanor H. Gustafson, "Collectors' Notes," *The Magazine Antiques* 128:9 (1985): 526–27; idem, "Collectors' Notes,"

The Magazine Antiques 130:10 (1986): 646–47; idem, "Collectors' Notes," *The Magazine Antiques* 135:3 (1989): 618, 620, 624; Betty Ring, *Girlhood Embroidery: American Samplers and Pictorial Needlework, 1650–1850* (New York: Alfred A. Knopf, 1993), 2:378–84; Robin Jaffee Frank, *Love and Loss: American Portrait and Mourning Miniatures* (New Haven: Yale University Press, 2000), 110–11, 121–22, 136–38.

19. *Self-Portrait (1765–1813)*, c. 1790–95

Watercolor, black ink, and graphite on paper; 5 3/8 × 4 5/8 in. (137 × 117 mm)
Signed below bust in brown ink: *S. Folwell Pinx.*[1]
Provenance: Norvin H. Green Collection, New York; Parke-Bernet Galleries, New York, 1955.
Bibliography: Parke-Bernet Galleries, New York, sale cat., 15 October 1955, lot 272; N-YHS 1974, 1:269, no. 681, ill.; Schorsch 1979, 57–58, fig. 21; Gustafson 1989, 620, ill.; Ring 1993, 2:378, fig. 405.
Necarsulmer Fund, 1955.98

Folwell showcases his skills as a silhouettist and miniaturist in this small profile bust portrait in a rectangular format. Although miniatures in profile by Folwell are unusual, as mentioned above the N-YHS holds one, *John Jones, M.D. (1729–1791).*[1] The identification of the present work as a self-portrait can be traced back to the auction catalogue of the Norvin H. Green sale at Parke-Bernet Galleries in 1955.

For artists, the making of self-portraits offered a free model and an artistic challenge, an opportunity to study both the inward and the outward landscape of the self.[2] The identification of this work as a self-portrait classifies it a tour de force, for it could only have been accomplished with the aid of two mirrors (any realistic self-portrait by definition implies the use of one).[3] Self-portraits in profile are fairly rare, although

they do exist, such as the one from 1758 by the English artist William Hogarth showing himself seated at the easel painting the Comic Muse.[4]

The visual evidence provided in figure 19.1 reinforces the conclusion that this watercolor is indeed a self-portrait of Folwell.[5] This scene of an early-nineteenth-century drawing class probably shows Folwell, at the far right, with his students engaged in drawing. Previous attempts to identify the master of this drawing class have been unsatisfactory. Among the candidates are John Rubens Smith or Archibald or Alexander Robertson (cats. 21 and 29, respectively), whose visages bear no resemblance to the man portrayed in the work.[6] Certainly the teacher's facial features, as well as his oval spectacles, are nearly identical to those of the sitter in the present sheet. Only the drawing instructor's graying hair suggests that the present sheet predates the highly significant classroom scene. A story by Eliza Little, published in Philadelphia in 1835, entitled "The Set of China," may, in part, describe the Folwells' school and the kind of regimen established in it, which included the portfolio of prints to be used as a design source.[7] In the atelier,

women work at drawing stands with wood paint boxes positioned nearby; a stretching frame holding paper for a watercolor leans against the left wall, while other mechanical devices to aid the student are placed around the room, including T squares for making grids or for drawing borders, a mirror, and dark curtains and shutters to direct the light. The placement of the tables at right angles was based on academic concepts of the ideal illumination in which to render a form in volume.[8] Until about 1840 a watercolorist's equipment, used by professionals and amateurs alike, was geared for use in the studio. After that time, with the development of portable media and a broader interest in plein air drawing, various devices helped to change watercolor more profoundly than any other medium during the nineteenth century.[9] Additional information about Ann Folwell's school of embroidery, where her husband taught drawing, is found in an advertisement of 18 September 1813 in the Philadelphia newspaper *Poulson's American Daily Advertiser*.[10]

1. N-YHS 1941, 164, no. 413, ill.; and N-YHS 1974, 1:408, no. 1072.

2. In the copious literature on the topic, see Pascal Bonafoux, *Portraits of the Artist: The Self-Portrait in Painting* (New York: Rizzoli, 1985).
3. An interesting example and commentary on the genre is the self-portrait by Johannes Gump (1646) in which he wittily represents himself from the back engaged at the easel painting his own visage by gazing into a trapezoidal mirror containing his reflection. Gump painted his own face twice, although his eyes are positioned differently in each image; see ibid., 22, ill.
4. Ibid., 80, ill.
5. Shelley 2002, 62, fig. 35, reproduces the watercolor as attributed to an unidentified artist. Priddy 2004, 24, fig. 50, attributes it to Folwell.
6. Gustafson 1989, 616.
7. Ibid.
8. Shelley 2002, 62.
9. Ibid., 64.
10. Cited by Deutsch 1981, 422. See also idem, "The Polite Lady: Portraits of American Schoolgirls and Their Accomplishments, 1925–1830," *The Magazine Antiques* 135:3 (1989): 742–51.

ROBERT FULTON

Little Britain, Pennsylvania 1765–New York, New York 1815

Famous for his engineering skills and celebrated as an inventor, Fulton was born on a farm in Lancaster County in the township of Little Britain (now Fulton), Pennsylvania. Even as a child he manifested an aptitude for mechanics, an interest that surfaced later in life. Best known for his work on steam-powered boats—bringing them from the experimental stage to a commercial success with the construction of the *Clermont*, in partnership with Chancellor Robert R. Livingston—and his advocacy of submarine warfare, Fulton began his adult life as a professional artist in Philadelphia, painting miniatures, portraits, and landscapes, as well as creating intricate compositions in hair. In 1786 the ambitious Fulton sailed for London, where he studied painting under the aegis of Benjamin West. Suffering from a prolonged adolescence, Fulton frequently depended on the

kindness of others, notably that of the Wests, who remained his lifelong friends. Eventually Fulton exhibited his work at the Royal Academy of Arts and the Royal Society of British Artists in London, although he quickly lost interest in a promising but passionless art career. Motivated by a need to make a mark, the opportunistic Fulton soon turned to the cutting-edge fields of mechanics and engineering, although he drew and painted his entire life.

While in England, the perennially idealistic Fulton fell under the spell of two burning technological issues: canal construction and steam-powered vessels. Responding to England's severe case of canal fever, Fulton advocated a series of small canals with inclined planes. Even though the inclined plane was not new, he received an English patent on his improved design in 1794 and published a canal

treatise in 1796 with seventeen plates that he designed and engraved (*A treatise on the improvement of canal navigation*). Unable to obtain funding in England, he crossed the Channel for France after the 1797 armistice between the two countries to raise money for his canal project. He remained in the intellectual crucible that was Paris until 1804 associating with its movers and shakers, Americans abroad as well as French *citoyens*. The youthful painter John Vanderlyn, who executed Fulton's portrait (cat. 31), was among those expatriates, as were the wealthy and well-connected Ruth (Baldwin) and Joel Barlow in whose household Fulton resided for seven years. Brimming with ideas, Fulton painted and patented Paris's first panorama (a bird's-eye view of the city), designed and tested the *Nautilus* (his prototype of a submarine, trying to sell it first to the French and then to the

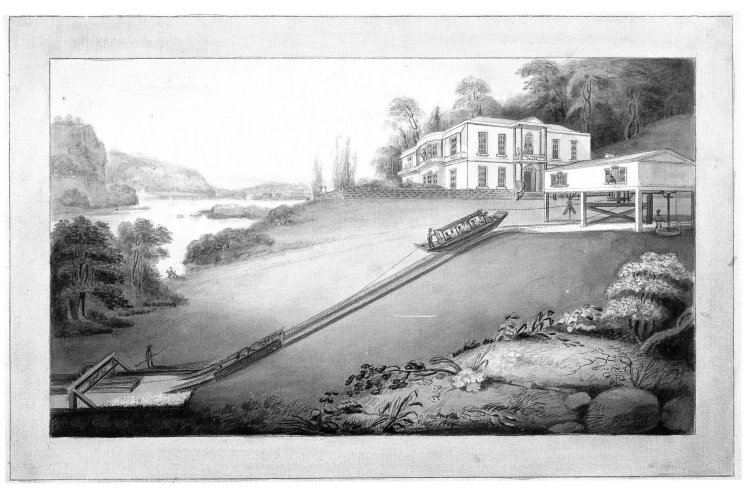

20

British), and worked on a steam-powered boat. He also met his future partner, the distinguished statesman and minister plenipotentiary to France, Robert Livingston.

Back in London in 1804, Fulton advanced his ideas to the British government about submersibles that could carry explosives, although two raids against the French using his novel craft were unsuccessful. After Nelson's victory at Trafalgar, Britain's control of the seas negated the government's interest in Fulton's temperamental weapons, and he turned instead to the development of steam-powered boats.

When Fulton returned to the United States in 1806 (fig. 20.1), he settled in New York City and formed a partnership with Livingston. Together they developed the *North River Steamboat of Clermont*, renamed several times but finally shortened to the *Clermont*, the first successful commercial steamboat, whose epic trial run on the Hudson River round-trip from New York to Albany (150 miles each way) took place in mid-August 1807. Instead of the four

days required by sailing sloops, one way took only thirty-two hours. Fulton, who continued to perfect his steamboats, married Harriet Livingston, niece of Livingston, in 1808 and attempted to interest the U.S. government in a submarine. A member of the 1812 commission that recommended building the Erie Canal, Fulton insisted that the world's first steam warship be built to protect New York Harbor against the British fleet. The *Demologus*, or *Fulton*, was successfully tried at sea but never used in battle. Before his untimely death from a respiratory infection, Fulton spent much of his wealth and later career in litigations involving the pirating of patents related to steamboats and in trying to suppress rival steamboat builders who found loopholes in his state-granted monopoly.

Bibliography: Cadwallader D. Colden, *The Life of Robert Fulton by his friend Cadwallader D. Colden* (New York: Kirk & Mercein, 1817); H. W. Dickinson, *Robert Fulton, Engineer and Artist, His Life and Works* (London: John Lane, 1913); John S. Morgan, *Robert Fulton* (New York: Mason/Charter, 1977); Philip 1985; Carrie Rebora, "Robert Fulton's Art Collection," *American Art Journal* 22:3 (1990): 40–63; Kirkpatrick Sale, *The Fire of His Genius: Robert Fulton and the American Dream* (New York: Free Press, 2001).

20. *Double-Inclined Plane with Boat Carried to an Upper Canal Level*; verso: mechanical detail drawings, 1797

Black ink and wash and graphite with scratching-out on card; graphite; 10 3/8 × 15 7/8 in. (264 × 403 mm)
Signed and dated at lower right in black ink: *Rob. Fulton / May 1797*; verso inscribed at upper left in black ink: *The figures in the Boat to be / made perpendicular to the horizon / And the perspec Of the Lower Canal / Corrected ie. The Lower Canal to / be made parallel to the horizontal line R. F. —*; at lower left in graphite: *Rods extending from the Fans to / Regulate the Water on the Wheel / ABC may be marked In the / engraving. / The new outline will do / Very well…* [illegible]
Provenance: Randall J. LeBoeuf Jr., Old Westbury, N.Y.
Bibliography: Koke 1982, 2:54–55, no. 1069, ill.; Roberta J. M. Olson, "Fulton at the Fulcrum: A Search for Identity," *New-York Journal of American History* 4 (Fall 2004): 133–39, fig. 1.
Bequest of Randall J. LeBoeuf Jr., 1976.60

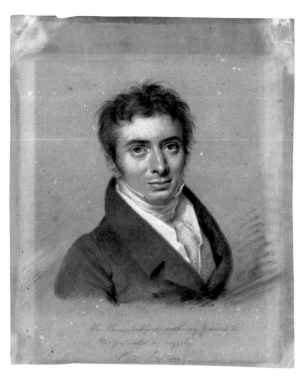

Fig. 20.1. Robert Fulton, *Self-Portrait (1765–1815)*, c. 1805–15. Conté crayon(?), gray wash, black, white, and pink chalk, and white gouache on brown paper, 9 7/8 × 7 15/16 in. (251 × 201 mm). The New-York Historical Society, Gift of Fulton Cutting, 1967.48

This sheet belongs to the LeBoeuf Bequest, an extraordinary cache of Fulton material that spreads across in many of the N-YHS collections. In its time considered the finest collection of Fultoniana in private hands,[1] it crowns the Society's earlier outstanding Fulton holdings. The work is one of the Society's two drawings by Fulton dating from 1797 that demonstrate his early involvement with canals, specifically the operation and mechanisms of the double-inclined plane. Fulton advocated a series of small canals to lower construction costs and speed up transport. He proposed to substitute either inclined planes, along which the boats might be drawn on rails, or vertical lifts to overcome differences in levels, especially where water was scarce. More than likely, Fulton executed these two sheets in support of his application for a canal patent in France.[2] They represent a later variation and refinement of the second plate in his 1796 treatise illustrating the double-inclined plane,[3] whose preparatory watercolors date from 1794–95.[4]

Fulton began preparing the French patent application soon after he arrived in Paris and also embarked on a heady ménage à trois with the wealthy and urbane Barlows, which lasted for the seven years he lived with them. While this childless, slightly older American couple

functioned as a surrogate family for young Fulton, he served as the emotional fulcrum of their relationship.[5] The survival of these drawings is important because much of Fulton's material from his Parisian period was lost when the vessel transporting his effects sank; even though his waterlogged case of papers was recovered after several months, much of its contents was unsalvageable.[6] One surviving portrait by Fulton from the time is the eerily charming watercolor of Charlotte de Villette (fig. 20.2), the recently deceased daughter of the trio's rue de Vaugirard neighbor, the Marquise Reine-Philiberte de Villette (Voltaire's adopted daughter, known as Bonne et Belle, and an intermediary for Talleyrand in the XYZ Affair).[7]

In a bid for patronage for his canal projects, Fulton began sending copies of his canal treatise to various individuals, among them Napoleon Bonaparte. In 1798 Fulton prefaced a leather-bound presentation copy of *A treatise* with a letter to Napoleon in French.[8] Fulton's hand-written notes in the printed text prove that he revised his ideas for his French patent, which was granted in early 1798.

Fulton's full-page illustrations for the patent application in the French Patent and Trademark Office in Paris are similar—in

format, media, and content, albeit executed in a more summary style—to the present drawing and its pendant. For example, the two sections of the pendant to catalogue 20 are repeated nearly verbatim on two separate plates (15 and 16) of the patent application manuscript. The upper section of plate 16 also resembles the present work.[9] One of France's administrators of inland navigation and an author of works on canals translated Fulton's canal treatise and published it in a smaller French quarto edition.[10]

The present drawing, dated May 1797 and executed immediately before Fulton left England for France in June 1797,[11] represents his refinements for the patent he intended to pursue in Paris. Importantly, the country house, which looks British, bears an inscription in English on the baluster of the second-floor porch: *THE INCLINED PLANE*. Not coincidentally, Fulton has rendered the country setting in a grisaille style like that which was practiced by contemporary British watercolorists. Fulton inscribed only the year on the pendant, which is even closer to the French patent application drawings suggesting that he may have drawn it in France.

As Fulton's engineering career gradually solidified, his early training as an artist was not wasted, since visual presentations became Fulton's major marketing tool. They enabled him to test his concepts without spending the time and money necessary for working models, giving him an advantage over inventors who were not draftsmen.[12] The Society's drawing and its pendant are related to a fascinating group of six canal navigation drawings, found at the Russian fortress of Swearbourg in 1855, each signed and dated 1799 by Fulton, and now in the Society's Department of Manuscripts. Fulton had presented these condensations of the plates in the English canal treatise to Augustin de Betancourt, a Napoleonic officer in the corps of engineers in Russia.[13] As presentation drawings, they were intended to encourage Betancourt to implement Fulton's canal schemes in the French empire.

Like them, the present drawing and its pendant served as Fulton's persuasive visual aids for presentations—the PowerPoint of the time—to win an audience's support for his project. Their large formats, together with the card on which they are executed, argue for this function. In his realization of the profound power of visual images, Fulton, an American visionary, was in the

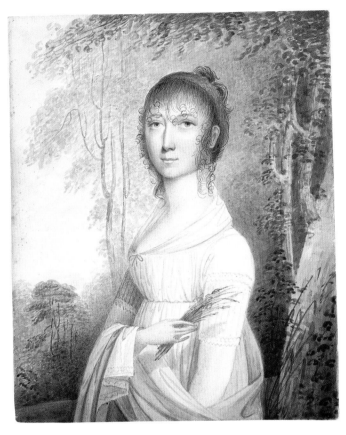

Fig. 20.2. Robert Fulton, *Charlotte de Villette (d. 1802)*, 1802. Watercolor, gray wash, and Conté crayon on paper wrapped over board (a commercially prepared tablet), 7 3/8 × 5 7/8 in. (187 × 149 mm). The New-York Historical Society, Bequest of Randall J. LeBoeuf Jr., 1976.14

vanguard of his era, an age enamored of visual spectacles like panoramas and magic lanterns.[14]

1. Its riches range from manuscripts (letters, patents, and unpublished texts) to furniture, paintings, prints, drawings, medals, ceramics (many examples of transferware), glass, miniatures, and so forth. See Randall J. LeBoeuf Jr., *Some Notes on the Life of Robert Fulton* (New York: South Street Seaport Museum, 1971).

2. The other is inv. no. 1976.61, in black ink and wash on card, 10 1/4 × 15 3/4 in. It is signed and dated at middle right in black ink: *Rob. Fulton / 1797*. See Koke 1982, 2:55, no. 1070; and Olson, "Fulton" 2004, fig. 2.

3. *A treatise on the improvement of canal navigation: exhibiting the numerous advantages to be derived from small canals … by R. Fulton, civil engineer* (London: I. and J. Taylor at the Architectural Library, High Holborn, 1796). The Society's library holds two copies.

4. Fulton's black ink and wash and watercolor preparatory designs are laid on sheets bound into a copy of *A treatise* (ibid.). This volume was in the collection of Stephen Whitney Phoenix until it was bequeathed in 1886 to the Rare Book and Manuscript Library of Columbia University. The sheets are the same size as the engraved

illustrations. The two preparatory illustrations for plate 9 are dated 1795 and 1794, respectively, suggesting the gestation period for Fulton's treatise.

5. See Olson, "Fulton" 2004, 133–39.

6. Colden 1817, 12.

7. According to Philip 1985, 127–28, when Barlow delivered Fulton's portrait to her grieving mother, he could not resist adding his own verses on the back, because, as he wrote Fulton, "I like to have your works and mine together." The brown paper that once sealed the reverse of the commercially prepared tablet bearing Charlotte's likeness, where Barlow's penned lines would have been added, has been removed. See also Olson, "Fulton" 2004, 156, fig. 4.

8. In the Rare Book Room of the NYPL. A transcription of his handwritten texts are published in "Robert Fulton on Canals for France and on Freedom of Trade, 1798," *New York Public Library Bulletin* 5 (1901): 348–65. It was formerly in the collection of Charles de Récicourt, the translator of the French edition of his canal treatise. See n. 10 below.

9. A summary of the patent was later written by the director of the Conservatoire Royal des Arts et Métiers and published (with summary engravings and with variations) in the collection *Description des machines et procédés spécifiés dans les brevets d'invention, de perfectionnement et d'importation, dont la durée est*

expirée (Paris, 1820), 4:207–23, pls. 16–21.

10. *Recherches sur les moyens de perfectionner les canaux de navigation*, trans. Charles de Récicourt (Paris: Dupain-Triel [et] Bernard [Imprimerie de Digeon], 1799). It contains only seven simplified, albeit larger, plates (not by Fulton) and other modifications, including specific projects for France in hopes that Fulton would serve as that country's official engineer. The National Union Catalogue cites, without a publication place or date, a single copy of another title on canals by Robert Fulton (*Supplement aux reflexions sur le système des petits canaux*) in the American Philosophical Society Library, Philadelphia. It appears to be a supplement to the French edition of 1799, starting with p. 225; the French edition ended on p. 224.

11. Philip 1985, 62.

12. Philip (ibid., 38) states that Fulton's drawings, together with his verbal descriptions, conveyed an impression that his machines were already in operation. See also Eleanore J. Fulton, "Robert Fulton as an Artist," *Papers Read before the Lancaster County Historical Society* 42:3 (1938): 49–95.

13. Executed in black ink and wash and graphite, the large-format, albeit abbreviated, drawings were secured from a nephew of Betancourt and presented to the Society in 1856.

14. See Barbara Maria Stafford, *Artful Science: Enlightenment Entertainment and the Eclipse of Visual Education* (Cambridge, Mass.: MIT Press, 1994); and Roberta J. M. Olson and Jay M. Pasachoff, *Fire in the Sky: Comets and Meteors, the Decisive Centuries, in British Art and Science* (Cambridge: Cambridge University Press, 1998).

ARCHIBALD ROBERTSON

Monymusk, Scotland 1765–New York, New York 1835

Archibald Robertson, the eldest son of the Scottish architect and draftsman William Robertson, attended King's College in Aberdeen and in 1782 was in Edinburgh, studying art with Henry Raeburn, among others. In 1786 he went to London for further study at the Royal Academy of Arts, receiving instruction from Sir Joshua Reynolds and Benjamin West. A draftsman, miniaturist, and portrait painter, Robertson became such a success in London that he was dubbed "the Reynolds of Scotland." Returning to Aberdeen, he established a drawing academy and accepted pupils. Soon a group of prominent New Yorkers, including Chancellor Robert R. Livingston, invited him to come to America to establish an academy in their city. Armed with a com-

mission from the Earl of Buchan to deliver to General Washington in Philadelphia a box made of wood from the oak tree that sheltered Sir William Wallace after the battle of Falkirk, Robertson left for the United States in 1791. At the earl's request he also painted a portrait of George Washington. Over a period of about five years, Robertson executed two miniatures, one on marble (1791; The N-YHS) and the other on ivory, as well as oil portraits of Washington and other members of his family.

In 1792 his younger brother, Alexander Robertson (cat. 29), joined him in New York, where together they founded the seminal Columbian Academy of Painting, housed at 79 Liberty Street, which instructed both "Ladies and Gentlemen" in "Drawing and painting in water colours, chalks,

&c, on paper, tiffany, silks, &c.; history devices, heads, figures, landscapes, flowers … architecture and perspective, &c." One of the first art schools in the United States, it was modeled on European drawing academies, with a curriculum in which its students studied from plaster casts and prints before turning to nature. While most of their students were amateurs, some professional artists studied at the Columbian Academy, among them John Vanderlyn (cat. 31). Although Archibald worked primarily as a drawing master at the academy, he also collaborated with his brother to produce watercolors and drawings of American landscape scenes, some of which Francis Jukes replicated in aquatints and printed in London. In 1794 Archibald married Eliza Abramse (1776–1865), also an artist and heiress of a Dutch patroon

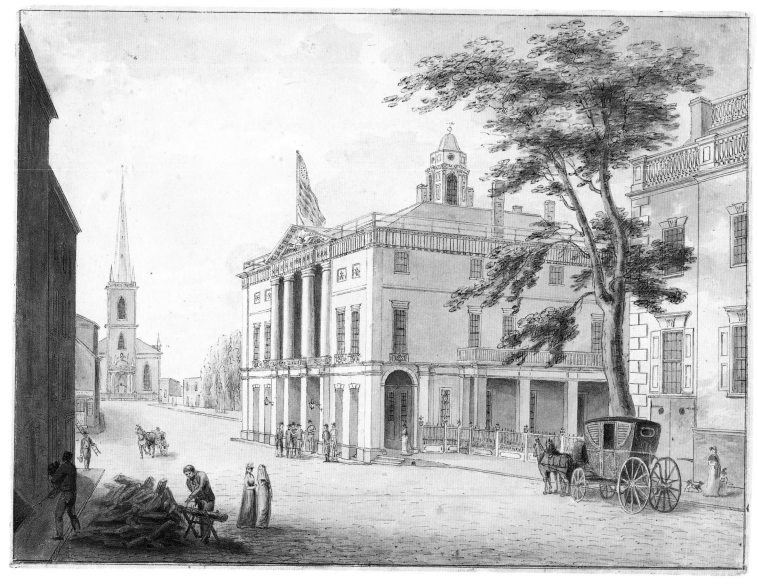

21

fortune; the couple had ten children, including the eldest son, Andrew James, who may have assisted his father on occasion.

In New York, Archibald continued to paint portraits (the N-YHS holds a number of miniatures given to him) and worked as an amateur architect. He championed a generalized approach to nature and was heavily influenced by the Reverend William Gilpin's and William Payne's writings on the picturesque. Around 1800 he wrote an unpublished treatise, "On the Art of Sketching," whose manuscript is in a private collection. Archibald Robertson published two instructional books on art, one a manual for his students, *Elements of the Graphic Arts* (1802), which also provided a short history of art in addition to practical rules for figure and landscape drawing, and *Treatise on Miniature Painting* (1808).

In 1802 the brothers ended their partnership because of a personal dispute, and Archibald managed the school alone, while Alexander opened his own academy. Advertisements published by both brothers suggest a rivalry between their two schools. In 1816 Archibald exhibited for the first time at the newly revived American Academy of the Fine Arts (est. 1802). He was a founder academician and served on its board of directors from 1817 to 1833. In his autobiographical manuscript (The Rosenbach Museum and Library, Philadelphia) Archibald wrote that he continued painting only until 1821, when he focused on literature. However, Longworth's New York City directories list the Columbian Academy through 1823. As a practitioner and teacher, Archibald Robertson, like his brother, played an important role in the transmission of English styles of portraiture and topographical drawing in the United States.

In addition to teaching, Archibald Robertson was active in public affairs and in 1825 was involved in the celebration marking the opening of the Erie Canal, designing the official badge and medal for the occasion. In his later years, he lost his eyesight, a tragedy for an artist, and died suddenly, survived by ten children.

Bibliography: Archibald Robertson, *Elements of the Graphic Arts* (New York: David Longworth, 1802); Emily Robertson, ed., *Letters and papers of Andrew Robertson, miniature painter … also a treatise on the art by his eldest brother, Archibald Robertson* (London: Eyre and Spottiswoode, 1895), 157–64; Mrs. J. Warren Winslow Goddard, "Archibald Robertson, the Founder of the First School of Art in America," *New York Genealogical and Biographical Record* 51:2 (1920): 130–37; John E. Stillwell, "Archibald Robertson, Miniaturist, 1765–1835," *New-York Historical Society Quarterly* 13:1 (1929): 1–33; New York, Kennedy Galleries, "A. & A. Robertson, Limners," in *American Drawings, Pastels and Watercolors: Part One, Works of the Eighteenth and Early Nineteenth Centuries*, sale cat. (New York: Kennedy Galleries, 1967), 14–27; Stebbins 1976, 52–54; Nygren et al. 1986, 286–88; Myers 1987, 178–80; Megan Holloway Fort, "Archibald and Alexander Robertson and Their Schools, The Columbian Academy of Painting, and The Academy of Painting and Drawing, New York, 1791–1835" (Ph.D. diss., City University of New York, 2006).

21. *View up Wall Street with City Hall [Federal Hall] and Trinity Church, New York City*, c. 1798

Watercolor, black ink, and graphite on paper; 8 1/2 × 11 1/4 in. (216 × 286 mm)
Inscribed at lower left in graphite: *by Robertson / Drawn in 1798*; former mount reputedly inscribed at lower center: *Old Town Hall, New York*
Provenance: David Grim, New York; Sophia Minton, New York.
Bibliography: Richard W. G. Vail, *Knickerbocker Birthday: A Sesqui-Centennial History of The New-York Historical Society, 1804–1954* (New York: New-York Historical Society, 1954), 31, ill.; Koke 1982, 3:100–101, no. 2404, ill.; Olson 2004, 28, fig. 7.
Gift of Sophia Minton, granddaughter of David Grim, 1864.14

Archibald Robertson's view up Wall Street toward Trinity Church features at the right New York's second City Hall after its transformation into Federal Hall.[1] Located at the corner of Wall and Nassau streets (26 Wall Street), the original structure was built by Dutch settlers in 1699. When the United States Congress, organized under the Articles of Confederation, moved to New York City in 1785, it took up residence in City Hall alongside the municipal government. In 1789–90 the engineer and architect Pierre-Charles L'Enfant, who had fought for the colonists during the American Revolution and later designed the grand plan for Washington, D.C., transformed City Hall into Federal Hall. The structure became the exclusive site of the new federal government, serving as the first capitol building from 1789 to August 1790, when the capital was moved briefly to Philadelphia, and Federal Hall reverted again to City Hall. The completed project, rumored to have cost $65,000, received high praise. On the balcony of this historic building, George Washington was inaugurated as the first president of the United States on 30 April 1789. The structure was also the first home of the New-York Historical Society (1804–9). Demolished in 1812, it was replaced by the United States Custom House built in 1842 (now the Federal Hall National Memorial), a Greek Revival-style building designed by the firm of Town and Davis.[2]

At the left of his view Robertson included Trinity Church, the second "Gothic" church completed in 1790 to replace the building ruined in the devastating fire of 1776. The taller steeple of the reconstructed church faced Wall Street and not west toward the Hudson River, as did the steeple of the first structure. The house seen at the far right is the mansion built by the Verplanck family in 1757.[3] An engraving from 1791–93 by Cornelius Tiebout shows Federal Hall from nearly the same vantage point on Wall Street but without the American flag unfurled above its pediment.[4]

Robertson's technique is allied to the early phase of English watercolors, when they resembled drawings that were tinted with color after their completion, rather than constructed with color from the beginning.[5] Stylistically, the watercolor is very close to the draftsmanship of Thomas Sandby and his brother Paul, the former being the British draftsman who exerted the greatest influence on artists working in America during the late eighteenth and early nineteenth centuries. Given the pastel palette, delicate draftsmanship, proportions of its figures and architecture, and emphasis on perspective of this drawing, Robertson more than likely knew Sandby's work.[6] A sheet by Sandby depicting the Piazza of Covent Garden in London with a carriage delineated like the one in the Society's sheet makes the stylistic connections clear.[7] Sandby was renowned for his "perspective views," which he promulgated in six annual lectures, beginning in 1770, illustrated by his own drawings, as the first Professor of Architecture at the Royal Academy in London (where Archibald Robertson studied). Sandby urged artists to render buildings from the side rather than from the front, as Robertson has done in the Society's sheet, which also features a diminishing perspective for the street. Additional evidence of Robertson's connection with Sandby is furnished by his other perspective drawings in the Society's collection.[8]

1. The first City Hall, the *stadt huys*, was created in 1653 in a preexisting tavern. The first structure built as City Hall was finished in 1700. Stokes 1915–28, 1:538–39.

2. There are several relics of Federal Hall and its furnishings in the Society's collections. Notable among them is a section of the wrought-iron balustrade with a cluster of thirteen decorative arrows symbolizing the thirteen original states (inv. no. 1884.9); see N-YHS 2000, 76–77, ill.

3. Deák 1988, 1:122, no. 184.

4. The print is inscribed *C. Tiebout Delineate & Sculpsit*. See ibid., 122–23, nos. 184, 185; 2: ills. The latter is a lithograph of 1879 after the engraving.

5. See Shelley 2002, 47.

6. See also Jane Roberts, *Views of Windsor by Thomas and Paul Sandby from the Collections of Her Majesty Queen Elizabeth II*, exh. cat. (London: Royal Collection, in association with Merrell Holberton Publishers, 1995); as well as Adolf Paul Oppé, *The Drawings of Paul and Thomas Sandby in the Collection of His Majesty the King at Windsor Castle* (Oxford: Phaidon Press, 1947).

7. Inv. no. 92.029, Wheaton College Collection, Norton, Mass. See Roberta J. M. Olson, ed., *The Art of Drawing: Selections from the Wheaton College Collection*, exh. cat. (Norton, Mass.: Watson Gallery, Wheaton College, 1997), 17, no. 5, ill.

8. See Koke 1982, 3:101–4, nos. 2405–11, esp. inv. nos. 1864.15, 1864.16, 1947.450, 1885.4 (a panoramic view of New York City seen from New Jersey, across the river, on five sheets of paper).

CATHARINE VERPLANCK

East Fishkill, New York 1765–Red Hook, New York 1833

Catharine Verplanck was born on the family estate in East Fishkill, New York, to Philip Jr. and Aefje Beekman Verplanck. Research has found nothing on her early life and education.

In 1786 she married Herman Hoffman of nearby Red Hook, New York, and together they had five children. Catharine Verplanck Hoffman died in May of 1833.

Bibliography: Koke 1982, 3:217–18.

22. *A View of Verplanck's Place, East Fishkill, New York*, 1783

Black ink and wash and graphite on paper, laid on Japanese paper; 10 × 14 1/4 in. (254 × 362 mm)
Signed and dated at lower center outside image in brown ink: *Catharine Verplanck FECIT AD 1783*; inscribed at upper center: *A view of Verplanck's place at Fish Kill.*
Watermark: Garden of Holland with seated Maid of Dort [Dordrecht] facing right and holding a hat on the point of a spear and a rampant lion facing right brandishing a scimitar and bundle of arrows, enclosed in a picket fence, below ITMIDDELINK, at right PRO PATRIA; GR, crowned
Provenance: Childs Gallery, Boston, 1971.
Bibliography: Koke 1982, 3:217–18, no. 2669, ill.
Abbott-Lenox Fund, 1971.3

Catharine Verplanck drew this naïve view of the Verplanck family homestead in East Fishkill before her marriage in 1786. The homestead was part of the 85,000-acre parcel of land purchased by the fur traders Gulian Verplanck and Francis Rombout in 1683 from the Wappinger Indians.[1] In 1708 the land was partitioned into three sections. The Verplancks retained the middle parcel, which included ponds, woodlands, rolling meadows, and cultivated farmland. During the first half of the eighteenth century, Gulian Verplanck built a house overlooking Newburgh Bay on the Hudson River, named Mount Gulian,[2] together with a gristmill and a sawmill on the west bank of Sprout Creek, which ran through the estate. The mill rapidly developed into a major commercial center for local farmers, prompting the construction of the road seen receding into the distance at the center of the drawing. The road led to docks and a storehouse on the Hudson River at Farmers' Landing.[3]

By 1757 Gulian's nephew Philip Verplanck Jr. was managing the mill business. Philip built his home on the east bank of Sprout Creek near the mill. The stones and bricks of the house, seen at upper left, were laid in the Flemish bond pattern; black bricks in the west gable formed the construction date of 1768. The house featured a gambrel roof sloping in a graceful bell curve, front and rear dormers, and the oval window visible in this view.[4] The main entrance of the house was noted for its paneled, divided door hung on iron strap hinges, punctuated with two large, slanted, oval, bull's-eye windows.[5] The central hall had a carved arch and wainscoting. Verplanck also depicted the mill house with its dam and bridge over Sprout Creek.

Verplanck's scene bustles with everyday activities. On the creek, a fisherman stands in a canoe hauling in a net while a man on the far bank dangles a fishing pole. She also included a horse-drawn cart waiting for cargo at the mill, a traveler on horseback who has just crossed the bridge, and another traveler passing by the mill house with a pack and walking stick.

Catharine's brother, William Beekman Verplanck, inherited the house after their father's death in 1777, and Catharine probably remained in his household until her marriage in 1786. Verplanck's heirs sold the house to Richard C. Van Wyck in 1827. Susan Varick Van Wyck remained in the house after her marriage to Edward Stringham, who took over the mill, which became known as Stringham's Mill.[6] The Verplanck–Van Wyck house still stands on the bank of Sprout Creek near the remnants of the former mill house.

A. M.

1. The Europeans paid in wampum, blankets, tobacco, guns, and other articles valued at approximately $1,250; Mount Gulian Historic Site website at www.mountgulian.org/index_files/verplanck.htm. See also Gulian C. Verplanck Papers, 1786–1870, Department of Manuscripts, The N-YHS; and William Edward Verplanck, *The History of Abraham Isaacse Verplanck and His Male Descendants in America* (Fishkill Landing, N.Y.: J. W. Spaight, 1892), 178–81.

2. In 1782 and early 1783 Mount Gulian was temporarily turned over to the Continental Army for the Revolutionary War headquarters of General Friedrich von Steuben, where he and others formed the first American veterans association, the Society of the Cincinnati, on 13 May 1783.

3. It was known in the eighteenth century as Farmers' Landing Road. See Helen Wilkinson Reynolds, *Dutch Houses in the Hudson Valley before 1776* (New York: Payson and Clarke, 1929), 400–402.

4. A photograph of the house, c. 1929 (ibid., 443, pl. 149), shows a distinctive roof balustrade that Catherine did not depict, indicating that it was probably added after 1783.

5. Ibid., 402.

6. Ibid. During the 1970s the primary Verplanck homestead, Mount Gulian, was restored through the combined efforts of Verplanck family descendants and local historical groups. Now listed on the National Register of Historic Places, the Mount Gulian Historic Site also incorporates the Stony Kill Farm Environmental Education Center. See www.mountgulian.org/index—files/verplanck.htm and www.dec.state.ny.us/website/education/stonykil.html.

ROBERT FIELD

Probably Gloucester, England c. 1769–Kingston, Jamaica 1819

An English-born painter and engraver active in North America, Robert Field studied drawing at the Royal Academy School in London in 1790. His three documented British mezzotint portraits after other artists' originals include that of Robert Lewis (c. 1790; Richmond Public Library, London).

In 1794, like many British artists, he immigrated to the United States. Field, who first settled in Philadelphia, then the seat of government, spent fourteen successful years as a miniaturist in Baltimore, Boston, Philadelphia, and Washington, D.C. He was patronized by, among others, George and Martha Washington as well as several signatories of the Declaration of Independence. He also was employed as an engraver. Field's works combined the painterly Georgian manner with the pragmatic, linear style of American portraiture.

In 1818 he left for Halifax, Nova Scotia, a city then enjoying great affluence as a British military post. While known only as a miniaturist in America, Field produced more than fifty major oil portraits during his eight-year stay in Canada, such as *Bishop Charles Inglis* (1810; National Portrait Gallery, London). He also executed and published an engraving of *Lieutenant General John Coape Sherbrooke* (1816; National Archives, Ottawa), loosely based on his full-length portrait of about 1815. Field's sophisticated images of Nova Scotia's gentry are relatively consistent in approach and intent, albeit more conservative, than their British prototypes. Their sobriety is typically American, and the artist's formal and symbolic devices often reflect his admiration for the American portraitist Gilbert Stuart. By 1814 Field did not have enough portrait commissions to make a living, and after briefly operating a stationery business, he moved to Jamaica in 1816, leaving only one recorded portrait from his West Indies period.

Bibliography: Harry Piers, *Robert Field: Portrait Painter in Oils, Miniature and Water-colours and Engraver* (New York: Frederic Fairchild Sherman, 1927); Frederic Fairchild Sherman, "Two Newly Discovered Watercolor Portraits by Robert Field," *Art in America* 20:2 (1932): 84–86; Art Gallery of Nova Scotia, *Robert Field, 1769–1819*, exh. cat. (Halifax: Art Gallery of Nova Scotia, 1978); Noble E. Cunningham Jr., *The Image of Thomas Jefferson in the Public Eye: Portraits for the People, 1800–1809* (Charlottesville: University Press of Virginia, 1981), 42, 87–92, 140, 152, no. 27; Robert G. Stewart, "Portraits of George and Martha Washington," *The Magazine Antiques* 135:2 (1989): 474–79.

23

23. *Thomas Jefferson (1743–1826)*, c. 1796–98

Watercolor, black ink, graphite, and white gouache on card, with adhered etiquette; 9 3/8 × 13 1/8 in. (238 × 333 mm)
Inscribed and signed by sitter at lower left in brown ink on adhered etiquette with partial stamp [… *NGTON* …]: *free*[?] / *Th: Jefferson Pr. US.* ;[1] inscribed and signed by artist at lower right of center in graphite: *T. JEFFERSON. Painted by R. Field.*; backing of old frame inscribed in black ink: *R. Field. The Artist. / London, England. To Charles Chauncey—Atty at Law. / Philada Pa. U.S.A. / Charles Chauncey / to Thomas S. Mitchell / Philada. / Thomas S. Mitchell / to Thomas J. Miles. / Philadelphia. / Thomas Jefferson Miles / To Colonel Thomas Carswell Miles—(his son) / Colonel Miles / To General J. Fred Pierson*; backing (now housed in the artist file) has stamp of a Parisian framer, and frame has old label printed and inscribed: *Loaned to the Pennsylvania Academy of the Fine Arts / by T. J. Miles / Register 1877, Summer No. 34*
Provenance: Charles Chauncey, Philadelphia; Thomas S. Mitchell, Philadelphia; Thomas Jefferson Miles, Philadelphia, 1877; Colonel Thomas Carswell Miles; General J. Fred Pierson, who sold it to the Society in 1923.
Bibliography: *New-York Historical Society Quarterly* 7:4 (1924): 119, ill.; Piers 1927, 186–87, ill. opp. 189; N-YHS 1941, 159, no. 402, ill.; N-YHS 1974, 1:400, no. 1048, ill.; Alfred L. Brush, "Life Portraits of Jefferson," in *Jefferson and the Arts: An Extended View*, ed. William Howard Adams (Washington, D.C.: National Gallery of Art, 1976), 48–50; Art Gallery of Nova Scotia 1978, 86–87, no. 49, ill.; Cunningham 1981, 88.
Louis Durr Fund, 1923.10

Thomas Jefferson, the third president of the United States, served two terms from 1801 to 1809. This unfinished portrait sketch was painted in Philadelphia about the time Jefferson became vice president under John Adams. An inscription at the lower left was added at a later date. On the backing of the old frame, a long inscription provides a partial provenance (see above).

Field's monochromatic watercolor over a graphite underdrawing predates the artist's engraving after Gilbert Stuart's famous 1805–7 portrait of Jefferson by more than a decade.[2] The stipple engraving, dated 14 March 1807 and featuring a bust-length portrait in an oval format, reproduces Stuart's famous three-quarter-length oil portrait painted for James Bowdoin III, now in the Bowdoin College Museum of Art.[3] Like the present sheet, both later works have a column on a baluster in the background, but the dramatic curtain wraps around the back of the column as opposed to draping in front, as in the Society's watercolor.

In both later works Jefferson wears a coat with a collar that is different from the one in Field's watercolor, and a ribbon ties back his more carefully coiffed hair. By his own confession Jefferson first sat for Stuart in 1800, but by the time Stuart came to Washington in 1805 he was still not satisfied with his portrait of the president and had him sit on two additional occasions, resulting in the popular image by Stuart that Field engraved.

Field, a miniaturist and engraver, was more accustomed to working in small scale, so this larger watercolor was a departure for him. The work's size suggests that Field executed the Society's sheet as the model for a planned engraving. Although there is no documentary evidence to substantiate that this likeness was taken from life, as Brush and others have contended,[4] this idea should be considered seriously, almost by default, as no other known portrait of the sitter could have served as a model.[5] Furthermore, the unfinished state of the watercolor with its emphasis on the sitter's head and powdered hair, coupled with the directness of Jefferson's stare, argues for its execution from life. After Jefferson had sat for his likeness, that is, his head, Field would have added the background with its monumental column and diagonal curtain, standard accoutrements in the formula of ennobling portraiture established by Titian in sixteenth-century Venice. Moreover, the classical column accords with the architectural tastes of Jefferson—for example, Monticello and the University of Virginia built on his designs—as well as the ideals of the new American republic emulating the grandeur that was Greece and the glory that was Rome. Several engravings of Jefferson issued during the early years of the nineteenth century show him full-length and feature both the column and the curtain. Examples include the widely distributed engravings of 1801 by David Edwin (in two states) and Cornelius Tiebout,[6] suggesting that many artists followed this formula fashionable for portraits at the time. Field, however, had anticipated this taste.

Field's portrait can be dated to about 1797 because of the youthful appearance of the sitter. In that year both the artist and Jefferson, then vice president, were in Philadelphia.[7] In that same year James Sharples (cat. 11) also executed his pastel profile portrait of Jefferson in the City of Brotherly Love (Independence National Historical Park Collection, Philadelphia).[8] This proposed early date of execution, as opposed to one during Jefferson's first years as president after Field had moved to Washington, is buttressed by the watercolor's provenance through Charles Chauncey, a Philadelphia lawyer and one of the founders of the Pennsylvania Academy of the Fine Arts.

Adhered to the watercolor's support at the lower left is an etiquette containing Thomas Jefferson's autograph signature, followed by the inscription in his hand stating that he is the president of the United States. The signature was most likely cut from a document, as it also bears a partial stamp that once contained the word *WASHINGTON*. This evidence, coupled with the artist's other inscriptions along the lower border, argue that Field planned to engrave this work and that he attached the etiquette with Jefferson's signature after 1801 in preparation for the engraving process. Perhaps Field returned briefly to this earlier watercolor in hopes of engraving it before abandoning it when he executed his oval engraving after the Stuart portrait.

1. Piers 1927, 186, suggests it is Jefferson's signature as president.
2. Cunningham 1981, 87–92, fig. 38.
3. Ibid., pl. VI. See also Richard McLanathan, *Gilbert Stuart* (New York: Harry N. Abrams, in association with the National Museum of American Art, Smithsonian Institution, 1986), 122–23, ill.
4. Brush 1976, 48–50, following Piers 1927, 186.
5. For the large number of images and portraits of Jefferson, see Cunningham 1981. For the life portraits, see Brush 1976, 20–100.
6. See Cunningham 1981, 55–69, figs. 28–30.
7. Piers 1927, 186; Brush 1976, 49; and Art Gallery of Nova Scotia 1978, 87, all support a date c. 1796 and an execution in Philadelphia.
8. Brush 1976, 43–44, ill.; and Cunningham 1981, 8–9, pl. III.

JOHN HILL

London, England 1770–West Nyack, New York 1850

John Hill, arguably the most highly trained and accomplished aquatint engraver working in America in the early nineteenth century, began as a printer's apprentice in London. About 1798 he was working independently as an aquatint engraver of topographical views and achieved considerable success reproducing works by J. M. W. Turner, Thomas Rowlandson, and Philippe de Loutherbourg. From 1801 to 1807 he engraved 121 plates for William Henry Pyne's *Microcosm* (1808) representing contemporary arts, agriculture, manufactures, trade, and amusements of Britain. Hill was also employed by Rudolph Ackermann (the publisher of the adventures of Dr. Syntax) to work on his *Microcosm of London* (1808–11), a portrait of the Regency city, and on series about Moscow, Oxford, and Cambridge. Although he was involved

in many other projects, by 1816 Hill had became concerned about his ability to support his growing family in a highly competitive market, precipitating his decision to leave England.

Immigrating to America in 1816, along with another of Ackermann's engravers, William James Bennett (cat. 41), he first settled in Philadelphia, then America's most populous city and an important publishing center. Bringing with him an unprecedented technical sophistication, Hill quickly became a leading printmaker. Among other works, he aquatinted a dozen plates of floral pieces and leaves for the treatise *A Series of Progressive Lessons intended to Elucidate the Art of Flower Painting in Water Colours* (Philadelphia: M[oses] Thomas, 1818). Nevertheless, little is known about his activity until 1819, when he began collaborating with the English-born

artist Joshua Shaw, aquatinting plates for Shaw's *Picturesque Views of American Scenery* (1819–21). Shaw's project, the first major series of landscapes to be printed in America, often Romantic in orientation, was planned to be issued serially in six parts of six views each, but it was never completed. Hill customarily pulled some impressions in black ink and others in brown ink ready for hand coloring.

Since the seventeenth century most views of America had been published in Europe; Hill's aquatints were the first high-quality prints produced in this country. His pioneering series opened American eyes to the great potential of the intaglio art of aquatint when executed by a master printmaker. The financial security Hill achieved in the venture allowed him to bring his wife, Ann Musgrove, and children to the United

24

States. By 1820 he had set up a printing room with its own press in his house. He produced his popular twelve-plate work *Drawing Book of Landscape Scenery; Studies from Nature* (1821) with the help of his wife, who pulled the prints, and his daughters Catherine (1805–1870) and Caroline (b. 1807), an artist until she went blind.

In 1821 Hill began producing aquatints for William Guy Wall's seminal *The Hudson River Portfolio* (issued serially 1820–25; cat. 48). Long considered a cornerstone in the development of American printmaking and landscape painting, its twenty views trace the roughly 315-mile course of the Hudson River from Luzerne to Governors Island near Manhattan. This undertaking, which marked the pinnacle of Hill's career, paved the way for a wider public appreciation of landscape and required Hill to move to New York City in 1822.

The prints were not issued in consecutive order, and only twenty of the twenty-four projected views were produced. During the 1830s Hill continued to strike prints of this enormously popular series that was a variation on European models. He also engraved numerous single prints, but the demand for aquatints declined when lithography gained ascendancy as a reproductive process. Until he

retired to Clarksville (now West Nyack) in Rockland County about 1840, several publishers employed Hill to engrave American landscape views after paintings by Bennett and book illustrations, such as nine plates of American scenery by E. Van Blon (pseudonym of John Hazlehurst Boneval Latrobe) in Fielding Lucas's *Progressive Drawing Book* (1827), the most ambitious drawing manual published in nineteenth-century America. John Hill's significant work in aquatint paved the way for an appreciation in the United States of the watercolor medium and of views of the American grand tour.

Hill was the patriarch of an artistic dynasty. He was the father of the landscape and topographical painter John William Hill (cats. 76 and 77) and grandfather of the landscape painter John Henry Hill (1839–1922). His American account book (1820–34), in the Society's Department of Manuscripts, meticulously records his expenditures and income as well as more biographical information than its English counterpart (Department of Drawings and Prints, The Metropolitan Museum of Art, New York). It invaluably documents the life of this talented and prolific printmaker during the golden age of American engraving.

Bibliography: John Hill, *The Art of Drawing Landscapes: Being Plain and Easy Directions for the Acquirement of this Useful and Elegant Accomplishment* (Baltimore: Fielding Lucas Jr. 1820); idem, *Drawing Book of Landscape Scenery; Studies from Nature* (New York: Henry I. Megarey; Charleston, S.C.: I. Mill, 1821); Richard J. Koke, "John Hill, Master of Aquatint," *New-York Historical Society Quarterly* 43:1 (1959): 51–117; idem 1961; Tobin Andrews Sparling, *American Scenery: The Art of John and John William Hill,* exh. cat. (New York: New York Public Library, 1984); Deák 1988, 1:653, for a listing of page references to the artist and his works.

24. *View of the Lower Aqueduct Crossing the Mohawk River on the Erie Canal, New York,* c. 1830–32

Graphite on paper; 9 5/8 × 13 1/2 in. (244 × 343 mm)
Inscribed at upper left in graphite: *Sept. 10, 1918.*
Provenance: Descent through the artist's family.
Bibliography: Koke 1961, 86, no. 178, ill.; Koke 1982, 2:131–32, no. 1204, ill.
Gift of Samuel Verplanck Hoffman, 1918.47

The prolific John Hill was one of the foremost engravers during the 1820s and 1830s, the great age of the American aquatint, yet only six of his original drawings survive.[1] The Society owns five of these extant sheets,[2] all of which are preliminary line drawings for John Hill's never-

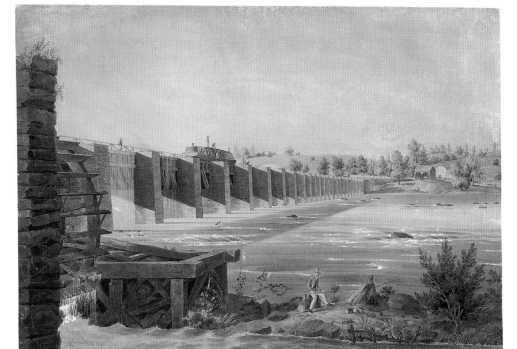

Fig. 24.1. John William Hill, *View of the Lower Aqueduct on the Erie Canal, New York,* c. 1829–30. Watercolor, white gouache, graphite, and black ink with selective glazing on paper, laid on board, 14 3/8 × 19 3/4 in. (365 × 502 mm). The New-York Historical Society, Watson Fund, 1974.47

completed aquatint series of the Erie Canal after the watercolors by his son John William Hill (cats. 76 and 77).[3] The composition of *View of the Lower Aqueduct* is nearly identical to that of John William's watercolor of the same view (fig. 24.1), except for the cropped foreground space and the elimination of the foreground figures. No aquatint of the composition has survived.[4]

Although the canal towns and the bustling life along the upstate New York waterway promised to provide an attractive series, it was never completed and published. With the invaluable assistance of his daughter Caroline,[5] Hill engraved several of these plates, pulling proofs in line and aquatint and preparing preliminary transfer sketches in graphite. Of the five views known in an engraved state, only one of them—*Junction of the Erie and Northern Canals*—was completed and colored with a title lettered in graphite (usually the plate was lettered for publication by a specialized engraver before the watercolor washes were applied).[6] The five surviving watercolors from this series preserve a highly significant record of this pivotal American waterway.

John Hill's preliminary outline drawings were executed in graphite as compositional layouts for the engraving process. They were followed by three stages: a trial proof after the plate had been etched in line; a trial proof with watercolor wash as a guide for aquatint tones; and a print from the plate after aquatinting, as demonstrated in four works for one of the plates for the Erie Canal series in the Society's collection (*Canal Boating in the 1830s*).[7] To capture atmospheric effects Hill printed several of the aquatints in three colors of ink: brown, indigo, and gray.

The Erie Canal, which opened to traffic in 1825, accomplished for upper New York State what the later western railroads did for the Plains states. While other early turnpikes, canals, and railroads in the regions east of the Mississippi River were built to connect established commercial centers, such as Albany with Boston or Philadelphia with New York, the Erie Canal was an exception. When it opened, most of the country its 363 miles traversed was still wilderness. Its existence virtually ensured that the areas along its towpaths, woodlands, and fertile valleys would become the province of homesteaders and empire builders and that its terminus at the mouth of the Hudson River, New York City, would become a national nexus, eclipsing Boston, Philadelphia, and New Orleans as this country's principal seaport. Boomtowns sprang up across the northwestern frontier as the canal facilitated the importation of people, goods, and civilizing forces. Its importance to settlement and commerce was short-lived, however, replaced in 1869 by the transcontinental railroad. In its day the canal had a great impact, precipitating the pivotal concept of "the West." It was in the region touched by the canal, as well as in the era of its construction, that American art and literature first asserted wholeheartedly the belief in the symbolic significance of the American landscape. Likewise, the canal initiated changes and technological progress that seemingly fulfilled at least part of the prophecy of cyclical history illustrated in Thomas Cole's (cats. 61 and 62) series "The Course of Empire" in the Society's collection.[8]

Hill's view of the lower aqueduct at what is today Crescent, New York, represents a now-destroyed water bridge supported on stone piers that carried the canal across the Mohawk River. On top of the bridge Hill depicted a boat serenely passing through the canal and over the river. Canal boats, unlike the railroad, did not disturb the pastoral quiet of upstate villages and landscapes, although the bridge represents the inroads of technology.

1. See Koke 1961, 85–87, nos. 174, 177–81.
2. Koke 1982, 2:131–33, nos. 1203–7. The sixth drawing is in the Metropolitan Museum of Art, New York (inv. no. 54.90.283). Avery et al. 2002, 104–6, no. 14, ill., states that it is believed to be the only "original" (meaning not after John William) drawing by the artist extant.
3. John Hill engraved five scenes taken along the Erie Canal from his son's watercolors (all five prints are in the Society's DPPAC, together with 106 others by him). Three of these drawings have corresponding prints, while two prints have no extant preliminary line drawings. See Koke 1959, 105–6; idem 1961, 63–67, nos. 138–42, for the engravings, and 86–87, nos. 177–181, for the drawings. See also Deák 1988, 1:249–50, no. 371; 2: ill., for another watercolor by John William Hill in the NYPL intended for the series.
4. Patricia Anderson, *The Course of Empire: The Erie Canal and the New York Landscape*, exh. cat. (Rochester, N.Y: Memorial Art Gallery, 1984), 68, suggests that the watercolor was the work by the same title that John William Hill exhibited at the NAD in 1830; see Cowdrey 1943, 1:230, no. 103, "View of the Lower Aqueduct on the Erie Canal." The artist exhibited additional works from the series in subsequent years but never for sale.
5. Koke 1959, 106 n. 78.
6. Ibid., 106; for the preparatory graphite sketch in the Society's collection (inv. no. 1918.45), see Koke 1982, 2:131, no. 1203, ill.
7. See Koke 1959, 56–57, ill. Hill's outline drawing for this aquatint (inv. no. 1918.46), like two others in the series, also contains color annotations; see also idem 1982, 2:132–33, no. 1205, ill. The prints are in the DPPAC.
8. Anderson 1984, 13, 15. For further reading on the Erie Canal, see Harvey Chambers, *The Birth of the Erie Canal* (New York: Bookman Associates, 1960); Barbara K. Walker and Warren S. Walker, eds., *The Erie Canal: Gateway to Empire* (Boston: Heath, 1963); and Carol Sheriff, *The Artificial River: The Erie Canal and the Paradox of Progress, 1817–1862* (New York: Hill and Wang, 1996).

CHARLES-BALTHAZAR-JULIEN FÉVRET DE SAINT-MÉMIN

Dijon, France 1770–1852

Born a French aristocrat and a member of a prominent Burgundian family, Charles-Balthazar-Julien Févret de Saint-Mémin became an artist out of necessity after seeking refuge in the United States from the storms of the French Revolution. Between his 1793 arrival in New York City and his return to France in 1814, he converted a gentleman's pastime into a profession, traveling throughout the United States with the fashionable people who patronized him for portraits.

Schooled in a local Jesuit college, Saint-Mémin went to Paris in 1783. He first enrolled in the École Militaire and a year later in the prestigious Gardes Françaises regiment, the elite royal household guard, serving there until the outbreak of the French Revolution in the summer of 1789. His military training equipped him with the skills of topographical draftsmanship. As a youth he already had demonstrated a talent for drawing (his earliest extant sheet is from 1788), and he may have studied at the drawing school in Dijon founded by François Devosge. After the abolition of the nobility in 1790, he went into exile near Coblenz, Germany, and began painting miniature portraits on ivory. Later, in Fribourg, Switzerland, he learned sculpture and gilding. Hoping to avoid being placed on the *Liste des Émigrés*, which could make him subject to the charge of conspiracy, Saint-Mémin and his father left France, planning to travel to the French colony of Saint-Domingue (present-day Santo Domingo) to live at the family's sugarcane plantation. Arriving in New York City in 1793, the pair heard of the riots and troubles at their intended destination and instead took up residence as guests of John R. Livingston (the brother of Robert R. Livingston, then the chancellor of New York State) at his Mount Pitt estate on the East River outside the city's limits.

By 1796 Saint-Mémin had taught himself the techniques of engraving, first rendering landscapes, probably with the aid of a mechanical perspective device such as a camera lucida, as evidenced in his 1794 *"View of the City and Harbor of New York, Taken from Mount Pitt, The Seat of John R. Livingston, Esqre.": Preparatory Drawing for the Etching* of 1796 (cat. 25). He continued to engrave architectural views, business cards, and panoramas to support his father and himself. From Thomas Bluget de Valdenuit (cat. 18), his partner in 1796–97 (first at 11 Fair Street and then at 27 Pine Street), he learned to take profile portraits in the manner used in Paris by Gilles-Louis Chrétien and his partner Edme Quenedey in the 1780s and 1790s. With the aid of a mechanical device called a physiognotrace, based on the original invention of Chrétien, he traced the sitter's profile with precision, transferring the life-size image onto paper and working up that image with bolder chalks, pastels, and Conté crayon. Each life-size portrait was drawn on beige paper usually coated with a pink wash, for which the artist charged $8. In preparation for engraving, the artist reduced the visage to about one-tenth the size with the aid of another device, a pantograph. This miniature portrait was engraved within a circular border on a square copperplate and printed. The savvy Saint-Mémin frequently marketed his life-size portraits as a package, again on a French model, with the engraved plate (reusable like a photographic negative) and twelve impressions costing $25 for men and $35 for ladies (due to their more intricate clothing and coiffures). Between 1796 and 1810 it is estimated that he made about nine hundred bust-length profile portraits.

Saint-Mémin briefly collaborated with other French exiles in the city, such as Louis Lemet, who imitated his style. Shortly after his mother and sister came to New York in 1798, the artist and his family moved to Burlington, New Jersey, where Madame Saint-Mémin and her daughter established a girls' school. Having executed portraits of New Yorkers, Saint-Mémin began traveling to various urban centers in search of additional clientele.

The profile format used by Saint-Mémin was inspired both by contemporary writings on physiognomy, which held that the human cranial structure revealed moral character and intellectual capabilities, and by recent excavations of Greek antiquities. These artifacts of the ancient democracy, which emphasized profile views, gave the new American republic a model to follow. Through his system Saint-Mémin created some of the most memorable images in the history of American portraiture. One of the most meticulous and elegant portraitists of the Federal period, Saint-Mémin worked in New York, Philadelphia, Baltimore, Washington, D.C., Richmond, Virginia, and Charleston, South Carolina. He executed likenesses of government leaders, statesmen, and military figures—such as George Washington, Thomas Jefferson, and Native American visitors who went to Washington in the wake of the Louisiana Purchase (1804–7)—providing a vast panorama of American life and personalities. He took care to individualize his portraits, and his success provoked contemporary artists to imitate his use of a mechanical drawing device. He also produced a selection of watercolor portraits, like that of Meriwether Lewis dressed as a frontiersman (essay fig. 5), and landscapes. The Society numbers thirteen drawings and a handful of prints by Saint-Mémin in its collections.

In 1810 Saint-Mémin went to France, returning to New York in 1812, when poor eyesight forced him to give up engraving. Instead, he painted portraits and landscapes in oil. With Napoleon's fall, Saint-Mémin renounced his American citizenship and moved to France in October 1814. He took with him a large number of his portraits, from which were formed three large collections (those of the National Portrait Gallery and the Corcoran Gallery of Art, both in Washington, D.C., and the Bibliothèque nationale de France, Paris), and several smaller groupings. In 1817 King Louis XVIII made him a lieutenant colonel in the army. As the director of the Musée des Beaux-Arts in Dijon (1817–52), Saint-Mémin transformed that provincial institution into one of the best museums in France. Although he no longer executed portraits, Saint-Mémin continued to work with technology, inventing an architectural perspective device—his *pantographe-perspectif* that traced from a plan an elevation in perspective—and an artist's mechanical horse. His research on French art resulted in his 1832 study of French fourteenth-century religious sculpture and the 1835 definitive catalogue of the Dijon Museum. He also played a major role in the preservation of Burgundian Gothic art and owing to his achievements was made a chevalier of the Legion of Honor in 1852.

Bibliography: Philippe Guignard, *Notice historique sur la vie et les travaux de M. Févret de Saint-Mémin* (Dijon: Imprimerie Loireau-Feuchot, 1853); Elias Dexter, ed., *The St.-Mémin Collection of Portraits, Consisting of Seven Hundred and Sixty Medallion Portraits, Principally of Distinguished Americans* (New York: Published by Elias Dexter, 1862); Norfleet Fillmore, *Saint-Mémin in Virginia: Portraits and Biographies* (Richmond, Va.: Dietz Press, 1942); Madeleine Herard, "Contribution à l'étude de l'émigration de Charles-Balthazar-Julien Févret de Saint-Mémin aux États-Unis de 1793 à 1814," *Mémoires de l'académie des*

25

sciences, arts, et belles-lettres de Dijon 117 (1963–65): 129–76; Musée des Beaux-Arts de Dijon, *Charles-Balthazar-Julien Févret de Saint-Mémin, artiste, archéologue, conservateur du Musée de Dijon* (Dijon: Musée des Beaux-Arts de Dijon, 1965); Ellen G. Miles, "Saint-Mémin, Valdenuit, Lemet: Federal Profiles," in *American Portrait Prints: Proceedings of the Tenth Annual American Print Conference*, ed. Wendy Rick Reeves (Charlottesville: Published for the National Portrait Gallery, Smithsonian Institution by the University Press of Virginia, 1984), 1–28; idem 1994.

Watermark: BUDGEN; escutcheon with a fleur-de-lis embellished with a B, below GR
Provenance: Probably descent through the artist's family; unidentified Parisian bookseller; John Anderson Jr., New York, 1901.
Bibliography: Stokes 1915–28, 1:439; Stokes and Haskell 1932, 67–68, 72; R. W. G. Vail, "Unknown Views of Old New York," *New-York Historical Society Quarterly* 33:3 (1949): 157, ill. 152–53; Koke 1982, 3:119–20, no. 2439, ill.; Miles 1994, 11–14, fig. 1:12, 439–41, no. 991.
Gift or purchase from John Anderson Jr., 1909.45

25. *"View of the City and Harbor of New York, Taken from Mount Pitt, The Seat of John R. Livingston, Esqre.": Preparatory Drawing for the Etching*, 1794

Black ink and wash and graphite on paper, squared for transfer; 16 3/8 × 25 3/4 in. (416 × 654 mm), irregular
Inscribed and dated at lower left in graphite: *New york pris de Mount-Pitt 1794*

When he first came to New York City in 1793, Saint-Mémin was a guest of John R. Livingston at his country home, Mount Pitt, on the East River northeast of the city. This landscape, squared for transfer to the copperplate, was preparatory for the etching, which the artist also hand colored and offered for sale in 1796.[1] It officially inaugurated Saint-Mémin's career

as an artist in the United States.[2] The event was later described by a member of the Livingston family, perhaps John R. Livingston himself:

> The Saint-Memins did not delay in associating themselves with my family. They came to live with us in a charming house situated just outside New York, from which one looked out over the city. The view was superb, and extended from the shore over the whole river. Charmed by the beauty of the scene, Saint-Memin made a very exact drawing of it. There was no other like it. We suggested that he engrave and publish it. I myself introduced him to the public library, so that he could acquire the basic principles of engraving from the Encyclopedia. He mastered them quickly. He was endowed with a thoughtful nature, and had an extraordinary aptitude for the sciences, a

remarkable manual dexterity, and an enduring perseverance.[3]

With the help of Livingston the print was successful, and Saint-Mémin continued engraving. He produced a series of architectural views, business cards, and panoramas—like the tripartite *View of the City of New-York from Brooklyn Heights* (1798, date depicted 1796)[4]—to support himself and his father, who accompanied him in exile. The print of New York Harbor from Mount Pitt has a pendant, *View of New York City from Long Island*, for which there is no preparatory drawing known, and for which the Society holds the original copperplate.[5] I. N. P. Stokes describes the pair as "perhaps the most beautiful views of New York that exist."[6]

Presumably Saint-Mémin drew this pastoral, panoramic vista of New York Harbor from the front porch of the Livingston house, which stood at the intersection of Grand and Clinton streets on the lower east side of Manhattan, looking south toward the East River. Grand Street, which ran parallel to the river directly in front of the Livingston house and was little more than a country lane at the time, is discernible nearly flush with the lower border in the immediate foreground of the etching. Clinton Street runs through the center of the composition toward the water; it is delineated in the print but not in the drawing, where the cart at the center suggests the location of this wide artery. In the middle distance in both works a coach travels north along Division Street, which is marked by a fence. In the distance on the left is the western end of Long Island; on the right is New York City. Saint-Mémin depicted the roof of the Rutgers house on the river at the left just under the point of Long Island. The house at the extreme right was also owned by the Livingstons until at least 1815. The little hamlet in the center of the tranquil view clusters around the U.S. Navy Yard between Catherine and Rutgers streets.[7]

The artist's original incomplete study served to lay out the composition for his etching. Its precision testifies to the artist's military training that no doubt involved topographical drafting. It also suggests the aid of a drafting device, such as a camera lucida or obscura, a supposition reinforced by the long, narrow proportions of the sheet, the exacting draftsmanship, and the artist's penchant for employing such devices. In the etching Saint-

Mémin altered some of the details and added others, completing the foreground and coulisse of trees at the left. Many of the extant impressions appear to have been hand colored and even mounted by the artist himself.[8]

This preparatory study, its related etching, and pendant print were extraordinary achievements for the young artist and marked his public debut as an engraver. They indicate his artistic ability and his sophistication, together with his adaptability to a novel situation and country. In all three views one senses Saint-Mémin's excitement about his new profession and his adopted land. In addition, the three are important historical documents about the early appearance of New York City.[9]

1. Stokes 1915–28, 1:438–41, pl. 62; Deák 1988, 1:134–35, no. 202; 2: ill.; and Miles 1994, 20, fig. 1:13, 439–41, no. 991. Two impressions, without and with hand coloring, are in the Society's DPPAC; see Vail 1949, 154, 156, ill., respectively. There is also a freer watercolor in the Preservation Society of Newport County, Newport, Rhode Island—believed by some earlier scholars to be a study by the artist—today considered a later copy; see Miles 1994, 440, and reproduced in Vail 1949, 150, ill., 153–54. Another copy attributed to Abram Hosier mentioned in the literature is in the Society's collections (inv. no. 1949.32; Koke 1982, 2:164, no. 1302).

2. For possibly earlier small, undated etchings c. 1794–96 in the Corcoran Gallery of Art, Washington, D.C., and the Musée des Beaux-Art de Dijon, see Miles 1994, figs. 1:9, 1:10, and 1:32; for other early etchings c. 1795, see ibid., 10–25.

3. Guignard 1853, 8, quoted and translated in Miles 1994, 12. For John R. Livingston, see Edwin Brockholst Livingston, *The Livingstons of Livingston Manor* (New York: The Knickerbocker Press, 1910), 522, 530, 536, 539; and Florence Van Rensselaer, *The Livingston Family in America and Its Scottish Origins* (New York, 1949), 100–101. Saint-Mémin probably learned the technical aspects of engraving from Denis Diderot and Jean Le Rond d'Alembert, *Encyclopédie* (1751–80).

4. An impression is in the DPPAC; Stokes 1915–28, 3:541–42, pl. 80-a; and Deák 1988, 1:144, no. 218; 2: ill. It was made with a pantograph of the artist's own invention and has ten numbered and twenty-six unnumbered references to the sites depicted in the lower margins.

5. Stokes 1915–28, 1:437–38, pl. 61; Deák 1988, 1:142, no. 215; 2: ill.; and Miles 1994, 441, no. 992. Both an uncolored and a colored impression of Saint-Mémin's *View of New York City from Long Island* are in the DPPAC; see, respectively, Vail 1949, 155, ill.; and Miles 1994, fig. 1.31.

6. Stokes 1915–28, 1:439.
7. Ibid., 439–40.
8. Miles 1994, 440.
9. Deák 1988, 1:134, notes that Stokes was inspired to write his *Iconography of Manhattan* while looking at Saint-Mémin's etching in the house of a friend in 1908.

Charles-Balthazar-Julien Févret de Saint-Mémin

26a. *Payouska (Pawhuska, c. 1752–1832), Chief of the Great Osage,* 1804

Charcoal with stumping, Conté crayon, black pastel, and black and white chalk over graphite on pink prepared paper,[1] nailed over canvas to a strainer; 22 3/4 × 17 1/8 in. (578 × 435 mm), irregular
Inscribed along left edge vertically in Conté crayon: *Payouska Chief of the Great Osage*; at lower center in graphite: *Payouska / Chef des Grands / Osages*; at middle right: *payouska / chef des Grands / Osages*
Provenance: Artist's family; probably acquired in 1859 by Elias Dexter of New York from the artist's descendants in Dijon through his agent, James B. Robertson; deposited by Dexter at the New-York Historical Society, 1860; purchased, 1861.
Bibliography: Theodore Bolton, "Saint-Mémin's Crayon Portraits," *Art in America* 9:4 (1921): 167, no. 28; idem, *Early American Portrait Draughtsmen in Crayons* (New York: F. F. Sherman, 1923), 69, no. 61; Luke Vincent Lockwood, "The St. Mémin Indian Portraits," *New-York Historical Society Quarterly* 12:1 (1928): 4, fig. 1; N-YHS 1941, 146, no. 369; Dorothy Wollon and Margaret Kinard, "Sir August J. Foster and 'The Wild Natives of the Woods,' 1805–1807," *William and Mary Quarterly* 9:2 (1952): 211–14, fig. 1; Francis Paul Prucha, *Indian Peace Medals in American History* (Madison: State Historical Society of Wisconsin, 1971), 31; N-YHS 1974, 2:606–7, no. 1570, ill.; Ellen G. Miles, "Saint-Mémin's Portraits of American Indians, 1804–1807," *American Art Journal* 20:4 (1988): 5, 11, 14, fig. 1; idem 1994, pl. 11, fig. 7:16, 142–43, 368, no. 644 (with additional bibliography).
Elizabeth Demilt Fund, 1860.92

26b. *Unidentified Osage Warrior Wearing Bird Headdress,* 1807

Charcoal with stumping, Conté crayon, black pastel, and black and white chalk on pink prepared paper, nailed over canvas to a strainer; 23 × 17 in. (584 × 432 mm)
Inscribed along left edge vertically in Conté crayon: *Osage Warrior*; at lower left in graphite: *Guerrier / Osage;* at lower right: *Guerriere / Osage*
Provenance: Artist's family; probably acquired in 1859 by Elias Dexter of New York from the artist's descendants in Dijon through his agent, James B. Robertson; deposited by Dexter at the New-York Historical Society, 1860; purchased, 1861.
Bibliography: Bolton 1921, 167, no. 30; idem 1923, 69, no. 60; Lockwood 1928, 9, fig. 4; N-YHS 1941, 146–47, no. 368, ill.; Wollon and Kinard 1952, 211–14, fig. 5; University of Pennsylvania, University Museum, *The Noble Savage: The American Indian in Art*, exh. cat. (Philadelphia: University Museum, 1958), no. 57; William Howard Adams, ed., *The Eye of Thomas Jefferson*, exh. cat. (Washington, D.C.:

National Gallery of Art, 1976), 76–77, no. 126, ill; Miles 1988, 20, fig. 8; idem 1994, 148, fig. 7:26, 366, no. 635.
Elizabeth Demilt Fund, 1860.91

With their sitters identified by their bilingual inscriptions, these stunning life-size portrayals belong to a group of eight Native American portraits (six men and two women) in the Society's collection drawn with the assistance of the physiognotrace by Saint-Mémin, all with a common provenance from the artist.[2] They were acquired in 1859 by Elias Dexter, a New York dealer and picture frame maker, through his agent, James B. Robertson, from the artist's descendants in Dijon, France.[3] These sitters were members of the three delegations of Plains Indians whose lands were acquired by the U.S. government in the Louisiana Purchase (1803). Sent to Washington, D.C., they visited the nation's capital three times, from July 1804 to early 1807. The itinerant Saint-Mémin was in Washington during their last trip. The dual purpose of the Indians' diplomatic missions was to meet President Thomas Jefferson (cat. 23) and to establish trade.

Saint-Mémin's eight large profile portraits in the collections (see also essay fig. 4) are part of a yet larger group of fifteen Native American portraits—nine large likenesses drawn with the aid of the physiognotrace (the ninth, owned by the American Philosophical Society, Philadelphia, is a version of another portrait held by the Society[4]) and six small watercolors (the one in the Society's collection is discussed in cat. 27). They are among the earliest and most accurate images of American Plains Indians known.[5] Although they all have inscriptions, few identify the sitters by name or by tribe, and only one is dated. It is therefore not clear who many of the sitters were or why the artist executed the portraits in a large format. He clearly valued these likenesses, as he kept them throughout his life. It has been suggested that Saint-Mémin, who in 1793 made now unlocated drawings of Indians while traveling through Canada, was the first artist interested in these exotic and esteemed visitors to the nation's capital.[6] No one could have missed reports of these visitors to the then-small town of Washington, as their appearance and deportment were covered in the local press. The artist may have contacted the distinguished visitors out of curiosity or admiration or, less likely, in hopes of issuing prints that he never made for larger circulation.

In the spring of 1807 Meriwether Lewis (essay fig. 5) was in Washington and commissioned from the artist "likenesses of the Indians &c necessary to my publication to be charged to the expences [*sic*] of that work," for which he paid Saint-Mémin $83.50.[7] Miles believes the drawing of a Delaware Indian in the American Philosophical Society may be the sole survivor of a hypothetical set that Lewis ordered from Saint-Mémin to illustrate his journals written during the exploration of the Louisiana Territory.[8] Lewis died before he could carry out his plans, and his journals were published posthumously without illustrations. Since Lewis was not in Washington in July 1804 when Saint-Mémin drew the portrait of Payouska, chief of the Great Osages, at least a portion of the Society's group was separate from the project envisioned by Lewis.

Unlike his other portraits, none of Saint-Mémin's Native American likenesses was engraved. These highly significant visual documents are not only the most ethnographically correct representations of Plains Indians but also the earliest known, predating those of Karl Bodmer, George Catlin (cat. 50), and Charles Bird King by many decades. Because Saint-Mémin used the physiognotrace, his profile portraits have a fidelity and objectivity not found in many other early depictions of Native Americans. Later painters of these indigenous peoples tended to emphasize their exotic costumes and customs, whereas Saint-Mémin stressed their noble character.

In these two portraits, the artist outlined the contour of the sitters' profiles with the mechanical physiognotrace, then developed the interior modeling with what were traditionally known as "crayons." That term could apply to pastels and chalks as well as to charcoal and newer fabricated media. Tellingly, Saint-Mémin used a different medium in the physiognotrace for the underdrawing of each portrait. This difference provides evidence to date them more precisely and to chart a stylistic development in his oeuvre. For the portrait of Payouska, who headed the 1804 delegation, the artist employed the more traditional graphite to outline his profile. This delicate line is most evident in the chin area. For the more boldly drawn *Osage Warrior Wearing Bird Headdress*, Saint-Mémin used the newly patented Conté crayon for the profile,[9] which suggests the

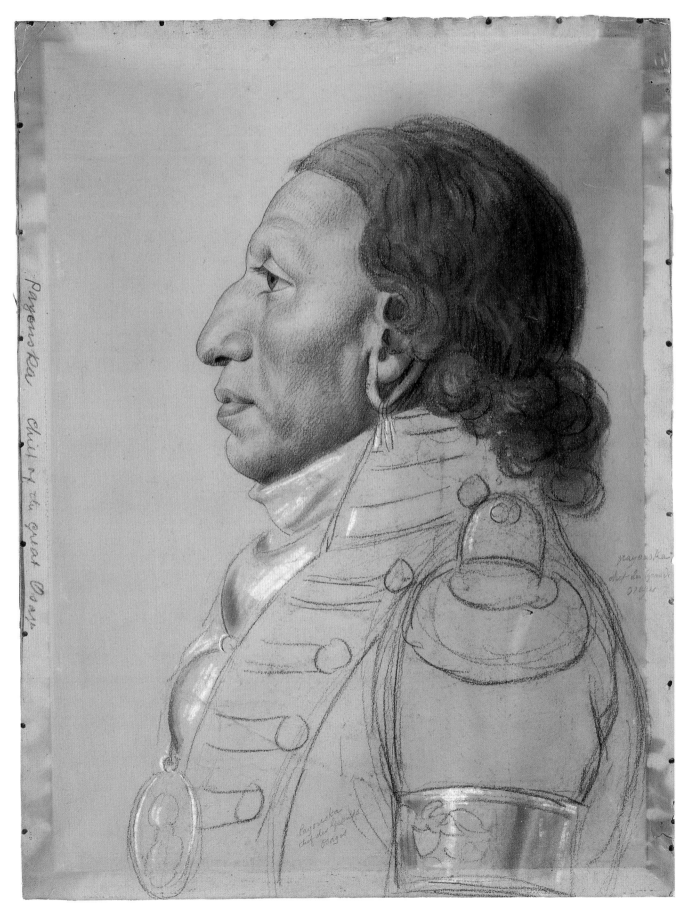

work was done later, a conclusion that is supported by the historical documentation which places the sitter in the third delegation, as is discussed below. Saint-Mémin's bold application of his media in *Osage Warrior* and its dramatic light and dark contrasts demonstrate an assurance and breadth that strongly argues for a later date.

As Saint-Mémin's helpful bilingual inscriptions state, Payouska was chief of the Great Osage, the largest of three Osage tribes in the Central Plains. His Osage name is recorded variously as Pawhuska, Pahuska, Cahagatonga, Papuisea, and Teshunhimga, among others. It was translated into French as Cheveux Blancs and then into English as White Hair. The origin of this influential Osage chief's name is controversial. La Flesche, in his dated *Dictionary of the Osage Language*, rendered it as Pa-huí-çka, "White-hair," in reference to the sacred white buffalo.[10] Other sources claim it derived from the Indian's own white hair. One early record stated that the name can be traced to a white wig that Payouska took from an American soldier in battle, which he believed possessed supernatural powers.[11]

Payouska was the leader of the first Osage delegation of Native Americans who arrived in Washington, D.C., from St. Louis on 11 July 1804. Accompanied by the fur trader Pierre Chouteau, the group consisted of twelve men and two boys. They were greeted by President Jefferson. Later that week the group, except for Payouska, performed a war dance for Jefferson, his cabinet, and members of Congress that was reported in diaries and the press. After greeting the delegation on 12 July, Jefferson delivered a more lengthy speech on 16 July in which he stated: "on your return tell your people that I take them all by the hand: that I become their father hereafter, that they shall know our nation only as friends and benefactors."[12] Already he had written his private reaction about the Osage to Robert Smith, his secretary of the navy:

> They are the finest men we have ever seen We shall endeavor to impress them strongly not only with our justice & liberality but with our power The truth is, they are the great nation South of the Missouri, their possession extending from thence to the Red river, as the Sioux are great North of that river. With these two powerful nations we must stand well, because in their quarter we are miserably weak.[13]

After leaving Washington, the delegation visited Baltimore, Philadelphia, New York, and Pittsburgh before returning to St. Louis on 3 October.

Jefferson, who was intent on preserving the culture of indigenous Americans, had stated that the Indians should appear in their native dress in Washington, directly reflecting his concern for recording their culture.[14] This portrait and that reproduced in the essay as figure 4 demonstrate how quickly the Osage relinquished their costume for that of the white man, at least on ceremonial occasions. When Saint-Mémin portrayed Payouska, the chief wore a United States military coat with epaulets, a silver armband,[15] and the silver peace medal that was a gift in honor of his visit to Washington.[16] Above the medal can be seen the curved outlines of what are probably two gorgets, or throat protectors, another type of silver decoration given to the Indian visitors. The majesty and power Saint-Mémin suggested in this profile—nearly an impossible task in a genre that is usually devoid of psychology—underline the great impression the individual made on him. It also agrees with the character assessment in a description of Payouska published in the *American Citizen* (New York) of 6 August 1804: "Their king is upward of six feet in stature, proportionally well made. With a large Roman nose, and dignified in his port. Perhaps no one brought up in savage life has ever been known to unite the same ease, politeness and nobleness of manners."[17] In Saint-Mémin's likeness, Payouska has long dark hair, which is atypical for an Osage of this period. Miles suggests that he is possibly wearing a wig,[18] although another portrait of Payouska shows him with long dark hair as well.[19] Perhaps, just as the chief did not have to dance as a sign of his high station, he also did not have to cut his hair as his warriors did.

The second likeness of the eight life-size examples in the Society's collection considered here portrays an unidentified Osage warrior.[20] He sports a more customary hairstyle that features a plucked skull embellished with an elaborate headdress, pierced and adorned ears, and a few chin hairs. Two smaller watercolor replicas by Saint-Mémin of this portrait exist. Each has slight variations that provide the color lacking in the life-size sheet along with additional costume details. The most precise replica, now in the Winterthur Museum in Delaware, is one of the five watercolors with a

provenance from Sir Augustus J. Foster, a British diplomat, who was among those individuals fascinated by the visiting Osage dignitaries.[21] In his memoirs Foster meticulously describes some of the Indians, their exotic regalia, and the customs that he witnessed. The same sitter in the Winterthur watercolor wears a silver armband engraved with an eagle holding the seal of the United States (cut off in the Society's drawing, which surely was the model taken from life) and black scarves around his neck and chest. His chest and arms are painted with a rich orange-red pigment, repeated in a patch on his cheek. The crest at the back of his head is also dyed red, his ear green, and the surrounding area blue-green to complement the multicolored headdress. A second watercolor, even smaller and more broadly executed—now in a private collection but perhaps taken by Saint-Mémin back to France—combines elements of Foster's sheet with those of the life-size version drawn with the physiognotrace in the Society's collection. Most importantly it is the source for the identifications and dates, as the inscription on its mount reads: *Portrait d'un Chef Sauvage fait par M. de St. Memin á Wasingthon au congrès tenu en 1807*.[22] On its verso a graphite inscription in abbreviated French in the artist's hand invaluably describes the sitter's striking costume and coloring. Translated into English it reads:

> The portion of the crest that touches the skull is composed of dyed red hair; the longest part is the pony tail, also dyed in red. The hair and eyebrows are plucked and not shaved, leaving the small crest and the two tresses that fall behind the head. The crown is made of vulture's beak with other waterfowl beaks and hummingbird skins. At the ear, dyed with powdered verdigris, is a tuft of swan's down dyed with powdered vermillion. The upper part of the earrings are made with small glass beads. The lower part is a tube of opaque white glass. The bracelet is silver. The black kerchief is worn to give an air of civilization.[23]

In all three portrayals the splendidly dressed Osage warrior faces left, and the general configurations of his costume are in agreement, down to the two silver ear piercings with the elaborate multistaged wampum and swan's-down adornment. However, only in Saint-Mémin's elegant watercolors are the vivid colors of the warrior's costume preserved.

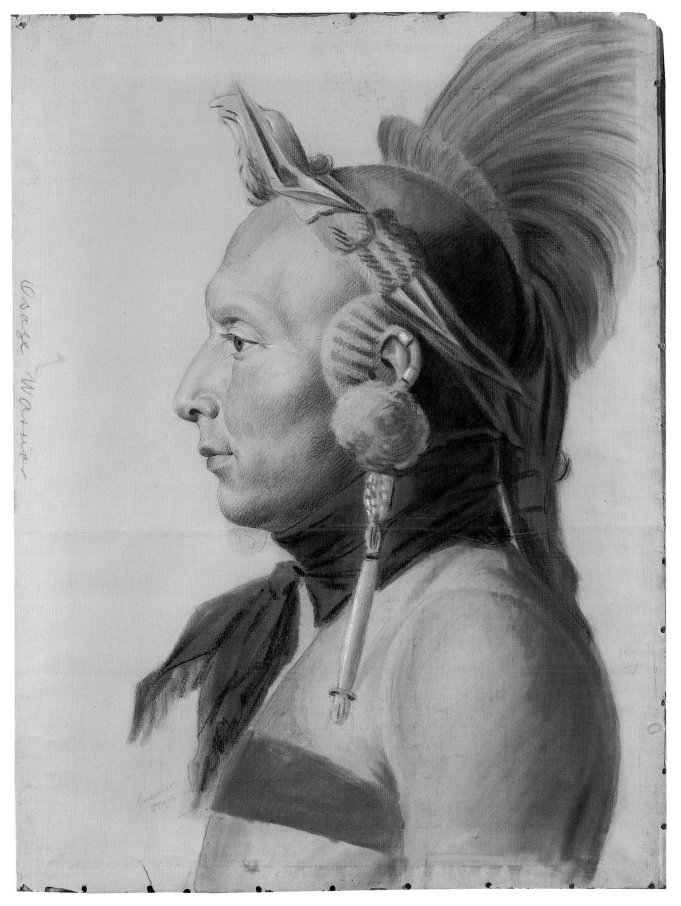

26b

The visiting Native Americans attracted so much attention, and by association so did Saint-Mémin's watercolor images, that the likeness of this Osage warrior was further disseminated in copies by other artists. When the Winterthur watercolor was in Foster's possession, Pavel Petrovich Paul Svinin, a Russian artist who served as secretary to the Russian consul general in the United States from 1811 to 1813 (at the time Foster was ambassador to the United States, 1811–12), copied it and another watercolor by Saint-Mémin, also now in the Society's collection (cat. 27).[24] In turn, Svinin's two copies were replicated by the Baroness Hyde de Neuville (cats. 15 and 16) in two watercolors in the Society's collection.[25] The baroness was always intent on recording the ethnicities she encountered in America. Because the Hyde de Neuvilles enjoyed easy access to members of the foreign diplomatic circles in Washington during their first stay in America (1807–14), she was no doubt able to meet both Foster and Svinin and to copy the latter's replicas of the Saint-Mémin portraits before their departures in 1813.

1. See Shelley 2002, 41, for a discussion of the prepared surface that provided a tooth to hold the powdery Conté crayon and charcoal in place.
2. Inv. nos. 1860.90–97. At one time the paper of each drawing was mounted in a similar way: pulled over canvas and nailed to a wooden strainer at the sides. They were also behind glass in period frames. Some of the objects, no doubt due to their fragile condition, had been separated from their strainers and frames. Those still intact have been removed from their frames to protect the friable materials. All eight are currently housed in custom-made sink mounts.
3. Miles 1994, 227 n. 16, notes that the Society paid Dexter $80 for the group.
4. Ibid., 145–47, fig. 7:19, 227 n. 26, 287, no. 246; it is on pink prepared paper. The artist kept the Society's nearly identical but more broadly executed portrait of the same individual on buff-colored paper in his possession (inv. no. 1860.97; ibid., fig. 2:70, 287, no. 247).
5. Ibid., 142, lists one Delaware, five Osage, and two Mandans represented in nine drawings and six watercolors. The artist kept eight large portraits (those in the Society's collection), to which he added inscriptions and one watercolor (now in a private collection) inscribing it with a description of the sitter (see n. 22 below).
6. Ibid., 148.
7. Donald Jackson, ed., *Letters of the Lewis and Clark Expedition, with Related Documents, 1783–1854* (Urbana: University of Illinois Press, 1978), 2:411. Adams

1976, 76, notes that it is not known if Saint-Mémin made the physiognotraces of Lewis in Washington or Philadelphia, as he and the Indians were in both cities in 1807. See Miles 1994, 148, 338–39, nos. 505–7, ills., for her entries on Saint-Mémin's portraits of Lewis: two physiognotraces and one watercolor.
8. Miles 1988, 29; and idem 1994, 148. See also n. 4 above for Saint-Mémin's two large physiognotrace drawings of the same sitter (a Delaware, possibly Montgomery Montour), for himself and another person, now in the American Philosophical Society and the N-YHS (Miles 1988, 25, figs. 15 and 17). The Philosophical Society's drawing was reproduced in a hand-colored lithograph attributed to Alfred Hoffy in Thomas L. McKenney and James Hall, *History of the Indian Tribes of North America*, 3 vols. (Philadelphia: E. C. Biddle, 1836–44), together with another lithograph after an unlocated Saint-Mémin version of the Osage depicted in fig. 4 of the essay and discussed in cat. 27 (Miles 1988, figs. 16 and 3, respectively).
9. This fabricated medium, made of fired graphite and clay, was patented in France in 1795 by Nicolas-Jacques Conté, an engineer who had been commissioned by the French government to devise a substitute for the fine-quality English Borrowdale graphite that had been embargoed during the Anglo-French wars. See Shelley 2002, 53.
10. Francis La Flesche, *A Dictionary of the Osage Language* (Brighton, Mich.: Native American Publishers, 1990), 125.
11. Miles 1994, 368. N-YHS 1974, 2:607, relates that Payouska received his name from an incident in a battle with American soldiers known as St. Clair's Defeat. Payouska, then a young warrior, wounded an officer who was wearing a powdered wig and was about to scalp him when the wig came off in his hands. Believing the wig had supernatural powers, Payouska henceforth wore it fastened to his roach. Regettably, little information is known about Payouska. His village, known as White Hair's village, in 1806 was situated on the east side of the Little Osage River, in the northern part of the present Vernon County, Missouri, near which Zebulon Pike established what he called Camp Independence. Today the county seat of Osage County, Pawhuska, Oklahoma, is named for him. See the website http://www.vpcharlescurtis.net/ksstudies.wh.html.
12. Jackson 1978, 202.
13. Ibid., 199–200, letter of 13 July 1804 in the Library of Congress, Washington, D.C.
14. Adams 1976, 77.
15. For a similar armlet, see Patricia Trenton and Patrick T. Houlihan, *Native Americans: Five Centuries of Changing Images* (New York: Harry N. Abrams, 1989), 50, fig. 51.
16. For a discussion of Osage costume, see Louis F. Burns, *Osage Indian Customs and Myths* (Fallbrook, Calif.: Ciga Press, 1989), 132–33, 151ff, who comments on the medallions and military coats, presentation gifts to

important members of the tribe.
17. Quoted in Lockwood 1928, 26.
18. Miles 1994, 368.
19. Posted without identification on http://www.vpcharlescurtis.net/ksstudies.wh.html, where he wears an elaborate headdress and a buffalo robe.
20. Miles 1994, 148 and 366, calls him "Osage Warrior II."
21. Inv. no. 1954.19.3, 7 1/2 × 6 3/4 in., Henry and Francis du Pont Winterthur Museum, Winterthur, Del.; Edgar P. Richardson, *American Paintings and Related Pictures in the Henry Francis du Pont Winterthur Museum* (Charlottesville: Published for the Henry Francis du Pont Winterthur Museum by the University Press of Virginia, 1986), 98–99, no. 50, ill.; and Miles 1994, fig. 7:27, 366–67, no. 646. It is signed *St. Memin fecit*. Trenton and Houlihan 1989, 89, identify the bird attached to the front of the warrior's head with green plant material as most likely the Carolina parakeet (*Conuropsis carolinensis*; cat. 42) with snowy egret plumes (*Egretta thula*; essay fig. 3) as added decoration. Emblematic of the personal medicine of this warrior, the bird is a protective spiritual power, although it may also refer to the warrior's name or that of his clan. They add that for the Osage, the hairstyle of a male designated his familial associations. Not everyone agrees with these identifications.
22. Miles 1994, pl. 12, 148, figs. 7:30, 7:31, 367, no. 637.
23. Ibid., 367.
24. The first is inv. no. 42.95.30 in the Metropolitan Museum of Art, New York; see Avery et al. 2002, 349, no. 353, ill. See also Avrahm Yarmolinsky, *Picturesque United States of America, 1811, 1812, 1813, Being a Memoir on Paul Svinin* (New York: William Edwin Rudge, 1930), pl. 29; and Miles 1988, fig. 25. See also cat. 27 n. 11 for its pendant.
25. Inv. nos. 1953.213 and 1953.214; see Koke 1982, 2:210–12, nos. 1455 and 1456; and Miles 1988, figs. 26 and 27.

Charles-Balthazar-Julien Févret de Saint-Mémin

27. *Unidentified Chief of the Little Osage ("Soldat du Chêne" ["Soldier of the Oak"]?), 1807*

Watercolor, gouache, black ink, and graphite on paper, mounted on card; 7 1/4 × 6 3/8 in. (184 × 162 mm)
Signed at lower left in black ink: *St. Memin fecit.*; verso of old mount inscribed at upper center in brown ink: *Ozage*[1]
Provenance: Sir Augustus John Foster, Washington, D.C.; descent through Foster's family; Sotheby's, London, 1926; Godspeed's Book Shop, Boston, 1927; Mr. and Mrs. Luke Vincent Lockwood, Greenwich, Conn.; Parke-Bernet Gallery, New York, 1954.
Bibliography: Sotheby's, London, sale cat., 18 November 1926, lot 635; Lockwood 1928, 7, fig. 4; Dorothy Wollon and Margaret Kinard, "Sir August J. Foster and 'The Wild Natives of the Woods,' 1805–1807," *William and Mary*

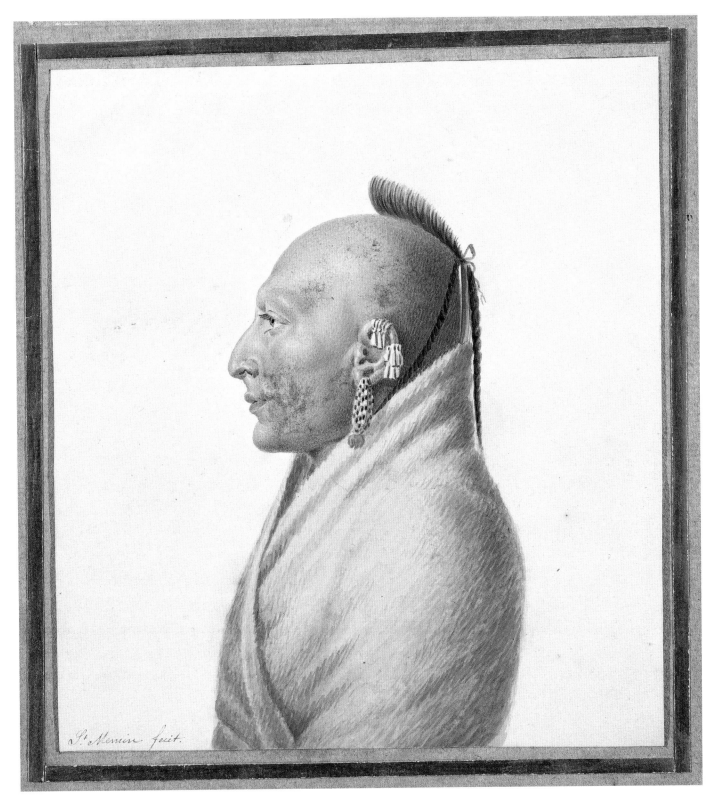

St. Memin fecit.

27

Quarterly 9:2 (1952): 211–14, fig. 4; Parke-Bernet Gallery, New York, sale cat., 13–15 May 1954, lot 439, ill. mistakenly as lot 438; Adams 1976, 76–77, no. 129, ill.; Miles 1988, 14, fig. 4; idem 1994, 148, fig. 7:23, 270, no. 162. Abbott Fund, with the help of Forsythe Wicks, John E. Parsons, and Edmund Astley Prentis, 1954.101

One of five watercolors once owned by Sir Augustus John Foster and perhaps related to a commission from Meriwether Lewis (essay fig. 5), this small, jewel-like image is a reduction likely via a pantograph of the Society's life-size portrait of the same individual drawn with the aid of a physiognotrace (essay fig. 4). It can be identified by the inscription on that likeness taken from life: *Indien chef des petits Osages*.[2] Whereas the sitter in the large sheet wears a United States military uniform coat with a ceremonial silver armband on his left arm and a silver medal around his neck, similar to that worn by Payouska whom Saint-Mémin drew in 1804 (cat. 26a), in this sheet he sports tribal costume: a white blanket with a border of a pink stripe on top of a green one. His ear adornments include blue and white wampum beads and silver bands with dangling attachments around the rim of his ear. The roots of his scalp lock hair are dyed red. Foster described two similarly accoutered members of the second Osage delegation on 22 December 1805, noting that "their hair [was] shaved as far as the crown where it was ornamented with feathers and formed into a tail behind inclosed in silver … . Their ears were pierced in two places which were much widened by the weight of the ear-rings suspended from them."[3]

Since the style of the life-size drawing resembles that of Saint-Mémin's earlier likeness of Payouska, and since the sitter wears a similar military uniform and silver adornments, it probably dates from the first delegation's visit in 1804. More than likely, then, the sitter of the present watercolor can be identified as the second leader of the 1804 delegation. When greeting the delegation, Thomas Jefferson (cat. 23) addressed one Osage as "Dog Soldier," saying that "the medal which we have given you will testify to your people and to all others the esteem we bear you, and the confidence we repose in you."[4] This sitter is probably the unknown individual identified as "Soldat du Chêne" or "Soldier of the Oak," who was listed as the second chief of the Little Osage by Zebulon Pike during his visit to the tribe in

1806. Pike transcribed the Osage name as "Watchkisingow" and gave the name in French as "soldat de chien," or dog soldier, an aural misunderstanding of "Soldat du Chêne," which Jefferson also made.[5]

Margaret Bayard Smith, wife of Samuel Harrison Smith, publisher of the *National Intelligencer*, attended a reception at the White House on New Year's Day 1806 for the Plains Indian dignitaries and was inspired to write the following description that informs the Society's watercolor:

> Tall, erect, finely proportioned and majestic in their appearance, dignified, graceful and lofty in their demeanor, they seemed to be nature's own nobility. By the President's desire they appeared in their own national costume … their faces and bodies in full paint … covered with blankets, worn as Spaniards wear their cloaks, wrapped gracefully around … . With the exception of a tuft of hair on the crown, the head was entirely smoothly shaven.[6]

Saint-Mémin defined his sitter's features by applying his pigments with delicate stippling and refined cross-hatching in a nearly Pointillist manner with a fine brush. He also used this technique, akin to that of a miniaturist, in the other four watercolors formerly in Foster's possession.[7] But the Society's sheet is the only example in which some pigments with a white lead content have oxidized and discolored, slightly marring the exquisite detail of the work.

An untraced portrait of the same sitter was lithographed for Thomas L. McKenney and James Hall's *History of the Indian Tribes of North America* (1836–44) as "Le-Soldat-Du-Chene." The lithograph is one of two after Saint-Mémin's Native American portraits attributed to Alfred Hoffy (as mentioned in cat. 26 n. 8). In the lithograph after the lost Saint-Mémin version, the sitter wears an animal skin robe or a blanket with a buffalo fur collar. McKenney and Hall state that the original from which the lithograph was taken was owned by the American Philosophical Society, which has no record of it. Miles cogently suggests that perhaps it was copied from the portrait by Saint-Mémin exhibited in 1818 at the Pennsylvania Academy of the Fine Arts as "Portrait of the soldier Duchene a warrior of the Little Osage Tribe— Was in Philadelphia in 1804 and 1807."[8] The

identification in the academy's records provides further evidence to suggest that figure 4 of the essay dates from the sitter's first visit in 1804, when he wore a uniform, while the watercolor considered here relates to a likeness taken when the sitter was slightly older and wore a robe.

All but one of Saint-Mémin's six known watercolor portraits of the Plains tribesmen, including the present watercolor, have a provenance from Augustus John Foster, secretary to the British minister, who wrote at some length about the Native American delegations that arrived in Washington in 1806 and 1807. In the past, most scholars have assumed that Foster was the patron of at least five portraits.[9] These six watercolors, all with similar dimensions, could also be considered candidates for the Lewis commission, and together with the full-length watercolor of the explorer (essay fig. 5) may have been intended for publication in his report of the Lewis and Clark expedition (cat. 26).[10] Whether Lewis or Foster was the patron, Foster eventually owned the matching set of five that depicts the same individuals represented in five of the Society's life-size drawings executed with the aid of a physiognotrace. Alternatively, the smaller works, perhaps reduced with the aid of the pantograph, may have been salable portrayals of these celebrities of the moment. Through this inspired change in media the artist was able to document the brilliant colors of the sitters' costumes. One can only speculate whether the works were commissioned or whether they represent the artist's trial balloon for another marketing scheme similar to his package deal for engraved portraits. In either case, Saint-Mémin made at least one yet smaller copy after one of the five watercolors in Foster's possession. Now in a private collection, this diminutive watercolor was probably taken back to France by the artist (see cat. 26 n. 22).

Like the watercolor related to the life-size *Unidentified Osage Warrior Wearing Bird Headdress* (cat. 26b), the present watercolor attracted much admiration for its subject matter and technique and was disseminated in copies by other artists. Pavel Petrovich Paul Svinin, a Russian artist who served as secretary to the Russian consul general in the United States (1811–13) at the time Foster was ambassador to the United States (1811–12), copied it and at least one other similar water-

color in Foster's possession.[11] He added many embellishments to this work, including a nose ring and facial tattoos absent in Saint-Mémin's original. More important, Svinin reversed the image so the sitter faced right to serve as a pendant to his copy of the *Unidentifed Osage Warrior Wearing Bird Headdress*; to both watercolors he added aureole-like treatments to the backgrounds. In turn, Svinin's two copies were studied by the Baroness Hyde de Neuville (cats. 15 and 16), who maintained Svinin's reversal of one of the images but discarded his aureole-like backgrounds and tattoos. Strangely, she rendered many details of the accoutrements, hair, and robe closer to those of Saint-Mémin's original in Foster's possession, suggesting she may have seen it as well.[12] Hyde de Neuville no doubt met both Svinin and Foster in the diplomatic circles of Washington and executed her watercolors between 1811 and 1813 before their departures from the scene.

1. The spelling of "Ozage" further underlines the provenance of the sheet and argues that the mount was that of Foster who in his descriptions used the same spelling; see Wollon and Kinard 1952, 197.

2. For the larger drawing, see Miles 1994, 150, fig. 7:22, 269–70, no. 161.

3. Quoted in Richard Beale Davis, ed., *Jeffersonian America: Notes on the United States of America Collected in the Years 1805–6–7 and 11–12 by Sir Augustus John Foster, Bart.* (San Marino, Calif.: Huntington Library, 1954), 31.

4. Quoted in Miles 1988, 14.

5. Ibid., 32 n. 26, quoting Donald Jackson, ed., *The Journals of Zebulon Montgomery Pike with Letters and Related Documents* (Norman: University of Oklahoma Press, 1966), 2:41.

6. Margaret Bayard Smith, *The First Forty Years of Washington Society*, ed. Gaillard Hunt (New York: C. Scribner's Sons, 1906), 2:401.

7. See esp. his watercolor of an Osage warrior in the Metropolitan Museum of Art, New York (inv. no. 54.82); Avery et al. 2002, 108–9, no. 16, ill.

8. Miles 1988, 14, 32 n. 29, cites Anna Wells Rutledge, *Cumulative Record of Exhibition Catalogues, The Pennsylvania Academy of the Fine Arts, 1807–1870* (Philadelphia: American Philosophical Society, 1955), 192.

9. Wollon and Kinard 1952, 191–214.

10. Independently, I had reached this conclusion but was thrilled to find it outlined in Patricia Trenton and Patrick T. Houlihan, *Native Americans: Five Centuries of Changing Images* (New York: Harry N. Abrams, 1989), 90.

11. Inv. no. 42.95.31 in the Metropolitan Museum of Art, New York: see Avery et al. 2002, 347, no. 336, ill. See also Avrahm Yarmolinsky, *Picturesque United States of America, 1811, 1812, 1813, Being a Memoir on Paul Svinin* (New York: William Edwin Rudge, 1930), pl. 29; and Miles 1988, fig. 24. See also cat. 26 n. 24.

12. Inv. no. 1953.214; see Koke 1982, 2:212, no. 1456; and Miles 1988, fig. 26.

JOSHUA ROWLEY WATSON

Topsham, Devon, England 1772–Exeter, England 1818

Following in the footsteps of his father, a captain in the British navy, Joshua Rowley Watson embarked on a naval career, although it is clear that drawing was his passion. After his father died in an attack on the French at St. Lucia (1780), the young Watson was placed under the guardianship of Captain Richard Rundle Burges, his mother's brother and a model officer, and began his formal education at Auchins Academy, Ewell, near London. Early in life Watson had begun drawing, for which he demonstrated an innate talent. At the time, drawing was viewed either as a gentlemanly accomplishment, akin to fencing or dancing, or was used for practical military purposes, especially in describing topography. In 1783, at the age of eleven, he entered the Maritime School in Paradise Row, Chelsea, which also taught drawing as a communication skill for military reconnaissance and as an exercise to sharpen observation. After completing his studies in 1785, he went on a short trip to France during 1786. In July of that year Watson first went to sea as a captain's servant on HMS *Savage*, under the command of his uncle. He was commissioned captain in the Royal Navy in 1798 and was on active duty at least until 1818, commanding several ships during the Napoleonic Wars.

His early watercolors from the 1790s include ship portraits, but between 1799 and 1804, while he was in the Exeter area, he studied landscape, copying some forty-odd views of Devon by the fashionable painter and drawing master William Payne. While the distinctive palette used by the local watercolorists Francis Towne and his student John White Abbott also may have influenced Watson, the Reverend William Gilpin's book *Observations on the Western Parts of England* (1798), a major work on the aesthetic of the picturesque, no doubt was a significant catalyst. After returning to active duty (1804–8), Watson went back to Devon to execute a series of picturesque views based on his own observations, once again commencing active duty in 1809.

In March 1816 Watson took a leave of absence from the navy for twelve months and sailed to Philadelphia. During his time in the United States Watson lived at Eaglesfield, one of the suburban villas that ornamented the Schuylkill River valley near Philadelphia in the early nineteenth century. It belonged to Richard Rundle, who is sometimes referred to as

Watson's uncle but who was really the uncle of his wife, Mary Manley. At this time Watson began his tour of the Northeast, whose itinerary he vividly recorded in his sketchbooks. In June 1817 he returned to Exeter, where he purchased a new home for his family in Dix's Field in the spring of 1818. Shortly thereafter, he died suddenly of a cerebral hemorrhage.

In 1819–20 two of Watson's views (depicting Washington's Sepulchre at Mount Vernon and St. Anthony's Falls on the Mississippi River on the present site of Minneapolis) were published in Joshua Shaw's highly significant *Picturesque Views of American Scenery*, engraved by John Hill (cat. 24), that together with *The Hudson River Portfolio* (cat. 48) contributed to the establishment of the American grand tour itinerary. With the exception of the two plates after Watson, all the other subjects in *Picturesque Views* were drawn by Shaw. Having never exhibited in his own country, Watson made his artistic debut posthumously in the United States, where two of his works were recorded in the annual exhibition at the Pennsylvania Academy of the Fine Arts in 1829 (views of Philadelphia and Exeter with its cathedral and river). One of these was the large independent watercolor Watson executed in America that depicts an expansive view of the Schuylkill River (*View on the Schuylkill from the Old Waterworks*, 1816–17; Atwater-Kent Museum, Philadelphia). Based on the less complete and more expressive studies in his sketchbooks, it also served after Watson's death as a model for one of the plates that Cephas G. Childs published in his *Views in Philadelphia and its environs* (1827–30).

Watson was a gentleman amateur in the best sense of the English tradition. Like Heriot (cat. 14), he was among the first to establish the quintessential American grand tour of the eastern seaboard, from Lake George to Mount Vernon, and thus made a small but notable contribution to the development of American landscape painting. As the repertoire of picturesque views sought by travelers of this period became canonical, so too did the standard tourist itinerary. Following a decade after Watson, the first generation of widely circulated prints, such as those of John Hill after William Guy Wall in *The Hudson River Portfolio* (cat. 48), etched this pilgrimage permanently in the popular mind. Watson's two sketchbooks

contain fresh, early views of these sites, offering insights about the formation of this landscape canon. Take, for example, Watson's vista of the Palisades with the Hudson Highlands in the background (essay fig. 8), which, when compared with Wall's less panoramic watercolor, demonstrates that Wall's more focused view stresses the geographic stratigraphy of the cliffs and the Hudson's water traffic (cat. 48a).

Watson's two seminal sketchbooks are in the Barra Foundation, Philadelphia, and the N-YHS. Keenly observed and elegantly drawn and organized, they reveal a special aptitude for wide expanses of water, architectural detail, and deep space. Watson's range and mastery of techniques are impressive, encompassing graphite sketches as well as grisaille scenes and watercolors. A large cache of varied works, including ones from his early career and drawings of ships (even a plan after a frigate owned by Robert Fulton [cats. 20 and 31]), machines, and bridges remain in the artist's family.

Bibliography: Kathleen A. Foster, *Captain Watson's Travels in America: The Sketchbooks and Diary of Joshua Rowley Watson, 1772–1818* (Philadelphia: University of Pennsylvania Press, 1997).

28a. *View of Boston, Massachusetts, Folios 20v–21r in a Sketchbook,* 1816

Black ink wash over graphite on two sheets of paper, bound into a sketchbook; each sheet 4 7/8 × 8 7/8 in. (124 × 225 mm), irregular
Inscribed and dated at lower right in brown ink: *Boston from the / Navy Yard at / Charlestown 10th. Augt.*
Watermark: J WHATMAN / 1813 (on other pages of sketchbook)
Provenance: Old Print Shop, New York.
Bibliography: Koke 1982, 3:251, no. 2804; Foster 1997, 331, pl. 68; Olson 2003, 191.
Beekman Family Association Fund, 1958.85

28b. *View of Lake George, New York, Folios 37v–38r in a Sketchbook,* 1816

Watercolor, graphite, and black ink wash on two sheets of paper, bound into a sketchbook; each sheet 4 7/8 × 8 7/8 in. (124 × 225 mm), irregular
Inscribed and dated along lower border in brown ink: *Lake George & Islands from the Point of Land under Frenchmens Mountain 29th July 1816*
Watermark: J WHATMAN / 1813 (on other pages of sketchbook)
Provenance: Old Print Shop, New York.

Bibliography: Koke 1982, 3:251, no. 2804; Foster 1997, 331, pl. 60; Olson 2003, 191, fig. 2.
Beekman Family Association Fund, 1958.85

Watson's two extant leather-bound sketchbooks hold significant records of early America. The first, in the Society's collection, has 138 sheets, one blank, dating between May (on board ship) and August 1816, while the second in the Barra Foundation in Philadelphia contains 110 sheets, dated from September 1816 through July 1817 (on board ship).[1] They are composed of pre-bound sheets of excellent English watercolor paper; the Society's sketchbook consists of paper watermarked "J WHATMAN / 1813."[2] Watson began each sketchbook at the end of the volume and worked forward.

Landscape is the central focus of Watson's sketchbooks, in which his rich visual vocabulary outshines his verbal skills in his diary. Nonetheless, his diary entries unite with the pictures to describe more completely his trip and his experience of the American landscape.[3] His sketchbooks rank among the most vivid pictorial records of early-nineteenth-century Americana, prefiguring *The Hudson River Portfolio* (cat. 48) and the establishment of the American grand tour. Not rigorously ordered, they are instead organic in nature. Some drawings are incomplete, numerous sides of the sketchbook pages are blank, and a few images are upside down or sideways. Single-page views—both vertically and horizontally oriented—and double-page panoramic spreads enliven the spontaneous layout. Watson used most of the pages chronologically from the back to the front. At a later time, someone in the artist's family numbered the images in graphite, assigning double-page spreads one number.[4] Although Foster's important study reproduces a generous selection of Watson's views, her volume is not a complete facsimile of the two sketchbooks.

Much of the spontaneity of Watson's views can be attributed to his habit of sketching while stagecoaches changed teams or steamboats paused to take on new passengers. He explained in his diary that he delineated his scenes quickly in graphite and later developed them with ink and wash and/or watercolor.[5] This technique was expedient for a topographical artist and was common practice for amateur and professional landscape painters alike. Watson experimented

with relatively novel techniques—such as brown, blue, and gray monochrome washes—and used a reed pen for quick strokes, departing from the crisper line and wash of the previous generation of English watercolorists and his own earlier style. At the same time, his style is more refined than the bolder applications of watercolor used by Heriot (cat. 14) in his roughly contemporary sketchbooks. While in America, Watson enjoyed the time and inclination to develop this broader style that also allowed him to capture more atmospheric effects and poetic sentiments.

The panoramic view of Boston from the navy yard in Charlestown drawn on 10 August 1816 in grisaille tones of black ink wash over graphite shows that Watson was magnetically pulled to his old maritime haunts.[6] Seen from the most easterly part of Charlestown's waterfront, just across from Chelsea, the area had a long association with the military aspects of seafaring. An early name for the area was Moulton Point, after the ship carpenter Robert Moulton. General William Howe had landed his military forces there, bound for Bunker Hill. In 1799 construction of a new naval yard had begun, which Watson shows, together with one of the three ships, the *Independence*, that were stationed in Boston at the time of his visit.[7] This panorama is one of seven views of Boston Watson included in this sketchbook.[8]

On 29 August 1816 Watson was at Lake George; catalogue 28b is one of five views of the Adirondack lake in his sketchbook.[9] After hiring a steamboat, Watson and his companion started to explore the lake, which is more than thirty-two miles long. In his diary for the day, Watson notes: "Finding we could not advance down the lake without much inconvenience, we landed in our way back, on the point under French Mountain so calld from the French forces having landed there from Canada when they advanced & took the Fort."[10] The fort in question is Fort George, which had replaced Fort William Henry (destroyed 1757). Watson's very sophisticated point of view, involving a set of V shapes formed by landmasses that draw the viewer into the landscape, lends a pronounced immediacy to his mountainous view in the Adirondacks.

1. The N-YHS sketchbook is signed, inscribed, and dated at the upper right of the inside front cover in brown ink: *J.R.W … . 1816.* It has copious inscriptions

and annotations throughout. The earliest drawing in the sketchbook is an undated, unfinished study of a ship, and the second, dated 25 May 1816, is also of a ship. The final two drawings, both of Weehawken, New Jersey, are dated 19 August 1816, the last faintly in graphite.

2. Foster 1997, n.p. [67]. The Barra Foundation sketchbook is watermarked "Ruse and Turner / 1813" and is slightly larger.

3. His American diary, which spans 21 April–August 1816, remains in the collection of Watson's descendants; see ibid., Appendix A, 285–316.

4. Since the folios are not consistently numbered in the sketchbook, the N-YHS has assigned a sequential numbering that is used in this catalogue.

5. Foster 1997, 255.

6. Ibid., 331.

7. Ibid.

8. The others are cited in ibid., 331; see pls. 65–67 and 69 for four others.

9. Ibid.; see pls. 59, 61, and fig. 66 for three others.

10. Ibid., 313.

28a

Lake George & Islan

28b

Boston from the
Navy Yard at
Charlestown +
16.th [illegible]

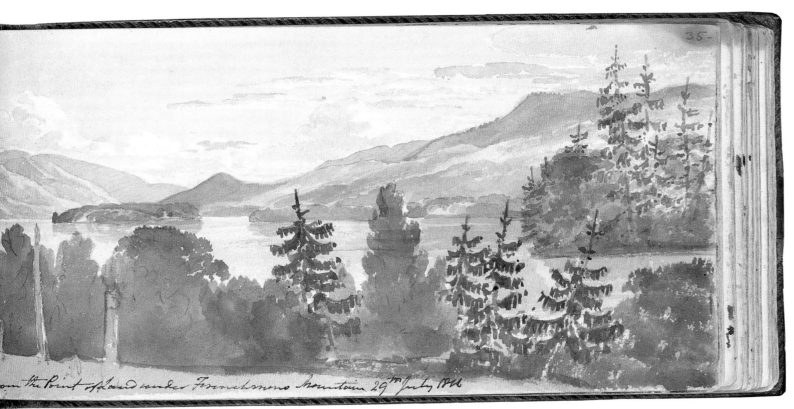

on the Point of Land under Frenchmens Mountain 29.th July 1816

ALEXANDER ROBERTSON

Aberdeen, Scotland 1772–New York, New York 1841

Alexander Robertson, like his elder brother Archibald (cat. 21), was born in Aberdeen, Scotland, where their father, William Robertson, was an architect and draftsman. Both brothers attended King's College in Aberdeen. Alexander left college in 1791 to attend classes at the Royal Academy of Arts in London before studying miniature painting for five months with Samuel Shelley. In 1792 Alexander emigrated from Liverpool to New York City, joining Archibald, who had just started the Columbian Academy of Painting, one of the first art schools in the United States. (Their younger brother, Andrew Robertson, a miniature painter, remained in London.) Both "Ladies and Gentlemen" were pupils at the Columbian Academy at 79 Liberty Street, where they were instructed in drawing and painting in watercolors and chalks on paper, tiffany, silks, as well as drawing plaster casts, landscapes, flowers, architecture, and perspective. The two brothers remained partners as teachers and painters for a decade after Alexander's arrival. They sometimes collaborated on works, as a rare engraved late-eighteenth-century label from the back of one of Archibald's watercolors attests: *Messrs: Archd. & Alexr. Robertson; / LIMNERS. / at the Columbian / Academy of / Painting & Drawing / No. / New York*.

In 1802 the two brothers ended their partnership in the Columbian Academy after a personal disagreement. Alexander established his own school, the Academy of Painting and Drawing, at 17 Dey Street, where he also resided, having left his brother's house to escape the extreme domesticity of that family environment, replete with ten children. That same year Archibald wrote the first drawing and watercolor manual published in the United States, *Elements of the Graphic Arts*. Advertisements by both brothers indicate a sense of competition between their two academies. By June 1820 Alexander had moved his school into a public space leased to the American Academy of the Fine Arts (he had been an academician since 1816), in the building housing the prestigious New York Institution of Learned and Scientific Establishments. When that institution lost its municipal support and lease in 1831, Alexander moved his academy back to his residence. Like his brother, he was active in the art community and in the American Academy of the Fine Arts, where he held a number of important positions: director (1816),

secretary (1817–25), and keeper (1820–35). In his capacity as secretary, he took part in a dramatic encounter with the young artists who were members of the New-York Drawing Association (also called the Society for the Improvement in Drawing) in December 1825. The result of the clash led directly to its transformation into the NAD. Alexander exhibited his drawings regularly, and a number of his works were engraved. Although better known as an instructor, Alexander Robertson also traveled as far north as Canada, executing topographical landscape drawings in a style similar to that of his brother. He married Mary Prevost (Prevoost), niece of Bishop Prevoost, and had several children. As practitioners and teachers, both Robertsons played an important role in the transmission of English styles of portraiture and topographical drawing in the United States.

Bibliography: New York, Kennedy Galleries, "A. & A. Robertson, Limners," in *American Drawings, Pastels and Watercolors: Part One, Works of the Eighteenth and Early Nineteenth Centuries*, sale cat. (New York: Kennedy Galleries, 1967), 14–27; Koke 1982, 3:98–99; Nygren et al. 1986, 286–88; Myers 1987, 178–180; Megan Holloway Fort, "Archibald and Alexander Robertson and Their Schools, The Columbian Academy of Painting, and The Academy of Painting and Drawing, New York, 1791–1835" (Ph.D. diss., City University of New York, 2006).

29. *View of Poughkeepsie, New York*; verso: sketch of landscape with house, 1796

Black ink over traces of graphite on paper, once bound into a sketchbook; graphite; 8 3/4 × 11 1/2 in. (222 × 292 mm), irregular
Inscribed at lower center outside image in black ink: *POUGHKEEPSIE.*; dated at lower right outside image: *2d September 1796.*
Watermark: J WHATMAN / 1794
Provenance: Louis P. Clover Jr., Philadelphia; Kennedy Galleries, New York, 1967.
Bibliography: Kennedy Galleries 1967, 16, fig. 14; Koke 1982, 3:98–99, no. 2301, ill.
Abbott-Lenox Fund, 1967.4

The style of Alexander Robertson's view of Poughkeepsie exemplifies the one he and his brother Archibald taught their students to master in order to produce a landscape quickly and easily. The foliage of the trees is drawn in round, looping outlines, while volume and shadow are achieved with a strong, linear, zigzag pattern,

and the most distant forms are indicated by a very light outline. The result, while convincing, produces a generalized view of nature.[1]

The traces of binding marks along the left edge of the sheet prove that it was once part of a sketchbook. The physical evidence for this theory is reinforced by the existence of twenty-four similar sketches, several of locations in and near Poughkeepsie, that most likely came from the same sketchbook. The entire group is executed in the same media and style and enjoys the same provenance.[2] These sheets, most of which are inscribed with dates and locations, were executed on the spot during Alexander's sketching trips between 2 September 1796 and 14 September 1798 to such locales as Long Island, New Rochelle, the Hudson River valley, Chancellor Robert R. Livingston's estate, Clermont, at Tivoli on the east bank of the Hudson near West Point, Red Hook, and Esopus Creek.[3] The backgrounds of several sheets preserve some of the earliest views of the Catskills known.[4] While a few are more highly worked up with pen and ink, others appear unfinished. As an aggregate, they reveal a highly significant but fledgling interest in American views and landscape, one that would eventually blossom with William Guy Wall's *The Hudson River Portfolio* (cat. 48). In fact, several of Alexander Robertson's works, engraved by Francis Jukes and published in London, foreshadow by nearly thirty years Wall's celebrated *Portfolio* (1820–25).[5] Like his brother, Alexander remained active in public life, becoming one of the original incorporators of the New York public school system.

1. Nygren et al. 1986, 288.
2. Kennedy Galleries 1967, 16–24, figs. 14–38. Another sketchbook, which covers the second half of Robertson's trip (the cover is inscribed *Sketches from nature made by Alexander Robertson, 1796–1797*) is in the McKinney Library of the Albany Institute of History and Art, N.Y. Like cat. 29, it was once owned by Lewis P. Clover Jr., a noted supplier of artists' materials and a publisher of prints; Myers 1987, 180 n. 6. This provenance suggests that Robertson may have entertained publishing the collection of drawings as prints.
3. Another drawing in the Society's collection (inv. no. 1956.12, dated 14 September 1796 and with similar media and measurements) was probably once also part of the same sketchbook. It depicts Clermont at Tivoli, the house of Chancellor Robert R. Livingston (founder and first president of the American Academy of the Fine Arts), which until her death in

POUGHKEEPSIE.

29

1800 was in the possession of his mother, Margaret
Beekman Livingston; see Koke 1982, 3:99, no. 2402,
ill.

4. Myers 1987, 180.
5. Notably the one entitled *Hudsons River / From
Chambers Creek looking thro' the HIGH LANDS*.

ALEXANDER ANDERSON

New York, New York 1775–Jersey City, New Jersey 1870

Alexander Anderson—who was active when New York City became the preeminent publishing center of the country as well as its main port—is considered the first significant American wood engraver (as opposed to a cutter) and one of the foremost book illustrators of the early nineteenth century. The new republic's growing prosperity and the increased interest in illustrated books and juvenile publications, such as *Instructive and Entertaining Emblems on Various Subjects. By Miss Thoughtful* (1796), were forces that had a significant positive effect on Anderson's success as an engraver. These conditions, together with a renaissance of wood engraving in England, furnished him with a ready market.

Anderson was self-taught and at the age of twelve was creating woodcuts for newspapers. Between 1792 and 1798, when he studied and practiced medicine (he had received his medical degree from Columbia College in 1796), wood engraving was his secondary occupation. Following the death of his family in the yellow fever epidemic of 1798, he sought to forget his loss by traveling to the West Indies to visit his uncle, also named Alexander Anderson, who was King George III's botanist and superintendent of the Botanic Gardens in St. Vincent. Returning to New York in 1800, Anderson abandoned medicine and worked solely as a graphic artist but continued to produce medical illustrations. He summarized his change of profession in his diary: "I soon discovered that the practice was a different thing from the study of physic. The responsibility appeared too great for the state of my mind."

Anderson was an early follower of the British artist Thomas Bewick, who produced medical illustrations and was responsible for the revival of wood engraving and the white-line technique employed by Anderson. Among Anderson's best-known works are the three hundred engraved illustrations for the American edition of Bewick's *General History of the Quadrupeds* (1804); his engraved full-length human skeleton enlarged from Bernhard Siegfried Albinus's work on anatomy (an impression is in the DPPAC); and numerous plates for religious works and school books. While he usually engraved the designs of other artists, such as Benjamin West, he was a skillful and original draftsman, as can be seen in his illustrations for William Durell's edition of Homer's *Iliad* (1808). Anderson exhibited frequently at the American Academy of the Fine

Arts and was among the "second fifteen" elected to the founding membership of the NAD (1826) (the "first fifteen" were the most active professional artists from the New-York Drawing Association, formed several months earlier). Anderson also collaborated on book illustrations with his friend John Wesley Jarvis (cat. 37) and attempted to educate himself in engraving techniques by studying the art of others and reading on the topic. One of the most influential books on his own theories of engraving was *The Analysis of Beauty* by the English artist William Hogarth. Anderson was most noted for engraving on the end grain of boxwood, whose polished surface is more durable than a copperplate, allowing the carver to achieve much finer detail than when cutting along the friable wood grain. Anderson produced the first documented end-grain boxwood engravings in America for Durell's 1795 edition of Arnaud Berquin's *Looking-Glass for the Mind*.

Enjoying a long and prolific career engraving for books, magazines, and printed ephemera, Anderson cut his last block in 1868 when he was about ninety-three years old. There is no evidence that he practiced medicine again, except occasionally for charitable reasons.

Although Anderson has been called "the father of American wood engraving," his reputation rests on his solid craftsmanship rather than on his artistic abilities. His linear

Fig. 30.1. Alexander Anderson, *The Bridewell Prison, New York City*, before 1838? Black ink and wash on paper, 4 7/16 × 6 3/4 in. (112 × 171 mm). The New-York Historical Society, Gift of Daniel Parish Jr., 1910.40

drawing style betrays his printmaking craft (fig. 30.1). Like Hogarth, his work has a humorous, bitingly satirical side, even in those prints that express a wistful desire for simplicity. Anderson, whose career coincides with the most vigorous period of American wood engraving, was the dominant illustrator in the country until the 1840s, when Felix Darley (cat. 97) introduced a freer style. Seventeen scrapbooks of Anderson's proofs, containing some ten thousand impressions, as well as portfolios of intaglio and relief engravings, are housed in the NYPL. The Society holds several of his notebooks, scrapbooks of his later engravings, his tools, 378 of his wood blocks, his unique *Wheel of Fortune* (1800), and over forty drawings in the DPPAC. The museum counts twenty-two drawings and watercolors, together with one miniature on ivory, in its holdings.

Bibliography: Benson J. Lossing, *A Memorial of Alexander Anderson, M.D., the First Engraver on Wood in America* (New York: Printed for the Subscribers, 1872); Frederic M. Burr,

30

Life and Works of Alexander Anderson, M.D., The First American Wood Engraver (New York: Burr Brothers, 1893); Helen M. Knubel, "Alexander Anderson and Early American Book Illustration," *Princeton University Library Chronicle* 1:3 (1940): 8–18; Albert Ten Eyck Gardner, "Doctor Alexander Anderson, the Pirates' Friend," *Bulletin of the Metropolitan Museum of Art* 9:8 (1951): 218–24; John F. Dingman, *Alexander Anderson (1775-1870), and the Background of Wood-Engraving in America* (San Marcos, Calif.: Dingman, 1984); Jane R. Pomeroy, "Alexander Anderson's Life and Engravings before 1800, with a Checklist of Publications Drawn from His Diary," *Proceedings of the American Antiquarian Society* 100:1 (1990): 137–230; Christopher Hoolihan, "Wood Engraving and American Medical Publishing in the Early Nineteenth Century," *Imprint New York NY 1976* 21:1 (1996): 20–28; Jane R. Pomeroy, *Alexander Anderson (1775-1870), Wood Engraver and Illustrator, An Annotated Bibliography*, 3 vols. (New Castle, Dela.: Oak Knoll Press; Worcester, Mass.: American Antiquarian Society, 2005).

30. *Isaac Van Vleck (1773–1810)*, c. 1800–1805

Watercolor, black ink, and graphite on paper, inlaid into a larger sheet; 3 3/16 × 2 1/16 in. (81 × 52 mm), oval
Verso inscribed vertically on mauve-tinted background in graphite: *Isaac Van Vleck*
Provenance: Daniel Parish Jr., New York.
Bibliography: N-YHS 1941, 323, no. 776; N-YHS 1974, 2:835–36, no. 2122, ill.
Gift of Daniel Parish Jr., 1912.19

The sitter's identification derives from the graphite inscription on the verso of this small portrait. Formerly, the sitter Isaac Van Vleck has been identified mistakenly as the artist's brother-in-law and the brother of Ann (who died in the yellow fever epidemic of 1798) and Jane Van Vleck, Alexander Anderson's first and second wives respectively.[1] A study of the Van Vleck family genealogy reveals that Jane and Ann had only one brother, Henry. However, though their father was named Isaac (1748–1804), his dates disqualify him as the sitter of this portrait. Therefore, if the inscription on the verso is correct, the sitter is another Isaac of the Van Vleck family, born in 1773. This Isaac's father was Abraham I. and his mother was Jannetje Vosburgh. He was second cousin to Jane and Ann (Abraham I. was cousin to Ann and Jane's father).[2] In *A Memorial of Alexander Anderson, M.D.*, Lossing wrote that the Van Vlecks were members "of a most excellent Moravian family then [1797] living on Partition Street, now [1872] West Fulton Street."[3]

When Anderson arrived back in New York from his trip to St. Vincent, he must have stayed with the elder Isaac Van Vleck—father of Ann and Jane and a notary public and gauger—at his house at 6 Upper Reed Street. On 16 March 1800 Anderson married Jane Van Vleck.[4] The couple had six children, one of whom, Ann, studied with her father and became an engraver.

This small portrait belongs to the important period in the artist's life when he worked to improve his art: "I applied myself closely, rather too closely to the arts and lost no time in amusements except some rambles out of town and even then I was attempting sketches."[5] The oval format of the work may have been in imitation of miniatures or his own oval woodcut portraits, or the sheet may have once been rectangular, like the similar portrait in the Society's collection Anderson painted of his second wife.[6] Both can be dated to about 1800–1805, based on the sitters' dress and coiffures. The family resemblance between the two subjects is quite pronounced, especially in their large, soulful eyes. Anderson also executed the pair in a bold, flat style, without the modeling often characteristic of his woodcuts.[7]

1. N-YHS 1974, 2:835–36.
2. Jane Van Vleck, *Ancestry and Descendants of Tielman Van Vleeck of Niew Amsterdam* (New York: privately printed, 1955), 254–55. A special thanks to Alexandra Mazzitelli for unraveling the genealogy.
3. Quoted in N-YHS 1974, 2:836.
4. Pomeroy 1990, 148.
5. Quoted in ibid., 168.
6. Inv. no. 1912.11, 3 1/4 × 2 1/4 in.; N-YHS 1974, 1:20, no. 39, ill.
7. See also his woodcut profile portrait of John Anderson Jr.: N-YHS 1974, 1:21–22, no. 44, ill.

JOHN VANDERLYN

Kingston, New York 1775–1852

John Vanderlyn, an important figure in American Romantic painting, was the descendant of Dutch settlers in the Hudson River valley. As a child, his grandfather, the portraitist Pieter Vanderlyn, introduced him to the work of the old masters. At fourteen, Vanderlyn was drawing after Dutch prints, and at sixteen he produced studies after the French academic artist Charles Lebrun. That year Vanderlyn moved from Kingston to New York City, where he first apprenticed to the art dealer Thomas Barrow and studied at Archibald and Alexander Robertson's Columbian Academy of Painting (cats. 21 and 29), where drawing skills were stressed. A copy Vanderlyn made of Gilbert Stuart's portrait of Aaron Burr attracted the attention of Burr, who offered him the opportunity to assist Stuart for a year in Philadelphia, which had succeeded New York as capital of the country. The following year, under Burr's sponsorship, Vanderlyn continued his studies abroad in Paris with the academic artist François-André Vincent. Except for a brief return to America in 1801–3 and visits to England (1803) and Italy (1805–7), Vanderlyn lived in France until 1815. After 1803 he exhibited history paintings at the Paris Salons, where in 1808 he was awarded a *médaille d'encouragement* from Napoleon for his *Caius Marius amid the Ruins of Carthage* (1807; Fine Arts Museums of San Francisco), which established his prominence in the European art world. His sensual canvas *Ariadne Asleep on the Island of Naxos* (1809–14; Pennsylvania Academy of the Fine Arts, Philadelphia) was the first female recumbent nude painted by an American artist. Although it did not win him the acclaim he hoped for—on the contrary, it created a scandal—the famous work was frequently copied in the early nineteenth century. Asher B. Durand (cats. 51–54), for example, engraved the painting in 1835 (for a preparatory drawing, see fig. 51.1). One of America's major Neoclassical painters, Vanderlyn was among the pioneering artists who sought to define a recognizable American art.

When he returned to America in 1815, Vanderlyn settled in New York City and received portrait commissions from many important individuals. Since his ambitious historical compositions found no market, he also pursued entrepreneurial ventures, as he had done earlier when he tried to get his 1801 views of Niagara Falls engraved. To ease his ongoing financial problems,

he erected the New York Rotunda (1818), a classical-style building near City Hall, where he exhibited British-made panoramas and his own heroically scaled *Panoramic View of the Palace and Gardens of Versailles* (1818–19; The Metropolitan Museum of Art, New York), together with history paintings, portraits, and copies of old masters. Evicted from the premises by the city in 1829, Vanderlyn continued to exhibit panoramas throughout the United States, in such cities as Charleston, Saratoga, and New Orleans, as well as in nearby Havana, Cuba, and Canada. The NAD had named him a member in 1826, but he refused the honor because of his involvement with the American Academy of the Fine Arts. Discouraged and debt-ridden, he retired to Kingston in 1829. He replicated his panoramic *View of Niagara Falls* (1803; Albany Institute of History and Art, N.Y.), which had influenced artists of the emerging Hudson River School, in his *Niagara Falls* (1842–43; Senate House Museum, Kingston, N.Y.). After spending eight frustrating years in Paris, beginning in 1839, working on a picture for the Rotunda of the U.S. Capitol (*The Landing of Columbus*, his last public commission, installed in 1846), he returned to Washington to paint portraits. Unsuccessful in most of his later enterprises, he gave up his Washington studio in 1852 and once again retired to Kingston, an impoverished and embittered man.

Bibliography: Louise Hunt Averill, "John Vanderlyn, American Painter (1775–1852)" (Ph.D. diss., Yale University, 1949); Marius Schoonmaker, *John Vanderlyn, Artist, 1775–1852: Biography* (Kingston, N.Y.: Senate House Association, 1950); Kenneth C. Lindsay, *The Works of John Vanderlyn: From Tammany to the Capitol*, exh. cat. (Binghamton: University Art Gallery, State University of New York, 1970); William Townsend Oedel, "John Vanderlyn: French Neoclassicism and the Search for an American Art" (Ph.D. diss., University of Delaware, 1981); Kevin J. Avery and Peter L. Fodera, *John Vanderlyn's Panoramic View of the Palace and Gardens of Versailles* (New York: Metropolitan Museum of Art, 1988).

31. *Robert Fulton (1765–1815)*, 1798

Probably Conté crayon, black chalk?,[1] and graphite with touches of white gouache on lightly oiled paper; 10 1/2 × 8 3/16 in. (267 × 208 mm)
Signed at lower right outside image in graphite: *Vanderlyn.—*; inscribed at lower center outside image: *Fulton*
Provenance: The Barlow family, New York; Judge Peter T. Barlow, New York; Samuel Latham Barlow, New York;

Dr. Maury A. Bromsen; Randall J. LeBoeuf Jr., Old Westbury, N.Y., 1960.
Bibliography: Lancaster (Pennsylvania) Historical Society, *Papers Read before the Lancaster County Historical Society* 13:8 (1909): ill. opp. 193; Alice Crary Sutcliffe, *Robert Fulton and the "Clermont": The Authoritative Story of Robert Fulton's Early Experiments, Persistent Efforts, and Historic Achievements* (New York: Century Co., 1909), 114, ill.; Eleanore J. Fulton, "Robert Fulton as an Artist," *Papers of the Lancaster County Historical Society* 42 (1938): 89, ill. opp. 81; Averill 1949, 367, no. 54; Lindsay 1970, 127, no. 17, ill.; Oedel 1981, 95–98, 507, fig. 43; Philip 1985, ill. opp. 180; Avery and Fodera 1988, 14–15, fig. 5; Fink 1990, 399–400; Olson 2004, 28–29, fig. 8; Roberta J. M. Olson, "Fulton at the Fulcrum: A Search for Identity," *New-York Journal of American History* 4 (2004): 133–39, fig. 3 (reversed); Ellen Paul Denker, "Collectors' Legacies," *The Magazine Antiques* 167:1 (2005): pl. 1.
Bequest of Randall J. LeBoeuf Jr., 1976.56

John Vanderlyn's bust-length portrait of his friend Robert Fulton, the artist-turned-inventor, was executed in Paris during the heady Revolutionary period of the Directory.[2] It celebrates the youthful promise of both men. Extraordinarily ambitious, Fulton associated with key players of the time, Americans abroad as well as French *citoyens*. Among those expatriates in the French capital was Vanderlyn, who had arrived under the patronage of Aaron Burr. His successful artistic career in France served as a foil to that of Fulton, who turned his major energies away from art toward more practical and scientific pursuits. Ironically, it was Fulton who in the end attained the fame and fortune both men pursued.

Fulton, who had studied painting in England with Benjamin West from 1786, was already involved with problems of engineering and mechanics before moving to France in 1797 (cat. 20). In 1799 he introduced to the French capital a panorama of the city, a combination of art and engineering that he had patented.[3] He remained in Paris until 1806, patenting his canal project with hopes that it would subsidize his design of a submarine prototype (the *Nautilus*) and his experiments with torpedoes and steam-powered boats. Fulton is best known for the construction, in association with Robert R. Livingston, of the first commercially successful steamboat, the *North River Steamboat* (after his death known as the *Clermont*), which steamed up the Hudson from New York to Albany and back in six days, from 17 to 22 August 1807.

31

Before embarking in earnest on his career as a history painter, Vanderlyn earned his income rendering portraits of members of the American community in Paris.[4] At the time, small-scale, fully modeled, and highly finished works, similar to this portrait of Fulton, enjoyed a vogue in Paris; they were drawn notably by Jean-Baptiste Isabey as well as by Jean-Auguste-Dominique Ingres. Vanderlyn's portrait has been compared in size, pose, mood, medium, and shape (albeit oval versus round) to Ingres's well-known *Portrait of Pierre-Guillaume Cazeaux* (private collection, New York) of the same year.[5] While both sitters convey an unusual intensity, Vanderlyn's charismatic likeness suggests the visionary aspect of Fulton's character. The drawing's oval format, a passing nod to the miniature tradition, adds to the intimacy and elegance of the highly refined sheet. At the time of this portrayal, the thirty-three-year-old brunette sitter must have been powdering his hair, despite his republican political ideals.

Stylistically, this sheet resembles a group of reserved portraits by Vanderlyn from about 1799, notably the rectangular pair portraying Daniel Strobel Jr. and his wife, Anna Church Strobel, with their son George, in the Metropolitan Museum of Art.[6] Vanderlyn executed these sheets in a variety of media similar to those of the present work, dominated by the newly introduced commercially prepared Conté crayon, which produces a highly nuanced sfumato (smoky) quality reminiscent of Leonardo da Vinci's drawings. The subtle tonal variations of the black powdery medium are achieved by the varying pressure of the artist's hand, which distributes the powder in a range of thicknesses. Highlights are created by exposing the paper or leaving it in reserve. The middle tones are made by "lifting" the powder by tamping it with pellets of dry or damp breadcrumbs.[7] As with the artist's portrayal of Daniel Strobel, in the portrait of Fulton Vanderlyn applied touches of white gouache, in this case to the cravat and the pupils of his eyes, where it lends vivacity to the sitter's riveting gaze.

Vanderlyn's sympathetic portrait belongs to an impressive group of Fultoniana, previously the largest in private hands, donated to the N-YHS through the bequests of Randall LeBoeuf Jr., a former member of the Society, in 1976, and his wife, Harriet Ross LeBoeuf, in 1998. With the addition of the LeBoeuf material, the Society's Fulton holdings have attained a preeminent position. Further, the Society holds a dozen (the museum has six) original works on paper and three portrait miniatures on ivory by Fulton, many of which have a LeBoeuf provenance.[8]

1. For a discussion of the complex use of black friable media, see Shelley 2002, 51–59, and for a discussion of Vanderlyn's technique specifically, 50, 52–54.

2. For Vanderlyn's training in Paris, see Weinberg 1991, 26–35.

3. Oedel 1981, 96–97, believes that Fulton had probably seen Robert Barker's panorama in London, taking note of its popularity and seeing a lucrative potential market in Paris. After Fulton obtained his patent, the poet-philosopher Joel Barlow, an intimate friend of Fulton, financed the construction of a large building (46 feet in diameter) on land facing the boulevard Montmartre. Fulton's first panorama was a view of Paris from the Pavillon de l'Unité at the Louvre, which was painted by others based on Fulton's design. In 1800 Fulton designed and partially painted a second panorama of the burning of Moscow, which captured the headstrong mood of France under First Consul Bonaparte. Vanderlyn, who was a witness to these spectacles, harbored a desire to duplicate Fulton's success by marketing the panorama phenomenon to achieve his dream of becoming a great history painter, a venture on which he embarked when he returned to New York in 1815. For the sitter, see Philip 1985.

4. Averill 1949, 26–28; and Oedel 1981, 88–105.

5. Avery et al. 2002, 116. On a commercially prepared tablet like that used the same year by Fulton in cat. 20, fig. 20.2, it was formerly in the collection of Mrs. Rudolf J. Heinemann, New York; see Hans Naef, *Die Bildniszeichnungen von J.-A.-D. Ingres* (Bern: Benteli Verlag, 1977), 4:40–41, no. 23, ill. For a contemporaneous drawing by Isabey, see Perrin Stein and Mary Tavener Holmes, *Eighteenth-Century Drawings in New York Collections*, exh. cat. (New York: Metropolitan Museum of Art, 1999), 224–25, no. 97, ill.

6. Inv. nos. 17.134.1 and 17.134.3; see Avery et al. 2002, 116–19, nos. 20 and 21, ills.

7. Shelley 2002, 50. Shelley writes (p. 31): "Vanderlyn's dense yet precise application of the black chalklike material, probably the newly introduced Conté crayon, to a specially prepared paper tablet reflects his familiarity with the latest French materials and techniques."

8. For some of these, see N-YHS 1974, 1:278–79, nos. 705, 706 (cat. 20, fig. 20.1), and 709; and Koke 1982, 2:54–55, nos. 1069–70. For other portraits of Fulton in the Society, see N-YHS 1974, 1:277–79, nos. 704, ill., 707, and 708.

JOHN WOOD

Scotland 1775–Richmond, Virginia 1822

Although nothing is known about his parents or early life, the writer, cartographer, teacher, mathematician, and miniaturist, John Wood was born in Scotland and may have received his education in France. He also resided briefly in Switzerland. His career, involving drafting skills and an interest in the arts and sciences, was characteristic of a late-eighteenth-century Scot. Back in Edinburgh in 1799, he was named master of the Academy for the Improvement of Arts in Scotland. That same year he published *A General View of the History of Switzerland*, which narrates his experiences in that country during the French invasion in 1798.

By 1800 Wood had traveled to the United States, first settling in New York City, where he tutored the sons and daughters of the local elite in Latin, Greek, and French. Reputedly Aaron Burr's daughter Theodosia was one of his pupils. For the next five years he maintained a New York address while seeking business opportunities in Philadelphia and Richmond, Virginia. He is listed variously in the New York City directories as a limner, teacher, author, and bookseller. Wood published a political pamphlet in Philadelphia in 1801 taking to task extreme Federalists and attracting the attention of leaders of the Jeffersonian Republican party. James Cheetham and David Denniston, publishers of the daily Republican newspaper the *American Citizen*, sized up Wood for Thomas Jefferson. Wood, Cheetham reported, "is a Good Mathematician, and elegant drawer [*sic*], and a Complete master of the Greek, latin, and french

languages. But he has *no fixed principles in politics* and in every respect he is a man of Great indecision and versatility … . By profession he is a republican: in action *anything*." The same year Wood signed a contract to write a five-hundred-page book on the presidency of John Adams for $200 (*The History of the Administration of John Adams*), which, when the libelous mishmash appeared in 1802, was referred to as "the suppressed history." It sparked a pamphlet war between the New York Republican party factions supporting Burr and DeWitt Clinton. The controversy injured Burr's chances of winning the New York governorship in 1804.

As early as 1803 Wood's advertisements to execute physiognotraces, silhouettes, and miniatures, and to teach math and drawing had

been carried in the Richmond papers. In Richmond he became associated with the hack writer Joseph M. Street, and in 1805 the pair went to Frankfurt, Kentucky, and briefly edited a weekly Republican paper, the *Western World*; in 1807 they published *Full Statement of the Trial and Acquittal of Aaron Burr*. Wood's Kentucky experience soured him on political advocacy; he therefore renewed his scientific interests, writing such studies as *A New Theory of the Diurnal Rotation of the Earth* (1809). In 1816 Thomas Jefferson recommended Wood to the governor of Virginia to map the rivers of tidewater Virginia. Three years later he was appointed surveyor general, the official cartographer for the state, with the assignment to produce a map of each county, in addition to one of the entire state. By 1822 Wood had submitted ninety-six county maps, after traveling to Washington, D.C., to correlate his findings with U.S. government maps, leaving only six unfinished at his death.

Bibliography: Stokes 1915–28, 1:459–60; *DAB*, 20:464–65; Koke 1982, 3:291–92; Harry M. Ward, "Wood, John," http://www.anb.org/articles/03/03-00546.html: *American National Biography Online* Feb. 2000.

32. *View of New York City from Long Island, New York: Study for an Aquatint*, c. 1800

Black ink and wash and graphite on paper; 13 5/8 × 19 7/8 in. (346 × 505 mm), irregular
Verso inscribed at lower left at a diagonal in graphite: *Wunderlich*
Watermark: Crowned escutcheon with fleur-de-lis, surmounting intertwined W
Provenance: Edwin Babcock Holden, New York; American Art Galleries, New York, 1910.
Bibliography: American Art Galleries, New York, sale cat., 21 April 1910, lot 1659; Stokes 1915–28, 1:459–60, pl. 74; Stokes and Haskell 1932, 79; Isaac Newton Phelps Stokes and Daniel C. Haskell, *American Historical Prints: Early Views of American Cities, etc. from the Phelps Stokes and Other Collections* (New York: New York Public Library, 1933), 45; Koke 1982, 3:291–92, no. 2933, ill.
Gift of Samuel Verplanck Hoffman, 1910.38

William Rollinson (cat. 17) etched an aquatint after this grisaille wash drawing by Wood,[1] which Deák has called "one of the most beautiful prints of eighteenth-century New York."[2] Generally known as Rollinson's View, the aquatint, with dimensions nearly identical to those of the

drawing, was published in New York jointly by Wood and Rollinson on 14 February 1801. Like Rollinson's own stylistically similar wash drawing of the Custom House in the Society's collection (cat. 17 with the identical provenance as Wood's drawing), *View of New York City from Long Island* exemplifies the wash technique then so fashionable in England. This monochrome technique was frequently used in preparatory drawings for aquatints, the print medium that most successfully imitated wash and watercolor drawings. The acknowledged master of the aquatint method, which experienced its golden age during the late eighteenth century, was Paul Sandby, whose works Wood's and Rollinson's drawings resemble.[3] Similar compositional formulas and proportions were employed by other contemporaneous artists working in North America, such as Thomas Birch (cat. 36).

In both the drawing and the aquatint, New York City is viewed across the water from the pastoral shores of Long Island, its skyline crowded with church spires, the skyscrapers of their day, stretching above the densely populated mass of Manhattan Island. The leafy coulisses of lofty trees and the billowing cloud formations add movement to the work, while the vessels in the water testify to the nautical activity that made the port city a cultural and economic force. Rollinson made minor changes on his aquatinted plate after Wood's preparatory drawing. They include diverse and more developed ships in the middle ground, completion of the sketchy tree trunk at the right of the composition, the addition of detailed foreground vegetation, and a more dramatic sky. In its general impression, the aquatint is bolder than the drawing, with stronger chiaroscuro, which lends it an abstract quality.

When Wood drew his view, New York was quickly becoming a crowded urban environment, as underlined in a comparison with Saint-Mémin's drawing and engraving of the city from Mount Pitt (cat. 25) and its pendant, which were taken from a location on Long Island similar to that of Wood's and Rollinson's views.[4] At that time, the New York City fathers were already in a dither about the crowding of people and buildings in the metropolis. By the winter of 1800–1801 the population was just under 61,000 inhabitants, but the authorities were nonetheless worried about their health since the

potential of epidemics was ubiquitous in the burgeoning urban environment.[5]

1. For the aquatint, of which there is an impression in the Society's DPPAC, see Stokes 1915–28, 1:459–60, pl. 74; and Deák 1988, 1:160, no. 240; 2: ill. It was probably purchased with the watercolor (lot 1659), at the American Art Galleries, New York, sale cat., 21 April 1910, lot 1658.
2. Deák 1988, 1:160.
3. See A. P. Oppé, *The Drawings of Paul and Thomas Sandby in the Collection of His Majesty the King at Windsor Castle* (Oxford: Phaidon Press, 1947); Anthony Griffiths, "Notes on Early Aquatint in England and France," *Print Quarterly* 4:3 (1987): 268–70; Jane Roberts, *Views of Windsor: Watercolours by Thomas and Paul Sandby from the Collection of Her Majesty Queen Elizabeth II*, exh. cat. (London: Royal Collection, in association with Merrell Holberton, 1995); and Roberta J. M. Olson and Jay M. Pasachoff, "The 'wonderful meteor' of 18 August 1783, the Sandbys, 'Samuel Scott,' and Heavenly Bodies," *Apollo* 146:429 (1997): 12–19, for additional bibliography.
4. For Saint-Mémin's etching *View of New York City from Long Island*, see Stokes 1915–28, 1:437–38, pl. 61; and Deák 1988, 1:142, no. 215; 2: ill.
5. See Deák 1988, 1:160, for additional information on population and sanitary problems.

JOHN JOSEPH HOLLAND

London, England c. 1776–New York, New York 1820

A townscape and theatrical scene painter, John Joseph Holland was apprenticed at the age of nine to the scene painter Gaetano Marinari, chief artist at the King's Theatre in London's Haymarket, where he learned his craft as well as architecture and landscape painting in watercolor. In 1794 Holland left the King's to paint scenery at Covent Garden. By the following year, he had returned to the King's, but in 1796 he was hired by Thomas Wignell, actor and manager for the Chestnut Street Theatre in Philadelphia, and came to America. In Philadelphia he worked with the theater's chief artist C. (probably Cotton) Milbourne, soon establishing himself as one of the leading scene painters and even replacing Milbourne in 1805 until his departure in 1807.

That same year he moved to New York City and redesigned the interior of the prestigious Park Theatre. His work was highly sought after, but too expensive for Benjamin Latrobe, who had asked Holland to decorate the walls of the House of Representatives in Washington, D.C. In 1811 the Grand Panorama at the corner of Broadway and Leonard Street exhibited a painting by Holland (*Panorama Representing the City and Environs of New York*), which was accompanied by a descriptive booklet published by the Shakespeare Gallery. Holland stayed on as

a scene painter at the Park Theatre until 1813. He then went into business on his own, helping to manage an acting company, the Theatrical Commonwealth. Soon after, he renovated the Olympic Theatre on Anthony Street and managed it from April to July 1814. During the War of 1812, Holland fought on the American side, and in the summer of 1814 he made drawings, now in the Society's collection, of the fortifications erected on both Manhattan and Long Island to defend the city.

In 1816 Holland returned to the Park Theatre, where he worked until his death. The writer William Dunlap, who knew Holland for many years, wrote about him in his *History of the Arts of Design* (1834); according to Dunlap, Holland never attempted to paint in oil. Two pupils who studied scene painting under him, Hugh Reinagle and John Evers, are represented in the Society's collection, including a miniature portrait in watercolor on ivory of Holland by Evers (1819).

Bibliography: William Dunlap, *A History of the American Theatre* (New York: J. & J. Harper, 1832), 191–92; idem 1834, 2:64–65; Groce and Wallace 1957, 322; Richard Stoddard, "Notes on John Joseph Holland, with a Design for the Baltimore Theatre, 1802," *Theatre Survey* 12:1 (1971): 58–66.

33a. *View at Fort Clinton, McGown's Pass, New York City*, 1814

Watercolor, black ink, and graphite on paper, laid on heavier paper; 22 7/8 × 30 3/4 in. (581 × 781 mm)
Inscribed below image in brown ink: *View at Fort Clinton McGowan's [sic] Pass.*; verso of heavier paper inscribed at lower left vertically in brown ink: *N. 9.*
Provenance: City of New York.

Bibliography: *Valentine's Manual* 1856, opp. 89 (lithographed by George Hayward); Benson J. Lossing, *The Pictorial Field-Book of the War of 1812* (New York: Harper & Brothers, 1869), 973; Edward Hageman Hall, *McGown's Pass and Vicinity* (New York: Published under the auspices of the American Scenic and Historic Preservation Society, 1905), ill. between 32 and 33; Stokes 1915–28, 3:555–56, pl. 82-B-c; Koke 1982, 2:147, no. 1234, ill.
Deposited by the Common Council of the City of New York, 1889.11

33b. *Barrier Gate, McGown's Pass, New York City*, 1814

Watercolor, black ink, graphite, and scratching-out with touches of gouache on paper, laid on heavier paper (together with inv. no. 1889.17); 11 3/4 × 30 3/4 in. (298 × 781 mm)
Inscribed below image in brown ink: *Gate at McGowan's [sic] Pass.*; verso of heavier paper inscribed vertically at lower left in brown ink: *No. 10.*
Provenance: City of New York

33a

Bibliography: *Valentine's Manual* 1856, opp. 592
(lithographed by George Hayward); Hall 1905, ill.
between 32 and 33; Stokes 1915–28, 3:554–55, pl. 82-B-b;
Koke 1982, 2:147–48, no. 1239, ill.
Deposited by the Common Council of the City of New
York, 1889.16

These are two of twelve watercolors by John
Joseph Holland[1] and six by John Joseph Holland
Associates[2] in the Society's collection that form
a group of thirty-three maps, plans, and views
in the *Report on the Defence of the City of New York*.
Prepared by Brigadier General J. G. Swift, chief
engineer of the United States Army, the report
was submitted to a committee of the New
York Common Council on 31 December 1814
during the War of 1812 (declared by Congress
on 18 June 1812). In July of that year, after secret
intelligence was received of an intended attack
on New York City, a special committee was ap-
pointed to determine what fortifications were
needed to protect the city. It was decided that
whereas the harbor was prepared, Hell Gate was
completely unprotected against a British inva-
sion by way of Long Island Sound.[3] Measures
were taken to remedy this situation with a series
of entrenchments, blockhouses, and barrier
gates across upper Manhattan Island construct-
ed under Swift's direction. This line began at
present-day 106th Street and the Harlem River,
ran westerly to McGown's Pass (now Central
Park at 123rd Street) and then further north-
westerly to the heights below Manhattanville
overlooking the Hudson River near what is now
125th Street. The views and illustrations of the
defenses are not signed, but the identities of the
artists are known from a statement at the end
of the report. Holland executed the large views,
and Captain James Renwick and Lieutenant
James Gadsden, assisted by Lieutenants Craig,
Turner, De Russy, Kemble, and Oothout, pre-
pared the smaller ones.[4]

The historian Benson J. Lossing found the
bound report in the garret of the old Hall of
Records in City Hall Park under a thick layer of
dust. He secured permission from the Common
Council to remove the report for study while
preparing his *Pictorial Field-Book of the War of 1812*
(1868) and returned it only in 1889, at which time
it was deposited at the Society for safekeeping.[5]

The first of the pair represents a view
looking east from within Fort Clinton, just
southwest of its northeast bastion (at the left),

across Benson's Creek and the marshes extend-
ing from the McGown's Pass area, to the East
River.[6] The pass was first identified with the
name of McGown in the year 1756, when Daniel
McGown purchased a nine-acre tract of land
from Jacob Dyckman, including the Dyckman or
Black Horse Tavern.[7] On 18 August 1814 the
Common Council of the City commenced
construction of a fort at McGown's Pass, named
Fort Clinton in honor of Mayor DeWitt Clinton.
It was the first in a chain of forts to be erected in
Harlem Heights. This earthwork crowned the
summit of the rock overlooking Harlem Mere,
six hundred feet east of Fort Fish. At an
elevation of nearly fifty feet, it occupied the site
of one of the Revolutionary War redoubts. Fort
Clinton was connected on the east with the head
of the natural barrier of Harlem Creek, before
1800 called Benson's Creek and before that
"Montanye's fonteyn." It was connected with
Nutter's Battery by a breastwork. About midway
between Fort Clinton and Nutter's Battery, the
Post Road crossed the line of this breastwork,
where the Barrier Gate, seen in catalogue 33b,
was positioned.

Holland's view of the Barrier Gate shows it
from the interior looking toward the northeast,
with its blockhouse above, which was erected to
guard the approach to the city from the north.[8]
On either side was a one-gun battery. Holland
also depicted the old Post Road (also known as
Kingsbridge Road). See catalogue 34 for a view
of Harlem Plains by Holland.

1. Inv. nos. 1889.11–1889.22; Koke 1982, 2:147–49, nos.
1234–45.
2. Inv. nos. 1889.23–1889.28; ibid., 149–51, nos. 1246–51.
3. For more details, see Hall 1905, 31–39, which
also contains an excellent map delineating the
fortifications of the area encompassed by northern
Central Park in relation to modern streets and
pathways.
4. Koke 1982, 2:150.
5. Stokes 1915–28, 3:552.
6. The lower margin of this sheet retains traces of
having been sewn into a binding. In the titles
of Holland's watercolors, the name McGown is
incorrectly spelled "McGowan."
7. Stokes 1915–28, 3:554–55, traces the owners of this
tract back to 1712.
8. The view of the exterior looking toward the
southwest is reproduced in Hall 1905, between 32
and 33.

33b

Gate at McGowans Pass.

WILLIAM JAMES PROCTOR

Active in New York City c. 1814–33

The draftsman of the 1814 military topographical map of the fortifications at Harlem on upper Manhattan Island discussed below is named in the map's inscription as "Wm. Js. Proctor." No doubt William James Proctor had been trained in the distinguished British military tradition of topographical drawing skills, as were so many European artists active in America in the late eighteenth and early nineteenth centuries.

Bibliography: Stokes 1915–28, 3:551.

William James Proctor and John Joseph Holland (cat. 33)

34. *Military Map of Harlem Heights with Landscape Vignette at Upper Right,* 1814

Watercolor and black ink on card, laid on canvas; 24 3/8 × 32 5/8 in. (619 × 828 mm), irregular

Inscribed and dated at lower left in black ink: *A / Military Topographical MAP / OF HAERLEM HEIGHTS AND PLAIN; / Constructed under the direction of Genl. I. G. SWIFT of US Engineers. / by Captn. JAMES RENWICK, of Genl. MAPE'S Brigade. / Drawn by Wm. Js. Proctor.*; at upper right: *To Colnel. NICHOLAS FISH, / and other Members of the COMMITTEE of DEFENCE; / THIS MAP, / is respectfully Dedicated / November 1814*; below nine references and annotations throughout

Provenance: City of New York.

Bibliography: *Valentine's Manual* 1856, vignette ill. opp. 236; Stokes 1915–28, 3:551–53, pl. 82-A; Koke 1982, 2:151, no. 1251.

Deposited by the Common Council of the City of New York, 1889.28

Charting the topography near the junctures of the Harlem and East rivers at Hell Gate, this map belongs to a group of twelve watercolors by John Joseph Holland[1] and six by John Joseph Holland Associates[2] in the Society's collection (cat. 33). These eighteen works are part of the thirty-three maps, plans, and views in the *Report on the Defence of the City of New York* prepared by Brigadier General J. G. Swift, chief engineer of the United States Army that were submitted to a committee of the

New York Common Council on 31 December 1814 during the War of 1812 (declared by Congress on 18 June 1812). Catalogue 34 is the largest of the set.

Holland, the chief draftsman of the project, drew the small watercolor vignette of Harlem Plains at the upper right in the map by William James Proctor,[3] about whom little is known.[4] Later, Holland's charming bucolic scene was lithographed by George Hayward and published in Valentine's *Manual of the Corporation of the City of New York* (1856). The map's decorative meander-pattern border—with masks and foliate ornaments at the corners, along with the cartouche in the lower left corner surmounted by an eagle perched on a globe in grisaille—

underlines the importance of the project, proves its nature as a presentation drawing, and suggests it may have been intended for engraving.

1. Inv. nos. 1889.11–1889.22; Koke 1982, 2:147–49, nos. 1234–45.
2. Inv. nos. 1889.23–1889.28; ibid., 150–51, nos. 1246–51.
3. Although William James Proctor is mentioned as the draftsman of the map in its inscription, Koke 1982, 3:151, notes the artist was one of the other individuals listed in the Swift report as the associates of Holland: "The artist is presumed to be either Captain James Renwick, Lieutenant James Gadsden, Lieutenant Isaac E. Craig, Lieutenant Daniel Turner, Lieutenant Lewis Gustavus De Russy, Lieutenant Kemble, or Lieutenant Oothout." Stokes 1915–28, 3:552, notes that the Swift report lists these draftsmen as responsible for the surveys, maps, and small views, while Holland is credited with the large views.
4. Only one published source has been located; it concerns legal claims against his and James B. Taylor's estates: Henry D. Cruger, *The Separate Answer of Henry D. Cruger, of the City of New York* (New York?, 1844?).

JACQUES-GÉRARD MILBERT

Paris, France 1766–1840

In post-Enlightenment fashion, Jacques-Gérard Milbert was both a naturalist and an artist. Although he was trained as an artist and frequented the atelier of Pierre-Henri de Valenciennes, Milbert eventually became a professor of drawing at the École des Mines in Paris (1795). He also worked as a geographer, engineer, and scholar. Early in his career Milbert traveled on several official scientific expeditions: to the Pyrenees, the Alps, the Rhône, and in 1800 to the Antarctic. For two years, he lived on the Indian Ocean island of Mauritius (1801–3), formerly the Île de France, and in 1812 published a two-volume illustrated study and atlas of the island (*Voyage pittoresque à l'Ile de France*). In November 1815 his love of exploration and travel took him to America, where he remained for eight years. Settling in New York City, he worked briefly for the French consul drawing machinery for steamboat designs. Soon he was supporting himself as a portraitist and drawing instructor; in 1817 he began exhibiting at the American Academy of the Fine Arts, where he became an academician in 1824 and a patron in 1825.

A year after his arrival, he was appointed engineer to the New York commission charged to map the soon-to-be-built canal between Lake Champlain and the Hudson River (1816–20). Milbert journeyed along the Hudson and through

the northeastern states, recording his travels and the topographic wonders he saw in a large number of drawings, a selection of which were lithographed after his return to Paris. It was through his efforts that the first living specimen of the American buffalo was introduced into France. After the trip, Milbert was appointed by the minister of France, the Baron Hyde de Neuville (see cats. 15 and 16), to collect natural history specimens along the Hudson for King Louis XVIII's collection. This commission began a seven-year task, during which Milbert walked not only collecting natural specimens but also recording life within the region in drawings and descriptions. The French traveler's intense curiosity about the lives of frontier inhabitants—like the Society's drawing of the baptism of the Anabaptists in the Hudson River at Sandy Hill—was matched by his interest as a naturalist in the topographic wonders he encountered and in the varieties of animals, insects, birds, plants, foliage, and minerals peculiar to the Western Hemisphere. He recorded his observations about all he saw in remarkable pictures and prose that constitute a valuable document of American social and natural history. A rare early American lithograph of 1821 reproducing one of his views by William Armand Barnet and Isaac Doolittle, who founded the first lithographic printing house in

the country in New York City, demonstrates that Milbert contemplated publishing views of his travels as early as that year.

After completing the project, Milbert returned to France in 1823 and presented the impressive number of specimens he had collected (well over seven thousand in fifty-eight shipments) that were destined for the Natural History Museum in Paris to the king. He then returned to his professorship at the École des Mines and published fourteen lithographic views of the state of New York, *A Series of Picturesque Views in North America* (1825). Three years later, Milbert published his ambitious *Itinéraire pittoresque du fleuve Hudson et des parties latérales de l'Amérique du Nord* (*The Picturesque Itinerary of the Hudson River and the Peripheral Parts of North America*), which chronicles in fifty-four images (a few by other artists, including William Guy Wall [cat. 48]) his visit to New York in a bound portfolio of plates with two volumes of text. Nine lithographers translated the drawings to lithographic stones, and the impressions were published in Paris as early examples of lithography. The Society's DPPAC holds a complete copy and an incomplete copy of the work. Although *The Picturesque Itinerary* was published in 1828–29, its views were made from 1816 to 1823. In many cases Milbert's account constitutes the first printed record of a

35a

locality, just as his drawings were the first executed of a number of the sites. Wall recorded many of these same locales in *The Hudson River Portfolio*, and they would become part of the intinerary of the American grand tour. All of the plates in the series, executed by a number of lithographers, are uncolored. To appeal to a wide audience, their titles are given in French, English, Latin, and German. The reportorial content and spontaneous quality of the drawings are preserved in the lithographs, a technique that had been introduced by Alois Senefelder about 1795.

Bibliography: Constance D. Sherman, "A French Explorer in the Hudson River Valley," *New-York Historical Society Quarterly* 45:3 (1961): 255–80; Jacques Gérard Milbert, *Picturesque Itinerary of the Hudson River and the Peripheral Parts of North America*, trans. Constance D. Sherman (Ridgewood, N.J.: Gregg Press, 1968); Deák 1988, 1:197–202, no. 299; Madeleine Ly-Tio-Fane, "De l'Île de France aux rives d'Hudson: parcours exemplaire du peintre naturaliste Jacques Gérard Milbert (1766–1840)," in *Le Monde créole: Peuplement, sociétés et condition humaine XVIIᵉ–XXᵉ siécles; Mélanges offerts à Hubert Gerbeau*, ed. Jacques Weber (Paris: Les Indes Savants, 2005), 75–89.

35a. *Village of Sandy Hill, New York*, c. 1817

Brown ink and wash and graphite on paper; 5 × 6 9/16 in. (127 × 167 mm)
Signed at lower left outside image in brown ink: *J. Milbert. delt.*; inscribed below at left: *Village of Sandy-Hill / 210. miles N. of New-York. / Albany* [cut]; at right: *Village de Sandy-Hill à / 210 milles n.ᵈ de New-York.*
Provenance: Kennedy Galleries, New York.
Bibliography: Koke 1982, 2:336, no. 1830, ill.; Ly-Tio-Fane 2005, 80 n. 27.
Abbott-Lenox Fund, 1979.65

35b. *Little Falls Bridge, Sacandaga, New York: Study for Plate 25 in "The Picturesque Itinerary of the Hudson River and the Peripheral Parts of North America,"* 1818

Brown ink and wash over graphite on paper, 5 × 6 3/4 in. (127 × 171 mm)
Signed at lower left outside image in brown ink: *J. Milbert.*; inscribed below along lower edge: *Little Falls bridge on the Hudson, Pont des Petites chutes de L'Hudson / 71*

miles from Albany.
Bibliography: Koke 1982, 2:338, no. 1833, ill.
Provenance: Daniel Parish Jr., New York.
Gift of Daniel Parish Jr., 1906.20

The Society owns four watercolors Milbert executed during his stay in America; two are discussed as a pair here, the first being a view of Sandy Hill. Located on the east bank of the Hudson River between Glens Falls and Fort Edward in Washington County, New York, Sandy Hill is now known as Hudson Falls. In 1817 Milbert journeyed north along the Hudson from New York City to Albany, Ballston Spa, and Saratoga. In June or very early July he continued on to Sandy Hill, about twenty miles northeast of Saratoga. Sandy Hill remained his base for the rest of the summer while he explored the countryside of upstate New York.[1] Two of Milbert's works depicting the environs around Sandy Hill were lithographed in *The Picturesque Itinerary of the Hudson River …. (Itinéraire pittoresque du fleuve Hudson)*: no. 19, showing the falls of the Hudson at Sandy Hill, and no. 20, de-

J. Milbert.

*Little Falls bridge on the Hudson, Pont des Petites chutes de L'hudson
71 miles from Albany.*

35b

picting the course of the river and the mills near Sandy Hill.[2] Milbert did not use catalogue 35a as the basis for one of the fifty-four lithographs, but its existence reinforces the conclusion that he chose for publication a selection from many views he made on his trip.

In contrast, Milbert selected catalogue 35b for plate 25 (labeled on the lithograph as "Bridge on the Hudson River Near Luzerne") of his *Picturesque Itinerary*, one of the two lithographs showing the environs of Luzerne (today Lake Luzerne).[3] Koke did not identify this work as preparatory for the lithograph, remarking only that this site should not be confused with Little Falls on the Mohawk River, west of Albany. After exploring the upper reaches of the Hudson River in 1818, Milbert commented on a series of cascades called the Little Falls in the Sacandaga-Luzerne area. There he saw "a handsome bridge supported by wood piles set on broad masses of calcareous rock, whose reddish hue reveals the presence of iron oxide. The rocks are stratified and their lower angles rounded by the perpetual movement of the water … , farther down, the

river resumes its capricious independence, forming a series of cascades called the Little Falls."[4] He proceeded to draw the view he described in catalogue 35b, which was later lithographed by Louis-Philipe-Alphonse Bichebois for the *Picturesque Itinerary*.

1. Koke 1982, 2:336.
2. Deák 1988, 1:199, no. 299, 19 and 20; 2: ills.
3. Ibid., 199, no. 299, 25; 2: ill.
4. Milbert 1968, 78.

THOMAS BIRCH

Warwickshire, England 1779–Philadelphia, Pennsylvania 1851

Thomas Birch was the son of William Russell Birch (1755–1834), an English engraver and painter of miniatures. At age fifteen Birch immigrated with his father to Philadelphia. Under the elder Birch's direction, Thomas prepared many of the twenty-eight drawings of the city and its environs reproduced in *The City of Philadelphia … as it appeared in the year 1800* (Springland near Bristol, Pa.: W. Birch, 1800). Often regarded as America's first marine artist, Birch is best known for seascapes and views of naval battles as well as for winter scenes, harbor views, landscapes, and portraits in miniature and oil.

Along with naval battles, Birch was drawn to dramatic marine vistas of storms and shipwrecks, the subjects of some of his most distinctive and solemn oil paintings, among them *Ship in a Storm* (1841; The N-YHS) and *Between the Rocks* (Pennsyl-

vania Academy of the Fine Arts, Philadelphia). He also represented the transformation and struggle of winter but animated these scenes with a joyful mood, populating the snow-blanketed, frigid, but sublimely beautiful terrain with horse-drawn sleighs, skaters, and boisterous revelers, as in *Winter Scene* (1832; Shelburne Museum, Vt.) and *Skating* (c. 1830–40; Museum of Fine Arts, Boston). Other well-known paintings by Birch include harbor scenes in Philadelphia and New York, like *New York Harbor* (1827; The N-YHS); western landscapes like *Conestoga Wagon on the Road* (c. 1814; Shelburne Museum, Vt.); and portraits, including the watercolor *Stephen Paine (1791–1830)* (c. 1824; The N-YHS). He also painted several scenes concerning the history of his adopted state of Pennsylvania, for example, *The Landing of William Penn* (c. 1850; Museum of Fine Arts, Boston).

The Society has eight drawings and three oil paintings of naval engagements from the War of 1812 by Thomas Birch, including several black ink drawings after Michele Felice Cornè (cat. 12) that were preparatory for plates in Abel Bowen's comprehensive illustrated history, *The Naval Monument* (1816). During his lifetime, Birch's work was frequently exhibited at the Pennsylvania Academy of the Fine Arts, where he was curator in 1811, and in New York at the NAD, the American Academy of the Fine Arts, and the American Art-Union.

Bibliography: Abel Bowen, *The Naval Monument* (Boston: Abel Bowen, sold by Cummings and Hilliard, 1816); William H. Gerdts, *Thomas Birch, 1799–1851, Paintings and Drawings*, exh. cat. (Philadelphia: Philadelphia Maritime Museum, 1966), 10–17; Carbone et al. 2006, 1:292–94.

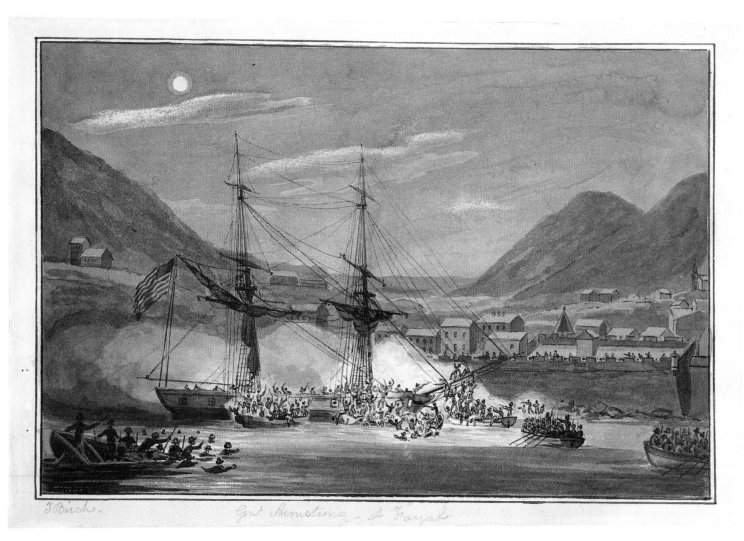

36

36. *Attack on the American Privateer "General Armstrong" at Fayal (Faial), Azores, Portugal*, 1814

Black ink, wash, and graphite with scratching-out on paper, inlaid into a larger sheet; 6 × 8 in. (152 × 203 mm)
Signed at lower left in black ink: *T Birch*; below in graphite: *T Birch.*; inscribed at lower center: *Genl Armstrong—at Fayal*
Bibliography: Gerdts 1966, 48, fig. 57; Koke 1982, 1:50–51, no. 150, ill.
Gift of Naval History Society Collection, 1925.140

In this dramatic and dynamic nocturne, Birch depicted the nearly legendary engagement late in the War of 1812 between the American privateer *General Armstrong* and the British squadron at the harbor of Fayal (Faial in modern Portuguese) in the Azores.[1] Birch placed the double-masted ship *General Armstrong* at center, framed by the volcanic mountains of the port city of Horta. The small war brig was a privateer under the command of Captain Samuel C. Reid, sanctioned by the U.S. government to prey on British ships. Private ownership distinguished a privateer from an ordinary warship, while letters of marque and reprisal (commissions issued by a government) distinguished it from a pirate craft.[2]

Birch's monochromatic drawing illustrates the events of the evening of 25 September 1814, after the *General Armstrong*, with fourteen guns and around ninety men, sailed into the neutral harbor at Fayal to take on water. Under a cloudy but moonlit sky, the privateer was spotted by three British ships headed for the Caribbean to join the flotilla assembling in preparation for the battle of New Orleans: the frigate *Rota* with thirty-eight guns, the war sloop *Carnation* with eighteen guns, and the immense seventy-four-gun ship of the line *Plantagenet*, commanded by Captain Robert Lloyd, an ardent opponent of privateering.[3] In his fury Captain Lloyd disregarded both the neutrality of Fayal and his urgent orders to meet up with the British fleet in Jamaica, instead sending four boats of men from the *Carnation* to board and capture the *General Armstrong*. The outnumbered men of the *Armstrong* valiantly repulsed the attacks, decimating the boarding parties, sinking some of their boats, and killing dozens of British sailors before they set foot on the privateer's decks. As the Americans drove off the first round of attackers,

Captain Lloyd ordered twelve barges armed with howitzers to advance. Birch's drawing shows the peak of this battle, with at least eight small vessels deployed to assault the *Armstrong*, two of which are damaged and sinking, while the crew of the little privateer struggles to hold their ship. Finally as morning dawned, Captain Reid, having driven off the much larger enemy forces twice, was forced to scuttle the *General Armstrong* and retreat with his men to an old castle in the city, where he broke down the drawbridge and prepared to continue the fight.[4]

Although the reports of casualties vary greatly, the British fleet sustained the majority of the losses, with somewhere between 34 and 200 killed and 86 to 140 wounded, while American losses totaled only 2 killed and 7 wounded.[5] The loss of the single privateer brig had very little impact on the American war effort, but the delay created by Captain Lloyd's wide-reaching decision to attack rather than meet the squadron bound for New Orleans had serious repercussions for the British. The depleted *Plantagenet* had to wait for new men, officers, and supplies; the *Carnation* had her topmast and bowsprit destroyed; the *Rota* lost all her officers; and two other ships from the British flotilla, *Calypso* and *Thais*, were forced to return to England with the wounded. The rendezvous of the British fleet headed for New Orleans was delayed for more than ten days, allowing General Andrew Jackson to reach the city with his Tennessee riflemen and make an alliance with Jean Laffite and the pirates of Barataria Bay (south of New Orleans). The British arrived at New Orleans to find the American forces prepared and entrenched in the city. The battle of New Orleans, really a series of battles between 23 December 1814 and 8 January 1815, was a decisive American victory, resulting in the British force's withdrawal into the Gulf of Mexico and heralding the end of the war.[6]

A. M.

1. For an account of the incident by the ship's captain, see Samuel C. Reid, *A Collection of Sundry Publications, and other documents, in relation to the attack made during the late war upon the private armed brig General Armstrong* (New York: John Gray, 1833).
2. Theodore Roosevelt, *The Naval War of 1812* (New York: G. P. Putnam's Sons, 1882), 338–40; Edgar Stanton Maclay, *A History of American Privateers* (New York: D. Appleton and Company, 1924), 491–502; and Donald Barr Chidsey, *The American Privateers* (New York:

Dodd, Mead and Company, 1962), 1–10.
3. Maclay 1924, 494; Fletcher Pratt, *The Navy, a History: The Story of a Service in Action* (Garden City, N.Y.: Doubleday, Doran Books, 1938), 209; and Chidsey 1962, 3.
4. Pratt 1938, 211.
5. The range of casualties is derived from Roosevelt 1882, 340; Maclay 1924, 498; Pratt 1938, 210; and Chidsey 1962, 7.
6. Ironically, the Treaty of Ghent that ended the hostilities between Britain and the United States was signed on 24 December 1814, one day after the siege began, but news of the settlement did not reach the British fleet until 14 February, weeks after their defeat.

JOHN WESLEY JARVIS

Baptized South Shields, England 1780–New York, New York 1840

A key figure in the New York City art world during the first decades of the nineteenth century, John Wesley Jarvis was a bohemian and a pioneer of realistic portraiture. In the early years of the nineteenth century, Jarvis successfully established himself as New York's leading portraitist. Unlike John Trumbull, Gilbert Stuart, and John Vanderlyn (cat. 31) who periodically visited the city during the first decades of the century, Jarvis was the first to establish a professional resident practice. His father, John Jarvis, had been born in New York City but was sent to England, the country of his ancestors, after his father's death. In 1783, after marrying Ann Lambert, the grandniece of the celebrated founder of Methodism, John Wesley, he moved back to America with his young family, including the future painter, who assumed the middle name Wesley to differentiate himself from his father.

John Wesley Jarvis grew up in Philadelphia, where he was apprenticed to the British-born painter and engraver Edward Savage, who was something of an impresario and a role model for the young artist. Jarvis cultivated his formidable natural talent during this apprenticeship, followed his master, whom he criticized, to New York in 1801, and by 1802 was established independently as an engraver, miniature painter, and silhouettist, and soon as a member of the intelligentsia. In 1803 he opened a short-lived, informal drawing school on Park Row (listed in the city directories for three years) in competition with the Columbian Academy of the Robertson brothers (cats. 21 and 29). The following year, when he relocated the school to the same address as his engraving practice at 28 Frankfort Street, he formed a profitable portrait business with Joseph Wood, which was dissolved in 1810. Jarvis then began the first of several winter trips to Baltimore and Charleston, South Carolina, where, according to his friend the writer Washington Irving, he was accepted by society and in great demand for portraits. In 1811 he exhibited a likeness of Irving (location unknown) at the first annual exhibition at the Pennsylvania Academy of the Fine Arts in Philadelphia, and the following year was among the first group of artists named academicians.

After reestablishing himself in New York and opening his own studio, Jarvis became a proficient, celebrated society painter, numbering among his patrons many statesmen and writers. The War of 1812, the event that crystallized the country's sense of national identity, propelled Jarvis into the front ranks of American artists with challenging commissions. He was offered the most important commission of his career in 1814 after both Gilbert Stuart and Thomas Sully (cat. 40) failed to show interest in executing a series of full-length portraits of naval and military heroes of the War of 1812 for New York's City Hall. Jarvis took nearly three years to complete the six portraits, assisted by the young Henry Inman (cat. 64), whom he hired to help with the project. In 1816 Jarvis was commissioned to paint DeWitt Clinton (Smithsonian American Art Museum, Washington, D.C.); requests from the sitter's political supporters prompted a string of replicas. That same year Jarvis began contributing works to the annual exhibitions of the American Academy of the Fine Arts, of which Clinton had assumed the presidency in 1813, and continued exhibiting there through the 1830s.

Although the American Academy of the Fine Arts does not appear to have hired him, as early as 1812 Jarvis had taken charge of the organization's plaster casts after famous sculptures, which eventually went to the NAD. He became the keeper of this collection when the academy moved to Government House in 1814. Jarvis innovatively began using the casts in his classes. This marked the first time an American public collection was used for pedagogical purposes and also supported the shift in instruction from the apprentice system to an institutional setting. (In the European academic systems, collections of reproductions of famous sculptures and anatomical fragments were considered an essential tool for training artists in learning to render a three-dimensional object in two dimensions.) Only in 1817 was Jarvis elected a member of the American Academy of the Fine Arts.

Jarvis was essentially self-taught, and his work, more spontaneous than refined, lacks the veneer of an academic training. Yet his finest works are lively, sophisticated, and reveal much of each sitter's personality and temperament. In his full-length portrait of Daniel D. Tompkins (c. 1820; The N-YHS), the beautifully painted figure and dramatic sky suggest the authority and energy that Tompkins, governor of New York from 1807 to 1817, brought to his political career. Many of Jarvis's portraits capture a spirit of national pride and optimism characteristic of this period in American history. For example, his likeness of Samuel Chester Reid (1815; The Minneapolis Institute of Arts) shows this hero of the War of 1812 poised on the deck of his ship engaged in battle, the embodiment of courage and command. Jarvis's only known sculpture, a realistic plaster bust of his friend Thomas Paine (1809; The N-YHS, which also owns Paine's death mask, made by Jarvis) is likewise naturalistically and dramatically modeled in a highly progressive manner. Jarvis had given the elderly, destitute political philosopher shelter in his house in 1806 and 1807.

Jarvis's considerable artistic and social skills made him among the most sought after and, for a time, wealthiest portrait painters in America during the first quarter of the nineteenth century. Besides working in his New York studio, where John Quidor and Inman were his apprentices, he made frequent painting excursions to such cities as Boston, Baltimore, Washington, D.C., New Orleans (where he met John James Audubon [cats. 42 and 43] in 1821), and Richmond, Virginia (1825–27), to supplement his income. His clientele was large, and with the help of assistants he could receive six sitters a day and complete six portraits in a week. A picturesque figure with a talent for storytelling, he was popular with the leading merchants and intellects of the day. Jarvis belonged to the Bread and Cheese Club, an early literary group, and in 1813 he was elected a member of the N-YHS. He exhibited in New York at the NAD (1826, 1833, 1834) but never became a member. For a period he was a famous celebrity whose eccentricities and wit were lauded by Thomas Seir Cummings in his *Historical Annals of the National Academy*, but his personal idiosyncrasies ended his success. Twice married, he fathered four children, but having demonstrated a fondness for drink, Jarvis sank into obscurity after suffering a stroke in 1834 and died penniless in his sister's home. The eldest of his two sons, Charles Wesley Jarvis, also became a painter (the N-YHS holds a number of his oil portraits).

Bibliography: Theodore Bolton and George C. Groce Jr., "John Wesley Jarvis: An Account of His Life and the First Catalogue of His Work," *Art Quarterly* 1:4 (1938): 299–321; Harold E. Dickson, "John Wesley Jarvis: Knickerbocker Painter," *New-York Historical Society Quarterly* 24:2 (1940): 47–64; idem, *John Wesley Jarvis, American Painter, 1780–1840*

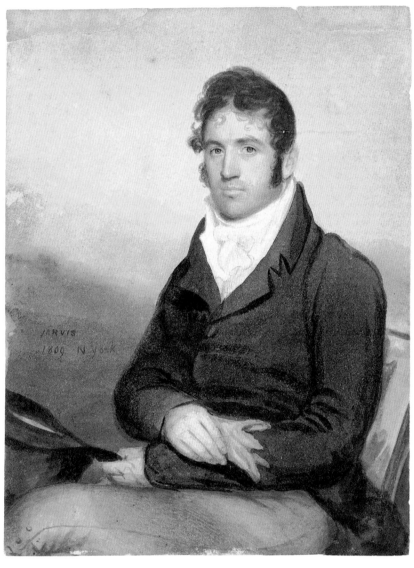

37

(New York: New-York Historical Society, 1949); Mark
DeSaussure Mitchell, "The Artist-Makers: Professional
Art Training in Mid-Nineteenth-Century New York City"
(Ph.D. diss., Princeton University, 2002), 12–52.

37. *Portrait of a Man (Possibly of the Gosman Family)*, c. 1809

Watercolor, black ink, and graphite on paper;
5 15/16 × 4 1/2 in. (150 × 114 mm), irregular
Signed, dated, and inscribed in black watercolor:
JARVIS/1809 N YORK
Provenance: Descent through the sitter's family.
Bibliography: Dickson 1949, 325, 330, fig. 94; N-YHS
1974, 1:298, no. 760, ill.
Bequest of Richard H. Gosman, 1946.306

Like the artist's portrait of Jacob Housman
(1810; The Detroit Institute of Arts),[1] this small
likeness, possibly portraying an unidenti-
fied member of the Gosman family, invites a
comparison with contemporary portraits by the
leading French Neoclassical portraitist Jacques-
Louis David. The sitter's gloves and hat identify
him as a gentleman. David used the same
accoutrements in his *Portrait of Pierre Sérizat*,
exhibited at the Paris Salon in 1795, where the
sitter, facing left, is dressed in a nearly identi-
cal manner, except that he wears his hat.[2] Even
Jarvis's placement of the inscription and signa-
ture at the left imitates a convention frequently
employed by David in his portraits of the 1790s.[3]

The casual posture of the sitter adds to the
immediacy of the artist's portrayal and comple-
ments his spontaneous application of the
pigment in the coiffure and garments. Jarvis's
artistic strengths are apparent in this watercolor:
his instantaneous seizure of the likeness and his
ability to transfer the mysterious aura of a perso-
nality to paper, together with the sitter's physical
appearance, such as his brilliant blue eyes.[4]

The style of the work, as well as the sitter's
hairstyle and visage, bears a remarkable
resemblance to two known portraits of Jarvis's
friend the writer Washington Irving. Both are
dated 1809, the year the young author was on
the brink of success. The first is a painting in the

collection of Historic Hudson Valley,[5] and the second is a drawing in the Yale University Art Gallery in New Haven.[6] Jarvis's portraits painted in his studio at 1 Wall Street about 1809 are considered among his finest.[7] It was also in that year, after the dominant New York portrait painter John Trumbull left for England in December 1808, that the field of opportunity opened for Jarvis and he became the most prestigious portrait painter in Manhattan.[8]

1. Dickson 1949, fig. 41.
2. See Antoine Schnapper, *David* (New York: Alpine Fine Arts Collection, 1982), fig. 101.
3. See ibid., figs. 66, 68, 104, 107; see also Antoine Schnapper et al., *Jacques-Louis David, 1748–1825*, exh. cat. (Paris: Éditions de la Réunion des Musées Nationaux, 1989).
4. The Society's collection numbers thirty-nine portraits by Jarvis: twenty-eight in oil, two miniatures on ivory, six drawings, one sculpture (Thomas Paine), and two death masks (Thomas Paine and John James Audubon).
5. Inv. no. SS.62.2 a–b, in oil on wood; see Dickson 1949, 135–36, fig. 47; and Kathleen Eagen Johnson, *The Limner's Trade: Selected Colonial and Federal Paintings from the Collection of Historic Hudson Valley*, exh. cat. (Tarrytown, N.Y.: Historic Hudson Valley Press, 1995), 27.
6. Inv. no. 1940.47, in brown ink and wash and graphite, 3 5/8 × 5 3/4 in.; see Dickson 1949, 136, fig. 17; and Mitchell 2002, fig. 1.20.
7. Mitchell 2002, 329–30.
8. See Dickson 1949, 128–37. See p. 131 for an advertisement Jarvis placed in the *Long Island Star* listing types of portraits he painted and their costs: "Whole Length Portraits $300 / Portraits with Hands 60 / Portraits without Hands 40 / Miniatures on Ivory 50 & 20 / Sketches on Paper with Hands 15 & 20 / Sketches on do. without do. 10 / Coloured Profiles 3." This information implies that the sitter of the Society's portrait paid either $15 or $20 for the likeness.

WILLIAM CONSTABLE

Horley, Surrey, England 1783–Brighton, England 1861

William Constable was an amateur artist, entrepreneur, portrait photographer, and inventor, who before becoming an artist had a long career as a civil engineer. As a surveyor and designer of railroad bridges, he was familiar with a variety of optical instruments, including the camera obscura, and while always remaining an amateur painter became a polymath of early Victorian culture.

Son of the owner of a watermill, Constable had little formal education. Instead, he assisted his father in various trades and studied drawing as a teenager during an apprenticeship with an engineering firm in Lewes. In 1802 the nineteen-year-old William joined his older brother Daniel in Brighton, where he had just opened a draper's shop. Later that year, William designed a plan of Brighton, then in its heyday as a fashionable resort, that advertised their business and gave directions to their shop on North Street. This map and business card were printed by Thomas "Clio" Rickman, a friend and biographer of Thomas Paine, the Revolutionary American, who had once lived and worked in Lewes. After four years, the brothers sold their flourishing drapery business, which evolved into one of Brighton's largest department stores, and used the proceeds to finance a journey to America.

In 1806 William and Daniel Constable sailed for New York City, arriving after a two-month voyage. Armed with an introduction from Rickman, they visited the exiled Paine. After William briefly studied painting, they began traveling on foot through New York State to Niagara Falls, where William made a number of sketches. Throughout their journey of exploration, William recorded the spectacular American landscape, including many waterfalls, in sketches that he worked up into finished compositions back in England. According to inscriptions made on various works by relatives (such as their nephew Dr. Clair J. Grece), William painted these watercolors and oils between 1808 and 1820, although some are dated as late as 1838. Arriving in Pittsburgh, Pennsylvania, the brothers purchased a flat-bottomed boat to travel three thousand miles down the Ohio and Mississippi rivers to New Orleans and the Gulf of Mexico. Returning overland to New York City, they sailed for England after two years in the New World, having logged more than thirteen thousand miles. Arriving at Plymouth, the two intrepid explorers walked home to Horley.

Upon his return, William Constable rebuilt the family watermill and went into partnership with his younger brother Charles, running the mill for the next half century (in the 1851 census, William listed his occupation as "Flour Manufacturer and Heliographic Artist"). After his marriage to Jemima Mott in 1816, Constable was appointed superintendent of the Sutton and Reigate Turnpike Trust and in 1818 surveyor of the London to Brighton Turnpike Road, a post that included the construction of the tunnel under Reigate Castle (1823, Europe's first tunnel road). He also designed and built the suspension bridge at Reigate Hill. In 1837, having been appointed engineer for a proposed railway in Jamaica, he sailed again for North America. While he was preparing to take a ship to the West Indian island, the project was canceled; nevertheless, he went to Jamaica and remained for a year "to see the beauty of that Country." William also visited relatives who had settled in the United States. Daniel had returned to America, becoming a United States citizen, but had died by the time of William's second visit. Their sister Mildred Constable Purse lived in Pittsford, New York, with her husband.

Back in England in 1838, Constable, now a widower, decided once more to make his home in Brighton. Having always been an inventor, he made a third visit to America in 1840 to promote various scientific devices, including a pulley and cable mechanism to rescue people from burning buildings and wrecked sailing vessels. It has been suggested that while in this country he had observed the work of early daguerreotypists and understood the commercial potential of

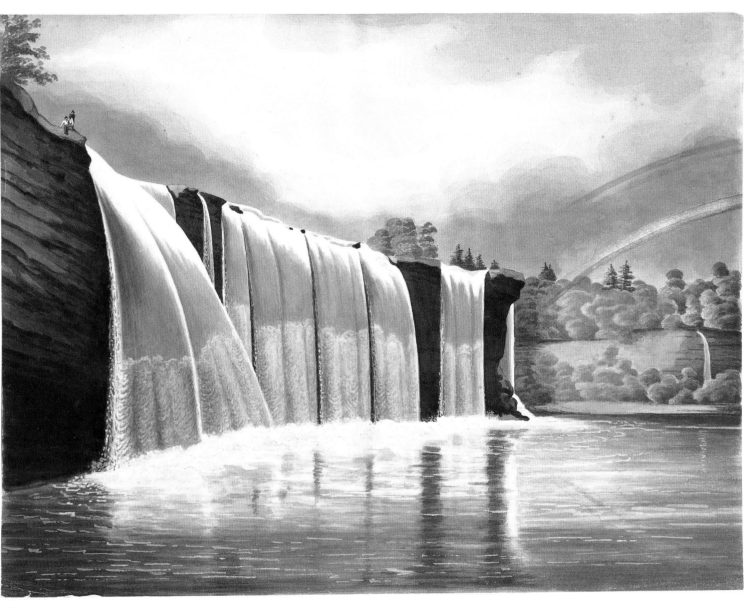

38

photography. By June 1841 Constable had purchased for the considerable sum of £1,000 the license to take daguerreotype portraits in Brighton from the British patent holder Richard Beard. He then opened his first photographic portrait studio in 57 Marine Parade and named it The Photographic Institution. Armed with an exclusive license, Constable maintained a monopoly in the production of photographic portraits in Brighton for ten years. Made famous in 1842 for taking the first photographic likeness of Prince Albert, Queen Victoria's consort, Constable's studio became the fashionable place

for aristocrats and members of the court to have their pictures taken.

Constable worked as a photographic artist for twenty years. At his death, one of his nieces with whom he lived, either Caroline or Eliza Constable, carried on the photographic portrait business until 1865. Although Constable had a limited formal education, he was an avid reader and had a considerable library. Throughout his life he indulged his wide range of interests, including botany and ornithology, and was an active member in the Natural History Society from its inception in 1855.

Bibliography: "William Constable," *Kennedy Quarterly* 7:4 (1967): 244–45; *Early Topographical Views of North America by William Constable (1783–1861)*, sale cat. (New York: Wunderlich & Company, 1984); Estill Curtis Pennington and James C. Kelly, *The South on Paper: Line, Color and Light* (Spartanburg, S.C.: Robert M. Hicklin Jr., 1985), 30, pls. 20, 21; Philippe Garner, "William Constable, Brighton's First Photographer," *History of Photography* 15:3 (1991): 236–40; http://www.spartacus.schoolnet.co.uk/Dsconstable.htm; J. Brian Jenkins, *Citizen Daniel (1775–1835) and the Call of America* (Hartford, Conn.: Aardvark Editorial Service, 2000).

38. *The Great Falls of the Genesee, Rochester, New York, with a Double Rainbow*, after 1808, possibly 1828–30

Watercolor and gouache over graphite with scratching-out on paper; 12 1/16 × 15 1/2 in. (307 × 394 mm)
Inscribed on verso at lower left in red ink: *The Great Fall of Genessee. / Sketched by William Constable on Saturday the 6th September 1806. / Copied by him after his return to England in 1808, probably between / 1808 and 1820 [phrase crossed out], and, as I find from a mem-dum in his / hand writing, begun on Sunday the 7th September 1828 and / finished on Sunday the 4th July 1830. / The figures above are intended to represent the brothers Daniel & William Constable. / Clair J. Grece*
Provenance: Descent through the artist's family to G. Lewis F. Grece, England; Reigate Town Hall Museum, Reigate, England; Sotheby's, London, 1980; Kennedy Galleries, New York.
Bibliography: Sotheby's, London, sale cat., 22 October 1980, lot 38 (probably).
Watson Fund, 1981.5

In this watercolor Constable depicted the Upper Falls (or High Falls) of the Genesee River, the most spectacular of the river's three cascades in the Finger Lakes region of New York before it empties into Lake Ontario. His view preserves the original appearance of this dramatic cascade that measures ninety-six feet in height and today is located in the center of Rochester, where it is crowned by the industrial New York Central Railroad bridge.[1] Certainly in Constable's time, when the cataract was in a wilderness area, the falls was more impressive. Today it can be viewed from the pedestrian-only Pont du Rennes bridge.

A nearly identical view of the same cascade with a rainbow by Constable—inscribed *Great Falls of the Genesee—6 September 1806*—surfaced on the market in 1984.[2] Minor variations between the two compositions are few, such as the two figures at the upper left of the Society's watercolor versus a figure in a boat below the cascade in the other example. The major difference between them is that in the Society's watercolor Constable represented a rare double rainbow. A secondary rainbow on the outside of a brighter primary rainbow occurs when raindrops high in the atmosphere refract and reflect light back to the viewer. These moisture droplets are higher than those producing the primary rainbow and are special because they internally reflect the incoming sunlight twice rather than just once. The sequence of the colors in the secondary rainbow is reversed from that in the primary, an

optical phenomenon that did not escape Constable's astute observation. A student of optics, he also depicted the reflection of the primary rainbow in the river below the cascade. After he returned to England in 1808, Constable executed multiple versions of many scenes that had captivated his interest in the New World, all with slight variations as in these two watercolors of the Great Falls of the Genesee. Another case in point is represented by a pair depicting Niagara Falls with a single rainbow, in this instance a watercolor and an oil.[3]

The provenance of many works by Constable (and most likely the Society's watercolor) can be traced to a sale on 22 October 1980 at Sotheby's, London. Listed as "The Property of a Museum," lots 34 through 44 encompassed a diary of the brothers' travels in America between July 1807 and February 1808 kept by Daniel, together with a folio of forty-three watercolors by William and documents (1806–22) (lot 34) and hundreds of works in ten additional lots. Among them was a folio of eight drawings (lot 38), four of which were watercolors of "The Falls of the Gennessee River, New York," three "inscribed on the verso in a later hand."[4] Because the Society's watercolor was purchased in 1981, it more than likely was part of lot 38 in the geographically divided groupings, together with its alternative version with a single rainbow that was reproduced in the catalogue for lot 38 (see n. 4 below).

William Constable's own diary from July 1806 to January 1807, which contains extensive comments on the Genesee, subsequently surfaced in a later auction. In his diary, Constable confided that "no words can convey the faintest idea of the majestic grandeur which reigns here and which is stamped on every object in this neighbourhood, or the awful sensations which are inspired in the soul on beholding them here the sublime and beautiful rule with uncontould [*sic*] sway."[5] Daniel's complementary diary records the great difficulties his brother endured in attempting to make sketches; in one spot the wind blew so much spray in his face that he could not continue.[6] The Society's watercolor captures this spirit, which, as in the artist's other New World scenes, combines elements of naïveté and sophistication. It exudes an undeniable charm and enthusiasm for observation that surpass his artistic limitations, and its early date makes it an important document of the American landscape.

1. The Genesee River's name, spelled in multiple ways, is derived from the Iroquois word meaning "good valley" or "pleasant valley." The Genesee River valley westward to Lake Erie and the Niagara River was the homeland of the Seneca Nation of the Iroquois Confederacy, also known as the Keepers of the Western Door, as they were the westernmost nation.
2. Formerly at Wunderlich & Company; see *The Magazine Antiques* 126:3 (1984): 495, ill., where the works measurements are given as 17 5/8 × 15 1/4 in., whereas in the catalogue *Early Topographical Views of North America by William Constable* 1984, no. 9, ill., they are correctly listed as 10 5/8 × 15 1/4 in. The inscription on the sheet's verso reads: *Sketched by William Constable on Saturday the 6th Sept. 1806. Copied by him after his return to England in 1808, probably between 1808 and 1820.*
3. The watercolor was one of a group formerly (1982) with Hirschl & Adler Galleries, New York; it features Table Rock at the left on which stand the two brothers and their dog Franklin. The oil on canvas, 14 × 18 in., was with Kennedy Galleries, New York, and featured Table Rock on the right with a seated figure, a standing figure, and a dog; see "William Constable" 1967, 243–44, fig. 256 (today in the collection of Peter Trowbridge Gill, according to McKinsey 1985, 106, fig. 48). The latter with its foreground eagle, pointed out by the rainbow's trajectory, also harbors a strong dose of optimistic national symbolism.
4. Sotheby's, London, sale cat., 22 October 1980, lots 34–44; fig. 38 reproduces Constable's other view of the Genesee Falls with nearly identical dimensions in lot 38 (listed later as measuring 12 × 15 1/2 in. and in the collection of Milberg Factors, Inc., New York; Nygren et al. 1986, 247, pls. 41, 152). It may be the same work cited in n. 2 above.
5. Sotheby's, London, sale cat., 28 March 1983, lot 64.
6. "William Constable" 1967, 245.

AMBROISE-LOUIS GARNERAY

Paris, France 1783–1857

Ambroise-Louis Garneray was the oldest of the four artistically talented children of the French painter Jean-François Garneray. Commonly referred to simply as "Louis," he was a multifaceted adventurer who earned his living as a seaman and corsair, artist, and author. At the age of thirteen he went to sea and worked as both a sailor and an artist, mostly employed to depict the heroic acts of his captains in the French republican navy. Garneray eventually sailed under Captain Robert Surcouf with corsairs on the privateer *La Confiance*, which preyed on British ships in the Indian Ocean during the Napoleonic Wars. The Royal Navy captured his ship in 1806, and Garneray was confined in a savage, crowded prison ship at Portsmouth Harbour, England. While in captivity Garneray struggled to develop his skills as an artist, securing small commissions from his work that helped him overcome the grim desperation of his surroundings. He also produced a unique series of drawings of the floating prison hulks that preserves the experiences of thousands of prisoners.

Garneray was freed in 1814 and returned to Paris, but his previous loyalty to Napoleon caused the Restoration government to deny him a naval commission. He served as painter to the Duc d'Angoulême after 1817 and was awarded the title *Peintre du Grand Amiral de France*. In 1819 Garneray prepared two engravings designed to promote the legal Bonapartist agricultural colony in Alabama, Aigleville, and the illegal military colony in Texas, Champ d'Asile. In these narrative scenes, clearly composed without firsthand knowledge of the terrain, Garneray depicted French soldiers in wool uniforms working in a Texas landscape featuring palm trees and wooded mountains.

While in Paris, Garneray began to associate with the opposition coalition in the studio of the artist and illustrator Horace Vernet, where he met the Romantic painter Théodore Géricault and the future King Louis-Philippe, who was instrumental in obtaining commissions for him after 1830. Géricault's influence on Garneray is evident in his spectacular portrayals of maritime scenes, such as *Attacking a Right Whale* (1835; Peabody Essex Museum, Salem, Mass.), which echo the drama of Géricault's tempestuous canvases, such as *The Raft of the Medusa* (1819; Musée du Louvre, Paris). Some of Garneray's

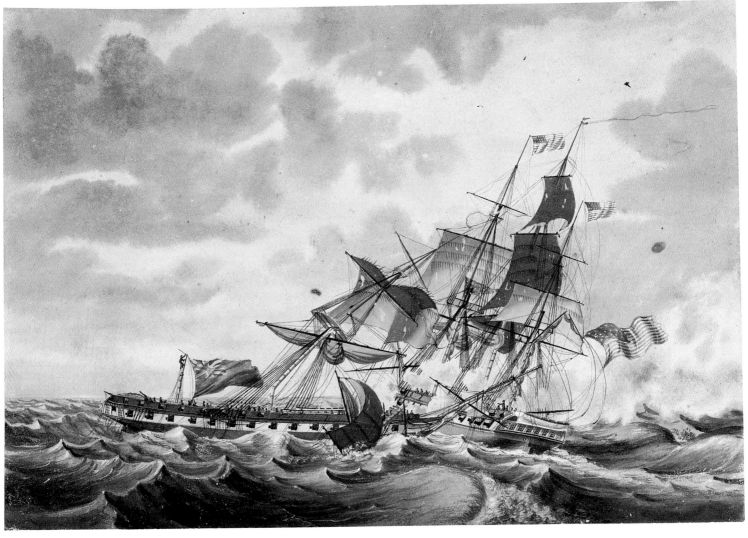

most notable marine paintings include *Napoleon's Return from Elba* (1831; Musée national des Châteaux de Versailles et de Trianon) and *Seizure of the "Kent" by "La Confiance"* (1836; Musée artistique et archéologique, La Roche-sur-Yon). Between 1830 and 1835 Garneray produced a series of coastal scenes that were engraved by Sigismond Himely for the five-volume *Vue des côtes de France dans l'océan et dans la Méditerranée*, written in collaboration with Étienne Jouy. Volume five of this series, entitled *Voyage maritime*, also included several views of North American coastlines and port cities, although there is no evidence that Garneray had traveled to the region.

As he approached age sixty-five, Garneray began to compile his memoirs, particularly his illicit adventures as a corsair and his life in prison. In 1848 he wrote the Ministère de l'Instruction Publique with a request for publication that observed, "There is no record of these feats of arms in the ministry of the Navy and after my death, they will be lost to history." Garneray's prison memoir was published in 1851, originally entitled *Mes Pontons; neuf années de captivité*. The story has been translated into Spanish and English and repeatedly reissued, most recently in 2003, illustrated with more than twenty-five engravings and paintings by Garneray. Several other accounts of his personal escapades have been published, including *Voyages, Aventures et Combats*, *Pirates et Négriers*, and *Le Négrier de Zanzibar*.

One of the foremost painters to be celebrated specifically for his portrayal of maritime subjects, Garneray began painting precise, formal depictions of ships in a style common to the eighteenth century that evolved into dramatic, active seascapes. He helped introduce dynamic scenes that conveyed the tumultuous action of the seafaring experience into a genre that reached its peak near the end of the artist's lifetime, as majestic, tall-masted sailing ships were steadily replaced by stolid steam vessels. Garneray regularly exhibited his marine paintings at the Paris Salons from 1817 until his death in 1857.

Bibliography: Messers. Hartmann and Millard, *Le Texas ou Notice Historique sur Le Champ D'Asile* (Paris: Chez Houdin, 1819), reprinted as *The Story of Champ d'Asile*, trans. Donald Joseph, ed. Fannie E. Ratchford (Santa Fe, N. Mex.: Rydal Press, 1937); Deák 1988, 1:291–92; Laurent Manoeuvre, *Louis Garneray, 1783–1857: Peintre, écrivain,*

Fig. 39.1. Michele Felice Cornè, *The "Constitution" in Close Action with the "Guerriere": Study for an Engraving*, c. 1816. Black ink and gray wash with touches of white gouache on green-gray washed paper, inlaid into a larger sheet, 6 1/8 × 9 7/8 in. (156 × 251 mm), irregular. The New-York Historical Society, Gift of the Naval History Society Collection, 1925.137

aventurier, exh. cat. (Arcueil: Anthèse, 1997), 17, 21–47, 147, 163, 169–213; [Ambroise-]Louis Garneray, *The Floating Prison: The Extraordinary Account of Nine Years Captivity on the British Prison Hulks during the Napoleonic Wars, 1806–1814*, trans. Richard Rose (London: Conway Maritime, 2003); Bénézit 2006, 5:1347–48.

39. *Engagement between the USS "Constitution" and HMS "Guerriere,"* after 1816

Watercolor, black ink, gouache, and graphite on paper, laid on board; 6 1/8 × 8 5/8 in. (155 × 219 mm)
Etiquette on mount inscribed in black ink: *Constitution and Guerriere*; label attached to reverse of board at lower right inscribed in graphite: *painted by Garneray / No 109 faubourg St Denis*; label attached at center in green ink: *Warmest part of the action that / took place the 19th of august 1812 / 1812 between the United States frigate / Constitution Cne Hull and the British / frigate Guerriere Cne Dacres / State of the Ships / Constitution 360 men and 54 guns / and Cannonades / Guerriere 332 men and 49 guns / and Cannones / the action lasted 2 hours and the / Guerriere being unmanageable was burnt*
Bibliography: Koke 1982, 2:58–59, no. 1084, ill.
Gift of Mrs. James Barnes, 1939.597

Because Garneray was imprisoned in England when the USS *Constitution* engaged HMS *Guerriere* on 19 August 1812, he could not have witnessed the events he depicted. One of the most significant and frequently portrayed naval engagements of the nineteenth century, this battle was repeatedly reproduced by contemporary artists and engraved for popular prints, which Garneray likely used in making this drawing. This scene of the defeat of the *Guerriere* is very close in composition to a view in a series of oil paintings of the battle done by Michele Felice

Cornè (cat. 12) and one of a similar set in ink wash by Thomas Birch (cat. 36).[1] Birch and Cornè made multiple versions of the scenes in various media, and several of the views were engraved and published between 1813 and 1816. These prints were renowned and frequently copied.[2]

The series consists of four episodes of the battle, the first presenting the initial encounter and the second showing the *Guerriere*'s mizzenmast fractured by artillery fire and slipping over the side of the ship. Garneray illustrated the third scene, when HMS *Guerriere* had lost its mizzenmast and the foremast collapsed, pulling down the mainmast. The *Guerriere*'s bowsprit is shown entangled in the mizzen rigging of the *Constitution*, making it impossible for the beleaguered ship to withdraw from battle and allowing the crew of the *Constitution* to continue to batter its crippled opponent. Garneray included a billowing British flag hoisted on the stubby remains of the *Guerriere*'s mizzenmast.[3] The Society also owns a drawing by Cornè of the second stage of the encounter showing the *Guerriere* obscured by clouds of smoke as its mizzenmast begins to collapse over the starboard side of the hull (fig. 39.1). The fourth scene of the battle depicts the completely dismasted *Guerriere* striking its colors in surrender.[4]

Garneray emphasized the British defeat by contrasting the *Guerriere*'s pathetic attempt to display the naval Union Jack at the base of its shattered mast with three high-flying Stars and Stripes and a navy pennant on the undamaged masts of the conquering *Constitution*. This detail may express Garneray's personal enmity for the British navy after his protracted stay in the

infamous prison ships at Portsmouth. The glorification of the American victory may also represent the amiable cultural and diplomatic relationships enjoyed by France and the United States during the nineteenth century.

A. M.

1. Cornè's series was commissioned by Commodore Hull of the *Constitution* in the fall of 1812, and Birch's series was engraved by C. Tiebout and published by James Webster in 1813; see n. 3 below.
2. Other versions include a view by William Strickland (1813; Library of Congress) that was engraved for the *Naval Chronicle*; a French engraving by Jean-Pierre Marie Jazet (one of Garneray's engravers) after a painting by Jean-Jerome Baugean entitled *USS "Constitution" Defeats HMS "Guerriere"* (c. 1813; New Haven Colony Historical Society); and a later lithograph by Nathaniel Currier, *The "Constitution" and "Guerriere"* (Currier & Ives, after 1835). All represent the same battle but have compositions that bear little resemblance to Garneray's version.
3. This feature is apparent only in Birch's views, although shown much smaller in a reversed composition, suggesting that Birch may be Garneray's source for this image (information courtesy of the Department of the Navy, Naval Historical Center). See also William H. Gerdts, *Thomas Birch, 1779–1851, Paintings and Drawings*, exh. cat. (Philadelphia: Philadelphia Maritime Museum, 1966).
4. Horace Kimball, *The Naval Battles of the United States* (Boston: Higgins and Bradley, 1857); Theodore Thomte, *Battles of the Frigate Constitution* (Chicago: Burdette & Company, 1966); Tyrone G. Martin, *A Most Fortunate Ship: A Narrative History of Old Ironsides* (Annapolis, Md.: Naval Institute Press, 1980), 145–65; and Spencer Tucker, *Handbook of 19th Century Naval Warfare* (Annapolis, Md.: Naval Institute Press, 2000), 44.

THOMAS SULLY

Horncastle, Lincolnshire, England 1783–Philadelphia, Pennsylvania 1872

One of the most prolific portraitists of the nineteenth century, Thomas Sully was also the premier portraitist of antebellum Philadelphia and the period's most important proponent of the Romantic British portrait style. He immigrated from his native England in 1792 with his family, who were actors and theatrical performers, to Richmond, Virginia. Sully made at least one appearance on stage as an acrobat in 1794 but was subsequently apprenticed to an insurance broker. Later, with his brother-in-law Jean Belzons, he worked as a scene and miniature painter. After an argument, he fled and joined his elder brother Lawrence, also a miniature painter, in Richmond. In 1801 they traveled to Norfolk, Virginia, where Sully remained to execute miniatures independently. In 1802 he began to paint in oil and spent time in the Norfolk studio of the portraitist Henry Benbridge. He returned to Richmond the following year, in part to help support his brother's family (Lawrence died in 1803), and opened his own studio. After marrying his widowed sister-in-law, Sarah Annis Sully, in 1806, the couple moved to New York City, where the young artist set up a studio in the lobby of the Park Theatre, catering to theater clients. In 1807 Sully moved his family to Hartford, Connecticut, and then went to Boston to visit Gilbert Stuart, at that time America's most admired portraitist, from whom he received helpful advice. Finding commissions scarce on his return to New York, he worked briefly as a studio assistant to John Wesley Jarvis (cat. 37) and soon thereafter moved to Philadelphia, where he resided for the rest of his life.

By 1808 Sully had established himself as a successful and popular portrait painter. After becoming a United States citizen in 1809, he placed his family in the care of the fellow painter and miniaturist with whom he had shared his first Philadelphia studio, Benjamin Trott, and left for England to reside in London from July 1809 to March 1810. Arriving with a letter of introduction from Charles Willson Peale and a list of subscriptions for old master copies to finance his travel, he entered the studio of Benjamin West, the American expatriate and master academician (president of the Royal Academy of Arts, 1792–1805), who was also a champion of young American painters. In addition Sully drew from the collection of plaster casts of ancient sculpture in the Antique Room of the Royal Academy and became friendly with the great British portraitist Sir Thomas Lawrence, learning to emulate his fashionable, fluidly painted likenesses.

When he returned to the United States, Sully portrayed the elite of Pennsylvania and Maryland society, and through his family's theatrical connections he secured several commissions for spectacular portraits of actors. With the aid of the actor-impresario Thomas Apthorpe Cooper, who previously had assisted him in New York, Sully received the most important commission of his early career, the portrait of George Frederick Cooke in the role of Richard II (1811; Pennsylvania Academy of the Fine Arts, Philadelphia). During the 1810s eager patrons sought his talents, but he suffered a setback later in the decade when his large historical canvas *Washington's Passage of the Delaware* (1819; Museum of Fine Arts, Boston), commissioned in 1817 by the state of North Carolina, was rejected. He turned to itinerant portrait work and began a period of extended stays in Trenton, New Jersey, and Baltimore. To supplement his income, in 1819 he established a partnership with the Philadelphia frame maker James Earle in their Sully and Earle Gallery, where he offered his paintings for sale.

Sully regained his popularity by the mid-1820s, partially due to several important portrait commissions (such as his *Marquis de Lafayette*, 1825–26; Independence National Historical Park Collection, Philadelphia) and to the deaths of Stuart and Peale later in the decade. Throughout the 1830s Sully was busy with a wide variety of portraits and literary subjects. His success was crowned in the fall of 1837 with a commission from the Sons of Saint George for a full-length portrait of England's new young Queen Victoria. Sometimes known as "the American Lawrence," he returned to England with his daughter Blanch to paint the portrait (1838; Collection of Mrs. Arthur Houghton Jr.). During the nearly yearlong visit, he entered into the lively cultural

40

life of London between sittings for the portrait and visited France before returning home in the summer of 1838. On his return, he devoted time to the completion of the queen's portrait and the fight for the rights to replicate it (resolved in his favor in 1839). Thereafter he resumed painting portraits with periodic tours of northeastern cities, specializing in portraits of women. He was an active member and teacher at the Pennsylvania Academy of the Fine Arts, although he declined its presidency in 1842.

Highly celebrated in his lifetime, the artist's later portraits became formulaic and were frequently painted after photographs. Sully kept numerous sketchbooks, journals, and a register of the works he painted (the latter two in the Historical Society of Pennsylvania, Philadelphia), which included approximately twenty-five hundred likenesses and an additional five hundred subject paintings during his long and prolific career. His records indicate that beginning in the 1860s he devoted more time to copies and fancy pieces. One year after his death his collected notes written in 1851 and revised were published under the title *Hints to Young Painters and the Process of Portrait Painting as Practiced by the Late Thomas Sully*.

Bibliography: Thomas Sully, *Hints to Young Painters and the Process of Portrait Painting as Practiced by the Late Thomas Sully* (Philadelphia: J. M. Stoddart and Co., 1873); Charles Henry Hart, ed., *A Register of Portraits Painted by Thomas Sully, 1801–1871* (Philadelphia, 1909); Edward Biddle and Mantle Fielding, *The Life and Works of Thomas Sully (1783–1842)* (Philadelphia: Wickersham Press, 1921); Monroe F. Fabian, *Mr. Sully, Portrait Painter*, exh. cat. (Washington, D.C.: National Portrait Gallery, 1983); Steven E. Bronson, "Thomas Sully: Style and Development in Masterworks of Portraiture, 1783–1839" (Ph.D. diss., University of Delaware, 1986); Carrie Rebora Barratt, *Queen Victoria and Thomas Sully*, exh. cat. (Princeton: Princeton University Press, in association with the Metropolitan Museum of Art, 2000).

40. *Woman and Child Reading, Folio 20 in the John Ludlow Morton Album*, 1831

Graphite and gray wash on card, bound into an album; 8 3/16 × 6 15/16 in. (208 × 176 mm)
Signed and dated at lower right in graphite: *TS.* [monogram] *1831.*; below in brown ink: *T. Sully. 16[sic]831.*
Provenance: John Ludlow Morton, New York; Harriet E. Morton Ellison; Emily Ellison Post, Jackson Heights, N.Y.
Bibliography: Koke 1982, 3:172, no. 2551, ill.
Bequest of Emily Ellison Post, 1944.384

This quick but elegant sketch reveals the charm and affability of Sully's style. It is one of the twenty-seven drawings of various artist-friends assembled by the artist John Ludlow Morton into an *album amicorum* (see also cats. 62 and 86).[1] The intimate relationship between a mother and child was one of Sully's specialties, as can be seen in his portrait of Rebecca Mifflin Harrison McMurtie and her son William, where the mother is seated reading with the child asleep on her lap (1816; The Westmoreland County Museum of Art, Greensburg, Pa.). Sully listed similar subjects involving children under the category "fancy subjects" and executed a number of them as casual sketches.[2] The meditative pose and sentiment that Sully captured in this sympathetic, insouciant sketch is highly characteristic of the early Romantic age.[3]

1. The Morton Album encompasses inv. nos. 1944.356–57 (including two miniatures on ivory) and 1944.365–91. One folio by Francis William Edmonds (inv. no. 1944. 386) has been removed. Inv. no. 1944.389 by George Whiting Flagg (cat. 86) has a faint drawing on its verso.

2. See Fabian 1983, 68–69, no. 27, ill. (also no. 26, ill., a study in the collection of Mabel H. Sully). See also Barratt 2000, fig. 29, a sheet with various sketches in brown ink and watercolor in the Brooklyn Museum, N.Y.

3. See Barratt 2000, 28, fig. 16, a watercolor in a private collection of the interior of Sully's rooms during his English sojourn to paint Queen Victoria in 1838. It contains a seated woman in profile with a similar dress and coiffure (more than likely his daughter Blanch).

WILLIAM JAMES BENNETT

Probably London, England c. 1784–New York, New York 1844

Born in England about 1784, William James Bennett studied at the Royal Academy of Arts in London beginning in 1801. He also studied with the watercolorist and figure painter Richard Westfall (who taught the young Victoria, later queen, when she was a princess), from whom it is presumed Bennett learned the techniques of printmaking. His career at the Royal Academy was interrupted by a stint in the British army. He served in the Mediterranean (Egypt and Malta) on the medical staff and traveled and sketched in Italy during leave. From 1808 to 1824 his works were exhibited in London, where he was a member of several societies dedicated to the promotion and appreciation of the watercolor medium, including the short-lived Associated Artists in Water-Colours (1802–12), of which he was a founding member, and the Society of Painters in Water-Colours (founded in 1804), where he exhibited 1820–25. Bennett started to receive commissions for engravings and aquatints about 1811 and published dozens of aquatints in the 1820s with some of London's most successful publishers, such as Rudolph Ackermann. His success hinged on several factors: his ardent involvement with watercolor painting during its golden age; his skill as an aquatint artist in the wake of the pioneer in the medium, Paul Sandby; and his propensity toward landscape.

Although he may have visited America as early as 1816, Bennett settled in New York about 1826, where his preeminence as a draftsman and engraver was immediately recognized. At the time, the marketing and public consumption of topographical prints in America were on the rise. European techniques and practitioners dominated the production of series celebrating American scenes and the distinctive charms of the New World's settings. Bennett's large aquatint views of the towns, ports, and scenery of the country, many after his own watercolors, rank among the finest American prints produced. At the request of the American publisher Henry J. Megarey, whom John Hill (cat. 24) recommended to the artist, Bennett commenced a series of documentary prints of New York street views, many of which were indebted to recent English prototypes. Although only one installment was published in 1834 as *Megarey's Street Views in the City of New-York*, they are among the most refined of the era. In high demand as a master printmaker, Bennett also executed four aquatints after watercolors by Nicolino Calyo depicting the Great Fire in New York City of 1835 (cat. 56) and its aftermath (cat. 57).

Bennett first exhibited in New York at the NAD in 1827, becoming an associate (1827) and then an academician (1829). From 1830 to 1839 he served in an elected capacity as the keeper of the academy's school. In recompense for his teaching and custodial duties, he was given lodgings in Clinton Hall at Beekman and Nassau streets, where the NAD had established its first home on the second floor. In 1829 Bennett contributed to an early commercial effort by Asher B. Durand (cats. 51–54) to publish scenes of American landscape. Although only the first issue of the projected series, "The American Landscape," was published, it included engravings after two of Bennett's watercolors as well as works by Durand, Thomas Cole (cats. 61 and 62), and Robert Walter Weir. In the same year Bennett visited Niagara Falls, a trip that resulted in some of his most spectacular work in America. He also went to Boston, West Point, and Baltimore, exhibiting works from these excursions at the NAD and publishing related folio-size topographical prints that constitute the crowning achievements of his career as a printmaker. Bennett was subsequently involved in two other series in which he was the engraver. For the first he teamed with George Harvey (cat. 63) to produce the five plates (four seasons and rare title page) for *Harvey's Scenes of the Primitive Forest of America, at the Four Periods of the Year* with English and American editions in 1841. In the early 1840s Bennett also undertook to make plates for F. B. Tower's *Illustrations of the Croton Aqueduct*.

During the American phase of his career, Bennett exhibited a number of paintings of American and European scenes at the Apollo Association, the American Art-Union, and the NAD, and sold works to the noted collector and mayor of New York City Philip Hone, among others. In the last year of his life, Bennett executed aquatints after ten watercolors for the *New Mirror* (formerly the *New-York Mirror*), six of which were maritime views, testifying to the

artist's skill in this genre. Living in New York City until 1843, Bennett then moved to Nyack, New York, but died shortly afterward in the city.

Bibliography: Helen Comstock, "An Attribution to William J. Bennett," *Connoisseur* 126:519 (1951): 202–3; Ronald Anthony De Silva, "William James Bennett: Painter and Engraver" (M.A. thesis, University of Delaware, Wilmington, 1970); Deák et al. 1988; Kevin J. Avery, "*Weehawken from Turtle Grove*: A Forgotten 'Knickerbocker' Watercolor by William J. Bennett," *Metropolitan Museum Journal* 36 (2001): 223–34.

41. *"Niagara Falls. Part of the American Fall, from the Foot of the Staircase": Study for an Aquatint*, c. 1829

Watercolor and selective glazing with touches of gouache, graphite, and scratching-out on paper, laid on board; 20 1/2 × 17 in. (521 × 432 mm)
Bibliography: Christie's, New York, sale cat., 21 September 1984, lot 12, ill.
Thomas Jefferson Bryan Fund, 1984.73

Niagara Falls is one of a pair of watercolors by Bennett depicting this iconic American cascade that the Society acquired from the same sale.[1] Both are related to the painting Bennett exhibited at the NAD in 1829 (*Falls of Niagara from below the Table Rock*), which is listed in the annual catalogue with the notation that the painting was "One of a Series of Views of the Falls, Publishing by H. I. Megarey, Esq."[2] Bennett's "series" of Niagara Falls consisted of four large hand-colored aquatints issued singly, not as a series or portfolio, that are among the finest prints made in America. John Hill engraved and hand colored two of them in 1829 (noted in Hill's account book in the Society's Department of Manuscripts); the present sheet was the model for the aquatint by Hill that represents the falls from the foot of the staircase (*NIAGARA FALLS. / Part of the American Fall, from the foot of the Stair Case*); its pendant depicts the falls from under Table Rock (*NIAGARA FALLS. / Part of the British Fall, taken from under the Table Rock*).[3] The remaining two aquatints Bennett engraved himself in 1830, and Hill printed and colored them.[4] All four were published by Henry J. Megarey of New York without dates of publication.[5] Favorably received by the press, their later circulation as lithographs proves their continuing popularity.[6]

The curiosity of European visitors and potential visitors about the New World was intensified with the surge of nationalism that arose in early-nineteenth-century America. At the same time as George Catlin (cat. 50) traveled west to record the indigenous American cultures and John James Audubon (cats. 42 and 43) documented American birds, scores of artists tried to capture the sites and wonders of the American landscape. Niagara Falls, a spectacle that was Romantic, awe-inspiring, and sublime was a favorite subject (see also cats. 8 and 96 and essay fig. 6).[7] Although these cascades are not the world's highest or largest waterfalls, they have an indescribable grandeur, increased by their early isolation and inaccessibility. Father Louis Hennepin, who in 1678 was the first known European to have seen them, wrote: "Betwixt the Lake Ontario and Erie, there is a vast and prodigious Cadence of Water which falls down after a surprising and astonishing manner, insomuch that the Universe does not afford its Parallel …. making outrageous Noise, more terrible than that of Thunder; for when the Wind blows from off the South, their dismal roaring may be heard above fifteen Leagues off."[8] Soon thereafter Niagara Falls became a significant subject in both art and literature, a major tourist destination, and an unceasing source of fascination to the seemingly insatiable public, for whom artists produced a staggering array of images.[9] The opening of the Erie Canal in 1825 exposed the site to mass tourism, trade, and industry to the extent that Niagara could no longer remain a sacred, separate landscape. "From a national icon, remote and imagistic," McKinsey writes, "Niagara was transformed into a fashionable resort, accessible by easy transportation."[10] As the middle class became more affluent, Niagara became a democratic touring destination. Bennett's watercolors for his two pairs of prints that were apparently sold near the falls[11] testify to the increasing numbers who were interested in visual souvenirs of their experience.

In his rather unusual view Bennett focused on the sheer wall of water formed as the American Falls plunges downward at the left, rendering the graceful curve of the Horseshoe Falls on the British-Canadian side in the background. McKinsey believes his representation is "perhaps the most controlled view" of Niagara that was circulated in popular prints in the 1830s and 1840s.[12] Bennett's tiny figures reinforce the awesome size and power of the sublime cascade.

1. The other is "*Niagara Falls. View of the American Fall, taken from Goat Island*": *Study for an Aquatint*; inv. no. 1984.72, in watercolor and selective glazing with touches of gouache, graphite, and scratching-out, 16 1/8 × 21 1/4 in. See Christie's, New York, sale cat., 21 September 1984, lot 13, ill.

2. Cowdrey 1943, 1:30, no. 125. In 1843 Bennett also exhibited *Niagara Falls from the Table Rock* and *Niagara Falls from the American Side* (ibid., 31, nos. 318, 322; no media given). The former may be related to the horizontally oriented view, reproduced in F. St. George Speedlove, "Niagara Falls Pictured," *The Magazine Antiques* 69:4 (1956): 337. A perusal of the works Bennett exhibited at the NAD reveals many waterfall subjects.

3. For these impressions, see Koke 1961, 61–63, nos. 135–36, ills.; Adamson et al. 1985, figs. 24 and 25; McKinsey 1985, fig. 44; and Deák et al. 1988, 74, 76, nos. 13 and 14, figs. 12 and 13. Hill's account book reveals that for each plate he received $100 for engraving, 12 cents for printing, and 50 cents for coloring.

4. They are *NIAGARA FALLS. View of the American Fall, taken from Goat Island*, whose pendant is *NIAGARA. View of the British Fall, taken from Goat Island*. For the aquatints, see Koke 1961, 80–81, nos. 167 and 168; Adamson et al. 1985, figs. 26 and 27; and Deák et al. 1988, 76, nos. 15 and 16, figs. 14 and 11.

5. The Society's DPPAC holds impressions of three of the prints after Bennett's views of Niagara Falls, save the one after the watercolor discussed here. See also Lane 1993, 57, ill., which mentions the two later aquatints in horizontal formats of the falls by Bennett and reproduces one (the sixth is also noted in Adamson et al. 1985, 132, no. 26, fig. 32, as after John R. Murray; and reproduced in Speedlove 1956, 337).

6. Deák et al. 1988, 36, notes in 1829 Gerlando Marsiglia executed two lithographs after the vertically oriented Bennett-Hill aquatints of the falls. See also Lane 1993, 55, 133–34, figs. 140–41, 145.

7. See Speedlove 1956, 334–37; and McKinsey 1985.

8. Quoted in Speedlove 1956, 334.

9. For additional bibliography on the subject, see Adamson et al. 1985; and McKinsey 1985.

10. McKinsey 1985, 127.

11. Prince Maximilian von Wied remarked in his journal when he visited the falls in 1832 that "some tolerably good representations of the falls by Megarey" were on sale at Fido's Confectionary, a souvenir shop on the Canadian side. Lane 1993, 57.

12. McKinsey, 1985, 144, fig. 58, singles out Bennett's *View of the British Fall, taken from Goat Island* as one of the most famous.

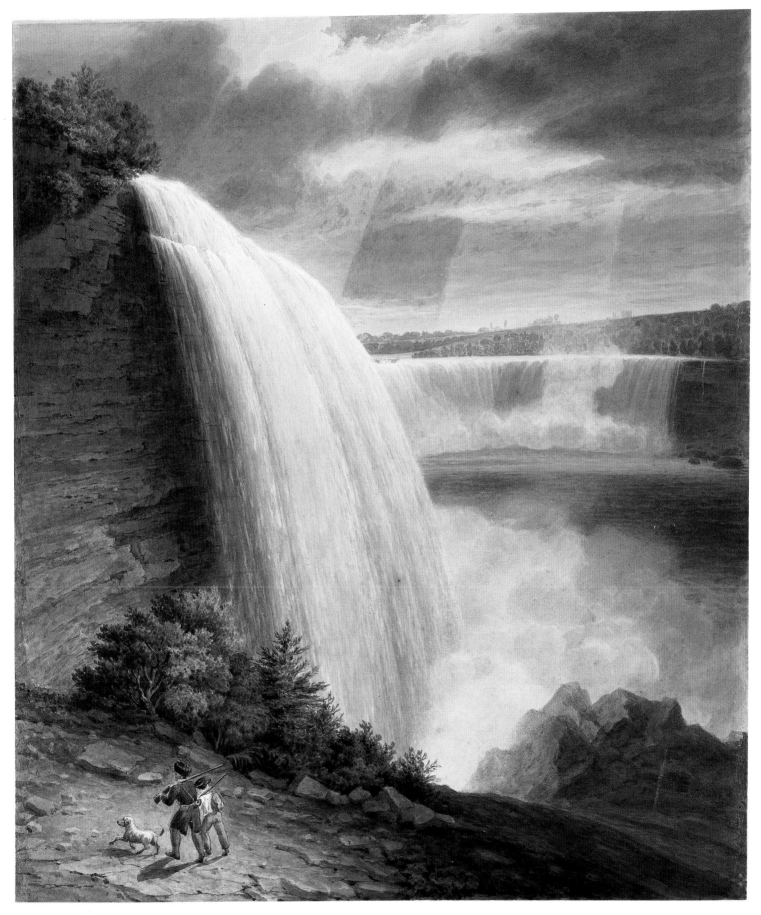

JOHN JAMES AUDUBON

Les Cayes, Saint-Domingue (Haiti), West Indies 1785–New York, New York 1851

Born illegitimate in Saint-Domingue (present-day Haiti) to Jeanne Rabine, a French chambermaid who died soon after his birth, and Captain Jean Audubon, the great field naturalist, artist, and entrepreneur John James Audubon was first known as Jean Rabine. When he was three years old, his father sent him to France to be raised by his wife Anne Moynet in Nantes and Couëron, site of his family's country home, La Gerbetière, near the mouth of the Loire River. Young Jean was renamed Jean-Jacques Fougère (meaning "fern") to placate the French Revolutionary authorities who disliked his Christian saint names and to help disguise his illegitimacy. When he was legally adopted by his father and stepmother in 1794, he became Jean-Jacques Audubon. As a youth he was encouraged to draw birds by his father and the naturalist Charles Marie Dessalines d'Orbigny. In 1803, at the age of eighteen, he was sent to oversee the family's property at Mill Grove, Pennsylvania, outside Philadelphia, to avoid conscription into Napoleon's army. Uninterested in practical affairs, Audubon spent his time hunting and drawing birds; many of his early studies, mostly in the traditional French eighteenth-century media of graphite and pastel, are in Houghton Library, Harvard University, Cambridge, Massachusetts. He also courted and married Lucy Bakewell, the English-born, highly accomplished young woman who lived on the neighboring property, Fatland Ford. In 1805 he adopted the nickname "Laforest" (Franglaise for "forest") and began developing an obsession for his new country, eventually fashioning himself as a frontiersman in the mode of Daniel Boone. In later years he came to embody for Europeans the Romantic image of Natty Bumppo, the noble frontiersman of James Fenimore Cooper's 1823 novel *The Pioneers*. In search of an occupation, he moved first to Louisville, Kentucky, where he opened a store for provisions. In 1810 Alexander Wilson, the Philadelphian naturalist looking for subscribers for his *American Ornithology* (1808–14), paid him a visit. Audubon, who had been told that his work was better than the images that appeared in Wilson's book, did not subscribe. Nevertheless, Wilson's project undoubtedly inspired him to begin his own large-scale publication on American birds.

Entrepreneurial by nature, Audubon was involved with several commercial ventures, including a store in Henderson, Kentucky, that failed owing to the economic upheavals that culminated in the Panic of 1819. Declaring bankruptcy in 1819, Audubon moved to Shippingsport, Kentucky, where he drew portraits of its inhabitants. The following year he worked briefly in Cincinnati, Ohio, in a drawing school and for the Western Museum of Cincinnati College (now the Museum of Natural History), where he stuffed specimens and painted landscape backgrounds for displays. Around this time, he began signing his drawings *John J. Audubon* and felt that he was an American (he had become a naturalized citizen in 1812; his seal was engraved *America is my country*). An adventurer at heart, Audubon could fence, sing, play the violin as well as the flute and other woodwinds, dance, ride a horse, hunt, and draw.

As his interest in ornithology increased, he decided after 1819 to dedicate himself to the publication of his own watercolors of American birds. *The Birds of America* (1827–38) became his magnificent obsession and an ambitious enterprise that defined his life. He sacrificed everything to bring it to fruition, a feat accomplished by an inspired mixture of vision, perseverance, and luck. To that end in October 1820, accompanied by his student the botanist Joseph Mason, Audubon left for a three-month collecting and drawing expedition down the Ohio and Mississippi rivers. At the end of this trip, in 1821 he explored the Louisiana bayous in search of additional birds. He painted each new species, while Mason rendered the detailed botanical specimens for more than fifty watercolors. In 1824 Audubon attempted to have his works engraved and published in Philadelphia, but he met with a disappointing reception from the scientific community there, due partly to his own arrogance and naïveté and partly to the community's posthumous loyalty to Wilson, fueled by Wilson's editor George Ord, who became Audubon's nemesis. For the next two years Audubon continued to paint and observe birds in the southern states, his passion unabated.

Having exhausted the possibilities for publishing his envisioned magnum opus on American soil, in May 1826 Audubon sailed for England, where he exhibited his watercolors at the Liverpool Royal Institution to great critical acclaim. To increase his income and in hopes of financing the publication of his works, he sold copies of them in oil. He also exhibited at the Royal Society of British Artists in London as well as at the Royal Scottish Academy and the Royal Institution of Edinburgh. In November 1826 he entered into an agreement with William Home Lizars to publish his watercolors as hand-colored engravings. After several months, however, with only ten plates completed, the contract was terminated when the colorists went on strike and Audubon was compelled to find a new publisher. Ultimately, this turn of events proved fortunate. Audubon went to London in search of an engraver and found Robert Havell Jr. (1793–1878) through Havell Senior, who was about to retire. The gifted engraver and Audubon were ideal collaborators and remained friends for life.

The complex genesis of *The Birds of America* involves a fascinating saga of collaboration and entrepreneurship. The extended, transatlantic project turned into a family affair, involving Audubon's entire nuclear and extended family, as well as that of his talented engraver. It encompassed many journeys in the United States and Europe in quest of specimens and subscribers in addition to supervising the production of the plates in Havell's London studio. Audubon's five-volume *Ornithological Biography* (1831–39) served as the accompanying text for the sumptuous *The Birds of America* folio. It was written with the assistance of William MacGillivray, the Scottish naturalist and university lecturer, who was Audubon's highly disciplined collaborator in Edinburgh. "Mac," as Audubon affectionately called him, helped with the more scientific aspects of avian anatomy, technical vocabulary, and English grammar. The other unsung hero of these companion volumes of "bird biographies" was Lucy Bakewell Audubon, who not only copied and edited the manuscript but functioned as the central organizing force of Audubon's life as well. Audubon also commissioned Joseph Bartholomew Kidd to paint the backgrounds in his oil paintings and to copy his watercolors in oil. These Audubon sold to finance the production of *The Birds*. From 1831 to 1833 Audubon received from Kidd about ninety-four oil copies, not all completed, from the first and second volumes of *The Birds*. These were unsigned and have consequently been difficult (without knowledge of their provenance) to distinguish

from copies painted by Audubon, who had studied oil painting briefly under Thomas Sully (cat. 40) in Philadelphia, and by his sons, Victor Gifford Audubon and John Woodhouse Audubon, both accomplished artists in their own right who collaborated with their father.

Audubon returned to the United States in 1829–30 in search of new birds, traveling in New Jersey and Pennsylvania. In 1831 he went to the Florida Keys, accompanied by the artist George Lehman, who executed many of the landscape backgrounds for Audubon's avian watercolors of this period. In Charleston, South Carolina, he also befriended the Reverend John Bachman, a naturalist who, after his wife's death, eventually married his sister-in-law and Audubon's friend and collaborator, Maria Martin. Martin added exquisitely delineated plants and insects to about thirty-five of Audubon's compositions. Since Audubon and his partners forged relatively seamless collaborations, attributions about their divisions of labor are difficult to make. Audubon continued his search for additional species in Labrador and Newfoundland with his son John Woodhouse, returning in 1834 to England, where Lucy and Victor were supervising the production of *The Birds*.

The Birds of America was completed in 1838 as a sumptuous double-elephant folio. Issued by subscription in 87 parts (fascicles), the set contains 435 hand-colored prints of 1,065 life-size birds representing 489 species. Havell produced these prints by a complex process of engraving, etching, and aquatint. This deluxe edition of *The Birds of America* is arguably the most spectacular color folio print series ever produced and one of the world's preeminent natural history documents. Superbly executed, it is considered the finest work of colored engraving involving aquatint. It was also one of the last, for beginning about 1830 lithography replaced engraving in art book production. Between 1840 and 1844 a seven-volume octavo edition of *The Birds of America* was produced by the Philadelphia firm of John T. Bowen. It contains 500 lithographs, 435 after the original prints (with some modifications) reduced by John Woodhouse Audubon with the aid of the camera lucida and a group of new birds, arranged more scientifically according to species and accompanied by text from the *Ornithological Biography*. There is also a group of avian anatomical diagrams.

All 435 preparatory watercolors for Havell's plates are in the N-YHS. Despite Audubon's claims of having studied in the studio of Jacques-Louis David, more likely he was self-taught, rendering his pioneering techniques all the more astounding. In his studies of avian species, Audubon progressed from simple pastels over graphite, a technique he had learned in France, to complex mixed-media combinations. He used a wide variety of materials experimentally— collage, watercolor, gouache, pastel, ink, oil paint, water-soluble glazes and adhesives, and chalk over a graphite underdrawing—making him one of America's most innovative draftsmen. In his attempt to portray birds as true to nature as possible, Audubon represented them in an unprecedented fashion: life-size. He frequently included both sexes and juveniles as well as adults and fledglings. Foreshadowing Darwinism, many of Audubon's most dramatic images openly challenge the traditional conception of a benevolent universe by pitting predators against prey, and even showing members of the same species in a violent struggle for survival. His watercolors and prints reflect the growing interest of naturalists in defining species according to not only anatomical traits but also characteristic behavioral patterns. Audubon's works generally present several birds from the same species engaged in typical group activities, such as hunting, feeding, courting, or caring for their young.

Audubon returned to New York City in 1839, first residing in lower Manhattan, where he was joined by Havell, who had been lured by Audubon's enthusiasm for America to emigrate. At Audubon's request, Havell also transported the copperplates (around seventy-five are extant, four in the Society's collection) and the watercolors to the United States. In 1842 Audubon settled at a thirty-five-acre estate with frontage on the Hudson River at Carmansville, near present-day 156th Street and Riverside Drive in the Washington Heights section of Manhattan. Audubon built his house on the property known as Minnie's Land, and lived there until his death, working on *The Viviparous Quadrupeds of North America* (1845–48). His sons Victor and John Woodhouse also resided with their wives on the property, which was sold in 1864 by Audubon's impoverished widow. All the buildings were destroyed in 1931 to make way for real estate

development. The name Minnie's Land derives from the Caledonian term of endearment for "mother," the name given to Lucy Bakewell Audubon by the boys when they lived in Scotland, testifying to her central position in the household and the family enterprises.

Audubon's second great work, *The Viviparous Quadrupeds of North America*, features 150 plates. Once again, his sons assisted in its production, but this time more dominantly, as John Woodhouse produced more than half the studies for the hand-colored lithographs. The Reverend Bachman wrote the text. Seeking new specimens, Audubon made his last expedition along the upper Missouri and Yellowstone rivers in 1843, accompanied by Bachman and the young naturalist Isaac Sprague. Afterward he began losing his sight, so that by 1847 he could no longer paint. There followed a rapid decline in his health, and then dementia.

During his lifetime Audubon was awarded many honors, including election to England's prestigious Royal Society, the highest scientific honor of his era. (He and Benjamin Franklin were the only American members until after the Civil War.) Today, he is considered one of America's finest watercolorists and illustrators of natural history. Audubon's keen awareness of ecological issues and his appreciation of the natural environment today find expression in the organization named after him, Audubon (formerly the National Audubon Society).

Bibliography: John James Audubon, "Method of Drawing Birds," *Edinburgh Journal of Science* 8 (1828): 48–54 (reprinted together with the 1831 manuscript of a similar essay in "My Style of Drawing Birds" [Ardsley, N.Y.: Overland Press for the Haydn Foundation, 1979]); idem, *Ornithological Biography, or, An Account of the Habits of the Birds of The United States of America*, 5 vols. (Edinburgh: A. Black, 1831–39); John James Audubon and John Bachman, *The Viviparous Quadrupeds of North America*, 3 vols. (New York: J. J. Audubon, 1845–48); Alice Ford, ed., *Audubon's Animals: The Quadrupeds of North America* (New York: Studio Publications, in association with Thomas Y. Crowell Company, 1951); idem, *John James Audubon* (Norman: University of Oklahoma Press, 1964; 2nd ed., New York: Abbeville Press, 1988); Waldemar H. Fries, *The Double Elephant Folio: The Story of Audubon's "Birds of America"* (Chicago: American Library Association, 1973; new ed. with appendix by Susanne M. Low, Amherst, Mass.: Zenaida Publishing, 2005); Annette Blaugrund and Theodore E. Stebbins Jr., eds., *John James Audubon: The Watercolors for "The Birds of America,"* exh. cat. (New York: Villard Books, Randon House, and New-York Historical Society, 1993); Sarah E. Boehme, ed., *John James*

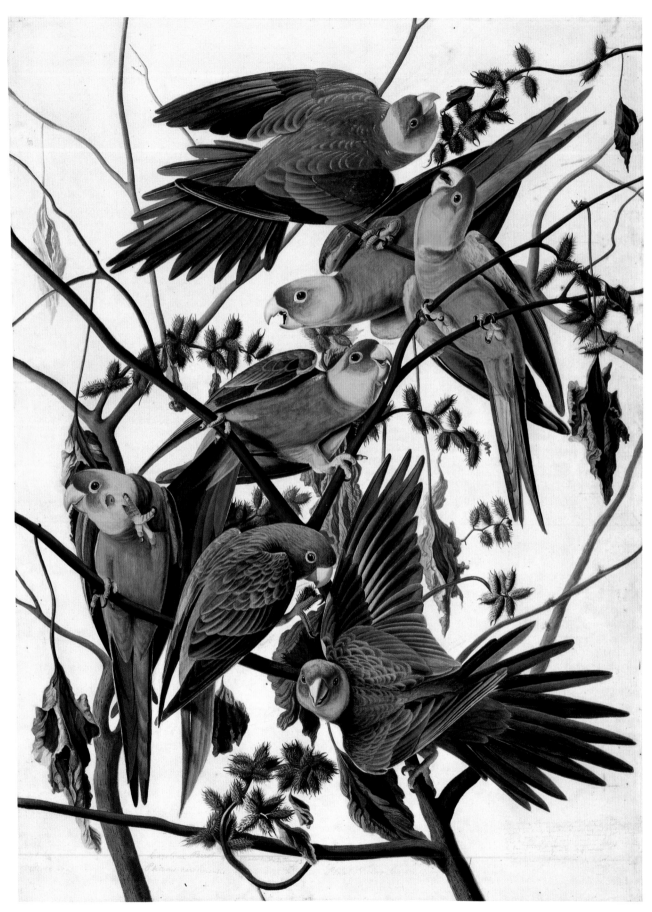

42a

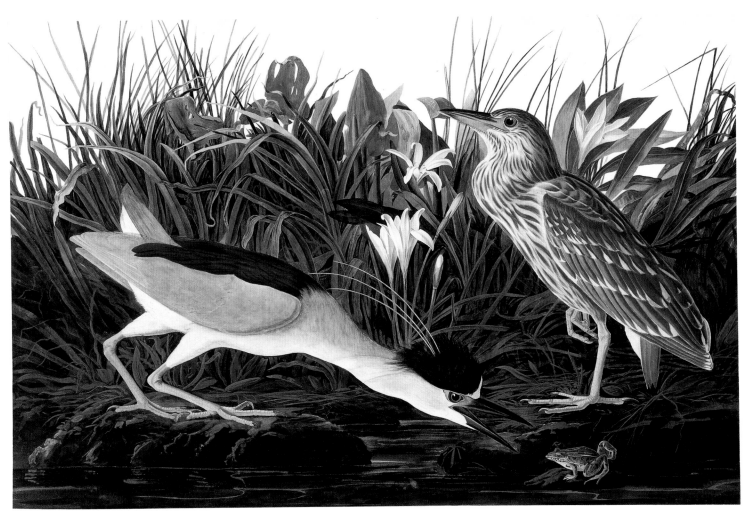

42b

Audubon in the West: The Last Expedition, Mammals of North America, exh. cat. (New York: Harry N. Abrams, 2000); Susanne M. Low, *A Guide to Audubon's "Birds of America"* (New Haven and New York: William Reese Company & Donald A. Heald, 2002); Yvon Chatelin et al., *Jean Jacques Audubon: Peintre, naturaliste, aventurier* (Nantes: Arts, Recherches et Créations, 2003); Duff Hart-Davis, *Audubon's Elephant: America's Greatest Naturalist and the Making of "The Birds of America"* (New York: H. Holt, 2004); Richard Rhodes, *John James Audubon: The Making of an American* (New York: Alfred A. Knopf, 2004); William Souder, *Under a Wild Sky: John James Audubon and the Making of the "Birds of America"* (New York: North Point Press, 2004); Roberta J. M. Olson, "John James Audubon," in *Great Natural Historians*, ed. R. Huxley (London: Natural History Museum and Thames and Hudson, 2007), 233–40.

42a. *Carolina Parakeet* (Conuropsis carolinensis), *Study for Havell Plate 26,* c. 1825

Watercolor, graphite, pastel, gouache, and black ink with scratching-out and selective glazing on paper, laid on thin board; 29 3/4 × 21 1/4 in. (756 × 540 mm)

Inscribed at lower left in graphite: *No 6 / Plate 26 —*; at lower left of center: *Carolina Parrot. Males 1. F. 2. Young 3 / Psitacus carolinensis*; at lower center: *Plant Vulgo Cuckle Burr.*; at lower right, where also signed: *The upper Specimen was shot over Bayou Sarah / and appeared so uncommon having 14 Tail feathers all very / distinct and firmly affixed in 14 diferent receptacles that I / drew it more to exhibit one of those astonishing fits of Nature / than any thing else — — it was a female — — / The green headed is also a singular although not / uncomon a Variety as the above one — — / Louisianna — December — J.J Audubon*; birds inscribed counterclockwise from lower center: *female; female; female N … [?]… / 14 Tail feathers; Male; Male; Young —.*

Watermark at the upper left in reverse: J WHATMAN / 1810[?]

Provenance: Mrs. John James (Lucy Bakewell) Audubon, New York, 1863.

Bibliography: Audubon 1831–39, 1:135–40; idem, *The Original Water-Color Paintings by John James Audubon for "The Birds of America": Reproduced in Color for the First Time from the Collection of the New-York Historical Society* (New York: American Heritage Publishing Co., 1966; reissued 1985), pl. 223; Blaugrund and Stebbins 1993, 154–55, ill.; Olson 2004, 22, fig. 2, 24.

Purchased for the Society by public subscription from Mrs. John J. Audubon, 1863.17.26

42b. *Black-crowned Night-Heron* (Nycticorax nycticorax), *Study for Havell Plate 236,* 1832

Watercolor, gouache, black ink, graphite, pastel, and collage with scratching-out and selective glazing on paper, laid on thin board; 25 7/16 × 37 7/8 in. (646 × 962 mm)

Birds numbered at lower center in graphite: *1*; at upper right: *2*

Watermark at the upper right in reverse: J WHATMAN / 1831

Provenance: Mrs. John James (Lucy Bakewell) Audubon, New York, 1863.

Bibliography: Audubon 1831–39, 3:274–82; 5:603; idem 1985, pl. 419; Blaugrund and Stebbins 1993, 192–94, ill. Purchased for the Society by public subscription from Mrs. John J. Audubon, 1863.17.236

During the height of the Civil War in 1863, the Society purchased by subscription from the naturalist's widow, Lucy Bakewell Audubon, its one-of-a-kind trove of all save one of the 435 known watercolors preparatory for *The Birds of America* (1827–38); the last was given to the Society in 1966.[1] They are preparatory for 433 of the 435 plates; no watercolors for plates 84 and 155 are known to exist. Audubon's innovations as a naturalist-artist are apparent in these dazzling drawings. He not only rendered the birds life-size but also captured them with all the drama of their avian life, enhanced with anthropomorphic anecdotes.[2] His years drawing portraits to support his family and his passion for birds induced him to capture the individuality of each species. Since every avian watercolor is based on a lifetime of observation and study, they effectively characterize the essence of each bird in a single arresting image. Turning the pages of the double-elephant folio plates was meant to simulate a tour through the lives and behavior of birds; it approximates an experience akin to the moving panoramas that entertained people during Audubon's era and foreshadowed the cinema. Although Audubon was criticized for not sequencing his plates in Linnaean order, he did not intend to produce a scientific catalogue but, rather, a work of art. Organizing the images organically gave the birds the semblance of life, as found in nature, and tipped the scale toward his artistic contributions.

Audubon executed all but three of the watercolors on the largest size of fine English paper then available (double-elephant size), produced by two mills, Balston Mill and the Hollingsworth Mill, whose watermarks are variations on J WHATMAN and J WHATMAN / TURKEY MILLS, respectively. He used only three sheets from an American mill (that of Joshua and Thomas Gilpin with the watermark TG & Co) on drawings dating between 1820 and 1821.[3] Once Havell had completed the copperplates, Audubon shipped the watercolors back to the United States and exhibited them publicly in 1839 for the last time at the Lyceum of Natural History in New York. At some point, all the sheets were mounted to thin card stock, perhaps in England before shipping.

Although it is impossible to summarize Audubon's contributions in a single entry, a consideration of a pair of his watercolors for *The Birds* begins to suggest his genius. The two represent the Carolina Parakeet and the Black-crowned Night Heron, respectively.

The Carolina Parakeet, called by Audubon the "Carolina Parrot," the only parrot native to the United States, was sighted for the final time in the wild in 1920.[4] On 21 February 1918 the last captive bird died in the Cincinnati Zoo. The once-abundant species became extinct, slaughtered as a pest to farmers and for sport, food, and feathers. Sold by the thousands as cage birds, they rarely bred in captivity. Examining Audubon's watercolor one can see that he unabashedly admired them for their panache and liveliness:

> the woods are the habitation best fitted for them, and there the richness of their plumage, their beautiful mode of flight, and even their screams afford welcome intimation that our darkest forests and most sequestered swamps are not destitute of charms … . The stacks of grain put up in the field are resorted to by flocks of these birds, which frequently cover them [like] a brilliantly coloured … carpet had been thrown over them.[5]

As early as 1808 Audubon spotted countless parakeets, heard their vociferous cries, and drew a single bird in a watercolor and pastel work of 1811.[6] He executed this brilliant watercolor about 1825 in Louisiana.[7] He included six adults, three males and three females, with yellow and red heads, and one juvenile with a green plumage on its head.[8] Already before 1831 he noticed that "our Parakeets are very rapidly diminishing in number … , where twenty-five years ago they were plentiful, scarcely any are now to be seen."[9]

His nearly cinematic grouping, arranged in an elegant S curve, shows the seven birds perching on a common cocklebur (*Xanthium strumarium*).[10] Audubon positioned them in various acrobatic postures, as if seen in consecutive stills of a movie; two are spreading their tail feathers (one with fourteen), and the lower bird is dramatically foreshortened to add great immediacy to the image. Audubon's depiction suggests through synesthesia their cries, which were never recorded. In a deft, highly experi-

mental stratigraphy of layers—overlaying watercolor and pastels—he has illusionistically re-created the textures of their feathers and, in a breathtaking tour de force of draftsmanship, their iridescence by meticulously outlining each barb and barbule of every feather in graphite—hundreds of strokes—that sparkle as the light catches them. Only in Audubon's ingenious depiction is this extinct species alive. The corresponding print is nearly identical in its composition, as is Kidd's oil after the watercolor, which descended through the Audubon family and is now in the American Museum of Natural History, New York.[11] The revolutionary nature of Audubon's depiction is underlined in comparison with Wilson's static profile view of the bird in the company of three different flycatchers, mostly in profile, in his *American Ornithology; or, The Natural History of the Birds of the United States*.[12]

Audubon executed his bold watercolor of the Black-crowned Night Heron, or Qua bird,[13] in June 1832 in Charleston, South Carolina, with George Lehman (c. 1800–1870), who most likely assisted him with the habitat and possibly other parts of the composition.[14] The flower growing amid the marsh grass on the muddy bank is a zephyr lily or rain lily (*Zephranthes atamasco*). In a seemingly simple composition with two birds and their prey, a frog, Audubon manages to summarize the life cycle of the bird. The narrative of the scene turns it into a vignette whose immediacy is heightened by its close point of view, as though the viewer were observing this avian drama, embedded with Audubon and hidden by marsh grass. This work, like many of his watercolors (most notably that of the Common Tern),[15] was influenced by Chinese paintings and perhaps Japanese woodblock prints.[16]

Audubon placed the juvenile Black-crowned Night Heron in its spotted camouflaging plumage on the right. Its awkward stance and aloof, glazed stare contrast with the highly motivated and intense adult (males and females have identical plumage). Audubon represented the adult with its characteristically flamboyant breeding plumes of maturity and yellow legs about to snatch a frog to nourish the youngster and to teach it survival skills. The posture that Audubon depicts is typical of that for procuring food;[17] its elongated neck belies the adult's usual *jizz* (G.I.S.S. [general impression of size and

shape]: proper posture, characteristic appearance, and proportions) that results in a thick neck and stocky appearance.[18] The Black-crowned Night Heron is not, as its name implies, exclusively nocturnal, but it does feed chiefly during the twilight, as Audubon suggests with the dark water and his controlled palette. The frog,[19] which may have been executed by Lehman, was painted on a separate piece of paper that Audubon collaged onto the background sheet. He also employed scratching-out with a stylus to render highlights in the dark water and masterfully used reserve areas of the white paper. Havell was quite faithful to the highly finished original watercolor when he and his shop produced the folio plate.

1. Remarkably, the $4,000 asking price was raised by eighty-nine donors. The Society also holds one of the largest caches of Auduboniana in the world.

 One hundred twenty complete copies of *The Birds of America* are extant today in collections around the world; see Low 2002, 3. G. Kirkpatrick, noted in Audubon's subscription list but otherwise unknown, was most likely the subscriber for the Society's copy of the double-elephant folio edition held in the DPPAC. It then went through the hands of several owners in England and finally the dukes of Newcastle, who had it bound in tooled and gilded leather, replete with their arms. In 1937 the contents of the Clumber Library, property of the late seventh Duke of Newcastle, were sold at auction at Sotheby's, London, sale cat., 21 June 1937. At that sale, the Rosenbach Company of Philadelphia, under the aegis of the collector and dealer Dr. A. S. W. Rosenbach, purchased the Society's copy (lot 31) for Mrs. Gratia Houghton Rinehart, sister of the eminent bibliophile Arthur Houghton Jr., who donated it to the Society.

2. In the spectrum of natural history, the time was ripe for Audubon's study. See the discussion of early western ornithological illustration in cat. 1. The stage had been set for Audubon by the recent ornithological publications of the Comte de Buffon (Georges-Louis LeClerc) and Audubon's later Philadelphia rival Alexander Wilson. Buffon's comprehensive *Histoire naturelle, générale et particulière* (1749–1804), prized for its beautiful illustrations, was Audubon's real prototype. Although Audubon was highly innovative, he also worked within a tradition about which he was aware, a subject that has not been thoroughly investigated. For example, except for the addition of one bird, Audubon's composition in both the watercolor and print of the Red-breasted Grosbeak (inv. no. 1863.17.127; Havell pl. 127) is identical to that of Jacques Philippe Cornut's in his *Canadensium plantarum* (Paris: Simon le Moyne, 1635). For a discussion of Audubon in the context of natural history and ornithological illustrations, see Amy R. W. Meyers, "Observations of an American Woodsman: John James Audubon as Field Naturalist," in Blaugrund and Stebbins 1993, 43–54; and Linda Dugan Partridge, "By the Book: Audubon and the Tradition of Ornithological Illustration," in *Art and Science in America: Issues of Representation*, ed. Amy R. W. Meyers (San Marino, Calif.: Huntington Library, 1998), 97–129.

3. For a discussion of Audubon's papers and innovative techniques, see Reba Fishman Snyder, "Complexity in Creation: A Detailed Look at the Watercolors for *The Birds of America*," in Blaugrund and Stebbins 1993, 55–68.

4. Arthur Cleveland Bent, *Life Histories of American Cuckoos, Goatsuckers, Hummingbirds and Their Allies* (New York: Dover Publications, 1964), 1:3.

5. Audubon 1831–39, 1:138, 140.

6. In the Houghton Library, Harvard University, Cambridge, Mass.; see Blaugrund and Stebbins 1993, 4, pl. 3.

7. Audubon pursued birds with the intensity of the hunter and shot many of his specimens. In prephotographic times, observation for scientific knowledge had not been disconnected from observation for game. Specimens could only be obtained by hunting. Audubon "invented" a board scored with a grid and impaling wires to render his fresh specimens in vivid, life-like postures; for his description of this device, see Audubon 1828. He also drew from living birds he had captured and preferred to draw from live models.

8. Audubon 1831–39, 1:139–40, characterizes all the birds that are numbered in the plate, stating that the males are more brilliant in their plumage and slightly larger.

9. Ibid., 138.

10. Audubon (ibid., 135), with the typical foresight that made him such an innovative mind, observed about the plant that was a nuisance to animals and plants: "To this day, no useful property has been discovered in the Cockle-burr, although in time it may prove as valuable either in medicine and chemistry as many other plants that had long been considered of no importance."

11. Audubon Art No. 5, oil on canvas; see Ella M. Foshay, *John James Audubon* (New York: Harry N. Abrams, in association with the National Museum of American Art, Smithsonian Institution, 1997), 56, ill. Kidd added the background foliage that does not appear in Audubon's watercolor or print.

12. See ibid., 58, ill.

13. Audubon 1831–39, 3:274, reports that this latter name was the bird's appellation in the eastern United States and lists additional regional names for the species.

14. Blaugrund and Stebbins 1993, 192.

15. Inv. no. 1863.17.309; see ibid., 254–55, ill.

16. See for example, ibid., 15–16. Also reproduced as fig. 14 is a Japanese print from the Meiji period that depicts Audubon opening a trunk and discovering that his drawings had been consumed by rats. It shows that in turn Japanese artists of this period, who looked to Western art, were intrigued by Audubon's works. Ford 1951, 33, states that the print was reproduced in Nakamura Mesano's *The Western Countries' Book of Successful Careers*, a Japanese translation of Samuel Smiles's book *Self Help*, published in 1859.

17. Audubon 1831–39, 3:279, writes: "On the ground, this bird exhibits none of the grace observed in all the true Herons; it walks in a stooping posture, the neck much retracted, until it sees its prey, when, with a sudden movement, it stretches it out and secures its food."

18. See Roger Tory Peterson, *A Field Guide to the Birds* (Boston: Houghton Mifflin Company, 1980), 104–5, ill.

19. Audubon 1831–39, 3:280, writes: "The frog, of which I have introduced a figure, is common in the retired swamps which the Night Heron frequents, and is often devoured by it."

John James Audubon

43. *Three Eastern Gray Squirrels (Sciurus carolinensis leucotis): Study for Plate 35 of "The Viviparous Quadrupeds of North America,"* 1842

Watercolor, black ink, pastel, graphite, gouache, and white lead pigment with selective glazing on ivory paper; 30 1/8 × 22 1/4 in. (765 × 565 mm)
Inscribed at upper left in brown ink: *No 7.* / *Plate 35.*; inscribed and dated at lower right below graphite border in graphite: *Sciurus migratorius.* [*Aud —* crossed out] *Bach. — Leucotis S$^{pc.}$ — Var.* / *N.Y. Dec.r 29th—1842. —* / *Migratory Squirrel*
Provenance: Frederic De Peyster, New York?
Bibliography: Boehme 2000, 150–51, ill.
Z.3330

Audubon called this species—of the family *Sciurdae* of the order *Rodentia* that is common in eastern North America—the "Migratory Squirrel" and added Bachman's name in his inscription. The *Sciurus carolinensis* is also known as the Cat Squirrel, Black Squirrel, Silvertail, Grayback, and Banner Tail.[1] Audubon wrote a lengthy passage on the creatures in *The Viviparous Quadrupeds of North America* (1845–48) in which he remarked that he had already seen these squirrels in 1819 while descending the Ohio River:

> This appears to be the most active and sprightly species of Squirrel existing in our Atlantic States … . This species … excited the wonder of the populace by … its singular long migrations … . The newspapers from the West contain many interesting details of these migrations … . The farmers in the Western wilds regard them with sensa-

tions which may be compared to the anxious apprehensions of the Eastern nations at the flight of the devouring locust … . Onward they come, devouring on their way every thing that is suited to their taste, laying waste the corn and wheat-fields … . It is often inquired, how these little creatures, that on common occasions have such an instinctive dread of water, are enabled to cross broad rivers … . it appeared to us, that they are not only unskillful sailors but clumsy swimmers … . They swam the Hudson at various places between Waterford and Saratoga; those which we observed crossing the river were swimming deep and awkwardly, their bodies and tails wholly submerged … . We kept some of these Squirrels alive; they were fed with hickory nuts, pecans, and ground or pea-nuts … .[2]

In this stunning sheet one sees John James Audubon's method of laying in his composition with a light graphite underdrawing. It is almost as though one were witnessing his process of creation and, thereby, participating in the drawing's genesis. This element of immediacy adds excitement to the viewing of Audubon's image.[3]

This sheet is one of three studies of squirrels by Audubon in the Society's collection preparatory for the imperial-size folio plates[4] that were first published in *The Quadrupeds*.[5] In this sheet, whose composition appears as plate 35, Audubon finished in mixed media only one squirrel and the tree branch on which the three arboreal rodents perch, but he outlined the placement of the two other squirrels. He already had established the positions of this pair the previous year in another watercolor of comparable size with a slightly different palette, now in the Morgan Library and Museum, New York. When executing the Society's sheet, he moved them closer together to tighten the composition.[6]

The *Sciurus carolinensis* occurs in two color phases, gray, as seen in the Society's watercolor, and black, which farther south is less common, indicating that the gene responsible for the black coloration is associated with cold-weather adaptation. There are also rare instances of a reddish color phase, and some animals may have a combination of colors. The Society's watercolor reveals that Audubon revised his earlier composition with two squirrels for publication. He also lavished much attention on the tree

branch, which he moved farther left to accommodate the third squirrel, embellishing its texture with gouache and mixed media. He employed a refined, expressive black ink line to delineate the long hairs of the animal's pelt as well as its whiskers, which appear to twitch. With his addition of the third squirrel, the resulting composite image for plate 35 is more complex and lively. This cut-and-paste manner of working was typical for most of the plates in *The Quadrupeds*, partially due to the collaborative nature of the enterprise. Rarely was a composition finished on one sheet of paper or canvas. It was up to the lithographer, J[ohn] T. Bowen, to integrate two or three watercolors or oils into one finished hand-colored lithograph in the first edition, which was issued in thirty parts (fascicles) of five prints each.[7]

Turning from feathers to fur, Audubon began his second major natural history project, *The Viviparous Quadrupeds of North America* (literally, four-footed animals bearing live offspring), which aimed to document North American mammals, in 1840 at Minnie's Land. Earlier he had painted mammals, most notably an otter caught in a trap, in England to finance the production of *The Birds of America*.[8] *The Quadrupeds* was funded in part by the octavo

edition of *The Birds* (1840–44), and, as with the earlier book, this project was a family affair. However, to a greater extent than *The Birds*, *The Quadrupeds* was in large part produced by Audubon's sons, together with his faithful naturalist friend and longtime collaborator, the Reverend John Bachman.[9] Bachman, who wrote the text, also accompanied Audubon on expeditions and provided specimens and advice on various aspects of the project. About half the life-size illustrations were executed in oil by John Woodhouse, despite engraved credit on the plate margins to Audubon himself. Many of the backgrounds were executed by Audubon's elder son, Victor Gifford, the third member of the Audubon dynasty of naturalist-artists.[10] Both Audubon sons had been trained from birth to work on the family business, *The Birds of America*.

Fig. 43.1. John James Audubon, *Studies of Six Bats*, 1846. Watercolor, graphite, black ink, and pastel with touches of glazing and scratching-out on paper, 23 × 30 5/8 in. (584 × 778 mm), irregular. The New-York Historical Society, Z.3333

As opposed to the hand-colored etchings and aquatints of *The Birds*, the first edition of *The Quadrupeds* was illustrated with hand-colored lithographs, the most recent innovation in illustration technology. Audubon's deteriorating health—he began losing his eyesight in 1846, followed by a stroke and perhaps the onset of dementia—explains the extensive participation in *The Quadrupeds* of his two sons and Bachman, who increasingly assumed its organization.[11] Whereas Audubon had studied the majority of the birds from live species, he more frequently employed skins and mounted specimens for *The Quadrupeds*. Nevertheless, he brought the skins to life with the aid of written descriptions sent him by Bachman and others. However, the project was truncated. Some of the mammals such as the bats, represented in the collection by fifteen watercolors by Audubon and John Woodhouse (fig. 43.1), were not included in the final book, which covered only half the projected number of mammals.[12]

Audubon's second extraordinary illustrative and cataloguing endeavor, which was never as popular as *The Birds*, cements his commitment to documenting visually the natural history of North America.[13] Like the English animalier artists George Stubbs and Edwin Landseer, Audubon's depictions of mammals reveal his outstanding artistic ability, compositional sensibility, technical virtuosity, and profound understanding, based on observation, of the creatures he drew. The squirrels in the Society's watercolors can only be understood within this tradition of painting animals.

1. For squirrels, see John Gurnell, *The Natural History of Squirrels* (New York: Facts on File, 1987); and http://fwie.fw.vt.edu/TN/TN10056.htm. For additional information, see Joseph Curtis Moore, "Relationships among the Living Squirrels of the *Sciurinae*," *Bulletin of the American Museum of Natural History* 118 (1959): 157–206; Monica Shorten, *Squirrels* (London: Collins, 1954); and Dorcas MacClintock, *Squirrels of North America* (New York: Van Nostrand Reinhold, 1970).

2. Audubon 1845–48, 1:267–72.

3. No provenance for this sheet or the other drawings of mammals by Audubon in the collection is known. Based on a slip of paper with Frederic De Peyster's name recently discovered with the mammals, it is tempting to trace them to De Peyster, the secretary and later president of the Society, who brokered the purchase of the bird watercolors from Lucy Bakewell Audubon.

4. The other two are inv. nos. Z.3327, Douglass's Spermophile (California Ground Squirrel), and Z.3328, the Red-tailed Squirrel. For these watercolors used for pls. 49 and 55 of *The Quadrupeds*, see Boehme 2000, ill. opp. 126 and 115, respectively.

5. See Ford 1951, 145, no. 76, ill., 200–201. The imperial-size folio first edition was followed by a smaller octavo edition, published in 1849–54. It contained five additional illustrations by John Woodhouse, and in it the cumbersome word *viviparous* was dropped.

6. Inv. no. 1976.12:5, in watercolor and graphite with some gouache on paper, 34 3/4 × 23 15/16 in.; see Boehme 2000, ill. opp. 148. The sheet, whose verso contains a drawing of a tail, is inscribed at the lower left: *Sciurus leucotis* [crossed out] / *Old male in Hickory — Nuts Pine —* / *New York Octr* 16th *1841*; at lower right: *1 — Old Male / 2 — female / 3 — young*. The Morgan also has another watercolor of a squirrel by Audubon, inv. no. 1976.12:2, a study for pl. 17 of *The Quadrupeds*.

7. Boehme 2000, 193, characterizes the history and contents of the various editions.

8. For an example of this "potboiler," as he termed the subject, see ibid., 38, ill.

9. See Robert M. Peck, "Audubon, Bachman, and *The Quadrupeds of North America*," *The Magazine Antiques* 158:5 (2000): 744–53, who points out that Audubon and Bachman were the most unlikely of friends. However, the hard-living, hard-drinking Audubon and the teetotaling, quiet pastor of a conservative Lutheran church in Charleston, South Carolina, were united by a passion for natural history.

10. Ford 1951, 448–49. Audubon's sons were married to Bachman's two eldest daughters, John Woodhouse to Maria Rebecca and Victor to Mary Eliza called "Rosy."

11. See also Gary A. Reynolds, *John James Audubon and His Sons*, exh. cat. (New York: Grey Art Gallery and Study Center, New York University, 1982), 57–61.

12. See Roberta J. M. Olson and Alexandra Mazzitelli, "Audubons' Bats: Like Father, Like Son?" *New-York Journal of American History* 66:2 (2003): 68–89.

13. When one English patron complained of the seeming excess of rodents in the book, Audubon patiently explained in a letter the reality of biological diversity and distribution: "In talking of squirrels, you say, like some of our subscribers in this country, that there are rather too many, and yet what can be done? This is the land of Squirrels and Woodpeckers and you must not be surprised to see a dozen more species of the former." Audubon to Wood (first name unknown), 14 March 1846, quoted in Boehme 2000, 113.

ATTRIBUTED TO DAVID CUSICK

Tuscarora village near Oneida, New York c. 1785–Tuscarora reservation near Niagara Falls, New York 1831

The Tuscarora brothers David and Dennis Cusick were among the founders of what has been called the Early Iroquois Realist watercolor style, admired alike by their Iroquois contemporaries and successors and by Americans and European visitors during the first half of the nineteenth century. Like many artists of that period, the Cusicks lacked formal artistic training. Despite their use of Iroquois culture as subject matter, their techniques and styles were based on Euro-American "folk art" rather than on traditional Iroquois art. The brothers were among the many children of the famous Nicholas Cusick, a Christian who had been converted by the missionary Samuel Kirkland. The elder Cusick fought on the side of the Americans in the Revolutionary War and also recruited Tuscarora and Oneida men for the cause. In 1779 he was commissioned a lieutenant and reputedly saved the life of the Marquis de Lafayette.

David, the elder brother, lived with Kirkland and his family from 1794 to 1800 while he attended the Hamilton Oneida Academy for the coeducation of Indian and Euro-American boys.

In 1799 Nicholas Cusick agreed to accompany the missionary Elkanah Holmes to Buffalo, New York, to act as his interpreter in negotiations with the chiefs of the Seneca mission. Becoming indispensable, he had moved his family to the Tuscarora reservation near Niagara Falls by 1802. David became a physician but made a contribution to historical studies in 1827, when he published a highly important book about Iroquois traditions, history, and myth (*David Cusick's Sketches of Ancient History of the Six Nations*). It distinguished between the Six Nations and the

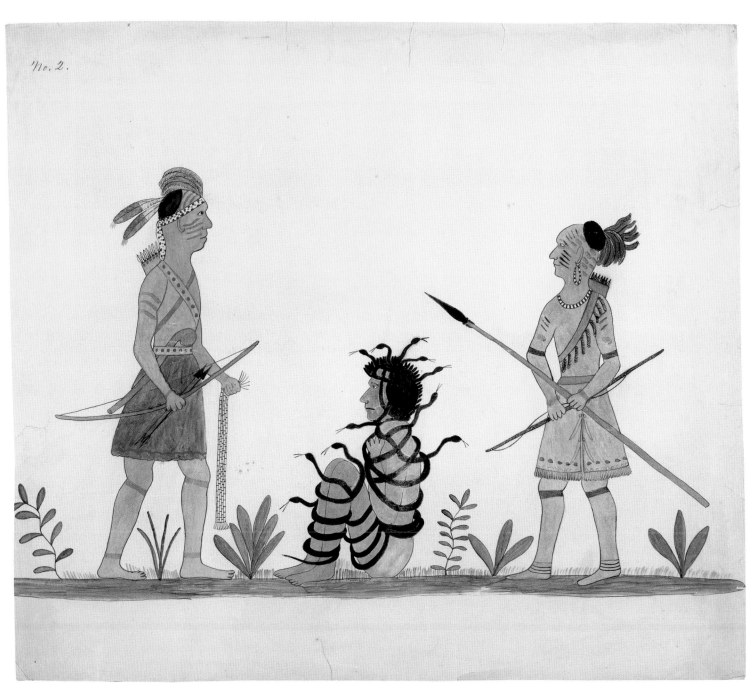

44

Five Nations of the Iroquois, recognizing that the Tuscarora were adopted as the sixth nation of the confederacy in 1723 soon after they had moved to New York from North Carolina. His book sold very well, especially to the tourists of Niagara Falls following the opening of the Erie Canal in 1825. Printed in 1827 without illustrations, a second edition of seven thousand copies appeared in 1828

with four woodcuts, three of which illustrated Iroquois traditions described in the text. A third, posthumous edition followed in 1848. Cusick's seminal work was influential; for example, in his 1846 report on the census of the New York Indians, Henry Rowe Schoolcraft published an engraving similar to a woodcut in Cusick's book. In his later works Schoolcraft included versions by

Seth Eastman of all four woodcuts from Cusick's pioneering work that sometimes credited their source. Schoolcraft also claimed that he "found the original drawing" for Cusick's first woodcut. It is not known whether that work was a watercolor or a copy of the woodcut.

Although "signed" watercolors by Dennis Cusick are known (and ten are attributed to

him), there are no signed original works by his elder brother. A number of contemporary individuals, however, recorded seeing watercolors by David Cusick (see below), and Sturtevant has recently attributed three works in the Society's collection to him. These sheets, discussed below, allow the resuscitation of this fascinating early indigenous artist to begin.

In 1831 at age forty-five, David Cusick died, possibly of tuberculosis; his younger brother Dennis had predeceased him in 1822. All the surviving examples of the Cusicks' art have Iroquois iconographic content, but contemporary accounts mention others that did not. Some of these missing works may yet surface as more precise traits characteristic of the brothers' respective styles are defined. A group of related works by other Early Iroquois Realists augurs an enlarged context in which to consider the Cusicks in future ethnological and art historical studies. Their watercolors were executed during a difficult time after the War of 1812, when the Iroquois had lost political influence with both the American and British governments and their lands were evaporating. Like David Cusick's book, these watercolors assert Iroquois identity and preserve powerful aspects of their culture.

Bibliography: William C. Sturtevant, "Early Iroquois Realist Artists," *American Indian Art Magazine* 31:2 (2006): 44–55, 95.

44. *Three Iroquois: Atotárho Protected by Black Snakes, Flanked by Deganawida(?) Offering Wampum and Hiawatha(?)*, c. 1827

Watercolor, black and brown ink, and brown gouache over graphite on beige paper, laid on canvas; 15 3/16 × 16 3/4 in. (386 × 425 mm)
Inscribed at upper left in brown ink: *No. 2.*
Watermark: R TURNER / CHAFFORD MILLS
Provenance: Jacob Beechtree, Oneida Castle, N.Y., 1845; Lansing Thurber, Utica, N.Y., 1845–49.
Bibliography: Sturtevant 2006, 45–50, fig. 3.
Gift of Lansing Thurber, X.520[dup]

This watercolor is one of three fascinating sheets in the Society's collection that Sturtevant recently attributed to David Cusick. They depict scenes from Iroquois life, distinctive clothing, and incidents of Iroquois folklore, history, and ritual. Although no original watercolors by David Cusick were known previously to exist,

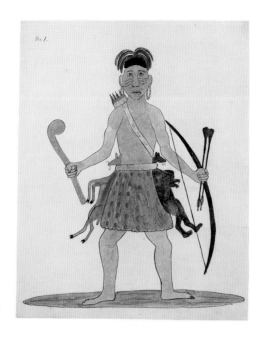

Sturtevant has convincingly attributed these three to the artist by comparing their stylistic conventions to the less skillful woodcuts by an unknown engraver, most likely after originals by Cusick, that illustrate the second edition of his *Sketches of Ancient History of the Six Nations*.[1]

The sheet highlighted here features a central figure of an Onondaga chief similar to one in the first woodcut of Cusick's book.[2] The scene depicts the founding of the Iroquois League, frequently dated to about 1500, although Cusick claims it happened a hundred years before Columbus. Atotárho is seated on the ground at the center, facing left, his body and head wrapped in protective snakes. The two flanking figures, not mentioned in Cusick's text, are probably Deganawida, on the left, who holds wampum that will replace the apotropaic snakes, and Hiawatha, on the right, the two other main characters in the standard stories of the founding of the Iroquois League. According to Cusick, Atotárho's snakes were replaced at his request by "a large belt of wampum [*sic*]; he became a law giver, and renewed the chain of alliance of the Five Nations and framed their internal government."[3] (The wampum is not depicted in the 1828 woodcut.) Various plants that act as filler motifs on the isocephalic ground line separate the figures and suggest a highly stylized, shallow, natural setting.

Although no other watercolors by David Cusick are known to survive, there is documen-

Fig. 44.1. Attributed to David Cusick, *Iroquois Mythological Giant Hunter Holding Weapons, with a Deer and Bear under His Belt*, c. 1827. Watercolor, brown ink, and brown gouache over graphite on beige paper, laid on canvas, 15 1/4 × 11 7/8 in. (387 × 302 mm). The New-York Historical Society, Gift of Lansing Thurber, INV. 519[dup]

tary evidence that he executed similar works. Thomas L. McKenney described watercolors by him, including the one McKenney purchased (an image of "The Stonish Giants," a vignette that was reproduced in the first woodcut of the *Sketches*).[4] After Philip Stansbury met David Cusick in 1821, he described him as "celebrated for his ingenuity in the art of painting." William Bullock, who visited him in 1827 while traveling to Niagara Falls, reported that his room was "decorated with colored drawings of his own execution, representing several subjects of the Indian history of his tribe." In the same year Cusick showed his drawings to the Reverend John Bachman, friend and collaborator of John James Audubon (cats. 42 and 43), and sold him one of his books.[5]

The Society's two other sheets attributed to David Cusick share with the present watercolor the same provenance that also buttresses their attribution to the artist. The subject of the first is a mythical giant hunter—the legendary giant of Cusick's text "Soh-nou-re-wah," Big Neck, with a deer and bear under his belt (fig. 44.1). The second features a frieze of three men, similar to the watercolor examined in this entry; at the left is a missionary, wearing a giant silver cross on his back and carrying a pipe, while at the right are the other two men holding weapons.[6] The provenances of all three can be traced back to 1845, when they were collected directly by the donor, Lansing Thurber, from an Oneida, Jacob Beechtree, of Oneida Castle in the region where the Cusicks lived before moving to the Tuscarora reservation. Beechtree told Thurber that they were painted by an unnamed Oneida. He probably confused one of Nicholas Cusick's other wives who was Oneida with David Cusick's mother, who, like him, was probably Tuscarora. This impeccable prov-

enance supports the attribution (on stylistic grounds) of the three works to David Cusick.[7]

The figures in the watercolor sport costumes, accoutrements, and war paint that vividly embody important Native American folkloric and historic traditions. The artist's specific characterizations not only render these watercolors invaluable documents for anthropologists and historians but also reclaim part of the indigenous human and artistic landscape of the North American continent.[8]

1. Sturtevant 2006, figs. 5–9, also reproduces watercolors by Dennis Cusick that feature more extensive settings.
2. Ibid., fig. 1.
3. Ibid., 49–50, which discusses the nineteenth-century characteristics of the costumes.
4. Ibid., 48. McKenney was the author of *Sketches of a Tour to the Lakes, of the Character and Customs of the Chippeway Indians, and of Incidents Connected with the Treaty of Fond du Lac* (originally published in 1827) and with James Hall, *History of the Indian Tribes of North America* (originally published in 1833–34).
5. Sturtevant 2006, 48.
6. Inv. no. X.521, in watercolor, black and brown ink, and brown gouache over graphite on beige paper, laid on canvas; 15 × 18 3/8 in. Ibid., 50. Sturtevant wonders if this missionary is a representation of the artist's father, Nicholas Cusick.
7. The donation was made to the Society's library, and the works were later transferred to the museum and given "X" numbers. Lansing Thurber's donation letter in the Department of Manuscripts (22 October 1849), addressed to George H. Moore, states: "I take great pleasure in presenting … the accompanying rude drawings … representing the Aboriginal race of our country. I procured them in the year 1845, from Beech Tree, a chief of one branch of the Oneida tribe at Oneida Castle. He informed me and the story was corroborated by his friends, that they were executed by one of the Indians of that tribe about ten years previous. They are evidently of that character termed 'picture-writing.'"
8. See Elisabeth Tooker, *Lewis H. Morgan on Iroquois Material Culture* (Tucson: University of Arizona Press, 1994). See also William C. Sturtevant, "Early Iroquois Realist Painting and Identity Marking," in *Native Art of North American Woodlands*, ed. J. C. H. King (forthcoming).

SIR DAVID WILKIE

Cults, Fife, Scotland 1785–at sea off Gibraltar 1841

David Wilkie may have inherited his rectitude and tenacity, even his periodic depressions, from his father, the minister of his native parish. Not a stellar student, Wilkie demonstrated an early artistic talent that expressed itself in drawings of genre scenes. In these he was influenced by a copy of Allan Ramsay's Scottish pastoral comedy in verse, *The Gentle Shepherd* (1725), whose 1788 edition illustrated by the Scottish painter David Allen he owned. One of his few early drawings to survive represents a scene drawn from it (1797; Kirkcaldy Museum and Art Gallery), and Wilkie cherished the demotic spirit of the work and its illustrations throughout his life. Allan not only influenced his early work but also encouraged his interest in Scottish vernacular subjects.

By 1799 Wilkie had determined to become a painter, despite parental misgivings, and enrolled in the Trustees' Academy in Edinburgh, where he studied with John Graham. Its curriculum included exercises in history painting, although he favored observations directly from life, as can be seen in his portraits of middle-class individuals. After leaving the academy in 1804, he painted his first genre canvas, *Pitlessie Fair* (National Gallery of Scotland, Edinburgh), a panorama of human activity set in his native parish but based on seventeenth-century Dutch and Flemish prints. The painting represents the germ of many later compositions, and it also revealed to the artist his lack of training. In search of additional education, the stimulus of other artists, and a wider market, he moved to London in 1805.

Wilkie soon enrolled as a student at the Royal Academy of Arts (1805), where he was influenced by Benjamin West and met the painter Benjamin Robert Haydon, who remained a close friend for many years. In 1806 Wilkie exhibited the *Village Politicians* (Collection of Lord Mansfield, Tayside), which brought him instant fame. His successive works were purchased by important collectors, such as Sir George Beaumont, and engraved. Although they were still dependent on David Teniers and other seventeenth-century Dutch and Flemish genre painters, the public perceived them as groundbreaking works that marked a new artistic era. Wilkie's originality lay less in his opposition to current academic values than in his artful individualizations of character and manipulation of detail, and in his ability to imbue figures with a psychological realism that went beyond the realism of the seventeenth century or the sentiments of the eighteenth. His understanding of human expression, which extended to the subtlety of mixed emotions, was aided by his knowledge of acting and of Charles Bell's *Essay on the Anatomy of Expression in Painting* (1806). Wilkie's drawings reveal him to have been a penetrating and persistent student of nature. Employing a Continental practice with a distinguished tradition (for example, as practiced by Tintoretto and Nicolas Poussin), he sometimes used small clay models, set as if on a stage, to aid in composing and lighting his groups. His frequently dramatic lighting also was influenced by the Dutch seventeenth-century masters Adriaen van Ostade and Rembrandt van Rijn as well as by posing models in front of lanterns.

In 1809 Wilkie was elected an associate of the Royal Academy, and in 1811 a full academician, although his art only reached maturity about 1813, as exemplified in *Letter of Introduction* (1813; National Gallery of Scotland, Edinburgh). Trips to the Continent (in 1814, 1816, and 1821) deepened his understanding of the works of Rembrandt, Titian, and Peter Paul Rubens. The culmination of this intense investigative period was his *Chelsea Pensioners Reading the Gazette of the Battle of Waterloo* (1818–22; Apsley House, The Wellington Museum, London), commissioned by the Duke of Wellington. To the public it was his triumph, a summary of his anecdotal power, and an expression of patriotic sentiment in a classless pictorial statement. The single greatest success of his career, it is a clear conflation of

45

genre and history painting with a decidedly contemporary air. After his *Entrance of George IV into Holyrood House* (1823–30; Royal Collection, Holyroodhouse Palace, Edinburgh), the sensitive Wilkie suffered several personal losses, precipitating a nervous breakdown. To recover, he left London in July 1825 for Rome, where he stayed for long periods interspersed with travel, including junkets to Spain (with his friend Washington Irving) to study the art of Diego Velázquez, Titian, and Bartolomé Esteban Murillo.

Back in England in June 1828, after paying a visit to Eugène Delacroix in Paris, he began what seemed like a new career. He believed that the experience of the grand tradition had altered his work. In 1829 he exhibited eight pictures at the Royal Academy, an unprecedented number for him. King George IV bought five of these, confirming the artist's popularity. In 1830 Wilkie succeeded Thomas Lawrence as Painter in Ordinary to the King, a post he retained under William IV (by whom he was knighted in 1836) and Queen Victoria. He continued to produce portraits,

some of his best work, while his other paintings of the period tended toward historical anecdote.

His production after 1828 had a mixed reception. Many admirers of his earlier more domestic genre subjects, likened to the novels of Sir Walter Scott, were disturbed by his homage to the old masters. Wilkie's admiration for Italian art reached back to Giotto, and he began to fixate on the art and life of the past. That focus precipitated his last journey, to the Holy Land. Beginning in 1840 he traveled overland to Syria and Palestine. Although no finished paintings survive from the trip, he made oil sketches. Wilkie set his return through Alexandria, Egypt, but died on his way back to London and was buried at sea.

Bibliography: Allan Cunningham, *Life of Sir David Wilkie*, 3 vols. (London: J. Murray, 1843); John Woodward, *Paintings and Drawings by Sir David Wilkie, 1785–1841*, exh. cat. in two parts (Edinburgh: National Gallery of Scotland; London: Royal Academy, 1958); Lindsay M. Errington, *Sir David Wilkie: Drawings and Paintings*, exh. cat. (Edinburgh: National Gallery of Scotland, 1975); David Blayney Brown, *Sir David Wilkie: Drawings and Sketches in the Ashmolean Museum*, exh. cat. (London: Morton Morris & Company, in

association with the Ashmolean Museum, Oxford, 1985); Lindsay Errington, *Tribute to Wilkie*, exh. cat. (Edinburgh: National Gallery of Scotland, 1985); H. A. D. Miles, David Blayney Brown, et al., *Sir David Wilkie of Scotland*, exh. cat. (Raleigh: North Carolina Museum of Art, 1987); Nicholas Tromans, *David Wilkie: Painter of Everyday Life*, exh. cat. (London: Dulwich Picture Gallery, 2002).

45. *Genre Scene: Two Seated Men with a Pair of Bird Carcasses and a Dog in an Interior; Three Vignettes; and a Study of Dentures*; verso: assorted studies of four heads, a hand, and figures, including a woman writing watched by a man wearing a hat and spectacles, c. 1810–22

Brown ink and wash and graphite on ivory paper; 7 5/16 × 9 1/8 in. (186 × 231 mm)
Inscribed at lower right in brown ink: *Sir D. Wilkie*; at upper left inverted: *and* / *and* / [illegible]; at upper right: *and*; verso inscribed and dated in graphite with accounting figures, ending with: *June 25 1822*; over graphite in brown ink: *Nitris Acid* / *Plough Court* / *Lombard*

Street; *122 French proofs — | 34 India — | Sent July 12th*; *GR | GR;*
a woman | writing
Provenance: Thomas Pritchard Rossiter, New York; Mrs.
William F. Bevan (granddaughter of Rossiter), Ruxton, Md.
Gift of Mrs. William F. Bevan, 1956.246

Not previously catalogued under the artist's name, this sheet is without doubt by Wilkie, a prolific and assured draftsman in the great European tradition of figure drawing. As can be seen in many of the artist's brown ink studies, the quality of the line and the chiaroscuro are reminiscent of Rembrandt's manner. (Wilkie also mastered the *trois crayons* manner of Rubens, which he employed for highly finished portraits.) The bulk of the artist's drawings relate directly or indirectly to his paintings. In those that cannot be identified as preparatory for a specific work, like the present sheet that contains sketches of assorted compositions and heads, the artist tried to capture fleeting expressions, poses, or groups. The various angles from which the studies were drawn, together with the diverse annotations on the verso, suggest that Wilkie used the sheet on several occasions over a period of time. The cropping of the composition on the recto and the inscriptions on the verso argue that the drawing has been trimmed.

The composition on the recto is more unified than the one on the verso. The primary scene features two older men dressed in country attire and seated at a table on which two avian carcasses, whose necks hang over the table's edge, are displayed. A large-brimmed hat, below the chair of the man on the right, suggests they

have just entered the room from the outdoors, an impression reinforced by the panting dog and the man's gesture of rubbing his head. Wilkie frequently depicted seated figures around a table, a common compositional formula of Netherlandish origin, in his early works—such as *Village Politicians* (1806); *The Penny Wedding* (1818; H. M. the Queen); and *Distraining for Rent* (1815; National Gallery of Scotland, Edinburgh)—although he also periodically used it in his later paintings, such as *The Reading of the Will* (1820; Bayerische Staatsgemäldesammlungen, Neue Pinakothek, Munich) and *Grace before Meal* (1839; City Museum and Art Gallery, Birmingham). Above the two men in the Society's drawing, Wilkie has rendered two vignettes in ink and at the left one in graphite that has animals in the foreground. They represent either the artist's separate thumbnail studies or pictures hanging on the wall. The larger and more developed of the two ink vignettes seems close in style and composition to a brown ink study (1815; Ashmolean Museum, Oxford) for the artist's unexecuted painting "The Village School."[1]

The quality of Wilkie's line in the present drawing approaches that of the artist's numerous ink studies preparatory for the *Chelsea Pensioners*, whose composition also revolves around a central table.[2] The Rembrandt-like application of ink and the cross-hatching around the woman writing on the sheet's verso is typical of his early ink drawings.[3] Moreover, the heads Wilkie drew on both the recto and verso resemble ones in dated works from the

artist's early phase. Finally, the activity of the two men on the recto also harmonizes with Wilkie's early interest in common occupations, as in his *Portrait of a Gamekeeper* (1810–11; private collection).[4] In fact, the man seated on the right wears identical leggings to those of the gamekeeper. In aggregate, the evidence points to a date from the earlier part of Wilkie's career for the Society's sheet.

Wilkie exerted an influence on a number of nineteenth-century American genre painters, providing them with contemporary models to balance those of seventeenth-century Dutch genre painters. Among those artists influenced by Wilkie's works were Francis William Edmonds and William Sidney Mount (cat. 70).[5] Certainly the provenance of this drawing, once in the collection of the artist Thomas Pritchard Rossiter (cat. 94), proves that Rossiter valued Wilkie's work and probably acquired the sheet sometime during his European travels.

1. See Brown 1985, no. 4, ill.
2. See ibid., nos. 11–23, ills.
3. See ibid., nos. 38 (figures seated around a table) and 39, ills. Wilkie drew many studies of hands, like the one on the verso, on numerous sheets preserved in the British Museum, the Victoria and Albert Museum, and the Courtauld Institute of Art, London.
4. See Tromans 2002, 58–59, no. 6, ill.; and Miles and Brown 1987, 153–55, no. 13, ill.
5. See, for example, Catherine Hoover, "The Influence of David Wilkie's Prints on the Genre Paintings of William Sidney Mount," *American Art Journal* 13:3 (1981): 4–33.

AUGUSTIN-AMANT-CONSTANT-FIDÈLE ÉDOUART

Dunkerque, France 1789–Quines, near Calais, France 1861

After losing his mother at a young age, Augustin Édouart began working at age fifteen and caring for a paralyzed father, whose fortunes were ruined in the French Revolution, and seventeen siblings. Within four years he was director of a china manufactory at St.-Yrieix-la-Perche, Haute-Vienne. Two years later he was commissioned *Inspecteur des Fourages* in Holland. Under Napoleon he went to Germany to produce several table services and joined the

Grand Army on its way to Russia, later going to Antwerp. Devoted to the Revolution and Napoleon, at the restoration of the monarchy in 1814 he became an expatriate in London, where he exhibited at the Royal Academy of Arts in 1815 and 1816. He also taught French and practiced the art of hairwork, modeling portraits in wax with real hair. After the death of his wife in 1825, he became a silhouette artist (a silhouettist; see also cat. 114). Traveling to Scotland, Ireland, and

Wales for the next fourteen years, he claimed to have cut fifty thousand silhouettes. His success was due in part to his talent with the scissors; he cut his silhouettes by hand in contrast to the more popular mechanical method using the physiognotrace. In 1839 Édouart embarked on an extended ten-year visit to the United States, the same year Louis-Jacques-Mandé Daguerre in Paris was registering his devices for taking daguerreotypes.

Fig. 46.1 Augustin-Amant-Constant-Fidèle Édouart, *Silhouette Self-Portrait (1789–1861)*, 1842. Etching with scratching-out and brown ink inscriptions on thin card, 5 1/4 × 3 1/4 in. (133 × 83 mm), irregular. The New-York Historical Society, Gift of Mrs. J. Insley Blair, Z.2340b

Édouart initiated his American career in New York City, where he lodged at 114 Broadway in the house of Roe Lockwood. Because he had been patronized by the royalty and nobility of Europe, his outstanding reputation as the master of the free-cut genre preceded him, and he easily became the fashionable silhouettist for America's elite in the decades before the advent of photography. One can follow his journeys by the advertisements he placed in local newspapers announcing his impending arrivals or departures. His crisp delineations provide an authentic social picture gallery of prominent statesmen and citizens and their families, a virtual Who Was Who of his time. In his peripatetic existence, he toured large popula-

tion centers, spas, and resorts in the East, Midwest, North, and South, setting up studios to cut likenesses. The length of his stays varied with the demand, but the volume of silhouettes he cut was staggering. After only five years in the United States, Édouart advertised in the New Orleans *Daily Picayune* that in an entrepreneurial spirit he was also exhibiting his extensive collection of 150,000 duplicate likenesses taken in Europe and the United States. Édouart always made at least two silhouettes of an individual, one for the patron and one for his archive.

In 1849, with the help of a son, Édouart packed his English and American reference folios in cases for the return voyage to France. At the end of the crossing, off the rocky coast of the Isle of Guernsey, the *Oneida* was wrecked, although its crew and passengers were saved. Remarkably, in the salvaged baggage were some of Édouart's duplicate folios, together with a few of his books and letters. He was so devastated by this experience, however, that he gave the rescued material to the family of Thomas Lukis of St. Peter Port, Guernsey, who sheltered him during his recovery. No evidence has been found that he resumed his career as a silhouettist.

To date at least twenty-one of Édouart's lost albums have been recovered and identified, although two were reported lost in World War I. Before that war, Jackson had advertised to find the albums to facilitate her research on the artist and purchased fifteen from the Lukis family in 1911 and another one in 1913. In 1921 she wrote *Ancestors in Silhouette, Cut by August Edouart*, one of a series of volumes on the artist, in which she gave a description of these folios. Jackson sold the American folios (six of the sixteen she purchased) to Arthur S. Vernay, who marketed them in a three-week sale in New York City (see below). He removed the silhouettes from the albums and matted and framed them for exhibition and sale. Today, one example whose provenance can be traced to his group is in the Society's collection. Reportedly, interested descendants formed long lines to retrieve silhouettes of lost ancestors for family archives from Vernay's sale. The remaining 862 were sold in bulk to the Reverend Glenn Tilley Morse, a New England silhouette collector and writer; in 1950 they were bequeathed to the Metropolitan Museum of Art, New York, where they are accompanied by a personal account of Édouart's

46

early life, recorded in his own words in a letter of 1837 (Mary Martin Collection).

Édouart also wrote *A Treatise on Silhouette Likenesses* (published in Cork in 1834 with a title page dated 1835), in which he states: "It has been my invariable practice to ask the names of my sitters, and write them on the backs of the duplicate, which duplicate I place in my book." In the same treatise he explained his creative process. He used a piece of paper that was white on one side and black on the other, folded the

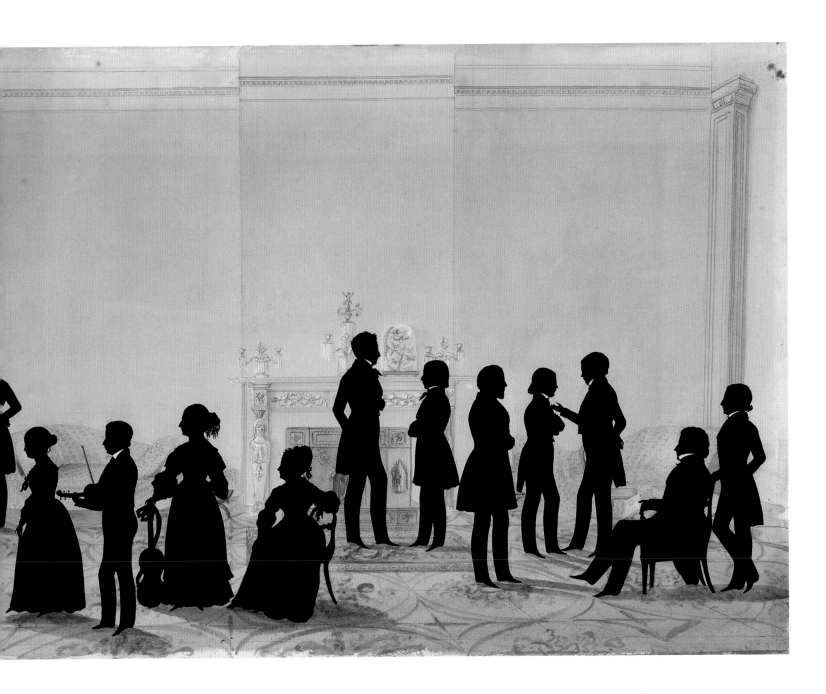

black side in and sketched his subjects' profiles in graphite on the white side. He cut the outlines in duplicate; the extra cutting was saved in his albums, much as a photographer saves negatives, to provide a reference for future cutting and advertisement. The silhouette given to the customer was mounted with gum arabic onto a background that was plain or bore a setting, either lithographed or painted in watercolor or wash. The completed silhouette was frequently placed in a flat curly maple frame

with a gold liner. He also executed silhouettes of celebrities, as evidenced by an album ("Scraps of Friendships") with clippings compiled in 1834 by a young Englishwoman at Marbury Hall, once belonging to Arthur Hugh Smith Barry; it contains twenty-three silhouettes by Édouart of visitors to the house and notable figures of the time, such as Niccolò Paganini, Baron de Rothschild, Sir Walter Scott, and Napoleon, which Édouart must have cut from his models (private collection, New York).

Knowledge of Édouart's practice provides a clear outline of his stylistic development. In the "shades" cut before 1842, he produced plain black outlines only. About 1842, influenced by the advent of the daguerreotype, he began to add embellishments in graphite and white chalk that lent a photographic appearance to the costumes, hair, and props. He usually made the figures 7 1/2 to 8 inches high, and his genius is evident in the details of costumes, furniture, and accoutrements that are rich in general references to

material culture (essay fig. 2). The slit collars backed by white paper and the delicate button-holes and feet have become the hallmarks of an Édouart silhouette, functioning as an unwritten signature. While Édouart inscribed the sitter, place, and date in European style on his duplicates, the mirror images of the silhouettes retained by the clients usually have only the artist's name at either lower corner of the background. Therefore, many times they cannot be identified without their mirror image, which is not always known or extant. In a tour de force of the scissors, Édouart even cut a "shade" of himself standing and cutting a silhouette of the comic actor John Liston. Intellectually and technically he took the art of the silhouette to the pinnacle of its practice during the nineteenth century, producing a sizable number of highly innovative themes involving animals and satirical subjects as well as wonderful portrayals of his children when they were toddlers. The N-YHS's multifaceted silhouette collection, numbering more than 360 objects, includes 24 silhouettes by the justly celebrated Édouart, including at least one of Édouart's own duplicate copies from the Vernay sale* and an example of the classical style lithographed silhouette self-portrait that he often gave to friends and sitters, customizing each with a personal inscription (fig. 46.1). In its DPPAC the Society also holds Jackson's photographic collection of Édouart's American silhouette portraits, comprising photographs and glass plates.

Bibliography: Emily (Mrs. F. Nevill) Jackson, *Catalogue of 5,200 Named and Dated English Silhouette Portraits by August Edouart, 1789–1861* (London: Walbrook, 1911); Arthur S. Vernay, *A Catalogue of American Silhouette Portraits Cut by August Edouart* (New York: privately printed, 1913); Emily (Mrs. F. Nevill) Jackson, *Ancestors in Silhouette, Cut by August Edouart* (London: John Lane the Bodley Head; New York: John Lane Company, 1921); idem, *Catalogue and Supplement of 5,800 Named and Dated American Silhouette Portraits by August Edouart, 1789–1861* (London: J. B. Shears & Sons, 192?); idem, *Catalogue of 3,800 Named and Dated American Silhouette Portraits by August Edouart, 1789–1861* (London: R. Clay and Sons, 1926); idem, *Silhouettes: A History and Dictionary of Artists* (1938; reprint, New York: Dover Publications, 1981), 96–101; Andrew Oliver, *Auguste Edouart's Silhouettes of Eminent Americans, 1839–1844* (Charlottesville: Published for the National Portrait Gallery, Smithsonian Institution by the University Press of Virginia, 1977); Helen Laughon and Nel Laughon, *August Edouart, a Quaker Album: American and English Duplicate Silhouettes, 1827–1845* (Richmond, Va.: Cheswick Press, 1987).

46. Dr. John C. Cheesman (1788–1862) and Family with Guests: Silhouette, 1840

Black prepared paper cutouts, laid on beige paper with graphite, brown ink and wash, and white gouache, mounted on canvas; 20 1/4 × 37 in. (514 × 940 mm)
Signed, dated, and inscribed at lower left in brown ink: *Augst. Edouart, fecit 1840. | 411 Broadway New York*
Bibliography: Mayhew and Myers 1980, 102, fig. 44; Brilliant et al. 2006, 68–69, no. 23, ill.
Z.2567

One of the Society's twenty-four silhouettes by Édouart is this expansive tableau depicting Dr. John Cummings Cheesman holding court at a reception in his house at 473 Broadway in New York City. According to the work's inscription, the silhouette was executed, or perhaps compiled, nearby in Édouart's studio, during the early part of the artist's career, when his studio was at 411 Broadway.[1] In his *Wealth and Biography of the Wealthy Citizens of New York City* (1842), Moses Beach called Cheesman a "distinguished physician," estimating his fortune at $100,000.[2] Cheesman graduated from the medical department of Queen's College (now Rutgers University) in 1812, subsequently residing in New York, where he became one of the most eminent physicians in the country and practiced for almost half a century. He held many important offices, among which were surgeon to the public institutions (now Charity Hospital) on Blackwell's Island and surgeon to Bellevue Hospital. For forty years he was also professionally connected to New York Hospital. In his leisure time, as this silhouette suggests, he must have appreciated music.

More than likely Édouart customized the setting for this ambitious family vignette, which like those of his other portraits resembles a stage set, with some elements from the interior of the Cheesman residence. Onto this background the artist pasted the seventeen figures, which Anne Verplanck has stated constitute the largest ensemble she has encountered in the artist's oeuvre.[3] Édouart arranged the Cheesman group in a formula "conversation piece," an eighteenth-century British portrait type known also by its early name "family piece."[4] Usually the sitters are informally seated and portrayed full-length in their surroundings actively engaged in conversation or a common activity. Since music and games added to the animation of social occasions and were an integral part of daily life,

they were frequently depicted in these intimate portrayals of family life before the advent of the camera. In this ambitious tableau, the concert has either just finished and people have broken up for socializing or the concert is about to begin in the palatial parlor suggested in the brown ink and wash backdrop. Its size and brown wash background made the Cheesman portrait a special and costly commission. Édouart executed other similar conversation pieces, such as a group silhouette in the Society's collection consisting of eight figures and one greyhound, whose nipples reveal she has borne a litter, that he cut the same year and placed in a more highly finished drawing room also rendered in wash.[5] These conversation pieces with their domestic possessions rendered in the background afford a glimpse into the materialism of the period. The exceptionally large patterns in the Cheesman carpet became fashionable about 1840, the very year this silhouette was taken.[6] No music or newspapers, which Édouart had specially printed for inclusion in his silhouettes, are present in the Cheesman tableau. However, they are found, together with commercial lithographic backgrounds, in other works by Édouart in the collection. An example is Édouart's highly sophisticated, poignant silhouette of Philip Milledoler Beekman, a toddler playing with his jack-in-the-box, who died when just fourteen months old on summer holiday in the resort town of Saratoga (essay fig. 2).[7]

Two of Édouart's duplicate silhouette images relating to the Cheesman conversation group can be identified: J. C. Cheesman Jr.—in reverse, holding a violin, and wearing a characteristic slit collar—and Miss Ann Cheesman—oddly facing in the same direction and supporting a viola. According to the inscriptions in the album in which they are both mounted, known as the Quaker Album (Friends Historical Library of Swarthmore College, Swarthmore, Pa.), both were cut on 29 March 1840 at 473 Broadway, the Cheesman residence. Originally four figures were laid on that page of the album; the two missing figures are Dr. J. C. Cheesman and his wife.[8] This evidence importantly provides the specific date when Édouart cut four of the principal parties in the Cheesman group. The mystery remains why Miss Cheesman was not in reverse from her cutting in the

Society's group portrait. The answer can be found in the difference between the two silhouettes of the young woman: the more graceful, svelte figure in the group is also more beautifully cut, with her body in better proportion, and the viola as well as her coiffure more intricately rendered with greater refinement. This evidence suggests that the artist did recut some of his silhouettes if they were not pleasing either to him or to his sitters. When grouping them in his album, Édouart selected the less resolved "shade" of Miss Cheesman facing left for aesthetic, compositional reasons, because, together with her brother, facing right, they harmoniously bracketed the inner silhouettes of their parents on the page.

* Inv. no. 2001.301, which includes four figures and is signed, dated 1840, and inscribed with the artist's address of 411 Broadway, depicts Mr. and Mrs. H. M. Schieffelin and family. It is referred to in a letter of 14 October 1913 from Arthur S. Vernay, the purchaser of the group of recovered albums, to Schuyler Schieffelin, housed in the drawing's object file. In this marketing ploy Vernay offers to sell two silhouettes of Mr. and Mrs. H. M. Schieffelin and Family and Mr. and Mrs. R. L. Schieffelin before his sale exhibition. It is probable that Vernay approached many New York families in much the same mode. Édouart used a variant spelling of the family's name; Jackson 1921, 223, lists shadows by Édouart of seven members of the Shieffelin family from 1–10 March 1840. Vernay closes his letter by noting: "The entire Collection, comprising in 3,954 will be placed on Exhibition very shortly and due notice will be given of the exact date. I hope that I may then have the pleasure of showing you these remarkable Portraits of well-known Americans of the middle of the XIX Century. It is a collection full of genealogical and historical interest."

1. An announcement (New York, 1840) of Édouart's business at 469 Broadway with a letter from Édouart to Luther Bradish, Broadside collection of the Society's library, suggests he may have moved his studio frequently.

2. Mayhew and Myers 1980, 102.

3. Verbal communication, winter 2002.

4. See Nina Fletcher Little, "The Conversation Piece in American Folk Art," *The Magazine Antiques* 94:5 (1968): 744–49; Mario Praz, *Conversation Pieces: A Survey of the Informal Group Portrait in Europe and America* (University Park: Pennsylvania State University Press, 1971), which also discusses the earlier evolution of the type from Dutch and Italian examples; Ellen G. D'Oench, *The Conversation Piece: Arthur Devis and His Contemporaries* (New Haven: Yale Center for British Art, 1980); Jackson 1981, 35; and Christine Lerche, *Painted Politeness: Private und öffentliche Selbstdarstellung im Conversation Piece des Johann Zoffany* (Weimar: VDG, Verlag und Datenbank für Geisteswissenschaften, 2006).

5. Inv. no. Z.3451; see Jackson 1981, pl. 57. By comparison with a single silhouette of Mrs. George Ring (daughter of George Mott) in the Quaker Album (Laughon and Laughon 1987, 66 1/2, ill.), the reverse of the woman near the pianoforte, the group may tentatively be identified as the George Ring family, whose group silhouette Jackson mentions (ibid., 10). Jackson 1921, 221, notes that Mrs. Ring was missing and that the silhouette was executed 21 March 1840, a day when another family member was cut, along with others in the same week.

6. Mayhew and Myers 1980, 102.

7. Inv. no. 1948.525, inscribed and signed at lower right in brown ink: *Aug.ˢᵗ Édouart. fecit / Saratoga 1846.*; verso inscribed at upper border in graphite: *Philip Milledoler Beekman / Second son of James W. Beekman / and Abian Steele Milledoler / Born June 12, 1845 / Died August 15, 1846.*

8. Laughon and Laughon 1987, 80, ill. All four figures are identified in inscriptions on the album page on which they were laid.

JAMES FULTON PRINGLE

Sydenham, Kent, England 1788–Brooklyn, New York 1847

James Pringle trained with his father, the English artist James Pringle Senior. Information on the Pringles is scarce, but James Junior may have served in the navy during the War of 1812. The young Pringle, who is best known as a marine painter, received commissions from members of the British admiralty and exhibited his works at the Royal Academy of Arts in London in 1800, 1812, 1816, and 1818. He left England in 1828 for New York City, settling first in Manhattan and then, by at least 1835, in Brooklyn. He added the middle name of Fulton in celebration of the inventor of the steamboat, Robert Fulton (cats. 20 and 31). Pringle exhibited paintings of ships at the NAD (1832–44) and at the Apollo Association (1838–41). Like his fellow marine painters and artists who depicted seascapes—Thomas Birch (cat. 36), and William James Bennett (cat. 41)—Pringle's paintings, not only of ships but also of shipyards, wrecks, and harbor views, gave life to the maritime activities in and around the port of New York in the 1830s. He collaborated with Robert Havell Jr. (the gifted engraver of John James Audubon's *The Birds of America* [cats. 42 and 43]), painting ships in at least one oil painting by Havell that in turn Havell reproduced in the hand-colored aquatint and etching *Panoramic View of New York (Taken from the North River)* (1840; The DPPAC holds the fourth state of 1844). The aquatint's inscription states that the vessels were painted by J. Pringle. One of them, the transoceanic steamship *British Queen*, had made her maiden voyage to New York in the summer of 1839, an event Pringle recorded in an oil painting (1839–40; The Stokes Collection, The NYPL).

Although Pringle must also have earned money by painting portraits (William Dunlap, in his *A History of the Rise of the Arts of Design*, referred to him as a portrait painter), during the 1830s and 1840s he received many commissions from local shipbuilders and ship captains. His paintings of ships and shipbuilding activities are significant contributions to American genre painting of the nineteenth century. At the time when New York City was the center of the shipbuilding industry, Pringle's paintings provide valuable records of the clipper ship era.

Bibliography: Cowdrey 1943, 2:83–84; John Wilmerding, *A History of American Marine Painting* (Salem, Mass.: Peabody Museum of Salem, 1968), 60; Koke 1982, 3:75–76; Deák 1988, 1:335–36, nos. 497, 498; Kornhauser 1996, 2:615.

Tippoo — Painted by James Pringle 1800

Fig. 47.1. James Fulton Pringle, *Self-Portrait*, *(1788–1847)*, c. 1815. Oil on canvas, 11 3/4 × 9 1/8 in. (298 × 231 mm). The New-York Historical Society, Gift of Mae L. P. Pringle, 1967.173

47. *Tippoo*, 1800

Watercolor and black ink over graphite on paper, laid on card; 13 1/2 × 13 1/8 in. (343 × 333 mm)
Inscribed at lower center outside image in black ink: *Tippoo*; signed and dated at lower right outside image in graphite: *Painted by James Pringle 1800.*; verso of board inscribed in graphite: *This Picture was painted by James Pringle / when he was 13 years old. / Edward T. Pringle.*
Provenance: Descent through the artist's family; Miss Mae L. P. Pringle, Brooklyn, N.Y.
Bibliography: Koke 1982, 3:76, no. 2350, ill.
Gift of Miss Mae L. P. Pringle, the artist's granddaughter, 1956.172

In this charming example of juvenilia, which he signed with great pride, the thirteen-year-old Pringle portrayed a household pet while he was still in England. Although atypical of his later specialization, marine painting, Pringle's attention to detail became a hallmark of his adult production. The Society also owns a self-portrait in oil by the artist (fig. 47.1) with the same provenance as this drawing in which Pringle's expression resembles that of Tippoo.[1]

Tippoo the cat was named for Tipu Sahib or Sultan (1749–1799), ruler of Mysore, India, in the late eighteenth century. He fought in his father's campaigns against the British, but after his succession made peace, only to provoke the British again and die defending his kingdom. Tipu's emblem of state was a tiger, and his lifelong obsession with the animal caused the British to call him "the Tiger of Mysore." A painted rosewood automaton of a tiger mauling a European soldier found in 1799 in Tipu's Palace at Seringapatam, which combined movement with two windpipe mechanisms and a manual organ, was named by the British *Tippoo's Tiger.* The British Army presented it to the East India Company, which put it on display in 1808 at the East India Company's Museum in London. Here it attracted the attention of nineteenth-century travelers, poets, and playwrights and retained its popularity as it moved with the museum to various London addresses. Eventually it found its way to the Victoria and Albert Museum, London.[2] Young Pringle either saw the object in storage before its public display or noticed its reproduction in an article, at which point he was so captivated by it that he named his tiger cat after this renowned automaton. The British spelling of Tipu's name as "Tippoo" was not just Pringle's invention. Sir

David Wilkie (cat. 45), who painted *Sir David Baird Discovering the Body of Tipu Sahib* (1838; National Gallery of Scotland, Edinburgh), like the young Pringle, spelled it phonetically in his correspondence about his painting.[3]

Savvy and sensitive, the *Felis domesticus* has intrigued humans for centuries with its mysterious aura of independence and self-satisfaction. A cat's ability to stay still for extended periods of time allowed young Pringle to study Tippoo almost as a still life. Clearly ruling his domestic roost, Tippoo embodies the saying frequently associated with felines, "everything here is mine," and demonstrates the status increasingly afforded pets during the nineteenth century.[4] By depicting Tippoo before a window draped with an elegant curtain and framing a view of a tree, Pringle underlined the cat's domesticated nature. The tree beckons Tippoo outside, alluding to his wild outdoor potential, while the curtain's tassels refer to his indoor amusement. Taken in conjunction with the astutely captured expression on the cat's face, it is clear that the precocious Pringle was visually analytical and aware of the many clues about his pet's nature that he placed in the work, which is, in fact, an animal portrait.

1. N-YHS 1974, 2:645, no. 1659, ill. For Pringle's oil painting *Arrival of the "British Queen" at New York Harbor* in the Stokes Collection, The NYPL (inv. no. 1839-D-1), see Deák 1988, 1:335–36, no. 497; 2: ill.; and for his *Ship Orpheus in a Storm* of 1838 in the Wadsworth Atheneum, Hartford, Conn., see Kornhauser 1996, 2:615, no. 368, ill.

2. Inv. no. 2545(IS), in painted wood, 26 × 70 in. In 1879 it was moved to the South Kensington Museum in London, later the Victoria and Albert Museum. See http://www.vam.ac.uk/collections/asia/object_stories/Tippoo's_tiger/index.html; http://footguards00.tripod.com/09GALLERY/Art/09_cornw-tipu.htm; and http://www.nationalgalleries.org.uk/tipu/tiger11.htm.

3. Inv. no. NG 2430; see David Blayney Brown, *Sir David Wilkie: Drawings and Sketches in the Ashmolean Museum*, exh. cat. (London: Morton Morris & Company, in association with the Ashmolean Museum, Oxford, 1985), nos. 50–55, ills., for Wilkie's painting and his studies for it; and H. A. D. Miles, David Blayney Brown et al., *Sir David Wilkie of Scotland (1785–1841)*, exh. cat. (Raleigh: North Carolina Museum of Art, 1987), 251–57, no. 42, ill.

4. For bibliography and a discussion of the history of pets, see Roberta J. M. Olson and Kathleen Hulser, "Petropolis: A Social History of Urban Animal Companions," *Visual Studies* 18:2 (2003): 132–42.

WILLIAM GUY WALL

Dublin, Ireland 1792–after 1864

At twenty-six years of age, in 1818, the Irish-born and trained landscape artist William Guy Wall arrived in New York City. It was then that Wall began his career, presumably a mature artist. He started exhibiting at the American Academy of the Fine Arts almost at once and probably showed views of Ireland. In the summer of 1820 Wall went on an extended sketching tour of the Hudson River valley and its environs. The works he produced as a result of this trip were the basis for his nearly immediate fame and fortune. Some of the watercolors recording sights on his tour were engraved by John Hill (cat. 24) in the serially produced *The Hudson River Portfolio* (1820–25), published by Henry J. Megarey in New York. The *Portfolio* follows in the footsteps of the well-established English taste for picturesque touring itineraries with both images and text. Turning its pages gave the viewer the sensation of traveling the Hudson even though most of Wall's views were drawn from the land rather than from the water. Evidence in the completed *Portfolio* suggests that Wall spent much of his time on the upper reaches of the river. Despite the developing vogue for wild scenery—and although the upper Hudson was only sparsely settled—Wall's watercolors almost always emphasize ways in which settlers manipulated the environment. Even when he drew potentially sublime waterfalls, he generally showed their power harnessed by human ingenuity. Importantly, the influential *Portfolio* helped to stimulate national pride and cultural identity. The first series of prints to make Americans aware of the beauty and sublimity of their own scenery, the *Portfolio* was so popular that it was reprinted in 1828 by G. & C. & H. Carvill. It is no wonder that Wall is often seen as a forerunner of the Hudson River School. All of the known surviving watercolors preparatory for the aquatints in the *Portfolio* are in the Society's collection.

A member of the Sketch Club in the 1820s, Wall was a founding member of the NAD, along with Thomas Cole (cats. 61 and 62), exhibiting there from 1826 to 1856 (he retained honorary membership until 1863). During this period he also exhibited frequently at such institutions as the Pennsylvania Academy of the Fine Arts in Philadelphia, the Boston Athenaeum, and the Apollo Association in New York. He lived in the United States from 1812 to about 1836. After 1828 Wall moved to Newport, Rhode Island, and then to New Haven, before returning to Dublin about 1836. Little is known about him in the years after his return to Ireland, although he exhibited at the Royal Hibernian Academy and the Society of Irish Artists and sold works to the Royal Irish Art Union, of which he was president in 1847. Apparently, he also painted backgrounds for the popular English silhouettist Master Wiliam James Hubard. While in Ireland, Wall continued to send paintings to the NAD. Returning to the United States about 1856, he lived in the Hudson River town of Newburgh, New York, until the early 1860s, when advanced age, lack of work, and family illness caused him to return to Ireland. This second American period was less successful than the first, as Wall did not adjust to the very competitive environment and new taste. The last known reference to Wall was in 1864, and the exact date of his death remains unknown. His son William Archibald Wall was also a landscape painter.

Bibliography: Helen Comstock, "The Connoisseur in America: The Watercolors of William Guy Wall," *The Connoisseur* 120:505 (1947): 42–43; Donald A. Shelley, "William Guy Wall and His Watercolors for the Historic *Hudson River Portfolio*," *New-York Historical Society Quarterly* 31:1 (1947): 25–45; John Howat, "A Picturesque Site in the Catskills: Kaaterskill Falls as Painted by William Guy Wall," *Honolulu Academy of Art Journal* 1 (1974): 16–29, 63–65; Koke 1982, 3:224; Nygren et al. 1986, 298–302; Myers 1987, 188–90; Deák 1988, 1:217–19, nos. 320 and 321; Stephanie Eu, "Prospects of Promise: The Aesthetic of the *Hudson River Portfolio*" (Ph.D. diss., Princeton University, 2000).

48a. *View of the Palisades, New Jersey: Preparatory Study for Plate 19 of "The Hudson River Portfolio,"* 1820

Watercolor, graphite, and scratching-out with touches of gouache on paper, laid on card; 14 × 21 in. (356 × 533 mm)
Provenance: John Austin Stevens, Brooklyn, N.Y.
Bibliography: Shelley 1947, 44; Koke 1961, 29–41 (discussion of plate order, esp. no. 88); Koke 1982, 3:227, 229, no. 2692, ill.; Deák 1988, 1: 217–19, nos. 320 and 321 (about the aquatints).
Louis Durr Fund, 1903.13

48b. *View of Baker's Falls, New York: Preparatory Study for Plate 8 of "The Hudson River Portfolio,"* 1820

Watercolor, selective glazing, gouache, graphite, and touches of scratching-out on paper, laid on card, laid on canvas; 14 × 20 7/8 in. (356 × 531 mm)
Provenance: Old Print Shop, New York.
Bibliography: *Old Print Shop Portfolio* 5:8 (1946): 173, fig. 1; Shelley 1947, 36, ill., 37, 44; Koke 1961, 29–41 (discussion of plate order, esp. no. 87); Koke 1982, 3:226–27, no. 2687, ill.; Deák 1988, 1:217–19, no. 320 (about the aquatints).
Purchased by the Society, 1946.97

Among the treasures of the Society are the only known eight surviving original watercolors by William Guy Wall preparatory for the plates of *The Hudson River Portfolio*, the first famous artworks documenting New York State's most important waterway.[1] This lavish collection of twenty topographic views was a landmark in the history of American landscape art and served as a pictorial equivalent to the literary productions of authors like Washington Irving and James Fenimore Cooper, whose works also recorded and paid tribute to the landscape of the Hudson River valley and Highlands. Wall's panoramic views, encompassing the mountains, waterfalls, mills, indigenous Americans, and frontier villages of the Hudson River, charted the course of this great waterway from Luzerne (today Lake Luzerne) to Governors Island in New York Harbor, two hundred miles downriver. The popularity of the historic *Portfolio* greatly enhanced the status of the river as a subject for the diverse group of landscape artists known as the Hudson River School, who were inspired and influenced by Wall's work. Like most eighteenth- and nineteenth-century books of engravings, *The Hudson River Portfolio* was serially issued. According to the prospectus printed on the inside cover of its first number, the complete *Portfolio* was to be issued in six installments, each of which was to contain four aquatints and accompanying text by John Agg. Perhaps because of the great expense of the project, only five numbers, for a total of twenty aquatints, were actually issued. John Rubens Smith began engraving the first four; his unsatisfactory work was redone by John Hill, who engraved the remaining sixteen plates. Plates 19 and 8, respectively, reproduce the two watercolors discussed here. Only one to two hundred copies of the original series seem to have been produced. Since the prints proved popular, thousands of individual impressions were pulled and sold in the late 1820s and 1830s, and a second edition of the entire work was published in 1828.[2]

In his history of the arts in America,

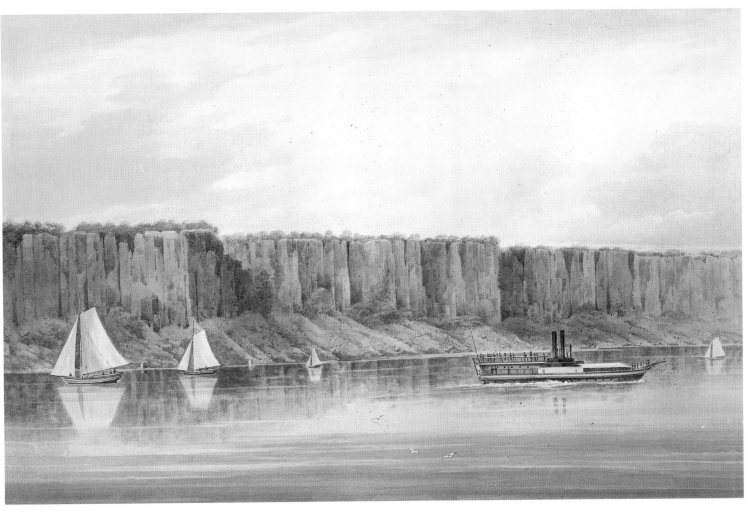

48a

published in 1834, William Dunlap remarked about Wall: "This gentleman has been indefatigable in studying American landscape, and his reputation stands deservedly high."[3] Wall's technique, however, was conservative, and all his surviving original drawings are horizontal, the natural orientation for landscapes. Most include foreground elements that establish scale and direct the viewer's attention to the topographical subject in the middle ground. Even though Dunlap claimed they were painted on the spot,[4] their size and finish suggest they were studio works completed after the artist's return to New York, but based on field sketches.[5] This modus operandi was the standard practice at the time.

The Palisades—also called the New Jersey Palisades or the Hudson Palisades—are a line of steep cliffs along the west side of the lower Hudson River in northeast New Jersey and

southern New York. They stretch north from Jersey City approximately forty miles to High Tor Mountain in Haverstraw, New York. Rising vertically from near the edge of the river only on the western shore, they range in height between 350 and 550 feet. Their cliffs are among the most dramatic geologic features in the vicinity of New York City, forming a canyon in the Hudson Valley north of Fort Lee, New Jersey, as well as providing a dramatic vista of the city. Wall has shown their stark splendor as dwarfing both the sailboats and the steamboats typical of the types that plied the waters of the Hudson.

Baker's Falls was named after Albert Baker, who went to the area from New York City in 1768. He built a short wing dam and sawmill on the Hudson River in Washington County at the site of the falls that today bear his name. These falls are believed to be the highest cascade on the

mighty Hudson River. Originally there was also a town by that name in the greater Glens Falls region, about fifty miles north of Albany and near the communities of Saratoga and Lake George. The town was built near an Iroquois trail that continued to be a vital travel route during the French and Indian Wars and the American Revolution. In 1810 the name Baker's Falls gave way to Sandy Hill, a name the village held until it was changed to Hudson Falls in 1910 (cat. 35). Wall's watercolor view of the cascade contains a towering pine that frames the right foreground in the original. It is omitted in the aquatint, allowing the river to flow unimpeded to the right, thereby opening up the composition to focus attention on the river. This marks one of the few obvious changes from Wall's watercolor models, as the majority of Hill's aquatints follow them closely.

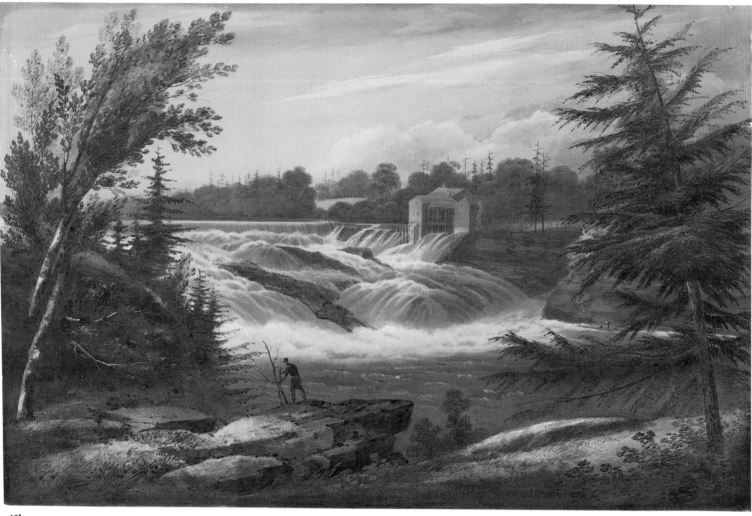

48b

Like other artists of his generation, Wall employed a wide array of watercolor techniques in these seminal works. For the broad expanses of sky and landscape he layered washes, sometimes blotting them, and occasionally sponged the masses of vegetation to add texture and variety. He also used scratching-out on the paper for certain types of highlights as well as kept portions of the paper in reserve by masking. Wall liberally employed selective glazing for luminosity and gouache, called by the British bodycolour, for opaque pigment effects.[6]

1. In addition to the eight preparatory watercolors (for pls. 6, 7, 8, 10, 15, 17, 18 [originally 22], 19), the Society has other representative works by Wall: three definite alternative watercolors not used in the final plates, one watercolor with larger dimensions that may have been related to another preparatory watercolor, two smaller watercolors, one sheet in brown ink, and four drawings in graphite; see Koke 1982, 3:224–35. These are supplemented by two watercolor copies after two of the justifiably famed prints and another copy after an unlocated original alternative view by Wall; see ibid., 235, nos. 2706–8. Shelley 1947, 44, writes that an original watercolor for pl. 20 was formerly in the Stokes Collection. Myers 1987, 190 n.1, notes all of the surviving watercolors are in the collection of the N-YHS with a few related drawings in the Metropolitan Museum of Art and the Brooklyn Museum.

2. For the publishing history of the *Portfolio*, see Richard Koke, "John Hill, Master of Aquatint, 1770–1850," *New-York Historical Society Quarterly* 43:1 (1959): 51–117; Koke 1961; and Deák 1988, 1:217–19, nos. 320 and 321. Frequently plates of the various printings were bound together.

3. William Dunlap, *A History of the Rise and Progress of the Arts of Design in the United States* (1834; New York:

Benjamin Blom, 1965), 3:103.

4. Ibid.

5. A graphite drawing in the Society's collection (inv. no. 1979.45), which may record the entrance of the Highlands of the Hudson, preserves the type of sketch Wall executed on location outdoors in preparation for his larger, more finished watercolors painted in the studio; see Koke 1982, 3:235, no. 2703. However, Shelley 1947, 35–36, believes they were all executed in the field and discusses their evolution from graphite outlines defining the compositions to finished watercolors.

6. See Shelley 2002, 71, for a brief discussion of Wall's techniques.

HENRY YOUNG

Saxony, Germany 1792–Pennsylvania, 1861

Henry Young was a parochial schoolteacher who emigrated from Saxony and settled in Union County, Pennsylvania, in 1817. He created drawings to supplement his teaching income from about 1823 until his death, specializing in certificates of birth, baptism, and marriage done in the fraktur tradition and formulaic scenes of celebration. Several drawings in the collection of the Free Library of Philadelphia, once attributed to three anonymous artists known as the Anchor Artist, the Early Centre County Artist, and the Late Centre County Artist, were all recently assigned to Henry Young. Young never painted the actual likenesses of his subjects but rather produced generic characters that he identified with inscriptions. The Society has a diverse collection of folk art pictures including portraits, landscapes, marine subjects, and historical and domestic scenes as well as calligraphic studies, illustrated family records, Pennsylvania-German frakturs, and mourning pictures.

Bibliography: Black and Lipman 1966, 193; Frederick S. Weiser and Howell J. Heaney, *The Pennsylvania German Fraktur of the Free Library of Philadelphia* (Breinigsville, Pa.: Pennsylvania German Society and Free Library of Philadelphia, 1976), 2: General Index, n.p.; Jean Lipman, Elizabeth V. Warren, and Robert Bishop, *Young America: A Folk Art History* (New York: Hudson Hills Press, in association with Museum of American Folk Art, 1986), 132.

49. *Betrothal Portrait of Miss Frances Taylor and Her Fiancé*, 1831

Watercolor and black ink with areas of glaze on beige paper; 12 × 7 7/8 in. (305 × 200 mm), irregular
Inscribed and dated at upper center in brown ink: *Miss Frances Taylor's / Picture Bought / A.D. 1831.*
Provenance: Elie Nadelman, Museum of Folk Arts, Riverdale-on-Hudson, Bronx, N.Y.
Bibliography: Black and Lipman 1966, 192–93, 201, ill.; Lipman, Warren, and Bishop 1986, 132, 136, ill.
Purchased from Elie Nadelman, 1937.1721

The N-YHS has in its collection a formulaic scene by the folk artist Henry Young generically referred to as "Man and Woman with Wine Glass." Works like this one were usually drawn, according to their inscriptions, to celebrate a betrothal or the birth of a child.[1] The term "folk art" is generally used to describe the unconventional works that are characterized by an artistic innocence and a technical naïveté that distinguish them from both the fine arts and the formal decorative arts. These watercolors frequently have an ethnic heritage, such as the German roots of Henry Young's fraktur drawings, which remains largely unaffected by the stylistic developments of academic art. While not a fraktur in the strictest definition, this sheet records for posterity an important family event in the spirit of the fraktur tradition.[2]

The Pennsylvania-German fraktur evolved from old German laws that required formal certificates of birth, baptism, and marriage to be registered with the state. The beautifully inscribed and elaborately embellished certificates became symbols of wealth and social status for German-speaking families, who continued the tradition in America although it was no longer mandated by law.[3] "Pennsylvania-German" is the most accurate term for the German-speaking Protestants who immigrated to America beginning in 1683, first settling in Germantown, near Philadelphia. They were colloquially referred to as the "Pennsylvania-Dutch," a corruption of the word *Deutsch*, meaning German, rather than *Dutch* meaning from the Netherlands. During the first decades of the nineteenth century, the designs and stylized motifs of the fraktur tradition spread beyond the Pennsylvania-German community to appear in many New England illuminated manuscripts, such as Almira Edson's *James and Jane Clark Tucker Family Register* (cat. 68).[4] Young's work is rooted in the same tradition as Edson's and more than twenty-five examples of Pennsylvania-German frakturs in the Society's collection.

In this charming scene, purchased from the Museum of Folk Arts formed by the noted collector and artist Elie Nadelman,[5] Miss Frances Taylor, identified in the inscription at upper center, is toasted by an unidentified gentleman presumed to be her fiancé. The date 1831 and the information that Miss Taylor herself purchased the picture was included in the atypical inscription. Like many of Young's celebratory scenes, this one features a pair of eight-pointed stars, a tripod table with heart-shaped turnings holding a wine decanter, and the artist's personal hallmark—a tiny bush at the lower right.[6]

In folk art, courtship scenes are a frequently revisited theme, as in another example in the Society's collection (fig. 49.1), wherein a young man and woman sit close together on a rocky prominence canopied by trees. A dog on a leash is curled sleepily at their feet, probably as a symbol of fidelity and domestic tranquility.[7] The couple examines a piece of fabric that the gentleman appears to admire, perhaps a garment the woman is sewing or embroidering for their wedding. A woodwind instrument, probably a recorder, protrudes from the bag at the woman's side, indicating that the couple shared music, a euphemism for making love.[8] In this sheet the effects of pictorial needlework are reproduced using pigments with the watercolor stipple technique and an unusual use of pin perforations.[9] The woman's dress, modeled in watercolor using the stipple technique,[10] was enhanced with perforations created by pricking the paper with a pin to represent a gauzy material. The artist of the courtship scene innovatively used these perforations in the woman's dress to create a three-dimensional, slightly risqué effect of translucent lace.[11] Like *Betrothal Portrait of Miss Frances Taylor and Her Fiancé* this work incorporates inventiveness, imagination, and veracity, and makes effective use of color and pattern to convey a strong sense of design, all characteristics of folk art.[12]

A. M.

1. Lipman, Warren, and Bishop 1986, 132; for other works by Young, see Weiser and Heaney 1976, 1: XIII–XXXIII, cats. 47–49; 2:385, 388–90.

2. Jean Lipman and Alice Winchester, *The Flowering of American Folk Art, 1776–1876*, exh. cat. (Philadelphia: Courage Books, in cooperation with Whitney Museum of American Art, 1987), 9, 104–5.

3. For a general reference on frakturs, see Henry S. Bornemen, *Pennsylvania German Illuminated Manuscripts: A Classification of Fraktur-Schriften and an Inquiry into Their History and Art* (Norristown, Pa.: Pennsylvania German Society, 1937).

4. Philip Isaacson, "Records of Passage: New England Illuminated Manuscripts in the Fraktur Tradition," *Clarion* 5 (Winter 1980–81): 30–35.

5. The Society purchased much of its folk art collection from Elie Nadelman's Museum of Folk Arts, located on his Riverdale-on-Hudson estate from about 1924 to 1934, when after its dissolution both the collection and the building in which it was housed were sold; see Elizabeth Stillinger, "Elie and Viola Nadelman's Unprecedented Museum of Folk Arts," *The Magazine Antiques* 146:4 (1994): 516–25.

6. See Black and Lipman 1966, 158–61, 184, ill., for another example of this domestic toasting ceremony by Young celebrating the popularity of Andrew Jackson, probably during his unsuccessful first run for president in 1825. Its composition is nearly identical to the Society's drawing, varying only in

Fig. 49.1. Unidentified Artist, *Seated Couple and Dog in an Idyllic Landscape*, c. 1790s. Watercolor, gouache, glazing, graphite, and pricking with a pin on paper, 14 1/2 × 16 1/4 in. (368 × 413 mm). The New-York Historical Society, INV.1200

the colors of the clothing and decorations. Young utilized a stock couple in his formulaic compositions but elevated the scene from its usual provincial domestic context into the arena of national politics with the inscription *General Jackson and his Lady* (c. 1825; Museum of Fine Arts, Boston, M. & M. Karolik Collection); see Stillinger 1999, 522, ill.

7. J. C. Cooper, *An Illustrated Encyclopaedia of Traditional Symbols* (London: Thames and Hudson, 1978), 52–53.

8. In a similar composition, *The Courtship* (c. 1815; private collection), the folk artist Eunice Pinney featured a young woman and man in the garden of a country estate. The facial expressions and distance of Pinney's couple, possibly in the very early stages of their courtship, convey an awkward discomfort in contrast to the quiet familiarity and physical closeness of the couple in the Society's unsigned watercolor; Lipman, Warren, and Bishop 1986, 134, ill.

9. The foliage in the tree at the upper left, the grasses and ferns around the stream, and the surfaces of the lake and stream are stylized with short parallel strokes of color, reminiscent of the embroidery stitches making up needlework landscapes and mourning scenes that were popular in the early nineteenth century. The distinct triangular streaks of smoke emanating from the chimneys in the town

resemble the tufts of fiber often used to represent smoke in pictorial needlework.

10. The trees at middle left and right and the softly modeled hills on the far shore of the lake demonstrate the artist's familiarity with the stipple technique, first used by English watercolorists in the late eighteenth century and adopted by American artists such as George Harvey (cat. 63) and the Pre-Raphaelites later in the nineteenth century.

11. This paper-pricking process, most often associated with the decoration of handcrafted greeting cards, was usually used to perforate patterns or to add embellishments, as in this case. The activity is related to both Pennsylvania-German and Swiss *Scherenschnitte*, or cut-paper designs, and the craft of ornare, or paper piercing. See Claudia Hopf, *Scherenschnitte: The Folk Art of Scissors Cutting; A History and Patterns Including Instructions* (Lancaster, Pa.: John Baer's Sons, 1971); and Janet Wilson, *The Search Press Book of Traditional Papercrafts: Parchment Craft, Stencil Embossing, Paper Pricking, Quilling* (Petaluma, Calif.: Search Press, 2001). Paper piercing was also used to transfer patterns from paper to fabric for embroidery.

12. Lipman and Winchester 1987, 9–10.

GEORGE CATLIN

Wilkes-Barre, Pennsylvania 1796–Jersey City, New Jersey 1872

Following a brief career as a lawyer, the American painter and writer George Catlin became the self-appointed pictorial historian of the indigenous American peoples. He produced a number of major collections of paintings and drawings and published a series of books chronicling his travels among the Native Americans of North, Central, and South America.

After living in Lucerne County, Pennsylvania, where the few clients of his law practice left him time to sketch and paint, the essentially self-taught Catlin moved to Philadelphia in 1820, intent on a career as an artist. Initially he specialized in miniatures but gradually concentrated on larger portraits in oil. He identified the animating purpose to his life and art when he observed a delegation of western American Indians visiting Philadelphia on their way to Washington during the winter of 1822–23. Captivated by the classic beauty of this "vanishing race" and their colorful, exotic attire, Catlin vowed to visit their lands and record their way of life, a goal he had to postpone for several years. In the meantime he continued to paint portraits and exhibit regularly at the Pennsylvania Academy of the Fine Arts in Philadelphia (from 1821), where he became a member in 1824.

Catlin painted his first portrait of a Native American in 1826, his celebrated likeness of the New York Seneca Chief Red Jacket (Gilcrease Museum, Tulsa, Okla.), but did not systematically record Indian culture until his first trip to the West (1830–36). When he moved to New York City in 1827, the year after he had been elected a member of the newly founded NAD, Catlin still yearned to expand his horizons and follow his ambition to become a history painter. Never really having been accepted by his fellow academicians, Catlin resigned from the NAD in 1828 after an unpleasant incident about the display of his canvases in the annual exhibition, further distancing himself from the eastern art establishment. When he married Clara Gregory, daughter of a prominent Albany family in 1828, some recognition had already come his way via a commission from the New York Common Council to paint a full-length portrait of Governor DeWitt Clinton (City Hall, New York). While wintering in Richmond, Virginia, in 1829–30, Catlin was commissioned to paint the delegates assembled to draw up a new Virginia constitution (Virginia Historical Society, Richmond). Both its

preparatory watercolor and a key of the 101 persons assembled are in the Society's collection.

Around that time Catlin returned with Romantic passion to his vow to record the appearance and customs of America's native peoples ("thus snatching from a hasty oblivion what could be saved for the benefit of posterity, and perpetuating it, as a fair and just monument, to the memory of a truly lofty and noble race," from Catlin's *Letters and Notes on the Manners, Customs, and Conditions of the North American Indians* [1841], 1:3). His stated goal was to win fame and fortune by creating an "Indian Gallery" that would command public support. To that end he moved in 1830 to St. Louis, Missouri, and two years later accompanied General William Clark on a diplomatic mission up the Mississippi River more than 1,600 miles to Fort Union, where he spent several weeks among indigenous people still relatively untouched by European civilization. There, at the edge of the frontier, he produced the most vivid and penetrating portraits of his career, painting the Blackfoot, the Crow, and all the river tribes, but concentrating on the Mandan, whose devastation by smallpox five years later confirmed the importance of his visionary enterprise. Later trips along the Arkansas, Red, and Mississippi rivers, as well as visits to Florida and the Great Lakes region, resulted in more than six hundred paintings and a substantial collection of artifacts. In addition, the prolific artist left a bewildering array of adaptations, studio versions, and replicas of his original works from life, all part of his mission of cultural preservation. Catlin's visual documentation is supplemented by the descriptions of his travels in letters to newspapers, which were collected in his 1841 classic study *Letters and Notes on the Manners, Customs, and Conditions of the North American Indians*—his major literary work, but only the first in a series of books documenting his travels and observations.

To help defray his costs, in 1837 Catlin mounted the first serious exhibition of his Indian Gallery, published his first catalogue, and began delivering public lectures, which drew on his personal recollections of life among the Native Americans. His Indian Gallery was a novelty. Artists before him, such as Charles-Balthazar-Julien Févret de Saint-Mémin, had painted Indian dignitaries visiting Washington (cats. 26

and 27; essay fig. 4) or had portrayed them in council with American officials, whereas Catlin observed his subjects in the field (essay fig. 16). Catlin's claim to originality also pivots on the nature and extent of his coverage. Besides more than three hundred portraits of men and women from fifty tribes, he displayed over two hundred paintings of Indians on their own turf engaged in everyday activities. He rightfully insisted that he was the first artist to offer a representative picture of Indian life based on personal observation. Though he described his paintings in his 1837 catalogue as "rather *fac similies*" of what he had seen and not "finished works of art," his best portraits portray people, not Romantic stereotypes, and the ethnographic value of his work has only appreciated with the passage of time.

In 1838 he began a lifelong effort to sell his Native American collection to the United States government. Frustrated in this hope, he became a regular supplicant, petitioning Congress with an urgency that mounted with his debts. When Congress rejected his initial petition, he moved to London in 1839 and took the Indian Gallery abroad, commencing a European tour in Great Britain. In 1844 he published *Catlin's North American Indian Portfolio*, hoping to reach a larger audience. When interest waned there, he crossed the Channel in 1845 to Paris, where he was entertained by King Louis-Philippe, and his gallery was praised by many individuals, including the writer Charles Baudelaire, who found Catlin's colors "intoxicating." In his singular appearance at the Paris Salon in 1846, Catlin exhibited two works, but fortune never followed fame for him. Fleeing ahead of the revolution that swept Louis-Philippe from the throne, Catlin returned to England with his three daughters (his wife and son had died of typhoid fever in France). Although his Indian Gallery was no longer a novelty in England, he nevertheless continued to publish, lecture, and slide toward financial ruin, and eventually prison.

Confident that Congress would eventually purchase his Indian Gallery, Catlin borrowed heavily against it and in 1852, after his fifth unsuccessful appeal in seven years to Congress, suffered financial collapse. Dispersal of his Indian Gallery was avoided only when the Philadelphia locomotive tycoon Joseph Harrison reimbursed the artist's creditors, took the entire collection as collateral, and shipped it to Philadelphia, where it

50a

languished until Harrison's heirs donated it to the Smithsonian Institution in Washington six years after Catlin's death.

Following his bankruptcy, Catlin entered a period of obscurity and despair. He lived hand-to-mouth for two years before he supposedly secured funds to travel to South America three times in the 1850s (his primary motive may have been a search for precious minerals and metals, although some individuals doubt he made the trips outside his imagination). He lived by selling souvenir compilations ("albums unique") of pencil outlines previously copied from his Indian portraits and publishing two successful children's

books recounting his travels: *Life Amongst the Indians* (1861) and *Last Rambles Amongst the Indians of the Rocky Mountains and the Andes* (1867). He also wrote a quirky self-help manual that was an unlikely popular success, *The Breath of Life; or, Mal-Respiration* (1861); a book defending his Mandan studies against charges of inaccuracy, *O-Kee-Pa: A Religious Ceremony; and Other Customs of the Mandans* (1867); and a theory about geologic catastrophe in the creation of the Western Hemisphere, *The Lifted and Subsided Rocks of America* (1870). In addition, he executed a second Indian gallery, consisting of a group of about six hundred "cartoons" (i.e., drawings), half recapitulating his

original collection, the rest showing Native Americans of the Northwest coast and South America. He called it the "Cartoon Collection" and in 1870 exhibited it in Brussels, where he had created a third collection, his "Outline Drawings" (in the N-YHS; see below).

After an absence of more than three decades, he returned to the United States in 1871 and showed his Cartoon Collection in New York at the Somerville Gallery on Fifth Avenue, without the accolades of earlier years but with a catalogue containing 603 entries. In February 1872 he accepted the invitation of his old friend Joseph Henry, secretary of the Smithsonian

Pl. 173.

Medecine Man (Blackfoot)

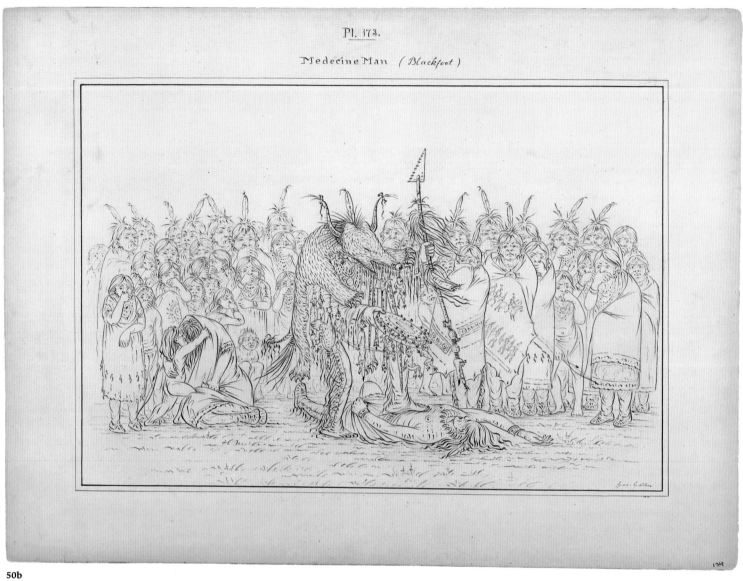

50b

Institution in Washington, to hang his Cartoon Collection on the second floor of the Smithsonian building in hopes that Congress would finally take an interest in it. That May he again petitioned Congress to purchase his original gallery, thereby allowing him to redeem it from storage in Philadelphia, where his principal creditor resided. At his death Congress had failed to act, and the Cartoon Collection also passed to his creditor's family. In 1965, 351 of these drawings were acquired by the National Gallery of Art in Washington, joining the Indian Gallery, now housed at the Smithsonian American Art Museum in that city.

Catlin's three large ensembles (the two in Washington and the Outline Drawings in the N-YHS), combined with his supporting publications and a prodigious number of other works, constitute the most comprehensive recording of the indigenous peoples of North and South America from 1830 to 1860. Catlin's paintings, long acknowledged as a key ethnographic resource, have only recently been discussed as compelling works of art. Often completed in haste and under adverse conditions by Catlin, who had trouble rendering human anatomy convincingly, his finest works combine a refreshing immediacy of execution with a pervasive sympathy for the dignity of America's native people.

The artist's papers are scattered in many institutions in the United States. The Smithsonian holds an important collection that is accessible in the AAA microfilm series, reels 2136–37. The principal family collection of papers is in the Bancroft Library, University of California, Berkeley, and some of his letters are in the Daniel Webster Papers at Morristown National Historic Park, New Jersey, as well as in the library of the N-YHS.

Bibliography: Thomas Donaldson, ed., *The George Catlin Indian Gallery in the U.S. National Museum (Smithsonian Institution) with Memoir and Statistics, Annual Report, Smithsonian Institution, 1885* (Washington, D.C.: The Institution, 1886); John C. Ewers, "George Catlin, Painter of Indians and the West," *Annual Report, Smithsonian Institution,*

1955 (Washington, D.C.: Government Printing Office, 1955); Harold McCracken, *George Catlin and the Old Frontier* (New York: Dial Press, 1959); Marjorie Catlin Roehm, ed., *The Letters of George Catlin and His Family: A Chronicle of the American West* (Berkeley: University of California Press, 1966); William H. Truettner, *The Natural Man Observed: A Study of Catlin's Indian Gallery* (Washington, D.C.: Smithsonian Institution Press, 1979); Brian W. Dippie, *Catlin and His Contemporaries: The Politics of Patronage* (Lincoln: University of Nebraska Press, 1990); Edgardo Carlos Krebs, "George Catlin and South America: A Look at His 'Lost' Years and His Paintings of Northeastern Argentina," *American Art Journal* 22:4 (1990): 4–39; Joan Carpenter Troccoli, *First Artist of the West: George Catlin Paintings and Watercolors*, exh. cat. (Tulsa, Okla.: Gilcrease Museum, 1993); George Gurney and Therese Thau Heyman, eds., *George Catlin and His Indian Gallery*, exh. cat. (Washington, D.C.: Smithsonian American Art Museum; New York: W. W. Norton & Company, 2002); George Catlin, *George Catlin's Souvenir of the North American Indians: A Facsimile of the Original Album* (Tulsa, Okla.: Gilcrease Museum, 2003); Benita Eisler, *The Redman's Bones: George Catlin and His Indian Gallery* (New York: WW Norton) (forthcoming).

50a. *Osage (Woman, Infant, and Three Men): Plate 52*,[1] 1866–68

Graphite and black ink on card; 18 1/4 × 24 1/8 in. (464 × 613 mm), irregular
Signed at lower right inside image in black ink: *Geo. Catlin*; inscribed at upper center outside image in black ink over graphite: *Pl. 52. / Osage*; at lower border outside image in black ink: *159 158 160 161*
Provenance: The artist's collection; Francis Putnam Catlin, the artist's brother, serving as agent to George Henry Moore, acting on behalf of the New-York Historical Society.[2]
Bibliography: Koke 1982, 1:140–59, no. 295, 52.
Purchased by the Society, 1872.23.52

50b. *Medicine Man (Blackfoot): Plate 173*,[3] 1866–68

Graphite and black ink on prepared card; 18 3/8 × 24 in. (467 × 610 mm), irregular
Signed at lower right inside image in black ink: *Geo. Catlin*; inscribed at upper center outside image in black ink over graphite: *Pl. 173. / Medecine Man (Blackfoot)*
Provenance: The artist's collection; Francis Putnam Catlin, the artist's brother, serving as agent to George Henry Moore, acting on behalf of the New-York Historical Society.
Bibliography: Koke 1982, 1:140–59, no. 295, 173, ill.; N-YHS 2000, 40, ill.
Purchased by the Society, 1872.23.173

50c. *Sioux and Pawnee Pipes: Plate 210*,[4] 1866–68

Graphite and black ink on prepared card; 18 × 24 in. (457 × 610 mm), irregular
Inscribed at upper center in black ink over graphite: *Pl. 210. / Sioux and Pawnee Pipes.*; numbered from upper to lower in graphite: *54, 55, 56, 57*
Provenance: The artist's collection; Francis Putnam Catlin, the artist's brother, serving as agent to George Henry Moore, acting on behalf of the New-York Historical Society.
Bibliography: Koke 1982, 1:140–59, no. 295, 210, ill.
Purchased by the Society, 1872.23.210

Catlin intended his work to serve as a significant pictorial ethnological record (despite what is recognized today as its inaccuracies) and less as an artistic endeavor. Catlin created the prototypes for his Outline Drawings in the Society's collection, officially known as his "Outlines of North American Indians," during the period when artists such as John James Audubon (cats. 42 and 43), Charles Bird King, and Karl Bodmer traveled throughout North America recording, cataloguing, and classifying the natural world of the newly explored continent. Although their works are now valued for their aesthetic as well as their historical content, at the time, they were seen as quasi-scientific or, in the case of Catlin's drawings, as ethnographic documentation.

After the seizure in 1852 of his Indian Gallery,[5] the bankrupt Catlin attempted to recreate his collection, partly from memory and partly with the aid of the sketchbooks and notes remaining in his possession. Among the first attempts was his Cartoon Collection, executed in oil paint on white card. Already about 1850, the prolific Catlin's financial problems had prompted him to seek innovative means of earning income. As a result, he turned to the currently popular concept of portfolios of drawings accompanied by explanatory text titled either "Souvenir Albums" or "Albums Unique,"[6] which he executed between 1849 and 1869 while living in Europe. Among the twelve-odd extant albums or collections of drawings varying in size, media, and number of images, perhaps the most ambitious is the Society's Outlines of North American Indians.

Catlin's Outline Drawings are linear studies in graphite and diluted black ink based on his original Indian Gallery and his later studies of Indians west of the Rockies. They were begun during his European "exile" in 1866 and completed at the end of 1868 in his quarters at the Hôtel Duc de Brabant, 8 rue de Brabant, in Brussels, Belgium.[7] The 220 Outline Drawings, like the 167 sheets in a smaller format in the NYPL, are large and unbound. Unlike Catlin's albums, the Outline Drawings do not contain separate handwritten descriptions. However, the artist published a "descriptive catalogue" in 1869 whose listed plates match those of the Society's compilation; three copies of this catalogue are held by the Society's library, including one with annotations in Catlin's hand.[8] In his introduction to this listing, the artist wrote that the collection served as a prospectus for an engraved or lithographic volume of the Outlines offered for subscription as part of a larger, ambitious work, "Catlin's North Americans." His brother Francis was the supervisor of this never-completed project.[9] Due to the nearly verbatim correspondence between the subjects of the Society's Outline Drawings and the 1869 *Descriptive Catalogue of Catlin's Outlines*, it seems probable that Catlin created the Outline Drawings for translation into a printed medium.[10] The artist's inscriptions on the Outline Drawings—noting plate numbers and identifications of the scenes depicted—reinforce the conclusion that he planned them for this reproductive effort. Further, there exists a manuscript "Subscription Book and Prospectus for George Catlin's *North Americans, 1869*," whose black leather cover is lettered in gold *The North Americans*. In his clear calligraphy, Catlin described this project, which seems identical to that of the *Descriptive Catalogue* and the Society's Outline Drawings.[11] Based on Catlin's short introduction to the *Descriptive Catalogue*, he may have also intended this brochure to serve a second purpose, as an exhibition catalogue, although no exhibition record has been located for it.

Originally Catlin must have executed 221 Outline Drawings. Before the publication of the *Descriptive Catalogue* in 1869, the artist withdrew plate 66 and omitted its listing in the *Descriptive Catalogue*, although he retained the old enumeration. In that listing he organized his Outline Drawings into three groups: 116 under the heading "Indian Portraits," which he stated contained 377 full-length figures; 100 under the rubric "Landscape, Sporting Scenes, Manners, Customs, and the Chase"; and four within the category "Mandan Religious Ceremony." It is in

Pl. 210.

Sioux and Pawnee Pipes.

50c

the commentary for those four physically arduous tribal rites of passage that Catlin spills the most ethnological ink, describing them in detail. This entry reproduces three of the Outline Drawings to provide a selective sampling of their subject matter.

At different junctures, starting in 1847, Catlin attempted to sell various combinations of his large collection to the Historical Society—for example, his Indian Gallery and his Cartoon Collection together for $120,000—although only in the last months of his life did he successfully place his Outlines in its permanent collection.[12] The relevant correspondence resides in the Society's Department of Manuscripts. Throughout the Society's collections are works in different media by the artist, including a map drawn in 1866–68 of the localities of the North American tribes in 1840.[13]

1. George Catlin, *Descriptive Catalogue of Catlin's Outlines of the North American Indian* (Baltimore: Printed by Sherwood & Co., 1869), 14, writes for pl. 52: "OSAGE. / 158. *Cler-mont*, —; head chief of the tribe; war club on his arm.; 159. *Wah-chee-te*, —; wife and child of chief.; 160. *Mun-ne-pus-ke*, He Who Is Not Afraid.; 161. *Nah-cum-e-sah*, The Man of the Bed. Two celebrated warriors equipped for war. A numerous and warlike tribe on the Arkansas."

2. In 1870 the librarian of the Society, George Henry Moore, acquired the set of drawings for the Historical Society directly from Francis Catlin, the brother of the artist who resided in Ripon, Wisconsin, and acted as his agent. The Society reimbursed Moore the $750 he paid to Catlin.

3. Catlin 1869, 31, comments for pl. 173: "Blackfoot Doctor, (a Medicine Man) under his medicine dress, endeavoring to cure his dying patient by sorcery, as he dances and sings and shakes his rattles over him. Witnessed by the author at the mouth of Yellow Stone in 1832." A version in the NYPL, Rare Book Room, is reproduced in Stebbins 1976, fig. 107.

4. Catlin 1869, 34, comments for pl. 210: "*Sioux Pipes*, with stems, and two calumets (pipes of peace)."

5. He called it the "old" or "original" collection.

6. Catlin's patrons were the educated and the well-to-do elite of society, including European nobility, who desired souvenirs of their tours of the West or who had a particular interest in natural studies. A case in point is the watercolor "facsimile" of his Indian Gallery—fifty watercolors and fifty pages of text—that Catlin executed in 1849 in England and sold to Sir Thomas Phillipps (Gilcrease Museum, Tulsa, Okla.); for a published facsimile of this album, see Catlin 2003.

7. Koke 1982, 1:141–43.

8. Cited in n. 1 above; see also M. Maxson Holloway, "Drawings by George Catlin," *New-York Historical Society Quarterly* 36:1 (1942): 12.

9. The project had a complicated, rocky, and not entirely documented history. Roehm 1966, 387–96, transcribes the relevant correspondence suggesting that Catlin had begun the envisioned work, a conclusion she supports (p. 392), despite the fact that at one point the artist indicates that he had changed his mind and planned lithographs made from his paintings instead of the Outlines.

10. Truettner 1979, 59, 129 nn. 39, 40, quotes Roehm 1966, 445–47, and believes that several "albums of cartoons, at the Henry E. Huntington Library, San Marino, Calif., may be the remains of this project," which Catlin hoped to reproduce by "photo-lithography." In its manuscript department Truettner claims the Huntington holds 203 "manuscript drawings" as well as other pieces of Catlin material and documents. Peter J. Blodgett of the Huntington Library has clarified the information about their Catlin material, which seems to relate to several projects. The Huntington holds 239 sheets, all having the inv. no. HM 35183, followed by individual item numbers. Fifty are executed in color, oil over graphite, measuring c. 17 3/4 × 24 in., and 145 are outlined in graphite, some gone over in ink, measuring c. 17 1/2 × 23 in., some of which may be counterproofs. The latter were once mounted and bound into an album. Forty-three are not original drawings but reproductive images inserted into the collection. Of the total, 218 represent native peoples or indigenous wildlife, mostly from North America. Twenty-one are unfinished oils illustrating the voyages of the French explorer René-Robert Cavelier, Sieur de La Salle in the New World (the original set consisted of 27 images, commissioned by King Louis-Philippe of France). The works can be traced back to 1892, when they were in the possession of Colonel Archibald Rogers of Hyde Park, New York.

11. In the Bancroft Library, University of California, Berkeley; see Roehm 1966, 445–48, for a transcription of the fascinating text and the names of the subscribers before the project was abandoned. The two-volume work, proposed in an edition of 400 copies at £20 per copy, was to have been accompanied by a text and a map of the localities of the tribes. The subscriber was to have received a printed list of all the illustrations. Presumably that was Catlin's *Descriptive Catalogue* of 1869.

12. For Catlin's letter to Francis about the sale, see Roehm 1966, 402, which makes it clear that the sale to the N-YHS ended the hopes of a lithographic edition of the plates. For a window into the complicated appeals, correspondence, and negotiations, or lack thereof, between the Society and the Catlins, see Holloway 1942, 12–16; Koke 1982, 1:152–53; and Dippie 1990, xiii–xiv, 122, 377–81. Catlin's last letter to the Society hoping to negotiate the transfer of his other two collections was written on 14 March 1872 from the Smithsonian Institution in Washington, where the director had given him rooms as well as free use of a room to exhibit his Cartoons.

13. Inv. no. 1872.23.222, only mentioned in Koke 1982, 1:153. Others are two oil portraits by Catlin (of Governor DeWitt Clinton, c. 1825, and General Winfield Scott, c. 1835; N-YHS 1974, 1:147, no. 352; 2:715, no. 1837, ill.); and the aforementioned watercolor of the Virginia Constitutional Convention of 1829–30 and an outline key to the identities of those portrayed that looks very much like the artist's later Outlines (Koke 1982, 1:139–41, no. 294, ills.). The Society's DPPAC holds several color lithographs, and its library, ephemera and early publications on the artist.

ASHER BROWN DURAND

Jefferson Village (now Maplewood), New Jersey 1796–1886

A personal friend of Thomas Cole (cats. 61 and 62), who mentored him in landscape painting, and a central artist of the Hudson River School aesthetic, Asher B. Durand (as he preferred to be called) spent nearly the first twenty-four years of his career, including his apprenticeship, as a successful and highly esteemed engraver of banknotes and fine art. He then turned briefly to portraits, finally finding his true calling in nature, painting landscapes of northeastern America that embody both a wilderness and a pastoral mode and a progressive expression of naturalism. The youngest of eight children and in delicate health, Durand spent much time observing his father, a watchmaker and silver-smith, from whom he learned a love of creation and a dedication to craft; he first engraved objects made by his father. In 1812 young Durand was apprenticed for five years to Peter Maverick of Newark, New Jersey, and later partnered with him in a flourishing New York office (P. Maverick, Durand & Co.) from 1817 to 1820. Their partnership was dissolved in 1820 when Durand accepted a commission to engrave John Trumbull's *Declaration of Independence* (1786–1820; Yale University Art Gallery, New Haven), thereby arousing Maverick's anger and freeing Durand to develop independently (essay fig. 13 is his preparatory drawing). He completed the large plate in 1823, and it was published the same year to critical acclaim and praise by Trumbull, establishing Durand as one of the leading engravers in the country. Essentially self-taught as a painter from the study of plates in books and prints, Durand's only real training, according to Henry T. Tuckerman (*Artist-Life* of 1847) who constructed Durand's persona as a model citizen and dedicated painter, was occasional drawing from casts of classical sculpture at the American Academy of the Fine Arts. The ambitious young artist also studied human anatomy by attending lectures at Columbia Medical College; his anatomical drawings are in a notebook in the collection of the National Academy Museum.

During the 1820s Durand rose to prominence in the New York art world, and his choices indicate his desire for professional advancement. He garnered commissions to reproduce works by most of the country's leading artists, many of whom became his friends. Over the next fifteen years Durand became involved with a number of engraving ventures, including a second partnership with his brother Cyrus (A. B. & C. Durand, Wright & Co.), which concentrated on more commercial commissions for banknotes and book illustrations. He capped his eminent career as an engraver by producing nineteen plates, three after his own paintings, for James Herring and James B. Longacre's *National Portrait Gallery of Distinguished Americans* (1834–39) under the supervision of the American Academy of the Fine Arts. One of his last engravings (1835) was after John Vanderlyn's (cat. 31) sensationally famous *Ariadne Asleep on the Island of Naxos* (1809–14; Pennsylvania Academy of the Fine Arts, Philadelphia). In preparation for his print, considered one of the masterworks of nine-teenth-century American engraving, he purchased Vanderlyn's oil (which had remained unsold because of its scandalous nudity). Durand used it as a model for his own small oil study (c. 1831–35; The Metropolitan Museum of Art, New York), whose execution afforded him a visceral understanding of Vanderlyn's painting but more importantly testifies to his nascent interest in the oil medium. Figure 51.1 is the artist's prepara-tory drawing for his engraving, squared for transfer to the plate, which, unlike his oil study, was essential for his execution of the reproduc-tive print. (Like Vanderlyn's original, it was a critical success but a commercial failure.) Durand's talent as an engraver was based on his drawing skills, and he continued to insist on the importance of outline and precise renderings.

The artist first took up oil painting seriously in the 1830s, virtually giving up the burin for the brush in 1836 under the patronage of Luman Reed. The collector-businessman had commis-sioned Durand to paint a series of presidential portraits (1834–36) and envisioned his protégé as becoming a first-rate portraitist. Although professionally identified as an engraver in the NAD's first publications and catalogues, Durand had contributed portraits and landscapes to its first six exhibitions. Quitting the drudgery of the engraving profession, he listed himself in the New York City directories as a portrait painter, and when Reed died suddenly in 1836, Durand's recent portrait of him was hanging at the NAD. Without Reed's financial backing and encouragement, Durand was devastated and began aiming his ambitions beyond the relatively lowly status of portrait painting. Reed's demise also cemented the friendship between Cole and Durand, who sought solace and inspiration in each other's company. After accompanying Cole and his wife, Maria Bartow, on a pivotal sketching trip (the first of many) to Schroon Lake in the Adirondacks during the summer of 1837, Durand dedicated himself to becoming a landscape painter, on whom Cole's influence and tendency toward allegory was apparent in his early work. Although no paintings from the expedition have been located, a fragmentary sketchbook in the N-YHS documents this seminal tour.

Under the patronage of Jonathan Sturges, a former partner of Reed and successor in art collecting, Durand studied in Europe for thirteen months (1840–41). He traveled with fellow artists John Frederick Kensett (cat. 88), Thomas Pritchard Rossiter (cat. 94), and John W. Casilear to England, France, the Low Countries, and Switzerland, with a long sojourn in Italy (November 1840–May 1841). In England he met the genre painter Sir David Wilkie (cat. 45) but was especially eager to see the art of Claude Lorrain and J. M. W. Turner. Durand was understandably most impressed with the plein air studies of John Constable, whose work most closely corresponded to the aesthetic aims and practices Durand was formulating. Not surprisingly, his journals reveal his exuberant reaction to local scenery. He shared with Cole (five years his junior but a committed painter from the outset of his career) and the poet William Cullen Bryant (cat. 64) a belief in nature as a place of spiritual revelation, but his more direct approach to the natural world and his revolutionary studies, often painted *en plein air* (outdoors), ally him with Realist European painters. Durand's European sojourn provided an education in the old masters, resulting in a veneer of sophistication to his works, a credential that critics previously had found lacking in his paintings. This "exile," as he termed it, also exposed Durand to his European contemporaries who gave him a taste of art's potential when freed from past traditions. These examples allowed him to follow the muse of empirical observation, to leave the studio, and to focus on landscape. In 1843 Durand began to exhibit his oil studies, blurring the lines in the traditional separation between the private, plein air sketch and the finished exhibition painting in a progressively naturalistic manner.

Fig. 51.1. Asher B. Durand, *Ariadne (after Vanderlyn): Preparatory Drawing for the Engraving*, c. 1833. Graphite on paper, squared and numbered for transfer; 17 1/8 × 20 3/4 in. (435 × 527 mm). The New-York Historical Society, Gift of the Durand family, X.502

After the death of Cole in 1848, the torch was passed to Durand, who assumed the exclusive mantle of leadership of the Hudson River painters (previously Cole had represented the ideal, heroic trend in landscape and Durand the real and pastoral). Rather than using nature as a backdrop for moralizing as Cole did, Durand, who shared Cole's belief in the American landscape as a manifestation of divine promise, extolled nature as an entity in itself. More down-to-earth, he recorded its particulars with great immediacy, frequently in a more human scale than many artists of his time. His artistic maturity is best characterized by the term *naturalism*. Experiencing a communion with nature as a lifelong spiritual journey, he executed countless independent drawings and filled numerous sketchbooks with studies, many

focusing on trees. Much to his financial success, the first part of his productivity as a landscape painter coincided with the end of the period when American scenery was invested with significance as part of the broader search for cultural identity, and landscape itself was deemed a national subject.

Together with Thomas Seir Cummings, John Frazee, Henry Inman (cat. 64), and Samuel F. B. Morse, Durand formed the core of activist artists seeking substantive change in New York's art establishments. In 1825 he was elected to James Fenimore Cooper's Bread and Cheese Club, and that same year he chaired the meeting of a group of artists who met at the N-YHS to form the New-York Drawing Association. In January 1826 this parent organization became the NAD, and Durand was elected one of the

founding members. He became a member of the NAD's Council in 1827, served as its vice president in 1844–45, and the next year succeeded Morse as its second president, serving until 1861. His presence at the NAD formally placed the stamp of legitimacy on landscape painting in America. With Cole and Bryant, he was also a founder of the Sketch Club in 1827, which metamorphosed into the influential Century Association, of which he was a member.

Durand, who played a major role in formulating the theory and practice of mid-nineteenth-century American landscape painting, was much influenced by the English critic and artist John Ruskin and his then-sensational *Modern Painters* (first published in England in 1843). Ruskin passionately urged artists to reject interpretation in favor of a meticulous transcription of visible

51

phenomena, where he believed lay the infinite creativity and truth of God. Ruskin's reverence for nature with his emphasis on particulars when painting landscape partially contradicted the notions of the sublime that had been embraced by the Hudson River School. As Ruskin advocated, Durand began to paint directly from nature, filtering Ruskin's ideas through his own patriotic idealism that regarded wilderness as an important part of the national identity. Spending his summers sketching in the Adirondack, Catskill, and White mountains, he developed the accumulated studies into formal oils in his New York studio. In 1855 he composed some of the key statements of nineteenth-century American landscape theory in his nine "Letters on Landscape Painting," which were published in *The Crayon: A Journal Devoted to the Graphic Arts, and the Literature Related to Them*, the influential art periodical coedited by his son John Durand and the artist-journalist William J. Stillman. His "Letters" promulgated the view that nature was the primary arbiter of artistic truth. This belief in naturalism—at the time equated with modernism—was echoed the very same year by the American poet Walt Whitman in his *Leaves of Grass* and by the French painter Gustave Courbet in his "Manifesto of Realism." In his day Durand was known for certain pictorial types and innovations, such as the pastoral landscape and his signature vertical forest interior (*The Beeches*, 1845; The Metropolitan Museum of Art, New York; and *A Brook in the Woods*, c. 1854; The N-YHS). As sectional strife in the nation and new European models began to undermine the public's taste for Durand's pastoral landscapes, he functioned as the elder statesman of the New York art world. In 1866 he exhibited two landscapes at the Paris Salon, his singular experience in that venue, but soon thereafter, in the spring of 1869, he left New York City for a home and studio he had newly built on the family's property in Jefferson Village, where he continued to paint for nine years. He was buried in Green-Wood Cemetery in Brooklyn.

The artist's empiricism and dedication are evident in the eight complete sketchbooks, around 296 drawings (including twenty sheets from the two disassembled sketchbooks), and around 110 paintings together with an extensive trove of objects in the Society's museum, documents (Department of Manuscripts), and

prints (DPPAC) that make the N-YHS the largest single Durand repository in the world. This rich cache is largely owing to the generosity of his descendants: his son John Durand; his daughter Lucy Maria Durand Woodman, an artist in her own right; and his granddaughter Nora Durand Woodman. The vast majority of his drawings are studies of trees rendered with solid realism and a poetic depth. Although his drawings were primarily for personal study, they played a central role in Durand's aesthetic and working process.

Bibliography: John Durand, *The Life and Times of A. B. Durand* (New York: Scribner's Sons, 1894); Lawall 1966; Wayne Craven, "Asher B. Durand's Career as an Engraver," *American Journal of Art* 3:1 (1971): 39–57; David B. Lawall, *A. B. Durand, 1796–1886*, exh. cat. (Montclair, N.J.: Montclair Art Museum, 1971); idem, *Asher Brown Durand: His Art and Art Theory in Relation to His Times* (New York: Garland, 1977); idem, *Asher B. Durand: A Documentary Catalogue of the Narrative and Landscape Paintings* (New York: Garland Publishing, 1978); Hudson River Museum 1983; Barbara Dayer Gallati, "Asher B. Durand as Draftsman," in Hudson River Museum 1983, 62–64; Harvey 1998, esp. 126–41; H. Daniel Peck, "Unlikely Kindred Spirits: A New Vision of Landscape in the Works of Henry David Thoreau and Asher B. Durand," *American Literary History* 17:4 (2005): 687–713; Linda S. Ferber, ed., *Kindred Spirits: Asher B. Durand and the American Landscape* (Brooklyn: Brooklyn Museum, in association with D Giles Limited, London, 2007).

51. *Self-Portrait (1796–1886)*, 1830–33

Graphite on paper, laid on board; 10 1/8 × 7 3/4 in. (257 × 196 mm)
Signed and inscribed on board at lower center in graphite: *A.B.D. by himself*
Provenance: Descent through the artist's family.
Bibliography: N-YHS 1941, 84, no. 212; N-YHS 1974, 1:233–34, no. 581, ill.; Foshay and Novak 2000, 53; Ferber 2007, 61–62, pl. 10.
Gift of Miss Nora Durand Woodman, the artist's granddaughter, 1935.7

With this sheet Durand created one of the most remarkably arresting self-portraits produced by a nineteenth-century American artist. He drew the highly self-conscious portrayal just before engraving portraits for Herring and Longacre's *National Portrait Gallery of Distinguished Americans* and Luman Reed's commission of seven presidential portraits.[1] Already Durand had accumulated a fair amount of experience making portraits. During his apprenticeship with Maverick, for whom he engraved likenesses by

other artists, Durand had sought training as a portraitist. William Dunlap relates in his *A History of the Rise of the Art of Design*: "Becoming intimate with Mr. Samuel Waldo, he [Durand] received advice and instruction from that gentleman respecting portraiture, which led to his execution of his first engraving in that department."[2] Equally important is the introspective nature of the sitter's melancholic expression and brooding pose, occasioned in part, no doubt, by the premature death in 1830 of his first wife, Lucy Baldwin Durand, an event that devastated the artist. The period was a difficult one for Durand, whose mother died in 1832, the year of the cholera epidemic that resulted in his self-imposed exile from New York in New Jersey and financial pressures. During the period of rejuvenation when Durand executed this probing self-examination, he was aided by several contemporary theories and philosophies regarding health reforms and phrenology. It is significant that one of the two portraits the artist exhibited at the NAD in 1833 portrays his friend Sylvester Graham, the inventor of graham bread who also advocated exercise in the fresh air, vegetarianism, abstinence from tobacco and alcohol, and restricted sexual activity. Durand's acquaintance with Graham's ideas has been documented and may have been behind his avoidance of extremes and his desire to seek the "natural" by painting outdoors in the fresh air and eliminating sublime elements from his paintings in favor of the pastoral mode.[3] The artist subscribed to a set of beliefs and practices that included a lifelong interest in diet, exercise, homeopathy, and physiology.[4]

An earlier self-portrait in the collection (essay fig. 12), which is signed *A. B. Durand Esqr.* and dates from the time of his partnership with Maverick, communicates a youthful optimism in contrast to the more deliberate presentation of the self in this later sheet, drawn when the artist was in his mid-thirties and preoccupied with mortality. Like the later portrayal, the earlier self-study is Romantic but in an active rather than a contemplative vein. The artist's wild, unkempt hair, together with his face drawn frontally in great detail and his body only lightly sketched in profile, lends a spontaneous *sprezzatura* to the tiny sheet that was once part of a pocket sketch pad. While the sitter's attitude conveys movement, as though he has just turned toward the viewer, it

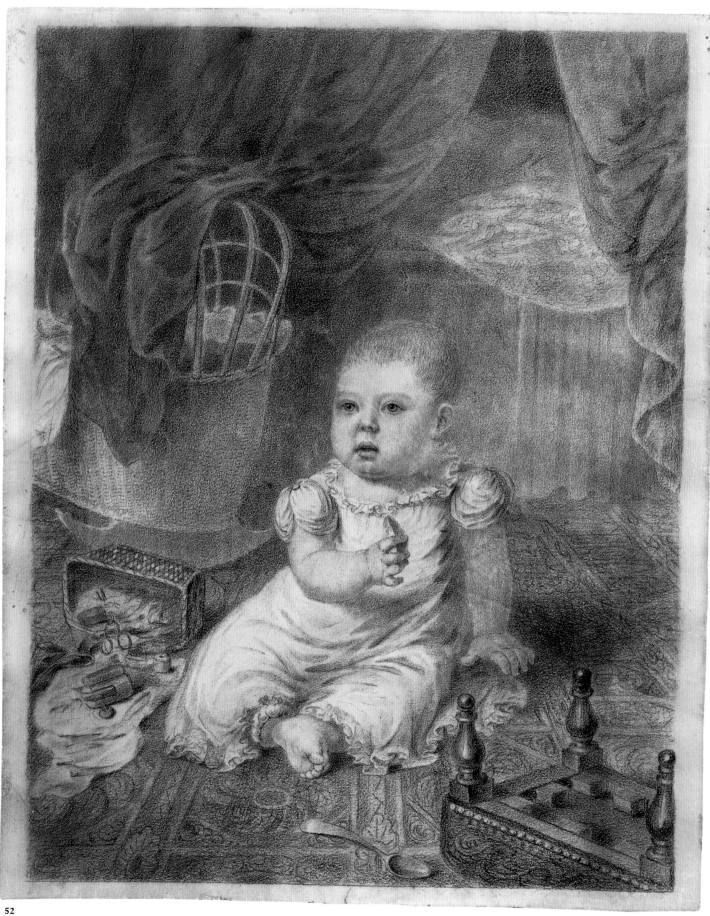

52

may be alternatively, and more technically, interpreted as the result of Durand studying his own visage in the mirror and adding his body as an afterthought.[5] It has also been observed that the sitter's coiffure and posture are the same as those depicted in William Jewett's portrait of Durand from about 1819 in the N-YHS collection, which suggests that Durand may have copied that oil in his little sketch.[6]

Alternatively, in this more mature and assured self-portrait, the artist assumes the classic "thinker pose," revered since ancient Greece to communicate a thoughtful mood. Not only did the great printmaker Albrecht Dürer use it for his own early pen-and-ink self-portrait (1491), but also Michelangelo Buonarotti immortalized it in his *Last Judgment* in the Sistine Chapel (1535–41), followed by a legion of other artists. In addition, the pose was linked to the melancholic temperament and the Saturnian genius, again commemorated by Dürer in his famous print *Melencolia I* (1514), a spiritual self-portrait.[7] The German Romantics, who influenced Durand, also followed Dürer's prototype, frequently employing this head-in-hand posture in a bust-length format—including a self-portrait drawing of 1788 by Gerdt Hardoff that very closely resembles Durand's and an oil by Philipp Otto Runge (1804)—whose iconography refers to the melancholic artist and his reverie.[8] Durand, who possessed a general melancholic outlook on life,[9] posed himself leaning on a pedestal, instead of the book used by Hardoff, gazing boldly at the viewer. His artistic sensitivity, communicated by his deeply shaded eyes, heavy eyebrows, and sensuous lips, is matched by his intelligence, underlined by his voluminous coiffure, penetrating gaze, and strong forehead. In the end, Durand's self-portrait functions as a showcase of his skillful draftsmanship featuring varying intensities of line and poetic, unfinished passages.

* There are eight complete sketchbooks—inv. nos. 1918.57, 1918.59, 1918.60, 1932.58, 1935.173, X.485, X.486, X.487—and at least two disassembled, fragmentary sketchbooks—inv. nos. 1918.70 and 1918.86–94, drawings from the "Schroon Lake Sketchbook," and inv. nos. 1918.99–108 (numbered at upper right from 2 [repeated on a second sheet] to 10), drawings from the "Kingston Sketchbook."

1. For an oil on canvas self-portrait from about 1835 in the collections (inv. no. 1907.2), see N-YHS 1941,

84–85, no. 211, ill.; and 1974, 1:234, no. 582.

2. William Dunlap, *A History of the Rise of the Arts of Design in the United States*, ed. Rita Weiss, 2 vols. in 3 (1834; New York: Dover, 1969), 2:286.

3. See Barbara Dayer Gallati, "Asher B. Durand's Early Career: A Portrait of the Artist as an Ambitious Man," in Ferber 2007, 61–64. She refers to Charles Colbert, *A Measure of Perfection: Phrenology and the Fine Arts* (Chapel Hill: University of North Carolina Press, 1997), which focuses on Durand's art in the 1830s and 1840s in arguing that, contrary to Lawall, Transcendentalism and Associationism have received too much credit for the formation of American landscape aesthetics. Colbert believes that the pseudoscience of phrenology was equally important as a foundation for a nature philosophy grounded on the notion that human beings are organic creatures and must exist in harmony with nature in order to flourish. He links Durand to these theories as well as to Graham's campaign for physical and moral purity.

4. Linda S. Ferber, "Asher B. Durand, American Landscape Painter," in Ferber 2007, 130.

5. See Foshay and Novak 2000, 52–53, ill.

6. N-YHS 1974, 1:233.

7. Erwin Panofsky, *Albrecht Dürer* (Princeton: Princeton University Press, 1942), 2:103, no. 997, fig. 25.

8. For a number of these portraits, see Werner Hofmann et al., *Runge in seiner Zeit*, exh. cat. (Hamburg: Hamburger Kunsthalle, 1977), 253–55, 273–74.

9. See Barbara Dayer Gallati, "'A Year of Toilsome Exile': Asher B. Durand's European Sojourn," in Ferber 2007, 84.

Asher Brown Durand

52. *Caroline Durand (1826–1902)*, c. 1827

Conté crayon and graphite with scratching-out on beige paper, laid on Japanese paper; 14 5/8 × 11 1/2 in. (372 × 292 mm)
Verso inscribed diagonally across center in graphite: *Portrait John Durand; | infant son of | Asher B. Durand. | See change below (eldest daughter of | Asher B. Durand, | Caroline drawn by | Asher B. Durand) | see Miss Woodman's Letter | July 26, 1932*
Provenance: Descent through the artist's family.
Bibliography: J. Durand 1894, 39; Lawall 1966, 3:270–71, no. 5; 4: fig. 28; Hudson River Museum 1983, 42, no. 39, fig. 17.
Gift of Miss Nora Durand Woodman, the artist's granddaughter, 1932.223

In the monograph on his father, John Durand wrote about this tour-de-force sheet: "Only three elaborate pencil drawings remain to show what he accomplished during these years [1820s]: … and the last, a drawing of his first child seated on the floor by his cradle."[1] John Durand mistakenly believed that this drawing

represented himself, when in fact the sitter is his sister Caroline at around one year of age, as correctly identified in a letter from Miss Nora Durand Woodman of 27 July 1932 to the Society. Caroline was the second child of the artist and his first wife, Lucy Baldwin, who died in 1830.[2] Durand also painted Caroline's likeness in two oils in the collection: one a small canvas of about 1838–42 and the other a group portrait of 1832 with her brother John and her sister Lucy M. Durand in a sylvan setting, where the artist had taken them to escape the cholera epidemic sweeping New York City.[3]

The obsessively rendered sheet, drawn like a trompe l'oeil print with borders of blank paper and a highly worked surface, testifies to Durand's contemporaneous occupation as an engraver. His use of Conté crayon prefigures the feeling of a lithograph. Nevertheless, its composition and technique resemble the artist's ambitious stipple engravings, and even more closely his dense line engravings, such as the standing nude *Musidora* of 1825, that date from around the same time, a moment when he was also involved with portraiture.[4] A comparison of Caroline's portrait with the similar preparatory study in the Prints and Photographs Division of the NYPL for the engraving *Musidora*, the second of the three drawings described by John Durand, suggests that at one time Durand may have intended to engrave the portrait of his infant daughter as well.[5]

Dressed as a toddler in a long white costume, Caroline sits on an ornately patterned floral carpet. She dominates the domestic scene, intimately set in her parents' bedroom where the skirt and curtains of their bed create the backdrop, draping over her wicker cradle at the left to suggest that she had disturbed their rest. In this work Durand has not only drawn a portrait of his daughter but has also captured the chaos wrought on his domestic bliss by this new addition to the family. Supporting this interpretation of the work is the overturned paisley-upholstered footstool and spoon. Young Caroline engages the viewer directly with a piercingly intense, almost imperious gaze that Durand has accentuated by outlining her eyelids and scratching-out with a sharp implement a dot of the black crayon that he used for her pupils. In her proper right hand, the toddler holds a piece of fruit on which she has been

53

sucking in an age-appropriate manner. Since the fruit looks like an apple slice, it may harbor allusions to the Old Testament narrative of the Fall of Man (and thus to her innocence and mischievousness). Next to the baby's proper right hand holding the apple slice is a still life communicating additional domestic disorder: her mother's overturned sewing basket. In this topsy-turvy toddler's world, scissors, cloth, spools of thread, ribbon, and other sewing implements are strewn across the floor. Placed in the center of the composition and sitting regally like a reigning monarch, Caroline holds court over her kingdom of chaos.

With its fanatical detail and celebration of the cult of naïveté and infancy, Durand's portrait resembles the contemporary obsessive work of several German artists, best exemplified by the oeuvre of Philipp Otto Runge, who specialized in this Romantic genre that was allied to a mystical celebration of nature through complex symbolism.[6] Durand's engraving activities may have exposed him to their ideas and compositions, a theory supported by the similarity of Durand's self-portrait discussed in catalogue 51 to those by German artists of the period, whose beliefs about the spiritual dimension of nature harmonized with his.

1. Durand 1894, 39.
2. In 1834 the artist married Mary Frank, an alliance that brought him domestic and personal stability until her death in 1857.
3. Inv. nos. 1907.25 and 1903.2; see N-YHS 1974, 1:236, no. 590 (mistakenly dated c. 1825–30, whereas it depicts a twelve-to-sixteen-year-old young girl) and 237–38, no. 599, ill. For the latter, see also Gallati, "Asher B. Durand's Early Career," in Ferber 2007, 58, 61, 64, fig. 25.
4. See, for example, Hudson River Museum 1983, 20, no. 7, fig. 2, and 33–34, no. 27, fig. 11 (*Musidora*), among many others.
5. Ibid., 33, no. 26; as well as Lawall 1966, 3:269–70, 477; 4: fig. 9. For Durand's career as an engraver, see Craven 1971; and Gallati, "Asher B. Durand's Early Career," in Ferber 2007, 45–58.
6. See Jörg Traeger, *Philipp Otto Runge: Die Hülsenbeckschen Kinder; Von der Reflexion des Naiven im Kunstwerk der Romantik* (Frankfurt am Main: Fischer Taschenbuch Verlag, 1987); and idem, *Philipp Otto Runge und sein Werk* (Munich: Prestel-Verlag, 1975). Friedrich Schiller's *Ueber naïve und sentimentalische Dichtung* (1795/96) was important to the development of these interests. Some of Runge's works were engraved and may have been known by Durand.

Asher Brown Durand

53. *"Dover Stone Church," Dover Plains, New York*, c. 1847

Graphite with white gouache on gray paper, mounted on card; 14 × 10 in. (356 × 254 mm)
Inscribed at lower right in graphite: *Stone Church / Dover Plains* [gone over twice]
Provenance: Descent through the artist's family.
Bibliography: Lawall 1966, 3:315, no. 66; Koke 1982, 1:325, no. 633; Hudson River Museum 1983, 75, no. 98, fig. 35; Tracie Felker, *Master Drawings of the Hudson River School*, exh. cat. (New York: Gallery Association of New York State, 1993), fig. 6.
Gift of Miss Nora Durand Woodman, the artist's granddaughter, 1918.125

Most likely Durand drew this sheet and a pair of graphite studies executed near Dover Plains, New York, on the same sketching trip. One of the pair is in the Society's collection,[1] while the other remains unlocated.[2] Together, these three drawings preserve the artist's preparatory investigations of this geographic area preliminary to his 1848 canvas *Dover Plains, Dutchess County, New York* (1848; Smithsonian American Art Museum, Washington, D.C.).[3]

Dover Plains, in Dutchess County, is situated in the southeastern part of New York State near the Connecticut line, ten miles northeast of Poughkeepsie. The natural rock cavern known as the Dover Stone Church is located in an eroded ravine near Dover Plains. Its name derives from the similarity of its pointed entrance (measuring approximately 70 by 14 feet) to the arched vaults found in the naves of Gothic churches. This natural chapel attracted the artist, who, like other Hudson River School painters, looked to nature for religious and moral inspiration, but Durand also turned to nature for its physically therapeutic properties.[4] Certainly Durand could not have missed the similarities between the rock formation resulting from natural processes and religious architecture, which allude to the sublime grandeur he increasingly sought to banish from his art. A transitional work, this drawing is the product of an experimental period in Durand's career and is animated by ambivalent, often conflicting ideas. Its Ruskinian approach of truth to nature, stressing the particulars of the elements, such as the geology of the rocks and the botany of the trees, reduces the sublimity of the scene and signals a new

direction in the artist's work. The picturesque elements of his signature vertical landscape, including the highly individualized trees, the artist's pictorial obsession, supplement a Romantic sentiment that still suffuses this naturalistic work and Durand's celebrated canvas of 1849, *Kindred Spirits* (The Crystal Bridges Museum of American Art, Bentonville, Ark.) to which this sheet is certainly a compositional and intellectual prelude.

Durand's *Kindred Spirits* was commissioned by Jonathan Sturges as a gift for the poet and journalist William Cullen Bryant (cat. 64) in gratitude for the eulogy he had delivered in honor of Thomas Cole.[5] This memorial, which embodies the intense friendship shared by these three men and the spiritual ameliorative effects they found in nature, has become a signature piece of nineteenth-century American art, arguably the most frequently reproduced painting of the period.[6] The artist signed his name at the lower left, thereby inhabiting this idyll of companionship via his brush. He inserted the names of the two full-length figures, his mentor Cole and Bryant, into the picture by "carving" them in paint on the trunk of the tree in left foreground. The men stand on an outcropping of rock that may be based on what is now known as Church's Ledge, although very few scholars today believe that Durand depicted Kaaterskill Clove, long associated with the work of Cole, as he observed it.[7] Instead, most argue that while the artist drew on observations of the geography of the Clove, he manipulated it, making a composite landscape rather than an actual view, contrary to most of Durand's works.[8] Ferber interprets the painting as Durand's memorializing his friend as forever standing in the gorge in the naturalistic camp, distant from his later religious cycles.[9] What is important for our purposes, however, is that the three men shared the belief that nature was a sacred, restorative place; in *Kindred Spirits* they exist in the realm of the immortals, the mountains.[10] A precursor to that seminal painting's composition and thesis is found in *Dover Stone Church*, the drawing that is the focus of this entry.

Unlike many of the artist's nature studies, *Dover Stone Church* is a fully realized, sophisticated composition. Instead of entering the pictorial space in the middle ground via distant figures, as in *Kindred Spirits*, the viewer is placed

54a

54b

into the foreground inside the spatial window. At the lower edge Durand has drawn a fallen tree trunk that functions as a bridge, complete with a rustic railing supported by three poles. This well-known device—used by Flemish painters and Italian Renaissance artists in works Durand would have known (for example, Andrea Mantegna in his *Execution of Saint James* and Giovanni Bellini in his *Transfiguration*)—visually leads the spectator into the composition. It literally bridges the gap between the viewer and the pictorial space, while lending an immediacy, almost physical in nature, to the visual experience. In his well-known letters on landscape painting published in the *Crayon* during 1855, Durand instructs the neophyte landscape painter to begin with a conception of the whole composition. "Proceed then, choosing the more simple foreground object—a fragment of rock, or trunk of a tree; choose them when distinctly marked by strong light and shade, and thereby more readily comprehended … In the tree trunk, for example, and also in the rock …

you see the application of perspective, and a demonstration of the law which governs the expression of space."[11] Durand followed his own instructions verbatim in this sheet, beginning with the foreground and progressing to the back, rendering the rocks and trees that he loved to study. As he continued to work up the composition more fully with darker applications of graphite and white gouache, he indicated more emphatically the areas of light and shade. His consummate skill in rendering broad ranges of tone, from the dense shadow of the natural cavern to the delicate hatching of the foliage, is revealed in this prophetic sheet.

1. Inv. no. 1918.85; Lawall 1966, 3:315, no. 67; and Koke 1982, 1:325, no. 634, ill.
2. Lawall 1966, 3:315–16, no. 68; and Linda S. Ferber, "Asher B. Durand, American Landscape Painter," in Ferber 2007, 154, pl. 53, whose panoramic format was an innovation on the Claudian tradition and was praised for its "exceeding truth."
3. For a related oil study formerly at M. Knoedler and Co., New York, see Lawall 1978, 184, no. 388, fig. 231, and for the painting, see John K. Howat et al.,

American Paradise: The World of the Hudson River School, exh. cat. (New York: Metropolitan Museum of Art, 1987), 107–8, ill.

4. See Ferber, "Asher B. Durand: American Landscape Painter," in Ferber 2007, 154, who points out Durand's acquaintance with Alexander Jackson Downing and his aesthetic theories concerning the therapeutic power of landscape design, citing Kenneth Blair Hawkins, "The Therapeutic Landscape: Nature, Architecture, and Mind in Nineteenth-Century America" (Ph.D. diss., University of Rochester, 1991).
5. Hudson River Museum 1983, 33, no. 26; Wilton and Barringer 2002, 68–70, no. 1, ill.; and Ferber, "Asher B. Durand: American Landscape Painter," in Ferber 2007, 159–61.
6. Ella M. Foshay, "Intimate Friends," in Foshay and Novak 2000, 11; and Howat et al. 1987, 108–10.
7. See Wilton and Barringer 2002, 70. Foshay, "Intimate Friends," in Foshay and Novak 2000, 32 n. 1, believes that the landscape in *Kindred Spirits* is based on *Gelyna; View near Ticonderoga*, painted twenty years earlier by Cole. See also James T. Callow, *Kindred Spirits: Knickerbocker Writers and American Artists, 1807–1855* (Chapel Hill: University of North Carolina Press, 1967), 62–69. According to Wilton and Barringer

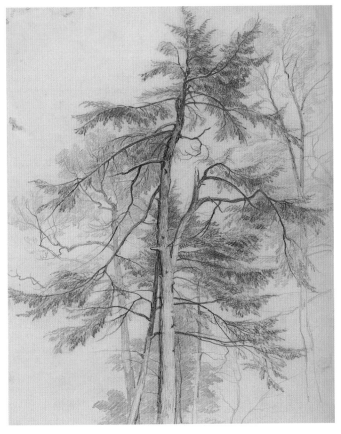

54c

2002, 71, Durand may have been the first American artist in the early 1830s to adopt a systematic practice of making studies in oil directly from nature. He seems to have abandoned the practice until 1844, when he took it up again, possibly as a result of reading C. R. Leslie's *Memoirs of John Constable* (1834).

8. Myers 1987, 70.

9. Ferber, "Asher B. Durand: American Landscape Painter," in Ferber 2007, 161.

10. For mountains, long the abode of gods in mythology, in American paintings, see Olson 2003.

11. Durand, "Letter III," *Crayon* 1:5 (31 January 1855): 66. In the first issue of the *Crayon*, William Cullen Bryant, in his essay "The Landscape Element in American Poetry," *Crayon* 1:1 (3 January 1855): 3, noted: "In landscape we generally begin with foregrounds, and the poet, as the painter, should paint them well before he goes further."

Asher Brown Durand

54a. *Study of Trees and Rocks, Catskill Mountains, New York*, c. 1849

Graphite on gray-green paper; 14 × 9 7/8 in. (356 × 251 mm), irregular
Verso inscribed at lower right in graphite: *Catskill*
Provenance: Descent through the artist's family.
Bibliography: Lawall 1966, 3:317, no. 74, fig. 103H; Jo Miller, *Drawings of the Hudson River School, 1825–1875*, exh. cat. (Brooklyn: Brooklyn Museum of Art, 1969), no. 47, ill.; Koke 1982, 1:328–29, no. 658, ill.; Harvey 1998, 130, fig. 63; Lee A. Vedder, "Heeding the Call of Nature," *New-York Journal of American History* 65:4 (2004): fig. 6.
Gift of Miss Nora Durand Woodman, the artist's granddaughter, 1918.67

54b. *Study of Four Tree Trunks (Three Birches)*

Graphite on beige paper; 12 1/2 × 9 5/8 in. (317 × 244 mm), irregular
Provenance: Descent through the artist's family.
Bibliography: Lawall 1966, 3:361, no. 307; Koke 1982,

1:373, no. 912; Hudson River Museum 1983, 80–81, no. 108, fig. 40; Foshay and Novak 2000, 57, 61, ill.
Gift of Miss Nora Durand Woodman, the artist's granddaughter, 1918.325

54c. *Study of Trees, Catskill Mountains, New York*, c. 1848–49

Graphite on gray-green paper; 14 × 10 in. (356 × 254 mm), irregular
Inscribed at lower right in graphite: *Catskill Mnts. / Set*; verso inscribed at center: *10*
Provenance: Descent through the artist's family.
Bibliography: Lawall 1966, 3:317, no. 75; Koke 1982, 1:326, no. 641.
Gift of Miss Nora Durand Woodman, the artist's granddaughter, 1918.83

Since his art celebrated nature above everything else, one can understand why Durand admonished artists to study nature directly and to learn to paint landscape before studying the work of great artists.[1] For Durand, tree studies represented the ultimate expression of his desire to explore nature firsthand, to express the ideal through the real. Trees, an age-old fertility symbol, were Durand's obsession, the virtual hallmark of his work, embodying his reverence for nature as a manifestation of the divine.

During his restorative summer forays into the mountains, notably the Adirondacks and the Catskills, the artist made numerous detailed sketches of individual trees and arboreal groups in graphite and oil (hundreds in the N-YHS alone). The triptych of plein air studies explored in this entry reflects a Ruskinian emphasis on botanical details and crispness. Durand drew them not only to gain an understanding of arboreal structures and forms but also for later reference in the studio.[2] Collectively they demonstrate one of the most important lessons the artist gleaned from his association with Cole: the need to learn the distinguishing characteristics of nature's forms in order to paint with confidence in the studio. Durand knew that from his tree studies (what he called "exemplars") and the knowledge resulting from them he could create an entire forest.[3] Not surprisingly, each of these three tree studies finds echoes in Durand's later oil sketches or finished paintings, underlining their essential role in his creative process.

Trees were one of Durand's favorite motifs for a number of reasons. Certainly they afforded

him the opportunity to use line as an expressive entity, varying its width, darkness, and rapidity to capture contour and movement as well as light and shade. During his years as an engraver, he had carefully honed the draftsmanship and linear skills he employed so dexterously in these studies. It is clear that drawing was Durand's forte and his basic artistic activity, a conclusion supported by a comment Caroline (cat. 52) wrote to her brother John: "Pa can't make his color work well at all, and consequently has gone to making sketches instead of studies much to his disappointment."[4]

The artist also wrote eloquently on the topic of his preferred subject matter. In his important nine letters on landscape painting, published in the *Crayon* during 1855 and often considered a progressive manifesto of landscape practice, Durand states exactly how significant he considers these sentinels of nature.

Form is the first subject to engage your attention. Take pencil and paper, not the palette and brushes, and draw with scrupulous fidelity the outline or contour of such objects as you shall select, and, so far as your judgment goes, choose the most beautiful or characteristic of its kind. If your subject be a tree, observe particularly wherein it differs from those of other species; in the first place, the termination of its foliage, best seen when relieved on the sky, whether pointed or rounded, drooping or springing upward, &c, &c; next mark the character of its trunk and branches, the manner in which the latter shoot off from the parent stem, their direction, curves, and angles. Every kind of tree has its traits of individuality—some kinds assimilate, others differ widely—with careful attention, these peculiarities are easily learned and so, in a greater or less degree, with all other objects. By this course you will also obtain the knowledge of that natural variety of form, so essential to protect you against frequent repetition and monotony. A moment's reflection will convince you of the vital importance of drawing, and the continual demand for its exercise in the practice of outline, before you begin.[5]

Amplifying his thoughts, he explains how to obtain the structure and detail he has captured in these three sheets:

Take a tree, for instance: with its infinity of leafage, you perceive at once that direct imitation is impossible; that is, such an imitation of its foliage as you produce of its trunk, or of the rock beneath, for to that effect each leaf must be defined as far as seen, or, at least a great portion of them, and with the same precision with which you express the scoring of its trunk. You are then to *represent* this foliage in every essential characteristic … . To do this, some analysis of its structure is necessary. In the first place, it presents you with form, and mass, so far like a solid object, which it is not, and herein is your greatest difficulty; it is open and permeable, and in a measure transparent, so that you see its nearer surface, and through that its central portions and opposite limit. If you attempt to portray it by the usual process for rounded objects—its local color in the great mass of light and natural gradation into the shade of its receding surface—you will only have the effect of a solid object. You must do much more than this.[6]

Lawall believes the dead tree trunk at the lower right of *Kindred Spirits* is similar to the dead trunk in catalogue 54a.[7] Yet the other trees in the drawings of the triptych (b and c), both of which Durand assuredly rendered around the same time, also resemble trees in *Kindred Spirits* and other landscapes by the artist. They demonstrate how he utilized these intensive direct studies from nature for his studio compositions. His drawings from the summer of 1849, made in Newburgh and Catskill, display this sense of structure and integration with the landscape. In catalogue 54a, Durand has emphasized the propensity of pines to take hold on a steep slope between the rocks, their trunks growing upward at a nearly ninety-degree angle to the ground.[8]

Similarly, the trees of the central sheet (cat. 54b), drawn from a closer vantage point, resemble an arboreal group in an oil sketch in the collection by the artist of about 1855–57.[9] Durand often concentrated on specific portions of trees to perfect his skills. In this work, he focused on their trunks, cropping other parts of the trees to create an attractive composition and masterfully rendering the contrasts of light and dark in their crisply textured bark. The three trees on the left are probably paper birches, while the one on the right is a big-tooth aspen.[10]

Catalogue 54c, which Durand delineated in two shades of graphite, contains additional evidence of his working process, both of his hand (the technical process) and of his mind (the intellectual progression). At the upper left the artist sharpened his graphite in swirling coils, while with his inscription at the right he indicated that the sheet belongs to a "set" of studies on his arboreal obsession.

1. Durand, "Letter I," *Crayon* 1:1 (3 January 1855): 2: "Yes! go first to Nature to learn to paint landscape, and when you shall have learnt to imitate her, you may then study the pictures of great artists with benefit … . I would urge on any young student in landscape painting, the importance of painting direct from Nature as soon as he shall have acquired the first rudiments of Art."
2. John Ruskin articulated a more formal expression of beliefs about studying from nature similar to those of Durand in his influential *Modern Painters* (1843–60).
3. Paraphrased from Harvey 1998, 130.
4. Caroline Durand to John Durand, 9 August 1856, West Campton, Durand Papers, The NYPL.
5. Durand, "Letter II," *Crayon* 1:3 (17 January 1855): 34.
6. Durand, "Letter V," *Crayon* 1:10 (7 March 1855): 146.
7. Lawall 1966, 3:317, no. 74.
8. See Harvey 1998, 130, no. 10, ill., for a related oil sketch also in the N-YHS collection (inv. no. 1932.49); see also ibid., 142–43, no. 16, ill., for Daniel Huntington's (cat. 87) portrait of Durand at an easel *en plein air* painting an oil sketch of trees. Ironically, the sketch is a reduced copy of the studio version (1857; The Century Association, New York).
9. Inv. no. 1887.8; see Koke 1982, 1:340–41, no. 697, ill.
10. Hudson River Museum 1983, 80.

JOSEPH BEEKMAN SMITH

New York, New York 1798–Camden, New Jersey 1876

A marine and townscape painter, Joseph Beekman Smith spent most of his life in New York City. In its directories for 1823–24, he is listed as a cork cutter, while in 1828 he is listed at 63 Fulton Street with Peter C. Smith, perhaps a brother, a printer who ran a bookstore at the same address. This skeletal information suggests that Joseph Smith went from cutting cork to becoming a painter and working with printmakers. This conclusion is supported by the collaboration of the two Smiths on a preparatory painting and/or drawing for an aquatint of the John Street Methodist Church (First Episcopal Methodist Church) in New York City, engraved by John Hill (cat. 24). It was reproduced as the frontispiece to *A Short Historical Account of the Early Society of Methodists, Established in the City of New York in the Year 1763* (New York: J. B. and P. C. Smith, 1824) and as an independent print on heavy paper. Joseph Smith also executed an oil painting of John Street that included the church (1817; John Street Methodist Church, New York) as well as other works representing its three successive structures (see below).

Joseph Smith's interest in the John Street Methodist Church suggests that the artist was an ardent Methodist. Indeed, his father Joseph B. Smith Senior, was a founder and trustee of the John Street church from 1790 to 1840; an impressive tablet in his memory hangs on the wall of the present building. Although it is known that the younger Smith married Ann E. Steell and lived with their four children on Fulton Street in New York, the documentation of his life is far from complete.

In 1852 Joseph Smith and his son William S. (b. 1821) formed a partnership in Brooklyn known as Joseph B. Smith and Son, Marine Artists. It is listed until about 1861, when Joseph Smith began working on his own again (his son may have served in the Civil War). Together they painted originals for four Currier & Ives ship prints in the popular series issued in 1855—those of the clipper ships *Adelaide*, *Great Republic*, *Ocean Express*, and *Red Jacket*. During his later career Smith was known primarily as a marine painter, although he also executed caricatures that he occasionally signed "Joseph B. 'J. Cruikshank' Smith," identifying himself with the noted English caricaturist. In his later years, he was a resident of Camden, New Jersey.

Bibliography: John A. Kouwenhoven, *The Columbia Historical Portrait of New York* (Garden City, N.J.: Doubleday, 1953), 62–64; Ethel Howell, "Joseph B. Smith, Painter," *The Magazine Antiques* 67:2 (1955): 150–51; Rossiter 1962, 1:278; Arthur Bruce Moss, "Joseph Beekman Smith, Methodist Artist, and the Original Painting of the John Street Church," *Methodist History* 3:4 (1965): 30–31; Brooklyn Museum, *Brooklyn before the Bridge: American Paintings from the Long Island Historical Society*, exh. cat. (Brooklyn: Brooklyn Museum, 1982), 134; Deák 1988, 1:203–5.

55. *The Three Buildings of the John Street Methodist Church, New York City (1768–1841): Study for a Lithograph*, 1841–44

Watercolor, black ink, and graphite on paper, laid on board, overmatted; 16 1/4 × 39 1/8 in. (413 × 994 mm), irregular
Signed at middle right outside image in black ink: *J.B. Smith.*; copious additional inscriptions, some framed in etiquettes, two with a date of 1844, including at lower center below images: *Respectfully inscribed to the Trustees and Members of the* / FIRST METHODIST EPISCOPAL CHURCH IN JOHN-STREET N.YORK.
Bibliography: Stokes 1915–28, 1:344–46; 3:900, no. 146; Koke 1961, 44–46; idem 1982, 3:141, no. 2476, ill.
X.387

This trio of vignettes preserves the features of the first Methodist church erected in the United States and its two subsequent buildings. It was preparatory for a large color lithograph copyrighted in 1844 by Endicott, 22 John Street in New York, a copy of which is held by the Society's DPPAC.[1] The first view depicts the initial building, constructed in 1768. This structure is also recorded in an 1823 aquatint after a work by Joseph B. Smith and Peter C. Smith executed before its demolition in 1817, engraved by John Hill, an uncolored impression of which is in the Society's collection. The aquatint also appeared as the frontispiece to *A Short Historical Account of the Early Society of Methodists, Established in the City of New York in the Year 1763* (1824).[2] At the right in this aquatint is an earlier house, the parsonage, which partially blocks the church's facade; it also appears in the first vignette of catalogue 55. In addition to the first edifice, the triptych format of the present drawing and its related lithograph features vignettes of the second church, as rebuilt in 1817 (later demolished when the street was widened), and the present building (erected and dedicated in 1841). The latter provides a terminus post quem for the tripartite watercolor. Smith identified all three structures

in inscriptions directly beneath their respective representations. Below the three vignettes and their inscriptions are five smaller windows; four of which bear inscriptions including the names of the "old" board of trustees and the trustees of 1844. The largest, central vignette contains a scene of the Old Rigging Loft, where the Methodists held services from 1766 to 1768. Its inscription reads *The Old Rigging Loft as it now / stands 120 William Street. 1844 – / formerly Cart and Horse-Street.*

The large lithograph has a different, more vertical format with expanded text and vignettes of the 1817 structure at the top and of the two successive buildings at the lower left and right, respectively. It was popular and apparently sold at least 259 subscription copies at $5 a print.[3] A smaller lithograph depicting only the first church that L. W. A. Endicott & Co. Lith. of 59 Beekman Street in New York published in 1844 is inscribed *The First Methodist Church and Parsonage in America. / John Street New York / Church Edifice dedicated by Philip Embury 30th October 1768.* It sold for $2 a copy and had 202 subscribers.[4]

Joseph Beekman Smith also depicted the first structure that housed the John Street Methodist Church (the First Methodist Episcopal Church) in other works. One of them is a thirty-by-sixty-inch panoramic oil painting representing the south side of John Street from William to Nassau streets that includes the early edifice, which has been dated by some individuals to 1817.[5] Formerly in the collection of the Reverend Francis G. Howell of Brooklyn, today the painting belongs to the John Street Methodist Church.[6] Joseph Smith probably painted the oil based on an earlier sketch before the demolition of the first edifice and its rebuilding in 1817, perhaps with the assistance of Peter Smith (the inscription on Hill's aquatint of 1823 may refer to this oil as its preparatory work).[7] However, there is the distinct possibility that the two Smiths executed another work in preparation for the Hill aquatint and, in fact, that Joseph Smith also made an initial study or studies on the spot for this panoramic oil painting of John Street.[8] A watercolor in the MCNY, whose lettering resembles that found on the Society's watercolor, may have been preparatory for the smaller color lithograph by L. W. A. Endicott & Co. noted above; the MCNY dates its watercolor to 1841–44.[9] All these representations of the church feature differences in the architec-

Dedicated by the Revᵈ Philip Embury.

The first erected in America, Founded AD 1768.

Dedicated by the Revᵈ Nathan Bangs D.

Rebuilt 1817 and taken down to widen the Street.

Old Board of Trustees

Joseph Smith............President
Lancaster S Burling.....Secretary
Gilbert Coutant.........Treasurer
George Suckley Cen.
James Donaldson
Nicholas Schureman
Peter Vanclew
Stephen Dando
Gabriel P Disosway
Andrew C Wheeler
Josiah Johnson
Elaphalet Wheeler
Wm. C. Cleare

Respectfully inscribed to the

FIRST METHODIST EPISCOPAL

CH

This Church
The First Erected by the Methodist Society
in America was built 1768 — Rebuilt 1817
according to the time it shall be said
What has God Wrought" num 30.23

The OLD RIGGING LOFT, as it now
Stands 120 William Street 1844 —
formerly Cart and Horse-Street —

55

tural details, vantage points, and perspectives. Later, in 1868, two-thirds of Smith's oil painting of John Street was engraved in reverse on steel by Lewis [Luigi] Delnoce and published by Joseph B. Smith & Co.[10]

During the early days of New York City, the locale depicted by Smith was in Golden Hill, an area bounded by the present William, John, Fulton, and Cliff streets. The Old Rigging Loft that Smith depicted in the lower central vignette of this watercolor was on William Street near the location where the first blood of the American Revolution was shed at the Battle of Golden Hill.

Built in 1768, the John Street Church marks the earliest presence of the Methodist Society in America. Originally known as the Wesley Chapel, it represents one of the very few religious edifices that have remained in the oldest part of New

York until the present time. Its address is now 44 John Street. After meeting in homes and a rigging loft for two years, the Methodists decided to build a chapel. Their preacher, Philip Embury, designed the earliest structure based on Irish and English Methodist models that were familiar to him before coming to America. The initial building was constructed of ballast stone, and its exterior was covered in light blue plaster.[11] A carpenter by trade, Embury also built the pulpit, which still exists in the present church, the third on the site and the third edifice depicted in the Society's watercolor. In accordance with colonial laws against a building exclusively dedicated to divine worship, this early chapel included features for "domestic purposes."[12]

Visible on duty at the entrance door to this first structure in all the works by Smith is Peter

Williams, the black sexton. First a slave whose loyalist owner fled to Britain after the Revolutionary War, he was purchased by the trustees of John Street Methodist Church for £40. Working as a sexton, Williams gradually repaid the congregation for his "price," thereby gaining his freedom. He later became a prosperous tobacco merchant and in reaction to discrimination against blacks in the John Street Church used some of his wealth to establish the African Methodist Episcopal Zion Church.[13]

1. The color lithograph measures 22 5/8 × 29 3/4 in. See Stokes 1915–28, 1:344; 3:900, no. 145; Moss 1965, 31–32; and Koke 1982, 3:141.

2. The plate mark of the aquatint measures 12 3/16 × 15 3/16 in. See Stokes 1915–28, 1:344–46, pl. 43; Koke 1961, 45–47, no. 97, ill.; and Deák 1988, 1:203–4, no. 302; 2: ill. See also Moss 1965.

3. Stokes 1915–28, 1:344; however, Howell 1955, 151, states there were 231 subscribers recorded in the subscription book, now in the possession of the John Street Methodist Church.

4. It measures 12 3/4 × 17 1/2 in.; Stokes 1915–28, 1:344; 3:900, no. 147, dates it "probably shortly after 1844."

5. Moss 1965, 35, believes that due to its sophistication Smith must have painted it at a later time based on an earlier study or studies.

6. See Howell 1955, 150, ill.

7. Deák 1988, 1:204, concurs that Peter was probably Joseph's brother.

8. Today the John Street Methodist Church dates the painting 1817–40/44.

9. Inv. no. 52.100.9, 18 3/4 × 26 1/2 in. See Jerry E. Patterson, *The City of New York: A History Illustrated from the Collections of the Museum of the City of New York* (New York: Harry N. Abrams, 1978), 82, no. 96, ill., where the measurements are given as 21 × 28 in. The unpublished catalogue entry in the watercolor's

object file derives its date from Moss 1965, 30–31, which states: "Soon after the dedication of the new edifice, April 5, 1841, Joseph B. Smith made another drawing, similar to those representing the earlier buildings." Moss also states that a lithograph was prepared from this drawing for use in various Methodist histories.

10. Two impressions of the steel engraving by Delnoce are in the collection of the MCNY (inv. nos. 29.100.2158 and 55.198.1). Those images measure 10 1/4 × 17 1/2 in., and their paper 12 1/2 × 23 3/4 in.; the inscriptions include a credit for the prototype painting then in the possession of Joseph Smith, M.D., probably Joseph B. Smith's son. For this engraving, see Stokes 1915–28, 3:900, no. 148; and Deák 1988, 1:204–5, no. 303; 2: ill., as measuring 15 5/8 × 22 in.

11. Deák 1988, 1:203.

12. According to Matthew Hale Smithy, *Sunshine and Shadow in New York* (Hartford, Conn.: J. B. Burr, 1869), 467, Dutch law forbade all but Episcopal churches

to be built within the city limits. With the addition of a fireplace and a chimney, the Methodist chapel qualified as a domestic dwelling house rather than a house of worship; information in an unpublished catalogue entry in the object files of the MCNY. That file also includes more extensive histories of the church in the form of two photocopied brochures: *John Street Methodist Church: 44 John Street, New York, N.Y. 10038: Oldest Methodist Society in America, 1766–1966* (New York: John Street Methodist Church, 1966); and *The Story of Old John Street Church* (New York: Raynor R. Rogers, 1984).

13. For more information on Peter Williams, see the two brochures cited in n. 12 above as well as J. B. Wakely, *Lost Chapters Recovered from the Early History of American Methodism* (New York: Published for the Author by Carlton & Porter, 1858), 38–71; and Roi Ottley and William J. Weatherby, eds., *The Negro in New York: An Informal Social History* (New York: New York Public Library; Dobbs Ferry, N.Y.: Oceana Publications, 1967), 94–97; and Langston Hughes, Milton Meltzer, and C. Eric Lincoln, *A Pictorial History of Blackamericans* (New York: Crown Publishers, 1983), 61. For Williams's portrait in the Society's collection by an unidentified painter (inv. no. X.173), see N-YHS 1974, 2:894, no. 2275, ill.

NICOLINO CALYO

Naples, Italy 1799–New York, New York 1844

Comparatively little is known about Nicolino Calyo, but what can be reconstructed reveals a fascinating life set against the backdrop of revolutions in art and politics. Having studied at the Accademia di Belle Arti in his native city of Naples, where Wilhelm Tischbein was the director and the landscape style of Jakob Philipp Hackert was prevelant, Calyo became known for his picturesque gouaches, like those of Mount Vesuvius in the Neapolitan *veduta* tradition. Today he is best remembered for his scenes of New York City, most dramatically for his gouaches of the Great Fire of 1835 and for his charming watercolors of urban street life and its vendors, collectively referred to as "The Cries of New York."

Although he reportedly descended from minor Calabrian nobility, he took an active role in the widespread, failed rebellion of 1820 against the oppressive rule of the Bourbon king of Naples, Ferdinand IV. Forced to flee along with many of his compatriots and members of the revolutionary Carbonari—the secret society devoted to freedom from persecution, named for its origin among the poor charcoal burners of southern Italy, which led to the Italian nationalist movement—Calyo resumed his artistic career while traveling widely in Europe. Works he exhibited in Baltimore in 1835 suggest that he visited Rome, Athens, Paris, Palermo, Granada, and Gibraltar. By 1829 Calyo had settled briefly in Malta, where he probably remained, having befriended the British governor of the island, Lord Ponsonby, until 2 July 1832, when his third child was born. From Malta he moved to Spain, where his father held a position at the court of the Neapolitan-born Queen Christina. Calyo departed Spain in June 1833, shortly before the death of King Ferdinand VII and the Carlist rebellion. He then headed to America by way of the Canary and Cape Verde islands. By 31 August 1834 he is documented in the United States with a receipt he signed acknowledging payment for a gouache depicting the house built by a Dutchman in the outskirts of Baltimore, owned since 1815 by Dr. Thomas Edmonson (*View of Harlem*, The Henry Francis du Pont Winterthur Museum, Winterthur, Del.). During the spring of 1835 Calyo exhibited several large-scale paintings of mostly European subjects. None of these works is known to be extant, although they were highly acclaimed in the press. In June 1835 he departed for Philadelphia and then New York, to "enlarge his collection with two additional paintings of the great and increasing emporiums of American Commerce and Wealth" (quoted from the *Baltimore Republican*, 16 June 1835). New York City became the artist's permanent home, where, except for two alleged trips to Spain, he remained until his death.

Soon after his arrival in New York, the Great Fire of 16–17 December 1835 raged through the city. From Calyo's observations and sketches of the catastrophe, by night and day and from both inside and outside Manhattan, he produced at least twenty-two views of this sensational conflagration in the months and years following the event. They can be divided into four groups: nocturnal views depicting the burning of the Merchants' Exchange; morning views showing the aftermath of the fire from Exchange Place; Manhattan burning by night as seen from across the bay in Brooklyn and Williamsburg; and Manhattan still smoking in the morning after the conflagration viewed from Brooklyn. His particular fascination with fire scenes dates back to his early days in Naples, where after 1769 the French painter Pierre-Jacques Volaire painted and successfully marketed scenes of the eruptions of Vesuvius. Countless artists followed in his wake, including Calyo and a multitude of anonymous *vedutisti* catering to the Grand Tour market who repeated these dramatic nocturnal pyrotechnics in vivid gouache.

In addition to his taste for scenes of fires and explosions, Calyo rendered views in gouache of Baltimore, Philadelphia, and Niagara Falls, as well as the Bay of Naples with an American ship in its harbor, and the city of New York and its harbor, all indebted to the Neapolitan tradition in that medium. With other members of his family he also worked as a scene painter, designing a diorama of the Mexican War (1847) and a moving panorama of the Connecticut River (1850). His more unusual subjects encompass paintings with a handful of figures and a balloon ascension (The Maryland Historical Society, Baltimore). Calyo belonged to the group of émigré painters in nineteenth-century New York whose concern for local color and genre scenes helped to generate a new American interest in everyday subjects.

The major sources for documenting Calyo's career are newspaper accounts published during his lifetime and the New York directories. He was listed for the first time in 1836–37 in the directories as a "professor of drawing" at 402 Broadway, the same address he inscribed on another of his gouache views of the Great Fire of 1835 in the Society's collection, the one taken from Williamsburg. His various addresses and vocations demonstrate that he moved uptown with the city's growth (his last address is 120 East Twenty-first Street).

Other than the British-born printmaker William James Bennett (cat. 41), who engraved and reproduced in aquatint four of Calyo's scenes of the Great Fire, Calyo is not known to have associated with many artists. The renowned silhouette artist Augustin Édouart (cat. 46), however, executed a stunning silhouette of Calyo sketching (The Metropolitan Museum of Art, New York), while Calyo rendered two gouaches after a panorama of New York Harbor by Robert Havell Jr., the engraver of John James Audubon's *The Birds of America* (cats. 42 and 43). His social contacts seem to have centered on the Italian community, and he reportedly made his home a sanctuary for refugees from the Continental revolutions. For example, Louis Napoleon, the future Napoleon III of France, was in exile in New York in 1837 and was frequently Calyo's guest. In the early 1850s he entertained the Italian patriot Giuseppe Garibaldi during his celebrated American tour. Calyo's family-oriented life included his wife of over fifty years, Laura, whose obituary in *L'Eco d'Italia* (19 February 1881) described her as "distinguished." Calyo supplemented his income as a restorer of art and was a connoisseur of old master paintings as well as a collector. The connoisseur and print collector Shearjashub Spooner wrote: "The author knows of no man more competent to judge of the authenticity of paintings, by what masters they were executed, and to restore them when injured than his friend, Signor Nicolino Calyo, … an accomplished scholar, a skillful artist, a true connoisseur; … and … an honest man." Calyo's house was reported to have been "a museum of curiosities … rare engravings, etchings, copies of old masters and relics of almost every part of the world." He is buried at Calvary Cemetery in Woodside, Queens, New York.

Bibliography: S. Spooner, *A Biographical History of the Fine Arts New York* (New York: Leypoldt and Holt, 1867), 1:xxii; "Obituary: Nicolino Vicompte di Calyo," *New York Daily*

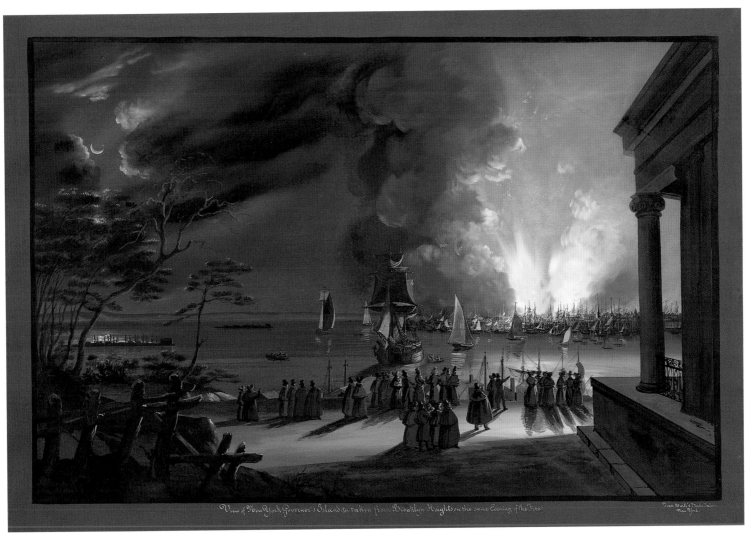

View of New York Governor's Island &c. taken from Brooklyn Heights on the same Evening of the Fire. From Atwill's Music Saloon / New York.

56

Tribune, 14 December 1884, 2; Margaret Sloane Patterson, "Nicolino Calyo and His Paintings of the Great Fire of New York, December 16th and 17th, 1835," *American Art Journal* 14:2 (1982): 4–22; Nancy Cochran, "Costumes of the Orders of the New Metropolis: A Study of Nicolino Calyo and the Nineteenth-Century Street Cries of New York" (M.A. thesis, Hunter College, The City University of New York, 1999).

56. *The Great Fire of 1835: View of New York City Taken from Brooklyn Heights on the Same Evening of the Fire*, c. 1835

Gouache on heavy paper, laid on Japanese paper, wrapped over board;[1] 20 1/8 × 27 3/16 in. (512 × 690 mm), irregular
Inscribed at center below image in pink gouache: *View of New York, Governor's Island &. taken from Brooklyn Heights, on the same Evening of the Fire.*; at lower right outside image in white gouache: *From Atwill's Music Saloon / New York.*
Provenance: Robert Fridenberg, New York, 1935.
Bibliography: Koke 1982, 1:130–31, no. 281, ill.; Patterson 1982, 17, fig. 17.
Purchased by the Society, 1935.167

The Great Fire of 1835 broke out on the night of 16 December 1835 and raged for more than fifteen hours. On what was reportedly the coldest day in New York City in thirty-six years, the temperature dropped to seventeen degrees below zero. Not only the river but most of the hydrants, cisterns, and wells in the city were frozen, making efforts to combat the fire almost useless. Starting in a dry-goods and hardware store, the Great Fire was one of the most disastrous in the history of the city. By the time the fire was brought under control, nearly seven hundred buildings had been destroyed in the area bounded by Wall Street, South Street, Coenties Slip, and Broad Street. The conflagration razed virtually all that remained of the old colonial city, which had survived earlier catastrophic conflagrations in 1776 and 1778. In all, nearly $20,000,000 worth of choice business property was destroyed within a fifty-two-acre area, most of the downtown business district.

Its magnitude is best described by Philip Hone, one of New York's most distinguished citizens and its mayor from 1825 to 1827. In his diary entry for 17 December 1835, he remarked:

How shall I record the events of last night, or how attempt to describe the most awful calamity which has ever visited these United States? … I am fatigued in body, disturbed in

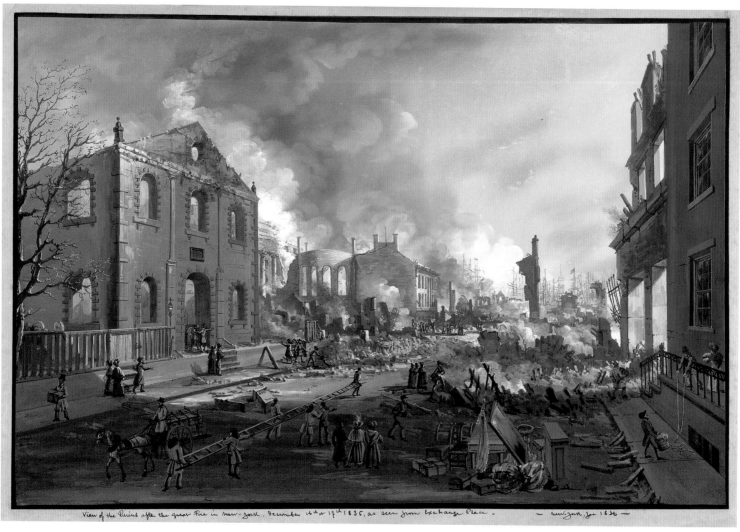

View of the Ruins after the great Fire in New-York, December 16th & 17th 1835, as seen from Exchange Place. — New-York, Jan. 1836 —

mind, and my fancy filled with images of horror which my pen is inadequate to describe. Nearly half the first ward is in ashes. The fire broke out at nine o'clock last evening…. When I arrived at the spot the scene exceeded all description; the progress of the flames, like flashes of lightning, communicated in every direction, and a few minutes sufficed to level the lofty edifices on every side. The buildings covered an area of a mile square … filled with merchandise, all of which lie in a mass of burning smoking ruins rendering the streets indistinguishable.[2]
New York's insurance industry staggered under these losses. A short time later, banks suspended payment, resulting in many bankruptcies. The general inability of volunteer firefighting units

to contain the blaze led the Board of Assistant Aldermen to urge a reorganization of the Fire Department, rewriting of the building codes, and the development of the Croton Water System for an improved water supply.[3]

Calyo made a specialty of gouache renderings of the fire,[4] having exported the technique capable of expressing spectacular light effects to New York, where he virtually cornered the market. The Society owns five gouaches by Calyo of this fire, including three nocturnal views where it rages out of control and two diurnal scenes of the smoldering ruins left in its wake (cat. 57).[5] He based these gouaches on sketches that he made on the spot.[6]

The inscription at the lower right of this sheet refers to a music store operated by Joseph F. Atwill, listed in the New York directories first

at 137 Broadway (1833–34), then at 201 Broadway (1834–49), and finally at 300 Broadway (1849–50), moving uptown with the growth of the city.[7] This inscription attests to the authenticity of the work that is known in another version.

Patterson believes the Society's gouache was the earliest in this third group of Calyo's fire scenes drawn from Brooklyn or Williamsburg.[8] The artist rendered New York Bay bathed in the red glow of the fire reflected on the water that dims the crescent moon, punctuated by silhouetted trees and spectators in the foreground witnessing the conflagration. At the far right Calyo included a Greek Revival building with an Ionic portico to provide a dramatic spatial element that links the viewer with the scene and provides a symbolic architectural contrast to the

destruction across the bay.[9] A closely allied daylight view in the Metropolitan Museum of Art, which Patterson places in her fourth group, contains a similar portico at the right and has nearly identical measurements. Calyo did not conceive it as a pendant,[10] although he sometimes executed his scenes of the Great Fire of 1835 in pairs representing the nocturnal fire and its diurnal aftermath. The pendant to the present work is another gouache in the Society's collection with a similar inscription citing Atwill's, similar measurements, and an identical original frame as well as provenance.[11]

1. At one time the sheet was laid on canvas.
2. Philip Hone, *The Diary of Philip Hone, 1828–1851*, ed. Allan Nevins (New York: Dodd, Mead and Company, 1927), 1:185–88.
3. Ramirez 2000, 92.
4. For the Italian gouache tradition, see Giulio Briganti, *The View Painters of Europe* (London: Phaidon Press, 1970); Castel Sant'Elmo, *All'ombra del Vesuvio: Napoli nella veduta europea dal Quattrocento al Ottocento*, exh. cat. (Naples: Electa, 1990), esp. 245–300; and Ian Jenkins and Kim Sloan, *Vases and Volcanoes: Sir William Hamilton and His Collection*, exh. cat. (London: Published for the Trustees of the British Museum by the British Museum Press, 1996).
5. The others are inv. nos. 1935.166, 1926.78, 1980.53, and 1980.54 (cat. 57); for the first two, see Koke 1982, 1:129–32, 132, nos. 280 and 282, ills. The N-YHS owns twenty-eight works by Calyo, including twenty-one "Cries" (cat. 58) and two views of New York, in addition to the five gouaches of the Great Fire. The Society also has a variant of inv. no. 1926.78 of the Great Fire by Calyo's nephew Louis Taffien (inv. no. 1962.83), signed and inscribed in Spanish; see Koke 1982, 3:173–74, no. 2554a, ill.
6. Some of Calyo's other gouaches are more decorative and resemble the wallpapers that were all the vogue, produced by gouache artists in France and Italy; see Odile Nouvel-Kammerer, *Papiers peints panoramiques*, exh. cat. (Paris: Musée des Arts Décoratifs/ Flammarion, 1990), esp. 310–11, nos. 79 and 80, ills.
7. Patterson 1982, 17 n. 37, believes the piano warehouse and sheet music establishment's building also housed Calyo's first studio in New York, but that he occupied it too late for a listing in the 1835 city directory.
8. Ibid., 16–17. The other, slightly smaller, reproduced as her fig. 16, is in a private collection.
9. Patterson (ibid., 16 n. 36) suggests the building fragment may represent part of one of Underhill's Colonnade Buildings, completed between 1837 and 1839 on Columbia Heights near Middagh Street in Brooklyn.
10. See ibid., fig. 18; and Avery et al. 2002, 296, no. 34, ill.
11. Inv. no. 1935.166; Koke 1982, 1:129–30, no. 280, ill. (with a windmill).

Nicolino Calyo

57. *View of the Ruins after the Great Fire of New York, 16 and 17 December 1835, as Seen from Exchange Place, New York City*, 1836

Gouache on heavy paper, laid on a larger sheet; 16 9/16 × 24 in. (420 × 610 mm)
Inscribed and dated below image on second sheet in brown ink: *View of the Ruins after the Great Fire in New-York, December 16ᵗʰ & 17ᵗʰ 1835, as seen from Exchange Place. – New-York, Jan 1836 –*
Provenance: The Market, Paris; Old Print Shop, New York; J. William Middendorf II, New York; Kennedy Galleries, New York, 1979.
Bibliography: Patterson 1982, 15, fig. 10; Voorsanger and Howat 2000, 582, no. 111, ill.
Thomas Jefferson Bryan Fund, 1980.54

One of Calyo's specialties was the Great Fire of 1835 and the devastation it wreaked on New York City (cat. 56), frequently rendered in pairs, as is the case with the present sheet and its pendant with an identical provenance. Whereas this diurnal gouache features the aftermath of the fire with the smoking city in ruins, its nocturnal pendant depicts the south side of Wall Street being engulfed in flames.[1] Its pendant also includes the Fulton Fire Insurance Company office to the right of the old Merchants' Exchange, a reminder that more than half of the fire insurance companies in New York were wiped out by the conflagration. The daytime scene reveals the extent of destruction along Exchange Place looking east, with the still-standing facade of the old Garden Street Dutch Reformed Church on the left, its entrance protected from looters by guards. Calyo's gouache is the only contemporary representation of the significant church, as rebuilt in 1807. It was in the belfry of this building that the cornerstone of the old church in the fort (cat. 3) had been preserved; it perished in this fire.[2] In his diary, Philip Hone, the former mayor of New York, enlarges on the great loss from the fire in this location: "The Exchange and the church, from being considered out of reach of danger, were made the receptacles of an immense amount of valuable dry goods, all of which were consumed."[3]

In contrast to the dramatically high vantage point and pandemonium of its nocturnal pendant, Calyo painted his day view from ground level, a point of view that adds to the desolation,

once again captured by Hone in his diary entry for 19 December: "I went yesterday and to-day to see the ruins; it is an awful sight. The whole area from Wall Street to Coenties Slip, bounded by Broad Street to the river … are now a mass of smoking ruins. Nineteen blocks are destroyed, and an estimated total of 674 buildings."[4]

The media and style of this pair are indebted to the Neapolitan specialists in gouache *vedute*, testifying to the artist's youthful training, while the picturesque details and perspective suggest his experience as a set designer. Calyo's freely applied, virtuoso brushstrokes capture the confusion of the population amid the smoldering ruins, with firemen, rescued objects, and the city's life rhythm in shock. The rosy tones in the sky preserve echoes of the previous night's raging flames.

Together with its pendant (see n. 1), the work was engraved by the master printmaker William James Bennett (cat. 41) and published as popular hand-colored aquatints by Lewis P. Clover in New York City (1836).[5] The pair's dimensions, compositions, coloring, and details are nearly identical to their corresponding aquatints, underlining the fact they served as the models for the prints.

As was his custom, Calyo also executed other versions of both the nocturnal and diurnal views, frequently in pairs and all with variations. Another version of the nocturnal Merchants' Exchange scene in the MCNY is signed and inscribed as having been painted on the spot; it also shows the artist at work on the roof of the Bank of America building,[6] whereas in the Society's version, the pendant to the present work, he stands pointing at the fire while talking to his companion who is standing on a ladder. Another pair of smaller gouaches, location unknown, was once in the collection of J. P. Morgan, the financier.[7] A third pair (both dated 1837), again in a smaller format, their horizontal measurements proportionally shorter than the other sets, was once in the J. William Middendorf II collection and was exhibited at the Metropolitan Museum of Art and the Baltimore Museum of Art in 1967.[8] This third pair has most recently been published as being in the Richard Dietrich collection.[9] In addition, there are nocturnal and diurnal views that most likely once had mates, testimony not only to the popularity of the subject but also, despite the

multiple prints available, to the demand for Calyo's original gouaches, each of which offers unique anecdotal details and differing points of view.[10] Calyo also included versions of the Great Fire of 1835, along with views of New York Harbor, in his "Cries" series (cat. 58).

1. Inv. no. 1980.53, 16 7/16 × 24 in. For *View of the Great Fire of New York December 16 and 17, 1835, as Seen from the Top of the New Building of the Bank of America, Corner of Wall and William Streets, New York City*, 1836, see Patterson 1982, 8, fig. 5; and Voorsanger and Howat 2000, 582, no. 110, ill. Its detailed background appears as though painted with a magnifying glass. Calyo rendered amazing effects, for example, light shining through the water being poured on the flames, spectators using spyglasses to shield their eyes, and firefighters heroically battling the flames.

2. Stokes 1915–28, 3:618. The original church on the site was built in 1692 on what was then Church Street. Subsequently, the street name was changed to Exchange Place. It still exists just south of Wall Street.

3. Hone 1927, 1:188.

4. Ibid., 190–91.

5. For the two hand-colored aquatints with nearly identical dimensions, whose original copperplates and other impressions are also in the Society's DPPAC, see Stokes 1915–28, 3:617–18, pls. 114-a and b; Patterson 1982, figs. 6 and 11; and Deák et al. 1988, 81–82, nos. 31 and 32, who on p. 82 quotes the publisher's advertisement: "These beautiful ruins are fast disappearing, and in a few months no vestige of them will be left: in a few years, they will linger as a dream in the memory of the present generation, and the recollection of the most disastrous fire that ever befell this city, will, like all earthly things, pass into oblivion."

6. Inv. no. 52.100.7, 12 7/8 × 20 1/4 in.; see Patterson 1982, fig. 9; and Ramirez 2000, 92–93, no. 11, ill. (with mistaken measurements).

7. Patterson 1982, fig. 7, reproduces the nocturnal scene, also illustrated with its pendant in *The Magazine Antiques* 46:6 (1944): 352, figs. 1 and 2 (courtesy of Douglas Curry, 12 1/4 × 19 1/4 in.). Patterson 1982, 15, believes her fig. 12 (without measurements) was the diurnal view of Morgan's pair. It is, however, yet another version whose nocturnal pendant, with the same provenance, is most likely reproduced as her fig. 8 (12 3/4 × 19 in.; see n. 10 below).

8. Metropolitan Museum of Art, *American Paintings and Historical Prints from the Middendorf Collection*, exh. cat. (New York: Metropolitan Museum of Art, 1967), 17a and b, ills. (11 1/4 × 15 1/2 in.). The daylight scene was reproduced in *Art Digest* 20:12 (1946): 21; both are also recorded in *The Kennedy Quarterly: Early American Views, 1700–1880* (New York: Kennedy Galleries, 1963), 197, nos. 311, ill., and 312.

9. See Patterson 1982, 4, figs. 1 and 13.

10. For others, see ibid., 10, fig. 8, in a private collection, reproduced courtesy of Kennedy Galleries (12 3/4 × 19 in.) (see n. 7 above); 13, fig. 12, location unknown, courtesy Kennedy Galleries (without measurements).

Nicolino Calyo

58a. *The Strawberry Girl*, c. 1840–44

Watercolor and graphite with touches of gouache on paper, formerly bound into an album; 14 7/8 × 10 3/8 in. (378 × 264 mm)
Inscribed at the lower center in brown ink: *The Strawberry Girl*; at lower left margin vertically in graphite: *33*
Provenance: Mr. and Mrs. Richard Leech, London.
Bibliography: Cochran 1999, 210.
Thomas Jefferson Bryan Fund, 1980.25

58b. *The Auctioneer in Public Streets*, c. 1840–44

Watercolor, graphite, and gouache on paper, formerly bound into an album; 10 3/8 × 14 3/4 in. (264 × 375 mm)
Inscribed at the lower center in brown ink: *The Auctioner* [sic] *in public streets*; on wall at upper left: *CHATAM* [sic] *Square / 102*; at lower right margin in graphite: *15*; various other fragmentary inscriptions on banners
Provenance: Mr. and Mrs. Richard Leech, London.
Bibliography: Cochran 1999, 210.
Thomas Jefferson Bryan Fund, 1980.34

This pair belongs to a watercolor series of occupational portraits and scenes, whose subject matter is frequently referred to as "The Cries." Traces of binding on the left borders indicate that the group was once bound into an album that contained depictions of small-time New York City street vendors and genre scenes, together with several city views and landscapes. As with his gouaches of the Great Fire of 1835 (cats. 56 and 57), Calyo repeated these vignettes serially during the 1840s. To date two other watercolor and gouache sets, most likely once also bound into albums, have been identified and partially reconstructed. While many of the figures and scenes are the same, minor variations abound among the versions, and some of the vignettes are unique. All three sets may be fragments of even larger series that all relate to a group of fifteen engravings after Calyo bound with a cover dating from 1846. The majority of the watercolors in the three series are in the Yale University Art Gallery, New Haven;[1] the MCNY;[2] and the N-YHS (its twenty-one vignettes are from a set originally comprising at least fifty-eight scenes).[3]

For over five centuries various sets of "Cries" have recorded images of urban culture and its itinerant street vendors and tradesmen. Their origins can be traced back to the seventeenth-century Bolognese genre tradition of Annibale Carracci, although street criers were a fixture of ancient urban life.[4] When issued in small books or pamphlets, "The Cries" also featured texts of varying lengths. For his "Cries," Calyo followed established European and American precedents, but he was also heavily influenced by the contemporary Italian watercolor prototypes discussed below.

The European prototypes for Calyo's watercolors encompass English and French examples.[5] English precedents date back to the seventeenth-century artist of French-Dutch heritage Marcellus Lauron (Laroon), whose representations, including a woman selling strawberries, were engraved and published in a series of editions beginning in 1688 (*The Cryes of the City of London*).[6] During the eighteenth century, artists such as Thomas Rowlandson, Thomas Francis Wheatley, David Allen, Paul Sandby, and George Cruikshank documented the carnivalesque street culture of London that flourished after the fire of 1666 in their "Cries."[7] With the explosion of journalism and printing in the late eighteenth century, many other editions of "The Cries of London" were published. These small books, really pamphlets made for children, influenced nineteenth-century American editions that frequently featured more text. Interestingly, the English "Cries" were linked to early-seventeenth-century street music composed by Richard Dering—"The city cries" and "The country cries."[8] Likewise, the French "Cries" were allied to songs produced by itinerant musicians ("Les chanteurs de rues") that appeared in an illustrated edition of 1775. The apogee of the French "Cries" occurred in the 1820s with Carle Vernet's one hundred lithographic plates (*Cris de Paris, dessinés d'après nature*).[9]

One of Calyo's American antecedents is the 1808 *The Cries of New York*,[10] which was followed by other editions and the appearance of its images on decorative objects.[11] While none of the printed editions examined contains an auction scene set in the long-established place for such sales, Chatham Square—as in the examples in the three watercolor series ("The Auctioneer in the Public Streets"[12])—all feature a female

The Strawberry Girl

The Auctioner in public streets

58b

strawberry vendor, labeled above the image *STRAWBERRIES*, and below her cry, *Fine Ripe Strawberries*. Calyo's watercolor illustration of "The Strawberry Girl" finds reflection in the 1846 printed edition of "The Cries of New York," whose illustrations contain larger architectural settings for the figures and poems by Frances Sargent Locke Osgood.[13] Its engraver, Henry Harrison, illustrated the volume in a style and format quite distant from Calyo's watercolors.[14] However, Osgood's poem is the verbal equivalent of Calyo's image of the coquettish Strawberry Girl in her calico cotton gown.

"Strawberries! Strawberries! fine, ripe and red!
As your lips, little lady, that smile at the sight,"

See how the glow from that sad face has fled!
Buy—buy her strawberries! buy ere the night![15]

Without a doubt, the similar illustrations by the prolific Bolognese-born Roman artist Bartolomeo Pinelli, who also worked in Naples, strongly influenced Calyo's "Cries." Pinelli's picturesque vernacular scenes were widely circulated in watercolor albums (from 1807) and engraved series (from 1809) that were published not only in Italy but also in England and France.[16] Expanding on an eighteenth-century Neapolitan tradition,[17] Pinelli's illustrations feature street vendors and scenes in a folkloric celebration of regional customs. Their democratic media of

watercolor over graphite and the proportions of their figures resemble those of Calyo. Moreover, Pinelli's nationalistic sentiments would have appealed to Calyo, whose revolutionary republican beliefs led to his immigration to the United States. Like Calyo, Pinelli had fought against foreign occupiers of the Italian boot and espoused nationalistic ideals in proto-Risorgimento Italy.[18] In 1814 Pinelli published a series of Neapolitan *Costumi*,[19] suggesting that they were prototypes Calyo would have remembered before his flight from Italy.

In the wake of the Enlightenment and increasing urbanization, street cries expressed the intense commercial activity, ethnically mixed

populations, and material culture of international-al port cities. Along with the desire to depict the artisanal diversity of the metropolis, Calyo's "Cries" reflect a growing middle-class taste for more socially conscious images, as demonstrated in the art of William Sidney Mount (cat. 70) and Henry Inman (cat. 64, whose innovative depiction of a newsboy exhibited at the NAD in 1841 received a positive critical reception). Calyo's "Cries" reveal the diversity of New York's population following the opening of the Erie Canal in 1825 and the advent of transatlantic steam travel after 1838. His series also respond to novel social and cultural attitudes, including a respect for the self-made man, an attitude that during the 1840s helped shape a new socially conscious urban art.[20] Although they only allude to the harsher sides of city life, with its growing segregation of social classes and a large popula-tion of itinerants, Calyo's series provide a gently humorous, sympathetic view of working-class figures. They contrast with the more journalistic approaches of engravings, lithographs, and photographs. Rather than recording specific individuals, Calyo depicted types, most estab-lished in earlier "Cries," that capture yet tame the unruly complexities of antebellum New York.[21]

1. Inv. nos. 2001.71.2.1–53. A gift from the estate of Paul Mellon, fifty came from an original group of fifty-nine that was exhibited in 1931; see Kennedy and Company, *An Exhibition of Contemporary Drawings [Done in the early part of the Nineteenth Century] of Old New York and American Views at the Galleries of Kennedy and Company*, sale cat. (New York: Kennedy and Company, 1931). They were joined by three other "Cries" from another series, according to Cochran 1999, 1ff.

2. Inv. nos. 55.6.1–36. The MCNY also houses the Margaret Sloane Patterson Papers (Research Archive, Gift of Mrs. Margaret Sloane Patterson, 1994). These include the manuscript of her unpublished monograph on Calyo, replete with entries.

3. Inv. nos. 1980.22–42. A receipt of object form, dated 10 November 1980 in the Society's object files, records that Mr. Richard Leech, 67 Cadogan Square, London, offered fifty-eight "Cries," of which the Society purchased twenty-one and returned thirty-seven. The other thirty-seven are listed in Old Print Shop, *The Old Print Shop Portfolio* 41:1 (1982): 6–7. See also Cochran 1999, 209–14 (appendices with a partial reconstruction of the three watercolor series and a list of fourteen of the fifteen engravings, minus the Scissors Grinder, in which she lists fifty-three of the fifty-eight in the set offered to the N-YHS).

4. See Marguerite Pitsch, *Essai de catalogue sur l'iconographie de la vie populaire à Paris au XVIIIᵉ siècle* (Paris: A. et J. Picard, 1952); Karen F. Beall, *Kaufrufe und Strassenhändler / Cries and Itinerant Trades: Eine Bibliographie / A Bibliography*, trans. Sabine Solf (Hamburg: E. Hauswedell, 1975), 18–23; and Vincent Milliot, *Les "Cris de Paris," ou, le peuple travesti: les representations des petits métiers parisiens (XVIᵉ–XVIIIᵉ siècles)* (Paris: Publications de la Sorbonne, 1995). The Carracci "Cries" were published by G. M. Mitelli in 1660 (*Di Bologna l'arti per via d'An.ibal' Ca.raci*) and reissued.

5. See Dorothea D. Reeves, "Come Buy! Old Time Street-Sellers of London and Paris and Their Cries," *Harvard Library Bulletin* 20:2 (1972): 158–75.

6. For the set of seventy-four, see Sean Shesgreen, *The Cries and Hawkers of London, Engravings and Drawings by Marcellus Laroon* (Stanford, Calif.: Stanford University Press, 1990). They were issued through the eighteenth century. See also idem, "The Cries of London in the Seventeenth Century," *Papers of the Bibliographical Society of America* 86:3 (1992): 269–94.

7. For Sandby's *Twelve Cries of London* (1760), see Ian Jenkins and Kim Sloan, *Vases and Volcanoes: Sir William Hamilton and His Collection*, exh. cat. (London: Published for the Trustees of the British Museum by the British Museum Press, 1996), 242–49.

8. A later edition of about 1974, published in London by Stainer & Bell and in New York by Galaxy Music Corp. in five parts for voices and viols, is in the NYPL.

9. See Alfred Franklin, *Les Rues et les cris de Paris au XIIIᵉ siècle: pièces historiques publiées d'après les manuscrits de la Bibliothèque nationale et précédés d'une étude sur les rues de Paris au XIIIᵉ siècle* (Paris: L. Willen; P. Daffis, 1874); and Victor Fournel, *Les Cris de Paris; types et physiognomies d'autrefois* (Paris: Firmin-Didot, 1889).

10. Its small format (2 3/8 × 4 7/8 in.) features moralistic passages and wood engravings. It was printed by Samuel Wood, who also issued other editions and *The Cries of London* (New York, 1809–16). There was an earlier American edition of *The Cries of London, as they are daily exhibited in that city* published by A. Reed in Hartford, Connecticut, in 1807. See Michael Joseph, "The Cries of Pearl Street," *American Book Collector* 8 (1987): 3–8.

11. Motifs from the "Cries" are found on commemorative kerchiefs, on imported Staffordshire ware, and as chalkware figurines produced in America by Italian immigrant craftsmen; see Voorsanger and Howat 2000, 29, fig. 24, for a commemorative, copperplate-printed cotton handkerchief with "The Cries of New York," probably by a English manufacturer for the New York City market, c. 1815–20 (inv. no. 68.60; The Metropolitan Museum of Art, New York).

12. For a variant to the N-YHS composition in the MCNY, which differs only in the most minor details, see *Connoisseur* 90:376 (1932): 420, ill. See also Jerry E. Patterson, *The City of New York: A History Illustrated from the Collections of the Museum of the City of New York* (New York: H. N. Abrams, 1978), 120, fig. 143, showing E. Didier's oil (inv. no. 31.222.1), representing an auction or "vendue" in Chatham Square that was shown at the NAD in 1843.

13. *The Cries of New-York* (New York: John Doggett Jr., 1846). Its witty satiric verses are by Osgood, who was a member of the informal New York literati around Edgar Allan Poe. See Cochran 1999, 143.

14. The cover, or wrapper, of this chapbook with its intricate ornamental architecture is inscribed at the lower left and right, respectively: CALYO. Del. and HARRISON. Sc. The wood engraver Henry Harrison was active in New York about 1844–46.

15. *The Cries of New-York* 1846, 17. Cochran 1999, 35–36, notes that the girl's dress demonstrates the abundance of cotton in New York and indirectly acknowledges the slave trade and its relationship to the antebellum cotton industry. See Cochran 1999, fig. 10, for a variant of the N-YHS watercolor in the Yale University Art Gallery, New Haven (inv. no. 2001.71.2.1).

16. For the first extant engraved series, *Nuova Raccolta di cinquanta motivi pittoreschi e costumi di Roma*, see Giovanni Incisa della Rocchetta, *Bartolomeo Pinelli*, exh. cat. (Rome: Museo di Roma, 1956), 61–62; and Maurizio Fagiolo and Maurizio Marini, *Bartolomeo Pinelli, 1781–1835 e il suo tempo*, exh. cat. (Rome: Centro Iniziative Culturali Pantheon and Rondanini Galleria d'Arte Contemporanea, 1983), 300. This was succeeded by nearly annual publications of different *Costumi* of Italy as well as of Switzerland.

17. The Neapolitan tradition included the 1773 *Raccolta di varii vestimenti ed arti del Regno di Napoli* by Pietro Fabris (never widely known because it was not issued in large numbers) and depictions after 1781 by Fabris's pupil, the gouache artist Xavier Della Gatta. See Castel Sant'Elmo, *All'ombra del Vesuvio: Napoli nella veduta europea dal Quattrocento al Ottocento*, exh. cat. (Naples: Electa, 1990), 382–85 and 377–78, respectively; and Jenkins and Sloan 1996, 248–50, nos. 150–52, ills. Some of these images eventually decorated table services. In Venice G. Zompini also had followed Carracci's types (1753).

18. See Roberta J. M. Olson, "Bartolomeo Pinelli: An Underestimated Ottocento Master," *Drawing* 2:4 (1980): 73–78; and idem, "An Album of Drawings by Bartolomeo Pinelli," *Master Drawings* 39:1 (2001): 12–44.

19. *Raccolta di 50 costumi li più interessanti delle città terre e paesi in provincie diverse del Regno di Napoli* (Rome: Presso Lorenzo Lazzari neg.te al Corso n. 180, 1814); see Incisa della Rocchetta 1956, 77–78; and Fagiolo and Marini 1983, 301–2.

20. See William H. Gerdts and Carrie Rebora, *The Art of Henry Inman*, exh. cat. (Washington, D.C.: National Portrait Gallery, Smithsonian Institution, 1987), 131, no. 63; and Elizabeth Johns, *American Genre Painting: The Politics of Everyday Life* (New Haven: Yale University Press, 1991), 178, 184–87.

21. See Voorsanger and Howat 2000, 28.

MARY MCCOMB

New York, New York, active c. 1809–?

Little is known about the life of Mary McComb, the artist of this drawing and daughter of the architect John McComb Jr., who designed the Montauk Point lighthouse and other important landmarks in New York. When she was born, her father and mother, Elizabeth Glean Mc-Comb, lived on Washington Street in New York City, but the exact dates of her birth and death have been lost. McComb apparently showed considerable talent in art as a young woman, and the artist John Trumbull, a friend of her father's and president of the American Academy of the Fine Arts, often visited the family's home and observed Mary's work. McComb never married, remaining with her family throughout her life. At the time of her death, she had several of her own drawings in her possession, including *Montauk Point Lighthouse*. McComb's only known oil painting, a view of a massive fieldstone house overlooking a river, *A Country*

Seat (1809), is in the collection of the Wadsworth Atheneum (Hartford, Conn.) and can be traced to its original purchase from the American Academy of the Fine Arts in New York in 1842.

Bibliography: Helen A. Collingwood, McComb Family Papers, 1787–1858, Department of Manuscripts, The N-YHS; Koke 1982, 2:294–95; Kornhauser 1996, 2:553–54.

59. *Montauk Point Lighthouse, Long Island, New York*, c. 1820s

Watercolor, graphite, gouache, brown ink, and scratching-out on paper, laid on card; 14 5/8 × 22 in. (371 × 559 mm)
Inscribed and signed at lower left outside image in graphite: *Drawn by Mary McComb / Daughter to John McComb, Jr*; at lower center outside image inside of a cartouche in brown ink: *A VIEW of The LIGHTHOUSE ON / Mantock [sic] Point*
Provenance: John McComb Jr., the artist's father; Mrs. Edward S. Wilde, the artist's niece.

Bibliography: Koke 1982, 2:294–95, no. 1670, ill.
Gift of Daniel Parish Jr., 1898.3

During the eighteenth century, Montauk Point was renowned as one of the most treacherous areas of the transatlantic trade route. The rocky point projecting into the often-foggy Atlantic Ocean was the site of numerous shipwrecks, taking a heavy toll on shipping and passenger traffic to and from Europe. The South Shore of Long Island from Fire Island to Montauk offered few sheltered inlets, and the wrecks of brigs, sloops, and schooners littered the long, exposed beaches of Mastic Beach, Quogue, and East Hampton, as well as around Montauk Point. In 1781, for example, the British ship *Culloden*, pursuing the French fleet sailing out of Newport, Rhode Island, in support of the American rebellion, was damaged on the reefs and sank near the entrance to Fort Pond Bay just west of Montauk Point.

The timbers of its hull have remained visible at low tide for more than two hundred years.[1]

At the end of the Revolution, the new American government embarked on a plan to improve coastal hazards that impeded access to the principal ports of New York, Baltimore, and Philadelphia to stimulate the international trade that would allow the nascent United States to survive as an independent nation. In 1792 Congress appropriated the funds to purchase the land on Montauk Point, $255.12, with the express purpose of building a lighthouse for the safety of mariners. The initiative was authorized by President Washington in 1795, and the lowest bid for the construction, submitted by the architect John McComb Jr. (1763–1853), was accepted at $22,300.00.[2] McComb was well respected in his field after he successfully built the lighthouse at Cape Henry, Virginia, in 1791. He went on to design and construct the Eaton's Neck lighthouse on the North Shore of Long Island at Northport in 1799 and City Hall in New York City from 1803 to 1812 with Joseph F. Mangin (cat. 66).[3]

In this drawing by the architect's daughter Mary McComb, the lighthouse stands at the right against a starkly vacant sky. She conveyed the rural character of the Montauk area through the bucolic scene of cattle grazing in the rolling pastures that surrounded the lighthouse. Several ships sail safely around the treacherous reefs and shoals off Montauk Point. In 1860 the lighthouse was rebuilt and the tower increased to 108 feet, its present height. The original lighthouse keeper's house and barn, depicted below the promontory known as Turtle Hill, were demolished and replaced by the present keeper's house in 1860.[4] From 1797 through the 1850s the lighthouse burned whale oil. In the 1860s the lamp was converted to kerosene and fitted with a light-amplifying fresnel lens. In 1940 the lighthouse beacon was finally electrified.

This watercolor resembles McComb's oil painting *A Country Seat*, in which the house occupies the left side of the sheet under a cloudless sky, and a few laborers and sheep suggest a rural atmosphere. In both works McComb included a representation of a misty shore in the distance. In *Montauk Point Lighthouse*, she depicted the barely visible shorelines of Connecticut and Block Island, Rhode Island, behind Montauk Point, whereas in *A Country Seat* she showed the far bank of a great river, probably the Hudson, below the unnamed country estate.[5]

Montauk Point lighthouse stood as the American symbol of welcome for nearly a century and was frequently the first sight of the New World to greet ships at the end of the long and perilous transatlantic voyage. It represented the transition of the United States from a colonial possession to an independent trading nation, which opened its arms to millions of Europeans who saw it as the promised land. Only with the construction of the Statue of Liberty (cat. 110) during the 1880s did the Montauk Point lighthouse lose its preeminence as the symbolic beacon of welcome to America. The lighthouse tower was again extensively restored between 1997 and 1999, both to preserve the building and to return it more closely to its original appearance.
A. M.

1. See http://www.longislandgenealogy.com/lighthouse.html.
2. Ibid.
3. McComb was also noted for his designs for Alexander Hall (1815) at Princeton Theological Seminary, now Princeton University, and Queen's Building (1808–9) at Queen's College, now Rutgers University, a fine example of Federalist architecture that was recently designated a national monument; see http://ruweb.rutgers.edu/timeline/1800a.htm.
4. See http://www.montauklighthouse.com/museum.htm. By 1990 Turtle Hill had been so thoroughly eroded by storms that the lighthouse no longer appeared to sit on a hill.
5. Kornhauser 1996, 2:554, no. 328, ill.

AMBROSE ANDREWS

West Stockbridge, Massachusetts 1801–Palmyra, New York? c. 1877

Little is known about the itinerant portrait, miniature, and landscape painter Ambrose Andrews until Philip Schuyler became his patron in 1824. Andrews inscribed the Schuyler family portrait he executed (see below) with his address as Great Barrington, Massachusetts. Recent scholarship is slowly bringing his career to light; he was a painter of ambition who was only briefly at the center of the country's artistic life in New York City.

In the Empire City Andrews attended the first formal art academy in the country, the American Academy of the Fine Arts, for two months in 1824 under the patronage of Schuyler and the supervision of Alexander Anderson (cat. 30). Having exhausted his funds, he returned to Massachusetts and, on the advice of the critic William Dunlap, borrowed several books and a small statuette of the ancient Farnese-type Hercules to facilitate his independent studies. Andrews considered good draftsmanship the central skill of an artist, writing, "Excellence in drawing is the foundation of excellence in every department of the art. Drawing constitutes the basis of the art of Painting." Yearning to continue his education, Andrews petitioned Schuyler for a loan of another hundred dollars and was apparently successful, as he returned to New York the following winter. At that time he joined other artists and art students in protesting the policies of the American Academy and participated in the founding of the New-York Drawing Association, along with Thomas Cole (cats. 61 and 62) and Samuel F. B. Morse. Shortly thereafter this group spawned the NAD. In 1826 Andrews is listed among the academy's first eleven pupils, together with Asher B. Durand (cats. 51–54) and Alexander Jackson Davis (cat. 67). In 1826 he married and soon had five children; later he lamented that he should not have married before he had established himself as an artist. Within a few years Andrews was forced to become an itinerant portrait painter. Barely able to support himself, he also copied old master and contemporary paintings. In addition, he worked as a daguerreotypist and tinter of photographs, succumbing to commercialism and serving the very medium that had eroded the demand for painted portraits.

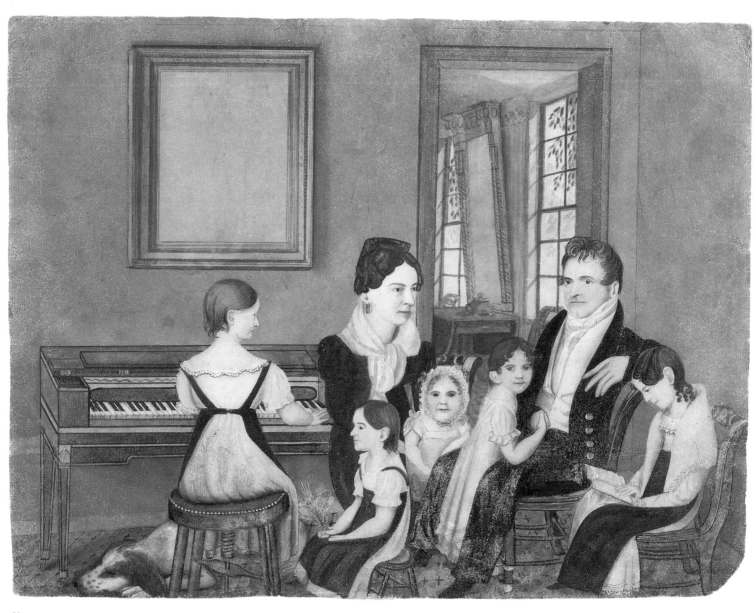

60

Andrew's geographically wide-ranging career took him to many places, including New York (1829–31 with periodic returns), Connecticut (1837), Texas (1837–41), and Louisiana (1841–42). After 1844 he was active in Saint Louis, New York City and State (Buffalo), Vermont, and Canada. Andrews exhibited widely, including at the capital of the Texas republic in 1837, the Pennsylvania Academy of the Fine Arts in 1848, the American Art-Union in 1849, the Royal Academy of Arts in London, England, in 1859, and the NAD sporadically from 1837 until 1853 (landscapes and portraits, some of them miniatures and "cabinet portraits"). Among his portraits are likenesses of Henry Clay copied after John Neagle's painting (1843; United States Capitol Collection, Washington, D.C.), Sam Houston (a miniature, untraced), and the ambitious *Children of Nathan Starr* (1835; The Metropolitan Museum of Art, New York). The artist is listed in the New York City directories for the last time in 1862, and his whereabouts remain unknown until 1869, when he settled in Palmyra, New York. He may have been associated with an art gallery that opened there in 1870, and he remained in Palmyra until at least 1875. After his early involvement with associations in New York City, Andrews never returned to the mainstream of artistic life in America.

Bibliography: Ambrose Andrews, "Letterbook of Ambrose Andrews, 1844–1856," MS 48, Thomas J. Watson Library, The Metropolitan Museum of Art, New York; Cowdrey 1943, 1:10; Groce and Wallace 1957, 759; Doreen Bolger, "Ambrose Andrews and His Masterpiece, *The Children of Nathan Starr*," *American Art Journal* 22:1 (1990): 4–19; Falk 1999, 3724.

60. *The Philip Schuyler (1788–1865) Family*, 1824

Watercolor, black ink, and graphite on beige paper; 9 3/8 × 12 in. (238 × 305 mm), irregular
Label on backing of former frame inscribed and dated in ink: *Picture painted at Schuyler / ville by a travelling artist / – Philip Schuyler / – Grace Hunter Schuyler / – Ruth – Grace / – Elizabeth – Catherine & Harriet. / artist Ambrose Andrews. 1824. Grt. Barrington*
Provenance: Elizabeth Harison, New York.
Bibliography: Nina Fletcher Little, "The Conversation Piece in American Folk Art," *The Magazine Antiques* 94:5 (1968). 746, fig. 6; N-YHS 1974, 2:708–9, no. 1826, ill.; Mayhew and Myers 1980, 116, fig. 56; Bolger 1990, 5, fig. 2; Brilliant et al. 2006, 58–59, no. 18, ill.
Gift of Elizabeth Harison, 1952.81

Andrews represented the family of Philip Schuyler in the parlor of their home in Schuylerville, New York, not far from the artist's birthplace and now part of Saratoga National Historical Park. The Schuylers were among New York's most prominent families that first settled in New Netherland about 1650 in a community that became Albany, New York, and forged an American dynasty through successful business enterprises and marriages with other well-to-do families of Dutch descent, including the Livingstons, the Van Cortlandts, and the Van Rensselaers. Upon the untimely death of his father, Philip Schuyler, the sixth-generation scion, inherited much of the family fortune at the age of seven and was raised by his grandfather. He eventually moved to New York City, where he lived with his aunt (Elizabeth Schuyler) and her husband (Alexander Hamilton) and earned an A. B. degree from Columbia College in 1806. After graduating, he married Grace Hunter (1790–1855) and turned to public service. Schuyler served as a member of the New York State legislature and as United States consul at Liverpool, England.

Andrews portrayed Philip Schuyler and his wife surrounded by their five children and their Welsh springer spaniel, symbolic of fidelity and domestic bliss, asleep under the piano. Two of the children are seated in profile looking left and do not interact with the others. Ruth Catherine (b. 1813), the eldest, reads quietly at the far right next to her father, while Grace (b. 1818), the middle daughter, sits in the foreground holding a hand-made fan of five wheat stalks, tied with a pink ribbon. Andrews depicted the second daughter, Elizabeth (b. 1815), from behind with her head in profile, playing the piano that ostensibly provides harmony and the reason for the family dynamics. He characterizes the two youngest as dependent on their parents: Catharine (b. 1821) stands between her father's legs, leaning on his lap, while the baby Harriet (b. 1823), shown frontally, sits on her mother's lap. Having had no formal training when he drew this portrait, the twenty-three-year-old Andrews took the likenesses of the family members at different sittings and inserted the individual visages into the composition as he painted them, a procedure that explains their different scales and the disjointed manner in which they interact. Other awkward passages result from the artist's lack of formal training. After Andrews completed this charmingly naïve family portrait, Schuyler rewarded him for his work by becoming his patron and underwriting his study at the American Academy of the Fine Arts in the fall of 1824.[1]

Andrews's work is related to an eighteenth-century British type of portraiture known as the "conversation piece,"[2] in which groups of individuals, usually families, are formally seated and portrayed full-length in their surroundings, either indoors or outdoors on their property. Typically they are actively engaged in conversation or a common activity, creating an intimate portrayal of family life before the advent of the camera and its ability to capture candid moments. Andrews was one of many untrained American artists who took this European source and adapted it to portray America's gentry.[3] Since music and games added to social occasions and were an integral part of daily life, they frequently animate conversation pieces. A piano was the focal point of many family musical gatherings and, therefore, was featured in the genre, as in this example, whose spinet has been identified as the best early illustration of an inlaid Hepplewhite piano.[4] Settings were important emblematic glosses to these conversation pieces. They provided evidence of the sitters' social status and prosperity and today are an invaluable source for the study of material culture. In the background of the Schuyler portrait Andrews included fascinating features of their parlor and its adjoining room, among them a simple Empire mirror over the piano, two painted "fancy"-style chairs and a stool, a gilt pier mirror, a revolving, upholstered piano stool with metal tacks, a drop-leaf table, and a pair of tall, paned windows through which leafy branches flutter in the light to create a sense of well-being.

1. In a letter dated 8 April 1825, in the Society's Department of Manuscripts, Andrews wrote to Schuyler: "I take this opportunity to express my grateful acknowledgments, for the assistance which you have given me. The fact itself of having been patronized by you has operated greatly to my advantage. When the circumstance of your assisting me is known it appears to inspire an idea of far more merit in me than I possess. When I reflect on the kind reception which I met from you, the respectable manner in which I was entertained at your residence, the felicitous manner in which I spent my time while there, your accommodating me with funds and letters of recommendation & introduction, and then the good which has already resulted to me—I say when I reflect on these favours, my bosom swells with gratitude too great to express." N-YHS 1974, 2:708–9.
2. See Mario Praz, *Conversation Pieces: A Survey of the Informal Group Portrait in Europe and America* (University Park: Pennsylvania State University Press, 1971); Ellen G. D'Oench, *The Conversation Piece: Arthur Devis and His Contemporaries*, exh. cat. (New Haven: Yale Center for British Art, 1980); and Christine Lerche, *Painted Politeness: Private und öffentliche Selbstdarstellung im Conversation Piece des Johann Zoffany* (Weimar: VDG, Verlag, und Datenbank für Geisteswissenschaften, 2006).
3. Little 1968, 745.
4. Mayhew and Myers 1980, 116.

THOMAS COLE

Bolton-le-Moor, Lancashire, England 1801–Catskill, New York 1848

America's first great landscapist and the leading figure in American landscape painting during the first half of the nineteenth century, Thomas Cole was English by birth. He had a significant influence on the country's first fraternity of painters, the Hudson River School, among them Jasper Francis Cropsey (cat. 98), Asher B. Durand (cats. 51–54), and Frederic Edwin Church, Cole's only student. During the 1850s these artists elaborated on the moralizing, narrative landscape that Cole pioneered in the 1830s. Gradually Cole's expressive, often allegorical, Romantic manner was eclipsed by a more direct and objective rendering from nature, but his position as the father of the American landscape tradition remained unchallenged.

Before immigrating to America, Cole apprenticed in 1815 to an engraver of calico designs in Chorley, Lancashire, and by 1817 was working as an engraver's assistant in Liverpool. In 1818 he and his family arrived in Philadelphia, where he found work as an engraver and produced illustrations for an edition of John Bunyan's *Holy War* (1682). After a trip to the West Indian island of Saint Eustatius to visit an ailing friend, in 1819 he joined his family in Steubenville, Ohio, where he received rudimentary training in oil painting from an itinerant portraitist and studied English instruction books. Coming of age on the frontier, Cole was largely autodidactic. He began painting portraits in 1821, seeking work in towns along the Ohio River and teaching drawing in the Ohio towns of Zanesville and Chillicothe. In this rural location Cole sensed the fragility of the American wilderness, a condition that preoccupied him throughout his life. Only in the spring of 1823, when he joined his family in Pittsburgh, did he begin to draw directly from nature (see below). Cole soon departed for cosmopolitan Philadelphia to pursue a more artistic career, studying at the Pennsylvania Academy of the Fine Arts, where he exhibited a landscape in 1824. Moving to New York City the following year, he set up a studio in his father's house and continued to paint landscapes, the sale of which provided him with the funds to make his first sketching trip up the Hudson River to the Catskill Mountains. From the graphite sketches made on this trip Cole painted several landscapes. His early views of the American wilderness were fresh and direct, reinvigorating the worn conventions of

the picturesque and the sublime and seemingly surpassing the topographical tradition. Cole's seminal landscapes, exhibited in New York for the first time in 1825 at Colman's Art Supply Store, brought his art to the attention of John Trumbull (patriarch of American history painting), Durand (who succeeded Cole as the most influential spokesman for landscape as a genre), and William Dunlap (the early writer on American art who lauded his efforts in the *New York Evening Post*), all of whom purchased his paintings. They were instrumental in securing him such influential patrons as Daniel Wadsworth of Hartford, Connecticut, founder of the first public art museum in the United States (the Wadsworth Atheneum), and Robert Gilmor Jr. of Baltimore, thereby ensuring the young painter's success. Cole was so highly regarded by 1826 that he became a founding member of the NAD (elected in the second group).

Cole's early works were suffused with the drama of weather, seasonal cycles, and natural flux, conditions through which he explored his own emotional states. These concerns are also evident in the poetry he wrote his entire life. His verse and diaries provide an essential gloss on his art and reveal in his thinking a strong literary and moralizing current that bound nature and imagination together.

In the late 1820s Cole turned to biblical themes under the influence of the recently published mezzotints of John Martin and the works of Salvator Rosa. In June 1829 Cole began a three-year European stay, financed by Gilmor, that profoundly changed his artistic vision. He not only studied the old masters, especially the art of Claude Lorrain, but also in England met Martin, John Constable, and J. M. W. Turner. After a brief stop in Paris, he continued on to Rome, where he occupied the studio that had belonged to Claude on the Via del Babuino and was moved by the vestiges of Italy's cultural heritage and the ruins that dot the countryside. He began formulating his ideas for his first allegorical series, "The Course of Empire" (1833–36; The N-YHS), which was commissioned by the wealthy New York merchant and collector Luman Reed when Cole returned to America. Cole's analogy between ancient and modern republics—their cultural arrogance and their fall—had been explored by Edward Gibbon (*Decline and Fall of the Roman Empire*, 1776–88) and Lord Byron ("Childe

Harold's Pilgrimage," 1812–18). In 1835 Cole gave a lecture at the New York Lyceum entitled "American Scenery" (subsequently published as an influential essay in the *American Monthly Magazine*), in which he lamented human "cultivation" of nature and extolled the virtues of the wilderness. Such didactic serial allegories consumed a large part of the artist's energies through the remainder of his career.

In 1836 he married Maria Bartow of Catskill and settled there in her family's home. Until the end of the decade he continued to paint Italian scenes based on his sketches as well as American views. One of his excursions in search of material was a visit with Durand to Schroon Lake in 1837. Cole convinced Samuel Ward, a prominent New York banker, to sponsor a second series, "The Voyage of Life" (1839–40; Munson-Williams-Proctor Institute, Utica, N. Y.), which was replicated in a second version and engraved by the American Art-Union for distribution in 1848. Like Reed, Ward died before the series was completed, leaving Cole to deal with the public exhibition of the paintings.

Cole became America's foremost landscapist and transformed landscape painting into America's most characteristic genre. While he prepared the way for plein air naturalism that overtook American painting in the 1850s, his own methods and sentiments were grounded in older attitudes. Even in such works as *View from Mount Holyoke, Northampton, Massachusetts, after a Thunderstorm* (also known as *Oxbow on the Connecticut River*, 1836; The Metropolitan Museum of Art, New York), Cole infused pure landscape with a dynamic sense of historical change. His increasing awareness of the clash between nature and culture is evident in both his painting and his writing. Nevertheless, his preparatory oil sketches retained a revealing and often spontaneous execution.

Seeking to revive his youthful inspiration, Cole again traveled to Europe in 1841, and shortly before returning to America the following year he joined the Episcopalian Church. Thereafter, both his paintings and poetry were inspired not only by his communion with nature but also by his religious devotion. Even as Cole's pastoral paintings of the 1840s became the touchstones for American landscape art over the next decade, the artist remained at root culturally disenchanted, his art dominated by personal symbolism. He

61

looked to art as an antidote for rampant American commercialism and felt discouraged about the social role of artists and the patronage available to them in a democratic culture. One result was his unfinished series "The Cross and the World" (c. 1846–48). Occasionally he produced works with a broader cultural significance, and his friendships in the artistic and literary community—such as with William Cullen Bryant (cat. 64), newspaper editor, poet, and apostle of America's cult of landscape—remained strong. With his work Cole had kindled a national passion for landscape that Bryant immortalized in his eulogy and Durand commemorated in his painting *Kindred Spirits* (1849; The Crystal Bridges Museum of American Art, Bentonville, Ark.).

Bibliography: Thomas Cole, "Essay on American Scenery" (1835), reprinted in John W. McCoubrey, ed., *American Art: 1700–1960: Sources and Documents* (Englewood Cliffs, N.J.: Prentice Hall, 1965), 98–110; Marshall B. Tymn, *Thomas Cole's Poetry* (York, Pa.: Liberty Cap Books, 1972); idem, ed., *The Collected Essays and Prose Sketches of Thomas Cole* (St. Paul, Minn.: John Colet Press, 1980); Howard S. Merritt, *To Walk with Nature: The Drawings of Thomas Cole: An Exhibition*, exh. cat. (Yonkers, N.Y.: Hudson River Museum, 1981); Elwood C. Parry III, *The Art of Thomas Cole: Ambition and Imagination* (Newark: University of Delaware Press, 1988); idem, "Thomas Cole's Early Drawings: In Search of a Signature Style," *Bulletin of the Detroit Institute of Arts* 66:1 (1990): 7–18; Earl A. Powell, *Thomas Cole* (New York: Harry N. Abrams, 1990); Kathleen Erwin, *Fair Scenes and Glorious Wonders: Thomas Cole in Italy, Switzerland, and England*, exh. cat. (Detroit: Detroit Institute of Arts, 1991); Christine T. Robinson, ed., *Thomas Cole: Drawn to Nature*, exh. cat. (Albany, N.Y.: Institute of History and Art, 1993); Alan Wallach and William Truettner, eds., *Thomas Cole: Landscape into History*, exh. cat. (New Haven: Yale University Press, for the Smithsonian American Art Museum, Washington, D.C., 1994); Foshay and Novak 2000.

61. *Study of Tree Trunks*; verso: sketch of leaves and tree branches, 1823

Brown ink and wash on paper that has disintegrated into two pieces; brown ink over graphite; 5 15/16 × 10 1/8 in. (151 × 257 mm), irregular
Inscribed and signed on a second, lower section of paper in brown ink: *From Nature / near Pittsburgh / Thomas Cole*; piece of wood, part of the original montage, has a label inscribed in brown ink: *Near Pittsburgh / by T. Cole / [illegible]*
Provenance: Miss Polly Alloway, Goshen, N.Y.
Bibliography: Koke 1982, 1:208, 210, no. 358, ill.; Parry

62a

62b

1990, 11, fig. 9.

Gift of an anonymous donor, 1947.418

Cole's success as a painter was in great measure attributable to his habit of sketching directly from nature, a practice that endowed his paintings with a vivacity and veracity unprecedented in American landscape. Cole was a prolific draftsman, and there are roughly two thousand drawings by him extant, including eighteen sketchbooks, more than any other American artist of his time.[1] The majority of his drawings are either quick topographical sketches of specific locations or detailed studies of individual motifs, especially trees and plants.[2]

The Society's boldly rendered sheet, although small in size, is highly significant. It dates from the pivotal year 1823, when Cole was twenty-two years old and united his two lifelong passions (according to Dunlap in his *A History of the Rise and Progress of the Arts of Design in the United States*): drawing and "the contemplation of the scenery of nature."[3] This work and its signature can be compared with two early studies of tree trunks in the Detroit Institute of Arts, one dated 1823, that support its date and secure its attribution.[4]

As one of the first studies Cole drew "From Nature"—as he so proudly inscribed the sheet—the work documents one of his initial exercises in sketching directly outdoors. Cole's inscription locates the site of his study in the countryside "near Pittsburgh" during his brief residency there in the spring of 1823. With energized pen strokes Cole has captured the power of nature in process. The turbulent, gnarled forms of his tree trunk become an expressive vehicle not only for the raw force of nature, and its potential for both growth and destruction, but also for Cole's emotions about it. After making his first tree studies in 1823, throughout his life Cole continued to be attracted to the subject, in all stages of growth and decay, wildly and anthropomorphically contorted or quiet.

According to Stebbins, the archetypal Cole drawing is a tree study, and Cole was the first artist in the United States to focus on trees.[5] While German and English Romantic artists, such as Caspar David Friedrich and John Constable, had studied trees for many of the same reasons as Cole, Stebbins believes that no earlier artist had carried the study to such obsessive lengths. He has noted that each of

Cole's drawing types had a distinct purpose, and that as a well-read young man Cole may have been influenced by various English manuals of the period, which urged the importance of studying trees and their individual qualities. For example, the *Landscape Magazine* (1793) instructed: "Unless each tree represented, differs in representation, according to its nature from others around it, what mortal shall divine its intentions." Cole's practice was subsequently taken up by other artists, making trees one of the favorite subjects of the Hudson River School. Above all, Cole bequeathed this obsession for arboreal studies to Durand (cat. 54).

1. Merritt 1981, 4.
2. Avery et al. 2002, 163. In 1939 the Detroit Institute of Arts purchased from Cole's granddaughter eighteen sketchbooks and more than five hundred independent sheets that span the artist's entire career. This archive includes the great majority of Cole's extant drawings. See Erwin 1991.
3. Dunlap, quoted in Merritt 1981, 5.
4. Inv. nos. 39.108 and 39.162, the former in graphite and the latter in brown ink and white heightening; see ibid., 12, nos. 4 and 5, ills. The first sheet is inscribed and signed in the same hand as the Society's drawing: *From Nature / June 28th 1823 / Thomas Cole*. A letter of 16 June 1839 in the Society's Department of Manuscripts from Cole to Asher B. Durand also helps to authenticate the inscription and signature on both sheets. For Cole's early drawings, some of trees, see also Tracie Felker, "First Impressions: Thomas Cole's Drawings of His 1825 Trip Up the Hudson River," *American Art Journal* 24:1–2 (1992): 60–89.
5. Stebbins 1976, 109–10. For another study of a ravaged tree trunk by the artist in the Yale University Art Gallery, New Haven, see Mary Alice Mackay, "Sketch Club Drawings for Byron's 'Darkness' and Scott's 'Lay of the Minstrel,'" *Master Drawings* 35:2 (1997): fig. 11.

Thomas Cole

62a. *Landscape with Waterfalls, Folio 10 in the John Ludlow Morton Album*, 1827

Conté crayon and graphite on paper, bound into album; 3 3/4 × 5 1/8 in. (95 × 130 mm), image
Signed and dated at lower right outside image in graphite: *T Cole. 1827*
Provenance: Collection of John Ludlow Morton, New York; Harriet E. Morton Ellison; Emily Ellison Post, Jackson Heights, N.Y.
Bibliography: Koke 1982, 1:186, no. 339, ill.
Bequest of Emily Ellison Post, 1944.375

62b. *Shipwreck Scene (Allegory of Fortune/Hope), Folio 11 in the John Ludlow Morton Album*, 1828

Conté crayon and graphite on paper, laid on an album page; 3 5/16 × 4 1/8 in. (84 × 104 mm)
Signed and dated at lower right outside image in graphite: *T Cole –1828.*; inscribed below image partially erased: *Hope afraid in … the …*
Provenance: Collection of John Ludlow Morton, New York; Harriet E. Morton Ellison; Emily Ellison Post, Jackson Heights, N.Y.
Bibliography: Koke 1982, 1:189, no. 341, ill.; Sarah Burns, *Painting the Dark Side: Art and the Gothic Imagination in Nineteenth-Century America* (Berkeley: University of California Press, 2004), 5, fig. 3.
Bequest of Emily Ellison Post, 1944.376.

These two diminutive vignettes belong to a group of twenty-seven small works by various artist friends that John Ludlow Morton (1792–1871) assembled between 1826 and 1836 into an *album amicorum* (see also cats. 40 and 86). Morton, about whose early training little is known, had his *View on the Susquehanna* engraved and published in the October 1815 issue of the monthly literary journal the *Port Folio*.

Early in his career Morton shared a studio with his brothers Edmund and Henry Jackson Morton in their father's home at 9 State Street in the Battery, although he did not list himself officially as an artist in the New York directories until 1860. In 1825 he joined the New-York Drawing Association and was instrumental in the founding of the Sketch Club in 1827, whose first recorded meeting was at his home. When the NAD was established in 1826, Morton became its first secretary, a position he held for eighteen years. He was made an associate in 1828 and an academician in 1832. Morton exhibited landscapes, portraits, and historical paintings at the NAD throughout his career, as well as at the American Art-Union. He was also an illustrator, and one of his landscape vignettes embellished Francis Herbert's poem "A Scene on the Banks of the Hudson" in the *Talisman for 1828* and the 1836 Philadelphia edition of Edward Hazen's *Panorama of Professions and Trades*. He married Emily Ellison in 1830 and beginning about 1863 divided his time between a studio in New York City and a home in New Windsor, New York, where he farmed. Morton's unique album of drawings and highly finished, often jewel-like works, presented to him by his friends, afford a

unique window into the artistic circles of New York in the early nineteenth century and the growing importance of drawings as independent, collectible works of art embodying the "signature" of the artist.[1]

This pair of drawings by Cole predates his magisterial five-part allegorical cycle "The Course of Empire" (1833–36), also in the Society's collection.[2] As relatively early examples of Cole's draftsmanship they are quite significant.[3] The earlier of the two, dated 1827, appears to be an imaginary view of a powerful cascade. By employing landscape as a metaphor, it embodies the poetic sentiments of the sublime and the picturesque. Even in this tiny sheet, in which he has exaggerated the size of the rocky crags, Cole suggests the awesome power of nature, evoking a primeval time before human habitation. The second sheet, dated to the following year, is more blatantly allegorical and foreshadows Cole's "Course of Empire" cycle. It is a highly symbolic,

albeit cliched, depiction of a shipwreck, where the ship *Fortune*, identified by an inscription near the shattered mast in the foreground (*FORTUNE*), has broken apart on the jagged rock of life. A lone survivor waves a flag, a distress signal, from atop the rock, hoping to attract the attention of a passing vessel. No doubt this personal, poetic sheet held an emblematic significance that Cole shared with his friend Morton. Both sheets resemble other early drawings by the artist.[4]

1. Stebbins 1976, 113–14; Koke 1982, 2:392, no. 2049; and Joy Heyrman, "'Signature Drawings': Social Networks and Collecting Practices in Antebellum Albums" (Ph.D. diss., University of Maryland, forthcoming).
2. For a discussion and bibliography on Cole's cycle, see Wilton and Barringer 2002, 95–109.
3. In addition to cat. 61 there are two other drawings by Cole in the collection: *On the Catskill, New York* (1956.70) and *Sketch of Four Palm Trees*; verso: partial male profile, from the disassembled album of Thomas Seir Cummings (inv. no. 1979.51); see Koke 1982, 1:206, no. 353, ill., and 210, no. 359. There is also an oil sketch on paper (inv. no. 1947.417) entitled *Romantic Landscape* ("*Last of the Mohicans*"); ibid., 187–89, no. 340, ill.
4. For example, a page in a sketchbook in the Detroit Institute of Arts, *Torre Maschio, Volterra* (inv. no. 39.562.35); see Erwin 1991, 6, ill. Also, a composition similar to *Shipwreck Scene* in graphite is in the same collection, *Hope Deferred Maketh the Heart Sick*, 1828; see Burns 2004, 5, fig. 2, for a discussion of possible romantic and personal meanings the two works held for the artist.

GEORGE HARVEY

Tottenham, England 1799–1880

George Harvey is primarily remembered for his spectacular watercolor landscapes, although he was also a painter of oils, a miniaturist, an architect, and a poet and writer. His artistic training in England is unknown, although he may be the G. Harvey who exhibited the still life *Flowers* at the Royal Academy of Arts in 1819. In the preface to his 1841 *Scenes in the Primeval Forests of America*, the artist wrote about his early studies: "It was this atmospheric effect that caught my enthusiasm… . This early impulse … caused me to become an Artist: a student of the form and poetry of nature: and … it has been my highest delight to ramble uncontrolled in search of the picturesque." After immigrating to the United States in 1820, he spent two years sketching in the Midwest, then the frontier, and southern Canada. One of his earliest surviving watercolors, *Near the Head of Lake Ontario* (c. 1825; The N-YHS) demonstrates his impressive abilities with the medium. Harvey belonged to a generation of gifted Anglo-American artists practicing in the United States that included John Hill (cat.

24), William James Bennett (cat. 41), and William Guy Wall (cat. 48). Like them, Harvey depicted American scenery for the European market. His most important project, the "Atmospheric Landscapes of North America," was an ambitious watercolor series originally intended for publication as prints.

By 1827 Harvey had established residence in Brooklyn, where he worked as a miniaturist, and the following year he made his debut at the NAD. Despite his election as an associate in 1828, he relocated to Boston in 1829, where he worked successfully (he claimed in these years to have executed more than four hundred miniatures) and exhibited regularly at the Athenaeum. In 1830–31 he returned to England for further study, coming back to the United States in 1833. Early in 1834, on medical advice to spend time outdoors, he purchased acreage that included marble and stone quarries at Greenburgh in Westchester County (now Hastings-on-Hudson), where he built Woodbank, a rustic country residence. The following year, the writer

Washington Irving, his neighbor in Tarrytown, asked for Harvey's help in redesigning his late-seventeenth-century picturesque farmhouse that became known as Sunnyside. In 1836 Harvey engaged Bennett to engrave his projected series of "Atmospheric Landscapes," which he planned to sell serially by subscription in eight numbers of five prints each. His models included Wall's *The Hudson River Portfolio* (1820–25) and Nathaniel Parker Willis's *American Scenery* (1839–42). Harvey intended to draft the text that Irving was to revise and edit. In 1837 he leased a studio to work on the project at the old New York University Building, where his neighbor (and informal advisor and mentor) Samuel F. B. Morse was a veteran academician. By about 1839–40 he had completed most of the watercolors, which his prospectus stated had been inspired by early empirical observations of sky, climate, and light and informed by the Linnean classification of clouds formulated by the English chemist and meteorologist Luke Howard (*Climate of London*, 1818–20), which is accepted to this day. Howard's

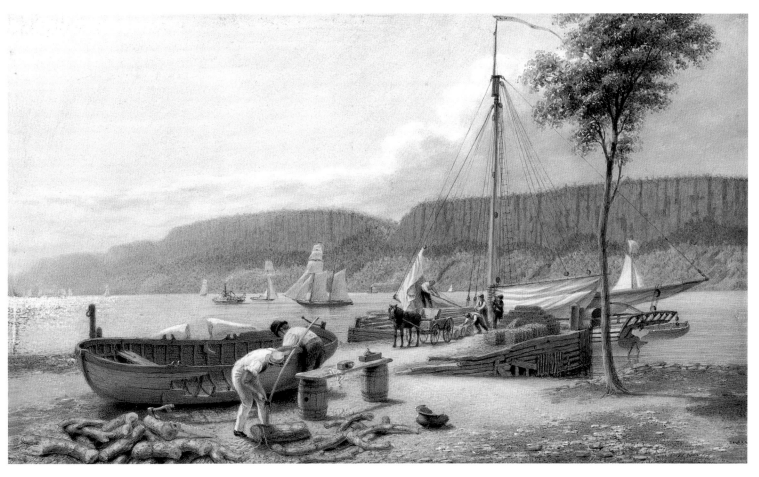

63a

work first appeared in an article in 1803, and it paralleled the independently painted cloud studies of the English artist John Constable, which were also influential on Harvey's art. (Howard and Harvey were also connected by geography, as the former moved to the artist's birthplace, Tottenham, after 1812.) Harvey campaigned to gather support for his project, exhibiting landscapes from the series in New York, Boston, London, and Paris.

Nevertheless, only the four seasons from the series, together with a letterpress text, were published in 1841 in English and American editions; the latter included a fifth print, a title page. The exquisitely hand-colored, subtly modulated aquatints, really a prospectus for the larger project, were issued with the altered title *Harvey's Scenes of the Primitive Forest of America, at the Four Periods of the Year*. The English edition was dedicated to Queen Victoria. Harvey viewed this quartet of seasons—the "Epochs of the

Year"—as preceding the projected "Different Epochs of the Day" (for a total of forty plates including an emblematic title page).* Frustrated in his efforts to promote this project, Harvey exhibited four oils of the seasons (probably painted after the watercolors and more durable in marketing the series) for sale at the NAD in 1842 and at the Boston Athenaeum in 1844, together with the watercolors of the same subjects that were not for sale. Although he received endorsements from important artists, Harvey struggled in vain for another decade during unsound financial times, even selling his Westchester property in 1846, to secure funds to engrave and publish the additional views.

In 1849, while working on his project in London, the artist received an invitation to deliver a series of lectures on his "Atmospheric Landscapes" at the Royal Institution. His success was followed by popular lecture tours in England and the United States. Harvey

illustrated these talks, which he variously billed as "The Discovery, the Resources and Progress of the United States, North of Virginia," with sixty-eight images based on his watercolors replicated on glass slides and projected to a size of sixteen by eighteen feet by the Drummond Lamp (or magic lantern). In 1850 he opened his own lecture hall in London, the Royal Gallery of Illustration, next to the Haymarket Theatre, presenting nightly lectures that belonged to the international vogue for popular entertainments presaging the cinema.

Details of Harvey's life after 1850 are scant. He continued to alternate periods of residency in England and the United States. It appears that ill health forced him to close his London gallery soon after it opened. He may have then returned to Boston to resume miniature painting, for in 1851, after advertising his glass images in the *Boston Transcript*, he leased his magic lantern show to the young Albert

63b

Bierstadt (cat. 102), who presented the "Dissolving Views" of American scenery and sold Harvey's descriptive pamphlets to audiences in New Bedford, Massachusetts, and Providence, Rhode Island. By 1857 Harvey was back in London, traveling between the United States and England during the 1860s and 1870s, and visiting Florida as well as Bermuda (1872–75). In Florida he executed his nocturnal view of a swamp lit by the moon and the random trails of fireflies like those left on photographic plates (*Moonlit Pool with Heron*, 1857; The N-YHS, which may be the work with fireflies in motion commissioned by John Eliot Howard, son of the meteorologist Luke Howard). Long before 1866

Harvey formally abandoned his "Atmospheric Landscapes" project, selling all the watercolors as a group in England to the younger Howard to prevent their dispersal. In 1871 he attempted unsuccessfully to publish a series of chromolithographs of Newport scenery based on his watercolors of that popular Rhode Island resort. Then, in 1876, Harvey published an illustrated book of poetry and plays in London (*The Sires and Sons from Albion Sprung … The Man of Thought and the Man of Action*) under the nom de plume George St. George.

Bibliography: George Harvey, *Harvey's Scenes in the Primitive Forest of America* (London: Published by George Harvey and Messrs. Ackermann & Co., 1841; also in a

New York edition the same year; and reprinted in *The Magazine of History with Notes and Queries*, 27, extra nos. 105–8 [Tarrytown, N.Y., 1925], 130–59); idem, *An Index to the Original Water Color Drawings and Oil Paintings, Executed by Mr. Harvey, and Now Exhibiting for a Short Time at No. 322 Broadway … . Also, the Address Upon the Utility of the Fine Arts, Delivered Before the American Institute in 1842* (New York: C. C. & C. Childs, Printers, 1843); idem, *Harvey's Illustrations of the Forest Wilds and Uncultivated Wastes of Our Country … explanatory of the philosophy of climate … Being An Epitome of the Introduction to the Eight Lectures which the Artist had the Honor of Delivering Before the Members of the Royal Institution of Great Britain, in 1849* (Boston: Printed by Dutton & Wentworth, 1851); idem, *Harvey's Illustrations of Our Country, with an Outline of its Social Progress, Political Development, and Material Resources, Being an Epitome of a Part of Eight Lectures the Artist Had the Honor of Delivering*

Before the Members of the Royal Institution of Great Britain, in 1849 (Boston: Printed by Dutton & Wentworth, 1851); Barbara N. Parker, "George Harvey and His Atmospheric Landscapes," *Bulletin of the Museum of Fine Arts* 41:243 (1943): 7–9; Donald A. Shelley, "George Harvey and His Atmospheric Landscapes of North America," *New-York Historical Society Quarterly* 32:2 (1948): 104–13; idem, "George Harvey, English Painter of Atmospheric Landscapes in America," *American Collector* 17:3 (1948): 10–13; Rossiter 1962, 1:176–77; Deák 1988, 1:315–18, nos. 468–472; Christine Jones Huber, "George Harvey's Atmospheric Landscapes: Picturesque, Scientific, and Historic American Scenes" (M.A. thesis, University of North Carolina, Chapel Hill, 1989); Dearinger 2004, 259–60; Carbone et al. 2006, 2:603–6.

63a. *Afternoon: Hastings Landing, Palisades Rocks in Shadow, New York,* 1836–37

Watercolor, gouache, graphite, scratching-out, and touches of black ink and glazing on paper, laid on brown card; 8 3/8 × 13 3/4 in. (213 × 349 mm)
Signed at lower right in brown watercolor: *G. HARVEY*; card inscribed above in brown watercolor: *AFTER-NOON*; below: *HASTINGS-LANDING, PALISADE ROCKS in SHADOW.*
Provenance: John Eliot Howard, England.
Bibliography: Harvey 1843, 24, no. 30; idem 1851, 19–20; Cowdrey 1943, 1:214, for 1837, either no. 189 ("Scene on the Hudson, Afternoon," for sale) or no. 200 ("Hastings North River Landing"); Stebbins 1976, 143–45, fig. 113; Robert F. Perkins Jr. and William J. Gavin III, eds., *The Boston Athenaeum Art Exhibition Index: 1827–1874* (Boston: The Library of the Boston Athenaeum, 1980), 73, no. 30, for 1844; Koke 1982, 2:99–100, 102, no. 1151, ill.; James L. Yarnall and Willian H. Gerdts, *The National Museum of American Art's Index to American Art Exhibition Catalogues from the Beginning through the 1876 Centennial Year* (Boston: G. K. Hall and Co., 1986), 3:1643, no. 41450; Huber 1989, 65, 98, pl. 9.
Gift of Mrs. Screven Lorillard, 1952.410

63b. *Snow Storm: Canada Settlers in Their Sugar Camp,* 1830s–42

Watercolor, graphite, gouache, white lead pigment, selective glazing, and slight scratching-out on paper, laid on beige card; 10 1/8 × 13 7/8 in. (257 × 353 mm)
Signed at lower left of center in gray watercolor: *G. HARVEY.*; card inscribed above in brown watercolor: *SNOW STORM.*; below: *CANADA SETTLERS in their SUGAR CAMP.*
Provenance: John Eliot Howard, England; Kennedy & Company, New York, 1940.
Bibliography: Harvey 1843, 23, no. 15; idem 1851, 12–13; *One Hundred Years Ago in North America: An Exhibition of Water Color Drawings by George W. Harvey*, sale cat. (New York: Kennedy & Company, 1940), n.p.; Perkins and Gavin 1980, no. 30, for 1844; Koke 1982, 2:98–99, no. 1148, ill.; Yarnall and Gerdts 1986, 3:1646, no. 41530; Huber 1989, 34–35, 59–63, 97, pl. 6.
Gift of Charles E. Dunlap, 1947.557

Rainbows,[1] thunderstorms,[2] fires, clouds,[3] the warm breath of cattle in the cold morning air,[4] and the moon[5] are among the meteorological effects Harvey depicted in the watercolors for the second installment of his "Atmospheric Landscapes of North America," nineteen of which are among the thirty-seven works by Harvey in the Society's collection.[6] Harvey began the set about 1836 and first exhibited it as a discrete group in New York City in 1843.[7] Twenty-two of those pictures are known today.[8] They constitute the only series of American drawings devoted to geographical regions observed at specific times of day and under specific weather conditions, although there were European prototypes for depicting the times of day and the seasons, beginning with illustrations for Books of Hours in medieval times (such as the *Très Riches Heures* by the Limbourg Brothers). The artist believed that weather effects and the climate of North America were different from those of Europe and more extreme than those of England. He included them in his landscape series as an appropriate characteristic of the American landscape and sometimes even as the subject itself, as in catalogue 63b. Huber believes that Harvey considered climate emblematic of America as well as an indication of divine providence.[9]

Harvey's poetic watercolors are the earliest topographical works executed in America using a stipple technique, anticipating by a generation the American Pre-Raphaelites and the later French Pointillists. The artist derived his precise style and manipulated media from both the British watercolor tradition and techniques used for executing miniatures on ivory. His "Atmospheric Landscapes" seem to have coalesced as a series somewhat organically during his restorative period along the Hudson River, when he was led, he related, "particularly to study and notice the ever-varying atmospheric effects of the American climate. He [Harvey peculiarly describes himself in the third person] undertook to illustrate them with his pencil, and thus, almost accidentally, commenced a set of atmospheric landscapes."[10]

As early as 1837 Harvey exhibited works at the annual NAD exhibition with titles corresponding to some of his later "Atmospheric Landscapes," followed in 1842 by four seasonal views (with versions in oil).[11] When he returned to Europe, sometime between 1837 and 1842, he took twenty-two of these landscapes with him in hopes of garnering support for having the cycle engraved. In England he received two important endorsements, the first from the electrical scientist Michael Faraday and the second from the American minister to Paris, Lewis Cass (later senator from Michigan). Their support encouraged him to focus in subsequent works more specifically on celestial and meteorological phenomena and geographical diversity.

Harvey's profound debt to Howard's seminal meteorological study, *Climate of London* (1818–20), is demonstrated by the fact that he sold his original watercolors for the cycle to Luke Howard's son, John Eliot Howard.[12] The artist explained the intellectual genesis of his project in terms of history painting, noting that he aspired to portray the "History of the Day," thereby linking his "Atmospheric Landscapes" to the genre epitomized by Thomas Cole's (cats. 61 and 62) "Course of Empire" suite of five paintings that charted the rise and fall of a nation-state in the diurnal cycle from dawn to nightfall.[13] By contrast, Harvey's message was optimistic and republican; it celebrated progress through imagery that recorded the process of settlement, cultivation, development, technology, and the use of natural resources in North America from Virginia to lower Canada. As opposed to a more standard tour of American scenery and sights, the artist arranged his scenes and his slide exhibition, which foreshadowed the documentary film, to suggest an episodic progression through a single day, with seasonal variations interspersed.[14]

Both works featured in this entry, which are laid on card mounts bearing the artist's titles, showcase Harvey's ability at portraying atmospheric effects and were exhibited at the Boston Athenaeum in 1844. The watercolor of Hastings Landing on the Hudson River, with the Palisades in the background, represents a subject similar to two watercolors Harvey exhibited at the NAD in 1837 (*Scene on the Hudson, Afternoon* and *Hastings, North River Landing*). It may be the same as either one of those very

watercolors or a variation on the theme.[15] The sheet represents one of the two Hudson River docks located on the artist's twenty-acre property at Hastings-on-Hudson, which he purchased in 1834 and that included a stone quarry. The "stone wharf" was located at the foot of Washington Avenue, while the "quarry wharf" was situated at the south end of the waterfront.[16] Koke believes that the work's early date can be proven by comparison with an oil of a similar subject signed and dated 1836 in the Museum of Fine Arts, Boston.[17] At the left Harvey's use of scratching or scraping the surface of the paper to reveal white highlights, a technique popular with British watercolorists in the 1820s, combines with the stippled orange gouache he applied to convey the reflections of the setting sun on the river's surface.

Harvey's other watercolor featured in this entry represents a snowstorm and Canadian settlers collecting and boiling maple sap to make syrup. In this tour de force of synesthesia, which may represent a recollection of his early travels, the artist expertly communicates the frigid temperatures, blowing snow, and humid air of the late winter scene. At the lower left Harvey scraped the paper to suggest snow and elsewhere, by applying gouache and expertly using the paper's reserve, conveyed the look of heavy snowflakes. The viewer enters Harvey's scene with the pioneer boy emptying sap into a bucket before dumping it into the barrel on the "jumper" pulled by a horse. Just right of center his father tends the fire where the sap is boiled, while farther to the right his mother walks toward a log cabin in the background.[18]

Harvey's watercolors reveal a keen eye, more accomplished in observing atmospheric effects than in rendering accurate topography, perhaps a result of his lack of formal training. There are no other comparable American watercolors of the period in either style or ambition. Harvey's magical stipple technique is unique in American art, and his observations of meteorological effects are rare. The latter were certainly part and parcel of Harvey's British heritage, where the study of atmospheric effects was ardently pursued, by amateurs and professional artists alike,[19] as an end in itself, not just to evoke the sublime or picturesque aesthetic response, as was the tendency in American art. Various British watercolorists before Harvey left

England in 1820—such as William Henry Hunt, George Robert Lewis, John Linnell, and William Turner of Oxford, but especially Robert Hills at the beginning of the nineteenth century—had employed a stipple technique or tiny brush-strokes. Hills, the first secretary of the Society of Painters in Water-Colours (established in 1804), painted landscapes in a refined stipple technique that derived from a long tradition of British miniature painting and anticipated the elaborate and precise watercolor technique of the Pre-Raphaelite painter William Henry Hunt later in the century.[20] On his return trips to England, Harvey had the opportunity to come in contact with English artists using the technique, such as Hills, and after 1848, the Pre-Raphaelite artists, whose landscapes share with Harvey's a hallucinatory quality.[21]

* The rare title page preserves Harvey's original title for the larger projected series: *HARVEY'S | AMERICAN | SCENERY. | representing different | ATMOSPHERIC | EFFECTS | at different times of | DAY*. See Deák 1988, 2: fig. 468. A special thanks to Linda S. Ferber and Stephen R. Edidin for sharing information about Harvey, some of it from documents in the artist's files in the Burlington Public Library, Burlington, Iowa.

1. Seen in another Harvey watercolor in the N-YHS series set on the Boston Common (inv. no. 1947.411; Koke 1982, 2:98–99, 101, no. 1150, ill.).

2. Seen in another Harvey watercolor in the N-YHS series set at the shore in Long Branch, New Jersey (inv. no. 1947.552; ibid., 98, no. 1149, ill.).

3. Seen in a number of Harvey watercolors in the N-YHS series, including ones labeled "Cirro Cumulus" and "Cumulus" (inv. nos. 1947.501 and 1947.500; ibid., 97–98, nos. 1145 and 1146, ills.). For Constable who, like other British and German artists and poets of the period, viewed the sky as a manifestation of the divine in nature, see Edward Morris, *Constable's Clouds: Paintings and Cloud Studies by John Constable*, exh. cat. (Edinburgh: National Galleries of Scotland, 2000). Barbara Novak, *Nature and Culture: American Landscape Painting* (New York: Oxford University Press, 1995), 83, believes that while American scientific interest in clouds can be allied with Constable, their profound philosophical affinities were aligned with the German and Scandinavian landscape painters, such as the Norwegian Johann Christian Carus, who in 1821 started to paint cloud studies in Dresden.

4. Seen in another Harvey watercolor in the N-YHS series set in Flatbush and Green-Wood Cemetery (inv. no. 1947.553; Koke 1982, 2:96–97, no. 1143, ill.), fig. 14 in the catalogue essay.

5. Seen in another Harvey watercolor in the N-YHS

series set on the western prairies (inv. no. 1947.553; ibid., 103, no. 1158, ill.).

6. In 1947 Charles E. Dunlap gave eighteen watercolors and three oils by Harvey, establishing the Society as the largest repository of his works (today, there are twenty-seven watercolors, four oils [plus two attributed to the artist], and four miniatures). The library also holds a copy of *Harvey's Scenes of the Primitive Forest of America, at the Four Periods of the Year*, which provides a complete list of the plates that Harvey planned to publish. Among the Society's watercolors is the one preparatory for *Summer* engraved by Bennett (inv. no. 1947.495; Koke 1982, 2:103–6, no. 1159, ill.; and Deák 1988, 1:317, no. 470; 2: ill.), as well as eighteen watercolors for the "Epochs of the Day." See Shelley, *New-York Historical Society Quarterly* 1948, 106–7 (which also cites the particulars of the American edition), 111–13. See also Koke 1982, 2:94–113, and for Bennett's title page and plates featured in the American edition in the I. N. Phelps Stokes Collection in the NYPL, Deák 1988, 1:315–8, nos. 468–72; 2: ills.; and Deák et al. 1988, 48–51, figs. 23–27. The Society's Department of Manuscripts holds letters by and to the artist from 1844 to 1867.

7. At 322 Broadway in New York City (see Harvey 1843, which includes letters from various artists testifying to the merit of the works and proposals for publishing the "Historical or Atmospheric American Landscape Scenes") and later in Boston; see also Yarnall and Gerdts 1986, 1:23; and Shelley, *New-York Historical Society Quarterly* 1948 and *American Collector* 1948.

8. Avery et al. 2002, 160.

9. Huber 1989, 68–74. In this emblematic significance she sees the influence of Constable, Cole, and Alexander von Humboldt (and his topical *Cosmos: Outline of the Physical World*). Harvey articulated his philosophy of climate in a lecture at the Royal Institution in London in 1849, which was later reprinted in *Harvey's Illustrations of the Forest Wilds and Uncultivated Wastes of Our Country*, 1851. Harvey's talk had three theses: that climate had an effect on the moral and intellectual development of people; that the multiplicity of races in America was a positive sign for its future; and that the climate was controlled by divine providence (an idea that was earlier articulated by von Humboldt), which had a special interest in the British and American peoples.

10. George Harvey, *Harvey's Royal Gallery of Illustration, Next Door to the Haymarket Theatre, A Descriptive Pamphlet of the Original Drawings of American Scenery, under Various Atmospheric Effects of Storm and Calm: of Sunshine and Shade; together with Sketches of the Homes and Haunts of the British Poets, by George Harvey, A.N.A. To which is Prefixed A Brief Autobiography of the Artist's Life* (London: Printed by W. J. Golbourn, 1850), 3.

11. See Cowdrey 1943, 1:214–15, nos. 296, 300, 307, 312, identified as "four original paintings constituting the first part of a series of forty, now in the course of publication."

12. Huber 1989, 52–53; for Howard, see also Novak 1995, 80–82.
13. Harvey 1841/1925, 139–41.
14. Avery et al. 2002, 162.
15. Cowdrey 1943, 1:214, nos. 189 (for sale) and 200. Actually, there were three Hudson River views in the 1837 show; for the third depicting morning (no. 201), see n. 17 below. Perkins and Gavin 1980, 74, no. 90, lists "Afternoon" view in Hastings on the Hudson River for sale at the Athenaeum in 1844; it is further described (p. 298) as a "View looking North. Hastings Steam Boat Landing on the right. The West Point Mountains in the distance." The Society's example looks toward the southwest.
16. Koke 1982, 2:100; and Huber 1989, 36–39, which notes that the marble in the quarry was of high quality and that after 1837 the income from the quarries enabled Harvey to undertake his youthful dream, the "Atmospheric Landscape" series.
17. Koke 1982, 2:100. See also Museum of Fine Arts, *M. and M. Karolik Collection of American Paintings, 1815 to 1865* (Cambridge, Mass.: Published by Harvard University Press for the Museum, 1949), 298–99, ill. This may be the third Hudson River view (*Morning, View of the Palisades, Looking down the River*) referenced in n. 15 above.
18. Harvey described the winter weather, the technique for making maple sugar, and identified the "jumper" in *Harvey's Illustrations of Our Country, with an Outline of its Social Progress, Political Development, and Material Resources*, 1851, 12–13. See also Huber 1989, 60–61.
19. See Roberta J. M. Olson and Jay M. Pasachoff, *Fire in the Sky: Comets and Meteors, the Decisive Centuries, in British Art and Science* (Cambridge: Cambridge University Press, 1998).
20. For Hills, see Scott Wilcox, *British Watercolors: Drawings of the 18th and 19th Centuries from the Yale Center for British Art*, exh. cat. (New York: Hudson Hills Press, in association with the Yale Center for British Art and the American Federation of Arts, 1985), no. 27. For examples of his work, see Andrew Wilton and Anne Lyles, *The Great Age of British Watercolours, 1750–1880*, exh. cat. (London: Royal Academy of Arts; Munich: Prestel Verlag, 1993), figs. 183 and 184.
21. See, for example, Mary Bennett, *Artists of the Pre-Raphaelite Circle: The First Generation, Catalogue of the Works in the Walker Art Gallery, Lady Lever Art Gallery and Sudley Art Gallery* (London: Lund Humphries, Published for the National Museums and Galleries on Merseyside, 1988).

HENRY INMAN

Utica, New York 1801–New York, New York 1846

The son of an English land agent who had immigrated to America in 1792, Henry Inman became one of the most esteemed portraitists working in New York City during the 1820s and 1830s. He studied under an itinerant drawing master before moving to New York City with his family in 1812. Two years later, at the age of thirteen, he obtained an apprenticeship with the city's leading portrait painter, John Wesley Jarvis (cat. 37), attracted to him not only for his skill as an artist but also for his collection of paintings stored above his studio at 1 Murray Street, near the newly completed City Hall (cat. 66). Inman worked closely with Jarvis, eventually accompanying him on his travels and serving more as a collaborator, even going with him to New Orleans in 1820–21 for the winter. Within this partnership Inman established a specialty in miniature painting. He began his independent career as a portrait and miniature painter in Albany, New York, in the winter of 1821–22, after Jarvis had departed, although he again painted in partnership with Jarvis in Boston the following fall. In 1823 he set up his own studio in New York City and later delegated the painting of miniatures to his student and eventual partner, Thomas Seir Cummings. That same year he made his debut at the American Academy of the Fine Arts with an oil portrait and a scene based on the writings of Washington Irving and became an academician.

Instrumental in founding the NAD in New York in 1826 (one of the "first fifteen"), Inman became vice president of the new organization (1826–31, a post he accepted a second time, from 1838 to 1844) and found himself at the center of Knickerbocker society, New York's rapidly developing cultural circle. He began to receive portrait commissions from prominent families and city government officials but also painted literary, historical, landscape, and genre subjects. Many of these were engraved for illustration in journals and popular giftbooks, furthering his reputation.

Inman moved to Philadelphia in 1831 and joined the engraver Cephas G. Childs as a partner in the short-lived lithographic firm of Childs & Inman, providing meticulously drafted designs that were reproduced by the firm's lithographer. Inman continued to paint portraits despite the presence and competition of Thomas Sully (cat. 40), Philadelphia's reigning portrait painter. While Sully had his greatest success with women's portraits, Inman excelled in those of his male sitters, whom he portrayed with dignity.

After three years in Philadelphia, Inman returned to resume his position in New York, where he enjoyed the height of his career and uninterrupted success from 1834 to 1839. Although he was the city's acknowledged preeminent portraitist, he decried the public's "rage for portraits," which prevented artists from exercising their full powers. Like Sully in Philadelphia, Inman was termed "the American Lawrence," referring to the English artist Sir Thomas Lawrence, with whom Sully's flashier elegance made a better parallel. Inman's Romantic style is marked by softened contours, tempered by a restrained brush that describes sitters with good-natured expressions. His propensity toward sweetness in portrayals of women, such as his *Portrait of Georgiana Buckham and Her Mother* (1839; Museum of Fine Arts, Boston), rarely slipped into sentimentality and never colored his vigorous, candid portraits of men. His later subjects exhibit less of the poetic materiality characteristic of mid-nineteenth-century portraiture and the influence of photographic naturalism.

Financial reverses (after the economic crisis of 1837) and his deteriorating health (asthma) contributed to a decline in Inman's productivity during his later years, when he created some of

64

his most beautiful works. Among his best-known genre paintings is *Mumble the Peg* (1842; Pennsylvania Academy of the Fine Arts, Philadelphia). He traveled to Great Britain from July 1844 to April 1845 in hopes of restoring his health and fortune, and reviving his spirits. After painting several portraits, including one of William Wordsworth after a visit to the writer at his home, Inman considered continuing his successful career in London, but instead decided to return to New York. He became ill in the autumn and died the following January. The Society holds sixteen paintings, eight drawings, and five stunning miniatures on ivory by Inman.

Bibliography: *Catalogue of 115 Indian Portraits ... lithographed copies by Inman, from the ... collection in the War Department at Washington, most of which were taken from life by King in that City* (Philadelphia: Masonic Hall, 1836); Art-Union, *Catalogue of Works by the Late Henry Inman with a Biographical Sketch*, exh. cat. (New York: Van Norden & King, 1846); Theodore Bolton, "Henry Inman: An Account of His Life and Work," *Art Quarterly* 3:3 (1940): 353–75, 401–18 ("A Catalogue of the Paintings of Henry Inman," supplement); H. E. Dickson, "Where Inman Began His Apprenticeship," *The Magazine Antiques* 50:6 (1946): 396–97; William H. Gerdts, "Henry Inman in New Jersey," *Proceedings of the New Jersey Historical Society* 78:3 (1960): 178–87; William H. Gerdts and Carrie Rebora, *The Art of Henry Inman*, exh. cat. (Washington, D.C.: National Portrait Gallery, Smithsonian Institution, 1987); Dearinger 2004, 302–3.

64. *William Cullen Bryant (1794–1878)*, 1827

Watercolor, graphite, and charcoal with touches of black and brown ink and white gouache on paper; 4 7/16 × 4 1/8 in. (113 × 104 mm)
Verso inscribed, signed, and dated at upper center in brown ink: *Likeness of W. C Bryant. | – By Inman 1827. –*
Provenance: Descent through the sitter's family; Anna R. Fairchild, New York.
Bibliography: Bolton 1940, 403, no. 13; N-YHS 1941, 39, 41, no. 95, ill.; N-YHS 1974, 1:106–7, no. 253, ill.; Gerdts and Rebora 1987, 152, no. 82, ill.; Foshay and Novak 2000, 60. Gift of Anna R. Fairchild, niece of the sitter, 1910.20

When William Cullen Bryant was asked which of the portraits of himself he preferred, he replied: "Unlike Irving, I prefer the portraits made of me in my old age. Of the earlier pictures, I presume the best are Inman's and my friend Durand's, which ... hangs in the parlor of Roslyn [at his home, Cedarmere, on Long Island]."[1] Inman's small likeness in watercolor was executed not long after Bryant had assumed his editorial position with the *New York Evening Post*.

The poet, editor, and naturalist was born in Cummington, Massachusetts, the son of a physician and a descendant of early Puritan immigrants. The precocious "Cullen," as he was called, received little formal education but studied classics and scriptures at home, publishing his first poems at the age of thirteen in the *Hampshire Gazette* of Northampton, Massachusetts, and in a pamphlet of verse in Boston. He studied for a year at Williams College but, unable to afford Yale University, turned to the law, studying with attorneys. Practicing law for ten years in Plainfield and Great Barrington, Massachusetts, after passing the bar in 1815, he escaped the petty wrangles of litigation by taking long walks through the countryside. His

meditations on the natural scenery of the Berkshires fed the poetry he wrote on the side, and his reading of the "Lyrical Ballads" of William Wordsworth confirmed his own responses to natural beauty. In 1817 Bryant began submitting his work to the *North American Review*, where his famous deist nature poem "Thanatopsis" first appeared that year and attracted much attention. In 1825, already established as one of America's most brilliant, original, and prolific poets, he became the editor of the *New York Review and Athenaeum Magazine*, a literary journal. His reputation was further enhanced by public lectures at the Athenaeum Society and the American Academy of the Fine Arts. He also became a member of the Sketch Club, a society of New York literati that metamorphosed into the Century Association. Joining the staff of the *New York Evening Post* in 1827, he became its editor in chief after two years, a position he held for nearly fifty years. In 1832 a volume of his collected works appeared, entitled *Poems*, giving substantial form to American nature poetry.

Bryant was a close friend of many poets, authors, and artists, including Asher B. Durand (cats. 51–54), who immortalized the bond between Bryant and the painter Thomas Cole (cats. 61 and 62) in his famous painting *Kindred Spirits* (1849; The Crystal Bridges Museum of American Art, Bentonville, Ark.). Commissioned by Jonathan Sturges as a gift to Bryant in gratitude for the eulogy he delivered in honor of Cole at the artist's funeral in 1848, it embodies the connections between these three men. They shared the belief that nature, particularly in America, was a spiritual place that could bring about true enlightenment; it was a place in which artists and poets could explore both the tangible world and intangible truths. They communicated their ideas in landscape paintings and nature poems that guided the direction of cultural ideas and aesthetic expression in nineteenth-century America.[2] Bryant wrote more than 150 poems, for which he is remembered today, together with his prominent place in the history of American journalism. On several occasions Bryant addressed the members of the N-YHS and served as its secretary and vice president.[3]

Inman's half-length portrait of Bryant, executed in a refined watercolor and graphite technique, owes a great deal to the artist's ability as a painter of delicate miniatures on ivory. However, it substitutes a bolder line, especially in the background, for the delicate stippling technique of miniatures. The likeness resembles other relatively large "miniature" portraits on paper by Inman from the 1820s, all measuring over three inches square.[4] However, it is larger than any of these, and its relative monumentality accentuates the intensity of its sitter's gaze. The work also reveals Inman's proficiency in suggesting both the physical textures of his sitters' hair and costumes and the psychological fabric of their characters. While many artists painted Bryant's portrait, this watercolor is one of the earliest. It was well known in its time, as it was engraved and published in the *New-York Mirror* (1837) and the *United States Magazine and Democratic Review* (1842).[5] It is also possible that the watercolor may have been intended as a study for an oil painting whose existence cannot be verified but is listed in Bolton's catalogue under oil paintings.[6]

1. Quoted in James Grant Wilson, *Bryant and His Friends: Some Reminiscences of Knickerbocker Writers* (New York: Ford Howard & Hulbert, 1886), 114.
2. See Foshay and Novak 2000.
3. N-YHS 1974, 1:106. The Society has four other portraits of Bryant in its collections: two sculptures and two oil paintings. See N-YHS 1974, 1:106–8, nos. 251–55. For Bryant, see also William Cullen Bryant, *The American Landscape* (New York: Elam Bliss, 1830); idem, *Miscellanies First Published under the Name of the Talisman* (New York: Elam Bliss, 1833); Godwin Parke, *A Biography of William Cullen Bryant with Extracts from His Private Correspondence* (New York: D. Appleton & Co., 1883); William Aspenwall Bradley, *William Cullen Bryant* (New York: Macmillan Company, 1905); James T. Callow, *Kindred Spirits: Knickerbocker Writers and American Artists, 1807–1855* (Chapel Hill: University of North Carolina Press, 1967); Charles Henry Brown, *William Cullen Bryant* (New York: Scribner, 1971); Holly Jean Pinto, *William Cullen Bryant and the Hudson River School of Painting*, exh. cat. (Roslyn, N.Y.: Nassau County Museum of Fine Art, 1981); and Albert F. McLean, "Bryant, William Cullen," http://www.amb.org/articles/16/16-00213.html, *American National Biography Online Feb. 2000*, Oxford University Press.
4. Gerdts and Rebora 1987, 145, no. 74, 146, no. 76, and 148, no. 78, all ill. It is especially close to Inman's portrait of Aaron Burr (c. 1826) in the Society's collection (inv. no. 1931.61, 4 1/2 × 3 1/2 in.); see N-YHS 1974, 1:115–16, no. 272, ill.
5. Gerdts and Rebora 1987, 152.
6. Bolton 1940, 403, no. 13. He notes the engraving is inscribed *H. Inman N.A. Delt | G. Parker Sculpt | you(r) obt. Sevt. | W.C. Bryant | Painted and Engraved Expressly for the New-York Mirror*. However, the word *painted* in the inscription could also refer to the execution of this watercolor.

CHARLES BURTON

England active 1802–42

Little is known about Charles Burton's career on either side of the Atlantic. In England, where his family was involved with printing, the artist frequently signed his works with his first initial and was known primarily as a draftsman. According to the handwritten autobiography (1863) of the portrait painter and publisher James Herring in the Society's Department of Manuscripts, when he was a child in England he first heard about Burton as a painter of magic lantern slides and transparencies in 1802. Burton may have arrived in America in 1819, when a C. Burton, living on Chambers Street in New York City, exhibited two landscapes at the American Academy of the Fine Arts. Between 1828 and 1831, a Charles Burton, who is probably the same individual recorded as C. Burton, is listed in New York City directories as a draftsman; he also may be the same artist who worked with John William Casilear as a banknote engraver. Burton's most important project was his collaboration in 1831 with George Melksham Bourne on the New York views that are generally considered to be the most beautifully executed sequence of New York City vignettes. In nineteen double plates, it illustrated Manhattan's public and private buildings against a kaleidoscope of urban life. The diminutive engravings, for which Burton provided the lion's share of preparatory drawings, offer a distinct flavor of the prospering metropolis in an era when shipping and trade fi-nanced the city's growth and when top hats and extravagant bonnets were in fashion.

In 1831 Burton showed three items at the annual exhibition of the NAD (the artist's only appearance): a group of sixteen views of New York locations in a frame, a view of Wall Street, and one of Ramapo, New Jersey. Herring recalled meeting Burton about 1836 in Wilmington, Delaware, where the latter was teaching drawing and painting. Shortly afterward Burton may have moved south, for a C. Burton was recorded painting portraits in Jefferson County, Virginia (now West Virginia), between 1838 and 1839, and an artist of the same name opened a drawing school in Richmond in 1841. An advertisement for this school in the *Richmond Compiler* (25 October 1841) offers night classes as well as instruction in sketching real objects and "machine drawing," sectional and perspective, architecture, and portraits with the camera lucida. A Charles Burton was listed in the Baltimore city directory for 1842 as a scientific draftsman, but after that year his trail in the United States goes cold. Soon thereafter a C. Burton exhibited a number of architectural paintings at the Royal Academy of Arts in London, suggesting that he returned to his native country in the early 1840s.

During his residence in America (c. 1819–42), Burton established a reputation as a draftsman of diminutive ink and wash drawings and watercolors that were engraved. In honor of the Marquis de Lafayette's triumphal visit to New York City in 1824, he produced a series of miniature views of Manhattan for a memorial volume presented to the French hero. From that time until 1831 engravings after Burton's designs appeared regularly in the *New-York Mirror*, a journal with a reputation for publishing high-quality illustrations. In addition, some of Burton's designs decorated blue-and-white Staffordshire earthenware.

Bibliography: Stokes 1915–28, 3:594–98; Joseph Downes, "The Capitol," *Metropolitan Museum of Art Bulletin* 1:5 (1943): 171–74; Koke 1982, 1:105–21; Deák 1988, 1:262–64.

65. *Steamboat Wharf, Whitehall Street, New York City: Study for Plate 12B of "Bourne's Views of New York,"* c. 1831

Brown ink and wash, gray wash, and graphite with touches of scratching-out on paper; 6 1/8 × 6 15/16 in. (155 × 176 mm), irregular
Signed at lower left below image in brown ink: *C Burton Delt*; inscribed at lower right in graphite: [two lines erased] *Steam boat wharf, Whitehall St.*
Provenance: William J. Davis, New York, 1844–65; Stephen Whitney Phoenix, New York, 1865–81.
Bibliography: Davis Library Sale, Bangs, Merwin & Co., New York, sale cat., 17 April 1865, lot 1739; Koke 1982, 1:117–18, no. 265, ill.
Bequest of Stephen Whitney Phoenix, 1881.18

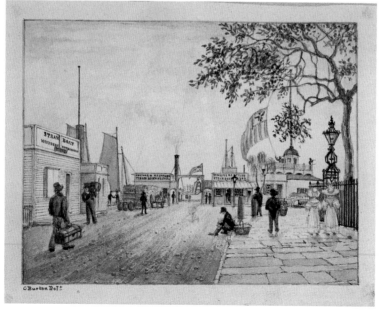

65

66a

The composition of this charming vignette was engraved faithfully by George W. Hatch and James Smillie and published in 1831 by George Melksham Bourne as one of two views on plate 12 of "Bourne's Views of New York," entitled *Steam Boat Wharf, Whitehall Street, New York*.[1] This sheet is reputedly one of the two untrimmed and signed drawings by Burton made for the series.[2] It shows in foreshortened perspective the approach to the steamboat wharf on the East River adjacent to the Custom House (portrayed from the front in another watercolor in the collection by Marie-François-Régis Gignoux, cat. 80).

Thirty-four of Burton's drawings were reproduced in the nineteen numbered double plates for George Melksham Bourne's important series of New York City views (1831), engraved most notably by James Smillie and several other individuals. Smillie himself executed drawings for three other vignettes (one after a sketch by Burton), while a work by William Guy Wall (cat. 48) provided the model for one vignette of plate 17.[3] Of the twenty-three drawings by Burton in the collection, twenty-two are preparatory for Bourne's vignettes. Eighteen, including this sheet, have a Phoenix provenance, two have a Smillie provenance, and two were acquired in exchange with Hirschl & Adler Galleries. Of these, Bourne used nineteen for plates in his series. Burton probably exhibited some of these vignettes in his only recorded exhibition at the

NAD in 1831 as part of the composite "Frame with 16 views in New-York, Publishing by Bourne."[4] No doubt their diminutive size caused Burton to frame them as a group in order more readily to advertise their impending publication.

1. For the engraving, see Stokes 1915–28, 3:596; and Deák 1988, 1:262–64, no. 392; 2: fig. 392.12.
2. Stokes 1915–28, 3:595–96.
3. Ibid., 596. For the series, see ibid., 594–98; and Deák 1988, 1:262–64, no. 392; 2: ills. No complete set of Bourne's series is known to exist. The Society's DPPAC holds thirty-one of the thirty-four prints after Burton's drawings belonging to the famous series of thirty-eight prints (minus plates 16 and 19).
4. Cowdrey 1943, 1:61, no. 193.

Charles Burton

66a. *City Hall, New York City*, c. 1831

Brown ink and wash, gray wash, and graphite on paper; 5 5/8 × 6 3/4 in. (143 × 171 mm), irregular
Signed at lower left below image in brown ink: *C. Burton Delt*; inscribed at lower right in graphite: *City Hall, Park*
Provenance: James Smillie, New York; Ralph Smillie; Mrs. Ralph Smillie, Essex Falls, N.J.
Bibliography: Koke 1982, 1:121, no. 270, ill.
Gift of Mrs. Ralph Smillie, 1968.47

66b. *Council Chamber, City Hall, New York City; Study for Plate 9A of "Bourne's Views of New York,"* c. 1831

Brown ink and wash, gray wash, and graphite on paper; 2 3/4 × 3 1/2 in. (70 × 88 mm), irregular
Verso inscribed vertically along left margin in brown ink: *Room in city hall*
Provenance: William J. Davis, 1844–65; Stephen Whitney Phoenix, New York, 1865–81.
Bibliography: Davis Library Sale, Bangs, Merwin & Co., New York, sale cat., 17 April 1865, lot 1739; Stokes 1915–38, 3:598, pl. 102-b; Koke 1982, 1:116, no. 262, ill.; Peter M. Kenny, Frances F. Bretter, and Ulrich Leber, *Honoré Lannuier, Cabinet Maker from Paris: The Life and Work of a French Ebéniste in Federal New York*, exh. cat. (New York: Metropolitan Museum of Art, 1998), 140, fig. 82.
Bequest of Stephen Whitney Phoenix, 1881.16

Burton's two drawings provide exterior and interior views of this important civic structure. Both were executed as candidates for the series of New York City scenes published by George Melksham Bourne in 1831, but only the Council Chamber was engraved, as was catalogue 65.

The small representation of the south and west facades of New York's City Hall, as viewed from the Broadway side of the building, has a provenance from the engraver James Smillie's collection, arguing that the artist prepared it as a possible candidate for inclusion in the vignette series published by Bourne, although it was never engraved by Smillie or any of the other engravers

66b

employed on the project. The building stands in City Hall Park between Broadway and Park Row. Designed by Joseph François Mangin and John McComb Jr.,[1] its cornerstone was laid on 20 September 1803 by Mayor Edward Livingston, and it was first occupied by the city government on 12 August 1811. Burton's rare interior view of the Governor's Room in City Hall, also with a Smillie provenance and in the collection, was likewise probably executed for possible inclusion in the series but never engraved.[2]

In contrast, Burton's interior view of the City Hall Council Chamber was engraved by Stephen H. Fosette and published in 1831 by Bourne as plate 9A in his series with the title *Council Chamber, City Hall, New York*.[3] The composition and details of the engraving are, as usual, nearly identical to those of the drawing. Situated on the southwest corner of the second story of the edifice and now called the Room of the Committee of the Whole, the chamber is architecturally distinguished by a plaster-dome ceiling resting on a circle of Corinthian columns. A decorative wrought-iron grill created a separate area from which the public could view the council's proceedings. Burton's drawing, which is the earliest known depiction of the room, also shows the chairs commissioned in 1802 from the celebrated cabinetmaker Honoré Lannuier, his sole public commission. Burton's vignette features Lannuier's mahogany armchairs (twenty-four were commissioned), an amalgam of French and English design, set

before desks arranged in horseshoe-shaped tiers around the mayor's chair raised on a platform.[4]

Burton's drawing style is distinguished by its precision and by the diminutive size of the figures in relation to their surroundings. His vignettes preparatory for the Bourne views document the halcyon days of early New York and the rhythm of life in its ample urban spaces. Burton also recorded events of interest, such as in his view of Park Place, engraved by Smillie for Bourne's views, that includes one of the balloon ascensions of Charles Ferson Durant, the first American aeronaut.[5] In general, the artist's careful renderings of the buildings are convincing on a small scale, although his grasp of perspective was limited, perhaps because he was largely self-taught.[6] Burton also executed larger-scale watercolors, for example, a view of the Capitol building in Washington, D.C. (1824), and an ambitious view of Erasmus Hall Academy in Flatbush, Brooklyn (1826).[7]

1. For a drawing of the elevation by Mangin and McComb from 1802 in the DPPAC, see Kenny, Bretter, and Leber 1998, 139, fig. 80.
2. Inv. no. 1968.48; Koke 1982, 1:120, no. 269, ill.
3. Stokes 1915–28, 3:595; and Deák 1988, 1:262–64, no. 392; 2: fig. 392.9. The Society's DPPAC holds an impression.
4. See Kenny, Bretter, and Leber 1998, 139–42.
5. Inv. no. 1881.9; see Koke 1982, 1:112–13, no. 255, ill. Durant's first flight took place at Castle Garden on 9 September 1830, followed by four other successful flights from the same location, the final one on 14 June 1833.
6. Avery et al. 2002, 142.
7. Inv. no. 42.138 in the Metropolitan Museum of Art, New York (ibid., 142, no. 34, ill.), 16 × 24 11/16 in., and inv. no. 1979.81 in the N-YHS (Koke 1982, 1:105–6, no. 248, ill.), 21 1/4 × 31 in.

ALEXANDER JACKSON DAVIS

New York, New York 1803–West Orange, New Jersey 1892

From the 1830s through the 1850s Alexander Jackson Davis was one of America's most influential architects. His work ranges from major governmental and institutional buildings to ornamental garden structures, and his main contribution to American architecture was his introduction of the European picturesque aesthetic into his designs of Italianate and Gothic Revival country houses and cottages. With his partner, Ithiel Town, he also refined and popularized the American Greek Revival style. In addition, he revolutionized the nation's architectural drawing through rendering buildings in Romantic landscape settings rather than in the analytical, spartan Neoclassical style that preceded him. Further, he helped form the American Institution of Architects in 1836 and advanced professionalism in his country's architecture through scrupulous office practices. For instance, he was the first American architect to use printed, standardized specifications.

Son of a bookseller, Davis left school at the age of sixteen to work as a type compositor and to learn the printing trade in a half brother's newspaper office in Alexandria, Virginia. Bored by the work, Davis read gothic novels, made drawings of prison and castle interiors that resembled Giovanni Piranesi's engravings of imaginary prisons, and acted in amateur theatricals, for which he may have also designed stage sets. When his apprenticeship was completed in 1823, he returned to New York City, having decided to become an artist. He studied at the American Academy of the Fine Arts, the New-York Drawing Association (becoming a member in 1825), and the Antique School of the NAD, where he studied drawing and perspective (he was an associate from 1828 to about 1838). He befriended many important artists of the time, including John Trumbull, Samuel F. B. Morse, and Rembrandt Peale, who advised him to concentrate on architecture. Rapidly learning the skills of an architectural illustrator and draftsman, he also acquired a reputation for views of New York buildings, many of which were published as lithographs and engravings. A case in point is figure 67.1, originally a Greek Revival church by Josiah R. Brady, which was engraved and published in the *New-York Mirror* in 1829. His talent as an illustrator of architecture had an important effect on his architectural career. Design, not structure or theory, was his chief

Fig. 67.1. Alexander Jackson Davis, *B'Nai Jeshuran Synagogue, New York City*, c. 1829. Black and brown ink, gray wash, and graphite, 8 3/4 × 11 1/8 in. (222 × 283 mm), irregular. The New-York Historical Society, X.430

interest and strength. He was a superb watercolorist and, throughout his career, did most of his own drafting.

Beginning his career in architecture in 1826, he worked as a draftsman for the noted architect Josiah R. Brady as well as for Town and Martin E. Thompson, one of America's first professional architectural firms. Town made Davis a partner in 1829, which gave him extraordinary opportunities and placed him on the cutting edge of developments in American architecture. Town was a leader of the Greek Revival style, as well as a respected engineer and expert in bridge construction, whose structural knowledge and connections, combined with Davis's draftsmanship, quickly made the firm one of the most influential in the country. Although Davis never visited Europe, Town's European travels and extensive library, the best architectural library in America at the time, meant the firm was current with European developments and gave them an enormous advantage. Town also had important social contacts, some of which Davis used to great benefit during the six years he spent with him in the firm. During this period Davis looked for inspiration to classical works, including those of Vitruvius, Pliny the Younger, Andrea Palladio, Étienne-Louis Boullée, Claude-Nicolas Ledoux, and William Chambers, and developed into a brilliantly original designer with a sound knowledge of architectural principles. Davis's first executed design was a Greek Revival house for James A. Hillhouse in New Haven, Connecticut (1828–31), which brought him immediate recognition. Thereaf-

ter, Town & Davis, and occasionally Davis alone, designed many of the country's most notable buildings in the Greek Revival style, including the Connecticut capitol at New Haven (1827–31; demolished); the Indiana capitol in Indianapolis (1831–36; demolished); the United States Custom House in New York City (1833–42; now Federal Hall National Monument); and the North Carolina capitol in Raleigh (1833).

After the partnership with Town was dissolved in 1835, Davis worked independently for the remainder of his career. In 1836 he began writing his pattern book, *Rural Residences*, the first American book about the design of country houses. It was illustrated with hand-colored lithographs that helped introduce the concepts of picturesque architecture to this country. His picturesque theory developed from reading British writers, including Thomas Gilpin, Edmund Burke, Uvedale Price, Richard Payne Knight, and Humphrey Repton, all influential on British garden design. Due to the financial panic of 1837 only two of the proposed six parts of *Rural Residences* were issued in 1838. Although relatively few copies were sold, the publication precipitated an important collaboration. In 1839 Davis designed and drew illustrations for the widely read books of the landscape gardener and influential landscape and architectural theorist Alexander Jackson Downing, such as *The Architecture of Country Houses* (1850), and popularized the style of the picturesque.

After his association with Downing ended in 1843, Davis achieved his greatest popularity. During the 1840s and 1850s, Davis became the

leading architect of country houses in a variety of picturesque styles, the most popular being the Gothic Revival and Italianate, sometimes designing their interiors and furniture. (Davis designed only a few Gothic Revival churches, as he remained outside the mainstream of ecclesiastical theory and practice of his day.) More than one hundred of his designs for villas and cottages were built. Some critics objected to the use of Gothic Revival, claiming it was inappropriate for institutions in a republic. Davis ignored these criticisms and designed over a dozen castellated villas influenced by the books of the English architect Augustus Charles Pugin. Davis's work in the Gothic Revival style was crowned by Knoll, built for General William Paulding on the Hudson River in Tarrytown, New York, which he planned in 1838 (it was later enlarged by Davis for George Merritt and renamed Lyndhurst).

His last significant project (1853–70) was designed in collaboration with the developer Llewellyn S. Haskell: it consisted of a residential community for Llewellyn Park, West Orange, New Jersey, the finest picturesquely planned architectural enclave in the country. His popularity waned after the Civil War—due to a changing taste for the Second Empire and High Victorian styles in which Davis refused to work, the rising number of European immigrant architects, the increased training of American architects abroad, and the introduction of formal architectural education in American universities. He went into semiretirement about 1874 at Wildmont, his own villa in Llewellyn Park. Although Davis's rural-oriented design impeded his understanding of the requirements of urban construction, one of his most important contributions was the Davisean window, a multistoried, stacked window that anticipated the unified and strongly vertical facades of such later architects as Louis Sullivan. Davis devoted his last decades to the defense of his own conception of art and to the organization of his drawings and papers.

In addition to the twenty-four drawings by Davis in the museum's collection, the Society also has an extensive cache of his architectural plans and renderings, as well as prints by him in the DPPAC. His correspondence and other documents are housed in the library's Department of Manuscripts. Avery Architectural and Fine Arts Library at Columbia University in New York also has substantial holdings of Davis material.

Bibliography: Edna Donnell, "A. J. Davis and the Gothic Revival," *Metropolitan Museum Studies* 5 (1936): 183–233; Roger Hale Newton, *Town & Davis, Architects: Pioneers in American Revivalist Architecture, 1812–1870* (New York: Columbia University Press, 1942); John Donoghue, "Alexander Jackson Davis, Romantic Architect, 1803–1892" (Ph.D. diss., New York University, 1977); Patrick Alexander Snadon, "A. J. Davis and the Gothic Revival Castle in America, 1832–1865" (Ph.D. diss., Cornell University, 1988); Amelia Peck, ed., *Alexander Jackson Davis, American Architect, 1803–1892*, exh. cat. (New York: Metropolitan Museum of Art and Rizzoli, 1992); Carrie Rebora and Ameila Peck, "The Artistic Career of Alexander Jackson Davis," *The Magazine Antiques* 142:5 (1992): 704–12.

67. *Greek Revival Double Parlor*, c. 1830

Watercolor, black ink and wash, and gouache with scratching-out over graphite on paper, laid on canvas; 15 13/16 × 21 1/2 in. (401 × 546 mm)
Inscribed at lower center in graphite: *Parlour of J. C. Stevens house. College Place, Murray St.*
Provenance: Daniel Parish Jr., New York.
Bibliography: Mayhew and Myers 1980, pl. 9; Koke 1982, 1:257, no. 459, ill.; C. Stevens Laise, "A. J. Davis and American Classicism," *The Magazine Antiques* 136:6 (1989): 1323–25, pl. IV; Historic Hudson Valley, *A. J. Davis and American Classicism*, exh. cat. (Tarrytown, N.Y.: Sleepy Hollow Press, 1989), 17, ill.; Peck 1992, 87, fig. 4.6, pl.54; Voorsanger and Howat 2000, 291, 582, no. 112, ill.; Olson 2004, 20, fig. 1; Priddy 2004, xxi, fig. 1.
Gift of Daniel Parish Jr., 1908.28

Town & Davis designed many Grecian suburban and country villas, typically consisting of central temple units and possibly modeled on villas by John Nash and Decimus Burton in Regent's Park, London. Three fine, early villas were the Hillhouse (1828, demolished) and Skinner villas (1830–34) in New Haven and the Russell villa (1829) in Middletown, Connecticut. Later Grecian villas by Davis, such as the Stevens mansion (1845, demolished) in New York City, a dinosaur from the day it was begun, tended to be giant cubic masses articulated with lush Corinthian porticoes. As indicated in the inscription, the sheet was once thought to be Davis's design for the John Cox Stevens Neoclassical residence on the southeast corner of Murray Street and College Place (now West Broadway) in New York City. However, the design of the interior does not match the exterior elevation of the Stevens house, as preserved in another drawing in the collection (essay fig. 1).[1] The Ionic columns of the parlor do not harmonize with the taller

and more ornate Corinthian columns of the exterior portico but rather resemble Davis's earlier tetrastyle Ionic temple facade of the Aaron N. Skinner house.[2] As in the Skinner villa, the watercolor shows little wall space between the Davisean windows, whereas the facade of the Stevens residence featured larger spaces between the fenestration.

Since interior renderings by Davis are quite rare, this highly finished perspective study of a double parlor in the Neoclassical style is one of his best-known works. It may have been intended as a presentation drawing for a commission that was never executed or for a client whom he wanted to interest with a prospective idea. Davis furnished the parlors in the watercolor with elegant tables, klismos-like chairs, mirrors, urns, and paintings, derived from designs of Thomas Hope.[3] Both the designs of the furniture and the parlor style help to date the sheet to the 1830s. Only in the largest of Greek Revival houses of the 1830s were the matching parlors much longer than those of the 1820s and separated by a narrow wall that often encased a pair of sliding doors, flanked by pairs of Ionic or Corinthian columns. In the pair of Greek Revival parlors in the Society's sheet, Davis depicted two pairs of Ionic columns (without doors), an unusual treatment found only in the grandest of houses,[4] such as those of La Grange Terrace (1832–34; demolished).[5] This handsome work may be the drawing Davis recorded in his daybook in early April 1830 as "Drawing Perspective view interior of parlour several days"; the previous week he had noted "[Drawing] Interior Drawing room. (study of Hope's furniture)."[6]

1. See Koke 1982, 1:256–57, no. 458, ill.
2. For the Skinner home, see Newton 1942, 6; and Donoghue 1977, fig. 33, the latter of which shows the tripartite windows between the columns of the portico that once were probably Davisean but later, with the modification of the wings, altered. For Davis's drawing of an Ionic tetrastyle facade with Davisean windows, his elevation for the New York Lyceum in the A. J. Davis Collection of the DPPAC, see Historic Hudson Valley 1989, 17, ill. Peck 1992, 106, lists Greek Revival commissions for that time period.
3. Peck 1992, 87.
4. Voorsanger and Howat 2000, 180.
5. Ibid., 580, no. 86, ill., for a drawing of the exterior facade only later identified as Colonnade Row. See also Diamonstein 1998, 71, ill.
6. Daybook, vol. 1, The NYPL, Manuscript Division, A. J. Davis Papers.

Parlour of J.C. Stevens house. College Place & Murray St.

67

ALMIRA EDSON

Halifax, Vermont 1803–Vernon, Connecticut 1886

Almira Edson was the fourth child of Rebecca Taylor and Jesse Edson, who was a graduate of Dartmouth College and a Congregationalist minister in Halifax, Vermont. Jesse Edson died in 1805 and Almira's mother remarried and moved in with Captain Edward Adams of nearby Colrain, Massachusetts, in 1810. Edson began creating family registers during the early 1830s when she drew the *James and Jane Clark Tucker Family Register* and the *Family Register of Dennis and Lucy Frary Stebbins* (c. 1835; private collection). Little is known about her life until she joined the Putney Perfectionists in 1841, founded by John Humphrey Noyes in Putney, Vermont, the antecedent of the Oneida Community of western New York. The only firsthand description of Edson comes from Noyes, recorded in the proceedings of a dispute that eventually led to her expulsion from the group. Noyes perceived the spirited Edson as "possessing naturally a brilliant mind and great fluency of speech" but disapproved of her "decided proclivity to teach and to rule."

In Putney, Edson met another newcomer to the utopian group, John Lyvere. The two became enamored and decided to marry, a violation of Noyes's perfectionist tenet of "complex marriage" in which every man was thought of as married to every woman (and vice versa) but no two people were allowed to form an exclusive attachment. Noyes accused them of licentious behavior because their conventional marriage, which he considered selfish and idolatrous, placed romantic love over brotherly love, and expelled them from the Putney community in 1842.

In the 1850 census Edson and Lyvere were recorded as residents of Vernon, Connecticut, where her older sister Rowena Thompson lived. After that there is little information about their activities. The latest work attributed to Almira Edson is *The Family Register of William C. and Emily Porter Russell* (c. 1847; private collection) of Ellington, Connecticut, near Vernon. Edson died in 1886 with no drawings or art supplies in her estate.

Bibliography: George Wallingford Noyes, *John Humphrey Noyes: The Putney Community* (Oneida, N.Y., 1931), 51–53; Constance Noyes Robertson, *Oneida Community, an Autobiography, 1851–1876* (Syracuse, N.Y.: Syracuse University Press, 1970); Carroll Edson, *Edson Family History* (Ann Arbor, Mich.: Edwards Brothers, c. 1970), 355; Arthur B. Kern and Sybil B. Kern, "Almira Edson, Painter of Family Registers," *The Magazine Antiques* 122:3 (1982): 558–61.

68. *James and Jane Clark Tucker Family Register*, c. 1834

Watercolor and brown and black ink; 18 3/8 × 23 in. (467 × 584 mm)
Signed and inscribed at lower right in brown ink:
Executed by Almira Edson, Halifax, Vt.
Bibliography: Kern and Kern 1982, 558–61, ill.
Gift of Mrs. J. Insley Blair, X.474

Illuminated family registers were a common form of decorative folk art in early-nineteenth-century America, an era when the absence of consistent public records compelled families to chronicle the vital statistics of their members for posterity.[1] The New England family register was related to the Pennsylvania-German fraktur tradition of the eighteenth century, in which the names of people with their dates of birth and marriage were recorded calligraphically on a sheet of paper with highly stylized symbolic motifs decorating the uninscribed areas.[2] Almira Edson's family registers, like frakturs, frequently feature stylized birds, flowers, and human figures, particularly women and infants. They also incorporate many elements of the traditional English mourning picture, including columns, swags and draperies, stylized weeping willow trees, urns, tombs, and mourning relatives.[3]

In Edson's *James and Jane Clark Tucker Family Register*, the entire cycle of life and death is represented in the composition, from the infant in its mother's arms at the upper left corner, to the children innocently frolicking with lambs above the swag, to the funeral urn at the upper right corner and the red-clad mourners weeping beside the willow-framed tombs at lower center. The linear stylization of the willow leaves resembles the embroidered patterns of the traditional English stitched mourning scenes that were the models for drawn family registers and memorial pictures.[4] The Corinthian order columns with fluted shafts flanking the curtains are covered with pink roses in full bloom to represent maturity, the full bloom of life. The sheet is decorated with rosebuds, trees, flowers, hearts, birds— symbols of birth, abundance, prosperity, and happiness—and calligraphic flourishes.[5]

Little additional information besides that contained in the family register is known about the James and Jane Clark Tucker family. No deaths were recorded during the time the family maintained the register. They lived in Halifax, Vermont, during the first half of the nineteenth century, and son Joseph, the second child listed on the register, married in nearby Colrain, Massachusetts.[6] While many questions about the Tucker family and the artist Almira Edson who created their record remain unanswered, the register is an outstanding example of New England calligraphic drawing and places Edson among the talented female folk artists of nineteenth-century America.

A. M.

1. Black and Lipman 1966, 205–7; and Jean Lipman and Alice Winchester, *The Flowering of American Folk Art, 1776–1876*, exh. cat. (Philadelphia: Courage Books, in cooperation with Whitney Museum of American Art, 1987), 104–5.
2. The Pennsylvania-German fraktur tradition evolved from old German laws requiring certificates of birth, baptism, and marriage to be registered with the local government; see Henry Young (cat. 49); and Frederick S. Weiser and Howell J. Heaney, *The Pennsylvania German Fraktur of the Free Library of Philadelphia* (Breinigsville, Pa.: Pennsylvania German Society and Free Library of Philadelphia, 1976), 1: XII–XXXIII. The Society's collection includes more than twenty-five examples of Pennsylvania-German frakturs.
3. Kern and Kern 1982, 558; Philip Isaacson, "Records of Passage: New England Illuminated Manuscripts in the Fraktur Tradition," *Clarion* 5 (Winter 1980–81): 30–35; and Betty Ring, *Girlhood Embroidery: American Samplers and Pictorial Needlework, 1650–1850* (New York: Alfred A. Knopf, 1993), 1:144–46, 195–97, 206–23, 245–48. The Society has several examples of textile mourning pictures in the English tradition, see inv. nos. 1916.8 (Elenor B. Sice, mourning embroidery, 1823), 1937.343 (Henrietta Schnip, mourning sampler, c. 1828), 1968.1 (A. D. Beekman, mourning embroidery, c. 1810), and 1968.2 (Eliza Beekman, mourning embroidery, c. 1810).
4. Jean Lipman, Elizabeth V. Warren, and Robert Bishop, *Young America: A Folk Art History* (New York: Hudson Hills Press, in association with Museum of American Folk Art, 1986), 138, 144; and Lipman and Winchester 1987, 80.
5. For further discussion of the symbols mentioned, see J. C. Cooper, *An Illustrated Encyclopaedia of Traditional Symbols* (London: Thames and Hudson, 1978), 20, 70, 82, 94–95, 141, 176–78, 184, 192.
6. Kern and Kern 1982, 559.

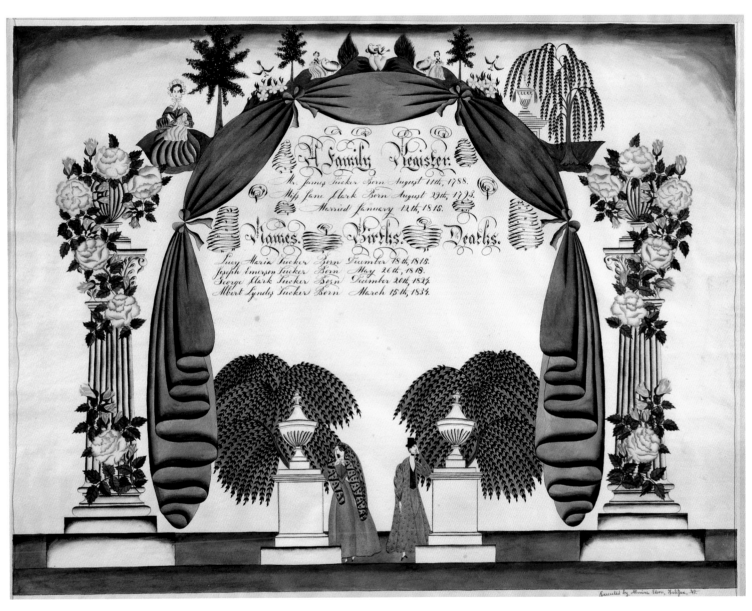

68

WILLIAM JOY (AND JOHN CANTILOE JOY?)

Great Yarmouth, England 1803–London, England after 1859, 1866 or 1867?

William Joy and his brother John Cantiloe Joy (1806–1859) carried on the Anglo-Dutch tradition of sea painting. They were educated at Wright's Southdown Academy in the North Sea coast town of Great Yarmouth, England. Sometimes designated "the Brothers Joy," the two frequently collaborated on the same work. At the time a wealthy and eccentric school friend of Lord Nelson, Captain G.W. Manby, was barrack master in that Norfolk town. Manby was also an inventor of maritime devices and a patron of the arts, and he had a particular interest in marine paintings. In addition to being an avid collector, on his various sea voyages he sketched compositions that William Joy later worked up into paintings. As young artists, the two brothers were brought to Manby's attention, and he was sufficiently impressed to help them. In 1818 he gave them a studio in the Royal Hospital, where he allowed them to copy marine works from his collection and to observe the sea. Manby instilled in the Joys some of his passion for the sea and ships, teaching them the construction of seafaring vessels, knowledge that is reflected in their technically correct works.

William Joy had already exhibited works at the Norwich Society in 1814, when he may have made his first contact with Manby. In 1820 Manby organized and sponsored an exhibition of the brothers' works in the barracks in honor of the king's birthday, inviting many of his influential friends (such as Dawson Turner, a patron of John Sell Cotman and a collector), an event that marked the beginning of their very successful careers. Soon they were receiving commissions and exhibiting regularly with the Norwich Society to positive notices in the press.

In 1829 or 1830 William Joy went to London at Manby's recommendation to widen his clientele. His brother soon followed, and they enjoyed the patronage of the Earl of Abergavenny. Remaining in London for two years, they moved to Portsmouth in 1832 to work as government draftsmen, but returned to London. Their later years were divided between Chichester, Sussex, and London. William exhibited in London at the British Institution (1823 and 1845), and both brothers showed at the Suffolk Street Gallery. A death certificate establishes that John Cantiloe Joy died in 1859 at 15 King Street, Soho, London; his brother William was at his side. It is generally thought they died within a short time of one

another, although William's death date is frequently given as 1866 or 1867.

While the brothers frequently collaborated nearly seamlessly, William seems to have been the more dominant of the inseparable siblings. He painted in both oil and watercolor and specialized in dramatic works with stormy skies and seas, whereas John reputedly worked only in graphite and watercolor. As their works are generally unsigned or bear the signature "JOY," the task of distinguishing the work of one brother from the other is difficult.

Bibliography: Josephine Walpole, *Art and Artists of the Norwich School* (Woodbridge, Suffolk: Antique Collectors' Club, 1997), 146–48; H. L. Mallalieu, *The Dictionary of British Watercolour Artists up to 1920* (Woodbridge, Suffolk: Antique Collectors' Club, 2002), 1:339; Lindsey Macfarlane, "Joy, William," in *Oxford Dictionary of National Biography*, Oxford University Press, 2004, http://www.oxforddnb.com/view/article/15150.

69. *Queen Victoria's Visit in the Royal Yacht "Victoria & Albert I" to HMS "Victory,"* c. 1845

Watercolor, graphite, scratching-out, and touches of gouache on paper; 7 3/4 × 11 3/8 in. (196 × 289 mm)
Verso of old mount inscribed: *Queen Victoria's Visit by Paddle Steamer to the "Victory", which is Hove to*
Provenance: Randall J. LeBoeuf Jr., Old Westbury, N.Y.
Bequest of Randall J. LeBoeuf Jr., 1976.63

According to an inscription on the verso of the watercolor's former mount, the work records Queen Victoria's visit to HMS *Victory* at Portsmouth Harbor on the southern coast of England. The famous flagship of Vice-Admiral Lord Nelson at the Battle of Trafalgar (21 October 1805) and of Admiral Sir John Jervis at the Battle of Cape St. Vincent (14 February 1797) was among the most renowned warships in the world. It was ordered in 1758, the same year in which Horatio Nelson was born. The keel was laid at Chatham Dockyard in 1759, and the ship was finished six years later. Her construction encompassed twenty-seven miles of rigging, four acres of sails, and required two thousand mature trees to build. The *Victory* saw almost constant service from 1778 to 1812, when she was retired to Portsmouth. (Today the storied ship remains in retirement but still in commission as a historic site for maritime education in Portsmouth Harbor.) Joy's watercolor shows

Queen Victoria arriving at the *Victory* on the steam-powered royal yacht *Victoria & Albert I*, whose completion date in 1843 provides a general terminus post quem for the work. From the moment the *Victoria & Albert I* was finished, Queen Victoria took every opportunity to make use of the craft. A few years later, on 21 June 1845, the Royal Navy formed an Experimental Squadron to carry out sailing trials at Spithead, the sheltered strait between Portsmouth and the Isle of Wight, with a royal review that set the precedent for many others during the queen's long reign. This event establishes a more precise terminus post quem for Joy's watercolor, in which the two vessels fly the Union Jack to emphasize the nationalist sentiment of the moment.[1]

Since both Joys were known for their maritime watercolors featuring ships, and their works are nearly indistinguishable, it is difficult to attribute the Society's unsigned sheet. While the planar treatment of the ships and the formulaic composition of this watercolor are notably similar to many works attributed to William Joy,[2] the styles of the two have not been sufficiently studied or differentiated to posit an airtight attribution.[3]

1. For another watercolor preserving the Spithead inaugural review on the *Victoria & Albert I*, see Bonham's, London, sale cat., 21 September 2005, lot 62, ill., which is attributed to both William and John Cantiloe Joy. Previously, the watercolor had been given to William only, underlining the attribution problems inherent in the work of the two brothers (Sotheby's, London, sale cat., 22 May 1991, lot 40). William painted the same subject in oil; see Sotheby's, London, sale cat., 9 November 1994, lot 5, ill.

2. See Scott Wilcox, *British Watercolors: Drawings of the 18th and 19th Centuries from the Yale Center for British Art*, exh. cat. (New York: Hudson Hills Press, in association with the Yale Center for British Art and the American Federation of Arts, 1985), no. 64, ill., a watercolor, *Dutch Fishing Boats at Anchor in an Estuary*, c. 1850–60 (inv. no. B1977.14.6211).

3. Walpole 1997, 146–48, suggests possible stylistic differences but does not provide any visual evidence or analysis. An oil painting in the Society's collection (inv. no. 1951.69), a copy of one of three paintings of the subject by Dominic Serres, *Forcing the Hudson River Passage*, is signed at the lower right: *W. Joy*; see Koke 1982, 2:236–37, no. 1557, ill.

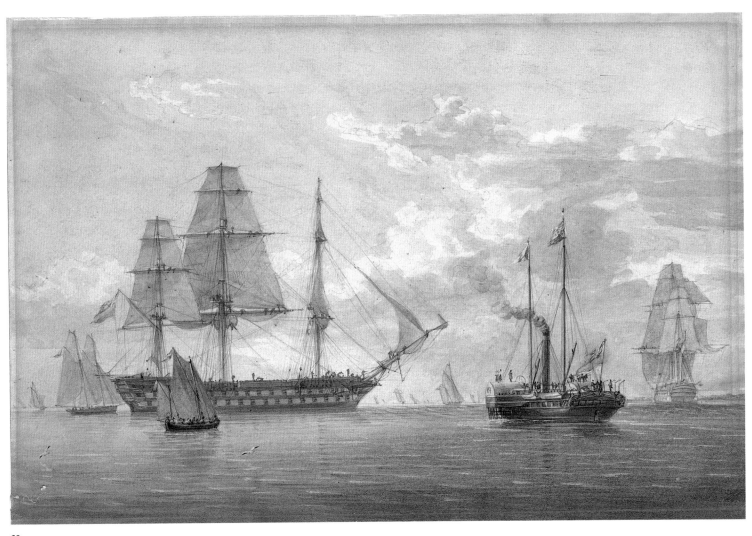

69

WILLIAM SIDNEY MOUNT

Setauket, Long Island, New York 1807–Stony Brook, New York 1868

America's first internationally renowned genre painter, William Sidney Mount spent most of his life on rural Long Island. He was brought up with his sister and three brothers on his grandfather's farm in Stony Brook, where his mother had moved after the death of his father in 1814. Two of his brothers, Henry Smith and Shepard Alonzo, also became artists. In 1815 young William was sent to New York City to live with his uncle Micah Hawkins, who ran a tavern and grocery, was a musician and composer of considerable talent, and fostered William's love of music. Returning to Long Island the following year to help his mother, Mount went back to the metropolis in 1824, again lodging with his uncle, and apprenticed as a sign painter to his brother Henry. Frustrated by the limitations of sign painting, whose compositional influence is apparent in his paintings, he enrolled in the antique drawing class at the newly founded NAD from 1826 to 1827. For a short time Mount also studied with Henry Inman (cat. 64). Mount aspired to become a painter of historical subjects, although his first efforts were portraits. The historical scenes that followed, such as *Saul and the Witch of Endor* (1828; Smithsonian American Art Museum, Washington, D.C.), were linear, flat, and brightly colored, as would be expected from his background. Exhibiting at the NAD from 1828 until his death, he became an associate in 1831 and a full academician in 1832. After 1827 the unmarried artist began living intermittently on Long Island, although he attempted unsuccessfully to establish a portrait-painting business in New York with his brother Shepard Alonzo, and in 1829 he reestablished his residency on the Mount farm in Stony Brook, an estate he owned jointly with his brothers. All the brothers, save Robert Nelson who lived in Setauket, resided there with their families. At this juncture, William began to focus exclusively on everyday rustic subjects and popular culture, perhaps inspired by seventeenth-century Dutch and Flemish painters like David Teniers and engravings after the Scottish painter David Wilkie (cat. 44), to whom critics likened his work, even calling him "the American Wilkie."

Mount's first attempt at genre painting, *Rustic Dance after a Sleigh Ride* (1830; Museum of Fine Arts, Boston), which he exhibited at the NAD, was enthusiastically received, and he was heralded as one of America's most promising genre painters. It embodied a theme that the artist revisited throughout his career in paintings that frequently carried a politically oriented, satirical note: the contrast between the shrewd city dweller and the country bumpkin. His *Bargaining for a Horse* (1835; The N-YHS), commissioned by the businessman-collector Luman Reed, ostensibly about the horse being sold, also comments on the "horsetrading" that Americans engaged in during the 1830s, a time rife with political bargaining and economic speculation. The painting enjoyed a huge success and, like many of his canvases, was engraved. Mount's themes usually rose above partisan issues to satirize the political process and social issues. His often simplified, spartan compositions belie the complex layers of emblematic meaning behind his images.

One of the most accomplished American genre painters of his era, rivaled only by George Caleb Bingham, Mount depicted a variety of rural themes, most notably celebrations of music making in which his favorite musician was the fiddle player. An accomplished violinist and musician himself, Mount collected rustic music, published songbooks, and designed a special type of violin that he patented. In one of his best-known paintings, *The Power of Music* (1847; The Cleveland Museum of Art), an African American man leans against the outside wall of a barn, absorbed in the music produced by the group within. Mount was unusual for his day in depicting this listener without caricature. Recog-

nizing the importance of his point of view in the 1850s, the art dealer William Schaus, an agent for the French firm Goupil, Vibert & Co. (later Goupil & Co.), commissioned from Mount a number of works depicting African American musicians that were lithographed for wide distribution in Europe. Part of their popularity was based on his representations of these musicians in a social context that Europeans believed reflected the racial tensions of the late 1850s and 1860s in the United States (fig. 70.1). Many of Mount's paintings expressed complicated moralistic and political views, and he was one of the first major American artists to portray African Americans with dignity, although his family had owned slaves. Unfortunately, Mount's own views on the complex issues of race and slavery in antebellum America are enigmatic, although he is thought to have adhered to the Cass wing of the Democrats. Because of his humble subject matter and skillful realistic execution, Mount's work was well received by the American public during the era of Jacksonian democracy, while his serene agrarian paintings were also a welcome contrast to the increasing complexities of the industrial revolution.

Mount accepted commissions from several influential New York patrons, in addition to Reed and Jonathan Sturges. They offered to send him to Europe for further study, but he declined, making only local trips and spending the rest of his life painting in Stony Brook. A favorite of newspaper and journal critics, Mount had a wit

Fig. 70.1. William Sidney Mount, *Study for "Dawn of Day" ("Politically Dead" or "The Break of Day"),* 1867. Graphite, 3 1/4 × 4 in. (83 × 102 mm). The New-York Historical Society, Department of Manuscripts

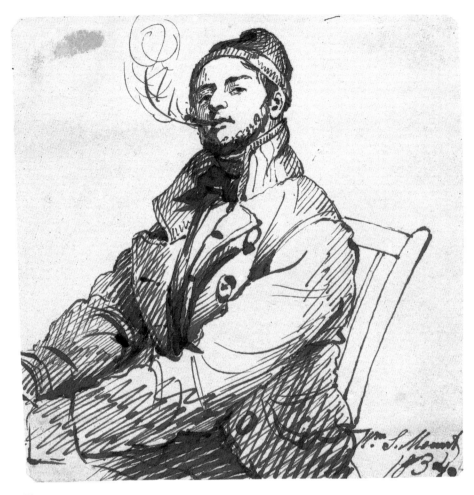

70

unique among American artists that dared to exercise a form of national self-criticism.

Amazingly self-conscious about his painting methods, Mount kept journals in which he recorded his experiments with pigments and brushes, as well as biographical facts and observations about the life around him. He also documented his inventions, sketched extensively in notebooks, and painted plein air sketches, devising a studio-wagon in which he traveled throughout Long Island. Although Mount made a large number of sketches of city characters, he almost exclusively painted rural scenes, which were in great demand. Mount also executed portraits, many of which were posthumous visages, and he is recorded as commenting that his best patron was death. The collections are rich in Mount material, including nine paintings and nine drawings (one of which, *Dancing in the Barn*, contains a fiddler), as well as numerous prints (in

the DPPAC), and letters and papers dating from 1833 to 1868 (in the Department of Manuscripts).

Bibliography: Bartlett Cowdrey and Herman Warner Williams Jr., *William Sidney Mount, 1807–1868: An American Painter* (New York: Published for the Metropolitan Museum of Art by Columbia University Press, 1944); Alfred Frankenstein, *Painter of Rural America: William Sidney Mount, 1807–1868*, exh. cat. (Washington, D.C.: H. K. Press, 1968); Suffolk Museum & Carriage House, *Drawings and Sketches by William Sidney Mount, 1807–1868* (Stony Brook, N.Y.: Suffolk Museum & Carriage House, 1974); Alfred Frankenstein, *William Sidney Mount* (New York: Harry N. Abrams, 1975); Catherine Hoover, "The Influence of David Wilkie's Prints on the Genre Paintings of William Sidney Mount," *American Art Journal* 13:3 (1982): 4–33; David Cassedy and Gail Schrott, *William Sidney Mount: Annotated Bibliography and Listings of Archival Holdings of the Museums at Stony Brook* (Stony Brook, N.Y.: Museums at Stony Brook, 1983); idem, *William Sidney Mount: Works in the Collection of the Museums at Stony Brook* (Stony Brook, N.Y.: Museums at Stony Brook, 1983); Janice Gray Armstrong, ed., *Catching the Tune: Music and William Sidney Mount* (Stony Brook, N.Y.: Museums at Stony Brook 1984); Elizabeth Johns, *American Genre Painting: The Politics of Everyday Life* (New Haven: Yale University Press, 1991), 248, for a listing of page references to the artist and his works; Frederick C. Moffatt, "Barnburning and Hunkerism: William Sidney Mount's *Power of Music*," *Winterthur Portfolio* 29:1 (1994): 19–42; Deborah J. Johnson et al., *William Sidney Mount: Painter of American Life*, exh. cat. (New York: American Federation of Arts, 1998).

70. *Study for a Figure in "After Dinner,"* 1834

Brown ink on paper, laid on heavy ivory paper from a disassembled album; 5 1/4 × 5 in. (133 × 127 mm), irregular
Signed and dated at lower right in brown ink: *Wm. S. Mount / 1834.*
Provenance: Jas.[?] C. Maguire Collection, Washington, D.C.; Thomas Dowling, Washington, D.C., 1888.
Bibliography: N-YHS 1974, 2:927, no. 2361, ill.
Gift of an anonymous donor, 1947.415

Music was important to Mount. His friends knew him not only as an artist but also as a talented musician. He played his fiddle for local dances and concerts, collected music (now in the Museums at Stony Brook), and invented a violin he called the "Cradle of Harmony" or the "hollow-back" violin, which he patented in 1852 and exhibited at New York City's Crystal Palace Exhibition in 1853.[1] Mount designed this violin with a concave back, reversed f-holes, and a guitarlike shape for the special needs of rural fiddlers, who entertained without accompaniment and needed an instrument that could produce more volume than a conventional violin.[2] Not coincidentally, rural fiddlers populate many of Mount's canvases. In his first self-portrait (1828), the artist had represented himself holding a wooden flute,[3] and he wrote: "All the great painters were fond of music."[4] Not surprisingly, therefore, Mount painted many pictures of musical subjects, including the one for which this sketch is a study, during an age when music became the favorite Romantic art in America.[5]

In 1834 Mount sent *After Dinner* (fig. 70.2), to the annual NAD exhibition, where it was positively received.[6] This dashing sketch is preparatory for the man sitting at the right, smoking, his hands clasped around his knees as he listens to the violin music. All three men in the work, their appetite for food sated, sit listening to music and sipping claret. The man in the top hat dressed in elegant city garb on the left is a gentleman, while the man wearing a red Monmouth cap on the right looks like a dockhand who frequented taverns on the New York waterfront. The pivotal fiddler turned in contrapposto at the center divides the two social types poised before a bare, dark background, characteristic of the artist's early studio paintings. Positioned at the fulcrum of the composition, the fiddler embodies the power of music to unify the two social classes.

A skillful portraitist, Mount continued to paint and draw portraits throughout his life. He also included self-portraits and likenesses of friends and family in his paintings, together with settings based on actual rooms and locations. As in many works, such as *California News* (1850; Museums at Stony Brook) in which Mount used his friends and relatives as models but never identified them,[7] *After Dinner* contains figures from Mount's immediate circle. Certainly

the young man playing the fiddle at the center is a self-portrait. This hypothesis is proven in a visual comparison with two works in the Museums at Stony Brook: Mount's earliest self-portrait of 1828, in which the artist's widow's peak is prominently shown, and where he holds a wooden flute; and the more elegant portrait of 1832, in which a shock of hair over his forehead softens the effect of his distinctive hairline.[8] The other two figures in *After Dinner* cannot be identified as definitively, although they resemble types Mount painted in other works and represent denizens of different social-occupational categories that music brings together harmoniously. The left figure sporting muttonchops bears some resemblance to the artist's older brother Henry.[9] The rakish figure on the right may be the likeness of another brother, Robert Nelson, a dancing instructor and violinist who suffered from intemperance; he was the model for a figure in Mount's *Just in Tune* (1849; Museums at Stony Brook), where his facial hair also includes a mustache.[10] As evidenced by the glasses on the table, the painting is set in a tavern, like several other works by Mount related to temperance issues and seventeenth-century Dutch prototypes.[11] Rather than a rustic watering hole, this tavern is a city establishment, perhaps like those on the East River near the artist's uncle's store on Catherine Slip.

The restrained tone of *After Dinner*, its bare background occupying nearly half of its composition, its male trio, and its musical subject, all relate to Mount's early portraits and the old master model for his composition: Titian's *The Concert* (fig. 70.3). Until 1880 Titian's canvas was also attributed to his teacher Giorgione, the Venetian painter who, himself a musician of repute, invented and popularized pictures of musical themes in a half-length format.[12] Titian's three musicians, dominated by a central triangular figure in contrapposto like the one in Mount's painting, represent the allegory of the three ages of man—youth, middle age, and old age. When Titian painted it, music was an essential part of a gentleman's education. Although Mount turned down a number of offers to travel to Europe, he was influenced by Dutch and Flemish as well as French and Italian paintings, sometimes known through prints: for example, Correggio's *Jupiter and Antiope* informed the composition of *Farmers*

Nooning of 1836.[13] That Mount knew and admired Titian is clear from the artist's letter to Thomas H. Hadaway (22 April 1855) in which he characterizes Titian's palette: "White, yellow Ocher, Indian Red or its substitute Light red. Black, Blue, Bright Yellow, Vermillion, Lake and Burnt Oil. The Browns were Burnt Sienna, Umber and Bister."[14] Except for the blue (also absent in Titian's *The Concert*), these are precisely the colors Mount employed in *After Dinner*, whose distinctive dark, blank background derives from his study of early-sixteenth-century Venetian paintings, in which the artist clearly found both an artistic and a musical resonance.

1. Frankenstein 1975, 79–94; and Martha V. Pike, "Catching the Tune," in Armstrong 1984, 8.

2. Cassedy and Schrott, *Works* 1983, 83, ill.; and Laurence Libin, "Instrument Innovation and William Sydney Mount's 'Cradle of Harmony,'" in Armstrong 1984, 56–65. The painting *Catching the Tune* (1866), found in Mount's studio at his death, contains a young man, clearly a self-portrait, holding the violin; ibid., 42, ill. A study for the man whistling at the right of *Catching the Tune* (see Frankenstein 1975, fig. 155) relates to its respective painting in a manner analogous to the figure in the Society's sheet for the right figure in *After Dinner*. For the instrument itself, made by Thomas Seabury, see Cassedy and Schrott, *Works* 1983, 83, ill. Both painting and violin are in the Stony Brook Museums.

3. Cassedy and Schrott, *Works* 1983, 34–35, ill.

4. In his diary/journal of 1857–68, 16 February 1863. Mount prefaced his remark with: "I believe I must have a violin in my studio—to practice upon. To stimulate me more to painting. I remember that when I painted my best pictures I played upon the violin much more than I do now. The violin was the favorite instrument of Wilkie." Quoted in Frankenstein 1975, 364–65.

5. Libin 1984, 60.

6. Cowdrey 1943, 2:42, no. 99. For the painting (inv. no. 1972.33), see Peter G. Buckley, "'The Place to Make an Artist Work,'" in Armstrong 1984, 24–25, ill. It will be included in *Life, Liberty and the Pursuit of Happiness: American Art, 1660–1893, from the Yale University Art Gallery*, exh. cat. (New Haven: Yale University Press, forthcoming). Frankenstein 1975, 469, quotes Mount's recording of the work: "A group of three figures. A man playing the violin while the others are listening. I believe I called it after dinner. Sold to Mr. James H. Patterson. Size of picture 11 in by 11 inches and painted on white wood. $30.00."

7. Cassedy and Schrott, *Works* 1983, 60–61, ill., which suggests some of the identities of the people and the locations Mount used. See also John Wilmerding, *Signs of the Artist: Signatures and Self-Expression in American Paintings* (New Haven: Yale University Press, 2005), 77–85, about Mount's personal involvements in his pictures.

8. Cassedy and Schrott, *Works* 1983, 34–35 and 6, ills., respectively.

9. See Frankenstein 1975, 23–24, pls. 7 and 8 for William's 1828 and 1831 portraits of him (healthy and beardless) as well as two drawings of 1841, one posthumous, in which his features are pinched, his nose is more prominent, and in which he sports muttonchops and a beard (ibid., 62, pls. 22 and 23). See also Jacqueline Overton, "The Talented Mount Brothers," reprint from *Long Island Forum*, July 1942, 7, ill.

10. Johnson et al. 1998, 70–71, fig. 63. Graham C. Boettcher, in his entry on the painting in *Life, Liberty, and the Pursuit of Happiness* (forthcoming), believes this character to be an Irish stereotype. The figure's red hair and beard show his fieriness, and his ruddy complexion suggests intoxication. Boettcher further interprets the red cap as resembling a rooster's comb in a visual pun on cockiness.

11. For example, *The Breakdown* (*Bar-room Scene* or "*Walking the Crack*," as Mount sometimes called it) of 1835, the cause célèbre at the NAD exhibition in which a young boy wears a red cap similar to the one worn by the youth in *After Dinner*; Frankenstein 1975, 248, pl. 88. For drawings of tavern scenes, see ibid., fig. 148; and Suffolk Museum & Carriage House 1974, 45 and 57, ills.

12. See Comune di Venezia, Assessorato alla Cultura, and National Gallery of Art, Washington, D.C., *Titian: Prince of Painters*, exh. cat. (Venice: Marsilio Editori, 1990), 144, no. 3, ill.

13. See, for example, Johnson et al. 1998, 40–42, ills. See also William T. Oedel and Todd S. Gernes, "The Painter's Triumph: William Sidney Mount and the Formation of a Middle Class Art," *Winterthur Portfolio* 23:2–3 (1988): 111–27.

14. Quoted in Frankenstein 1975, 297.

WILLIAM HENRY BARTLETT

London, England 1809–at sea 1854

Born in Kentish Town, London, the topographical artist William Henry Bartlett was apprenticed at the age of twelve for seven years to John Britton, an antiquarian architect. Britton sent him around England to make sketches and architectural drawings, some of which were used for the illustrations in Britton's *Cathedral Antiquities of England* (1814–32), *Christian Architecture in England* (1826), and *Picturesque Antiquities of the English Cities* (1830). Having completed his apprenticeship, Bartlett became a minor but prolific figure among the topographical illustrators of the 1820s and 1830s during the age of Richard Parks Bonington and J. M. W. Turner. He also exhibited at the Royal Academy of Arts in 1831 and 1833 and at the New Watercolour Society. In 1821 he married Susanna Moon, niece of Sir Francis Moon, fine art publisher and lord mayor of London (1854–55).

For the next ten years Bartlett traveled all over Europe, the Middle East, and North America, sketching and fulfilling commissions for drawings to be included in travel books, many of which were published by George Virtue. In 1832 he met Dr. William Beattie, with whom he collaborated on an illustrated travel book of Switzerland, followed by another with John Carne on the Holy Land and Syria. Bartlett also provided illustrations for other books by Beattie: *Scotland Illustrated* (1838), *The Waldenses* (1838), and *The Castles and Abbeys of England* (1844). In 1836–37 he spent a year in North America, the first of four visits between 1836 and 1854, sent by Virtue to make drawings preparatory for engravings to accompany the texts by the Knickerbocker writer Nathaniel Parker Willis in *American Scenery* (1840) and *Canadian Scenery* (1842). He also executed the illustrations for Nicholas van Kampen's *The History and Topography of Holland and Belgium* (1837) and *The Beauties of the Bosphorus* (1839) by Julia Pardoe.

By the mid-1840s the demand for travel book illustrations had slackened, and Bartlett turned to writing his own books, twelve in number, with steel engravings and woodcuts prepared from his drawings. *Walks about the City and Environs of Jerusalem* (1844) was followed by *Forty Days in the Desert on the Track of the Israelites* (1848) and *The Nile Boat* (1849). He was among the most well-traveled of artists, visiting the Near East six times, for example. Bartlett also wrote and illustrated a history of early colonial America,

The Pilgrim Fathers (1853), and published in three volumes *A History of the United States of America* (1856). In addition, he worked as an editor at *Sharpe's London Magazine* from 1849 to 1852.

An intrepid traveler who had been in poor health for most of his life, Bartlett died suddenly on board the French steamer *Egypt* on his way home from Smyrna, Turkey, and was buried at sea. His last book, *Jerusalem Revisited* (1855), was being printed at the time of his death.

Bibliography: Bartlett Cowdrey, "William Bartlett and the American Scene," *New York History* 22:4 (1941): 388–400; Frank Place, *W. H. Bartlett, Illustrator of American Scenery* (n.p., 1944); Alexander M. Ross, *William Henry Bartlett: Artist, Author, and Traveller* (Toronto: University of Toronto Press, 1973).

71a. *Kaaterskill Falls from Above the Ravine, Catskill Mountains, New York: Study for an Engraving*, c. 1836–37

Brown ink wash with touches of white heightening on paper, laid on card; 4 11/16 × 7 in. (119 × 178 mm)
Verso inscribed at center right in brown ink: *The Cauterskill Fall / from above the ravine*; at lower center in graphite: *Aug[?] 1 / NB. All from the foreground is / forest. So give it the / proper character*
Provenance: Daniel Parish Jr., New York.
Bibliography: Stebbins 1976, 144, fig. 111; Koke 1982, 1:29, no. 104, ill.
Gift of Daniel Parish Jr., 1900.7

71b. *Genesee Falls, Rochester, New York: Study for an Engraving*, c. 1836–37

Brown ink wash with scratching-out on paper; 4 5/8 × 7 3/16 in. (117 × 182 mm)
Verso inscribed at right center in brown ink: *The Genesee Falls / Rochester*
Provenance: Daniel Parish Jr., New York.
Bibliography: Koke 1982, 1:29, no. 103, ill.
Gift of Daniel Parish Jr., 1900.9

The Society's four original drawings by Bartlett, one of the most important of the early draftsmen who recorded American views,[1] date from the artist's first trip to the United States in 1836–37. Each is a study for one of the 119 steel engravings after Bartlett's sketches that accompany Willis's poetic text in the widely distributed two-volume *American Scenery*, published in installments, each consisting of four views and several pages of text.[2] The book was im-

mensely influential, as it helped to expand the iconography for the American grand tour. The publication date of the serially released book is 1840, although the individual plates bear dates ranging from 1838 to 1842. Bartlett's views were among the most popular early representations of the scenery of nineteenth-century America, which began in earnest with William Guy Wall's *The Hudson River Portfolio* (1820–25; cat. 48) and *The American Landscape* (1830), whose primary illustrator and author were, respectively, Asher B. Durand (cats. 51–54) and William Cullen Bryant (cat. 64).

Bartlett's view of Kaaterskill Falls[3] was engraved by James Tibbots Willmore with the caption *The Catterskill Falls (From above the Ravine.)*,[4] while that of Genesee Falls was engraved by John Cousen with the caption *The Genesse Falls, Rochester.*[5] Both prints, with measurements nearly identical to their preparatory drawings, were first published in London by George Virtue in 1838, and then reissued later as plates in Willis's *American Scenery*.[6] Bartlett quickly executed the wash drawings, his brush flickering confidently over the small sheets; more attention was given to the rhythm of execution than to topographical detail.

When traveling, Bartlett made numerous graphite sketches of the people, landscapes, and architecture he encountered.[7] Later he reworked these compositions into the small but detailed brown ink and wash views similar to the two examined here for the engraver of the plates. Occasionally he executed more elaborate watercolor views, demonstrating his ability as a colorist. As can be seen in these small sketches of two spectacular waterfalls, Bartlett heightened the picturesque aspects inherent in the geography and flora of each place. Both locations became mandatory stops on the American grand tour. They appealed to Americans and embodied the aesthetic of the sublime currently in vogue.[8] In both Bartlett seems to have placed the viewer on a precipice, nearly hanging in midair, to add an element of frisson. By not depicting a single human figure in his view of Kaaterskill Falls—although he includes the observation platform atop the falls that blends into the landscape—Bartlett intensified the loneliness evoked by the thin trickle of water in the vast expanse of Kaaterskill Clove.[9] The printmaker diluted the vastness of

71a

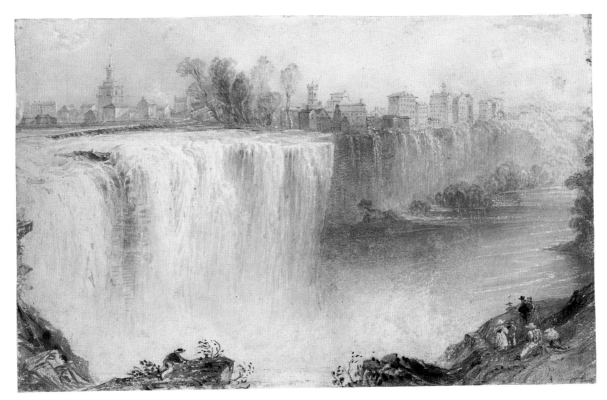

71b

the looming foreground void by adding soaring birds to Bartlett's sublime vista. In contrast, Bartlett inserted a group of spectators precariously poised on a cliff at the far right of his view of Genesee Falls; they gaze at the broad cascade whose roar the viewer can almost hear. For other views of Kaaterskill Falls, the highest waterfall in New York State, see catalogue 109b, and for the Upper Falls of the Genesee River, the most stunning of the series of three cascades, and the one Bartlett depicted, see catalogue 38.

1. Stebbins 1976, 144.
2. Impressions of all four are in the Society's DPPAC. These studies were no doubt based on larger watercolors made *in situ*.
3. Kaaterskill appears variously as Catskill, Cauterskill, and Catterskill. The archaic Dutch word *Kaaterskill* derives from *Kaaters*, male wildcats, and *kill*, stream; Reverend Charles Rockwell, *The Catskill Mountains and the Region Around* (New York: Taintor Brothers & Co., 1869), 265.
4. See Nathaniel Parker Willis, *American Scenery* (Barre, Mass.: Imprint Society, 1971), 209, ill. The DPPAC, which has extensive holdings of prints after Bartlett, has one impression.
5. Ibid., 130, ill. The DPPAC holds four impressions, two of which are colored.
6. Nathaniel Parker Willis, *American Scenery; or, Land, Lake, and River Illustrations of Transatlantic Nature from Drawings by W. H. Bartlett* (London: George Virtue; New York: R. Martin & Co., 1840), 2: unnumbered pl. between 2 and 3; and 1: unnumbered pl. between 88 and 89, respectively.
7. For a case in point, see Christie's, London, sale cat., 17 November 1987, lots 19–29, more than one hundred sheets in graphite, brown wash, and watercolor that comprise the majority of the artist's working drawings for *Pictures from Sicily* (1853).
8. See Myers 1987, 59. See also idem 1990.
9. Myers 1990, 1:211, notes that in Bartlett's other view of the falls, *Catterskill Falls from Below*, engraved for Willis's *American Scenery*, the artist conceals the presence of the observation deck. He believes that like every artist who drew the falls, Bartlett had to decide whether to represent it as a tourist destination or as wilderness. Bartlett's innovative solution was to offer his audience (and that of Willis's book) both options, two incompatible views of the same site.

GEORGE RICHMOND

Brompton, England 1809–London, England 1896

Known as a history and portrait painter, George Richmond was also a watercolorist, draftsman, engraver, and sculptor. Born into a family of artists, he studied under Henry Fuseli at the Royal Academy of Arts in London, making his debut in 1825. That same year he met the poet-painter William Blake at the home of John Linnell, which proved to be a decisive event in his life and career. Like his lifelong friend Samuel Palmer, Richmond fell under Blake's spell and formed close friendships with Blake's other disciples, including Edward Calvert. He visited Palmer in Shoreham, chiefly in 1827, and both he and Calvert became prominent members of Palmer's youthful band of like-minded individuals called the "Ancients." Richmond's visionary paintings were Christian and literary in theme, archaic in style, and high-minded in tone. Unlike Palmer, who concentrated on landscape, Richmond focused on the human figure as a means of expression. Richmond's visionary phase, though tempered by ideas from his academic training, was nevertheless intense.

This early style, however, did not survive Richmond's visits to Paris to study works by the old masters in the Musée du Louvre or the financial pressures following his marriage in 1831 to Julia Tatham, daughter of the architect Charles Heathcote Tatham. They had fifteen children, of whom only ten survived infancy, including William Blake Richmond, later Sir William, a painter, sculptor, and designer. Compelled to make a living, Richmond turned with a vengeance to portraiture, producing seventy-three portraits in the first year of his marriage; by 1836 he was earning £1,000 from this bread-and-butter occupation. His portraits and watercolors are marked by their richness of color, a trait borrowed from the Venetian masters he studied while in Italy—first from 1837 to 1839, when the Richmonds spent time with the Palmers, and again from 1840 to 1841—and are reminiscent of J. M. W. Turner's palette. On this second Venetian visit, he met the influential critic and artist John Ruskin, who became a close friend. Richmond achieved a distinguished reputation as a portraitist and is well represented in the National Portrait Gallery in London, including a likeness of Samuel Palmer in watercolor and gouache on ivory from 1829 and its preparatory study in watercolor on paper. In these and other works his rich use of color is reminiscent of Sir Anthony Van Dyck and Sir Thomas Lawrence. Despite a yearning to express himself in other ways (for example, through landscape), and despite his early promise as a visionary painter, his true achievement lay in portraiture. By recording the visages and characters of many eminent Victorians, he seemed to follow Alexander Pope's aphorism, "The proper study of mankind is Man" (*An Essay on Man*, Ep. 2, l. 2).

Something of a social lion, Richmond enjoyed an enormous circle of friends, including leading personalities of the day like Prime Minister William Ewart Gladstone, and was elected an associate of the Royal Academy in 1857 (full member in 1866). He exhibited in London not only at the Royal Academy but also at the British Institution and the Society of British Artists. Among other honors accorded to him, in 1871 he was offered, but refused, the directorship of the National Gallery, London.

Bibliography: Raymond Lister, *George Richmond: A Critical Biography* (London: Robin Garton, 1981); David Blayney Brown, "George Richmond," in Jane Turner, ed., *The Dictionary of Art* (London: Macmillan Publishers, 2002), web form: http://www.groveart.com, 26:353–54.

72. *Aaron Vail (1796–1878)*, 1835

Watercolor, gouache, and graphite on card; 11 5/8 × 9 1/8 in. (295 × 231 mm), irregular
Signed and dated at lower right in graphite: *Geo.*

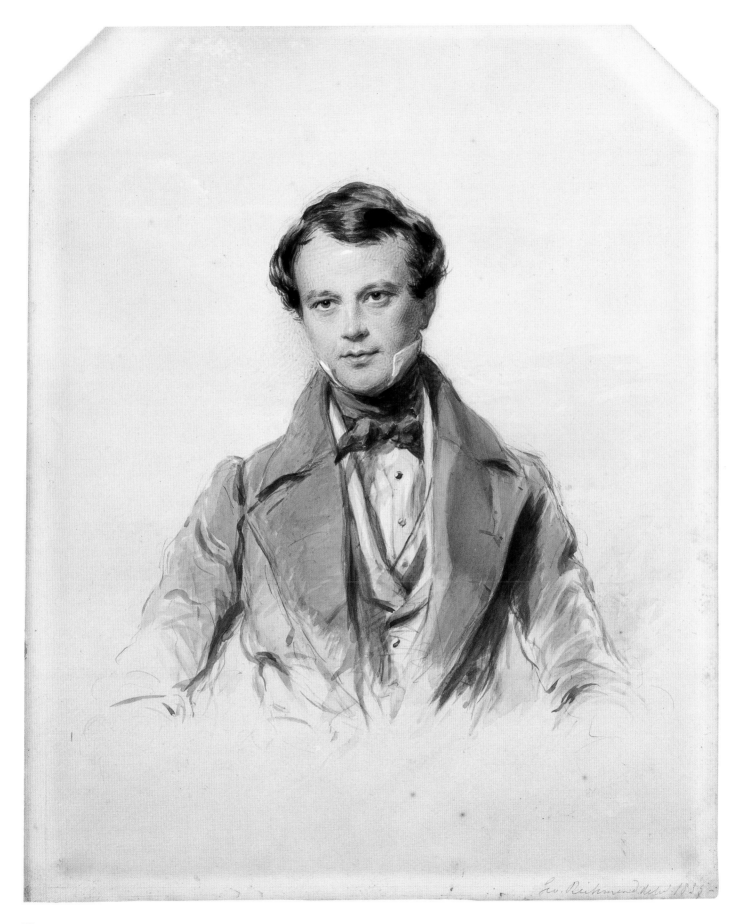

72

Richmond delit. 1835 –
Provenance: Descent through the sitter's family.
Bibliography: N-YHS 1974, 2:813–14, no. 2078, ill.; Lister 1981, 173; Roberta J. M. Olson, "A Selection of European Paintings and Objects," *The Magazine Antiques* 167:1 (2005): 185, 186, pl. 10.
Bequest of Jacques de Bon, 1968.38

The sitter was born at Lorient (formerly L'Orient), France, the son of the United States Consul Aaron Vail and his French wife, Elizabeth Dubois des Corbieres. His father—descended from a Quaker family in Dutchess County, New York—served as the American commercial agent in this busy port during the Napoleonic era (1803–15).[1] In 1815, when Vail Sr. died, the family returned to the United States, living in Washington, D.C., where young Vail embarked on a diplomatic career. He first served as a clerk and was rapidly promoted in the Department of State under Presidents James Monroe (a Francophile), John Quincy Adams, and Andrew Jackson, with whom he corresponded. Martin Van Buren, who served for a short time as minister to England, selected Vail to accompany him to London in 1831, where he served with marked ability as secretary of the American legation and later chargé d'affaires (1832–36). As Richmond's urbane portrait would suggest, Vail was completely at home in London society, remaining on excellent terms with such British statesmen as Viscount Palmerston and the Duke of Wellington. In 1835 he married Emilie Salles, daughter of a wealthy New York merchant who had been born in France. Vail's wife was the sister of his brother's (Eugene Aaron Vail) wife (Julia Salles) and also grandmother of Madame Jacques de Bon, wife of the donor.[2]

When he returned to Washington in 1836, Vail's most difficult task in the Department of State was handling the American claims for compensation that arose from the release of slaves from American ships forced into British ports in the West Indies. In the wake of the Canadian rebellion of 1837, he also handled the crisis when Americans were imprisoned on suspicion of their involvement. Appointed chief clerk of the Department of State in 1838, he served until July 1840. During this time he acted on numerous occasions as secretary of state. Subsequently, he was assigned a post in Madrid as chargé d'affaires until 1842, when Washington Irving arrived as United States ambassador, and

Vail was transferred to New York City. He declined the positions of assistant secretary of state offered by President Franklin Pierce and minister to France tendered by President James Buchanan for reasons of ill health. Truly a citizen of the world and exemplary of the new breed of international American that arose about 1825, Aaron Vail died in Pau (Basses-Pyrénnes), France.[3]

Known for his bravura society portraits, Richmond portrayed the still youthful-appearing sitter, aged thirty-nine, most sympathetically. Stylistically, the watercolor resembles other portraits from the same time, such as those of Rowland Hill (first Viscount Hill) from 1834[4] and the artist's father, Thomas Richmond, about 1835–36.[5] The Society's watercolor is noted in a list of the artist's works compiled mainly from his accounts and other manuscripts: "Vale, Mr. [£5.5] 1835."[6]

1. The senior Vail also reputedly knew Chancellor Robert R. Livingston and Robert Fulton (cats. 20 and 31) and discussed steam navigation with them. Nathaniel Cutting related that Vail lent Fulton John Fitch's drawings and specifications for his steam vessel for several months. Vail had taken out a French patent on his boat in Fitch's name, at the price of a lucrative share in the potential profits. Fitch had gone to France in hopes of locating financing for his boat, although the raging battles of the revolution there thwarted his plans. Fulton benefited from Fitch's ideas, undoubtedly believing he would not be suspected of plagiarism since Fitch had died. John S. Morgan, *Robert Fulton* (New York: Mason/Charter, 1977), 109; and Philip 1985, 139, 141.
2. An old label on the back of the original frame has a partially legible inscription: *Aaron Vail Grand Pere de Madame Jacques de Bon nee Bradshaw … .*
3. *DAB* 19:136; *National Cyclopedia of American Biography* (New York: James T. White and Company, 1937), 5:555–56; and *Who Was Who in America*, vol. 4, *Historical Volume, 1607–1896* (Chicago: Marquis-Who's Who, 1963), 545. The Vails had five children, of whom a son and two daughters survived him.
4. David Saywell and Jacob Simon, *Complete Illustrated Catalogue: National Portrait Gallery, London* (London: Unicorn Press, 2004), 302, ill.
5. Lister 1981, pl. XXIII, fig. 45, in the collection of the late Anthony Richmond.
6. Ibid., 173.

ALFRED JACOB MILLER

Baltimore, Maryland 1810–1874

Alfred Jacob Miller began his career copying paintings in Baltimore's Peale Museum. From 1831 to 1832 he studied with the portrait painter Thomas Sully (cat. 40) in Philadelphia. Encouraged by wealthy Baltimore patrons, including Johns Hopkins and Robert Gilmor Jr., Miller departed for France, where he studied in Paris at the École des Beaux-Arts. He also copied old master paintings in the Musée du Louvre and was influenced by the paintings of J. M. W. Turner and Eugène Delacroix, who embarked on his Moroccan journey while Miller was in Europe. Miller's sketchbooks also contain portraits of the young French painters Constant Troyon and Ernest Meissonier (cat. 84), suggesting they were among his acquaintances. Miller visited Italy and particularly Rome, where he befriended the American sculptor Horatio Greenough and the French painter Horace Vernet, among others, attended the English Life School, and participated in the spirited artistic gatherings at the Caffè Greco. He returned to Baltimore to open a portrait studio in 1834 and briefly experimented with lithography, designing several sheet music covers. Three years later Miller moved to New Orleans, where the Scottish adventurer Captain William Drummond Stewart, a British army veteran of Waterloo, engaged him to record the scenery and incidents on an expedition to the Rocky Mountains, probably Stewart's fifth trip. Their party joined the American Fur Company group in the spring of 1837. The expedition brought Miller into close contact with Native Americans of the region, whose hunting and social customs he depicted—along with those of fur trappers in the Far West at their annual trading gatherings—in more than two hundred watercolor and wash sketches. Miller was one of the first eyewitness artists to leave a detailed visual account of the life of the American mountain trappers, and one of the earliest painters of the American West, the Rocky Mountains, and scenery along the Oregon Trail before the advent of the covered wagon.

Miller's Rocky Mountain paintings rank as some of the most Romantic and authentic images of the American West ever created. Of the work of the three pioneering "explorer artists" in the 1830s—Miller, Karl Bodmer, and George Catlin (cat. 50)—Miller's is the most imaginative. His free, vigorous style brings to life such works as *The Last Greenhorn* (1837; Buffalo Bill Historical Center, Cody, Wyo.; a watercolor version is in the Walters Art Museum, Baltimore, and a brown wash version is in the Joslyn Art Museum, Omaha, Neb.). His oeuvre offers a unique record of the drama, danger, and picturesque qualities of the American West, executed first in quick graphite sketches in his pocket sketchbook and later elaborated in wash drawings, watercolors, and oil paintings.

Following the expedition, Miller returned first to New Orleans (November 1837) and then to Baltimore (July 1838), where he resumed his career as a portrait painter, while continuing to embellish his sketches and translate them into paintings. In 1840 he traveled to Scotland to execute a series of oil paintings based on his western sketches for Captain Stewart's hunting lodge and ancestral seat, Murthly Castle in Perthshire. Reputedly Miller also painted for other local notables and took rooms in London in late 1841 to paint religious works for Stewart, at which time he dined with a young Queen Victoria. By 1842 he was back in Baltimore, settling into his comfortable routine of painting portraits, oils, and copies, as well as restoring paintings and producing versions of his western drawings. Among the latter are a collection of about two hundred watercolors Miller executed for William T. Walters (1859–60; Walters Art Museum, Baltimore) and a group of forty scenes for Alexander Brown of Liverpool (1867; Public Archives of Canada, Ottawa). Miller, who may have wanted to be the "Delacroix of the West," was known as a gentleman bachelor and a bon vivant who played the violin for amusement and seemed to have been virtually untouched by the Civil War, with the exception of several drawings. Two of the largest collections of Miller's western genre are in the Joslyn Art Museum in Omaha, Nebraska, and the Gilcrease Museum in Tulsa, Oklahoma, which also holds Miller's manuscript "Rough Draughts for Notes to Indian Sketches," based on his lost journal of the Rocky Mountain trip.

Bibliography: Bernard De Voto, *Across the Wide Missouri* (Boston: Houghton Mifflin Company, 1947); Wilbur Harvey Hunter Jr., *The Paintings of Alfred Jacob Miller: Artist of Baltimore and the West*, exh. cat. (Baltimore: Peale Museum, 1950); R. W. G. Vail, "The First Artist of the Oregon Trail," *New-York Historical Society Quarterly* 34:1 (1950): 25–30; *A Descriptive Catalogue of a Collection of Drawings by Alfred Jacob Miller in the Public Archives of Canada* (Ottawa: Edmond Cloutier, 1951); Marvin C. Ross, ed., *The West of Alfred Jacob Miller (1837), From the Notes and Watercolors in the Walters Art Gallery* (Norman: University of Oklahoma Press, 1968); William R. Johnston, "Alfred Jacob Miller—Would-be Illustrator," *Walters Art Gallery Bulletin* 30:3 (1977): 2–4; Ron Tyler, ed., *Alfred Jacob Miller: Artist on the Oregon Trail*, exh. cat. (Fort Worth: Amon Carter Museum, 1982); Joan Carpenter Triccoli, *Alfred Jacob Miller Watercolors of the American West*, exh. cat. (Tulsa, Okla.: Thomas Gilcrease Museum Association, 1990); Lisa Strong, "Images of Indigenous Aristocracy in Alfred Jacob Miller," *American Art* 13:1 (1999): 62–83.

73. *A Buffalo Surround in the Pawnee Country (c. 1837)*, 1840

Brown ink and wash, glazing, scratching-out, graphite, and touches of watercolor and gouache on two sheets of paper, laid on card; 9 1/4 × 14 1/2 in. (235 × 368 mm)
Dated and signed with a monogram at lower left in brown ink: *XXI / 1840 / AJM* [partially legible][1]
Provenance: Private collection, Great Britain; private collection, United States.
Bibliography: Vail 1950, 24, ill.; Ross 1968, XXI; Koke 1982, 2:341–42, no. 1836, ill.; Tyler 1982, 311, no. 352A, pl. 93.
Gift of Charles E. Dunlap, Thomas W. Streeter, Forsyth Wickes, Louise C. Wills, and George A. Zabriskie, 1949.273

In 1837 Miller accompanied Captain William Drummond Stewart on an expedition into the Rocky Mountains, during which he made hundreds of sketches of Indian life. He later elaborated on these in his Baltimore studio, producing drawings and eighteen large oil paintings for Murthly Castle, Stewart's seventeenth-century ancestral seat in Scotland. In 1839 Miller exhibited the oils at the Apollo Gallery in New York City, where they were positively received by the public, which was just beginning to be interested in images of the West.[2] Afterward Stewart—who was now Sir William and a baronet (the title had passed to him together with the family estates on the death of his brother in 1838)—took them to Scotland. The following summer Miller joined his patron at Murthly Castle and completed the series of twenty-eight large oils by November 1841.[3] By the artist's estimation, between 1837 and 1842 he executed 150 preliminary sketches that he reworked into twenty-eight oils and eighty-seven watercolors for Stewart.[4] Miller also spent time painting religious works for Stewart in London, where he met Catlin, before returning to Baltimore in April 1842.[5]

The date inscribed on the Society's sheet, 1840, indicates that it was drawn in Scotland at

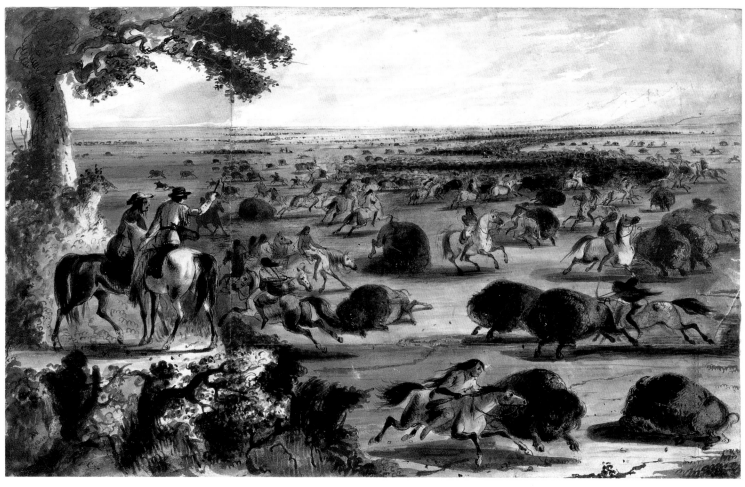

73

Murthly Castle while Miller was completing his series of large paintings, some of which are today in American public and private collections.[6] An earlier version of the central right part of the sheet, a wash drawing inscribed *A Surround*, is in the Joslyn Art Museum; it contains the annotations *more space* and *dust*.[7] For the Society's drawing Miller joined two pieces of paper.[8] The L-shaped addition along its left and lower borders supplements the earlier sketch by furnishing the requested "more space" and "dust," together with a generally revised composition. Notably, figures were added at the lower left, including one of Stewart riding a white horse (see below).

During their expedition Stewart and Miller had followed the Platte River across the Plains through Pawnee territory to Fort Laramie, where they encountered great herds of buffalo. Their progress and their later adventures are

described by Bernard De Voto in *Across the Wide Missouri*. When a large herd was sighted, the Indians would send their fleetest riders to race around it, yelling and forming a circle, called a buffalo surround, that they continually drew tighter. When the whole group was pushed close together, Miller recalled: "Now they begin firing, and as this throws them [the buffalo] into a headlong panic and furious rage, each man selects his animal."[9] Miller claimed: "The dexterity and grace of the Indians and the thousands upon thousands of Buffalo moving in every direction over an illimitable prairie form a scene altogether, that in the whole world beside, cannot be matched."[10]

In addition to Miller, Stewart was joined by head man and chief hunter Antoine Clement, of Cree and French Canadian descent. He accompanied Stewart back to Scotland and became for several years one of the Scotsman's retainers at

Murthly Castle.[11] In the Society's drawing Miller depicted Stewart and Clement on horseback, dressed in buckskins and watching the buffalo surround from the knoll at the left; Clement, shown in profile with black hair down to his shoulders and a Roman nose, wears a white hat, while Stewart, mounted on a white horse seen from the rear, wears a black hat.[12] Miller represented both men numerous times in action in other wash and watercolor drawings.[13] While Miller did not include the two men in the very different depiction of the buffalo surround in the Murthly series, he may have executed the Society's drawing as an early compositional idea for that subject, which he abandoned in favor of the painting today in the Joslyn Art Museum (see n. 6 below).

For the remainder of his career Miller repeated his western themes with variations. He painted many buffalo hunts and surrounds as well as representations of a woman riding a

horse and chasing a buffalo.[14] In these works Miller romanticized his subject to convey the spirit and colorful action of Plains life.

1. Vail 1950, 29, claimed that there is a "faint indication of lettering between the date and monogram which may be the almost obliterated title: '*A Surround*.'" There is much rubbing and lifting of the glazing in this area of the drawing, which has lost some of its pigmentation.

2. See Tyler 1982, 37 n. 52, for a list of the eighteen paintings exhibited.

3. In a letter to his brother Decatur H. Miller, of 15 December 1840, Miller describes part of the series that hung in Stewart's bedchamber in the lodge: "Along the ceiling extend brass rods from which are suspended reminiscences of the Rocky Mountains painted by your unworthy brother"; quoted in Lisa Strong, "American Indians and Scottish Identity in Sir William Drummond Stewart's Collection," *Winterthur Portfolio* 35:2–3 (2000): 141. Strong 1999, 81 n. 5, claims the series was not hung together but, according to Miller, in the drawing room, library, and Stewart's bedroom. For the Stewart commission, see Tyler 1982, 19–45, which on 45 n. 70 discusses the dispersion of Miller's paintings at Stewart's death. Today, only two remain at Murthly Castle. For Stewart, see Mae Reed Porter and Odessa Davenport, *Scotsman in Buckskin: Sir William Drummond Stewart and the Rocky Mountain Fur Trade* (New York: Hastings House, 1963); and Strong 1999. Miller's journal is a 130-page manuscript in the collection of L. Vernon Miller, Baltimore. Strong 1999, 81 n. 2, believes it was written late in the artist's life.

4. Strong 1999, 63.

5. Vail 1950, 27.

6. Ibid., 28, which concludes (p. 29) that the Society's sheet is a study for one of the oils for Murthly Castle, "but not the painting with the same title now in the Philbrook Art Museum at Tulsa Oklahoma" (Vail meant the work that was once exhibited at the Philbrook). The related Murthly canvas of about 1840, measuring 65 × 93 1/2 in., is today in the Joslyn Art Museum, Omaha, Neb., inv. no. 1963.611; see Tyler 1982, 312, no. 353, ill. on 52.

7. InterNorth Art Foundation Collection, inv. no. 723, 10 1/4 × 17 1/4 in.; see De Voto 1947, pl. LXI; Vail 1950, 28, which states Miller executed it on the Plains; and Tyler 1982, 311, no. 352, pl. 92.

8. Debbie White of the Alfred Jacob Miller Limited Company related in written correspondence of 13 June 2006 that only in a very few cases did Miller collage together two pieces of paper. She reported that there are one or two examples at the Beinecke Rare Book and Manuscript Library at Yale University, New Haven, in which Miller pasted an oil onto a watercolor background.

9. Quoted in Tyler 1982, caption to pl. 94.

10. Quoted in ibid., caption to pl. 93.

11. Stewart, with a complex nationalistic zeal, was intent on restocking Scotland and his estates with flora and fauna, including buffalo, from the Pacific Northwest. The two areas were considered to be especially good matches, sharing the same climate; see Strong 2000, 127–55.

12. For a bust-length portrait in watercolor of Stewart by Miller, see Hunter 1950, fig. IV. For Henry Inman's (cat. 64) portrait of Stewart in the Joslyn Art Museum, Omaha, Neb., painted at Murthly Castle in 1844, see Tyler 1982, pl. 28.

13. Vail 1950, 29; and Tyler 1982, throughout. For Miller's portrait of Clement in the Walters Art Museum, Baltimore, see ibid., 200, no. 52A, ill.; and for a double portrait of the two in the Gilcrease Museum, Tulsa, Okla., see Triccoli 1990, 51–52, no. 38, ill. Strong 2000, 140, believes that Miller's representation of Stewart as a cultural intermediary—like Edward Waverley with the Highlanders in Sir Walter Scott's *Waverley*–may have been influenced by the novels of Scott, whose books Miller read enthusiastically and which he illustrated in his sketchbooks.

14. See Tyler 1982, 310–20, for a listing. For Miller's "Surrounds," see ibid., 311–13: two wash drawings (no. 352 in the Joslyn Art Museum, Omaha, Neb., and no. 352A, the Society's work); an oil painting (no. 352B in the Whitney Gallery of Western Art, Buffalo Bill Historical Center, Cody, Wyo.); two unlocated works mentioned in the artist's account book for 1848 and 1858 (nos. 352D and 352E); a watercolor (no. 352F in the Walters Art Museum, Baltimore, inv. no. 37.1940.200); a drawing in watercolor, gouache, and ink over graphite (no. 352G in the Public Archives of Canada, Ottawa); and an oil on canvas (no. 353 in the Joslyn Art Museum, Omaha, Neb., inv. no. 1963.611), formerly at Murthly Castle, that is accompanied by two drawings in the same museum (nos. 354 and 355, InterNorth Art Foundation Collection, inv. nos. 745 and 729, respectively). In his "Notes to Water Colour Drawings of Indian Life by Alfred J. Miller, Baltimore, U.S., 1867," which accompanied the group of forty scenes he made for Alexander Brown, the artist comments extensively on "A 'Surround'" (*Descriptive Catalogue … Public Archives of Canada* 1951, 38–39, no. 40).

DAVID MATTHEW

c. 1810–San Francisco, California c. 1890

The machinist and engineer David Matthew produced a group of four drawings illustrating the early construction and operation of locomotive engines on New York's Hudson and Mohawk Railroad during the 1830s. Matthew began his apprenticeship at the West Point Foundry in New York City as a machine fitter in 1826. In 1831 he supervised the assembly of the first train engine built in America, the steam locomotive *DeWitt Clinton*. Matthew also acted as operating engineer for many of its initial passenger runs on the Mohawk and Hudson Railroad, as well as for the English-built locomotive engine *Robert Fulton*. By 1833 Matthew listed his occupation as a master machinist for the Mohawk and Hudson, and in 1836 he joined the Utica and Schenectady Railroad, where he remained until 1842, when he accepted a managerial position in an iron foundry.

Throughout his working life Matthew was active in the development of railroad technology. He held various mechanical patents and

further claimed to have invented some of the fundamental devices associated with modern railroads, including the roundhouse and turntable, the snowplow, the spark arrester, and the sheltered cab. His 1856 treatise, "David Matthew's Patents for Spark Arresters," suggests that he held several patents for spark-arresting devices, and a suit he brought against Baldwin Locomotive Works in 1860 for patent infringements on smokestack designs indicates he may have owned the legal rights to certain technological improvements. While there is no doubt that Matthew was indeed a pioneer in the use and improvement of new locomotive technology, there is little documentary evidence to support his claim of initial invention.

Matthew moved to San Francisco and worked as an engineer for the San Francisco Gaslight Company during the 1880s. In 1883 and 1884, more than fifty years after the landmark first run of the locomotive engine *DeWitt Clinton*

with Matthew at the controls, he sketched from memory the four early railroad scenes in the N-YHS's collection, including three featuring the *DeWitt Clinton* (one of its construction). These sheets, two depicting its route and one the route of the *Robert Fulton*, recall the experience of the riders on the first American passenger locomotives powered by steam and include detailed information that could have been retained only by one of the initial builders and engineers, making them significant documents in the study of American railroad history.

Bibliography: William H. Brown, *The History of the First Locomotives in America: From Original Documents, and the Testimony of Living Witnesses* (New York: Appleton, 1874), 70–74, 170–85; J. Snowden Bell, "Locomotive Spark Arresters," *Journal of the Franklin Institute* 109:1 (1880): 1–16; John H. White, *American Locomotives: An Engineering History, 1830–1880* (Baltimore: Johns Hopkins University Press, 1968), 73, 114 n. 75, 116 nn. 77, 78; Koke 1982, 2:316–18.

74. *Locomotive "DeWitt Clinton" in 1831*, 1884

Black ink and watercolor on paper, whose verso is printed with a patent license application, laid on card; 11 1/4 × 17 7/8 in. (286 × 454 mm), irregular
Extensively inscribed, signed, and dated along lower edge in black ink, with many misspelled words: *See The First Steam Train by Locomotive, of Eastren bound Passingers, and Merchants over the Mohawk and Hudson Railway, | from the Packet Boats on Erie Canal and Stage Coaches on Mohawk Pike at Schenectady to the Steam Boats on the Hudson River at Albaney New York. | Run on 10ᵗʰ August 1831. Locomotive Engine DE WIT CLINTON, American built Engine built at West Point Foundry Shops N.Y. | City. David Matthew, Supt. of building and Engineer who ran the | train. | And the drawer of this Pictor at San Francisco Cal. | May 1884. nearly Fifty three years after its Runing. An Apprentice of the West Point Found Shop, New York City. | And Supt of the building the three first Locomotives built in United States.*; signed and inscribed at lower right: *David Matthew. | Copyrighted 1886. By D MATTHEW. | 1161 HOWARD St. SAN FRANCISCO Cal*
Provenance: Collection of Fred E. Williamson, president of New York Central Railroad (1931–44).
Bibliography: Brown 1874, 70–72, 170–85; Koke 1982, 2:316–17, no. 1712, ill.
Gift of the Estate of Hilda R. Williamson, 1975.3

The engineer and artist David Matthew rides in the open cab of the first American-made steam locomotive, the *DeWitt Clinton*, in this naïve rendition that illustrates the rapid development of transportation following the success of the Erie Canal.[1] The lengthy inscription relates the details of the locomotive's first passenger run for the Mohawk and Hudson line on 10 August 1831 and connects the railroad to other means of transport. In the upper center of his view Matthew depicted the Erie Canal running parallel to the Mohawk River; according to his inscription, the barges are traveling southeast toward the locks at Schenectady. Below the canal the *DeWitt Clinton* draws a train of passenger coaches on the new Mohawk and Hudson Railroad. In the inscription Matthew also identified a paddlewheel steamboat on the Hudson River, a large packet ship on the canal, and horse-drawn coaches on the Mohawk Pike. He included a chain of coaches being hoisted uphill by a stationary engine on the Mohawk and Hudson Inclined-Plane cable road, although it did not begin service until the spring of 1832, to further demonstrate the interrelationship of the various forms of transportation developing during the 1830s.

Matthew supervised the assembly of the *DeWitt Clinton*'s steam engine at the West Point Foundry in New York City before taking the helm as engineer. His experience on the exposed platform behind the steam boiler, engulfed in black smoke and showered by sparks, surely influenced his future activities in technical design and fueled his interest in spark arresters and sheltered cabs.[2] Even honored guests on this ceremonious initial excursion must have had a rough ride, as sparks swirled around the converted street coaches that were chained together to form the train. The outside passengers resorted to beating each other's smoldering clothing, and the crude train was halted early in its journey so wooden fence posts could be secured between the coaches to prevent them from crashing together and jerking apart every time the train changed speed.[3]

Although the Erie Canal was the premier route for transporting freight in the 1820s and 1830s, passengers were frustrated by its circuitous course and the lengthy delays caused by the many locks. Coach services, cable roads, and the Mohawk and Hudson Railroad developed to expedite journeys, allowing canal boat passengers to disembark, take land routes over rather than around the hills of central New York State, and arrive at their destination ahead of the boats.[4] The Mohawk and Hudson Railroad was the first line constructed expressly for the transportation of passengers and the first to employ an American-made locomotive. In 1831 the only other railroads in the United States were short-range industrial lines that ran with English-built locomotives specifically designed to haul coal from mines.[5] Matthew's sheet preserves not only the initial run of the locomotive *DeWitt Clinton* and the events of 10 August 1831 but also captures this era of rapid development in all sectors of the transportation industry.
A. M.

1. Constructed between 1820 and 1825, the Erie Canal provided the first major shipping and transportation route to the western frontier.
2. Brown 1874, 171; and White 1968, 114–16. See also Benjamin H. Barrows, *The Evolution of the Locomotive from 1813 to 1891* (Chicago: Knight and Leonard for the Union Pacific Railroad, 1891); Edwin P. Alexander, *Iron Horse: American Locomotives, 1829–1900* (New York: W. W. Norton, 1941); and Reed Kinert, *Early American Steam Locomotives: The First Seven Decades, 1830–1900* (Seattle: Superior Publishing, 1962).
3. Brown 1874, 173–74.
4. Ronald E. Shaw, *Erie Water West: A History of the Erie Canal, 1792–1854* (Lexington: University of Kentucky Press, 1966), 281, 287; Patricia Anderson, *The Course of Empire: The Erie Canal and the New York Landscape*, exh. cat. (Rochester, N.Y.: Memorial Art Gallery, 1984), 66–67; and Carol Sheriff, *The Artificial River: The Erie Canal and the Paradox of Progress, 1817–1862* (New York: Hill and Wang, 1996), 72–74, 78, 173.
5. Brown 1874, 70–72.

JOSEPH H. DAVIS

Limington, Maine 1811 (active c. 1832–37)–Woburn, Massachusetts 1865

Little is known about this prolific naïve portraitist who worked in rural New England in the 1830s and who, in addition to his name, signed himself the "Left Hand Painter." An inscription and signature on a watercolor discovered in an attic in Dover, New Hampshire, rescued from anonymity the artist Joseph H. Davis, who painted a sizable group of American "folk art" portraits. This watercolor is inscribed with the sitter's name, followed by *Joseph H. Davis Left Hand Painter*. As a historical person, Davis remains elusive, although he has been associated with the legendary Pine Hill Joe of Newfield, Maine, who earned $1.50 per portrait. After 1837 Davis, the itinerant artist of some 150 likenesses portraying upstanding New Englanders in comfortable domestic settings, ceased painting and appears to have become a land trader and inventor.

Davis painted his portraits between 1832 and 1837 for patrons who lived in a small area of southern New Hampshire and neighboring parts of Maine. He rendered his subjects, mostly farmers and their families, in formulaic compositions with bold patterns in which single sitters stand and groups sit, but he is best known for his double portraits of married couples. His subjects usually are dressed in their most fashionable finery, surrounded by colorful furnishings belonging to the exuberant "fancy" style of the early nineteenth century, indicative of their refinement and status. The artist repeated many of these accoutrements with slight variations in his compositions; among his favorite stock motifs are trompe l'oeil painted tables, pairs of chairs, garlands above tables, and boldly patterned kaleidescopic floorcovers. The "fancy" chairs seem to be of his own design, while all the other decorative accessories derive from the standard vocabulary of midcentury drawing books, English prints, textiles, and wallpapers.

His eclectic, distinctive style permits relatively easy attributions. Clearly indebted to the work of itinerant silhouette cutters, Davis laid in his charming compositions with graphite and added bold, flat watercolor and gouache enhanced by outlines in black ink. Although he never modeled his sitter's visages, he usually inscribed their names and ages in distinctive calligraphy whose ingenious style was of his own invention, combining traditional script with elaborate flourishes. Davis portrays his sitters in a limited repertoire of poses, usually in the simplest posture for making likenesses: the profile. Davis's style developed over his short career, and he became a more precise draftsman, a better colorist, and a more elegant designer of ornament. Other works by the artist are found in the Museum of Fine Arts, Boston; the National Gallery of Art, Washington, D.C.; and the Metropolitan Museum of Art, New York.

Bibliography: Frank O. Spinney, "Joseph H. Davis, New Hampshire Artist in the 1830s," *The Magazine Antiques*

44:4 (1943): 177–80; idem, "Joseph H. Davis," in *Primitive Painters in America, 1750–1950: An Anthology*, ed. Jean Lipman and Alice Winchester (New York: Dodd, Mead, 1950), 97–105; Rossiter 1962, 2:122–26; Nina Fletcher Little, "New Light on Joseph H. Davis, 'Left Hand Painter,'" *The Magazine Antiques* 98:5 (1970): 754–57; Norbert Savage and Gail Savage, "J. A. Davis," *The Magazine Antiques* 104:5 (1973): 872–75; Gail Savage, Norbert H. Savage, and Esther Sparks, *Three New England Painters*, exh. cat. (Chicago: Art Institute of Chicago, 1974), 22–41; Beatrix T. Rumford, ed., *American Folk Portraits: Paintings and Drawings from the Abby Aldrich Rockefeller Folk Art Center* (Boston: New York Graphic Society, in association with the Colonial Williamsburg Foundation, 1981), 83–87; Arthur B. Kern and Sybil B. Kern, "Joseph H. Davis: Identity Established," *Clarion* 14 (Summer 1989): 45–53.

75. *James (1777–?) and Sarah Clark Tuttle (c. 1779–?)*, 1836

Gouache, watercolor, graphite, and black ink with selective glazing on ivory paper; 9 3/4 × 14 3/4 in. (247 × 374 mm), irregular
Inscribed and dated at lower left in black ink: *James Tuttle. Aged 58. September 15th 1835*; at lower center: *Painted AT Strafford / Jany 25th. 1836.*; at lower right: *Sarah Tuttle. Aged 56. Octbr". 25. 1835*
Provenance: Elie Nadelman, Museum of Folk Arts, Riverdale-on-Hudson, Bronx, N.Y.
Bibliography: Black and Lipman 1966, 102, fig. 114; Spinney 1943, 178, fig. 3; Koke 1982, 1:259–60, no. 467, ill.; *Geriatric Nursing: American Journal of Care for the Aging* 6:1 (1985): cover ill.; Kern and Kern 1989, 49, 53 n. 79; Brilliant et al. 2006, 16, fig. 5, 172–73, no. 72, ill.
Purchased from Elie Nadelman, 1937.1715

The itinerant Davis executed the Society's double portrait of James and Sarah Tuttle seated in their parlor on 25 January 1836 at Strafford, New Hampshire. James Tuttle was born in 1777 (a birth date calculated by subtracting the date of 1835 from Tuttle's inscribed age of fifty-eight) and married Sarah Clark (b. c. 1778–79). The Society also holds Davis's standing profile portraits of two of their thirteen children, Esther and Betsy, probably painted on the same visit.[1] Little else is known about the lives of Tuttle and his family, although the town records for Strafford in 1823 and 1824 report that he was voted surveyor of lumber for both years. Among other local documents is a deed, dated 1833, recording that Joseph Hawking granted to Tuttle the land on which he lived, together with the iron work, tools, and saw. Another deed of the same year records Ebenezer Foss granting Tuttle part

interest in a sawmill erected on Tuttle's land.[2] This enterprise, no doubt, was responsible for the family's prosperity and is commemorated in the framed picture draped with celebratory laurel swags above the faux-grained table.

Davis's iconic image provides additional information about the sitters to supplement that contained in the sheet's inscriptions. While the framed landscape with its sawmill above the table customizes the watercolor, many other formulaic elements enlarge his portrayal of the Tuttles more generically.[3] The cat is the secondary focus of the portrait, and a cat or dog below a central table was nearly de rigueur in Davis's group portraits.[4] However, in the Tuttle portrait the feline not only functions as a signifier of domesticity but also helps complete the family unit in an empty nest depiction that is lacking their thirteen children. The otherwise solitary couple faces each other, sitting in "fancy"-style chairs,[5] heraldically flanking the faux-grained table. On the table an emblematic bowl of fruit and top hat join the landscape and laurel swags to signify abundance and success. The colorful country furnishings referring to the couple's material prosperity contrast with the couple's dignified expressions and stiff poses. Tuttle points to the open Bible on the table, and his wife holds a small book (probably for devotions) to underline their piety and literacy.

1. Inv. nos. 1937.1716 (dated *1836*) and 1937.1717 (dated *Jany 1836*), also with provenances from Elie Nadelman (Museum of Folk Arts, Riverdale-on-Hudson, Bronx, N.Y.); see Koke 1982, 1:260–61, nos. 468–69, ills. For Elie and Viola Nadelman's Museum of Folk Art, first named The Museum of Folk and Peasant Art, disbanded as a consequence of the Great Depression, see Christine I. Oaklander, "Elie and Viola Nadelman: Pioneers in Folk Art Collecting," *Folk Art* 17:3 (1992): 48–55; and Elizabeth Stillinger, "Elie and Viola Nadelman's Unprecedented Museum of Folk Arts," *The Magazine Antiques* 146:4 (1994): 516–25. For additional bibliography and the sale of its collection to the N-YHS, see Barbara Haskell, *Elie Nadelman: Sculptor of Modern Life*, exh. cat. (New York: Whitney Museum of American Art, 2003), 180–88, 226.
2. Koke 1982, 1:260.
3. For example, Davis also represented a top hat, a Holy Bible pointed out by the male, a swag around a painting over the central table, a still life of fruit, and a similarly boldly patterned painted floorcloth or carpet in *John and Abigail Montgomery*, 1836, in the National Gallery of Art (inv. no. 1967.20.8; Savage and Savage 1974, 30, no. 14, ill.). The differences between

the two compositions include a dog instead of a cat, rocking chairs, and individualization of the sitters' faces and clothes. Each of the paintings Davis depicted on the back walls of his compositions also seem highly individualized and emblematic of their sitters.
4. Rumford 1981, 85, no. 54, ill., reproduces a similar composition in the portrait Davis made of the Tilton family in the Abby Aldrich Rockefeller Museum of Folk Art, Williamsburg, Virginia.
5. See Priddy 2004, fig. 2, for another portrait by Davis with similar chairs.

JOHN WILLIAM HILL

London, England 1812–West Nyack, New York 1879

Son of the famous engraver John Hill (cat. 24) and the father of the watercolorist John Henry Hill (1839–1922), John William Hill was a painter of landscapes and still lifes, whose career bridged the era of the topographical tradition of his father and the Pre-Raphaelitism of his son. At the age of seven, he immigrated with his family to Philadelphia, moving with them to New York City in 1822. For seven years he was apprenticed to his father, whom he probably helped engrave plates for William Guy Wall's *The Hudson River Portfolio* (cat. 48). He continued to assist and then collaborate with his father in printing ventures. In 1828 John William launched his independent artistic career by exhibiting at the NAD in New York, where he became an associate in 1833. He showed there fairly regularly until 1873, counting among his submissions more Hudson River subjects than any artist associated with the Hudson River School. About 1830 his father engraved John William's drawing *Fire Engine No. 34*, a fixture in their Greenwich Village neighborhood, and during the next several years executed a number of scenes along the newly opened Erie Canal after his son's watercolors (cat. 24, fig. 24.1).

Working more independently, John William visited London in 1833 to study briefly with a friend of his father's and to view the works of the old masters. For five years, between 1836 and 1841, he served as a topographical artist for the New York State Geological Survey and also provided illustrations for the *Zoology of New York*, a part of *The Natural History of New York*, whose publication began in 1842. In 1838 John William moved to Rockland County, New York, where his father had purchased land in 1837, and spent the remainder of his life in a home on the Nyack Turnpike in the hamlet of Clarksville (now West Nyack), the town to which his father and mother retired about 1840. He also maintained an address at the old family home on West Tenth Street, keeping his professional life centered in New York. In the 1840s he collaborated with the publishing firm of Smith Brothers in its project to illustrate the major cities of North America, from Halifax to Havana, frequently in bird's-eye views for reproduction as prints. One of his most spectacular is the large watercolor *New York from the East River* (1852) in the Society's collection, published as an aquatint by Francis and George Warren Smith in 1855 (an impression is in the DPPAC).

During the 1850s, John William Hill's style underwent a significant shift away from the older topographic approach. In 1850 he became a founding member of the short-lived New York Water Color Society, a group that exhibited only once in 1853 at the Crystal Palace in New York. After reading John Ruskin's then-sensational *Modern Painters* about 1855 (first published in England in 1843; American edition, 1847), Hill was profoundly affected by the English critic's passionate prose and theory. Ruskin urged artists to reject interpretation in favor of a meticulous transcription of visible phenomena, wherein he believed lay the infinite creativity and truth of God. His reverence for nature and emphasis on a particular approach to landscape painting contradicted the notions of the sublime that had been integral to the Hudson River School. Following Ruskin's advice, Hill began to paint directly from nature and to study the particulars of geology and natural phenomena, gradually relinquishing his watercolor technique dependent on the application of washes to a reliance on stippling, in the manner of the British Pre-Raphaelites. He also turned to painting rural and suburban scenery in Rockland County and along the lower Hudson River in works that reveal the impact of a Pre-Raphaelite aesthetic (essay fig. 10).

In the years before the Civil War, Hill traveled to New York's Catskills and throughout New England to paint and sketch. He exhibited intermittently at the Pennsylvania Academy of the Fine Arts in Philadelphia and in 1857 opened a studio on Beekman Street in New York City, later moving to upper Broadway near Grace Church. Hill became increasingly involved with the Society for the Advancement of Truth in Art, the American counterpart of the Pre-Raphaelites, founded in 1863. Its members were American followers of Ruskin, and Hill was a founding member of the group when it briefly published its periodical, *The New Path*; he was elected its first president, an honorary position. Throughout his life John William Hill also illustrated books and taught.

Bibliography: John Henry Hill, *John William Hill: An Artist's Memorial* (New York, 1888); John Scott, "The Hill Family of Clarksville," *South of the Mountains* 19:1 (1975): 5–18; Tobin Andrews Sparling, *American Scenery: The Art of John and John William Hill*, exh. cat. (New York: New York Public Library, 1984); Annette Blaugrund and May Brawley Hill, "John William Hill, 1812–1879," in Ferber and Gerdts 1985, 180–92; Deák 1988, 1:653, for a listing of page references to the artist and his works.

76. *Dead Blue Jay*, c. 1865

Watercolor and graphite with selective light glazing on paper, mounted on card; 5 7/8 × 12 in. (149 × 305 mm)
Signed at lower right in red watercolor: *J.W. Hill*.
Provenance: Mrs. Charlan Whiteley Plummer Gellatly, New York, 1957.
Bibliography: William H. Gerdts, "The Influence of Ruskin and Pre-Raphaelitism on American Still-Life Painting," *American Art Journal* 1:3 (1969): 88–89, fig. 6; Stebbins 1976, 155, fig. 121; Koke 1982, 2:143, no. 1229, ill.; Ferber and Gerdts 1985, 51, fig. 17; 183, no. 30, ill.
Gift of Mrs. Charlan Whiteley Plummer Gellatly, 1957.94

This meticulous life-size drawing of a dead blue jay resting on a table goes beyond a naturalist's ornithological approach to anatomy in its poignant commentary on the fragility and impermanence of life.[1] It is a *natura morte* or *vanitas* subject rephrased in a Pre-Raphaelite mode. The rigidity of the bird contrasts with the still-brilliant color of its wings and the softness of its breast feathers, while its lifelessness is underlined by the open window framing a tree, the bird's natural habitat, in the background. The cumulative, patient, and loving application of the stippled watercolor strokes, a Pre-Raphaelite technique, adds subtle vivacity to its blue pigments and moral weight to its meditative tone. Considering the work brings to mind Ruskin's eloquent remark about the watercolor medium: "There is nothing that obeys the artist's hand so exquisitely … nothing that records the subtlest pleasures of sight so perfectly … . All the splendours of the prism and the jewel are vulgar and few compared to the subdued blending of infinite opalescence in finely-inlaid water colour."[2]

Since their English counterparts studied similar subjects, it is not surprising that dead songbirds occupied a place in the subject repertoire of American Pre-Raphaelite artists. A case in point is the English painter William Henry Hunt, who was influential on John William Hill and painted exquisite depictions of avian specimens as part of the still-life tradition.[3] Moreover, John William Hill's friend and colleague Thomas Charles Farrer, the English-born student of Ruskin who provided a direct link to the critic's aesthetics for American artists, showed several watercolors of dead blue jays in his one-person exhibition of still lifes at Knoedler's in 1865.[4] Hill is known to have painted at least eight still lifes of game (some with birds hung as trophies), which he exhibited

76

during his lifetime; two of these were included in his sale at S. Field's Art Gallery in Brooklyn in 1888.[5] However, the work closest to catalogue 76 is Hill's *Golden Robin (Baltimore Oriole)* of 1866, in which the artist placed the dead songbird against a background of grasses.[6] The artist's son, John Henry Hill, followed suit in his etching *Black-capped Titmouse (Chickadee)* and his advice to the art student in his *Sketches from Nature*.[7]

1. It contrasts with the ornithological approaches of Pierre Vase (or Eskrich) and his collaborators (cat. 1) and of John James Audubon (cat. 42).
2. John Ruskin, letter to the London *Times*, 14 April 1886, quoted in Kathleen Foster, "The Pre-Raphaelite Medium: Ruskin, Turner, and American Watercolor," in Ferber and Gerdts 1985, 79.
3. See John Witt, *William Henry Hunt (1790–1864), Life and Work* (London: Barrie & Jenkins, 1982), figs. 53, 81, 111.
4. Ferber and Gerdts 1985, 154, 171, 183.
5. Ibid., 184, nos. 32 and 33, ills. (the latter also pl. 17), which cites S. Field's Art Gallery, Brooklyn, New York, *Catalogue of water-color paintings by J. H. Hill and the late J. W. Hill to be sold at auction*, 11 December 1888.
6. See Richard York Gallery, *Determined Realists: The American Pre-Raphaelites*, exh. brochure (New York: Richard York Gallery, 1992), cover ill.
7. See Ferber and Gerdts 1985, fig. 18, 171, nos. 18 and 19, ill., 183.

John William Hill
77. *Bird's Nest and Dog Roses*, 1867

Watercolor, gouache, graphite, and selective glazing with scratching-out on paper; 10 13/16 × 14 in. (275 × 356 mm)
Signed and dated at lower right in red watercolor: *J.W. Hill | 1867*
Provenance: Gordon Lester Ford, Brooklyn, N.Y., before 1879; Mrs. Russell Skeel Jr., Harriman, N.Y., and Tucson, Ariz., 1947.
Bibliography: Gerdts 1969, 88–89, fig. 5; William H. Gerdts and Russell Burke, *American Still-Life Painting* (New York: Praeger Publishers, 1971), 117, pl. XV; Koke 1982, 2:140, 142, no. 1223, ill.; Betsy B. Jones, *Edwin Romanzo Elmer, 1850–1923* (Northampton, Mass.: Smith College Museum of Art, 1983), 50, fig. 42; Ella M. Foshay, *Reflections of Nature: Flowers in American Art*, exh. cat. (New York: Alfred A. Knopf, in association with the Whitney Museum of American Art, 1984), 45–46, fig. 33; Ferber and Gerdts 1985, 183, no. 31, ill., pl. 3.
Gift of Mrs. Roswell Skeel Jr., 1947.519

This type of informal still life combining sprigs of flowers and birds' nests in a natural setting was a specialty of the influential English watercolorist and Victorian still-life painter William Henry Hunt, a personal friend of Ruskin. From their correspondence with the British expatriate artist Thomas Charles Farrer, it is clear that both

John William and John Henry Hill were aware of Hunt's work by the late 1850s. Hunt's studies of nests in hedgerows earned him the nickname "Bird's Nest" Hunt, and he painted in a method he later characterized as "pure color over pure color," that is, watercolor applied by means of hatching and stippling.[1] Although not a member of the Pre-Raphaelite Brotherhood, Hunt was admired by them. His techniques and subject matter, praised by Ruskin, served as models for American artists, who saw nine of his watercolors when they were included in the traveling American exhibition of British art in 1857–58, whose New York venue was the NAD (1857).[2] One of the earliest American disciples of Ruskin, John William also may have seen Hunt's paintings in 1833 at the Old Water-Colour Society exhibitions during his trip to London. Regardless, by the 1850s Hunt's still lifes were also widely reproduced in lithographs and chromolithographs. In *Bird's Nest and Dog Roses*, Hill's debt to Hunt even extends to the watercolor's specific subject, for Hunt also painted at least one work depicting dog roses with a bird's nest.[3]

Hill's exacting stipple technique in this watercolor approaches that of Hunt, although Hill used the white of the paper for luminosity

77

instead of Hunt's ground of Chinese white with a glazing.[4] Both artists, however, used minutely applied stippled brushstrokes of unmixed, often interlaced hues to achieve the greatest possible brilliance and saturation of color, lending an astonishing clarity to the objects depicted. By emphasizing the bird's-eye point of view, Hill added an even greater sense of immediacy.

John William Hill exhibited a work entitled *Bird's Nest* in the March 1869 exhibition of the Brooklyn Art Association, while *Fruit and Bird's Nest* owned by Alexander Forman was included in his 1879 memorial exhibition, along with the present watercolor, which at the time was

owned by Gordon L. Ford.[5] The same year that his father executed this watercolor, John Henry Hill produced ink drawings of two similar subjects, *Thrush's Nest* (etched in his *Sketches from Nature*) and *Lark's Nest*.[6]

1. For Hunt, see Graham Reynolds, *Victorian Painters* (London: Herbert Press, 1987), 173, fig. 120 (*Primrose and Birds' Nests*, a watercolor in the Victoria and Albert Museum, London) with a variant formerly in a private collection reproduced in Ferber and Gerdts 1985, 283, no. 124, ill., whose composition is amazingly like that of catalogue 77. See also John Witt, *William Henry Hunt (1790–1864), Life and Work* (London: Barrie & Jenkins, 1982); Central Art Gallery, *William H. Hunt, 1790–1864*, exh. cat.

(Wolverhampton: Wolverhampton Art Gallery and Museums, 1986); and Hirschl & Adler Galleries, *"Bird's Nest" Hunt and His Followers*, exh. cat. (New York: Hirschl & Adler Galleries, 1986).

2. Ferber and Gerdts 1985, 282. For the exhibition, see Susan P. Casteras, "The 1857–58 Exhibition of English Art in America and Critical Responses to Pre-Raphaelitism," in ibid., 109–33. Subsequently the exhibition, with varying numbers of works, moved on to the Pennsylvania Academy of the Fine Arts in Philadelphia and then to the Boston Athenaeum.

3. Witt 1982, 255, no. 153.

4. Ferber and Gerdts 1985, 183.

5. Ibid.

6. Ibid., 172, no. 20, ill., and 173–74, no. 21, ill.

FRANCES FLORA BOND PALMER

Leicester, England 1812–Brooklyn, New York 1876

78

Frances Flora Bond Palmer, called "Fanny," was already an experienced artist, draftsman, and lithographer when she emigrated from her home in Leicester, England, in late 1843 with her husband, Edmund Seymour Palmer, and her sister and brother. They settled on Ann Street in New York City and immediately opened a printing business, seeking work from other publishers while producing their own prints under the name F. & S. Palmer, Lithographers. Seymour Palmer preferred hunting and socializing to working and spent most of his time in the field or tavern, leaving Fanny to run the business and support the family. She produced a wide range of lithographs including town views, cityscapes, architectural designs, and illustrations for sheet music. Palmer printed many of her own compositions and transferred the original drawings of other artists and architects to stone, such as her noted 1845 lithograph of Alexander Jackson Davis's (cat. 67) design, *Suburban Gothic Villa, Murray Hill, New York City. Residence of W. C. Wadell,*

which was reissued by Nathaniel Currier in 1846. F. & S. Palmer also produced a series of architectural lithographs for William H. Ranlett's *The Architect, A Series of Ornamental Designs* (1847–51).

In 1849 Nathaniel Currier published several detailed lithographs of New York City, including a view from Brooklyn Heights, and another from Weehawken, New Jersey, both copied from Palmer's drawings. Currier also issued a view entitled *High Bridge at Harlem, N.Y.* after her finished watercolor *High Bridge, New York, 1849* (Eno Collection, The NYPL). These three prints from 1849 mark the beginning of the productive association between Palmer and Currier (and later Currier & Ives) that lasted nearly twenty years, allowing her to be the main provider for her family, which had moved to suburban Brooklyn about 1850.

Credited on prints as "F. F. Palmer," she was among the most prolific and versatile artists working for Currier & Ives. Although she is recognized as a principal designer of the

archetypal Currier & Ives idealized rural genre scene, her works encompass a remarkably broad range of historical, industrial, and geographical subjects, including military and naval battles, railroad and steamboat scenes, and western frontier landscapes. Palmer's vibrant compositions are characterized by deep perspectives, panoramic vistas, dramatic lighting, and atmospheric effects that often emphasize the sublime beauty of the American landscape while celebrating the transformational forces of technology and development.

Because Palmer never traveled west of New Jersey, all of her western and military compositions, including her noted 1846 print *Battle of Palo Alto* (F. & S. Palmer, New York), and the Society's watercolor study for the Currier & Ives print *Terrific Engagement Between "Monitor" 2 Guns and "Merrimac" Ten Guns* (fig. 78.1), were based on eyewitness accounts, photographs, or other prints. These views often reveal inconsistencies associated with Palmer's lack of personal exper-

Fig. 78.1. Frances Flora Bond Palmer, *The Terrific Engagement between the "Monitor" and "Merrimac": Study for a Lithograph*, c. 1862. Watercolor, black ink, gouache, and graphite on gray paper, 18 1/2 × 26 1/4 in. (470 × 667 mm), irregular. The New-York Historical Society, Gift of Daniel Parish Jr., 1900.10

ience with the subject matter. Yet her compositions, even those created from secondhand descriptions, were very effective and popular.

Palmer worked for Currier & Ives until 1868, producing about 170 of the firm's finest lithographs. When Henry Shaw Newman selected the prints for his 1933 collection, *The Best Fifty Currier & Ives Lithographs, large folio size* (New York: Old Print Shop), 20 percent of them were by Palmer. In Marshall R. Berkoff's 1991 compilation of prints, *Currier & Ives: The New Best Fifty* (Milwaukee: American Historical Print Collectors Society, 1991), the proportion had increased to 30 percent, more than any other artist represented. Palmer was a pioneer in the field of graphic arts whose commercial success was unmatched by any other woman artist of her era, and her prints decorated the homes of thousands of American families.

Bibliography: Harry T. Peters, *Currier & Ives: Printmakers to the American People* (Garden City, N.Y.: Doubleday, Doran & Company, 1929), 26–29; Mary Bartlett Cowdrey, "Fanny Palmer, an American Lithographer," in *Prints*, ed. Carl Zigrosser (New York: Rinehart and Winston, 1962), 217–34; Koke 1982, 3:57–60; Charlotte Streifer Rubinstein, "The Early Career of Frances Flora Bond Palmer (1812–1876)," *American Art Journal* 17:4 (1985): 71–88; idem, "Fanny Palmer: The Workhorse of Currier & Ives," in *Fanny Palmer: A Long Island Woman Who Portrayed America*, exh. cat. (Cold Spring Harbor, N.Y.: Society for the Preservation of Long Island Antiquities, 1997), 7–16.

78. *Staten Island and the Narrows from Fort Hamilton, New York: Study for a Lithograph*, c. 1861

Watercolor, gouache, black ink, and graphite on heavy watercolor paper; 18 3/8 × 29 in. (467 × 737 mm), irregular
Provenance: Edwin Allen Cruikshank, New York; Mrs. Susie Cruikshank Snyder.
Bibliography: Koke 1982, 3:59, no. 2317, ill.
Gift of Mrs. Susie Cruikshank Snyder, 1925.147

Currier & Ives depended on Fanny Palmer's talent, industry, and accuracy, and expected lithographs prepared by her to be both popular and profitable. Palmer was best known for her prints, which she frequently drew directly onto the lithographic stones, rarely producing finished watercolors. Among her completed compositions are two views of the Mississippi,[1] the previously mentioned depiction of High Bridge, and this rendering of Staten Island.

Palmer probably made a preliminary sketch for this view of Staten Island at Fort Hamilton near her home in Brooklyn for the lithograph issued by Nathaniel Currier in 1861 under the title *Staten Island and the Narrows from Fort Hamilton*.[2] In the watercolor, Fort Hamilton is visible in the right foreground, with cannons and guards in the yard. A steamboat passes through the Narrows, an area pinched between Bay Ridge in Brooklyn, on

the right, and the Southfield area of Staten Island, which separates the upper part of New York Bay from the lower part. The island bastion of Fort Lafayette is at the center, and Fort Wadsworth on Staten Island is visible in the distance at the middle left.[3] The view upriver toward Manhattan encompasses several sailing ships, another steamer, and the docks serving Fort Hamilton. It probably relates to the later of two Currier lithographs featuring this view of New York Bay mentioned earlier; in the other, *The Narrows from Fort Hamilton*, the view is directed slightly more upriver.[4]

The Currier & Ives print that corresponds to this watercolor of Staten Island and the Narrows differs in several ways from Palmer's original. In it most of Fort Hamilton was omitted, as were the sentries posted at the entrances, leaving only the stone retaining wall, two cannons, and the wrought-iron gate to indicate its presence. Earlier scholars did not attribute the Society's watercolor of Staten Island to Palmer because of the differences between the two and the lack of a signature and thus considered it a variant copy after the print.[5] However, when her studies are compared to their corresponding prints, similar minor changes are evident. Moreover, it is very unlikely that a work made after the Currier print would have included a wider view than in the lithograph, with more of Fort Hamilton accurately depicted. Research also clearly demonstrates that Palmer signed her studies only occasionally, even her more finished watercolors, as evidenced by her two views of the Mississippi in the Museum of Fine Arts, Boston, only one of which is signed.[6]

The two seated women and the standing man Palmer included at the lower center of her watercolor were replaced in the lithograph with a man, woman, and girl, all standing; in addition, a second horse-drawn carriage was inserted near the Fort Hamilton gate. These figures were probably added by another artist at

Currier's shop, as Palmer considered the portrayal of human figures one of her artistic weaknesses and often delegated their completion to other artists.[7] However, the female figures in the watercolor are very similar in appearance, costume, and facial features to those in Palmer's oil painting *Abbott's Collegiate Institute*, arguing for the attribution of the sheet to Palmer.[8]

The second Currier lithograph of a similar view, *The Narrows from Fort Hamilton*, which is unattributed and undated, may have also been produced from one of Palmer's drawings. It has a more bucolic atmosphere and Fort Hamilton seems tranquil in comparison to the wartime activity depicted in catalogue 78. In *The Narrows*, the Brooklyn shore around Fort Hamilton is dramatically altered, with no roadbed between the retaining wall and the waterline and changes to the trees and hill to the left of the fort. However, the scene incorporates a view of the fort similar to the one in the Society's watercolor, which was left out of its corresponding Currier print. It is undoubtedly related to Palmer's *Staten Island and the Narrows from Fort Hamilton*, but the sequence of publication has not been found in the extant records of Currier & Ives.

A. M.

1. The two watercolors in the Museum of Fine Arts, Boston are entitled *The Mississippi in Time of War* (1862; inv. no. 53.2450), and *The Mississippi in Time of Peace* (1865; inv. no. 53.245); see Rossiter 1962, 1:253–54, 256–57, nos. 129 and 130, ills.

2. See Gale Research Company, ed., *Currier & Ives: A Catalogue Raisonné* (Detroit: Book Tower, 1984), 2:631, no. 6123, ill. on 603. An impression is in the Society's DPPAC.

3. For the early geography of New York Bay, see John Randel Jr., "Map of Upper Bay, New York, and New Jersey," MS, New York, c. 1814, Department of Manuscripts, The N-YHS; for the history of the Narrows region, see Triborough Bridge and Tunnel Authority, *Spanning the Narrows* (New York, 1964); for the early history of the forts of the Narrows region, see Jonathan Williams, *Plan of Col. Jonathan Williams, for fortifying the Narrows between Long and Staten Islands* (New-York: printed for the Corporation of the City of New-York, by H. C. Southwick, 1807).

4. Gale 1984, 1:478, no. 4757, ill. on 480.

5. See Koke 1982, 3:59.

6. Rossiter 1962, 1:253.

7. Rubinstein 1997, 11, who also notes that in Palmer's era women artists were not permitted to study nudes, which impeded their ability to depict the human figure (n. 11).

8. *Kennedy Quarterly* 5:4 (1965): 300, no. 327, ill.

AUGUSTUS KOLLNER
Württemberg, Germany 1813–Philadelphia, Pennsylvania 1906

When Augustus Kollner (born Köllner) was only sixteen, he began working as an engraver for the printer Carl Ebner in Stuttgart, Germany, primarily designing advertisements and illustrations. In 1830 Kollner published three portfolios of etchings featuring animals, including his "Studies of Horses," the first example of his lifelong passion for portraying equines. During the 1830s he was employed by Thierry Frères, printers in Paris, where he further developed his engraving, etching, and lithographic skills, and cultivated his interest in painting and drawing. Seeking a greater commercial market for his work, in 1839 Kollner sailed for America, where he worked in Washington, D.C., for the lithographer Philip Haas. The following year, he set out on a sketching excursion of the American countryside, the first of many annual summer tours on which he drew the landscapes, town views, and cityscapes of the United States.

In 1840 Kollner settled into a studio and shop in Philadelphia, advertising himself as a specialist in watercolor and oil equestrian portraits of ladies, gentlemen, and military officers and horses. Although he thought of himself primarily as an artist, Kollner was most successful as a printer and lithographer. He produced a wide variety of prints, whose subjects ranged from lithographic patent medicine labels to his portfolio of twelve etchings, *Studies of Horses in Different Positions* (1847). In 1847 Kollner joined the printing firm of Brechemin & Camp (later known as Kollner, Camp, & Company), contributing vignettes for books, sheet music, maps, and business and visiting cards, and designing show bills, labels, and advertisements. Brechemin & Camp boasted to customers that Kollner possessed more than five hundred picturesque views, a collection he assembled from the sketches drawn during his summer tours.

Kollner's most sophisticated and successful set of prints was entitled *Views of the Most Interesting Objects and Scenery In The United States of America: Drawn from Nature* (1848–51). Also known as *Views of American Cities*, the folio included fifty-four beautifully colored lithographs of American and Canadian scenes. The N-YHS holds two of the original drawings for the prints in this series, and, in the library, a complete, unbound set. In conjunction with the American Sunday-School Union, Kollner also produced a notable series of illustrated children's books, beginning in 1850 with *Common Sights in Town & Country. Delineated & Described for Young Children*. In the tradition of the earlier "Cries of London" and "Cries of New-York" (cat. 58), this book contained finely executed lithographs of quotidian occupations, each accompanied by descriptive text with a moral theme. Kollner expanded the successful series with *Common Sights on Land and Water* (1852) and *City Sights for Country Eyes* (1856), among others. He also helped compose the huge (four-by-seven-foot) and detailed *Map of the City of New-York Extending Northward to Fiftieth St.* (published by M. Dripps in 1851) and contributed the eighteen vignettes of landmark buildings featured on its border.

In his advertising brochure of 1851 (Pennsylvania Academy of the Fine Arts, Philadelphia), Kollner described himself as a "Designer, Engraver & Lithographer: Copperplate & Lithographic Printer," with printed examples of a diploma certificate, an architectural rendering, and botanical and anatomical illustrations. His lack of interest in chromolithography and his decreasing activity in the social and artistic circles of Philadelphia led to the marginaliza-

79

tion of his business during the 1860s. After
returning from a brief stint as a Union army
sketch artist during the Civil War, Kollner
retired from commercial lithography to focus on
painting historical scenes. He soon discovered
that the preferences of art patrons had changed
and the few works that he exhibited at the
Pennsylvania Academy of the Fine Arts in 1865
and 1868, for example, *Aeneas at Carthage* (c.
1868), received very little attention. Kollner
continued to paint in watercolor, sketch, and
make etchings until about 1899. Since his death,
his work has been appreciated as much for its
documentary nature as for its artistic value.

Bibliography: Stokes 1915–28, 3:706–7; Nicholas
Wainwright, "Augustus Kollner, Artist," *Pennsylvania
Magazine of History and Biography* 84:3 (1960): 325–51;
Philadelphia Museum of Art, *Philadelphia: Three Centuries*

of American Art, exh. cat. (Philadelphia: Philadelphia
Museum of Art, 1976), 290, 332–33; Koke 1982, 2:249–51;
Peter Hastings Falk, ed., *The Annual Exhibition Record of
the Pennsylvania Academy of Arts, 1807–1870* (Philadelphia:
Sound View Press, 1988–89), 1:115.

79. *View of Broadway, New York City: Study for Plate 44 in Kollner's "Views of American Cities,"* 1850

Brown ink and wash, watercolor, gouache, and graphite
on light brown paper, laid on card; 7 13/16 × 11 1/4 in. (198
× 286 mm)
Inscribed and signed at lower left in brown ink: *Drawn from
nature by A. Kollner.*; inscribed at lower center: *Broad-Way.*
Provenance: Edwin Babcock Holden, New York;
American Art Galleries, New York, 1910.
Bibliography: Augustus Kollner, *Views of the Most
Interesting Objects and Scenery In The United States of America:*

Drawn from Nature (New York and Paris: Goupil, Vibert, &
Co., 1848–51); Stokes and Haskell 1932, 164; American Art
Galleries, New York, sale cat., 21 April 1910, lot 1935; Koke
1982, 2:250–51, no. 1559, ill.
Gift of Samuel Verplanck Hoffman, 1910.36

In 1848 Kollner began his most complicated and
ambitious project, *Views of the Most Interesting
Objects and Scenery In The United States of America:
Drawn from Nature* (1848–51), often bound under
the title *Views of American Cities.*[1] He sent his origi-
nal drawings for this series to publisher Goupil,
Vibert & Co. in Paris, where they were transferred
to stone by Isidore Laurent Deroy. The result-
ing folio of fifty-four finely detailed and richly
colored lithographs portrayed street scenes and
cityscapes in the Northeast and Canada, from
Washington, D.C., to Quebec, and abound with
details of local geography and city life. Also

featured are picturesque landscapes, including seven dramatic scenes of Niagara Falls. The Society holds two of the original drawings for the prints in this folio: plate 44, *New-York, Broad-way, 1850*; and plate 47, *New-York, Wall Street, 1850*.[2]

In this study for plate 44, Kollner accurately depicted the details of the geography and architecture of the Broadway neighborhood while conveying the dynamic atmosphere and bustling activity of the area. The fashionable Astor House hotel and restaurant, at the extreme right with its Greek Revival portico, was built in 1834; it extended from Barclay to Vesey streets. Next to the Astor, partially hidden by trees, is St. Paul's Chapel designed in the Classical Revival style of the Georgian period and notable for its four fluted brownstone columns.[3] The building beside the church displays a sign that identifies it as Mathew Brady's Daguerrean Miniature Gallery and portrait studio, on the corner of Fulton Street, established in 1843. The noted and notorious Barnum's Museum dominates the left side of the view, recognizable by the immense and striking signs depicting sea serpents and exotic scenes. Hazy in the distance downtown is the Gothic Revival spire of Trinity Church on Wall Street.[4]

In Kollner's watercolor study, the street teems with horse-drawn carriages and men in top hats on horseback, while women in wide skirts stroll along the sidewalks. The coaches are finely detailed and are characterized by his signature high-stepping horses, passengers in the windows, and drivers wielding whips. A dog runs across the muddy cobblestone street while pedestrians walk on the wooden planks that angle to left of center. The scene conveys the stimulating, animated, and cosmopolitan lifestyle of the burgeoning city in 1850.

Few of the original watercolors for Kollner's portfolio *Views of American Cities* have been located, but the lithographs have long been considered to be among the finest landscape and city views produced during this era.[5] The geographic range of the subjects, the attractiveness of the compositions, the fine details of the architectural elements, and the inclusion of figures and vehicles contributed to the outstanding success of Kollner's prints in his day.
A. M.

1. The copy in the N-YHS library is unbound, with seven copies of the frontispiece printed in gold and bronze metallic inks: "Views of the most interesting objects and Scenery In The United States Of America Drawn from Nature." The Library of Congress catalogues this folio under the title on the binding of its copy, *Views of American Cities*.
2. Helen Comstock, ed., "Kollner's *Views of American Cities*," *Old Print Shop Portfolio* 3:9 (1944): 195–96.
3. St. Paul's Chapel at Broadway and Vesey Street is presently the only surviving pre-Revolutionary church in Manhattan and the oldest building continuously in public use.
4. Comstock 1944, 199–200.
5. Comstock (ibid., 195–96) stated that the location and media of the originals were unknown, and that they were presumed to have remained in France after publication. The Society's holdings demonstrate that at least two of the originals were watercolor and ink drawings and were brought back to the United States by 1910, the year of their donation. The MCNY holds a related watercolor by Kollner, *Broadway* (c. 1850; inv. no. 52.100.3), which lacks the inscription at the lower center and includes a large tree to the left of Barnum's Museum that is not present in the corresponding print.

MARIE-FRANÇOIS-RÉGIS GIGNOUX

Lyon, France 1814–Paris, France 1882

Régis Gignoux, to use the shortened name preferred by the artist, studied first at the Academy of St. Pierre in his native Lyon before entering the École des Beaux-Arts in Paris, where he worked under Horace Vernet and Paul Delaroche, who encouraged him to develop his talent in landscape painting. Following in the footsteps of his brother and pursuing a young American woman he had met, Gignoux immigrated to the United States in 1840 and established residence in Brooklyn. That same year he married the Brooklyn-born Elizabeth A. Christmas, and together they raised eight children. In 1841 he embarked on a yearlong sketching tour of the Allegheny and Catskill mountains and became enthralled with American scenery. His interest in landscape painting intensified through his friendship with Robert Walter Weir, a drawing instructor and painter of the Hudson River School whom he visited at West Point, New York. He first gained notice for his atmospheric winter landscapes, which, influenced by German and Dutch examples, were in great demand. Although Gignoux's early works blend French and American characteristics, he gradually became associated with the Hudson River School.

Drawn into the active art world on the East Coast, Gignoux began to exhibit extensively, first at the NAD (1842), the Pennsylvania Academy of the Fine Arts in Philadelphia, and the Boston Athenaeum. In 1843 he showed *Interior of Mammoth Cave, Kentucky* (c. 1843; The N-YHS) at the NAD to critical acclaim. He also had joined the American Art-Union in 1842 and became an associate of the NAD in 1843. That same year he exhibited work at the Brooklyn Institute (the germ of the Brooklyn Museum).

By 1844 Gignoux had opened his own studio in New York's Granite Building, where he gave private lessons to students (including George Inness from 1843 to 1845) who were attracted by his popularity and success. He also briefly took classes at the NAD in 1844. Gignoux continued traveling throughout America to gather material for paintings of its landscapes, such as his views of Niagara Falls from the late 1840s that drew critical praise. In 1850 he set out on a summer journey to the coast of Maine with Frederic Edwin Church and Richard William Hubbard, returning to be elected an academician by the NAD (1851). Soon thereafter an engraving of his work was included in George P. Putnam's 1852 landscape giftbook, *Home Book for the Picturesque*, which illustrated works by leading Hudson River School painters.

With prestigious patrons such as Charles

80

Gould, the Baron de Rothschild, and the Earl of Ellesmere, Gignoux's stature in the art world was firmly established. He was among the first to join the illustrious congregation of artists at the famous Tenth Street Studio Building in 1858 (others included residents Albert Bierstadt [cat. 102], Church, and Worthington Whittredge as well as visitors Jasper Francis Cropsey [cats. 98 and 99] and John Frederick Kensett [cat. 88]). Gignoux stayed there until 1869. That same year his painting *Dismal Swamp* (1850; Museum of Fine Arts, Boston) commanded the highest price paid for a painting at H. H. Leed's auction house. Perhaps his most celebrated work is the canvas *Niagara, The Table Rock—Winter* (1847; United States Senate Collection, Washington, D.C.), one of at least four canvases of the falls in wintertime by the artist, which was exhibited in 1847 at the NAD. (One of Gignoux's sublime winter Niagara scenes also attracted European attention when it was exhibited at the Paris Salon in 1870.) In 1855 Gignoux returned to France, the first of several visits before 1869, and exhibited four paintings

at the Paris Salon, and in 1857 he visited Quebec, Canada. He also began to work more locally in Brooklyn, helping to organize the first exhibition at the Brooklyn Atheneum in 1856 and founding the Brooklyn Art Association, serving as its first president (1861–69) and exhibiting there annually. Evidence of his stature can be gauged by his participation in another giftbook, *A Landscape Book, by American Artists and American Authors* (1868). In seventeen chapters it pairs sixteen steel engravings after paintings of American scenes by artists of the Hudson River School with writings by prominent authors. The text for Gignoux's illustration of the Housatonic Valley in winter was penned by William Cullen Bryant (cat. 64).

Returning to his native France in 1869, Gignoux settled in Paris, kept a villa at Nice, and continued to exhibit (some American but mostly European landscapes) until his death in 1882. He returned briefly to New York in March 1874 for a visit. Among his most famous works are landscapes painted on his travels to the

mountain ranges of New York, the coast of Maine, and other wilderness areas in North America. Painted in a sophisticated manner that blends French and American characteristics, they preserve his sense of discovery and excitement about his adopted land.

Bibliography: Henry T. Tuckerman, *Book of the Artists: American Artist Life, Comprising Biographical and Critical Sketches of American Artists, Preceded by an Historical Account of the Rise and Progress of Art in America* (New York: G. P. Putnam & Son, 1870), 507–10; Clara Erskind Clement and Laurence Hutton, *Artists of the Nineteenth Century and Their Works* (Boston and New York: Houghton Mifflin Company, 1907), 296; Clark S. Marlor, *A History of the Brooklyn Art Association with an Index of Exhibitions* (New York: J. F. Carr, 1970), 6–7; Martha Hutson, "The American Winter Landscape, 1830–1870," *American Art Review* 2:1 (1975): 60–78, esp. 67–68, 70–71; Fink 1990, 346; Dearinger 2004, 226; Carbone et al. 2006, 1:553–55.

80. *The Barge Office, New York City*, c. 1841

Watercolor, gouache, and Conté crayon on paper, laid on board; 9 × 15 3/8 in. (228 × 391 mm)
Signed at lower left in Conté crayon: *Gignoux*; reverse of board along upper border has partially obliterated inscription in black ink: [illegible] *father Joseph | (Medical | Health) officer of the Port of New York | – Painted circa 1800 – | William F. Beekman*; at middle left: *Partially obliterated top line reads 'Painted by [R. F.] Gignoux for my | great-grandfather Joseph Bayley', The artist's name appears both as Regis Francois or Francois Regis Gignoux | (1816–1882). | The date depicted is ca. 1800=1802 | though painted at a much later date, for the artist did not come to America | until ca. 1841 and returned to France | in 1870. He was a member of the National Academy and first president | of the Brooklyn Academy.*; two labels at center inscribed in brown ink: *Dr. Joseph Bayley | was Health | officer to the | Port. 1800–1826 | His daughter | Josephine married | Richard | Lawrence | my grandfather | William F. Beekman*
Provenance: The Beekman family, New York.
Bibliography: Koke 1982, 2:67, no. 1099, ill.
Gift of Dr. Fenwick Beekman, 1954.17

The information given in the various inscriptions on the reverse of the board (see above) and on the old mat does not agree with Gignoux's known arrival in America in 1840.[1] Although the artist could have executed this watercolor and the small oil painting of the same subject (see below) anytime after his immigration until his return to France in 1869, stylistically the work seems to date from the 1840s. Furthermore, the appearance of Castle Garden in the far left background in Gignoux's watercolor, which was not roofed over until 1845, reinforces a date in the early 1840s. Most important, Gignoux's small oil painting of Castle Garden and the Battery in the Society's collection is signed and dated 1841,[2] underlining the fact that the artist depicted the harbor landmarks of lower Manhattan soon after his arrival in this country.

The picturesque United States Barge Office on the wooded shore of the southeast corner of Battery Park at the foot of Whitehall Street served as offices and short-term residences for customs officials from 1830 to 1880. It also overlooked the dock for the flat-bottomed barges that agents dispatched to inspect incoming ships before allowing them to berth. The wooden pilings visible in the right foreground mark the departure point of the Staten Island Ferry, whose small terminal building is seen at the extreme right (a new terminal now stands where the barge office was).

Castle Garden was formerly Castle Clinton (1808–11), built to protect New York Harbor from a feared British invasion that never occurred during the War of 1812.[3] By 1880 the barge office that Gignoux depicted had been demolished and replaced by a larger building to accommodate the expanded customs inspection staff needed to serve the Port of New York, which by that time was handling more than half the national value of all export and import commerce.[4] Room for this larger structure was created by expanding the Battery, as landfill taken from Manhattan construction sites was deposited offshore.[5]

Gignoux also painted a related oil, for which this watercolor is perhaps a study, that today is in the MCNY.[6] Although its composition is similar, the oil's proportions are more vertical, affording a larger expanse of sky and water in the foreground, as well as accommodating more wooden pilings at the right. The artist added other anecdotal details to his oil; for example, the U.S. Customs flag flies from the barge office cupola, indicating that an inspector is on duty. Because of the uncertainty of ships' arrival times, the barge office was staffed around the clock. Gignoux also depicted laundry drying on the roof that probably belonged to an officer on duty, underlining the constant vigil kept at the site.

In contrast to the darker palette of the oil painting, Gignoux's watercolor has a light, impressionistic feel, characteristic of the medium. The artist also inscribed the area of the building above the roof and below the balustrade *REVENUE OFFICE*, a detail not found in the oil painting, to suggest that he may have executed the watercolor *en plein air*.

1. Dr. Joseph Bayley (1775–1836) died before Gignoux's arrival. The discarded mat was lettered with the following inscription: *OLD CUSTOM HOUSE, STATEN ISLAND | PAINTED BY GIGNOUX | FOR DR. JOSEPH BAYLEY | – CIRCA 1802 –*.
2. Inv. no. 1926.38; Koke 1982, 2:66–67, no. 1095, ill.
3. In 1823 Castle Clinton was given to the city and converted into an entertainment center, known as Castle Garden, until the city reclaimed it to serve as an immigration center from 1855 to 1890. The original Castle Clinton was probably designed by John McComb Jr., the architect of City Hall, and Lieutenant Colonel Jonathan Williams, who proposed the ring of forts that protected the harbor and for whom the fort on Governors Island is named. For additional information, see

Diamonstein 1998, 60, ill.
4. For a view of the land approach to the Staten Island Ferry and the same early Barge Office, see Chas. H. Haswell, *Reminiscences of an Octogenarian (1816 to 1860)* (New York: Harper & Brothers Publishers, 1897), 41, ill. For the remodeled, larger Palladian structure as it appeared in 1870, see John Hardy, *Manual of the Corporation of the City of New York* (New York: Common Council, 1871), ill. between 198 and 199.
5. In 1907 the U.S. Customs Service relocated to a new Beaux-Arts facility designed by the noted architect Cass Gilbert, where it remained until its move in 1974 to the World Trade Center (no. 6). Most of its facilities are now in Newark, New Jersey, and at the ports.
6. Inv. no. 70.3, in oil on canvas, 26 3/4 × 21 3/4 in.; see Ramirez 2000, 126–27, no. 27, ill.

JAMES BARD

New York, New York 1815–1897

James Bard and his twin brother, John, were born into a modest laborer's family in the then suburban village of Chelsea on the Lower East Side of Manhattan. The Bard brothers grew up near the steamboat piers on the Hudson River, where they watched the passing ships and together developed an interest in their depiction. Their first ship portrait of the *Bellona* (location unknown) was reputedly painted when the twins were only twelve years old. By 1831 the Bard brothers had formed a partnership and painted ship portraits on commission, but they did not consistently sign and date their works until 1837. Among these early ship portraits are views of the steamboats *DeWitt Clinton* and *Fanny* (c. 1831; Mariners' Museum, Newport News, Va.).

In 1838 James and John Bard were listed in the New York City directory as "Bard, John & James, painters, 137 Elm." After 1839 only James was listed as a painter, variously on Broome, Waverly, and Washington streets. Nevertheless, they continued to sign ship portraits *J. & J. Bard* through 1849, indicating that either the partnership persisted or that commercial success depended on the recognition of the "J. & J. Bard" name. James Bard signed paintings without John as early as 1837, demonstrating that he pursued his art as an individual concurrently with his work for the partnership. Their collaborative paintings and James's solo works include portraits of steamboats, schooners, clippers, and racing yachts.

Together the Bard brothers recorded many of the important ships passing through Long Island Sound and along the Hudson River, and the accurate nautical observances in these paintings still intrigue historians of navigation. In 1842 James Bard contributed two watercolor ship portraits to the American Institute's annual exhibition. The last known work signed *J. & J. Bard* was dated 1849, suggesting that John had abandoned their partnership by 1850; he died destitute in the almshouse on Blackwell's Island in 1856. However, the increase in shipbuilding during the late nineteenth century contributed to James's continued success. At the time of James Bard's death, Samuel Ward Stanton wrote in a tribute that he had completed over 4,000 paintings, though only slightly more than 430 known works are currently attributed to the two brothers. James's last known work is a sketch dated 1892, just five years before his death.

The N-YHS holds seven watercolors and thirty-three oil paintings by James Bard and his brother John, most of them depicting steamboats, with several tugboats, schooners, and a sloop. In 1987, on the ninetieth anniversary of James Bard's death, the National Museum of American Art in Washington, D.C., mounted a retrospective exhibition celebrating the career and works of the Bard brothers.

Bibliography: Harold S. Sniffen and Alexander Crosby Brown, "James and John Bard Painters of Steamboat Portraits," *Art in America* 37:2 (1949): 51–78; Museum of

81

American Folk Art, *Steamboat Portraits of the Hudson, by James and John Bard* (New York: Museum of Folk Art, 1965); Koke 1982, 1:16–26; Anthony Peluso Jr., *The Bard Brothers: Painting America under Steam and Sail* (New York: Harry N. Abrams, in association with the Mariners' Museum, 1997).

81. *Steamboat "Sylvan Dell,"* c. 1872–86

Gouache, watercolor, pastel, graphite, and metallic pigment with selective glazing on paper, laid on board; 24 3/8 × 39 in. (619 × 991 mm), image
Inscribed and signed at lower right in white gouache: *DRAWN & PAINTED BY J. BARD. NY.*
Provenance: James S. Hall, Books, Prints and Maps, Brooklyn, N.Y.
Bibliography: A. J. Wall, "The Sylvan Steamboats of the East River New York to Harlem," *New-York Historical Society Quarterly* 8:3 (1924): 59–72, ill.; Anthony Peluso Jr., *J. & J. Bard, Picture Painters* (New York: Hudson River Press, 1977), 78–79, ill. on 85; Koke 1982, 1:25, no. 93.
Purchased by the Society, 1924.104

The steamboat *Sylvan Dell* was built in 1872 in Greenpoint, Brooklyn, the fifth of the *Sylvan* steamers and the swiftest of the fleet of ships nicknamed the "Harlem Flyers," operated by the Harlem & New York Navigation Company.[1] The ship ran for ten years between Peck's Slip on the Lower East Side and Harlem, a ride that cost commuters six cents. Later, the *Sylvan Dell* ran from Bay Ridge in Brooklyn to Glen Island (near New Rochelle) in Westchester County. Known as "The Queen of New York Harbor," the *Sylvan Dell* was sold in 1886 to the Gloucester Ferry Company, which operated a ferry service from Philadelphia across the Delaware River to Gloucester, New Jersey, from about 1865 through the early twentieth century.[2]

James Bard's depictions of both steamboats and sailing vessels incorporate the traditions of ship portraiture and reflect the artist's significant, albeit untrained, talent. With precedents dating back to antiquity, marine painting and ship portraiture had flourished among the seafaring Europeans nations of the eighteenth century, particularly among the Dutch, French (cats. 12 and 39), and English.[3] Owners and captains often commissioned portraits to record the majesty and superiority of their newest ships. Ship portraits became popular in the United States during the early nineteenth century, an era of increasing American marine enterprise, when steamers and fast ships like clippers represented progress and stood as symbols of speed, beauty, and artisanship. Though somewhat artistically primitive, Bard's portraits were made from direct observation and precise measurements, resulting in drawings with proportional accuracy. He used mechanical drawing tools including a straightedge, T square, and triangle to achieve precision, and applied gold leaf and metallic pigments to add authenticity.[4] The bold simplicity of his works contributes to their impact and charm.

Carefully rendered details, an emphasis on pristine ships flying a full set of flags or with sails fully rigged, and precise proportions all demonstrate Bard's familiarity with European marine and ship portraiture traditions.[5] Bard painted the *Sylvan Dell* with a traditional broadside view at water level, facing right to left. It is one of three known watercolor versions of the *Sylvan Dell*; the other two are held by the Mariners' Museum, in Newport News, Virginia, and the MCNY.[6]

Bard conventionally placed dark-hulled vessels against a clear horizon and blue sky, while light-hulled ships were frequently set off by a green shoreline, as in the portraits of the *Sylvan* steamers.[7] Rather than basing his backgrounds on observation, he composed simple but realistic settings that he married with images of the vessels. For his portraits of Hudson River ships, he meticulously re-created some of the most recognizable vistas along the river as settings, such as the view of Storm King Mountain behind the *Daniel Drew* (New York State Museum, Albany, N.Y.) as it steamed through Newburgh Bay, or the glimpse of Castle Williams on Governors Island, New York, visible forward of the *Reindeer* (1850; The N-YHS). The view behind the *Sylvan Dell* and the other *Sylvan* ships shows the wooded residential neighborhoods of then-suburban Harlem, Brooklyn, or Queens as seen from across the East River. Bard often included small figures and other vessels as embellishments to his portraits: naïvely drawn gentlemen in top hats and occasionally a bonneted woman stroll the decks of his ships, and sometimes a pilot can be seen in the pilot house.

The steamboat *Sylvan Dell* was destroyed in 1919 when it burned at Salem, New Jersey, during a ferry run. The Society also holds depictions by Bard of the four other "Sylvan" steamers: the *Sylvan Glen* (1870), *Sylvan Grove* (1871), *Sylvan Shore* (c. 1870), and *Sylvan Stream* (1871).[8]

A. M.

1. Fred Erving Dayton, *Steamboat Days* (New York: Frederick A. Stokes Co., 1925), 297, 428–29; and Koke 1982, 1:25.
2. William W. Fausser, *The Sea Beach to Coney Island* (New York, 1979?). For the dates, see *Gloucester Ferry Co. v. Commonwealth of Pennsylvania*, 114 U.S. 196, 5 S. Ct. 826, 29 L. Ed. 158, in *Black's Law Dictionary* (St. Paul, Minn.: West Publishing Co., 1973), 1670.
3. Peluso 1997, 9.
4. Ibid., 120.
5. Ibid., 10–11.
6. Ibid., 170. Peluso also notes that three oil versions of the *Sylvan Dell* are believed to exist: two in private collections, and one known only from a photograph.
7. Ibid., 113.
8. Inv. nos. 1924.105, 1924.106, 1924.107, 1924.108, respectively; Koke 1982, 1:23–25, nos. 81, 83, 84, 94.

EDWARD [EDUARD] BURCKHARDT

Basel, Switzerland 1815–Paris, France 1903

Son of a ribbon manufacturer, Eduard Burckhardt was born in Switzerland and in 1836 is recorded in New York City. In 1839 he wrote an unpublished statistical account of the United States in German, French, and English, which is in the Society's library. It contains eleven original drawings (in the same media as the work discussed below) and ten maps. A watercolor view of Thomas Buchanan's country house and Youle's Shot Tower on the East River, also dated 1839, is signed *Edward Bouchard* and has been attributed to Burckhardt, who also frequently signed his name with the German spelling of his first name, "Eduard," exhibiting the bilingual orientation of his native country (see n. 1 below). A businessman by profession, Burckhardt married Maria Elizabeth Tomes of New York City in 1853 and is listed as a silk merchant in the New York City directories for 1859–61, 1865–67, and 1869. Becoming a wealthy man, after 1870 he settled in Europe, living principally in Paris and Wiesbaden for the remainder of his life. In Paris he and his wife befriended the young John Singer Sargent (cats. 124 and 125) and became part of his intimate circle. Sargent painted Burckhardt's portrait (1880; private collection), as well as those of members of his family. They include portrayals of his younger daughter Charlotte Louise, with whom Sargent may have been infatuated; his wife (1885; Collection of Gavin Hadden, Va.); Charlotte Louise's dog Pointy; Burckhardt's elder daughter Valerie (c. 1880?; private collection, with a related drawing in the Museum of Art, Rhode Island School of Design, Providence); and Charlotte Louise holding a flower, Sargent's well-known *Lady with the Rose* (1882; The Metropolitan Museum of Art, New York), which was exhibited at the Paris Salon of 1882.

Unfortunately, not much more is known about this fascinating figure. One wonders why Burckhardt undertook his exhaustive "A Statistical Account of the United States," a manuscript of 232 pages in the Society's Department of Manuscripts. Perhaps he composed the ambitious work on commission or even entertained the idea of publishing it in hopes of indicating to Europeans the investment potential in America. The manuscript features chapters on each of the states as well as on the branches of government, manufacturing, and finance, together with ten foldout maps and drawings of places of interest—the United

States Bank in Philadelphia, the Erie Canal, the national Capitol, and various bridges and ships. Certainly Burckhardt came from a background conversant with art and may have had some training before emigrating. His elder brother, Johann Ludwig Burckhardt-Schönauer, was a painter in Basel, where during the nineteenth century there were a number of artists and engravers with the same surname.

Bibliography: Eduard Burckhardt, "A Statistical Account of the United States," MS in German, French, and English, 1839, Department of Manuscripts, The N-YHS; *Schweizerisches Geschlechterbuch: Almanach Généalogique Suisse* (Zurich: Genealogisches Institut Zwicky, 1907), 2:636; Koke 1982, 1:99; Ormond and Kilmurray 1998, 49, 64–65, 71, ill.

82. *Panoramic View of New York City (in Eight Sections)*, 1842–45

Black ink over graphite on eight sheets of ivory paper with partial black ink borders, laid on Japanese paper; overall 13 3/16 × 240 in. (330 × 6096 mm) (approx. 13 3/16 × 30 in. [330 × 762 mm] each)
Provenance: Descent through the artist's family.
Bibliography: "New York City in 1842 Described by Samuel Dexter Ward (1821–1905)," *Quarterly of the New-York Historical Society* 21:4 (1937): 116, ill.; John A. Kouwenhoven, *The Columbia Historical Portrait of New York* (Garden City, N.Y.: Doubleday, 1953), 190–93, ill.; Koke 1982, 1:99–103, no. 246, ill.; N-YHS 2000, 34–35, ill.
Gift of Mrs. Harold Farquhar Hadden (Valerie Burckhardt), daughter of the artist, 1915.76

Burckhardt executed this drawing in eight sections. When joined together in a circle, they create a 240-inch panorama of New York City as it appeared in the 1840s from the steeple of the North Dutch Church on the northwest corner of Fulton and William streets. The artist had a fixed point of view and pivoted 360 degrees to draw his panorama, no doubt using a straightedge and a mechanical device, such as a camera lucida, to transfer each of the eight views to paper. Although the church steeple as an aerial perch disappeared long ago, the observation decks of the Empire State Building and Rockefeller Center (and formerly the World Trade Center; cat. 144) now attract visitors to New York seeking to view the cityscape from the highest possible vantage point.

Topographical views, like this eight-part panorama, were rendered to help visitors grasp the city in its entirety. By the mid–nineteenth

century, New York had become the most densely populated metropolis in the United States. In Burckhardt's time inhabitants gradually moved uptown, "above Bleecker," to Union and Washington squares, and would soon populate Madison Square and Gramercy Park. In a period before travel in airplanes, viewing the world in this manner or in hot-air balloons was a novelty. Whereas travelers on the Grand Tour climbed mountains and towers to take in panoramic vistas of the surrounding landscape, the convincing genre of the panorama made the experience available to everyone.

Other than the drawings and maps in his statistical account of the United States, this is the only drawing known securely attributed to Burckhardt.[1] Its precise draftsmanship and use of parallel ink lines, which are more controlled than in his other drawings, recall the style of an engraver, suggesting that Burckhardt intended the work to be engraved. The lettering of the signage on its buildings, such as *NEW YORK SUN* and *BOOK BINDING*, record the different commercial concentrations of the city at midcentury. As a document, Burckhardt's eight-part tour de force preserves a 360-degree view that includes a legion of buildings no longer standing and evidence that by 1845 New York City was both crowded and sprawling.

The genre of panoramas arose with the post-Enlightenment discovery of the horizon. They consisted of continuous narrative scenes or landscapes painted to conform to a flat or curved background, which surrounds or is unrolled before the viewer. The word *panorama* was coined in the late eighteenth century to describe this technical form of topographical landscape by combining two Greek roots, *pan* (all) and *horama* (view). Considered the first true bourgeois mass medium, panoramas were usually drawn or painted in a broad and direct manner, akin to scene or theatrical painting, and were frequently executed on a very large scale. The first successful panorama was painted in 1788 by the Scottish painter Robert Barker, who exhibited a view of Edinburgh in that city, followed by his view of London (1791), which was engraved in a series of six aquatints (1792).[2] Hot on their heels came a flood of panoramas depicting major cities in Europe and America as well as battle scenes from the Napoleonic Wars. A case in point is John Vanderlyn's (cat. 31) *The Palace and Gardens of*

Versailles (1816–19; The Metropolitan Museum of Art, New York), which the artist exhibited until 1829 in a rotunda he had built on a leased corner of City Hall Park in New York City. Because panoramas provided each nation or city a visual means of apprehending what was most vital about itself, they became central to the emergent nationalism of the nineteenth century. By midcentury panoramas were a widespread form of popular entertainment. During the latter part of the century, the United States was the capital of the panorama as well as the major exporter of proprietors of the genre. This ephemeral form was not only a mania but also shaped the public act of seeing; it was essentially the antecedent of the stereopticon and motion pictures, especially animation and the process called "Cinerama."[3] Sometimes theatrical realism enhanced the panorama with the use of smoke, steam, or sound effects. At midcentury the rolled panorama, a kind of portable mural, became a common amusement and educational device. The format of Burckhardt's drawing may also be related to this subtype. Accompanied by a lecture and often music, the painting, on canvas and wound between two poles, was slowly unrolled behind a frame or revealed in sections. Among the longest and most ambitious of these rolled panoramas was one measuring 1,200 feet that depicted the landscape along the Mississippi River by the American artist John Banvard.[4] After the invention of photography in 1839, photographers also participated in this desire to show panoramas of cities and landscapes, first by placing daguerreotype plates side by side.

Burckhardt's ambitious drawing is one of several panoramas in the Society's collections. Others include views of New York City from the Hudson River and the East River, which are copies after engraved views by Robert Havell Jr. and a 1823 view of New York from Pavonia, New Jersey, by Archibald Robertson (cat.21).[5]

diameter. The viewer, standing on a platform in the cylinder's center, turns around and successively sees all points of the horizon. The effect of being surrounded by a landscape or event was heightened in various ways, such as filling the space between the viewer and the cylinder walls with three-dimensional objects that gradually seemed to become part of the picture or the use of indirect lighting to give the illusion that light is emanating from the painting itself. The term *panorama* is also used for a continuous painted backdrop surrounding a theatrical audience. The first theatrical panorama was invented as a major scenic innovation, the Diorama, by Louis-Jacques-Mandé Daguerre in 1822.

4. For additional bibliography and a history of the panorama, Oetterman 1997.

5. Inv. nos. 1943. 401 and 1943.490, 1885.4; Koke 1982, 2:117, nos. 1180 and 1181; 3:104, no. 2409, ill.

1. Koke 1982, 1:99, cites the *Old Print Shop Portfolio* 12:4 (1952): *76–77*, ill., which discusses a view of Thomas Buchanan's country house and Youle's Shot Tower, signed and dated 1836 by "Edward Bouchard," the last name the French form of "Burckhardt."

2. Barker's panorama may have influenced Burckhardt's conception; see Oetterman 1997, 64–65, fig. 1.16.

3. A true panorama is exhibited on the walls of a large cylinder. The earliest version was about 60 feet in diameter, and the later ones as large as 130 feet in

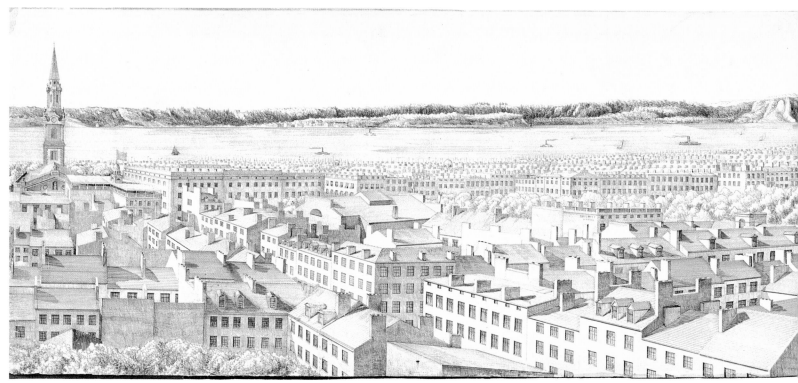

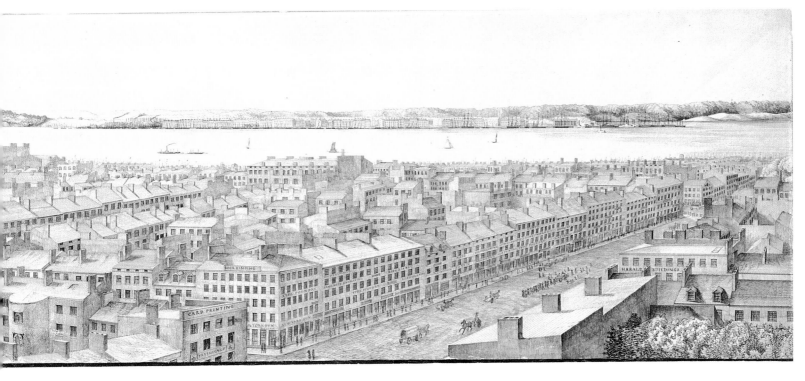

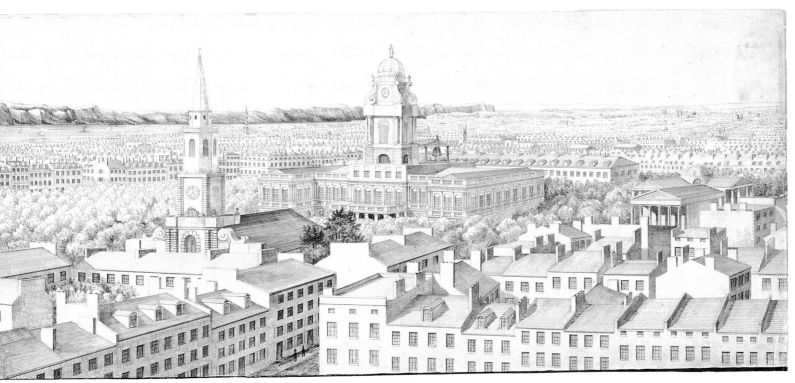

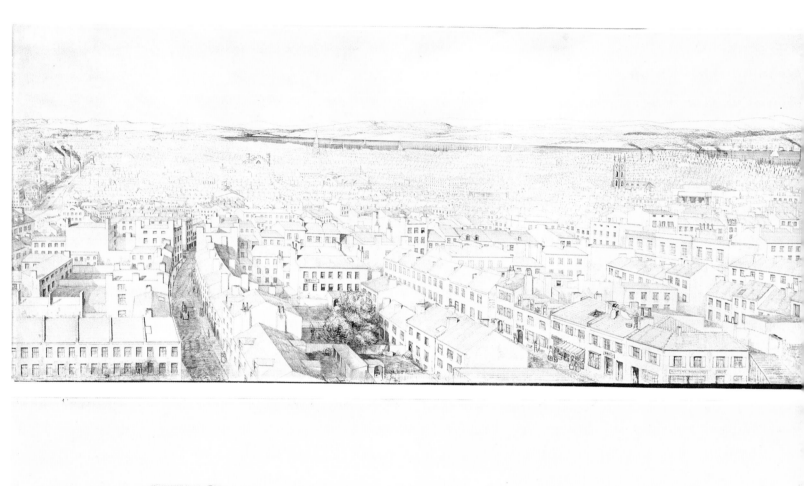

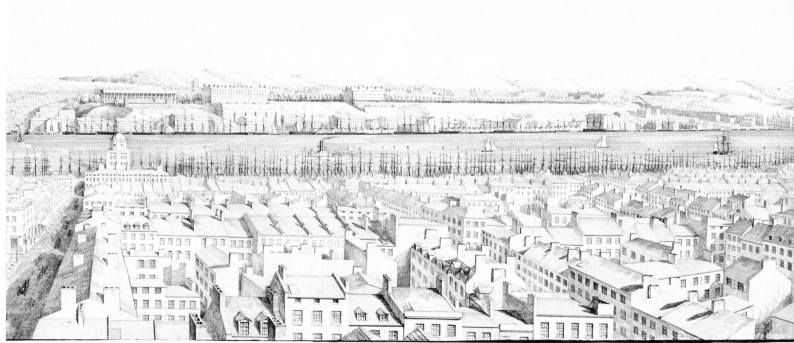

82

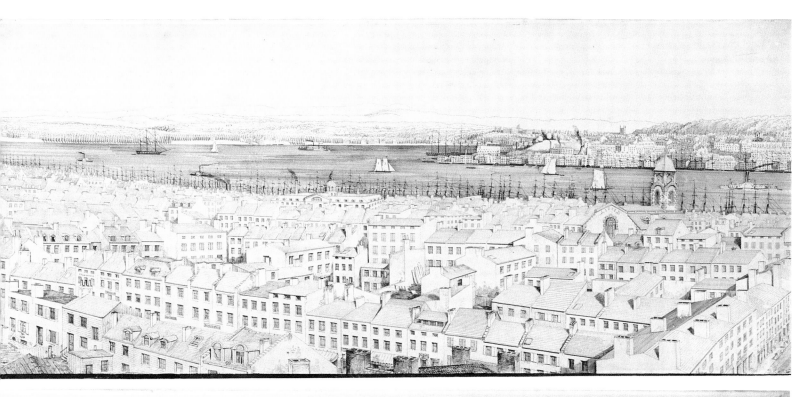

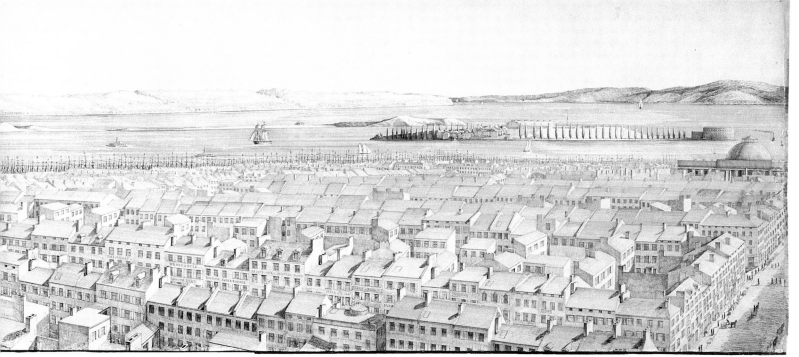

THOMAS COUTURE

Senlis, Oise, France 1815–Villiers-le-Bel, France 1879

As a child, the French history painter and influential teacher Thomas Couture showed a penchant for cutting silhouettes and an interest in art. From his early instruction at the drawing school of the Conservatoire des Arts et Métiers through his formal studies with Antoine-Jean Gros and Paul Delaroche, Couture demonstrated a precocious ability in drawing. Although expected to win the Prix de Rome for many years, he only achieved a second prize in 1837. Disgusted with the politics of the academic system, he took an independent path, later attacking the curriculum of the École des Beaux-Arts and discouraging his own students from entering that institution. During his student days in Gros's atelier he had made the acquaintance of George P. A. Healy, who later did much to promote Couture's work and teaching methods in America.

Couture's early Salon submissions were moralizing and anecdotal, yet his use of bright color and the surface texture of his pigments (derived from Alexandre-Gabriel Decamps and Eugène Delacroix) seemed fresh to French audiences. His literary bent and his methodical use of drawing demonstrated his mastery of academic tenets. Critics, such as Théophile Gautier, proclaimed him the leader of a new school that mediated between the old and the new and that would hopefully revitalize Salon painting. The tinge of compromise hinted at in this statement was consonant with the politics of King Louis-Philippe. Not happy at being cast into this role, Couture longed to make a statement worthy of artists like Jacques-Louis David and called for modernity in art. To that end, during the mid-1840s, he began to work on his monumental canvas *The Romans during the Decadence* (completed 1847; Musée d'Orsay, Paris). The triumph of the Salon of 1847, it would become his best-known work. The painting was also interpreted as a satire on the July Monarchy (1840–48). The collapse of the July Monarchy with the counter-revolution supporting the installation of Louis-Napoléon as emperor seemed to confirm its prophetic nature. Due to the altered political climate, Couture's first commissioned work, *Enrollment of the Volunteers of 1792* (begun 1847; Musée Département de l'Oise, Beauvais), was meant to underline the relationship of the Second Republic and the Revolution of 1789 but lost its raison d'être and was never completed.

For some time Couture managed to maintain close ties with the various governments of Napoleon III. He received a number of major commissions, including one to decorate the Chapel of the Holy Virgin in St. Eustache, Paris, one of the few public works he completed. A combination of jealous intrigues and his unstable temperament led to a falling-out with the imperial family, resulting in few finished works.

Having married Héloise-Marie Servent in 1859, Couture gradually retired to his native Senlis, eventually purchasing an eighteenth-century château outside of Paris at Villiers-le-Bel. By 1869 he lived virtually in seclusion, associating with his friends and a core of students, many of them Americans (such as Healy), and devoted the rest of his life to painting small canvases for private patrons, a great number of whom were Americans. From this period date his famous small genre works and his extraordinary Harlequin and carnival pictures, which, although popular at the time, have been generally forgotten by the public. In these works he poured out his disillusionment. His moving *Death [Illness] of Pierrot* (1859–60; The Nelson-Atkins Museum of Art, Kansas City, Mo.) and *The Duel after the Masked Ball* (1857–59; The Walters Art Museum, Baltimore), although cloaked in contemporary carnival costumes, were his statements about a free spirit stifled by the material world. The melancholy of these pictures recalls that found in similar subjects painted over a century earlier by Jean-Antoine Watteau. In many ways, Couture's artistic career was a casualty of French politics and its series of revolutions as well as his own inability to work within established systems. As the years passed, his art became more satiric and bitter.

Although Couture was also a particularly gifted portraitist, his posthumous reputation rests mainly on his pedagogical skills. In 1847 he had opened an atelier in Paris that was independent of the two prevailing trends, the Neoclassical and Romantic schools. Becoming an extremely popular teacher, he exercised a profound influence, standing for a distrust of the academic system and its honors. Innovative technical procedures, together with an obsession with pure color and spontaneous brushwork that resembled an oil sketch, became his hallmarks. As his pedagogy looked to the future, it is not surprising to find among his pupils forward-looking iconoclasts such as Édouard Manet, Pierre Puvis de Chavannes, and many English and American artists who preferred his teaching to the more rigid discipline of the École and the Düsseldorf school—notably John La Farge, William Morris Hunt, and Eastman Johnson.

Couture's influence reached into every nook and cranny of the American artistic experience after midcentury, either directly or through his long chain of disciples. He gave American painters, who after 1850 came in increasing numbers to Paris to study, the tools for representing the myths and collective fantasies of a struggling nation. Further, Couture brought to the attention of the American artists the deeper meaning of the oil sketch.* Although many of Couture's paintings and drawings were destroyed during the Franco-Prussian War (1870–71), the Musée d'Art et Archéologie in Senlis has a collection of his portraits and oil sketches, while this prolific draftsman's drawings are found in many public and private collections. Two of his writings (*Méthodes et entretiens d'atelier*, 1868, translated into English in 1879; and *Paysage: Entretiens d'atelier*, 1869) preserve his ideas on art.

Bibliography: Roger-Ballu, *Catalogue des oeuvres de Th. Couture exposées du Palais de L'industrie* (Paris: A. Quantin et Cie, Imprimeurs, 1880); Georges Bertauts-Couture, *Thomas Couture: Sa vie, son oeuvre, son caractère, ses idées, sa méthode, par lui-même et par son petit-fils* (Paris: Le Garrec, Éditeur, 1932); Marchal E. Landgren, *American Pupils of Thomas Couture*, exh. cat. (College Park: University of Maryland Art Gallery, 1970); Jan Van Nimmen et al., *Thomas Couture: Paintings and Drawings in American Collections*, exh. cat. (College Park: University of Maryland Art Gallery, 1970); Albert Boime, Robert Kashey, and Martin L. H. Reymert, *Thomas Couture*, sale cat. (New York: Shepherd Gallery, 1971); Albert Boime, *Thomas Couture and the Eclectic Vision* (New Haven: Yale University Press, 1980); Benedicte Ottinger, ed., *Thomas Couture, 1815–1879: Portraits d'une époque* (Paris: Somogy; Senlis: Musée de Senlis, 2003).

83. *Sketch of Nude Figure Holding a Scythe (The Personification of Death)*, 1846–79

Graphite on gray paper; 10 × 8 7/8 in. (254 × 225 mm), irregular
Inscribed by John Ward Dunsmore at lower center in graphite: *pencil sketch by / Couture*; stamped at lower left: *JOHN WARD DUNSMORE COLLECTION, 1941*
Watermark: E D & C^ie (with surrounding scrolls)

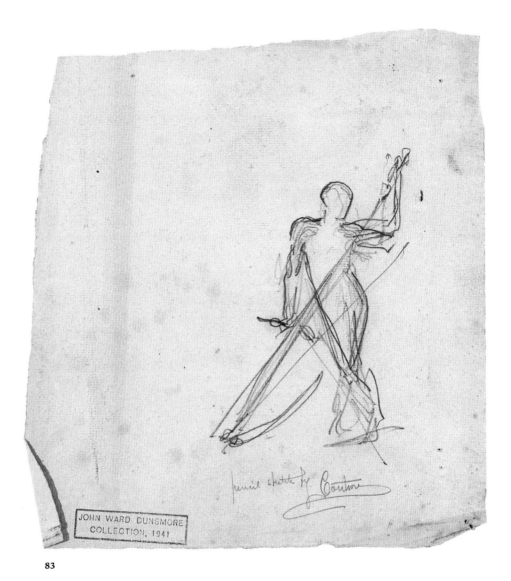

83

Provenance: John Ward Dunsmore, Dover, N.J., 1941.
Gift of John Ward Dunsmore, Z.3387

The provenance of this sheet from the collection of the illustrator and Colonial Revival artist John Ward Dunsmore (cat. 123), who studied with Couture from 1875 to 1879, speaks volumes about Couture's status as a prestigious teacher.[1] Its sketchy figure holds a large scythe, thus identifying it as the personification of Death. Couture's drawing together with Dunsmore's moving deathbed profile portrait of the French artist in the Society's collection (cat. 123) make an especially poignant and ironic pair. From Dunsmore's portrait it is clear that he observed his deceased master on his bier and in tribute rendered his profile in a black and white chalk drawing whose style imitates Couture's own celebrated draftsmanship.[2] The appearance of this single sketch by Couture in the Dunsmore material suggests that Dunsmore, like Giorgio Vasari in Michelangelo's studio, took a drawing by his teacher that had been discarded (note the ripped-off edge) by the great artist.

In subject the quick drawing is related to Couture's *Danse macabre*, an oil sketch on board in the Musée des Troyes (1846),[3] whose theme was apparently reprised toward the end of the artist's life with references to the grotesque images of Gustave Doré.[4] Certainly the medieval theme of the Dance of Death was topical in the late 1870s, after Charles Camille Saint-Saëns had composed his *Danse macabre* (1874).

Couture's preferred drawing style stressed outline, expressive and assured, as in this freely rendered study, where the contours of the figure immediately establish its character.[5] Not surprisingly, Couture believed that drawing "surpasses everything else,"[6] even light and color, and he would not permit his pupils to touch a brush until they drew expertly.[7]

* Boime 1980, 611.

1. See Landgren 1970, 31, for Dunsmore's biography. For Couture's influence on his many American students, including Frederic Edwin Church, and contact with Dunsmore, see Boime 1980, 557–612.

2. Boime, Kashey, and Reymert 1971, n.p., notes, "Couture's standard medium for his studies was black chalk which he often heightened with white."

3. Inv. no. 05.2.2. Bertauts-Couture 1932, 152, lists the painting *Danse macabre*; see also Musée de Troyes, *Catalogue des tableaux exposés au Musée de Troyes fondé et dirigé par la Société académique de l'Aube* (Troyes: Au Musée, 1907), 36, no. 74, which terms it an *equisse* and dates it to 1848. The accession records of the

museum note that it is signed and dated *Th. Couture / 1846*, information that is verified by a photograph of the painting sent to the Society by Chantal Rouquet, Conservateur en Chef.

4. Martin L. H. Reymert et al., *Ingres and Delacroix through Degas and Puvis de Chavannes: The Figure in French Art, 1800–1870*, exh. cat. (New York: Shepherd Gallery Associates, 1975), 183, states that one of the

final works Couture painted was on the same theme.

5. For comparable studies, see Boime, Kashey, and Reymert 1971, nos. 34–36, ills.

6. Couture, quoted in ibid., n.p.

7. Albert Boime (ibid.) writes apropos of the Society's sketch: "For any new project he made hasty drafts … often no more than amorphous scribbles or stick-figure diagrams. Seemingly without hesitation he

got the essential movement and expressive quality he wished … . The groping movement … first traced … ghostly recordings of the model's presence before setting out the definite form. He never tried to erase or conceal these preliminaries, nor did he fear to draw into and over figures outlined previously."

(JEAN-LOUIS) ERNEST MEISSONIER

Lyon, France 1815–Paris, France 1891

The French painter, sculptor, and illustrator Ernest Meissonier was mainly self-taught, although he was briefly a student of Jules Potier and studied for five months with Léon Cogniet. He gained early experience with art by designing wood engravings for book illustrations. These images were intricate and exhaustively detailed, helping to form the style for which he became famous as a painter. His first painting was *Flemish Burghers* (1834; The Wallace Collection, London), which he exhibited at the Paris Salon of 1834. Thereafter he specialized in very small-scale genre or historical scenes featuring costumes and accessories exquisitely rendered with meticulous detail. He was inspired in part by the work of Dutch and Flemish masters, such as Gabriel Metsu and Gerard ter Borch, as well as by eighteenth-century French artists and the contemporary Romantic theater and its costume designs. His genre subjects include seventeenth-century artists and musicians (*Painter Showing His Drawings*, c. 1850; The Wallace Collection, London) and rowdy cavaliers (*Jovial Trooper*, 1865; The Walters Art Museum, Baltimore). Even in his eyewitness view of the demolished barricade and its fallen defenders (*Remembrance of Civil War*, 1848; Musée du Louvre, Paris), his habit of making a detailed study of each object is evident. He also went to great lengths to achieve authenticity, for example, borrowing the very cloak a general had used in a battle he was depicting.

Meissonier specialized in a range of military subjects. Although he depicted the Emperor Napoleon III for his Second Empire clients and a few events of contemporary history, he otherwise devoted himself to recreating events

of the past, chiefly of the Revolutionary and Empire periods in both small and large compositions. His most ambitious project was a series of events in Napoleon's military career, again distinguished by painstaking research and attention to detail. Extending his ambition to the realm of history painting, and impelled by his own experiences, Meissonier sketched an allegorical response to the Franco-Prussian War (*Siege of Paris, 1870–1871*, begun 1870; Musée du Louvre, Paris) and in 1874 obtained a commission (never realized) for a mural in the Pantheon. In 1871 he painted the monumental *Ruins of the Tuileries* (Château de Compiègne), showing the shell of the great palace that had been burned during the Commune.

By 1862, and perhaps as early as 1848, Meisonnier began to sculpt figures, especially horses, in wax over an armature with cloth, metal, and leather. The three-dimensional figures served largely as aids to his paintings. Only posthumously were they exhibited and cast in bronze multiples. He also collected historical costumes and arms and armor, bequeathing his collection to the Musée de l'Armée, Paris. Hardworking and conscientious, Meissonier became immensely successful; by the 1860s he was the most famous and best-paid painter in France. He built a country house at Poissy with a railway track and a moving car from which he could study horses in motion.

From about 1840 Meissonier's paintings elicited effusive reviews by critics, such as Théophile Gautier, who stressed their affinity with seventeenth-century masters and praised the microscopic perfection of the artist's "Lilliputian" gallery. His highly priced works,

many of which established record-breaking prices, were in much demand by the social and financial elite of midcentury France and England. In the 1870s and 1880s the fashionable art dealer Georges Petit represented his work, which was then sought after by wealthy American collectors traveling in Europe, such as William Vanderbilt and Collis P. Huntington. The artist was one of the most popular painters in America during the 1880s and was represented in nearly every noteworthy collection. For French authors like Charles Baudelaire, Honoré de Balzac, the Goncourt brothers, and Émile Zola, Meissonier's paintings epitomized nouveau riche taste. His success also made him the target of scorn by younger artists in the Realist tradition, such as Edgar Degas and Gustave Courbet. Meissonier gradually withdrew from the public forum of the Salon, but in 1890 came back to public life by leading a secession from the established Salon of the Société des Artistes Français (then identified with William Bouguereau) and, with Pierre Puvis de Chavannes, founding the more innovative Société Nationale des Beaux-Arts. After the heyday of the Impressionist exhibitions in the mid-1870s, this organization is credited with ending the hegemony of the official Salon and initiating the series of secession groups that characterized the development of modern art in Europe over the next several decades.

Much honored during his lifetime, Meissonier was elected to the Académie des Beaux-Arts (1861), which he served as president twice (1876 and 1891). He was president of the jury of the Exposition Universelle in Paris (1889) and the first artist to receive the Grand Cross of

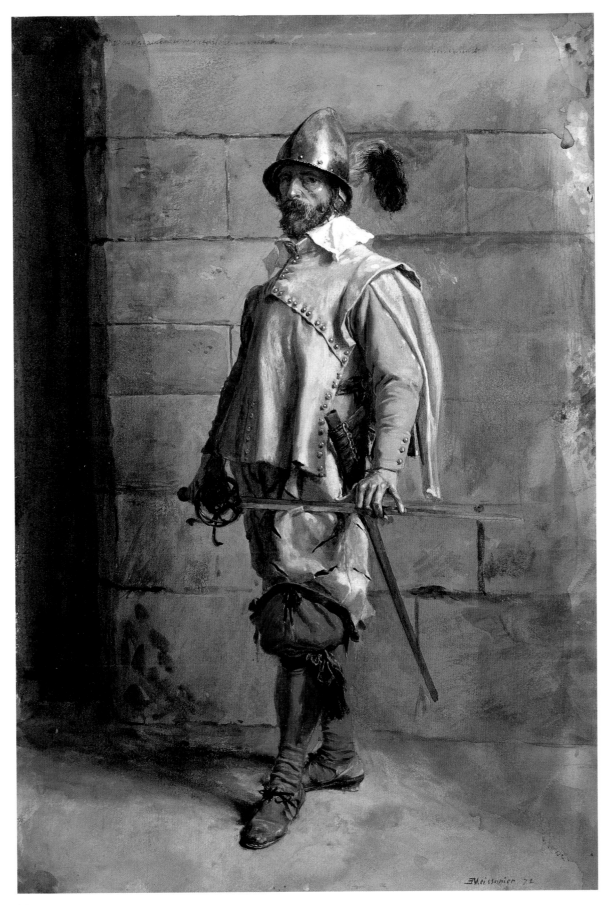

the Legion of Honor (1889). He had only a few pupils, most notably his son, Charles Meissonier, and the military painter Édouard Detaille, but his success encouraged many derivative artists to specialize in historical pieces.

Bibliography: Vallery C. O. Gréard, *Meissonier: His Life and His Art*, trans. Lady Mary Loyd and Florence Simmonds (New York: A. C. Armstrong and Son, 1897); Philippe Durey and Constance Cain Hungerford, *Ernest Meissonier: Rétrospective*, exh. cat. (Lyon: Musée des Beaux-Arts de Lyon, 1993); Marc J. Gotlieb, *The Plight of Emulation: Ernest Meissonier and French Salon Painting* (Princeton: Princeton University Press, 1996); Constance Cain Hungerford, *Ernest Meissonier: Master in His Genre* (New York: Cambridge University Press, 1999).

84. *The Cavalier, Self-Portrait in Period Costume*, c. 1866–70

Watercolor and gouache over graphite on paper, laid on board; 13 1/4 × 8 7/8 in. (336 × 225 mm)
Signed and dated at lower right in brown watercolor: E[backwards]*Meissonier 72*
Provenance: Donated by the artist to the sale of foreign paintings contributed by artists in aid of the Chicago fire sufferers, 1872; Robert L. Stuart, New York; Mrs. Robert L. Stuart, New York, 1882; The New York Public Library, 1892.
Bibliography: Edward Strahan, ed., *The Art Treasures of America* (Philadelphia, 1879), 3:57; National Academy of Design, *Catalogue of the Pedestal Fund Art Loan Exhibition at the National Academy of Design*, exh. cat. (New York: National Academy of Design, 1883), 18, no. 1; Maureen C. O'Brien, *European Paintings at the 1883 Pedestal Fund Art Loan Exhibition*, exh. cat. (Southampton, N.Y.: Parrish Art Museum, 1986), 166–67, no. 54, ill. (also pl. XXII); Eric M. Zafran, *Cavaliers and Cardinals: Nineteenth-Century French Anecdotal Paintings*, exh. cat. (Cincinnati: Taft Museum, 1992), 80–81, no. 26, ill.
The Robert L. Stuart Collection, S-223

This seventeenth-century Louis XIII costume piece showcases Meissonier's meticulous technique yet has a freer style than his oil paintings. The cavalier stands before a fortresslike backdrop engaging the viewer's eyes directly. Zafran aptly observed that it is perhaps not by chance that the artist chose this strong image of self-determination as his contribution to aid survivors of the great Chicago fire of 8–9 October 1871.[1] Although Meissonier signed the watercolor in his characteristic manner and dated it 1872, the year it was donated, there can be no doubt that he had painted it earlier.[2] From photographs documenting the length and color of the artist's beard, the work appears to date from the late 1860s. By 1869 Meissonier had begun to grow a longer beard, which by 1872 had reached below his pectorals on its way to becoming the flowing white cascades of his later years.[3]

Single, standing cavaliers had long been one of the artist's specialties. As his fame increased and his features assumed the nobility of age, Meissonier saw himself more and more in the heroic roles of an aging cavalier or a philosopher.[4] In the former role he was able to make use of his large collection of historic costumes, such as the morion helmet with plume, and armaments he wears in this watercolor.[5]

1. Zafran 1992, 80. The conflagration left three hundred dead and ninety thousand homeless; see James H. Goodsell, *History of the Great Chicago Fire* (New York: J. H. and C. M. Goodsell, 1871).
2. Strahan 1879, 3:57, mistakenly dated it 1874.
3. See Gréard 1897, 347–51. Meissonier with his long beard was also the subject of well-known bronzes by his friends Vincenzo Gemito and Emmanuel Frémiet, as well as numerous self-portraits.
4. Zafran 1992, 80, notes a similar, dated self-portrait in costume, *Captain of the Guard—Louis XIII: Portrait of the Artist*, 1865, as in the James H. Stebbins Collection, New York (see Strahan 1879, 1:96, ill.). Meissonier painted cavaliers in other works; see Hungerford 1999, figs. 42 (*Innocents and Sly Ones [The Game of Picquet]*, 1861; National Museum of Wales, Cardiff) and 44 (*The Captain [Louis XIII Cavalier]*, 1861; The Wallace Collection, London).
5. As a barometer of Meissonier's wide influence, the Society's only drawing by the artist John La Farge is after a study by Meissonier, *The Old Beadle* (inv. no. 1952.442; Koke 1982, 2:255, no. 1565).

THOMAS ALMOND AYRES
New Jersey 1816–at sea off California 1858

A native of New Jersey, Thomas Ayres moved as a young adult with his family to Wisconsin. He showed an early interest in landscape and later was employed as a draftsman by an engineering firm in St. Paul, Minnesota, spending his leisure time dabbling in watercolors and oils. Like many young men in search of adventure, Ayres sailed to California, aboard the *Panama* on 4 February 1849, and arrived in San Francisco in August with the first rush of gold seekers. Failing to strike it rich swiftly, he decided to trade in his shovel for a drawing instrument and in order to earn a livelihood began sketching mining camps, Native Americans, and scenes of northern California (and the boomtown of San Francisco) and its colorful denizens. Sketches dated from 1850 to 1854 reveal that he traveled through various gold rush towns. From his on-the-spot drawings, the artist also embarked in 1854 on an ambitious project to have forty-six of his drawings translated into oil paintings to be exhibited as a "Panorama of California." Seeking to capitalize on the popularity of huge panoramas of western landscape subjects, Ayres commissioned Thomas A. Smith to paint the oils (now lost) after his drawings of the mining regions from Mount Shasta in the north to Tejon Pass in the south. Although most of his scenes were landscapes, their titles suggest that Ayres occasionally depicted miners at work as well as settlers engaging in exotic frontier activities, such as lassoing wild horses. In the flyer he published to accompany the "Panorama of California," Ayres declared the pictures were painted for exhibition in the Atlantic states and in Europe. Before taking the paintings east, Ayres exhibited them at both D. L. Gunn's art store and the Music Hall in San Francisco, where they were enthusiastically received.

In 1855 Ayres made history as the first artist to enter and sketch the wonders of Yosemite Valley, the incredible seven-mile-long chasm bordered by towering cliffs and punctuated by waterfalls. He was engaged by James Mason Hutchings to accompany the first tourist party

85

to the valley in June of that year and to make sketches for publication in the journal Hutchings was planning, *Hutchings Illustrated California Magazine*. Ayres recorded some thirteen views during a five-day visit, becoming the first person to offer visual proof through sketches—and later his magazine illustrations and lithographs—that a valley of extraordinary beauty had been discovered in the heart of California's Sierra Nevada. He exhibited these drawings at McNulty's Hall in Sacramento. Lithographs after the drawings were issued later in 1855, and an article with four engravings after Ayres's sketches appeared the following July. A second trip to Yosemite in 1856 produced more views of its spectacular landscape. Ayres took these to New York City, where he is reported to have exhibited them. As a result, he received more orders than he could fill. It was at this time that Ayres executed the drawings of Highwood, the

James Gore King estate in Weehawken, New Jersey, that are in the collection (see below).

Engaged by *Harper's Weekly* to create illustrations of California for a series of planned articles in 1858, Ayres traveled through southern California, embarking on a schooner at San Pedro for a return visit to San Francisco. Shortly after leaving port, the *Laura Bevon* encountered a severe storm and sank; Ayres and all aboard perished on 26 April 1858. Although his career was cut short, Ayres was instrumental in capturing California scenery in his black-and-white drawings. Best known for his views of Yosemite, Ayres's work was critical in attracting other artists to Yosemite by the late 1850s, in representing the topography of the Sierra foothills for the first time, and in documenting the changing landscape of San Francisco.

Bibliography: Jeanne Van Nostrand, "Thomas A. Ayres: Artist-Argonaut of California," *California Historical Society Quarterly* 20:3 (1941): 275–79; Joseph Armstrong Baird Jr., *Views of Yosemite: The Last Stance of the Romantic Landscape*, exh. cat. (Fresno, Calif.: Fresno Arts Center, 1982), 8; Nancy K. Anderson, "Thomas Ayres and His Early Views of San Francisco: Five Newly Discovered Drawings," *American Art Journal* 19:3 (1987): 19–28; Janice T. Driesbach and Harvey L. Jones, "First in the Field: Thomas A. Ayres and E. Hall Martin," in Driesbach, Jones, and Katherine Church Holland, *Art of the Gold Rush*, exh. cat. (Oakland: Oakland Museum of Art; Sacramento: Crocker Art Museum; Berkeley: University of California Press, 1999), 7–10, 117–18.

85. *The End of the Greenhouse, Highwood, Weehawken Heights, New Jersey, Looking toward the Elysian Fields and Castle Point, Hoboken, with a View of Staten Island, New York*, 1857

Graphite, Conté crayon, black and white chalk, charcoal with stumping, and white gouache, with scratching-out and selective glazing on prepared paper, laid on Bristol

Board; 10 3/4 × 17 1/4 in. (273 × 438 mm)
Signed and dated at lower right with a stylus: *T.A. Ayres 1857*
Provenance: James Gore King II, probably Weehawken, N.J.
Bibliography: Koke 1982, 1:8, no. 26.
Gift of James Gore King II, 1928.106

This engaging and slightly mysterious scene is one of sixteen views in the collection commissioned from Thomas A. Ayres during his 1857 trip to the East Coast that illustrate the character of Highwood, the estate of James Gore King (1791–1853), in Weehawken Heights, New Jersey.[1] J. C. Bancroft commissioned them on the occasion of his marriage to one of King's eight children, Frederica G. King, in November 1857. The bride-to-be had selected the locations of these mementoes of her childhood home, which were finished on the eve of the wedding.

As a group, the series successfully captures the once-rural character of the locale and the palatial mid-nineteenth-century estate. Located on the summit of the Palisades at Weehawken in Hudson County, Highwood overlooked the Hudson River and the present-day approach to the Lincoln Tunnel. Bordered on the east by the river and on the west by Weehawken Avenue and the Bulls Ferry Road, the site on Highwood Bluff, also called King Point, commanded a spectacular view of the Hudson and beyond to Staten Island, Manhattan, and Long Island.

Several of the sixteen views, like this example, depict buildings on the estate, while others represent landscape vistas from the property that evoke scenes of the Hudson River School of painters.[2]

The haunting, silvery quality of Ayres's drawing results in part from its somewhat unconventional support, a commercially prepared paper with texture, frequently mounted on board. As in his drawings from 1855 in California, Ayres applied graphite, Conté crayon, and black and white chalks in various combinations to this prepared surface that had been coated with sand or marble dust. The artist then scratched out details and made his inscriptions with a stylus.[3] Ayres's untrained style also adds a fresh and slightly primitive quality to his works.

The property of Highwood was acquired by James Gore King, who had been born in New York City and educated in England and France, while his father was serving as minister to the Court of St. James. After beginning a banking career in Liverpool, England, King moved back to New York and became a successful businessman and a partner of Archibald Gracie, whose daughter he married in 1813. A cultured man, King was also president of the New York & Erie Railroad until 1837, served as a representative from New Jersey in Congress from 1849 to 1851, and was head of the prestigious banking house of James G. King & Sons.

In 1873 the grounds of Highwood were still part of King's estate, but by the early 1890s the property had become a popular amusement and resort complex known as Eldorado, which subsequently disappeared in a spectacular fire. The sculptor Karl Bitter later used one of the Eldorado buildings that survived the conflagration as a studio and built a home on the crest of the Palisades near the site of the former King mansion. The famous dueling ground on which Alexander Hamilton and Aaron Burr confronted each other in 1804 is located on the riverbank at the foot of King Point.

In addition to the Ayres drawings, the Society owns a manuscript map entitled *Highwood, the Property of J. G. King*. Drawn in 1843 by J. S. Lawrence, it indicates in great detail the buildings, drives, and natural features of the estate.[4]

1. Inv. nos. 1928.100–115; Koke 1982, 1:7–10, nos. 18–33.
2. Esp. inv. no. 1928.110; see Koke 1982, 1:8, no. 28, ill.
3. Anderson 1987, 20. For this technique, see also James Thomas Flexner, "Monochromatic Drawings: A Forgotten Branch of American Art," *American Magazine of Art* 38:2 (1945): 62–65; and Rossiter 1962, 2:172, 180, 185, 188, 190.
4. Outside the margins of this map in the Society's Department of Manuscripts are notes in a later hand that identify the location of the Devil's Pulpit, the Ha-Ha Fence, Highwood Bluff, and the adjoining properties.

GEORGE WHITING FLAGG
New Haven, Connecticut 1816–Nantucket, Massachusetts 1897

George Whiting Flagg, a nephew of the painter Washington Allston and a protégé of Luman Reed, was known as a portrait, genre, and historical painter. When he was three years old his parents moved to Charleston, South Carolina, where his father practiced law. During the next ten years he developed a passion for drawing and took lessons with James Bowman, who accompanied him to Boston, where for eighteen months Flagg received instruction in art from his uncle, Washington Allston. Flagg soon became celebrated as one of Boston's youngest portraitists. When he was seventeen, he at-

tracted the attention of the patron and collector Luman Reed, who undertook to support his artistic development for the next seven years.

Moving back to live with his family who had transferred to New Haven, he soon departed for Europe in 1834 with the sponsorship of Reed that he obtained with the backing of Thomas Cole (cats. 61 and 62) and Nathaniel Jocelyn of New Haven. He studied the old masters and contemporary painters of note in England, France, and Italy for nearly a year, returning first to Boston and then settling in New York City about 1843. All the paintings he produced for Reed, both in

Europe and after his return home, were figure subjects, most based on historical events as interpreted through literary sources. By attempting such complex Shakespearean subjects as the *Murder of the Princes in the Tower* and *Falstaff Playing King (Falstaff Enacting Henry IV)* (see below), Flagg demonstrated his ambition to fulfill Reed's hope that his works would rank with those by the old masters. In 1843 he was elected an honorary member of the NAD and then an academician in 1851. He exhibited at the NAD intermittently from 1834 to 1885 and at the Pennsylvania Academy of the Fine Arts in

86

Philadelphia from 1844 to 1853. During the Civil War, Flagg lived and worked in London, returning to the United States in 1867, at which time he ceased to actively exhibit his work. He moved to Nantucket in 1887. The Society has in its collections thirteen paintings and six drawings by George Whiting Flagg.

Bibliography: William Dunlap, *A History of the Rise of the Arts of Design in the United States*, ed. Rita Weiss, 2 vols. in 3 (1834; New York: Dover, 1969), 3:259; Ella M. Foshay, "Luman Reed, a New York Patron of American Art," *The Magazine Antiques* 138:5 (1990): 1080; idem, *Mr. Luman Reed's Picture Gallery: A Pioneer Collection of American Art*, exh. cat. (New York: Harry N. Abrams, in association with New-York Historical Society, 1990), 225, for a listing of pages where Flagg and his works are discussed; Timothy Burgard, "New Discoveries in American Art: Two Painted Door Panels from Luman Reed's Gallery," *American Art Journal* 23:1 (1991): 70–74.

86. *The Highwayman and the Woman, Folio 29 in the John Ludlow Morton Album*; verso: figure of a woman wearing a hat, 1836

Black ink and gray wash with touches of scratching-out and white gouache on paper; graphite, bound into an album; 3 3/4 × 4 1/4 in. (95 × 108 mm), image
Signed and dated at lower right below image in gray wash: *FLAGG 1836*
Provenance: John Ludlow Morton, New York; Harriet E. Morton Ellison; Emily Ellison Post, Jackson Heights, N.Y.
Bibliography: Koke 1982, 2:32, 34, no. 989, ill.
Bequest of Emily Ellison Post, 1944.389

Made when Flagg was only twenty years old, this enigmatic nocturnal subject may be an illustration for an unknown text or an allegory. In the work Flagg depicted a woman, probably an apparition, with one hand extended upward and the other pointing to counter the violent thrust of the highwayman and his pistol, as though negating his nefarious action with an appeal to a higher authority. The pose and type of this dramatic female figure, with her hair wildly blown forward, suggest the influence of Henry Fuseli, the visionary Neoclassical artist, whose works or prints the young Flagg may have been studying.[1] Certainly Flagg shared with Fuseli an interest in Shakespeare, the literary source for Flagg's canvas *Falstaff Playing King (Falstaff Enacting Henry IV)* (c.

1834; The N-YHS)[2] as well as his door panel of Falstaff painted for Luman Reed's Gallery in his Greenwich Street town house (1836; The N-YHS).[3]

Flagg's wash drawing belongs to a group of twenty-seven small works by various artist friends that John Ludlow Morton assembled between 1826 and 1836 into an *album amicorum* that also included two of his own works.[4] Morton, a significant figure in the art world of New York City, joined the New-York Drawing Association in 1825 and was a founding member of the NAD in 1826. Because Morton included this work in his album, it provides early evidence of Flagg's presence in New York, just after he returned to Boston from Europe and before he settled in the city in 1843. By including Flagg in the album, Morton singled him out as an important contemporary artist, whose drawing in this case reflects his recent exposure to European ideas and genre illustration and prefigures his move to London.

Flagg seems to have had in mind the works of two different artists when executing this work. The first is the aforementioned Fuseli, whose influence can be seen in the isocephalic

composition as well as the apparition's ghostly qualities, histrionic gestures, and mannered, daggerlike tendrils of hair.[5] The second artist is the Italian printmaker and illustrator Bartolomeo Pinelli, renowned for his widely disseminated prints of *briganti* (brigands), produced from about 1814 to 1834 and first featured in his *Costumi* series that appeared in French- and English-language editions.[6] Flagg's awareness of these two illustrators, whose works were widely circulated in Europe, demonstrates the American artist's adaptation of European models to suit his own vision.

1. See Gert Schiff, *Johann Heinrich Füssli, 1741–1825*, 2 vols. (Zurich: Verlag Berichthaus; Munich: Prestel, 1973). The influence of his uncle, Washington Allston, is also apparent.

2. Inv. no. 1858.16, which was in Luman Reed's collection; Koke 1982, 2:28, no. 981; and Burgard 1991, 72–73, fig. 4.

3. Inv. no. 1959.117; Burgard 1991, 72–73, fig. 3. The Society also holds other works with Shakespearean subjects by Flagg, such as *Murder of the Princes* based on *Richard III* (inv. no. 1858.48; Koke 1982, 2:27–28, no. 980, ill.). For Fuseli and Shakespeare, see Fred Licht et al., *Füssli pittore di Shakespeare: Pittura e teatro, 1775–1825*, exh. cat. (Milan: Electa for Fondazione Magnani Rocca, Mamiano di Traversetolo [Parma], 1997). For the career of Luman Reed as a patron, collector, and friend of painters, see Wayne Craven, "Luman Reed, Patron: His Collection and Gallery," *American Art Journal* 12:2 (1980): 40–59; Ellwood C. Parry III, "Thomas Cole's Ideas for Mr. Reed's Doors," *American Art Journal* 12:3 (1980): 33–45; and Foshay 1990.

4. For other works in the Morton Album, see cats. 40 and 62.

5. See Nancy L. Pressly, *The Fuseli Circle in Rome: Early Romantic Art of the 1770s*, exh. cat. (New Haven: Yale Center for British Art, 1979); Schiff 1973; and David H. Weinglass, *Prints and Engraved Illustrations by and after Henry Fuseli: A Catalogue Raisonné* (London: Scolar Press, 1994).

6. See Incisa della Rocchetta, *Bartolomeo Pinelli*, exh. cat. (Rome: Museo di Roma, 1956); Roberta J. M. Olson, "Bartolomeo Pinelli: An Underestimated Ottocento Master," *Drawing* 2:4 (1980): 73–78; Maurizio Fagiolo and Maurizio Marini, *Bartolomeo Pinelli, 1781–1835, e il suo tempo*, exh. cat. (Rome: Centro Iniziative Culturali Pantheon and Rondanini Galleria d'Arte Contemporanea, 1983); and Roberta J. M. Olson, "An Album of Drawings by Bartolomeo Pinelli," *Master Drawings* 39:1 (2001): 12–44.

DANIEL HUNTINGTON

New York, New York 1816–1906

The leading portraitist in New York City during the post–Civil War period, Daniel Huntington was born into a distinguished New England family and exerted significant influence on his contemporaries in the late-nineteenth-century art world. He studied at Yale College for a year and graduated from Hamilton College in Clinton, New York, where he met the portraitist Charles Loring Elliott, who encouraged his studies in art after painting the young man's portrait. He also may have been influenced by his visits to the studio of the illustrious history painter John Trumbull, to whom his mother was related. In 1835 he returned to New York and studied with Samuel F. B. Morse in the University Building and later worked as an apprentice with Henry Inman (cat. 64), honing his skills at the NAD during the late 1830s. Huntington, who retained a conservative, academic orientation throughout his career, was elected an associate of the NAD in 1839 and an academician the following year. He exhibited there every year from 1836 to 1901 and twice served as its president (1862–70, 1876–91), the longest-tenured holder of that office. With an engaging personality and talent for institutional affairs, Huntington became a powerful presence at the NAD. Although based in the Empire City, he exhibited at all the major art institutions in the country, as well as at the Royal Academy of Arts in London and at the 1867 Exposition Universelle in Paris. In 1847 he was a founding member of the Century Association, over which he presided between 1879 and 1895. The painter later helped found the Metropolitan Museum of Art and served as its vice president from 1870 until 1903.

Early in his career, when he was commissioned to draw some views along the Hudson River, Huntington showed an interest in landscape painting, although his academic training and religious convictions inspired him to paint historical, especially religious, subjects. He furthered his studies in Europe (1839–40), spending most of his time in Italy, where in Florence he executed *A Sibyl* (1839–40; The N-YHS) and *Florentine Girl* (c. 1840; Pennsylvania Academy of the Fine Arts, Philadelphia). These canvases reflect the spiritual earnestness of the German Nazarenes, who were also in Italy at the time, and the technique of the Italian Renaissance painters he was studying. When he returned to New York, Huntington established his reputation with the widely acclaimed *Mercy's Dream* (1841; Pennsylvania Academy of the Fine Arts, Philadelphia), derived from John Bunyan's *The Pilgrim's Progress* and painted with a delicacy and refinement reminiscent of Raphael. After marrying Harriet Sophia Richards, he returned to Europe (1843–45), painting and producing illustrations for an engraved edition of Henry Wadsworth Longfellow's poems. He spent most of his time in Italy and England, becoming acquainted with William Holman Hunt and other Pre-Raphaelite artists. In the late 1840s Huntington turned naturally to subject matter from English history.

Returning to New York City in 1845, Huntington resumed his portrait work and gained the support of influential New Yorkers. In 1850 the artist was honored by a large solo exhibition at the American Art-Union, organized by William Cullen Bryant (cat. 64) and other friends, which demonstrated Huntington's popularity with his fellow artists and the public. From this point he turned increasingly to portraiture, painting in total about one thousand likenesses. While his earliest reveal Inman's influence in their blended surfaces and straightforward compositions, by the 1850s Huntington's reputation attracted commissions for elaborate, full-scale portraits, which he rendered with looser brushwork and dramatic

looking N.E. [...] Lake Geo.
Sep 20. 71 -

87

lighting inspired by Titian and Sir Joshua Reynolds. Huntington returned to Europe for a third, longer visit from 1851 to 1858, spending much of his time in London, where he completed a number of prestigious portraits, such as one of the director of the Royal Academy, *Sir Charles Lock Eastlake* (1851; The N-YHS). Among his other distinguished sitters was William Cullen Bryant (1866; Brooklyn Museum). Two of the three works he exhibited at the 1893 World's Columbian Exposition in Chicago were also portraits. His group portrait *American Projectors of the Atlantic Cable* (1894; Chamber of Commerce, New York) crowned his prolific career and includes, among others, likenesses of Cyrus W. Field, Samuel F. B. Morse, and the artist sketching.

Until the end of his career, Huntington continued to paint works other than portraits, including history paintings that anticipated the interest in the colonial period, a vogue that became widespread by the country's centennial. With religious allegories, such as *Sowing the Word* (1868; The N-YHS), he reaffirmed his early ideal that art should be a moral force and his admiration for the old masters, underlined by his final trip abroad to Spain in 1882. Huntington, who was fundamentally conservative in both technique and principles, had a flair for institutional administration and exerted a considerable influence in the academic art establishment of his day. His official roles outlasted the appreciation for his art, which increasingly appeared outmoded in comparison to works by younger, European-trained artists.

Bibliography: *Catalogue of Paintings, by Daniel Huntington, N.A., Exhibiting at the Art-Union Buildings, 497 Broadway* (New York: Art-Union, 1850); Daniel Huntington, introduction to *Manual of The Fine Arts: Critical and Historical with an Introduction by D. Huntington* (New York: Published by A. S. Barnes and Burr, 1862), 11–14; S. G. W. Benjamin, "Daniel Huntington," *American Art Review* 2:1 (1881): 223–28, and 2:2 (1881): 1–6; Daniel Huntington, *Asher B. Durand: A Memorial Address* (New York: Printed for The Century, 1887); Keeler Art Galleries, *The Daniel Huntington Collection of Paintings*, sale cat. (New York: Keeler Art Galleries, 27–28 January 1916); Agnes Gilchrist, "Daniel Huntington, Portrait Painter, over Seven Decades," *The Magazine Antiques* 87:6 (1965): 709–11; Jay E. Cantor, *Drawn from Nature/Drawn from Life: Studies and Sketches by Frederic Church, Winslow Homer and Daniel Huntington: From the Collection of the Cooper-Hewitt Museum of Decorative Arts and Design, Smithsonian Institution: An Exhibition*, exh. cat. (New York: American Federation of Arts, 1971), nos. 32–46; William H. Gerdts, "Daniel Huntington's *Mercy Dream*: A Pilgrimage through Bunyanesque Imagery," *Winterthur Portfolio* 14:2 (1979):

171–94; Natalie Spassky et al., *American Paintings in the Metropolitan Museum of Art, Volume 2, A Catalogue of Works by Artists Born between 1816 and 1845* (New York: Metropolitan Museum of Art, in association with Princeton University Press, 1985), 56–73; Carr and Gurney 1993, 266–67; Nancy Rash, "History and Family: Daniel Huntington and the Patronage of Thomas Davis Day," *Archives of American Art Journal* 34:3 (1994): 2–15; Wendy Greenhouse, "Daniel Huntington and the Ideal of Christian Art," *Winterthur Portfolio* 31:2–3 (1996): 103–40; Dearinger 2004, 290–91.

87. *Study of Rocks on the Shore of Lake George, New York, Folio 11r in a Sketchbook*, 1871

Graphite on ivory paper, bound into a sketchbook; 6 × 9 in. (152 × 228 mm)
Inscribed and dated at lower left in graphite: *Looking N.E. / from Florie's Isld – Lake Geo. / Sept. 20. 71 –*
Bibliography: Koke 1982, 2:187, no. 1378.
X.439

This folio is one of thirty-seven landscape sketches Huntington drew at Lake Mohonk and Lake George, New York, in one of three sketchbooks in the Society's collection that he had purchased from Goupil's.[1] As a staunch academician, Huntington subscribed to the tenet that proper draftsmanship was at the core of accomplished painting. He was, in fact, a prolific draftsman, and his extant drawings number over a thousand, the vast majority

dating from early in his career.[2] He carried portable sketchbooks, like the one that contains this folio, with him wherever he traveled. Collectively, the sketchbooks filled with private, intimate studies demonstrate that Huntington never gave up landscape, despite his portrait commissions.[3]

Like Asher B. Durand (cats. 51–54), his friend and fellow founding member of the NAD, Huntington was fascinated with trees and rocks.[4] Coincidentally, according to inscriptions on three drawings in the Society's collections (12–14 September 1871), Durand was at Lake George around the same time that Huntington drew this folio.[5] Huntington arrived in Lake George on 16 September. In this folio he focused on the geological formations in the foreground and their reflections in the waters of the lake, although he included trees in the middle ground and the faint, atmospheric indications of the surrounding mountains in the *non-finito* background. This accomplished sheet demonstrates Huntington's ability to render plein air sketches in graphite, capturing with specificity his observations of enduring natural features. One wonders whether the artist selected this particular rocky area because it featured not only thriving trees but also a dead, fallen tree that adds an allegorical gloss on nature's cycle of life, death, and rebirth.

1. Goupil's, at 150 Fifth Avenue and 22nd Street, sold paintings, engravings, and artists' materials. The endpaper of the sketchbook's front cover is inscribed at lower left in graphite *DHuntington*. The two other sketchbooks in the Society's collection are inv. nos. X.440, with sketches of Lake Mohonk and Lake George, and X.441, containing a number of portraits; Koke 1982, 2:187, nos. 1379 and 1380. The Society also holds twenty-nine oils by Huntington, twenty-three of them portraits.

2. The principal repository of Huntington's drawings is the Cooper-Hewitt, National Design Museum, Smithsonian Institution, New York.

3. He also had studied the human figure. Avery et al. 2002, 204–5, ill., reproduces Huntington's seated male nude life study from 1838 in the collection of the Metropolitan Museum of Art, New York (inv. no. C158), proving that the NAD offered life classes as early as 1838.

4. For several reproductions of Huntington's earlier rock and tree studies and a page from a Goupil sketchbook from the same period as the Society's (inv. no. 36.124, The Metropolitan Museum of Art, New York), see ibid., 317–18, nos. 153–59, ills.

5. For Durand's drawings (inv. nos. 1918.204, 1918.205, 1918.84), see Koke 1982, 1:359–60, nos. 795–97; see also Lawall 1966, 3:345, nos. 201–3. Huntington painted Durand, palette in hand (1857; The Century Association, New York) and also delivered a memorial address for Durand, published in 1887.

JOHN FREDERICK KENSETT
Cheshire, Connecticut 1816–New York, New York 1872

Born into a family of skilled engravers, John Frederick Kensett learned the craft from his father, Thomas, who was also a successful publisher in a New Haven shop he shared with his wife's brother, Alfred Daggett. He apprenticed briefly in the prestigious New York firm of Peter Maverick and then, after his father's death, with his uncle's new firm in Connecticut. He became friends wth the painter Thomas Pritchard Rossiter (cat. 94) and began to draw from a set of casts sent to him by John William Casilear. By the 1830s Kensett was a full-time engraver working in New Haven, New York City (1835–37), and Albany. From this training he acquired the skills

that made him an exceptional draftsman and allowed him to render subtle modulations of gray tonalities, which lent luminous tonal values to his paintings. With a painting career in mind, he began exhibiting at the NAD in 1838, when the Hudson River School aesthetic held sway.

On 1 June 1840 Kensett sailed for London on his European Grand Tour in the company of the artists Asher B. Durand (cats. 51–54), Casilear, and Rossiter. He remained for seven years, studying the old masters and developing his skills as a painter in London, where he visited his father's family, studied works in important galleries, and produced a number of engravings to finance his

trip. He then moved on to Paris; Rossiter's painting *A Studio Reception, Paris* (1841; Institute of History and Art, Albany, N.Y.) documents the studio Kensett shared with him. It contains portraits of Kensett, Rossiter, Durand, the Boston landscapist Benjamin Champney, Casilear, and Thomas Cole (cats. 61 and 62), together with a copy of Titian's *Entombment* (c. 1525; Museé du Louvre, Paris) on the wall. When Rossiter left Paris for Rome in 1841, Kensett shared the studio with Champney and, subsequently in 1845, after receiving a small inheritance, traveled with him in Germany, Switzerland, and Italy. In Paris Kensett met John James Audubon (cats. 42 and

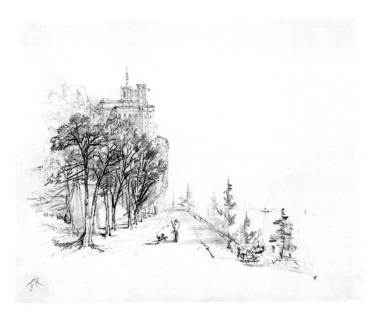

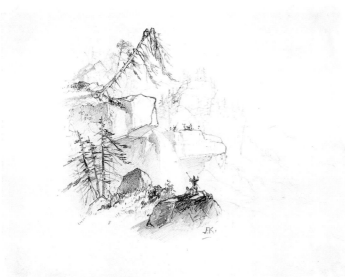

Fig. 88.1. John Frederick Kensett, *Sketch of Mountainous Scene with Castle (probably Rheinstein on the Rhine River)*; verso: magic act: woman levitating over furniture, c. 1845. Graphite on paper, 7 × 8 1/2 in. (178 × 216 mm), irregular. The New-York Historical Society, Gift of Mrs. William F. Bevan, 1956.73.1

Fig. 88.2. John Frederick Kensett, *Sketch of a Mountainous Landscape*, c. 1845–47. Graphite on paper, 6 3/4 × 8 1/2 in. (171 × 216 mm), irregular. The New-York Historical Society, Gift of Mrs. William F. Bevan, 1956.73.3

during the winter months, following the same calendar the subsequent year.

At first Kensett had supported himself partially by engraving and later by painting, cleverly selling his paintings through the American Art-Union and the NAD and establishing his reputation in New York while still in Europe. When he returned to America in the fall of 1847, he was immediately recognized as a gifted painter and was soon elected an associate (1848) and then an academician (1849) of the NAD, exhibiting there annually from 1847 until his death. His trip through New England with Durand and Casilear in 1848 began a lifelong practice of summer sketching excursions, primarily in the Northeast, and prompted his membership in the Sketch Club. Kensett, a bachelor, was also an active participant in the politics of art, serving as a member of the National Art Commission (1859, President James Buchanan's advisory council for the decoration of the Capitol in Washington, D.C.), chairman of the New York Sanitary Fair of 1864 (which raised funds for Union army medical services), and president of the charitable Artists' Fund Society (1865–70).

One of the most popular artists of his day, Kensett was also a very influential member of the second generation of the Hudson River School. His work as a painter of landscapes and coastal views demonstrates his skillful assimilation of the style and techniques of the Hudson River School and his eventual departure from it. In the 1850s Kensett had begun to explore his northeastern coastal views with the more reductive and refined aesthetic that would characterize his later work. His experimentation with the saturation and values of hues resulted in warm, shimmering effects of light, which permeate his finest compositions. His mature style shifted from the more conventional, anecdotal, picturesque modes of the Hudson River School to the quiet openness, light, and simplification of form, color, and composition that are associated with the somewhat controversial, more recently coined phenomenon termed Luminism. This new vision, for which Kensett is best remembered today, dominated the remainder of his career. His later, broad vistas across valleys and over expanses of serene water created distinct articulations of hour and mood, notably in his many views of the Shrewsbury River. *Marine off Big Rock* (1864;

43) and Cole, who became a good friend and may have influenced him to specialize in landscape. Living in the Latin Quarter and frequently dining with John Vanderlyn (cat. 31), Kensett soon became part of Vanderlyn's expatriate circle. Despite the disapproval of his uncle Daggett, who financed his travels, he lived the bohemian life of an art student, attended drawing classes (possibly at the Académie Suisse), and copied works in the Musée du Louvre. Returning to England for sketching tours in September 1841 and in 1843 (called back to oversee the disposal of his grandmother's estate), he executed his first landscape paintings based on sketches of the

Lake District and sent several to New York for exhibition at the Apollo Association. The woods around Windsor Castle became one of his favorite haunts, where he practiced his drawing skills, demonstrated a clear preference for landscape that he had developed in England and France, and carried on "a steady course of study from nature." In 1845 Kensett arrived in Rome, where he joined Rossiter and his group of friends and where his lifelong friendship with Thomas Hicks began, after Hicks had nursed him back to health from a serious illness. The group toured the Italian countryside and picturesque sites in southern Italy, such as Naples and Pompeii,

Cummer Art Gallery, Jacksonville, Fla.) is a mature example of Kensett's singular style in his departure from Hudson River School imagery. It contains a sense of balanced, geometric precision and a spareness that contrast with his earlier, more crowded pictures. *Sunset on the Sea* (1872; The Metropolitan Museum of Art, New York) typifies the final phase of Kensett's career, characterized by a distillation of forms and a rich evocation of hue that create a mood of intimate tranquillity, expressing spirituality. He spent his final years painting the Connecticut coastline on the Long Island Sound, most frequently in the area near his studio on Contentment Island near Darien.

On his later summer sketching excursions to gather material, Kensett made a number of trips to the American West, also visiting the Upper Mississippi and Missouri rivers. In 1870 he went to Colorado with Worthington Whittredge and Sanford Robinson Gifford (cat. 100). He also revisited Europe at least four times. Kensett's well-known selflessness led to his untimely death. After unsuccessfully attempting to save the wife of a friend, the artist Vincent Coyler, from drowning in Long Island Sound, he caught pneumonia and died of heart failure. Prolific and diligent, he left over six hundred paintings in his studio at the time of his death and was an indefatigable draftsman. He is buried in Green-Wood Cemetery in Brooklyn.

Kensett's ideas about color influenced Ogden Rood, whose book *Modern Chromatics* (1879) was significant in the development of late-nineteenth-century color theory, including that of the French Post-Impressionist Georges Seurat. Involved in the art community of his time, Kensett played prominent roles in the functions and affairs of the NAD, as a founding member of the prestigious Century Association in 1849 (formerly the Sketch Club), and as a founding member and trustee of the Metropolitan Museum of Art (1870).

Bibliography: John K. Howat, *John Frederick Kensett, 1816–1872*, exh. cat. (New York: American Federation of Arts, 1968); John Driscoll, *John Kensett: Drawings*, exh. cat. (University Park, Pa.: State University Museum of Art, 1978); Mark White Sullivan, "John F. Kensett, American Landscape Painter" (Ph.D. diss., Bryn Mawr College, 1981); John Driscoll and John K. Howat, *John F. Kensett: An American Master*, exh. cat. (Worcester, Mass.: Worcester Art Museum, in association with W. W. Norton & Company, 1985); Janice Simon, *Image of Contentment: John Frederick Kensett and the Connecticut Shore*, exh. cat. (Mattituck, N.Y.: Mattituck Museum, 2001); Melissa Geisler Trafton, "Critics, Collectors, and the Nineteenth-Century Taste for the Paintings of John Frederick Kensett" (Ph.D. diss., University of California, Berkeley, 2003); Dearinger 2004, 332–34.

88. *Moonlit Scene of Windsor Castle, England*, c. 1840–44

Black and brown ink and wash, watercolor, and scratching-out, with a touch of red gouache on heavy watercolor paper; 5 1/16 × 7 in. (128 × 177 mm)
Verso inscribed at center in graphite: *1013 | Windsor Castle | Moonlight | no. 2 | 10 x 12*
Provenance: Miss Polly Alloway, Goshen, N.Y.
Bibliography: *New-York Historical Society Quarterly* 32:1 (1948): 62; Koke 1982, 2:240, no. 1534, ill.
Gift of Mrs. William F. Bevan, 1947.419

The attribution of this rather unusual drawing derives from the lettering on its old mount, *J. F. Kensett*. The inscription on its verso also harmonizes with Kensett's inscriptions on the drawings he executed in England. From what is known about his early years in Europe and the few sketches that survive, the young engraver turned artist was absorbing many stimuli and experimenting with various techniques. During his first residency in London (from June to mid-August 1840), Kensett immediately embarked on campaigns to see all the paintings in that capital (at the British Institution, the National Gallery, the Dulwich Gallery, the Royal Academy, and in private collections) and to walk through the countryside near Windsor.[1] In his diary for 1841, Kensett wrote: "Thursday left this a.m. [illegible] 7 1/2 & passed through [illegible] beautiful town famed for its medicine Baths & having got a most imposing view of W. Castle." Later he records the cost for a "Visit to W. Castle."[2] Windsor Castle and moonlight scenes held a pronounced fascination for Kensett at this period, as four paintings of Windsor Castle and three moonlight landscapes are listed in the posthumous sale of his collection.[3] It may have been on one of these early English walks that he executed this small work, whose scratching-out betrays his training as an engraver and his youthful technical experimentation. Like his traveling companion and friend Durand, Kensett admired Claude Lorrain and John Constable, both of whose works are reflected in

this drawing's naturalism.[4] Its small size may be explained by Kensett's engagement at the time in engraving projects, including vignettes, for the firm of Jocelyn, Draper, Toppan & Company of Philadelphia.[5] Although in mid-August 1840 Kensett left for Paris with Rossiter, he returned to London several times for extended periods. This lovely nocturnal scene could date from any one of his English sojourns, including those in 1843 and 1844, when he lived with his uncle, John R. Kensett, at Hampton Court during the spring and summer, drawing in the English countryside, including around Windsor Castle.[6]

Of the pantheon of old masters Kensett had studied, Claude had made the strongest impression on him, as evidenced by this sheet.[7] His copy of Claude's *Seaport with the Landing of Cleopatra* (1642; Musée du Louvre, Paris) made about 1842 (private collection) has a composition nearly identical to that of the present sheet, including the placement of the bright light source.[8] However, the style of the present sheet is unusual for Kensett, who is known for his more linear graphite drawings, such as the vignettes he probably drew during his European travels in Switzerland, Germany, and Italy (figs. 88.1 and 88.2).[9] Even two of his drawings of Windsor Castle (one dated 16 July 1843) are executed in his more customary draftsmanship and medium.[10] Kensett's nocturne is actually closer to his English painting style, with its thick impasto, agitated brushwork, and gloomy palette, sometimes with traces of scumbling.[11]

In his later years, Kensett's memories of England were fond ones. His comments to the historian Henry T. Tuckerman reveal that his artistic self-confidence matured in the English environment, which he associated with Windsor: "My real life commenced there, in the study of the stately woods of Windsor, and the famous beeches of Burnham, and the lovely and fascinating landscape that surrounds them."[12] Kensett communicated similar sentiments in this youthful sheet, where his Claudian composition is infused with a Romantic moonlight worthy of Constable himself, and where the serenity and dramatic glow hint at later developments.[13]

1. Howat 1968, n.p. Evidence from Gifford's first European trip underlines the fact that Windsor Castle was de rigueur on the sketching itinerary for artists; see John F. Weir, *A Memorial Catalogue of the Paintings of Sanford Robinson Gifford*, exh. cat. (New

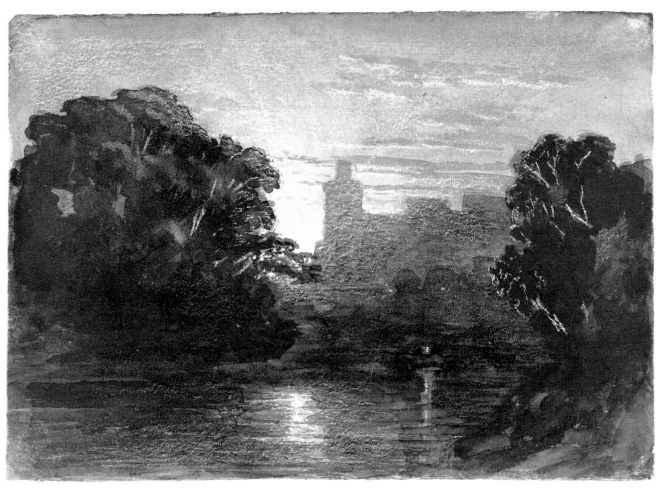

88

York: Metropolitan Museum of Art, 1881), 16, nos. 65 and 65, sketches of Windsor Castle from 1855–57; and Avery and Kelly 2003, 100–101, no. 4, ill., that records four different paintings of Windsor Castle and reproduces Gifford's sketch with a rainbow.

2. John Frederick Kensett Papers, owned by James R. Kellogg, grandnephew of the artist, microfilmed by the AAA, 1968, reel N68/85.

3. *The Collection of over Five Hundred Paintings and Studies by the Late John F. Kensett*, sale cat. (New York: Robert Somerville Auctioneer, 1873), nos. 273, 305, 363, 520, 575, 616, 623. Driscoll 1978, 28–31, notes and reproduces a handful of works depicting Windsor Castle and its park.

4. Sullivan 1981, 29–31. Howat 1968, n.p., relates that in 1843 Kensett was copying Claude's paintings in the Louvre. Driscoll and Howat 1985, 52, notes that Kensett was also influenced by J. M. W. Turner, and that he owned one painting each by Constable and Turner. He may have met Turner in the early 1840s and seen Constable's works in private collections.

5. Howat 1968, n.p. The AAA has the complete journal for 1840–41 in the Kensett Papers on microfilm reels N68/84 and N68/85, but almost nothing is legible on the microfilm.

6. Sullivan 1981, 10.

7. Driscoll and Howat 1985, 52.

8. Ibid., figs. 18 and 19. It was also at this time that Kensett fell under the influence of the uninspired English artist John Henry Boddington, who imitated Constable's simple compositions, heavy use of browns and greens, and thick, highly visible brushstrokes.

9. Both with provenances from Rossiter and signed with the artist's monogram; see Koke 1982, 2:238–39, nos. 1530 and 1532, as well as 1531, ills. The location of the former can now be identified as most likely the picturesque thirteenth-century Castle Rheinstein, 260 feet above the Rhine River, by comparison with Gifford's painting of 1872–73 in the Washington University Gallery of Art, St. Louis (Avery and Kelly 2003, 60, fig. 40). When Kensett left for Italy in 1845, he reportedly changed his style (ibid., 42).

10. For one in a private collection, see Driscoll and Howat 1985, 55, fig. 22 (Driscoll 1978, 28, no. 5, ill., identifies it as *Windsor Castle from the Park*, in the collection of Mrs. John D. Rockefeller). Another sheet with a view of Windsor Castle from a distance was with Babcock Galleries (ibid., 30, no. 7, ill.).

11. For a contemporary oil painting that is very close in style, *Outskirts of Windsor Forest* (Ira Spanierman Gallery, New York), which was exhibited at the NAD in 1845, see Howat 1968, no. 6, ill. For a second oil with a similar dark palette, *Glimpse of Windsor Castle* (Bernard & S. Dean Levy), see Driscoll 1978, 29, fig. 3.

12. Henry T. Tuckerman, *Book of the Artists: American Artist Life, Comprising Biographical and Critical Sketches of American Artists, Preceded by an Historical Account of the Rise and Progress of Art in America* (New York: G. P. Putnam & Son, 1867), 510.

13. Kensett was a Romantic, to the extent that he viewed nature as the embodiment of divinity; and he was a Transcendentalist, as he believed that people could perceive the holiness in creation. His faith in a tripartite union of God, nature, and humankind is symbolized by a small packet of flowers he picked at the tomb of Jean-Jacques Rousseau on 22 September 1847 and preserved for the rest of his life, as noted in Driscoll and Howat 1985, 55.

PHILIPPE-RÉGIS-DENIS DE KEREDERN, COMTE DE TROBRIAND

Château des Rochettes, Tours, France 1816–Bayport, New York 1897

Of all the Frenchmen who participated in the American Civil War, General Régis de Trobriand is undoubtedly the best known. He owes his celebrity not only to his qualities as a commander but also to his abilities as a writer. Even today, Americans consider his 1867 book, *Four Years of Campaigning with the Army of the Potomac*, one of the best eyewitness accounts of the war.

Artist, writer, and soldier, Philippe-Régis-Denis de Keredern de Trobriand was born in Sainte Radegonde near Tours at the Château des Rochettes. Progeny of a very old Breton family, he was made a page in the Bourbon court of Charles X of France and reared almost as a brother to the young prince Henry, the Comte de Chambord. Aristocratic Trobriand attended the military academy of St. Cyr, but when the House of Orléans superseded the Bourbons, his family fell into disfavor. At this time Trobriand expected to follow the example of his forebears by beginning a military career, but after the 1830 revolution his loyalist father refused to swear allegiance to the government of Louis-Philippe. The elder Trobriand even demanded that his son remove *Philippe* from his name out of hatred for the Orléans; thereafter he was known as Régis de Trobriand. By 1834 young Trobriand had graduated from the Université d'Orléans and four years later earned a *Licencie-en-droit* from the Université de Poiters, although he never practiced law. He was also left with a triangular scar above his heart from a duel he had fought. During his student years he wrote a novel, *Les Gentilhommes de l'Ouest*, which took an unpopular anti-Orléans stance. When his father died in 1841, Trobriand inherited the baronetcy and visited America for the first time. Spending one year in the principal cities of the United States and Canada, he took the grand tour of North America that had been popularized in the 1820s.

In New York City he composed schoolbooks and wrote another novel, *The Rebel*, about a French-speaking Canadian who resisted the English. With his education, title, and good looks he also enjoyed the status of a social lion. Two years later, about 1843, he married Mary Mason Jones, the daughter of the president of Chemical Bank. Soon thereafter the couple moved to Venice and joined the court of the exiled Comte de Chambord, spending three years in elegant surroundings, where Trobriand continued the study of painting that he had

begun during his military education. Initiating a peripatetic period, Trobriand returned to New York in 1847 and visited Niagara Falls at the request of *Illustration de Paris* to execute sketches for an illustrated article. At the death of his father-in-law Trobriand felt obliged to return to New York, where he became editor of the *Courrier des États-Unis*, the French newspaper that was once published by Joseph Bonaparte (brother of Napoleon I), writing music and drama reviews that provide an irreplaceable record of the artistic and intellectual life of New York during the era. After expressing an admiration for the American republic and its freedom, he became a naturalized United States citizen in 1861. With the outbreak of the Civil War, Trobriand commanded the French regiment known as the Gardes Lafayette in New York City, which became part of the Fifty-fifth Regiment, New York Militia, transferring a year later to New York's Thirty-eighth. When the war ended he held the rank of major general, having fought at Fredericksburg, Chancellorsville, and Gettysburg. The only other Frenchman to attain that rank in the American army was the Marquis de Lafayette, a volunteer during the American Revolutionary War.

In 1866 Trobriand was appointed colonel in the regular army and assigned to the Thirty-first Infantry. That year he returned to France and wrote *Quatre ans de campagne à l'Armée du Potomac*; the next year he was appointed to the command of the Thirteenth Infantry, policing the territory of Montana, where he was a diligent and thoughtful commander, if somewhat rigid and unimpressed by his fellow officers. Trobriand's Dakota journal was first published in 1926. The Indian people he encountered, including Sitting Bull, suffered the effects of disease and the destruction of their way of life, but he took a fairly hard-nosed view of their situation. For thirteen years he served in Dakota, Montana, Utah, Wyoming, and Louisiana. Four paintings and numerous sketches from this period, mostly scenes of the upper Missouri River (in the State Historical Society of North Dakota, Bismarck) make up the largest grouping of early paintings by a serious artist that remain in North Dakota, although George Catlin (cat. 50), Karl Bodmer, and John James Audubon (cats. 42 and 43) visited the area as well.

Having become a count in 1875, Trobriand

retired in 1879 and settled in New Orleans during the winter, where he devoted himself to painting, writing, and gardening. He spent summers visiting family, either in France or New York City. His oldest daughter, Marie-Caroline de Trobriand Post, published her father's unedited letters; they reveal him both as embodying the elegance and best traits of the old *haute noblesse* and as thoroughly American.

Bibliography: Régis de Trobriand, *Four Years with the Army of the Potomac*, trans. George K. Dauchy (1867; Boston: Ticknor and Company, 1889); Marie-Caroline de Trobriand Post, *The Life and Memoirs of Comte Régis de Trobriand, Major-General in the Army of the United States by His Daughter* (New York: E. P. Dutton & Company, 1910); Régis de Trobriand, *Military Life in Dakota: The Journal of Philippe Régis de Trobriand*, trans. and ed. Lucile M. Kane (St. Paul, Minn.: Alvord Memorial Commission, 1951); Albert Krebs, "Régis de Trobriand et *Le Courrier des États-Unis, Journal Français de New York* (1841–1865)," *Revue d'histoire moderne et contemporaine* 18 (1971): 574–88; Régis de Trobriand, *Our Noble Blood: The Civil War Letters of Major-General U.S.V.*, ed. William B. Styple (Kearny, N.J.: Belle Grove, 1997).

89. *View of Puentes Grandes with the Villa Diago, Near Havana, Cuba*, 1849

Watercolor, gouache, and graphite on ivory watercolor paper; 6 15/16 × 11 9/16 in. (176 × 294 mm)
Inscribed and dated at lower left in brown ink: *Puentes-grandes / Havana 1849*
Provenance: Descent through the artist's family; Waldron Kintzing Post, New York.
Bibliography: Koke 1982, 3:197, no. 2621.
Gift of Waldron Kintzing Post, grandson of the artist, 1950.206

One of three drawings in the Society's collection depicting views of Puentes Grandes, a town that in the nineteenth century was near Havana, Cuba,[1] this watercolor belongs to a larger group of thirty-one works by Trobriand in the Society's collection, including two sketchbooks, all of which descended directly through the artist's family. Another sheet of the trio is inscribed with the name of the large building depicted in the center of this view, the Villa Diago. This smaller drawing, which the artist probably sketched in situ, is the preparatory study for the central buildings in catalogue 89, although aspects of its landscape vary. Its inscriptions suggest that Trobriand may have entertained the idea of publishing a series of works illustrating his travels or planned to write an illustrated

89

article on them.[2] Supporting this conclusion are the inscriptions on the third sheet, a watercolor that features a view of the town of Puentes Grandes.[3] The three contain depictions of the locale the artist visited when traveling in the company of Baron Alphonse de Rothschild during the winter of 1848 and spring of 1849. In December 1848 the pair started for Cuba by way of Charleston, South Carolina, where they spent New Year's Day 1849. They then took a ship for the Antilles, spending two months in the islands before sailing for New Orleans.

The watercolor belongs to the artist's most productive artistic period. In her book about her father, Marie-Caroline de Trobriand Post writes: "The period of my father's life from 1847 and 1861 may be designated as the literary and artistic one, for apart from his writing, he devoted much time to music and painting."[4] The work successfully conveys the humid tropical atmosphere and climate of Cuba as well as its distinctive architecture. It also reveals

Trobriand's knowledge of artistic traditions and command of the watercolor medium and suggests that he had been trained as a military draftsman in an age when drawing, valued for its role in processing knowledge and in sharpening perception, was part of the military curriculum.

1. Today Puentes Grandes is incorporated into greater Havana.
2. Inv. no. 1950.416, in graphite on beige paper, 6 1/2 × 9 5/8 in., inscribed below the image in graphite: *La villa Diago, prise de la route de la Havana.* / *III*; at the upper left: *3 article* / *n°. 4.* See Koke 1982, 3:197, no. 2622.
3. Inv. no. 1950.205, in watercolor and graphite on ivory watercolor paper, 7 7/16 × 14 11/16 in., inscribed at the lower left in graphite: *Le village de Puentes-Grandes.* / *III*; at the upper left: *3 article* / *n°. 3.* See ibid., 197, no. 2620.
4. Post 1910, 226.

RUFUS ALEXANDER GRIDER

Lititz, Pennsylvania 1817–Canajoharie, New York 1900

Rufus Alexander Grider was born to parents of Swiss descent. He attended John Beck's School for Boys in Lititz, where his artistic ability became evident despite his lack of formal training. As a young man he held various positions while pursuing his artistic interests in his free time. From a very young age Grider practiced drawing and studied local history with intense devotion, often seeking crumbling historic structures to preserve in his sketches. Between 1864 and 1882 he was a shopkeeper and an insurance agent, owned the Sun Inn in Bethlehem, Pennsylvania, and played flute and oboe for the Bethlehem Philharmonic. In 1883 Grider settled in Canajoharie, in New York's historic Mohawk Valley, where he taught drawing at the Union Free School and worked as a curator at Fort Rensselaer until 1898.

From 1886 to 1897 Grider spent his vacations visiting historic sites in New York and New England to sketch aging structures or ruins and to record significant objects, including powder horns. This passionate interest in local history and his desire to preserve information on vanishing colonial and Revolutionary sites inspired his creation of this singular collection of drawings of powder horns, which was donated to the N-YHS in 1907. The Grider collection of over 450 watercolors reproduce the detailed and often faint images engraved on these early implements. When Grider drew them, many of the horns were in private collections and relatively inaccessible. He frequently made his depictions more complete by "unfurling" the engraving to show the entire conical surface as a single flat image or by including both front and rear views of the horns. Most sheets also feature vignettes of historical sites including forts, battlefields, monuments, and homes, as well as portraits of important military figures.

Grider delighted in extensively inscribing many of the sheets with the names of the original and contemporary owners of the horns, anecdotal local history, short biographies of significant figures, and accounts of military events. He reconstructed long-vanished structures and historic sites, meticulously researching the original architectural and landscape details. He frequently consulted eighteenth-century sketches and prints as well as written descriptions from newspapers, manuscripts, and family archives to provide authenticity. Before his death in 1900, Grider also produced nine sketchbooks featuring historic structures together with an unlocated collection of 105 drawings of Iroquois masks (the original masks were destroyed in a fire at the New York State Museum in 1911). These sketchbooks, containing more than nine hundred drawings, tracings, and watercolors, are housed in the New York State Library in Albany. The Grider collection furnishes a folk-art record that helps provide a comprehensive reconstruction of the colonial period in New York.

Bibliography: Thomas A. Dickinson, "Rufus Alexander Grider," *Proceedings of the Worcester Society of Antiquity* 17 (January 1900): 110–13; Rufus A. Grider, "Powder Horns, Their History and Use," ed. A. J. Wall, *New-York Historical Society Quarterly* 15:1 (1931): 3–24; R. W. G. Vail, "The Grider Collection of Schoharie Valley Pictorial History," *Schoharie County Historical Society Quarterly* 7 (January 1944): 8–16; Ray Byrne, "Art Teacher Left Legacy of History," *Schenectady Union-Star*, 19 June 1963, 7; Koke 1982, 2:76–78; Roderic H. Blackburn and Ruth Piwonka, *Remembrance of Patria: Dutch Arts and Culture in Colonial America, 1609–1776*, exh. cat. (New York: Produced by the Publishing Center for Cultural Resources for the Albany Institute of History and Art, 1988), 143–45.

90. *Powder Horn: William Starling (FW-212), with Carving Unfurled to Show a Plan of Fort Niagara, New York*, 1897

Watercolor, brown and black ink and wash, gouache, graphite, and gold, copper, silver, and blue metallic pigment, with selective glazing, on beige paper; 12 3/4 × 15 1/2 in. (324 × 394 mm)
Signed, inscribed, and dated at lower center below horn in black ink: *Rufus A. Grider Canajoharie N.Y. 1897.*; inscribed below in brown ink: *This HORN celebrates the great victory / gained by Sir Wᵐ Johnson in 1759 by taking Forts / NIAGARA & that 4 miles beyond, ONTARIO. the force / consisted mostly of provincials.*; at upper right: *The Wᵐ STARLING. / this fine French War horn is / now owned at Tribes Hill N.Y. / by Clarence P. Vrooman*; verso annotation notes that this horn was donated to the N-YHS, inv. no. 1947.91.
Bibliography: Charles E. Baker, "The William Starling Powder Horn and the Niagara Campaign of 1759," *New-York Historical Society Quarterly* 32:2 (1948): 88–103; Koke 1982, 2:76–78, no. 1116, ill.
Gift of Isaac J. Greenwood, 1907.36.185

The Grider collection of powder horn drawings consists of 453 sheets donated in 1907 by Isaac Greenwood.[1] During the several centuries in which flintlock muskets and pistols were the predominant firearms, the basic design and function of powder horns remained constant. Typically made of cow horn or occasionally stag antler or gourd, powder horns provided a relatively moisture-tight, spark-proof, durable vessel with a narrow spout ideal for pouring gunpowder neatly into a gun barrel. The smooth, cream-colored surfaces of the horns, like blank canvases, seemed to invite personalization and decoration both by the owners, mostly soldiers, sportsmen, and hunters, and by professional engravers.[2]

The drawings, including several sheets displaying multiple powder horns, depict the engraving on 534 American and foreign horns made predominantly in the eighteenth and early nineteenth centuries; several older European horns and some powder flasks are also included.[3] Grider combined watercolor techniques with fine ink and graphite lines, gouache, and glazing to convey the intricacy of the carved and often dyed images, adding unusual sparkling metallic pigments in gold, copper, bronze, silver, blue, and green to reproduce metal ornamentation and woven metallic cords.

The William Starling powder horn (fig. 90.1), donated to the N-YHS in 1947, was in a private collection at the time Grider drew it in 1897. He depicted this horn with the carving near the spout unfurled to display a detailed plan of Fort Niagara on Lake Ontario, with important features marked by letters that correspond to a key engraved near the butt of the horn. Fort Ontario on the Oswego River is also shown, as well as a river marked *ISTE Rvr*, which can only be the Niagara River.[4] A comparison of this drawing and the engraving on the Starling powder horn reveals Grider's exacting precision in faithfully reproducing the complex detail of the incised designs.

A. M.

1. The collection also includes three sheets containing mounted photographs of European ivory horns.
2. Blackburn and Piwonka 1988, 144.
3. See Koke 1982, 2:76–77; see also Stephen V. Grancsay, *American Engraved Powder Horns: A Study Based on the H. J. Grenville Gilbert Collection* (New York: Metropolitan Museum of Art, 1946), 1–10; and John S. du Mont, *American Engraved Powder Horns: The Golden Age, 1755–1783* (Canaan, N.H.: Phoenix Publishing, 1978), 3–13.
4. William P. Munger, *Historical Atlas of New York State* (Phoenix, N.Y.: Frank E. Richards, 1941), 85, 147.

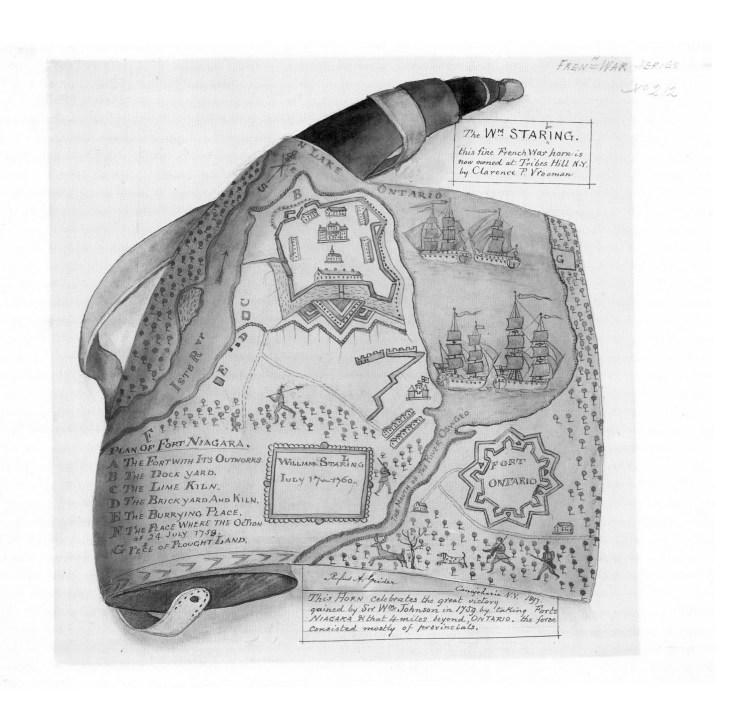

The Wm STARING.

this fine French War horn is
now owned at Tribes Hill N.Y.
by Clarence P. Vrooman

ONTARIO LAKE

B

ONTARIO

G

ISTER vr

PLAN OF FORT NIAGARA.
A THE FORT WITH ITS OUTWORKS.
B THE DOCK YARD.
C THE LIME KILN.
D THE BRICK YARD AND KILN.
E THE BURRYING PLACE.
F THE PLACE WHERE THE ACTION
OF 24 JULY 1759.
G PECE OF PLOUGHT LAND.

WILLIAM L STARING
JULY 17ᵗʰ 1760.

THE MOUTH OF THE RIVER OSWGEO

FORT
ONTARIO

Rufus A. Grider Canajoharie N.Y. 1897.

This HORN celebrates the great victory
gained by Sir Wm. Johnson in 1759 by taking Forts
NIAGARA & that 4 miles beyond, ONTARIO. the force
consisted mostly of provincials.

90

Fig. 90.1. Powder horn of William Starling, c. 1760. Animal horn, wood, and metal, 12 1/8 × 3 1/4 × 3 1/2 in. (308 × 83 × 89 mm). The New-York Historical Society, Gift of George A. Zabriskie, 1947.91

INDIAN

5

R. Grider Jan 4 1890

The BLACK HAWK.

now owned by M^{rs} HELEN BEARDSLEE at EAST CREEK Station Herkimer C^o, N.Y.
BlackHawk took sides with the British in the war of 1812 — his residence was in ILLINOIS — in 1832 the U.S. made war with him, took him prisoner, brought him East a Captive & Exhibited him. He died in Captivity this fine PowderHorn he bequeathed to the Soldier who attended him during his last illness. The Artist ALONZO PEASE of Utica N.Y. obt the horn from the Soldier & M^{rs} B.from the Artist. The horn is from a Buffalo — the STRAP is of Deerskin cov^d with scarlet Army Cloth & ornamented with Beads & by female Indians.

neg. 34245

91

Rufus Alexander Grider

91. *Powder Horn: The Black Hawk (I-5), with Ornamented Strap*, 1890

Black ink and wash, gouache, watercolor, graphite, and gold metallic pigment with selective glazing; 11 3/4 × 14 3/4 in. (298 × 375 mm), irregular
Signed and dated at middle left below horn in brown ink: *RA. Grider June 4th 1890.*; inscribed at lower right: *The BLACK HAWK, / now owned by Mᵣˢ HELEN BEARDSLEE / at EAST CREEK Station Herkimer Cº N.Y. / Black Hawk took sides with the Britʰ in the war of / 1812–his residence was in ILLINOIS– in / 1832 the U.S. made war with him, took / him prisoner, brought him East a Captive / & Exhibited him. He died in Captivity / this fine Powder Horn he bequeathed to the / Soldier who attended him during his last / illness. The Artist ALONZO*

PEASE of Utica N.Y. / obtᵈ the horn from the Soldier & Mᵣ B. from the / Artist. The horn is from a Buffalo–the STRAP / is of Deerskin covᵈ with Scarlet Army Cloth & orna- / mented with Beads & by female Indians.; verso has mounted letter from former owner of horn
Gift of Isaac J. Greenwood, 1907.36.389

This drawing depicts a Sauk Indian powder horn and ornamented strap once owned by Chief Black Hawk. The work demonstrates Grider's technical experimentation intended to convey authentic texture and color; for example, he applied gouache in three-dimensional dots to simulate the glass beading on the Native American crafted strap. It is representative of the more than 20 horns Grider illustrated that were decorated and used by indigenous North Americans of various tribes, including the Zuni, Apache, Eskimo, Sioux, Ute, and Onondaga. Images of powder horns carried by American soldiers during the French and Indian and the Revolutionary Wars, totaling more than 370, dominate the collection. Other sheets illustrate soldier's horns used during the War of 1812, the Mexican War, and on the western frontier. The collection also includes drawings of nearly 40 hunting and sporting horns and 60 illustrations of powder horns and flasks made in Europe, Asia, Africa, and South America, as well as Grider's 27-page manuscript listing these watercolors.

A. M.

WILLIAM RICKARBY MILLER

Staindrop, County Durham, England 1818–Bronx?, New York 1893

Known principally as a painter of landscape and architecture, although he also worked as an illustrator, William Rickarby Miller is especially appreciated for his watercolors. He was one of the most prolific watercolorists in America during the mid–nineteenth century before the founding of the American Society of Painters in Water Colors in 1866. Although he painted in many of the same locations as the Hudson River School artists, he is not considered part of that group, which strove for dramatic, poetic effects. By contrast, his work is more intimate and narrative in content. Born in northeast England and reared in a Quaker household that taught the values of hard work, simplicity, and morality, young Miller was probably trained by his father, an animal and landscape painter who also ran a stationery shop. Early sketches like those on the North Tyne River (fig. 92.1) near Hadrian's Wall, Staindrop, and Durham testify to his education at art school in Newcastle. Miller's experience of the English countryside was more extensive than his provincial roots would imply, as his drawings reveal that he traveled to various locations including London and Yorkshire. The freedom of technique seen in figure 92.1 demonstrates his technical grounding in the English watercolor tradition (like that of the Norwich School and John Sell Cotman) and resembles the watercolors of Samuel Palmer. Miller also may have been familiar with the picturesque engraved scenes on Staffordshire transferware produced solely for the American market, some derived from *The Hudson River Portfolio* (cat. 48) and copies of American landscapes.

Long captivated by stories of American life and Native Americans, Miller immigrated to the United States in the fall of 1844 or early 1845, accompanied by a sister and two brothers who settled in Maumee City, Ohio. Miller first lived in Buffalo, New York, but within three years had moved permanently to New York City. In 1846 he wrote "My Rules and Plans of Life" (Department of Manuscripts, The N-YHS), which shows the strong influence of Alexander Campbell, one of the founders of the Disciples of Christ, a congregation that maintained a belief in independent, individual worship. Although his journals are suffused with a Calvinist belief in predestination, his writings attest that he approached art as a means to produce realistic views rather than expound a theoretical or philosophical belief. After some difficulty launching his career, he received several commissions for watercolors through the American Art-Union, at a time when watercolors were scarcely appreciated on this side of the Atlantic. Miller continued to sell through the Art-Union until it ceased operation in 1852. He was a careful and conscientious delineator of landscape, and although he never abandoned landscape painting, he was frequently forced to take up portraiture or illustration to earn a living. One such period began in 1853 and marked a significant rise in his popularity.

That same year he made his debut at the NAD, first exhibiting a drawing, *Ravine at Sing Sing*, then in the collection of John William Hill (cats. 76 and 77). Miller continued exhibiting there until 1876, during the period of his most brilliant and successful watercolors. In 1853 he also completed his first book illustration assignment with steel engravings for G. P. Putnam and Company's *Homes of American Authors*, featuring the homes of Ralph Waldo Emerson and Washington Irving. Beginning in 1853 illustrated weeklies—such as *Gleason's* (later *Ballou's*) *Pictorial Drawing-Room Companion*, *Putnam's Monthly Magazine*, and *Frank Leslie's Illustrated Newspaper*—also began to carry his woodcut designs. Among other things he copied for them were landscape paintings by the Hudson River School artists Jasper Francis Cropsey (cats. 98 and 99) and Asher B. Durand (cats. 51–54). When magazine assignments seemed to slack off toward the end of the 1860s, Miller considered relinquishing his career and

joining M. Knoedler Company (formerly Goupil). However, through the patronage of Henry W. Gear (an artists' supplier), George M. Wing (an agent), and John L. Chambers (a secretary), Miller was able to resume painting on commission, albeit remaining in a precarious financial position.

In his later years Miller occasionally produced oil paintings but was predominantly preoccupied after 1873 with what he called "A Thousand Gems" of American landscapes, which remained unpublished. He envisioned them as ensuring him a place in the constellation of great artists. Later signing some of them "Miller-Corot," an allusion to the French artist Jean-Baptiste-Camille Corot who died in 1875, Miller identified with the Barbizon painter's lyricism and the pastoral mood of his works. Many of Miller's preliminary drawings for "A Thousand Gems" are in the Society's collections (seventy-eight are inscribed thusly); they relate to his later work in oil.

Miller was a disciplined worker and prolific painter who produced hundreds of watercolors and pen and ink sketches. His works show a sensitivity to tonal values rather than color, a result of his copying prints. He was a great admirer of Renaissance Venetian painters and sought through experimentation with media to discover their lost methods. However, his latent conservatism prevented him from achieving their breadth and their layering of colored glazes. Although he worked primarily in watercolor, Miller seems to have participated in the annual exhibitions of the American Society of Painters in Water Colors only once, in 1881, an odd occurrence during the heyday of the medium in America (c. 1878–82). At this time people considered watercolor a distinct art form—a taste partly fostered by Miller's work—that rivaled oil painting. Later in the century, artists tended to execute watercolors in wide brushstrokes, while Miller's works remained more tightly painted and traditionally composed. Nevertheless, Miller's work constitutes an important stylistic bridge between the generation succeeding him—that of William Trost Richards (cat. 109), Thomas Moran, and Winslow Homer—and the older topographic tradition.

His life had a tragic ending. Miller's rigidity, moralizing nature, and misanthropy led to an estrangement from his wife, a devotee of Swedenborgianism, and his children in 1867. Afterward, the artist led a secluded life, devoting his time to traveling, learning languages, writing music (he was an accomplished guitarist), plays, and poetry, and sketching rural scenes. It is believed that he died on one such excursion to the Bronx during July 1893.

Fig. 92.1. William Rickarby Miller, *High Fall, Hareshaw Linn, England*; verso: sketch of Trout Fall, 1839. Graphite, watercolor, and gouache on gray paper; graphite, 15 × 10 1/2 in. (381 × 267 mm). The New-York Historical Society, James B. Wilbur Fund, 1955.134

Three substantial gifts to the Society of works in various media and documents have rescued William Rickarby Miller from oblivion. In 1947 George A. Zabriskie presented to the Society 114 drawings, woodcuts, engravings, and oil paintings. Subsequently, Mrs. Grace Miller Carlock and Mrs. Margaret Peters, granddaughters of the artist, together with other family members donated papers as well as works of art. Since those significant gifts, the Society has both received others and purchased works by Miller to swell the museum's holdings to 199 (11 oils and 188 drawings). The documentary materials, including his diary, birth certificate, poetry, and a notebook, are in the Department of Manuscripts, while many prints are in the DPPAC. With this additional information, Miller emerges as a much more versatile artist and a fascinating personality, whose oeuvre deserves further study.

Bibliography: Grace Miller Carlock, "William Rickarby Miller," *New-York Historical Society Quarterly* 31:4 (1947): 199–209; Donald Shelley, "Addendum: William R. Miller," *New-York Historical Society Quarterly* 31:4 (1947): 210–11; Donald Shelley, "William R. Miller: Forgotten 19th Century Artist," *American Collector* 16 (1947): 16, 23; Koke 1982, 2:342–77; Alexandra Corbin, "William Rickarby Miller," *Art & Antiques* 6:3 (1983): 64–71; Myers 1987, 165–66.

92. *Self-Portrait (1818–1893) Sketching in the Woods*, 1848

Watercolor, gouache, white lead pigment, black and brown ink, and selective glazing over graphite on paper, laid on card; 5 1/4 × 3 1/4 in. (133 × 82 mm)
Signed, inscribed, and dated at lower right in brown ink: *WR. Miller / Weehawken NJ. 1848.*
Provenance: George A. Zabriskie , New York.
Bibliography: Shelley, *American Collector*, 1947, 16, 23, ill.; N-YHS 1974, 2:539, no. 1413, ill.; Corbin 1983, 64, ill.
Gift of George A. Zabriskie, 1947.356

This tiny early self-portrait, made only a few years after Miller's arrival in America, shows the artist seated in the woods with a sketch pad on his lap. Painted in broad, swift strokes in the open air, its spontaneously rendered surface emphasizes the dappled light as it filters through the trees, falling on the forest floor and bathing the artist's figure. Painted in a bold plein air manner that anticipates French Impressionism, its technique is still linked to the English watercolor tradition. The amazing transparency

92

of Miller's broad strokes of pigment show him at the height of his powers. Here, as in figure 92.1, Miller combined graphite and transparent watercolor in a distinctive manner, with a great deal of the paper left in reserve. Unlike his predecessors, who generally obscured all traces of preliminary drawing, Miller capitalized on his underdrawing, especially in the foliage, making it an essential element of the composition and allowing it to remain visible through the broad washes of transparent color.[1] The white paper, somewhat unusual for Miller, here provides a highly keyed luminosity that adds to the bleaching-out effect of the sunlight.[2] (In the 1850s Miller's watercolor technique became more highly finished and his colors more brilliant, as in catalogue 93.) Miller may have used a mirror to record this image infused with such great

immediacy. The artist portrays himself focusing on an object, and his recording of such specific light effects argues that he probably used this common artistic device. That conclusion is predicated on the artist being left-handed, a hypothesis supported in the backward slant of his inscriptions and signatures.

A letter in the Society's Department of Manuscripts from Miller to his sister in England (dated 10 February 1848) reveals his difficulties as a struggling, unrecognized artist when he executed this intimate work. He tells her that he was working for the American Art-Union and was enjoying much about his adopted country: "Many things in America I like exceedingly, its climate is so superior to home, its chances of doing better, etc [but] a bachelor's life is in America of all lives the most miserable." Miller probably was

happiest when he was outdoors, alone with his sketch pad and the beauties of nature.[3]

Although Miller worked during the same period and in the same geographic area as the painters of the Hudson River School, and even copied their works for reproduction, he did not count himself among them. Whereas they tended toward grander views of the majestic countryside, Miller focused on intimate subjects, frequently with narrative elements.[4] Nonetheless, he shared with his contemporaries Romantic notions of the picturesque and the mysterious workings of nature.

1. Shelley 2002, 58–59, which also points out that in the nineteenth century graphite also became the customary medium for the underdrawing in watercolor compositions. Previously, the technique was similar to that of the topographic tradition, that

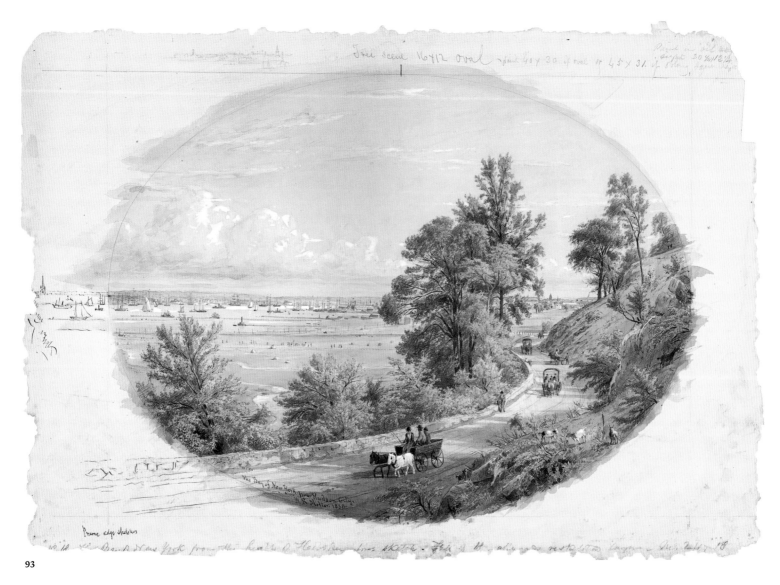

93

is, tinted drawings consisting of ink outlines filled in with watercolor.

2. Ibid. Shelley notes that Miller frequently worked on colored paper, usually one with a green tonality, an English practice, although English artists tended to favor blue paper. The colored papers produced a subdued hue overall and, when areas were left unpainted in reserve, created small touches of color in the work.

3. Corbin 1983, 65.

4. Ibid.

William Rickarby Miller

93. *The Bay of New York from Hudson City, New Jersey*, 1858

Watercolor, gouache, graphite, and black ink on paper; 15 × 20 3/8 in. (381 × 518 mm), irregular

Inscribed, signed, and dated at lower left in brown watercolor: *The Bay of New York. from Hudson City / W. R. Miller. 1858.*; many annotations outside image
Provenance: Robert Carlen, Philadelphia, 1966.
Bibliography: Stebbins 1976, 153–54, fig. 119; Koke 1982, 2:355–57, no. 1890, ill.
Abbott-Lenox Fund, 1966.3

The New Jersey shore of the Hudson River between Jersey City and Hoboken was a quiet sylvan setting in 1858, when Miller sat down above the public road on the rocky hillside and sketched this view of the Hudson River with New York Harbor. New York City appears at the extreme left, and in the center and right distance is the thriving, small metropolis of Jersey City, which the artist called in his inscription *Hudson City*. Today this area is covered with wharves and

industrial development. In 1880 Miller painted a larger rectangular version of the same view, *Bay of New York from the Heights of Hoboken*, that now is in a private collection.[1] Miller's panoramic view presents an orderly, sunny landscape in which the figures and nature are in harmony below a sky filled with cumulus clouds.

Even after years in the United States, Miller remained true to his British training and the early-nineteenth-century English watercolor tradition. His later meticulous approach incorporated wet- and dry-brush techniques, with gouache highlights, over his ever-insistent graphite lines that establish form and structure. During the 1850s the artist's style resembled the contemporary watercolors that William Turner of Oxford was executing in England. Miller's

preference for accurately recording sites in sunlight, without interpretation or allegory, was probably a function of his obsessive personality rather than a barometer of the times, when most artists used mood and atmosphere to make landscapes more expressive.[2]

In his later style, Miller's English traits are combined with a naturalism akin to that found in contemporaneous paintings by Durand, president of the NAD between 1845 and 1861. Miller was surely conversant with the work of Durand and the Hudson River School painters, for he not only lived in New York and exhibited at the American Art-Union and the NAD but also copied paintings by Durand and Cropsey for reproduction in *Frank Leslie's Illustrated Newspaper* and worked briefly with Jervis McEntee in the Catskills.[3] The inscription on Miller's self-portrait (cat. 92) identifying its site as Weehawken indicates that the artist worked in close proximity to Durand, who often sketched in the 1840s and early 1850s in Hoboken, just south of Weehawken on the south bank of the Hudson, very near where, in fact, this watercolor was executed. Despite all the geographic, iconographic, and contextual links between the two, Miller seems to have socialized little with other artists, and his style developed relatively independently. True to Miller's inclinations, this watercolor is more picturesque than topographic and is concerned with communicating the beauty of the place and sunshine rather than capturing atmospheric effects. Thus, Miller's feathery strokes eloquently define a general, bucolic world that appears undisturbed by social or personal tensions.

1. Measuring 25 × 37 in., it was with Hirschl & Adler Galleries in 1979; see Corbin 1983, 66, ill.
2. Miller did, however, occasionally execute drawings and watercolors of moonlit and sunset/twilight scenes that are tranquil and pastoral.
3. Corbin 1983, 67; and Avery et al. 2002, 216.

THOMAS PRITCHARD ROSSITER

New Haven, Connecticut 1818–Cold Spring, New York 1871

A prolific artist who produced over five hundred historical genre paintings, portraits, and landscapes, Thomas Pritchard Rossiter (fig. 94.1) is primarily remembered as a minor figure of the Hudson River School. During his lifetime, however, he was an important and pivotal figure in the national and expatriate artistic circles of his time, both in New York City and Europe.

Rossiter first worked with his uncle, a sign painter. In 1836 he was studying with the engraver and portraitist Nathaniel Jocelyn, and by the age of twenty he had set up his own portrait studio in New Haven. After exhibiting at the NAD in 1837 and at the Apollo Association in 1839, he came to the attention of the president of the NAD, Samuel F. B. Morse, and moved to New York City in 1839. In June of the following year, when he became an associate of the NAD, Rossiter accompanied John Frederick Kensett (cat. 88), Asher B. Durand (cats. 51–54), and John Casilear on a European tour. After a brief stay in London, the young artists arrived in Paris, where he and Kensett studied at the École Préparation des Beaux-Arts and possibly at the Académie Suisse. Rossiter's painting *A Studio Reception, Paris* (1841; Institute of History and Art, Albany, N.Y.) documents the atelier Rossiter shared with Kensett and preserves the interaction of the American artists abroad. It contains portraits of Rossiter at the easel, Durand, and Thomas Cole (cats. 61 and 62), among others, and a

Fig. 94.1. Asher Brown Durand, *Thomas Pritchard Rossiter (1818–1871)*, 1840. Charcoal on brown paper, 8 1/8 × 9 in. (206 × 229 mm). The New-York Historical Society, Gift of Mrs. William F. Bevan, granddaughter of the sitter, 1956.71

copy of Titian's *Entombment* (c. 1525; Musée du Louvre, Paris) on the wall. In the fall of 1841 Rossiter crossed the Alps with Cole and settled in Italy. Remaining there for five years, he became the hub of a circle of expatriate American artists wintering in Rome who associated at the famous Caffè Greco and who also stayed in Florence during the summers while on extended sketching trips through Italy, Germany, and Switzerland.

Reestablishing himself in New York in 1846, Rossiter was elected an academician of the NAD and the following year became a founding member of the Century Association. By 1851 he was sharing a studio with fellow artists Kensett, Casilear, and Louis Lang and had turned to painting large historical and biblical canvases,

94

although he continued receiving numerous portrait commissions. From 1852 to 1853 he served as a visiting lecturer at the NAD. Shortly after his marriage in 1853 to Anna E. Parmly, he returned to Europe for a second time, first spending two years in Paris, where he exhibited at the Exposition Universelle of 1855 (winning three gold medals) and established a studio on the Place Vendôme. After the death of his wife in 1856, Rossiter returned to New York and opened an art gallery in his home off Fifth Avenue, which was designed for the combined purposes by Richard Morris Hunt. During the 1850s and 1860s the artist spent most of his energy creating two series of figurative paintings, one devoted to the

life of George Washington (including *Washington and Lafayette at Mount Vernon*, 1859; The Metropolitan Museum of Art, New York) and the other to the life of Christ. These and earlier figurative scenes, all of which appealed to popular American taste, toured the country, bringing Rossiter substantial fame and fortune. In 1858 he was among a group of New York artists who were invited to take an "artists' excursion" on the Baltimore and Ohio Railroad. Traveling from Baltimore into Virginia, the artists found new material for landscapes along the route. The following year, Rossiter expanded his landscape repertoire and traveled west, visiting the Great Lakes, Michigan, and Minnesota. After his second

marriage, Rossiter returned to a house he had designed in Cold Spring Harbor, New York, where he worked until his death.

Bibliography: Edith Rossiter Bevan, "Thomas Pritchard Rossiter," typescript, Ruston, Md., 1957 (Department of Manuscripts, The N-YHS); Ilene Susan Fort, "High Art and the American Experience: The Career of Thomas Pritchard Rossiter" (M.A. thesis, Queens College, New York, 1975); Weinberg 1991, 26; Dearinger 2004, 481–82.

94. *"View Opposite My Balcony" (Lungarno Corsini with the Ponte Santa Trìnita), Florence, Italy,* 1842

Graphite on paper; 8 3/4 × 11 5/8 in. (222 × 295 mm)

Inscribed and dated at lower right in graphite: *casa nobile / View opposite my balcony Florence / Sept. 1842*; at lower center: *Palace of the King of Holland*; various color annotations at upper right
Provenance: Descent through the artist's family.
Bibliography: Koke 1982, 3:111–12, no. 2424, ill.
Gift of Mrs. William F. Bevan, granddaughter of the artist, 1956.72

One of six drawings and a sketchbook by Rossiter in the collection, this work from the artist's first European sojourn shows a view across the Arno River from his lodgings on the Oltrarno (the side of the river across from the center of town). Rossiter had arrived in Florence from Rome on 19 June 1842. Shortly thereafter he befriended James Deveaux, a South Carolina portrait painter, and George Loring Brown, the landscape painter; the young artists met alternately in each other's rooms once a week to sketch. In 1844 Rossiter wrote in a letter: "I was fortunate in procuring rooms on the Arno, with a large balcony overhanging the river, and here, during the long summer twilights and balmy evenings, it was his [Deveaux's] delight to come and converse upon art and the associations with Florence, and the poetry of existence in such a land."[1]

The artist's inscriptions reference only two of the palazzi along the Lungarno Corsini to the left of the Ponte Santa Trinita (at the far right) visible from his balcony, suggesting he was intoxicated by the atmosphere and charm of the city rather than its fabled history. The drawing indicates that his lodgings were located across the Arno River on the Lungarno Guicciardini. Beyond the Ponte Santa Trinita at the far right Rossiter has depicted the grandiose Palazzo Spini-Feroni, one of the largest Florentine medieval private palaces, begun in 1289. To the left of this bridge are various other palazzi, including two palaces of the Gianfigliazzi family (one with a trecento tower)—in which Louis Bonaparte, ex-king of Holland, lived for a time—that line the Lungarno Corsini, its embankments built up to protect the city from periodic flooding.

1. Letter written in memory of his friend John Deveaux, quoted in Koke 1982, 3:112.

JOSEPH TUBBY
Tottenham, England 1821–Quonochontanaug, Rhode Island 1896

Born in a town that is now part of North London, Joseph Tubby immigrated with his Quaker family to New York City in 1832. Young Tubby began his artistic training while employed by his father, a building contractor in Kingston, New York, painting houses and signs and stenciling designs on interior walls. Primarily an autodidact, he may have had some instructions from a local portraitist, identified only by his surname, Black, who painted Tubby's portrait. Although Tubby's only academic training consisted of the copies he made after paintings by old masters, he began painting landscapes and working in the Hudson River School tradition.

The artist's professional career as a painter began in 1851, when he started exhibiting at the NAD in New York City, continuing through 1860 and again in 1884. He also showed works at the Pennsylvania Academy of the Fine Arts in Philadelphia. Tubby began sharing a studio in New York with the artist Jervis McEntee, who lived near Kingston, and the two artists took walking and sketching tours together in the Catskill and Adirondack mountains, beginning with a two-month trip in the summer of 1851. For most of his career Tubby worked in and around Kingston, painting hundreds of landscapes commissioned by friends and neighbors. During the 1860s he moved to Montclair, New Jersey, then an exciting art center. By the end of the nineteenth century, Montclair was the most important art colony in New Jersey, as artists sought rural retreats farther away from the large communities near New York undergoing urbanization. There he became friends with the painter George Inness, who influenced Tubby's more painterly and dramatic later landscapes. During the last seven years of his life, the artist taught in both Brooklyn and Montclair.

Tubby and his oeuvre still await a thorough scholarly investigation. His papers, two account books, and four sketchbooks are held by the AAA, donated in 1956–58 by Gertrude O. Tubby, his daughter, who also donated to the Society four other works in oil and a sketchbook and to the Smith College Museum of Art, Northampton, Massachusetts, four paintings. The Senate House Museum in Kingston, New York, also holds four oils by the artist. Since much of Tubby's work was commissioned, the lion's share remains in private collections.

Bibliography: Cowdrey 1943, 1:167; Senate House Museum, *Exhibition of Paintings by Joseph Tubby*, exh. pamphlet (Kingston, N.Y.: Senate House Museum, 1953); William H. Gerdts, *Painting and Sculpture in New Jersey* (Princeton: Van Nostrand, 1964), 156, 165, 188; Naylor 1973, 1075; Koke 1982, 3:202–3; William H. Gerdts, *Art across America* (New York: Abbeville Press, 1990), 1:172, 243; Falk 1999, 3:334.

95. *Early Fall Scene in the Catskills, New York*; verso: oval vignette with fall scene in the Catskills, c. 1860–88

Oil with varnish on card; oil on textured paper, laid on card; 9 7/8 × 15 1/8 in. (251 × 384 mm), irregular
Signed at lower right in blue oil paint: *Joseph Tubby*; verso of card support signed at lower right in blue oil paint: *Joseph Tubby*; inscribed above in graphite: *July 15*[?]
Provenance: Descent through the artist's family; Gertrude O. Tubby, Montclair, N.J.
Bibliography: Koke 1982, 3:203, no. 2643.
Gift of Gertrude O. Tubby, daughter of the artist, 1951.353

Both sides of the work's card support contain plein air oil sketches of landscapes, whose locations, according to the information passed down through Tubby's family, are in the Catskills. Not far from Kingston, this area was one of the artist's favorite sketching haunts and the site of several works featured in the 1953–54 exhibition of the artist's work at the Senate House Museum in Kingston.[1] Tubby painted the late summer or early fall scene directly on the recto of the card,[2] while he executed on paper the

95

brilliant autumn landscape that is laid on the verso of the card support.

Tubby specialized in fall scenes alive with a brilliant autumnal palette, as proven by assorted notices of his exhibited works. A case in point is *Autumn in the Catskills*, lent to the 1953–54 exhibition of his work by Mrs. John N. Cordts.[3] Whereas in Europe, Romantic painters rarely depicted autumn foliage, Thomas Cole (cats. 61 and 62) and Jasper Francis Cropsey (cats. 98 and 99), especially, made it a leitmotif in their works, so that fall scenes became a hallmark of American painting.[4] Already by 1860 Tubby had exhibited an autumnal scene at the NAD.[5]

Due to the absence of any firmly established stylistic chronology for the artist's oeuvre, it is difficult to assign a specific date to either of these studies. However, the breadth of the freshly executed study on the recto and the palette of the

work on the verso reveal the presence of George Inness, who was highly influential on Tubby's later oeuvre, arguing for a date late in his career.[6] The *non-finito* quality of the recto adds to its feeling of spontaneity and directness.

1. Senate House Museum 1953, nos. 2–5, 15. The Smith College Museum of Art, Northampton, Mass., also owns a canvas from c. 1880, *Kaaterskill Mountains near Kingston, N.Y.* (inv. no. 1951.264). The oval format of the sketch on the verso was one Tubby used frequently, as in two works in the Senate House Museum, Kingston (inv. nos. 1976.1102A, *Shipyards at Rondout*; and 1976.1103A, *View of Rondout Creek*). Many thanks to Dean Preston for supplying the 1953 catalogue.

2. Koke 1982, 3:203, no. 2643, entitled it "Fall Scene in the Catskills, N.Y."

3. Senate House Museum 1953, no. 3. Another example in oil on canvas is *Autumn Foliage, Summit, New Jersey* (inv. no. 1951.262 in the the Smith College Museum of Art).

4. Andrew Wilton, "The Sublime in the Old World and the New," in Wilton and Barringer 2002, 25.

5. Cowdrey 1943, 2:167, no. 382. In 1860 Tubby still listed his address as Rondout, New York, in Ulster County, which was also one of his favorite places to paint.

6. In its collections the Society has by the artist three other oil sketches, one oil on canvas painting, and a sketchbook (1887–89)—inv. nos. 1951.351, 1951.352, 1951.349, and 1959.740, all with the same provenance from the artist's daughter; see Koke 1982, 3:202–3, nos. 2638–42.

RALPH GORE

England, active 1821–?

The initials *R.G.* inscribed on the Society's sweeping panorama discussed below have been linked to a British army officer named Ralph Gore. According to British army lists, Gore served in the Thirty-third Regiment of Foot (infantry) from 1809 to 1821, and then is recorded as a lieutenant colonel on half pay and as a storekeeper, Ordinance Establishment, Quebec, in 1824. He is listed as a lieutenant in 1809 and a captain in 1814 and received a medal for his performance in the Battle of Waterloo (1815). The Thirty-third Regiment of Foot served in America during the Revolutionary War (1776–81) and in Canada at various times until 1848. The highly technical rendering of this demanding view suggests that the artist was trained as a military draftsman in the English topographic tradition of Paul Sandby (see below).

Bibliography: *Old Print Shop Portfolio* 1:7 (1952): 156–57; Mary Allodi, *Canadian Water-colours and Drawings in the Royal Ontario Museum* (Toronto: Royal Ontario Museum, 1974), 1: nos. 785–87; Koke 1982, 2:69–70.

96. *The Falls of Niagara from the Upper Balcony of Brown's Hotel, Ontario, Canada*, 1821

Watercolor and brown ink over graphite on ivory paper; 15 13/16 × 39 1/2 in. (402 × 1004 mm)
Inscribed, signed, and dated at lower center outside image in brown ink: *The Falls of Niagara from the upper Balcony of Brown's Hotel R.G. 27th September 1821 / This representation should, according to Rule, be divided into two Pictures as it comprises full 120 Degrees of the Circle; but I have left them undivided to shew the immense body of water which precipitates itself over the Fall.;* inscribed at lower left outside image: *Yards / Breadth by edge of Falls 1200 / Ditto straight line 960 / Breadth … the Islands 1950;* at lower right outside image: *Feet Inches / Perpendicular height of horse shoe Fall 156 " 6 / Dº of American Fall (opposite) 162 " 6 / Perpendicular from Rapids to edge of Fall 57 " / From foot of Falls to Queens town 7 Miles below 101 ";* verso inscribed at center in graphite: *by Ralph Gore / Collection of Hon. Lady Curzon Howe / Clifton Castle, Ripon, Yorks.*
Provenance: Lady Mary Anna Curzon-Howe, Clifton Castle, Ripon, Yorkshire, England; Frank T. Sabin Gallery, London, England, 1951;[2] Old Print Shop, New York, 1952.
Bibliography: *Old Print Shop Portfolio* 11:7 (March 1952): 156–57, fig. 11; Albright-Knox Art Gallery, *Three Centuries of Niagara Falls*, exh. cat. (Buffalo, N.Y.: Albright-Knox Gallery, 1964), no. 83, ill.; Koke 1982, 2:69–70, no. 1103, ill.; McKinsey 1985, 72, 295 n. 23.
Foster-Jarvis Fund, 1952.285

The style and format of the watercolor strongly suggest that Gore was aware of military draftsmen who specialized in topographic drawings, a tradition from which many of the early landscapes of North America arise. At the Royal Military Academy at Woolwich, topographic drawing was an integral part of an officer's education, whose curriculum also included map making and the use of watercolor. A key figure in this tradition was the influential British watercolorist Paul Sandby, who had been trained in surveying and was a founding member of the Royal Academy of Arts (1768). He had been appointed chief drawing master at Woolwich in 1768, and his son Thomas Paul succeeded him when he retired in 1797.[3] Gore's style seems a coarser version of Sandby's highly refined technique, even while his compositions resemble Sandby's panoramic views of military installations and later civilian English landscapes.[4]

Like Thomas Davies in his sweeping views of Niagara Falls (cat. 8 and essay fig. 6), Gore responded uniquely to the challenge presented by the spectacular scene.[5] His notations of precise statistics and his emphasis on objective observation of this breathtaking natural phenomenon, as opposed to more picturesque details, are evidence of his military background. The black ink framing lines and Gore's lettering along the sheet's lower border, together with the legend, suggest that he may have either intended to have the work engraved or copied this format from contemporary prints.

Most likely Gore executed three other drawings of Niagara Falls that are in the Royal Ontario Museum, Toronto, one of which also bears the initials *R.G.* and includes a view of Brown's Hotel (noted in the inscription on the Society's drawing).[6] None of the trio, all taken from different vantage points, is as panoramic in scope and as large as the Society's sheet, although the watercolor with a rainbow arching over the American Falls is taken from the identical position as the Society's horizontal watercolor. However, it is narrower and lacks the distant views of the Niagara River below the cataract to the left of the American Falls and above the cataract to the right of the Canadian Falls, the latter of which occupies nearly half of the Society's watercolor's composition. The Toronto drawings represent more focused studies of Gore's ambitious work celebrating this sublime stop on the American grand tour. The artist recognized the drawing's singularity in his inscribed comments (see above).

A seemingly endless number of artists and printmakers produced views of Niagara Falls after the first known image by Europeans appeared in 1697, an engraving illustrating Father Louis Hennepin's popular travel book *Nouvelle Découverte d'un très grand pays Situé dans l'Amérique.* One of the earliest views of this American icon is by Davies, drawn during an exploratory tour of the Lake Ontario shoreline in 1760–61 and known only in an engraving by Ignace Fougeron. It shows the two cataracts from a similar vantage point as taken by Gore but without his panoramic approach. In his composition Davies solved the most obstinate dilemma endemic to the scene: how to represent the site in its entirety while capturing the uplifting nature of its sublimity.[7] Before Gore several artists had attempted a different panoramic approach with a vantage point at the river's edge below the cataracts, notably Edmund Hemm in his watercolor *A View of Niagara Falls* (1799), and Bonfils in his engraving *Vue d'une partie des deux Branches de la Cataracte de Niagara* (1801).[8] In the first decade of the nineteenth century, John Vanderlyn (cat. 31) and John Trumbull captured the grandeur of Niagara in panoramic views that did not stress the curve of the horseshoe shape of the Canadian falls. In the same year that Gore drew his view, Thomas Hanford Wentworth published a less elongated version of the same composition as Gore employed (*A General View of the River, Rapids, and Falls of Niagara* in his *Views of Niagara*).[9] Other artists—among them an unidentified British artist, Alexander Wilson, Vanderlyn, Alvan Fisher, and George Catlin (cat. 50)—produced panoramic views of Niagara Falls, but none with the point of view and the wide horizontal format used by Gore.[10] All these attempts were doomed from the beginning, for no topographically accurate flat view could ever evoke the cataracts' power and grandeur. They would simply be too distant and removed to capture the scale, the roaring sound, and engulfing mists of the raw phenomenon.

The natural wonder, with its eastern America Falls separated by Goat Island from its western Canadian Horseshoe Falls, presented a ready-made panorama, and its theatrical potential did not go unnoticed. While promoters and stuntmen transformed the cataracts into a theatrical event, Philip de Loutherbourg in London had included

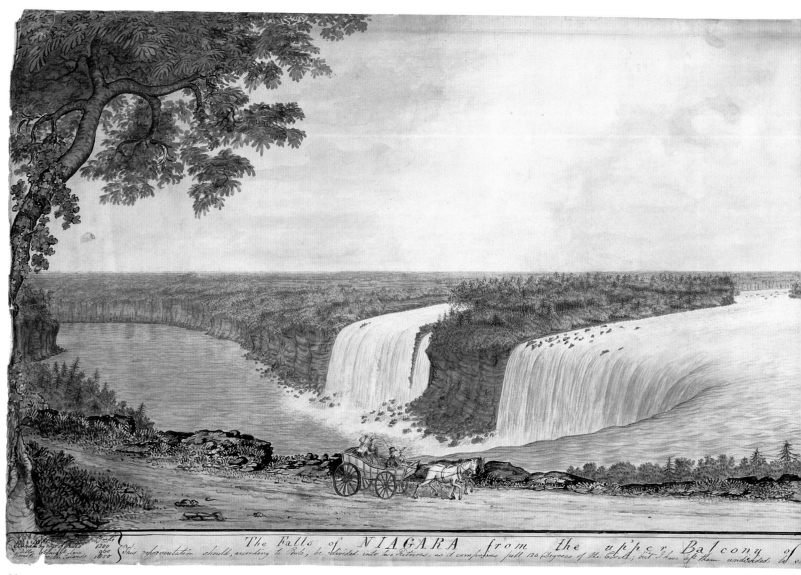

The Falls of NIAGARA from the upper Balcony of...

already in 1781 a scene of the falls in his famous Eidophusikon, a series of theatrical tableaux accompanied by innovative sound and light effects. The most successful public entertainment to feature Niagara was the commercial panorama spectacle. As the genre reached its peak in America during the 1820s and 1830s, several panoramas depicted Niagara, although only one is preserved in a detailed verbal account by Robert Burford with a visual engraved key after drawings by him taken in 1832.[11] The lost cyclorama was painted by Burford and toured the United States beginning in 1834 after its 1833 showing in London. Others, including moving versions best suited to portray its wonders, followed later in the century, presaging the cinema.[12]

As early as 1820, the year before Gore made his watercolor, Niagara Falls had ceased to be a pristine spectacular natural phenomenon;

instead, it became a fixture observed by tourists, as in Gore's watercolor.[13] In fact, in his inscriptions on the Society's watercolor and on one of the three watercolors in Toronto, Gore refers to "Brown's Hotel," on whose upper balcony he executed the panorama discussed in this entry. Its real name was the Ontario House Tavern where Adam (or John?) Brown was for many years the proprietor; it was located two miles south of Queenston, Ontario, on the west side of Portage Road, a short distance from its rival, the Pavilion House. During the Rebellion of 1837–38 it was converted into a barracks, and in 1859 it was torn down. An early guidebook describes this hotel as "a large white building, with colonnades in front, about one-fourth of a mile above the Falls of Niagara."[14] The hotel's balcony afforded Gore an almost bird's-eye vista from the Canadian side of Niagara Falls to the

American side and up the Niagara River above the cataract. He included a horse-drawn carriage, two tourists on horseback pointing out the view, and a hunter in the foreground near the edge of the precipice; these elements quietly increase the awe and frisson engendered by this sublime location while underlining its nature as a tourist destination. By far the most important idea that nineteenth-century visitors brought to Niagara Falls was the paradigm for the emotional experience of the sublime. Edmund Burke's *A Philosophical Enquiry into the Origin of Our Ideas of the Sublime and Beautiful* (1756) was, in effect, the first guidebook of the falls; as Sears surmises, "it provided a prescription for the emotions that grand objects were supposed to evoke."[15] Gore's tourists serve as a prelude to the mass tourism and marketing that engulfed the site later in the nineteenth century.

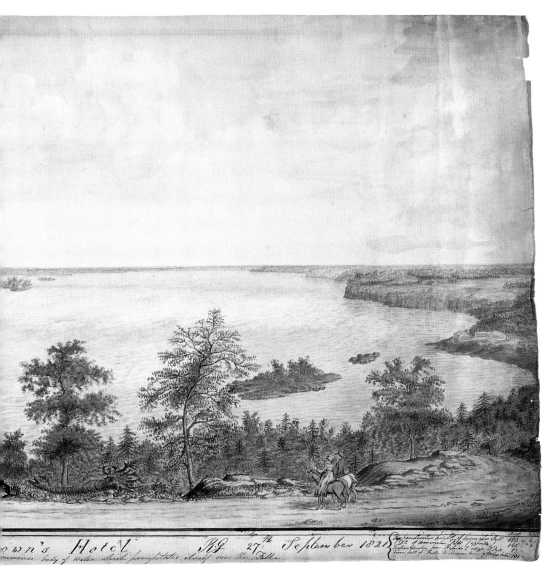

9. Ibid., 295 n. 23.

10. Ibid., figs. 30, 29, 27, 51, 34, respectively. See also the picturesque pair by Trumbull (1808) in the N-YHS (Adamson et al. 1985, figs. 16 and 17). For representations of Niagara Falls, see also Lane 1993.

11. Lane 1993, 151–52, fig. 63. For the pamphlet by Robert Burford, *Description of a View of the Falls of Niagara, Now Exhibiting at the Panorama … .* (London: T. Burrell, 1833), see Adamson et al. 1985, 157, no. 184. The Society's library has a copy of the London pamphlet, as well as one published in New York (without a date, c. 1834 or 1835?) and another in Boston (1837). In New York the panorama was displayed on Broadway at the corner of Prince and Mercer streets.

12. For panoramas in general, see Oetterman 1997; for those of Niagara Falls, see 140 (London, 1880s, by Paul Philippoteaux); 335 (Boston, 1849, by William Burr); 340, where Oetterman writes: "Not surprisingly, Niagara Falls became one of the most popular topics. S. P. Brewer, William Burr, Joseph W. Ingraham, and Regis de Trobriand [cat. 89] showed a *Physiorama* with twenty different views of the falls 'in full motion!'" According to J. E. Arrington, the longest, most popular, and best moving panorama on the subject, first shown in New York in 1853, was by Gottfried Nikolaus Tracht, a German immigrant who Americanized his name as "Godfrey Nicholas Frankenstein." See also Joseph Earl Arrington, "Godfrey N. Frankenstein's Moving Panorama of Niagara Falls," *New York History* 49 (April 1968): 169–99. Oetterman 1997, 341–43, also discusses Burr's "Moving Mirror of the Great Lakes, the Niagara, St. Lawrence and Saguenay Rivers," which opened in New York in 1849.

13. John F. Sears, "Doing Niagara Falls in the Nineteenth Century," in Adamson et al. 1985, 103. A decade later, the intrepid Frances Trollope visited the site and was uncharacteristically bowled over. She wrote: "As for me, I can only say that the wonder, terror, and delight completely overwhelmed me. I wept with a strange mixture of pleasure and of pain, and certainly was, for some time, too violently affected in the *physique* to be capable of much pleasure; but when this emotion of the senses subsided, and I had recovered some degree of composure, my enjoyment was very great indeed. To say I was not disappointed is but a weak expression to convey the surprise and astonishment which this long dreamed of scene produced. It has to me something beyond its vastness; there is a shadowy mystery hangs about it which neither the eye nor even the imagination can penetrate." *Domestic Manners of the Americans* (London: Whittaker, Treacher, & Co.; New York: Reprinted for the booksellers, 1832), 303.

14. John William Orr, *Pictorial Guide to the Falls of Niagara: A Manual for Visitors* (Buffalo, N.Y.: Press of Salisbury and Clapp, 1842), 63. See also Greenhill and Mahoney 1969.

15. Sears 1985, 103.

1. Lady Mary Anna Curzon-Howe (1848–1929) was the daughter of Anne Gore (d. 1877) and Richard William Curzon, Earl Howe (1796–1870), who succeeded his paternal grandfather as Viscount Curzon in 1820 and was created Earl Howe in 1821. Koke did not mention the possible relation between the artist and the former owner, Lady Mary Anna Curzon-Howe. Ralph Gore may have been the uncle of Lady Curzon-Howe or some other close relation, and that fact is an important part of the work's provenance. Thanks to Alexandra Mazzitelli for making these genealogical connections.

2. Suggested by Mary Allodi in a letter of 5 July 1977, as the Royal Ontario Museum, Toronto, acquired its three watercolors by Gore (see n. 6 below) depicting Niagara Falls in 1951 from that dealer.

3. For Paul Sandby, see Johnson Ball, *Paul and Thomas Sandby, Royal Academicians: An Anglo-Danish Saga of Art, Love and War in Georgian London* (Cheddar, Somerset: Charles Skilton, 1985); Yale Center for British Art, *The Art of Paul Sandby*, exh. cat. (New Haven: Yale Center for British Art, 1985); and Luke Herrmann, *Paul and Thomas Sandby*, exh. cat. (London: B. T. Batsford, in association with the Victoria and Albert Museum, 1986).

4. See Yale Center for British Art 1985, figs. 16, 17, 18a, 19, for the military installation views, and figs. 20, 23, 24, and 77, for other landscapes. For an early panorama across Zeeland by Paul's brother, Thomas Sandby, dated 1748, see Herrmann 1986, fig. 2.

5. For Niagara Falls, see also the work by William James Bennett (cat. 41); Ralph Greenhill and Thomas D. Mahoney, *Niagara* (Toronto: University of Toronto Press, 1969); Adamson et al. 1985; and McKinsey 1985.

6. Allodi 1974, 1: nos. 785, ill., 786, 787. They are, respectively, inv. no. 951.67.10, 14 11/16 × 22 in., inscribed at lower right: *R.G. Oct.ʳ. 1821*; at lower center: *The Falls of Niagara from the American side, with a view of Brown's Hotel & the old Indian ladder now improved into a cover'd staircase*; inv. no. 951.67.11, 13 1/2 × 21 1/8 in., a view with a rainbow; and inv. no. 951.67.12, 14 7/8 × 21 1/4 in.

7. Adamson et al. 1985, 19, fig. 5.

8. McKinsey 1985, 72–73, figs. 32 and 33.

FELIX O. C. DARLEY

Philadelphia, Pennsylvania 1822–Claymont, Delaware 1888

The illustrator Felix Octavius Carr Darley first apprenticed to a business house in Philadelphia at the age of fourteen. His brother-in-law, the fashionable portraitist Thomas Sully (cat. 40), probably inspired his interest in the visual arts. Darley taught himself to draw in his spare time and was influenced by the Neoclassical style of the English illustrator and sculptor John Flaxman, whose spartan, linear etchings made a permanent impression on the youth. Darley began his meteoric career in 1842, when some of his drawings of street scenes were published in *The Saturday Museum*. Following a sketch-

ing trip west of the Mississippi, he produced outline drawings for lithographic reproduction in the very successful *Scenes in Indian Life* (1843). His early book illustrations began to appear the same year in such periodicals as *Godey's Lady's Book* and the *Democratic Review*. Sketches for John Frost's *Pictorial History of the United States* (1844) were Darley's first major success.

After moving to New York City in 1848 to be nearer his publishers, Darley dominated the field of American illustration with his visualizations of works by writers such as Washington Irving and James Fenimore Cooper. Immedi-

ately after he moved to New York, the directors of the American Art-Union hired him to design a series of lithographs for a proposed edition of Washington Irving's "Rip Van Winkle." A copy of the *Illustrations of Rip Van Winkle* was distributed as a premium to every member of the Art-Union (20,000 copies were planned). Darley completed the sixth and final lithograph in late 1848 or 1849. The work was so popular with both the reviewers and Art-Union members that in 1849 the directors hired Darley to execute a set of six lithographs for Irving's "The Legend of Sleepy Hollow." These two series made

97

Darley's reputation. A prolific and sometimes facile draftsman, he drew illustrations for hundreds of titles, contributed regularly to *Appleton's* and *Harper's* magazines, and also drew banknote vignettes during a highly successful career that spanned four decades. So great was his fame in his lifetime that many books were advertised as "illustrated by Darley." A draftsman, not a printmaker, he usually drew in graphite or graphite and wash, and his designs were usually engraved by reproductive printmakers on wood or steel or transferred to a lithographic stone by others.

Perhaps the best-known American illustrator of the nineteenth century, Darley was made an honorary member of the NAD in 1851 and was elected an academician the following year. He also belonged to both the American Society of Painters in Water Colors and the Artists' Fund Society of New York. He frequently exhibited at the Pennsylvania Academy of the Fine Arts in Philadelphia and the NAD. Darley married in 1859 and settled in Claymont, Delaware, twenty miles south of Philadelphia, where in the studio at his estate, The Wren's Nest, he produced many of his illustrations.

In response to the new nation's need for self-definition, Darley's influential work helped to establish American character types, especially through his nearly five hundred illustrations for Cooper's novels and a similar number for Benson J. Lossing's *Our Country* (1875–77). Moreover, he illustrated the writings of Charles Dickens, Henry Wadsworth Longfellow, Nathaniel Hawthorne, Edgar Allan Poe, and William Shakespeare, among other authors. As a gauge of his popularity, his works appeared in every American periodical of importance. Influenced by various European artists throughout his life—like the Romantic painter and printmaker Eugène Delacroix—Darley's images find a parallel in the oeuvre of Bartolomeo Pinelli, an Italian artist one generation older who, unlike Darley, was also a prolific printmaker. Needless to say, Darley's work exerted a strong influence on his generation of American illustrators. Although Darley used photography as a reproductive tool, photographs exerted no obvious stylistic impact on his oeuvre.

Bibliography: Frank Weitenkampf, "Illustrated by Darley," *International Studio* 80:443 (1925): 445–49; idem, "F. O. C. Darley, American Illustrator," *Art Quarterly* 10:2 (1947): 110–13; Theodore Bolton, "The Book Illustrations of Felix Octavius Carr Darley," *Proceedings of the American Antiquarian Society* 61:1 (1951): 136–82; Ethel King, *Darley the Most Popular Illustrator of His Time* (Brooklyn: Theo. Gaus' Sons, 1964); John C. Ewers, "Not Quite Redmen: The Plains Indian Illustrations of Felix O. C. Darley," *American Art Journal* 3:2 (1971): 88–98; Sue W. Reed, "F. O. C. Darley's Outline Illustrations," in *The American Illustrated Book in the Nineteenth Century*, ed. Gerald W. R. Ward (Winterthur, Del.: Henry Francis du Pont Winterthur Museum, 1987), 113–35; Nancy Finlay, *Inventing the American Past: The Art of F. O. C. Darley*, exh. cat. (New York: New York Public Library, 1999).

97. *"The Return of Rip Van Winkle": Study for Plate V in "Illustrations of Rip Van Winkle,"* c. 1848

Graphite on paper, squared for transfer; 10 9/16 × 14 3/4 in. (268 × 374 mm), irregular
Inscribed at upper right in graphite: Nº 5.
Watermark: T ROBESON / PHILL
Provenance: Mrs. Nelson K. Benton, New York.
Bibliography: Koke 1982, 1:242–43, no. 426, ill.
Gift of Mrs. Nelson K. Benton, 1949.107

Darley's line drawing is the preparatory work for one of six lithographs published in 1849 by the American Art-Union in *Illustrations of Rip Van Winkle, Designed and Etched by Felix O. C. Darley, for the Members of the American Art-Union.*[1] Squared for transfer, the drawing is almost identical to the print in size and composition.[2] In this scene Rip Van Winkle returns home after twenty summers of sleep. His house lies in ruins, and, tragically, even his old, half-starved dog Wolf, a symbol of fidelity, does not recognize him.[3] The success of Darley's images, together with those for Irving's other famous short story, "The Legend of Sleepy Hollow," made him one of the most popular illustrators of his day.

Like all of Darley's mature works, the *Illustrations of Rip Van Winkle* are line drawings with very little shading. Of the six, reviewers were most impressed with the one for which the Society's drawing is a study. The reviewer in the *Literary World* wrote:

> There is something of that sincerity of the Puritan in Mr. Darley's composition which we inherit from the gloomy earnestness of our English sires, and which is the strength of the American character. Look at the tragic figure of Rip Van Winkle … as he returns to his dilapidated roof and broken threshold, and gazes on the dog, which looked like his old companion, but unlike that friend, "snarled, showed his teeth, and passed on." The attitude, the accessories, the weeds and thistles keeping guard over the desolation, the sadly wondering tragic countenance, are not in the letter of the story, but a grandeur borrowed from the artist's genius.[4]

A smaller, more complete watercolor of the composition with minor changes is in the collection of Historic Hudson Valley, Tarrytown, New York.[5] Darley's illustrations enjoyed such popularity that his Rip Van Winkle plates were redrawn and issued again as lithographs in 1974 by an artist who incorporated color into the reworked originals.[6]

1. Two copies of the illustrations, one published in 1848 and the other in 1849, are in the Society's library. The lithograph is inscribed at the lower center: *Darley inven.ᵗ et sculp.ᵗ*; at lower right: *Printed by Sarony & Major, New York*; at upper right, outside image: *No. 5*. For the series, see Bolton 1951, 155; and Finlay 1999, 40, no. 21.

2. For the lithograph, see Avery and Kelly 2003, 138, fig. 84; also cited by Finlay 1999, 40, no. 25.

3. For another treatment of the subject and background, see Christopher Kent Wilson, "John Quidor's *The Return of Rip Van Winkle* at the National Gallery of Art: The Interpretation of an American Myth," *American Art Journal* 19:4 (1987): 21–45.

4. *Literary World* 3 (11 November 1848): 812, as quoted in Myers 1987, 125.

5. See Myers 1987, 34, pl. 9 ("Rip's Return"), 124, for reference to two watercolor and black ink drawings, of a set of six, related to Darley's *Illustrations of Rip Van Winkle* in the collection of Historic Hudson Valley, Tarrytown, N.Y. Myers states they may be copies by Darley after his completion of the commission. See also Myers 1990, 1:xii, no. 24, pl. 24.

6. These offset lithographs of designs by Darley were redrawn and colored by Fritz Kredel for Washington Irving, *Rip Van Winkle and The Legend of Sleepy Hollow* (Tarrytown, N.Y.: Sleepy Hollow Restorations, 1974); see Finlay 1999, 40.

JASPER FRANCIS CROPSEY

Near Rossville, Staten Island, New York 1823–Hastings-on-Hudson, New York 1900

Called "America's painter of autumn," Jasper Cropsey was one of the best known of the second generation of Hudson River School painters. Born on a Staten Island farm, Cropsey's early training was in architecture, and he spent five years apprenticed to the architectural firm of Joseph Trench in New York City (1837–42). He began to paint in his spare time, encouraged by William T. Ranney, Henry Inman (cat. 64), and William Sidney Mount (cat. 70). Trench hired the English painter Edward Maury to give the young architect watercolor lessons. When he left Trench's office, Cropsey continued to support himself with architectural commissions in his own firm, while beginning to exhibit at the NAD in 1843. That same year he began devoting himself to painting full time, and the following year he was elected an associate of the NAD.

From 1847 to 1849 he went abroad on a Grand Tour of Europe with his new wife, Maria Cooley, first visiting England's Lake District and Scotland, then Paris, Switzerland, and finally Italy. While in Rome Cropsey worked in the same studio in the Via del Babuino that Thomas Cole (cats. 61 and 62), his artistic mentor, had occupied.

On his return to the United States, Cropsey set to work producing paintings from the sketches he had made in Europe. He soon turned to American scenery, spending his winters in New York City and his summers at Greenwood Lake, New Jersey (his favorite spot for communing with nature), the White Mountains of New Hampshire, and the Hudson River valley. After achieving success as a painter, Cropsey was elected an academician of the NAD in 1851. While his early landscapes were heavily influenced—in both painterly technique and allegorical content—by Cole, Cropsey began to emphasize nature over moral content by stressing seasonal change. Although he adopted Cole's methods, he forged them into a personal style that would endure throughout his career. In addition to Cole and J. M. W. Turner, he clearly admired Asher B. Durand (cats. 51–54). Cropsey's essay "Up among the Clouds," published in the *Crayon* in August 1855, clearly emulates Durand's "Letters on Landscape Painting" that had been published in the same journal earlier that year.

After selling the contents of his studio, Cropsey and his wife sailed for England in 1856 and settled in London, where his landscape

paintings were appreciated, and he exhibited regularly at the Royal Academy of Arts. In 1860 his canvas *Autumn on the Hudson* was exhibited and won accolades from the critics, several of whom noted its similarities to the work of the Pre-Raphaelites. Cropsey enjoyed an outstanding success in England, and his services to Queen Victoria as an American commissioner for the London Exposition of 1862 earned him a medal. He became a celebrity and counted among his influential friends the critic John Ruskin, the polymath Sir Charles Eastlake, president of the Royal Academy, and the American painter Daniel Huntington (cat. 87).

Cropsey returned to the United States in 1863, during the height of the Civil War. He subsequently painted a few studies of soldiers in action, and his landscapes began to reflect a growing concern with light and characteristics later associated with a debated and recently identified movement termed "Luminism." Although the pictorial vision of America as a new and bountiful Eden tended to fade after the Civil War, Cropsey continued to paint in that vein, specializing in autumnal scenes. In the mid-1860s his renewed interest in architecture prompted him to design a number of private houses, including Aladdin, his grand residence in Warwick, New York, that he was forced to sell in 1884 when his painting career became less lucrative. Among his executed architectural projects were the Sixth Avenue Elevated Station in New York City. Cropsey's loosely painted, casual rustic scenes of the 1880s betray an interest in the French Barbizon painters. A founder of the American Society for Painters in Water Colors (later the American Watercolor Society) in 1866, in later years Cropsey was an active practitioner of that medium. In 1885 the Cropseys moved to Hastings-on-Hudson, where the artist duplicated his Aladdin studio and worked until his death on idealized American landscapes in the manner of the Hudson River School, long after the demand for them had evaporated. Today his last home is occupied by the Newington-Cropsey Foundation, a public museum maintained by his descendants.

Bibliography: Peter Bermingham, *Jasper F. Cropsey, 1823–1900: A Retrospective View of America's Painter of Autumn*, exh. cat. (College Park: University of Maryland Art Gallery, 1968); William S. Talbot, *Jasper F. Cropsey, 1823–1900*, exh. cat. (Washington, D.C.: Smithsonian Institution Press, 1970); idem, *Jasper F. Cropsey, 1823–1900* (New York: Garland Publishing, 1977); Kenneth W. Maddox, *An Unprejudiced Eye: The Drawings of Jasper F. Cropsey*, exh. cat. (Yonkers, N.Y.: Hudson River Museum, 1980); Carrie Rebora, *Jasper Cropsey Watercolors*, exh. cat. (New York: National Academy of Design, 1985); Ella Foshay et al., *Jasper Cropsey, Artist and Architect: Paintings, Drawings, and Photographs from the Collections of the Newington-Cropsey Foundation and The New-York Historical Society*, exh. cat. (New York: New-York Historical Society, 1987); Nancy Hall-Duncan, *A Man for All Seasons: Jasper Francis Cropsey*, exh. cat. (Greenwich, Conn.: Bruce Museum, 1988).

98. *Study for "Youle's Shot Tower, New York City,"* 1844

Graphite on paper; 13 3/8 × 10 3/8 in. (340 × 264 mm), irregular
Signed and dated at lower right in graphite: *J. F Cropsey Oct. 1. 1844.–*; inscribed at middle right: *C Road / B[illegible] / flowers*
Provenance: Descent through the artist's family; Mrs. H. Brown Reinhardt, Wilmington, Del.; Jeffrey R. Brown, North Amherst, Mass., 1978.
Bibliography: Koke 1982, 1:229–30, no. 397, ill.
Watson Fund, 1978.51

This preparatory study for Cropsey's painting of the former East River landmark has nearly the same composition and dimensions as the signed and dated (1845) canvas in the Society's collection (fig. 98.1).[1] Cropsey painted two other similar oils that have nearly identical dimensions and minor variations. Both versions, one in the MCNY[2] and the other in the Newington-Cropsey Foundation, Hastings-on Hudson,[3] are signed and dated 1845. A third, larger canvas, is also in the MCNY.[4] Not surprisingly, all four works reflect the artist's interest and formal training in architecture yet are among the very few works he executed representing architectural structures that he had not designed. However, the elegant draftsmanship of this drawing is unlike the more regimented lines of the artist's architectural drawings. Rather, it is delicate and suggestively impressionistic, lending to this lightly drawn sheet a fresh, atmospheric quality.

From the early eighteenth century, shot towers were constructed in the United States for the manufacture of munitions. Cropsey the architect was attracted by their height, as they were among the tallest structures in existence at the time. Molten lead was dropped from the top

98

of the tower through a sievelike device. As it fell, it formed into small balls. Water in a vat at the bottom would catch and cool the shot. When hardened, dried, and polished, it was bagged for sale to be used in shotguns. George Youle, a dry-goods merchant, had erected this shot tower in 1823 on the shore of Manhattan's East River, between Fifty-third and Fifty-fourth streets. John McComb Jr. (for his daughter's watercolor, cat. 59), architect of New York City Hall, is believed to have been its designer. An earlier tower on the same site, erected in 1821, collapsed after being partially built. The second tower, which is depicted in this drawing and its related oil paintings, was demolished sometime between 1923 and 1933.[5] The small inlet Cropsey depicted in front of the tower provided a landing place for boats transporting prisoners and hospital patients to the Charity Hospital, Alms-House, Work-House, and other institutions across the river on Blackwell's Island.

1. See Koke 1982, 1:229–31, no. 398, ill. See also Stokes 1915–28, 3:601; and Talbot 1970, 64–66.
2. Inv. no. 81.4, 24 × 20 1/2 in.; Ramirez 2000, 102–3, no. 16, ill. The reflection on the water is more intense in this version, and the palette is darker, with the tower in shadow.
3. Hall-Duncan 1988, n.p., lists this painting in the Foundation's collection as 24 × 20 1/4 in.; for a reproduction, see http://www.newingtoncropsey.com/Collection/oils/0454.htm. It has yet a different palette featuring extremely bright reds.
4. Inv. no. 29.100.1320, 38 1/8 × 34 1/8 in.

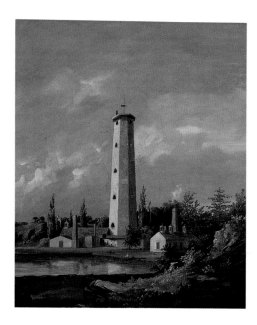

Fig. 98.1. Jasper Francis Cropsey, *Youle's Shot Tower N.Y.C.*, 1845. Oil on canvas, 24 × 20 in. (610 × 508 mm). The New-York Historical Society, Purchased by the Society, 1923.13

5. A. Everett Peterson, *Landmarks of New York* (New York: City History Club, 1923), 73, notes: "So strongly was the tower built that when the present owner of the property contracted for its demolition a few years ago, the contractor gave up the job after removing the upper portion; so the base to a height of about ten feet still remains."

Jasper Francis Cropsey

99. *Italian Landscape near Rome: Study for "Mountain Stream,"* 1847

Oil on paper, laid on canvas; 9 7/8 × 14 1/8 in. (251 × 359 mm)
Signed, dated, and inscribed at lower center in brown oil: *J.F. Cropsey 1847 / Rome*
Provenance: Robert L. Stuart Collection, New York, 1862; Mrs. Robert L. Stuart, 1882; The New York Public Library.
Bibliography: New York Public Library, *Catalogue of Paintings in the Picture Galleries of the New York Public Library: Astor, Lenox and Tilden Foundations* (New York: Printed at the New York Public Library, 1941), 21, no. 102 (earlier eds.: 1897, 27; 1912, 23; 1934, 23).
The Robert L. Stuart Collection, S-102

Previously entitled *View near Rome*, this work resembles in technique, mountainous setting, and composition several other works in the Newington-Cropsey Foundation, Hastings-on-Hudson, New York, including a slightly larger canvas from the same year, *Rugged Mountain Scene (Italian)*.[1] It has been suggested that the latter work may have been inspired by Cropsey's journey over the Alps via the Simplon Pass en route to Italy, as well as by Cole's paintings, an argument that can be taken further by noting that the artist painted both works in Rome.[2] They represent variations on the pastoral landscape with grand and picturesque mountains, a theme then in vogue with painters of all nationalities who flocked to Italy for its charming *vedute*, ideal climate, and pleasing way of life.[3] While this scene may also reflect Cropsey's delight in the picturesque Alban Hills near Rome that he sketched in the late fall of 1847[4] as well as the topography east of Rome, it has a decidedly

generic cast. Although ruins similar to those of the medieval fortified town on the hill at the center of the composition and the aqueduct bridge at the right dot the countryside near Rome, the ruined devotional cross, a moralizing footnote, and the bucolic peasants suggest that Cropsey painted at least part of the work in his studio (including the torch-bearing religious procession on the aqueduct bridge). In fact, the artist had rendered a similar rustic cross, a more prominent ruined tower, and a goatherd in a small canvas before he went to Italy, *Station of the Cross, Italy* (1844; The Newington-Cropsey Foundation, Hastings-on-Hudson, N.Y.).[5] That work nearly replicates Cole's larger *Landscape with a Tower* (n.d.; formerly in The George F. McMurray Collection, Trinity College, Hartford, Conn.).[6] Cropsey's inclusion of a similar yet smaller overgrown cross at the left of this oil sketch also is a tribute to Cole.

The sketch's paper support strongly suggests that it was at least partially executed out of doors. The notion of a two-pronged campaign, both outdoors and in the studio, is supported by the composite feeling of the work, which reveals the young Cropsey experimenting with new approaches, albeit somewhat erratically, and beginning to depart from Cole's conventions.

Like many plein air sketches, the work is preparatory; it is a study for Cropsey's larger canvas in the Arnot Art Museum in Elmira, New York, formerly entitled *Italian Landscape* and now known as *Mountain Stream*.[7] Maddox has recently related the Arnot canvas to a painting mentioned in a letter of 4 September 1848 from John Mackie Falconer to Cropsey describing six paintings Cropsey had sent to New York from Rome in February 1848.[8] Falconer's favorite of the six was *Mountain Stream* because he thought it more unified than the others.[9]

1. In oil on canvas, 18 1/4 × 26 in. Foshay et al. 1987, 40–41, no. 5, ill.; and Duncan-Hall 1988, pl. 2.
2. Foshay et al. 1987, 40. Cropsey's interest in clouds, which was articulated in his 1855 essay "Up among the Clouds" in the *Crayon*, is already apparent in this work. See also Barbara Novak, *Nature and Culture: American Landscape Painting* (New York: Oxford University Press, 1995), 78–100, for her essay on clouds in American landscape painting that considers Cropsey's contribution.
3. To demonstrate that Cropsey was painting in this well-established oil sketch tradition, which had its

99

birth in Rome, see Anna Ottani Cavina, *I paesaggi della ragione: La città neoclassica da David a Humbert de Superville* (Turin: Einaudi, 1994); Philip Conisbee et al., *In the Light of Italy: Corot and Early Open-Air Painting*, exh. cat. (Washington, D.C.: National Gallery of Art, 1996); and Anna Ottani Cavina et al., *Paysages d'Italie: les peintres du plein air (1780–1839)*, exh. cat. (Paris: Réunion des Musées Nationaux; Milan: Electa, 2001). For the American contribution to the oil sketch tradition after 1830, see Harvey 1998.

4. As noted in Talbot 1970, 67, no. 5, in an entry on *Landscape with Figures near Rome*, signed and dated the same year, with similar dimensions.

5. Hall-Duncan 1988, fig. 11, 11 1/2 × 13 1/2 in. Kenneth W. Maddox (e-mail message, 22 June 2006) noted that the Newington-Cropsey Foundation currently entitles the painting *Italian Ruin*. The title may be changed to *Evening, a Composition*, based on evidence that it is the same work Cropsey exhibited at the NAD

and at the Brooklyn Institute, which a critic describes in words that suggest this work and its tower.

6. Hall-Duncan 1988, fig. 10, 13 3/4 × 10 1/2 in. (not 23 3/4 × 28 1/2 in., as noted in this source). Thanks to Kenneth W. Maddox for this information.

7. Inv. no. 160, in oil on canvas, 21 3/8 × 31 3/8 in.; see Talbot 1970, 340, no. 21, ill. The change in title was originally pointed out by Kenneth W. Maddox. While the compositions of the two works are nearly identical, there are minor differences between them.

8. According to Kenneth W. Maddox (letter, 22 July 2002), who is preparing a catalogue raisonné on Cropsey's oeuvre, the other paintings were *Italia* (which Maddox identifies as *Landscape with Figures near Rome*, 1847; Pennsylvania Academy of the Fine Arts, Philadelphia); *Alpine Scenery* (probably *Rugged Mountain Scenery*, 1847; Mrs. John C. Newington); *Italian Cottage, American Scenery* (c. 1847; location unknown); *Torre dei Schiavi* (c. 1847; location

unknown); and *Retired Life* (1847; Mrs. John C. Newington). A smaller study exists for *Alpine Scenery*.

9. According to Maddox (letter, 22 July 2002), Falconer liked the way Cropsey ran "the water *into* the picture in 'Mountain Stream,' think you managed its disappearance very happily—and then you wag! To put the torch carrying procession in there, lighting up open day at so expensive a rate. Satirizing monkery by the way—are they searching for that social comfort you say they want?" Falconer's letter is known only through the typescript made by a descendant of Cropsey, kindly provided by Maddox from the collection of the Newington-Cropsey Foundation.

SANFORD ROBINSON GIFFORD

Greenfield, New York 1823–New York, New York 1880

Sanford Robinson Gifford's formative years were unusually important to his artistic development. He was alone among his contemporaries in actually having been born and raised in the very center of the Hudson River valley (in bustling Hudson, New York) and is the only one of the Hudson River School painters to have attended college (Brown University, for three semesters, in 1842–43). Gifford also may have begun his art studies with Henry Ary in Hudson, although his first exposure to art occurred at home, where his eldest brother, Charles, covered the walls of his room with engravings of European paintings. His family was sufficiently prosperous to free him of the pecuniary concerns of most artists, allowing him to pursue his art independently. He moved to New York City in 1845 and studied with the British watercolorist and drawing master John Rubens Smith. Gifford also enrolled in figure drawing classes at the NAD (1846–48) and attended anatomy lectures at the Crosby Street Medical College. After a year of studying the human figure, he decided to specialize in landscape painting. An admirer of the work of Thomas Cole (cats. 61 and 62), he took a sketching trip during the summer of 1846 and visited some of that artist's favorite haunts in the Berkshire and Catskill mountains, an experience that inspired him to turn seriously to landscape painting.

Gifford's earliest works show the combined influence of Cole's style and his own nature studies. He first exhibited his work at the NAD in 1847, the same year the American Art-Union accepted one of his landscapes for distribution through engraving to its members. The next year the Art-Union showed eight of Gifford's canvases. The NAD elected him an associate in 1851 and an academician in 1854.

Like most American landscape painters of his day and following Cole and Jasper Francis Cropsey (cats. 98 and 99), Gifford decided to supplement his training with European travel, leaving for his Grand Tour in 1855. Arriving in England, he studied the work of John Constable and J. M. W. Turner and met the influential critic John Ruskin. That autumn he went to France, spending over a year in Paris, Fontainebleau, and Barbizon, where he was greatly impressed with the work of Jean-François Millet. He continued his travels in Germany, Switzerland, and Italy. In Rome he joined the lively expatriate community that included Worthington Whittredge and Albert Bierstadt (cat. 102), with whom he traveled to Naples and Sicily. Paintings from this tour, such as *Lake of Nemi* (1856–57; The Toledo Museum of Art), reveal his departure from the darker tonalities and structured compositions of his Hudson River School predecessors, such as Cole, in favor of landscapes painted with barely noticeable brushstrokes bathed in light that diffuses topographical detail.

When he returned to the United States in 1857, Gifford rented a space in the Tenth Street Studio Building in New York City, where he painted for the remainder of his life and associated with a wide circle of artists and writers, including Jervis McEntee and Eastman Johnson. On annual summer sketching trips with his fellow landscape painters—to the Catskills, the Adirondacks, and many other scenic locations in New Jersey, Maine, New Hampshire, and Vermont—he made graphite sketches that he later developed in the studio into oil paintings. He favored the Catskills and produced numerous canvases of the area, such as *Kaaterskill Clove* (1862; The Metropolitan Museum of Art, New York), which shows the successful culmination of his experiments with the dissolution of form in atmospheric light. In 1861 he enlisted in the Seventh Regiment of the New York National

Guard and spent part of the next three summers in and around Washington, D.C. While serving during the Civil War, he also produced works that reveal his fascination with light effects.

Between the summer of 1868 and the autumn of 1869 Gifford again traveled abroad, visiting Italy (Venice), Greece, Egypt, Syria, Palestine, and Turkey. The sites he saw inspired many of his later paintings. Shortly after his return, in 1870 he joined other artists and prominent New Yorkers to found the Metropolitan Museum of Art. That same year he joined Worthington Whittredge and John Frederick Kensett (cat. 88) in an exploration of the Rocky Mountains of Colorado. Then he accompanied a government survey expedition to Wyoming with the geologist Ferdinand V. Hayden. He traveled to California, British Columbia, and Alaska in 1874 and chose to paint spectacular sights like Mount Rainier, but he never abandoned the more familiar scenery of the Catskill region. His popularity by midcentury can be gauged by his representation with an unequaled thirteen paintings in the Philadelphia Centennial Exhibition. In 1880 after a trip with his wife (Mary Cecilia Canfield, whom he wed secretly in 1877) to Lake Superior for convalescence, he died of malarial fever and pneumonia. In 1881 the Metropolitan Museum of Art mounted a large memorial exhibition of Gifford's work, accompanied by a catalogue listing 739 of his paintings. It confirmed his position as a major member of the second generation of the Hudson River School. Subsequently, he has sometimes been viewed as an important exponent of the debated movement termed "Luminism."

Bibliography: John F. Weir, *A Memorial Catalogue of the Paintings of Sanford Robinson Gifford*, exh. cat. (New York: Press F. Hart & Co., under the auspices of the Metropolitan Museum of Art, 1881); Nicolai Cikovsky Jr., *Sanford Robinson Gifford [1823–1880]*, exh. cat. (Austin: University of Texas Art Museum, 1970); Ila S. Weiss, "Sanford R. Gifford in Europe: A Sketchbook of 1868," *American Art Journal* 9:2 (1977): 83–103; idem, *Sanford Robinson Gifford (1823–1880)* (New York: Garland Publishing, 1977); idem, *Poetic Landscape: The Art and Experience of Sanford R. Gifford* (Newark: University of Delaware Press; London: Associated University Presses, 1987); Avery and Kelly 2003.

100. *Profile Portrait of a Young Man*; verso: six studies of male heads (several of Charles Gifford, 1827–1861) and one of a horse, 1844

Graphite on beige paper; 3 15/16 × 3 9/16 in. (100 × 90 mm), irrregular
Inscribed and dated at lower left in graphite: *Hudson Nov 1844*; verso inscribed along upper margin in graphite: *H + A F1633*
Provenance: Collection and estate of the artist; Richard Butler, 1881; Gifford Pinchot, Grey Towers, Pa., 1946; heirs of Gifford Pinchot, 1978; Mr. and Mrs. Stuart P. Feld, New York.
Bibliography: Weiss 1987, 57, ill. (recto only).
Gift of Mr. and Mrs. Stuart P. Feld, 1983.49

As the inscription documents, Gifford sketched this sheet at Hudson, New York, shortly after leaving Brown University. Gifford recounted in a letter of 6 November 1874: "In 1842 I entered Brown University and remained there two years. Soon after leaving the university I devoted myself to the pursuit of Art to which I had always been inclined."[1] At this early juncture, before turning to landscape painting, the young Gifford focused on portraits and figure studies.[2] More than likely the youthful sitter portrayed in profile on the recto of this sheet wearing a cap with a visor (a type fashionable at the time) was a friend or family member. Of the six quickly sketched heads on the verso, the three at the left (two of which are fragmentary studies, cropped when the paper was cut) seem to portray the artist's eldest brother, Charles, whose characteristic shock of hair and full lips are preserved in an anonymous daguerreotype and another drawing of 1846 by his younger brother.[3] In 1846 Charles, a horticulturist who suffered from depression and migraines, moved to Milwaukee, Wisconsin, where he converted to his wife's Swedenborgian faith. Fifteen years later he died of an overdose of the chloral hydrate that he took to alleviate his condition. The brothers, who were close, shared a profound interest in nature and art.

In style the Society's drawing corresponds to Gifford's earliest known sketchbook, dated between August 1844 and May 1847.[4] Its eighty-two pages, documenting the youth's formative period and his first two years as an art student in New York City, confirm his overwhelming interest in portraiture during this time.[5] The sketchbook's assorted studies of visages include both sexes of all ages, some posed, others candidly rendered, together with caricatures. Although Gifford rendered the quick sketches on the verso of the Society's sheet with a certain *sprezzatura* and sometimes a touch of satire, he strove for greater individualization in the more finished portrait of a youth wearing a cap on the recto, which may also represent his brother Charles, although the profile pose and the hat make an absolute identification difficult.

1. "Journal," 1:20, 10 June 1855, AAA, quoted in Cikovsky 1970, 8.
2. Avery and Kelly 2003, 6. See also the early work listed in Weir 1881, 13–16.
3. The drawing is inv. no. 56.357 in the Museum of Fine Arts, Boston; see Avery and Kelly 2003, 28, fig. 19; and Weiss 1987, 52, which reproduces the daguerreotype as in the collection of Sanford Gifford, M.D.
4. Inv. no. 2001.157 in the Fogg Art Museum, Harvard University, Cambridge, Mass. Weiss 1987, 332, cited it as SG2 when it was formerly in the collection of Sanford Gifford, M.D. It is one of the twelve sketchbooks the museum received from Sanford Gifford. The Brooklyn Museum holds another sketchbook from 1867–68 with American and European drawings (inv. no. BM 17.141); Carbone et al. 2006, 1:551 n. 2.
5. Weir 1881, 14, lists a number of portraits Gifford made before his first trip abroad in 1855–57.

CHRISTIAN SCHUESSELE (SCHUSSELE)

Guebwiller, Haut-Rhin, Alsace, France 1824 or 1826–Merchantville, New Jersey 1879

Known primarily as a teacher responsible for the educational curriculum of the Pennsylvania Academy of the Fine Arts along the lines of a European academy, Christian Schuessele was also a painter, most notably of genre scenes. Born into a prosperous family in Alsace while it was still under French control, Schuessele persuaded his parents to allow him to study art, but he was self-taught until he left home to study lithography at the Art Academy of Strasbourg in 1841. After two years he went to Paris, where he studied at the École des Beaux-Arts and in the atelier of the academic artist Paul Delaroche, who was then considered one of the most successful established painters and whose studio was viewed as a spawning ground for the talent of the next generation. Schuessele also worked with Adolphe Yvon, a portrait and history painter who had been a student of Delaroche. Although the young artist secured an impressive chromolithograph commission to reproduce popular paintings from the collection in the former royal château in Versailles, the French revolution of 1848 encouraged him to seek a better working environment by immigrating to the United States.

Schuessele settled in Philadelphia, a city with a large population of German immigrants, and worked as a chromolithographer (one of the first in the country) and wood engraver. Soon thereafter he married Cecilia Muringer, daughter of a French lithographer whom he had met in Paris. His main interest, however, had turned to painting. In 1851 he completed *The Artist's Recreation*, which was exhibited at the Pennsylvania Academy of the Fine Arts. The following year, in 1852, *Clear the Track* was purchased by the president of the academy, J. L. Claghorn, and engraved by John Sartain. With these encouragements, Schuessele became a full-time painter in 1854. Although he is better known for his slightly saccharine genre subjects and portraits, he also executed history paintings. Schuessele entered into the rich intellectual life of Philadelphia, as evidenced by his collaboration with James McAlpin Sommerville—physician, amateur naturalist, artist, and member of the Academy of Natural Sciences—on an opulent watercolor of an undersea environment, *Ocean Life* (1859; The Metropolitan Museum of Art, New York). He was active in many local art groups and was a member of the Philadelphia Sketch Club, the Pennsylvania Academy of the Fine Arts, the Graphic Arts Association, and the Artists' Fund Society, the latter of which he served as president.

About 1863 Schuessele developed palsy in his right hand that by 1865 had spread to his entire body. In search of a cure, he went to Europe, but after an unsuccessful operation he returned to Philadelphia, where he was unanimously elected to fill the newly established chair of drawing and painting at the academy, holding it until his death (1868–79). Although Schuessele emphasized study of the figure, he overemphasized drawing after plaster casts, establishing a conservative practice and pedagogy and influencing his pupil and later assistant, Thomas Eakins. When Schuessele died, Eakins inherited his position and reintroduced more life drawing.

Bibliography: Ronald J. Onorato, "The Context of the Pennsylvania Academy: Thomas Eakins's Assistantship to Christian Schuessele," *Arts Magazine* 53:9 (1979): 121–29; Weinberg 1991, 38–41; Avery et al. 2002, 244–46.

101. *The Happy Home*, 1857

Black and brown ink and wash, watercolor, and graphite on watercolor paper; 17 3/8 × 13 7/8 in. (442 × 353 mm)
Signed, inscribed, and dated at lower left in graphite: *Schuessele / Philadᵃ 1857*; reportedly inscribed on verso of former mount in graphite: *The Happy Home / C. Schuessele*.
Provenance: Adelaide Milton de Groot, New York.
Bibliography: Koke 1982, 3:127–28, no. 2462, ill.
Gift of Miss Adelaide Milton de Groot, 1941.601

This grisaille drawing is characteristic of Schuessele's domestic genre scenes that frequently revolve around bourgeois families and children.[1] The mother, the center of the household, embroiders before the hearth, while a young girl decorates her hair, a sentimental, slightly frivolous moment observed by the paterfamilias seated in the "thinker pose" before a table laden with books. Accoutrements of learning, such as an adjacent cabinet of books and a classicizing bust, all emblems of his intellectual pursuits, surround him. On the wall in this well-appointed parlor hangs a Romantic landscape, while its mantelpiece supports a melodramatic two-figure sculpture with tragic, Neoclassical overtones and an urn. Schuessele blatantly celebrates the virtues of hearth and home cherished by midcentury Americans, in this case depicting a well-to-do family and the rich material culture they enjoyed. Completing the scene of domestic bliss is a contented cat that the artist has grouped with the distaff members of the family.

A stylistically identical work in the same media and with a similar familial theme was sold at auction in 1991. Also dated 1857, it is a study for *Lesson in Charity*, a painting with a moral theme that Schuessele exhibited at the thirty-fourth annual exhibition at the Pennsylvania Academy of the Fine Arts in 1858.[2] Given these similarities, the Society's sheet may also be a study for a painting. One possible candidate is *House Enjoyment*, exhibited at the Pennsylvania Academy in 1857 and owned by J. L. Claghorn, the president of the academy and frequent patron of the artist.[3]

1. Onorato 1979, 128 n. 4, points out that the artist preferred spelling his name *Schuessele*, using it to sign works of art and in the stamp that appears on many of his drawings.
2. See Schwarz, Philadelphia, *American Watercolors and Pastels*, sale cat., November 1991, lot 28, ill.; and Peter Hastings Falk, ed., *The Annual Exhibition Record of the Pennsylvania Academy of Arts, 1807–1870* (Philadelphia: Sound View Press, 1988–89), 1:199, no. 170.
3. Falk 1988–89, 1:199, no. 125, where it is listed as in the collection of J. L. Claghorn.

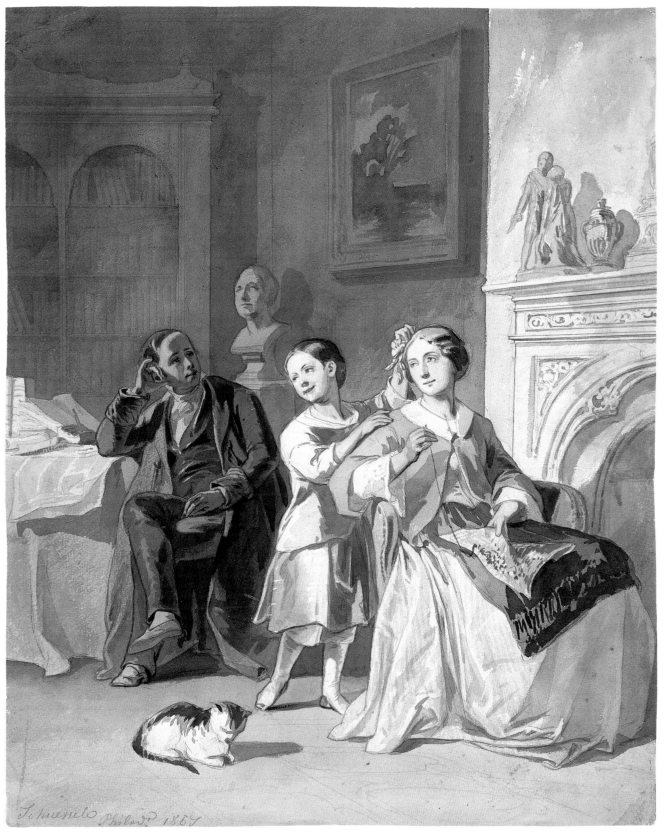

101

ALBERT BIERSTADT

Solingen, Germany 1830–New York, New York 1902

With a career spanning the entire second half of the nineteenth century, Albert Bierstadt emerged as the first technically sophisticated artist to travel to the Far West of the North American continent and to adapt his mastery of European and Hudson River School prototypes to the powerful, new, panoramic landscapes of the Rocky Mountains, the Sierra Nevada, and Yosemite Valley. In expressing the concept of Manifest Destiny through his painted images, Bierstadt produced iconic landscapes resonant with nationalistic and religious symbolism.

Born near Düsseldorf, Germany, Bierstadt spent his early childhood years in New Bedford, Massachusetts, where his family immigrated two years after his birth. No details concerning his early development as an artist, however, have come to light. Lacking funds for formal art instruction, he spent several years as an itinerant drawing instructor (he advertised himself in New Bedford as a teacher of monochromatic painting) and from 1850 to 1853 exhibited landscapes in Boston, where he worked as a daguerreotypist. In 1851 he contracted with George Harvey (cat. 63) to tour Harvey's magic lantern show of "Atmospheric Landscapes," pictures painted on glass slides and projected as gigantic images. Bierstadt became a United States citizen in 1853 shortly before departing for Düsseldorf, where he hoped to study with Johann Peter Hasenclever, a distant relative and a celebrated member of the art world in Düsseldorf. Hasenclever's death shortly before Bierstadt's arrival altered the course of his artistic education. The young artist turned for advice instead to Carl Friedrich Lessing and Andreas Achenbach, and rather than enrolling in the academy he forged allegiances to his fellow American artists Emanuel Gottlieb Leutze and Worthington Whittredge. After four years of study and travel in Germany, Switzerland, and Italy, Bierstadt had mastered the painting technique taught at Düsseldorf, characterized by powerful contrasts of light and shadow and strong local color, as well as the conventions of Alpine and genre painting, and had dedicated himself to his lifelong habit of plein air oil painting. He also met other European painters and American artists abroad, among them Sanford Robinson Gifford (cat. 100) in Rome. In 1857 Bierstadt returned to New Bedford. The following year, he made his New York debut, contributing the large *Lake Lucerne (Switzerland)* (1858; National Gallery of Art, Washington, D.C.) to the annual exhibition at the NAD, gaining him membership in that institution.

The turning point in his career occurred in 1859, a full decade after the siren call of California gold had drawn thousands across the Rocky Mountains, when Bierstadt traveled west for six months with Colonel Frederick West Lander's Honey Road Survey Party to map an overland route to the Pacific. Like other artists who were offered opportunities to explore the western part of the continent under the auspices of the American government, which sponsored surveys of the vast territories newly incorporated under federal rule, Bierstadt traveled as a civilian artist on this expedition to improve the wagon roads of the South Pass from Fort Kearney to the eastern border of California. Equipped with a camera, he accompanied the expedition as far as South Pass, high in the Rocky Mountains, not only making sketches but also taking stereoscopic photographs of Indians, emigrants, and members of the party. On his return east, Bierstadt gave his negatives to his brothers Edward and Charles Bierstadt, who shortly thereafter opened their successful photography business in New Bedford. With this endeavor Bierstadt embraced the role of the artist as adventurer, like John James Audubon (cats. 42 and 43), and emulated the model established by Frederic Edwin Church in South America and the Far North.

Within three months of his return in 1860, Bierstadt had moved to New York City, and after taking space in the Tenth Street Studio Building (where he stayed until 1879) with his friends from the Düsseldorf years, he set to work on the first of the large western landscapes on which his reputation is based. In 1860 he exhibited *Base of the Rocky Mountains, Laramie Peak* (location unknown) at the NAD, thereby laying artistic claim on the landscape of the American West and ensuring his success (the *New-York Tribune* termed it "the *piece de resistance*" of the exhibition). The same year he was elected an academician of the NAD. Of all the paintings he produced following his first trip west, none drew more attention than *The Rocky Mountains, Lander's Peak* (1863; The Metropolitan Museum of Art, New York). A huge canvas combining distant mountain grandeur with a close-up view of Indian camp life, *The Rocky Mountains* was seen by some as the North American equivalent of Church's *Heart of the Andes* (1859; The Metropolitan Museum of Art, New York). One of two canvases depicting a location identified as "Lander's Peak"—the other of the same year is in the Fogg Art Museum, Harvard University Art Museums, Cambridge, Massachusetts—the work represents the artist's personal tribute to Lander, who died of wounds received in combat during the Civil War. Both pictures depict not an actual mountain but an imaginary "ideal" majestic peak in the Rockies that, through the very geography of America as envisioned by Bierstadt, commemorates a pioneer of the West and a hero. At New York's Metropolitan Fair in 1864 to benefit the United States Sanitary Commission, *The Rocky Mountains, Lander's Peak* was installed opposite Church's celebrated *Heart of the Andes*. At this fair Bierstadt also organized the "Indian Department," which displayed Native American artifacts and a wigwam and featured a group of performing Indians.

From May to December 1863 the artist made his second trip west, accompanied by the writer Fitz Hugh Ludlow. Traveling by stagecoach and on horseback, the pair reached San Francisco in July, spent seven weeks in Yosemite Valley, and then rode north as far as the Columbia River in Oregon before returning east. Following this expedition, Bierstadt produced a series of works showing the awesome geography and spiritual power of Yosemite Valley. Such images of undisturbed nature served as welcome antidotes to the chaos and carnage of the Civil War then ravaging the eastern landscape. In 1865 Bierstadt sold his painting *The Rocky Mountains* to James McHenry, an English railroad financier for £25,000. The sale marked not only the artist's economic ascendancy but also his entry into European and American society. The following year Bierstadt's traveling companion on his second western trip, Rosalie Osborne Ludlow, obtained a divorce from her husband and married the painter. The artist claimed the role of the primary interpreter of the American West at the very moment when public excitement about westward expansion crested. At the peak of his celebrity and wealth Bierstadt built a magnificent home, Malkasten (German for "paint box"), which was completed in 1866 and

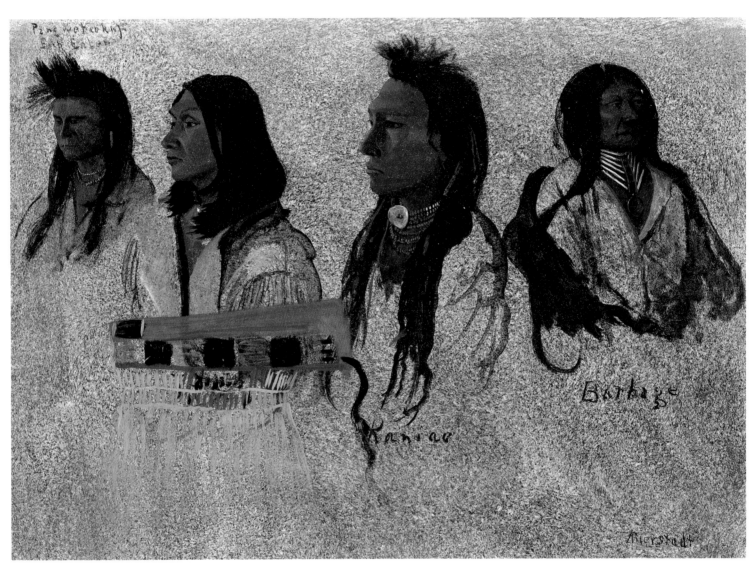

102a

then destroyed by fire in 1882, on the banks of the Hudson River at Irvington, New York. (The fire destroyed the contents of the artist's studio including his works of art, library, and Native American artifacts.)

In June 1867 Bierstadt and his wife departed for Europe, where they spent two years traveling and mingling with potential patrons among the wealthy and the titled. During that time he was awarded the Legion of Honor by Napoleon III. He also began a number of mythic rather than topographic paintings that would occupy much of his time in the 1870s. From 1869 to 1889 he exhibited works at the Paris Salon. Returning to California and Yosemite in 1871 for two years in search of fresh subjects, he found that the

transcontinental railroad had flooded the valley with tourists and so turned his attention to less accessible and still pristine wilderness areas. One of the works from this trip is the mammoth *Donner Lake from the Summit* (1873; The N-YHS), commissioned by Collis P. Huntington, the railroad magnate. In this tour-de-force canvas, Bierstadt depicted the point at which the Central Pacific Railroad reached its highest passage over the Sierra Nevada. Bierstadt journeyed to Donner Pass in the High Sierra with Huntington, who had overseen the laying of the transcontinental line, and Clarence King, a distinguished geologist who led the War Department's geological exploration of the fortieth parallel (1867–73). Huntington wanted

the work to depict the location where the engineering and construction crews faced their greatest challenge. Together the artist and his patron traveled to the summit, where Huntington reportedly selected the point from which he wished the picture painted.

Returning east in 1873, Bierstadt began work on a new series of paintings of California as well as a commissioned work for the U.S. Capitol, *Discovery of the Hudson* (1875; in situ). In 1877, when his wife's health required a warmer climate, he began regular trips to Nassau in the Bahamas. The island's lush landscape and tropical light offered new subject matter and encouraged him to adopt a brighter palette. In the following decade he traveled constantly,

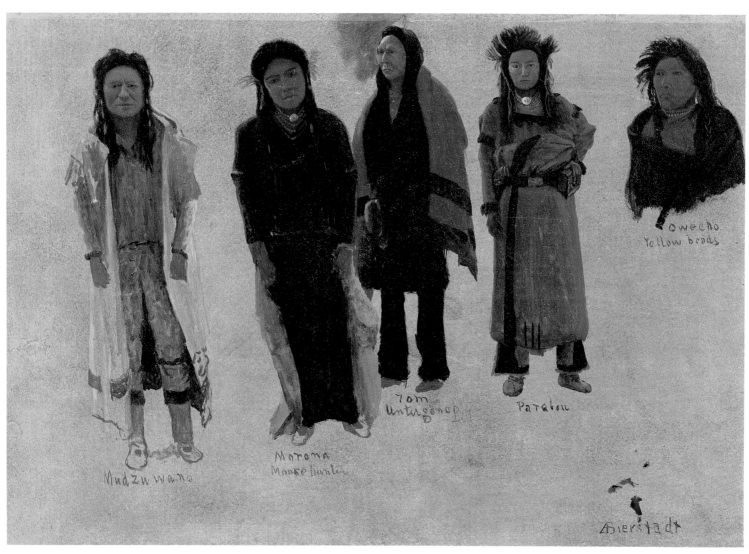

102b

from the West Coast to Europe, and in 1889 to Alaska and the Canadian Rockies.

As early as the mid-1870s the growing American taste for European-influenced art had begun to affect his reputation. Americans were more interested in painterly, intimate French works or Thomas Moran's Turneresque views of western scenery than Bierstadt's dramatic, ponderous, panoramic machines that adhered to the Düsseldorf style of descriptive realism (which had already begun to wane in popularity by 1857). But the most painful blow occurred in 1889, when the American selection committee for the Exposition Universelle in Paris rejected his final ambitious western panorama, *Last of the Buffalo* (1888; Corcoran Gallery of Art, Washing-

ton, D.C.). Declaring the work too large and not representative of contemporary American art, the committee reinforced the view that Bierstadt was an outmoded master. Demonstrating the showmanship that had sustained him throughout his career, Bierstadt nevertheless exhibited the canvas at the Paris Salon. The artist last showed his work publicly at the NAD in its 1888 annual. The revival of interest in Bierstadt's art during the 1960s was sparked by a new appreciation of his fresh, quickly executed sketches done in preparation for the larger works.

Bibliography: Gordon Hendricks, "The First Three Western Journeys of Albert Bierstadt," *Art Bulletin* 46:3 (1964): 333–65; idem, *ABierstadt*, exh. cat. (Fort Worth: Amon Carter Museum, 1972); idem, *Albert Bierstadt: Painter of the American West* (New York: Harry N. Abrams, in association with the Amon Carter Museum of Western Art, 1974); Matthew Baigell, *Albert Bierstadt* (New York: Watson-Guptill, 1981); Gordon Hendricks, *Albert Bierstadt: Painter of the American West* (New York: Harrison House, 1988); Nancy Anderson and Linda Ferber, *Albert Bierstadt: Art and Enterprise*, exh. cat. (New York: Hudson Hills Press, in association with the Brooklyn Museum, 1991); Dearinger 2004, 42–43.

102a. *Four Portraits of North American Indians*; verso: sketch of brave riding a horse and shooting a bow and arrow, 1859

Oil on gray marbleized prepared heavy paper; graphite; 13 7/8 × 18 7/8 in. (352 × 480 mm)
Signed at lower right in brown oil: *ABierstadt*; sitters' identities inscribed from left to right: *Pang wetiekirp*[?] / *Fish Eater*; *Kaniac*; *Barbage*
Provenance: Cornelius Michaelsen, New York; Rains Galleries, New York, 1935; Adelaide Milton de Groot Collection, New York.
Bibliography: Rains Galleries, New York, sale cat., 8 May 1935, lot 72, ill.; Hendricks 1964, 360, no. 159; Hendricks 1974, no. Cl-178, ill.; Koke 1982, 1:46–47, no. 144, ill.; Anderson and Ferber 1991, 162, no. 25, ill.; Olson 2004, 31, fig. 11.
Gift of Miss Adelaide Milton de Groot, 1941.1209

102b. *Five Portraits of North American Indians*, 1859

Oil on gray prepared heavy textured paper; 13 9/16 × 18 7/8 in. (345 × 480 mm)
Signed at lower right in brown oil: *ABierstadt*; sitters' identities inscribed from left to right: *Mudzuwano*; *Morona / Moose hunter*; *Tom Untergonop*; *Patabou*; *Owecho / Yellow beads*
Provenance: Cornelius Michaelsen Collection, New York; Rains Galleries, New York, 1935; Adelaide Milton de Groot Collection, New York.
Bibliography: Rains Galleries, New York, sale cat., 8 May 1935, lot 73; Hendricks 1964, 360, no. 158; Hendricks 1974, no. CL-179, ill.; Koke 1982, 1:46–47, no. 145, ill.; Anderson and Ferber 1991, 161, no. 24, ill.
Gift of Miss Adelaide Milton de Groot, 1941.1210

Both of these stunning oil sketches that document individual North American Indians—exhibiting similar spontaneous styles, supports, media, and inscriptions—date from one of Bierstadt's three western trips. As plein air painting in oils was central to Bierstadt's artistic process, the pair was more than likely executed outdoors, a conclusion bolstered by the free application of their pigments and the heavy, textured nature of their supports. There is, however, no consensus about their dates in the literature on the artist, which is surprisingly lacking in documentation. Without presenting any proof, Hendricks believes that the "strong-to-conclusive" evidence points to dates for both from either Bierstadt's 1863 or 1871–73 trip,[1] whereas Anderson and Ferber date both to the artist's earliest western

trip, about 1859, without amplification.[2]

Evidence supports the dating advocated by Anderson and Ferber during the earliest western expedition in 1859 for both works. For example, a work in oil on paper with four studies of Indians in the Museum of Fine Arts, Boston has nearly identical dimensions and is remarkably similar in style. According to Bierstadt's inscription on the verso, it was executed near the fur-trading post Fort Laramie at the Laramie Fork on the North Platte River and probably portrays members of the Teton Dakotas (Western Sioux) of the Oglala or Brulé tribes.[3] Moreover, the arrangement of the sitters in the Society's two works resembles some of Bierstadt's stereographs of Native Americans made during his first western trip in 1859, as well as the Indians in his wood engraving of the Lander party crossing the Platte River published in *Harper's Weekly* in 1859.[4] As was his practice, Bierstadt probably executed these studies on the spot.[5] Eadweard Muybridge, the father of the motion picture, documented Bierstadt among the Mariposa Indians at the gate of Yosemite painting in this fashion.[6] In the artist's letters about the Lander party's expedition that were published in the New Bedford *Mercury*, among other newspapers and periodicals, he sometimes recorded their meetings with Indians. His letter of 18 June 1859 reports that he and his companions were visited by a party of Indians, including a chief named "Dog Belly," and that he obtained stereoscopic portraits and completed "some fine studies," no doubt similar to the two in the Society's collection.[7] In another letter, published on 7 July of the same year, Bierstadt noted that the scenery near Fort Laramie was "fine" and the dress of some of the Indians was "gorgeous in the extreme," as are his portrayals in these works.[8]

1. Hendricks 1964, 360.
2. Anderson and Ferber 1991, 161–62. See Hendricks 1964, 346, fig. 28, for a map of the artist's itineraries in 1859 and 1863; 349, fig. 1, for the 1871–73 trip.
3. Inv. no. 48.411 in the M. and M. Karolik Collection, Museum of Fine Arts, Boston, in oil on paper, laid on paperboard, 13 1/2 × 19 1/4 in.; it is signed and monogrammed on the recto, and its verso inscription was visible before mounting: *Indians near Fort Laramie*. See Carol Troyen et al., *American Paintings in the Museum of Fine Arts, Boston* (Boston: Museum of Fine Arts, 1997), 20, ill. See also Museum of Fine Arts, *M. and M. Karolik Collection of American Paintings, 1815 to 1865* (Cambridge, Mass.: Published

by Harvard University Press for the Museum, 1949), 76–79, ill. Hendricks 1974, fig. 59, dates it "1859?"
4. See Hendricks 1974, figs. 42 and 43, for stereographs of Oglala Sioux in Horse Creek, Nebraska, and Shoshone children, respectively, in the Society's DPPAC; and Albert Bierstadt, "The Pike's Peak Gold Mines," *Harper's Weekly*, 13 August 1859, 516, ill., for the wood engraving.
5. See Harvey 1998, 26, 38–40.
6. See Hendricks 1972, fig. 58, labeled "Albert Bierstadt's Studio," showing him painting sketches of Indians outdoors in 1872 during his third trip west. See idem 1974, figs. 151 (another stereograph from 1872 depicting a similar session) and 152 (fig. 58 in his 1972 book).
7. Anderson and Ferber 1991, 144.
8. Ibid., 145.

LARS CHRISTENSEN

Norway, active 1830s

Lars Christensen was a Norwegian mariner sailing with the English bark *Edward Reed*. He resided at the Seaman's Retreat on Staten Island for three weeks, reputedly from 1 March to 20 March 1833, while being successfully treated for urethritis. Christensen depicted the second Retreat building that was completed in 1836, indicating that the year of his treatment may have been wrongly transcribed from the original manuscript record or that he returned at a later time. Christensen's charming watercolor has the naïve style of an untrained hand, with the rudimentary perspective and distorted proportions common to folk art of the early nineteenth century, as discussed in entries on works by Joseph H. Davis (cat. 75) and Catharine Verplanck (cat. 22).

Bibliography: Koke 1982, 1:177.

103. *Seaman's Retreat, Staten Island, New York*, 1830s

Watercolor and brown and black ink, with touches of gouache; 10 × 15 7/8 in. (254 × 403 mm)

Inscribed at lower center outside image in black ink: *Seamens Retreat*; signed below at lower right outside image in brown ink: *by Lars Christensen*.
Watermark: S & A BUTLER / US
Bibliography: Koke 1982, 1:177, no. 324, ill.
Purchased by the Society, 1930.55

In the early nineteenth century several medical and charitable institutions established facilities on rural Staten Island, Richmond County, New York. The island's first full-time hospital was the Seaman's Retreat, founded in 1831 by the state of New York.[1] The Retreat, specifically dedicated to the care of sailors and seamen, was built on a forty-acre site between Stapleton and Vanderbilt Landing in the Clifton or Edgewater district.[2] This state hospital was supported by a seamen's tax levied on every ship entering the Port of New York and served the international maritime community, accepting patients from all seafaring nations.

The original 1831 Seaman's Retreat home, depicted at the lower left in Christensen's watercolor, rapidly became overcrowded. Construction on the new structure, at center,

was begun on 4 July 1834 with the ceremonial placement of the cornerstone; it was completed in 1836.[3] In the succeeding decades, the hospital added the Lunatic Asylum (1837, housed in the original Seaman's Retreat building), the Mariner's Family Asylum (1853), and an Old Ladies' Home, as well as a small willow-shaded cemetery. Nearby, Sailor's Snug Harbor (1833) was established for the purpose of maintaining and supporting aged sailors who had served at least five years under the U.S. flag.[4]

In its first twenty-five years, the Seaman's Retreat received over 58,000 patients, releasing around 52,000 as cured or relieved. Only 2,856 deaths were recorded in more than forty-two years of operation.[5] In 1882 the state of New York sold the Seaman's Fund and Retreat property to the Marine Society of New York, which transferred it to the federal government in 1885 for the purpose of establishing a permanent marine hospital for the port. It was renamed the United States Public Health Service Hospital, which served the maritime community for over ninety years. The site was taken over by St.

Vincent's Medical Center in 1981 and renamed the Bayley Seton Hospital, which began phasing out operations in 2003 with the intention of closing the site.[6]

A. M.

1. Seaman's Fund and Retreat, *Seaman's Fund and Retreat: Annual Report of the Physician in Chief and Auditing Committee for 1862, with a Historical Sketch of the Retreat* (New York: J. M. Davis, Book and Job Printer, 1863), 25–38. The Marine Hospital at the Quarantine Station offered hospital accommodations only for four months of the year.

2. It is the location of present-day Bay Street and Vanderbilt Avenue, currently the home of St. Vincent's Hospital-Bayley Seton Campus and St. Elizabeth Ann's Health Care and Rehabilitation Center (Sisters of Charity Healthcare). See Diamonstein 1998, 75, ill.

3. Seaman's Fund and Retreat 1863, 39–40; and Staten Island Institute of Arts and Sciences, *Staten Island: An Architectural History*, exh. cat. (New York: Publishing Center for Cultural Resources, 1979), 11.

4. Ira K. Morris, *Morris's Memorial History of Staten Island, New York* (New York: Memorial Publishing, 1898–1900), 2:423–28. See also Richard M. Bayles, ed., *History of Richmond County (Staten Island), New York: From Its Discovery to the Present Time* (New York: L. E. Preston, 1887), 643–46; and Charles W. Leng, *Staten Island and Its People: A History, 1609–1929*, 5 vols. (New York: Lewis Historical Publications, 1929–33), 1:226, 246; 2:580, 885, 1006.

5. See J. J. Clute, *Annals of Staten Island: From Its Discovery to the Present Time* (New York: Press of C. Vogt, 1877); the records of the Seaman's Fund and Retreat are now held by the U.S. National Archives and Records Administration at College Park, Md., collection designation 90.4.37, including minutes of the Board of Trustees, 1843–50, 1863–67; financial records, 1831–66; ship registers, 1854–73; patient registers, 1835–82; case histories, 1831–70; and the death register, 1831–73.

6. See St. Vincent's Medical Center of Richmond, *A Proposal for the Conversion to Community Sponsorship of the United States Public Health Service Hospital on Staten Island … by St. Vincent's Medical Center of Richmond, August 15, 1981* (Staten Island, N.Y.: St. Vincent's Medical Center, 1981); and Richard Pérez-Peña, "St. Vincent's to Close Two Hospitals in Network," *New York Times*, 16 April 2004, sec. B, 4.

SAMUEL COLMAN

Portland, Maine 1832–New York, New York 1920

The American painter, interior designer, and writer Samuel Colman grew up in New York City, where his father became a successful publisher and seller of books and prints. Henry T. Tuckerman credits the family bookstore on Broadway, a popular meeting place for artists and writers, as providing Colman with an aesthetic appreciation and early introduction to such Hudson River School painters as Asher B. Durand (cats. 51–54), with whom he is said to have studied briefly about 1850. In 1851 one of his works was accepted for inclusion in the annual exhibition of the NAD. Having won early recognition for his paintings of popular Hudson River School locations, he was elected an associate of the NAD in 1854. During the 1850s and 1860s he painted for the most part in the manner of the Hudson River School and established a summer studio in North Conway, New Hampshire, which he shared with Aaron Draper Shattuck, Daniel Huntington (cat. 87), William Sidney Mount (cat. 70), and Sanford Robinson Gifford (cat. 100). His family ties with the art world were strengthened in 1860 when his sister Marian married Shattuck.

An avid traveler, Colman embarked on his first European tour in 1860–61 to broaden his studies and repertoire, visiting France, Italy, Switzerland, and the more exotic locales of southern Spain and Morocco. On his return Colman incorporated new themes and locations into his work. His reputation was secured in the 1860s with his paintings of Romantic Spanish sites, notably the large *Hill of the Alhambra, Granada* (1865; The Metropolitan Museum of Art, New York). He was one of the first American painters to venture off the traditional Grand Tour route and become interested in Spain and Oriental subject matter.

In 1862 Colman married Annie Lawrence Dunham and was elected an academician of the NAD; he then entered fully into the fraternity of American painters. After turning increasingly to the medium of watercolor, four years later he was one of the founders of the American Society of Painters in Water Colors (later the American Watercolor Society), serving as its first president. In 1870 he journeyed to California, following the completion of the Union Pacific Railway, and in 1871 the inveterate traveler began a four-year extensive tour, this time to Egypt, Algeria, Morocco, Italy, France, England, and the Netherlands, an experience that contributed to the ever-expanding richness of his palette. Colman also was a founding member of the dissident Society of American Artists, established in 1877 as an alternative to the increasingly conservative NAD and consisting of young, European-trained painters. The same year he began serious efforts as an etcher and joined the newly formed New York Etching Club.

A passionate collector of Asian art and artifacts, as well as an active participant in the politics of art and a progressive figure in the Aesthetic Movement, Colman expressed his strong interest in the decorative arts through his involvement with the interior design firm Associated Artists, which he founded with Louis Comfort Tiffany (cat. 137), Lockwood de Forest, and Candace Wheeler in 1879. Colman did not invest any money in the business, but rather was Tiffany's mentor and friend, and worked for him on a more or less independent basis. The firm collaborated on interior design projects including the redecoration of the White House in 1882 before the partnership dissolved in 1883. Colman, who was famous for his designs for wallpapers, fabrics, and ceiling papers, also participated in the decoration of the New York City interiors of the Seventh Regiment Armory (1879–80) and the Havemeyer mansion at 1 East Sixty-sixth Street, begun in 1888 by Charles Haight (demolished). He also decorated his own home in Newport, Rhode Island (1883), designed by McKim, Mead & White, which became a showcase for his ideas, and displayed his Asian art, along with Barbizon School paintings, in his

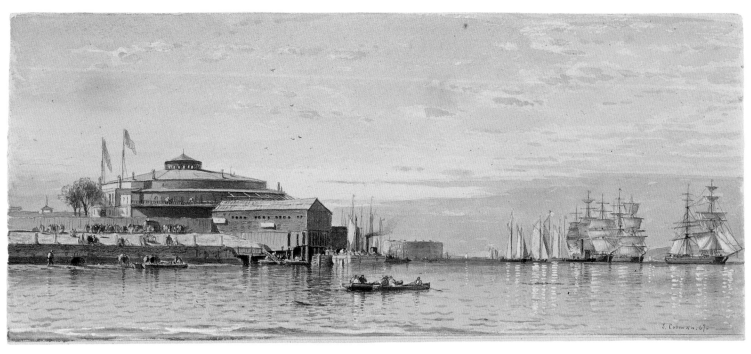

104

house on Central Park West. From the mid-1880s Colman made regular sketching trips through the American and Canadian West, producing vivid and atmospheric watercolors, a practice he continued until 1906. Although in 1882 he resigned from the NAD, apparently his resignation was not accepted and he exhibited there again in 1892, 1895, and 1896. By the early 1900s he had curtailed most of his artistic activities and in 1902 sold his large Asian collection at auction (more than 1,200 lots) to focus on writing theoretical treatises on art and aesthetics, such as *Nature's Harmonic Unity* (1912) and *Proportional Form* (1920).

Bibliography: Samuel Colman, *Nature's Harmonic Unity: A Treatise on Its Relation to Proportional Form*, ed. C. Arthur Coan (New York: G. P. Putnam's Sons, Knickerbocker Press, 1912); Samuel Colman and C. Arthur Coan, *Proportional Form: Further Studies in the Science of Beauty, Being Supplemental to Those Set Forth in "Nature's Harmonic Unity"* (New York: G. P. Putnam's Sons, Knickerbocker Press, 1920); Wilson H. Faude, "Associated Artists and the American Renaissance in the Decorative Arts," *Winterthur Portfolio* 10 (1975): 101–30; Wayne Craven, "Samuel Colman, 1832–1920: Rediscovered Painter of Far Away Places," *American Art Journal* 8:1 (1976): 16–37; Maribeth Flynn, "Art and Design: Samuel Colman and the Aesthetic Movement" (M.A. thesis, Hunter College, The City University of New York, 1999); Roberta A. Mayer and Carolyn K. Lane, "Disassociating the 'Associated Artists': The Early Business Ventures of Louis C. Tiffany,

Candace T. Wheeler, and Lockwood de Forest," *Studies in the Decorative Arts* 8:2 (2001): 2–36; Regina Soria et al., *Viaggiatori appassionati: Elihu Vedder e altri paesaggisti americani dell'Ottocento in Italia*, exh. cat. (San Gimignano: Galleria d'Arte Moderna e Contemporanea "Raffaele De Grada"; Rome: Museo Hendrik C. Andersen, 2002), 183; Dearinger 2004, 112–13.

104. *Castle Garden and the Bay of New York*, 1867

Watercolor and gouache over graphite on paper; 6 1/4 × 14 in. (159 × 356 mm)
Signed and dated at lower right in brown watercolor: *S. Colman. 67 –*
Provenance: Whitman W. Kenyon, Smithtown, N.Y.; Anderson Galleries, New York; David A. McCabe, Conn.; Berry-Hill Galleries, New York, 1983.
Bibliography: *Putnam's Magazine* 1 (May 1868): 645; *Putnam's Magazine* 1 (June 1868): 772; Anderson Galleries, New York, sale cat., 14–15 December 1926, lot 30, ill.; Craven 1976, 22 n. 16.
Thomas Jefferson Bryan Fund, 1983.3

This watercolor is related to Colman's larger oil painting *Castle Garden* that was exhibited at the NAD at its forty-third annual exhibition in 1868.[1] According to a critic writing in *Putnam's Magazine*, the oil was one of the main attractions of the exhibition.[2] The watercolor may have been a preliminary study for that untraced work

as its composition and style are very representative of Colman's work in oils at the time, including another oil in the Society's collection, a view of the Narrows and Fort Lafayette in New York Harbor, executed before the latter burned on 1 December 1868.[3] This painting belongs to a series depicting New York Harbor that Colman executed between 1865 and 1869, all of which show the influence of the English Romantic painter J. M. W. Turner.[4] Similarly, Colman's focus on light, atmosphere, and color in the present watercolor, coupled with the translucency of the medium, demonstrates his knowledge of Turner's watercolor technique and maritime settings. His heavy reliance on the graphite underdrawing, however, lends his work a more linear, tighter quality than is encountered in Turner's freer watercolors.

Before the 1860s, few professional American artists painted in watercolor, a medium used more frequently by amateurs and then generally thought to be inferior to oil pigments. After an exhibition of English art at the NAD in 1857 and another exhibit of watercolors by foreign artists in New York in 1865,[5] American artists, with Colman in the vanguard, began to realize the great potential of the medium. He became one of the founding members of the American Society of Painters in Water Colors on 5

December 1866, whose first exhibition was held jointly with the NAD winter show at the academy's new Venetian palace-style quarters. Coincidentally, this is the very year in which Colman executed the Society's watercolor showcasing his skill in the medium. It is tempting, therefore, to conclude that the Society's watercolor may have been included in this initial exhibition.[6] The members described their interest in the watercolor medium in a pamphlet published shortly thereafter in words that are apropos to the Society's watercolor:

> Of the advantages that water color painting in some respects possesses over oil, it may be well here to say a few words.... The masters of water color, however, maintain, with some reason, that for certain luminous qualities, for purity of tint and tone, for delicate gradation especially in skies and distance, their favorite style of painting has decided advantages over oil.[7]

The group's membership grew quickly, and the anonymous reviewer in the January 1868 issue of *Putnam's* noted the rise of watercolor as an important medium and recognized Colman's pivotal contribution: "Colman, who is President of the Society, has thrown himself heart and soul into the work and has produced a large number of watercolors, which for all that is admirable in the art, will bear comparison with the best of English work."[8] In the February issue of the same magazine, another unidentified critic wrote about the exhibition: "the palm of superiority must be adjudged to Mr. Samuel Colman, the President."[9]

Reviews of the 1868 NAD exhibition noted that in Colman's critically acclaimed oil of Castle Garden, the artist "painted the Castle as it looks to-day; its old-time shape almost lost in the modern additions and changes to which it has been subjected."[10] A critic previewing works for the upcoming exhibition in the May 1868 issue of *Putnam's* wrote about the oil, but his comments also are applicable to the watercolor:

> The subject is ... the Battery and Castle Garden, as seen from the water, with Governor's Island on the right. The shipping, the Battery grounds, the old "castle" with its peculiar architecture, and the fortifications ... present a rare combination of picturesque material, of which none of our artists could make better use than

Colman On the right, between the Battery and Castle William, lies a little fleet of shipping The Battery presents its usual scene of varied and busy life ... in combination with delicacy and refinement of detail ... [and] fills the spectator's mind with ideas of beauty and romance but rarely associated with the lower end of New York. We are glad to learn that this fine picture is intended to be the first of a series devoted to the more picturesque parts of our city, for which Colman has made a very large number of studies.[11]

Built between 1808 and 1811, the circular structure—one of seven forts proposed (only six were built) by Lieutenant Colonel Jonathan Miller for New York Harbor to protect it from a possible British attack during the Napoleonic era—was originally known as the West Battery. Constructed on an artificial island one hundred yards offshore, it was connected to Manhattan by a timber causeway. At the end of the War of 1812, the fort was named Castle Clinton in honor of DeWitt Clinton, former mayor of New York City and governor of New York State. Then, in June 1824, it was leased to the city as a place of public entertainment and opened as Castle Garden on 3 July of that year. It quickly became one of the favorite "places of resort" for concerts, fireworks, balloon ascensions, and demonstrations of the latest scientific instruments, even hosting the gala subscription ball in honor of the Marquis de Lafayette on 14 September of its opening year. In the 1840s the structure was roofed over and more serious entertainments were offered, such as operas and the 11 September 1850 American debut concert presented by P. T. Barnum of the "Swedish Nightingale," Jenny Lind. In 1855 Castle Garden, then under lease to the state of New York, was opened as an immigrant landing depot, where between 1855 and 1889 more than eight million immigrants entered the United States. This was its function when Colman painted it, which explains the wooden waterfront accretions he depicted.[12]

1. Naylor 1973, 1:177, no. 269. There is no record of the watercolor being exhibited in the newly formed American Society of Painters in Water Colors. According to Liza Kirwin in correspondence with David A. McCabe (1 November 1982), the work may have been exhibited at Samuel P. Avery's gallery. Avery was Colman's friend and a New York dealer

from 1864 through the 1870s. Unfortunately, Avery's catalogues from 1867 to 1870 do not list watercolors. For a background of watercolors in America, see Metropolitan Museum of Art, *Two Hundred Years of Watercolor Painting in America*, exh. cat. (New York: Metropolitan Museum of Art, 1966); Kathleen Adair Foster, "Makers of the American Watercolor Movement, 1860–1890," 2 vols. (Ph.D. diss., Yale University, 1983); and idem, "Ruskin, Turner, and the American Watercolor," in Ferber and Gerdts 1985, 79–107.

2. *Putnam's Magazine* 1 (June 1868): 772. The critic praises the painting's atmospheric effects and refers to Colman's sketches of many portions of the city.

3. Inv. no. 1976.2; see Koke 1982, 1:212–13, no. 365, ill.; and Craven 1976, figs. 10–12.

4. Craven 1976, 22. One of Colman's most Turneresque paintings is *Gibraltar from the Neutral Ground*, c. 1863–66 in the Wadsworth Atheneum, Hartford; see Kornhauser 1996, 1:250–51, no. 137, ill.

5. Susan P. Casteras, "The 1857–58 Exhibition of English Art in America and Critical Responses to Pre-Raphaelitism," in Ferber and Gerdts 1985, 109–33. See also Shelley 2002, 33–36; and Kathleen A. Foster, "Writing the History of American Watercolors and Drawings," in John Wilmerding et al., *American Art in the Princeton University Art Museum: Volume I, Drawings and Watercolors*, exh. cat. (Princeton: Princeton University Art Museum, 2004), 52–60, for additional comments about the history of the medium in the United States.

6. An anonymous critic writing in *Putnam's Magazine* 1 (January 1868): 131–32, noted: "The most striking Art feature of Fall and Winter is the great interest suddenly manifested by the New York public in water-colors Many of our readers will remember the impressions made by the fine collection in the East Room of the National Academy Building last Winter, —the first large collection of water-colors ever formed in this country Their qualities of tone and color were so admirable and attractive, that the oil-paintings in the exhibition were quite neglected in their favor."

7. Ralph Fabri, *History of the American Watercolor Society* (New York: American Watercolor Society, 1969), 14.

8. *Putnam's Magazine* 1 (January 1868): 132.

9. *Putnam's Magazine* 1 (February 1868): 257.

10. *National Academy of Design Exhibition of 1868* (New York: D. Appleton & Company, 1868), 79–80.

11. *Putnam's Magazine* 1 (May 1868): 645.

12. In 1896 the structure was converted into the New York Aquarium by the firm of McKim, Mead & White, its function until Robert Moses moved the aquarium in 1941. In 1950 the building was designated a national monument and was restored in 1970; see Kenneth T. Jackson, ed., *The Encyclopedia of New York City* (New Haven: Yale University Press; New York: New-York Historical Society, 1995), 189.

ROBERT KNOX SNEDEN

Annapolis Royal, Nova Scotia, Canada 1832–Bath, New York 1918

Before the discovery of his Civil War diaries in the 1990s, very little was known about the draftsman, cartographer, and architect Robert Knox Sneden. For many decades the artist was incorrectly identified by the N-YHS in its records and publications as Richard K. Sneden (taken from a Rockland County history published by W. S. Gilman in 1903, *Story of the Ferry*). With the publication in 2000 of *Eye of the Storm*, Sneden's historic Civil War memoir, much has been learned about this enigmatic and obsessive artist. The grandson of a loyalist who fled to Canada during the American Revolution, Sneden and his family moved to New York City from Nova Scotia about 1850. He soon began a career as an architect and engineer, producing drawings of the geography and landmarks of lower New York State. His earliest known watercolor is a view of his ancestral home, Sneden's Landing, dated 1858, in the Society's collection.

In 1861 Sneden enlisted as a quartermaster for the Fortieth New York Volunteers "Mozart Regiment" and in 1862 was assigned to the Third Army Corps in the Army of the Potomac as a topographical engineer and cartographer. During the next three years, he created over five

hundred maps, watercolors, and sketches and kept five volumes of notes that he later assembled into a comprehensive record of his experiences in the Civil War. Sneden participated in some of the war's most significant campaigns, including the Seven Days' Battle and the Second Battle of Bull Run, only to be captured by Mosby's Raiders in Virginia on 27 November 1863. He was incarcerated in a series of military prisons, culminating in a nearly seven-month stay in the notorious Andersonville camp. While on parole from Andersonville as an assistant to a Confederate surgeon, Sneden was freed in a prisoner exchange and returned to New York in fragile health on 26 December 1864.

After the war Sneden continued to work as an architect and engineer, for some years at the Wall Street firm of William B. Olmstead. Seven of his drawings of historical residences were engraved by the Heliographic Engraving Company for publication in the *Atlas of New York and Vicinity* (1868). Sneden's later works in the Society's collection depict subjects in Rockland and Westchester counties, the Bronx, and Maine, with annotations indicating that he probably lived near Monsey, New York, in the

1880s. Never marrying or documenting any details of his postwar life, Sneden labored single-mindedly on the Civil War memoir he never considered complete. The incessant researching and reworking of his diaries seemed to have absorbed all his time and attention. In 1905 Sneden retired to the State Sailors' and Soldiers' Home at Bath, New York.

Bibliography: F. W. Beers, ed., *Atlas of New York and Vicinity from Actual Surveys* (New York: Beers, Ellis & Soule, 1868), 73–75; Robert Knox Sneden, *Eye of the Storm*, ed. Charles F. Bryan Jr. and Nelson D. Lankford (New York: Free Press, 2000); Ken Ringle, "A Brush with History: Robert Sneden's Civil War Memoir Was as Unknown as Its Author; But Now It's a Different Story," *Washington Post*, 20 December 2000, sec. C, 1; Virginia Historical Society, Richmond, "The Sneden Civil War Collection," online exh. cat., 2002, http://www.vahistorical.org/sneden/index.html; Jessica Dawson, "A Soldier's Civil War Story," *Washington Post*, 20 March 2003, sec. C, 5.

Fig. 105.1. Robert Knox Sneden, *View of Glenerie Falls, Esopus Creek near Saugerties, New York*, 1859. Watercolor, black ink, selective glazing, graphite, and touches of gouache on heavy paper, squared for transfer, 6 1/8 × 9 3/8 in. (156 × 238 mm), irregular. The New-York Historical Society, Purchased by the Society, 1936.924

Sneden's Landing. opposite Dobb's Ferry. Hudson River NY. 1858.

105

105. *View of Sneden's Landing from Dobbs Ferry, New York*, 1858

Watercolor, black ink, graphite, scraping, and touches of gouache on heavy paper; 4 7/16 × 9 1/2 in. (113 × 241 mm), irregular
Signed at lower left outside image in black ink: *Sneden. del*; inscribed and dated at lower center outside image: *Sneden's Landing. opposite Dobb's Ferry. Hudson River NY. 1858.*
Bibliography: Koke 1982, 3:143, no. 2479, ill.
Purchased by the Society, 1936.923

Seen from Dobbs Ferry across the Hudson River, Sneden's Landing pier is dwarfed by the looming, magnificent cliffs of the Palisades. This region of Rockland County on the river at the foot of the Palisades has been known as Sneden's Landing since the mid-1700s. An ancestor of Robert Knox Sneden, Robert Sneden, married Mary Dobbs, the daughter of the owner of Dobbs Ferry on the Westchester side of the Hudson River, and by 1740 had built Sneden's Landing on the Rockland side to receive ferry trade across the river.[1] The masts on the ships that Sneden depicted sailing on the Hudson emphasize the renowned vertical geological structure of the majestic Palisade cliff face. These vertical striations are only slightly obscured at left by the inclusion of a vernal waterfall, one of many that commonly form in this region.

As evidence of his work as a printmaker, Sneden's watercolor of Glenerie Falls has a vignette border and has been squared for transfer (fig. 105.1), indicating that he planned to have it engraved, although no record of its publication has been found. He centered the cataract within an autumnal landscape of feathery trees and mountain scenery. Figures fishing and boating in the foreground provide a sense of scale for the sharply stepped rapids of the falls. Glenerie Falls is located on Esopus Creek in New York's Hudson Valley, a few miles south of the city of Saugerties in the region formerly known as the Village of Glenerie.[2]
A. M.

1. For Rockland County history, see Rockleigh Anniversary Committee, *50th Anniversary, Borough of Rockleigh, NJ: 1923–1973* (Rockleigh, N.J.: The Committee, 1974); and Wilfred Blanch Talman, *How Things Began in Rockland County and Places Nearby* (New City, N.Y.: Historical Society of Rockland County, 1977).
2. F. W. Beers, ed., *County Atlas of Ulster New York* (New York: Walker & Jewett, 1875), 32–33, 40–42.

THE CIVIL WAR DRAWINGS COLLECTION

The N-YHS collection encompasses a significant trove of nearly 140 sheets depicting a variety of eyewitness views chronicling events of the Civil War, both major and minor. The drawings were produced by professional artist-reporters and amateurs, including soldiers and civilian observers, for publication in the American pictorial press, primarily *Frank Leslie's Illustrated Newspaper*. These artists sent views of the war, fought mostly in Confederate territory, to Northerners avidly following its course from a distance. Before the development of action photography, the images provided visual evidence of the battles as well as bringing the intimate details of the daily lives of soldiers to a public eager for news of loved ones and of events. While some of the sheets were never engraved for publication, at least 31 made their initial appearances in *Frank Leslie's*, occasionally modified by the engraver or integrated into larger compositions.

In spite of continuing developments in photographic imaging during the 1860s, drawings dominated the publishing industry for technological as well as psychological reasons. Photographic equipment and processes were cumbersome and, because of the long exposure times, could record only static scenes. In addition, the images had to be developed immediately following each shot, a process that did not allow the capture of action images and curtailed spontaneity. Most significant, the technology necessary to transfer photographic images mechanically onto printing plates had not yet been invented, so photographs had to be converted into line drawings before engraving.

By contrast, drawings evoked the immediacy of battlefield action and life at the front and conveyed the movements of troops and the uncontrived experience of the field soldier. They also could be transferred rapidly to print blocks. Frank Leslie (born Henry Carter, 1821–1880), himself an artist and engraver as well as a publisher, developed a revolutionary assembly-line system in which a drawing was divided into sections for concurrent engraving by many separate engravers onto small wooden print blocks, which were then assembled to form the entire image. Drawings that would take more than a week for an individual to complete could be finished in a single day using Leslie's system of more than thirty engravers working on the same illustration. The ability to publish images

of an event within a week of its occurrence established *Frank Leslie's Illustrated Newspaper* as one of the preeminent periodicals of the Civil War era.

The importance of field drawings continued after the technological shortcomings of photography were resolved, particularly in reporting the events of war. The sensitivity of drawings conveyed the personal experience of battle more powerfully than stark and alienatingly graphic photographs. Artist-reporters continued to record events with drawings throughout the nineteenth and early twentieth centuries; an example is William Glackens's coverage of the Spanish-American War (cat. 133).

The core of the Society's Civil War drawings trove, around 110 sheets by *Frank Leslie's* often anonymous "Special Artists," was purchased in 1945 from the collector John T. Kavanaugh. Although Leslie only rarely credited his artists by name, some of the professional "Special Artists" employed by the newspaper and represented in the N-YHS collection have been identified. They include Henri Lovie, William T. Crane, E. B. Bensell, James Earl Taylor, Charles E. H. Bonwill, John F. E. Hillen (whose initials are often wrongly transcribed as "J. T. E." or "G. T. E."), Frederick B. Schell, Francis H. Schell, Philip F. Wharton, artist and author David Hunter "Porte Crayon" Strother, and illustrator Arthur Lumley. Other drawings were sent to Leslie by field soldiers who recorded their personal experiences, such as Lieutenant Henry Mehles. His three views in the N-YHS collection include a scene of the fortifications at Hilton Head and a plan of the gunboat ram *Indianola*. His style and proficiency suggest he had significant training as a draftsman, a proposition reinforced by his position of lieutenant in the First New York Engineers.

In addition to the Kavanaugh collection, the Society also possesses at least thirty related original graphic works of Civil War subjects, including drawings, paintings, and portraits by the artists Benson J. Lossing, Frances Flora Bond Palmer (cat. 78; fig. 78.1), Thomas Nast (cat. 115), John M. August Will, and by field soldiers. Outstanding among these works are three sketchbooks, one with studies of uniforms and humorous cartoons, another that includes scenes from the 1863 New York City draft riots, and a third by a soldier documenting his daily

experiences. The library's Department of Manuscripts also holds a rare manuscript containing sketches by a Confederate soldier imprisoned in 1864 at Point Lookout, Maryland.

Bibliography: Mrs. Frank Leslie, *Frank Leslie's Illustrated Famous Leaders and Battle Scenes of the Civil War* (New York: Mrs. Frank Leslie, 1894 and 1896); Philip Van Doren Stern, *They Were There: The Civil War in Action as Seen by Its Combat Artists* (New York: Crown Publishers, 1959); National Gallery of Art, *The Civil War: A Centennial Exhibition of Eyewitness Drawings* (Washington, D.C.: National Gallery of Art, Smithsonian Institution, 1961); Budd Leslie Gambee Jr., "Frank Leslie's Illustrated Newspaper, 1855–1860: Artistic and Technical Operations of a Pioneer Pictorial New Weekly in America" (Ph.D. diss., University of Michigan, Ann Arbor, 1963); Library of Congress, Prints & Photographs Online Catalogue, "Civil War Treasures from the New-York Historical Society," http://lcweb2.loc.gov/ammem/ndlpcoop/nhihtml/cwnyhshome.html.

Unidentified Civil War Artist*

106a. *Baxter's Philadelphia Fire Zouaves Being Reviewed by President Lincoln at the White House, Washington, D.C.*, 1861

Graphite on paper; 8 3/8 × 9 3/8 in. (213 × 238 mm)
Inscribed along lower edge in graphite: *The Philadelphia Fire Zouaves being reviewed / by President Lincoln–Wanslley– RN [or PM?]–*; verso inscribed at left vertically: *The Large Envelopes ar all used up.*
Provenance: John T. Kavanaugh Collection, Rutherford, N.J., 1945.
Bibliography: Stern 1959, 36, pl. 35.
James B. Wilbur Fund, 1945.580.38

In this drawing that was submitted to *Frank Leslie's* but never engraved, the Philadelphia Fire Zouaves, part of the Seventy-second Pennsylvania Volunteer Infantry, parade by President Lincoln in Washington, D.C., in early September 1861 for review following their initial enlistment. Lincoln can be seen towering above the crowd in front of the White House as the soldiers in their signature pantaloons and kepis marched past him for the reception of their regimental colors.[1] The mounted mustached officer visible behind Lincoln is probably regimental commander Colonel DeWitt Clinton Baxter. Sometimes called Baxter's Fire Zouaves, the California Brigade, or the Philadelphia Brigade, the division possessed the unusual honor of being under the direct authority of the president, who personally selected their assignments. The company experienced

106a

heavy losses at the battles of Antietam, Fredericksburg, and Chancellorville, before valiantly defending the Bloody Angle at Gettysburg during Pickett's charge. After returning to Philadelphia following the siege of Petersburg, the Fire Zouaves were disbanded on 12 August 1864.[2]

E. B. Hough

Nothing is known about the artist that *Frank Leslie's Illustrated Newspaper* credited as "E. B. Hough" on the engraving made from this drawing, published on 21 May 1864. He is not to be confused with Franklin Benjamin Hough, a physician and author who served as a Civil War regimental surgeon in 1862 in the Virginia

and Maryland campaigns, but was no longer enlisted in 1864.

106b. *"The Blockade of Mobile— Chasing a Blockade Runner at Night": Illustration for "Frank Leslie's Illustrated Newspaper" (21 May 1864)*; verso: quick sketch of same composition, 1864

Graphite on paper; 6 5/8 × 10 in. (168 × 254 mm), irregular
Verso inscribed at center in graphite: *Chasing a blockade runner / by the old 'Jackson' in Miss*[?] *Sound*
Provenance: John T. Kavanaugh Collection, Rutherford, N.J., 1945.
James B. Wilbur Fund, 1945.580.8

This drawing was initially engraved and published under the title *The Blockade of Mobile—Chasing a Blockade Runner at Night.—From a Sketch by E. B. Hough*, in *Frank Leslie's Illustrated Newspaper* on 21 May 1864.[3] In this nocturnal marine scene, Union naval officers stand watch on the deck of a steamship, tracking a Confederate blockade-runner with their scopes. The blockade of Mobile, Alabama, was part of the Union's Anaconda Plan to constrict the South economically and militarily by sealing off its commercial ports and harbors, thereby inhibiting both trade and transportation. Blockade runners, Confederate ships attempting to carry goods through the blockade, were often captured by Union ves-

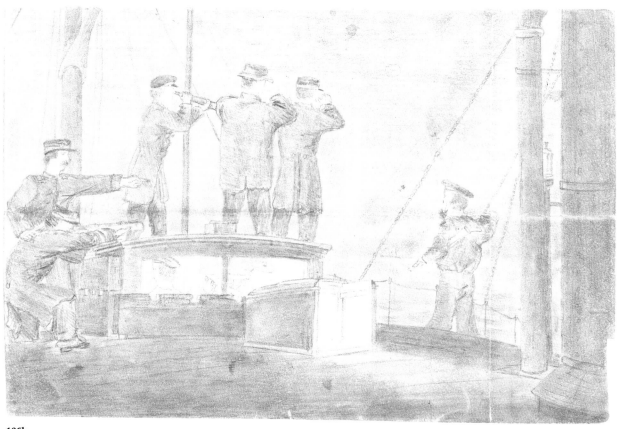

106b

sels. The blockade of Mobile ended on 5 August 1862 with the battle of Mobile Bay, in which a Union fleet led by Rear Admiral David Farragut captured the Confederate fleet, including the flagship CSS *Tennessee*, an event that closed Mobile Harbor for the duration of the war.[4]

In contrast to the serious, dispassionate reportage of Hough's drawing, a cartoon in the Civil War collection satirizes the extended military standoff between General McClellan's Army of the Potomac and Confederate General Beauregard's Army of the Shenandoah during the fall and winter of 1861 (fig. 106b.1). In this wry cartoon published in *Frank Leslie's* under the title *Masterly Inactivity or Six Months on the Potomac*,[5] the enthroned McClellan and Beauregard recline leisurely, observing each other across the Potomac through exaggerated telescopes as the troops encamped at their sides hurl stones in a parody of battle. Both generals, depicted here with attitudes of regal indifference, fancied themselves as latter-day Napoleons.[6] Following early Union losses, McClellan drilled his troops for several months without attempting any

Fig. 106b.1. Albert Berghaus, *Cartoon: "24 Weeks on the Potomac": Illustration for "Frank Leslie's Illustrated Newspaper" (1 February 1862)*, 1862. Black ink over graphite on ivory paper, 6 3/16 × 9 3/16 in. (157 × 233 mm). The New-York Historical Society, James B. Wilbur Fund, 1945.580.82

significant offensive action, while Beauregard took advantage of the respite from combat to assemble and train his army as well. McClellan ignored executive orders to advance until finally relieved of supreme command in March 1862, when he was ordered to lead the Army of the Potomac against Richmond, marking the beginning of the Peninsular Campaign.

Unidentified Civil War Artist*

This unidentified artist produced at least four works in the N-YHS Civil War collection that through style and handwriting can be attributed to the same individual (cat. 106c, inv. nos. 1945.580.61, 1945.580.80, and 1945.580.91).

106c. *President Abraham Lincoln's Coffin Lying in State at the White House, Washington, D.C.,* 1865

Graphite on paper; 7 3/8 × 9 11/16 in. (187 × 246 mm)
Inscribed at lower center in graphite: *President Lincolns Coffin*; various annotations about colors and flowers; verso inscribed at upper center in graphite: *Presidt Lincolns Coffin / Washington D.C. / at the White House*
Provenance: John T. Kavanaugh Collection, Rutherford, N.J., 1945.
James B. Wilbur Fund, 1945.580.44

Before his funeral train left for Illinois, President Lincoln's body lay in state at the White House and the Capitol Rotunda in Washington, D.C., 19–21 April 1865. This unpublished sheet contains a representation of his bier, austere in comparison with the ornate displays produced by some of the major cities along the funeral train route (cats. 106d and 106e). It consisted of a bed of pine boards covered in black broadcloth under a simple draped canopy. A modest arrangement of flowers was placed on the coffin above Lincoln's chest. In the eulogy delivered during Lincoln's funeral on 19 April, the Reverend Dr. Phineas D. Gurley expressed the shock and grief of the nation when he lamented: "It was a cruel, cruel hand, that dark hand of the assassin, which smote our honored, wise, and noble President, and filled the land with sorrow."[7] Gurley foretold the powerful influence the assassination would have on the national identity of the newly restored Union when he exclaimed:

> Though our beloved President is slain, our beloved country is saved. [His] grave will be a precious and a consecrated spot. The friends of Liberty and of the Union will

repair to it in years and ages to come, to pronounce the memory of its occupant blessed, and, gathering from his very ashes, and from the rehearsal of his deeds and virtues, fresh incentives to patriotism, they will there renew their vows of fidelity to their country.[8]

On the morning of 21 April, after a two-hour processional, Lincoln's coffin was borne to the train of dark-garlanded cars that carried him past mourners in eight states on the way to his final resting place in Springfield, Illinois.[9]

Unidentified Civil War Artist*

Although this artist has eluded identification, his style and handwriting indicate that he produced two of the anonymous Civil War works in the N-YHS collection, the significant pair of poignant views of President Lincoln's funeral services in Illinois.

106d. *President Abraham Lincoln Lying in State in the Chicago Courthouse, Illinois,* 1865

Graphite, Conté crayon, and pastel on ivory paper; 13 5/16 × 9 3/4 in. (338 × 248 mm), irregular
Inscribed at upper left in graphite: *Illinois*; numerous color and detail annotations; verso inscribed at upper center in graphite: *Lincoln / Lying in State in the / Court House / Chicago*
Provenance: John T. Kavanaugh Collection, Rutherford, N.J., 1945.
James B. Wilbur Fund, 1945.580.25

106e. *"The Funeral—Catafalque at Springfield, Illinois," President Abraham Lincoln's Funeral in the State Capitol: Illustration for "Frank Leslie's Illustrated Newspaper" (10 June 1865),* 1865

Graphite and black ink and wash on ivory paper; 9 5/8 × 13 in. (244 × 330 mm), irregular
Inscribed at upper right in graphite: *Used*; verso inscribed at upper right in graphite: *Presdt Lincoln's Funeral / Lying in State / in the Capitol Springfield*
Provenance: John T. Kavanaugh Collection, Rutherford, N.J., 1945.
James B. Wilbur Fund, 1945.580.51

Catalogue 106d depicts the magnificent catafalque built for Abraham Lincoln's funeral in Chicago, an imposing, ornate construction designed in the tradition of the sixteenth-century

Italian state funerals of the Florentine dukes. A bier surrounded by swags of black cloth, slanted to reveal the president's body clearly, rested under an opulently tasseled, gathered, and fringed canopy. This catafalque stood in the center of the courthouse rotunda directly under the dome, where it was estimated that more than 125,000 people passed by Lincoln's coffin. Catalogue 106e, published in *Frank Leslie's* under the title *The Funeral—Catafalque at Springfield, Illinois,*[10] depicts the massive catafalque built at the state capitol, a similarly elaborate structure with gold-trimmed black curtains at each corner of the canopy held up by columns and a platform that allowed mourners to stand beside the casket. It was placed in the Hall of Representatives, the room in which Lincoln had delivered his famous "House Divided" address in 1858. In both sheets, the grief-stricken crowds surrounding Lincoln's biers convey the anguish that must have moved the many thousands of citizens who attended the funerals.

Together these works record the two funeral services for President Lincoln in his home state of Illinois following his assassination on 14 April 1865. After leaving Washington, D.C., on 21 April, Lincoln's funeral train stopped at the cities of Baltimore, Philadelphia, New York, Albany, Columbus (Ohio), and Indianapolis as well as many smaller towns. It arrived in Chicago on 1 May for perhaps the grandest of the funerals held to express the national outpouring of grief. After a four-hour processional, the coffin was taken to Cook County Courthouse, where viewing began around 5:00 in the afternoon and continued through the night until 8:00 the next evening. A similar scene occurred at Springfield on 3 May, where mourners filed uninterrupted past Lincoln's majestic catafalque, from 10:00 in the morning until 10:00 the following morning.[11]
A. M.

* Cat. 106a: Unidentified Civil War Artist 23; cat. 106c: Unidentified Civil War Artist 27; cat. 106d, e: Unidentified Civil War Artist 12.

1. American Zouave units adopted the distinctive uniform of the French-Algerian Zouave troops, which were first organized in the 1830s and gained notoriety during the Crimean War (1854) for their ferocity. The American uniforms included brightly colored pantaloons and, in some regiments, red fezes; see Don Troiani, *Don Troiani's Regiments and Uniforms of the Civil War* (Mechanicsburg, Pa.: Stackpole Books, 2002), 61–65, 91–93. See

106c

106e

106d

also United States Army Pennsylvania Infantry
Regiment, 72nd, *Fiftieth Anniversary of Baxter's
Philadelphia Fire Zouaves 72nd Regiment Pennsylvania
Volunteers, August 10th 1861 to August 10th, 1911*
(Philadelphia: Bowers Printing, 1911), 1–16; and
Robin Smith, *American Civil War Zouaves* (Botley,
England: Osprey Publications, 1996), 4–64.

2. Frank H. Taylor, *Philadelphia in the Civil War, 1861–1865*
(The City of Philadelphia, 1913), 91–92.

3. *Frank Leslie's Illustrated Newspaper* 18:451 (21 May 1864):
141.

4. Bern Anderson, *By Sea and by River: A Naval History
of the Civil War* (New York: Alfred E. Knopf, 1962),
233–47.

5. *Frank Leslie's Illustrated Newspaper* 13:323 (1 February
1862): 176; the drawing is inscribed *24 Weeks on
the Potomac* but was published as *Six Months on
the Potomac*. The artist originally may have been

trying to emphasize the length of the duration by
chronicling it in weeks.

6. T. Harry Williams, *P. G. T. Beauregard: Napoleon in Gray*
(Baton Rouge: Louisiana State University Press,
1995); and Stephen W. Sears, *George B. McClellan: The
Young Napoleon* (New York: Da Capo Press, 1999).

7. Phineas D. Gurley et al., *Sermons Preached in Boston on
the Death of Abraham Lincoln. Together with the Funeral
Services in the East Room of the Executive Mansion at
Washington* (Boston: J. E. Tilton, 1865), 17.

8. Ibid., 26.

9. Dorothy Meserve Kunhardt and Philip B. Kunhardt
Jr., *Twenty Days: A Narrative in Text and Pictures of the
Assassination of Abraham Lincoln* (New York: Harper &
Row, 1965), 86–133; and Victor Searcher, *The Farewell
to Lincoln* (New York: Abingdon Press, 1965), 72–93.

10. *Frank Leslie's Illustrated Newspaper* 20:506 (10 June
1865): 488.

11. Scott D. Trostel, *The Lincoln Funeral Train: The Final
Journey and National Funeral for Abraham Lincoln*
(Fletcher, Ohio: Cam-Tech Publishing, 2002), 176–
98. See also Kunhardt and Kunhardt 1965, 232–86;
and Searcher 1965, 235–48.

GEORGE HENRY BOUGHTON

Near Norwich, England 1833–Campden Hill, London, England 1905

A noted landscape and genre painter in the United States and Europe and one of the first artists to explore the painterly possibilities of America's colonial past, George Henry Boughton specialized in scenes of England, Brittany, and the Netherlands. His family immigrated to the United States when he was three years old and settled in Albany, New York. Soon after their arrival, Boughton's parents died, and he was raised by his elder brother, in whose hat and fur business he began sketching and decorating hatboxes instead of focusing on commerce.

Self-taught, Boughton began to paint seriously about 1851, copying reproductions in the *Art Journal* and sketching in nature with three other aspiring artists: Homer Dodge Martin, Launt Thompson, and Edward Gay. The four soon joined Charles Calverly, Erastus Dow Palmer, and Asa Twitchell who met in Annesley's art store in Albany. Boughton initially gravitated toward landscape, exhibiting his first painting at the American Art-Union in 1852 and then two paintings at the NAD. After selling a painting to the Art-Union, he traveled to England and Scotland in 1856, returning to Albany the following year. Shortly thereafter, he moved to New York City, where he continued to exhibit and became a tenant at the famous Tenth Street Studio Building (1857–61). His first success, *Winter Twilight near Albany, New York* (1858; The N-YHS), was exhibited at the NAD and bought by Robert L. Stuart. Its sale enabled him to go to France, and by 1861 Boughton was living in Paris and studying with Édouard Frère and Édouard May, who taught him the methods of Thomas Couture (cat. 83). A year later Boughton set up a studio at 23 Newman Street in London, England, associating with a circle of American artists and focusing on American colonial themes for American patrons. Boughton's home soon became a gathering place for British and American artists and writers. His closest friend was Edwin Austin Abbey, an American expatriate artist who wholeheartedly adopted his new country. John Singer Sargent (cats. 124 and 125) and James McNeill Whistler were among other frequenters of the group. Boughton enjoyed success, and his later work was influenced by the Aesthetic Movement.

Except for short periods of travel, primarily in Brittany and the Netherlands, Boughton remained in England but continued to exhibit in the United States—at the NAD (1853–74), the Pennsylvania Academy of the Fine Arts in Philadelphia, and the Philadelphia Centennial Exposition (in the British section)—as well as in London at the British Institution and the Royal Academy of Arts (1860–1904). He also exhibited one easel painting at the World's Columbian Exposition in Chicago in 1893. Boughton was a member of the NAD (honorary, 1859–60; academician in 1871), the Royal Academy (associate in 1879, member in 1896), and the Tile Club (1877).

Later in his career Boughton specialized in detailed and somewhat sentimentalized historical subjects of eighteenth-century England and Knickerbocker New York. He provided illustrations for a British limited edition of Washington Irving's *Rip Van Winkle* (1893) and for an American edition of Nathaniel Hawthorne's *The Scarlet Letter* (1908). His most famous painting is *Pilgrims Going to Church (Early Puritans of New England Going to Church)* (1867; The N-YHS), which he exhibited at the Royal Academy in the year of its completion. This icon of America's Puritan past and Thanksgiving was eventually purchased by the important American collector Robert L. Stuart, who also owned the artist's early landscape *Winter Twilight near Albany, New York* and the watercolor discussed in this entry. To date there has been no systematic study of his life and art.

Bibliography: Alice Meynell, "An American A.R.A.," *Magazine of Art* 5 (1882): 397–401; Alfred Lys Baldry, *G. H. Boughton, R.A., His Life and Work: The Christmas Art Annual* (London: Art Journal, 1904), 1–32; Edward Morris, "Edwin Austin Abbey and His American Circle in England," *Apollo* 104:175 (1976): 220–21; William B. Becker, "The American Cliché Verre," *History of Photography* 3:1 (1979): 71–80; Hope B. Werness, "Vincent Van Gogh and a Lost Painting by G. H. Boughton," *Gazette des Beaux-Arts* 106 (September 1985): 71–75; Josefine Leistra, *George Henry Boughton's GOD SPEED! Pelgrims op weg naar Canterbury*, exh. cat. (Amsterdam: Rijksmuseum Vincent Van Gogh; Zwolle: Uitgeverij Waanders, 1987); Xander Van Eck, "Van Gogh and George Henry Boughton," *Burlington Magazine* 132:1049 (1990): 539–40; Carr and Gurney 1993, 210; Ronald de Leeuw, "George Henry Boughton and the 'Beautiful Picture' in Van Gogh's 1876 Sermon," *Van Gogh Museum Journal* 1 (1995): 48–61; Kornhauser 1996, 1:125–27; Dearinger 2004, 59–61.

107. *Normandy Girl Caught in a Shower*, c. 1861

Watercolor, gouache, black chalk, and graphite with selective glazing on paper, laid on panel; 13 5/8 × 9 3/4 in. (346 × 247 mm)
Signed at lower right in red gouache: *G.HB.*
Provenance: Robert L. Stuart, New York; Mrs. Robert L. Stuart, New York, 1882; The New York Public Library, 1892.
Bibliography: United States, Centennial Commission, *Official Catalogue: Department of Art* (Philadelphia: John R. Nagle and Co., 1876), 25, no. 287; Mrs. Robert Leighton Stuart, *Mrs. R. L. Stuart's Collection of Paintings* (New York: 961 Fifth Avenue, 1885), 37, no. 128; New York Public Library, *Catalogue of Paintings in the Picture Galleries* (New York: New York Public Library, Astor, Lenox and Tilden Foundations, 1941), 34, no. 241; Koke 1982, 1:75–76, no. 183, ill.
The Robert L. Stuart Collection, S-241

Robert Leighton Stuart began collecting in the early 1850s to establish himself among the city's cultural elite, express his patriotism, and assert moral and religious values.[1] His initial acquisitions and most of the works in his collection were by European artists, although he also fostered the work of aspiring American artists.[2] After the 1867 Exposition Universelle in Paris, where Stuart served on the selection jury for the American installation, his interest in European art intensified due to the indifferent response of critics to the American offerings.

The present watercolor was exhibited in the Centennial Exhibition in Philadelphia in 1876 as *Normandy Girl Caught in a Shower*, lent by Stuart who was no doubt drawn to it by the finesse of its execution and the prayer book clasped under the subject's arm.[3] In her 1885 catalogue of her husband's collection, Stuart's widow had changed the title to *Doorway Shelter*.[4] In this catalogue the work's original title has been restored.

The watercolor belongs to the type of peasant scenes tinged with allegory on which Boughton built his early reputation, such as *The Breton Pastoral*, which he exhibited at the NAD in 1867.[5] Its rustic young heroine combines a quaint European subject shown realistically with a dash of sentimentality, evoked by her distress over the momentary shower. These three accessible elements appealed to American collectors seeking the sophistication of European art with an easily understandable narrative rendered in a realistic style.[6] Boughton's stress on feminine grace and charm

107

and a high-key palette are typical of the period and are linked to similar traits in the art of Whistler.[7] In its seeming involvement with the purity and simplicity of country folk, it betrays the influence of the English Pre-Raphaelites and, more important, looks forward to the early works of the Post-Impressionists Vincent van Gogh and Paul Gauguin later in the century. Not surprisingly, Van Gogh was taken by Boughton's work and commented about it in letters. While Van Gogh was working for Goupil's art dealership in London and as a lay minister in England, he particularly admired the work of John Everett Millais and the French Barbizon painters, as well as lesser lights, such as

Boughton, who also painted a number of Dutch genre scenes. In a letter of August 1876 to his brother Theo, Van Gogh commented on Boughton's painting *God Speed! Pilgrims Setting Out for Canterbury* (1874; location unknown), which he saw when it was exhibited at the Royal Academy. Van Gogh repeated many of the same observations about Boughton's work, probably in reference to another painting, in one of his sermons around two years later. Boughton's gentle melancholy and poignancy made a tremendous impact on the young artist, who would transform his impressions of them into his own powerful statements that frequently depict peasants.[8]

1. See Paul Spencer Sternberger, "Wealth Judiciously Expended," *Journal of the History of Collections* 15:2 (2003): 229–40.
2. See also Stuart 1885.
3. *International Exhibition, 1876, Official Catalogue* (Philadelphia: J. R. Nagle and Co., 1876), does not list the art exhibited.
4. Stuart 1885, 37.
5. Naylor 1973, 1:80.
6. For this quest for sophistication, see Roberta J. M. Olson, "A Selection of European Paintings and Objects," *The Magazine Antiques* 167:1 (2005): 182–87.
7. Detroit Institute of Arts, *The Quest for Unity: American Art Between the World's Fairs, 1876–1893*, exh. cat. (Detroit: Detroit Institute of Arts, 1983), 89.
8. Werness 1985, 71–75; and Van Eck 1990, 539–40.

GEORGE HOLSTON

Highgate, England 1833–Mount Vernon, New York 1923

Immigrating to the United States in 1867, Holston became an American citizen shortly after the end of the Civil War. From 1868 to 1912 he lived and worked as an artist in New York City. After living at many addresses in the city, in 1912 he moved to Mount Vernon, New York, where he continued to paint professionally. The Society has in its collection thirteen of his watercolors that demonstrate Holston's training in the English watercolor tradition. They record local views and picturesque places in the boroughs of New York City (such as the Bronx River) as well as at sites in the states of New York and New Jersey, all exhibiting a pronounced interest in landscapes with water. There is little information about Holston's career. He neither exhibited at the Royal Academy of Arts in England nor at the NAD in New York, nor the Pennsylvania Academy of the Fine Arts in Philadelphia, although he is recorded as exhibiting once at the Boston Art Club. In 1881 Holston showed two watercolors there, both for sale: *Sketch at Tarrytown, NY* and *Flowers*.

Bibliography: Koke 1982, 2:152–54; Janice H. Chadbourne, Karl Gabosh, and Charles O. Vogel, *The Boston Art Club: Exhibition Record* (Madison, Conn.: Sound View Press, 1991), 217; Falk 1999, 2:1604.

108. *Beach at East Hampton, Long Island, New York*, c. 1879

Watercolor, gouache, and graphite on paper, laid on board; 7 3/4 × 14 7/16 in. (197 × 367 mm)
Signed at lower left in brown watercolor: *George Holston*
Provenance: Acquired from the son of the artist, William Holston, Weehawken, N.J.
Bibliography: Koke 1982, 2:153–54, no. 1263, ill.
Purchased by the Society, 1949.288

This seascape is the unique example in the collection to record the beautiful, broad Atlantic beaches of eastern Long Island. At the left, between the East Hampton dunes and the sea, is a temporary pavilion constructed of thatch that furnished shade from the intense summer sun. Several dinghies and anchors litter the beach. A group of people, some holding parasols, stands on the shore enjoying the cooling breezes while others brave the shallow waters. On the horizon several boats, including a steamship and a sailboat, glide out to sea as four seagulls hover overhead, trolling the beach in their timeless rhythm. With a high-toned palette, Holston has captured the bleaching effects of summer sunlight, revealing knowledge of current developments in the American watercolor tradition and those of the French Impressionists.

In 1949 the artist's family dated the watercolor to 1879,[1] which establishes an approximate

date for the sheet. Nevertheless, it demonstrates that in technique and subject matter Holston was working in advance of the most noted painter of scenes of Long Island and the Hamptons in the late nineteenth century, William Merritt Chase, Holston's slightly younger contemporary. Chase's oil painting *A Sunny Day at Shinnecock Bay* (c. 1892; private collection) resembles Holston's watercolor painted around thirteen years earlier.[2] Throughout his career Chase depicted the beaches of Long Island and in 1891 established his summer School of Art at Shinnecock near Southampton. While this is the only work known by Holston depicting the beaches of Long Island, it shows him engaged on subjects that prefigure those of Chase.

The years directly before 1877 marked a pivotal period in the New York art world with implications for the future, as in 1877 the NAD announced it would reopen its free classes the next season. This presented an immediate threat to the Art Students League, which was forced to charge tuition fees to cover its expenses. Lemuel E. Wilmarth, an influential instructor at the Art Students League who had left the NAD to form the league with his students in 1875, resigned that position in 1877 to move back to the NAD. That same year, because of the controversies surrounding the exhibition policies of the NAD

108

(a reluctance to give wall space to new exhibitors in favor of long-term members of the organization), a number of artists decided to form their own group, the Society of American Artists, which held its own exhibition the following year. This turmoil was played out against the exciting backdrop of the formation of major public art museums and collections: the Metropolitan Museum of Art in New York; the Museum of Fine Arts in Boston; and the Corcoran Gallery of Art in Washington, D.C., among others.[3] The year also marked the tenth anniversary of the American Watercolor Society, founded on 5 December 1866, when the mature society became a force in American art.[4] Strangely, Holston, who seems to have worked very independently, is not recorded in any of its membership lists.[5]

1. Koke 1982, 2:154.
2. See Ronald G. Pisano, *A Leading Spirit in American Art: William Merritt Chase, 1849–1916*, exh. cat. (Seattle: Henry Art Gallery, University of Washington, 1983), pl. 161. It is one of several similar beach scenes Chase painted that year. For Chase, see also Parrish Art Museum, *William Merritt Chase, 1849–1916: A Retrospective Exhibition*, exh. cat. (Southampton, N.Y.: Parrish Art Museum, 1957); Keith L. Bryant Jr., *William Merritt Chase: A Genteel Bohemian* (Columbia: University of Missouri Press, 1991); and D. Scott Atkinson and Nicolai Cikovsky Jr., *William Merritt Chase: Summers at Shinnecock, 1891–1902*, exh. cat. (Washington, D.C.: National Gallery of Art, 1987).
3. See Ronald G. Pisano, "New York in the 1870s," in Pisano 1983, 39–40.
4. For more on the role and development of watercolor in America, see Kathleen Adair Foster, "Makers of the American Watercolor Movement, 1860–1890" (Ph.D. diss., Yale University, 1982).
5. Ralph Fabri, *History of the American Watercolor Society* (New York: American Watercolor Society, 1969).

WILLIAM TROST RICHARDS
Philadelphia, Pennsylvania 1833–Newport, Rhode Island 1905

One of America's most prolific and talented landscapists and marine painters of the second half of the nineteenth century, William Trost Richards interrupted his secondary education to support his family. His formal education at the Central High School of Philadelphia ended with his father's death in 1847, forcing him, as the eldest son, to find work in a store. By 1859 Richards began work full-time as a designer and illustrator of ornamental metalwork for the lighting-fixture firm of Archer, Warner & Miskey & Co., which he continued until 1854 (although a part-time affiliation with the firm supplemented his income until 1858). During this period, which saw the blossoming of the native tradition of landscape painting, he studied draftsmanship and painting with Paul Weber, a German émigré artist working in Philadelphia who also taught William Stanley Haseltine and Thomas Moran. In 1852 Richards made his debut at the Pennsylvania Academy of the Fine Arts, where he exhibited a landscape, together with a subject drawn from John Bunyan's *The Pilgrim's Progress*. Richards also pursued other intellectual interests, such as participating in a debating and literary society, the Forensic and Literary Circle. In fact, a deep familiarity with American and English literature and poetry enriched Richards's response to landscape for his entire career.

As a young landscapist Richards looked to New York City, the center of the Hudson River School. A Wordsworthian lover of nature who worked close to observed reality, he made a seminal sketching trip up the Hudson River and visited the Crystal Palace Exhibition in New York City in 1853. The next year he took a studio with Alexander Lawrie above James Earle's gallery in Philadelphia's Chestnut Street and made two trips to New York, where in April he met the Hudson River School painters John Frederick Kensett (cat. 88), Frederic Edwin Church, and Samuel Colman (cat. 104). During his second trip in May he met Jasper Francis Cropsey (cats. 98 and 99), with whom he went on several sketching trips. In 1855–56 Richards toured Europe with Haseltine and Lawrie, spending several months in Düsseldorf, where he joined an American community of artists that included Emanuel Gottlieb Leutze and Albert Bierstadt (cat. 102). Finding contemporary landscape painting in Europe less inspiring than in his native country, he returned to Philadelphia in 1856 and married Anna Matlack, an aspiring

poet and a Quaker, with whom he settled in Germantown. The couple soon collaborated on manuscript volumes of her poems and his miniature vignette landscapes (one is in the Brooklyn Museum). The following year at the annual of the Pennsylvania Academy Richards exhibited both American and European landscape subjects that demonstrated his improved technical mastery and assimilation of the Hudson River School style and iconography.

Richards most likely read the first two volumes of John Ruskin's *Modern Painters* (London, 1843–46) during the 1850s, for about that time he began to show an interest in geological subjects and spent the summers sketching in the Catskills, Adirondacks, and the mountains of Pennsylvania. Striving for the fidelity to nature he had seen in Pre-Raphaelite painting in an exhibition of British art at the Pennsylvania Academy in 1858, Richards began to paint outdoors. In the 1860s he executed several highly detailed landscapes, such as *June Woods* (1864; The N-YHS), and botanical studies. Richards was successful in his goals, as Henry T. Tuckerman in his *Book of the Artists* (1867) mentions Richards's work as a model of Pre-Raphaelite literalness. He may have turned to Ruskin's ideas partly as a reaction to the sectional strife of the late 1850s, which led to the Civil War and eroded long-held assumptions of cultural unity that were fundamental to the notion of a national landscape.

In the spring of 1863 Richards was unanimously elected to membership in the Association for the Advancement of Truth in Art, the American Pre-Raphaelite organization consisting of the followers of Ruskin, and as an academician of the Pennsylvania Academy of the Fine Arts. In 1862 he had been named an honorary member of the NAD in New York (an academician in 1871). Richards made his second trip to Europe in 1866 looking for a market for his works and exhibited two paintings in the American department at the Exposition Universelle in Paris in 1867. After spending three months in the French capital, he traveled to Darmstadt, Germany, where with his family he lived near Paul Weber, and then toured in Italy and Switzerland. After a turbulent return voyage in December, an event that was said to encourage a latent interest in marine painting, Richards commemorated the crossing in *Mid Ocean* (1869;

location unknown). From 1868 to 1874 Richards summered on the Atlantic coast, an environment that reinforced his inclination for painting coastal topography; his works of this time have visual and stylistic parallels to the work of Francis A. Silva and Alfred Thomas Bricher that persisted for the remainder of his career. At first he treated these marine locations as meticulously as his woodland views, but eventually his technique became broader. From 1874 he exhibited with the American Society of Painters in Water Colors (the American Watercolor Society), of which he was a member, and from 1875 to 1884 he executed a large number of watercolors—both portfolio size and miniature "coupons"—for George Whitney, a friend and collector in Philadelphia. The Reverend Elias Lyman Magoon was another one of Richards's major patrons, who in 1880 made a gift of eighty-five watercolors to the Metropolitan Museum of Art.

Like his earlier trips to Europe, Richard's third sojourn was timed to coincide with the 1878 Exposition Universelle in Paris. The artist remained in England with his family until 1880, searching for fresh subject matter and new markets. Sketching scenes for increasingly dramatic and varied marine paintings, he also exhibited at the Royal Academy of Arts in London and sent back paintings and watercolors of the British coast for exhibition in the United States. During the winter he polished his reputation abroad, cultivating a network of English dealers and colleagues.

When he returned to the United States in 1881, he built a summerhouse called Graycliff on Conanicut Island near Newport, Rhode Island, overlooking Narragansett Bay, a locale that would contribute important subjects for his future repertoire. It afforded him ready access to the sea and made sketching outdoors in watercolor and oil convenient. He also purchased property—Oldmixon Farm in Chester County, Pennsylvania—where on sojourns between 1884 and 1889 he returned to landscape subjects. In these works he captured the rolling hills of the Brandywine Valley in elegiac paintings that celebrated agriculture and the seasons. Richards's interest in capturing natural light and reflections have been loosely associated with similar concerns of the Impressionists, but his handling of pigment is tighter and his palette more tonal. Only his oil sketches have an

109a

impressionistic freshness and luminosity.

The sudden death of his primary patron George Whitney in 1885 and the subsequent sale of his collection dealt the artist a major personal and professional blow. Nevertheless, he continued to paint and exhibit. The Pennsylvania Academy of the Fine Arts honored Richards with its Temple Prize Silver Medal in 1885, and his work was awarded a bronze medal at the 1889 Paris Exposition Universelle. In 1890 he moved permanently to Newport, traveling between there and Europe while actively painting landscapes and seascapes. In 1900, the year of Anna Richards's death, the federal government commandeered his Conanicut property for military purposes. For the last five years of his life based in Newport, Richards

remained productive and peripatetic. The year of his death, 1905, the Pennsylvania Academy awarded him its Gold Medal of Honor, crowning his career with great distinction.

Bibliography: Linda S. Ferber, *William Trost Richards, American Landscape and Marine Painter, 1833–1905*, exh. cat. (Brooklyn: Brooklyn Museum, 1973); idem, *William Trost Richards (1833–1905): American Landscape and Marine Painter* (New York: Garland Publishing, 1980); idem, *Tokens of Friendship: Miniature Watercolors by William T. Richards from the Richard and Gloria Manney Collection*, exh. cat. (New York: Metropolitan Museum of Art, 1982); idem, *"Never At Fault": The Drawings of William Trost Richards*, exh. cat. (Yonkers, N.Y.: Hudson River Museum, 1986); Debra J. Force and Linda S. Ferber, *William Trost Richards: Rediscovered Oils, Watercolors, and Drawings from the Artist's Family*, sale cat. (New York: Beacon Hill Fine Art, 1996); Linda S. Ferber, *Pastoral Interlude: William T. Richards in Chester County*, exh. cat. (Chadds Ford, Pa.: Brandywine River Museum, 2001); Linda S. Ferber and Caroline M. Welsh, *In Search of a National Landscape: William Trost Richards and the Artists' Adirondacks, 1850–1870*, exh. cat. (Blue Mountain Lake, N.Y.: Adirondack Museum, 2002); Carbone et al. 2006, 2:889–92.

109a. *Oval Vignette with a View of the Hudson River from West Point, New York*, c. 1853

Black ink and wash and graphite with scratching-out on heavy ivory paper; 7 1/4 × 9 7/8 in. (184 × 251 mm)
Signed at lower left of image in brown ink: *W.T. RICHARDS.*; inscribed at lower left of sheet: *From / West Point*
Provenance: Chemung County Historical Society, Elmira, N.Y.
Bibliography: Koke 1982, 3:91, no. 2394, ill.
Gift of the Chemung County Historical Society, 1975.36

Katerskill Falls.

Catskill Mountains.

New York.

109b

109b. *Oval Vignette View of Kaaterskill Falls, Catskill Mountains, New York,* c. 1853

Black ink and wash and graphite with scratching-out on heavy ivory paper; 10 × 7 3/8 in. (254 × 187 mm), irregular
Signed at lower center of image in brown ink: *WILLIAM. T. RICHARDS.*; inscribed at lower left of sheet: *Katerskill Falls. / Catskill Mountains. / New York.*; verso inscribed at upper right in brown ink: *Robert P. Smith / 17 Minor Street*
Provenance: Chemung County Historical Society, Elmira, N.Y.
Bibliography: Koke 1982, 3:91–92, no. 2395, ill.; Ferber 1986, 23, no. 8.
Gift of the Chemung County Historical Society, 1975.37

Both of these vignettes belong to the early phase of Richards's career, when already in 1850–51 he had rendered an oval vignette as the title page to an essay about solitary walks and worked with typical Hudson River School subject matter.[1] Vignettes were a feature of nineteenth-century illustration, and these two are linked to the artist's early work as an illustrator, a less-studied facet of his career. During this formative period, J. M. W. Turner's well-known oval vignettes from the 1830s, especially those in brown ink in the *Liber Studiorum*, were highly influential on Richards's work.[2] These two drawings relate to Richards's literary interests and his involvement in a project called "The Landscape Feeling of American Poets." Begun in 1853 and occupying him for a year, the series consisted of a selection of the most beautiful and characteristic landscape descriptions by American poets, for which Richards planned to render twelve or more illustrations that would emphasize poetic content over topographic accuracy. It was never published, and today only four of his vignettes for it have been identified. By his own admission, Richards drew his inspiration for these images from Thomas Cole (cats. 61 and 62) and Turner, as can be seen in his illustration of a passage from Edgar Allan Poe's "Dream Landscape" for the project that is indebted to Turner.[3]

In August 1853 Richards first visited New York, where he saw the exhibition *Industry of All Nations* in the Crystal Palace, which was erected on the site now occupied by the New York Public Library. From there, he traveled about one hundred miles up the Hudson River as far as the village of Catskill on the west bank. As so many

artists before him did, he kept a visual diary of his journey. He may have adapted one of these sketches for catalogue 109a that depicts the Hudson River from West Point. Included in his travels were those haunts well established during the early nineteenth century as mandatory in both tourists' and artists' picturesque itineraries. Cole, dead then only five years, had most dramatically recorded these scenes in many of his works. Richards acknowledged Cole's primary role as an interpreter of this region by making what he termed a "pilgrimage" to his home and grave at Catskill. From the village, Richards traveled inland west to Catskill Clove and Kaaterskill Falls (the site of cat. 109b), both near the Catskill Mountain House, the famed resort hotel located on South Mountain.[4] Dated drawings document Richards's presence in the vicinity for a week.

Catskill Clove, the scenic spot some two miles from the Catskill Mountain House in Greene County near the Hudson River, is a deep notch in the mountains with irregular rocks and woods; *clove* is an archaic term for "valley." A favorite sketching ground for artists, it provided Richards with subject matter for a variety of studies and was associated not only with the works of Cole but also with those of the writers Washington Irving and James Fenimore Cooper. In the 1800s the clove and falls were mandatory stops on the American grand tour and as familiar to world travelers as Niagara Falls.[5]

Kaaterskill Falls was one of the most dramatic waterfalls known at the time, consisting of two cascades that evoked the sublimity of nature. The first plummeted some 176 feet before a deep natural amphitheater of stratified rock, while the second cascaded down an additional 85 feet. Cole first painted the falls in 1825, and the success of his subsequent paintings of the subject encouraged other artists to produce oil paintings of the area.[6] Cole's drawing from about 1825–26 in the Detroit Institute of Arts was most likely executed in situ and was preparatory for the large horizontal view of the falls he painted for the steamboat *Albany* in 1827.[7] Because of its placement in a steamboat stateroom, it was probably the most influential of Cole's five known paintings of Kaaterskill Falls.[8] In his vignette of this cascade, Richards, like most artists including Cole, chose to depict the stunning natural wonder from the

foot of the lower falls looking up to the summit. Its dynamic oval format seems to expand and contract the irregular plunge of the water, creating an eccentric and expressive sublime composition populated with Lilliputian tourists climbing the cliffs. He exaggerated the curving geologic formations and rock stratigraphy to echo the vignette's oval shape so that it almost takes on characteristics of a fish-eye lens. The artist also executed *en plein air* a less manipulated rectangular composition in graphite featuring the falls (Museum of Fine Arts, Boston) that is dated 16 August 1853 and more than likely served as the springboard for this more illustrative vignette.[9]

1. In the William Trost Richards Papers, AAA; see Ferber 1986, 16–17, no. 1, ill. For other vignettes from the same decade, see Carol M. Osborne, "William Trost Richards Drawings at Stanford," *Drawing* 14:6 (1993): 122, figs. 2 and 3; and Avery et al. 2002, 259–60, no. 94, ill.

2. See Jan Piggott, *Turner's Vignettes,* exh. cat. (London: Tate Gallery, 1993). See also Andrew Wilton, *J. M. W. Turner: His Art and Life* (New York: Rizzoli, 1979). The *Liber Studiorum,* a series of seventy-one plates in etched outline and mezzotint, published between 1807 and 1819, was a critical corpus for Turner as a theoretician of painting. A portfolio of eight color lithographs after Turner, once owned by Richards himself, was given to the Stanford University Art Museum (now the Iris & B. Gerald Cantor Center for Visual Arts, Stanford University); see Osborne 1993, 122.

3. Inv. no. 72.32.14 in the Brooklyn Museum; see Ferber 1986, 26–27, no. 10, ill. Another surviving landscape for the project illustrates a passage from John Greenleaf Whittier's "Pictures" and is also in the Brooklyn Museum (inv. no. 72.32.15; ibid., 24–25, no. 9, ill.). A third, for "Metempsychosis of the Pine" by Bayard Taylor, is in the NAD (inv. no. 1982.2502); see Dita Amory et al., *Nature Observed, Nature Interpreted,* exh. cat. (New York: National Academy of Design with Cooper-Hewitt National Design Museum, Smithsonian Institution, 1995), 121–22, no. 63, ill. A fourth, for Henry Stoddard's "Castle in the Air," is in the Iris & B. Gerald Cantor Center for Visual Arts, Stanford University (see Osborne 1993, 122, fig. 2). For the entire project, see Ferber 1980, 24–29. Ferber 1986, 23, points out that on his honeymoon in 1856 Richards produced a manuscript volume of his wife's poetry with vignette illustrations in brown ink, some of which are even closer to Turner's *Liber Studiorum.* One of these is illustrated in Ferber 1980, fig. 169.

4. Kaaterskill appears variously as Catskill, Cauterskill, and Catterskill. The archaic Dutch word *Kaaterskill* derives from *Kaaters,* meaning "male wildcats," and *kill,* meaning "stream"; see Reverend Charles Rockwell, *The Catskill Mountains and the Region Around*

(New York: Taintor Brothers & Co., 1869), 265.

. See Myers 1987; and Raymond Beecher, *Kaaterskill Clove: Where Nature Met Art* (Hensonville, N.Y.: Black Dome Press, 2004). For a discussion of the falls as a tourist attraction, their treatment by artists as well as in mass-produced images, see Myers 1990, 1:207–14.

. See Myers 1987, 41–59, reproducing several works by Cole, Thomas Hilson, William Guy Wall (cat.

48), Gerlando Marsiglia, Thomas Doughty, William Henry Bartlett (cat. 71), Thomas Nast (cat. 115), and Jacob Ward.

. See ibid., pl. 13 and fig. 9 (courtesy of Vose Galleries, Boston), respectively. See also Kenneth John Myers, "Art and Commerce in Jacksonian America: The Steamboat *Albany* Collection," *Art Bulletin* 82:3 (2000): 503–28.

. Myers 1987, 46. For example, Jacob C. Ward's view of

1833 recalls Cole's composition, which he could have easily seen on the boat (ibid., pl. 18).

. Inv. no. 1973.247, in the M. & M. Karolik Collection; Ferber 1973, 45, no. 3; idem 1980, fig. 11, reproduces it but reads the date in the inscription as 1852, which Ferber later corrected in idem 1986, 23, no. 7, to 1853.

FRÉDÉRIC-AUGUSTE BARTHOLDI
Colmar, Alsace, France 1834–Paris, France 1904

Born in Alsace, when it was still part of France, Frédéric-Auguste Bartholdi first studied architecture with Eugène-Emmanuel Viollet-le-Duc and then painting with Ary Scheffer in Paris. Scheffer recognized his pupil's interest in sculpture and encouraged him to study with Jean-François Soitoux.

The precocious Bartholdi encountered success at an early age. After several commissions, in 1852, at eighteen, he exhibited at the Paris Salon for the first time (*The Good Samaritan*). That same year, his native city commissioned from him a grandiose sculpture of General Jean Rapp, who had served under Napoleon I. The first of many monumental works, it was shown at the Exposition Universelle of 1855 in Paris, garnering immediate fame and success for the young man. A trip to Egypt four years later furthered his infatuation with large-scale works. Impressed by the size of ancient Egyptian colossi, he conceived the idea for a gigantic sculptural lighthouse featuring a Nubian female for the entrance to the Suez Canal, but it was never executed. It was based on ancient reports of the Pharos of Alexandria and the Colossus of Rhodes, wonders of the Ancient World.

As early as 1865 Édouard de Laboulaye, a French politician and fervent advocate of Franco-American friendship, wished to celebrate the centennial of American independence with a suitable monument that France could give to the American people. Bartholdi enthusiastically endorsed Laboulaye's dream of commemorating the friendship forged during the American Revolution. Working for years through the Franco-American Union, together they raised

money for their project. Around this time, Bartholdi began thinking about a monumental statue for New York Harbor. In 1871 the sculptor made his first trip to the United States in hopes of interesting people in a public monument to commemorate the Franco-American friendship. While in America, he obtained two commissions: a statue of Lafayette for New York City (1873) and a relief for the Brattle Street Church in Boston (1874).

The plan for *Liberty Enlightening the World*, the official title of the Statue of Liberty, however, did not gain support until 1875, when fund-raising started in France. Between 1875 and 1886 the artist painstakingly developed the work from clay models to its final casting in metal. He collaborated with the engineer Gustave Eiffel, engineer of the eponymous tower, who devised the internal structural frame needed to construct a statue of such unprecedented scale. He designed the massive iron pylon and secondary skeletal framework that allow the statue's copper skin to move independently yet stand upright. The fascinating construction of the colossal work in Paris is documented by a great many photographs. By 1876 Bartholdi returned to America as a member of the French delegation to the Centennial Exhibition in Philadelphia, where the arm and torch of the Statue of Liberty were displayed. In 1878 he also exhibited a small-scale reproduction of the statue at the Exposition Universelle in Paris, where it enjoyed an immediate success. Meanwhile, fund-raising efforts took place on both sides of the Atlantic. By 1881 the French had raised $400,000 to realize the statue, but not until 1885 did the United

States raise the funds necessary to build the statue's base. Following its display in Paris, the statue was dismantled (350 pieces packed in 214 crates), shipped in parts, and reassembled on Bedloe's Island.

The monument *Liberty Enlightening the World* and the *Lion of Belfort* remain the artist's best-known works. Bartholdi was a member of the French Legion of Honor, to which he was named a commander in 1886.

Bibliography: Jacques Betz, *Bartholdi* (Paris: Éditions de Minuit, 1954); Andre Gschaedler, *True Light on the Statue of Liberty and Its Creator* (Narberth, Pa.: Livingston Publishing Company, 1966).

110. *Statue of Liberty, Bedloe's Island, New York City*, 1888

Watercolor over graphite on paper, overmatted; 3 5/16 × 4 13/16 in. (84 × 122 mm), image
Signed at lower left in brown ink: *Bartholdi*; mat inscribed and dated at lower right in brown ink: *A Madame Lumley / hommage respecteuse / Bartholdi / 1888*
Provenance: Mrs. Rossetta (Laubheim) Lumley, New York; Miss Elsie Lumley, Mamaroneck, N.Y.
Bibliography: Koke 1982, 1:28, no. 102, ill.
Abbott-Lenox Fund, 1972.24

Bartholdi's watercolor represents a view of his *Liberty Enlightening the World* in New York Harbor. The statue was presented to the United States in 1884 as a gift from the French nation, erected on Bedloe's Island (renamed Liberty Island in 1956), and dedicated by President Grover Cleveland on 28 October 1886.[1] The sculpture's massive base, with its stately granite pedestal articulated with fluted pilasters, was designed

110

by the architect Richard Morris Hunt. It consists of a mélange of ancient architectural features Hunt gleaned from many models, including an ancient coin preserving the Pharos of Alexandria.[2] Likewise, the statue itself has an eclectic series of prototypes ranging from the ancient world to contemporary France, all of which shed light on its complex, controversial meaning. Among these are statues of Roman goddesses, more specifically Libertas, the personification of liberty and freedom, and the designs for the 1852 competition for an ideal lighthouse held at the École des Beaux-Arts in Paris.[3]

The tallest metal sculpture ever constructed, *Liberty Enlightening the World* is believed to exceed the height of the Colossus of Rhodes, one of the Seven Wonders of the Ancient World. Statue and pedestal together measure 305 feet 1 inch (the

statue alone measures 151 feet 1 inch, its arm 42 feet, and its torch 21 feet). Reputedly forty persons can stand in the head and twelve in the torch. To help raise the necessary funds to finance the pedestal, the *Pedestal Fund Art Loan Exhibition* was organized at the NAD, then on Twenty-third Street, of rarely loaned treasures.[4] "The New Colossus," a poem written in 1883 by Emma Lazarus to raise money for its pedestal, was forgotten until it was rediscovered in a Manhattan bookstore, after which the text was inscribed on the plaque placed on its base in 1903. The statue on its granite pedestal stands inside the courtyard of the star-shaped walls of Fort Wood, which had been completed for the War of 1812. The United States Lighthouse Board had responsibility for the operation of the Statue of Liberty until 1901. On 15 October 1924

the statue and Fort Wood were declared a national monument by presidential decree. Later, in 1937, the territory of the monument was expanded to include all of Bedloe's Island.

This small watercolor, really a souvenir, is inscribed to Mrs. Rossetta (Laubheim) Lumley. She and her husband, Alexander, were friends of the Bartholdis. The Lumleys divided their time between Paris and New York, where they lived at 126 West Ninety-third Street.[5] Bartholdi executed a number of similar small views of his famous monument as remembrances or mementos, as demonstrated by two drawings that have surfaced in a commercial gallery in Paris and a third in a private collection.[6]

The Society also has in its collections two sketches of the arm and torch of the statue when displayed in New York City's Madison Square

Park for six years, beginning in 1876, to raise funds for the statue.[7]

1. See Frédéric-Auguste Bartholdi, *The Statue of Liberty Enlightening the World* (New York: New York Bound, 1984; reprint of original published in the *North American Review*, 1885); and Barry Moreno, *The Statue of Liberty Encyclopedia* (New York: Simon and Schuster, 2000).

2. See Marvin Trachtenberg, *The Statue of Liberty* (1976; New York: Viking Penguin, 1986), fig. 13.

3. See ibid.; and Albert Boime, "The Engendering of Moderate Politics: The Statue of Liberty," in *The Unveiling of the National Icons: A Plea for Patriotic Iconoclasm in a Nationalist Era* (Cambridge: Cambridge University Press, 1997), 82–135. Billed as a gift from the French nation to the people of New York, the statue was something of a diplomatic maneuver, a bid for trade advantage, and a celebration of democracy intending to sway internal French politics. It was also an instrument of French and American statecraft, intended to heighten interest in commerce and to call attention to French technology. It has been labeled an antimonarchical (against Napoleon III) and antislavery symbol. See also Wilton S. Dillon and Neil G. Kotler, eds., *The Statue of Liberty Revisited: Making a Universal Symbol* (Washington, D.C.: Smithsonian Institution Press, 1994).

4. See Maureen C. O'Brien, *European Paintings at the 1883 Pedestal Fund Art Loan Exhibition*, exh. cat. (Southampton, N.Y.: Parrish Art Museum, 1986) for a summary and bibliography.

5. Koke 1982, 1:28, notes that Alexander Lumley was the owner of a cloak business in New York City.

6. In 2002 the two were with the Galerie Hopkins Custot in Paris. The first, probably painted after 1886, measures 3 7/8 × 7 7/8 in.; it is signed at lower right *Bartholdi* and dedicated *A Melle Hitschl en souvenir de l'auteur*. The third in a private American collection measures 12 15/16 × 5 1/2 in. and is signed at the lower right *Bartholdi* and inscribed at the lower left *New York*.

7. The two drawings are by Samuel T. Shaw (inv. no. 1946.385; Koke 1982, 3:136, no. 2466) and Charles Magnus and Company (inv. no. X.509).

THOMAS HIRAM HOTCHKISS

Coxsackie, New York c. 1833–Taormina, Sicily, Italy 1869

Thomas Hotchkiss ranks among the most poetic of nineteenth-century American landscapists. A friend of Asher B. Durand (cats. 51–54), he first received recognition in the late 1850s for his landscapes painted in the mode of the Hudson River School. In 1860 he moved to Italy, where he was welcomed into the literary and artistic circles of the American expatriate community in Rome until his untimely death.

Born into a poor family in upstate New York, Hotchkiss as a youth worked in a brickyard, receiving no encouragement from his family in his artistic pursuits. Following his calling, he exhibited his first painting, a genre scene with children, in April 1853 at the Rochester studio of Henry Johnson Brent. In May 1855 he is recorded sketching at Palenville, a popular artists' colony near Catskill Clove, and began exhibiting at the NAD in 1856 with three Catskill Clove landscapes. For the first few years of his career he worked in the artistic circle of Durand, which included Daniel Huntington (cat. 87). His early works are nature studies made in the Catskill Mountains, such as essay figure 17 and his earliest dated painting, *Catskill Mountains, Shandaken, New York* (1856; The N-YHS). With its minutiae observed directly from nature, the latter painting reveals the influence of John Ruskin, the English artist and foremost critic of the time, whose writings Hotchkiss owned. From August through October 1856 he sketched at North Conway, New Hampshire, on the eastern flank of the White Mountains with colleagues such as Samuel Colman (cat. 104), while Durand sketched nearby in West Campton. The following year Hotchkiss worked at Catskill with either James McDougal Hart or William Hart and John William Hill (cats. 76 and 77), and the following summer with Durand. His work received excellent notices in the *Crayon* (1857), and he established a lasting relationship with Durand and his family, especially Lucy, Durand's daughter. Lucy (later Mrs. George Woodman), whom Hotchkiss termed the "good angel of my life," bequeathed most of Hotchkiss's work to the Society through her daughter Nora. In 1859 Hotchkiss was a tenant at the famous Tenth Street Studio Building in New York City and exhibited at the NAD, where he was elected an associate. After a sketching trip at Geneseo with Durand and James Suydam, in December 1859 the young artist sailed for Europe.

Hotchkiss reached London by February 1860, where he admired the work of J. M. W. Turner in the National Gallery and Ruskin's private collection; he especially was drawn to Turner's more broadly rendered watercolors. After a brief stop in Paris in the early spring, he arrived in Florence. There—in the smoke-filled room of the Caffè Michelangelo that since the 1850s had been the forum for a daily battle against prevailing academic trends—Hotchkiss, along with Charles Caryl Coleman, met Elihu Vedder, an American artist who had been living in Italy for three years. The artistic controversies discussed at the café revolved around technique as well as style and were inspired by the new currents of Gustave Courbet's Realism and painting *en plein air*. The group of Italian artists who frequented the café became known as the Macchiaioli because of their technique, based on spots (*macchie*) or broad splashes of color and exaggerated chiaroscuro. Their impressionistic style was decades in advance of French Impressionism and influenced Hotchkiss's development toward a broader application of pigment. During the Italian Risorgimento, the revolutionary movement for national unity, refugees from the Bourbon government in Naples and the papacy in Rome gravitated to the Caffè Michelangelo, as did foreign artists such as Edgar Degas and political refugees. In this environment Vedder and Hotchkiss quickly became friends, copying old master paintings and sketching in the countryside outside Florence near Fiesole. Vedder called Hotchkiss his "dearest and best-loved friend" and reminisced about the tall and asthenic artist in his *Digressions of V*:

He was a very tall, spare, delicate-looking man, who had evidently suffered in his youth for he had worked in a brickyard under a hard relative who was strongly opposed to his artistic tendencies, and had

… laid up … the germs of that malady [tuberculosis] which was ultimately to be the cause of his death. For he died young, and now lies in his neglected grave in the land which he loved so passionately and painted so lovingly.

Vedder characterized Hotchkiss's art at this time as "the pure product of Ruskin." Hotchkiss's choice of blue paper as a support for several watercolors from this period with views of picturesque hilltowns (essay fig. 18) indicates his awareness of this European drawing practice, in which artists used colored papers as a middle tone, developing the image by adding highlights and shadows. In June Hotchkiss visited the small walled Tuscan town of San Gimignano, northwest of Siena, where he depicted the Torre del Commune. This thirteenth-century brick tower in the main piazza once was one of more than fifty similar structures, of which only thirteen now stand. His scene is nearly identical to a darker-toned oil sketch that Vedder had executed two years earlier (1858; The Hyde Museum, Glens Falls, N.Y.), suggesting that Vedder may have shared some of his sketches with Hotchkiss before this trip. Hotchkiss continued sketching at Volterra in June and traveled to Switzerland in August, finally settling in Rome and renting a studio in the Palazzo Barberini. He took up Roman residence at a moment when American artists were beginning to study in Paris. Already by the late 1840s Italy had, in fact, lost some of its allure as a place to study painting, as American artists had begun to gravitate to the art academy in Düsseldorf, Germany.

Soon after his arrival in the Eternal City, Hotchkiss began sketching important monuments of ancient Rome and the Roman Campagna, focusing on them with an obsessive vehemence. He also took life-drawing classes and frequented the notorious Caffè Greco, a bohemian, artistic melting pot. While still based in Rome, during the summer of 1864 Hotchkiss began painting at Taormina, Sicily, once an important Greek colony in Magna Graecia. Subsequently, in the spring of 1865, he sent two paintings to the NAD exhibition. That summer, the restless Hotchkiss, already consumptive, traveled to Paris, and then in the fall to London, possibly with William Linnell, visiting the noted British landscape artist John Linnell at Redhill, Surrey. While in London he stayed with the Pre-Raphaelite painter Henry Wallis and also traveled to northern Wales.

After Vedder, now firmly established as a visionary artist, came back to Rome in late 1866, the two artists renewed their friendship, and in the summer of 1867 they embarked on a sketching trip. Then in September 1868 Hotchkiss returned to the United States, possibly with Vedder, where he visited Thomas Cole's (cats. 61 and 62) studio. In October he was back in Rome in poor health, when Sanford Robinson Gifford (cat. 100) visited him. Gifford wrote in his diary that he had found his friend "very weak from bleeding." Nevertheless, Hotchkiss traveled to Venice in January 1869, looking for "a little change of air," and then to the Tyrol. Journeying for the last time to Sicily— to fulfill a commission from W. S. Gurnee of Irvington, New York, to paint the spectacular ruins of the ancient Greek amphitheater at Taormina near Mount Etna on the Straits of Messina—Hotchkiss died on 19 August in the arms of his fellow artist John Rollin Tilton.

Attempts to contact Hotchkiss's brother and cousin failed. In the summer of 1870 John Durand, the son of Asher B., began corresponding with the American consul in Rome to remove Hotchkiss's effects to New York City. Because Durand handled the settlement of the artist's estate, many of Hotchkiss's studies came into the possession of the Durand family. They were subsequently given to the Society in 1932 by Asher B. Durand's granddaughter, Nora Durand Woodman. In March 1871, the year Italy was united as a country, the artist's other remaining effects in Rome were auctioned by order of the American consul, and many were acquired by American artists. On 9 December additional effects were auctioned by Johnston & Van Tassell in New York by order of the public administrator.

A cosmopolitan figure, Hotchkiss numbered important artists of many nationalities among his friends and patrons. Although chronically without funds and sometimes desperate, Hotchkiss was himself a sophisticated collector and connoisseur who bought Renaissance paintings by Luca Signorelli and Piero di Cosimo, including Piero's two hunting scene *spalliere* that were auctioned at the New York sale of his effects and eventually acquired by the Metropolitan Museum of Art. A complex and erudite person, Hotchkiss also owned many books and rare manuscripts during his residence in Italy.

At the time of his death Hotchkiss's studies of the amphitheater at Taormina had just reached maturity, but with the dispersal of his works, his artistic reputation was never established. However, his paintings had been admired not only by his fellow artists but also by several leading critics, among them James Jackson Jarves and Henry T. Tuckerman. Yet it was not until the exhibition of his work at the NAD in 1993 that his achievements were publicly recognized.

Most of Hotchkiss's known works are in the Society's collections: twelve oil paintings, twenty oil sketches on paper, and fifty-seven drawings and watercolors (as well as two sheets formerly attributed to him). The library holds two copies of the catalogue listing the artist's effects that were sold on 9 December 1871 at Johnston & Van Tassell, Auctioneers, New York (one of them annotated), four letters to Lucy Durand Woodman, the only photograph of the artist (in the company of Vedder), and several newspaper clippings with a mention of Hotchkiss (Hotchkiss Papers, Department of Manuscripts, The N-YHS). Two boxes of Hotchkiss's personal correspondence and papers were sent to the City of New York and have never been found.

Bibliography: Elihu Vedder, *The Degressions of V, Written for His Own Fun and That of His Friends by Elihu Vedder* (Boston and New York: Houghton Mifflin Co., 1910), 418; Barbara Novak, "Thomas H. Hotchkiss, an American in Italy," *Art in America* 50:4 (1962): 26–27; Barbara Novak O'Doherty, "Thomas H. Hotchkiss, an American in Italy," *Art Quarterly* 29:1 (1966): 2–28; Natalia Wright, "The Official Record of Thomas Hotchkiss' Death: Evidence for the Date of His Birth," *Art Quarterly* 30:3/4 (1967): 264–65; Theodore E. Stebbins Jr. et al., *The Lure of Italy: American Artists and the Italian Experience, 1760–1914,* exh. cat. (Boston: Museum of Fine Arts, in association with Harry N. Abrams, 1992), 273–75; Barbara Novak and Tracie Felker, *Dreams and Shadows: Thomas H. Hotchkiss in Nineteenth-Century Italy,* exh. cat. (New York: New-York Historical Society, in association with Universe Books, 1993); Regina Soria et al., *Viaggiatori appassionati: Elihu Vedder e altri paesaggisti americani dell'Ottocento in Italia,* exh. cat. (San Gimignano: Galleria d'Arte Moderna e Contemporanea "Raffaele De Grada"; Rome: Museo Hendrik C. Andersen, 2002), esp. 181–82.

111

111. *Ruins of the Claudian Aqueduct, Roman Campagna, Italy: Preparatory Drawing for "Roman Aqueduct,"* c. 1861–62

Graphite and gray wash on off-white paper, squared, numbered, and traced with a blunt instrument for transfer; verso rubbed with charcoal for transfer; 7 7/8 × 17 13/16 in. (200 × 453 mm)
Multiple color and number annotations, all in graphite save one in black ink; verso inscribed at upper left by two different hands in graphite: *T. H. Hotchkiss / Roman Campagna.*
Watermark: P M
Provenance: Estate of Thomas Hiram Hotchkiss; Asher B. Durand and family; Lucy Durand Woodman, Orange, N.J.
Bibliography: Novak and Felker 1993, 79–81, fig. 3, 127, no. 46.
INV. 14909

In a letter to Lucy Durand Woodman of 25 December 1862, Hotchkiss wrote: "The landscape of Italy is so very beautiful that I could almost wish to stay here forever."[1] In catalogue 111, Hotchkiss has captured the haunting loneliness of the vast places he revisited during his stay in Italy.

One of the most popular subjects for nineteenth-century landscape painters working in Rome was the picturesque Claudian Aqueduct that sprawled iconically across the Roman Campagna. The Roman emperor Caligula had

begun construction of the aqueduct, which was completed by his successor Claudius in A.D. 52. Although in ruin for centuries, more than ten miles of its arches still stretched across the Campagna in the nineteenth century, gracefully punctuating the rolling plain and serving as fodder for Romantic ruminations. Like other Roman ruins, it was a reminder of the impermanence of life and civilizations, and an example of the lost Arcadia.[2] In ancient times this feat of engineering carried water—using gravitational flow generated by small descents in the conduit to keep the water moving—from the Monti Tiburtini over thirty miles to the center of Rome. It was one of eleven principal systems that supplied the metropolis, guaranteeing a steady supply of water, one of the rights of Roman citizenship. This chain of arches was among several Roman monuments (the Colosseum, the Tor de' Schiavi, and the Arch of Titus were others) that intrigued Hotchkiss. His fascination dates from his first days in the Eternal City, and his investigations were facilitated by the two copies of a sixteenth-century guidebook he owned (*Le antichità della città di Roma*), both in the N-YHS library, one of which is inscribed *bought in Rome, Italy, by T. H. Hotchkiss, 1860.*[3]

Hotchkiss's drawing of the aqueduct, preparatory for his unfinished canvas *Roman*

Aqueduct (fig. 111.1), is squared for transfer and enlargement. The sheet's fascinating multiple inscriptions in the artist's crabbed handwriting concern measurements and color that reveal much about his working method for larger canvases. The drawing and its related canvas probably date about 1861–62 and are nearly identical to a canvas of the same dimensions painted by John Rollin Tilton (1862; Museum of Fine Arts, Boston).[4] In fact, the points of view of these three works are so close that they may have resulted from a joint sketching expedition in the Campagna. Hotchkiss's linear drawing preserves evidence for two methods of transfer in the studio: a grid system, which could also be used for enlargement; and rubbing the verso with charcoal and tracing the contours on the recto with a blunt instrument, to be used for transfer only. The sheet is one of only two surviving drawings with evidence of his transfer techniques.[5] Another related study of the Claudian Aqueduct in the collection—a closer view from the same viewpoint and hence with larger arches and more of the structure on the left delineated—in graphite and gray wash on blue paper also has incised marks for transfer.[6] The size of the aqueduct's arches and the inclusion of additional architectural elements at the left suggest Hotchkiss used the latter drawing to transfer this

Fig. 111.1. Thomas Hiram Hotchkiss, *Roman Aqueduct*, c. 1854–69. Oil on canvas, 16 1/8 × 32 in. (410 × 813 mm). The New-York Historical Society, Gift of Miss Nora Durand Woodman, 1932.38

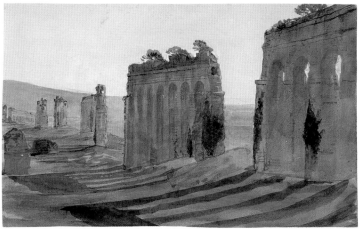

Fig. 111.2. Thomas Hiram Hotchkiss, *Section of the Claudian Aqueduct with Shadows, in the Roman Campagna, Italy*, c. 1861–62. Watercolor, gouache, and graphite, from a disassembled sketchbook, 5 × 7 3/4 in. (127 × 197 mm). The New-York Historical Society, Gift of Miss Nora Durand Woodman, X.443c

In the composition of catalogue 111 and its related canvas, Hotchkiss, like Tilton, may have been influenced by Cole's *Aqueduct near Rome* (1832; Washington University Art Gallery, St. Louis). At that time Cole's painting was in a private collection, but it was known through an engraving by James Smillie published by Tuckerman as the frontispiece of his *Italian Sketch Book* (1835).[11] However, Cole's realistic painting differs from the work by Hotchkiss as it focuses on the ruins themselves.

Hotchkiss's commitment to direct visual experience was related to contemporary trends in both France and Italy. Although he had no formal training in Paris, Hotchkiss created light-infused paintings that share some qualities with French oil sketches rendered *en plein air*. Moreover, his interest in painting outdoors links him not only to earlier French artists[12] but also to the contemporary French Barbizon painters, whose poetic landscapes became popular in the United States in the mid-1850s. Moreover, it is similar to the practices of the Macchiaioli, the group of Italian artists centered in Florence since the mid-1850s,[13] who produced small, brightly colored, and broadly painted realistic studies of their surroundings. Among them was Nino Costa, whom Hotchkiss could have met in either Florence or Rome. Costa's oil sketch of the Claudian Aqueduct in the Museum of Fine Arts, Boston is close to the Hotchkiss drawing discussed here and to the related unfinished canvas in its point of view, freedom of technique, and breadth.[14]

1. Hotchkiss Papers, Department of Manuscripts, The N-YHS.

2. William Vance, *America's Rome* (New Haven: Yale University Press, 1989), 1:45, points out that for American artists there was an "ambivalent attitude toward imperial power, its rise, its glories and terrors, and its fall."

3. Bernardo Gamucci, *Le antichità della città di Roma* (Venice: Appresso Giovanni Varisco & i compagni, 1569). Both copies from the estate were presented

part of the composition to the canvas, but he probably referred to both studies while painting.

Hotchkiss was one of many artists in the nineteenth century who sketched and painted the Claudian Aqueduct, the ruin on the Campagna most popular with American artists.[7] Unlike other artists, he did not paint his views to sell to tourists as souvenir *vedute* of a major Roman monument. Rather, he studied it obsessively for himself, rendering it from many angles and distances in at least four other limpid watercolors, which capture the mood of the place rather than focusing on the archaeological or architectural features. The artist's transparent, subtle washes suggest the light and mists of the evocative locale in a way that is almost precociously modern (fig. 111.2). Their reductive, dreamlike compositions and layering of brilliant color washes, influenced by Turner, make them

among his most experimental plein air studies.[8] In the majority of these watercolors Hotchkiss painted sections of the arcade embedded in the landscape with the Apennine Mountains in the background, although he uniquely studied the entire, seemingly infinite expanse of the structure on two sheets, once adjacent pages in a sketchbook; these can now be reunited to appreciate more fully Hotchkiss's brooding study of this icon of the ancient world. In this sweeping panoramic view of the aqueduct, Hotchkiss rendered the fleeting sensations of light and color in superimposed, transparent washes accented with a few touches of opaque gouache. He inscribed the empty landscape populated only by a flock of sheep at the right *afternoon Ju[?] 3rd / 61*, suggesting approximate dates for all of his watercolor studies.[9] The artist also executed at least one oil sketch on paper of the subject.[10]

by Nora Durand Woodman. Hotchkiss's fascination with aqueducts might date from his arrival on the Continent, as shown by two works in the Museum of Fine Arts, Boston: inv. nos. 20.857 (oil on paper), which looks like the Claudian Aqueduct; and 20.858 (watercolor and ink), dated 1860, which is executed in a more Ruskinian style and may depict a different aqueduct in a mountainous setting, as it lacks the entablature of the Claudian Aqueduct. Both have a provenance from Lucy Durand Woodman and were gifts of Mary Woodman. See Novak O'Doherty 1966, figs. 8 and 9, respectively.

4. Inv. no. 10.18, measuring 11 1/2 × 36 1/4 in.; Novak and Felker 1993, 79, fig. 2.

5. Novak and Felker (ibid., 81), states it is the only sheet with evidence of transfer techniques.

6. Inv. no. INV.14910, 8 3/4 × 17 1/4 in., irregular.

7. Among the numerous American artists who painted this magical landscape around the Claudian Aqueduct were Cole, George Loring Brown, Jasper Francis Cropsey (cats. 98 and 99), Gifford, Tilton, and George Inness; Novak and Felker 1993, 80. For additional American artists who painted some of the ancient monuments on which Hotchkiss focused, see Vance 1989, 1:68–105; Charles C. Eldredge, "Torre dei Schiavi: Monument and Metaphor," *Smithsonian Studies in American Art* 1:2 (1987): 15–33; and Lois Dinnerstein, "The Significance of the Colosseum in the First Century of American Art," *Arts Magazine* 58:10 (1984): 116–20.

8. The five watercolors are fig. 111.2, inv. nos. X.443d, X.443r, X.443b, and X.443e; see also Novak and Felker 1993, 80–83, figs. 4–8, 127, nos. 48–51, 129, no. 63. Koke 1982, 2:179, no. 1356, wrote on the collection of small watercolors, then bound into a sketchbook (inv. no. X.443). The covers still exist, although the artworks have since been rehoused.

9. Inv. nos. X.443b and X.443e; Novak and Felker 1993, 82–83, figs. 7 and 8.

10. Inv. no. 1932.198; ibid., 83, fig. 9, 123, no. 25.

11. Novak and Felker (ibid., 82–83 n. 2) points out that the engraving was also published in the *Token* (1837). For Cole's painting, see Vance 1989, 1: fig. 17.

12. See Peter Galassi, *Corot in Italy: Open-Air Painting and the Classical Tradition* (New Haven and London: Yale University Press, 1991); Philip Conisbee et al., *In the Light of Italy: Corot and Early Open-Air Painting*, exh. cat. (Washington, D.C.: National Gallery of Art, 1996); Christopher Riopelle and Xavier Bray, *A Brush with Nature: The Gere Collection of Landscape Oil Sketches*, exh. cat. (London: National Gallery Publications, 1999); and Anna Ottani Cavina, *Paysages d'Italie: Les Peintres de plein air (1780–1830)*, exh. cat. (Paris: Réunion des Musées Nationaux; Milan: Electa, 2001).

13. See Ettore Spalletti, *Gli anni del Caffè Michelangelo (1848–1861)* (Rome: De Luca Editore, 1985); Norma Broude, *The Macchiaioli: Italian Painters of the Nineteenth Century* (New Haven: Yale University Press, 1987); and, for a summary of the Macchiaioli,

their goals and accomplishments, and additional bibliography, Roberta J. M. Olson, *Ottocento: Romanticism and Revolution in 19th-Century Italian Painting*, exh. cat. (New York: American Federation of Arts; Florence: Centro Di, 1992), 26–30.

14. Inv. no. 04.1616, in oil on panel, 8 1/4 × 16 7/8 in.; see Anne-Paule Quinsac, *Ottocento Painting*, exh. cat. (Columbia, S.C.: Columbia Museum of Art, 1973), 66, no. 17, ill. For Costa, see Alessandro Marabottini, *Nino Costa* (Turin: Umberto Allemandi & C., 1990); and for his English associates, Sandra Berresford, Giuliano Matteucci, and Paul Nicholls, *Nino Costa ed i suoi amici inglesi*, exh. cat. (Milan: Circolo della Stampa, 1982).

Thomas Hiram Hotchkiss

112. *View of the Ruins of the Greek Theater at Taormina and Mount Etna, Sicily*, 1868

Oil and graphite on heavy paper, laid on Japanese paper, mounted onto a new wood panel; 12 3/16 × 16 1/2 in. (309 × 419 mm)
Verso inscribed (before conservation): *T.H. Hotchkiss / Sicily / Mt. Etna*
Provenance: Estate of Thomas Hiram Hotchkiss; Asher B. Durand and family; Lucy Durand Woodman, Orange, N.J.; Nora Durand Woodman
Bibliography: Koke 1982, 2:179–80, 1355a, ill.; Novak and Felker 1993, 106–7, fig. 4, 124, no. 31.
Gift of Nora Durand Woodman, 1932.210

Elihu Vedder, one of Hotchkiss's closest friends, singled out one of the artist's similar views from inside the amphitheater at Taormina for praise: "His view of Mount Etna is marvellous in its detailed accuracy; the eye seeking for it, can trace the tracks of every eruption ancient and modern—and yet with all this detail the vast space is filled in with a clear and delicate atmosphere."[1] Hotchkiss painted this view, one of the most spectacular in Sicily, a number of times.

Perched on the side of a mountain 850 feet above sea level, the theater, first built by Greek colonists of Magna Graecia and later modified by the Romans, was cut into a natural hollow of the hillside in such a way that the audience's gaze was directed from the seating area (*cavea*) through the stationary architectural backdrop (*scenae frons*) to the snowcapped peak of Mount Etna in the distance. The scene of sublime beauty was long a stop of artists, including Cole, whose monumental canvas *Mount Etna from Taormina, Sicily* (1843; Wadsworth Atheneum, Hartford, Conn.)[2] is close to all four of Hotchkiss's known views of the site (three of which are in the N-YHS). By Hotchkiss's

time this composition was fairly standard, albeit partially due to the physical limitations of the site.[3] Two of Hotchkiss's variations on the theme are panoramic in their expanse and dated to 1868: a plein air oil sketch on canvas laid on panel belonging to the Society, in which he painted the theater in shadow,[4] and a larger, even more panoramic view in oil in a private collection—which, most likely, given its size and finish, was painted in the studio.[5] Since Hotchkiss had been at Taormina in the summer of 1864 and had produced views of Etna,[6] it is possible that two undated works—catalogue 112 and a small unfinished oil painted on canvas and laid on panel also in the Society's collection[7]—could date either as early as 1864 or as late as his final trip.

Hotchkiss received at least one commission for a view from Taormina from W. S. Gurnee of Irvington, New York. In an undated letter to Lucy Durand Woodman from Venice (probably in 1869), Hotchkiss wrote: "Just before I left Rome I had an order from a Mr. Gurnee of New York to paint a picture of the Theatre at Taormina in Sicily and I shall go down there in August and stay until October or November."[8] It is not known whether Hotchkiss finished this painting, but evidence suggests he did not, as Gurnee, also a patron of Vedder, and William H. Herriman, an associate of J. P. Morgan and an American collector in Rome, were active bidders at Hotchkiss's estate auction, where Gurnee may have been seeking a version of the painting the artist had failed to complete.[9] It is known that Herriman subsequently owned a view of Taormina by Hotchkiss,[10] presumably acquired at the posthumous auction of the artist's effects. Yewell wrote Vedder a year after Hotchkiss's death saying that he had seen the artist's last studies made at Taormina in the American consul's office in Rome, probably right before the auction.[11] Subsequently Yewell, who expressed his admiration for these oil sketches, considering them the finest of Hotchkiss's work, acquired *Ruins of Greek Theater* (University of Iowa Museum of Art, Iowa City). It is more finished than the present work, and Hotchkiss painted it from a location farther to the right inside the theater.[12] Alternatively, Yewell may have purchased it at the New York auction of Hotchkiss's material, as an annotated copy of the auction catalogue lists him as a successful bidder.[13]

Hotchkiss executed this oil sketch with higher tonalities than he used in his other

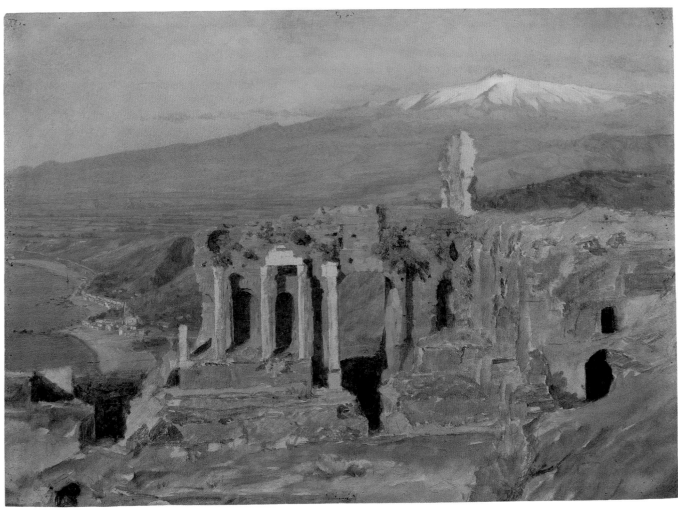

112

versions of the subject because he painted it near midday, stressing the bleaching effects of the Mediterranean sun. The others he painted in the late afternoon, filling them with dark shadows. For this work Hotchkiss also employed a less horizontal format and focused on the right section of the *scenae frons* with its white marble columns. In blocking in the composition, he diluted his oil pigments so that they functioned like watercolors; his graphite underdrawing can be seen through the fluid, transparent oil washes. In this unique view, Hotchkiss painted Mount Etna without steam issuing from the volcano, whereas two of his three more horizontal works of the subject that feature the volcano show steam rising from its cone, as in Cole's painting. The paper support has multiple pinholes, suggesting that Hotchkiss worked on

this spontaneous plein air sketch, assuredly one of his finest, during several sittings.

Friends and contemporaries generally acknowledged that Hotchkiss had done his best work at this pilgrimage stop for tourists.[14] Shortly after Hotchkiss died, the critic James Jackson Jarves wrote: "Death has recently robbed the country of perhaps its most promising landscapist, Hotchkiss, who had settled in Rome. He had rare native gifts … . He lived so absorbed in his work that but few individuals ever had an opportunity to know his rare ability, and died just as it was maturing to a point that would have placed him at the very head of the American landscapists."[15]

1. Vedder 1910, 429. For Vedder, see Regina Soria, *Elihu Vedder: American Visionary Artist in Rome* (Rutherford, N.J.: Fairleigh Dickinson University Press, 1970);

and Joshua Taylor et al., *Perceptions and Evocations: The Art of Elihu Vedder*, exh. cat. (Washington, D.C.: Published for the National Collection of Fine Arts by the Smithsonian Institution Press, 1979).

2. See Kornhauser 1996, 1:243–46, no. 134, ill. Ellwood C. Parry III, *The Art of Thomas Cole: Ambition and Imagination* (Newark: University of Delaware Press, 1988), 292, suggests Cole's composition was derived from an 1823 engraving after a work by the English watercolorist Peter De Wint.

3. Novak and Felker 1993, 106, points out that Sanford Robinson Gifford's sketchbook in the Brooklyn Museum from 1868 features a nearly identical arrangement. See Ila S. Weiss, *Poetic Landscape: The Art and Experience of Sanford R. Gifford* (Newark: University of Delaware Press; London: Associated University Presses, 1987), 117, ill.

4. Inv. no. 1932.45, 4 11/16 × 10 5/16 in.; see Novak and Felker 1993, 105, fig. 2, 121, no. 11.

5. 15 3/4 × 30 3/4 in.; ibid., 7, fig. 1 (color), 104, fig. 1.

6. See ibid., 108 n. 4, quoting the *New York Evening Post*, which reported in "Affairs in Rome: The Painters," on 6 January 1865, that "Hotchkiss has made a visit to Sicily the past summer, and has brought back the most charming studies from the neighborhood of Etna I have ever seen." George Yewell also recorded in his diary of 3 December 1867 that Hotchkiss showed him Sicilian views and studies of Etna from Taormina; Novak also posits another trip in 1867.

7. Inv. no. 1932.41, 12 1/8 × 16 1/2 in.; Novak and Felker 1993, 106, fig. 3, 121, no. 7.

8. Hotchkiss Papers, Department of Manuscripts, The N-YHS.

9. Carrie Vedder to her sister, 19 March 1871, Elihu Vedder Papers, AAA, reel 516, frames 512–14.

10. Novak and Felker 1993, 109 n. 11.

11. Elihu Vedder Papers, AAA, reel 516, frames 356–58.

12. Inv. no. X1971.1, in oil on canvas, 16 3/4 × 22 1/2 in.

13. Novak and Felker 1993, 109 n. 13.

14. See n. 1 above; and [David] Maitland Armstrong, *Day before Yesterday: Reminiscences of a Varied Life* (New York: Charles Scribner's Sons, 1920), 189: "Some of his finest work was done at Taormina, where a favorite subject was that most beautiful ruin in the world, the Greek Theatre."

15. James Jackson Jarves, "Art-Museums, Amateurs and Artists in America," *Art-Journal* 9:5 (1870): 130.

ROSWELL H. GRAVES JR.

American, active 1836–73

Little is known about the personal life of Roswell H. Graves Jr., who worked as a civil engineer and city surveyor in New York City and neighboring Brooklyn as early as 1836. From 1841 to 1850 he was a surveyor in the New York Street Commissioner's Department. Landscape architecture did not then exist as a separate profession, and evidently Graves, like other civil engineers of his day, took an interest in the design of city parks. He was hired by the City of New York in 1853 to make surveys of Central Park, then in its initial stages of development. In June 1856 he was appointed consulting engineer and landscape designer to the park, apparently working under the direction of Egbert L. Viele. When the commissioners of Central Park staged a public competition in 1858 for a comprehensive plan to develop the park, Graves entered an elaborate scheme. His plan was designated number 25, and four watercolors by him in the Society's collection were among thirteen such views he submitted as part of his unsuccessful entry.

Although the competition for the park was won by Frederick Law Olmsted and Calvert Vaux, Graves continued to practice his profession until 1873. He is sometimes listed as Rosewill Graves in directories in both New York City and Brooklyn.

Bibliography: Koke 1982, 2:73–74.

113a. *Submission Illustration for the Central Park Competition: View from the Site of the Principal Entrance on Fifty-ninth Street, Looking Northerly, New York City*, 1857

Brown ink and wash, graphite, and touches of white lead pigment on heavy paper, mounted on green paper; 10 3/4 × 14 7/8 in. (273 × 378 mm)
Mount inscribed and dated below in brown wash: *View from the site of the principal Entrance on 59th. Street. (1857.) / — looking Northerly.*; at upper left in graphite: *No. 1.*; at lower left: *No 6.A. / Catalogue letter "I"*
Provenance: Descent through the artist's family; Mrs. Yvonne S. Graves, New York.
Bibliography: New York City, Board of Commissioners of the Central Park, "Catalogue of Plans for the Improvement of the Central Park," *Descriptions of Designs for the Improvement of Central Park* (New York, 1858), 5 (Table of Contents), no. 25, I; Koke 1982, 2:74, no. 1111, ill.; Morrison H. Heckscher, "Creating Central Park," *Metropolitan Museum of Art Bulletin* 65:3 (2008): 22, fig. 18.
Purchased by the Society, 1925.158

113b. *Submission Illustration for the Central Park Competition: View from the Site of the Principal Entrance on Fifty-ninth Street, Looking Northerly— Illustrating Improvements, New York City*, 1857

Brown ink and wash and graphite on heavy paper, mounted on green paper; 10 7/8 × 14 7/8 in. (276 × 378 mm)
Mount inscribed below in brown wash: *Landscape from same point—illustrating improvements.*; at upper left in graphite: *No. 1*; at lower left: *Catalogue letter "K"*
Provenance: Descent through the artist's family; Mrs. Yvonne S. Graves, New York.
Bibliography: Board of Commissioners of the Central Park 1858, 5, no. 25, K (Table of Contents); Koke 1982, 2:74, no. 1112; Heckscher 2008, 22, fig. 19.
Purchased by the Society, 1925.188

Central Park was the first landscaped public park in the United States. Advocates for creating the park—primarily wealthy merchants and landowners—admired the public grounds of London and Paris and argued that New York City needed a comparable facility to establish its international reputation. A public park, they also reasoned, would offer their own families an attractive setting for carriage rides and provide working-class New Yorkers with a healthy alternative to the saloon. After three years of debate over site and cost, in 1853 the state legislature authorized the city to use the power of eminent domain to acquire more than 700 acres of land in the center of Manhattan. An irregular terrain of swamps and bluffs, punctuated by rocky outcroppings, made the land between Fifth and Eighth avenues and 59th and 106th streets undesirable for private development. Creating the park, however, required displacing roughly 1,600 poor residents—including Irish pig farmers and German gardeners who lived in shanties on the site and at Eighth Avenue and 82nd Street, Seneca Village, founded about 1825 and one of the city's most stable African American settlements, boasting three churches and a school. The extension of the boundaries to 110th Street in 1863 brought the park to its current 843 acres.

On 13 October 1857, just two weeks after the park dwellers left their homes, the Board of Commissioners of the Central Park held the country's first landscape design contest and offered prizes for the four best proposals for "laying out the park." Although the commissioners had hoped to attract European experts in landscape design, all but two of the competitors

View from the site of the principal Entrance on 59th Street. (1857.)
— looking Northerly.

113a

Landscape from same point — illustrating improvements.

113b

who can be identified were Americans. At least half of them were New Yorkers, including Roswell Graves Jr. The surviving verbal descriptions demonstrate that the contestants recognized common problems with the site and, in many cases, offered similar practical and aesthetic solutions.[1] Most entries embraced the logic of ordering the park—particularly its drives and lakes—in conformity with the natural topography, as seen in the drawings by Graves, whose transformations work with the preexisting landscape features. Virtually all the designers recommended that the area north of the existing receiving reservoir and the planned new park be naturalistically treated with scenic carriage drives and walks generally following the contours identified by Egbert Viele in his topographical survey and first plan. First prize went to plan number 33, the "Greensward" plan, submitted by the park's superintendent Frederick Law Olmsted and the English-born architect Calvert Vaux, who had been the former partner of the popular landscape gardener Alexander Jackson Downing. The designers sought to create a pastoral design in the English Romantic tradition. This decision would later be hailed as a landmark in the history of landscape architecture.[2]

Graves was an engineer on the staff of the Parks Commission. Although his competition plan does not survive, four of thirteen watercolor views from his submission are in the Society's collection. They consist of two pairs showing the existing conditions of two key locations in 1857 and what they might look like with "improved" landscape design. These "before" and "after" drawings owe their conception to the eighteenth- and early-nineteenth-century English garden design tradition of William Kent, Lancelot "Capability" Brown, and Humphrey Repton. The other pair, not discussed here, features a view looking west across what is now Central Park from the northeast corner of Sixth Avenue and 105th Street; its improved pastoral view entails even more manipulation of the natural landscape, with the creation of an artificial river, replete with a bridge, a classical herm, meandering paths, and garden architecture.[3]

The "before" view of the pair, catalogue 113a, shows a rather desolate and abandoned scene: a flat and unkempt (note the tree stump) undulating field with the Yorkville Reservoir in the distance. By contrast, the "after," improved view, catalogue 113b, has tamed the wild area with plantings of trees and bushes enlivened by winding but manicured paths.[4] It more closely embodies the spirit of Central Park, as realized, than does the fanciful "after" view of the other pair.[5]

Much of Graves's verbal description of his proposal considers its practical, structural, and functional aspects, from roads and irrigation to architecture, bridges, bridle and footpaths, iron railings, and lighting. Yet he also includes such decorative and aesthetic features as a labyrinth:

> The proposition … seems to call for a practical development of taste and treatment, rather than an illustrated ideality, or general plan of procedure … . But few foot-paths are laid down, because I prefer first accommodating the interiors to the proper support of grouping and growth of trees, and leaving the route for the foot-paths a secondary matter. They cannot be chosen, and permanently graveled, &, until the trees are planted, and cared for, at the best;—therefore, we lose nothing by deferring their exact location for the present … . Much good judgment is exhibited in treating Parks, by seeking rather for young and thrifty trees, than in doctoring old ones. In the *Bois de Boulogne* there are but few trees above 30 feet high.[6]

1. For a verbal description of Graves's plan, see Board of Commissioners of the Central Park 1858, 1–42. His estimated cost for the proposal was $1,487,147.

2. For the complex history of the competition and additional bibliography, see Roy Rosenzweig and Elizabeth Blackmar, *The Park and the People: A History of Central Park* (Ithaca, N.Y.: Cornell University Press, 1976), 95–120, and Heckscher 2008, 7–75.

3. Inv. nos. 1925.159 and 1925.189; see Koke 1982, 2:73, nos. 1109, ill., 1110 (ill. in Rosenzweig and Blackmar 1976, 113).

4. Both were exhibited in *Central Park: A Sesquicentennial Celebration*, at the Metropolitan Museum of Art in 2003, without a catalogue.

5. For Central Park, see especially Rosenzweig and Blackmar 1976; Eugene Kinkead, *Central Park, 1857–1995: The Birth, Decline, and Renewal of a National Treasure* (New York: W. W. Norton & Company, 1990); and Sara Cedar Miller, *Central Park: An American Masterpiece* (New York: Harry N. Abrams, in association with the Central Park Conservancy, 2003).

6. Board of Commissioners of the Central Park 1858, 14, 17, 27.

SILHOUETTES IN THE NEW-YORK HISTORICAL SOCIETY COLLECTION

Included in the collections of the New-York Historical Society are more than 360 silhouettes that date from the eighteenth through the twenty-first centuries. The art of black, profile, cut-paper portraits, originally referred to as "shades," "shadows," and "shadow portraits," developed in Europe in part from the miniature portrait and folk paper-cutting traditions. The art form gained acceptance during the eighteenth century, particularly in Britain and France, due in some degree to its resemblance to classical Greek black figure vase painting and carved cameos. The term *silhouette* was derived from the name of the finance minister to Louis XV of France, Étienne de Silhouette, whose economic policies made him despised by both the aristocracy and peasantry. After he was forced out of office, "à la Silhouette" became a derisive phrase used to describe anything inexpensive, unpretentious, or lacking vibrancy, like the plain, black profile portraits. Silhouettes emerged as a popular form of casual portraiture in the United States frequently practiced by amateurs during the eighteenth century, when there were few academically trained portraitists.

A skilled profile artist could produce silhouette portraits quickly, economically, and conveniently for the sitters, without needing the extensive training or special materials required for oil portraits. These could be profiles created either by hand or by machine tracing and cutting, or by drawing or painting. Silhouette portraits are usually either bust- or full-length and occasionally include household objects like furniture. A few unusual examples feature entire landscape scenes, architectural renderings, or phrases in which the letters are cut in continuous profile. The silhouette as a serious art form became obsolete as the daguerreotype grew common in the mid–nineteenth century, but the format was revived several times as a party entertainment in the late nineteenth century and again in the 1930s.

The Society's collection includes examples of the major classifications of silhouettes: cutout, hollow-cut, and drawn or painted. The most common are the cutout silhouettes, which were usually executed by cutting black paper freehand with scissors. The black profile was then mounted on light-colored stock, sometimes with a lithographic background, and frequently embellished with painted or drawn details. Hollow-cut silhouettes were usually created from light-colored paper using tracing or cutting devices that left "hollow" profile images. When these profiles were backed with black fabric or paper, the final silhouette was created. Painted silhouettes were made with black ink, gouache, or watercolor and were often accented with bronzing and white highlights to emphasize details of the hair or costume. The works incorporate a broad range of materials and supports, including plaster, wood, textile, both laid and wove papers, hand-coated and prepared black and blue papers, lead-white and iridescent purple prepared papers, and machine-coated black papers. Some are elaborately framed, several with gold and black églomisé embellishments, and a few are reverse-mounted under glass.

Many of the most notable artists of the silhouette genre are represented by works in the Society's collection, as well as some very important sitters, such as William Bache's bust of Alexander Hamilton. The Society also holds silhouettes by the noted American profilists William Henry Brown, Thomas Edwards, and William King, as well as several by the British artist John Field and the team of Field & Miers. A large cache of cut-out silhouettes by the French master Augustin Édouart (cat. 46) includes several large family groupings with furniture and lithographed backgrounds.

Several celebrated silhouette prodigies are also represented, including William James (Master) Hubard who began his career in Britain at age twelve, cut Queen Victoria's profile at age fifteen, and had opened a gallery in New York City by his seventeenth birthday; Jarvis Frary Hankes, a young man who toured the Northeast cutting silhouettes rapidly and reportedly with great skill, signing them *Master Hanks*; and Martha Anne Honeywell (c. 1787–after 1848), a woman born without arms and with only three toes, who supported herself cutting profiles, for a time in a regular performance at Barnum's Museum in New York. She reportedly utilized scissors with her mouth and toes, and similarly worked embroidery. The Society has two examples of a common silhouette subject for Honeywell, the entire text of the Lord's Prayer cut in continuous script from a single small sheet of paper (fig. 114.1).

Several important silhouettes in the Society's collection were done by artists not primarily known for profiles. These include a painted silhouette from 1812 of then Secretary of the Treasury Albert Gallatin by Robert Fulton (cats. 20 and 31), a group of ten hollow-cut silhouettes by the miniature painter John Ramage, and a single beautifully detailed painted silhouette by the French profilist Thomas Bluget de Valdenuit and his early partner Charles-Balthazar-Julien Févret de Saint-Mémin (cat. 18). The painted *Silhouette of George Washington* (c. 1791–1813) by the artist and designer Samuel Folwell (cat. 19) was so well known during the nineteenth century that the folk artist Rufus A. Grider (cat. 90) reproduced the image as a vignette in one of his historical powderhorn montages (1890) in the Society's collection. The N-YHS also holds a finely detailed

Fig. 114.1. Martha Anne Honeywell, *The "Lord's Prayer": Silhouette*, 1845. Beige paper cutout laid on black, light blue, and purple papers, pierced with a pin and stitched in silk, 6 1/2 × 6 in. (165 × 152 mm), irregular. The New-York Historical Society, INV.10816

114a

fishing scene attributed to Lydia Cummings and three scenes made as souvenirs from the resort town of Saratoga, New York (cat. 114).

The Society's collection also encompasses several unusual groupings of silhouettes, including forty-five full-length profiles done at Miss Haines' School for Young Ladies in 1859 during a visit by an unidentified itinerant silhouettist, and over forty facial profiles drawn by Ohio Senator Benjamin Tappan, probably in his youth when he studied painting with Gilbert Stuart and apprenticed as a printer and engraver. There are also ninety machine-cut silhouettes acquired after the closing of the Peale Museum in Philadelphia; they all have a

blind stamp that reads *Peale's Museum* or *Museum*, with a single example stamped *Peale*. These hollow-cut silhouettes were probably made by Charles Willson Peale or by a family slave, Moses Williams, who was taught the art by Peale and cut many of them (reportedly with such skill that he earned his freedom, became self-supporting, and purchased a brick house).

Of the later silhouettes, Rudolph Bunner's group of three intricate miniature painted examples, including a man smoking a cigarette with a small dog and a cat, from about 1900, and C. G. Davis's painted profile of the frigate USS *Chesapeake* from 1934 are outstanding. Recently silhouettes of both portrait and scenic subjects

have again emerged as a multifaceted, independent art form with the provocative, critically acclaimed works of Béatrice Coron (cat. 148) and Kara Walker, who use silhouettes to explore conventions of portraiture, narrative, and racial identity.

Bibliography: William Henry Brown, *Portrait Gallery of Distinguished American Citizens, with Biographical Sketches and Fac-Similes of Original Letters* (Hartford, Conn.: E. B. & E. C. Kellogg, 1845); Rembrandt Peale, "Notes and Queries. The Physiognotrace," *Crayon* 4:10 (1856): 307–8; Desmond Coke, *The Art of the Silhouette* (London: M. Secker, 1913); Emily (Mrs. F. Nevill) Jackson, *Silhouette: Notes and Dictionary* (London: Methuen & Company, 1938); Alice Van Leer Carrick, *A History of American Silhouettes* (Rutland, Vt.: Charles E. Tuttle, 1968); D. Brenton Simons, "New England Silhouettes: Profile Portraits, c. 1790–1850," *New*

114b

England Historic Genealogy News Letter 3–4 (June–August 1992): 100–104; Penley Knipe, "Paper Profiles: American Portrait Silhouettes," *Journal of the American Institute for Conservation* 4:3 (2002): 203–23; special thanks to Clara Ines Rojas-Sebesta for her unpublished evaluation and conservation report, "New-York Historical Society Collection of Silhouettes," typescript, 2003.

Unidentified Silhouette Artist*

114a. *Saratoga Races: Silhouette*, c. 1873

Black prepared paper cutout, reverse-mounted on glass; 5 3/4 × 8 in. (146 × 203 mm), irregular
Black prepared paper cutout inscription below racing scene: *SARATOGA RACES*
Z.2512

The two silhouette scenes discussed in catalogue 114 are remarkable examples that were probably cut with a mechanical device or with the aid of a pantograph.[1] This vibrant scene of the Saratoga steeplechase features a finely detailed landscape and figures. The scene was donated together with two silhouettes representing landmarks of the popular New York resort town, *Dr. Strong's Sanatorium* and *The Clarendon Hotel*.[2] Nothing has been found about the unidentified artist who cut the silhouette scenes about 1870 at the fashionable spa community. Probably purchased as souvenirs by a visitor to Saratoga, this trio of silhouettes may have been made by an itinerant artist in a limited-engage-ment performance or by a resident artist who made them for tourists.

In *Saratoga Races*, six racers ride from left to right, passing over the flag-marked hurdles. The artist has precisely delineated the slim reins held by each rider and created varied patterns for the course, punctuated by stone fences, stone paths, hedges, and fallen logs. Even the large, spreading central tree is animated with five birds in the branches at the upper left. The steeplechase event was first run at Saratoga in 1870.[3] In 1908 the steeplechase track at Saratoga was closed following the passage of the Agnew-Hart antigambling bill. It was rebuilt in the 1920s, and by 1940 Saratoga, Belmont Park, and

Aqueduct had the only permanent steeplechase courses in the United States.

Attributed to Lydia M. Cummings
New York, New York 1837–Hackensack?, New Jersey 1927

The second scenic silhouette is attributed to Lydia Cummings, the daughter of the miniature artist and founding member of the NAD, Thomas Seir Cummings. In fact, Cummings may have merely been the owner of this probably mechanically produced sheet. The few facts that have been found about Lydia Cummings's life were derived from the art, writings, and biography of her father. Her likeness is known from her miniature portrait painted on ivory by her father when she was three or four. The delicate portrait of the blond toddler was incorporated into one of the elder Cummings's most remarkable and noted works, *A Mother's Pearls* (1841; The Metropolitan Museum of Art, New York), a necklace created from the miniature portraits of the Cummingses' first nine children, mounted in oval gold frames connected by gold chains. Lydia Cummings never married, living with her parents and an unmarried sister in New York until her father retired in 1866. The family then moved to Mansfield Center, Connecticut, and after the death of Lydia's mother, to Hackensack, New Jersey, closer to New York and her many siblings' families.

Bibliography: Whitney Hartshorne, "Thomas Seir Cummings—Miniaturist," *America in Britain* 6:3 (1968): 5–8; Voorsanger and Howat 2000, 386, 576, no. 22, ill.

114b. *Silhouetted Fishing Scene: Man Net Fishing from a Boat with a Woman, Man, and Seated Horn Player on Shore near Four Cows and a Goat*, c. 1850

Black prepared paper cutout; 5 3/4 × 4 1/8 in. (146 × 104 mm), irregular
Provenance: Thomas Seir Cummings Collection, New York, 1866; Mansfield, Conn., 1889; and Hackensack, N. J., after 1889.
Gift of Whitney Hartshorne, 1979.33

This detailed fishing scene silhouette is a tour de force of minute detail and skillful composition. The fisherman stands in his boat on a placid lake, hauling on a mesh net, with his wicker creel basket in the stern near what appears to be a gaff. A man on the shore with a receding chin tugs on the other end of the net, while a woman standing nearby holds a string of fish. Under the ruffled and varied tree foliage a horn player sits beside four cows and a billy goat. Carefully placed slits highlight the elevation of the promontory and add movement and light to the surface of the water.
A. M.

* Unidentified Silhouette Artist 76.
1. Peale 1856, 307–8.
2. Inv. nos. Z.2562 and Z.2561, respectively. Located on Saratoga's Broadway, the Clarendon Hotel, with the Washington Spring in its courtyard, was a popular stop for the wealthy spa and racing crowd visiting from New York; Dr. Strong's Sanatorium and Strong Spring, between Spring and Philadelphia streets, was a fashionable spa offering recreation, massage, and steam and mineral baths; see Edward Hotaling, *They're Off! Horse Racing at Saratoga* (Syracuse, N.Y.: Syracuse University Press, 1995), 51, 60; and Grace Maguire Swanner, *Saratoga, Queen of Spas* (Utica, N.Y.: North Country Books, 1988), 85, 87, 128, 151.
3. Hotaling 1995, 97.

THOMAS NAST
Landau in der Pfalz, Germany 1840–Guayaquil, Ecuador 1902

Illustrator and caricaturist of German extraction who created a significant portion of America's repertoire of national and political symbols, Thomas Nast immigrated to the United States and settled in New York City when he was six. A precocious draftsman and essentially self-taught, Nast studied briefly with the German-born allegorical history painter Theodore Kaufmann and for a short time under Thomas Seir Cummings at the NAD, where he exhibited from 1862 to 1870.

At the age of fifteen in late 1855 or early 1856 Nast embarked on his career as an illustrator and graphic journalist at *Frank Leslie's Illustrated Newspaper*, one of the new illustrated weeklies which published his work through 1858 or early 1859. The youthful prodigy also worked as a doorman for Thomas Jefferson Bryan's Gallery of Christian Art at 839 Broadway, where, against the rules, he cultivated his skill as a copyist of the European and American works in this significant collection, which eventually was given to the N-YHS. Nast also taught himself the styles and methods used by French and English illustrators and caricaturists, among them Honoré Daumier, Gustave Doré, John Leech, and John Tenniel. *Harper's Weekly*, the most important American magazine of the period, published Nast's work for the first time in 1859. The following year, after a series on tenement life, Nast reported on the sensational Heenan-Sayers prize fight in England for the *New York Illustrated News*. He spent four months in 1860 covering Giuseppe Garibaldi's victorious Risorgimento campaign in Sicily and southern Italy for the *News*, the *Illustrated London News*, and *Le Monde illustré*. He also acted as an aide on General Garibaldi's staff, dressed as a Garibaldian, and was entrusted with several diplomatic missions of delicacy and importance. He remained a lifelong admirer of Garibaldi, whose campaign he documented in sketches.

Nast applied his experience sketching battle scenes in Italy to covering the remainder of the American Civil War after his return in 1861. His numerous pictorial comments wielded great influence for the Union and placed *Harper's Weekly* among the more influential journals of the day. Although Nast later worked for assorted publications, including *Puck*, his contributions to *Harper's*, where he was on the staff between 1862 and 1886, are the most highly regarded. During those years, encouraged by the publisher Fletcher Harper, he began to pursue conceptual political commentary instead of documentary

illustrations, thus establishing the power of the American political cartoon. Nast's evolution from academic artist to caricaturist coincided with the dynamic events of the era. Even though his Civil War drawings for *Harper's* were primarily trenchant propaganda against the Confederacy or sentimental representations of warfare on the front and its effects at home, Abraham Lincoln called Nast the "Union's best recruiting sergeant." At *Harper's Weekly*, Nast also focused on the conflicts of war and political corruption, translating with missionary zeal his personal idealism into energetically patriotic drawings and socially charged metaphoric images. During the period of Reconstruction he created some of his most memorable and historic work, and his peerless pictorial satires occasionally achieved a broader humanist statement about war and corruption. In the twenty years following the Civil War, serving as the country's conscience, he continued his fight for the recognition of the rights of former slaves and all minorities under the Civil Rights Bill of 1875.

Nast took the intensified naturalism of high art and incorporated it in the popular, accessible cartoon. Renowned for reducing the complexities of political issues into simple terms and vivid symbols, he frequently drew on a menagerie of animals to make his points, in the manner of the French caricaturist Jean-Ignace-Isidore Gérard (called Grandville). Nast is credited with creating and popularizing a pantheon of influential and enduring American symbols, including the Republican elephant, the Democratic donkey, and the Tammany Tiger. His art even helped to shape the images of Santa Claus (as a corpulent and charitable embodiment of Christmas and American commercialism, based on a distantly remembered, thin European folk saint), Uncle Sam, and Columbia. While Nast's political cartoons relate to earlier American ephemera, his most direct stylistic influence was the British illustrated press (as featured in *Punch*, for example) and its gifted caricaturists such as John Tenniel, James Gillray, and George Cruikshank. After 1865 Nast increasingly based his portrait caricatures on photographs, as did many other cartoonists, and his satire turned more venomous.

Beginning with Lincoln in 1861, all of the subsequent six presidential candidates backed by Nast and *Harper's* were elected, earning Nast the name "president maker." After the Civil War, Nast's controversial reputation escalated, so that his brash criticism and radical Republican ridicule of President Andrew Johnson's corruption helped Ulysses S. Grant win the presidency in 1869. As an imaginative political cartoonist he wielded great power, and he expressed his social idealism in layered, well-designed images with multiple sources in European history, painting, and caricature. Despite his forte as a cartoonist, throughout the 1860s Nast continued to paint as well and occasionally exhibited political subjects at the NAD and the Artists' Fund Society. In 1867 he produced a series of thirty-three large historical subjects entitled *The Grand Caricaturama*. But he is most famous for his relentless battle from 1869 to 1871 against the Tweed Ring, a gang of corrupt politicians who controlled the government of New York City. Headed by "Boss" William Marcy Tweed, the group defrauded the city of millions of dollars. The ring was finally broken as the result of the public campaign aroused by Nast's devastating cartoons. Tweed escaped to Spain, where he was identified with the help of one of Nast's cartoons. Caricature has seldom, if ever, been so bitingly eloquent as in Nast's "The Tammany Tiger Let Loose" (*Harper's Weekly*, 11 November 1871).

Harper's rewarded him from 1873 with an annual retainer and a fee for each drawing, but by the 1870s Nast's position at the magazine had become tenuous, owing to its growing conservatism after the retirement of Harper in 1875 and Nast's uncensored approach. When the color lithographs published in Joseph Keppler's *Puck* began challenging Nast's style, Nast left *Harper's* in 1886 and returned to illustration and painting. In 1890 he published a book, *Thomas Nast's Christmas Drawings for the Human Race*. Subsequently, while working as a freelance illustrator, he became overwhelmed by financial losses (partly as a result, ironically, of his failed investments in the firm of Grant & Ward, to which President Grant had lent his name after leaving office). In 1902, as a modest reward for bolstering the Republican Party, President Theodore Roosevelt appointed Nast to a consular post in Guayaquil on the coast of Ecuador. Six months later Nast died of yellow fever in the infested city.

Thomas Nast, the foremost cartoonist and image maker of his time, is rightfully known for his role in shaping the image of nineteenth-century America. Although he documented and provided commentary for many significant events of American history, his great theme was reform. Hailed by some as the father of American cartooning, Nast produced an immense and evocative body of work, covering topics from the sublime to the ridiculous.

Bibliography: Warren Lee Goss, *The Soldier's Story of His Captivity at Andersonville, Belle Isle and Other Rebel Prisons (with Illustrations by Thomas Nast)* (Boston: Lee and Shepard, 1868); Albert Bigelow Paine, *Th. Nast: His Period and His Pictures* (New York: Macmillan Company; London: Macmillan & Co., 1904); F. Weitenkampf, "Thomas Nast, Artist in Caricature," *Bulletin of the New York Public Library* 36 (1933): 770–74; John Chalmers Vinson, *Thomas Nast: Political Cartoonist* (Athens: University of Georgia Press, 1967); Morton Keller, *The Art and Politics of Thomas Nast* (New York: Oxford University Press, 1968); Albert Boime, "Thomas Nast and French Art," *American Art Journal* 4:1 (1972): 43–65; Thomas Nast St. Hill, *Thomas Nast: Cartoons and Illustrations* (New York: Dover Publications, 1974); Alan Levy, "Thomas Nast's Triumphant Return to Germany," *Art News* 78:3 (1979): 118–19, 122–23, 125; Mary Flynn, "Thomas Nast: Crusading Cartoonist," *Connoisseur* 208:837 (1981): 235–37; Albert Boime, "Thomas Nast and the Social Role of the Artist," in *Van Gogh 100: Contributions to the Study of Art and Architecture 4*, ed. Joseph D. Masheck (Westport, Conn.: Greenwood Press, 1996), 71–111; Adam Gopnik, "The Man Who Invented Santa Claus: Thomas Nast's Eye for Who's Been Naughty and Who's Been Nice," *New Yorker*, 15 December 1997, 83–102; Sarah Burns, "Party Animals: Thomas Nast, William Holbrook Beard, and the Bears of Wall Street," *American Art Journal* 30:1–2 (1999): 8–35; N. A., "The Political Pen of Thomas Nast," *American Art Review* 11:1 (1999): 114–15.

115. *Study for "Departure of the Seventh Regiment for the War, April 19, 1861,"* c. 1865–69

Oil over graphite on brown paper, varnished, laid on board, nailed and mounted on a wood panel; 22 1/2 × 32 3/4 in. (572 × 832 mm)
Signed at lower left in black oil: *Th: Nast.*
Provenance: Bennett Book Studios, New York, 1946.
Bibliography: "Thomas Nast," *Harper's Weekly*, 26 August 1871, 804; Paine 1904, 78, ill.; Koke 1982, 3:4, no. 2064, ill.; Alice Abell Caulkins, *Thomas Nast and the Glorious Cause*, exh. cat. (Morristown, N.J.: Macculloch Hall Historical Museum, 1996), 9.
Gift of George A. Zabriskie, 1946.174

Nast's freely painted work depicts the departure from New York City of the Seventh Regiment, New York State Militia, for service in the Civil

115

War on 19 April 1861.[1] Nast portrayed the troops marching down Broadway to the Jersey City Ferry at the foot of Cortlandt Street as they passed the fashionable jewelers Ball, Black and Company (565 Broadway) at the southwest corner of Prince Street. The regiment is being reviewed from a pediment above a door at the left by Major Robert Anderson of Fort Sumter fame, who only five days before had surrendered the fort in the harbor of Charleston, South Carolina, to the Confederates. The hero's presence in the place of honor stoked the fires of retaliation. On the day of the march, the *New York Times* captured the sentiments behind the regimental parade:

> Broadway, to-day will tremble with the march of the Seventh Regiment on their way to Washington. What reception they may receive on their march has been already

foreshadowed by the action of liberal merchants, the outspoken expression of the populace, the crowds that nightly press around the armory. New-York loves the Seventh. It has distilled all its best blood into it. Hard as the parting may be, there are few fathers that will not flow with honest pride as they see their sons pass down the street to-day on their sacred mission for the conservation of the Union.[2]

The Society's work is the *bozzetto*, the traditional academic study, for Nast's more finished canvas that was completed in 1869. The painting, signed at the lower right *Th. Nast, 1869*, was exhibited at the NAD in 1870 (on loan from James B. Ingersoll);[3] it was Nast's final attempt at history painting before a hiatus of thirty years. Subsequently owned by General Emmons

Clark, the regimental commander, it was presented by his children to the Seventh Regiment, New York National Guard and now hangs in the regimental armory on Park Avenue and 66th Street, whose elegant interiors were designed by, among others, Herter Brothers and Louis Comfort Tiffany (cat. 137).[4] The composition of the painting, Nast's largest, is nearly identical to that of the oil study, except for its size and the fact that it has been cropped slightly along the upper and lower edges to convey the effects of eyewitness reportage. Both works are based on Nast's graphite drawing in his sketchbook (John Hay Library, Brown University, Providence, R.I.), in which it is apparent that Nast had placed himself in the line of the march.[5] Despite being a thumbnail sketch, it includes all the elements Nast needed to capture the event: the

sweep of the march, the perspective of the urban setting, and a lamppost at the lower right. The streetlamp frames the composition and functions as a symbolic beacon to the men of the crack regiment heading to the uncertainty of battle. Nast's sketch differs from the canvas in several groupings of figures (for example, an equestrian figure in the left foreground) and in some architectural elements.[6]

The Society's study stands between the spontaneous sketch and the finished oil. Its grisaille palette gives the impression of newsprint, stressing its timeliness and documentary qualities. Its bold execution also testifies to Nast's activity as a designer of woodcut illustrations. However, like the artist's finished canvas, this more freely painted work walks the tightrope between academic art and journalistic illustration that sought to revive academic traditions by producing history paintings of momentous contemporary events.[7]

It is not known precisely when Nast—who was a member of the regiment and later a member of the Seventh Regiment Veteran Club—began to elaborate his small eyewitness sketch of 1861 into the Society's oil on paper model, even though Caulkins has suggested that he commenced it once the commander of the Seventh Regiment commissioned from him a formal record of the departure.[8] For the two larger works Nast filled in the details of the marching troops and added several vignettes of sentimental interest: a policeman blocking an unruly bystander at the right, tearful farewells, children straining to see, a newsboy running in the foreground hawking papers, and a lame man with a cane, perhaps a patriotic veteran waving his hat in enthusiastic support. The blessing of the quasi-religious cause is suggested by the presence of Grace Church in the distance. And, as an observer noted: "The American colors were present everywhere." The shelling of Fort Sumter and of its American flag had infuriated Northerners, inspiring unprecedented purchases and displays of the American flag. Nast grasped the symbolic importance of the Broadway display and made the flags appear almost as a patriotic shield to protect these innocent soldiers embarking on their sacred mission.[9] To appreciate the drama of Nast's masterfully manipulated image, one need only compare it with the prosaic woodcut illustration of the event by an unnamed artist published in *Harper's Weekly* in 1861.[10] Although Nast produced major graphic images of the Civil War and its painful aftermath, his *Departure of the Seventh Regiment* and its study serve as prototypes for the patriotic flag series that Childe Hassam painted during and after World War I.[11]

1. "The Exodus of the Seventh," *New York Times*, 19 April 1861, 4, reports the event.

2. Ibid.

3. In oil on canvas, 54 1/2 × 109 in.; see Naylor 1973, 2:677, no. 217; and Caulkins 1996, 10, ill.

4. Mary Anne Hunting, "The Seventh Regiment Armory in New York City—Restoration of the Historic Site in New York," *The Magazine Antiques* 155:1 (1999): 158–67.

5. In graphite on paper, 4 1/2 × 2 1/2 in.; see Caulkins 1996, 10, ill.

6. See Frederick P. Todd, *Pro Patria et Gloria: The Illustrated Story of the One Hundred and Fifty Years of the Seventh Regiment of New York (107 Infantry Regiment, N.Y.N.G.)* (Hartsdale, N.Y.: Published for the Seventh Regiment by Rampart House, 1956). Caulkins 1996, 12, notes that the day Nast sketched the Seventh Regiment's march, the artist Sanford Robinson Gifford (cat. 100) was one of the soldiers who passed by.

7. More than likely Nast would have been aware of the Risorgimento battle scenes painted by the Macchiaioli artist Giovanni Fattori, whom he could have encountered in Italy during his time with Garibaldi. One of Fattori's paintings and its two *bozzetti* and cartoon that attracted much public attention at repeated exhibitions from 1860 to 1862 was *The Italian Camp during the Battle of Magenta* (Galleria d'Arte Moderna al Palazzo Pitti, Florence). See Livorno, Cisternino del Poccianti, *Fattori da Magenta a Montebello*, exh. cat. (Rome: De Luca Editore, 1983), 130–32, nos. 60–62, ills. Begun in 1859, it has a similar feeling to Nast's *Departure of the Seventh Regiment*. For one of its *bozzetti* of 1860 in the Galleria Nazionale d'Arte Moderna e Contemporanea, Rome, see Giuliano Matteucci et al., *Giovanni Fattori: Dipinti, 1854–1906*, exh. cat. (Florence: Artificio, 1987), no. 3, ill. Fattori painted contemporary battles on a scale reserved for history paintings that included innovative points of view and stressed immediacy and modernity. For Nast's time with Garibaldi and some of his drawings of the campaign, see Paine 1904, 43–63. For Nast's monument to Garibaldi, published in *Harper's Weekly*, 17 June 1882, see Boime 1996, fig. 6.15. Fattori also made many eyewitness sketches of battle scenes, which he reworked and also used for prints.

8. Caulkins 1996, 9.

9. Ibid.

10. *Harper's Weekly*, 4 May 1861, 381, ill. Carbone et al. 2006, 2:820, assigns the work, which is set at a different location on Broadway, to Nast. See *Harper's Weekly*, 30 April 1861, 381, for yet another illustration of the march by an unknown artist from a different vantage point.

11. See Barbara H. Weinberg et al., *Childe Hassam: American Impressionist*, exh. cat. (New York: Metropolitan Museum of Art, 2004), 218–22. For one of the series in the Society's collections (inv. no. 1984.68), see ibid., fig. 233.

ALFRED WORDSWORTH THOMPSON

Baltimore, Maryland 1840–Summit, New Jersey 1896

Known as an historical painter, Alfred Wordsworth Thompson was educated at Newton University in Baltimore and first studied law with his father before establishing a career in art. He visited Harpers Ferry in 1859 to sketch John Brown in prison and locations related to the raid, and one of these was published in *Harper's Weekly*. Several months later Thompson opened a studio in Baltimore. He worked as a sketch or "special artist" for *Harper's Weekly* and the *Illustrated London News*, supplying drawings that chronicled the early days of the Civil War.

Cutting short his participation in the War between the States as an artist-correspondent, Thompson left for Paris in 1861. He spent several years studying under Charles Gleyre, Émile Lambinet, Adolphe Yvon, the Italian Orientalist Alberto Pasini, and the sculptor Antoine Barye, with whom he concentrated on equine anatomy. His early landscapes were influenced by the Barbizon painters. In 1864–65 he began studies at the École des Beaux-Arts and entered a picture at the Salon of 1865 (*The Moorlands of Au Fargis*). After walking tours of Germany, Italy, and Sicily, Thompson returned to the United States in 1868 and set up a studio in New York City. He made several trips to North Carolina and Virginia, producing southern views that were noticed by the critics; for example, he exhibited *The Poor White Trash—A Home in the Sand Hills* at the spring exhibition of the Brooklyn Art Association. He became best known for his historical subjects of colonial America and the antebellum South, although his depictions of contemporary scenes and North African life were generally well received. *A May Day, Fifth Avenue*, shown at the 1880 NAD annual, garnered particular praise.

After becoming an associate in 1873, in 1875 Thompson became an academician at the NAD, where he exhibited from 1867 to 1896 and sold 125 pictures. He also participated in the Paris Exposition Universelle in 1878 (*School-house on the Hill*) and joined the newly formed Society of American Artists the same year. Thompson exhibited a work in the 1889 Exposition Universelle in Paris, earning a bronze medal (*A New England Farm House*; location unknown), and two oil paintings at the 1893 World's Columbian Exposition in Chicago. Over the next eighteen years, he traveled to Spain, Morocco, and Asia Minor in search of new subject matter, spending time in rural Oswego, New York, and eventually building a house that he named Stonewood in Summit, New Jersey. The Society's Department of Manuscripts holds the papers of Thompson and his wife, Mary S. Pumpelly Thompson.

Bibliography: Steward McGuzzler [Alfred Thompson], *Society as It Found Me Out* (New York: Carlton-Rigaud, 1890); John Speed Gilmor, "The National Academy of Design," *Quarterly Illustrator* 1:4 (1893): 245, 254; *DAB*, 18:48; Naylor 1973, 2:924–27; Annette Blaugrund et al., *Paris 1889: American Artists at the Universal Exposition*, exh.

116

cat. (Philadelphia: Pennsylvania Academy of the Fine Arts, in association with Harry N. Abrams, 1989), 17, 39, 292; Fink 1990, 396; Carr and Gurney 1993, 325; Sarah Burns, *Inventing the Modern Artist: Art and Culture in Gilded Age America* (New Haven: Yale University Press, 1996), 380; Dearinger 2004, 532.

116. *Bureaux de l'Amirauté de la Marine, Algiers, Algeria, with a Faint Sketch of Figures, Folios 14v and 15r in a Sketchbook*, 1883

Watercolor, graphite, white gouache, and black ink on the verso of a gray sheet of paper, bound into a sketchbook, and the recto of a beige sheet of paper, bound into a sketchbook; each 9 3/16 × 11 1/4 in. (233 × 285 mm), irregular
Dated at lower left of beige sheet in green watercolor: *Jan 9ᵗʰ 83*
Provenance: Whitney Museum of American Art, New York.
Bibliography: Koke 1982, 3:182, no. 2580 (on five sketchbooks)
Gift of the Whitney Museum of American Art, 1954.153d

Thompson's stunning watercolor—two-thirds of the two-page spread is reproduced here—belongs to one of five sketchbooks from the later years of the artist's career in the Society's collection.[1] He inscribed the cloth cover of this unpaginated sketchbook in graphite at the upper left *Algeria*, although it also contains watercolors executed in Spain (Cordoba) and Sicily (for example, panoramic views near Catania). This watercolor depicts a seaside building in the old harbor of Algiers, which Thompson drew again in another watercolor from the sketchbook but from a greater distance. Like many of his contemporaries, Thompson was fascinated with Oriental subjects, a trend initiated by French painters, such as Eugène Delacroix, in the early decades of the nineteenth century to which he had been exposed during his student days in Paris under Pasini.[2] The list of Romantic artists lured to Algiers by its exotic culture and brilliant color and light is legion. Not surprisingly, Thompson's true subject in this watercolor is the intense, bleaching Mediterranean sunlight and its effects on the exotic local architecture of Alger la Blanche, "Algiers the White," a name that refers to its glistening white buildings. The artist's treatment of this light has much in common with that of the English watercolorists David Roberts (in his Egyptian works executed in the 1830s and 1840s)[3] and John Frederick Lewis (in his Arab subjects).[4]

The location of Thompson's dated but previously unidentified watercolor can be pinpointed with the aid of the four-volume unpaginated diaries kept by Mary S. Pumpelly Thompson, the artist's wife and traveling companion, preserved in the Society's Department of Manuscripts. Having left Cádiz, Spain, for Algeria by way of Gibraltar, the couple arrived in Tangiers on 7 December 1883 and by 31 December of that year had made their way to Algiers, where that volume of the diary ends. The next volume commences on 8 February, when the couple is still in Algiers.

The history of that fabled city, now capital and chief seaport of Algeria but always a crossroads on the Mediterranean Sea, is fraught with conflict that is reflected in the architecture of Thompson's watercolor. Phoenician colonization marked the beginning of the historical age in North Africa during the twelfth century B.C.; successive conquests by the Carthaginians, the Romans, the Vandals, the Byzantines, the Arabs, the Spanish, the Turks, and the French all shaped its fascinating polyglot culture. Khair-ad-Din Barbarossa, one of the Greco-Turkish corsair rulers, created the artificial old harbor, site of Thompson's watercolor, in 1518–29 with the labor of Christian slaves.[5] By building a jetty from the mainland to an island, the Peñon of the Spaniards, and leveling the Spanish fortress, he created the famous impregnable harbor of the capital of the Barbary Coast. In Arabic this was called the *El-Jezair* (the islet), corrupted to "Algiers." To this day the islet has remained part of the Admiralty quarter of the city. It retained its sentinel lighthouse that was built in 1544. (Located behind the building in Thompson's watercolor, it can be seen in the frontal view of the same building in this sketchbook, drawn from a more distant vantage point.[6]) The harbor's jetty forms a U-shaped breakwater enclosing a shallow pool of calm water, where fishing and pleasure boats moored. On this jetty buildings were constructed for the administration of the port, including the Bureaux de l'Amirauté (the Bureau of the Admiralty). Sunk into the ground near the water's edge were cannons from the former fortifications, whose ends were used for mooring boats; Thompson included four of these buried cannons in the right foreground of his watercolor representing the picturesque facade of this maritime

building most favored by artists visiting Algiers since the 1830s.[7] An earlier view of the edifice, which has undergone numerous changes during its history, is preserved in William Wyld's watercolor *Bureaux des Magasins de la Marine, Algiers* (1833; Whitworth Art Gallery, University of Manchester, England).[8] Part of the Admiralty complex, the building is sometimes called Le Bordj el Coptan or Château de l'Amiral, and its two arches were later expanded toward the water and enlarged to number five.[9]

1. The Society also holds an oil of a Revolutionary War subject by Thompson, *The Parting Guests, 1775*, 1889 (inv. no. 1889.3); see Koke 1982, 3:182–83, no. 2581, ill.

2. For the Orientalists, see, among other sources, Mary Anne Stevens, ed., *The Orientalists: Delacroix to Matisse; The Allure of North Africa and the Near East*, exh. cat. (New York: Thames and Hudson; Washington, D.C.: National Gallery of Art, 1984); Gérard-Georges Lemaire, *The Orient in Western Art* (Cologne: Könemann, 2001); and Roger Benjamin, *Orientalist Aesthetics: Art, Colonialism, and French North Africa, 1880–1930* (Berkeley and Los Angeles: University of California Press, 2003).

3. See Helen Guiterman and Briony Llewellyn, *David Roberts*, exh. cat. (Oxford: Phaidon Press Limited, for the Barbican Art Gallery, London, 1987); and Deborah N. Mancoff, *David Roberts: Travels in Egypt and the Holy Land* (San Francisco: Pomegranate, 1999).

4. See Michael Lewis, *John Frederick Lewis, R.S., 1805–1876* (Leigh-on-Sea: F. Lewis, 1978).

5. The Barbary pirates controlled Algiers for three hundred years until French rule was established in 1830.

6. Thompson executed a third watercolor of the Admiralty complex in this sketchbook that represents another structure on the jetty.

7. See Marion Vidal-Bué, *Alger et ses peintres, 1830–1960* (Paris: Paris-Méditerranée, 2000), 24, which reproduces a color lithograph by Alexandre Genet featuring a bird's-eye view of the artificial harbor that shows the position on the jetty of the structure Thompson painted.

8. Inv. no. D.1920.10; see ibid., 91, ill. See also Charles Nugent, *British Watercolors in The Whitworth Art Gallery, The University of Manchester: A Summary Catalogue of the Drawings and Watercolors by Artists Born before 1880* (London: Philip Wilson Publishers, in association with the Whitworth Art Gallery, the University of Manchester, 2003), 290, ill.

9. Vidal-Bué 2000, 93.

F. AMENDOLA

Italy, active 1840s

117a

Although research has turned up nothing on the person who executed and signed this pair of watercolors, Amendola was certainly an untrained artist of Italian extraction and may have visited the United States only briefly. The surname suggests that the family harkened from the small town of that name in the province of Puglia near Foggia. A possible relative, even a son, Giovanni Battista Amendola (1848–1887) is recorded as a painter and sculptor in Naples.

Bibliography: Koke 1982, 1:3–4.

117a. *View of Governors Island, New York City*, 1844

Watercolor and black ink over graphite on board; 3 1/8 × 9 1/4 in. (79 × 235 mm)
Signed and dated inside image at lower right in black ink: *F. Amendola 1844*; inscribed below framing border at center in brown ink: *Isola del Governadore*
Bibliography: Koke 1982, 1:3–4, no. 8, ill.
Gift of an anonymous donor, X.277

117b. *View of New York City from the Bay near Bedloe's Island*, 1844

Watercolor and black ink over graphite on board; 5 5/16 × 9 3/16 in. (135 × 233 mm)
Signed and dated inside image at lower right in black ink: *F. Amendola. 1844*; inscribed below framing border at center in brown ink: *Veduta di New York presa dalla Baia presso il Forte di Bedlows Island*
Bibliography: Koke 1982, 1:3, no. 7, ill.
Gift of an anonymous donor, X.278

These two small vignettes document the appearance of the waterways around the Battery of New York Harbor in the year 1844. Amendola executed the first view from a vantage point on the Battery with the Hudson River steamboat *Albany* (inscribed *ALBAN*[N is backwards]*Y*), flying the American flag, and several sailing ships passing Governors Island. Built in 1826, the steamboat was constructed by Messrs. Stevens of Hoboken, New Jersey, who spared no expense in her construction and appointments.[1] At the right is Castle Williams (1811), and at the center, partially obscured, is Fort Columbus (1798), also flying the American colors. Governors Island, one of New York City's most historic landmarks, lies approximately half a mile off the tip of Manhattan. It has been an American military post without interruption since 1794. Giovanni da Verrazano in 1523 was the first known European to see the island, whose Native American name was *Pagganck* and whose Dutch name was *Nooten Eylandt* or *Nutten Island*. The director general of New Netherland bought Pagganck from indigenous Americans after the purchase of Mannahatta (Manhattan Island) in 1637. When the English captured New Amsterdam and renamed it New York, they also took Nutten Island, which the Dutch had not fortified despite its strategic location. Nine years later, the Dutch regained their lost province temporarily, losing it again under the terms of the Treaty of Westminster in 1674. The island became the location for the English governors,

hence earning the name The Governor's Island, although the official change from Nutten to The Governor's was delayed until a legislative act in 1784. Gradually the article *The* and the apostrophe were dropped.[2]

In the second watercolor Amendola depicted Castle Garden (cat. 104) in the middle distance. The structure was originally built as one of New York Harbor's forts, Castle Clinton (1808–11; cat. 80). Castle Williams on Governors Island is at the right, while in the left foreground, marked by the flag, is Fort Wood on Bedloe's (now Liberty) Island. The walls of this old fort form the base for the Statue of Liberty (cat. 110).

1. Koke 1982, 1:4. Later the *Albany* was lengthened and altered. For additional information on the *Albany*, see Kenneth John Myers, "Art and Commerce in Jacksonian America: The Steamboat *Albany* Collection," *Art Bulletin* 82:3 (2000): 503–28.
2. See Diamonstein 1998, 32, ill.

Veduta di New York presa dalla Baia presso il Forte di Bedlows Island

117b

JAMES T. SUTES (?)

Active mid–nineteenth century

The young man who drew this sheet can only be identified tentatively from the work's inscription as James T. Sutes(?). The name of his calligraphy instructor, J. G. Trego, is more clearly written, although nothing definitive is known about this individual.*

118. *Calligraphic Horse*, c. 1850

Brown and black ink and watercolor on paper; 18 1/4 × 17 7/8 in. (464 × 454 mm), irregular
Inscribed at lower right in brown ink: *Drawn by James T Sutes*[?] *under the tuition of JG Trego*
Provenance: Elie Nadelman, Museum of Folk Art, Riverdale-on-Hudson, N.Y.[1]
Bibliography: Koke 1982, 3:362–63, no. 3198, ill.
Purchased from Elie Nadelman, 1937.1723

A young male student drew this charming sheet to demonstrate his proficiency in pen work.[2] During the nineteenth century similar penmanship exercises, fancy pieces, and theorem still lifes were executed by schoolchildren as part of their education. Many were no doubt given to proud parents as evidence of classroom achievements. Student art was readily inspired by prints in magazines and illustrated Bibles or popular novels. Girls cleverly utilized elements from these same sources in their fancy pieces and mourning pictures, while schoolboys appropriated some of the motifs and combined them with copying from penmanship sample books as the basis for the calligraphic drawings they were required to execute with steel

pens. Understandably, more than one version of the same composition with slight variations frequently exists.

Animals were customary subjects in the penmanship genre, as children found them appealing.[3] Horses, leaping deer, and patriotic eagles are among the most common subjects, because the natural curves of these animals' bodies suited the repetitive and rhythmic flourishes necessary to the development of a confident calligraphic style.

Both students and their instructors produced works of often exceptional quality, but the works are without history other than what is found in their inscriptions. Instructors always exerted control over the type of work that was

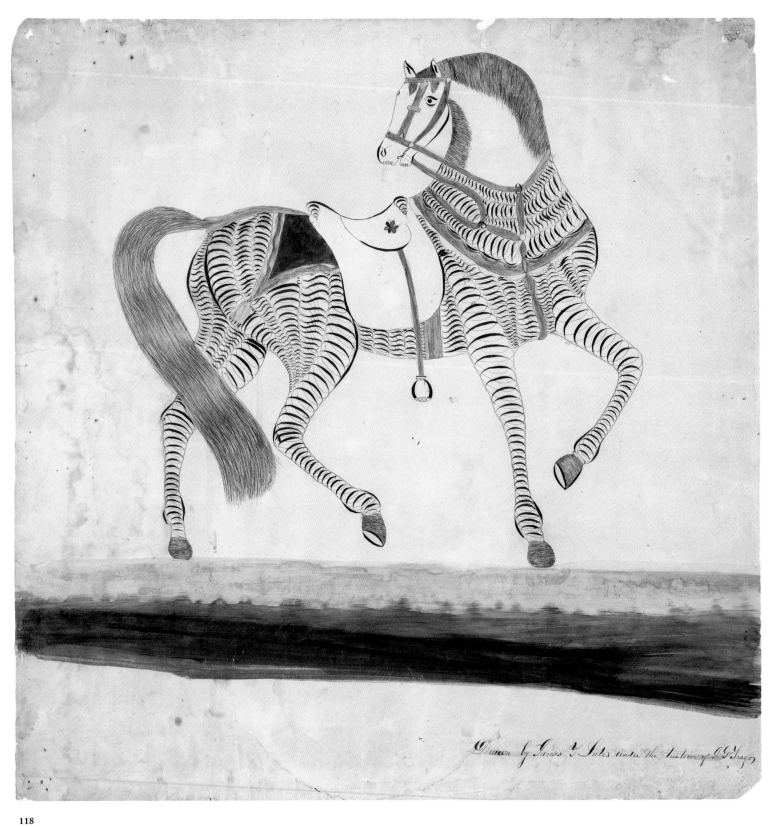

Drawn by James J. Sules under the tuition of J. G. Frey

created.[4] Teachers prepared some sheets as exemplars to copy; in cases where the work is excellent, it is often difficult to ascertain whether it is a teacher's model or a superior student copy, as in the case of a calligraphic drawing of a galloping horse in the Abby Aldrich Rockefeller Museum signed by J. W. Hamlen.[5] Nevertheless, it seems likely that this sheet was a student work as it is inscribed *PENMANSHIP*. Hamlen's work utilizes many of the same conventions as the calligrapher of the Society's sheet, such as the horse's mane and tail that convey the texture of the horsehair. Whereas the Society's drawing features a horse wearing tack signaling it is ready for its rider to mount—bridle, martingale, saddle blanket, and saddle with dropped stirrups—Hamlen's horse, which is depicted in a flying gallop pose with its mane and tail streaming, wears stylized tack, consisting only of a saddle blanket and bridle. Sutes's ground line adds a realistic touch to his image, as opposed to Hamlen's more common practice of filling the paper around the horse with additional calligraphy.[6] The young draftsman of the Society's example used the customary convention of stylized parallel flourishes within the horse's body to indicate a dappled coat and to suggest volume, whereas Hamlen's galloping equine body is decorated with intricate, fanciful, and decorative folk art designs.[7]

A comparison of the Society's calligraphic horse with three very similar works and a fourth more distantly related example proves that young Sutes was drawing after a readily available model whose source has not been identified. Another unidentified young artist rendered a nearly identical horse—walking right with its head facing left—on a slightly larger sheet in brown ink and watercolor, in the Abby Aldrich Rockefeller Museum. Its colors are slightly different; its saddle blanket is green with a reddish brown border and a turquoise tassel, while its stirrup leathers, girth, martingale, and bridle are reddish brown with a green decorative border on the lower chest strap of the martingale and the girth. Rumford dates the sheet to about 1850 and assigns its origin to Bucks County, Pennsylvania, where penmanship was routinely taught in German parochial, as well as secular, schools.[8] Although both it and the Society's sheet have an unusually thick foreground consisting of layers of black soil and green grass applied with a brush, the Society's horse is more loosely executed and the sheet's colors are less precisely applied (compare the blue saddle blanket with the green one in the Williamsburg example). Minor differences abound between the two drawings that were most likely based on a common model or, alternatively, linked by the instructor-pupil relationship. There are at least two other variations of this equine composition in which the caparisoned horse is shown walking left with its head facing right. One, in the Abby Aldrich Rockefeller Museum, is signed *H. G. Cuddleback*. Its excellent quality, elaborate style, and denser pen work may suggest, according to Rumford, that Cuddleback taught calligraphy.[9] Its ground line, rather than being painted, as in the Society's example and the related version in the Abby Aldrich Rockefeller Museum, consists of additional pen work. Cuddleback is known to have executed another similar horse on a sheet in the collection of Joseph and Janet Wolyniec whose orientation is unknown.[10] The fourth, more distantly related, calligraphic horse walks left with its head facing in the same direction and is in the Museum of Fine Arts, Boston. Drawn by C. Scherich under the tuition of J. Eichelberger, it is dated 1851.[11]

The evidence outlined in the previous paragraphs underlines the popularity of this equine composition for young male students and suggests there may have been two models in circulation, one for right-handed students and the other for left-handed calligraphers, that were also modified as they were circulated. While undeniably decorative, these charming calligraphic drawings served a serious function as classroom exercises in penmanship.

* A William T. Trego, who was born in 1859 and exhibited at the 1893 World's Columbian Exposition in Chicago, was taught by his father, Jonathan Trego of Philadelphia (Carr and Gurney 1993, 327). The elder Trego may have been the teacher of this work's calligrapher or related to him.

1. For this collection, see cat. 75 n. 1.

2. The word *calligraphy* derives from a Greek word meaning "beautiful writing." For a sampling of the variety of these exercises, see Beatrix T. Rumford, ed., *American Folk Paintings: Paintings and Drawings Other than Portraits from the Abby Aldrich Rockefeller Folk Art Center* (Boston: Little, Brown and Company, in association with the Colonial Williamsburg Foundation, 1988), 346–57. See also Bruce A.

Johnson, *Calligraphy: "Why Not Learn to Write,"* exh. cat. (New York: Museum of American Folk Art, 1975); and Alvin R. Dunton, *The Original Duntonian System of Rapid Writing* (Boston: Lee & Shepard; New York: Lee, Shepard & Dillingham, 1873).

3. For one of a lion, again by an unidentified artist but without an inscription, see Avery et al. 2002, 354, no. 395, ill.

4. Beatrix T. Rumford and Carolyn J. Weekley, *Treasures of American Folk Art: The Abby Aldrich Rockefeller Folk Art Center* (Boston: Little, Brown and Company, Bulfinch Press, in association with the Colonial Williamsburg Foundation, 1989), 185.

5. Inv. no. 57.312.3, 15 3/4 × 20 1/4 in.; ibid., fig. 140; and Rumford 1988, 350, no. 301, ill.

6. See also the drawing of a leaping deer by an unidentified artist in the collection of the Abby Aldrich Rockefeller Folk Art Museum (inv. no. 31.312.2, 21 7/8 × 29 1/8 in.; Rumford 1988, 357, no. 308, ill.).

7. For a calligraphic drawing featuring two heraldic rearing horses that is dated 1849 and has even more sophisticated parallel lines suggesting volume (Abby Aldrich Rockefeller Folk Art Museum; inv. no. 35.312.1, 21 7/8 × 16 1/8 in.), see ibid., 354–55, no. 306, ill., which states it may have a Pennsylvania origin.

8. Inv. no. 31.312.1, 22 7/8 × 17 5/8 in.; see ibid., 355–56, no. 307, ill. (it was found in Holicong, Bucks County, Pa.). In referencing the Society's sheet (wrongly identified as inv. no. 1937.1923), Rumford transcribed its inscription as *Drawn by James G. Sales under the tuition of J. G. Gray*. Koke 1982, 3:362, transcribed it as *Drawn by James T. Jules under the tuition of J. G. Trego*.

9. Inv. no. 64.312.3, 18 11/16 × 24 in; see Rumford 1988, 348, no. 298, ill.

10. It measures 19 × 26 in.; see Johnson 1975, 17, no. 182.

11. Inv. no. 56.416, in brownish black and gray inks and watercolor, 18 × 23 1/8 in., and inscribed at the lower left: *Drawn by C. Scherich under | The Tuition of J. Eichelberger | Jan 24th 1851*. See Rossiter 1962, 2:310–11, no. 1401, ill. The hill at the right contains small figures of men, hunting dogs, and an elephant. The sheet's calligraphy is more regularized, and the watercolor more transparent than in the other examples. Scherich also drew an armorial shield flanked heraldically by two rearing horses in the same collection (inv. no. 56.417; see ibid., 311, no. 1402, ill.).

JOHN BORNET

Active 1850–1856

Little is known about John Bornet, who was active for at least six years in New York City as an artist and lithographer during the mid–nineteenth century. He is documented in the city's directories between 1852 and 1856 and specialized in cityscapes that are dated from 1850 through 1856. A case in point is the pair of spectacular aerial vistas showing the topography of New York City and its surroundings (*Panorama of the Harbor of New York: Staten Island, and the Narrows* and *Panorama of Manhattan Island, City of New York and Environs*). These two remarkable bird's-eye-view lithographs were published by Goupil & Co., New York (1854; DPPAC, The N-YHS). For Goupil Bornet also produced pendant lithographs of the American and Canadian sides of Niagara Falls (1855–56). The American view is one of the most dramatic mid-nineteenth-century prints of this tourist magnet. In a tour-de-force manner, it shows both cascades with spray and light as seen from a vantage point near the foot of the American Falls.

The artist was best known for his *Souvenir of New York* (1851), a chromolithograph with selective hand-coloring, featuring eighteen vignettes of New York surrounding a bird's-eye view of lower Manhattan, for which he was both artist and lithographer. He also prepared the designs for over half of the twenty hand-colored chromolithographs in Henry Hoff's 1850 series *Views of New York* (nineteen of which are in the DPPAC). Bornet's drawings were also lithographed by other individuals, such as Edward Valois (*Bay of New York, Taken from the Battery*, 1851; DPPAC), the German-born painter and lithographer George Wilhelm Fasel, and additional lithographers mentioned below.

Bibliography: Stokes 1915–28, 3:705; Harry T. Peters, *America on Stone: The Other Printmakers to the American People* (1931; New York: Arno Press, 1976), 100; Stokes and Haskell 1932, 175; Groce and Wallace 1957, 65; Koke 1982, 1:73; Deák 1988, 1:415, no. 611, 416–17, no. 613; Falk 1999, 1:385; Decourcy E. McIntosh, "Merchandising America: American Views Published by the Maison Goupil," *The Magazine Antiques* 166:3 (2004): 128, 130; Marilyn Symmes, *Impressions of New York: Prints from the New York Historical Society*, exh. cat. (New York: Princeton Architectural Press and New-York Historical Society, 2004), 90, 106–7.

119a. *Scene on Hudson Street near the Ferry, Hoboken, New Jersey,* 1852

Graphite and orange watercolor wash on paper;
4 7/8 × 6 11/16 in. (124 × 170 mm)
Signed and dated at lower center inside image in graphite: *J. Bornet.—1852.*; inscribed at lower right outside image: *Scene on Hudson St near the Ferry*
Provenance: Daniel Parish Jr., New York.
Bibliography: Koke 1982, 1:73, no. 180.
Gift of Daniel Parish, Jr., 1912.45k

119b. *Elysian Fields, Hoboken, New Jersey,* 1852

Graphite and orange watercolor wash on paper;
4 7/8 × 6 5/8 in. (124 × 168 mm)
Signed and dated at lower right of center inside image in graphite: *J Bornet 1852.*; inscribed at lower right outside image: *Elysian Fields*
Provenance: Daniel Parish Jr., New York.
Bibliography: Koke 1982, 1:73, no. 180
Gift of Daniel Parish Jr., 1912.45L

119a

119b

119c

119c. *Saloon at Ferry, Hoboken, New Jersey*, 1852

Graphite and orange watercolor wash on paper; 4 7/8 × 6 11/16 in. (124 × 170 mm)
Signed and dated at lower left inside image in graphite on paper: *J. Bornet 1852.*; inscribed at lower right outside image: *Saloon at Ferry*
Provenance: Daniel Parish Jr., New York.
Bibliography: Koke 1982, 1:73, no. 180, ill.
Gift of Daniel Parish Jr., 1912.45n

These three small graphite scenes belong to a group of twenty-four representing buildings, sites, and vistas in the Hoboken and Weehawken, New Jersey, area bordering on the Hudson River and the famed Elysian Fields. Their intimate format contrasts with Bornet's more ambitious works, like his panoramas, some of which measure 24 by 36 inches.[1] No doubt this group was planned for a series of printed vignettes that may or may not have been completed. They resemble the style of Bornet's view of the Merchant's Exchange, chromolithographed by Charles Autenreich and published by Henry Hoff in the 1850 series *Views of New York*, subtitled *Twenty Beautiful Colored Views of the Most Remarkable and Prettiest Places, Buildings, and Streets of New York and Brooklyn*.[2] The publisher Hoff mounted each lithograph on card, whose decorative gold borders, inscriptions, and selective hand-coloring made them deluxe productions for the parlor akin to drawings or miniatures.[3] Perhaps Bornet's views of New Jersey were intended for a similar project or, alternatively, for a single print with multiple views, like his *Souvenir of New York* (1851).[4] That ambitious lithograph, which shows lower Manhattan from a vantage point in Brooklyn, contains in the background a view of the Palisades and one of the few glimpses of the Elysian Fields at Hoboken, for many years the favorite resort of New Yorkers and one of Bornet's major focal points in his series of twenty-four vignettes.[5]

Hoboken was originally an island, surrounded by the Hudson River on the east and a swamp at the foot of the Palisades. It was used seasonally as a campsite by the Lenni-Lenape until they fell victim to war, disease, and forced migration caused by Dutch and English settlers in the seventeenth century. The name "Hoboken" is derived from the original Lenape name for the area, *Hobocan Hackingh*, or land of the tobacco pipe; the Lenape made their pipes from the soapstone of Castle Point. The first European to discover the area was Henry Hudson, who anchored his ship off the northern coast of Hoboken in Weehawken Cove on 2 October 1609. On 12 July 1630 three Native Americans eventually sold the land that is now Hoboken to Michael Paauw, director of the Dutch West India Company, for eighty fathoms (146 meters [160 1/2 yards]) of wampum, twenty fathoms (37 meters [40 3/4 yards]) of cloth, twelve kettles, six guns, two blankets, one double kettle, and half a barrel of beer. The first European settlers of Hoboken were Dutch farmers. Hendrick van Vorst and Aeert van Putten built a farmhouse and brew house (the first in America) north of Castle Point. Eventually, the land came into the possession of William Bayard; originally a supporter of the Revolutionary cause, he converted to the loyalist Tory position in 1776 after the fall of New York. Following the American war for independence, the area that is now Hoboken was purchased at auction in 1784 by Colonel John Stevens, who in the early 1800s developed the waterfront as a lucrative resort for Manhattanites, which he also used as a laboratory for testing his mechanical inventions. Later in the century, the advantages of Hoboken (incorporated as a city in 1855) as a shipping port and industrial center would become apparent.

In 1832 the legendary Sybil's Cave advertised in the signage in the eleventh of Bornet's vignettes (*TO THE ELYSIAN FIELDS and SYBILS CAVE*) opened as an attraction near the Elysian Fields Park (cat. 119b).[6] At the time Hoboken was still a country spot located along the riverbank. At its most prominent point under the shade of Castle Point was the Sybil's Cave, where cool, refreshing water bubbling from the spring was sold to thirsty wayfarers at one cent a glass.[7] Edgar Allan Poe, the master American storyteller, used a real event that occurred in 1841 at Sybil's Cave as a basis for the detective story "The Mystery of Marie Roget." When in the 1880s the water served was found to be contaminated, the cave was shut, and in the 1930s it was filled with concrete. Presently there are plans to reopen the cave.[8]

Elysian Fields, the nearby park and fashionable pleasure resort on the Hudson River, took its name from the paradise of ancient Greek myth. Crowds came daily from New York City to enjoy its shady walks and quaff the refreshing beer dispensed in this vicinity. Its tall swing and other attractions foreshadowed today's amusement parks. It was here that P. T. Barnum instituted a buffalo hunt at the fort in the 1840s.

Although one of Bornet's twenty-four scenes depicted Weehawken Cove, where the duel between Aaron Burr and Alexander Hamilton took place,[9] the artist's emphasis was not on the historic associations of its locations but rather on their low-key picturesqueness, in contrast to the wilderness being tamed in William Guy Wall's pioneering *The Hudson River Portfolio* (1820–25; cat. 48). Bornet also featured adjacent charming watering holes of this tourist destination, such as the Saloon directly next to the ferry that ran from Hoboken to New York (cat. 119c). Nonetheless, Bornet was heir to the Wall tradition, celebrating picturesque locations on the Hudson River, as can be seen in his 1855 view of West Point and the Hudson Highlands, lithographed by Sarony & Co.[10]

1. See Symmes 2004, 106–7; and McIntosh 2004, nn. 39 and 40, which cites catalogues of Goupil and Co.
2. See Helen C. Comstock, "The Hoff Views of New York: A Rare Mid-Nineteenth-Century Series," *The Magazine Antiques* 51:4 (1947): 250–52 (the Merchant's Exchange is ill. on 251).
3. See Deák 1988, 1:406, no. 600; 2: ill. (a preparatory drawing for the view *University*); and Symmes 2004, 60–61, no. 26, ill., 287 (the chromolithograph *The Croton Water Reservoir*). Frank Weitenkampf, *The Eno Collection of New York City Views* (New York: Printed at The New York Public Library, 1925), 36, notes that the title page was lettered in gold: *The Empire City of New York*.
4. Deák 1988, 1:416–17, no. 613; 2: ill.
5. Stokes and Haskell 1932, 175.
6. Bornet drew the walks and the tall swing attraction of the Elysian Fields in other drawings from the series, inv. nos. 1912.45f, 1912.45v, 1912.45w, and 1912.45x.
7. Bornet recorded the entrance of the cave with its Gothic-style opening to stress the quasi-religious nature of this pilgrimage point and the nearby store with tables and stools in another drawing from the series (inv. no. 1912.45i).
8. http://en.wikipedia.org/wiki/Hoboken,_New_Jersey#History.
9. See Koke 1982, 1:73, no. 180, for a list of the twenty-four subjects in the series.
10. An impression is in the DPPAC; see John Ferguson Weir, "The Recollections of John Ferguson Weir (1841–1908)," *New-York Historical Society Quarterly* 41:2 (1957): 115, ill.

JAMES CARROLL BECKWITH

Hannibal, Missouri 1852–New York, New York 1917

J. Carroll Beckwith or Carroll Beckwith, as he preferred to be known, began his formal training in 1868 at the Chicago Academy of Design, where he enrolled in Conrad Diehl's class. Diehl was an accomplished draftsman who had studied in Düsseldorf, Germany. Under his tutelage, Beckwith cinched his devotion to the act of drawing and formulated his lifelong conviction that there is no better exercise than to draw the human body. After his father's business was destroyed in Chicago's Great Fire of 1871, Beckwith moved to New York, where he lived with his maternal uncle, John H. Sherwood, a cultured man who had made his fortune in real estate. Beckwith studied at the NAD under Lemuel Wilmarth, a student of Jean-Léon Gérôme, but yearned to experience art in the capitals of Europe, a path that seemed to guarantee success for an American artist. Two years later, in 1873, despite chronic ill health, he prepared to follow his classmates Julian Alden Weir and George de Forest Brush, boarding a steamship for England. Stopping briefly in London, he left for Paris several months later. "Then, I think, my real Art life began," he commented years later. "All that has gone before, was but a preamble."

In Paris, Beckwith found his friends already at work in Gérôme's atelier, where there was no room for him. He then heard about a new atelier, the *atelier des élèves*, conducted on new principles by Charles-Émile-Auguste Durand, the chic portraitist of the Third Republic elite who styled himself Carolus-Duran. The students were responsible for paying for the rent, heat, and models, but the master, who maintained a separate studio, examined and critiqued the students' works twice a week. After enrolling in Carolus-Duran's democratic atelier in 1873, Beckwith became a *massier* (student monitor) in charge of collecting fees. During the summer of 1874, he worked *en plein air* in Barbizon near Fontainebleau and other locations in the countryside. On his return to Paris in September, he felt ready after his yearlong study to compete for admission to the École des Beaux-Arts. John Singer Sargent, who had joined the atelier in May (cats. 124 and 125), was also ready to apply in October. Beckwith failed the *concours des places*, yet the eighteen-year-old Sargent was admitted to the prestigious institution, making Beckwith's failure all the more difficult to bear. Beckwith began to have serious reservations about Carolus-

Duran's instruction, and he supplemented his studies by working with the Realist Léon Bonnat, taking classes at the Académie Suisse, and studying the European masters in the Musée du Louvre. His hard work paid off, and in 1875 Beckwith was admitted into the École des Beaux-Arts. He also became more convinced that, Carolus-Duran notwithstanding, drawing was the mainstay of an artist's skills. In May 1875 he traveled to Venice, where he was impressed by Tintoretto's art, especially his paintings in the Scuola di San Rocco. During these travels Beckwith executed many small studies in graphite after Titian, Veronese, Tintoretto, and other old masters. After returning to Paris in late August 1875, he and Sargent rented a studio at 73, rue Notre-Dame-des-Champs. The two young artists also began assisting Carolus-Duran on his monumental ceiling canvas *The Triumph of Marie de Medici* in the Salle de Vernet of the Palais du Luxembourg, commissioned in 1875 but executed mainly in 1877–78 (Musée du Louvre, Paris). They inserted portraits of one another into the composition, continuing that Renaissance workshop tradition. In 1877 Beckwith successfully exhibited at the Paris Salon, where he showed works sporadically through 1890, and in 1891 he toured Europe with another American, the writer and artist William Walton, before the two returned to the United States. On the voyage home, they encountered William Merritt Chase, whom Beckwith had already met in Munich.

When he returned to New York in 1878, Beckwith set up a studio in the Sherwood Studio building at 58 West Fifty-seventh Street, which was owned by his uncle. He taught at the Art Students League (founded in 1875) almost without interruption until 1897 (he was listed on the roster from 1880 until after 1900), where he promoted the importance of drawing as a prerequisite to artistic excellence (his rigorous method served as a foil to Chase's freer style). It was generally hoped that Beckwith's demanding drawing courses would invigorate the league's curriculum. A well-respected and popular teacher, he also taught at the Metropolitan Art School, the Brooklyn Art Guild, and the Cooper Union. Passionate in his quest to affirm his artistic principles, he took small groups of students to his vacation residence in Onteora, in the Catskills. Becoming an active member of the Society of American Artists and of the Century

Association, Beckwith nevertheless continued his summer trips to Europe to study and paint *en plein air* in the French countryside. Despite his shyness, Beckwith became a popular public lecturer and found another outlet for his views in the press, writing for the *New York Times* and the *Herald Tribune*. He helped fight against tariffs that were imposed on imported artworks, becoming president of the Free Art League, which was formed to oppose the tax. Together with Chase, he worked on the *Pedestal Fund Art Loan Exhibition* (1883), which included cutting-edge European art and was mounted to help finance the pedestal for Frédéric-Auguste Bartholdi's *Statue of Liberty* (cat. 110). The Chase-Beckwith collaboration continued with the formation of the Society of Painters in Pastel (1882) and its first exhibition in 1884.

Throughout his career, Beckwith concentrated on portraits and figure studies, which he exhibited at the NAD, the Pennsylvania Academy of the Fine Arts in Philadelphia, and the Brooklyn Art Association, among other venues. With such works as his portrait of William Walton (1886; Century Association, New York), he gained recognition as one of the city's most popular portrait painters. In 1886 he became an associate of the NAD, and an academician in 1894. Always interested in idealized female imagery, Beckwith designed personifications that decorated the dome and pendentives of the entrance pavilion of the Manufactures and Liberal Arts Building at the 1893 World's Columbian Exposition in Chicago (Electricity, the Dynamo, the Arc-light, the Telegraph, and the Telephone). He also exhibited two easel paintings at the fair. After selling many of his belongings through the American Art Association, he and his wife, Bertha, traveled in 1910 to Italy, where he began painting small landscapes. Returning to the United States in 1912, Beckwith set up a studio in the Hotel Schuyler, where he painted until his death. An exhibition of his Versailles paintings at the Powell Gallery in New York in 1913 was so successful that he returned to France in the fall of that year to execute additional canvases. He may have conceived this series as his response to modernism, celebrating the past but breaking new ground stylistically. Throughout his career he remained true to his French training, later in life becoming a vocal crusader against the "new art." In 1917 he started an autobiography,

120a

"Souvenirs and Reminiscences," which remained unfinished (held at the NAD, together with forty-one yearly diaries, photographs, and other memorabilia). His poor health may have contributed to his suicide. In the minds of his fellow artists, J. Carroll Beckwith stood for an unwavering commitment to the highest ideals of academic art with drawing as its foundation.

The N-YHS has a large cache of Beckwith material, largely unexplored until 2005. The museum holds three albums, a gift from the NAD, containing 643 drawings by Beckwith, mostly small graphite sheets, together with a few drawings by several other artists.* These fascinating compilations include ten previously unpublished early portraits of Sargent by Beckwith, and six early drawings by Sargent (cats. 124 and 125), as well as a watercolor by Sargent's elder sister, Emily, who was an accomplished watercolorist. Many of Beckwith's studies are after the old masters and such modern artists as Eugène Delacroix, Carolus-Duran, and Richard Parks Bonington. The third album contains drawings relating to personifications of Electricity and the Telephone for Beckwith's Columbian Exposition project (1893). The Society's library holds Beckwith's diary for 1895; eight scrapbooks (containing photographs of the artist and his paintings), newspaper clippings, and memorabilia, including clippings relating to women's suffrage; and, in the DPPAC, a study collection of reproductions of Beckwith's paintings and prints.

Bibliography: Annette Blaugrund et al., *Paris 1889: American Artists at the Universal Exposition*, exh. cat. (Philadelphia: Pennsylvania Academy of the Fine Arts, in association with Harry N. Abrams, 1989), 112–14; Fink 1990, 319; Weinberg 1991, 199–202; William H. Gerdts et al., *Lasting Impressions: American Painters in France, 1865–1915*, exh. cat. (Evanston, Ill.: Terra Foundation for the Arts, 1992), 272–73; Carr and Gurney 1993, 204; John Davis, "'Our United Happy Family': Artists in the Sherwood Studio Building, 1880–1900," *Archives of American Art Journal* 36:3–4 (1996): 2–19; Kornhauser 1996, 1:88–89; Pepi Marchetti Franchi and Bruce Weber, *Intimate Revelations: The Art of Carroll Beckwith (1852–1917)*, exh. cat. (New York: Berry-Hill Galleries, 1999); Dearinger 2004, 35–37; Olson 2005; Adler, Hirshler, and Weinberg 2006, 66–68, 74, 98, 226.

120a. *John Singer Sargent (1856–1925) at the Easel, Holding a Palette*, c. 1875

Graphite with touches of purple watercolor on ivory paper, formerly mounted on a page of the James Carroll Beckwith Album 1; 6 5/8 × 4 in. (168 × 101 mm), irregular
Inscribed below on album page where formerly mounted, in graphite: *Sargent with palette / He was about 19 years old—*
Provenance: James Carroll Beckwith; The National Academy of Design, New York.

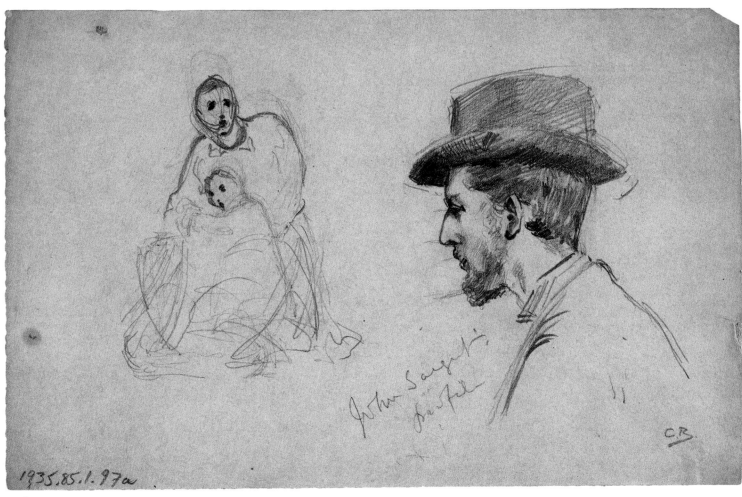

120b

Bibliography: Olson 2005, 418, 432, no. 1, fig. 5; Ormond and Kilmurray 2006, 19, fig. 2.
Gift of the National Academy of Design, 1935.85.1.94

120b. *John Singer Sargent (1856–1925) and Study of Two Figures*; verso: classical scene, c. 1874–78

Graphite on gray-green paper, formerly mounted on a page of the James Carroll Beckwith Album 1; 6 5/16 × 9 11/16 in. (160 × 246 mm), irregular
Signed at lower right in graphite: *C.B.*; inscribed at lower center: *John Sargent / profile*
Provenance: James Carroll Beckwith; The National Academy of Design, New York.
Bibliography: Olson 2005, 420, 432, no. 2, figs. 11, 24.
Gift of the National Academy of Design, 1935.85.1.97

120c. *John Singer Sargent (1856–1925), Seated and Holding the Fiddle of George de Forest Brush (1855–1941)*; verso: sketch of Sargent from the side, seated and holding Brush's fiddle, 1874

Graphite on ivory paper, formerly mounted on a page of the James Carroll Beckwith Album 2; 6 1/16 × 3 9/16 in. (154 × 90 mm)
Signed at lower right in graphite: *CB* [monogram]; inscribed along upper edge: *Studio 54 rue des Saint Peres*; dated at lower left: *June 17th 74*; inscribed right: *Sargent with / Brush's fiddle*
Provenance: James Carroll Beckwith; The National Academy of Design, New York.
Bibliography: Olson 2005, 418, 432–33, no. 3, figs. 6, 25.
Gift of the National Academy of Design, 1935.85.2.32

120d. *John Singer Sargent (1856–1925), Seen from the Side, Seated and Holding the Fiddle of George de Forest Brush (1855–1941)*, 1874

Graphite on ivory paper, formerly mounted on a page of the James Carroll Beckwith Album 2; 3 9/16 × 4 11/16 in. (90 × 119 mm)
Provenance: James Carroll Beckwith; The National Academy of Design, New York.
Bibliography: Olson 2005, 418, 433, no. 4, fig. 7.
Gift of the National Academy of Design, 1935.85.2.33

120e. *John Singer Sargent (1856–1925), Seen from the Back, Seated at an Easel and Holding a Palette*, 1875

Graphite on ivory paper, formerly mounted on a page of the James Carroll Beckwith Album 2; 6 1/16 × 3 9/16 in.

120c

(154 × 90 mm)
Signed and dated at lower left in graphite: *CB* [monogram] *75*; inscribed at upper right: *Sargent painting*
Provenance: James Carroll Beckwith; The National Academy of Design, New York.
Bibliography: Olson 2005, 420, 433, no. 5, fig. 13.
Gift of the National Academy of Design, 1935.85.2.83

120f. *The Reading Club: John Singer Sargent (1856–1925), Seated with Another Man and Reading Shakespeare*; verso: sketch of a woman holding up her hands, c. 1875

Graphite on ivory paper, formerly mounted on a page of the James Carroll Beckwith Album 2; 3 3/4 × 5 13/16 in. (95 × 148 mm)
Signed at lower right in graphite: *CB* [monogram]; inscribed at lower left: *The reading club*—; at lower right: *Sargent reading Shakespere*
Provenance: James Carroll Beckwith; The National Academy of Design, New York.
Bibliography: Olson 2005, 418–19, 433, no. 6, figs. 8, 26; Ormond and Kilmurray 2006, 19, fig. 4.
Gift of the National Academy of Design, 1935.85.2.151

120g. *John Singer Sargent (1856–1925) Playing the Piano in the Studio*; verso: hand study, c. 1875–76

Graphite on ivory paper, formerly mounted on a page of the James Carroll Beckwith Album 2; 5 13/16 × 3 3/4 in. (147 × 95 mm)
Signed at lower left in graphite: *CB* [monogram]; inscribed along lower edge: *Sargent practicing in the studio 73 rue N. D / des Champs*; below on album page where formerly mounted, in graphite: *SARGENT Practicing*
Provenance: James Carroll Beckwith; The National Academy of Design, New York.
Bibliography: Olson 2005, 419, 433–34, no. 7, figs. 9, 27; Ormond and Kilmurray 2006, 19, fig. 3.
Gift of the National Academy of Design, 1935.85.2.170

120h. *John Singer Sargent (1856–1925),* 1876

Graphite on ivory paper, formerly mounted on a page of the James Carroll Beckwith Album 2; 3 3/4 × 2 1/2 in. (95 × 64 mm)
Dated and signed at lower left in graphite: *April 16th 76 / CB* [monogram]; inscribed below on album page where formerly mounted, in graphite: *J. S. SARGENT / AET XX*
Provenance: James Carroll Beckwith; The National Academy of Design, New York.
Bibliography: Olson 2005, 421, 434, no. 8, fig. 12, cover ill.
Gift of the National Academy of Design, 1935.85.2.176

120i. *In the Atelier of Carolus-Duran: John Singer Sargent (1856–1925) Painting at the Easel in the Company of Frank Fowler (1852–1910) and an Unidentified Artist*; verso: two studies of a man in a bowler hat, c. 1874–76

Graphite on ivory paper, formerly mounted on a page of the James Carroll Beckwith Album 2; 3 13/16 × 4 1/4 in. (97 × 108 mm)
Signed at lower left in graphite: *C-B* [monogram]; inscribed at lower left: *In the Atelier*; inside image: *Sargent*; *Fowler*; and *?*
Provenance: James Carroll Beckwith; The National Academy of Design, New York.
Bibliography: Olson 2005, 418, 434, no. 9, figs. 4, 28; Ormond and Kilmurray 2006, 19, fig. 5.
Gift of the National Academy of Design, 1935.85.2.245

120d

120e

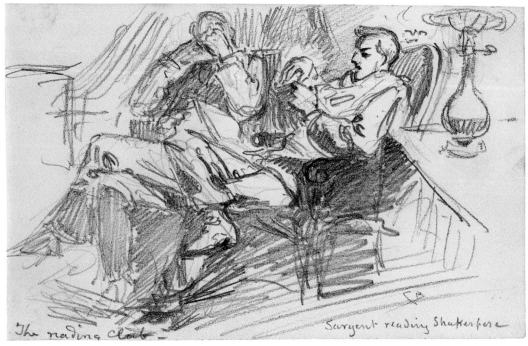

The reading Club

Sargent reading Shakespere

120f

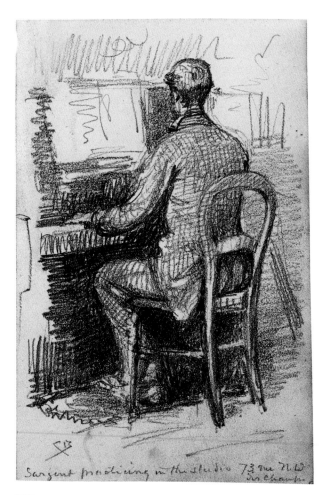

Sargent practicing in the studio 73 rue N.D.
des Champs

120g

120h

120j. *John Singer Sargent (1856–1925) and Eugène Lachaise (1857–1925) Fishing in a Boat at Saint Germain au Mont d'Or*; verso: variant of same composition and study of a bust-length figure, 1874–77

Graphite on ivory paper, formerly mounted on a page of the James Carroll Beckwith Album 2; 5 7/8 × 3 11/16 in. (149 × 94 mm)
Signed at middle right in graphite: *CB* [monogram]; inscribed at upper right: *St Germain au / Mont d'or*; at center inside image: *John*; at lower edge: *Eugene John*
Provenance: James Carroll Beckwith; The National Academy of Design, New York.
Bibliography: Olson 2005, 420–21, 434, no. 10, figs. 14, 29.
Gift of the National Academy of Design, 1935.85.2.261

This invaluable group of ten recently discovered and published drawings by Beckwith, each discussed briefly below, represents the earliest known portraits of Sargent.[1] Meeting in Carolus-Duran's atelier,[2] the young artists became fast friends. From the evidence contained in his writings and portraits, Beckwith was clearly mesmerized by Sargent. He confessed in his diary on 13 October 1874: "My talented friend Sargent has been working in my studio with me lately and his work makes me shake myself."[3]

His fascination with his colleague is apparent in these ten candid likenesses. Sargent returned the favor and portrayed a then-clean-shaven Beckwith in profile, painting at an easel and wearing a vest, in a small graphite drawing signed and dated June 1874.[4] Young artists frequently served as each other's models, since they were available in the studio and after hours for study without cost. As a group, Beckwith's ten drawings reveal fascinating insights into the fraternal relationship of these American artists in Paris and intimate facts about Sargent's habits and mien. Moreover, one of these sheets (cat. 120c), dated 17 June 1874, provides the first evidence of Beckwith's friendship with Sargent, not yet three weeks after he entered Carolus-Duran's atelier on 30 May 1874.

120a. In this sheet torn from a sketchbook, Beckwith portrayed Sargent, his long legs intertwined while painting at an easel, palette in hand. Beckwith captured Sargent's great personal panache and dedication.

120b. On the basis of the sitter's hat, this rather complete portrait was drawn out of doors, suggesting that the two artists were working *en plein air* by at least 1875, which was not an unusual phenomenon during the heyday of Impressionism. See also catalogue 120e below.

120c. This drawing documents an early encounter between Beckwith and Sargent. The verso contains an awkwardly proportioned sketch with the same composition as the following sheet (cat. 120d), abandoned, no doubt, in favor of a fresh start. George de Forest Brush, a fellow NAD colleague of Beckwith studying in Paris with Gérôme, was a member of Sargent's Parisian circle.

120d. By comparison with catalogue 120c, whose verso contains an abandoned variant composition, this drawing can also be dated to 17 June 1874. Beckwith drew the sheet at his first Parisian studio (54, rue des Saint Pères). Both studies illustrate Sargent's interest in music, his second passion after art. See also catalogue 120g below.

120e. As in catalogue 120b above, Sargent wears a hat and coat, suggesting that he was painting outside—not an unusual practice during the halcyon days of Impressionism—in the company of Beckwith.

120f. This intimate sketch documents a highly

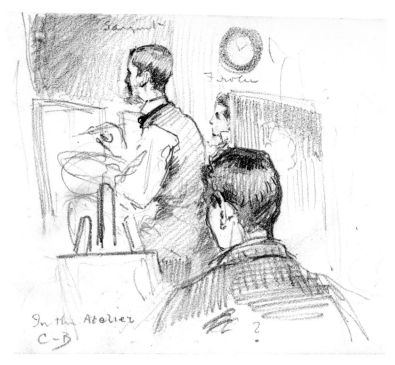

120i

120j

focused Sargent reading Shakespeare in the company of another man by the light of a gas lamp. Beckwith's assured, quick strokes capture his friend's intense concentration and echo the animated quality of Sargent's agile mind.

120g. Another activity in which Sargent excelled was playing the piano, a passion Beckwith documents in this work. Its inscription reveals that Sargent was not just playing the instrument but "practicing," suggesting real dedication and discipline. After painting, Sargent's consuming interest in life was music, which became not only his chief pleasure but also the nucleus of his social life.[5] This drawing, the only identified record of the interior of the studio shared by Sargent and Beckwith on the

rue Notre-Dame-des-Champs, reveals that it was furnished with an upright piano.

120h. Perhaps the most iconic of Beckwith's portraits of the young Sargent, this sheet's inscription demonstrates that Beckwith himself realized how powerful and haunting an image it was. The artist self-consciously inscribed the album page below it in the style and abbreviated Latin formula of bygone ages giving the sitter's name and age.[6] This inscription, with its old master resonance, may also be a commentary on Beckwith's assessment of Sargent's major talent and his hope for his own promise.

120i. From the vantage of his easel in the atelier of Carolus-Duran in Paris, Beckwith drew three

of his fellow students, including Frank Fowler (under the clock on the wall), whom Sargent had met in Florence in 1873, and Sargent holding a palette and brush before an easel. When Beckwith compiled his albums he did not recall the identity of the third artist, placing a question mark near him. Will Hicok Low, who was also in the atelier, recorded Sargent's entry into this lively environment on 16 May 1874:

> He made his appearance … almost bashfully, bringing a great roll of canvases and papers, which unrolled displayed to the eyes of Carolus and his pupils gathered about him sketches and studies in various mediums, seeming the work of many years; (and John Singer Sargent was only seventeen) … an amazement to the class … . The master

studied these many examples of adolescent work with keenest scrutiny, then said quietly: "You desire to enter the atelier as a pupil of mine? I shall be very glad to have you do so". And within a few days he had joined the class. Having a foundation in drawing which none among his new comrades could equal, this genius—surely the correct word—quickly acquired the methods then prevalent in the studio, and then proceeded to act as a stimulating force which far exceeded the benefits of instruction given by Carolus himself.[7]

120j. Eugène Lachaise was a fellow American art student in Paris with Sargent. During the summer of 1877, the two young men went on a painting holiday to Cancale in Brittany and then traveled with Beckwith to Saint-Senoch near Loches in the Loire Valley, where Lachaise's stepfather had a country house.[8] No doubt on a similar outing they relaxed and sketched at St. Germain au Mont d'Or, near Lyon. Beckwith drew his fairly avant-garde, cropped, and foreshortened composition from inside the boat,

viewing Sargent and Lachaise, both wearing berets and sitting in its bow fishing, to commemorate their holiday. Beckwith displayed in the album the complete vertical study on the sheet's recto rather than the horizontally oriented one on the verso. The similarity of Beckwith's composition to Édouard Manet's well-known *Boating* (The Metropolitan Museum of Art, New York), painted in the summer of 1874 and exhibited in the artist's studio in 1876 (also in the Salon of 1879), suggests a terminus post quem for the drawing.[9]

* A generous Save America's Treasures grant from the National Endowment for the Humanities has allowed for the removal and conservation of the lion's share of the sheets from the three albums.

1. Elaine Kilmurray and Richard Ormond, eds., *Sargent*, exh. cat. (London: Tate Gallery Publishing, 1988), 13, reproduces early photographs of Sargent. In Paris he grew a full beard about 1874, as seen in a photograph by an individual only identified as Otto (ibid., 272, fig. 82). With the evidence presented in these drawings, the heavier beard would appear to date from a later time.

2. For Carolus-Duran's atelier, see Weinberg 1991, 189–219.

3. James Carroll Beckwith Papers, 1871–1983, owned by the NAD, microfilmed by the AAA, reel 4798.

4. Inv. no. 1937.8.3, Fogg Art Museum, Harvard University, Cambridge, Mass.; see Olson 2005, 419–20, fig. 10.

5. Stanley Olson, *John Singer Sargent: His Portrait* (London and New York: St. Martin's Press, 1986), 71.

6. A nearly identical, but slightly more stylized, drawing lacking Beckwith's monogram is reproduced without a location in William A. Coffin, "Sargent and His Painting: With Special Reference to His Decorations in the Boston Public Library," *Century Illustrated Monthly Magazine* 52, n.s., 30 (1896): 171. Beckwith may have copied his original as a remembrance that he gave to Sargent or another friend. The sheet remains untraced, according to Elaine Kilmurray (e-mail message, 20 September 2005).

7. Quoted in H. Barbara Weinberg, "Sargent and Carolus-Duran," in Marc Simpson, with Richard Ormond and H. Barbara Weinberg, *Uncanny Spectacle: The Public Career of the Young John Singer Sargent*, exh. cat. (Williamstown, Mass.: Sterling and Francine Clark Art Institute, 1997), 5.

8. Ormond and Kilmurray 1998, 124.

9. Françoise Cachin et al., *Manet (1832–1883)*, exh. cat. (New York: Metropolitan Museum of Art, 1983), 356–59, no. 140, ill.

HOWARD PYLE
Wilmington, Delaware 1853–Florence, Italy 1911

Born to Quaker parents, Howard Pyle became one of the most influential American illustrators since Felix O. C. Darley (cat. 97). Pyle's creative abilities were encouraged by his mother, who exposed him to literature and influential British periodicals such as *Punch* and the *Illustrated London News*. At sixteen he attended the Pennsylvania Academy of the Fine Arts in Philadelphia, studying for three years with the Belgian artist Franz Van der Weilen. Pyle sold his first illustrated article to *Scribner's Monthly* in 1876, prompting him to relocate to New York. For the next three years Pyle nurtured his relationships with publishers and other artists including William Merritt Chase, Edwin Austin Abbey, Winslow Homer, and James Carroll Beckwith (cat. 120). He soon became a regular contributor to such illustrated periodicals as *Harper's*, *St. Nicholas*, and *McClure's*. Pyle returned to Wilmington in 1879 to establish his own studio

in the Brandywine River valley. His first children's book, *The Merry Adventures of Robin Hood*, appeared in 1883, followed by *Within the Capes* (1885), *Pepper and Salt* (1887), *The Wonder Clock* (1888), and many others. He also illustrated his own versions of classic tales including a four-book series retelling the legends of King Arthur (1903–10).

In 1894 Pyle began to teach, first at the Drexel Institute in Philadelphia, and later at the Drexel summer studio in Chadds Ford, Pennsylvania. Between 1900 and 1903 Pyle built a second studio alongside his own and sought students for a unique drawing class. He charged no fees except for a modest studio rental and worked with students daily. Some of the best-known illustrators of the early twentieth century attended Pyle's Brandywine School, including Maxfield Parrish, Harvey Dunn, N. C. Wyeth, Jessie Willcox Smith, Frank Schoonover,

and Elizabeth Shippen Green, among others. In spite of his conservative approach, Pyle recognized and encouraged artistic talent in women, and of the 110 students who enrolled in his classes, 40 were women. He also developed an interest in painting murals of historical subjects, and in 1906 he completed his first commission, *The Battle of Nashville*, which still hangs in the Minnesota State Capitol in St. Paul.

Pyle was best known as an illustrator of adventure fiction. He was passionate about capturing dramatic action in his works but eschewed the stiff, theatrically staged compositions of earlier illustrations. His style integrated exciting visual perspectives that conveyed both action and a sense of inclusion in the image. Pyle discarded the wan, passive, sentimental Victorian characters common to the moralizing children's fiction of the earlier nineteenth

century and replaced them with hearty, assertive characters displaying what he believed to be distinctly American personas.

Criticism leveled at Pyle's work throughout his career inevitably focused on his lack of classical academic training, and in 1910 he traveled to Italy with the intention of studying the old masters. He died in Florence in 1911 from a kidney infection.

Bibliography: Charles David Abbot, *Howard Pyle: A Chronicle* (New York: Harper and Bros., 1925), 17–43, 58–61, 111–40, 152–75, 203–49; Henry C. Pitz, *The Brandywine Tradition* (Boston: Houghton, Mifflin, 1969), 33–175; Koke 1982, 3:77–79; Reed 2001, 62–63, 102, 112–13, 119, 122, 126–27; Dearinger 2004, 453.

121. *Hamilton Addressing the Mob: Study for the Illustration in "Harper's New Monthly Magazine" (October 1884)*, 1884

Watercolor, black ink and wash, and gouache on card; 13 1/2 × 10 in. (343 × 254 mm)

Signed at lower right inside image in black ink: *H. Pyle*; inscribed below outside image in graphite: *He haranged [sic] the mob with great eloquence and / animation (Kings College P 109) / (Alex. Hamilton haranging [sic] the mob)*
Provenance: George A. Zabriskie, New York.
Bibliography: Koke 1982, 3:78, no. 2354, ill.
Gift of George A. Zabriskie, 1951.378

The perspective of this typical Howard Pyle historical illustration conveys the dramatic action and brings the viewer into the scene. Standing above the crowd beside his friend Robert Troup, Alexander Hamilton gestures broadly from the steps of King's College, now Columbia College, New York City, in this drawing that shows Hamilton haranguing the mob. On 10 May 1775 Hamilton defended the Tory president of King's College, Myles Cooper, from an angry group of anti-British colonists. Hamilton addressed the crowd with an oration on the "excessive impropriety of their conduct, and the disgrace they were bringing on the cause of liberty,"[1] delaying and distracting the protesters while Cooper escaped through a rear window. The engraving made after this sheet first appeared in *Harper's New Monthly Magazine* to illustrate an article entitled "King's College"[2] and posthumously in *Howard Pyle's Book of the American Spirit*.[3] The original woodblock engraved by F. H. Wellington of *Harper's* from this drawing in 1884 is in the Society's DPPAC.

A. M.

1. From a letter sent by Hamilton's college roommate Troup to Colonel Pickering in 1775; see John C. Hamilton, *The Life of Alexander Hamilton* (New York: D. Appleton and Co., 1840–41), 1:48.
2. John MacMullen, "King's College," *Harpers's New Monthly Magazine* 69:413 (1884): 715–23, ill. on 722.
3. Howard Pyle, *Howard Pyle's Book of the American Spirit*, ed. Merle Johnson and Francis J. Dowd (New York: Harper and Brothers, 1923), 193.

UNIDENTIFIED ARTIST WORKING FOR CHARLES MAGNUS & COMPANY

1854—?

Charles Magnus & Company was a prominent publishing house with offices in New York and Washington, D.C, specializing in lithographic illustrations, letterheads, letter sheets,* and stationery. The company, established by Charles Magnus (1826–1900) in 1854, produced countless large and small scenes and was particularly known for finely detailed bird's-eye views and panoramic vistas of major American cities. It also published pictures of newsworthy events, many images of the Civil War, and popular illustrated song sheets. Most of Charles Magnus & Company's lithographs were rendered from photographic models. The artists often remained anonymous, although the firm occasionally collaborated with well-known independent lithographers, including John Bachmann, who was credited as the artist of an 1859 bird's-eye view of New York published by Magnus & Company.

From its inception Charles Magnus & Company was a major producer of pictorial

Fig. 122.1. Unidentified Artist Working for Charles Magnus & Company, *Panoramic View of Coney Island, Brooklyn, New York.* Black ink, collage, white gouache, and graphite on paper, laid on card, crowned with a lunette extension of lined paper, and covered with a protective flap, 6 1/8 × 12 5/8 in. (156 × 320 mm), irregular. The New-York Historical Society, X.510

122

letterheads and letter sheets, which were popular until the postal service issued its first penny postcard in 1873. Publishers like Magnus & Company often embellished their letter sheets with a wide variety of small illustrations to attract customers. The company was also known for its photographic quality lithographs for stationery letterheads, including the noted *100 Views of New York and Environs*.

Charles Magnus & Company created lithographic illustrations both in black and white and colored tones. Among them are panoramic depictions of cities such as "New Orleans on the Mississippi River" and "Syracuse, New York" and a series of sweeping views of "The Great East River Bridge" (Brooklyn Bridge). Other notable lithographs by the company include street scenes in New York City at Bowling Green, City Hall, and Trinity Church; commemorative montages such as "Celebration All Over the United States in Honor of

Ocean Telegraphing, Sept. 1858" and "Terrible Railroad Disasters;" and views of London and Montreal after paintings by Edwin Whitefield.

The Society holds a cache of over forty of Charles Magnus & Company's studies for lithographs, several preparatory for its pamphlets *100 Letter-head Paintings of New York* and *48 Note Size Views*. These meticulously accurate illustrations preserve many lost nineteenth-century urban vistas of the burgeoning American cityscapes, and, in many cases, Magnus & Company views are the only known illustrations of a specific locality.

Bibliography: Harry Twyford Peters, *America on Stone: The Other Printmakers to the American People* (Garden City, N.Y.: Doubleday, Doran and Company, 1931), 83, 269–70; New York Public Library, *America on Stone: American Life in Lithographs*, exh. cat. (New York: New York Public Library, 1934); Ann Ugast, "American Pictorial Lettersheets," *Imprint* 4:2 (1979): 11–17; Koke 1982, 2:305–7; John William Reps, *Views and Viewmakers of Urban America: Lithographs of Towns and Cities in the United States and Canada, 1825–1925*

(Columbia: University of Missouri Press, 1984), 287, 320, 354, 393, 396–97, 403, 419; idem, *Bird's Eye Views: Historic Lithographs of North American Cities* (New York: Princeton Architectural Press, 1998), 39, 50.

122. *View of Brooklyn from the Brooklyn Bridge, Brooklyn, New York*, after 1883

Black ink, white gouache, and graphite on photo-sensitive paper, laid on card; 6 1/2 × 12 1/2 in. (165 × 317 mm), irregular
Various publication annotations on card
Gift of Daniel Parish Jr., 1904.22

This unusual dramatic vista of Brooklyn as seen from the Brooklyn Bridge was produced soon after the completion of John A. Roebling's famous bridge in 1883, when it was often referred to as "The Great East River Bridge." Many of these views were created by artists using photo-sensitive paper; details were delineated and added in ink and graphite with white heightening. Magnus & Company illustrations

were often enhanced with finely detailed drawn and printed figures, inserted or collaged into the composition to add activity to the scene. Although the company's early reputation was built on the popularity of its high-quality illustrated letter sheets, it grew to be one of the major suppliers of fine lithographic illustrations, like this view of Brooklyn Bridge.

The extraordinary perspective was taken from the top of the 276-foot-tall Brooklyn tower, looking east down the graceful curves of the four 15 1/2-inch steel wire suspension cables that support the bridge's center span.[1] The view anticipates the extreme perspectives of the bridge used by Joseph Stella in his paintings, especially *The Brooklyn Bridge: Variations on an Old Theme* (1939; Whitney Museum of American Art, New York). In the Magnus & Company drawing, the two outside carriage lanes flanking the tracks of the cable railways are visible; the busy pedestrian lane forms the center of the bridge. The train on the westbound track has left the long, vaulted Brooklyn terminus building at the eastern end of the bridge headed for New York City.[2] Brooklyn sprawls eastward from the anchorage point below the tower, with Old Fulton Street at center to the right of the bridge. Visible at the distant right are the cupola of City Hall and the Gothic-Revival spire of the Church of the Trinity (now Borough Hall and the Diocesan Church of St. Ann's and the Holy Trinity, respectively) on Montague Street.[3]

The Brooklyn Bridge was constructed between 1870 and 1883 under the management of chief engineer John Roebling and his son, Washington Roebling, who pioneered many new construction, anchorage, and cabling techniques on the monumental project. Never before had a nation, corporation, or an individual attempted to build a structure of the magnitude of the Brooklyn Bridge. When the bridge opened, it had the highest towers and the longest suspended central span of any bridge in the world. The success of the construction led to the conceptualization of the bridge as an icon of American ingenuity, progress, and design. The seven images of the bridge in the N-YHS Magnus material demonstrate the importance of the structure as a national landmark.

In contrast, the Magnus & Company letterhead illustration of Coney Island (fig. 122.1) provides a traditional panoramic view of the bustling amusement piers. It is one of two Magnus & Company depictions in the Society's collection of this important New York City area landmark and symbol of American inventiveness. Seen from the ocean side, the Coney Island Tower is barely visible in the far right foreground of the drawing, with the flags and banners flying over its major resort buildings, bathhouses, and amusement parks occupying the center of the view. The rare inclusion of hot-air balloons above the park makes this work a compelling scene of technological achievement. The artist assembled this composition by collaging a second, semicircular sheet to the top of the original drawing to provide an arched sky in which to place the high-flying balloons. The earliest recorded regularly scheduled Coney Island balloon ascensions originated from the Sea-Side Aquarium about 1878, and continued with free-flying, tethered, and motorized balloon rides into the 1920s.[4]

A. M.

* Lettersheets, folded sheets used as their own envelopes, were created before 1845, when postage was calculated based on the distance a letter traveled multiplied by the number of sheets sent. They were an economical form made of a large sheet, usually measuring about 21 by 17 inches.

1. The center span measures 1,595 1/2 feet; see "The Brooklyn Bridge," *Harper's New Monthly Magazine* 66:396 (1883): 925–46. For general references on the Brooklyn Bridge, see Samuel W. Green, ed., *A Complete History of the New York and Brooklyn Bridge: From Its Conception in 1866 to Its Completion in 1883* (New York: S. W. Green's Son, 1883); Alan Trachtenberg, *Brooklyn Bridge, Fact and Symbol* (New York: Oxford University Press, 1965); Brooklyn Museum, *The Great East River Bridge, 1883–1983*, exh. cat. (Brooklyn: Brooklyn Museum, 1983).

2. "Improvements in the Cable Railway of the New York and Brooklyn Bridge," *Scientific American* 59:3 (1888): 31, 39–40.

3. For another view with many of the same buildings, see Deák 1988, 1:368, no. 548; 2: ill.

4. Jeffery Stanton, "Coney Island Rides & Shows List," http://www.westland.net/coneyisland/articles/ridelist.htm, 1998. For general references on Coney Island, see Charles Denson, *Coney Island: Lost and Found* (Berkeley, Calif.: Ten Speed Press, 2002); and John S. Berman, *Coney Island* (New York: Barnes and Noble Books, 2003).

JOHN WARD DUNSMORE

Reily, Ohio 1856–Dover, New Jersey 1945

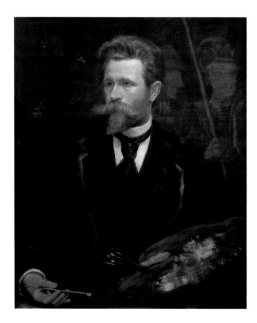

John Ward Dunsmore began his art training in 1872. He attended the Cincinnati Art Academy for two years before studying in France under Thomas Couture (cat. 83) and exhibiting at the Paris Salon in 1878. His works were also exhibited at the Suffolk Street Gallery in London and the NAD in New York. Soon after Couture's death in March 1879, Dunsmore returned to Cincinnati to establish a portrait studio and offer classes in drawing and painting.

During the 1880s Dunsmore traveled to London once again before returning to the Midwest to head the new Detroit Museum of Art in 1888, renamed the Detroit Institute of Arts. Dunsmore was a pioneering leader in the Detroit art community from 1888 to 1894. During his brief tenure as director of the museum he mounted an exhibition of American watercolors and opened the first school connected with the museum, the Art School of the Detroit Museum, which offered a full range of instruction. He resigned from the museum in 1891 to teach and assume directorship of the Art School, where he brought in well-known Michigan artists as instructors (such as the landscape artist Francis P. Paulus for advanced drawing and the portraitist Percy Ives for drawing from the antique) and offered classes in anatomy taught by trained physicians. In 1893 Dunsmore exhibited his oil painting *Mozart at the Piano* at the World's Columbian Exposition in Chicago (c. 1892; Wagnalls Memorial Foundation, Lithopolis, Ohio).

Fig. 123.1. John Ward Dunsmore, *Self-Portrait (1856–1945)*, 1897. Pastel on beige paper, 35 1/2 × 28 1/2 in. (902 × 724 mm), image. The New-York Historical Society, Gift of John Ward Dunsmore, 1945.358

While in Detroit, Dunsmore began to experiment with innovative etching techniques and to create commercial graphic designs, producing many hand-etched sheets as well as letterheads or crests for several institutions, among them the Astronomical Society of Michigan and the Cincinnati Art Club. In 1903 he moved to the New York metropolitan area and shifted his concentration to historical subjects, becoming a specialist in the depiction of Revolutionary War scenes.

Between 1937 and 1945 Dunsmore donated a significant cache of work from his studio in Dover, New Jersey, to the Society, including 64 oil paintings of historical subjects, 10 portraits (including a self-portrait; fig. 123.1), over 725 sketches, studies, and watercolors, as well as more than 100 etchings and prints, the latter held in the Society's DPPAC. The Fraunces Tavern Museum in New York City also owns a significant group of his historical paintings. The collection preserved by the N-YHS, with its substantial number of works in various media, provides insight into Dunsmore's creative process, while the unusual trove of preparatory studies sheds light on his methodology, forming a unique record of his artistic career.

A. M.

Bibliography: Arthur Hopkins Gibson, *Artists of Early Michigan* (College Park: University of Maryland Dept. of Art, 1970), 93; Marchal E. Landgren, *The American Pupils of Thomas Couture* (College Park: University of Maryland Dept. of Art, 1970), 16–18, 31; Millard F. Rogers, *Cincinnati Painters of the Golden Age* (New York: Abbeville Press, 1980), 45; William H. Peck, *The Detroit Institute of Arts: A Brief History* (Detroit: Wayne State University Press, 1991), 36–40; Carr and Gurney 1993, 283 .

123. *Portrait of Thomas Couture (1815–1879) on His Deathbed*, 1879

Black and white chalk on blue paper, laid on canvas; 19 5/16 × 25 1/4 in. (491 × 641 mm)
Signed and dated at middle right in black chalk: *J.W.D.* /

1879; inscribed at lower left over erased inscription in graphite: *Thomas Couture / Fait le jour apres sa mort / à Villiers-le bel 1879*
Provenance: John Ward Dunsmore, Dover, N.J.
Gift of John Ward Dunsmore, 1937.1792

In both form and content, Dunsmore's deathbed portrait of his teacher embodies the ultimate artistic tribute, because it is executed not in his own style but in that of his master, who was renowned for his black and white chalk drawings.[1] By mimicking Couture's style, Dunsmore declares in artistic language Couture's immortality and, thereby, denies his death in artistic circles. That is to say, his legacy lives on through his students. In addition, the sheet documents Dunsmore's presence during his teacher's death on 3 March 1879 at his château in Villiers-le-Bel, France.

Dunsmore's tribute is a fine likeness even when compared with lifetime portraits of the artist, such as a bronze oval medallion profile (1848) by another of his American pupils, William Morris Hunt,[2] and a white marble bust-length portrait by Tony Noël (1882).[3] While the format and subject of Dunsmore's effigy derive from Renaissance tombs and the practice of making death masks, the theme of the deceased depicted on his deathbed arose during the seventeenth century in the Lowlands.[4] The mixed motives for this tradition, both historical and emotional, were expanded when the nineteenth century became fascinated with the intersection of realism, death, and science. From the myth of the sixteenth-century Venetian master Tintoretto painting a portrait of his daughter Marietta (also a painter) on her deathbed, to photographic records of the deceased alone or in the company of the living, the theme grew to encompass the art world and its denizens.[5] Couture himself executed at least one similar deathbed portrait in black chalk on gray paper, *Madame Dumesnil sur son lit de mort* (1842; Musée des Beaux-Arts, Rouen).[6] In these visual epitaphs to the departed, artists like Dunsmore paid final homage to their deceased teachers in effigies made more poignant for being executed in their masters' styles.[7]

1. Albert Boime, Robert Kashey, and Martin L. H. Reymert, *Thomas Couture*, sale cat. (New York: Shepherd Gallery, 1971), n.p.
2. Landgren 1970, 8, ill. See also Beauvais, Musée Départemental de l'Oise, Ancien Palais Épiscopal,

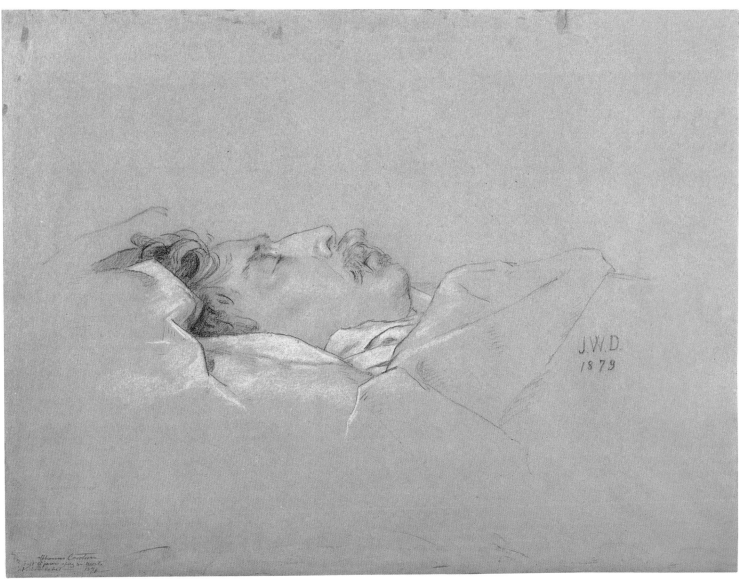

123

L'Enrôlement des volontaires de 1792: Thomas Couture
(1815–1879): Les Artistes au service de la patrie en danger,
exh. cat. (Paris: Presses Artistiques, 1989), 140, no.
113, ill., for an early self-portrait in Conté crayon
and white chalk (or gouache?) in the Musée d'Art et
Archéologie, Senlis (inv. no. 00.5.565).

3. Ibid., 146, no. 122, ill., in the Musée du Louvre, Paris,
inv. R. F. 735.

4. See Emmanuelle Héran, "Le Dernier Portrait
entre histoire et mémoire," in Musée d'Orsay,
Le Dernier Portrait, exh. cat. (Paris: Éditions de la
Réunion des Musées Nationaux, 2002), 25–101.
See also Dyveke Helsted, Life and Death Masks in
Thorvaldsen's Collection, trans. James Manley, exh. cat.
(Copenhagen: Thorvaldsen Museum, 1895).

5. Christine Peltre, "Un 'métier de croque-mort': Les
Portraits posthumes dans la critique d'art du XIXe

siècle," in Musée d'Orsay 2002, 102–11. A particularly
interesting example is a collaborative work by Jean-
Léon Gérôme and Louis-Gustave Boulanger depicting
Paul Baudry both on his deathbed and alive (fig. 1).

6. Inv. no. 927.5.1; see Musée d'Orsay 2002, 216–17, no.
36, ill.

7. For a parallel case, see Ismael Gentz's portrait of
his teacher Adolph Menzel on his deathbed (1905)
in Shepherd Gallery Associates, German Drawings
at Shepherd Gallery, 1790–1915, sale cat. (New York:
Shepherd Gallery Associates, 1994), no. 50, ill. Many
thanks to Robert Kashey for pointing out this
comparison.

JOHN SINGER SARGENT

Florence, Italy 1856–London, England 1925

John Singer Sargent, a cosmopolitan and highly successful expatriate American painter, is best known for his portraits. He was, in fact, the most fashionable portrait painter working in England and the United States in the late nineteenth century. Sargent also gained respect for his landscape and genre scenes as well as for his talent as a colorist and his brilliant mastery of the watercolor medium.

Born in Florence, Italy, slightly more than a year after his parents left Philadelphia, Sargent spent his youth on the European Continent. Like a growing number of affluent Americans, Sargent's parents traveled constantly with the social season to its various capitals and watering places. Educated primarily by his physician father, Sargent was a linguist, a fine pianist, and an avid reader of the classics, as reflected in James Carroll Beckwith's ten portraits of the young artist in the collection (cat. 120). The spirit of self-sufficiency experienced in these years, both physical and emotional, remained with him all his life.

Sargent demonstrated an early interest and talent in drawing that were encouraged by his mother. From his youth, Sargent was committed to becoming an artist. While the family wintered in Rome in 1868–69, the precocious teenager spent time in the studio of Carl Welsch, a German American artist. From there Sargent studied sporadically at the Accademia delle Belle Arti in Florence (1873–74), where his influences included academic Florentine draftsmen as well as the latter-day Macchiaioli. After traveling to Dresden and Venice, his family went to Paris so that Sargent could study in this highly acclaimed capital of art. He entered the new atelier of Charles-Émile-Auguste Durand (Carolus-Duran), which had become popular with many young American and British artists, including Beckwith. Sargent also began working in Beckwith's studio in 1874, eventually sharing another studio with him at 73, rue Notre-Dame-des-Champs, in the heart of the Latin Quarter. Under Carolus-Duran's tutelage Sargent was trained to concentrate on painting rather than on a prescribed course of drawing. He buttressed his education with life classes from Adolphe Yvon at the École des Beaux-Arts and with Léon Bonnat at the Petite École. In October 1875 Sargent passed the *concours des places* and matriculated at the École des Beaux-Arts. After his first visit to the United States in 1876, Sargent began showing at the Paris Salons in 1877.

That same year both Sargent and Beckwith assisted Carolus-Duran in painting the monumental canvas *The Triumph of Marie de Medici* for the ceiling of the Palais du Luxembourg (commissioned in 1875 and completed in 1878, now in the Musée du Louvre). The painting contains evidence of Sargent's technical precocity, which had impressed his contemporaries and his teacher. He was allowed to paint several figures, for which there are studies. In addition, Sargent inserted a portrait of Beckwith next to Beckwith's portrait of him, as a signature of their participation in the scheme. Sargent also contributed a portrait of Carolus-Duran as a tribute to his master and as a declaration of independence from him. (In turn, Carolus-Duran included a portrait of Sargent as well as a self-portrait, with the result that the work contains two likenesses of Sargent and Carolus-Duran.) On the cusp of superstardom, Sargent also painted a suave portrait of his teacher (1879; Sterling and Francine Clark Art Institute, Williamstown, Mass., for which there is a drawing preparatory for the image's dissemination as a print, Princeton University Art Museum, Princeton, N.J.). Whereas his fellow students from America and England eventually returned home, Sargent stayed in Paris but remained actively involved in the American art world throughout his career. He participated in the founding of the Society of American Artists and showed a work in its inaugural exhibition in 1878 in New York (the year he received an honorable mention at the Paris Salon) and in 1879 began to exhibit at the NAD.

Encouraged by Carolus-Duran—celebrated as the chic portraitist to the elite of the Third Republic—to sketch directly on the canvas and to emulate the style of Diego Velázquez, Sargent developed a fluid and masterfully quick, bravura brushstroke that was also indebted to Frans Hals. At first strongly influenced by the Impressionists and pleinairism, he, like his fellow American expatriate artist James McNeill Whistler, whom he met in Venice in 1880–81, became even more impressed by the art of Velázquez. After a trip to Spain, Sargent produced his first major large group portrait, *The Daughters of Edward Darley Boit* (1882; Museum of Fine Arts, Boston). Portraiture was to be his chosen genre and forte, and this work precipitated many commissions from both French and American patrons. In Paris Sargent was influenced not only by Whistler but also by Edgar Degas, as demonstrated by his *Rehearsal of the Pasdeloup Orchestra at the Cirque d'Hiver* (c. 1876–78; The Art Institute of Chicago, fig. 125.2) and *El Jaleo* (Salon of 1882; Isabella Stewart Gardner Museum, Boston). Certainly, the most controversial of Sargent's portraits was *Madame X* (1884; The Metropolitan Museum of Art, New York). Despite its mysterious title, the sitter was well known. She was Sargent's cousin Virginie Avegno, the wife of Pierre Gautreau and a leading "professional beauty" of Paris, who was called the "Madame Récamier of the Third Republic." The casual ease of her pose, the décolletage of her precariously worn gown (which Sargent first painted with one strap slipping down her arm), and the sheer hauteur of her crisply drawn profile caused the picture to be a spectacular failure when shown at the Salon of 1884.

The scandal it incurred encouraged Sargent's move to London, for his rising reputation was not matched by an increase in commissions. After initial visits he settled there permanently in 1886, urged to relocate by his friend the writer Henry James. At this time he painted in the Cotswolds and fell under the influence of his friend Claude Monet. In 1887 he returned to the United States (his first visit since 1876) to paint Mrs. Henry Marquand (Princeton University Art Museum, Princeton, N.J.), was greeted as a celebrity, and inundated with commissions. Sargent established a practice in New York and Boston that was nearly as lucrative as the one he had in London. Then, in 1890, he accepted a commission to decorate the Boston Public Library, designed by McKim, Mead & White, with a series of murals illustrating the development of religious thought (for which he used models from the Ziegfeld Follies), whose final panels were installed in 1916. The murals were followed by commissions for the rotunda and stairwell of the Museum of Fine Arts, Boston (1916–25) and for the Widener Library of Harvard University (1921–22); these commissions occupied a large part of the artist's energies for the remainder of his life. He was elected an associate of the NAD in 1891 and an academician in 1897.

Continuing to exhibit in the United States during the late 1880s and 1890s, in England Sargent was aligned with the New English Art Club (founded in 1886) and other cutting-edge groups. In 1893 the prolific painter showed no fewer than nine canvases at the World's Colum-

124a

124b

bian Exposition in Chicago. With his election to the Royal Academy of Arts in 1897, Sargent's career was definitely established. His bravura application of pigment, enriched with Impressionist qualities of light and color, seemed dazzling and avant-garde by comparison with the work of his contemporaries. Hailed as a latter-day Van Dyck by none other than the sculptor Auguste Rodin, Sargent's ability lay in representing his sitters with a rare immediacy that implied process, a dimension that foreshadows the onset of Futurism and moving pictures in the early twentieth century. Sargent's other influences include the paintings of Édouard Manet, Antonio Mancini, and Giovanni Boldini. By 1900 Sargent was the leading society portrait painter on both

sides of the Atlantic and was in touch with the leading literary and artistic figures of his era.

After the turn of the century, Sargent spent his summers on long sketching holidays in Switzerland and southern Europe with his sister Emily and artist friends. He also began working seriously in watercolor, producing virtuoso studies of light and color, notably of Venice, and turned away from portraiture after 1907 to paint subject pictures. Among his last projects was a series of sketches and finished works (for example *Gassed*, Imperial War Museum, London) resulting from his role as official war artist for the Allied forces during World War I.

After his death and the sale of his possessions, Sargent's reputation languished.

Although the artist's early portraits were always considered among the finest of the nineteenth century, his later work was criticized for excessively flattering his sitters and for not achieving psychologically penetrating portrayals. Wrongly, he was also accused of not being inventive in his compositions. Perhaps the ease with which he appeared to paint from the very beginning also worked against Sargent, or as Henry James remarked: the "talent which, on the very threshold of its career, has nothing more to learn." A complex personality, Sargent produced a staggering number of oils and watercolors, the lion's share of which are dazzling. His work was included in nearly every major international exhibition from the late

1870s to his last years and almost invariably won official acclaim. He was decorated by the French, Belgian, and German governments and received honorary degrees from Harvard, Yale, and Oxford universities, and his work was celebrated in impressive memorial exhibitions at the Metropolitan Museum of Art in New York and the Royal Academy in London. After several decades of eclipse, the critical resurrection of his reputation began in the 1950s and later surged in the 1970s, with many exhibitions examining his works and renewed scholarship that continues with the ongoing publication of the complete catalogue of his paintings.

Bibliography: Charles Merrill Mount, "Carolus-Duran and the Development of Sargent," *Art Quarterly* 26:4 (1963): 385–417; Richard Ormond, *John Singer Sargent: Paintings, Drawings, Watercolours* (London: Phaidon, 1970); Fink 1991, 388; Carr and Gurney 1993, 311–13; Marc Simpson, with Richard Ormond and H. Barbara Weinberg, *Uncanny Spectacle: The Public Career of the Young John Singer Sargent*, exh. cat. (Williamstown, Mass.: Sterling and Francine Clark Art Institute, 1997); Elaine Kilmurray and Richard Ormond, eds., *John Singer Sargent*, exh. cat. (Princeton: Princeton University Press, 1998); Ormond and Kilmurray 1998; Olson 2005; Ormond and Kilmurray 2006.

124a. *Figure Studies (after Tintoretto?)*, c. 1874

Graphite on ivory paper, formerly mounted on a page of the James Carroll Beckwith Album 1; 5 13/16 × 3 3/4 in. (148 × 95 mm)
Inscribed by Beckwith at lower center in graphite: *Figure from Tintoretto / by Sargent*; at lower left [erased]: *Florence.*[?]; at lower right: *Worship / of the / Golden Calf*; below in black ink: *10-B*
Provenance: James Carroll Beckwith, New York; The National Academy of Design, New York.
Bibliography: Olson 2005, 424–26, 435, fig. 15.
Gift of the National Academy of Design, 1935.85.1.10

124b. *Figure Studies after Tintoretto's "Worship of the Golden Calf"*; verso: sketch of a horse-drawn carriage and a more finished study of a horse, c. 1874

Graphite on ivory paper, formerly mounted on a page of the James Carroll Beckwith Album 2; 6 × 3 9/16 in. (153 × 90 mm)
Inscribed by Beckwith along lower edge in graphite: *by Sargent / describing Tintoritto'* [sic] *Golden Calf*
Provenance: James Carroll Beckwith, New York; The National Academy of Design, New York.

Fig. 124.1. John Singer Sargent, *Study of Three Figures from Tintoretto's "The Worship of the Golden Calf"*; verso: study of figures, including two from Tintoretto's *The Miracle of St. Mark*, 1874. Graphite on paper, 8 1/16 × 5 in. (204 × 127 mm). Private collection, New York

Bibliography: Olson 2005, 424–26, 435, figs. 16, 30.
Gift of the National Academy of Design, 1935.85.2.24

These two undated sheets belong to a group of six unpublished drawings by Sargent mounted on pages of three albums of drawings compiled by Beckwith (643 sheets, nearly all by the compiler).[1] They date from Sargent's early years in Paris, when he and Beckwith studied in the atelier of Carolus-Duran and became fast friends,[2] eventually sharing a studio.[3] None of the sheets is dated, and Beckwith pasted them into albums whose assigned dates were not rigorously applied. Beckwith carefully noted Sargent's authorship either on each sheet or on its album page. In viewing Sargent's youthful works alongside those of Beckwith, one is struck by the proximity of the two artists' styles. In several cases, such as two small graphite drawings with studies of a country house, their subject matter is also related.[4]

The two drawings discussed here, labeled after Tintoretto's *Worship of the Golden Calf* (1562–65; choir of the Church of the Madonna dell'Orto, Venice), date between 1874, when Sargent arrived in Carolus-Duran's studio, and 1878, when Beckwith returned to America. However, an inscription on a piece of paper attached to the verso of another drawing by Sargent after two of the same figures in Tintoretto's *Golden Calf* (fig. 124.1)—inscribed by Beckwith *Sketch by John S. Sargent illustrating figures from "The Worship of the Golden Calf," by Tintoretto in Venice: made in Paris in 1874—Beckwith*—suggests that the second drawing dates from 1874. If Beckwith's inscription is accurate, it proves that the study was executed in Paris after a reproduction of Tintoretto's painting rather than after the original work in Venice.[5]

Sargent was attracted to the works of Jacopo Robusti, called Il Tintoretto, one of the leading Venetian painters of the late sixteenth century, for a number of reasons. No doubt he appreci-

ated Tintoretto's painterly, experimental application of oil pigments, his dramatic colors, and the elegantly mannered yet strong poses of his figures. As in these two works, Sargent frequently gravitated to auxiliary figures in Tintoretto's compositions in which languid limbs assume theatrical gestures.

Sargent made many copies after works of art, and it is often difficult to determine whether he studied the originals or drew from photographs (which he collected from an early age) or other types of reproductions. A drawing in the Metropolitan Museum of Art after Tintoretto's *Mystical Marriage of Saint Catherine Attended by Doge Francesco Donato* is actually inscribed by Sargent as having been taken from a photograph by Carlo Naya and even contains Naya's negative number.[6]

Scholars do not believe that Sargent drew all of his early sheets after Tintoretto from reproductions; some were drawn in situ in Venice and elsewhere. A case in point is a highly finished drawing in the Metropolitan Museum from an album or scrapbook of Sargent's drawings that dates from his visits to Venice in 1870 and 1873 and includes sheets after Tintoretto.[7] Inscribed as executed in Venice, it depicts a woman holding a child from the left of Tintoretto's canvas *The Miracle of Saint Mark (Saint Mark Freeing a Christian Slave)*. This painting of 1548, now in the Accademia, Venice, is one of the well-known series Tintoretto painted for the Scuola di San Marco (see also n. 5 below). After Sargent's visit to Venice in May and June 1873, he expressed his interest in Tintoretto in a letter of 12 August 1873 to Vernon Lee (pseudonym of Violet Paget, Sargent's childhood friend who became a celebrated author): "But I long for the time when I can show you, in Rome, some drawings of particularly beautiful bits of Tintoretto that I did this spring, and try to convert you to at least some of my intense admiration for that great master."[8] Sargent may have also traveled to Venice in 1878 if the last digit is transcribed correctly in a letter from Mary Cassatt to Julian Alden Weir of 10 March 1878[?].[9]

While there is no way to determine definitively whether these two sheets were executed from photographs in Paris or on site in Venice, the assurance of the draftsmanship, together with their provenance from Beckwith and Beckwith's inscription on figure 124.1, suggests that they were indeed executed in Paris sometime in 1874.[10]

In addition, the verso of the Society's second sheet contains a Manet-like study of two horses and a carriage that would be more typical of Paris than of water-bound Venice with its canals.[11]

One last problem concerning this pair involves the source of the first sheet. While the figures are in poses favored by Tintoretto, especially in his works in the Scuola di San Rocco, no exact source can be identified for them. Beckwith's inscription, *Worship of the Golden Calf*, might, therefore, have been added when he compiled his albums and recognized the Tintoretto-like poses but was unable to recall their precise source.

The elegantly simplified pose of the full-length figure on the second sheet looks forward to Sargent's rightly famous, and infamous, *Madame X*. Another newly identified drawing by Sargent discussed in catalogue 125 also reveals why, from the earliest days of their association, Beckwith remained in the shadow of Sargent's huge talent and was eventually eclipsed by him.

1. The six drawings by Sargent and the ten early portraits of Sargent by Beckwith formerly mounted in these three albums are discussed more fully in Olson 2005.

2. For Sargent in Carolus-Duran's studio, see Weinberg 1991, 205–11. For the expatriate American community in Paris, see also Adler, Hirshler, and Weinberg 2006.

3. In October 1874 and March 1875 Sargent is recorded as working in Beckwith's studio. In August 1875 the two artists shared a rented studio at 73, rue Notre-Dame-des-Champs; see J. Carroll Beckwith Collection, owned by the NAD, microfilmed by the AAA, reel 4798, 23 August 1875: "I [Beckwith] have however taken an atelier for the winter in which Sargent shares with me the price 1000f."

4. See Olson 2005, 415, figs. 1 and 2, 435–36, no. 13. Sargent's drawing of a window with plants on its sill beneath roof tiles, abutted by a woven straw mat suspended to store objects (inv. no. 1935.85.2.263; for its verso, see ibid., fig. 31), is a detail of the house whose corner Beckwith sketched and signed with his monogram (inv. no. 1935.85.2.262). Beckwith pasted his drawing below Sargent's on the same album page.

5. An online source, which reproduces the sheet mounted on gray paper before its removal, shows that the inscription was originally mounted below on a separate piece of paper (www.ewolfs.com/ March%20Auctions/marchart01inside.html). See Flavia Ormond Fine Arts, *Master Drawings: Catalogue No. 11*, sale cat. (London: Flavia Ormond Fine Arts Limited, 2003), no. 17, ill., verso ill. opp. index. The verso of this sheet contains Sargent's abstract sketch after the woman holding a child at the left

of Tintoretto's *The Miracle of Saint Mark*. Sargent rendered the same woman and child in a more highly finished sheet in the Metropolitan Museum of Art; see n. 7 below. To the left, beyond the vertical dividing line, the artist drew a bishop figure accompanied by a dog, whose source cannot be identified.

6. Inv. no. 50.130.143h; see Stephanie L. Herdrich and H. Barbara Weinberg, *American Drawings and Watercolors in The Metropolitan Museum of Art: John Singer Sargent* (New York: Metropolitan Museum of Art, 2000), 112, no. 41, ill. Naya, a Venetian photographer whose principal subjects were Venice and its artworks, operated primarily from a shop in the Piazza San Marco but sold throughout Europe via his published catalogue.

7. Inv. no. 50.130.154e; see ibid., 116, no. 50, ill. The verso of this sheet contains four figures that the catalogue does not identify. The three on the right can now be identified as preserving the composition of Tintoretto's *Bacchus and Ariadne* in the Sala dell'Anticollegio, Palazzo Ducale, Venice; Sargent drew the sketchier standing figure in contrapposto at the left from another source, maybe a Madonna holding the Christ Child. Sargent, like Beckwith, compiled his own albums of drawings, some from dismantled sketchbooks (inv. nos. 50.130.154a–kk in the Metropolitan Museum of Art come from one album; see ibid., 412–13). Sargent also apparently drew figures from Tintoretto's oil sketch of Paradise in the Musée du Louvre; see ibid., 133, no. 56, ill. (inv. no. 50.130.143d).

8. Ibid., 116, no. 50. In a letter of 22 March 1874 from Florence, he wrote to his cousin Mrs. Austin: "I have learned in Venice to admire Tintoretto immensely and to consider him perhaps second only to Michel Angelo and Titian, whose beauties it was his aim to unite." In the same letter he asked her about obtaining photographs of an unnamed painting by Tintoretto; ibid., 116–17, no. 51.

9. Ormond and Kilmurray 1998, xiii, xviii n. 38.

10. Sargent also drew after Tintoretto's paintings as reproduced in prints and reversed. See Sargent's sketch of 1874–78 after Tintoretto's *Adoration of the Shepherds* (Scuola di San Rocco), in the Metropolitan Museum of Art (inv. no. 50.30.143d; Herdrich and Weinberg 2000, 134, no. 57, ill.).

11. See Olson 2005, fig. 30.

Sketch by J.S. Sargent of portion of the Luxembourg Gardens

Sketches by John Sargent

125

John Singer Sargent

125. *Study for "The Luxembourg Gardens at Twilight";* verso: studies for *Rehearsal of the Pasdeloup Orchestra at the Cirque d'Hiver,* c. 1876–78

Graphite on ivory paper, formerly mounted on a page of the James Carroll Beckwith Album 3; 7 13/16 × 12 3/16 in. (198 × 310 mm), irregular
Inscribed by Beckwith at lower left in graphite: *Sketch by J. S. Sargent of picture of the Luxembourg Gardens*; verso inscribed at lower left in graphite: *Sketches by John Sargent*
Provenance: James Carroll Beckwith, New York; The National Academy of Design, New York.
Bibliography: Olson 2005, 426–31, 436, no. 15, figs. 18 and 20; Ormond and Kilmurray 2006, 185, fig. 100 (recto); 191, fig. 108 (verso).
Gift of the National Academy of Design, 1935.85.3.153

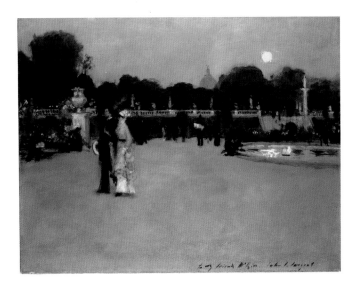

This boldly drawn sheet, no doubt executed on site, is the only known preparatory study for Sargent's haunting nocturnal canvas *The Luxembourg Gardens at Twilight* (fig. 125.1) in the Minneapolis Institute of Arts (usually dated c. 1878–79).[1]
In the Society's sheet, Sargent laid down the general composition of the canvas, placing the two strolling figures in the middle ground to the left rather than to the right of the nearby urn, as they appear in the painting. The artist's quick, assured strokes testify to his extraordinary graphic ability and in general foreshadow the freedom of twentieth-century draftsmanship.

Sargent presented the canvas to Charles Follen McKim of the New York architectural firm McKim, Mead & White, which built the Boston Public Library and persuaded its trustees to commission murals from Sargent in 1890. Although the date of Sargent's gift to his friend is unknown, McKim's presence in Paris in 1877–78 makes that date highly tempting.[2]

In the background of the painting (and the Society's sheet), Sargent depicted the dome of the Panthéon (to the left of the moon in the painting) as it appears from the gardens. The work's mauve and pearly gray tones of early evening's moist atmosphere, reminiscent of the works of James McNeill Whistler, are punctuated by the almost hallucinatory red of the flowers and the man's lit cigarette, the latter a nod to the bohemian ambiance of the place. Ormond notes the work's sophistication and modernity and its kinship to the townscapes of the Impressionists. He terms it a "sketch" and

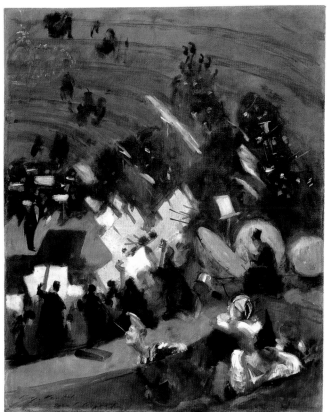

observes that the artist's sketches were usually prompted by an immediate response to particular visual stimuli.[3]

Another version of the painting, *In the Luxembourg Gardens,* signed, inscribed, and dated *John S. Sargent Paris / 1879,* is in the Philadelphia Museum of Art.[4] While very close to the

Minneapolis example, it has slight variations and lacks the Panthéon in the background. The fact that the Society's drawing, a first idea for the composition, contains the Panthéon, like the Minneapolis canvas, suggests that the Philadelphia work was the second of the two to be painted. It was also the one the artist chose to

exhibit at the NAD in 1879.[5] Unlike two other earlier instances when the artist repeated a composition in which one example is clearly more freely painted than the other, the application of pigment is similar in both versions of the *Luxembourg Gardens*; in the Minneapolis work it is only slightly looser. Thus the details of the more horizontal Philadelphia canvas—for instance, the correction in the foreshortening of the fountain's basin, the reflections in its water, the editing out of the dome of the Panthéon, and the female stroller's fancier dress—betray it as a reprise of the Minneapolis composition.

Sargent painted his scene near the great basin at the heart of the sunken gardens in the front of the Palais du Luxembourg, built in 1620 for Marie de Medici, widow of Henry IV, on the site of the former mansion of the Duke of Luxembourg. Encompassing 61.8 acres, the gardens, renovated in the 1860s, were one of Paris's most popular public green spaces during the nineteenth century. The palace housed the nation's collection of contemporary art, the Musée du Luxembourg (today the French Senate). Nearby was the École des Beaux-Arts, where Sargent and Beckwith studied. Located in the middle of the Latin Quarter, a warren of artists' studios, near where both young artists lived on the rue Notre-Dame-des-Champs, the gardens occupied an important role in Parisian life. They were frequented by the bohemians of the neighborhood, a custom reflected in literature of the time; for example, Victor Hugo in *Les Misérables* has Marius meeting Cosette in that location. When Sargent went to Paris to study in 1874, the Paris Commune, which had led to the deaths of over twenty thousand Parisians and left the Palais du Luxembourg badly burned, was only three years in the past. In its wake, the Third Republic rebuilt the damaged parts of the city. Part of the renovation was the commission given to Sargent's teacher Carolus-Duran to paint *The Triumph of Marie de Medici* for the remodeled palace in 1877–78 (commissioned in 1875), an enterprise on which Sargent (and Beckwith) worked. Further, the verso of this sheet contains sketches of figures reminiscent of those in *The Triumph of Marie de Medici*.[6]

The Society's sketchy study preserves Sargent's early idea for his magical scene of twilight, recording the transient passage of the denizens of the neighborhood and light in the gardens where he, no doubt, had spent much time. Moreover, the left-hand side of its verso contains three horizontal compositional sketches for his impressionistic *Rehearsal of the Pasdeloup Orchestra at the Cirque d'Hiver*, also known in two versions.[7] On the right of the sheet are quick, chaotic studies of clowns seated in the balcony that Sargent also drew in the lower right corners of all three compositional sketches at the left. He included these clowns in his earlier version of the *Rehearsal* in the Art Institute of Chicago (dated 1876–78 on the basis of its similarity to works by Edgar Degas shown at the 1874 and 1876 Impressionist exhibitions),[8] while the area they should inhabit in the composition in Boston is blank.[9] A more finished horizontal study in graphite preparatory for the Chicago version of *Rehearsal* is in the Metropolitan Museum of Art.[10] These four compositional studies, evidently sketched on the spot at the Cirque d'Hiver, contain animated sketches of clowns in action poses and argue for an early date for Sargent's depiction of the Luxembourg Gardens on the recto of the Society's drawing as well as the Minneapolis painting. Beckwith's own two graphite views of the Luxembourg Gardens in the Society's albums (one of which is dated 1875 and the other of which is inscribed *Luxembourg Gardens Twilight*)[11] not only reinforce Beckwith's development as parallel to that of Sargent but suggest an even earlier date for Sargent's genesis of the subject. Finally, the Society's bold drawing shows Sargent intent on capturing the random moments of urban life and reveal his desire to become a modernist painter in the tradition of Manet, Degas, Whistler, and Giuseppe De Nittis.

1. Inv. no. 16.20, in oil on canvas, 29 × 36 1/2 in. The inscription at the lower right reads *To my friend McKim John S. Sargent*. See Ormond 1970, 22, 237, pl. 14; Kilmurray and Ormond 1998, 84–85, no. 16; and Ormond and Kilmurray 2006, 188, no. 722, ill.

2. While the Minneapolis Institute of Arts records in its computer database that Sargent gave the canvas to McKim in 1879, there is no evidence as to when the gift was actually made. See Charles Moore, *The Life and Times of Charles Follen McKim* (Boston: Houghton Mifflin Company, 1929), 43–46, who notes McKim went to Paris in the fall of 1877, after his wife asked for a separation, and apparently remained there at least into August 1878, when he was in the company of Stanford White (who returned to America in 1879) and the sculptor Augustus Saint-Gaudens on a tour of the south of France. Charles Merrill Mount, *John Singer Sargent: A Biography* (New York: Norton, Kraus Reprint Co., 1969), 127–28, writes of McKim: "'Blarney Charlie,' or 'Charles the Charmer,' as he was so aptly called by St.-Gaudens, was more than simply the social member of the firm. But he could charm the birds off the trees when it needed to be done and he, too, quickly realized that in Sargent there lay an opportunity." Ormond and Kilmurray 2006, 185, 188, dates the gift to the 1890s and rightly judges the Philadelphia canvas to be the more finished one.

3. Ormond 1970, 22.

4. Inv. no. J1080, in oil on canvas, 25 7/8 × 36 1/8 in.; Kilmurray and Ormond 1998, 84–85, no. 16, ill., notes that the painting was in the collection of John H. Sherwood, Beckwith's maternal uncle, in 1879. It is tempting to assume that Sherwood, a cultured man, traveled to Paris, where he met his nephew's friend and acquired the canvas at that time. He was also a dealer with a gallery on Fourth Street. See Ormond and Kilmurray 2006, 185–87, no. 721, for additional history about the painting.

5. According to a letter in the files of the Minneapolis Institute of Art (dated 4 February, no year, from Sargent at the Copley Plaza, Boston, to Alan Burroughs, Curator of Paintings), Sargent could not remember which version he painted first. (The museum believes the year of the letter to have been 1924.) "I cannot remember which is the original sketch and which is the replica … I think I did them at the same time, and one was exhibited and bought by Mr. John G. Johnson, and the other I gave to McKim." A similar relation between two paintings from 1878 is presented by *Fishing for Oysters at Cancale* (Museum of Fine Arts, Boston) and *Oyster Gatherers of Cancale* (The Corcoran Gallery of Art, Washington, D.C.). The former, exhibited in New York in April 1878, is more freely executed and the latter, exhibited in Paris in July of that year, more finished (see Simpson, Ormond, and Weinberg 1997, 82–83, nos. 2 and 3, ills.).

6. These include figures leaning on a balustrade and a dangling leg. They may include Sargent's comic comment on the struggles of executing that ceiling painting. The grin on the face of one of the figures and the pointed hats worn by several (similar to ones found on the recto and verso of another sheet by Sargent in the Beckwith albums) relate to another pair of canvases by Sargent. For the other sheet, see n. 9 below.

7. The date of the work in the Museum of Fine Arts, Boston (inv. no. 22.598) is given as c. 1876–78 in Ormond 1970, 236, which discusses the other, larger version in the Art Institute of Chicago (inv. no. 81.1972, on loan from a private collection) and lists drawings related to it. Kilmurray and Ormond 1998, 84, no. 15, ill., dates the Chicago work to 1878 and the Boston painting to 1879–80; see also Ormond and Kilmurray 2006, 189–91, no. 723, ill., and 192–93, no.

724, ill., respectively (also for preparatory sketches), which wonders whether Sargent and Beckwith were friends of M. and Mme Pasdeloup. The orchestra led by Jules Étienne Pasdeloup presented free popular concerts on Sunday afternoons in Paris from November to May (1861–87), rehearsing in the Cirque d'Hiver, built in 1852 as the Cirque Napoléon near the Place de la République. It still stands. Sargent, a music lover, was drawn to these concerts.

8. See Olson 2005, 431, for a discussion of the dating of the painting.

9. The figures seated in a balcony on the verso of cat. 125 relate to the three clowns in the foreground balcony in the Chicago version of the *Rehearsal*. See Judith A. Barter et al., *American Arts at The Art Institute of Chicago: From Colonial Times to World War I* (Chicago: Art Institute of Chicago, 1998), 210–13,

no. 97, ill., which dates the painting to 1876/78. Sargent gave this version of the *Rehearsal* to Sir George Henschel, the renowned English composer, conductor, and musician, whom he met in 1887 (ibid., 213 n. 3). The two versions of the *Rehearsal* and the gift of one present an analogous situation to the gift of *The Luxembourg Gardens at Twilight* to McKim. The Boston version was acquired by the American painter Henry A. Bacon who reproduced it in his 1883 book, *Parisian Art and Artists*; see Adler, Hirshler, and Weinberg 2006, 257. Another drawing from the third Beckwith album in the Society (inv. no. 1935.85.3.154), mentioned in n. 6 above, contains on its recto and verso related sketches of the clowns in the balcony, one who humorously holds what seems like a paintbrush instead of an orchestra leader's baton in the Chicago canvas; see Olson 2005, 430–31,

figs. 21 and 22, 436, no. 16. The numerous studies of clowns for the balcony area of the two versions of the *Rehearsal* and the fact that this zone is blank in the Boston version underline that it remained problematic for the artist.

10. Inv. no. 50.130.154C; see Barter et al. 1998, 212, fig. 53; and Herdrich and Weinberg 2000, 152–53, no. 108, ill. (see also no. 109, ill., a study for musicians in the painting).

11. Inv. no. 1935.85.2.133, *Study of Auguste Cain's "Lion de Nubie et sa Proie" (1870) Sculpture in the Luxembourg Gardens, Paris*, dated 24 May 1875; and inv. no. 1935.85.2.137, *A View of the Luxembourg Gardens at Twilight, Paris*. See Olson 2005, 439 n. 39.

FREDERICK WILLIAM MACMONNIES

Brooklyn, New York 1863–New York, New York 1937

Frederick MacMonnies worked as both a sculptor in the Beaux-Arts tradition and a painter. He left school at the age of thirteen to help support his family. During his apprenticeship in New York City with Augustus Saint-Gaudens (1880–84), he rose from menial studio helper to assistant. In the evenings he also studied at Cooper Union, the Art Students League, and the NAD. Through Saint-Gaudens he met two architects who later became invaluable colleagues: Stanford White and Charles Follen McKim (both later principals of McKim, Mead & White) who lent him money in 1884 to go to Europe. MacMonnies visited London, Paris, and Munich, where he attended drawing and portrait classes at the Academy (1884–85). Returning briefly to New York, he again worked for Saint-Gaudens and submitted a prizewinning sculpture to the NAD. By 1886 MacMonnies was back in Paris, studying with Alexandre Falguière at the École des Beaux-Arts and winning the prestigious *prix d'atelier* in 1887 and 1888. He became Falguière's assistant and won honorable mention at the Salon of 1889. For the next thirty-odd years Mac-Monnies made Paris his home, and his reputation grew in tandem with his prodigious output.

His meteoric success brought MacMonnies American commissions and the independence to open his own studio. Beginning in 1888, he executed a series of small bronze cherubs for the Church of St. Paul the Apostle in New York. Subsequently, he created his first fanciful life-size fountain figures, *Pan of Rohallion* (1890; The Metropolitan Museum of Art, New York), for a country estate. These buoyant mythological creatures, with vibrant surfaces in the Art Nouveau style, introduced fountain sculpture as a new genre in the United States and inspired a novel generation of sculptors. MacMonnies produced these and more serious works in bronze, employing studio assistants to make reductions in several French and American foundries. In 1891 he was the first American awarded a second-class medal in sculpture at the Paris Salon. Of his two entries, his *Portrait of James S. T. Stranahan* (1891; Prospect Park, Brooklyn) won popular approval for its naturalism. His over-life-size bronze statue of Nathan Hale (City Hall Park, New York), for which he won a competition in 1889, was criticized for its lack of finish and being "too picturesque," but it was later applauded.

Despite these successes, it was MacMonnies's work at the World's Columbian Exposition of 1893 in Chicago that caught the public's eye and made his reputation soar. His thirty-nine-figure ensemble for the Columbian Fountain, a colossal temporary structure of staff (plaster and straw), included the central group *Barge of State* (destroyed). This allegorical work of Beaux-Arts bravura (cat. 128) became an icon of the American Renaissance. The same year his bronze life-size *Bacchante and Infant Faun*, unveiled at the Boston Public Library, scandalized Bostonians and had to be removed. When the library's architect McKim presented it to the Metropolitan Museum of Art in New York, the realistic female nude attracted widespread attention.

In the late 1890s MacMonnies returned to painting, alternating between the two media. Like his friend James McNeill Whistler and the Impressionists, MacMonnies admired the work of Diego Velázquez, whose paintings he copied in 1904 at the Museo del Prado in Madrid. MacMonnies taught painting with Whistler at the Académie Carmen and for almost two decades was a popular teacher of American artists in Paris and at his Giverny estate. His paintings have much in common with such contemporaneous portrait painters as his friend John Singer Sargent (cats. 124 and 125) and Giovanni Boldini.

MacMonnies's most ambitious public American monuments in the ten years after 1893 were for Prospect Park in Brooklyn: the *Quadriga* and the *Army* and *Navy* groups for the *Soldiers' and Sailors' Memorial Arch* (1898–1901). They typify nationalist sentiment captured in full-blown

One of two original sketches made by Frederick McMonnies for two groups of statues for the Washington Arch on Washington Square not approved by the Committee. W.R.Stewart

126a

One of two original sketches made by Frederick McMonnies for two groups of statues for the Washington Arch on Washington Square not approved by the Committee. W.R.Stewart

126b

Beaux-Arts style. His uniquely eclectic French style merged Neo-Baroque with Art Nouveau whiplash curves in the heroic bronze gatepost groups, the *Horse Tamers* (1900), for which MacMonnies was awarded a grand prize at the Exposition Universelle of 1900 in Paris. These near-mirror pairs of mounted riders restraining other rearing horses were intended to represent human intellect pitted against brute force. He modeled them from live prancing horses rigged in ropes at his Paris and Giverny studios, a technique he also used for other works. Despite his shift to direct carving in marble and the later influence of Auguste Rodin, MacMonnies's work never reflected modernist currents.

In 1900 the artist began a three-year interlude focusing on painting and nearly abandoned sculpture. In 1901 he was made an associate of the NAD (academician in 1906), and in 1903 he showed his paintings at the Durand-Ruel Galleries in Paris and New York. On his return to New York at the end of 1915, he took up residence in the Tenth Street Studio Building and executed another controversial work, *Civic Virtue* (1909–22), an over-life-size marble male nude with two sirens writhing at his feet. Public indignation forced its removal from City Hall Park, New York, to a plaza flanking the Queens Borough Hall. His last and most colossal monument was the 130-foot-8-inch-high *Battle of the Marne* (or *Monument Américain*) (1916–32; Meaux, France), the American nation's gift to France in return for the *Statue of Liberty* (New York Harbor; cat. 110). The output of his years in New York included several dozen portrait busts in bronze, marble, and oil. He was named a chevalier and commander of the French Legion of Honor and was elected as well to the American Academy of Arts and Letters. His first wife, Mary Fairchild, was a painter who later married Will Hicok Low, the muralist, in 1909. MacMonnies married Alice Jones in 1910.

Bibliography: Dewitt M. Lockman, Interview with Frederick MacMonnies, N.A., 29 January and 16 February 1927, lent by the New-York Historical Society, microfilmed by AAA, reel 503, frames 0869–0951; Edward J. Foote, "An Interview with Frederick W. MacMonnies, American Sculptor of the Beaux-Arts Era," *New-York Historical Society Quarterly* 61:3–4 (1977): 102–23; Robert Judson Clark, "Frederick MacMonnies and the Princeton Battle Monument," *Record of the Princeton Art Museum* 43:2 (1984): 6–76; Fink 1990, 368; Gerdts et al. 1992, 60–64; Mary Smart and Ethelyn Adina Gordon, *A Flight with Fame: The Life and Art of Frederick MacMonnies, 1863–1937* (Madison, Conn.: Sound View Press, 1996); Ethelyn Adina Gordon, "The Sculpture of Frederick William MacMonnies: A Critical Catalogue," 2 vols. (Ph.D. diss., New York University, 1998); Joyce Henri Robinson and Derrick R. Cartwright, *An Interlude in Giverny*, exh. cat. (University Park, Pa.: Palmer Museum of Art; Giverny: Musée d'Art Américain Giverny, 2000).

126a. *"Washington as President": Design for a Proposed Statuary Group, Washington Memorial Arch, New York City*, c. 1890

Black ink on beige paper, laid on board; 11 3/8 × 8 in. (289 × 203 mm)
Inscribed along lower edge in black ink: *One of two original sketches made by Frederick MᶜMonnies [sic] for / two groups of statues for the Washington Arch in Washington Square / not approved by the Committee / Wm R Stewart*
Bibliography: Foote 1977, 104; Koke 1982, 2:301, no. 1682; Gordon 1998, 1:307–8.
Gift of William Rhinelander Stewart, 1924.152

126b. *"Washington as Commander-in-Chief": Design for a Proposed Statuary Group, Washington Memorial Arch, New York City*, c. 1890

Black ink on beige paper, laid on board; 11 1/2 × 8 in. (292 × 203 mm)
Inscribed along lower edge in black ink: *One of two / Original sketches made by Frederick MᶜMonnies [sic] for two groups of / statues for the Washington Arch, in Washington Square not / approved by the Committee. / Wm. R Stewart*
Bibliography: Koke 1982, 2:301, no. 1683; Gordon 1998, 1:307–8.
Gift of William Rhinelander Stewart, 1924.153

Inscribed by the donor, William Rhinelander Stewart, the chairman of the Washington Memorial Arch Committee, this pair of studies preserves MacMonnies's early idea for two figural groups planned for the Washington Memorial Arch in storied Washington Square Park at the foot of Fifth Avenue.[1] The square was laid out in 1826 on what was previously a burial ground. A German cemetery covered the north side, while a potter's field held the south. Later, the grounds were used for public gallows and executions before houses were built between 1829 and 1833.

The stone arch replaced a temporary structure erected in 1889 to commemorate the centennial of George Washington's inauguration as first president of the United States.[2] Both the stone arch and its short-lived predecessor were designed by Stanford White and financed by subscription. The cornerstone was laid on 30 May 1890, and in 1892 the last block of marble was set in place by Stewart, who had initiated the work. Seventy-seven feet high and sixty-two feet wide, it was dedicated on 4 May 1895. Even though MacMonnies had executed its spandrel figures of

Peace, War, Fame, and Prosperity in 1895[3] and was a close friend of McKim, his designs for the proposed statuary groups were not executed.

MacMonnies's project included two three-quarter-round, monumental groups in relief for the pier pedestals on the north face of the arch. The subjects of the two ensembles were "Washington as General of the Armies in War accompanied by Courage and Hope: First in War" and "Washington as First President of the Republic in Peace accompanied by Wisdom and Justice: First in Peace."[4] MacMonnies made fifteen-foot-high plaster sketch models that were exhibited at the McKim, Mead & White offices in 1896, which today are known only from photographs.[5] The economic downturn in 1897 prevented the necessary fund-raising, and their execution in white Dover marble was delayed.

In 1912 Stewart and the committee reactivated the project. Working with William Kendall of McKim, Mead & White, the committee abandoned its 1896 commitment to MacMonnies. In 1913 the funding effort was resumed, seven years after White's infamous murder. Instead of returning to MacMonnies's models, Kendall commissioned Hermon Atkins MacNeil and Alexander Stirling Calder for the two three-figure reliefs related to MacMonnies's proposal that now embellish the arch. Representing George Washington as a general and a statesman, they were placed into position in 1916 and 1917, respectively.[6] MacMonnies had protested this change of sculptors, but Stewart maintained the ideas were his own.[7] Kendall had advised Stewart that he was under no obligation to resume working with MacMonnies for several reasons: Stewart denied that he had approved the sketches; the time that had elapsed; the lack of a binding contract; and the disadvantage of working with a sculptor residing abroad. According to Kendall, Stewart said that after MacMonnies left the country, White had suggested that a more accessible sculptor be found, noting that MacMonnies's scheme had been thought too expensive, his plaster sketches had been made without any assurance he would get the work, and that they were presently "not at all of the right character, [and they would] prefer to have something much more classic."[8] Stewart insisted that if MacMonnies persisted in his claim he would go to the press. MacMonnies took no further action, although the record clearly vindicates the sculptor's claims to more than

ownership of intellectual property, because the themes preserved in these two sheets are so close to the executed sculptures.[9]

Each of MacMonnies's studies for the two groups flanking the arch's opening consists of a three-figure group on pedestals with Washington at the center, flanked by two personifications of Virtues. Behind them is a fan of flags and banners, creating a patriotic, secular mandorla, a form based on religious models that connotes glory. Not coincidentally, they relate to the similarly positioned and composed groups on the Arch of Triumph in Paris, a monument on which MacMonnies's teacher Falguière had worked during the 1880s. They also correspond to the photographs of the plaster models mentioned above and harmonize with an outline scale drawing of the Washington Arch by White in graphite on tracing paper dated 28 February 1895 in the Society's McKim, Mead & White Archives; it has an overlay containing ink sketches by MacMonnies of both relief groups dated June 1895.[10] In July of that year the sculptor returned his overlay to White, who praised the design: "the Washington Arch sketches are *bully*."[11]

1. Henry James's novel *Washington Square* was first serialized in *Harper's* in 1880; for the square, see Mindy Cantor, ed., *Around the Square, 1830–1890: Essays on Life, Letters, and Architecture in Greenwich Village* (New York: New York University, 1982), esp. her essay on the arch (pp. 40–52); and *The History of the Washington Arch, in Washington Square, New York, Including the Ceremonies of Laying the Corner-Stone and the Dedication* (New York: Ford & Garnett, 1896). The Society's library has an extensive collection of materials pertaining to the arch, including a scrapbook of newspaper clippings and seven boxes of correspondence and documents.

2. The Society also holds an ink drawing of the temporary arch of 1889 by Francis Vinton Hoppin, then a draftsman in the employ of McKim, Mead & White, given by the same donor (inv. no. 1923.129; see Koke 1982, 2:155, no. 1267). For badges made for the Washington centennial celebration by Tiffany & Co., see cat. 136.

3. See Gordon 1998, 1:232–41, no. 36. In the Society's Department of Manuscripts is a letter of 23 August 1895 (44, rue de Sèvres, Paris) from MacMonnies to Stewart acknowledging receipt of $500 for models of the arch's spandrel figures.

4. See Smart and Gordon 1996, 296, no. 45; and Gordon 1998, 1:307–25, no. 45.

5. Gordon 1998, 1:307. They are preserved in the H. H. Sidman photographs of 1895–96 in the McKim, Mead & White Architectural Record Collection; see

ibid., 2: figs. 45.2 and 45.3.

6. Bruce Weber, *Homage to the Square: Picturing Washington Square, 1890–1965*, exh. cat. (New York: Berry-Hill Galleries, 2001), 65–66, figs. 29 and 30.

7. MacMonnies's first inkling of the change in sculptors is found in a letter in the Society's Department of Manuscripts, dated 28 March 1914 (38, rue du Luxembourg, Paris), in which he expresses his surprise to learn that others were executing figures for the arch very close to the designs he had originally planned and thought approved by Stewart's office. MacMonnies states far too optimistically: "I realize that this must be an error of the reporter who described my sketches while imputing them to other sculptors … . I shall greatly appreciate a word from you in regard to this affair tho' I imagine I have found the true explanation."

8. Quoted in Gordon 1998, 1:321.

9. Ibid.

10. Ibid., 1:307–8; 2: fig. 45.1.

11. Quoted in ibid., 1:310.

ROBERT HENRI

Cincinnati, Ohio 1865–New York, New York 1929

Born Robert Henry Cozad, Robert Henri became one of the leading personalities in American art of the early twentieth century (especially as a leader of the Ashcan School) and was known for his teaching skills, his ethnic portraits, and his social realism as well as his arts activism. During his youth Henri received schooling in Cincinnati but lived in Cozzadale, Ohio, and Cozad, Nebraska, frontier towns developed by his father John Jackson Cozad, a riverboat gambler and real estate promoter. When Henri's father shot an employee over a dispute in 1882, the family left Cozad despite the fact that he was cleared of the murder charge. They first moved to Denver, Colorado, and then to Atlantic City, New Jersey, where in 1883 Cozad changed his name to Richard H. Lee and presented his two sons as adopted children. Robert chose for his surname a variation on his middle name spelled to honor his French ancestry, pronounced "Hen-rye."

In 1886 Henri and his brother, known as Frank L. Southrn, moved to Philadelphia, where Henri attended classes at the Pennsylvania Academy of the Fine Arts, studying under Thomas Anshutz and Thomas Hovenden during his formative years. There he was also influenced by the realism of Thomas Eakins, the previous director of the academy. From 1888 to 1891 Henri lived in Paris and continued his training with Tony Robert-Fleury and William Bouguereau at the Académie Julian, whose curriculum offered freedom from academic strictures. Henri spent summers in popular artists' colonies in Pont-Aven and Barbizon, painting peasants as did many artists of his generation, and also traveled on the Continent. At the end of 1891 he returned to Philadelphia, where he again enrolled in the Pennsylvania Academy and began associating with John Sloan. Through Sloan Henri became acquainted with William Glackens (cat. 133), George Luks, and Everett Shinn, at that time all illustrators for the *Philadelphia Press*; these artists formed a social group that was interested in realistic art. Along with Sloan and Glackens, Henri formed the Charcoal Club, which met weekly in Henri's studio. A natural teacher and mentor, Henri began to teach at the Pennsylvania School of Design for Women (1892–95), where his pedagogical gifts were already evident. By 1893 he had opened his own summer school in Darby Creek, Pennsylvania, which attracted young Philadelphia artists and newspaper illustrators, among them the men who would form the core of the Eight. Returning to Europe in the summer of 1895 with Glackens and two other artists, the four bicycled through Holland and Belgium, studying the work of Frans Hals, Peter Paul Rubens, and Rembrandt van Rijn. Staying in Paris until 1897, Henri also went to London to view a large exhibition of the works of Diego Velázquez and an important Durand-Ruel exhibition of the works of Édouard Manet, resulting in his adoption of a looser brushstroke and a darker palette for the next decade. Henri debuted at the liberal Champ-de-Mars Salon of the Société nationale des Beaux-Arts in 1896 with a Velázquez-inspired portrait and exhibited two more portraits there the following year.

Henri returned to the United States in 1897 for his first solo exhibition at the Pennsylvania Academy, through which he met William Merritt Chase, who introduced him to the New York art world in 1900. Also at this time Henri married one of his students, Linda Craige, in June 1898. The couple left immediately for a honeymoon in Paris, where Henri began preparing for the 1899 Salon. Four of his canvases were accepted, one of which, *La Neige* (1899; Musée d'Orsay, Paris), the French government purchased for the Musée du Luxembourg.

After spending the summer in Madrid studying Velázquez, Henri settled in New York City. Between 1900 and 1902 he began his illustrious teaching career at the Veltin School. He later taught at the New York School of Art (1902–7), founded by Chase, the Modern School (1911–18), and the Art Students League (1918–25), among many other institutions, and began encouraging younger artists to free themselves from the academic confines of the art establishment. Sloan and Glackens, subscribers to his theories, also came to the city and helped him in this crusade. In 1909 he established the Henri Art School, where he taught until 1912; among his pupils were Edward Hopper, Stuart Davis, Rockwell Kent, and Yasuo Kuniyoshi. Although he joined the prestigious Society of American Artists in 1903, was elected to the NAD (associate in 1905, academician in 1906), and served on the committee that merged the two organizations in the spring of 1906, he had already begun participating in challenges to its authority, angered by the restrictive exhibition policies of the NAD. As a member of the thirty-person jury for the 1907 annual spring NAD show, one of the most important and selective venues in which emerging artists might gain recognition, Henri spoke out

against what he considered an unfair jury practice and asked for a review of some of the rejected works, but to no avail. In protest, he withdrew his own canvases from the accepted works.

Spurred by favorable newspaper articles by friendly critics, Henri formally presented his vision of a new American art when he helped organize a landmark exhibition at the Macbeth Gallery in New York in February 1908. His works were displayed along with those of seven other artist friends: Arthur B. Davies, Glackens, Ernest Lawson, Luks, Maurice Prendergast, Shinn, and Sloan, a group that subsequently became known as the Eight. More than seven thousand persons flocked to see the exhibit, which later toured other cities. Although the Eight would never again exhibit as a group, their reputations were always associated with the controversial show. Soon thereafter, Alfred Maurer, George Wesley Bellows, Hopper, and Guy Pène du Bois joined the artistic circle of Henri, Davies, Luks, Glackens, Sloan, and Shinn, and Henri married Marjorie Organ, an Irish American newspaper cartoonist.

After 1909 Henri's paintings became progressively more colorful, as he and his friends experimented with the techniques and higher-keyed palette of the painter and color theorist Hardesty Maratta; simultaneously under Henri's leadership, the independent movement gained speed. In 1910 Henri helped Sloan, Davies, and others organize the large *Exhibition of Independent Artists* at a vacant building on Thirty-fifth Street, where some 627 works of art hung unjuried, proving that a stimulating show could be organized as a kind of Salon des Refusés. Henri's group pursued a nonacademic direction by depicting alleys, tenements, and slum dwellings of New York. Although diverse in their styles, the artists were dedicated to common ideals: the validity of everyday life as subject matter for fine art and the belief that artists had the right to freedom of expression. These artists, known for their bravura brushwork that imparted spontaneity to their works, were informally dubbed the Ashcan School. (Only in 1934 did Holger Cahill and Alfred Barr confer the label in an article in *Art in America*.) Henri also helped organize the watershed *International Exhibition of Modern Art* at the Sixty-ninth Regiment Armory, called the Armory Show (see cat. 132), at which he exhibited five works. He also produced distinctive

work during three extended visits to Santa Fe, New Mexico, in 1916, 1917, and 1922.

An inspired and widely influential teacher, Henri admonished his pupils to ignore prevailing styles, such as Impressionism and academicism, and paint quickly in a slashing manner to capture the strength of the moment. He believed that artistic expression was vital to artistic integrity and that technique was important but should never be an end in itself. He advised his pupils: "Be a man first, be an artist later." He stated, "I am not interested in art as a means of making a living, but I am interested in art as a means of living life." He urged them to read the novels of Fyodor Dostoyevsky and Leo Tolstoy, to see plays by Henrik Ibsen, to listen to music by Richard Wagner, and to watch the dance of Isadora Duncan.

Henri was honored with the Beck Gold Medal by the Pennsylvania Academy of the Fine Arts (1914), and he received silver medals at the St. Louis World's Fair (1904) and the Panama-Pacific International Exposition in San Francisco (1915), as well as many other honors. Continuing his activism in New York City, Henri became a member of the Society of American Artists (1903) and the Society of Independent Artists (1916), as well as a founding member of the New Society of Artists (1919). A compilation of his lectures and reflections on art in 1923 (*The Art Spirit*) was published by a former student, Margery Ryerson. Shortly before his death, Henri received his final award, the Temple Gold Medal from the Pennsylvania Academy. A memorial exhibition of his art was held at the

Metropolitan Museum of Art in 1939. Henri is best remembered as a champion of social realism, and his leadership in establishing a vital American art remains one of the foundation stones of twentieth-century painting.

Bibliography: Nathaniel Pousette-Dart, ed., *Robert Henri* (New York: Frederick A. Stokes Company Publishers, 1922); Robert Henri, *The Art Spirit*, ed. Margery Ryerson (Philadelphia: J. B. Lippincott, 1923; reprint., New York: Harper & Row, 1984); Helen Appleton Read, *Robert Henri* (New York: Whitney Museum of American Art, 1931); William Innes Homer with the assistance of Violet Organ, *Robert Henri and His Circle* (Ithaca, N.Y.: Cornell University Press, 1969; rev. ed., New York: Hacker Art Books, 1998); Judith Zilczer, "The Eight on Tour, 1908–1909," *American Art Journal* 16:3 (1984): 20–48; Fink 1990, 355; Bernard B. Perlman, *Robert Henri: His Life and Art* (New York: Dover Publications, 1991); Weinberg 1991, 258–62; Valerie Ann Leeds, *My People: The Portraits of Robert Henri*, exh. cat. (Orlando, Fla.: Orlando Museum of Art, 1994); Susan Danly, "The Henri Circle and the American Impressionists," *American Art Review* 16:4 (2004): 88–99; M. Sue Kendall, "Ashcan School," *The Grove Dictionary of Art Online*, http://www.groveart.com (Oxford University Press) (accessed 22 March 2004); Dearinger 2004, 262–63; Valerie Ann Leeds, *Robert Henri: The Painted Spirit*, exh. cat. (New York: Gerald Peters Gallery, 2005); Marion Wardle, "The 'New Women' Art Students of Robert Henri," *American Art Review* 17:2 (2005): 156–63.

Fig. 127.1. Robert Henri, *Two Figures Walking*. Graphite on paper, 5 1/4 × 6 3/8 in. (133 × 162 mm), irregular. The New-York Historical Society, Gift from Mr. Allen S. Wilder, 1983.32

127

127. *Couple Holding Hands on a Loveseat*; verso: sketches of a couple before a fireplace and a couple standing, 1890s

Graphite and black crayon on paper; 15 1/8 × 11 in. (384 × 280 mm), irregular
Verso stamped at upper right: *Estate of Robert Henri / Hirschl & Adler / NYC*
Provenance: Estate of Robert Henri; Mr. and Mrs. Stuart P. Feld, New York.
Gift of Mr. and Mrs. Stuart P. Feld, 1983.44ab

Henri executed the three scenes on both sides of this sheet in the bold draftsmanship characteristic of his early career.[1] Already before 1900 his style was spartan and brash, a manner that would become the hallmark of the Social Realism of the Eight and the Ashcan School.[2] His summary, no-nonsense approach is also apparent in another small sheet in the Society's collection that represents two figures walking in a city (fig. 127.1), a favorite subject from the artist's early days in France.[3] In contrast to those of the individuals in figure 127.1, the costumes worn by some figures on this sheet are historic, not contemporary. The anachronistic vignettes suggest that Henri was working under the influence of his early colleagues and associates, such as John Sloan, who were illustrators. This sheet, therefore, may represent an unknown aspect of Henri's development.

In the vignette on the recto the artist depicted a mustachioed man in coattails seated on a loveseat holding the hand of a woman who gazes into his face. Henri drew this emotion-fraught moment, perhaps a proposal or a seduction scene, in a parlor furnished with a table set for a repast before a fireplace surmounted by a mirror.

The sketches on the verso are more quickly rendered. In the upper section Henri drew a variant of the couple seated before a fireplace on the recto that relates to his early works of the 1890s, including *A Normandy Fireplace*, which was exhibited in 1897 at the Pennsylvania Academy of the Fine Arts.[4] Below, in larger scale, he delineated a standing couple dressed in earlier costumes. All three sketches may relate to the same narrative.

In each of the vignettes, Henri used body language and interactions between the figures to express their inner states. The artist, who was known for his aphorisms, remarked: "The distinguishing mark of all great men is their humanity."[5] And, as this drawing demonstrates, Henri was attuned to humanity in both his art and his philosophy.

1. For a similar sheet, see Maynard Walker Gallery, *An Exhibition of Early Works by Robert Henri*, sale cat. (New York: Maynard Walker Gallery, 1962), no. 1, ill.
2. See a drawing of a female nude from 1900 in the Metropolitan Museum of Art, New York, in Stebbins 1976, fig. 246.
3. A work with similarly drawn figures is *Old Brittany Farmhouses*, 1902, oil on canvas; see Perlman 1991, fig. 50, when it was listed with Chapellier Galleries, New York.
4. Reproduced and discussed in the *Philadelphia Press*, 24 October 1897; Robert Henri Papers, 1872–1954, lent by Mrs. Janet LeClair, microfilmed by the AAA, reel 886, frame 1334.
5. Quoted in Read 1931, 7.

LYDIA FIELD EMMET

New Rochelle, New York 1866–New York, New York 1952

Lydia Field Emmet, who was primarily recognized for her portraits of children, was a great-granddaughter of Thomas Addis Emmet, an attorney general of New York State and brother of the Irish patriot and state physician of Ireland Dr. Robert Emmet. She hailed from a dynasty of women painters, beginning with Thomas Emmet's daughter Elizabeth, who had studied with Robert Fulton (cats. 20 and 31) about 1804, and including Lydia Emmet's sisters Rosina Emmet Sherwood and Jane Emmet De Glehn and their cousin Ellen Emmet Rand. Encouraged by her family to continue its artistic tradition, at seventeen Lydia studied in Paris for six months, together with her older sister Rosina and Candace Wheeler's daugher Dora. At the Académie Julian, Emmet's ability and style were praised by her teachers William Bouguereau, Gustave-Henri Colin, Félix-Henry Giacommotti, Tony Robert-Fleury, and Frederick MacMonnies (cat. 126). While in France she joined the summer colony of American artists near Claude Monet's home in Giverny. When she returned to New York in 1885, she seems to have studied independently with her sister Rosina's guidance and worked on a freelance basis for Wheeler's firm, Associated Artists. From 1889 to 1895 she studied at the Art Students League, taking classes with Kenyon Cox, H. Siddons Mowbray, and Robert Reid, as well as William Merritt Chase, who exerted the greatest influence on her work. When Chase began his summer school at Shinnecock Hills, Long Island (1891), she was adequately advanced to lead the preparatory class, which she taught from 1891 to 1893. She became an associate of the NAD in 1909 and an academician in 1911.

In her early work Emmet painted a variety of subjects. She executed a mural for the Woman's Building at the 1893 World's Columbian Exposition in Chicago, where she received her first recognition, winning an award for her two easel paintings (see below). Emmet was also commissioned to design the New York State seal for that fair. Afterward she built her reputation as a painter of society portraits in New York, Philadelphia, and Boston. Her portrait of Mrs. Herbert (Lou Henry) Hoover once hung in the White House. Throughout her forty-year career, she specialized in portrayals of children and commanded top prices for her commissions. Much of her work was executed in her studio at 535 Park Avenue or at her summer home, Strawberry Hill, in Stockbridge, Massachusetts, which she began building in 1905. She also won acclaim in 1889 for her stained-glass window designs for the Tiffany Glass Company (cat. 137), including one for the Mark Twain house in Hartford, Connecticut, and worked as an illustrator for magazines like *Harper's* to supplement her income. Emmet won a number of honors, among them a silver medal at the St. Louis World's Fair (1904), the Society of American Artists Shaw Prize (1906), various prizes at the NAD (among them the Thomas B. Clarke Prize in 1909), and the Popular Prize at the Corcoran Gallery in Washington, D.C. (1917).

Until her death, Emmet maintained a home (at 214 East Seventieth Street) as well as a studio in New York City and the house in Stockbridge. Always physically active (she swam daily), she was known for riding roundtrip from New York to Stockbridge on her horse, breaking her journey at friends' homes along the way. In the Berkshires, she drove a yellow Model T Ford, nicknamed Yellow Peril, after her reckless driving habits.

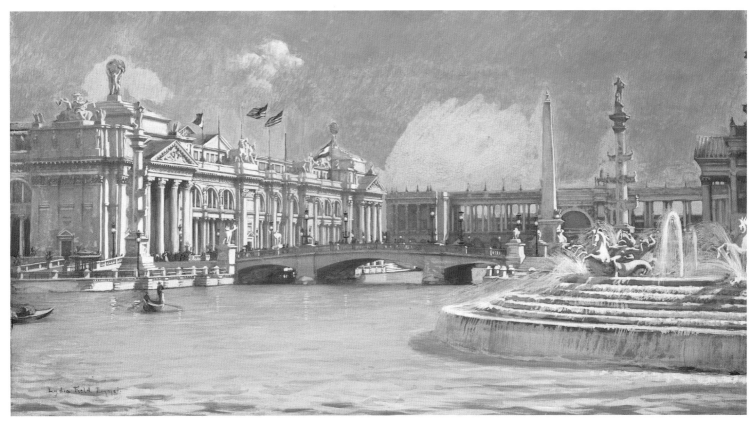

Bibliography: Jim L. Collins, *Women Artists in America* (Chattanooga: University of Tennessee, 1973), n.p.; Ronald G. Pisano, *The Students of William Merritt Chase*, exh. cat. (Huntington, N.Y.: Heckscher Museum, 1973), 14; Martha J. Hoppin, *The Emmets: A Family of Women Painter*s, exh. cat. (Pittsfield, Mass.: Berkshire Museum, 1982); Eleanor Tufts, *American Women Artists, 1830–1930* (Washington, D.C.: International Exhibitions Foundation, for the National Museum of Women in the Arts, 1987), cat. 20; Carr and Gurney 1993, 241; Tara Leigh Tappert, *The Emmets: A Generation of Gifted Women*, exh. cat. (New York: Borghi & Co., 1993); Falk 1999, 1:1044; Carbone et al. 2006, 1:515–16; Martin Eidelberg, Nina Gray, and Margaret K. Hofer, *A New Light on Tiffany: Clara Driscoll and the Tiffany Girls*, exh. cat. (New York: New-York Historical Society, in association with D Giles Limited, London, 2007), 27, 28, 182.

128. *View across the Great Basin of the World's Columbian Exposition, Chicago, Illinois*, 1893–94

Gouache, watercolor, white priming, oil paint, pastel, and graphite on paper, mounted on canvas (removed from stretcher); 16 × 29 1/16 in. (406 × 738 mm)
Signed at lower left in blue pastel: *Lydia Field Emmet*.
Provenance: McKim, Mead & White, New York.
Bibliography: Hoppin 1982, 23, 61, no. 59, fig. 10; Koke 1982, 2:14, no. 953, ill.; Amelia Peck and Carol Irish, *Candace Wheeler: The Art and Enterprise of American Design, 1875–1900*, exh. cat. (New York: Metropolitan Museum of Art, 2001), 226–28, no. 87, ill.
Gift of Mrs. James Ketchum Smith, 1968.49

Emmet's handsome gouache was donated to the Society by Mrs. James Ketchum Smith, wife of the later partner of Lawrence White, son of Stanford White and a principal architect in the firm of McKim, Mead & White. The work provides a view across the Great Basin at the World's Columbian Exposition of 1893 in Chicago that marked the debut of the United States as a major player on the world art scene. Emmet's work features the architecture designed by McKim, Mead & White, including the west facade of the Agricultural Building on the South Canal at the left. In the right distance at the end of this canal is the Obelisk, a reproduction of Cleopatra's Needle, which had been presented to the United States by the khedive of Egypt and erected in Central Park in 1881. In the right foreground is the Columbian Fountain marking the head of the Great Basin, which MacMonnies (Emmet's former instructor) designed. It features the allegorical figure of Columbia riding on a ship rowed by the Arts and Sciences and

steered by Father Time. Like her sister Rosina, Lydia was one of the many women, including Mary Cassatt, who decorated the interior of the Woman's Building on the commission of Candace Wheeler, who was in charge of its interior.[1] The building, one of the most successful in the exposition, was planned, designed, and organized entirely by women and showcased women's accomplishments in a great number of fields.[2] Emmet's mural (*Art, Science, and Literature*) on the east wall of the Hall of Honor, the most ambitious space in the building, depicted five female allegorical figures in contemporary dress who represented Painting, Sculpture, Embroidery, Music, and Literature; its pendant was painted by Rosina.[3] Both sisters were exhibitors in the Palace of Fine Arts as well, where Lydia showed *Noonday* and *The Mere* (locations unknown).[4]

Emmet's large watercolor, for which, according to her account books, she received $100 in 1894, provides a lasting record of the unique event.[5] Although the amount paid to the artist for this work is mentioned without the name of a patron, the work's provenance suggests it was purchased by a member of the McKim, Mead & White architectural firm.

The fair was named Columbian to commemorate the four-hundredth anniversary of the discovery of America by Christopher Columbus; although it was first scheduled to open in 1892, it was not completed on time. Its organizers conceived it as a celebration of humanity's greatest achievements in technology, agriculture, and the arts. Ironically, the fair coincided with the country's worst depression since the financial collapse of 1837. Despite those circumstances, the United States, acting as host to dozens of emissaries from many nations, asserted a new position of global leadership as it optimistically faced the next century. The fair attracted some twenty-seven million visitors over a six-month period.

Emmet's gouache makes clear why the exposition was known as the "White City," the "Dream City," and the "City Beautiful." Truly urban in feel and suggesting an idyllic metropolis, the Columbian Exposition departed in its size and emphasis from earlier American fairs and signaled a cosmopolitan tenor with emblems of human and national progress. Its temporary buildings were organized around a central court, at the head of which towered

Richard Morris Hunt's Administration Building; pavilions whose themes were the basic elements of America's economy (machinery, manufacturing, railroads, agriculture, mining, and electricity) were clustered around it. Many of the structures were designed in the palatial Neoclassical Beaux-Arts style, and their facades presented a harmonious, unified aspect. The majority of these edifices were dismantled after the fair closed on 29 October 1893. The only structure to survive, the Fine Arts Palace, was built to be permanent; it became Chicago's Museum of Science and Industry.[6]

1. Peck and Irish 2001, 227.
2. See Maud Howe Elliott, ed., *Art and Handicraft in the Woman's Building of the World's Columbian Exposition, Chicago, 1893* (Paris: Goupil & Company, 1893).
3. Peck and Irish 2001, 233–34, no. 91, ill.
4. See Hoppin 1982, fig. 9; and Carr and Gurney 1993, 241.
5. Peck and Irish 2001, 226.
6. For the exposition, see Peck and Irish 2001, 226–39; as well as David F. Burg, *Chicago's White City of 1893* (Lexington: University Press of Kentucky, 1976); Reid Badger, *The Great American Fair: The World's Columbian Exposition and American Culture* (Chicago: Nelson Hall, 1979); and Stanley Appelbaum, *The Chicago World's Fair of 1893: A Photographic Record; Photos from the Collections of the Avery Library of Columbia University and the Chicago Historical Society* (New York: Dover Publications, 1980); and Carr and Gurney 1993.

EDWARD PENFIELD

Brooklyn, New York 1866–Beacon, New York 1925

129

An innovative commercial poster designer, illustrator, and painter, Edward Penfield produced some of America's finest posters at the turn of the twentieth century, during the short-lived Golden Age of American poster art. He studied intermittently with George de Forest Brush, a leading force in American Impressionism, at the Art Students League in New York City. In 1890, at the age of twenty-four, during a pivotal time in American graphic design, Penfield became art editor of *Harper's Magazine* and shortly later of *Harper's Weekly* and *Harper's Bazaar*. Over the next decade, he continued to work as both an artist and an editor for the Harper publications, seeking out and encouraging the best talent in the country. He resigned his post in 1901 to devote more time to his own art. In the ensuing years Penfield painted several murals—such as those in the breakfast room of Harvard University's Randolph Hall, in Cambridge, Massachusetts, and the Rochester Country Club in Rochester, New York—but devoted most of his attention to poster designs that were influenced by Henri Toulouse-Lautrec, Aubrey Beardsley, Théophile Steinlen, and Japanese ukiyo-e, or "floating world," prints. Along with Will Bradley, he became one of the most important exponents of American poster art. Penfield also designed magazine covers for *Collier's Weekly* and *Harper's Monthly* as well as commercial advertisements and numerous calendars. In addition, he wrote articles for *Scrib-*ner's Magazine* and *Outing* and executed design work for the Beck Engraving Company of Philadelphia (1908–25). A product of Arts and Crafts idealism, Penfield advocated hand production and studio design over machine-made art.

Penfield's clean style and large silhouetted shapes were a product of simplification and elimination of detail. Horses and coaches were a favorite subject, typified by illustrations of the colonial Post Road and by his contribution to "The Ancestry of the Coach" (*Outing*, July 1901). This interest led to collecting ancient conveyances. A cat fancier, Penfield was also known for his portrayals of felines, as seen in a cover and poster for the May 1896 issue of *Harper's*. He also served on the art committee of the Salmagundi Club, was enlisted to produce posters for the government's Division of Pictorial Publicity during World War I, illustrated many books and magazines, and designed covers for the *Saturday Evening Post*, *Scribner's Magazine*, and the *Ladies' Home Journal*. He exhibited his work at the 1904 St. Louis World's Fair and in several of the yearly exhibitions of the American Watercolor Society.

In his post as art director for Harper's magazines and through his teaching at the Art Students League, Penfield exerted a profound influence on American illustration. In 1915–16 he taught two courses indicative of the country's increasing demand for commercial art training: Commercial Draughtsmanship and Posters and Lettering. Having served as president of the Society of Illustrators from 1921 to 1923 and after living a quiet life with his family in Pelham Manor, New York, he was posthumously elected to the Illustrators' Hall of Fame in 1998.

Bibliography: Charles Hiatt, *Picture Posters: A Short History of the Illustrated Placard* (London: George Bell and Sons; New York: Macmillan and Co., 1896), 285–89; C. B. Davis, "Edward Penfield and His Art," *Critic* 34:861 (March 1899): 232–36; Martin Hardie and Arthur K. Sabin, eds., *War Posters Issued by Belligerent and Neutral Nations, 1913–1919* (London: A. & C. Black, 1920), 28–29; *DAB*, 14:424–25; David Gibson, *Designed to Persuade: The Graphic Art of Edward Penfield*, exh. cat. (Yonkers, N.Y.: Hudson River Museum, 1984); Reed 2001, 80.

129. *"Liberty," the New York City to Lakewood, New Jersey, Coach: Study for a Poster*, 1903

Watercolor, gouache, black ink, and graphite on brown paper, laid on canvas; 16 7/8 × 44 1/4 in. (428 × 1124 mm)
Signed at lower right in black ink: artist's monogram / *EDWARD PENFIELD*
Provenance: James Hazen Hyde, New York.
Bibliography: Koke 1982, 3:64–65, no. 2328, ill.
Gift of James Hazen Hyde, 1947.90

This large, bold work is the final preparatory model for an unidentified poster advertising the short-lived run of the four-horse public coach *Liberty* that ran between New York City and Lakewood, New Jersey, by way of Newark and Freehold (lettered on the side of the coach) from 31 March to 15 May 1903.[1] The noted

French firm of Million Guiet & Co. (of 60, avenue Montaigne, Paris) built the conveyance for James Hazen Hyde, a Francophile and coaching enthusiast who maintained the run during the height of America's Gilded Age excess.[2] Hyde, the donor of this drawing, was also considered one of the top drivers of four-in-hand coaches, a sport almost unparalleled for its expense. Penfield may have depicted him seated on the box and driving the coach (see n. 4). The *Liberty* ran between the Holland House on Fifth Avenue at Thirtieth Street and the Hotel Laurel-in-the-Pines at Lakewood. It left New York at 9:00 a.m. on Tuesdays, Thursdays, and Saturdays, reaching Lakewood at 6:10 p.m. Returning on Mondays, Wednesdays, and Fridays, it departed at 8:30 a.m. and arrived in New York at 6:00 p.m. The distance covered was seventy-nine miles and required eleven teams of horses daily. A single trip cost $12 and a box seat $15, while the entire coach could be rented for $100.[3]

Hyde succeeded his father, Henry Baldwin Hyde, as president of the Equitable Life Assurance Society after serving as its vice president from 1899 to 1905. His passion, however, was for French history and culture. The founder of the Alliance Française in America, he wrote about French and American relations, eventually receiving the Grand Cross of the Legion of Honor from the French government.[4] His most extravagant expense was a French-themed party on 31 January 1905 held at New York's Sherry Hotel, which was transformed into a new Versailles with guests attending in opulent period attire. The cost of this lavish event, which lasted until dawn, was estimated at $200,000 in 1905 dollars. It was the catalyst for a commission to investigate the insurance industry's behavior, resulting in useful reforms. Hyde soon thereafter retired in France.[5] The Society also holds a series of twelve related watercolors of the *Liberty* along its run that Hyde commissioned from Max Francis Klepper in the same year that Penfield made his poster.[6]

Coaching parties to the racetrack and the country were favorite pastimes with New York society at the turn of the twentieth century before automobiles became common. Since Penfield shared Hyde's passion for coaches and horses, he was the ideal artist to execute Hyde's poster.[7] Studying coaching design and history was a favorite hobby of Penfield, who became a

collector of these vehicles and wrote about them. In fact, this poster design is nearly identical to Penfield's frontispiece for his article "The Ancestry of the Coach" published in *Outing* in 1901.[8] His passion for coaching also found expression in an unfinished book manuscript on coaches that survives among the family papers.[9]

The simple, bold style of Penfield's watercolor is highly decorative, and its defining black line and blocks of flat, strong color, reminiscent of Japanese woodblock prints, are characteristic of his cutting-edge posters. In his introduction to a 1896 poster collection, Penfield summarized his approach to poster design: "A poster should tell its story at once—a design that needs study is not a poster, no matter how well it is executed."[10] Penfield's son, Walker Penfield, described his father's artistic process from firsthand observation:

> After preliminary sketches had fixed the subject and layout of the poster, he would make a master drawing in black ink with pen and brush, mostly the latter. He would then color this in with watercolor. The next step would be to lay tracing paper over this master drawing, using a different piece for each color and painting in the appropriate areas in black ink. Each of these pieces of tracing paper became the diagram for one or another of the zinc plates … . He … went into the pressroom and mixed and blended the inks for a poster run, staying with the pressman until the presses settled down and the poster prints were coming out just as father desired them to.[11]

The Society's drawing, the final design for a poster that would then have been traced, demonstrates Penfield's pioneering role in powerful turn-of-the-century image making.

1. Koke 1982, 2:247. The other stops in New Jersey were Rahway, New Brunswick, Old Bridge, Matawan, Marlboro, and Farmingdale.
2. The firm of Million Guiet & Co. enjoyed the patronage of several wealthy Americans who spent a great deal of time in Paris, among them James Gordon Bennett and William G. Tiffany, all coaching enthusiasts.
3. Koke 1982, 2:247.
4. For Hyde's book *Les États-Unis et la France: Les Relations historiques franco-américaines (1776–1912)* (Paris: F. Alcan, 1913) and his life, see Patricia Beard, *After the Ball: Gilded Age Secrets, Boardroom Betrayals, and the Party That Ignited the Great Wall Street Scandal of 1905* (New

York: HarperCollins, 2003). The American Historical Association still offers the James Hazen Hyde Prize for the best work on Franco-American relations in the nineteenth century. Three portraits of Hyde, two by Theobald Chartran, are in the Society's collection; see N-YHS 1974, 1:378–79, nos. 987–89 (inv. nos. 1949.1; 1956.182; and 1949.2).
5. Hyde practiced his passion for coaching in France, as evidenced by the thick album with photogravure cards he collected, which was presented in 1959 to the Thomas J. Watson Library, The Metropolitan Museum of Art, New York: James Hazen Hyde, *Coaching in Touraine 5–16, 26–00* (n.p., 1900?).
6. Inv. nos. 1960.28–39; see Koke 1982, 2:246–47, no. 1550. Klepper's scene of coaching on Fifth Avenue (inv. no. 1945.526) dated 1900 is also in the Society's collection; ibid., 246, no. 1549.
7. See Reed 2001, 80, for a similarly colored illustration by Penfield of a coaching party drawn by four horses.
8. Edward Penfield, "The Ancestry of the Coach," *Outing* 38:4 (1901): 363–68.
9. Gibson 1984, 13.
10. Quoted in ibid., 1.
11. Quoted in ibid., 11.

OSCAR FLORIANUS BLUEMNER

Prenzlau, Germany 1867–South Braintree, Massachusetts 1938

Oscar Bluemner, who was esteemed in his own time and became an important figure in American modernism, was born into a family of architects and painters. Following the careers of his father and grandfather, he enrolled in the Royal Technical Academy in Berlin to train as an architect. There he met with success, not only for his building designs—for which he won the Royal Medal of Architecture in 1891—but also for the exceptional craftsmanship of his drawings. Four months after graduating, he fled the country to escape Kaiser Wilhelm II's conservative views on contemporary art and architecture as well as the growing militarism of the regime. As Bluemner later wrote, he "ran away a rebel" from a world that seemed "too hard and sterile from tradition for so tender a plant as a still vague thought of a new style."

Arriving in the United States in 1892, Bluemner worked as an architect for the next twenty years, first in Chicago and then New York City, where he settled in 1900. He specialized in what he called "pictorial architecture," country homes that demonstrated a particular sensitivity to color and light and were integrated into the landscape as if part of a composition a painter might create at his easel. Most of these were single-family bungalows that Bluemner linked to nature, which he saw as the true expression of the American spirit. His most notorious architectural achievement was his 1904 design for the Bronx County Courthouse. When the Tammany Hall architect Michael Garvin claimed authorship of the structure, Bluemner filed suit against Garvin. Although eventually vindicated as the rightful architect of the courthouse in 1906, Bluemner did not receive financial compensation until 1911. Disillusioned with the business of architecture, he turned to painting, resolving to design buildings only when financial insolvency demanded it. During this period, Bluemner became increasingly unhappy about his inability to persuade his architectural clients to accept his ideas about color. Soon he turned away from architecture entirely and began to realize his ideas on canvas. Most of his paintings are landscapes, without figures, depicting houses and other buildings in brilliantly colored, stylized settings. He also became active in the modernist art circle around Alfred Stieglitz's 291 gallery. Similar in age and cultural heritage (they had both studied at the Royal Technical Academy in Berlin), the two men developed a friendship and collaboration. Bluemner contributed essays to Stieglitz's journal *Camera Work*—including his essay published after the public's reaction to the 1913 Armory Show, in which he justified modern art on social and intellectual grounds—and Stieglitz supported Bluemner's art through sales and exhibitions at his various galleries.

Buoyed by Stieglitz's support and flush with the proceeds from his suit against Garvin, in 1911 Bluemner took a seven-month trip through Europe, where he had his first solo exhibition in Berlin at the Galerie Fritz Gurlitt and where he saw firsthand the important large surveys of vanguard art in Germany, France, and England. When he returned to the United States, he scraped down his canvases and moved his art further into abstraction by accentuating the structural clarity of his compositions and the expressionist intensity of their color—which, by then, he regarded as the agent of subjective expression.

He composed simplified architectural and landscape forms as interlocking grids of color planes that form brilliant prisms. Although Bluemner's bright colors in these works resemble those of the Post-Impressionists, the Synchromists, the Orphists, and various German Expressionists (ironically who flourished in the Germany he had left), Bluemner claimed that the early-nineteenth-century color theories of Johann Wolfgang von Goethe (*Zur Farbenlehre*, 1810) were more influential on his art. Goethe had questioned Isaac Newton's ideas regarding the exclusive physical nature of color and light and sought to derive laws about the subjective ways colors affect people and their perceptions. According to the marginal notes in some of his drawings, Bluemner also found the color theories of Ogden Rood and the Pointillist Paul Signac of use. As testimony of his modernist status, Bluemner's work was included in the landmark 1913 Armory Show (see cat. 132). Soon thereafter, his oils were featured in a one-man show at Stieglitz's 291 gallery in 1915. The artist's synthesis of crisp, geometric forms and juxtapositions of primary color proved too avant-garde for American audiences, and the show was a financial flop. But in 1916 Bluemner was honored with an invitation to join John Marin, Arthur Dove, and a select group of other progressive artists in the historic *Forum Exhibition of Modern American Painters* at the American Anderson Galleries in New York City.

Dissatisfied with the materialism of city life and longing for an intimate connection with nature, Bluemner moved in 1916 with his wife and children to rural Bloomfield, New Jersey, where he continued to develop his pictorial vocabulary of overlapping shapes, bold contours, and strong contrasts of color and tone. He created a system that ascribed meanings to specific colors and established their emotive symbolism. Despite support from the prestigious Bourgeois Gallery and its owner and the artist's friend Stephen Bourgeois, Bluemner's finances remained dismal. Both men became interested in Oriental art and philosophy and the Synthetist theories of Maurice Denis, leading to a belief in transcendental ideas and metaphysical speculation. He also came under the influence of the contemporary mystical thinker Ananda Coomaraswamy, curator of Asiatic art at the Museum of Fine Arts, Boston. In 1923 J. B. Neumann, whom Bluemner had met briefly in 1912 in Berlin, opened the New Art Circle gallery in New York and offered Bluemner a show the following year, which temporarily invigorated his art and enabled him to move to more comfortable quarters in Elizabeth, New Jersey. Although Bluemner's work was appreciated by many individuals involved with the arts—such as the critic Paul Rosenfeld, who bought five of his watercolors in 1923, and his friend the photographer Paul Strand, who purchased two works in 1925—it was generally not understood. Bluemner's astronomical asking prices further lowered interest. An intellectual who also wrote poetry, Bluemner published essays and art reviews in periodicals—such as *Art Digest*, *Camera Work*, and the *New York Times*—and exhibition brochures (including his essay "In Other Words," which was published in the catalogue accompanying the *Exhibition of Modern Art: Arranged by a Group of European and American Artists in New York*, at the Bourgeois Galleries in 1918).

By 1926 Bluemner's chronic poverty had hastened the death of his wife, Lina Schumm Bluemner. Grief stricken, Bluemner moved his family to South Braintree, Massachusetts. Over the next two years, he sublimated his angst in symbolic, dreamlike paintings and watercolors.

These works, particularly those with cosmic suns and moons, anticipate the paintings of Dove and Georgia O'Keeffe, who also may have influenced Bluemner (he wrote "A Painter's Comment," a preface to the catalogue of O'Keeffe's 1935 exhibition at Stieglitz's An American Place in New York). Shown in his one-man exhibition at Stieglitz's Intimate Gallery in the Anderson Galleries Building in 1928, they confirmed Bluemner's place as a gifted American modernist. There were few sales, however, and the artist's economic outlook fared no better in 1929, when the Whitney Studio Galleries showcased a series of his small oils, which he created from multiple layers of thin, transparent casein and varnish washes. The jewel-like luminosity of these nocturnes hinted at the dark moods of the future. In 1932 Bluemner participated in the first biennial exhibition at the Whitney Museum of American Art, and in 1933, during the Great Depression, he joined the Public Works of Art Project, New England Region. Although he continued to exhibit, with critics responding enthusiastically to his work, critical acclaim coincided with the onset of physical deterioration. Following an automobile accident in 1935, Bluemner was stricken by various ailments, followed by paralysis. Suffering from chronic pain and unable to walk, sleep, or see (the nightmare of all artists), he took his life in 1938.

Bluemner lost momentum in modernist circles because of his personality and his inability to market and promote his work successfully. His posthumous reputation was further hampered because until after 1999 his paintings were inaccessible in his estate. Moreover, because his art more obviously incorporated European modernist trends like Cubism, Fauvism, Expressionism, and Futurism, it clashed with other artists' desire to forge a truly American idiom. In addition, an American campaign against Germanic culture, engendered by World War I, colored the acceptance of Bluemner's paintings, which were seen as examples of its perils. With the Whitney Museum of American Art's exhibition in 2005, Bluemner and his American Fauvist art justifiably have been welcomed into the pantheon of American modernism. The evolution of his art and thought can be traced in the painting diaries that he kept from 1911 to 1936; they are held in the Oscar Bluemner Papers of the AAA (partially available on microfilm, reels N737 and 338–44). The N-YHS holds five drawings by this visionary artist, two of which are discussed below and one that is reproduced as figure 19 in the catalogue essay.

Bibliography: Bourgeois Galleries, *Exhibition of Modern Art: Arranged by a Group of European and American Artists in New York*, sale cat. (New York: Bourgeois Galleries, 1918); University Gallery, *Oscar Florianus Bluemner*, exh. cat. (Minneapolis: University of Minnesota, The University Gallery, 1939); Graham Gallery, *Oscar Bluemner, 1867–1939*, sale cat. (New York: Graham Gallery, 1967); Bernard Danenberg Galleries, *Oscar Bluemner: Paintings, Watercolors and Drawings*, sale cat. (New York: Bernard Danenberg Galleries, 1972); Jeffrey R. Hayes, *Oscar Bluemner, the New Jersey Years, 1916–1926*, exh. cat. (Mahwah, N.J.: Ramapo College Art Gallery, 1982); Barbara Mathes Gallery, *Oscar Bluemner: A Retrospective Exhibition*, sale cat. (New York: Barbara Mathes Gallery, 1985); Jeffrey R. Hayes, *Landscapes of Sorrows and Joy*, exh. cat. (Washington, D.C.: Corcoran Gallery of Art, 1988); Linda Hyman Fine Arts, *Oscar Bluemner: Works on Paper*, sale cat. (New York: Linda Hyman Fine Arts, 1988); Jeffrey R. Hayes, *Oscar Bluemner* (Cambridge: Cambridge University Press, 1991); Forum Gallery and Jerald Melberg Gallery, *Oscar Bluemner: A Modernist Mind and Mystical Spirit, 1867–1938*, sale cat. (New York: Forum Gallery; Charlotte, N.C.: Jerald Melberg Gallery, 2002); Patricia McDonnell, *Painting Berlin Stories* (New York: Peter Lang, 2003); Debra Force Fine Art, *Oscar Bluemner: Visions of the Modern Landscape*, sale cat. (New York: Debra Force Fine Art, 2004); Roberta Smith Favis, *Oscar Bluemner: A Daughter's Legacy; Selections from the Vera Bluemner Kouba Collection*, exh. cat. (Deland, Fla.: Duncan Gallery of Art, Stetson University, 2004); Barbara Haskell, *Oscar Bluemner: A Passion for Color*, exh. cat. (New York: Whitney Museum of American Art, 2005).

130a. *View in Van Cortlandt Park, Bronx, New York*; verso: thumbnail sketch of the same subject, 1916

Graphite, black ink, and scratching-out on buff paper; 4 7/8 × 5 15/16 in. (124 × 151 mm)
Signed at lower left in black ink: *OFB* [monogram]; inscribed below: *very / clear / & sharp*; at lower right: *Oct 7–16 / 4 PN / van Cortland PK*; numerous color annotations; verso inscribed at upper left in graphite: *Put with / Oaks Pond*; at upper right in black ink: *Idea / depth of / narro space / cool colors / warm & cold / Tone contrasts*; below: *lines in water, in trees, fole* [foliage] *& bag d* [background]; below: *Th shadow planes parallel to pctre plane / from fore to dist receding become / purer & lter in blue; the shado planes / at angle to—pctre plane are dK / local color = color + gy, those horizontal / are lightest & yellowish; of water sky— / blue + white. A brilliant red-levd maple in dist*
Provenance: Robert Bluemner, 1968; Mr. and Mrs. Stuart P. Feld, New York.
Gift of Mr. and Mrs. Stuart P. Feld, 1982.102

130b. *View in Van Cortlandt Park, Bronx, New York*, c. 1916

Black crayon on buff paper; 4 3/4 × 5 15/16 in. (121 × 151 mm)
Signed at lower left in black ink: *OFB* [monogram]; inscribed below: *Van Cortland Park S. 15–16 N.SW.*; above in brown crayon: *X*; color annotations; verso inscribed along upper border in graphite, red and orange crayon, and black ink: *Van Cortland Park for "Oaks Pond" Bluffs / # 3 / clear / clouds put blue shadows over / distant woods-hill / green foliage more yellowish in fore / ' ' ' bluish ' dist / ' ' ' ' in haze / ' ' ' ' ' shado / dK shadows total + pure local color (Böklin) V5 / lt hazes ' + ' small ' ' (Turner)*
Provenance: Robert Bluemner, 1968; Mr. and Mrs. Stuart P. Feld, New York.
Gift of Mr. and Mrs. Stuart P. Feld, 1982.103

Beginning about 1915 ponds or bodies of water surrounded by trees became one of the Bluemner's favorite subjects.[1] Frequently using monochromatic media (he preferred black crayon), the artist relied heavily on annotations to translate his sketches into living color. His color notes, like those covering these two small sheets, functioned as mnemonic aids for his subsequent paintings. Although it is impossible to envision the brilliantly prismatic colors specified by the artist's words, Bluemner's obsessive annotations demonstrate that color, along with the structure established by the architectonic framework of shapes, was tantamount in his art. In his concentration on color he is the heir of Vincent van Gogh, and in his emphasis on structure, of Paul Cézanne. Bluemner's awareness of his artistic predecessors is made manifest in his references to the nineteenth-century Romantic artists Arnold Böcklin and J. M. W. Turner on the second sheet discussed here.

Before his death in 1938, Bluemner wrote a revelatory essay for the catalogue of his 1939 exhibition at the University Gallery of the University of Minnesota in Minneapolis, in which he described the philosophy of his work:

Landscape painting speaks to the soul like a poem or music, more intimately than any other kind of painting. I present a surprising vision of landscape by the daring new use of colors: large vermillion shapes heard by the serene blue of our American sky, provokingly assertive of a glad defiance—an

130a

130b

ecstatic state of mind. I "introduced red" as Stieglitz said in 1915.[2]

To signal his passionate attachment to red, which he viewed as a powerful alter ego, in 1929 he coined his pseudonym, "The Vermillionaire."

The artist referred to his scenes as "Compositions for Color Themes" and often titled his works with musical themes, such as *Red Sharp, Red Flat*, and *In Low Key*. For Bluemner color created form and brought the landscape to life, and the combination of certain colors evoked emotions and moods.[3] Bluemner exhorted: "Look at my work in a way as you listen to music—look at the space filled with colors and try to feel; do not insist on 'understanding' what seems strange. When you 'FEEL' colors, you will understand the 'WHY' of their forms. It is so simple."[4]

For subject matter Bluemner turned to his local environment. He felt that the most intense color, mood, individuality, and advanced ideas could be expressed only through the familiar, which he found in the landscapes, canals, harbors, villages, and factories of New York, New Jersey, and Massachusetts. To him, such subjects represented the harmony between nature and humanity and, therefore, the "universal modern vision."[5] Bluemner's architectural training was instrumental to his structured compositions and evident in the industrial subjects he portrayed (see his view of the Harlem River from 1910, essay fig. 19).[6]

The inscriptions on the two sheets discussed here establish their location as Van Cortlandt Park. New York City's third largest park, it occupies 1,146 acres atop the ridges and valleys of the northwestern Bronx. Its richly forested heartland is fed by Tibbets Brook, and it contains the borough's largest freshwater lake, Van Cortlandt Lake. Its oldest house, a fine example of eighteenth-century Georgian architecture, was built in 1748 by Frederick Van Cortlandt and is now the national landmark Van Cortlandt House Museum.

It is not known whether Bluemner ever used these studies for any painting. Much later, in 1936, he painted a similar scene of Van Cortlandt Park in a canvas in the Museum of Fine Arts, Boston.[7] The inscriptions on the versos of these two studies indicate that they were part of his preparation for a picture of Oaks Pond (*Put with / Oaks Pond; for "Oaks Pond" Bluffs*). In Bloomfield Bluemner drew several views of Oaks Pond,[8]

which is near the lock of the ninety-mile-long Morris Canal, designed by James Renwick and completed in 1830.[9] He sketched landscapes near Oaks Pond, which may be the "'Oaks Pond' Bluffs" alluded to the inscriptions, and the Bloomfield Lock in Bloomfield, New Jersey, from at least 1917 until 1922.[10]

From September 1916 until May 1926, Bluemner made his home in the mill towns and small suburban villages of northeastern New Jersey. He lived in Bloomfield from 1916, the year these two sheets were executed, through January 1918. At a distance from "Fifth Avenue humbug" and close to the more "intimate" forms of nature that suited his ideals, he hoped to realize himself as a painter. During this period his theory of painting solidified. A group of small paintings and drawings demonstrates his delight in the area, which he painted more freely outdoors than the restricted geometry of his earlier works.[11] Among them are these two exuberant studies in which Bluemner communicated his rapture with nature.

1. See Debra Force Fine Art 2004, fig. 8, for a drawing of Davies Pond in Bloomfield, New Jersey. For a similar black crayon landscape—*River in Bloomfield, N.J.*—drawn on 9 October 1915, formerly with the Bernard Danenberg Galleries, New York, see the photograph in the Frick Art Reference Library.
2. Reprinted in University Gallery 1967, n.p.
3. The artist wrote:
 Red ... chief color and maximum of everything artistic; the strongest attraction, signal, warning, symbol of power, vitality, energy, life. Fire, blood sunball, passion, struggle ... excitement to rage. Advancing.
 Green ... opposite of red. Repose ... Middleground
 White Light. Energy. Snow. Cold ... Purity.
 Black Darkness. Foreground. Sorrow ... Society.
 Gray Opposite of color. Neutral ... Receding.
 Yellow ... Light. Warmth. Cheerful. Heightened to orange and red. Advancing. Intelligence. Opposed to:
 Blue Coolness. Distance. Space ... Passive. Contrast to red. Cheerfulness to Depression.
 Violet ... Distinction. Ceremonious, Rarity, Unrest. Distance. Light poor ... closest to gray.
 Quoted in Hayes 1991, 91–92, from Bluemner Papers, AAA, microfilm reel 339, frame 544.
4. Quoted in Graham Gallery 1967, n.p.
5. Hayes 1991, 23. For the elements of Emersonian Transcendentalism in the Stieglitz circle, see McDonell 2003, 46–53.
6. Linda Hyman Fine Arts 1988, 7, no. 3. He continued to render studies along the Harlem River, as in a drawing from 1919 (Hayes 1982, 17, no. 20).

7. Inv no. 60.1426, gift of the Massachusetts WPA Program.
8. See http://shannons.com/Auct_i/det/192-Bluemner.jpg, Shannon's Fine Art Auctioneers, Milford, Connecticut, sale, April 2001.
9. It was the first canal to climb hills via the use of the inclined plane, a feat Robert Fulton worked on in England at the end of the eighteenth century; see cat. 20.
10. See the crayon drawing (mistakenly identified as charcoal) in a private collection, in Hayes 1982, 80, fig. 48.
11. Ibid., 80.

CHARLES DANA GIBSON

Roxbury, Massachusetts 1867–New York, New York 1944

Charles Dana Gibson—famous as an illustrator and creator of that Belle Époque symbol of feminine pulchritude, "the Gibson Girl"—was born into a wealthy New England family from Roxbury, Massachusetts, then a suburb of Boston. His interest in art began in his youth when he watched his father cut silhouettes. At the age of eight, when his family moved to Flushing, New York, he followed suit, and by twelve the precocious and enterprising Gibson was selling his silhouettes. Realizing his talent, his parents apprenticed the fourteen-year-old to the sculptor Augustus Saint-Gaudens. After nearly a year in Saint-Gaudens's studio, the youth decided that sculpture was not his medium and voiced a preference for drawing in pen and ink. Subsequently, in 1883, Gibson enrolled in the Art Students League in New York City. Leaving school in 1885 because of his family's financial setbacks, he began his professional career. His first job was with the newly established magazine *Life*, a competitor of *Puck*. Gibson was hired to draw editorial cartoons featuring political figures. From the very start, however, he was interested in portraying the social set rather than politicians, and the magazine's readers clearly enjoyed the manner in which he poked fun at high society and the idiosyncrasies and foibles of its characters. Soon he was contributing to *Tid-Bits* (between 1886–88 known as *Time*), *Scribner's Magazine*, *Century*, and *Harper's* as well. In 1888 he made his first trip to Europe, studying for two months at the Académie Julian in Paris.

The artist first drew his "Gibson Girl" in 1891 and featured her in his initial independent portfolio of drawings of beautiful women, all of whom had the same face, probably modeled on that of his wife, Irene Langhorne Gibson. The Gibson Girl remained the female icon for the next two decades. She was the ideal modern American woman: youthful, statuesque with a wasp waist, athletic, smart, stylish, and desirable. She was also a fashion trendsetter: the clothes and accessories Gibson dressed her in spawned new fashion lines. His engaging creation permeated material culture, appearing on such diverse items as wallpaper, handkerchiefs, silver spoons, pillows, matchboxes, countless posters, and even Royal Doulton china. Gibson's facile, linear style added to the character's charm. She was born at precisely the moment when the nation was establishing nationalistic styles in art and architecture, searching for an American identity on the world stage; the Gibson Girl satisfied the need to forge an image of the modern American woman.

In 1904 Gibson's popularity and that of the Gibson Girl had grown so large that Robert Collier and his partner Condé Nast tried to sign Gibson to their magazine team at *Collier's Weekly*, as they had formerly done with Howard Pyle (cat. 121), Frederic Remington, and Maxfield Parrish. Gibson remained loyal to *Life*, but eventually the periodicals agreed to share his talents. He was awarded a lucrative contract whose monetary return was staggering at the time. Soon thereafter Gibson yearned to give up pure illustration and devote his time to painting in oils, but he realized that the height of his career was not the time for idealistic ventures. His works were so popular that photomechanical reproductive collections of his pen and ink drawings were issued periodically from 1894 in series published by Charles Scribner's Sons and R. H. Russell, such as *The Education of Mr. Pipp* (a study for one of its illustrations is in the Society's collection). Gibson's greatest popularity occurred between 1900 and 1910, although he was productive into the 1920s.

After he founded, with eight other artists, the Society of Illustrators in 1901 and later became its president, Gibson convened a subgroup of illustrators who pledged their efforts to help win World War I. Among them were James Montgomery Flagg and Howard Chandler Christy. Gibson had the foresight to register them as The Division of Pictorial Publicity in the U.S. Office of Public Information with himself as head. After the war ended, Gibson continued his personal quest of saving Western civilization by illustrating propaganda posters at a time when the public wanted to forget the war and cared more about flappers than the Gibson Girl.

In 1920 Gibson headed a syndicate of illustrators, writers, and staff members who bought *Life* magazine at auction (Gibson held the largest number of shares). Eventually faced with stiff competition by the *New Yorker* and other magazines, Gibson sold the magazine in 1932 and retired, finally taking up painting. He exhibited his paintings at the American Academy of Arts and Letters in 1934 to good reviews, but was soon forgotten. The Society holds a ceramic plate with a Gibson image, together with three drawings and one painting by Gibson, who commented on the social life and mores of his time, with a gently satiric tone.

Bibliography: W. Patten, *Charles Dana Gibson: A Study of the Man and Some Recent Examples of His Best Work* (New York: P. F. Collier & Son, 1905); Charles Dana Gibson, *The Gibson Book: A Collection of the Published Works of Charles Gibson*, 2 vols. (New York: Charles Scribner's Sons, 1906); idem, *Gibson New Cartoons: A Book of Charles Dana Gibson's Latest Drawings* (New York: Charles Scribner's Sons, 1916); American Academy of Arts and Letters, *A Catalogue of an Exhibition of Paintings and Drawings by Charles Dana Gibson: At the American Academy of Arts and Letters … New York City*, exh. cat. (New York: American Academy of Arts and Letters, 1934); Fairfax Downey, *Portrait of an Era as Drawn by C. D. Gibson* (New York: C. Scribner's Sons, 1936); Samuel Jackson Woolf, "The Gibson Girl Is Still with Us," *New York Times Magazine*, 20 September 1942, 15, 26; Charles Dana Gibson, *The Gibson Girl and Her America: The Best Drawings*, ed. Edmund V. Gillon Jr. (New York: Dover Publications, 1969); Fink 1990, 346; Sarah Burns, *Inventing the Modern Artist: Art and Culture in Gilded Age America* (New Haven: Yale University Press, 1996), 12–13, 101–6, 181–82, 293–95, 320–21; Reed 2001, 74–75.

131. *"Mrs. Vernon Had Crossed the Rubicon": Study for an Illustration in "Sweet Bells Out of Tune,"* 1892

Black ink and graphite with scratching-out on illustration board; 20 1/4 × 25 5/8 in. (514 × 651 mm)
Signed at lower right in black ink: *C. D. Gibson*; inscribed with various technical publication instructions
Provenance: Purchased by the donor from the artist during a studio visit, given to his sister; Miss Hortense A. Carney.
Bibliography: Mrs. Burton Harrison, *Sweet Bells Out of Tune* (New York: Century Co., 1893), 23, ill. (reissued from *Century Magazine* 45:1 [1892], 25, ill.); Koke 1982, 2:62–63, no. 1091, ill.
Gift of Dr. Sydney H. Carney Jr., in memory of his sister, Miss Hortense A. Carney, 1939.607

Charles Dana Gibson's combination of bravura draftsmanship and fashionable subjects focusing on high society and young women coming of age made him an ideal candidate for illustrating the novel *Sweet Bells Out of Tune* by Mrs. Burton Harrison (Constance Cary). The story originally appeared in six installments in the *Century Illustrated Monthly Magazine*, with eleven illustrations by Gibson, beginning in 1892; this drawing was reproduced in the first part of the series.[1] The following year the story was published as a book, again with Gibson's illustrations. It was not the first time that the artist had illustrated

131

one of Harrison's stories; his drawings had accompanied the author's initial story, "The Anglomaniacs," published anonymously in the *Century.*[2] Reputedly, Harrison was delighted with the editor's choice of the fashionable Gibson as illustrator, so it is no surprise that he would be invited to illustrate her second story.[3]

Harrison's novel narrates the story of New York newlyweds and their two families. The marriage joins the Hallidays, an old society family that had fallen onto hard times, and the Vernons, a nouveau-riche family. One of only a few full-page drawings in the magazine version, this picture represents the scene in which the

socially ambitious Mrs. Vernon, the groom's mother, has invited the Halliday girls to the opera, her box being right next to that of Mrs. Van Shuter, a New York society maven. As the opera was a place to see and be seen, Mrs. Vernon felt that she could enter the inner circle of society with the help of the Hallidays if only Mrs. Van Shuter would chat with her as she did with members of the in crowd. Gibson's drawing represents the scene when Betty, one of the Halliday girls, introduces the social-climbing Mrs. Vernon to Mrs. Van Shuter, allowing her into high society. The eager arriviste, Mrs. Vernon, is the woman on the left

wearing an ironic tiara, a "second-hand crown of real royalty, bought at a Paris sale."[4] Harrison describes the scene as follows:

> A few off-hand words from Betty, and the deed was done. Mrs. Van Shuter lifted her heavy eyelids, ducked her double chin; Mrs. Vernon's color rose, and her tiara tipped forward. Mrs. Vernon had crossed the Rubicon.[5] Dick Henderson and Freddy de Witt rehearsed it afterward at the club, and a number of lorgnons[6] took in the fact.[7]

When Gibson executed this illustration, his fortune had risen so expeditiously he was living the New York society life that both he and

Harrison fictively and satirically documented. Images of similar social content permeate Gibson's oeuvre that simultaneously portrays the lifestyle of the rich and pokes fun at their superficial concerns.

Gibson's linear *sprezzatura* draftsmanship, characterized by bold lines and contrasts, allowed him to "paint" his images with no more than white paper and black ink. Character, tone, and humor are embodied in his facile, simplified style, which was frequently emulated by the popular artists of his day and is still studied by illustrators. His masterful pen-and-ink works were reproduced in the new photomechanical printing technique that replaced line drawings formerly cut into wood or engraved on steel. Eliminating the cutter, the middleman, gave the artist greater control and freedom, qualities Gibson capitalized on in his illustrations.

1. *Century Magazine* 45:1 (1892): 25, ill.
2. *Century Magazine* 40:2–5 (1890): 269–82, 435–46, 575–86, 677–86.
3. Downey 1936, 110.
4. Harrison 1893, 20.
5. A Rubicon is a limit or watershed that when passed or exceeded results in an irrevocable commitment. It refers to Julius Caesar's crossing of this river in northern Italy from Cisalpine Gaul in 49 B.C., an act that initiated war.
6. *Lorgnon* is French for a special type of eyeglasses or opera glasses, and here refers to individuals who use their opera glasses to watch the audience.
7. Harrison 1893, 34.

JEROME MYERS

Petersburg, Virginia 1867–New York, New York 1940

Born to immigrant Jewish parents, Jerome Myers had an unstable and poverty-stricken childhood. His frequently absent father and sick mother influenced his perception of the world and his art. With his family, he lived in Philadelphia (where he was temporarily placed in an orphanage), Baltimore, and New Orleans before moving to New York City in 1886 at the age of nineteen. The following year he began evening classes at Cooper Union and within a year enrolled in night classes at the Art Students League, where George de Forest Brush and Kenyon Cox were his teachers. To support himself during eight years of study, he worked in the daytime variously as a photoengraver for the Moss Engraving Company, a theatrical scene designer, and a decorative painter. In 1895 he began working in the art department of the *New York Tribune*. Although his eight years of traditional training at the league provided a solid academic foundation, Myers found himself "more interested in character than pose." Drawn to the realities of life as he saw them on the Lower East Side and other immigrant neighborhoods around the city, he followed his personal inclinations and responded to local subject matter.

To capture human experience Myers started depicting the picturesque environs and people of the tenements. Not a social reformer who wished to expose the deplorable conditions in which many of the immigrant population lived, he instead celebrated their dignity and the family values embedded in this ethnic culture. The subjects of his urban realist art were common people working, resting, or enjoying themselves. Myers portrayed the spectrum of the life cycle—from the charm of childhood to the venerability of old age—in his idealization of difficult lives. He moved tirelessly through the city compiling preparatory sketches on pads of paper and also working in the art department of the *New York Tribune*.

Although fiercely dedicated to his New York subject matter, Myers traveled to Paris twice, once in 1896 and again in 1914, at the urging of the progressive English critic Roger Fry who had purchased some of his drawings. In his autobiography, *Artist in Manhattan* (1940), Myers wrote:

> So many artists had returned from Paris, who despite their advantages, had since gone under, while I more wisely than I knew, had gathered together my motives in the streets of New York, where the vast drama of life was each day freshly enacted. This country, this city, became my element: here I made a definitive commitment for my art life. What I had to say was my own. The language of my art I spoke was my own: simple and direct, from life to mood, from mood to life.

In January 1908 Myers mounted his first one-man exhibition at the Macbeth Gallery on Fifth Avenue. Although Robert Henri (cat. 127) did not invite Myers to join the pivotal group the Eight, who sought an alternative to academic art and showed at the same gallery the following year, Myers pursued a similar vision and means of expression, albeit with a more sentimental dimension. He exhibited in a number of important group exhibitions, including those at the Municipal Art Society, the Lotos Club, the Colonial Club, and at the 1904 St. Louis World's Fair, where his painting *Night Concert* was awarded the bronze medal, as well as regularly at the NAD, where he made his debut in 1902, the Pennsylvania Academy of the Fine Arts in Philadelphia from 1903, the Art Institute of Chicago from 1904, and the Carnegie Institute in Pittsburgh from 1905. Friendly with John Sloan and his circle, he was represented in the 1910 progressive, unjuried *Exhibition of the Independent Artists*, which also included Henri and other nontraditional artists. In many ways, Myers took the lead in creating new opportunities for independent artists. In 1911, along with Walt Kuhn and Elmer MacRae, he organized an exhibition of the work of the Pastellists, with the hope that the medium would gain greater popularity with the general public. Myers was also instrumental in the formation of the American Society of Painters, Sculptors and Engravers, the group that grew out of the Pastellists and was responsible for the cataclysmic Armory Show, held at the Sixty-ninth Regiment Armory in 1913 (17 February-15 March). In fact, it was in Myers's studio that the plan for the famous exhibition had its inception. Myers originally intended for the Armory Show to

include only American artists who were ignored by the NAD, although when Arthur B. Davies, who succeeded J. Alden Weir, reorganized the show, it encompassed European artists as well. Myers had hoped the exhibition would result in a widespread recognition of native realist artists, but instead many European figures, such as Marcel Duchamp and Pablo Picasso, revolutionized the New York art world in this first large-scale international exhibition of European modern art in the country. Myers, along with Henri, Sloan, George Luks, George Bellows, and Guy Pène du Bois, resigned from the project over this change in course, claiming the exhibition was "the great American betrayal."

Unlike the Ashcan School artists—John Sloan, Henri (leader of the group), William James Glackens (cat. 133), Luks, and Everett Shinn—Myers is not a well-known figure. Like them, however, he turned away from studio themes to observations of the urban environment and its rhythms and anecdotes. For fifty years he worked as a city realist, rendering unpretentious quotidian scenes of residents set in the crowded streets of the Lower East Side, frequently including children in his paintings, etchings, and drawings. Of Dutch extraction, Myers deeply admired Rembrandt van Rijn as a man and an artist, relating to his sympathetic and powerful portrayals of humanity. In his biography, Myers wrote: "It may be that Rembrandt's Dutch cottage has sustained me, even as his art has inspired. On faith and as an atavistic liberty, I have adopted him as an exemplar."

Jerome Myers's wife, Ethel Klinck Myers (1881–1960)—an artist in her own right, the assistant director of the Chase School of Art, and a designer of clothing to supplement their income—posthumously signed his unsigned works. She is noted particularly for her bronze statuettes, nine of which were exhibited at the 1913 Armory Show. She opened a semipermanent exhibition in 1940 of her husband's work at the Jerome Myers Gallery in Carnegie Hall, where Myers had his studio.

Myers was elected an associate of the NAD in 1921 and an academician in 1929, also earning the institution's Thomas B. Clarke Prize (1919), Second Altman Figure Prize (1931 and 1937), and Isidor Medal (1938). Moreover, the Carnegie Museum of Art in Pittsburgh awarded him its Carnegie Prize. His works are in the Phillips Col-lection and the National Gallery of Art, Washington, D.C.; the Metropolitan Museum of Art and the Whitney Museum of American Art, New York; the Los Angeles County Museum of Art; the Art Institute of Chicago; the Newark Museum; and the Milwaukee Art Institute, among many other museums.

Bibliography: Jerome Myers, *Artist in Manhattan* (New York: American Artists Group, 1940); Whitney Museum of American Art, *Jerome Myers Memorial Exhibition*, exh. cat. (New York: Whitney Museum of American Art, 1941); Grant Holcomb, "The Forgotten Legacy of Jerome Myers, (1867–1940): Painter of New York's Lower East Side," *American Art Journal* 9:1 (May 1977): 78–91; Falk 1999, 2:2379; Dearinger 2004, 410.

132. *The Orange Box*, c. 1910–23

Watercolor, black crayon, gouache, and black ink over graphite on paper; 10 1/4 × 8 1/2 in. (260 × 216 mm), irregular
Inscribed at lower left in graphite: JEROME / MYERS. / Em / *124* [encircled]
Provenance: Linda Hyman Fine Arts, New York; Mr. and Mrs. Jeffrey S. Grant, Scarsdale, N.Y.
Gift of Mr. and Mrs. Jeffrey S. Grant, 2001.236

A letter signed by Ethel Myers, the artist's wife, on her personal stationery and dated 8 October 1952 explains that she added the signature on her husband's unsigned works. Her handwriting matches that on the Society's drawing,[1] where she printed *JEROME MYERS* in a near approximation of his signature and added *Em*, signifying "Ethel Myers," followed by the number *124* in a circle to identify it as the 124th one she "signed."

Myers's realistic sidewalk scene, set before a Lower East Side greengrocer, captures the kaleidoscopic vibrancy of life in this immigrant neighborhood. The theme of the fruit stand was a favorite of Myers, as were markets, with their rich flow of life.[2] He had discovered that the energetic, often frenetic pace of urban existence could be seen in the microcosm of the marketplace, where immigrants purchased or peddled their wares in the crowded city streets. In this watercolor he also focused on the leisurely communal aspects of urban street life that he celebrated throughout his career.[3]

It is difficult to assign a specific date to this watercolor because Myers's style did not change significantly. It may date as early as 1910, as seen in a comparison with a very similar watercolor and chalk drawing depicting calico sellers on the Lower East Side (formerly with Kennedy Galleries, New York) that Holcomb dated about 1910, or as late as the early 1920s.[4] Descriptions of Myers's early spontaneous method of capturing the life around him reinforces this early dating. The artist carried a nine-by-eleven-inch sketch pad (the approximate measurements of this sheet) as he walked the streets of New York. He would stand and sketch people without attracting attention, sometimes hiding in doorways. Pène du Bois wrote that Myers had "always been a sort of day and night prowler, a phantom in the city streets, passing in and out of crowds."[5]

The basis of Myers's art was unquestionably drawing. As he himself confessed: "I have loved drawing for its own sake, without one addition of color or of a formal arrangement but as a communion between my subject and myself, with all its accidents of time and place, the interruptions that occurred like broken melodies, incompleted songs of the life I cared for."[6]

1. Jerome Myers Papers, owned by Virginia Downes, microfilmed by the AAA, reel N68–7. Thanks to Elizabeth Gaudino for her sleuthing in this matter.
2. For some of the markets he represented, mostly on the Lower East Side of New York, but also in Paris, see Myers 1940, 147, 157, 175, 185, 195, 205, 221, 223, ills.
3. Holcomb 1977, 90.
4. Ibid., 84, fig. 6. For later works, see *Street Converse*, signed and dated 1923, listed as in the collection of Mr. Katz, Baltimore, Jerome Myers Papers, reel N68–7. See also *East Side Corner* (1923; The Newark Museum, Newark, N.J.), reproduced in Myers 1940, 166–67, ill., who notes: "A cross-section of the East Side in its communal barter, in an interlude following the early morning's intense activity. There is time to gossip between sales, to exchange daily histories, to keep warm the human contact. Hardships and privations, while sharpening their wits, have yet not dulled the humor of these people, in a fervid life … in which the concern of one is the concern of all—the logical result of common persecutions now past, forgotten in the symphonic freedom of New York's East Side."
5. Guy Pène du Bois, "Artist in the Wilderness of New York," *New York Herald Tribune*, 31 March 1940, sec. IX, 7.
6. Quoted in Holcomb 1977, 81 n. 20.

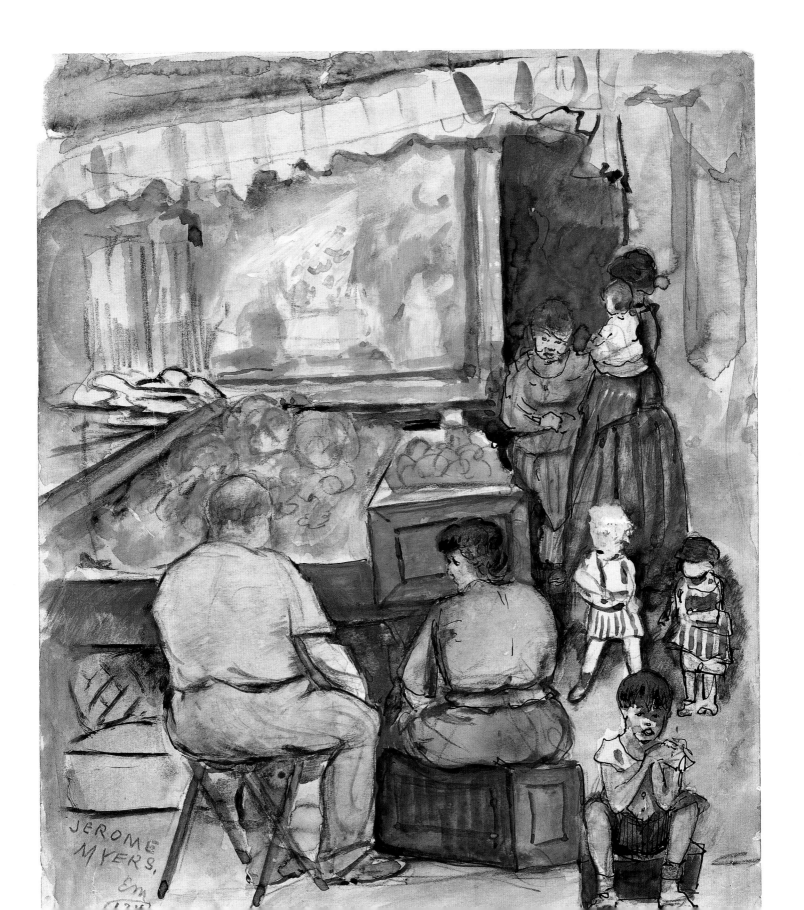

WILLIAM JAMES GLACKENS

Philadelphia, Pennsylvania 1870–Westport, Connecticut 1938

Best known as one of the young urban realists who exhibited in 1908 as the Eight, William James Glackens graduated from the prestigious Central High School in Philadelphia with his classmates Albert C. Barnes, the renowned future collector of modern art, and John Sloan, a fellow artist-reporter. He commenced his career as a newspaper illustrator in Philadelphia. Working first for the *Philadelphia Record* in 1891, the following year he joined Sloan on the art staff of the *Philadelphia Press*, where he met George Luks and Everett Shinn, moving on to the *Philadelphia Public Ledger* and perfecting his ability as a quick-sketch artist. Through Sloan in 1892 he befriended Robert Henri (cat. 127), the future leader of the Eight, who persuaded him in 1894 to take up oil painting. The same year he studied sporadically at the Pennsylvania Academy of the Fine Arts under Thomas Anshutz and Henry Thouron. Glackens, together with his group of realist friends, participated in the short-lived Charcoal Club, whose members worked from the nude in a progressive manner.

In 1894 Glackens and Henri shared a Chestnut Street studio and the next year traveled in Europe, where in 1896 Glackens debuted his work at the Salon of the Société des Beaux-Arts in Paris. Shortly after returning to the United States that same year, Glackens followed Henri's lead in moving to New York City, where they shared a studio. Glackens supported himself as an illustrative journalist, drawing cartoons for a number of periodicals, among them the *New York World*, the *New York Herald*, *Scribner's*, *Colliers*, and the *Saturday Evening Post*, as well as by illustrating books. In 1898 he and Luks went to Cuba to report on the Spanish-American War for *McClure's Magazine*. After 1899 Glackens concentrated increasingly on painting and made his debut in the annual exhibition of the Society of American Artists in 1900. He also began a particularly successful association with the *Saturday Evening Post*, for which he produced illustrations primarily for popular fiction through 1912. For the subject matter of his paintings he turned to scenes set in city parks and cafés. About 1905 he decided to devote himself to painting, adopting the broad brushstrokes of masters he had studied from Diego Velázquez to James McNeill Whistler and

such paintings as *Hammerstein's Roof Garden* (1902; Whitney Museum of American Art, New York). His marriage to Edith Dimock, an artist and daughter of a wealthy Hartford, Connecticut, silk manufacturer, brought financial security and a home on Washington Square North. His studio on the south side of the square provided the location of many of his works. Glackens was elected a member of the Society of American Artists in 1905; when that organization and the NAD merged in 1906, he automatically became an associate of the NAD (academician in 1933). By 1905 Glackens had adopted a more high-toned Impressionistic style, seen notably in *Chez Mouquin* (1905; The Art Institute of Chicago). This work, directly inspired by Manet, depicts James B. Moore (owner of the Cafe Francis where the Ashcan painters frequently met) at Mouquin's (a French restaurant under the Sixth Avenue Elevated train). Glackens's interest in French antecedents led him temporarily to adopt Pierre-Auguste Renoir's palette until 1910, when he discarded urban themes in favor of studio models, still lifes, landscapes, and seaside subjects. The rejection of several submissions by Glackens and Luks from the 1907 NAD annual exhibition spurred Henri to form the group that subsequently became the Eight. The group's landmark exhibition, which signaled a turning point in Glackens's career, was held at the Macbeth Gallery in New York in 1908 and traveled to nine additional venues.

In 1910 Glackens's old schoolmate Dr. Albert Barnes contacted him, and the artist urged him to collect Impressionist and Post-Impressionist paintings instead of works by the Barbizon painters. In 1912 Barnes sent Glackens as his agent to France with funds to buy art. Glackens returned with works by Paul Cézanne, Renoir, Edgar Degas, Vincent van Gogh, Claude Monet, Paul Gauguin, Alfred Sisley, Camille Pissarro, Georges Seurat, and other painters in the vanguard of French art, which formed the nucleus of the distinguished Barnes Foundation Collection in Merion, Pennsylvania.

A lifelong opponent of the academic system, Glackens advocated exhibitions with no juries and no prizes. He continued his involvement with alternative exhibitions and in 1910 helped

Street, where some 627 works of art hung jury-free, proving that a stimulating show could be organized as a kind of Salon des Refusés. In 1912–13 he chaired the committee that selected American entries for the fabled Armory Show (*International Exhibition of Modern Art*), in which he also exhibited, and his interest in French modernist work allied him with a more progressive circle of painters that included Arthur B. Davies. Nonetheless, he continued to exhibit at the NAD's annual and winter exhibitions through 1915. Glackens also served as the first president of the Society of Independent Artists (1917). After this date there was no notable development in his art, although he continued to paint (he concentrated on interiors during the winter months), dividing his time between his New York studio and France. He had a number of solo exhibitions, including a small exhibition at the Whitney Studio gallery in 1922, and in 1925 began a long-standing association with Kraushaar Art Galleries. In 1924 he was awarded the Temple Medal of the Pennsylvania Academy of the Fine Arts and in 1937 the grand prize for *Central Park, Winter* (1905; The Metropolitan Museum of Art, New York) at the Exposition Universelle in Paris. After his sudden death the following year, the Whitney Museum of American Art in New York organized a memorial exhibition of Glackens's works selected by his colleagues. From 1939 to 1947 Edith Glackens mounted small annual exhibitions in their Ninth Street home.

Bibliography: Ira Glackens, *William Glackens and the Ashcan Group: The Emergence of Realism in American Art* (New York: Crown Publishers, 1957); Alan Maxwell Fern, "Drawings by William Glackens," *Library of Congress Annual Reports on Acquisitions* 20:1 (1962): 12–18; Leslie Katz, *William Glackens in Retrospect*, exh. cat. (Washington, D.C.: Library of Congress, 1966); Janet A. Flint, *Drawings by William Glackens, 1870–1938*, exh. cat. (Washington, D.C.: Published for the National Collection of Fine Arts by the Smithsonian Institution Press, 1972); Ira Glackens, *William Glackens and the Eight: The Artists Who Freed American Art* (New York: Horizon Press, 1984); Nancy Allyn, *William Glackens: Illustrator in New York, 1897–1919*, exh. cat. (Wilmington: Delaware Art Museum, 1985); Nancy Allyn and Elizabeth H. Hawkes, *William Glackens: A Catalogue of His Book Illustrations*, exh. cat. (Wilmington: Delaware Art Museum, 1987); William H. Gerdts, *William Glackens*, exh. cat. (Fort Lauderdale, Fla.: Museum of Art; New York: Abbeville Press, 1996); Dearinger 2004, 227–28.

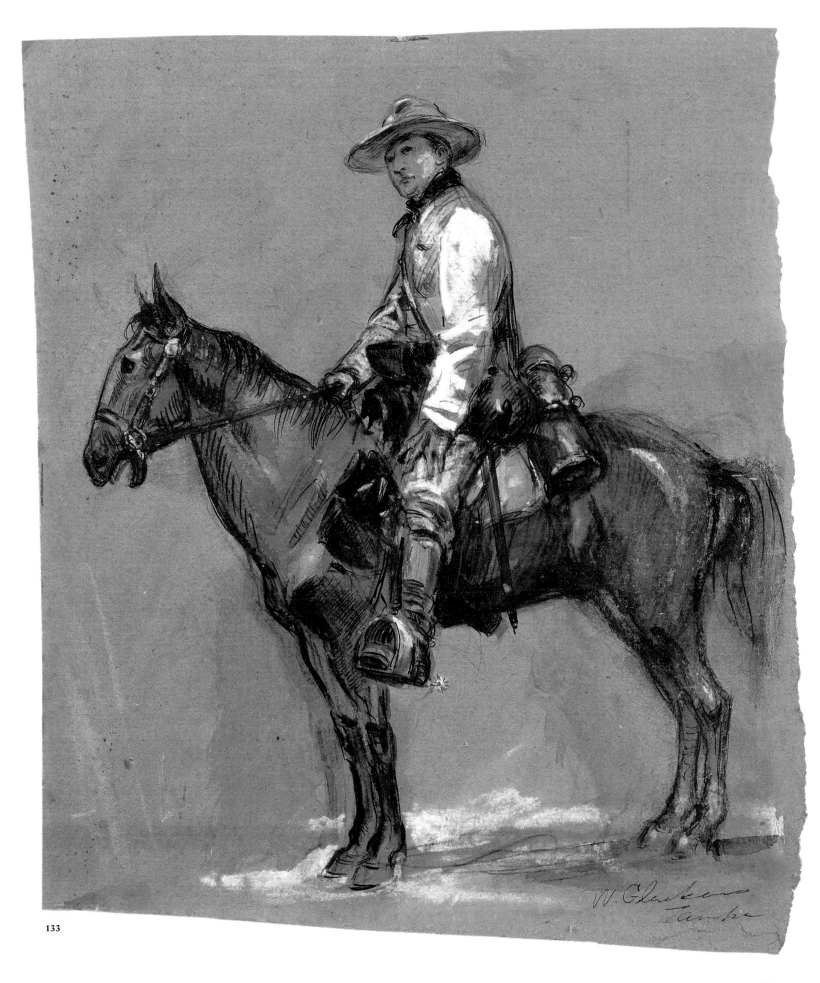

133

133. *Volunteer Cavalryman on Horseback*, 1898

Black ink, gray wash, white gouache, charcoal, and graphite on brown paper, laid on board; 11 1/2 × 9 5/8 in. (292 × 245 mm), irregular
Signed and inscribed at lower right in black ink: *W. Glackens / Tampa*; mount inscribed at lower left in black ink [partially scraped off]: [illegible] *Gomez's*; at upper right: *#7466*
Provenance: Samuel Hopkins Adams, Auburn, N.Y.
Bibliography: Koke 1982, 2:68, no. 1100, ill.; Olson 2004, 32–33, fig. 14.
Gift of Samuel Hopkins Adams, 1946.372

The winter of 1897–98 was a fateful one for Glackens. Political tensions between the United States and Spain over Cuba steadily mounted, and on 15 February the USS *Maine* exploded in Havana Harbor. By 24 April Spain had been forced into declaring war on the United States. Glackens soon found himself in Tampa, Florida, during the beginning days of the brief Spanish-American War, sent as special correspondent for *McClure's Magazine*. Detailed instructions from the manager of the magazine's art department defined his job: "go to Cuba with the American troops" and send "illustrations telling the story of the departure, voyage and arrival and subsequent work and fights of the U.S. troops."[1] Scheduled to meet the news correspondent Stephen Bonsal in Tampa, he was told to send everything he drew, no matter how rushed its execution. Whatever he sent would either be used in the magazine or sent to the managing editors of the newspaper the *World*.

As noted in the inscription, Glackens drew this bold sheet, which was never published, at invasion headquarters in Tampa.[2] Bonsal and Glackens traveled to Cuba to capture the action for *McClure's* in this last moment before photojournalism totally eclipsed journalistic illustration. Glackens's resulting illustrations appeared in the October and December 1898 issues of *McClure's*, as well as in *Munsey's Magazine* (March–May 1899).[3] Although photographers had made the documentary sketch artist virtually obsolete, Glackens excelled at this genre. His illustrations of the Spanish-American War have been viewed as marking the apotheosis of American graphic journalism. The panache of this sheet stylistically resembles Glackens's published illustrations[4] and other sheets in the largest collection of his war drawings, which is held by the Library of Congress.[5] The Society's work testifies to the importance of artist-reporters on newspaper and magazine staffs, especially in New York City, the capital of American journalism.

When Glackens returned to the United States, he discovered the war had ended so suddenly (the peace treaty was signed on 12 August 1898) that many of his drawings were not received until hostilities had ceased. Therefore, they were neither paid for nor used.[6] Glackens never worked as an artist-reporter again, although he continued to produce illustrations for magazines. In Cuba his art had advanced under the inspiration of historic events, and his high excitement about rising to the challenge before his departure from Tampa is communicated in this bold representation of a cavalryman.

1. Glackens 1957, 23.
2. A similar illustration, also never published, is entitled *Loading Horses on the Transports at Port Tampa* and is signed and inscribed *W. Glackens, Tampa*. It, along with other sheets drawn by Glackens in Tampa, is in the Library of Congress, Prints and Photographs Division; see http://lcweb2.loc.gov/cgi-bin/query.
3. See Allyn and Hawkes 1987, 20–21, 24–25, nos. 320–34, 480–91, ills.
4. For similar equestrian figures, see Stephen Bonsal, "The Fight for Santiago: The Account of an Eye-Witness," *McClure's* 11:6 (1898): 504, ill. See also Glackens 1957, 24–26, with illustrations.
5. See Fern 1962, esp. 16–18, for a checklist of the library's holdings.
6. Ibid., 16.

VICTOR SEMON PÉRARD
Paris, France 1870–Bellport, Long Island, New York 1957

The illustrator Victor Semon Pérard was born in Paris and received his early art training at the École des Beaux-Arts, where he studied with Jean-Léon Gérôme. After coming to New York City in the 1890s, he studied at the NAD and the Art Students League. To further his knowledge of anatomy, he attended the New York University Medical College, an experience that would be instrumental in his later career as a teacher and writer of instructional books for artists. Following this preparation, Pérard entered the field of illustration, working for *Scribner's Magazine*, *Harper's Weekly*, and the *Century*, as well as several book publishers.

A gifted teacher, Pérard lectured on anatomy and taught at the Traphagen School and in the Woman's Art Department at Cooper Union (1914–32) in New York. He reached an even larger audience of students through his twenty books, many of which were used in art schools worldwide, including *Anatomy and Drawing* (1928), *Hands and Their Construction* (1940), and *Drawing Horses* (1944). An active member of the Society of Illustrators and the Salmagundi Club, Pérard exhibited widely and is represented in many museum collections, including those of the Metropolitan Museum of Art, the N-YHS (five examples, including one depicting skaters in Central Park), and the Cooper Union Art School in New York, as well as the Library of Congress and the National Gallery of Art in Washington, D.C.

Bibliography: Koke 1982, 3:65–67; Reed 2001, 81.

134. *The Flatiron Building: Fifth Avenue and Madison Square, New York City*, 1907

Black ink, black crayon, and gouache on paper, mounted on card; 18 × 12 in. (457 × 305 mm)
Signed at lower right inside image in black ink: *Victor*

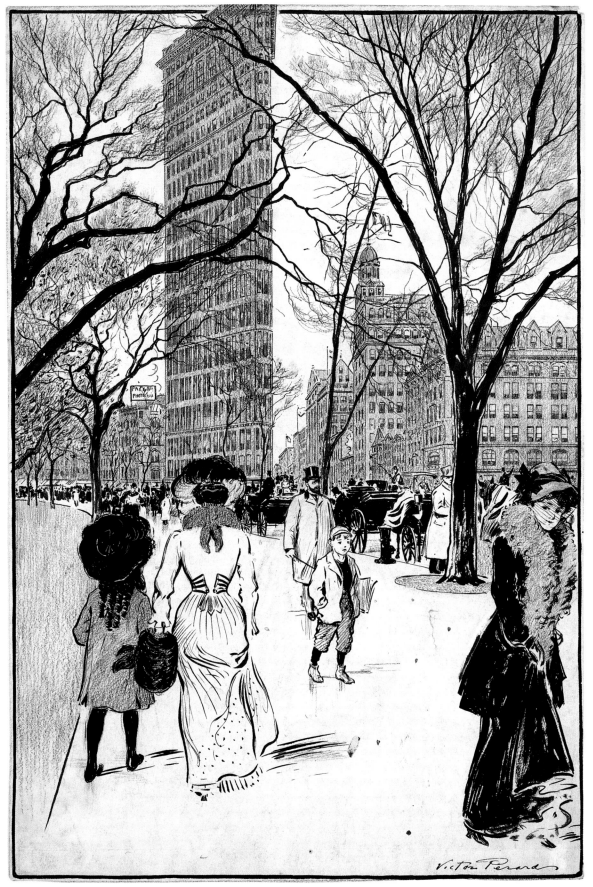

Perard; verso inscribed and dated at lower center in graphite: *Flat Iron Bldg, 1907*
Bibliography: Koke 1982, 3:66–67, no. 2333, ill.; Bruce Weber, *The Prowed Tower: Early Images of the Flatiron Building*, exh. brochure (New York: Berry-Hill Galleries, 1991), no. 16, ill.
Gift of Victor Semon Pérard, 1947.72

The Flatiron Building has stirred the imaginations of artists since its striking silhouette rose on the lower Manhattan skyline and its scaffold was removed in 1902–3. Surprisingly designated a landmark only in 1966, the Flatiron Building was briefly identified as the tallest building in the world and one of the first to use a steel frame. The structure remains one of the most recognized buildings in America. The famous photographer Alfred Stieglitz, who immortalized the building with his camera soon after it was completed,[1] remarked: "The Flatiron is to the United States what the Parthenon was to Greece."[2]

In 1899 Samuel Newhouse purchased the triangular area of land between Twenty-second and Twenty-third streets, bounded by the intersection of Broadway and Fifth Avenue, from the Eno family for $690,000, only to sell it in 1901 to the Fuller Company. The George A. Fuller Building, as the Flatiron was officially known, was designed by the Chicago architect Daniel H. Burnham and was an immediate sensation owing to its twenty-floor height, its narrow triangular plan, and the treacherous winds that blew around it (cat. 148). The structure's eclectic style, a French Renaissance veneer over a steel skeleton, straddled modernism and a more traditional architectural approach.[3] Because the Flatiron's shape entirely fills its plot of land, it rises with a stunning lightness, conveying an excitingly giddy quality that Pérard captured in his drawing. It is a structure of extremes, measuring only six feet in width at its apex. The building rapidly became a Manhattan icon and a subject of seemingly endless interest for photographers and artists, such as members of the Eight (Ernest Lawson, John Sloan, and Everett Shinn) and visiting European artists and architects.[4] Edward Steichen, among others, noted its resemblance to a ship and saw it as an almost mythical part of the urban landscape and a symbol of progress. The high tower on two intersecting avenues created downdrafts that blew up women's long skirts, encouraging males to loiter and ogle.

Legend has it that the phrase "Twenty-three Skiddoo" derived from the shouts of policemen charged with clearing Twenty-third Street of male gawkers.[5] In its early days the Flatiron was an object of controversy.[6] Sir Philip Burne-Jones, an English visitor writing of his visit to New York in 1902, said of the Flatiron Building: "One vast horror, facing Madison Square, is distinctly responsible for a new form of hurricane, which meets unsuspecting pedestrians as they reach the corner … I suppose the wind is in some way intercepted by the towering height of the building, and forced down with fury a little rude crowd of loafers and street arabs used to congregate upon the curb to jeer at and gloat over the distress of ladies whose skirts were blown into their eyes as they rounded the treacherous corner."[7] Deaths were even attributed to the wind blowing pedestrians into traffic. Despite its popularity, the structure was sometimes referred to as "Burnham's Folly."

George A. Fuller, the owner of the Flatiron Building, maintained an office there for twenty years. When he sold the structure in 1925 to erect a second Fuller Building in Manhattan (on Fifty-seventh Street), its official name became the Flatiron Building, harkening back to the original plans in which it had been referred to as the Flatiron.

Pérard's drawing demonstrates the modernity of the location at the turn of the twentieth century, when Madison Square was fast becoming more commercial.[8] The structure's modernity is complemented by Pérard's design, which crops the figures and the top stories of the building to exaggerate its height. Together with a lack of modeling, this approach reveals the illustrator's awareness of Japanese ukiyo-e prints, so influential on both American and European artists of the late nineteenth century.[9] Not coincidentally, Pérard's composition resembles the famous photograph of the subject by Steichen, taken in 1904 from nearly the same location and manipulated to look like a nocturnal scene.[10] The candid nature of Pérard's work, perhaps based on an unidentifed photographic model, is emphasized by the point of view from the sidewalk of Fifth Avenue, the backs of two figures, and the self-conscious gaze of the woman walking out of the picture frame at the right.

Since many photographers had established their studios in the neighborhood, it is no

wonder that the Flatiron Building became a photographic icon at the beginning of the century. (Carl) Sadakichi Hartmann, the poet, playwright, and critic (whose pen name was Sidney Allan), remarked of the Flatiron:

> At all events, it is a building—although belonging to no style to be found in handbooks or histories of architecture—which, by its peculiar shape and towering height, attracts the attention of every passerby. True enough, there are skyscrapers which are still higher … but never in the history of mankind has a little triangular piece of real estate been utilized in such a *raffiné* manner… It is typically American in conception as well as execution. It is a curiosity of modern architecture a building without a main façade, resembling more than anything else the prow of a giant man-of-war. And we would not be astonished in the least, if the whole triangular block would suddenly begin to move northward through the crowd of pedestrians and traffic of our two leading thoroughfares, which would break like waves of the ocean on the huge prow-like angle.[11]

The Flatiron prophetically pointed the way for the northward march of development on Manhattan Island. Although Pérard's work captures many of the qualities that made the Flatiron famous, the reason for its execution remains a mystery. No doubt this understudied artist intended it as an illustration, but to date its purpose remains unknown.

1. Peter Gwillim Kreitler and Weston J. Naef, *Flatiron: A Photographic History of the World's First Steel Frame Skyscraper, 1901–1990* (Washington, D.C.: American Institute of Architects Press, 1990), 19, ill., an image of the building in the snow.
2. Ibid., 18.
3. Paul Goldberger, *The Skyscraper* (New York: Knopf, 1981), 38, notes that the Flatiron represented a retreat from the innovative work that made Burnham's name during his partnership with John Wellburn Root: its "French Renaissance blanket or ornament covers the façade like a great shimmering curtain." See also idem, "The Flatiron Building," *Portfolio* 3:1 (1981): 100–103. Two M.A. theses have focused on the edifice: Agnes Mills, "The Flatiron Building, New York City: An Analysis of Its Place in the Work of D. H. Burnham and Company in the Architectural Environment of New York City 1902" (M.A. thesis, Institute of Fine Arts, New York University, 1958); and Barbara A. Meyer, "The

Flatiron Building—an American Icon" (M.A. thesis, Hunter College, City University of New York, 1987).

4. See Weber 1991.

5. Ibid., 38. Many postcards of the Flatiron were produced, including ones that showed skirts blowing in the air and officers of the law chasing loiterers. The alternative interpretation holds that Twenty-third Street was a thoroughfare leading to West Side ferries leaving Manhattan.

6. See Weber 1991.

7. Sir Philip Burne-Jones, *Dollars and Democracy* (New York: D. Appleton and Co., 1904), 58–59.

8. Miriam Berman, *Madison Square: The Park and Its Celebrated Landmarks* (Salt Lake City: Gibbs Smith, Publisher, 2001).

9. The artist seems to have specialized in bold illustrations of urban scenes with slightly unusual points of view. For example, Pérard's *Horse Car of South Street, New York City* (inv. no. 1953.91), in oil on board, is a view of the port dynamically executed from a moving vehicle drawn by two horses, one of the artist's specialties; see Koke 1982, 3:67, no. 2331, ill.; Reed 2001, 81, ill.

10. See Dennis Longwell, *Steichen, the Master Prints, 1895–1914: The Symbolist Period* (New York: Museum of Modern Art, 1978), 135, ill. Steichen had his studio at 291 Fifth Avenue, between Thirtieth and Thirty-first Streets.

11. Sidney Allan, "The Flat-Iron Building: An Esthetical Dissertation," *Camera Work* 4 (October 1903): 36.

CAROLINE VAN HOOK BEAN

Washington, D.C. 1879–1980

135

Caroline van Hook Bean, recognized for her urban scenes of New York City and Washington, D.C., lived to the age of 101 and maintained, arguably, one of the longest active careers of any American artist. Her precocious talent was noted at age seven, when she exhibited her work at the Cosmos Club in Washington. At fifteen, when her parents spent a year in Paris, she began her painting studies with Harry Thompson. When they returned to the United States, the family moved to New York, where her father, Dr. Tarleton H. Bean, an ichthyologist for the Smithsonian Institution, was appointed director of the New York Aquarium. After enrolling in Smith College and graduating in 1903, she studied at the St. Louis School of Art in Missouri and the NAD in New York with William Merritt Chase, having spent three summers at his Shinnecock School near Southampton on Long Island. Bean also studied with Barnardus (Bart) J. Bloommers in Holland, whom she married (1913–19), and briefly with John Singer Sargent (cats. 124 and 125) in London.

During her lifetime, Van Hook Bean (who signed her surname in various forms) exhibited her Impressionist-influenced works at several galleries in New York. She produced her most successful work, hailed by the critics as "brilliant" and "joyous," during World War I: a series representing the city in wartime. Her final show was a retrospective in 1970 at the Chapellier Galleries in New York. Entitled *New York City Wartime (1918–1919)*, it paralleled an exhibition held in 1919 of many of the same works—minus those purchased by prominent collectors of the time, such as Dwight Morrow, J. P. Morgan, Adolf Lewisohn, and George F. Baker. She also exhibited works at the Art Institute of Chicago and the Corcoran Gallery of Art, in Washington, among other institutions.

In 1929 Van Hook Bean returned to Washington, where she continued to paint portraits and city street scenes in her Georgetown studio. In 1927 she had married Algernon H. Binyon, the English aviation automotive engineer who worked for the Bureau of Standards; he died in 1941. Van Hook Bean also worked as an architect and helped restore old houses in Georgetown, afterward painting the restored residences. In America's capital, she remained involved with art as a member of the Society of Washington Artists and the Washington Society of Etchers until her death in 1980.

Bibliography: Chapellier Galleries, *Caroline van Hook Bean, American (1880–)*: "New York City in Wartime (1918–1919)," exh. pamphlet (New York: Chapellier Galleries, 1970); "Talk of the Town: Caroline van Hook Bean," *New Yorker*, 18 April 1970, 34; Ronald G. Pisano, *The Students of William Merritt Chase*, exh. cat. (Huntington, N.Y.: Heckscher Museum, 1973), 10; Koke 1982, 3:212; Falk 1999, 247; Time Line: Caroline Van Hook Bean (Binyon), March 1973, The Ronald G. Pisano Papers, 1972–2000, AAA, unmicrofilmed manuscript collection.

135. *The New York Public Library Steps, New York*, 1918

Pastel, Conté crayon, gouache, charcoal, and watercolor on gray paper; 21 7/16 × 15 in. (545 × 381 mm)
Signed at lower right in black pastel: *Caroline van H Bean*; inscribed and dated at lower left inside image: *The Library Steps—5th ave / August 1918*; at lower right of center outside image: *2 [encircled]*; at lower center outside image: *—2v—*
Bibliography: Koke 1982, 3:212, no. 2659.
X.461

Van Hook Bean's view of the New York Public Library steps and one of its recumbent lions features a United States Army Tank Corps display in the foreground. The sheet belongs to her 1918–19 series of depictions of New York City during World War I. A resident during that time, she portrayed the city at a moment of fervor and transition and captured compelling scenes documenting the festive end to this "war to end all wars." At the time many parts of the city were decorated and/or filled with scenes of jubilation, as she depicted in her similar pastel in the collection representing the corner of the Flatiron Building (cat. 134) with a World War I victory display on its "cowcatcher" prow against the backdrop of Madison Square (see note 5 below).

Writing about her exhibition showcasing the series at the Mussmann Galleries in 1919, the art critic Frederick James Gregg noted in the *New York Herald*:

> It is a brilliant and joyous show … . Here, for the first time so far as we know, is a presentation of many parts of the city as it was when it was decked out in the battle flags of the Allies. There are those who hold that New York is not picturesque. Miss Bean has demonstrated that any such charge is a ridiculous slander.[1]

Certainly several of Van Hook Bean's works can be compared with the flag paintings of Childe Hassam generated by the same celebration at the end of World War I.[2]

Many of the twenty gouaches and oils exhibited at Chapellier Galleries in 1970 preserve the temporary structures built for the victory celebrations, such as the Arch of Freedom erected in Madison Square[3] or the temporary sculpture group of Allied soldiers and flags on top of the Flatiron Building's prow,[4] a smaller version of the one in the Society's collection.[5] A variant of the drawing considered here was executed one year later and included in the 1919 exhibition. As the artist drew it from a greater distance, the later gouache depicts a broader expanse of the New York Public Library facade, together with the vehicular traffic on Fifth Avenue.[6]

1. Quoted in Chapellier Galleries 1970, 3.
2. See H. Barbara Weinberg, *Childe Hassam: American Impressionist*, exh. cat. (New York: Metropolitan Museum of Art, 2004), esp. 407, no. 44, fig. 233, Hassam's painting in the Society's collection (inv. no. 1984.68).
3. Chapellier Galleries 1970, 4, fig. 1, in gouache, 18 1/2 × 12 in.
4. Ibid., 7, fig. 13, in gouache, 14 × 9 1/2 in.
5. Inv. no. X.462, in pastel, Conté crayon, gouache, charcoal, and watercolor on gray paper, laid on board, 21 7/8 × 15 1/8 in.; see Koke 1982, 3:212, no. 2658, ill.
6. Chapellier Galleries 1970, 5, fig. 8, entitled *The Library, Fifth Avenue, New York City (December, 1919)*, in gouache, 18 1/2 × 13 in.

TIFFANY & COMPANY

Founded 1837

For more than 160 years, Tiffany & Co. has epitomized the pinnacle of American wealth, luxury, and good design. On 21 September, in the midst of the panic of 1837, Charles Lewis Tiffany (1812–1902) and John B. Young (1802–1852) founded Tiffany & Young, a small emporium of stationery and dry goods at 259 Broadway in New York City (in a building that served as the fourth home of the N-YHS from 1832 to 1837). Tiffany proved to be a gifted entrepreneur with an impeccable sense of style. He quickly began catering to newly rich clients unsure of their tastes by offering rare and exotic imported goods. The store made its mark in the luxury goods world by establishing nonnegotiable selling prices for all items; during the first year the firm grew steadily. In 1841 it expanded with a third partner, John L. Ellis (Tiffany, Young & Ellis) and added jewelry, silver, porcelain, crystal glassware, personal accessories, Swiss watches, and bronze statuary to its merchandise. With New York burgeoning into a large metropolis, the demand for luxury items continued to increase, and Tiffany became a major purveyor.

As a champion of American craftsmanship and materials, Tiffany & Co. began producing jewelry and sterling flatware patterns in 1848, becoming one of the greatest merchant-jewelers in the United States. The firm worked to produce the purest sterling available on the model of the British. Its purity standard (925/1000) was immediately recognized by knowledgeable silver customers and eventually became the U.S. sterling silver standard. The company continued to help the United States government establish standards in gemology, such as setting the standard weights for precious stones (1907) and measuring the purity of platinum (1926).

The quickening of the silver trade in America is well illustrated by the rise of Tiffany & Co. Captains of industry had the means and desire to purchase the best that money could buy, and Tiffany became one of their primary suppliers. Soon after it was founded in 1837, Tiffany introduced its signature "Tiffany Blue Box" in a distinctive shade of aqua, rather like a robin's egg, in which all merchandise purchased was wrapped. By 1845 the firm had created its "Blue Books," catalogues that allowed people all over the country to order merchandise. This color became the hallmark of the company, whose savvy marketing was clearly another forte. About

1846 Charles L. Tiffany began to commission silverware from the leading American silversmith, John C. Moore, and in 1851 brought him into the company. In that year Moore's eldest son, the designer Edward Chandler Moore, took over direction of the factory. Under the elder Moore's direction the company rose to dominate the domestic silver market (Tiffany eventually acquired the Moore firm in 1869). By 1853 the company was known as Tiffany & Co. and occupied premises at 550 Broadway. Already by 1850 Tiffany had opened a branch in Paris, marking the beginning of its international expansion and paralleling the movement of many Americans who began traveling to Europe in greater numbers. The prosperous and industrious years following the Civil War, dubbed by Mark Twain "the Gilded Age," were especially good for Tiffany & Co. With the emergence of a large wealthy class, silver catered to the opulent purses of people at one end of the social scale, while the steady drop in price ultimately brought small silver objects within the range of all but the most humble households.

Americans, who had not previously known such immense wealth, continued to evidence a seemingly insatiable demand for ever-more opulent luxury goods, including tea services, objets d'art, and jewelry. Tiffany met this market with increasing diversification. At the Expositions Universelles of 1867 and 1878 in Paris, the firm won several medals, the first ever given to an American silver maker. At the 1878 exposition Tiffany & Co. won its first grand prize for silverware, and Charles Lewis Tiffany was named a chevalier of the Legion of Honor. In 1871, one year after the firm moved to Union Square, Edward C. Moore, who had also joined the company as chief designer and manager, created the celebrated Japanese pattern for flatware, now called Audubon.

Through the end of the nineteenth century, Tiffany & Co. won wide acclaim for the high quality of its products and innovative design and received many important official commissions. The company acquired its now-famous canary yellow Tiffany diamond (weighing 128.51 carats) in 1878. In 1885 Tiffany & Co. was commissioned by the U.S. government to redesign the United States Seal that appeared on U.S. currency and that still is found on the American one-dollar bill. For Tiffany's silver

display at the Chicago World's Columbian Exposition of 1893, John T. Curran designed its major showpiece, the opulent enameled silver and inlaid *Magnolia Vase* (The Metropolitan Museum of Art, New York).

By 1900 Tiffany & Co. included among its clients twenty-three royal families, Queen Victoria, celebrities, millionaires, and successive American presidents. Louis Comfort Tiffany (cat. 137) inherited the business when his father died in 1902. From 1905 to 1940 the store was located in the Venetian palazzo building at Thirty-seventh Street and Fifth Avenue. In 1930 Tiffany & Co. produced one of its most famous trophies, that of the New York Yacht Club. The 18-karat-gold trophy that is still in use was so positively received that the company developed an entire department for producing trophies. Tiffany & Co. moved to its distinctive flagship building that resembles an Art Deco bank vault on Fifth Avenue at Fifty-seventh Street in 1940. To this day it produces and sells in stores throughout the world its designs for jewelry, flatware, and hollowware, together with those of prominent European and American jewelers.

Bibliography: John Loring, *Tiffany's 150 Years* (Garden City, N.Y.: Doubleday, 1987); Charles L. Venable, *Silver in America, 1840–1940: A Century of Splendor* (Dallas: Dallas Museum of Art, 1995), esp. 28–29; Charles Hope Carpenter Jr., *Tiffany Silver* (New York: Dodd, Mead & Co., 1978; rev. ed., San Francisco: A. Wofsy Fine Art, 1997); John Loring, *Magnificent Tiffany Silver* (New York: Harry N. Abrams, 2001).

136. *Designs for 35 Pin Bars and Ribbons for the Badges of the Centennial Celebration of the Inauguration of George Washington*, 1889

Watercolor, graphite, and brown and black ink with touches of white gouache and metallic pigments on paper; 15 5/8 × 18 11/16 in. (398 × 475 mm)
Signed at lower right in graphite: *Tiffany & Co*; stamped in blue ink at lower left: THIS DRAWING TO BE / RETURNED TO TIFFANY & CO. / WHO RESERVE THE SOLE / RIGHT TO ESTIMATE / UPON IT.; inscribed at lower center in black ink: *Size*.
Provenance: Charlotte Whiting Havemeyer, New York.[1]
Gift of Mrs. Charlotte Havemeyer, Z.3377

This sheet features reduced-scale designs for thirty-five pin bars and ribbons of badges for the centennial celebration of the inauguration

Size.

of George Washington, all numbered in black ink on the sheet, together with a life-size model at the lower center. It was made for presentation to the Washington Centennial Celebration Committee and represents only one facet of Tiffany & Co.'s participation in this significant national commemoration. The Society numbers in its collection nineteen of the badges depicted in the watercolor, all but one with their original medallic component and some represented by multiple examples.[2] In the watercolor the

medals are shown as blank disks, and in several instances the inscriptions on pin bars and the ribbon colors of the actual objects vary from their designs in the watercolor.

George Washington was inaugurated as the first president of the United States on 30 April 1789. The centennial of this anniversary was centered in New York City, whose citizens in conjunction with the chamber of commerce of the state of New York, the N-YHS, the order of the Society of the Cincinnati, and the Society of

the Sons of the Revolution organized a Grand Committee of Citizens to plan and direct the celebration. The three-day affair began on 29 April, when President Benjamin Harrison was rowed down the Hudson to reenact and commemorate Washington's triumphal entry into New York at the end of the American Revolution. For the occasion Stanford White designed an elaborate temporary wooden triumphal arch for Washington Square (cat. 126). Other parades, banquets, displays, fireworks,

and religious ceremonies at the historic old St. Paul's Chapel were orchestrated around the "literary exercises" of 30 April 1789. Appropriately, these were held in front of the subtreasury building on Wall Street, formerly the site of Federal Hall, where Washington took his oath of office (it was also the first location of the N-YHS, founded in 1804).[3]

A number of die-struck and cast medals with the likeness of Washington were produced in connection with this national celebration.[4] Among them was a medallion with a 4 1/2 inch (114 mm) diameter designed by Augustus Saint-Gaudens.[5] The smaller medallic components of the ceremonial badges designed by Tiffany in the Society's watercolor were struck as a variation of this larger medallion;[6] the badges were worn by members of the committee and the invited dignitaries at the ceremonies.

From the time of the Civil War to the present, Tiffany & Co. has been involved with the production of hundreds of medals. Many are distinguished examples of the art, and some were designed by leading artists of the day. Among the most noteworthy are the Dewey Medal, designed by Daniel Chester French in 1898, and the United States Congressional Medal of Honor used by the Navy from 1917 to 1942.[7] The Society's watercolor provides evidence of the broader dissemination of these sculptural designs and the high quality of Tiffany & Co.'s presentation watercolors produced for their clients' approval.

1. Charlotte Havemeyer was also known as Mrs. Henry O. Havemeyer. Louis Comfort Tiffany with Samuel Colman (cat. 104) decorated the Havemeyer home at 848 Fifth Avenue in 1890–92. See Robert Koch, *Louis C. Tiffany, Rebel in Glass* (New York: Crown Publishers, 1982), 72, 101.

2. The watercolor depicts the following designs (an asterisk [*] signals that the design is represented in the Society's collection by an example, usually including the pin bar, ribbon, and medal): *1. President; 2. Chairman General Committees; 3. Chairman Executive Committees/Chairman; 4. Secretary; *5. General Committee; *6. Plan & Scope Com.; *7. States Committee; *8. (no medal) States Committee/Chairman; *9. Gen. Government Committee; 10. Gen. Government Committee Chairman; *11. Army Committee; 12. Army Committee Chairman; *13. Navy Committee; 14. Navy Committee Chairman; *15. Entertainment Committee; 16. Entertainment Committee Chairman; *17. Finance Committee; 18. Finance Committee Chairman; *19. R. R. & Transportation Committee; 20. R. R. & Transportation Committee Chairman; *21. Art & Exhibition Committee; 22. Art & Exhibition Committee Chairman; *23. Literary Exercises; 24. Literary Exercises Chairman; *25. St. Paul's Chapel Committee; 26. St. Paul's Chapel Committee Chairman; 27. President U.S.A.; 28. Vice President U.S.A.; 29. Governor N.Y.; 30. Special Aide; *31. Guest; *32. New York Legislature; *33. New York Alderman; *34. Literary Exercises Platform Committee Sub Treasury; and *35. St. Paul's Chapel Committee Aisle Committee.

3. See Clarence Winthrop Bowen, ed., *The History of the Centennial Celebration of the Inauguration of George Washington as First President of the United States* (New York: D. Appleton and Company, 1892); and idem, *The Centennial Celebration of the Inauguration of George Washington as First President of the United States: Official Programme* (New York?, 1889).

4. See Susan H. Douglas, "George Washington Medals of 1889: An Illustrated List of the Medals of the Centennial Celebration of the Inauguration of George Washington, 1889," *Numismatist* 62:5 (1949): 274–83; 6, 344–50; 7, 387–409, esp. 407, no. 54, ill., which provides earlier bibliography.

5. For additional information on the medal, see Douglas 1949, 405–6, no. 53, ill.; Susan Luftschen, *One Hundred Years of American Medallic Art, 1845–1945* (Ithaca, N.Y.: John E. Marqusee Collection, Herbert F. Johnson Museum of Art, Cornell University, 1995), 68, no. 346, ill., with an extensive bibliography; John H. Dryfhout et al., *Augustus Saint-Gaudens, 1848–1907*, exh. cat. (Paris: Éditions d'Art, 1999), 201–2, no. 117, ill., and Russell Rulau and George Fuld, *Medallic Portraits of Washington* (Iola, Wisc.: Krause Publications, 1999). The design program for the commemorative medal developed in a series of meetings of the Washington Centennial Celebration Committee. Saint-Gaudens, who did not accept money for the commission, was unable to give it his full time and gave the work to his assistant Philip Martiny, who created the models. See also Louise Hall Tharp, *Saint-Gaudens and the Gilded Era* (Boston: Little, Brown and Company, 1969), 235–36; and John H. Dryfhout, *The Work of Augustus Saint-Gaudens* (Hanover, N.H.: University Press of New England, 1982), 177–78, no. 134, ill.

6. The medallic component of the badges is 1 3/8 inches in diameter. For the images and inscriptions on the obverse and reverse of the medallic component, see Douglas 1949, 407, no. 54, ill.; and Luftschen 1995, 68, no. 347. See also Dryfhout et al. 1999, 202. Bowen 1892, 121, reproduces some of the Tiffany badges.

7. Carpenter 1997, 132.

LOUIS COMFORT TIFFANY AND TIFFANY STUDIOS

New York, New York 1848–1933; Studios active 1902–38

Louis Comfort Tiffany—the designer, painter, and entrepreneur who became one of America's preeminent masters of the decorative arts, renowned for his Art Nouveau glass and jewelry—was born into New York's prominent jewelry retailing family. After four years of study at the Eagleswood Military Academy near Perth Amboy, New Jersey, Louis Comfort became a landscape painter instead of joining his father, Charles Lewis Tiffany, at Tiffany & Co. (cat. 136), which he eventually inherited. He studied under George Inness, from whom he gained an appreciation of nature that would provide subject matter for later designs, and enrolled in the antique class at the NAD for the academic year 1866–67, first exhibiting there in 1867. In 1868 he continued his training in Paris under Léon-Charles-Adrien Bailly, making his debut at the Paris Salon with a still life. On his return to New York in 1869, he established a studio in the YMCA Building, joined the American Society of Painters in Water Colors and the Century Association, and began painting views of the Hudson River. (The Society holds one of Tiffany's oil paintings from the 1870s, *View of the Palisades, New Jersey*.) In 1870 he met Samuel Colman (cat. 104), with whom he took a sketching trip to California; later the two men would share an interest in the forms, ornament, and patterns of Islamic and Romanesque art and a passion for watercolor and the decorative arts. That same year Tiffany made another trip to Europe and embarked on an extensive tour of North Africa, Gibraltar, Spain, Sicily, Malta, Naples, and Rome. This journey awakened his sense of color and light and his love of exoticism, so prevalent in his later works. In 1871 he was elected an associate of the NAD and an academician in 1880, but he later rebelled against that institution's conservative attitudes.

By 1872, the year he married Mary Woodbridge Goddard, Tiffany's broadening interests included experiments in glass and an intensified focus on the decorative arts, arising from contact with Edward C. Moore, the general manager and chief designer of Tiffany & Co. and an important collector of Asian and Near Eastern art. Tiffany began to paint travel scenes and landscapes in the fashionable Orientalist style as well as experimenting with such novel subject matter as New York City slums. From the mid-1870s he formed a collection of East Asian (particularly Japanese) decorative arts that

reflected his taste for the exotic and mystical. In 1877—together with John La Farge, Augustus Saint-Gaudens, and other American avant-garde figures—he formed the American Art Association (from 1878 the Society of American Artists), which advocated modern European painting styles, and served as its first treasurer. Although Tiffany continued to paint, by the late 1870s his interests had turned primarily to the design and manufacture of decorative objects.

During the 1870s Tiffany was increasingly drawn to the applied arts, experimenting with stained-glass techniques at commercial glasshouses in New York and exhibiting his first ornamental stained-glass windows in 1876. In 1879 he focused more directly on the decorative arts when he established an interior-decorating firm with three other artists (Colman, Lockwood de Forest, and Candace T. Wheeler), known as Louis C. Tiffany & Company, Associated Artists, which dissolved in 1883 despite successfully providing choice interiors with progressive designs—notably those of the Seventh Regiment Armory (1880); the Union League Club (1880–81); the Mark Twain residence in Hartford, Connecticut (1881–82); and the White House (1882–83). Tiffany began to experiment with glass mosaics, designed his first wallpapers, and in 1881 registered a patent for an opalescent glass, which enabled him to create a unique style of stained glass. His development was dealt a temporary blow by the death of his first wife in 1884 and financial losses. In 1885 he worked with Thomas Edison to develop the lighting for the Lyceum Theater in New York City, the first theater illuminated exclusively by electricity, and married a second time, to Louise Wakeman Knox.

Although Tiffany continued to decorate the residences and offices of wealthy clients throughout his career, he devoted increasing energy to experimental glass production. He had started the Tiffany Glass Company in 1885 to supply institutions such as churches with windows. Although Tiffany was not responsible for all the designs and did not make the glass produced in his workshops, he closely supervised its production. After the Tiffany Chapel was displayed at the 1893 World's Columbian Exposition in Chicago, where it was awarded fifty-four medals (and where Tiffany exhibited two of his paintings), the company (with its own glass furnaces in Corona, New York) became the

largest stained-glass studio in the nation. It produced windows for new church buildings, homes (even the White House), and public buildings, as well as for mausoleums and memorial chapels. In 1894 Tiffany registered his Favrile glass trademark (from the archaic French *fabrile* meaning "handmade"), initiating one of the most successful branches of his business, the production of vases and lamps. He sent a selection of Favrile wares for exhibition at the Société des Beaux-Arts in Paris that year and in 1895, when he also showed a series of stained-glass windows designed by the avant-garde French artists known as the Nabis. His glass and windows also were featured at the Parisian gallery L'Art Nouveau, run by Siegfried Bing. Tiffany opened a New York showroom in 1898 for the display and sale of his decorative works, to which he added leaded glass lamps in 1899. His work continued to win favor at the Paris Exposition Universelle of 1900, and in 1902, the year of his father's death, he renamed the firm Tiffany Studios. Although the lamps are now the most widely recognized product of Tiffany Studios, the firm produced a staggering variety of goods and at its peak employed more than two hundred craftsmen and artists, including twenty-six women, whose manual dexterity Tiffany praised. At the same time Tiffany also completed ambitious decorative commissions, including the Chicago Public Library (1900) and his own eighty-four-room summer home, Laurelton Hall, in Oyster Bay, New York (1902–4, now demolished).

After his father's death in 1902, Tiffany assumed the position of art director for Tiffany & Co. He produced objects and fulfilled decorative commissions but in 1918 resigned as art director and in 1919 created the Louis Comfort Tiffany Foundation to provide grants for young artists. Finally retiring from Tiffany Studios in 1920, he divided it into Louis C. Tiffany Glass Furnaces, Inc., which produced Favrile glass through 1924, and Tiffany Ecclesiastical Department, which continued making Tiffany Studios windows, lamps, and mosaics until its bankruptcy in 1932. After Tiffany's death in 1933, his former employees established Westminster Memorial Studios to complete the outstanding commissions of Tiffany Studios.

Bibliography: Naylor 1973, 2:936–37; Wilson H. Faude, "Associated Artists and the American Renaissance in the Decorative Arts," *Winterthur Portfolio* 10 (1975): 101–30;

137a

Koke 1982, 3:188–89; Alastair Duncan, Martin Eidelberg, and Neil Harris, *Masterworks of Louis Comfort Tiffany* (New York: Harry N. Abrams, 1990); Fink 1990, 397; Alastair Duncan, *Louis Comfort Tiffany* (New York: Harry N. Abrams, in association with the National Museum of American Art, Smithsonian Institution, 1992); Carr and Gurney 1993, 326; Alice Cooney Frelinghuysen, "Louis Comfort Tiffany at the Metropolitan Museum," *Metropolitan Museum of Art Bulletin* 56:1 (1998): 4–100; Martin Eidelberg and Nancy A. McClelland, *Behind the Scenes of Tiffany Glassmaking* (New York: Saint Martin's Press, in association with Christie's Fine Arts Auctioneers, 2001); Roberta A. Mayer and Carolyn K. Lane, "Disassociating the 'Associated Artists': The Early Business Ventures of Louis C. Tiffany, Candace T. Wheeler, and Lockwood de Forest," *Studies in the Decorative Arts* 8:2 (2002): 2–36; John Loring, *Louis Comfort Tiffany at Tiffany & Co.* (New York: Harry N. Abrams, 2002); Nina Gray, "The Work of Tiffany Studios," *The Magazine Antiques* 167:1 (2005): 194–98; Marilyn Johnson et al., *Louis Comfort Tiffany: Artist for the Ages*, exh. cat. (London: Scala Publishers, 2005); Alice Cooney Frelinghuysen, *Louis Comfort Tiffany and Laurelton Hall: An Artist's Country Estate*, exh. cat. (New York: Metropolitan Museum of Art, 2006).

137a. *Design for a Stained-Glass Window with St. Anthony of Padua, for a Mausoleum in St. John's Cemetery*, c. 1907

Watercolor, gouache, black ink, and graphite on paper, laid on board, overmatted in original presentation mount with irregular ogive arch; 4 5/16 × 2 1/2 in. (110 × 63 mm), image
Inscribed inside image along lower border in watercolor: *abcdefghijklmnop baumhe dalot*; signed on presentation mount at lower right in graphite: *Louis C. Tiffany*; mount inscribed below window: - SKETCH - NO. - 4285 - - SCALE - 1" = 1' - 0" - / - SUGGESTION - FOR - / - WINDOW - / - IN - MAUSOLEUM - AT - / - ST. JOHN'S - CEMETERY - / - LOUIS - C. - TIFFANY - STUDIOS - / - NEW - YORK - CITY - N.Y. - / - MR -J- SIGNAIGI - / - NEW - YORK - / - APPROVED - BY -
Provenance: Dr. Egon Neustadt, New York.
Gift of Dr. Egon Neustadt, N84.139

137b. *Design for a Stained-Glass Window, Bunnell Studio, Carnegie Hall, Cleveland, Ohio*, c. 1923

Watercolor, gouache, and Conté crayon on paper, laid on board, overmatted in original presentation mount; 3 1/4 × 2 1/8 in. (82 × 54 mm), image
Inscribed on original presentation mount below window at center in graphite: - SKETCH - NO. - 2874 - - SCALE - 1" = 1' - 0" - / - SCHEME - A - - SUGGESTION – FOR - / - WINDOW - / BUNNELL. STUDIO - / - CARNEGIE - HALL - / - CLEVELAND - O - / ECCLESIASTICAL DEPT - / TIFFANY STUDIOS / - NEW - YORK - CITY - NY - / - APPROVED -BY -
Provenance: Dr. Egon Neustadt, New York.
Bibliography: Olson 2004, 33–34, fig. 15.
Gift of Dr. Egon Neustadt, N84.140

A significant part of Tiffany's multifaceted design service was the production of stained-glass windows. His involvement with the manufacture of glass can be traced to the early 1870s, when he began to rent time at commercial glass furnaces in the New York area. Later in the decade he received his first commissions for ecclesiastical and domestic windows, the latter of which depended on the cachet of his family name. He executed these for wealthy private clients and for his own residences, including his Manhattan mansion at Madison Avenue and Seventy-second Street designed by Stanford White. Tiffany's progress in his adopted medium accelerated in the 1880s at a pace that appears to have been related directly to his growing disenchantment with the profes-

137b

sion of interior design. Impatient for individual success, he searched increasingly within the world of stained glass for the recognition that he felt had eluded him as an interior designer, amicably dissolving the partnership of Louis C. Tiffany & Company, Associated Artists in 1883.

On 1 December 1885 Tiffany formally embarked on his novel venture with a new firm, the Tiffany Glass Company. He was finally on the road to an independent career in the applied arts, one that would bring him international acclaim beyond his own expectations. During the 1880s he strove to meet the explosion of church construction that followed the Civil War, when the nation experienced a fervid spiritual resurgence. In 1875 alone more than four thousand churches of all denominations were under construction, each embellished with memorials to former communicants and members of the clergy.[1] The Tiffany Glass Company was perfectly placed to capitalize on the increased demand for stained glass and other liturgical objects. The tempo of church construction continued through the decade, drawing Tiffany farther from his role as artist-designer into that of entrepreneur. To offset this shift in his responsibilities he began to assemble the team of designers, among them Frederick Wilson, Clara Driscoll, and Agnes Fairchild Northrop, who formed the nucleus of the

window department of his company well into the next century.[2] This was advantageous to Tiffany, who had specialized in landscapes and was neither adept in drawing the human figure nor trained in biblical iconography. However, he retained the commissions from prized clients and thus balanced his time between artistic and commercial considerations. He also employed eminent artists to provide designs, such as Howard Pyle (cat. 121), Lydia Field Emmet (cat. 128), Maxfield Parrish, and Frank Brangwyn. To his credit, he was not worried that their participation would diminish his role but, as a canny businessman, thought such associations would only lend luster to his own works. Similarly, he permitted his designers to translate works by old masters and nineteenth-century painters—from Sandro Botticelli and Annibale Carracci to Gustave Doré, John James Audubon (his Carolina Parakeet, cat. 42[3]), and William Holman Hunt—into glass. His designs were influenced by the English Arts and Crafts movement founded by William Morris as well as French Art Nouveau and its celebration of nature and sinuous forms.

To maintain final control of the firm's production, Tiffany initiated a system whereby he reviewed all designs prepared by the Window Department before they were submitted to customers. They were signed by Tiffany when

approved, as was done on the hand-lettered presentation mount for the Mausoleum at St. John's Cemetery (see below).[4] The firm's surviving window cartoons invariably bear Tiffany's penciled initials or signature under the heading *Approved By*, often with notations in the margins.

By the mid-1880s the secular windows Tiffany designed for private clients and for his own projects had increased both in numbers and aesthetic importance. At the end of the decade the Tiffany Glass Company was the largest stained-glass studio in the nation, although the history of Tiffany as a master glassmaker and artist did not really begin until 1892, when he established his own glass furnaces in Corona, New York. Buoyed by his enthusiastic reception at the 1893 Columbian Exposition, he set out to conquer the international market, which took him to Paris and London. In 1900 he again changed the company's name to Tiffany Studios. He also attempted to persuade church traditionalists to accept his unorthodox, sometimes secularized, window imagery. His windows became more technically complex and breathtakingly beautiful. No official record survives of the commissions executed after 1910, the year the firm published the last of its three lists of completed commissions, mostly ecclesiastical (1893, 1897, 1910).[5] Window production at the studio reached its high point

between 1900 and 1910. Thereafter, especially with the onset of World War I, demand fell.[6]

Two jewel-like designs for stained-glass windows in the Society's holdings are discussed here; one features a religious theme and the other, a secular subject.[7] It is unclear whether either of these designs was executed after being presented to clients, but one was approved by Louis C. Tiffany and the other was painted by him.

The first window, probably the earlier of the two, was, according to the beautifully hand-lettered inscription on its presentation mount, executed for an unknown mausoleum in an unidentified St. John's Cemetery for a Mr. J. Signaigi. No supporting documentation has been located.[8] The single multilobed window contains a representation of Saint Anthony of Padua holding the Christ Child while standing in a flowering meadow with trees symbolic of the Christian Paradise. The nonsensical alphabetic inscription in Gothic letters in the lower border only holds the place for an inscription to be selected by the patron after approving the design. The work's format and size resemble other Tiffany Studios designs for mausoleum windows and can be dated by comparison with another example containing an inscription set in a nearly identical border. Inscribed *I am the Resurrection and the Life*, the comparative watercolor is in the Metropolitan Museum of Art, New York, and its window was designed about 1907 for the mausoleum of Mr. John W. Brennan in Hudson, New York.[9]

Catalogue 136b depicts a secular subject, a tropical sunset, and, based on its style, was made more than a decade later. Its bold, painterly application of pigment can be attributed to Louis C. Tiffany himself. It compares favorably, especially in its freely applied brushstrokes and mixed media, to two works in the Metropolitan Museum of Art by Tiffany: a nocturnal tropical scene with palm trees, in watercolor and gouache on paper; and an exotic flower, in oil on canvas.[10] The Society's dramatic tropical sunset scene, framed by architectural components in the Egyptian Revival style, is painted with an intensely bright palette. These eclectic elements pay tribute to Tiffany's early travels to North Africa, where he became obsessed with pattern, light, and color, and to his enduring fascination with the Orient and nature. The Egyptianizing elements suggest that the watercolor dates either after his trip up the Nile in 1908 or more likely from about 1923, after Howard Carter opened the tomb of the Egyptian pharaoh Tutankhamun at Luxor, Egypt. Thereafter Egyptian motifs, like the winged sun disk in the upper section of this window design, became the vogue. Another undated but later Tiffany Studios window design for a mausoleum features sphinxes and pyramids.[11] The landscape of the Society's watercolor also resembles scenes Tiffany may have encountered in Florida. Tiffany Studios produced a number of windows with palm trees, such as one of the New Jerusalem windows in the Judson Memorial, May Memorial Church, Syracuse, New York (1903).[12]

It is not known whether this tropical sunset window designed by Tiffany was ever fabricated; the absence of Tiffany's signature of approval on its presentation mount argues that is was not. Following clues contained in the inscriptions on this mount, research has shown that the Carnegie Hall Building, its intended location, is an eleven-story structure at 1200–1220 Huron Road Mall in downtown Cleveland, today known as Playhouse Square Plaza. According to a 1929 city directory, the building housed offices for the Cleveland Church Bureau, the School of Popular Music, the Classical Arts Association, and several music and dance studios, one of which, the Bunnell Studio, is noted in the mount's inscription. Documents in the files of the Ohio Historic Preservation Office of the Ohio Historical Society date the eclectic Beaux-Arts building to about 1920. Other records in the same office suggest that the Creswell Parking Garage, built by William S. Ferguson about 1905, was renovated about 1920 to become the Carnegie Hall Building. The date of the building argues that Tiffany's stained-glass window design most likely dates from after the discovery of "King Tut's Tomb." If the window was produced and installed, it does not remain in the structure, whose interior was most recently renovated in 1984, nor is its construction recorded in any known document.

1. Duncan 1992, 56.
2. Ibid., 57, discusses some of the most important: Joseph Lauber, Will Hicok Low, Jacob Adolphus Holzer, Edward Peck Sperry, Wilson, and Northrop, the latter joining the women's work force in the glass department in 1884. She became the principal designer after Tiffany of nonfigural landscape and floral window compositions. For other women, including Clara Driscoll, see Martin Eidelberg, Nina Gray, and Margaret K. Hofer, *A New Light on Tiffany: Clara Driscoll and the Tiffany Girls*, exh. cat. (New York: New-York Historical Society, in association with D Giles Limited, London, 2007).
3. For the Carolina Parakeet window taken from Audubon's *The Birds of America* and a tea screen with the same motif Tiffany showed at the International Exposition held in 1915 in San Francisco, see Loring 2002, 176–77, ills.
4. Robert Koch, *Louis C. Tiffany, Rebel in Glass* (New York: Crown Publishers, 1966), 109, notes that Tiffany signed the mats of two of the watercolors reproduced in his book.
5. Ibid., 70. Koch notes that the 1910 *A Partial List of Windows* (copy in the Boston Public Library) has 119 pages of lists; see also idem, "The Stained Glass Decades: A Study of Louis Comfort Tiffany (1848–1933)," 2 vols. (Ph.D. diss., Yale University, 1957).
6. Alastair Duncan, *Tiffany Windows* (New York: Simon and Schuster, 1980), 35.
7. The other two watercolors of Tiffany stained-glass window designs are inv. nos. N84.141 and N84.142; for the latter and its correct attribution to Northrop, see Gray 2005, 196–97, pl. VI.
8. Unlike the case for Tiffany & Co, no archive survives for Tiffany Studios, whose contents were dispersed and destroyed.
9. Inv. no. 67.654.230, in a similar presentation mount.
10. Inv. nos. 67.654.28 and 67.654.112, respectively. Alice Cooney Frelinghuysen, verbal communication, 18 August 2005, agrees with the attribution. I am most grateful to her for generously allowing me to study the extensive unpublished Tiffany collection of watercolors and paintings in the Metropolitan Museum of Art, which is the subject of a future exhibition that she is curating and for which she is writing the catalogue.
11. Inv. no. 67.654.280, in the Metropolitan Museum of Art.
12. For other windows with tropical scenes, see Duncan 1980, pls. 39, 44, 45, 50, 86.

CHESLEY BONESTELL

San Francisco, California 1888–Carmel, California 1986

Initially trained as an architect, Chesley Bonestell developed an intense interest in astronomy, illustration, and painting early in his career. He took night classes at the Hopkins Art Institute in San Francisco between 1904 and 1907, producing several illustrations that were featured in *Sunset Magazine* before enrolling in the architectural design program at Columbia College in New York City. Bonestell began to work for the San Francisco architectural firm of Willis Polk in 1910 and eventually became its chief design engineer. He left the firm in 1918 and traveled between California, London, and New York, working on a variety of architectural jobs before settling in Berkeley, California, in 1931. The following year Bonestell provided isometric designs for sections of the Golden Gate Bridge but soon turned his creative energy to the dynamic emergent field of motion picture set and scenery design. He became a celebrated special effects and set designer, contributing to such films as *Citizen Kane* (1941), *How Green Was My Valley* (1941), *The Magnificent Ambersons* (1942), *When Worlds Collide* (1951), and *War of the Worlds* (1953).

During his years working for the film industry Bonestell began to concentrate on depicting fantastic views of other worlds and projections of the future. He produced vivid, detailed scenes that envisioned space exploration, distant planets, and astronomical formations such as galaxies when actual space science was in its infancy. Bonestell's first book of space art, *Conquest of Space* (1949), with text written by the German astronomer Willy Ley, is presently considered a classic. Over the next two decades, he published more than ten collections of space art images, including such cult classics as *The Conquest of the Moon* (1953), *The Exploration of Mars* (1956), *Beyond the Solar System* (1964), and *Beyond Jupiter* (1972). His fantasy worlds also appeared in films, including *Destination Moon* (1950) and *Flight to Mars* (1951), as well as in many magazine articles for *Life* (1944–46) and *Collier's* (1950–54).

Bonestell's illustrations and spacecraft designs were also incorporated into games, television shows, jigsaw puzzles, and toys, bringing his vision to millions of people. Many consider his masterwork the forty-foot mural of the lunar surface titled *A Panorama on the Moon* (1956–57), commissioned for the Hayden Planetarium at the Museum of Science in Boston (now in the collection of the Smithsonian

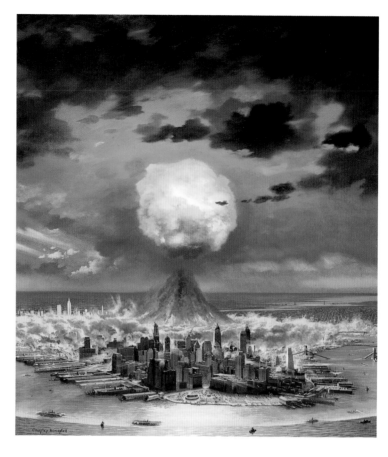

Fig. 138.1. Chesley Bonestell, *Atom Bomb Hits New York City*, 1950. Oil on paper, laid on board, 21 1/2 × 18 in. (546 × 457 mm). The New-York Historical Society, Gift of Chesley Bonestell, 1956.7

National Air and Space Museum). Among aficionados of vintage science fiction Bonestell holds cult-figure status. His pioneering contribution to the art of the science fiction and fantasy genre has been officially recognized by the Association of Science Fiction & Fantasy Artists, whose peer achievement awards are now called the Chesley Awards.

Bibliography: Chesley Bonestell, *Beyond Jupiter: The Worlds of Tomorrow* (Boston: Little, Brown and Company, 1972); Koke 1982, 1:69–72; David A. Harvey, *Visions of Space: Artists Journey through the Cosmos* (Limpsfield, England: Paper Tiger, 1989), 13–15, 34–35, 70–71; Frederick I. Ordway III and Randy Liebermann, *Blueprint for Space: Science Fiction to Science Fact* (Washington, D.C.: Smithsonian Institution Press, 1992); Vincent DiFate, *Infinite Worlds: The Fantastic Visions of Science Fiction Art* (New York: Penguin Studio, 1997), 5–6, 41–47, 124–27; Melvin Schuetz, *A Chesley Bonestell Space Art Chronology* (Parkland, Fla.: Universal Publishers, 1999); Ron Miller and Frederick C. Durant III, with Melvin Schuetz, *The Art of Chesley Bonestell* (London: Paper Tiger, 2001); Reed 2001, 263.

138. *Atom Bombing of New York City*, 1950

Oil on paper, laid on masonite; 17 3/8 × 32 3/4 in. (441 × 832 mm)
Signed at lower left in oil: *Chesley Bonestell*
Provenance: Chesley Bonestell.
Bibliography: Koke 1982, 1:69–70, no. 176, ill.; John Lear, "Hiroshima U.S.A., Can Anything Be Done about It?" *Collier's* 126:6 (5 August 1950): 11–15, 60, 12–13, ill.; Miller and Durant 2001, 176–77 ill. as in *Collier's*.
Gift of Chesley Bonestell, 1956.8

During the highly charged atmosphere of Cold War America in the 1950s Bonestell created the five haunting and disturbing scenes of worldwide atomic devastation for *Collier's* magazine, now in the collection of the N-YHS. In 1950 and 1951 *Collier's* commissioned Bonestell to give form to the fears of Americans with his illustrations of nuclear destruction, first for an article by John Lear called "Hiroshima U.S.A., Can Anything Be Done about It?" and the following year for "Washington under the Bomb" and "A-Bomb Mission to Moscow."[1]

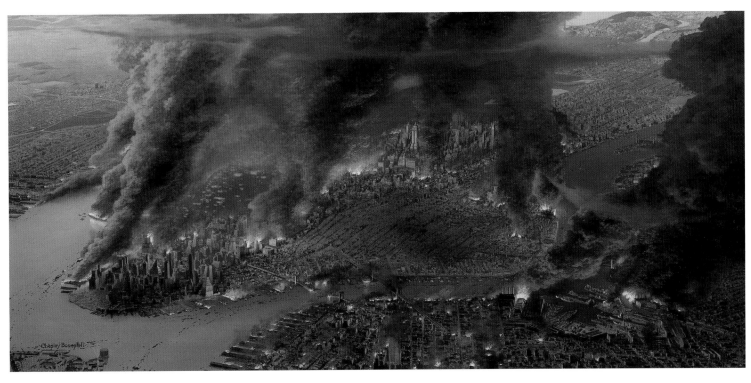

138

In this image, Manhattan and its boroughs have been turned into scenes of conflagration after being struck by an atomic bomb. Bonestell envisioned the development of lower Manhattan with remarkable foresight; his skyscrapers create a skyline surprisingly similar to the one that was constructed during the 1960s. Smoke billows from fires in many buildings and on streets and piers; the center span of the Brooklyn Bridge has collapsed into the East River. The Hudson River shore of New Jersey burns, as do parts of Brooklyn and Queens. Retrospectively, Bonestell's apocalyptic images appear all the more disturbing by their similarity to the attacks of 11 September 2001. His vision of smoke enveloping portions of the bombed-out Battery, obscuring it from view, is startlingly close to scenes of the actual attacks; see, for example, Donna Levinstone's dusky pastel *Eternal Rest* (cat. 147). The caption for the picture in the 1950 article read: "A cloud of black grime masked the lower city ... Where 100,000 people had lived—in an area roughly fifteen blocks long and twenty across—there was now an ugly brown-red scar Beyond the rim of the scar, thousands of fires were lighted."[2]

A related study was used for the cover of the 5 August 1950 *Collier's* (fig. 138.1),[3] which shows a mushroom cloud from an atomic blast forming over midtown New York. In it the skyscrapers of the Battery stand starkly in front of the flattened city center as a shock wave emanates from the blast zone.

Bonestell's troubling visions of future war gave form to the fears of the Cold War generation. He hoped his scenes of potential disaster would deter the war hawks of the succeeding decades. Bonestell died in 1986, before the terrorist attacks of 2001 that turned his cautionary vision into a devastating reality.
A. M.

1. Lear 1950, 11–15; the Washington and Moscow scenes were used for articles that appeared in *Collier's* on 27 October 1951; Koke 1982, 1:71, nos. 177, ill., and 178. The fifth scene, *The H Bomb Hits Lower New York*, was published in the Sunday newspaper supplement *This Week*, for the article by Ralph E. Flanders, "The Sword and the Bible," 21 October 1951; Koke 1982, 1:71–72, no. 179, ill.
2. Lear 1950, 12–13, caption.
3. Inv. no. 1956.7; see Lear 1950, cover ill.; and Koke 1982, 1:69–70, no. 175, ill.

UNIDENTIFIED ARTIST*

Active c. 1890

139

Although the artist who drew this group—probably representing reporters from various newspapers assigned to cover the police department in New York City—has not been identified, the drawing's reportorial style suggests the hand of a newspaper illustrator.

139. *Group Portrait of Jacob August Riis (1849–1914) and Five Men*, c. 1890

Black crayon on beige board; 13 1/2 × 10 15/16 in. (343 × 278 mm)

Verso inscribed at center in graphite: *Jacob Riis, lower left, / with hand in vest, at time / when he was a N.Y. police / reporter and at time of publication / of his 'How the Other Half Lives.' / artist unknown.*
Provenance: Baroness Alma Dahlerup, president of the Danish-American Women's Association of New York. Gift of Baroness Alma Dahlerup, 1957.78

This composition in crayon of six men before a building depicts the reporter Jacob Riis at the time his seminal pictorial essay, *How the Other Half Lives: Studies among the Tenements of New York* (1890), was published.[1] He stands at lower left, wearing

spectacles and a jaunty cap, his hand tucked into his vest in a rhetorical pose. Even in this sketchy portrayal, Riis can be identified by his slim, angular face, slight build, and distinctive oval-framed eyeglasses, the style he wore throughout his life. The group of men with Riis were probably fellow police reporters, journalists, and photographers assigned by their various newspaper employers near the police station to report on crime.

Born in Ribe, Denmark, Riis immigrated to America in 1870. Trained as a carpenter, he was taught English by his father, a teacher who also

exposed him to American literature, particularly James Fenimore Cooper's tales of the Wild West from which he formed images of America as a land of bison herds, beaver dams, and Indian ambushes.[2] When he arrived in New York City, Riis was distressed to find a burgeoning metropolis rather than virgin wilderness and soon discovered that his first purchase in America, a revolver pistol, was less useful than his carpenter's hammer and saw. He was forced to travel in search of work, eventually finding manual labor in the coal mines of western Pennsylvania and in the brickyards of southern New Jersey.[3]

After several years of extreme poverty, struggle, and even homelessness, Riis finally found regular employment in 1877 as a reporter and photographer for the *New York Tribune*. His experiences reporting on crime in the slums over the next decade inspired him to join the reformers then crusading for better living conditions for the impoverished immigrants flocking to New York. Riis was spurred on by his perceptions of the injustice, exploitation, and relentless despair of what he termed the "cheerless lives"[4] of the urban poor. In 1889 *Scribner's Magazine* published an article by Riis that became the foundation of his most important and galvanizing photographic essay, *How the Other Half Lives*, a pivotal work that precipitated much-needed reforms and brought him national attention, securing his reputation as a primary figure in the history of documentary photography.[5]

Riis met Theodore Roosevelt, then president of the New York City Police Board, in 1895 and soon gained his admiration and support. Roosevelt offered him several government administrative positions both in New York and later in Washington, D.C., which Riis turned down to continue his reform crusade at the local level, where he was able to implement tangible, practical improvements. Roosevelt wrote in 1901 that he agreed with reformers who viewed Riis as perhaps "the most useful citizen of New York."[6] In a 1914 memorial, Roosevelt claimed: "if I were asked to name a fellowman who came the nearest to being the ideal American citizen, I should name Jacob Riis."[7]

Riis employed a blend of sentimental but honest reporting and unapologetically visceral photography to motivate action in the reform movements, making him a contemporary icon of both journalism and social reform. His words and images prompted changes in urban infrastructures, from providing access to clean water to the construction of sewers, settlement houses, parks, and housing projects. Soon after the appearance of *How the Other Half Lives*, when the Society's portrait was drawn, Riis left the *Tribune* for the New York *Evening Sun*. His success and fame earned him the moniker "boss reporter" from the other (even rival) newsmen and may explain his prominent position in the left foreground of the group.[8] Riis continued his work until his death in 1914, producing books that highlighted the plight of the poor, children, immigrants, and slum dwellers, including the photographic social reform exposés *Out of Mulberry Street: Stories of Tenement Life in New York City*, *The Battle with the Slum*, and *Children of the Tenements*.[9]

A. M.

* Unidentified Artist 114

1. Jacob A. Riis, *How the Other Half Lives: Studies among the Tenements of New York* (New York: Charles Scribner's Sons, 1890); see also Jacob Riis, *The Making of an American* (1901; reprint, London: Collier-Macmillan, 1970).

2. Edith Patterson Meyer, *"Not Charity, but Justice": The Story of Jacob A. Riis* (New York: Vanguard Press, 1974), 1–2.

3. Ibid., 3–5.

4. Ibid., 53.

5. Ibid., 55.

6. Theodore Roosevelt, "Reform through Social Work: Some Forces That Tell for Decency in New York City," *McClure's* 16:5 (1901): 453.

7. Theodore Roosevelt, "Memorial," *Outlook* (6 June 1914), and a similar statement in idem, *Theodore Roosevelt: An Autobiography* (New York: Macmillan Company, 1913), 70.

8. Meyer 1974, 60–62.

9. *Out of Mulberry Street: Stories of Tenement Life in New York City* (New York: Century Co., 1898); *The Battle with the Slum* (New York and London: Macmillan Company, 1902); and *Children of the Tenements* (New York: Macmillan Company, 1905). See also Alexander Alland, *Jacob A. Riis: Photographer and Citizen* (Millerton, N.Y.: Aperture Books, 1974; reprint, 1993).

LIONEL SAMSON REISS

Jaroslaw, Poland 1894–New York, New York 1988

The painter, printmaker, and watercolorist Lionel S. Reiss began his career, like so many American artists, as a designer and illustrator. He also held executive positions as an art director in the advertising field and created, among other concepts, the MGM Lion logo.

Born in the Austro-Polish province of Galicia, Reiss came to the United States with his family in 1899 and settled in the Lower East Side of New York City, as did Raphael Soyer (cat. 142) and Jerome Myers (cat. 132). He studied at the Art Students League under George Bellows and worked as an illustrator for Universal Pictures. In 1917 he began working as an artist for the War Information Bureau, becoming an American citizen in 1920, and continued freelancing with a variety of publishers and lithographers. From 1918 to 1921 Reiss served as an art director for the Goldwyn Picture Corporation. In the early 1920s he left New York to travel through eastern Europe, North Africa, and the Near East in order to create a visual record of the Jewish people. Upon his return to New York in 1926, Reiss held the position of art director for the advertising agency Hanf-Metzinger.

In 1930 Reiss made the career-altering decision to leave his lucrative position in commercial illustration and to devote his time to fine art. To that end, he closed his New York studio and traveled in search of subjects for his pictorial record of Jewish ghetto life. His portfolios of drawings formed the basis for three books, the last being *A World of Twilight* (1971). Sensing that the traditions of Jewish culture were in jeopardy of being lost, his work documents Jewish life in the *shtetl*. In all his work the artist focused on class distinctions and the socioeconomic status of his subjects. Reiss also won recognition for his paintings of the American urban scene.

Among Reiss's single-person exhibitions was a 1939 watercolor show at the Midtown Galleries in New York. It featured bucolic landscapes and still lifes, many of which were set in Bucks County, Pennsylvania, where the artist had lived for five years. In 1938 Reiss moved back to New York and two years later set up a studio at 206 East Fifty-ninth Street, where he began recording scenes of that midtown thoroughfare. In 1940 his work exhibited at the Museum of Modern Art was judged the best in the category "Artist as Reporter." Thirty-seven of his watercolors and paintings of New York life were shown in 1946 at the Associated Artists Galleries as "Manhattan Cross-town," some of which are in the Society's collection.

His other later subjects include seascapes and fishing scenes of Gloucester, Massachusetts; a series of watercolors that conveyed his personal reaction to the Holocaust; a series of ink drawings that illustrated the poetry of Hayim Nahman Bialik; and, finally, a group of murals entitled *Genesis*, depicting biblical scenes. Reiss worked on these murals for more than twenty years, until he was ninety-two years old.

Reiss's work has been included in numerous exhibitions in American museums, such as the Whitney Museum of American Art, the Museum of Modern Art, the Art Institute of Chicago, and the NAD. His works are found in the permanent collections of Brandeis University, Columbia University, the Jewish Museum of the Jewish Theological Seminary, the Jewish Museum, Park Avenue Synagogue, the Reiss Art Collection of the Judaica Division of the Widener Library at Harvard University, the Sinai Center of Chicago, the Brooklyn Museum, and in Israel at the Bezalel Museum in Jerusalem and the Tel Aviv Museum, among others. The N-YHS lists ninety-five works by Reiss in its database, including four oil paintings (*Rain on 59th Street, New York City*, c. 1946, among them) and ninety-one watercolor and wash drawings, many of them in two series mounted in albums: the seventy-five monochrome wash "59th Street Drawings" and the twelve watercolors from "Manhattan Cross-town," both dating from about 1945–46.

Bibliography: *The Works of Lionel S. Reiss*, exh. pamphlet (n.p., 1924); Lionel S. Reiss, *My Models Were Jews: A Painter's Pilgrimage to Many Lands; A Selection of One Hundred and Seventy-eight Paintings, Drawings, and Etchings by Lionel S. Reiss* (New York: Gordon Press, 1938); "Lionel Reiss Judged Best 'Artist as Reporter' in PM Competition," *Art Digest* 14:16 (1940): 24; Associated American Artists Galleries, *Lionel Reiss: Manhattan Crosstown*, sale cat. (New York: Associated American Artists Galleries, 1946); Lionel Reiss, *New Lights and Old Shadows: New Lights of an Israel Reborn, Old Shadows of a Vanished World; A Selection of Two Hundred and Ten Paintings, Watercolors, Drawings, and Etchings by Lionel S. Reiss* (New York: Reconstuctionist Press, 1954); Peter Hastings Falk, ed., *The Annual Exhibition Record of the National Academy of Design, 1901–1950* (Madison, Conn.: Sound View Press, 1990), 436; Cheryl Chase Slutzky, "Two Reconstructionist Artists, Rediscovered," *Reconstructionism Today* 10:3 (2003): 3–5; idem, *To Follow in the Footsteps of the Wandering Jew: The Art of Lionel S. Reiss* (Cambridge, Mass.: Harvard College Library, Judaica Division, forthcoming).

140. *Going Home (Near Bloomingdale's at the 59th Street Elevated Station), New York City*, c. 1946

Watercolor, gouache, black ink, and graphite on watercolor paper, laid on board; 19 × 25 5/8 in. (482 × 650 mm)
Signed at lower left in black ink: *Lionel S. Reiss*
Provenance: Purchased from the artist.
Bibliography: M. B. "One World in One Street," *New York Times Magazine*, 19 May 1946, 22, ill.; Associated American Artists Galleries 1946, no. 27, ill.; Koke 1982, 3:84–85, no. 2367, ill.
Foster-Jarvis Fund, and contribution of Henry Goldberg, 1976.11

In this large watercolor Reiss shows tired workers—shopgirls from the department store Bloomingdale's, laborers, businessmen, and mothers and children—as they climb the stairs to the Third Avenue Elevated station at Fifty-ninth Street in a style clearly linked to the Social Realism of Reginald Marsh. Elevated trains, the earliest form of rapid transit in the United States, were developed in New York City in the last half of the nineteenth century. The Third Avenue El opened in 1878 with steam engines and was electrified with all the city's Els between 1900 and 1904. It last ran on 2 September 1975, making Reiss's watercolor a time capsule documenting a nostalgic memory of lost New York.[1]

With his studio on East Fifty-ninth Street, Reiss was an inhabitant of the lively East Side neighborhood animated with the traffic to and from the Fifty-ninth Street Bridge and Bloomingdale's. He recorded its denizens from all walks of life, social strata, and races with much compassion and not without a sense of humor. Some of the seventy-five monochrome wash drawings in his "59th Street Drawings" are in the tradition of the occupational "Cries" depicted by Nicolino Calyo in the early nineteenth century (cat. 58) and also have similarities to illustrations in the *New Yorker*.

This large watercolor is related to Reiss's smaller ones collected in the album "Manhattan Crosstown" and was shown with them in an exhibition of the same title in 1946 at the Associated Artists Galleries. The series title refers to the east-west axis of Fifty-ninth Street. A contemporary, anonymous critic stated that it

140

was painted in the "language New Yorkese of the Sloan school."[2] In this and other series, the artist captured the honky-tonk atmosphere of post–World War II New York in a latter-day Ashcan School style. He also featured city monuments and destination places—from the Queensboro Bridge to the Plaza Auction Galleries at 9 East Fifty-ninth Street—as well as the permanent and temporary inhabitants of the metropolis, among them cabbies, traffic cops, derelicts, soldiers and sailors back from duty, socialites, doormen, and children. In the process he recorded elements of a passing way of life, of a lost New York, among them a horse-drawn fruit and vegetable wagon and an organ grinder. Reiss affectionately depicted the

fascinating texture of the city and its pulsing crowds, from the "bookworms" who pored over tomes at Cox's Bookshop at 123 East Fifty-ninth Street to the equestrians and skaters of Central Park, the folks lunching at Rumpelmayer's— then a New York institution for midday dining—the Plaza Hotel, a pet shop, a ballgame, a dice game on a roof, and, as in this work, the pedestrian traffic around the shopping magnet of Bloomingdale's, established in 1872.[3]

1. For the El, see Joseph Cunningham and Leonard O. Dettart, *A History of the New York City Subway System* (New York?: Cunningham, c. 1976–77); Brian J. Cudahy, *The New York Subway: Its Construction and Equipment* (New York: Fordham University Press, 1991); and Tim McNeese, *The New York Subway System* (San Diego, Calif.: Lucent Books, 1997).

2. "Lionel Reiss," *Art News* 45:4 (1946): 50.

3. For a contemporary review, see Judith Kaye Reed, "Portrait of a Street," *Art Digest* 20:17 (1946): 17.

ENIT ZERNER KAUFMAN

Rossitz, Moravia (Rosice, Czech Republic) 1897–New York, New York 1961

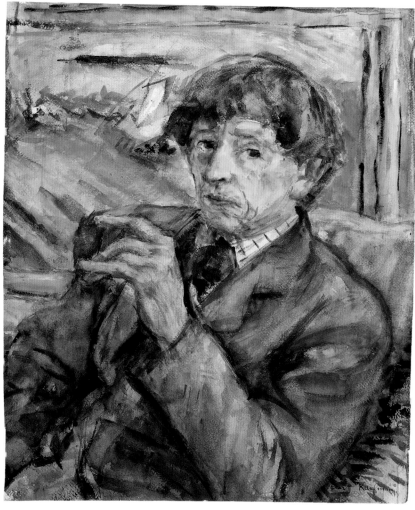

141a

Enit Zerner was born near Vienna, where she studied art at the Kunstgewerbeschule and the Akademie der Bildenden Künste, and later under the guidance of the Expressionists Oskar Kokoschka and Egon Schiele. She became a successful portrait painter in Europe, and her works were featured in several exhibitions in Paris, for example, at the Gallery Tedesco in 1937. The artist's life was dramatically changed with the onset of World War II. She fled the turbulence of Europe and Hitler's rise in 1939 with her second husband, the lawyer Edward Kaufman, for the uncertainty of a new life in the United States. She quickly became a United States citizen and restarted her career, teaching art at City College of New York and working to rebuild her reputation as a portraitist.

Not long after her arrival, she told the prolific writer Dorothy Canfield Fisher, "I wanted to see the faces of American men and women who have in the last decades made this nation what it is." Between 1940 and 1945 the artist created a group of portraits not on commission but for her own collection. In 1946 Kaufman and Fisher collaborated on *American Portraits*, a selection of sixty-eight illustrations by Kaufman that accompany biographical sketches by Fisher. Kaufman's participation in the book grew out of her experience as a painter of prominent figures and as a refugee from a region whose leadership had gone astray. The authors were interested in probing the nature of leadership and asked many of their subjects to write down their thoughts on the topic. Kaufman and Fisher initially considered incorporating these responses into *American Portraits*; instead, these "Statements of Leadership" were featured in a piece by Fisher published in a Sunday edition of the *New York Times* in 1951. Kaufman chose subjects for the book according to her assessment of their social importance and their contributions to the character of the United States, a nation that for her embodied freedom and opportunity. As had been the case in Europe, many of her sitters, whom she painted from life, were distinguished figures in government, education, and the arts.

By the end of her career, Kaufman had the distinction of painting four American presidents—Herbert Hoover, Franklin D. Roosevelt, Harry S. Truman, and Dwight D. Eisenhower— and numerous other memorable individuals, such as the poets Carl Sandburg and Robert Frost, the singer Marian Anderson, the actress Helen

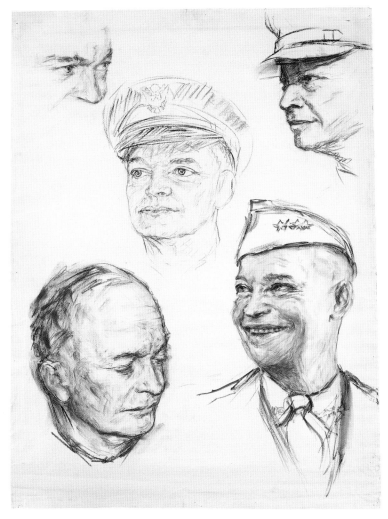

141b

Hayes, the architect Frank Lloyd Wright, the labor leader Philip Murray, the artists Thomas Hart Benton and Georgia O'Keeffe, and Secretary of State Cordell Hull. Her work was featured in exhibitions at the National Museum of Art, Smithsonian Institution, in Washington, D.C. (*The American Century*, 1944), which traveled nationally through 1946; the N-YHS (1948); and the Loeb Student Center of New York University (1964). The Society has eighty-seven portraits by Kaufman, two in oil; they form a permanent record of American culture and values in a time of political and social upheaval. The Harry Ransom Humanities Research Center at the University of Texas, Austin, holds the artist's papers, including letters and manuscripts collected by Kaufman for the publication of *American Portraits*.

Bibliography: Dorothy Canfield Fisher, "Gallery of American Leaders," *New York Times*, 24 September 1944, Magazine sec., 20–21, 46; Enit Kaufman and Dorothy Canfield Fisher, *American Portraits* (New York: Henry Holt and Company, 1946); obituary, *New York Times*, 20 January 1961, 26; Cary Cordova, "World War II America through Portraiture: Enit Kaufman's *American Portraits*," typescript, c. 2000, copy in curatorial files, The N-YHS.

141a. *John Marin (1872–1953)*, c. 1940–45

Watercolor, gouache, white tempera, and touches of charcoal on heavy watercolor paper; 22 5/16 × 18 1/8 in. (567 × 461 mm)
Signed at lower right in black ink: *Enit Kaufman*
Bibliography: Kaufman and Fisher 1946, 106–8, ill.; N-YHS 1974, 2:523, no. 1375, ill.; Cordova c. 2000.
Gift of Enit Kaufman, 1947.167

141b. *Five Studies of Dwight D. Eisenhower (1890–1969)*, c. 1942–45

Pastel, watercolor, and chalk on paper; 30 3/4 × 22 3/4 in. (781 × 578 mm)
Bibliography: Kaufman and Fisher 1946, 242–46, ill.; N-YHS 1974, 1:250–51, no. 630, ill.
Gift of Enit Kaufman, 1947.200

141c. *Marian Anderson (1897–1993)*, c. 1940–45

Watercolor, gouache, white tempera, and charcoal on heavy watercolor paper; 27 1/4 × 20 5/8 in. (692 × 524 mm)
Bibliography: Kaufman and Fisher 1946, 310–11, ill.; N-YHS 1974, 1:22–23, no. 47, ill.; N-YHS 2000, 48–49, ill.
Gift of Enit Kaufman, 1947.216

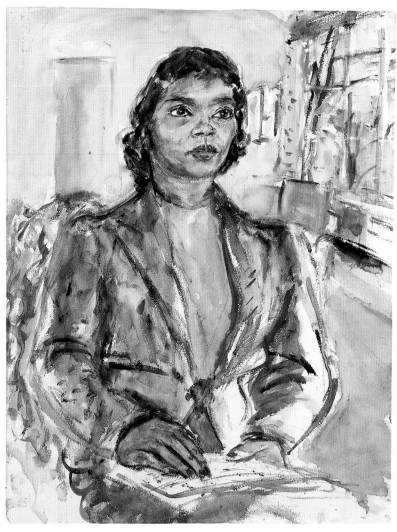

141c

These examples of Kaufman's portraiture, all reproduced in *American Portraits*, her collaborative work with Dorothy Canfield Fisher, showcase her project on portraits of American leaders in the fields of art, politics, and music, respectively.

The painter and printmaker John Marin is recognized as one of the seminal modernist American artists of the twentieth century and is particularly renowned for his expressionistic watercolor landscapes of Maine and views of Manhattan. Educated at the Pennsylvania Academy of the Fine Arts in Philadelphia and the Art Students League in New York City, he made his first significant works in the medium of etching. Many of these were cityscapes executed during his time abroad (1905–9). With the first important exhibition of his work in

1909 at 291, Alfred Stieglitz's New York gallery and pioneering center of modern art, Marin began using watercolor in a novel, dynamic, and lyrical way that emphasized his inventiveness. Kaufman portrayed Marin seated before one of his signature works.[1]

Kaufman's five studies of General Dwight David Eisenhower—later the thirty-fourth president of the United States (1953–61), who brought to the presidency his prestige as a commanding general of victorious troops during World War II—depict him as a man of action. When Kaufman made these drawings, Eisenhower was still at the front. The artist rendered several studies of the general's visage—unusually for her, based on photographs—to compensate for the lack of personal

contact. As a two-term president, Eisenhower worked to ease the tensions of the Cold War and to obtain a truce with Korea. A moderate Republican, his popularity was evident by the ubiquitous slogan "I like Ike," which emerged when he won a landslide victory in 1953. Before leaving office, he cautioned that excess military expenditures could compromise the American way of life.[2]

Kaufman's portrayal of Marian Anderson captures the calm and dignified stage presence of one of America's most distinguished contraltos. Anderson charmed audiences worldwide with her powerful voice that spanned three octaves, the full range of two normal voices, and her diverse repertoire of oratorios, lieder, arias, and Negro spirituals,

sung in nine different languages. Many African American operatic and concert singers have credited the celebrated contralto as their inspiration in seeking professional vocal careers. Supported spiritually and financially by the black community who recognized her talent, Anderson faced racism for the first time when she applied for admission to a local music school. Eventually, Anderson studied with the tenor coach Giuseppe Boghetti, performing with great success abroad. When she returned to the United States, under the management of the legendary impresario Sol Hurok, she became the country's third-highest box-office draw. On 10 April 1939, with encouragement from Eleanor Roosevelt and support from the Department of the Interior, Anderson performed in an open-air concert at the Lincoln Memorial in Washington, D.C., after the Daughters of the American Revolution refused her request to perform at its national headquarters. The event came to symbolize the struggle for racial equality in the country. The diva, who shattered racial barriers, retired in 1965 with a concert in Philadelphia.[3]

From her composure in Kaufman's portrait it would be difficult to guess that only shortly earlier she had stood at the center of a national controversy, which would change the direction of race relations in the United States.

1. See Ruth E. Fine, *John Marin*, exh. cat. (Washington, D.C.: National Gallery of Art; New York: Abbeville Press, 1990), for bibliography on the artist.
2. See Stephen E. Ambrose, *Eisenhower* (New York: Simon and Schuster, 1983).
3. See Allan Keiler, *A Singer's Journey* (New York: Scribner, 2000).

RAPHAEL SOYER

Borisoglebsk, Russia 1899–New York, New York 1987

Born into a family of Russian origin deported by the tsarist regime, Raphael Soyer and his twin brother Moses immigrated with their family, including their brother Isaac, to the United States in 1913, eventually settling in the Lower East Side of New York City. Their father, a Hebrew teacher and writer, encouraged artistic and intellectual pursuits. The twins studied painting at Cooper Union and the NAD. Raphael took classes there between 1918 and 1922 as well as at the Art Students League. Guy Pène du Bois, a teacher at the league, recognized his talent and introduced him to the dealer Charles Daniel, who gave him his first solo exhibition at the Daniel Gallery in 1929. The show was so successful that it secured Soyer's position as a professional artist and enabled him to devote much of his time to painting. Each brother also had a successful career as a teacher, Raphael instructing intermittently at the Art Students League (1933–42). As painters, the brothers were prominent in the Social Realist Fourteenth Street School that flourished in Greenwich Village during the 1930s. Deserted Manhattan streetscapes were a favorite theme of Raphael Soyer's early years, and during the Depression he executed numerous studies of unemployed men. In 1931 he married Rebecca Letz, a teacher. Her financial support rendered him ineligible for commissions from the Works Progress Administration (although later he executed a mural with Moses for the Kingsessing Post Office Station, Philadelphia).* During the same period, fellow painter Nicolai Cikovsky introduced him to the John Reed Club—a group of artists, writers, and leftists—where the topic of Social Realism was much discussed. By the mid-1930s Soyer had become a leading advocate of realism, as evidenced not only in his uninterrupted stream of oil paintings but also in watercolors, lithographs, and book illustrations. He came to believe that artists he admired and was influenced by—among them Rembrandt van Rijn, Edgar Degas, and Thomas Eakins—revealed their times by emphasizing inner character above physical beauty.

Except for a period during the Depression, Soyer executed almost all of his works in the studio. In his crowd scenes and down-and-out subjects, the faces and demeanor of his protagonists reveal the difficult times in which they lived and the human price of the Depression. Although Soyer's personal sympathies were leftist, his art remained apolitical. Like other members of the Fourteenth Street School, Soyer avoided subjects that were particularly critical of society, preferring to depict the drab anguish of individual human beings. The experience of immigrant life in the United States also provided him with a rich source of imagery, and he represented his family's middle-class Jewish life with reverence and nostalgia. Soyer portrayed his subjects with strong, flat colors, which evoke a sense of isolation. Common themes were intimate studies of solitary women, often nudes, and portraits of fellow artists. He also executed many self-portraits. Soyer's world never ceased to be poignant, peopled with men and women caught in moments of quiet self-absorption and loneliness, even if depicted in parties or in crowds. His recordings of downtown art gatherings throughout the decades present a vivid record of the New York art scene.

From the early 1960s he exhibited at the Forum Gallery in New York City and had a retrospective at the Whitney Museum of American Art in 1967. In his later years, Soyer remained a champion of realism, even at a time when Abstract Expressionism dominated the American art world.

Bibliography: Raphael Soyer, *A Painter's Pilgrimage: An Account of a Journey with Drawings by the Author* (New York: Crown Publishers, 1962); Sylvan Cole Jr., ed., *Raphael Soyer, Fifty Years of Printmaking* (New York: Da Capo Press, 1967); Lloyd Goodrich, *Raphael Soyer*, exh. cat. (New York: Published for the Whitney Museum of American Art by F. A. Praeger, 1967); Raphael Soyer, *Self-Revealment: A Memoir* (New York: Maecenas Press, 1969); Lloyd Goodrich, *Raphael Soyer* (New York: Harry N. Abrams, 1972); Raphael Soyer, *Diary of an Artist* (Washington, D.C.: New Republic Books, 1977); Raphael Soyer, oral history interview, by Milton Brown, 13 May–1 June 1981, transcribed and microfilmed by the AAA, reel 3418; Samantha Baskind, *Raphael Soyer and the Search for Modern Jewish Art* (Chapel Hill: University of North Carolina Press, 2004).

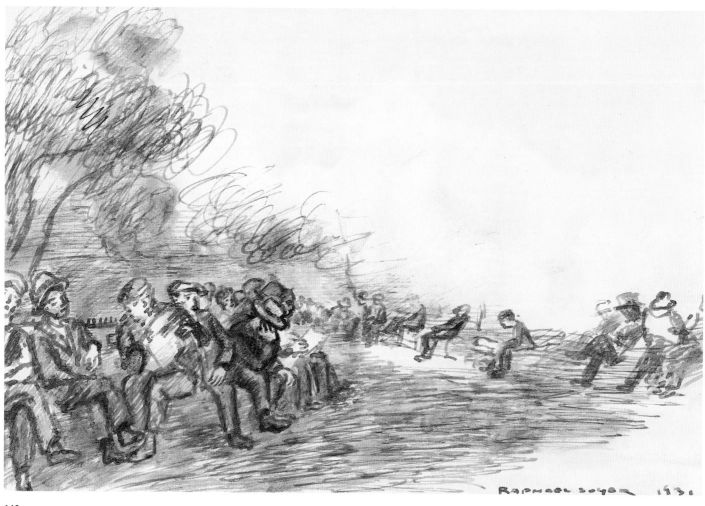

142

142. *Park Scene with Figures on Benches,* 1931

Black ink and graphite on paper, laid on board, overmatted; 6 3/4 × 9 1/2 in. (171 × 241 mm), image
Signed and dated at lower right in black ink: *RAPHAEL SOYER 1931*
Provenance: F. A. R. Gallery, New York; Mr. and Mrs. Theodore N. Newman, New York.
Gift of Mrs. Rose Newman in memory of her husband Theodore N. Newman, 1985.17

Toward the end of the 1920s and during the Great Depression, a group of painters in New York developed as the urban counterpart to the American Regionalists. Painting scenes of everyday life against the backdrop of Manhattan's rising skyline, artists in the Ashcan tradition looked to the inner city for their inspiration, but the mood of their art changed from one of celebration to desperation as they portrayed aspects of the Depression. Fourteenth Street, with its hustle and bustle, became the center for soapbox oration and community activity. The artists who lived and worked in studios in the area, among them Raphael Soyer, became known as the Fourteenth Street School. They rejected European modernism and ideal abstraction and instead rendered the pathos of the street and the underdog.

As a proponent of urban realism, Soyer was fascinated with parks and the contradiction of people being together yet remaining isolated from one another. Nowhere is this more apparent than in his canvas *In Washington Square* (c. 1935; Samuel P. Harn Museum of Art, Gainesville, Fla.).[1] In this work Soyer depicted figures seated on a park bench against a backdrop of trees. Formerly the site of this painting had been identified as Union Square Park, the same park Soyer rendered in the lithograph *Union Square* (1929–30), which dates from the same period as the Society's drawing and features the equestrian sculpture of George Washington.[2] Union Square was the park of Soyer's neighborhood, which at the time was treeless. The original design by Frederick Law Olmsted and Calvert Vaux (1871) had been destroyed in 1928 to make way for a subway concourse; in its place was a paved, treeless space that is preserved in the artist's canvas *In the City Park*, 1934.[3]

The park Soyer depicted in the Society's drawing, its walk lined with trees and curving banks of benches filled with seated anonymous figures, is unknown. By his own admission, Soyer also frequented Washington Square Park on sketching forays during the 1930s where, like his friend the artist Ben Shahn,[4] he eloquently

captured the dispiriting mood of the Depression. Soyer depicted Washington Square Park in his lithograph *Springtime*, based on his oil painting in the Samuel P. Harn Museum mentioned above.[5] Two lithographs set in Washington Square Park in 1929–30 also strongly suggest that Soyer drew the Society's sheet in that locale.[6] However, since the artist was not concerned with describing its space, the identity of its setting will probably never be definitively determined. Soyer's fascination with the urban stage of parks continued through his European trip of 1961, when he drew the denizens of public parks in both Paris and Antwerp, which he likewise never identified.[7]

The mood in the Society's drawing seems less charged with Depression sentiment than the other works mentioned above, although there are clearly individuals, such as the man at the left with his head in his hands, who are thinking heavy thoughts. In general, the Society's drawing is less polemical, a tone underlined by the presence of long shadows, which establish that Soyer sketched the scene *en plein air* in the late afternoon of a sunny day. When Milton Brown asked the artist about Social Realism in an interview in 1981, Soyer replied: "But then I

think of the people in the street. I painted people who were out of work. I mean, they just sat there, either in the sun or in the shade, and did nothing. I painted them a lot. And that too many have considered Social Realism."[8] It is probably this population that Soyer recorded in the present sheet, which embodies his artistic aim: "Realism to me is to paint the world through oneself … . Great realism consists of many elements—the abstract, the physical, the literary, the poetic, the metaphysical, the psychological … from the cabala: 'If you wish to get hold of the invisible you must penetrate as deeply as possible into the visible.'"[9]

* A cover design for the *New Yorker* by Moses Soyer and James Penney is in the Society's collection; inv. no. 2006.18.9 (*Life Study of Ballet Class*, 1934–35, in oil on ivory paper, 12 × 14 1/8 in., irregular).

1. Inv. no. 1996.2; see Goodrich 1972, 82, ill., for its earlier title, *In City Park*, and a date of c. 1934.

2. For the Fourteenth Street neighborhood and Union Square and the depiction of women that frequented it, see Ellen Wiley Todd, "Gender, Occupation and Class in Paintings by the Fourteenth Street School, 1935–40" (Ph.D. diss., Stanford University, 1987). For recent pictures of Union Square, see Stanley I. Grand et al., *Between Heaven and Hell: Union Square*

in the 1930s, exh. cat. (Wilkes-Barre, Pa.: Sordoni Art Gallery, Wilkes University, 1996). See also Kenneth T. Jackson, ed., *The Encyclopedia of New York City* (New Haven: Yale University Press; New York: New-York Historical Society, 1995), 1211.

3. See Goodrich 1967, 34, 76, no. 21, ill., then in the collection of the Forum Gallery, New York.

4. For a photograph of Ben Shahn in 1933–34 seated on a bench similar to those in the Society's drawing, see Bruce Weber, *Homage to the Square: Picturing Washington Square, 1890–1965*, exh. cat. (New York: Berry-Hill Galleries, 2001), 73, fig. 25.

5. See ibid., 72, fig. 24. Weber notes that in the 1930s Union Square Park inspired more politically inclined pictures than Washington Square. For Washington Square, see also Jackson 1995, 1243.

6. See Cole 1967, nos. 17 (with similar bench sitters and trees) and 18, ills.

7. See Soyer 1962, 93, 95, 127, ills.

8. Brown 1981, 40.

9. Quoted in Patricia Hills, *Raphael Soyer's New York: People and Places*, exh. cat. (New York: Cooper Union, 1984), n.p. For more information on the artist, see the Raphael Soyer Papers, 1899–1987, AAA, reels N68–1, 867–68, 4888–90.

JON CORBINO
Vittoria, Sicily, Italy 1905–Sarasota, Florida 1964

Born on the island of Sicily and brought to the United States at the age of eight, Jon Corbino was a New York City artist. He attended the Ethical Culture School and the Art Students League, as well as the Pennsylvania Academy of the Fine Arts in Philadelphia. He exhibited widely and won numerous honors and prizes, among them Guggenheim Fellowships (1936–38), prizes at the NAD and the Pennsylvania Academy of the Fine Arts, and election as an associate (1938) and academician (1940) of the NAD. In 1941 he received the first grant awarded a visual artist from the National Institute of Arts and Letters, which the poet Stephen Vincent Benet presented at Carnegie Hall. Corbino's work was also featured in three Venice Biennales.

Corbino was known for his heroic themes embodying the anxieties of America. He

depicted disasters such as wars and floods—for example, *Rebellion* (1936; Museum of Art, Carnegie Institute, Pittsburgh) and *Ohio Flood* (1937; Montclair Art Museum, Montclair, N.J.)—which were in effect tributes to the perseverance of individuals against unknown forces and the will to survive. He was admired for his skillful draftsmanship and his brilliant, often smoldering colors, and celebrated for his love of horses. He frequently painted these powerful animals as mythic symbols of cosmic forces drawn from Greek legends or literature, like *Study for "Horsemen of the Apocalypse"* (1945; Hofstra Museum, Hofstra University, Hempstead, N.Y.). The fantasy of the circus and the ballet worlds also fascinated him, as can be seen in *Circus Tightrope Walkers* (1957; The Parrish Art Museum, Southampton, N.Y.), and he frequently painted

backstage scenes, capturing performers in reflective moments. His art was influenced by his study of such old masters as Michelangelo Buonarotti and Peter Paul Rubens, but it was artists of the Venetian sixteenth century—Tintoretto, Paolo Veronese, Titian, and Jacopo Bassano—who left the most profound impression on his art. In response to trends of the times, about 1944 Corbino began to paint with a freer brushstroke and to forge a more abstract style, although he never relinquished representational images as did Jackson Pollock. Corbino also worked as a sculptor and ceramist.

Works by Corbino are in numerous museums across the country, such as the Metropolitan Museum of Art, the Whitney Museum of American Art, and the Brooklyn Museum in New York; the Art Institute of

143

Chicago; the Portland Museum of Art in Oregon; and the Walker Art Center in Minneapolis. In 1987 an exhibition of his work at the Museum of Fine Arts, St. Petersburg, Florida, and the Hickory Museum of Art, Hickory, North Carolina, was accompanied by a substantial catalogue.

Bibliography: Marcia Corbino and Diane Lesko, *Jon Corbino: An Heroic Vision*, exh. cat. (St. Petersburg, Fla.: Museum of Fine Arts, 1987).

Fig. 143.1. Jon Corbino, *"Carmen Jones,"* 1944. Oil on canvas, 19 1/2 × 24 in. (496 × 610 mm). The New-York Historical Society, Gift of the Estate of Laurie Vance Johnson and Edward Dudley Hume Johnson, 2001.102

143. *Study for "Carmen Jones,"* 1944

Watercolor and graphite on paper; 5 × 6 3/4 in. (127 × 171 mm), irregular
Inscribed and signed at bottom in green watercolor:
…[illegible] *Carmen Jones Happy Easter! Corbino*
Provenance: Kleeman Galleries, New York; Laurie Vance and E. D. H. Johnson, Princeton, N.J.
Gift of the Estate of Laurie Vance Johnson and Edward Dudley Hume Johnson, 2001.104

Corbino's small but bold watercolor is the study for his canvas *"Carmen Jones"* (fig. 143.1).[1] A third related work by Corbino in the collection with the same provenance is a study of a single female dancer (*Dancing Figure*).[2]

The musical *Carmen Jones*, first performed in 1943, is a modern interpretation of the well-known opera *Carmen* (libretto by Henri Meilhac and Ludovic Halévy and music by Georges Bizet), adapted from Prosper Mérimée's scandalous 1847 novel. With its book and lyrics by Oscar Hammerstein II, the musical moves the

story of Carmen from a cigarette factory in Spain to a parachute factory in the United States and employs black dialect. By modernizing the plot and locale and converting its Spaniards into American blacks, Hammerstein invested *Carmen* with contemporary pertinence. *Time* magazine reported that the play "Turns the opera 'Carmen' into the most brilliant show on Broadway." Otto Preminger directed the all-black cast of the 1954 movie, which won the Golden Globe for Best Motion Picture and featured Harry Belafonte and Dorothy Dandridge in the starring roles.

Corbino's exuberant watercolor study and canvas are wonderful examples of cultural crossover and transformation. They have that quintessential "Only in New York" quality, wherein a quotation from the past serves a very modern, very American theme with New York City references. Rather than documenting the

theatrical production by illustrating a scene in the play, Corbino took the theme as a springboard to create his dynamic interpretation of the movement and power behind music, dance, and black culture. In a similar manner Pablo Picasso had used the Parisian ballet *Parade* as the starting point to explore Cubist space. The drawing is more closely connected to the figures on the stage in the theatrical production than is the painting, which walks a tightrope between Surrealism and Expressionism. Both the oil and watercolor flirt with abstraction and share much in common with the styles of his contemporaries like Pollock and Arshile Gorky.[3] Like early Pollock, Corbino was strongly influenced by jazz. The action-oriented lines and passionate palette in these two works, while reminiscent of early Abstract Expressionism, when artists still included some representational images, are more directly linked to jazz rhythms than any of Pollock's works.

1. The artist gave the signed painting to his friends E. D. H. and Laurie Vance Johnson. E. D. H. Johnson, who was Holmes Professor of Belles Lettres at Princeton University, and Corbino attended a performance of *Carmen Jones* in New York in 1944.
2. Inv. no. 2001.103, in black ink and watercolor over graphite on paper coated with albumen glazing, laid on board, 6 1/2 × 4 5/8 in. Inscribed at lower left in brown watercolor: *To Dudley from all of us*; signed below in black ink: *Corbino 44*. Its original frame, like that of the present drawing, also had a label on the backing of its frame from Kleeman Galleries. Corbino exhibited at the Kleeman Galleries in the month of January in 1944, 1945 (when these two works were probably shown), and 1947; see Corbino and Lesko 1987, 120.
3. The years 1944 and 1945 were pivotal for Corbino's stylistic development. See, for example, *Moonlight* of 1944; ibid., fig. 46 and pl. 10.

RICHARD WELLING

Hartford, Connecticut 1926–

Richard Welling was born and still lives in Hartford, Connecticut. He studied at the Yale School of Fine Arts and at the Parsons School of Design, New York, from which he graduated in 1949. For seven years he was assistant art director at the Charles Brunelle Company in Hartford. A freelance designer since 1957, Welling has participated in exhibitions at Trinity College, the National Arts Club of New York City, the Connecticut Academy of Fine Arts, and the Connecticut Watercolor Society. No stranger to executing multiple-view "portraits" of buildings, he rendered a series of fifty drawings commissioned by the Hartford National Bank to document the construction of its new building, and another series of one hundred drawings of the new Travelers Insurance Company Building while under construction in downtown Hartford. In addition, he has drawn the New York skyline, which he adapted into a series of prints. The artist continues to draw the skyline of Hartford and to exhibit his work.

Welling is also the author of two books about his drawing specialty: *The Technique of*

Drawing Buildings (1971) and *Drawing with Markers* (1974), which has sold more than nineteen thousand copies in five editions. He has also taught (at the Wadsworth Atheneum, among other institutions) and has been a member of the Connecticut Academy of Fine Arts and of the Salmagundi Club of New York.

Bibliography: Richard Welling, *The Technique of Drawing Buildings* (New York: Watson-Guptill Publications, 1971); idem, *Drawing with Markers* (New York: Watson-Guptill Publications; London: Pitman Publishing, 1974).

144. *World Trade Center Construction Site: Triptych Panorama Including the North (74 Stories) and South Towers (26 Stories) Under Construction*, 1970

Black felt-tip pen on three sheets of paper; each 23 1/2 × 17 7/8 in. (597 × 454 mm), irregular
Right sheet signed and dated at lower right in black felt-tip pen: *WELLING / JUNE 18, 1970*; left sheet dated and inscribed at lower right in black felt-tip pen: *June 18, 1970 / NORTH TOWER 74 / SOUTH TOWER 26*; at the lower left in graphite: *13*; verso of right sheet inscribed at lower left in

black felt-tip pen: *20. MANHATTAN SKYLINE*
Bibliography: Welling 1971, 78, ill. (left sheet of the three).
Gift of Richard Welling, 2002.43.9

This large triptych is one of fourteen drawings donated by the artist to the Society that preserves Welling's obsession with the construction of the World Trade Center (WTC), 1966–72. The group belongs to a larger invaluable series of drawings (40–45, including sketchbook pages) by Welling documenting the construction of the building complex. From its genesis the artist was drawn to the site and recorded it from different geographic locations; for example, one sheet depicts only the site's footprint, delineated on 6 June 1969.[1] Although the triptych includes the WTC towers, it is really a panoramic view of Manhattan, one that acknowledges yet contrasts with many of the earlier panoramic views of the city in the collection, especially the eight-section panorama from 1842–45 by Edward Burckhardt (cat. 82).[2]

In his chapter "Hard Hat Area: Drawing the Intricacies of Construction and Demolition," Welling comments on the left sheet of the triptych:

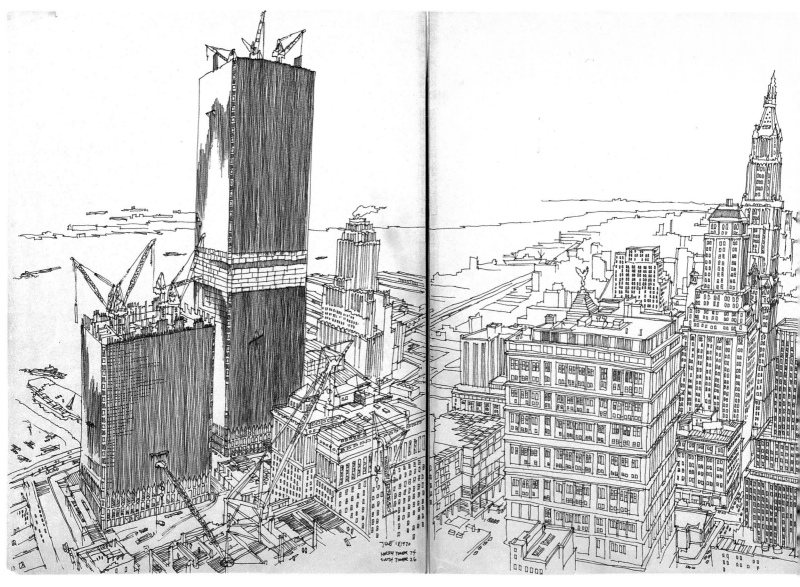

144

A bird's-eye view is, in itself, exciting, and when your subject is also exciting—watch out! You may become so engrossed in what's going on below that you lose interest in drawing. I drew this in about three hours from the forty-third floor of a neighboring skyscraper. The tall tower (which, by the way, is only half completed!) was positioned on my paper first as a reference point for the rest of the sketch.[3]

His subsequent discussion about the danger and excitement of on-site drawing captures his emotional and visual involvement with the WTC that he documented with his felt-tip pen

as he wrote the text of this volume.

Designed by Minoru Yamasaki (1912–), the World Trade Center, despite its tragic destruction, remains one of this architect's most famous structures. As one of the most celebrated architects of the 1960s, Yamasaki won the commission with the New York City firm of Emery Roth and Sons over a dozen other architects. The challenge was to create twelve million square feet of floor area on a sixteen-acre site. Yamasaki met the demands with two towers of 110 floors each rising about 1,353 feet to punctuate the skyline of lower Manhattan. For a number of years the Twin Towers were the

tallest structures in the world (until the Sears Tower was built in Chicago in 1974, which was then surpassed in 1998 by the Petronas Tower in Kuala Lumpur, Malaysia). On a clear day, from the observation decks, one could see forty-five miles in any direction. To build the pair, Yamasaki reexamined the skyscraper, tempering its first principles with modern technology and a variation of his facade screen veneer. The haunting image of its still-smoking ruins is burned in the memories of those who witnessed the events of the week following 11 September 2001 (cat. 147). Richard Welling's drawings document the optimistic rise of the structures.

1. Inv. no. 2002.43.10, in the Society's collection.
2. See Welling 1971, 140–51, for his chapter "The
 Panoramic View: A Case History," illustrating
 Hartford and Manhattan before the Twin
 Towers. For a historical look at the phenomenon
 of panorama, see Oetterman 1997; and Bernard
 Comment, *The Panorama*, trans. Anne-Marie
 Glasheen (London: Reaktion Books, 1999).
3. Welling 1971, 78.

RICHARD JOHN HAAS

Spring Green, Wisconsin 1936–

Growing up in the picturesque valley of Spring Green, the location of Taliesin East (one of the houses of the architect Frank Lloyd Wright), Richard John Haas was first exposed to the arts through the Taliesin Foundation. As a teenager he visited the residence and worked there with his uncle, who was a stonemason for Wright. His family eventually moved to Milwaukee, where Haas attended the University of Wisconsin (B.S., 1958). Following graduate studies at the University of Minnesota in Minneapolis (M.F.A., 1964), Haas taught art at Michigan State University in Lansing and then moved to New York City. He accepted a teaching appointment at Bennington College in Vermont, where he taught printmaking for nearly ten years. He gave up teaching full-time in 1979 to pursue his career as a mural painter.

Haas painted his first mural in 1975 at the intersection of Prince and Greene streets in Manhattan. Since then, he has completed more than 120 murals, both indoors and out, in which his early exposure to Wright's architecture finds expression via his obsession with monumental architectural forms. Haas specializes in trompe l'oeil paintings that transform drab urban exteriors and neglected buildings, particularly nineteenth-century cast-iron industrial buildings, into fictive structures. Building on the Italian illusionistic fresco tradition for covering large surfaces of plaster, which flourished from the fourteenth century through the Baroque period, Haas revitalizes forgotten buildings in eroding city centers by creating new life-size "false facades" that seamlessly blend into the existing urban environment. Today, his illusionistic murals can be seen in many cities throughout the United States.

Haas now teaches selectively, such as a mural course at the NAD and courses at the Skowhegan School of Painting and Sculpture in Madison, Maine, where he serves on the board of directors. He has been honored by the American Institute of Architects Medal of Honor and the Municipal Art Society Award (both 1977) and has been awarded fellowships from the National Endowment for the Arts (1987) and the Guggenheim Foundation (1983). The artist has shown his work extensively in over thirty one-person shows—including at the Whitney Museum of American Art (1974), the San Francisco Museum of Modern Art (1980), the St. Louis Art Museum

(1984), and the Williams College Art Museum, Williamstown, Massachusetts (1987)—and in numerous group exhibitions. An academician of the NAD (1996; associate in 1993), his paintings and prints are in the collections of many institutions: the Brooklyn Museum, the Metropolitan Museum of Art, the Museum of Modern Art, New York, and the St. Louis Art Museum, among others.

Bibliography: Richard Haas, *Richard Haas, An Architecture of Illusion* (New York: Rizzoli, 1981); Allen Freeman, "Mural Seemingly in the Third Dimension: Recent Works of the Remarkable Richard Haas," *Architecture* 74:4 (1985): 72–79; Richard Haas, *Richard Haas, Architectural Projects, 1974–1988* (New York: Brook Alexander; Chicago: Rhona Hoffman Gallery, 1988); B. Adams, "Richard Haas," *Art in America* 77:9 (1989): 210–11; Richard Haas, *Richard Haas: Prints, 1962–the Present* (New York: Richard Haas, 1999); idem, *The City Is My Canvas* (Munich: Prestel Publishing, 2001); idem, *The Prints of Richard Haas: A Catalogue Raisonné, 1970–2004* (New York: John Szoke Editions, 2005).

145. *View of St. Patrick's Cathedral from Inside Rockefeller Center: Study for a Set of Painted Doors*, 2002

Gouache, colored pencil, and graphite on gray paper; 23 7/8 × 18 in. (606 × 457 mm)
Signed and dated at lower right in white gouache: *R. Haas 2002*
Provenance: Michael Ingbar Gallery of Architectural Art, New York.
The 20th Century Acquisition Fund, 2002.46

Not only does Haas create huge architectural murals, but he also, as in this case, paints interior surfaces with illusionistic views that create fictive "windows" to the outside world. In the Society's work Haas painted a view looking past the iconic Art Deco sculpture depicting Atlas holding the world by Lee Lowrie and Rene Chambellan (1937) from inside the double doors in the Rockefeller Center complex (1929–40) on Fifth Avenue between Fiftieth and Fifty-first streets, whose principal architect was Raymond Hood. The view looks through the busy pedestrian and vehicular traffic of Fifth Avenue to the facade of St. Patrick's, the Roman Catholic cathedral church of the archdiocese of New York, by James Renwick (1859–79). Haas's design constitutes a witty, self-conscious allusion to the famous perspective view that the architect Leone Battista Alberti painted in 1436

from inside the double doors of the Cathedral of Florence looking at the Baptistry. In its precise realism, Haas's drawing distills what makes New York City one of the great tourist meccas in the United States: the juxtaposition of impressive public spaces with intimate vantage points and experiences. Haas has also executed more straightforward representations of the monuments depicted, such as his watercolor of St. Patrick's Cathedral from 1980.[1]

The Society's sheet is a preparatory study for the artist's larger painting executed on a functioning set of double wooden doors (private collection), designed once again to fool the eye and all the senses.[2] Its composition and concept pay homage to celebrated historical examples of similar trompe l'oeil tricks that delighted Italian Renaissance patrons and their guests, notably Paolo Veronese's three illusionistically painted doors in the Villa Barbaro at Maser, built by Andrea Palladio in the mid-sixteenth century.[3] In his work Haas has cleverly fused the older Italian prototypes with the American trompe l'oeil still-life tradition practiced by artists like John Peto and William Harnett.[4]

1. Haas 1981, 55, ill. The watercolor measures 38 1/4 × 20 1/2 in.
2. David Findlay Jr., *Points of View*, sale brochure (New York: David Findlay Jr., 2002), cover ill. The doors measure 80 × 48 in.
3. Teresio Pignatti, *Veronese* (Milan: Electa, 1995), 1:186–89, 226, ills.
4. Also in this tradition is Asher B. Durand's door panel in the Society's collection executed for Luman Reed's Picture Gallery, *Boys Playing Marbles* of 1836; it contains an opened door (inv. no. 1940.484; Koke 1982, 1:305–6, no. 584, ill.).

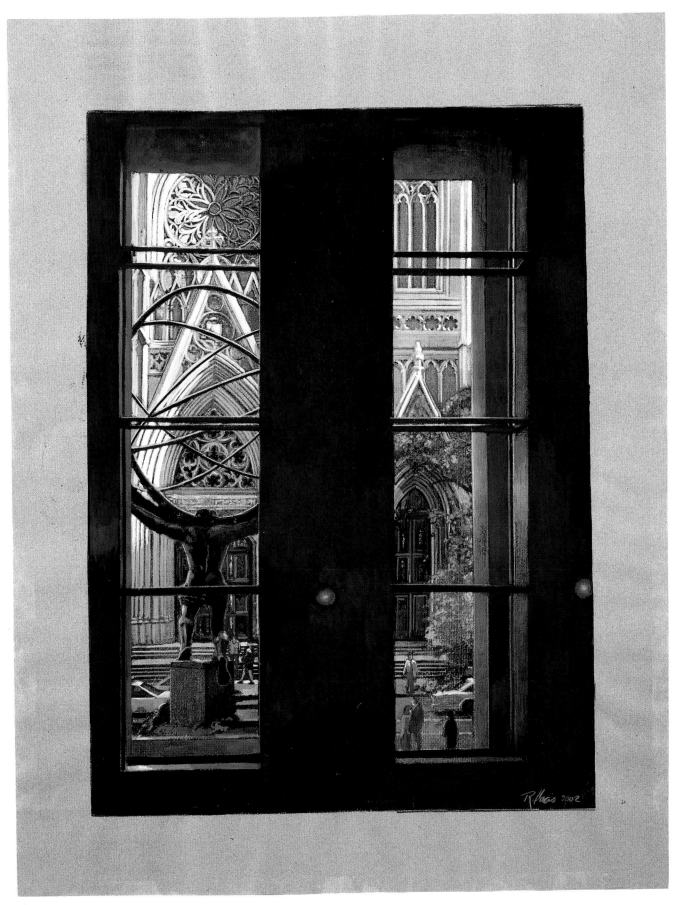

FREDERICK BROSEN

New York, New York 1954–

Growing up on Manhattan's Upper West Side, Frederick Brosen developed his interest in the visual arts while attending New York's Fiorello H. LaGuardia High School of Music and Art, where he learned painting, sculpture, and printmaking. Brosen has stated that the opportunities and encouragement he received there made a major difference in his life and art. He received his B.A. from the City College of New York (1976) and his M.F.A. from the Pratt Institute in Brooklyn (1979). Brosen also studied at the Art Students League in New York (1976–77) and was an artist in residence at Dartmouth College, Hanover, New Hampshire, during the spring semester of the 1984–85 academic year. Since the neighborhoods, buildings, parks, monuments, and the essence of urban life exerted such a great influence on him in his early years, the city became his natural landscape, and watercolor his medium of choice. On an extended trip to Europe in 1987, Brosen refined his selection process and his interest in architectural imagery as he explored the streetscapes of Paris and Amsterdam.

In his vision of the cityscape Brosen includes little movement; on the contrary, it is serene, still, atmospheric, and, perhaps, even a little lonely with few, if any, people. The artist often bicycles at dawn, when the streets are deserted, to research new subjects. Hence his haunting, somewhat enigmatic paintings, which make the viewer wonder about the life of the buildings, who occupies them, and who walks the streets. In other words, although his architectural details are precise and realistic, he is more than a topographical draftsman. Brosen's highly structured compositions and his soft, saturated use of watercolor lend his work a nonphotographic quality. Reality has been subtly changed—simplified, patterned, and balanced— to turn it into art.

Brosen's minutely rendered but painterly watercolors are represented in the permanent collections of the N-YHS—*McIntire Building* (1989) and *Audubon Terrace* (1998)—and those of the Metropolitan Museum of Art, New York; the Hood Museum, Hanover, New Hampshire; and the Knoxville Museum of Art in Tennessee, as well as in private and corporate collections. He has had solo exhibitions at the Forum Gallery in New York; the Frye Art Museum, Seattle; and the Coplan Gallery, Boca Raton, Florida, among others. Brosen has also participated in many group exhibitions, including ones at the Brooklyn Museum; the Bruce Museum, Greenwich, Connecticut; and the NAD, where he has taught for more than ten years. The artist has also been an instructor at the Art Students League in New York City. When asked which of his own paintings he considered most important in his development as a watercolorist, he answered *Gansevoort Street* (1987), depicting a locale in downtown New York. He considers *Doyers Street* (2001) in New York's Chinatown the most visually satisfying of his works because of the way light and textures work together, although *Engine 55, East Broome Street* (1998) is the most often reproduced. Nevertheless, throughout his career, Brosen has remained loyal to his interpretation of the urban scene, particularly the architectural romance of old New York.

Bibliography: John Russell, "Frederick Brosen: Recent Watercolors," *New York Times*, 30 September 1983, sec. C, 20; Valerie R. Rivers, "Precise Watercolors," *American Artist* 54:576 (1990): 43–47, 73, 74; Pepe Karmel, "Marginal Areas of New York City's Landscape," *New York Times*, 11 August 1995, sec. C, 20; *Who's Who in American Art* (New York: Bowker, 1999–2000), 149; Frederick Brosen, "The Ever Evocative Cityscape," *Watercolor Magazine* 6:23 (2000): 92–101; Ric Burns, Alan Feuer, and Frederick Brosen, *Still New York* (New York: Vendome Press, 2005); Alan Feuer, "Witness to the Wee Hours," *New York Times*, 28 August 2005, The City sec., 8.

146. *Audubon Terrace, New York City,* 1998

Watercolor on heavy watercolor paper; 43 × 29 in. (1092 × 737 mm), image
Signed and dated at lower right in black ink: *BROSEN 98*
Provenance: Forum Gallery, New York, 2001.
Partial gift of Mr. and Mrs. John J. Roche and the 20th Century Acquisition Fund, 2001.304

Audubon Terrace is located in the block between 155th and 156th streets, west of Broadway, in the Washington Heights section of upper Manhattan. Designated in 1979 by the Landmark Preservation Commission of New York City as a historic district, the site was originally farmland acquired in 1841 by the painter and naturalist John James Audubon (cats. 42 and 43).[1] At 156th Street near the edge of the Hudson River he built a frame house and stable as part of an estate he called Minnie's Land. It was from this house (demolished in 1931 to make way for the real estate development) that his friend Samuel F. B. Morse transmitted the first long-distance telegraph message. Audubon's two sons built houses on the portion of the estate that is now Audubon Terrace. After Audubon's death, his wife began to sell off portions of the estate, and by 1870 it had become a residential area known as Audubon Park, with large homes surrounded by gardens.

In 1904 Archer Milton Huntington, a philanthropist and scholar, began buying the section east of Riverside Drive referred to as Audubon Park to develop as an urban cultural center; it eventually became known as Audubon Terrace.[2] As a first step in this plan, he founded the Hispanic Society of America in 1904 and offered the land to other cultural institutions. His cousin Charles Pratt Huntington was chosen as the architect for the complex. With Huntington's encouragement and funding, other buildings were added: the American Geographical Society, the Museum of the American Indian, the American Numismatic Society, and the Church of Our Lady of Esperanza. All were designed in a unified Neo-Renaissance style, grouped around a central terraced courtyard. After Huntington's death, two other buildings went up, designed by the firms of McKim, Mead & White and Cass Gilbert: the American Academy of Arts and Letters and the National Institute of Arts and Letters. Since that time the Numismatic Society and the Museum of the American Indian have moved; the Geographical Society building was taken over by Boricua College; and the American Academy and the Institute of Arts and Letters merged in 1976 to become the American Academy of Arts and Letters.

Sculpture became an important element in the development of the complex in keeping with Beaux-Arts principles, and Archer M. Huntington's wife, Anna Hyatt Huntington, a prominent sculptor, designed a number of works that were executed between 1927 and 1944. Most are placed in a lower brick courtyard enclosed by stone balustrades, which is the subject of Brosen's painting. The impressive group of sculptures includes a monumental bronze replica of Huntington's equestrian statue *El Cid* (1927) on a high stone base, heroic statues that stand at the four corners of the stepped base, and deer that adorn the entrance.[3] A long shadow covers the lower two-thirds of the painting to accentuate the pervading melancholy in the deserted piazza.[4]

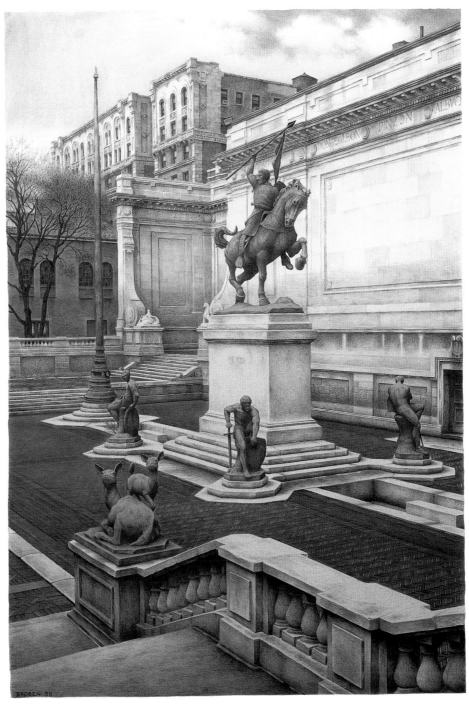

146

In organizing his composition Brosen worked from photographs and drawings taken from different angles of the site. He manipulated the elements for his final version, for which he employed the traditional grid pattern to square the preparatory drawing for transferring and enlarging the image in the watercolor. His washes and layers of color achieve the luminosity and intensity of the tones that infuse the artist's poetic urban landscapes.

J. B.

1. See City of New York Landmarks Preservation Commission, *Audubon Terrace Historic District Designation Report* (New York: The Commission, 1979).
2. For Huntington, whose town house on Fifth Avenue now houses the NAD, see David B. Dearinger, *The Archer M. Huntington Townhouse: Home of the National Academy of Design* (New York: National Academy of Design, 2002), 8–15.
3. For a photograph of Anna Hyatt Huntington with a model of the equestrian sculpture, see ibid., 13, ill.
4. Burns, Feuer, and Brosen 2005, 124.

DONNA LEVINSTONE
New York, New York 1955–

147

Donna Levinstone was born and raised in New York City. Spending time as a child on Fire Island and on Long Island in the Hamptons, she observed nature intensely. Her artistic training began at the High School of Music and Art, and she earned her B.A. at the State University of New York, Stony Brook. She furthered her artistic education at the Pratt Institute and at the Art Students League, obtaining additional training in the pastel medium from her membership in the Pastel Society of America.

Levinstone's body of work generally consists of landscapes, which she often produces serially. In creating both monochromatic and multi-colored works on paper, the artist utilizes white Stonehenge paper and American and European pastels that are often handmade and soft. The locations of Levinstone's landscapes are almost never identifiable, although she begins with an actual place in mind. Her nonspecific settings increase the dreamlike quality inherent in the medium itself. As the critic Helen A. Harrison has commented: "[Levinstone's scenes] are more like landscapes of the imagination."

Levinstone has exhibited in several New York galleries, as well as in other cities of the Northeast, California, and Illinois to positive reviews. She also participated in *True Colors:*

Meditations on the American Spirit, an exhibition at the National Arts Club, New York, that reflected the emotional aftermath of 11 September 2001. Her work is currently represented by Kathryn Markel Fine Arts in New York City, and numerous corporate collections—such as AT&T, Philip Morris, General Electric Company, Citibank, The Disney Company, and Fidelity— hold examples of her work.

Bibliography: M. Stephen Doherty, "Donna Levinstone's Pastel Landscapes," *American Artist* 56:595 (1992): 26–29; Helen A. Harrison, "How Lighting Can Be Handled Skillfully," *New York Times*, 24 May 1992, L.I. sec., 15; Carole Katchen, *Painting with Passion: How to Paint What You Feel* (Cincinnati: North Light Books, 1994), 106–11; Mila Andre, "Artist's 9/11 Reflections on Display," *Daily News*, 9 July 2002, 5.

147. *Eternal Rest*, 2002

Black and orange pastel on paper with deckled edges; 22 1/4 × 27 5/8 in. (565 × 702 mm)
Gift of Donna Levinstone, 2002.67.1

If her earlier landscapes were optimistically serene and anonymous in nature, Levinstone's pastels portraying the events of 11 September 2001 are quite the opposite.[1] Her customary lyrical mood turned somber to embody a profound

personal sadness, as she reflected on her city's tragedy.[2] Her images confront the viewer with the darkness and confusion of the catastrophic event, as dust and demolition replace the artist's typical wispy clouds and soft light. Levinstone's hallmark stillness and anesthetized reality underline the surreal aspects of the devastating event.

Just before nine in the morning on 11 September 2001, the United States was attacked by terrorists associated with the Muslim fundamentalist organization Al Qaeda, nineteen of whose members hijacked four airplanes with the intention of using them as weapons against important national landmarks. The World Trade Center Twin Towers in New York City and the Pentagon in Washington, D.C., were the primary sites targeted by the terrorists, who succeeded in flying airplanes into each of the two towers and the Pentagon before the nation's defenses could respond. The North Tower was struck first between floors 93 and 98, followed by the South Tower, which was pierced between floors 78 and 84. The large quantities of fuel present in the fully loaded jets caused the damaged sections of the World Trade Center towers to burn ferociously for about an hour. The intense heat destabilized the structural skeletons of the towers, which collapsed, the South Tower falling first, at about

10:00 a.m., followed by the North Tower about twenty minutes later. The third plane struck the Pentagon at about 9:20 a.m., while the fourth hijacked plane crashed into an unpopulated wooded region in Pennsylvania after the passengers courageously attempted to regain control from the terrorists and prevent the use of the plane in another attack. Over 2,700 people were killed, including the passengers on the planes, representing citizens of more than ninety countries.[3]

Levinstone's *Eternal Rest* is a triptych that portrays three distinct moments of the collapse of the World Trade Center's Twin Towers (cat. 144), replicating the episodic nature of the event as it was experienced by most people who watched it unfold on television. Levinstone's black and orange palette turns her work into a vision of hell, the nightmare of a towering inferno come true. In the first scene, half of the South Tower is in the process of falling as orange smoke rises out of its top. The second scene portrays a momentary pause with the smoke engulfing remnants of the two towers rising vertically, while the third shows Ground Zero leveled and the eruption of poisonous debris invading lower Manhattan. By framing the middle vignette with two more active, turbulent compositions, the artist forces the viewer to focus on the eerie stillness of the central scene that visually re-creates the gasp of disbelief uttered by viewers that day as they waited for the end of the tragic spectacle.

Levinstone's purposeful choice of the triptych format references fourteenth- and fifteenth-century European tripartite paintings that depict a religious subject in the center flanked by honored patrons (sometimes deceased) or saints. By applying this format to the events of 11 September 2001 Levinstone elevates the tragedy to a spiritual level, where the center scene's calmness can be interpreted as an elegy to the martyrs and its vertical movement as transcendence to a holy realm. This central eye of the storm pays silent tribute to the lives lost in this surreal yet precise moment of tragedy.

1. The Society has another work by the artist on this galvanizing theme, *September 11, 2001*, 2002, in black and white pastel on paper with deckled edges, 25 3/4 × 22 1/4 in. (inv. no. 2002.67.2).
2. Miles O'Brien, "National Arts Club Presents 'American Spirit' Exhibit," *CNN Sunday Morning*, 14 July 2002.
3. For the event, see James Glanz, "A Day of Terror: The Buildings," *New York Times*, 12 September 2001, sec. A, 3; N. R. Kleinfield, "U.S. Attacked: Hijacked Jets Destroy Twin Towers," *New York Times*, 12 September 2001, sec. A, 1; Jere Longman and Sara Rimer, "A Day of Terror: Pennsylvania Crash," *New York Times*, 12 September 2001, sec. A, 16; Richard Bernstein and the staff of the *New York Times*, *Out of the Blue: The Story of September 11, 2001, from Jihad to Ground Zero* (New York: Times Books, 2002); William Langewiesche, *American Ground: Unbuilding the World Trade Center* (New York: North Point Press, 2002); "Traces of Terror: Across New York and the Nation, Many Ways to Reflect on 9/11," *New York Times*, 7 September 2002, sec. A, 8.

BÉATRICE CORON

Lyon, France 1956–

Born in the Rhône-Alpes region of France, Béatrice Coron studied art at the École des Beaux-Arts of her native city and Mandarin Chinese at the Université of Lyon III. Although she discovered the technique of making paper cutouts during her studies in France, Coron put her art on hold and worked as a tourism manager for French and American companies for ten years. Before moving permanently to New York City in 1984, Coron lived in Egypt and Mexico for a year each and two years in Taiwan, where her interest in art forms using paper first developed fully. In 1993 she became a United States citizen.

Internationally known as an illustrator and a designer, Coron defines herself as an "eclectic iconoclast." While working in different media as a book artist, paper cutter, sculptor, and conceptual artist, she has been a fixture of the art book world for many years. Committed to her craft, Coron has given numerous workshops in both paper-cutting techniques and art books at such institutions as the American Craft Museum (now the Museum of Arts and Design, New York), New York City libraries, and the New York Center for Book Arts, among others. She has served as vice president of the Guild of American Papercutters, of which she is a member. In her paper cutouts and accordion books, Coron has reinvigorated the traditional silhouette genre that was wildly popular with amateurs and professionals alike from 1750 to 1850 (cats. 46 and 114, essay fig. 2). She has also breathed new life into other book types, as with her *New York City Bestiary: 12 Tableaux of New York Animals* (1997). Her works are both playful and cutting in their satire and insights.

Having exhibited widely in France and the United States in solo exhibitions and group shows, Coron's recent exhibitions include *Personal Cities*, at the Brooklyn Public Library (2005); *Dessiner avec des ciseaux*, at the Maison des Mémoires, Carcassonne, France (2004); *sagacity: the cutting edge*, at the Chicago Center for Book and Paper Arts (2003); and *Beyond Reading*, at the Ellipse Art Center, Arlington, Virginia (2003). Coron's twenty-three-foot-long white papercutting roll of a cityscape, *White City*, was featured in the exhibition *Decalage-Time lag* in Yokohama, Japan, in 2005.

Coron produces paper cutouts ranging from miniature to life-size in a kaleidoscopic variety of subjects. Her humorous social commentary is omnipresent. For example, *New York Mule Train* (2002) is a horizontal silhouette of expressively postured people's legs wearing mules (backless shoes), while *Inner City* (2001), measuring 162 by 52 inches, exposes in silhouette the internal workings of all levels of the urban macrocosm. Occasionally her cutouts are the size of rooms and create entire environments. Her public art installation *Working in the Same Direction*—a permanent stainless steel sculpture commissioned by the Percent for Art Program of the New York Department of Cultural Affairs, the New York City Fire Department, and the Department of Design and Construction—has been on view at

148

the Fire and Emergency Station at Rossville Avenue and Veterans Road, Staten Island, since May 2003. This nine-foot sculpture commemorates the merger of the Emergency Medical Services with the Fire Department. In a similar vein are her stainless steel decorative fence for the Kostner Station in Chicago, commissioned by the Chicago Transit Authority and the Department of Cultural Affairs (2004), and her faceted glass mural *Bronx Literature* for the Metropolitan Transportation Authority Arts in Transit that was installed at Burke Station in the Bronx in 2005.

Coron's artist's books and paper cuts are in the permanent collections of numerous museums in Europe and the United States,

including those of the National Gallery of Art Library in Washington, D.C.; the Metropolitan Museum of Art, the Library of the Museum of Modern Art, the Museum of the City of New York, and the Brooklyn Museum, New York; the Walker Art Center, Minneapolis; Princeton University Library, Princeton, New Jersey; and the Bibliothèque nationale de France, Paris.

Bibliography: Christophe Comentale, "Béatrice Coron ou l'art du papier découpé de la création éclectique aux séries aléatoires," *Art & Métiers du Livre* 211 (September–October 1998): 16–20; Helen Hiebert, *Paper Illuminated* (Pownal, Vt.: Storey Books, 2001), 39; Celina Di Pisa, *Come decorare con gli stencil* (Bolzano: Stafil, 2003), 61–63.

148. *Photographer's Corner*, 1999

Black paper cutouts, laid on white board; 8 × 10 in. (203 × 254 mm)
Signed at lower left in graphite: *Coron*; verso inscribed, dated, and signed in graphite: *Photographer's Corner / 1999—MTA 23rd St Proposal— / Beatrice Coron*
The 20th Century Acquisition Fund, 2002.55

"Photographer's Corner" is the colloquial name given to the corner in front of the iconic Flatiron Building, located at the intersection of Twenty-third Street, Broadway, and Fifth Avenue in New York City. It derives from the fact that photographers, such as Alfred Stieglitz and Edward Steichen, had their studios in the neighborhood.

In her composition Coron exploits the legends concerning this notoriously windy intersection, such as the claim that wind, accelerated by the odd angles of the streets, is reported to have killed at least one pedestrian by blowing him into traffic. Some people assert that the saying "Twenty-three Skidoo" arose from the legendary wind that created such havoc for pedestrians (see cat. 134).

Coron's composition includes the celebrated George A. Fuller Building, generally known as the Flatiron Building, which was opened in 1902. Its twenty-floor height, its narrow triangular plan, and the treacherous winds that blew about it made the Flatiron an immediate sensation. Writers and photographers like Steichen noted its resemblance to a ship and saw the structure as a symbol of progress. Sir Philip Burne-Jones, an Englishman who wrote of his visit to New York in 1902, said of the Fuller Building: "One vast

horror, facing Madison Square, is distinctly responsible for a new form of hurricane, which meets unsuspecting pedestrians as they reach the corner, causing them extreme discomfort. I suppose the wind is in some way intercepted by the towering height of the building, and forced down with fury into an unaccustomed channel. When its effects first became noticeable, a little rude crowd of loafers … used to congregate upon the curb to jeer at and gloat over the distress of ladies whose skirts were blown into their eyes as they rounded the treacherous corner."[1]

Coron first became interested in this historic location and the Flatiron Building in 1999 while working on a proposal to decorate the Manhattan Transit Authority N/R platform at Twenty-third Street. Her submission to the Metropolitan Transit Authority competition to renovate the subway platform was judged a runner-up.

The present sheet is one of three paper cutouts for her design in which she sought to bring "air into the underground … . I made the image as if the viewer had already lost his or her footing, making the landmark buildings appear at times upside down and in unusual perspectives."[2] Her technique recalls the silhouette genre, popular between 1750 and 1850 before the advent of photography. Her witty and highly literate use of the cutout medium pays homage to the older tradition while being innovative in technique and scale and use of the computer. The "worm's-eye" view provides a novel perspective on this urban myth at the end of the millennium.

1. Sir Philip Burne-Jones, *Dollars and Democracy* (New York: D. Appleton and Co, 1904), 58–59.
2. E-mail message, 23 January 2002.

TRACY 168 (MICHAEL TRACY)
New York, New York 1957–

Countless graffiti writers cite the pioneering graffiti artist active in the Bronx, TRACY 168, as an inspiration. Michael Tracy studied at the High School of Art and Design in Manhattan and has claimed the Institute of Higher Learning better known as the Lexington IRT as his true alma mater. TRACY 168 started his career in 1971, when "writing" (that is, graffiti writing) was in its infancy, and has continued to be active through several generations of later writers. He was one of a small band of innovators who began to adorn New York with bubble letters, cartoon characters, and psychedelic images that hissed from spray-paint cans. His draftsmanship and unique sense of color and style set him apart from other writers of his time. Tracy covered numerous subway cars in their entirety with detailed illustrations, helping to establish the trend in graffiti culture of embellishing whole cars. He then turned to mural paintings replete with backgrounds in the Bronx, some of which still stand, such as the one executed years ago on an auto parts store at the corner of Arthur Avenue and East Fordham Road. Intended to "beautify the neighborhood," it features Fred, Wilma, and Pebbles Flintstone

and the Rubbles in their Stone Age car. Tracy's sources range from Hanna-Barbera, creators of the Flintstones, to the Bible. His first paid assignment was the side of French Charlys Bar on Webster Avenue in the Bronx.

Tracy, known as the inventor of WILD STYLE, has become a minor cult figure and has worked at many jobs to support his art. He also has collaborated with other writers and founded the crews WANTED and WILD STYLE with such writers as CLIFF, LSD, P NUT, KING 2, CHI CHI 133, LIONEL 168, SONNY 107, and ZEST. TRACY 168 neither depicts blood or guns nor glorifies violence. He claims that his aim is to lift the human spirit of the city, particularly in the wake of the terrorist attacks of 11 September 2001. For example, he painted the World Trade Center towers, a police helicopter, a police car, and a street sign shaped like a Celtic cross on the metal grates of the Brother's police equipment store on Webster Avenue. He has painted everywhere and has claimed for his canvas the insides and outsides of buildings, as well as subway cars and even a pinball machine. Another of his panoramic murals embellishes the R. G. Ortiz

Funeral Home on the Grand Concourse. It shows a heavenly paradise of lush trees and water that seems like an extension of Poe Park across the street. In 2004 he painted a human-size TRACY 168 in Queens that was visible from the No. 7 train to tell the world that he is still here and creating, a survivor.

Bibliography: Holland Cotter, "Art in Review: Retroactive 1," *New York Times*, 7 May 1999, sec. E, 34; Guernsey's, New York, *Graffiti Art*, sale cat., 13 June 2000, 48–49; Ivor L. Miller, *Aerosol Kingdom: Subway Painters of New York City* (Jackson: University Press of Mississippi, 2001), 13, 21, 78, 116, 117, 123, 129, 149; Dan Berry, "Michelangelo Did Ceilings; He Does Walls," *New York Times*, 10 March 2004, sec. B, 1.

149a. *WILD STYLE: TRACY 168*, 1992

Black marker and felt-tip pen on heavy paper with glue residue from bound border at left; 9 × 12 1/4 in. (228 × 311 mm)
Signed at lower left in black felt-tip pen: … *TRACY*… ; various other inscriptions, including at upper center: *WILD STYLE*
Provenance: Martinez Gallery, New York.
The 20th Century Acquisition Fund, 2003.38.6

149a

149b. *BUGGIN*, 1992

Black felt-tip pen and colored markers on paper; 8 1/2 ×
10 3/4 in. (216 × 273 mm)
Inscribed at lower right in black felt-tip pen: *WILD /
STYLE*; at upper right in red and purple marker: *BUGGIN*
Provenance: Martinez Gallery, New York.
The 20th Century Acquisition Fund, 2003.38.7

This entry focuses on the two graffiti drawings in
the Society's collection by the artist with the tag
TRACY 168; they belong to a cluster of thirteen
graffiti works by various artists acquired at the
same time.[1] Ephemeral by nature, edgy, and often
compared to jazz, this kinetic, public, renegade
urban art form is sometimes painted on moving
surfaces like subway cars, and less frequently on
other forms of transportation, where the flexible
pictorial language is always in action. Arresting

in its graphic boldness, graffiti writing usu-
ally triumphantly carries the artist's name and
fame—sometimes from borough to borough—in
highly stylized characters that become a hallmark
of each individual, like an inflated silversmith's
mark. They reveal street art's creative energy and
testify to the vitality of urban outsider artists. At
their best, these works of American graffiti are
examples of sophisticated urban design, riffs
on a culture of mass media and advertising that
enshrine the identity of their maker and carry per-
sonal messages.[2] An early example in the Society's
collection is the unusual, unexecuted design for a
33 rpm UA (United Artists) album cover by FLINT
707, one of the United Graffiti Artists, started by
Hugo Martinez in 1972 (fig. 149.1).[3]

Graffiti derives from the Italian words
graffito or *sgraffito*, from the verbs *graffiare* and

sgraffiare, meaning "to scratch." The slang word
graff, colloquial for "writing," is ultimately
related to *autograph*, citing the maker's signa-
ture, and *graphic*, meaning "drawn." The topic of
graffiti brings up many social, legal, and
emotional issues regarding property and
freedom of expression. The genre of graffiti can
be traced back to unauthorized or illegal urban
signage and commentary reaching beyond
Egyptian and Roman times, as far back as people
have had the means to make a mark. Since the
colonial era, American city walls functioned as
spontaneous bulletin boards for signs, hand-
bills, and uninvited scribblings of passersby.
During the late twentieth century graffiti was
first primarily used by political activists to make
statements and by street gangs to mark territory.
It was only in the late 1960s that writing's

149b

current identity started to form, first as scrawls and then as youthful renegade writing.

The underground art movement known by many names, commonly termed "graffiti," began in Philadelphia in the mid- to late 1960s.[4] Over the past forty years, graffiti has played a larger and more controversial sociological role in urban environments, as it has grown in scale and scope of articulation. Considered by some to be vandalism (it is still illegal) and by others to be art, it belongs to a period in American history when urban planners fought to keep old central business districts alive in the age of the automobile and suburban sprawl. They sought many ways to animate downtowns, but hip-hop culture, of which graffiti is a part, accomplished this naturally. It was a sign that young people remained in cities and were having fun, if in a

highly visible, graphic, and rebellious manner.[5] It had a romantic, outlaw allure, as the artists took real risks of being arrested when they executed their works. Ironically fought by many purists of architectural preservation, graffiti lent a quirky vitality to the otherwise dying urban fabric and inspired segments of the fashion, music, and advertising industries. Based in the metropolitan macho culture of competition, graffiti writing was fueled by a rage against a society that seemed not to care about its young people. Although it had a guerilla mystique, writing was a form of communication, and it was perceived as the only way to escape the ghetto and become known and recognized. It was also indebted to Pop art and comic books. In the SoHo district of Manhattan, Keith Haring and Jean-Michel Basquiat straddled the line between fine art and street art.

Graffiti artists, who suffer from a kind of graphomania, frequently execute small-scale drawings for practice or as studies for future projects. A number of these in the Society's collection are drawn on disposable or discarded and thus recycled paper—scraps of lined and plain paper, paper towels, perforated computer paper, or stationery—frequently with markers, ballpoints or felt-tip pens, media not usually associated with high art. Some of these drawings show the artist's tag design as it evolves with graphic energy across the page in a stream-of-consciousness fashion. In the smaller studies the striking calligraphy of many of the writers is apparent, along with their strong color sense that follows the muse of speed and spontaneity.

Debts to cartoon culture and Pop art are apparent in Tracy's baroque *BUGGIN* vision, and

Fig. 149.1. FLINT 707 (Eddie Salgado), *Design for a Double-Sided Album Cover, Front and Rear: The World's a Ghetto / WAR! / UA,* c. 1971–72. Tempera, acrylic polymers, and black felt-tip pen over graphite on two sheets of heavy paper, formerly glued together, 12 × 11 15/16 in. (305 × 303 mm). The New-York Historical Society, The 20th Century Acquisition Fund, 2003.38.1a, b

the variety of his eclectic styles is suggested by comparing it with the spiky, whimsical *WILD STYLE,*[6] whose similarity to the works of the German Expressionist Paul Klee, the Abstract Expressionist Franz Kline, and Islamic calligraphy is astounding. TRACY 168, the inventor of the term *Wild Style* noted:

> After the colors the challenge became who could do the biggest piece, the wildest. Then it was top-to-bottom, whole car, whole train … . We got into lettering. Everyone was trying to develop their own technique. When I would go into a yard (train), the first thing I would do is look around and see who was good. That would be my objective. To burn the best writer in the yard, and I wouldn't leave until I did something better than him."[7]

Wild Style writing was developed as a language and a cultural statement whose home was the Bronx. Tracy recently remarked: "I started wild style. Wild means untamed, and style means I have class. So I was like an animal but with respect. And they used that word for the hip-hop movie. They thought it was a saying that was all over the street, but it was just the way we lived."[8]

The title of Tracy's *BUGGIN* derives from the slang word meaning to act crazy or strange; his image consists of the intertwined tags of other writers he teamed with and the crew of WILD STYLE: CHI CHI 133, PHASE 2, RIFF 170, KOOL, and KING 2. TRACY 168, one of the inner-city writers who also belongs to a crew called WANTED, defined it this way: "Wild Style is what you do in your life. Whatever you do, do it to the best of your ability."[9] Tracy's work, like those of other writers of the genre, is magical in both its

complexity and its realism of capturing life on the move.[10] The influence of graffiti and the youth culture that spawned TRACY 168 and his contemporaries continue to affect American art and culture in ever more subtle ways.

1. Hugo Martinez supplied the basic information on TRACY 168 and these works. For nearly a decade the Martinez Gallery has devoted itself to exhibiting and documenting the genre known as graffiti art. See Cotter 1999. The other writers represented in the Society's collection are FLINT 707 (Eddie Salgado), RIFF 170 (Clarence Byrd, aka CASH 2), CASE 2 (Jeff Brown, aka KASE), PHASE 2, and COCO (Roberto Gualtieri). Legal considerations prohibit revealing the names of some graffiti writers, stressing the outlaw roots of the genre. See also Hugo Martinez and Antonio Zaya, *Graffiti NYC* (Munich: Prestel Publishers, 2006).

2. In 1985 an exhibition of graffiti writers at the Sidney Janis Gallery in New York began to integrate the genre into the mainstream. The sculptor Henry Chalfant began to photograph graffiti works, and his photos were exhibited at the O. K. Harris and Martinez Gallery in New York, giving the genre recognition. See also Martha Cooper and Henry Chalfant, *Subway Art* (New York: Holt, Rinehart and Winston, 1984); Joseph Sciorra and Martha Cooper, *R. I. P.: Memorial Wall Art* (New York: Henry Holt & Company, 1994); idem, *R. I. P.: New York Spraycan Memorials* (London: Thames and Hudson, 1994); Chiostro del Bramante, *American Graffiti,* exh. cat. (Rome: Electa Napoli, 1997); George Nelson, *Hip Hop America* (New York: Penguin Books, 1998); Stephen Powers, *The Art of Getting over: Graffiti at the Millennium* (New York: St. Martin's Press, 1999); and Miller 2001. See also http://geocities.com/phathop2/rap_evolution3.html and http://www.daveyd.com/historyofgraf.html.

3. http://www.soundslam.com/HipHop_Timeline/Graffiti.php. UGA selected top subway artists from all around the city and presented their work in the formal context of an art gallery. Hugo Martinez also founded the Razor Gallery in SoHo, a successful venue for writers. FLINT 707's "*War!*" is reproduced in Guernsey's 2000, 21, no. 14, ill.

4. http://www.daveyd.com/historyofgraf.html.

5. Some of these insights are indebted to Kathleen Hulser, written communication, 12 December 2000.

6. WILD STYLE was a writer's crew in the 1970s led by TRACY 168. The term *wild style* has since been adopted widely by writers to denote complicated lettering forms developed by many innovators throughout the course of the aerosol movement. Miller 2001, 197, which also points out (p. 13) that aerosol art was primarily produced by blacks and Latinos in the early 1970s. In the Society's drawing *WILD STYLE: TRACY 168,* the artist has included one of his earlier tags Lovester I.

7. Quoted in http://www.bronxmall.com/tracy168/past.html.

8. Quoted in Dimitri Ehrlich and Gregor Ehrlich, "Graffiti in Its Own," *New York Magazine,* 3–10 July 2006, 53.

9. Quoted in http://www.hiphop-network.com/articles/graffitiarticles/tracy168.asp.

10. Graffiti is now international and is having a renaissance not only on subways of the MTA but on buildings, where its ephemeral nature is apparent and the battle between art and defacement continues; see Rob Walker, "Painting the Town (Again)," *New York Times Magazine,* 3 October 2004, 44, 46; David Gonzalez, "Remembering, and Defending Subway Graffiti," *New York Times,* 16 November 2004, sec. B, 1, 8; and Shadi Rahimi, "Cat-and-Mouse Game, with Spray Paint," *New York Times,* 5 August 2005, sec. B, 1, 4.

EVE ASCHHEIM

New York, New York 1958–

Eve Aschheim is an internationally recognized artist who has participated in many group and solo exhibitions in the United States and western Europe. She studied at the University of California, at the Berkeley (B.A.) and Davis (M.F.A.) campuses. Living in New York City, she teaches at Princeton University in Princeton, New Jersey, where she is director of the Visual Arts Program. Over the years Aschheim has been the recipient of many awards, among them two Pollock-Krasner Foundation Grants (1990, 2001), a grant from the Elizabeth Foundation for the Arts, a National Endowment for the Arts Fellowship (1991), and the Richard and Hinda Rosenthal Award from the American Academy of Arts and Letters (1997). Moreover, she is represented in major collections of drawings and paintings in both the United States and Europe, for example, in the private collections of Werner H. and Sarah-Ann Kramarsky, Arturo Schwarz, and Michael and Julie Rubenstein, as well as in the collections of the National Gallery of Art,

Washington, D.C.; the Museum of Modern Art, New York; the Fogg Art Museum of Harvard University, Cambridge, Massachusetts; the Lannan Foundation, Santa Fe, New Mexico; the University of New Mexico, Albuquerque; the Yale University Art Gallery, New Haven; and the Hamburger Bahnhof, Berlin, as well as the Kunstmuseum, Bonn, both in Germany.

Bibliography: Pamela M. Lee et al., *"Drawing is another kind of language": Recent American Drawings from a New York Private Collection*, exh. cat. (Stuttgart: Daco-Verlag Günter Bläse, in association with Harvard University Art Museums, 1997), 30–33; Lund, Galleri Magnus Åklundh; Cologne, Galerie Benden & Klimczak; and Berlin, Galerie Rainer Borgemeister, *Eve Aschheim: Paintings and Drawings*, sale cat. (Bonn: Weidle Verlag, 1999), including essays by Carter Ratcliff ("Subtleties of Light and Air: The Paintings and Drawings of Eve Aschheim," 57–60) and Barbara Weidle ("Interview with Eve Aschheim," 66–69); Regina Coppola, ed., *Eve Aschheim: Recent Work*, exh. cat. (Amherst: University Gallery at the Fine Arts Center, University of Massachusetts, 2005).

150a. *Water III*, 1996

Graphite over ground on heavy paper with deckled edges; 15 3/4 × 17 3/4 in. (400 × 451 mm), irregular
Gift of John Yau, 2002.13.1

150b. *Water VII*, 1997

Graphite over ground on heavy paper with deckled edges; 14 3/4 × 17 in. (375 × 432 mm), irregular
Gift of John Yau, 2002.13.2

150c. *Strange Water*, 1999–2000

Black and gray ink applied with a tree twig on heavy paper with deckled edges; 9 3/4 × 12 13/16 in. (248 × 325 mm), irregular
The 20th Century Acquisition Fund, 2002.18

This trio belongs to the "Water Series," a group of about two hundred drawings and studies.[1] From the window of her studio on West Street (the West Side Highway), the artist looks out

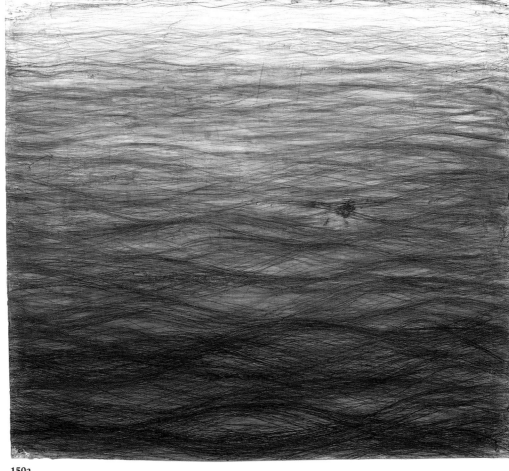

150a

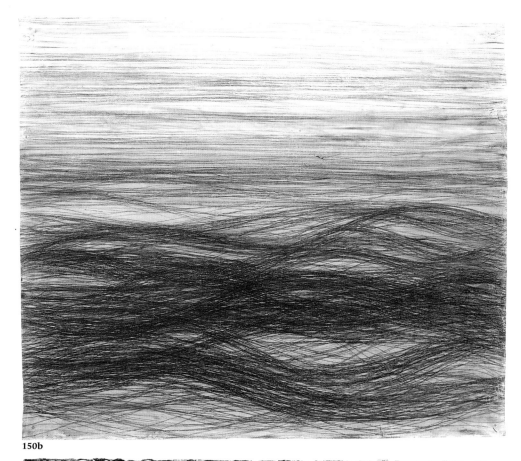

150b

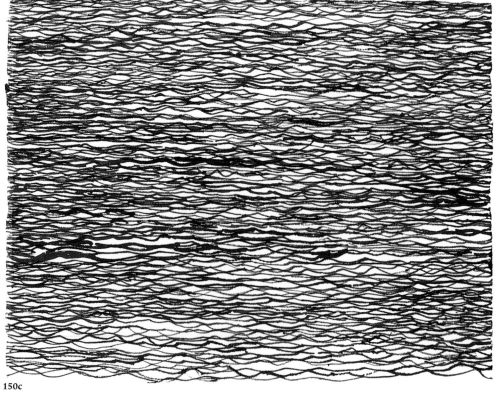

150c

on the Hudson River. Since 1996 Aschheim has studied this river, focusing on the water's surface in all seasons and weather. In both her smaller studies and larger works, the artist's obsession with the Hudson's infinitely varying patterns and movements is apparent. The scintillating lines of her works—whether executed in graphite, ink applied with a tree twig or Venetian glass pen, or encaustic—have an unmistakably watery feel as they move dynamically over the surface of the support, meeting and parting rhythmically to simulate the water itself. They also create suggestions of flickering light reflected from the interplay of the waves, ripples, swells, and cross currents that animate the river. As a group they illustrate the Greek pre-Socratic philosopher Heraclitus's pronouncement that you can never step in the "same" river twice. In a conversation, the artist related that long after she was involved with her "Water Series," she recalled having read while near Paris a highly pertinent passage from Marcel Proust's *Remembrance of Things Past* describing the always changing nature of water.[2]

In her choice of subject matter, Aschheim follows in the tradition of America's first native school of landscape painting, the Hudson River School. Nevertheless, her approach and techniques are related to European masters—to Leonardo da Vinci's famous Deluge drawings and to the Conté crayon drawings of Georges Seurat—as well as some contemporary American artists, such as Vija Celmins and her lithographs, drypoints, and woodcuts of the ocean surface dating from 1970 to 2000.[3] Aschheim's focus also can be allied to that of Claude Monet, whose late water lily series records the transient surfaces of the ponds at his country house in Giverny, France. Unlike Monet's series that study the facade of Rouen Cathedral or haystacks in all seasons and all times of day, water adds an additional variable of change. Not only do the light and air change throughout the days and the year, but the surface studied is itself in a constant process of becoming.

In essence, Aschheim has followed the study of the Hudson River to the final stage of realism, which implies the permanence of change and flux within nature. Pure abstraction lies only a step beyond Aschheim's art, a fact that lends a certain edge to her work. The technical beauty, delicacy, and fragility of her graphite works are akin to those of metalpoint drawings by old master artists. Thus, her art resonates with references to the past while being a product of the present and simultaneously suggesting the unending change that is the future.

Since Aschheim believes that the surface of the Hudson "is too complex to see completely," the intricacies of her drawings run parallel to those of the river, producing what she calls a "virtual picture."[4] Therefore, she includes among the subjects of her water drawings of the Hudson River the concept of representation itself—or, rather, "the limitations of representation."[5]

In an interview with the artist, Barbara Weidle asked the following question: "When I was in your studio for the first time, and looked out the window and saw the Hudson River, I thought I knew why you did these water drawings. But as you told me recently they have a lot more to do with Leonardo's water drawings." Aschheim replied:

The drawings really did come from looking at the water. Actually a lot of my work has been influenced by this view, which is a very active landscape. Where you have cars passing, boats passing, birds, planes, people, skaters. And then you also have the wind, and one of the effects of the wind is the waves. Every day I would look at the water and I noticed that it's never the same. The waves are different; their size, frothiness, color, and direction constantly change. And I was thinking about how impossible it is to represent the river. I mean even a photograph isn't adequate because it changes before the second is up. So you don't really have an accurate picture of what the water is. When I made those drawings I was thinking of Leonardo among other artists. What I like about Leonardo is that he looked for the structure in the water. And when I looked for the structure of the water I saw something else—a picture of the virtual volume of the water, a volume that I recreated by drawing the water's undulating plane It's a type of abstraction, making a fluid structure through a composite of many split seconds of viewing. If I am looking at the part closest to me, the part far away is doing something else. When you have that vast an amount of activity you can only capture a certain amount of it. So it depended on how the drawing was going, how much informa-tion I would incorporate. Obviously if I kept going the whole thing would be black, so that at a certain point I would stop.[6]

Aschheim's water drawings take the Hudson River School tradition into the end of the twentieth and the beginning of the twenty-first century while maintaining connections with the past.[7]

1. Communication from the artist, 10 October 2004. Selections from the trio have been exhibited at the Society twice: in the Luce Center Drawing Niche, *From a Woman's Point of View: In Celebration of the Year of the Woman* (2003), and in *New Views: Modern New York Cityscapes* (2004).

2. Conversation with Roberta J. M. Olson, December 2001: "I got the sensitivity originally from Proust who in *Remembrance of Things Past* described how the water is different every day, and how you look at it and it changes. Then [Brice] Marden said 'Water is the hardest thing to draw', when I was at his studio around [19]96 or so. That is when I actually decided to start. And the direct catalyst was when I saw Jasper John's *Tango*, a black drawing (that had nothing to do with water), in the Kramarsky collection and I came home and made my first water drawing a few days later, thinking it was my version of an all-black drawing." The latter part of the quote applies particularly to the first black water drawing in the Pollock Gallery, Southern Methodist University (Eve Aschheim, e-mail message, 24 November 2007).

3. Samantha Rippner, *The Prints of Vija Celmins*, exh. cat. (New York: Metropolitan Museum of Art, 2002), figs. 3, 5, 8, 13, 21, 22, 29, 33, 34.

4. Quoted in Ratcliff, in Galerie Rainer Borgemeister 1999, 59.

5. Ibid.

6. Quoted in Weidle, in Galerie Rainer Borgemeister 1999, 68–69.

7. The Hudson River remains a topical subject for artists; see, for example, John Yau and Thomas Nelson, *The New Response: Contemporary Painters of the Hudson River*, exh. cat. (Albany, N.Y.: Albany Institute of History and Art, 1986).

EDWARD ANDREW ZEGA
Upper Makefield, Pennsylvania 1962–

BERND H. DAMS
Mülheim an der Ruhr, Germany 1963–

Edward Andrew Zega (sometimes known as Andrew Zega) graduated from Princeton University in 1983 with a B.A. degree in English literature and writing. From 1985 to 1987 he worked in publishing in New York City. In 1988 he began his association with Robert A. M. Stern Architects in the city, producing renderings for competitions, client presentations, and publications. Zega also illustrated *The American Houses of Robert A. M. Stern* and a children's book, *The House That Bob Built* (both Rizzoli), and began designing interior furnishings for companies and private clients.

Bernd H. Dams received his Master of Architecture degree from Munich Technical University in 1991. His doctoral thesis, which addressed the genesis of the French château of Marly, was awarded the Friedrich Wilhelm Prize and the Borchers Medal from the Rheinisch-Westfälische Technische Hochschule, Aachen (1998). During the 1980s he worked as an assistant to the directors of the Cooper-Hewitt Museum and the New Museum of Contemporary Art, both in New York, as well as at Christie's in Munich and New York. In 1989 he began a five-year association with Stern as an architectural designer.

Former New Yorkers trained as architects, Zega and Dams met while both were employed at Robert A. M. Stern Architects. In their drawings, the artists combine the conventions of architectural presentation—the use of projected shadow to give three-dimensionality to precisely scaled elevation drawings—with a highly precise watercolor technique. This intense realism—notable in its concern for the quality of light on surfaces and in shadow, the evocation of the texture of materials, and the patina of age—is evident in all their works. Since 1994 they have exhibited their watercolors of historic European garden architecture at Didier Aaron in New York and at Galerie de Bayser in Paris. As most of the structures they render have been destroyed or severely altered, their drawings combine extensive archival research with a thorough knowledge of period architectural practice. They have jointly authored and illustrated three historical books about European architecture and gardens (see Bibliography, below).

Bibliography: Bernd H. Dams and Andrew Zega, *Pleasure Pavilions and Follies in the Gardens of the Ancien Régime* (Paris: Flammarion, 1995); idem, *Garden Vases* (Paris: Alain de Gourcuff, 2000); Andrew Zega and Bernd H.

Dams, *Palaces of the Sun King: Versailles, Trianon, Marly: The Châteaux of Louis XIV* (New York: Rizzoli, 2002).

151. *Wire Trash Basket*, 2003

Black ink and wash, graphite, and watercolor on heavy paper, mounted on foam core; 35 1/2 × 27 7/16 in. (902 × 697 mm)
Verso of foam core inscribed, dated, and signed at center in graphite: *NYC Wire Trash Basket / Central Park / © 2003 EDWARD ANDREW ZEGA / & BERND H. DAMS / EANDREW Zega Bernd Dams*
Provenance: Didier Aaron, New York.
The 20th Century Acquisition Fund, 2004.29

On this large sheet Zega and Dams have rendered the seemingly quotidian wire trash basket manufactured by Corcraft Products as a life-size elevation without the distracting pattern of its back side, to create an iconic and easily legible form. The drawing was made as part of a series the pair created to celebrate the beauty of Central Park's legacy on the occasion of its 150th anniversary. The works—all executed in a realistic technique on a white ground—were presented in an exhibition at Didier Aaron Gallery in New York to honor the park's sesquicentennial in 2003.[1] Most of the other watercolors in the series depict destroyed or altered architectural structures or unrealized projects that date from the park's inception with the Greensward Plan of Frederick Law Olmsted and Calvert Vaux (see cat. 113). All the works exhibited, save one, focused on nineteenth-century architectural details or monuments, the exception being the sculptural *Trash Basket*. Sculpture played a major role in the embellishment of this urban space from its beginning, either in the form of freestanding monuments or as ornament that enriched important structures and the landscape itself. While trash baskets are utilitarian objects, Zega and Dams have isolated this receptacle from its function and demonstrated that it is an elegant object worthy of aesthetic appreciation. It is one of several trash basket models that punctuate Central Park to remind people to preserve the pristine landscape.[2]

While the life-size scale of the meticulously rendered basket lends it the confrontational immediacy of a Pop art object, its exacting delineation contributes to a Minimalist elegance, worthy of the artist Agnes Martin.[3] No doubt this humble object's design harbors

unintentional allusions to Renaissance explorations of perspective, such as the drawings by Paolo Uccello of the linear perspective lines that define the volumes of a chalice and a wooden form around which drapery was wound to create a headdress (*mazzocchio*).[4] These inadvertent similarities add a historical resonance to the sheet that was certainly appreciated by Zega and Dams.

The drawing takes as its model the Standard Expanded Metal Wastebasket (model number MO5539500, black), designed in the early 1980s. Produced by Corcraft Products of the New York State Department of Correctional Services, the receptacle is manufactured by female inmates of the prison in Albion, New York. Unfortunately, neither its designer nor its original design drawings could be located, although the Society has an example of this sentinel of cleanliness that once stood in Central Park near the Conservancy's administration building.[5] Both the object and the drawing by Zega and Dams relate to an important chapter in the history of Central Park: the renascence of this city treasure after decades of neglect. It symbolizes the greening of the civic oasis, reflecting the ecological movement of the late 1970s and 1980s, and provides a window into civic bureaucracy and its patronage of penal system products.

Because of the basket's collapsibility and the large spaces between the mesh, this model of the classic New York trash basket is an endangered species and is slowly being phased out in favor of several redesigned models. Nevertheless, it is still used in Central Park in green areas not accessible to trucks that empty garbage, as well as occasionally on New York City streets. The newer models feature netting of smaller mesh to prevent animals from entering and a stronger reinforced frame to help prevent it from collapsing when emptied.[6]

In their drawing Zega and Dams have preserved for posterity the outline and surface of this rapidly disappearing species of trash basket. By reducing the three-dimensional object to a two-dimensional image, they have created anachronistically a Pop art icon, not without the scintillating optical effects of Op art, as in the work of the artist Bridget Riley.[7]

1. The series was on view 1–24 October 2003.
2. Dams commented about their four-year-long research on the objects they drew for the Didier Aaron exhibition in Wendy Moonan, "Central

Park: A Lost World Lives Anew," *New York Times*, 3 October 2003, sec. E, 38: "We went to all the archival sources—the New-York Historical Society, the Museum of the City of New York, the municipal archives and the Olmsted Association." He also remarked that they selected their subjects for their "graphic power," adding, "Then we took our own measurements, did sketches and photos."

3.　See Barbara Haskell, *Agnes Martin*, exh. cat. (New York: Whitney Museum of American Art, 1992); and Ned Rifkin, *Agnes Martin: The Nineties and Beyond*, exh. cat. (Houston: Menil Collection, in association with Hatje Cantz, 2002).

4.　For Paolo Uccello's drawings, see Francesco Borsi and Stefano Borsi, *Paolo Uccello*, trans. Elfreda Powell (New York: Harry N. Abrams, 1994), 159 and 161, ills.

5.　Inv. no. 2004.24, Gift of the City of New York and the Central Park Conservancy, in metal and black paint, 28 3/4 in. high, 22 1/8 in. diameter at its widest point. Corcraft's 2004 calendar photograph for the month of July featured female inmates manufacturing the model. Each waste receptacle retails at $42, delivered to a loading dock, or $46.20, for inside delivery, as listed in *Corcraft Products: Pricing & Specification Guide* (Albany, N.Y., 2004), 130. Thanks to Douglas Blonsky, President of the Central Park Conservancy,

and Casimir Lazickas, Corcraft Products, for this information.

6.　Currently, park employees line the baskets with plastic garbage bags in hopes of extending the life of what they consider the "most elegant model" of all the metal wastebaskets produced by Corcraft, according to Douglas Blonsky, personal communication, 2004.

7.　See Paul Moorhouse, ed., *Bridget Riley*, exh. cat. (London: Tate Publishers, 2003); and Frances Marie Follin, *Embodied Visions: Bridget Riley, Op Art, and the Sixties* (London: Thames & Hudson, 2004).

MATTEO PERICOLI
Milan, Italy 1968–

Matteo Pericoli, the architect and illustrator whose family roots are in the Marches of northeastern Italy, graduated from the Polytechnic School of Architecture in Milan. After moving to New York City in 1995, he worked at the architectural firm of Richard Meier & Partners until 2000, while also beginning his career as an illustrator. He has published drawings and articles in various newspapers and magazines in both Italy and the United States. Pericoli regularly contributes illustrations to the Italian national newspaper *La Stampa* and publishes as a writer in *L'Unità*. His drawings have been featured in the *New York Times*, *Harper's*, and the *New Yorker*, among others.

Pericoli began working on his two drawings of the West and East Side skylines of Manhattan, *Manhattan Unfurled*, in 1998 after taking a Circle Line boat tour around the island that enabled him to see the city in its entirety and its diversity. Two and a half years and 890 inches of paper later, his two black ink drawings on scrolls were completed. The two original thirty-seven-foot-long drawings were featured in an exhibition at the N-YHS (fall and winter 2001–2) and published as an accordion-format facsimile book. In contrast to the sweeping eight-part panorama of the city drawn by Edward Burckhardt in 1842–45 (cat. 82), Pericoli's two drawings turn that precinematic tradition inside out. Burckhardt's series pans 360 degrees from a fixed point, whereas Pericoli's renderings

circumambulate the entire shoreline of Manhattan. To obtain the views essential for this novel twist on the historic panorama tradition, Pericoli traveled by Circle Line boat, motorcycle, and bicycle through the boroughs of New York City, adjacent New Jersey, and the perimeter of Manhattan itself.

After *Manhattan Unfurled* was published, Pericoli began working on a single, thirty-two-foot-long color drawing of the Manhattan skyline as seen from Central Park looking out (*Manhattan Within*). Again, the drawing was published in an accordion-format facsimile edition, while the work, together with the hundreds of photographs Pericoli used to complete it, were exhibited at the Municipal Art Society in early 2004.

Bibliography: Matteo Pericoli, *Manhattan Unfurled* (New York: Random House, 2001); idem, *Manhattan Within* (New York: Random House, 2003); idem, *See the City: The Journey of Manhattan Unfurled* (New York: Knopf Books, 2004).

152. *Manhattan in a Book*, 2000

Watercolor, brown ink, and gouache on heavy watercolor paper; 7 7/16 × 10 5/16 in. (189 × 262 mm)
Signed and dated at lower right in brown ink: *Mpericoli oo*; verso signed, dated, and inscribed at upper left in graphite: *MATTEO PERICOLI / JULY 2000 / 'MANHATTAN IN A BOOK'*
Gift of Matteo Pericoli, 2001.158

This whimsical watercolor was commissioned by Maria B. Campbell and Associates, Inc., an in-

ternational literary agency that represented the artist, for use as the signature design of its website. It relates directly to the genesis of the obsessive *Manhattan Unfurled* project, showing the fabled skyline of Manhattan in color magically transforming itself into a black ink drawing in a sketchbook. The only trace of the artist is the ink pen propped up against the sketchbook. In essence, the small sheet illustrates the artist's conceptual process for *Manhattan Unfurled*, wherein the skyline literally jumps onto the page. The sheet preserves the transition from the "real" city to the "drawn" one, in which the cityscape metamorphoses into a book.

Since the seventeenth century, artists have responded to the challenge of "imaging" New York City (beginning with cat. 3), a diverse and dense metropolis, in a comprehensive manner. Both *Manhattan Unfurled* and *Manhattan in a Book* relate to a traditional Western artistic problem known since antiquity: how to represent a three-dimensional perspective view on a two-dimensional surface. One of the solutions to the problem, employed in Europe and the United States, was the panorama. Coined in the late eighteenth century, the term derived from two Greek words, *pan* (all) and *horama* (view), and referred to a technical form of topographical landscape composition.[1]

Just as travel broadens one's horizons, Pericoli's drawings crystallize his intense infatuation with Manhattan's skyline. They also

152

relate to the eighteenth-century concept of the horizon, a symbol of hope, alluding to paradise beyond what one can see. During the nineteenth century, America—with its social and religious freedoms, broad geographic expanses, and endlessly inviting horizons—became the Promised Land for many newcomers. *Manhattan Unfurled* and *Manhattan in a Book* can be understood as the recently arrived Italian artist's urbanized, millennial responses to that tradition.

1. See cat. 82; Oetterman 1997; and Bernard Comment, *Panorama*, trans. Anne-Marie Glasheen (London: Reaktion Books, 1999) for bibliography on the history of the panorama.

SHORT REFERENCES

Sources that appear here were cited in three or more entries. Many other publications were used as reference or for background information, which for reasons of space cannot be cited here. Chief among them is Jane Turner, ed., *The Dictionary of Art*, 34 vols. (London: Macmillan Publishers, 2002), at http://www.groveart.com, which was instrumental in compiling the basic bibliographies and biographies of the artists.

Adamson et al. 1985
Adamson, Jeremy Elwell, et al. *Niagara: Two Centuries of Changing Attitudes, 1697–1901.* Exh. cat. Washington, D.C.: Corcoran Gallery of Art, 1985.

Adler, Hirshler, and Weinberg 2006
Adler, Kathleen, Erica H. Hirshler, and H. Barbara Weinberg. *Americans in Paris, 1860–1900.* Exh. cat. London: National Gallery, 2006.

Avery and Kelly 2003
Avery, Kevin J., and Franklin Kelly, eds. *Hudson River School Visions: The Landscapes of Sanford R. Gifford.* Exh. cat. New York: Metropolitan Museum of Art; New Haven: Yale University Press, 2003.

Avery et al. 2002
Avery, Kevin J., et al. *American Drawings and Watercolors in the Metropolitan Museum of Art: Volume I, A Catalogue of Works by Artists Born before 1835.* Exh. cat. New York: Metropolitan Museum of Art, 2002.

Bénézit 2006
Bénézit, Emmanuel, ed. *Dictionary of Artists.* 14 vols. Paris: Gründ, 2006.

Black and Lipman 1966
Black, Mary, and Jean Lipman. *American Folk Painting.* New York: Clarkson N. Potter, 1966.

Brilliant et al. 2006
Brilliant, Richard, et al. *Group Dynamics: Family Portraits and Scenes of Everyday Life at the New-York Historical Society.* Exh. cat. New York: New-York Historical Society, in association with The New Press, 2006.

Carbone et al. 2006
Carbone, Teresa A., et al. *American Paintings in the Brooklyn Museum: Artists Born by 1876.* 2 vols. Brooklyn: Brooklyn Museum, in association with D Giles Limited, London, 2006.

Carr and Gurney 1993
Carr, Carolyn Kinder, and George Gurney. *Revisiting the White City: American Art at the 1893 World's Fair.* Exh. cat. Washington, D.C.: National Museum of American Art and National Portrait Gallery, Smithsonian Institution, 1993.

Cowdrey 1943
Cowdrey, Mary Bartlett. *National Academy of Design Exhibition Record, 1826–1860.* 2 vols. New York: New-York Historical Society, 1943.

DAB
Dictionary of American Biography. 22 vols. New York: Charles Scribner's Sons, 1928–58.

Deák 1988
Deák, Gloria Gilda. *Picturing America, 1497–1899: Prints, Maps, and Drawings Bearing on the New World Discoveries and on the Development of the Territory That Is Now the United States.* 2 vols. Princeton: Princeton University Press, 1988.

Deák et al. 1988
Deák, Gloria Gilda, et al. *William James Bennett: Master of the Aquatint View.* Exh. cat. New York: New York Public Library, 1988.

Dearinger 2004
Dearinger, David B., ed. *Paintings and Sculpture in the Collection of the National Academy of Design: Volume I, 1826–1925.* New York and Manchester, Vt.: Hudson Hills Press, 2004.

Diamonstein 1998
Diamonstein, Barbaralee. *The Landmarks of New York III.* New York: Harry N. Abrams, Publishers, 1998.

Falk 1999
Falk, Peter Hastings. *Who Was Who in American Art: 1564–1975: 400 Years of Artists in America.* 3 vols. Madison, Conn.: Sound View Press, 1999.

Ferber and Gerdts 1985
Ferber, Linda S., and William H. Gerdts. *The New Path: Ruskin and the American Pre-Raphaelites.* Exh. cat. Brooklyn: Brooklyn Museum, 1985.

Fink 1990
Fink, Lois Marie. *American Art at the Nineteenth-Century Paris Salons.* Washington, D.C.: National Museum of American Art, Smithsonian Institution; Cambridge: Cambridge University Press, 1990.

Foshay and Novak 2000
Foshay, Ella M., and Barbara Novak. *Intimate Friends: Thomas Cole, Asher B. Durand, and William Cullen Bryant.* Exh. cat. New York: New-York Historical Society, 2000.

Groce and Wallace 1957
Groce, George C., and David H. Wallace. *The New-York Historical Society's Dictionary of Artists in America, 1564–1860.* New Haven: Yale University Press, 1957.

Harvey 1998
Harvey, Eleanor Jones. *The Painted Sketch: American Impressions from 1830–1880.* Exh. cat. Dallas: Dallas Museum of Art, 1998.

Hudson River Museum 1983
The Hudson River Museum. *Asher B. Durand: An Engraver's and a Farmer's Art.* Exh. cat. Yonkers, N.Y.: Hudson River Museum, 1983.

Jeffares 2006
Jeffares, Neil. *Dictionary of Pastellists before 1800.* London: Unicorn Press, 2006.

Koke 1961
Koke, Richard J. *A Checklist of the American Engravings of John Hill (1770–1850), Master of Aquatint, Together with a List of Prints Colored by Him and a List of His Extant Original Drawings.* New York: New-York Historical Society, 1961.

Koke 1982
Koke, Richard J. *American Landscape and Genre Paintings in The New-York Historical Society.* 3 vols. New York: New-York Historical Society; Boston: G. K. Hall & Co., 1982.

Kornhauser 1996
Kornhauser, Elizabeth Mankin. *American Paintings before 1945 in the Wadsworth Atheneum.* 2 vols. Hartford, Conn.: Wadsworth Atheneum; New Haven; Yale University Press, 1996.

Lane 1993
Lane, Christopher W. *Impressions of Niagara: The Charles Rand Penny Collection of Prints of Niagara Falls and the Niagara River from the Sixteenth to the Early Twentieth Century.* Exh. cat. Philadelphia: Philadelphia Print Shop, 1993.

Lawall 1966
Lawall, David B. "Asher Brown Durand: His Art and Art Theory in Relation to His Times." 4 vols. Ph.D. diss., Princeton University, 1966.

Mayhew and Myers 1980
Mayhew, Edgar de Noailles, and Minor Myers Jr. *A Documentary History of American Interiors:*

From the Colonial Era to 1915. New York: Charles Scribner's Sons, 1980.

McKinsey 1985
McKinsey, Elizabeth. *Niagara Falls: Icon of the American Sublime*. Cambridge: Cambridge University Press, 1985.

Miles 1994
Miles, Ellen G. *Saint-Mémin and the Neoclassical Profile Portrait in America*, edited by Dru Dowdy. Washington, D.C.: National Portrait Gallery and the Smithsonian Institution Press, 1994.

Myers 1987
Myers, Kenneth J. *The Catskills: Painters, Writers, and Tourists in the Mountains, 1820–1895*. Exh. cat. Yonkers, N.Y.: Hudson River Museum, 1987.

Myers 1990
Myers, Kenneth J. "Selling the Sublime: The Catskills and the Social Construction of Landscape Experience in the United States, 1776–1876." 2 vols. Ph.D. diss., Yale University, 1990.

Naylor 1973
Naylor, Maria, ed. *The National Academy of Design Exhibition Record, 1861–1900*. 2 vols. New York: Kennedy Galleries, 1973.

N-YHS 1941
New-York Historical Society. *Catalogue of American Portraits in The New-York Historical Society*. New York: New-York Historical Society, 1941.

N-YHS 1974
New-York Historical Society. *Catalogue of American Portraits in The New-York Historical Society*. 2 vols. New York: New-York Historical Society; New Haven: Yale University Press, 1974.

N-YHS 2000
The New York Historical Society. *Perspectives on the Collections of The New-York Historical Society: The Henry Luce III Center for the Study of American Culture*. New York: New-York Historical Society, 2000.

Nygren et al. 1986
Nygren, Edward J., et al. *Views and Visions: American Landscape before 1830*. Exh. cat. Washington, D.C.: Corcoran Gallery of Art, 1986.

Oetterman 1997
Oetterman, Stephen. *The Panorama: History of a Mass Medium*, translated by Deborah Lucas Schneider. New York: Zone Books, 1997.

Olson 2003
Olson, Roberta J. M. "Le montagne nella pittura americana dove giungono ispirazioni e opportunità dal sublime attraverso la dottrina del 'Manifest Destiny.'" In Gabriella Belli, Paola Giacomoni, and Anna Ottani Cavina, eds., *Montagna. Arte, scienza, mito da Dürer a Warhol*. Exh. cat. Trento and Rovereto: Museo di Arte Moderna e Contemporanea di Trento e Rovereto; Milan: Skira, 2003, 189-201.

Olson 2004
Olson, Roberta J. M. "One of the Best-Kept Secrets: The Drawings Collection of the New-York Historical Society," *Master Drawings*, 42:1 (2004): 19–36.

Olson 2005
Olson, Roberta J. M. "John Singer Sargent and James Carroll Beckwith, Two Americans in Paris: A Trove of Their Unpublished Drawings," *Master Drawings* 43:4 (2005): 415–39.

Ormond and Kilmurray 1998
Ormond, Richard, and Elaine Kilmurray. *John Singer Sargent: Complete Paintings*. Vol. 1. *The Early Portraits*. New Haven: Published for The Paul Mellon Centre for Studies in British Art by Yale University Press, 1998.

Ormond and Kilmurray 2006
Ormond, Richard, and Elaine Kilmurray. *John Singer Sargent: Complete Paintings*. Vol. 4. *Figures and Landscapes, 1874–1882*. New Haven: Published for the Paul Mellon Centre for Studies in British Art by Yale University Press, 2006.

Philip 1985
Philip, Cynthia Owen. *Robert Fulton: A Biography*. New York: Franklin Watts, 1985.

Priddy 2004
Priddy, Sumpter, III. *American Fancy: Exuberance in the Arts, 1790–1840*. Exh. cat. Milwaukee, Wisc.: Chipstone Foundation, 2004.

Ramirez 2000
Ramirez, Jan Seidler, ed. *Painting the Town: Cityscapes of New York*. Exh. cat. New York: Museum of the City of New York, 2000.

Reed 2001
Reed, Walt. *The Illustrator in America 1860-2000*. New York: The Society of Illustrators, 2001.

Rossiter 1962
Rossiter, Henry P. *M. & M. Karolik Collection of American Water Colors and Drawings, 1800–1875*. 2 vols. Boston: Museum of Fine Arts, 1962.

Shelley 2002
Shelley, Marjorie. "The Craft of American Drawing: Early Eighteenth to Late Nineteenth Century." In Kevin J. Avery et al., *American Drawings and Watercolors in the Metropolitan Museum of Art: Volume I, A Catalogue of Works by Artists Born before 1835*. Exh. cat. New York: Metropolitan Museum of Art; New Haven: Yale University Press, 2002, 28–78

Stebbins 1976
Stebbins, Theodore E., Jr. *American Master Drawings and Watercolors: A History of Works on Paper from Colonial Times to the Present*. New York: Harper & Row Publishers, 1976.

Stokes 1915–28
Stokes, Isaac Newton Phelps. *The Iconography of Manhattan Island, 1498–1909*. 6 vols. New York: R. H. Dodd, 1915–28.

Stokes and Haskell 1932
Stokes, Isaac Newton Phelps, and Daniel C. Haskell. *American Historical Prints, Early Views of American Cities, etc. from the Phelps Stokes and Other Collections*. New York: New York Public Library, 1932.

Valentine's Manual 1856
Valentine, David Thomas. *Manual of the Corporation of the City of New York*. 28 vols. New York: Printed by order of the Common Council, 1841–70.

Voorsanger and Howat 2000
Voorsanger, Catherine Hoover, and John K. Howat, eds. *Art and the Empire City: New York, 1825–1861*. Exh. cat. New York: Metropolitan Museum of Art; New Haven: Yale University Press, 2000.

Weinberg 1991
Weinberg, H. Barbara. *The Lure of Paris: Nineteenth-Century American Painters and Their French Teachers*. New York: Abbeville Press Publications, 1991.

Wilton and Barringer 2002
Wilton, Andrew, and Tim Barringer. *American Sublime: Landscape Painting in the United States, 1820–1880*. Exh. cat. London: Tate Britain, 2002.

INDEX